Here is a kaleidoscopic assemblage and poetic history of New York: an unparalleled and original homage to the city, composed entirely of quotations. Drawn from a huge array of sources—histories, memoirs, newspaper articles, novels, government documents, emails—and organized into interpretive categories that reveal the philosophical architecture of the city, <u>Capital</u> is the ne plus ultra of books on the ultimate megalopolis.

It is also a book of experimental literature that transposes Walter Benjamin's unfinished magnum opus of literary montage on the modern city, <u>The Arcades Project</u>, from 19th-century Paris to 20th-century New York, bringing the streets to life in categories such as "Sex," "Commodity," "Downtown," "Subway," and "Mapplethorpe."

<u>Capital</u> is a book designed to fascinate and to fail—for can a megalopolis truly be written? Can a history, no matter how extensive, ever be comprehensive? Each reading of this book, and of New York, is a unique and impossible passage.

Capital

KENNETH

GOLDSMITH

New York: Capital of the 20th Century

First published by Verso 2015
Kenneth Goldsmith 2015

1 3 5 7 9 10 8 6 4 2

Verso
UK: 6 Meard Street, London W1F 0EG
US: 20 Jay Street, Suite 1010, Brooklyn, NY 11201
www.versobooks.com

Verso is the imprint of New Left Books

ISBN-13: 978-1-78478-156-9 (HC)
eISBN-13: 978-1-78478-157-6 (US)
eISBN-13: 978-1-78478-158-3 (UK)

British Library Cataloguting in Publication Data
A catalogue record for this book is available from the British Library

Library of Congress Cataloging-in-Publication Data

Goldsmith, Kenneth, compiler.
 Capital / Kenneth Goldsmith.
 pages ; cm
 ISBN 978-1-78478-156-9 (hardcover : acid-free paper)—ISBN 978-1-78478-157-6
 (US : acid-free paper)—ISBN 978-1-78478-158-3 (UK : acid-free paper)
 1. New York (N.Y.)—Quotations, maxims, etc. 2. Quotations, English.
 3. Quotations. I. Title.
 PN6084.N38G65 2015
 974.7'1—dc23
 2015019932

Typeset in Century Old Style by MJ & N Gavan, Truro, Cornwall
Page design by Neil Donnelly, Brooklyn, NY
Printed in the US by Maple Press

For Doovie & Boog

Facilis descensus Averno;
Noctes atque dies patet atri ianua Ditis;
Sed revocare gradum superasque evadere ad auras,
Hoc opus, hic labor est.

Virgil, *Aeneid*

Contents

Part 1

Allen and Brickman,
Manhattan, p. 1

Chapter One. He adored New York City. He idolized it all out of proportion. Uh, no, make that, he-he … romanticized it all out of proportion. Now … to him … no matter what the season was, this was still a town that existed in black and white and pulsated to the great tunes of George Gershwin. Ahhh, no, let me start this over. Chapter One. He was too romantic about Manhattan as he was about everything else. He thrived on the hustle-bustle of the crowds and the traffic. To him, New York meant beautiful women and street-smart guys who seemed to know all the angles. Nah, no … corny, too corny … for … my taste … I mean, let me try and make it more profound. Chapter One. He adored New York City. To him, it was a metaphor for the decay of contemporary culture. The same lack of individual integrity to cause so many people to take the easy way out … was rapidly turning the town of his dreams in—No, it's gonna be too preachy. I mean, you know … let's face it, I wanna sell some books here. Chapter One. He adored New York City, although to him, it was a metaphor for the decay of contemporary culture. How hard it was to exist in a society desensitized by drugs, loud music, television, crime, garbage. Too angry. I don't wanna be angry. Chapter One. He was as tough and romantic as the city he loved. Behind his black-rimmed glasses was the coiled sexual power of a jungle cat. I love this. New York was his town. And it always would be.

Preface

Brook, p. 53	Enough leeks to coat all Fifth Avenue with vichyssoise.
Conrad, p. 316	A Good Humor bar gooily obstructing Park Avenue.
Berger, *Eight Million*, p. 164	A violin crafted from wood from an old house in Elizabeth Street.
Conrad, p. 203	The Library lions refuse any longer to guard people who believe that wisdom lies in books and vow that they'll repatriate themselves to Africa, "where there is still some freedom."
Ibid., p. 169	The statue of Father Duffy in Times Square, mummified on his pedestal by a shroud of plastic sheeting, bundled in his sacking against his cross, against a sky of streaming neon and balletic peanuts.
Federal Writers, *Panorama*, p. 407	When the south tube of the Lincoln Tunnel was officially opened on December 12, 1937, it had already been sanctified by the legend that its glass roof was intended to give travelers a good view of the fishes in the North River.
Talese, p. 48	On Sutton Place a man fishes out his eighteenth-story window for eels.
Atkinson, p. 229	If it were blood pouring out of the hydrants, would people stanch the flow?
Mitchell, *Ears*, p. 189	A naked butcher on a roof in Hester Street.
Barnes, *New York*	Dogs wag their tails up and down instead of sideways in the Flatiron Building.
Bennett, *Deconstructing*, p. 41	Sea monkeys from a curio shop peddling twentieth-century Americana, and these sea monkeys mutate into King Kong–sized jumbo shrimp that almost destroy the futuristic city of New New York.
Koolhaas, p. 15	An urban science fiction.
Conrad, p. 174	A thick-hipped and swollen-breasted nude ignores the snow on the Museum of Modern Art courtyard, tilting her pelvis at the muffled landscape.
Ibid.	Cloud-descended, these Venuses in transit between the sky and the streets land on the city's rooftops.
Sanders, *Celluloid*, p. 279	What is a ship, in fact, but the great skyscraper turned upon its side and set free?
Steele, p. 26	Los Angeles is just New York lying down.
Williams, *Collected*, p. 187	skyscrapers filled with nut-chocolates
Powell, p. 12	An evening up on the Empire State roof—the strangest experience. The huge tomb in steel and glass, the ride to the eighty-fourth floor and there, under the clouds, a Hawaiian string quartet, lounge, concessions and, a thousand feet below, New York—a garden of golden lights winking on and off, automobiles, trucks winding in and out, and not a sound. All as silent as a dead city—it looks *adagio* down there.
Didion, "Goodbye," pp. 168–77	The Seagram Building fountains dissolve into snowflakes, I enter a revolving door at twenty and come out a good deal older.

The buildings, as conceived by architects, will be cigar boxes set on end.

White, *Here*, p. 55

Dalí's New York is a laboratory of intensified entropy, where things become surreal in a thermodynamic malaise.

Conrad, p. 146

One of Oldenburg's 1965 projects was an ironing board, canopying the Lower East Side. The board replicates the shape of Manhattan and with its shadow blesses the former ghetto. Its baldachin testifies to the "million miles of devoted ironing" done beneath it by immigrant mothers sprucing up their offspring.

Ibid., p. 318

He would love to pad Central Park and the slope of Park Avenue with green baize, in homage to the grass of the former and the merely titular vegetation of the latter, and to use them as pool tables. Colored balls would be sent bumping through the park to roll down the declivity of the avenue. They'd be collected at Grand Central and shipped back uptown on the underground railroad tracks. At 96th Street they'd pop into view again, ready to resume the game.

N. cit.

Christo during the 1960s planned the packaging of three New York buildings, 2 Broadway, 20 Exchange Place, and the Allied Chemical Tower in Times Square.

Conrad, p. 312

Bill told me he had been walking uptown one afternoon and at the corner of 53rd and 7th he had noticed a man across the street who was making peculiar gestures in front of his face. It was Breton and he was fighting off a butterfly. A butterfly had attacked the Parisian poet in the middle of New York.

Denby and Cornfield, p. 3

Breton continued to live in New York City; he remained totally French, untouched by his residence in America, almost as though he had never left Paris.

Myers, p. 37

As reality goes into hiding in the prudish city, realism becomes an illicit art. Sometimes Marsh was denied permission to sketch in the burlesque houses, so he taught himself to scribble on paper concealed in his pocket.

Conrad, p. 97

He wishes that some aesthetic tyrant would make amends for the grayness of New York by decreeing that all the avenues be painted in contrasting colors.

Ibid., pp. 139–40

The patterning of tracks in Washington Square after a blizzard is decorative rondure.

Ibid., p. 175

Surreal New York is a pornotopia, a jungle of regression or an infirmary of the psychologically maimed.

Ibid., p. 142

Invading New York, the modernists put it through a succession of iconographic torments. It's demolished by the cubists, electrified by the futurists, sterilized by the purists. Cubism piles up New York's architectural building blocks only to capsize them. Surrealism carnivorously interprets its stone and steel as flesh, of which it makes a meal. Inside the body, the surrealist city rots; purism arrests that fate by setting its temperature at a sanitary degree zero. But the radical muralists, unrelenting, inscribe on the city's walls a prophecy of doom.

Ibid., p. 127

Tex Rickard built a giant swimming pool in Madison Square Garden in 1921. The giant white-tiled pool was 250 feet long by 100 feet wide, two-thirds the

Aycock and Scott, p. 137

size of a football field. The water tank held 1,500,000 gallons of water. The ends of the pool had a depth of three feet and sloped to the center for a depth of fifteen feet, an area that served amateur and professional swim and dive competitions on Thursday evenings. A cascading waterfall was incorporated into the design at one end.

Conrad, p. 291

On the side of a blazing warehouse is a proud advertisement for the food products manufactured therein: "SIMPLY ADD BOILING WATER." And the fire occurs, to make the joke even crueler, on Water Street.

Sanders, *Celluloid*, p. 284

Astronauts from the future discover that the mysterious world on which they have landed actually sits atop a post-apocalyptic New York—the ruined Grand Central has become the temple for a future race; a wide, double staircase serves as the altar. Like Luthor's lair, this set is not a reconstruction of the real building, but a rather free interpretation that takes advantage of the enormous familiarity of the station's design, manifested in details as simple as the shape of an arch or a style of lettering. In such details resides Grand Central's power as an almost universally recognizable "place," even as it offers a superb springboard for fantasy. How many other structures could be so universally identified by a few fragments of their graphics?

Crane, *Active*, p. 32

Stephen Crane's description of the sensation of riding in an elevator, written in 1899: "The little cage sank swiftly; floor after floor seemed to be rising with marvelous speed; the whole building was winging straight into the sky."

Haden, p. 49

Transference of night imaginations to the daytime world—a way of forcing the impressions gained on the radically changed night streets back upon the "real" world.

Conrad, p. 207

The city is a built dream, a vision incarnated. What makes it grow is its image of itself.

Stern, p. 55

I am going to carry my bed into New York City tonight
complete with dangling sheets and ripped blankets;
I am going to push it across three dark highways.

Pomerance, p. 3

A dream, not a place.

Kozloff

These New Yorkers are often shunted to the margins of a spectacle that is half like a poster and half like a dream. They exist in an urban-scape made up of just bits and pieces that have little in common but their amputation by the frame.

Weegee, *Naked*, p. 20

Sleep ... is where you find it. But the other fire escape is somewhat overcrowded ... it's not so bad sleeping that way ... except when it starts to rain ... then back to the stuffy tenement rooms.

McCourt, p. 79

Both Kansas and Oz, both black-and-white and technicolor, with wicked witches on both sides of town, and good ones too, showing up in bubbles every so often—if you know how to blow them.

Riesenberg and Alland, p. 13

Battery Park, the rendezvous of dreams.

Ibid., p. 206

Absent-minded city of unconscious revelations in our mental age of the nightjar and the candle.

A Dream City

I stopped in this restaurant down on 2nd Avenue, sat at the counter for a moment and ordered a cup of coffee, feeling kind of warm and happy, the remnants of some dream from that morning still in my head.

Wojnarowicz, p. 187

There were tracks of iron stalking through the air, and streets that were as steep as canyons, and stairways that mounted in vast flights to noble plazas, and steps that led down into deep places where were, strangely enough, underworld silences. And there were parks and flowers and rivers. And then, after twenty years, here it stood, as amazing almost as my dream, save that in the waking the flush of life was over it. It possessed the tang of contests and dreams and enthusiasms and delights and terrors and despairs. Through its ways and canyons and open spaces and underground passages were running, seething, sparkling, darkling, a mass of beings such as my dream-city never knew.

Dreiser, p. 1

Here, in this ever renewed dreamland of the city, the comic-book shadows and cinematic styles of 1930s Manhattan are always present, always available, beckoning us to a mythical past.

Kingwell, p. 200

Cinema

A thousand movie screens flickered in New York from morning to midnight.

Jones, *Dynamite*, p. 200

Wandering through the souk of the Lower East Side, you could find the Palestine, the Florence, the Ruby, and the Windsor (among many others, most of which were nicknamed The Itch); they, too, died, driven into the Lost City with the great Yiddish theaters: the Grand, the Orpheum, the Yiddish Arts. Out in Queens, around 165th Street, the Loew's Valencia closed, along with the Alden, the Merrick, the Jamaica, the Savoy, and the Hillside. On East 14th Street in Manhattan, there was a place called the Jefferson, where we went to see the Spanish movies and vaudeville acts, improbably trying to learn the language from Pedro Infante and Jorge Negrete, lusting for Sarita Montiel, laughing at the comedy of Johnny El Men, while ice-cream vendors worked the aisles. Gone. In Times Square, the Capitol disappeared, the Roxy, the Criterion, the Strand. The Laffmovie on 42nd Street played comedies all day long, but now, where Laurel and Hardy once tried to deliver Christmas trees, the movies are about ripped flesh. Who now can verify the existence of the old Pike's Opera House on 23rd Street and Eighth Avenue (converted first to vaudeville and then to movies after the Metropolitan Opera established itself at 39th Street and Broadway)? It was torn down to make way for the ILGWU houses, thus eradicating the building where Jay Gould once had his office and where Fred Astaire learned to dance. And most astonishing and final of all, the Paramount itself was murdered in its sleep.

Hamill, "Lost"

You should not begin with the city and move inwards to the screen; you should begin with the screen and move outwards to the city.

Baudrillard, *America*, p. 56

The view of Manhattan's skyline emerging, walking on the Brooklyn Bridge to Manhattan: However far the stranger has come to see this view, he will almost certainly feel that it has been somewhere in his background for most of his life, courtesy of the cinema or (as likely) the television screen.

Moorhouse, p. 19

When they shoot, no one dies. The Pop city is becoming a kindergarten.

Conrad, p. 310

Sanders, *Celluloid*, p. 67
From a brownstone wall to carved wood paneling to a limestone facade. Dozens of these panels stood drying outside the shop, awaiting the artful painting that would assure their verisimilitude. The thick plantings of a soundstage Central Park—either real or, more likely, artificial—could be provided by the nursery's greensmen; the enormous plate-glass windows of a mythical Fifth Avenue department store readily supplied by the studio glazier. The Chinese or Yiddish store signage that graced the Lower East Side's streets were no challenge for artisans of the paint-splattered sign shop, while the lacy ironwork of a Gramercy Park balcony was probably not iron at all but inexpensive "pot" metal, cast from a plaster original produced in the high, glassy sculptor's studio.

Ibid., p. 199
With lobby, elevator, and hallway behind us, we at last open the door and enter the apartment itself—and therein find the single most familiar interior in New York movies. As in the real city, where apartments are by far the most common kind of domestic interior, the movie apartment long ago became the standard setting for middle-class New York life, the background of hundreds upon hundreds of films.

With its relatively simple and standardized layouts, the movie apartment's importance has often been less a space in itself than the neutral canvas for a decorating scheme bent upon revealing its occupant's personality.

Ibid., p. 143
"New York Street"—half a dozen can be found around today's Los Angeles: at the height of the studio era, six decades, almost twenty such "streets" stood around Southern California, on lots large and small, celebrated and obscure.

Ibid., pp. 143–5
Brick facades and brownstone stoops, canvas awnings and fire hydrants and street lamps evoke a New York that is, if anything, a little *too* real, even brick popping out with intense clarity. But soon discrepant details start to creep in, like the strange incongruities of real dramas. There are few people, no traffic, and a very un–New York sense of quiet. Through the upper windows can be glimpsed not bedrooms, but snatches of blue sky. Views of good-sized hills and, yes, snow-peaked mountains appear beyond the building cornices. As in a dream, these peculiar details hint at something about the experience we are having (something, in fact, we already know).

But meanwhile the street continues to beckon, encouraging us to stay within its surreal confines. At the end of the block we spot another street, crossing ours. We turn the corner and find ourselves on a new street, somewhat different in style and mood but still plainly part of the same city. Ahead there is another intersection, and another block; by now we realize that the term "New York Street" is something of a misnomer: this is not one street but many, an entire matrix of streets, in fact, meeting at odd angles and T-shaped intersections and spreading over several acres.

Eventually, however, we wander a few steps too far, and catch sight of the buildings from the back—only to be instantly confronted by the secret they tried so hard to keep: that they are not buildings at all, but merely false fronts, propped up with bracing. Nothing could be farther from the conscious urban clarity of the façades than this behind-the-scenes thicket of raw lumber. The front doors and entries, so prominent from the sidewalk, are from here hardly visible, leading not to actual parlors or lobbies but, we now see, to vestibules just big enough for an actress to kiss the leading man goodnight before scampering down the steps and onto the next scene. Behind the upper-floor windows, meanwhile, are narrow platforms stretched below the sills, allowing grips and stagehands to install curtains or flower pots, or rig lights, or cover the windows with sheets of non-reflective cloth, called duvetyn, to

keep the sky from poking through and destroying the illusion. And no matter what elaborate materials are implied up front—granite, limestone, brick— from behind it is plain that these "buildings" are all made of the same stuff: plywood sheets, overlaid with molded veneers of plaster staff or fiberglass. This is a street just inches thick.

It has always been thus, ever since Hollywood first started reconstructing New York on a large scale in the early 1920s. To do so, the city's urban fabric had to be sliced in two—the outer layer of its buildings neatly sheared away from the interiors, which were shot inside enclosed soundstages, some distance away. The reason lay in part with the nature of film stock itself, which responds very differently to natural and artificial light: the higher "color temperature" of the sun's light makes it difficult to blend with that of electric lamps. From this technical constraint arose an entire production strategy, separating the movie city's exterior skins from everything else. Lacking any internal structure, the "buildings" of New York Street formed a membrane-like container, a vessel of space that encompassed only the public, outdoor life of the city—a reality with some provocative implications of its own.

Night scenes on the New York Street were rarely filmed after dark, when expensive overtime provisions would be in effect, but during the day, with sections of street darkened by black tarpaulins stretched from timber frameworks rising above the facades on either side. The result was an almost surreal sight: a cocoon-like enclosure, blocking out the bright sun of a California day to create a sleek, velvety Manhattan night. *Ibid.*, pp. 176–7

[...]

In this light, it was worth taking a last look at the New York Street itself, still standing in the California sun. For clearly it was a place with its own distinctive reality, less a copy of the real city than a vigorous interpretation. This was especially true of its layout, more picturesque than the notoriously rectilinear Manhattan street grid, where except for a few blocks in Greenwich Village and another couple near Wall Street, the streets are arrow-straight, flying off into infinity. The blocks of Hollywood's New York Street, by contrast, had a gentle bend midway in their length, or met each other in T-shaped intersections very unlike the real city. Though the effect may have been picturesque, the motivation was anything but: bending the street, or having it intersect another, served to close down the vista and eliminate the need for expensive additional streets trailing into the distance.

The curious result, evident in countless films, was to give a distinctly small-town scale to one of the world's largest cities. In doing so, the filmic street illustrated one of the more surprising characteristics of New York: that what outsiders see as endless stretches of avenue actually break down for residents into small overlapping neighborhoods, each just a few blocks in size and encompassing the shops and services of daily life. The New York Street's great conceit, that it could condense the urbanism of the sprawling metropolis into a few blocks, thus made manifest what most New Yorkers know to be the truth, that their "city" does in large part consist of the few blocks around them.

The apartments all had to be separately wired to allow their lights to be switched or off individually, as they would in a real city. A subtle lighting design was required to ensure that the apartment interiors did not appear artificially bright, like shop windows, when seen from outside. And the huge space of the courtyard itself had to be bathed in the glare of a summer day. *Ibid.*, p. 237

Ibid., pp. 58–9

Los Angeles's horizontal endlessness … would be avenged by movie New York's overwhelming verticality. If the real New York had many tall buildings, it had plenty of low ones as well, especially in its outer boroughs and residential districts. But the dream city would seem to be all vertical, every scene playing in a penthouse, on a terrace, in a rooftop nightclub, every window looking onto a glittering view of rising towers.

Los Angeles's sleepy boulevards, meanwhile, would be retaliated against with an imaginary New York street life that surpassed almost anything the real city could offer. The lowliest side-street would have scores of pedestrians rushing purposefully across the frame; dozens more sat on stoops and played on the sidewalk. The quiet landscape of Los Angeles's bungalows or the orange groves of the San Fernando Valley would be shattered by the backlot cries of the Italian hurdy-gurdy man, the Irish cop, the Jewish pushcart vendor, as if packing, by scripted instruction, all of New York's human diversity onto a single block. And on these streets, leading men and women would constantly bump into one another, chance encounters that not only served the needs of the plot—but worked to demonstrate how a real city worked.

With the twilight, imagination took a special leap. The dream city would burn most brightly after dark, would indeed seem to live by night, as if to exorcise Los Angeles's dreary early-to-bed puritanism. The rain-slicked streets, the bright glow of the theaters as audiences spilled out, the warm interiors of the supper clubs, the sequence of overlapping neon signs ("Panorama Club," "Casino Moderne," "Café Intime") that signified a romantic dusk-to-dawn, all these would feed the projected fantasies of the ex–New Yorkers. The movement, by turns languid and urgent, of the *demimondaine* through a nocturnal cocoon of dark, slick exteriors and luminous interiors would give movie New York its most dreamlike aspect.

The characters moving through these evenings, walking these streets, surveying this skyline from its upper precincts were in some sense the greatest creation of all: idealized "New Yorkers," polished and elegant, or exquisitely rough-hewn, and equipped with all the wit and style that had once graced the Round Table and its like. In these filmic New Yorkers—Cary Grant and Katharine Hepburn, Fred Astaire and Ginger Rogers, Myrna Loy and William Powell, Jimmy Cagney and Bette Davis—the style of Café Society was wed to the verbal agility of the Algonquin crowd to create an elite worthy of populating the impossibly grand city that the writers were inventing. As Pauline Kael has noted, apropos of one of the greatest of these "New Yorkers": "Sitting out in Los Angeles, the expatriate New York writers projected their fantasies of Eastern connoisseurship and suavity. Los Angeles itself has never recovered from the inferiority complex that its movies nourished, and every movie-going kid in America felt that people in New York were smarter, livelier, and better looking than anyone in his hometown. There were no Cary Grants in the sticks. He and his counterparts were to be found only in the imaginary cities of the movies."

Ibid., p. 63

If shooting the real city was impossible, Hollywood would simply rebuild New York.

Ibid., pp. 66–7

Tall file cabinets bulged with thousands of special photographs of New York, taken by crews regularly sent back East to shoot parts of the city for a specific film or to supplement the general collection. They recorded everything, from the broadest skyscraper views to the homeliest details of streets and sidewalks, creating a file-cabinet panorama that comprised one of the most exhaustive urban portraitures ever realized.

Many of the collection's images were prosaic, at least when looked at individually. But they gained a kind of cumulative power from the sheer volume with which they were assembled. Nothing was beneath the studio's notice, not even the humblest elements of the civic landscape: the lampposts, fire hydrants, police call-boxes, street signs, and manhole covers that constituted New York's municipal "street furniture," even down to the granite Belgian blocks that gave the street bed its distinctive cobbled texture. Other views showed the various building fronts that lined the city's streets: the awnings and show windows of department stores, the classically carved names over the entrances to banks and office buildings, the elegant stenciled lettering on the glazed storefronts of *modistes* and jewelry shops. The images sought to catalog every element of the urban landscape, both inside and out: the riveted columns and ornate staircases of the El; the benches, water fountains, and statuary of Central and Bryant Parks; the canopies, taxi lights, and uniformed doormen of Park Avenue apartment houses. And onward, through hotel lobbies and elevator cabs, bars and restaurants, tenement hallways and the observation deck of the Empire State Building. Probably never has any living city been documented quite so obsessively, in thousands of sharp, large-format photographs carried across a continent to be assembled, labeled, and filed into an encyclopedic collection, all for the purpose of rebuilding any and every portion of it on a moment's notice.

Against shooting on location in New York. Studio telegram to director hoping to shoot in NYC: A TREE IS A TREE, A ROCK IS A ROCK, SHOOT THE PICTURE IN GRIFFITH PARK. *Ibid.*, p. 332

This being Manhattan, a totally made-over rock with barely a patch of what is natural left upon it, it is taken for granted that what does not exist can spontaneously be created. *Ibid.*, p. 143

Rosalind Russell: "I had the same set in I don't know how many pictures! Ten or fifteen!! The opening shot was always an air shot over New York. Then it would bleed into my suite of offices on the fortieth floor of Radio City. Out of the window behind me was always a view of the Empire State Building, in order to identify the setting. I used to say to cameraman Joe Walker, 'Joe, where was the Empire State Building in the last picture?' He would say, 'I had it a little to the left.' I'd say, 'Well, this time throw it over to the right.'" *Ibid.*, p. 62

Hitchcock quietly sitting between takes of *Rear Window* in different spots around the set, as if to more fully enjoy the "city" he had brought into being. *Ibid.*, p. 238

The year of *Rear Window*'s release, 1954, also marked the construction of a landmark in postwar urban design: the Pruitt-Igoe Houses in St. Louis, a design similar to most postwar housing developments across the country. A series of freestanding slabs poised in open space, it offered no hierarchies at all outside the apartment door. There were no rear windows at Pruitt-Igoe. Or front windows, for that matter. Every window was the same. Everything existed in a field of open space, equal to everything else. As an expression of the professional understanding of cities at the time, it represented what can only be described as a profound impoverishment of urban vision, a broad failure of imagination that transcended this particular project's notorious social failure, which resulted in its state-sponsored destruction by dynamite, two decades later. *Ibid.*, p. 241

Ibid., p. 330	*The Naked City* (1948): the first feature shot on location in New York since the late 1920s … two hundred thousand New Yorkers turned out to watch the camera crews; at one point the producers turned to a professional juggler to help distract the crowds while the actual shooting was completed.
Trager, p. 430	Unable to find a suitable freestanding tenement on the Lower East Side, the designer for *batteries not included* (1987) and his crew spent ten weeks constructing a four-story exterior set on a bombed-out lot in Alphabet City, built on three sides and wide open in the back, whose façade of brick-patterned fiberglass was "aged" by burning, chipping, and staining. The result looked so authentic that passersby inquired about available apartments and the sanitation department emptied prop garbage cans in front of the building.
Sante, "My Lost City"	One day, probably early in 1980, a film crew commandeered Eleventh Street between Avenues A and B and, with minimal adjustments, returned the block to the way it had looked in 1910. All they did was to pull the plywood coverings off storefront windows, paint names in gold letters on those windows, and pile goods up behind them. They spread straw in the gutters and hung washlines across the street. They fitted selected residents with period clothes and called forth a parade of horse-drawn conveyances. When I walked down that street at night, with all the trappings up but the crew absent, I felt like a ghost. The tenements were aspects of the natural landscape, like caves or rock ledges, across which all of us—inhabitants, landlords, dope dealers, beat cops, tourists—flitted for a few seasons, like the pigeons and the cockroaches and the rats, barely registering as individuals in the ceaseless churning of generations.
Sanders, *Celluloid*, p. 381	Sprayed with graffiti and strewn with garbage, streets in Toronto and Montreal became blandly familiar stand-ins for crime-ridden "New York" neighborhoods.
Ibid., p. 215	It was rewarding for filmmakers to cast middle-class citizens into a loft setting and show them trying, and often failing, to find their bearings.
Conrad, p. 74	Battery Place and the Bay are operatic, the stage for a thrilling fairy spectacle.
Sanders, *Celluloid*, p. 333	Photographed in the spring or fall, the city proved a cinematographer's delight, with its complex cloud formations, its lucid sea-washed air, and its relatively low sun angles, which softened the daylight and cast long shadows on the buildings' ornamented masonry—offering unbounded visual richness and texture that registered handsomely on black-and-white film.
Conrad, p. 274	During the day, his New Yorkers pine for the oblivious dark. The movies sell them an artificial night: many of them go to matinees just to sleep.
Wilson, "Leaving New York," p. 477	People are waiting in line in the cold to see the new Gloria Swanson picture.
Halle and Beveridge, p. 487	Filmmakers that represent NYC as a city of ethnic and racial groups: Allen on Jews; Scorsese on Italians; and Spike Lee on African Americans.
Allen and Brickman, *Manhattan*	The exterior of a movie theater, its marquee saying: "Inagaki's Chushingura; Dovzhenko's Earth."
Ibid.	(They move into the ticket line, still talking. A billboard next to them reads "INGMAR BERGMAN'S 'FACE TO FACE,' LIV ULLMANN".)

A Dream City — Cinema

I'm not in the mood to see a four-hour documentary on Nazis.

Ibid.

The movies being shot all over SoHo tonight are backing up traffic everywhere.

Ellis, *Glamorama*, p. 153

From 1977 to the present there is only one ethnically themed New York hit movie, the comedy *Coming to America* (1988). In it, an African aristocrat travels to New York City seeking an untraditional wife.

Halle and Beveridge, p. 487

I like the idea that people in New York have to wait in line for movies. You go by so many theaters where there are long, long lines. But nobody looks unhappy about it. It costs so much money just to live now, and if you're on a date, you can spend your whole date time in line, and that way it saves you money because you don't have to think of other things to do while you're waiting and you get to know your person, and you suffer a little together, and then you're entertained for two hours. So you've gotten very close, you've shared a complete experience. And the idea of waiting for something makes it more exciting anyway. Never getting in is the most exciting, but after that waiting to get in is the most exciting.

Warhol, *Philosophy*, p. 115

Shefter, p. 1 | If, as Walter Benjamin said, the capital of the nineteenth century was Paris, then the capital of the American Century was New York.

Wallock, p. 9 | Skyscrapers and swing, action painting and modern dance, Beat poetry and Pop art, *Partisan Review* and *West Side Story*, the Living Theater and the Guggenheim Museum: if Paris was, in Walter Benjamin's famous phrase "the capital of the nineteenth century," then New York surely has become the capital of the twentieth.

White, *Here*, p. 55 | New York is not a capital city—it is not a national capital or a state capital. But it is by way of becoming the capital of the world.

Wolfe, *Bonfire*, p. 78 | There it was, the Rome, the Paris, the London of the twentieth century, the city of ambition, the dense magnetic rock, the irresistible destination of all those who insist on being where things are happening.

Norman, p. 682 | John Lennon: "If I had lived in Roman times, I would have lived in Rome. Where else? Today America is the Roman Empire and New York is Rome itself."

Ibid., p. 9 | Walter Winchell: "New York is a glorious monument to the 20th century."

Haring, p. 90 | Now I live in New York City, which I believe to be the center of the world.

Caro, p. 838 | Imperial Rome was one-eighth the size of New York.

Ibid. | Athens at the height of its glory was never larger than Yonkers.

Bockris, *Warhol*, p. 78 | Manhattan was the unchallenged center of the planet. Political decisions were made in Washington, but most of the other decisions that counted in the United States—those involving the disposition of money and fame and the recognition of literary and artistic achievements—were made on that rocky island, that diamond iceberg between rivers. Eight major papers made everything that happened in the five boroughs, no matter how trivial, sound grave and consequential, while a battalion of gossip columnists made the city seem smaller than it was with their breathless chatter about the famous, and those who would like to be famous.

Ballon, p. 68 | Whatever the cause of the New York turnaround, it would not have been possible without Robert Moses. Had he not lived, or had he chosen to spend his productive years in isolation on a beach or a mountaintop, Gotham would have lacked the wherewithal to adjust to the demands of the modern world. Had the city not undertaken a massive program of public works between 1924 and 1970, had it not built an arterial highway system, and had it not relocated 200,000 people from old-law tenements to new public housing projects, New York would not have been able to claim in the 1990s that it was the capital of the twentieth century, the capital of capitalism, and the capital of the world.

Bennett, *Deconstructing*, pp. 12–13 | Greenberg plotted modernist art's relocation from Paris to New York City as the "main premises of Western art … migrated to the United States, along with the center of gravity of industrial production and political power."

Trager, p. 565 | In 1948, Jack Kerouac writes, "What a great city New York is! We are living at just the right time—Johnson and his London, Balzac and his Paris, Socrates and his Athens—the same thing again."

B Empire

16

A metropolis without being a national capital or even symbol.

Bender, *Unfinished*, p. xi

Not representing the nation but rather its own culture and economy.

Ibid.

No wonder that one accustomed to the rich memories of the Old World thinks he has come upon an eighth wonder—a city without a past!

Josephy and McBride, p. 52

I had witnessed the growth and expansion of New York … and therefore I was feeling entitled to interpret the titanic efforts, the conquests already obtained by the imperial city in order to become what now She is, the center of the world.

Sharpe, p. 199

While Europeans still shivered, exhausted in their damp monochrome deprivation in the aftermath of the ruinous war, New Yorkers assumed world leadership with a cool sophistication that they'd previously granted to Paris, Rome or London. In the excited, urgent chatter in the new air-conditioned offices, in the packed bars and increasingly worldly restaurants, in the crammed theater lobbies and Fifth Avenue stores there was a new confidence gained from global domination. New Yorkers basked in the health and wealth reflected back at them in the glass and chrome of their elegant bustling streets. They reveled in the status as citizens of the busiest, noisiest, fastest growing, most advanced, most cosmopolitan, coolest, most desirable and most photogenic city in the world.

Cracknell, pp. 16–17

The sun is rising overhead, the sun which once shone brightly on Europe alone and threw slanting rays merely upon New York. The sun has moved across the Atlantic. The far coasts of Europe still shine with light. But they shine mildly, softly, like eastern coasts in late summer afternoon when the sun commences to slope toward the western sea. And behind us, over the American hinterland, morning rays slant where deep, impenetrable murkiness lay, and begin to unveil the face of a continent. But over New York dayspring commences to flood his fruity warmth.

Rosenfeld, p. 471

B Empire

The returning troops marched up Fifth Avenue and girls were instinctively drawn East and North toward them—this was the greatest nation and there was gala in the air.

Fitzgerald, "My Lost City," p. 108

There was a certain romantic grandeur to American pessimism that was different from anything found in Europe. Money was flowing again. The ash-in-your-eye bleakness of New York in the Depression was lifting.

Stevens and Swan, p. 297

Manhattan is the sun at the center of all the wealth in the universe. No power on earth, or in the rumored colonies of the moon and the planet Mars, is greater than the power emanating from Manhattan. If there was a Golden Age of Babylon, in which all that made it a name of infamy had not existed, Manhattan is that Babylon. There are streets of gold in Manhattan.

Abbott, "Bowery," p. 78

New York always asserts itself. Gathering into itself all ships and all flags, New York makes a summary of and a distillation from the world, equalizing all nations and all creatures, as cubism does in showing them all to be recombinations of a few unitary and universal forms. Abstraction, like New York, is a melting pot.

Conrad, p. 117

It is the place where all the aspirations of the Western world meet to form one vast master aspiration as powerful as the suction of a steam dredge. It is the icing on the pie called Christian civilization. That it may have buildings

Mencken, p. 188

higher than any other, and bawdry shows enough, and door-openers enough, and noise and confusion enough—that these imperial ends may be achieved, millions sweat and slave on all the forlorn farms of the earth, and in all the miserable slums, including its own. It pays more for a meal than the Slovak or a Pole pays for a wife, and the meal is better than the wife. It gets the best of everything, and especially of what, by all reputable ethical systems, is the worst. It has passed beyond all fear of Hell or hope of Heaven. The primary postulates of all the rest of the world are its familiar jokes. A city apart, it is breeding a race apart. Is that race American? Then so is a bashi-bazouk American. Is it decent? Then so is a street-walker decent. But I don't think that it may be reasonably denounced as dull.

White, *Here*, p. 29

A poem compresses much in a small space and adds music, thus heightening its meaning. The city is like poetry: it compresses all life, all races and breeds, into a small island and adds music and the accompaniment of internal engines. The island of Manhattan is without any doubt the greatest human concentrate on earth, the poem whose magic is comprehensible to millions of permanent residents but whose full meaning will always remain elusive. At the feet of the tallest and plushiest offices lie the crummiest slums. The genteel mysteries housed in the Riverside Church are only a few blocks from the voodoo charms of Harlem. The merchant princes, riding to Wall Street in their limousines down the East River Drive, pass within a few hundred yards of the gypsy kings; but the princes do not know they are passing kings, and the kings are not up yet anyway—they live a more leisurely life than the princes and get drunk more consistently.

Paris

Bender, *Unfinished*, p. xi

New York is not and will not be Paris.

Stein, *Paris France*, p. 13

Paris was where the twentieth century was.

Koolhaas, p. 20

Manhattan is a counter-Paris, an anti-London.

Federal Writers, *Panorama*, p. 10

Manhattan, the other of Mont-Saint-Michel.

Bender, p. 335

Instead of being a province of Paris, or even an imitator of Paris, New York in the 1940s became Paris.

Parsons, p. 152

The New Yorker dreams of Paris while the Parisian wonders about New York ... They all remain unreal for us.

Hawes

New York's new identity is as the American Paris. It becomes cultured by its importation of vice.

Hawes

Park Avenue, like Paris, is finished. It will never be changed.

Irwin, p. 220

"On the Champs-Élysées," he said, "or in Mayfair, I feel myself a part of the street. Spiritually I seem to own a piece of it. Park Avenue—beautiful, yes, and absolutely American—but a little scornful. In Mayfair and in the fine districts of Paris and Rome, you see façades, but in Park Avenue only walls. A façade welcomes; a wall forbids. A curious manifestation in a democracy, isn't it?"

Seen from Broadway, the massacres in France seemed like a colossal advertising stunt for the benefit of some giant corporation.

Jones, *Modernism*, p. 57

The city's transformation is Parisian in the wrong way: the old bits of the city are taken over by the rich while the poor and the unwashed are crowded right off the island.

Gopnik, p. 11

Paris represents "years to think," he writes, while "in New York one falls too easily in the habit of working without thinking on account of the amount of work there is to do."

Koolhaas, p. 162

They've planted sycamore trees on Third Avenue: by 1960 it'll look like the Boulevard St. Germain and the only eyes that scope you being seen on the second floor will be the little eyes of nesting sparrows.

McCourt, p. 95

Without notable exception, the gray-stone or cream-brick buildings are of French Renaissance architecture. Their builders have even adapted that trick which the French so well understand, of making the façades to these marts of luxury a trifle more ornate than would seem tasteful for public buildings or office structures. Fifth Avenue adapted its street-lamps, stretching their double line of twin saffron globes over the curve of the hill, from the Bois de Boulogne; and even the graceful traffic towers took their inspiration from the court accessories of Louis XIV. In the nineteenth century the French put their stamp on the creation and distribution of luxury goods the world over. The glory is now passing from Paris to New York, from the Rue de la Paix to Fifth Avenue. But they have had a partial revenge. This successful rival has itself become half French.

Irwin, pp. 185–6

The world's second metropolis.

Dos Passos, p. 11

city of cities
I feel you a thousand times
more than chaotic paris
more than the prey
of any naked starving girl
at the folies bergere

Meyer, p. 296

In 1930 the Chrysler Building was the first structure to rise higher than the Eiffel Tower, which was erected in 1899.

Trager, p. 453

The Abstraction Expressionist painters felt that New York City, especially with the influx of European painters during World War II, had replaced Paris as the art capital of the world. Their belief was that expressed by O'Hara: "New York is everywhere like Paris!"

Gooch, p. 191

As a poet of the New York School of Poetry, O'Hara also lived aesthetically under the umbrella of the Cedar painters, who had coined the phrase "New York School" to cover their own painting as a sort of joke-cum-power-play on the "Ecole de Paris."

Ibid., p. 212

"You know, Paris has been limping along as the world center of art since 1936." "But what will replace the school of Paris?" I asked. "The place where the money is," he replied, "New York."

Myers, p. 66

Always desperate for the café life of Paris, for their own version of Picasso's Au Lapin Agile, the painters had gathered during most of the 1940 season at

Gooch, p. 214

the Waldorf Cafeteria at Sixth Avenue and Eighth Street where they drank coffee and talked leftist politics and modern art.

Conrad, p. 174

Living near Washington Square because the rooftops there remind him of Paris.

Irwin, p. 185

As Gramercy Park seems a bit of London and Stuyvesant Square a corner of Philadelphia, so this is a piece of Paris. A taller Paris, if you will, and a richer Paris but bearing the stamp nevertheless.

Ibid., p. 188

A fashionable *modiste* told me once that her French seamstresses, landing from the boat, go at once to a cooperative French boarding-house, thence to the job. From that time forth, the work-room, the boarding-house, and the Woman's City bound their lives. They never see an American newspaper—not even a tabloid—but the girls in the house combine and subscribe for *Le Matin* and the *Courrier des Etats Unis.* Three or four years of this, and then Mlle. Parisienne suddenly packs up her modest trunk and goes home by steerage. She has saved up a *dot*; now she can marry and live happily ever after in her dear Paris!

NY Journal, p. 65

One of the special characteristics of New York is that it is different from a London or a Paris because it's the financial capital, and the cultural capital, but not the political capital.

Bennett, *Deconstructing,* p. 18

Ginsberg's poetry walked down the streets of New York in the black cloak of French poetry.

Charyn, "Masonry," p. 153

I miss New York when I'm away. Paris is a city of monuments and streets with buildings that are so symmetrical, they look like stranded ocean liners. But I cannot find that great, brooding mix of aces, that sense of a constant carnival.

James, p. 82

I must dip into these depths, if it proves possible, later on; let me content myself for the moment with remembering how from the first, on all such ground, my thought went straight to poor great wonder-working Émile Zola and *his* love of the human aggregation, the artificial microcosm, which had to spend itself on great shops, great businesses, great "apartment-houses," of inferior, of mere Parisian scale. His image, it seemed to me, really asked for compassion—in the presence of this material that his energy of evocation, his alone, would have been of a stature to meddle with. What if *Le Ventre de Paris*, what if *Au Bonheur des Dames*, what if *Pot-Bouille* and *L'Argent*, could but have come into being under the New York inspiration?

White, *Physical*, p. 121

The Grand Concourse was an experiment in boulevardism. A Bronx mirror of Park Avenue—but without the "Park." In Brooklyn, both Eastern and Ocean parkways, laid out by Frederick Law Olmsted, designer of both Central and Prospect parks, were intended as boulevards and still serve as great auto routes without the tall and grand buildings intended in the Parisian manner.

Berman, *Solid*, p. 295

The Grand Concourse, from whose heights I watched and thought, was our borough's closest thing to a Parisian boulevard.

Hawes

On the development of Park Avenue: The treatment of a whole area, residential buildings interacting with a great symbolic monument at their center, was not unlike Napoleon's plan for Paris.

Park Avenue was insulated against the ruder aspects of city life. Its park malls, landscaped with undulating walkways to suggest a leisurely stroll, looked like trim little European gardens.

Ibid.

Park Avenue buildings looked like clusters of houses or small European villages.

Ibid.

And the express elevators take forty-five seconds to go from the bottom to the top, that is, for sixty-five stories, a time equal to that taken by our elevators, sanctimoniously installed in the Haussmann stairwells, to go to the sixth story.

Corbusier, p. 45

Paris bistro, you disappointed me on my return from Manhattan, with your faded charm. It's too old, too old, saddening!

Ibid., p. 46

Let's throw a bridge across the Atlantic. New York is the city nearest to Paris.

Ibid., p. 92

What are we in our flat cities? What is our response to the skyscrapers of Manhattan? Versailles and Fontainebleau, Touraine with Chenonceaux and Chambord? They came to study all that at the Ecole des Beaux-Arts in Paris, and they have made skyscrapers out of them!

Ibid., p. 95

The USA is no longer the purchaser of "French good taste."

Ibid.

The Americanization of Europe: Paris, capital of the *Valutaschweine*, became the bourne of good and gay New Yorkers.

Federal Writers, *Panorama*, pp. 3–4

I wish I were reeling around Paris
instead of reeling around New York

O'Hara, p. 328

World City

New York is really the oldest city in the world. Meaning it is the oldest *modern* city. It was born modern. Rome only becomes a modern city after the war, with the '50s boom. London and Paris too. Beijing, a truly ancient city, only becomes modern after the "open door" policy in the '80s. Within the frame of modernity, New York is what is ancient. It is a kind of living archaeology of modern urban forms.

Wark, email

Unlike London and Paris, the two other great capitals of bourgeois civilization, Manhattan has never really been symbolized by middle-class housing. The sweep of semi-detached houses in Knightsbridge or Kensington, the long boulevards filled with bourgeoisie in the sixteenth and eighth *arrondissements* of Paris, sum up the image of those places. New York, on the other hand, is famous for William Randolph Hearst's penthouse and Sister Eileen's basement apartment, or, more recently for the Trump Tower aerie and the Tribeca loft. A nuclear family living in a little house in Manhattan is a sight. The old enclaves of the true bourgeoisies, Riverside Drive and York Avenue, were on the margins of the island, and their high period was a short one.

Gopnik, p. 33

New York is nothing like Paris; it is nothing like London; and it is not Spokane multiplied by sixty, or Detroit multiplied by four. It is by all odds the loftiest of cities. It even managed to reach the highest point in the sky at the lowest moment of the depression. The Empire State Building shot

White, *Here*, p. 30

twelve-hundred-and-fifty feet into the air when it was madness to put out as much as six inches of new growth. (The building has a mooring mast that no dirigible has ever tied to; it employs a man to flush toilets in slack times; it has been hit by an airplane in a fog, struck countless times by lightning, and been jumped off of by so many unhappy people that pedestrians instinctively quicken step when passing 5th Avenue and 34th Street.)

Bender, *Unfinished*, p. xi

Those who have Paris or Vienna or Budapest or Mexico City or Buenos Aires (or one of many other cities) in their minds as proper metropolitan centers will be disappointed by New York. From such a point of view New York has not yet completed its progress to full metropolitan status.

Brooks, *Subway*, p. 3

In 1930 a journalist comparing the transit systems of the world concluded that New York's subways were more an expression of itself than any in Europe. "In no European city," he said, "would the subway be chosen as a symbol of urban life." The subway represents New York City as surely as the freeway represents Los Angeles.

Ford, *America*, p. 97

It is all very well for someone who has never been much in Italy to say that the Italian quarters of New York resemble Naples; they do not. They resemble New York where some Italians live … and grow less and less Italian.

Riesenberg and Alland, p. 188

While viewing the Bay of Naples, you dream of New York Bay.

Ford, *America*, p. 288

New York does not have white sunlight, white housefronts, white plane trunks—nor indeed does it have the Mediterranean just round the corner of the square.

Mencken, p. 180

But the life of the city, it must be confessed, is as interesting as its physical aspect is dull. It is, even more than London or Paris, the modern Babylon, and since 1914 it has entered upon a period of luxuriousness that far surpasses anything seen on earth since the fall of the Eastern Empire.

Hood, p. 192

Visitors from Europe view New York with more astonishment than any tourist could possibly feel in "doing Rome."

Conrad, p. 174

Washington Square is the Latin piazza where pleasure becomes performance.

White, *Here*, p. 47

The collision and the intermingling of these millions of foreign-born people representing so many races and creeds make New York a permanent exhibit of the phenomenon of one world. The citizens of New York are tolerant not only from disposition but from necessity. The city has to be tolerant, otherwise it would explode in a radioactive cloud of hate and rancor and bigotry. If the people were to depart even briefly from the peace of cosmopolitan intercourse, the town would blow up higher than a kite. In New York smolders every race problem there is, but the noticeable thing is not the problem but the inviolate truce.

Conrad, p. 115

Marcel Duchamp could praise New York for a deracination which was the condition of the migratory modernist, who must be a world citizen: "The artist," he said, "should be able to work in one place quite as well as another."

Bender, p. 117

Duchamp, on arriving in New York in 1913, declared "New York is itself a work of art, a complete work of art." Europe, he thought, was finished. This view was shared by Francis Picabia: "New York," he famously declared in

1913, "is the cubist city, the futurist city. It expresses in its architecture, its life, its spirit, the modern thought."

In a manner, New York may be said to be the essential America: acutely conscious of itself as an entity and yet composed, as no other city in the world is composed, of a thousand alien elements. On the other hand, the capital of every country in the world is something quite "other" than the country itself, and this may be said even more of America and New York than of England and London, France and Paris, Italy and Rome. In the United States, each State has its capital and its own tradition, while New York represents the cosmopolitan world which is growing up on the western shores of the Atlantic.

New York contains more people than the other eight greatest cities of America combined. In fact, it is only possible for a percentage of the population to be out of doors at the same time. Failure as unminded, everyone must laugh and grow rich in the town built upon commerce. The idle leave it, the elite escape from it. Ezra Pound, leader of the young poets, has not returned in twenty-five years.

Herbert Croly's visions for the construction of New York in the twentieth century: "If New York was built like a grand and important city, it would function like one."

I can think of no great city of this world (putting aside Rio de Janeiro, Sydney and San Francisco) that is set amid scenes of greater natural beauty than New York, by which I mean, of course, Manhattan. Recall Berlin on its dismal plain, Paris and London on their toy rivers, Madrid on its desert, Copenhagen on its swamp, Rome on its ancient sewer and its absurd little hills, and then glance at Manhattan on its narrow and rock-ribbed island, with deep rivers to either side and the wide bay before it. No wonder its early visitors, however much they denounced the Dutch, always paused to praise the scene! Before it grew up, indeed, New York must have been strangely beautiful. But it was the beauty of freshness and unsophistication—in brief, of youth—and now it is no more. The town today, I think is quite the ugliest in the world—uglier, even, than Liverpool, Chicago or Berlin. If it were actually beautiful, as London, say, is beautiful, or Munich, or Charleston, or Florence, or even parts of Paris and Washington, the New Yorkers would not be so childishly appreciative of the few so-called beauty spots that it has—for example, Washington Square, Gramercy Park, Fifth Avenue and Riverside Drive. Washington Square, save for one short row of old houses on the North side, is actually very shabby and ugly—a blot rather than a beauty spot. The trees, year in and year out, have a mangy and sclerotic air; the grass is like stable litter; the tall tower on the South side is ungraceful and preposterous; the memorial arch is dirty and undignified; the whole place looks dingy, frowsy and forlorn. Compare it to Mt. Vernon Square in Baltimore: the difference is that between a charwoman and a grand lady. As for Gramercy Park, it is celebrated only because it is in New York; if it were in Washington or London, it would not attract a glance. Fifth Avenue, to me, seems to be showy rather than beautiful. What gives it its distinction is simply its spick-and-span appearance of wealth; it is the only New York street that looks well fed and clean. Riverside Drive lacks even so much; it is second-rate from end to end, and especially where it is gaudiest. What absurd and hideous houses, with their brummagem Frenchiness, their pathetic effort to look aristocratic! What bad landscaping! What grotesque monuments! From its heights the rich look down upon the foul scars of the Palisades, as the rich of Fifth Avenue and Central Park West look down upon the anemic grass, bare rocks and blowing newspapers of Central Park.

Beaton, *New York*, p. 247

Hawes

Mencken, pp. 179–80

Alone among the cities of the East, New York has never developed a domestic architecture of any charm, or, indeed, of any character at all. There are neighborhoods in Boston, in Philadelphia, in Baltimore and in many lesser cities that have all the dignity and beauty of London, but in New York, the brownstone mania of the nineteenth century brought down the whole town to one level of depressing ugliness, and since brownstone has gone out there has been no development whatever of indigenous design, but only a naïve copying of models—the skyscraper from Chicago and the dwelling-house from Paris. Along Fifth Avenue, from the Fifty-ninth Street corner to the upper end of Central Park, there is not a single house that looks reposeful and habitable. Along Park Avenue—but Park Avenue, for all its flash of creamy brick, is surely one of the most hideous streets in all the world!

Peretti, p. 3

Politicians ritualistically praised New York as the largest Irish city, the largest German city after Berlin, and the largest Italian city after Rome.

Corbusier, p. 109

We saw the mystic city of the New World appear far away, rising up from Manhattan. It passed us at close range: a spectacle of brutality and savagery. In contrast to our hopes the skyscrapers were not made of glass, but of tiara-crowned masses of stone. They carry up a thousand feet in the sky, a completely new and prodigious architectural event; with one stroke Europe is thrust aside.

Ford, *America*, p. 48

Well, one hears eternally that New York is not America. It is obviously not Europe—the Atlantic lies between. Is it, then, the outer fringes of America— or the end of Europe? Perhaps, the one overlapping the other, here we have the beginning of the world.

Balliett, p. 89

Sometimes Europe doesn't compare well. London slows you down. Rome is too crowded. Munich is a showcase. Zurich hems you in.

Rosenfeld, p. 471

The city is a center like every other point upon the circumference of the globe. The circle of the globe commences here, too. The port of New York lies on a single plane with all the world to-day. A single plane unites it with every other port and seacoast and point of the whole world. Out of the American hinterland, out of the depths of the inarticulate American unconsciousness, a spring has come, a push and a resilience; and here where Europe meets America we have come to sit at the focal point where two upsurging forces balance.

Ibid., p. 467

It was beauty in America one wanted, not in France or in Switzerland. It was the towers of Manhattan one wanted to see suddenly garlanded with loveliness.

Ibid., p. 472

We had been sponging on Europe for direction instead of developing our own, and Europe had been handing out nice little packages of spiritual direction to us. But then Europe fell into disorder and lost her way, and we were thrown back on ourselves to find inside ourselves sustaining faith.

Warhol, *Philosophy*, p. 159

It seems so much easier to entertain in Europe than in New York. You just throw open the doors to the garden and eat out in the open air with flowers and trees all around. Whereas New York is funny, most of the time things just don't come off. In Europe, even having tea in the backyard can be wonderful. But in New York it's complicated—if the restaurant is nice, the food can be bad and if the food is good, the lighting can be bad, and if the lighting is good, the air circulation can be bad.

At that time we all talked a great deal about scale in New York, and about the difference of instinctive scale in signs, painted color, clothes, gestures, everyday expressions between Europe and America. We were happy to be in a city the beauty of which was unknown, uncozy, and not small scale.

Merrill, p. 820

This waterfront, seen so, always raises in me an emotion so subtle and complex as to defy analysis. There is a sense of romance in it, and awe; and beyond all that, a curious longing to do or experience something violent. That element in emotion is akin to what I felt once at Verdun when for the first time I stood among two thousand guns pouring curtain-fire.

Irwin, p. 16

An apartment was … a rare laboratory in which a tenant might try out strange paraphernalia reserved for a modern life. Its gadgets and gimmicks and services distinguished it from the European counterparts, which had served as the models of design and urban behavior and had once been the source of all inspiration. In Paris or Vienna, apartments were still simple houses coincidentally built one on top of the other, as Hubert and Pirsson had phrased it twenty years earlier.

Hawes

He suffers from the delusion that there are no health resorts or mineral springs or natural scenery in his own country comparable with those of Europe.

Girdner, p. 55

No monumental malls, no colonnaded boulevards or pompous segmented circuses, only a bare minimum of statued squares.

Morris, *Manhattan '45*, p. 18

Our city is unquestionably the most marvelous that so far has appeared in civilization. There is nothing in the annals of history to compare with its incomparable growth, its commercial importance and its remarkable activities in a thousand directions. When it is recalled that our City Directory is only one-hundred-thirty-six years old, while the directories of London and Paris are nearly one thousand, you get some idea of the tremendous growth of our city in a very, very short time. It seems to be reborn almost every quarter of a century. It is quite within bounds to say that almost ninety per cent of the buildings now standing were not in existence fifty years ago; and the building at which we gaze to-day with so much pride and exultation will doubtless follow their forebears within the next half century.

Brown, *Valentine's*, p. 155

The City of New York in 1860 might have been placed on another continent, compared with what it was twenty-five years later, and in any comparison with to-day's aspect, there are absolutely no words adequate for the description.

While New York was rising into the air, London and the towns of Germany were satisfied with the illusory idea of garden cities: a rural humanity, living idyllically in cottages, served daily by a purgatory of transportation systems.

Corbusier, pp. 36–7

London is a wide flat pie of redbrick suburbs with the West End stuck in the middle like a currant. New York is a huge rich raisin and is the biggest city I can imagine.

Behan, p. 12

When it's three o'clock in New York, it's still 1938 in London.

Hamann, p. 11

In Algiers, a single skyscraper will suffice.
In Barcelona, two skyscrapers.
In Antwerp, three skyscrapers.

Corbusier, p. 68

Sharpe, p. 198

The opulent shops, with their immense show-windows, remind one of our own boulevards; but the electricity which flows in rivers, and dominates everything, is a thousand times more aggressive than it is with us. Everything seems to vibrate, to crackle … One is himself electrified almost to the point of quivering under the stimulus … The apparitions flash out, move, fade away, quickly, very quickly—so quickly, indeed, that the eye barely follows them. From time to time, some enormous advertisement perched on top of a dark sky-scraper, almost invisible in the murky atmosphere, breaks out into red flame, like a constellation, hammers some name in your memory, and then as quickly vanishes.

Van Vechten, p. 137

The physical changes in the city are even more amazing than the atmosphere changes. All cities alter somewhat in the course of time, but they alter slowly. In Rome we can follow the trend of these alterations through the last two thousand years, a souvenir of every century remains. Medieval Paris has entirely disappeared, and there are comparatively few traces even of the eighteenth century in modern London, but what has happened in the way of demolition and construction in these two cities has happened separately and not unexpectedly. New York on the other hand is in a constant state of mutation. If a city conceivably may be compared to a liquid, it may be reasonably said that New York is fluid: it flows.

Atkinson, p. 262

It is truly the city of Now.

McInerney, *Bright Lights*, p. 151

Out into the sunlight of Fifth Avenue and the Plaza, a gargantuan white chateau rising in the middle of the island like a New Money dream of the Old World.

Jackson and Dunbar, p. 677

The minarets of Ellis Island.

Corbusier, p. 36

Morocco, which is contemporary with New York, is not under the sign of the new times.

Lopate, *Waterfront*, p. 200

In New York, precisely because it is so polyglot and international, the walker-writer can turn a corner and imagine being in Prague, say, or Montevideo.

Riesenberg and Alland, p. 188

You smell brown fog on the East River, even though the sun is burning you in Calcutta or in Singapore.

Federal Writers, *Panorama*, p. 3

A book of verse:

> "Under the stone I saw the flow
> express Times Square at five o'clock
> eyes set in darkness"

read in a sheepherder's hut in New South Wales.

Cosmopolis

Bercovici, pp. 52–3

The map of Europe is reproduced in New York by the different nationalities living here; each nationality having as neighbor the same that it has in Europe. Thus the Greeks, Turks, Syrians, and Italians are close neighbors in Europe and also here. The same thing applies to the Russians who are neighbors with the Roumanians, the Poles, the Austrians, and the Germans.

B Empire — Cosmopolis

New York, an immense seaport, is as landlocked for its inhabitants as Moscow. Corbusier, p. 190

The Syrian Quarter on the lower west side: Tins of olive-oil with gaudy labels in French and Arabic … water-pipes, their stems tassled in scarlet and bright lemon … Prussian blue … golden-brown taborets inlaid with white woods like ivory … heaps of cream and purple egg-plant and russet pomegranates … big, flat cakes shaped like artists' palettes or like doughnuts seen in the distortion of a magic mirror, their surfaces dusted with fine seeds … appetizing piles of yellow, white, and pink nougat … rows of glass jars brimming with strange, big seeds—whether used for food or for medicament, I do not know … streamers and foamy pikes of fine-meshed lace … buff earthen oil-jars in the classic form of a Greek amphora … Turkish vases, their enamel an intricate kaleidoscope … Buddhas of glazed pottery or enameled metal in green, tawny-red and gold. The eye grows weary with color. Irwin, p. 32

But when I walked out of Malouf's store, boys were just lighting the paper lanterns for a block dance. Across the street hung a big war poster with famous sayings penned underneath. Bercovici, p. 85

As if lit by a huge flying glow-worm, the torch of the Lady of Liberty in bronze pointed to the flitting stars. Dark-eyed men and women returned home, to the Orient from the Occident. Night was coming.

The East Side housewife can within a few blocks shop at will in Italy, Germany, Hungary, Bohemia, or Palestine. Conrad, p. 261

If you ever find yourself on Thirty-fourth Street near Seventh Avenue, don't fail to hunt up a certain Spanish table d'hote restaurant. This section of New York is like a border town on the lower Pyrenees in France. People speak French with the Spanish accent and Spanish with the singsong of Southern France. Bercovici, pp. 22–3

Sitting on the broad steps of the fine old massive brown stone houses of the district, children of old Catalonia, Dons and Doñas from Madrid and Barcelona, using a Latinized English all their own, exchange stories and opinions with their French neighbors.

Chords struck on a guitar, to accompany a subdued voice, high colors on the window curtains, a mixed odor of garlic, incense and heavy-scented perfumes, suggest something indefinably Moorish, Alhambresque; slow yet passionate, like cold fire.

And lo! the mirage vanishes! You are out of the district. The modest warm curve of the Orient has disappeared, the arrogant cold straight line of the Occident stares at you. You are in the heart of busy old New York.

You hear people talk about the disadvantages of living in New York. Personally, I cannot think of greater happiness than being in this great metropolis if only for the reason that I can be all over Europe in one night. Five cents carfare lands you in the French district. Five more minutes reading of the "Subway Sun" lands you in Hungary; from whence you can tramp in fifteen minutes to Italy or Greece or Turkey, as the spirit moves you, or inclination dictates. You can eat your breakfast in a Russian restaurant on East Fifth Street; have caviar and Bolshevik talk; go for lunch in China, on Mott Street, where they will serve you tea grown on the highest mountain of Asia; for dinner, you can have your choice between Persian, French, Hindu, or Greek menus, and still have the cuisines of a dozen other foreign nationalities to choose from if you are alive the next morning. Ibid., p. 54

Haden-Guest, p. 17

When the rest of the world thinks about New York, they mean about Manhattan. The odds that partygoing Manhattanites are more likely to have dined, drunk, and danced in boîtes in London, Paris, St. Moritz, Miami, and Los Angeles than in Queens, Brooklyn, the Bronx, and Staten Island bounce off the scale.

Manhattanites have a whole xenophobic repertoire to deal with humans who happen to dwell in the outer boroughs. They mock their accents, deplore their dress codes, and have names for them—BBQs (for Brooklyn, Bronx, and Queens), Bridge and Tunnels (for the ways in and out of the city), and 718s (for the Brooklyn and Queens area codes). In *Saturday Night Fever* John Travolta's arrival in Manhattan is depicted as though a Neanderthal were suddenly to find himself stumbling among Homo sapiens, and Melanie Griffith, the commuter from Staten Island in *Working Girl*, is shown sporting her big hair, leather coat, and lots of jewelry, like the totems of some peculiar tribe.

Atkinson, p. 15

When I say "New York" in these pages, I have to mean "Manhattan Island." Greater New York is too big to write about. If I were to attempt to include all the other boroughs that make up the city—Queens, Richmond, Brooklyn and the Bronx—I would find myself in trouble ... Manhattan is my world; Manhattan is where I was born and raised. When I write about New York, I had better stick to that.

Sanders, *Celluloid*, p. 176

Beyond Manhattan, the movie city all but dropped off the map: Brooklyn was reduced to a handful of picturesque blocks, while the Bronx, Queens, and Staten Island scarcely existed at all.

Abbott, "Bowery," p. 78

Manhattan is not a decent city. Salt Lake City is a decent city. There is no mad rush of human beings to go to Salt Lake City, either. Unless we carefully define what we mean by the word culture, we cannot seriously say that there is culture in any "decent" city.

Dreiser, p. 4

And then, again, I think of all the powerful or semi-powerful men and women throughout the world, toiling at one task or another—a store, a mine, a bank, a profession—somewhere outside of New York, whose one ambition is to reach the place where their wealth will permit them to enter and remain in New York, dominant above the mass, luxuriating in what they consider luxury.

Douglas, p. 73

Then he came to New York; don't we all?

Prehistoric

The asphalt paves a jungle. Conrad, p. 287

when the pavement was grass, when Severini, p. 49
it was swamp, through the age of tusk and mammoth, through the age of
silent sunrise

New York had all the iridescence of the beginning of the world. Fitzgerald, *Crack-up*, p. 25

The cockroach and the ginkgo tree are the oldest things on earth. LeSueur, p. xiv

The ginkgo rates as a fossil growth—it has gone unchanged for millions of Berger, *New York*, p. 95
years, and is exactly like specimens found in Paleozoic, Triassic, Jurassic and
Tertiary formations.

Roaches as prehistoric relics. Blandford, p. 7

The greatest of cities towers above prehistoric depositories of garnet, beryl, Berger, *New York*, p. 54
tourmaline, jasper, muscovite, zircon, chrysoberyl, agate, malachite, opal,
rose, smoky and milky quartz—even minute veins of gold and of silver.

By day New York turns to practicality, to the provident tasks of survival. But Caldwell, p. 353
at night ancient Manhattan comes back as a ghost from a deeper world still
living but unwisely forgotten.

The tradition of dumping the grotesque elastic heads worn by Thanksgiving Berger, *New York*, p. 112
Day parade flankers in the basement of the Museum of Natural History, right
alongside stores of brown dinosaur bones and other prehistoric relics.

He visits the Museum of Natural History to estimate his adversary and sees Conrad, p. 178
there the stranded, lumbering skeletons of prehistoric beasts. He wonders
at the forces which produced them, the indifference, apparently, with which
they had been allowed to die. Nature's atavistic unconcern about its creatures
corresponds to the modern city's carelessness of its harried inhabitants.

During the excavations for the Cortlandt Street subway station in 1916, Solis, p. 14
the workers suddenly came across the remains of an old vessel, a ship
that arrived from the Netherlands in 1613. Part of the ship obstructing the
subway dig was salvaged. The remainder, along with the other old artifacts
(a cannon ball, tools, pipes, shards) were reburied. Although archaeologists
were assigned to look for the vessel when the area was excavated again
during the construction of the World Trade Center, they were unable to
locate the rest of the ship.

In the midst of all this—the wealth of things that have disappeared and the Maffi, pp. 9–10
little (or much) that has survived (names, memories, signs)—one presence
has survived down the centuries and millennia to the present day. A silent,
stern witness to events, it can be touched with a hand. Erupting from the
deep, dark heart of the earth, the black, shale rocks that sprout from the
green knolls of Central Park, and the clear dolomitic rocks that rub shoulders
in the primeval forest at the northernmost extremity of the island, have
always been here: they proceeded and accompanied the recent history of
natives, the Dutch, the Huguenots, the Africans, the Jews, the English, and
the Americans.

Brass, p. 189

Leon Trotsky: "Today, not only in peasant homes but also in the city sky-scrapers, there lives alongside the twentieth century the tenth or the thirteenth. A hundred million people use electricity and still believe in the magic power of signs and exorcism."

Finney, p. 66

I tried. I stared out at the uncountable thousands of windows in the sooty sides of hundreds of buildings, and down at the streets nearly solid with car tops. I tried to turn it back into a rural scene, imagining a man down there with buckles on his shoes and wearing a pigtailed white wig, walking along a dusty country road called the broad way. It was impossible.

Pomerance, p. 10

Adam and Eve, naked and panicky, were stumbling across the Brooklyn Bridge away from Manhattan, with a great Godly hand in the sky sternly pointing them the way ... There was no reason at all to suppose, looking at this static moment, that Adam and Eve would be stopping on the other side of the East River. Might they not have to wend their way all the way out the L.I.E., into Nassau, and then Suffolk Counties, and thence maybe by ferry into the upper reaches of Connecticut, even Massachusetts?

Bunyan, p. 6

Bowling Green: a small clearing in the primeval forest.

Delgiannakis

In ancient New York, everyone shared walls.

Antiquity

Moscow, p. 110

The first—and only—simulated Greek temple to adorn the city's skyline sat anachronistically and incongruously atop 50–52 Wall Street. A penthouse of forgotten gods, the structure could best be seen from the air.

Conrad, p. 200

The Royal Insurance Company Building at 150 William Street (1931) balances a Greek temple on its head, while the Bank of New York at 48 Wall (1929) has for its headdress a copper eagle with upraised wings ... The Cunard Building (1921) at 25 Broadway raises the ocean to roof level, setting atop itself a Nereid frisking on sea horse among a ruffled bed of waves.

Irwin, pp. 14–15

The Standard Oil Building on Lower Broadway: "Two wings extend toward you, like the paws of a sphinx. Over these the tower; topped by a pyramid and a single glorified chimney which streams a plume of smoke like incense, and flanked by four obelisks. The group of which this tower is the crown creates an illusion not uncommon among the building-masses of Manhattan. It seems impossible to believe that one is not beholding a splendid hill-city, like the Acropolis ... There is another view of this group even more stirring to the imagination; but to see it as its best, you must pick your day and hour. Some morning when the skies are overcast and the air is perfectly still, go to Telegram Square under the elevated, put your back to the westward walls, and look up again. The tower with its obelisks just peeps above the bizarre elevated structure and the roofs to eastward. All the lower buildings about it are streaming columns of white smoke against the violet-gray skies. It seems then like the exalted altar of some strange rite; an altar beyond the conception of man—raised by the gods to a greater god."

N. cit.

On an Upper East Side rooftop in 1956 a Greek nymph, clutching her lyre as she surveys the city: her terrace is a chapel, sacred to a Mediterranean cult of physical delectation.

The slogan on the General Post Office on Eighth Avenue is a mistranslation of Herodotus. Herodotus says: "No snow, nor rain, day's heat, nor gloom hinders their speedily going on their appointed rounds." This reference in Herodotus was to Persian couriers who figured in the to-do between the Greeks and the Persians five centuries before Christ. It was translated by William Mitchell Kendall, senior architect for McKim, Meade & White, who designed the building just before WWI as: "NEITHER SNOW, NOR RAIN, NOR HEAT, NOR GLOOM OF NIGHT, STAYS THESE COURIERS FROM THE SWIFT COMPLETION OF THEIR APPOINTED ROUNDS" and boldly added the signature HERODOTUS. The quotation was approved by the Post Office. Kendall, an amateur linguist, combed all the English translations: Rawlinson's, Macauley's, Carey's, but thought they hadn't quite caught it.

Berger, New York, p. 202

A third-rate Babylon.

O'Connell, p. 303

There was Babylon and Nineveh; they were built of brick. Athens was goldmarble columns. Rome was held up on broad arches of rubble. In Constantinople the minarets flame like great candles round the Golden Horn … Steel, glass, tile, concrete will be the materials of the skyscrapers. Crammed on the narrow island the millionwindowed buildings will jut, glittering pyramid on pyramid, white cloudheads piled above a thunderstorm.

Dos Passos, p. 12

In our ramble amid the arguments of Abaddon, loud with the disputes of *meum* and *tuum*, the wranglings of poverty and wealth, we are lifted by a taut wire at speed without effort and at a moderate charge, to the topmost terraces of Illium, the high stage of this Radian City, the Thirteenth Wonder of an Amusing World.

Riesenberg and Alland, p. 92

In this forest of glass, steel and cement, in this extraordinary New York so difficult to define you will rediscover, O voyager, the gigantic masks of the antique gods, you will rediscover the eternal sadness of the plaster Antinous and the immense solitude of the Pantheon on summer nights, beneath the great sky all streaming with stars.

de Chirico, "I Was in New York," p. 401

Fifth Avenue, an Elysian Fields with flags as its foliage.

Conrad, p. 87

New York as a cemetery of immemorial Titans, whose gravestones are the granite house-tops.

Ibid., p. 74

Stained glass panels in the Empire State Building include the Colossus of Rhodes. Chares of Lindus, who designed the massive bronze Colossus in 278 B.C., committed suicide when it far overran its construction budget.

Kingwell, p. 30

New York is becoming as much a vanished city as Atlantis or the lowest layer of Schliemann's Troy.

Trager, p. 483

We will somehow escape Manhattan, fleeing like the last Trojans, in a sailboat, gliding out past the Statue of Liberty.

Gopnik, p. 182

The green and red guide lines in the subway shuttle system stem directly from the legend of Theseus' slaying of the Minotaur in the labyrinth in Crete.

Berger, New York, p. 102

Once Robert remarked that when he got on the Fifth Avenue bus, he felt he was in reality the King of Crete.

Holleran, "Anniversary," p. 6

Conrad, p. 100

"Prometheus in Rockefeller Center," is greeted by an idolatrous crowd: the gilded bringer of fire, having leaped perhaps from the top of the skyscraper above (which is as hubristic as he), lands in the ice rink, and the pirouetting skaters dance for joy on their blades or abase themselves in adoring, humbled heaps.

Riesenberg and Alland, p. 92

Out on Fifth Avenue, in cold candent light, reflected by the mocking moon, lies Melpomene prostrate before the toes of Atlas, and a grinning Momus sits upon his brazen head.

Fitzgerald, *Crack-up*, p. 29

For us the city was inevitably linked up with Bacchic diversions, mild or fantastic. We had no incentive to meet the city half way.

McCourt, p. 154

Realize that the East and North rivers, with a little assistance from the Harlem Ship Canal, ring Manhattan island exactly as Phlegethon and Cocytus ring Hades, and that we are all of us alive on this island of fallen souls. We entered under Cancer—the island's sign and must depart under Capricorn, in the cold of the year and the dead of the night.

Joshi

My coming to New York had been a mistake; for whereas I had looked for poignant wonder and inspiration in the teeming labyrinths of ancient streets that twist endlessly from forgotten courts and squares and waterfronts to courts and squares and waterfronts equally forgotten, and in the Cyclopean modern towers and pinnacles that rose blackly Babylonian under waning moons, I had found instead only a sense of horror and oppression which threatened to master, paralyse, and annihilate me.

Roman

Lancaster, p. 63

The great hall of Penn Station: Designed after the Tepidarium of the ancient baths of Caracalla.

Morris, *Incredible*, p. 289

Externally, Pennsylvania Station resembled an ancient Roman, Doric temple.

Huxtable, *Goodbye*, p. 50

The soot-stained travertine of Penn Station's interiors, reputed to be the first used in this country, was from quarries in Tivoli employed in building the Eternal City. Its mellow, golden cream was used in the Colosseum in the first century A.D. and St. Peter's fifteen centuries later. New York could be called the Mortal Metropolis.

Sharpe, p. 187

The raw, massive hole that will become Pennsylvania Station is partially lit by arc lamps, partially plunged into a deep darkness punctuated by a raging fire around which huddle minute workers in the bottom of the pit. Like a battlefield at night, the scene gives evidence of a terrible and costly struggle; it is by turns garish, gloomy, infernal.

Wolfe, *You Can't*, p. 43

The station, as he entered it, was murmurous with the immense and distant sound of time. Great, slant beacons of moted light fell ponderously athwart the station's floor, and the calm voice of time hovered along the wall and ceiling of that mighty room, distilled out of the voices and movements of the people who swarmed beneath. It had the murmur of a distant sea, the languorous lapse and flow of waters on a beach. It was elemental, detached, indifferent to the lives of men. They contributed to it as drops of rain contribute to a river that draws its flood and movement majestically from great depths, out of purple hills at evening.

Few buildings are vast enough to hold the sound of time, and ... there was a superb fitness in the fact that the one which held it better than all others should be a railroad station. For here, as nowhere else on earth, men were brought together for a moment at the beginning or end of their new memorable journeys, here one saw their greetings and farewells, here, in a single instant, one got the entire picture of the human destiny. Men came and went, they passed and vanished, all were moving through the moments of their lives to death, all made small tickings in the sound of time—but the voice of time remained aloof and unperturbed, a drowsy and eternal murmur below the immense and distant roof.

If you can forget the spindling steel pillars supporting the outer runways of the Brooklyn Bridge, these odd cave-shops have a Roman sturdiness, a very simple beauty of proportionate building grown ripe with use. They much resemble, indeed, the dwellings of the Theater of Marcellus in Rome over which the New York tourist raves, in ignorance that we have almost a replica at home. *Irwin, p. 73*

The Judson Church is a cream-colored variant of Santa Maria Cosmedin. *Irwin, p. 117*

The window panels of the Cornell Medical Center are deliberately modeled after the Palace of the Popes. *Mumford, Sidewalk, p. 66*

He likens the New York skyline to that of San Gimignano. *Conrad, p. 75*

A Venice in the making, a latter-day Rome, picturesqueness by an anticipated decay, a transatlantic Paris, an impressionist pleasance. *Ibid., p. 83*

A thirsting Venice. *Ibid., p. 127*

Looking down on the electric luminosity at midnight, undulating stream of blue and grey and frosty white as the tonalities of Venice. But it's a Venice gone wrong, desiccated and petrified, a Venice of receded seas, a spun-steel Venice, sans hope, sans faith, sans vision. *Ibid., p. 73*

Huneker's heroine imagines New York as a stony Venice, from which the seas have despairingly receded. De Casseres liquefies it again and believes it to be afloat on an ocean of alcohol. He nicknames it a Booze Venice and dubs its main thoroughfare the Great Tight Way. *Ibid., p. 202*

The streets turn into rivers of molten tar, like a Venice from hell, with crazed cabdrivers careening like possessed gondoliers. *Sullivan, 1001, p. 55*

SoHo was supposed to be a Venice of the New World. Anderson-Spivy and Archer, p. 13

The past, even the immediate past, in New York is organized more or less like the cemetery in Venice: The skeletons are buried and then, after a dozen years, dug up and evicted and thrown onto a second island in a mixed-up heap of remembrance. New Yorkers live on that second island and sort through crazy heaps of memory to find a past. There are compensations for our indifference, though. Freed from its connection to its origins, the past has more carry. Gopnik, p. 109

In 1905, the story went around of two strangers meeting in the city: "What do you know of New York?" said one wanderer to another. "Only what I have read in Dante," was the bleak reply. Sharpe, p. 201

Ibid. Later, Isabel Bishop would paint *Dante and Virgil in Union Square* (1932).

Riesenberg and Alland, p. 71 Leonardo da Vinci would turn subways into pipe galleries and transport tunnels for dry rubbish, instead of human beings. He would start at Houston Street and level the blocks between Second and Third avenues, with a park space in the center, and, young-thinking Leonardo, ages ahead of the experts, would cut down blocks of crosstown houses, at suitable intervals, making true express streets and sub-surface parking areas, plus grass parks with benches.

Conrad, p. 75 A 1919 view of the Cortlandt Street ferry from the Jersey shore uses the interior of the ferry house with its chains and pulleys as a Piranesian vault, a carious, overgrown prison which consumes the Manhattan skyline across the river.

Hapgood, pp. 370–1 Then there are fastidious people from up-town, some of them bringing with them thoughts and half memories, dim and splendid, of things they had seen in Rome and Greece, in many a noble little Italian town, and in the mysterious and race-trodden homes of men in the Orient.

Morris, *Manhattan '45*, p. 203 Roman dungeons or attic walls of Montmartre propped against the Seventh Avenue sidewalk outside of the Met.

Simpich, p. 281 Today Long Island makes better rope than the Romans did.

Gothic, Medieval

Bender, *Unfinished*, p. xvi As one walks north from the Battery, one moves through and beyond a medieval street plan, one populated in our time by skyscrapers.

Television, "Venus" Broadway looked so medieval
It seemed to flap, like little pages

Christman, p. 57 We have not, in a modern city like Brooklyn, such marked specimens of magnificent architecture as the ancient or mediaeval cities, many of whose ruins yet remain.

Conrad, p. 288 Steely New York has a Gothic cellarage.

Morris, *Incredible*, p. 297 A five-room furnished suite at a luxurious hotel, its walls practically invisible under her aggregated Vermeers, Rembrandts and Italian primitives. These were indisputably more authentic than her Scotch and gin. A "little Gothic nest" high up in the Ritz Tower.

Hawes In the twenties, an age that was celebrating the lightness of being, the medieval was still popular, and many of the social elite abandoned their town houses for the twelfth floor of an apartment house, only to expend great effort in the elaboration of vaulted vestibules, stone arches, and Gothic stairways. They were still seeking the reassurance of the heavy and permanent, albeit encased in the steel skeleton of a fifteen-story skyscraper.

Gopnik, p. 293 Maybe there is no city left, and these familiar comedies of density are busy parts of a soon-to-be consigned past; we are in a Brueghel painting and not wise enough to know it yet. New York, which was lost, and then found, and then lost again, only to be found again, at least for now, may be as doomed as the dodo no matter what we do or whom we do it for.

The Macy Parade is moving between the cliffs and buildings; its great helium-filled giants ... its dragons and nameless monsters blot out the sky, held to earth by medieval soldiers and fairy-tale characters.

N. cit.

Egyptian

From the ruins, lonely and inexplicable as the sphinx, rose the Empire State Building.

Fitzgerald, *Jazz*, p. 28

I glimpsed the Queensboro Bridge as if through a haze or smoke, first an edge, then the top—but which I now suddenly saw whole! It was a PYRAMID, the real thing, resembling those the Egyptians built. Not the mightiest, perhaps, but undoubtedly the last of all the pyramids erected on earth.

Lobas, p. 91

The Triborough Bridge. Its anchorages, the masses of concrete in which its cables would be embedded, would be as big as any pyramid built by an Egyptian Pharaoh, its roadways wider than the widest roadways built by the Caesars of Rome.

Caro, p. 386

The anchorage of the Hell's Gate Bridge: "Immense things they are, beside the Nile they would pass for pyramids."

Ibid., p. 397

The Brooklyn Bridge's pylons were conceived in the style of the gateways to the temples at Edfu and elsewhere along the River Nile.

Moorhouse, p. 22

The whole of it stretched out and illuminated by the silvery gray light of the afternoon. I had never seen New York from such a vantage point. Its skyscrapers became minarets, it seemed to float on a low-lying mist. It was Baghdad.

Myers, pp. 73–4

In 1904, O. Henry began characterizing New York as "Baghdad-on-the-Subway."

Fitzpatrick, *Subway*, p. 5

Indigenous, Archaeological

Here is the last survival of prehistoric man (brought from his habitat in Lodi, New Jersey).

Riesenberg and Alland, p. 154

The Telephone Building and all its brothers on Manhattan seem descendants from the very earliest native school of architecture. The building is only a sophisticated and glorified version of the old Southwestern Indian pueblo. Except for some remnants in Acoma, Sister of the Eagle, only two exemplars of that style survive—the twin pueblos at Taos.
 The Summer House at Taos might have suggested this building, as Strasbourg Cathedral probably suggested the Woolworth Building. In cold fact, the two styles have no historical connection. Adaptation to use is the first law of successful architecture. The Indian pueblo builders raised their structures high because they must needs huddle for defense against raiding enemies; the New Yorker, because he must get all he can out of the most expensive land in the world. The Indian narrowed each successive story partly because he had not found how to build a frame for a square, multi-storied structure, and partly because he wanted sun-balconies for each apartment; the American, because he wanted light in the lower windows. Perhaps, however, one common subtler influence moved them both. As

Irwin, p. 19

artists, they may have felt rather than perceived that this form harmonizes somehow with the shrewd, violent light of the American continent. But there it is, the accidental culmination of that art which budded in the Mesa Verde caves before Christ was born.

Berger, *New York*, p. 300.

The Manhattan Savings Bank at Madison Avenue and Forty-seventh Street is offering in its lobby this week authentically garbed Puritan choristers against a seventeenth-century New England setting, singing Thanksgiving music. The soloist, a pretty contralto in Indian maiden garb, is Hoté-Mawe, a Cherokee. She sings ancient traditional dawn and sunset songs, the butterfly dance, the happy song of her tribe and a moving invocation to the sun god, all against the background clink of coins going into, and out of, the tellers' cages.

Aycock and Scott, p. 164

On razing Madison Square Garden in 1925: "There is probably no other nation in the world which could lament a thirty-year-old building as an ancient relic of a forgotten age."

Brook, p. 285

No place for antiquarians. There are no ruins, and never will be. They would be too costly. New York is exactingly different because it insists that you live precisely in the present, with all your capacities stretched to the limit.

Finney, p. 67

Those places are fragments still remaining, of days which once lay out there as real as the day lying out there now: still-surviving fragments of a clear April morning of 1871, a gray winter afternoon of 1840, a rainy dawn of 1793.

C Antiquity — Indigenous, Archaeological

In the real country, far from other people and the cozy hum of electric generators and the clatter of traffic, I am often frightened. The nights are impossibly dark, and the animal noises from the deep woods where coyotes chase rabbits and owls pick off their prey terrify me. Nature in the country is not so cute. I listen to something howling in the trees on the other side of a flimsy cottage wall, and I feel utterly defenseless. I long for the safety of the city, where nature is so beautifully and spectacularly kept on a leash. I long for Manhattan, where my door is locked at night and the noises are the comforting human noises of cars and crowds.

Cheever, "Country," p. 152

Astonishing city free of microbes and captive elephants.

Riesenberg and Alland, p. 202

It's difficult to see in the Manhattan of today any trace of that primeval island. But not impossible. Perhaps the place to start is with a pair of trees: two gaunt pines growing close together, just west of Broadway, in the south graveyard of Trinity Church. Almost hidden in the corner between the walls of the church and the sacristy, they're nearly always in shadow. But at the right time, seen from the right vantage point, they make it possible to imagine the island of the Lenape and the earliest Dutch, surviving spectrally amidst four centuries of development.

Caldwell, p. 10

Standing at the corner of Broadway and Rector Street on a clear late winter afternoon, these pines loom starkly against the brown stones of the church. The steeple rises above, and above that an expanse of sky. When darkness falls, the pines sink gradually into the shadows between the church and attached chapel, the spire and the buttress in sharp relief behind. Ignore the skyscrapers (easily done from there) and you see something that would have been there in 1700. In darkness the brownstone church loses its shape: imagine it gone (the original church opened in 1697), multiply the pines in your imagination, and you see it as it was even in 1650—a graveyard, among the earliest in New Amsterdam.

When most Americans think about environmentalism, they picture wild, unspoiled landscapes—the earth before it was transmogrified by human habitation. New York City is one of the most thoroughly altered landscapes imaginable, an almost wholly artificial environment, in which the terrain's primeval contours have long since been obliterated and most of the parts that resemble nature (the trees on side streets, the rocks in Central Park) are essentially decorations.

Owen, p. 11

The last relics of the primeval forest that blanketed Manhattan when the white man first arrived survive precariously on forty acres along the Bronx River gorge in the South Bronx. The trees, stately Canadian hemlocks, rise on one of the few sites in the nation that has never been logged. The virgin forest dates back to the end of the Ice Age some 20,000 years ago.

Moscow, p. 125

In the stoniest pavement of the city there are cracks. And out of the bleakest soil, between these cracks, a few blades of grass will sooner or later show, whose seeds are borne by the birds; here, even, the germ of a tree will take root and spring up, if no foot disturbs it.

Mumford, "Metropolitan," p. 33

A city is not a tree.

Kittler, p. 720

The New York I lived in, on the other hand, was rapidly regressing. It was a ruin in the making, and my friends and I were camped out amid its potsherds and tumuli. This did not distress me—quite the contrary. I was enthralled by decay and eager for more: ailanthus trees growing through cracks in the

Sante, "My Lost City"

asphalt, ponds and streams forming in leveled blocks and slowly making their way to the shoreline, wild animals returning from centuries of exile. Such a scenario did not seem so far-fetched then. Already in the mid-1970s, when I was a student at Columbia, my windows gave out onto the plaza of the School of International Affairs, where on winter nights troops of feral dogs would arrive to bed down on the heating grates. Since then the city had lapsed even further. On Canal Street stood a five-story building empty of human tenants that had been taken over from top to bottom by pigeons. If you walked east on Houston Street from the Bowery on a summer night, the jungle growth of vacant blocks gave a foretaste of the impending wilderness, when lianas would engird the skyscrapers and mushrooms would cover Times Square.

Hawes There were vacant lots everywhere, sometimes whole blocks of them, and occasionally, a farm or a farmhouse. There were working railroad tracks below Riverside, from which the smell of the cattle en route to market would rise with the eastern wind. There were barnyard animals and apple trees that bloomed in May at the corner of 79th and Broadway, on the farm on the Astor property. Above 125th Street, agricultural tracts, interspersed with roadhouses and beer gardens, where Sunday cyclists downed schooners of beer for five cents.

Ibid. A southern view from Sherman Square, at 72nd Street, taken in 1897, shows how lush and carefully tended the middle islands of Broadway are—the grass as thick and even as a lawn, the flowerbeds enclosed in ornate stone planters.

Ibid. Where Canal Street cut west of Broadway, meadows were flooded by the evening tide.

Campbell, *Darkness*, p. 89 In the old days when this whole seething turbulent spot was quiet meadows sloping to the East River.

Bercovici, p. 186 The Bronx, between Claremont Parkway and Bronx Park, has known Hirsh Roth of the firm of Hirsh Roth & Co., wholesale and retail liquor dealers, for the last twenty years. He was there, a believer in the Bronx, when it was yet all rocks and farms, with a few scattered wooden shacks. He was there when the downtown people moved to the Bronx because the doctor said they needed country air and higher ground.

Berger, *New York*, pp. 252–3 The fuss and hubbub over the sites for the Lincoln Center for Performing Arts, for a Fordham University campus and for a Lincoln Square housing project would have been way beyond the wildest imagining of the husbandmen and gentlemen farmers who settled the area almost 300 years ago.

They could not have dreamed that their Bloemendaal (Dutch version) or Blooming Dale (later English form)—their Valley of the Flowers—would one day be a tight and untidy huddle of weathered brownstones and decaying tenements swarming with contending hosts of middle-class and impoverished city dwellers.

Eighteenth- and nineteenth-century visitors and guidebook scribblers thought that the Valley of the Flowers, with its lush gardens, fruit orchards, great-girthed elms and dreamy views of the lordly Hudson, was one of the loveliest spots on earth.

Frances Trollope drove the five miles from City Hall in 1831 to visit with gentry who had summer homes there. She wrote later: "Hardly an acre of Manhattan but shews some pretty villas or stately mansions … Among these perhaps, the loveliest is one situated in the beautiful Village of Bloomingdale."

Dutch farmers broke Lincoln Square soil and ran ox-drawn plows across Indian trails down to the Hudson as early as 1660. Indians and mynheers alike found monster oysters, giant lobsters, sturgeon, shad and crabs. There was good hunting, too.

Flocks of passenger pigeons would virtually shut out the sky some days. Foxes, wolves and bear roamed the woods. Blooming Dale made ideal country seats for English squires who owned great numbers of slaves. Silver streams, branches of the Great Kill that came in at 42nd Street, were alive with fish.

The squires hunted wild foxes, raised blooded horses; lived pretty much as they had in Merrie England—until the American Revolution. The war tore neighbors apart. James Delancey's Bloomingdale farm was burned by patriots. After the war it went, at auction, to John Somerindyke.

The Reign of Terror in France brought royal refugees into the area. Mme. D'Auliffe, lady-in-waiting to Marie Antoinette, built a French cottage near Broadway, a half-mile above Lincoln Square. She and her daughters entertained Talleyrand there and Louis-Philippe, King of France. Louis-Philippe taught school in Bloomingdale in 1799.

Edgar Allan Poe wrote "The Raven" in Bloomingdale's upper reaches. George Pope Morris's "Woodman, Spare That Tree" flowed from his pen in Bloomingdale after he and an unidentified "old gentleman" on a walk in the Flowery Vale had paid $10 between them to persuade a woodcutter to swing his axe at some lesser giant than the primitive elm he had set his heart upon.

The area's loveliness was doomed from about 1825 when J. L. Norton, William De Peyster and others of the gentry allowed the City Fathers to put the first streets through. In 1826 a stoneyard was built on the lovely river bank between Fifty-eighth and Sixtieth Streets. Squatters filtered in during the Fifties.

Hip-to-hip brownstones and cobbled pavement hid a good part of the Valley of Flowers by 1885, although there were still some wide spaces in and around Lincoln Square. The gentry's family gravestones were kicked over in the frenzied population push that came with the subway cut-through around 1904. Then new theatres threw their brazen lights, but they were death candles. The area turned slummy.

Now the Valley of the Flowers will change again. Metropolitan Opera stars will lift their voices where the larks sang. Fordham undergraduates will walk green sod where the crude plow and the ringing axe echoed three centuries ago.

Skyscrapers as tendril-covered shoots bursting from urban soil.

Sharpe, p. 228

Plants sprouting from a brick cliff beneath Tudor City.

Conrad, p. 175

Palms may soon sprout in Central Park. The climate of New York may be undergoing change.

Riesenberg and Alland, p. 185

Washington Square, Gramercy Park, Madison Square, Tompkins Square are all located on one-time swamps.

Federal Writers, *Panorama*, p. 24

A short distance to the west, and formerly in the densest woods, is the location of a veritable freak of nature, the mysterious Black Swamp, in whose dreaded and notorious waters, feared since the days of the Indians, so many blooded cattle have met their death. For the longest time this marsh defied all efforts to fill it up. Thousands of tons of earth and rock would be dumped into its deep maw. Success was apparently in sight, but when the next day dawned all would have disappeared as if by magic, leaving only the dark waters in sight, smiling in the morning sun. Human persistence, backed

Brown, *Valentine's*, p. 243

by more thousands of tons of material, at last proved triumphant, and now Morris Avenue reigns supreme.

Geology

Douglas, p. 59

The city had crystallized itself, had set itself. The sky was different … The people were etched with a sharper acid.

Granick, p. 17

The largest garnet crystal ever found in the U.S.A. came out of a ditch on West 35ᵗʰ Street, and for some time was used as a doorstep.

Ford, *America*, p. 108

I do like stones to be covered with moss or ivy and that, in consequence, Paris round the Arc de Triomphe de l'Etoile really repels me. The stones of New York are no less machine-sawn, hard and antiseptically resistant to the growth of lichen.

Josephy and McBride, p. 64

"Is there any danger of Manhattan sinking under the weight of its skyscrapers?" we asked Mr. Alfred Rheinstein, our favorite New York builder. He says not, since what is put onto the earth usually weighs less than what has been taken out.

Gooch, p. 241

The red sandstone for Manhattan's brownstones was mined at Sneden's Landing, a very private and small community along the Hudson just twelve miles north of the George Washington Bridge. Residents included Orson Welles, Noël Coward, John Dos Passos, John Steinbeck, Aaron Copland and Jerome Robbins.

Conrad, p. 148

He sketched a stone he had picked up in Central Park. It already had the shape of a skull.

Federal Writers, *Panorama*, p. 405

Framed in the spirit that called for "the conquest of nature" instead of an accommodation between nature and man, [Robert Moses] preferred to iron out the hills of Manhattan by force rather than attempt to blend them into the contexture of a more habitable city.

Sanders, *Celluloid*, p. 359

"There aren't any mountains in Manhattan," she points out.
"Tall buildings," he replies.
"Same thing."

Hawes

Where Broadway stood, a rocky ridge once ran diagonally up across the island like a sash.

Irwin, p. 39

Momentarily he is gazing straight along Broadway. It slashes the building-mass clean and sheer and narrow, suggesting infinite heights and mysteries. Man, you would say, had nothing to do with it; the hand of nature, working through eons, eroded this gorge.

Conrad, p. 249

In New York City 690 men and women are employed in the "extraction of minerals."

Trebay, p. 226

From Park Avenue at 93ʳᵈ Street, Manhattan drops away in geologic, economic, and spiritual degrees. On that spot the city's ancient bedrock rises to one of its highest points. To the west shine the sycamores in the park and the Eldorado's lights. Southward lies the magisterial city, flanking the broad, solemn avenue with Harry Helmsley's flashing gilding at its foot. To the east

there is a hill banded by the gray river; as you descend it, the granite facades become brownstone and then red brick and yellow, and the doormen and fine food shops disappear.

A 1932 photograph of Rockefeller Center under construction: "The aged and weathered, almost fleshly formations of rock are gouged out and carted away, to be supplanted by the riveted skeletal steel of the rising buildings."

Conrad, p. 167

Long stretches of road like the Bowery or Broadway actually retracting ancient trails atop the summit of hills (later leveled out in the wake of property speculation), over water meadows and marshlands.

Maffi, p. 4

The skyscrapers of New York and Chicago are made of stone and not of glass. Whole quarries have been fastened to their steel skeletons by means of cramps, quarries suspended in empty space. It is inconceivable. I thought that I would find an erect city of steel. Not at all! It is a city of stone.

Corbusier, p. 66

Gleaming richery exploding out of the ground. Curtained glass and radiant jewels.

Donleavy

The many faces of Jesse James resplendent on a rock at Spuyten Duyvil.

Berrigan, *Collected*, p. 92

Jumping off a high rock on the north side into the currents of Spuyten Duyvil and letting the currents carry you across to Manhattan.

Trebay, p. 350

The bottom of Spuyten Duyvil is manmade and endless, dredged in the earliest years of the century as the Harlem ship channel. No one ever hit it. The motorboats that thud across the surface now are like bugs on a pond.

Ibid.

Flora

Probably the most active farm in New York City lies, incongruously, in the East River. It is on Rikers Island, and is worked by men from the city's penitentiary and workhouse.

Berger, *New York*, p. 156

The farm by 1930, with the accumulations of city waste dumped on its margins, has grown to about 500 acres.

Last year, felon farmers raised 10,895 pounds of chickens and gathered 5,917 dozen eggs; they brought in a vegetable crop that came to 59,315 pounds. They've grown 75,000 trees for the Park Department and 70,000 flowering shrubs. They have a sizable peach orchard—268 trees—and get a crop from that, too.

The farm output is for city institution kitchens, mostly for city prisons. The bakery on the island turned out over 2 million loaves last year for prisons and public school lunchrooms.

Prisoner work farms on Rikers Island in the 1930s. A sixty-acre farm cultivated by prisoners is being steadily enlarged; the renowned prison piggery produces more than fifty thousand pounds of pork every year.

WPA Guide, p. 426

New York is pastoral only to those who are out of work.

Conrad, p. 171

One penthouse hostess offered her dinner guests the novelty of corn harvested from her "little farm" on the thirty-second floor.

Morris, *Incredible*, p. 297

D Nature—Flora

Berger, *New York*, p. 99 Pump-house crews eat from a vegetable garden in Central Park: tomatoes, lettuce, sweet fennel, fresh scallions, and cucumbers.

Ibid., p. 104 The Bronx has had its own Johnny Appleseed for fifty-four years. He has planted fig trees, peach trees, finochio, hot peppers, sweet peppers, miniature tomatoes, eggplant, beets, corn, lettuce, long squash, round squash, garlic, onions, string beans, carrots, basil, Swiss chard.

He has sown seeds of his own all these years. He has grafted apples onto pears, pears onto apples. He has preserved enough each fall to feed himself, his wife, his two sons, his daughters and sons-and-daughters-in-law and their five children. He has kept his neighbors in fruits and vegetables. He toils from sunup to sundown. He is a contented man.

The garlic shakes when the Pelham trains rumble by. If he passes an empty lot, he stops dead and his eyes come alive. He always says: "There is a sin."

Hughes, *Big Sea*, p. 80 He kept saying: "Where is the grass? Where will I keep my chickens? *Puta madre!* There is no grass?"

Finney, p. 176 I stared out over a strange astonishing view of farm after tiny farm clear to the Hudson.

Ibid. Here they are—the farmers and livestock raisers beside the elegant Dakota doing their chores, the kids playing, the animals foraging for whatever they could find among patches of half-melted snow.

Trager, p. 456 The last Manhattan farm ceases operations at the corner of Broadway and 213th Street in 1930.

Gopnik, p. 110 New York is sad before it is busy, it is a kind of inverted garden, with all the flowers blooming down in the basements.

Berger, *New York*, p. 240 The world's smallest garden in a three-room flat in Brooklyn. Planted lemon seeds, orange seeds, grapefruit seeds, podocarp, ardisia, and begonias in toothpaste-tube caps and thimbles. Watering is done with an eye-dropper; main garden tools are a razor-blade and toothpick.

Ibid., pp. 254–5 There is a green world high above the pavement that city groundlings rarely see. Familiar and exotic growths flourish in this sky acreage. The same birds, insects and crawling things that invade open countryside plantings climb to apartment house and skyscraper gardens—as high as thirty-eight floors at Radio City—to rob or destroy crops … The Schwartzes, like most other crow's-nest horticulturists, grow thousands of annuals and perennials. They put their fruits and berries up in jars. They fight off crows, woodpeckers, bats, pigeons, aphids, tent caterpillars and go after all sorts of crawlers with spray guns. They grow magnificent orchids. Their pet dachshund, Penny, cremated, sleeps inside a miniature grave fence under an olive tree … The Rooftop Gardeners eat under whispering leaves with flower scent drifting across their candlelit tables. Some sleep in their gardens, under the stars. Some have forsaken the country entirely; just live on their green roofs.

Trebay, p. 215 A housewife from the Jacob Riis projects favors tropical zebra plants from Woolworth's.

Nature — Flora

The East Village, on 9th Street at Avenue D, on 8th Street farther west, in lots tucked up between tenements and fenced off from the debris, is alive with produce: lettuce leaves, collard from the sun and rats, grows in one plot beneath a stuffed sock-monkey effigy. On a stake in another patch, a plastic hobby horse is impaled: he snorts mid-air over a plot of beans.

Ibid., p. 203

A local witch grows medicinal herbs in her 6BC plot.

Ibid., p. 215

In the Channel Gardens in Rockefeller, Swiss chard, broccoli, carrots and sweet corn were growing as Victory Gardens. Two hundred tomato plants grew in beds along the rim overlooking the Lower Plaza skating rink.

Diehl, p. 151

The exit of the BMT subway in Brooklyn Heights is guarded by an old church made of red flagstones and surrounded by a heavy black iron gate. Imprisoned behind these gates are five bushes I remember from my childhood, bushes so ugly that you would wonder why they had been planted at all, until one spring day when they blossomed into thousands of yellow flowers called forsythia. As I emerged from the subway my monochrome vision suddenly registered yellow; all five bushes were bursting with flowers. I couldn't understand it. It was midwinter and freezing. Snow was still on the ground.

Wornov, p. 221

Once the tree tips and the eaves of roofs met, their height equal, and they would lend an extra quality to each other like two friends, two women meeting to share the substance and bake a cake: like a woman just about to take a bath, like a woman always just about to be refreshed, oh like moonlight on snow it was then, like furnaces pouring out their plentitude of heat to the iced streets, and birds nestling between the rows of houses and warm bars, and warm feelings.

Coleman, p. 207

A tree in a treepot in Times Square has to make oxygen for a million people. In New York you really do have to hustle, and the trees know this, too—just look at them. The other day on 57th Street, I was walking and I was looking at the new, sloping Solow building across the street and I walked straight into a treepot. I was embarrassed because there was no way at all to carry it off. I just fell on top of this tree on West 57th Street because I wasn't ready for it to be there.

Warhol, *Philosophy*, p. 154

Television aerials look like pruned and spiky saplings, sunning themselves in the hope that they too may grow.

Conrad, p. 175

Flags look like a vegetative outgrowth on the dour stone of the buildings.

Ibid., p. 87

The leafbud straggles forth
toward the frigid light of the airshaft

Rich, "Upper Broadway," p. 57

Below the shops in Madison Square Park a lone tree stood in the darkness, a happy beacon; then comparative loneliness and unlighted windows to a point below Fourteenth Street.

Berger, *New York*, pp. 241–2

Plants grew pale and died in the air-shaft window.

There are no trees in the city! That is the way it is.

Corbusier, p. 71

Even plants hardy enough to thrive in a thin bed of city dust and soot need watering.

Johnson, "Minor Characters," p. 974

Conrad, p. 198	New Yorkers who lash each other using twigs of birch and premature chrysanthemums—with the means of sensual arousal and of chastisement.
Irwin, p. 196	Gasoline or vibration or both combine hereabout to blight all vegetable life; the scattered trees of Bryant Park are very sick.
Brook, p. 12	There isn't much vegetation here, apart from packets of marijuana.
Galwey, p. 421	Electric glamour of tree boughs.
Blandford, p. 183	The Hamptons: Manhattan with pruned and pristine trees and aquamarine pools.
Ibid., p. 120	Doubtless Connecticut is magnificent right now in its plump vermillion and yellow plumage, but so too is Central Park.
O'Hara, p. 197	One need never leave the confines of New York to get all the greenery one wishes—I can't even enjoy a blade of grass unless I know there's a subway handy, or a record store or some other sign that people do not totally *regret* life.
White, *Here*, p. 56	A block or two west of the new City of Man in Turtle Bay there is an old willow tree that presides over an interior garden. It is a battered tree, long suffering and much climbed, held together by strands of wire but beloved of those who know it. In a way it symbolizes the city: life under difficulties, growth against odds, sap-rise in the midst of concrete, and the steady reaching for the sun. Whenever I look at it nowadays, and feel the cold shadow of the planes, I think: "This must be saved, this particular thing, this very tree." If it were to go, all would go—this city, this mischievous and marvelous monument which not to look upon would be like death.
Hardwick, "Sleepless," p. 449	No tree was to be seen, but as if by a miracle little heaps of twigs and blown leaves gathered in the gutters.
Mumford, *Modern Art*, p. 42	The rocky base of Manhattan, always unkind to life, steadily lost its filament of soil. The trees in the streets became more infrequent as the city grew; and their leaves grew sear before autumn came … while only the ailanthus tree, quick growing and lean living, kept the back yards occasionally green, to gladden the lonely young men and women from the country, who faced their first year in the city from hall bedrooms on the top-floor rear of unamiable boardinghouses.
Williams and Noël, p. 177	Ailanthus trees, the Tree of Heaven.
Josephy and McBride, p. 62	We were fascinated to learn that a skyscraper may contain the following exotic woods, whose very names would make a Kipling poem if they could be rhymed up a bit: Satinwood from San Domingo; Makassar ebony from the Dutch East Indies; bubingo wood from South America; English gray harewood; padouk from the British East Indies; avodire from the French Congo; East Indian rosewood; Australian sandalwood; Brazilian burl; and South African madrone.
Trager, p. 452	Woolworth heiress Barbara Hutton turns 18, November 1930. Debut ball at Ritz-Carlton Hotel, whose first floor has been transformed with white birches, eucalyptus trees from California, mountain heather, scarlet poinsettias,

D Nature — Flora

and 10,000 American beauty roses (workmen have labored for two days and nights to create the opulent bower).

Here, the flowers themselves have forgotten nature, and enter heartily into the artifices of a sophisticated society.

Beaton, *New York*, p. 84

Often enough city roses are attached to a padlocked chain.

Trebay, p. 217

As far as I can tell, the rose bush outside the brick apartment house at 305 Madison Avenue has no official affiliation.

Ibid., p. 216

At this moment it is a red rose giving its voluptuousness all to the residents of Chinatown.

Ibid.

Daniel Coetzee recently took charge of the Jefferson Market Library garden, where some of the rose bushes are nearly twenty years old, practically ancient in New York.

Ibid., p. 215

Perhaps New York City itself is an unexpected place for a rose, but they seem to thrive here in lots reclaimed from pulverized rubble, dumped tires, auto parts, and in soil fertilized with shredded bread wrappers, condoms, and poison-green puddles of antifreeze.

Ibid., p. 216

Outside a tenement in the East 80s, for instance, there's a leggy, cascading Golden Shower; by a Chelsea stoop, a rare Zepherine Drouhin; in a rigidly tasteful Greenwich Village commons, an example of Aloha; and not far from the Claremont stables on West 89th Street, I once spotted an unidentifiable climber—possibly the old-fashioned white named Dr. Van Fleet—that looked fat and happy, maybe from a diet of rotted manure.

Ibid.

Girls tittering in a nickelodeon are a bouquet, an untended growth garnered from the arboreal paradise which was the impressionist city.

Conrad, p. 114

Fauna

It is a city with cats sleeping under parked cars, two stone armadillos crawling up St. Patrick's Cathedral, and thousands of ants creeping on top of the Empire State Building.

Talese, p. 2

It's the Bronx. It has woods, deer, fish, muskrats, possum, owls, snakes.

Donleavy

You can swim in the rivers without fear of disease, and even swim at night with the seals in the Prospect Park Zoo. You can trust the oysters from Long Island Sound.

Hamill, "Lost"

If you were to take a wild lion or a tiger or a hippopotamus or an elephant and force it to ride the New York subways in rush hour every day for a week, the poor creature would have a nervous breakdown.

Atkinson, pp. 18–19

Sometimes a bewildered cat or dog gets into the Lincoln Tunnel. Occasionally a duck or hen falls from a poulterer's truck. The inspector remembered when a steer dropped off a cattle truck in the tunnel.

Berger, *Eight Million*, p. 204

A clowder of some sixty to seventy semi-wild cats, mostly tiger-topped and white-bellied, prowls the yards and fences back of the chip-faced brownstones

Berger, *New York*, p. 103

on the north side of Fifty-first Street between Eighth and Ninth Avenues. The block legend is that the cluster never leaves the yards, that it has lived there sixty years or so. All the cats have six claws on each paw. Weird, primitive thing to run into so near Times Square.

Peyton, p. 11

A six-month-old civet cat, who had escaped from his cage at the antelope house, was captured in the service entrance of Bergdorf Goodman store, at Fifty-eighth Street and Fifth Avenue. He ducked through the wheels of a victoria and crossed Fifty-ninth Street. He swept passed the Plaza Hotel, over Fifty-eighth Street, and headed for the entrance of Bergdorf Goodman. The cat doubled back and sped down the service entrance to the store.

Dos Passos, p. 19

Ladies screamed and ran in all directions this morning at eleven thirty when a big snake crawled out of a crack in the masonry of the retaining wall of the reservoir at Fifth Avenue and Forty-second Street and started to cross the sidewalk.

Mueller, p. 247

Out of the subway grilles a plethora of snakes filled the sidewalks.

Mitchell, *Ears*, p. 467

The stuff from which Confusion Dust is made does not grow on bushes in Central Park and they will lock you up if you try to steal the snakes in the Reptile House in the Bronx.

Talese, p. 48

At 608 West 48th Street you can rent a lion for $250 a day.

Conrad, p. 197

In this delicious sweltering fatigue, New York seems almost pastoral. He expects a flock of sheep to turn the corner.

Talese, p. 80

We have to get to sheep fast before maggots get to them. Dead sheep have a horrible odor, much worse than horses.

Behan, p. 12

A city is a place where you are least likely to get a bite from a wild sheep.

Hawes

Fifth Avenue and 91st Street in 1901: wild game, wandering goats, and a clear blue horizon.

Moore, "New York," p. 42

the centre of the wholesale fur trade,
starred with teepees of ermine and peopled with foxes,
the ground dotted with deer-skins—white with white spots

Jones and Yaniv

In 1999 a carriage horse was electrocuted when it stepped on a Con Ed cover near Park Avenue.

Talese, p. 79

Each week an average of four horses will drop dead in the city.

Haden, pp. 57–8

This decline of the horse removed one especially potent experience of monstrosity in the city—that of seeing and smelling dead horses in the street (15,000 were worked to death in 1900 alone, dying in the street). The smell of a dead old horse in the night air was said to be appalling … "When a horse died, its carcass would be left to rot until it had disintegrated enough for someone to pick up the pieces."

Talese, p. 80

A three-bell signal means that an animal has dropped dead somewhere in New York.

D Nature — Fauna

In 1905, horses were grazing in Elmhurst on a site that is present-day Queens Boulevard. Winkleman, p. 30

Until 1800 cows grazed on the site of the first Waldorf. Koolhaas, p. 150

Fat pigs, scarred from fights with wandering dog packs, slopped and grunted through Broadway mud, rooting for dainties. Berger, *Eight Million*, p. 25

When Times Square was a dark spot, when pigs, steers and mustangs were herded from barges down Eleventh Avenue. Berger, *New York*, p. 88

A nine-foot shark was removed that someone left one night on Park Avenue and 150th Street in the Bronx. Talese, p. 79

Today I drove from the appointment onto the West Side Highway through the tunnel to Brooklyn. I wanted to film the beluga whales. These whales are so beautiful. Pale, almost gray-white bodies, streaming through the sun, luminous waters of a giant tank viewed from the side in a darkened building. Wojnarowicz, p. 204

George I. Schwartz's specimens he dug out of his own backyard on Fifty-ninth Avenue in Queens: assorted beetles, cicadas, snails, slugs, butterflies, garter snakes, DeKay's snakes, toads, mantises, moths, pill bugs, water bugs, caterpillars. Mr. Schwartz knows a man who found 350 snakes within thirty square feet in Flushing. Berger, *New York*, p. 27

Since newspapers reported about ten days ago that a little girl in Flushing, Queens, had been nipped by a black widow spider she had picked up with a stone, the Health Department in town had been getting quite a collection of live black widows. More than thirty have been turned in … New York has always had black widows, at least since the mid-eighteenth century. *Ibid.*, p. 107

An occasional butterfly pirouettes through Wall Street's canyon. Federal Writers, *Panorama*, p. 34

The tiger swallowtail butterfly grazing in a patch of threadleaf coreopsis on the Bowery carries a sheen on his wings that indicates he's local, newly emerged from his cocoon. Trebay, p. 217

Rockefeller, whose lifelong hobby was collecting beetles. Glanz, p. 11

Mrs. Astor reports bedbugs in the Ritz. Riesenberg and Alland, p. 20

Do you know what's eating this city. Besides envy and graft. The cockroach. Donleavy

Baby cockroaches sneak back again behind the basin. *Ibid.*

The eternal New York war against the cockroach is being waged with J-O Paste and Flit. Hamill, "Lost"

And I killed a roach and it was a trauma. A very big trauma. I felt really terrible. Warhol, *Diaries*, p. 682

I know, I know—yesterday I was so worried about killing a cockroach. But this is different—the cockroach didn't do anything to anybody, and I didn't kill it right so it was squirming and it was so big, it'd lived to be so big. *Ibid.*, p. 684

Bockris, *Burroughs*, pp. 176–7

BOCKRIS: Up at the Natural History Museum there is a woman studying the international roach population, spending nights with them, and doing very close-up portraits of them. She obviously knows what's going on, whatever it is. These roaches are widespread and venomously effective.
BURROUGHS: Widespread they are, yes.
BOCKRIS: They're brave and aggressive creatures, because what chance do they stand against you when they come out?
O'BRIEN: Some of them are smart, some of them learn to jump at the right time.
BURROUGHS: Some of them have wings.
BOCKRIS: You stated flatly that all waterbugs had wings.
BURROUGHS: As far as I know, although they may undergo various cycles.
O'BRIEN: They eat plastic.
BURROUGHS: Yes. They eat glue, they eat the bindings out of your books.
BOCKRIS: We're closer to roaches than almost anything else in New York and we don't know anything about them, their habits.
BURROUGHS: I think you're a bleeding heart do-gooder; you think we should get to know more about roaches. I doubt it, frankly.

Warhol, *Diaries*, p. 580

There's a big fly in here and I'm going to open the window to let it out, there's this black guy across the street with plastic bags going from door to door ringing. Could he really be a dry cleaner? One door just opened, I'll wait to see if he comes out with more bags, but if I pull the shade so the fly will stay out, then I won't be able to see out, oh, here he comes, yes, he's got another bag, but, he's going toward Park with it.

Beaton, *New York*, p. 167

… while on the mountain-sides of Harlem Park are still a few squirrels, last survivals of an almost extinct race, the rest having been shot and their skins sold by the Harlem Negroes.

Atkinson, p. 264

And then there is a whole race of pigeon and squirrel feeders, whose generosity stuffs to bursting the gluttons in parks and public places. These scatterers of grain may not all be lonely people, of course, but they give the impression that the pigeons and the squirrels fill a large part of their lives. I never see an elderly lady toting a bag of earnestly collected crumbs and crusts to her part-time pets that I do not reflect on the injustice of the situation. These gentle ladies, feeding the never-satiated birds, make me feel that it would be far better if the situation were reversed. A nice roast pigeon would make a nourishing meal for one of these kind women and I'd be willing to do something about it. A squirrel pie would fatten and redden the pale cheeks of elderly gentlemen who doubtless deprive themselves of small comforts to feed those ungrateful gray rodents, the squirrels. Pigeons and squirrels give these lonely people the illusion of being needed and loved.

Conroy, p. 44

Pigeons rise from the airshaft and scatter.

Eiseley, pp. 790–1

New York is not, on the whole, the best place to enjoy the downright miraculous nature of the planet. There are, I do not doubt, many remarkable stories to be heard there and many strange sights to be seen, but to grasp a marvel fully it must be savored from all aspects. This cannot be done while one is being jostled and hustled along a crowded street. Nevertheless, in any city there are true wildernesses where a man can be alone. It can happen in a hotel room, or on the high roofs at dawn.

One night on the twentieth floor of a midtown hotel I awoke in the dark and grew restless. On an impulse I climbed upon the broad old-fashioned windowsill, opened the curtains and peered out. It was the hour just before

dawn, the hour when men sigh in their sleep, or, if awake, strive to focus their wavering eyesight upon a world emerging from the shadows. I leaned out sleepily through the open window. I had expected depths, but not the sight I saw.

I found I was looking down from that great height into a series of curious cupolas or lofts that I could just barely make out in the darkness. As I looked, the outlines of these lofts became more distinct because the light was being reflected from the wings of pigeons who, in utter silence, were beginning to float outward upon the city. In and out through the open slits in the cupolas passed the white-winged birds on their mysterious errands. At this hour the city was theirs, and quietly, without the brush of a single wing tip against stone in that high, eerie place, they were taking over the spires of Manhattan. They were pouring upward in a light that was not yet perceptible to human eyes, while far down in the black darkness of the alleys it was still midnight.

As I crouched half asleep across the sill, I had a moment's illusion that the world had changed in the night, as in some immense snowfall, and that if I were to leave, it would have to be as these other inhabitants were doing, by the window. I should have to launch out into that great bottomless void with the simple confidence of young birds reared high up there among the familiar chimney pots and interposed horrors of the abyss.

I leaned farther out. To and fro went the white wings, to and fro. There were no sounds from any of them. They knew man was asleep and this light for a little while was theirs. Or perhaps I had only dreamed about man in this city of wings—which he could surely never have built. Perhaps I, myself, was one of these birds dreaming unpleasantly a moment of old dangers far below as I teetered on a window ledge.

Around and around went the wings. It needed only a little courage, only a little shove from the window ledge to enter that city of light. The muscles of my hands were already making little premonitory lunges. I wanted to enter that city and go away over the roofs in the first dawn. I wanted to enter it so badly that I drew back carefully into the room and opened the hall door. I found my coat on the chair, and it slowly became clear to me that there was a way down through the floors, that I was, after all, only a man.

I dressed then and went back to my own kind, and I have been rather more than usually careful ever since not to look into the city of light. I had seen, just once, man's greatest creation from a strange inverted angle, and it was not really his at all. I will never forget how those wings went round and round, and how, by the merest pressure of the fingers and a feeling for air, one might go away over the roofs. It is a knowledge, however, that is better kept to oneself. I think of it sometimes in such a way that the wings, beginning far down in the black depths of the mind, begin to rise and whirl till all the mind is lit by their spinning, and there is a sense of things passing away, but lightly, as a wing might veer over an obstacle.

Flagpoles attract them; so do pillars, perhaps from some primeval instinct for guarding one's rear. They also like to form in a line abreast at the curb, facing inward toward the action.

WPA Guide, p. xxxii

It is curious that, in the most modern of cities, the most ancient form of messenger service should be employed. At the half-time siren at distant football or baseball matches, a flock of pigeons will be released to fly with the latest photographs of the match back to the roof of Mr. Hearst's building downtown; and I believe that the latest Paris fashions are flown from the Atlantic liners straight to *Harper's Bazaar*.

Vreeland Archive, NYPL

Donleavy

Where pale pigeons unleash trifling indignities splattering on balconies and windowsills.

Ibid.

Lapping the leaves outside my window where a pair of pigeons were flapping and screwing.

Beaton, *New York*, p. 40

Perhaps New Yorkers cannot find time to look from windows. Perhaps it is only on Sundays that they see the pale yellow sky, the sunset of rose and opal, and the pigeons. A distant flock of black, brown and white specks vanishes completely each time it wheels back and forth over the same three blocks of skyscrapers. Soaring, dipping and weaving in unison, the pigeons repeat, continuously, their conjuror's trick of disappearance and reappearance, until their leader drops to rest on a rooftop, where an Italian boy comes to feed them.

Ford, *America*, pp. 62–3

For one thing has always caused a note of sadness to me—the fact that I seldom see a bird here. And for me a city without a bird is like a house without a piano—something a little deadened. I seldom see—practically never see— even the humble, troublesome sparrow in New York. Even years ago that fact used to impress me. One went along the streets and never saw a bird. There were, however, other beautiful flying things. A great moth with a wing- spread larger than that of a sparrow. And, after that, I used to take pleasure in observing those fine things floating with the boldest and most beautiful flight in the world—smoother than that of the finches and more floating than the swallows—over the buses on Fifth Avenue or round and round the trees of Madison Square in an autumn season. I have not seen them lately—but that, I am aware, is no proof that they are no longer there. For sitting the other day with a lady in the window of the National Arts Club looking down over Gramercy Park—which in London would be called a square—I remarked to her that New York had for me always a certain note of sadness because there are no birds here—not even sparrows. She remarked drily: "If you will give yourself the trouble to look down you will see at least seventeen." And there they were—at least seventeen sparrows flying across the gray winter grass of the square.

Berger, *New York*, p. 14

Brooklyn Bridge aerial workers never disturb birds' nests up in the towers if the nests hold eggs. Craft superstition says the destruction of eggs means ill fortune.

Ibid., p. 234

In early evening when thin winter light begins to fade in Chambers Street, starling flights drop through the dusk to twittery homing in the portico of the Old County Courthouse just north of City Hall. They roost there in thousands and their bedding song is as of thousands of nail files, synchronized.

The nine City Court justices who have chambers in the structure are accustomed to starling feathers floating in on their papers. They say it gives them the feeling they are in the city, but not of it.

Ibid., p. 125

The most clamorous show in New York's wintry dusk is the mass return to nesting of starlings from city parks and other open spaces that are bird feeding grounds. The flocks move in dark masses, blacker than thunder cloud.

Uptown, coming from Westchester, they have a way-stop at Trinity Cemetery in 155th Street off Broadway. Downtown, they swoop into the Municipal Building arches and into courthouse porticoes off Foley Square, usually a little after 5 P.M. Their combined twittering startles city dwellers

D Nature — Fauna

who've never heard all that sound before. The flocks take off for their feeding grounds again in frosty dawn with the same outcry.

Yesterday at 4:30 p.m. a group of starlings swerved around the rigging of elevated billboards along Riverside Drive, swung abruptly about a large gas tank and then swooped below the underpinnings of the 125th Street viaduct to roost for the night.

Peyton, p. 8

A storm which swept the Atlantic coast late in 1932 brought a swarm of Arctic birds, called dovekies, and dashed many of them against the skyscrapers. Thousands were found all over the city, their limp bodies draped on telephone wires, in the streets, on the lakes and lawns of the parks.

Federal Writers, *Panorama*, p. 32

A songbird of the canary family, the house finch (*Carpodacus purpureus*) has been taken illegally by nets in the Sierras and sold through the 1930s to dealers at a few dollars per hundred: it will propagate itself throughout New York … entertaining the city with arguably the most musical call of any wild bird.

Trager, p. 525

Hartz Mountain founder arrives in New York in 1926 from Germany with 5,000 singing canaries.

Ibid., p. 471

More ducks than people live on Long Island.

Simpich, p. 281

A monkey was captured in the subway in 1960.

Kennedy, *Subwayland*, p. 107

"Say, what is it anyway?"
He says he understands it's "some kind of gorilla."
"Ain't we got enough of them in New York already?" she demands.

Lovelace, *King Kong*

Allen and Brickman, *Manhattan*, p. 181

The words "United Artists, a Transamerica Company," appear in white over a silent black screen, cutting almost immediately and suddenly to a series of shots of the New York City skyline. As "Rhapsody in Blue" is heard over the scenery, the images flash on and off: the skyline at dawn, the sun silhouetting the Empire State Building, jutting skyscrapers, parking lots, crowded streets, the Brooklyn Bridge, neon lights advertising Broadway, Coca-Cola, various hotels, the snow-covered and lamp-lit streets of Park Avenue and Central Park, the garment district, an excited demonstration downtown ... As the music swells over the Manhattan scenery, Ike's voice is heard, as if reading aloud from his writings.

Riesenberg and Alland, pp. 92–3

We sweep the turquoise haze of contemptuous Palisades, gazing unwinking at the young intruder city. We see the Park, a parallelogram of green; the Hudson slinks off to the north. But south, done to a turn, below our eyes spreads an impossible nightmare. It is the Floor of Hell. It is the cockpit of a ghoulish ideology, a blind era that winks at the malnutrition of children, while boosting the prices of groceries by destroying food.

This before us, and around us, is Big Headquarters, the city of office men and agents, middlemen and lawyers, exempt crooks, public relations fakirs, venial judges, priests, police, and the victims of circumstances.

We look down on a hallucination, a mad Halicarnassus sacked each night by the cohorts of Comus, entered by thieves and saved from time to time by temporary Galahads. The sneering city curls brown smoke from its chimney censers; the bitter incense carries a faint odor as of burning sacrificial flesh.

Sanders, *Celluloid*, p. 67

Over the decades, the New York skyline has opened countless feature films—more films, probably, than any other single place on earth. The specific shot varies all the time, of course: a view of midtown from the East River in one film, downtown Manhattan from Brooklyn in another; a sweeping aerial of the entire island in yet another. We may see the city by day, its towers rising tall and solid, or by night, those same towers dissolved into the tracery of a million points of light. Accompanying the view might be that familiar "big city" theme music—its brisk tempo, dissonant brass, and bustling xylophone conjuring up busy streets, taxi horns, and rushing crowds. Or a haunting blue melody, a saxophone and orchestra evoking a kind of sweet urban sadness. Or simply a medley of city sounds—traffic, police sirens, a tolling church bell.

White, *Here*, p. 31

The summer traveler swings in over Hell Gate Bridge and from the window of his sleeping car as it glides above the pigeon lofts and backyards of Queens looks southwest to where the morning light first strikes the steel peaks of midtown, and he sees its upward thrust unmistakable: the great walls and towers rising, the smoke rising, the heat not yet rising, the hopes and ferments of so many awakening millions rising—this vigorous spear that presses heaven hard.

Fitzgerald, *Gatsby*, p. 68

The city seen from the Queensboro Bridge is always the city seen for the first time, in its first wild promise of all the mystery and the beauty in the world.

Mumford, *Sidewalk*, p. 85

One becomes aware of Manhattan itself in the distance, a shimmering silvery-blue mass, mountainous and buoyant, like a bundle of Zeppelins set on end; and, though one sees it now for the hundredth time, one feels like a little boy witnessing a skyrocket ascend, one wants to greet it with a cheer.

As architecture, New York ought to be in fact what it seems so surely at a distance: the most exhilarating embodiment of modern form. Unfortunately, it is not. As one walks through the streets of the city once more, amid such a mass of new and almost new buildings, one has a fresh sense of shame over all this misapplied energy and wasted magnificence.

From the river, the Woolworth tower shows its most airy metamorphosis; a needle, stitching the clouds—as Howells said of the Palazzo Publico in Siena, not so much a tower as a flight.

Irwin, p. 17

X looks at lower Manhattan. The city gleams in clustered cliffs of jewels.

Jolas, p. 474

A colossal hair-comb turned upward and so deprived of half its teeth that the others, at their uneven intervals, count doubly as sharp spikes.

James, p. 136

"Someone to Watch Over Me" is still playing as the film switches to the 59th Street Bridge. It is almost dawn and the scene has a nearly perfect feel of light and beauty to it. Mary and Ike, their backs to the camera, are sitting on a bench looking out over the water.

Allen and Brickman, *Manhattan*, p. 210

marvelous geometropolis
clinging to manhattan
island's arm
and caressing the sun
with rectangular
skyscraper fingers

Farfa, p. 296

The sun has risen behind Brooklyn. The windows of Manhattan have caught fire.

O'Connell, p. 141

Squares after squares of flame, set and cut into the ether.

Sharpe, p. 130

Sparkling with windows like mica.

O'Connell, p. 139

Gradually mellowing, the scene at night is most significant of all. Then the towering mass of the island deepens to a rich silhouette against the sky, luminous with the city glow. The lower end is deserted, and looms mysterious and awful in its empty vastness. To one who goes in for rich effects there can be nothing more impressive of the value of New York, as a unique city, than a study of the various and bizarre pictures it makes from such vantage points as the Brooklyn Heights, the ferries, or from any of the several bridges. There, comfortably ensconced, one may ponder at one's leisure upon its most curious unsubstantial quality, as of some gigantic Luna Park, its outlines traced by prodigal dots of light, its features illumined in so strange a fashion as to make them appear translucent; the whole high strung to the strident note of perpetual fête.

Henderson, pp. 18–19

Laid back in the calm of the night, the moving Hudson River at our backs and sides … movement of lights coiling and fracturing on the dark surface of the water, looking back through the darkness towards the skyline, Empire State Building, shafts of illuminated sides of darkened windows, spheres of luminous streetlamps, barely illuminated water tanks, the moon half full and blazing out there in its loneliness: some kind of barometer of the senses depending on time and distance you feel. Normandy moon has a clear foreign sense. New York City moon not so remote and wondrous.

Wojnarowicz, pp. 115–16

E Panorama — Wide

Simpich, p. 281

As if squeezed from myriad rainbows, here float infinite vistas of color, some painted walls blending so gradually into a skylike blue that sometimes it's hard to tell where man's work ends and real sky begins.

Lovecraft, *Fiction*, p. 295

I had seen it in the sunset from a bridge, majestic above its waters, its incredible peaks and pyramids rising flowerlike and delicate from pools of violet mist to play with the flaming clouds and the first stars of evening. Then it had lighted up window by window above the shimmering tides where lanterns nodded and glided and deep horns bayed weird harmonies, and had itself become a starry firmament of dream, redolent of faery music, and one with the marvels of Carcassonne and Samarcand and El Dorado and all glorious and half-fabulous cities.

Fitzgerald, *My Lost City*, p. 113

As the ship glided up the river, the city burst thunderously upon us in the early dusk—the white glacier of lower New York swooping down like a strand of a bridge to rise into uptown New York, a miracle of foamy light suspended by the stars. A band started to play on deck, but the majesty of the city made the march trivial and tinkling.

Kerouac, *Lonesome*, p. 105

Whole panoramas of New York everywhere, from New Jersey, from skyscrapers.

Above

Barthes, *Reader*, p. 160

To paint New York from above, at the top, is to rely once again on the first spiritualist myth, i.e., that geometry kills man.

Conrad, p. 105

Aerial perspectives cantilever bare rooms in a bleak sky or elide architecture, propping up unanchored arrays of water tanks, chimney pots, and cornices with no buildings to belong to.

Donleavy

Water towers on all the flat tarred roofs.

Amin and Thrift, p. 3.

Not an accretion of streets and squares that can be comprehended by the pedestrian, but instead manifests its shape from the air.

Mumford, *Sidewalk*, p. 51

The thick summer sky flared to the east with the lights of Harlem, and on this high roof one had a sense of separation from the rest of the world one usually doesn't achieve in Nature at a level lower than five thousand feet.

Corbusier, p. 65

My hotel room is on the twenty-first floor, about two hundred and twenty-five feet above the ground. I was greatly surprised to find that I had by no means lost contact with the ground. My myopic eyes easily, even very clearly, grasp the activities in the street—people, cars in movement.

Morris, *Incredible*, p. 354

Gaze down on Manhattan Island from the air, and you will see the world's most extravagant architectural fantasy. It won't look the same next week.

Brook, p. 14

It's a city of shapes that hang together and rearrange themselves as if seen through a kaleidoscope. Move twenty years and the view changes. Even if the foreground hardly shifts, the entire background may have vanished and been replaced. No two views are ever the same.

Brennan, p. 32

From the street, or from any window, the city often seems like a place thrown up without regard for reason, and haunted by chaos. But from any rooftop

the city comes into focus. The roof is in proportion to the building beneath it, and from any roof it can easily be seen that all the other roofs, and their walls, are in proportion to each other and to the city. The buildings are tightly packed together, without regard to size or height, and light and shadow strike across them so that the scene changes every minute. The struggle for space in Manhattan creates an oceanic uproar in the air above the streets, and every roof turns into a magic carpet just as soon as someone is standing on it.

The multi-souled city opens its central viscera and extends its peripheral members like tentacles.

de Torre, *Mental Diagram*, p. 57

To assure himself that New York is beautiful, the pedestrian must crane his neck in crowded streets, and perhaps doubt still remains. Yet only from the windows, making the buildings into great honey-combs, can New York be seen at her most beautiful.

Beaton, p. 39

(for New York is in fact a deep city, not a high one)

Barthes, *Eiffel*, p. 150

Proscenium

The skyline view is a kind of proscenium, after all, a metaphoric arch framing everything to come, offering a reassuring familiarity even as it plunges us into a new and unpredictable experience. How many places are as widely (or instantly) recognizable as New York? Older films sometimes placed a printed title across the view; newer ones rarely do—but in any case the name has always been superfluous. Like Big Ben or the Taj Mahal, the New York skyline is one of the world's unmistakable icons, thanks in large part to films themselves: each new opening shot trades on—and reinforces—the skyline's preexisting fame. Unlike those other icons, though, the skyline carries civic as well as national significance, standing for a city as much as (or more than) a country. And unlike the others it is not just a single structure but an entire place—the very thing, in fact, being symbolized. The Eiffel Tower denotes Paris; the skyline not only denotes but is New York.

Sanders, *Celluloid*, p. 67

Of course, the skyline also denotes something else: the "big city," the endless metropolis. This turns out to be less a function of the skyline's vertical thrust, surprisingly, than its horizontal spread: its hundreds upon hundreds of buildings, with their thousands upon thousands of windows—each window providing the symbolic marker of an individual and so, by extension, an individual story. Over the next few hours, the skyline vista suggests, we will follow one such story—but we might well have turned to some other window and there found another, equally interesting story to watch. Next time, perhaps. There are, the skyline proposes, millions of stories to choose from—a whole city of stories, all proceeding at once, whether we happen to see them or not.

Some establishing shots try for more, searching the skyline for clues about the story to come. The image that starts *Young Man with a Horn* (1950) gazes high up at the Chrysler Building, soaring into the sky as confidently as the jazz trumpeter on the soundtrack rises into his upper register. But soon the camera begins to tilt down, descending roof by roof to the modest tenement apartment of piano player Hoagy Carmichael, the film's narrator. This turns out to be a sketch of the film itself—a struggle between the transcendent "high note" that cornetist Kirk Douglas dreams of reaching and the worldly complexities of life and love that threaten to wreck his career. An identical shot, opening *Miracle in the Rain* (1956), offers a simpler meaning: New York, as the narrator tells us, is home to not only the high and mighty (the

skyscrapers) but to millions of ordinary people—including Jane Wyatt, a tenement dweller who is the film's romantic lead. Barbara Stanwyck's smoky voice-over at the opening of 1949's "East Side, West Side" ("Yes, this is my town … the most exciting city in the world, they say, the most glamorous, the most frightening, and above all, the fastest … ") underpins a glide from the sleek towers of midtown to a modest apartment house on Gramercy Park ("for me, it's home"), again evoking the distinction between the celebrated and the ordinary—and the city's embrace of both.

The same kind of movement is elsewhere turned to very different purpose. Among other things, the New York skyline remains an abiding symbol of American wealth and power; an opening that shifts from the gleaming spires to a slum district effectively reminds the audience that the wretched conditions they will be sharing over the next few hours are to be found not in some obscure locality but in proximity to a national landmark. Over time, the simple tilt or pan from proud skyscrapers in the distance to shabby tenements nearby (in *Street Scene*, 1931, and *The Window*, 1949) has given way to the ambitious, planimetric aerial shots that open *West Side Story* (1961) and *New Jack City* (1991), which, surveying all parts of New York from above—as if through a giant microscope—imply a kind of social-science objectivity, linking the city's richest and poorest districts in a single socioeconomic system.

Conrad, p. 77

Huneker likened it to "a mad medley of pepperboxes perched on cigar boxes" and said the windows of the office blocks on Wall Street resembled waffles.

Edholm, p. 104

Honeycombs! That's what they are,
Those lights from city windows

Douglas, p. 436

A "democratic" skyline, in which buildings complement one another, and a "star" skyline, in which buildings compete with each other; in Manhattan, buildings challenged each other directly.

Smith, *Charcoals*

In this twisted, seething mass stand quaint houses with hipped roofs; squat buildings crouching close to escape being trampled on—some hugging the sides of huge steel giants as if for protection; patches of thread-bare sod sighed over by melancholy trees guarding long forgotten graves; narrow, baffled streets dodging in and out, their tired eyes on the river; stretches of wind-swept spaces bound by sea-walls, off which the eager, busy tugs and statelier ships weave their way, waving flags of white steam as they pass; wooden wharves choked with queer shaped bales smelling of spice, and ill-made boxes stained with bilge water, against which lie black and white monsters topped with red funnels, surmounting decks of steel.

Sullivan, *1001*, p. 16

City of skyscrapers, man-made Rocky Mountain range.

Irwin, p. 78

Here, on days when the violet mists obscure the distance, it is a curving cliff; the upper turrets of the higher structures might be castles or temples balanced on the dizzy edge.

Ibid., p. 15

To the European these colossi seem either banal, meaningless, the sinister proof of a material civilization, or a startling new achievement in art. And I have often wondered whether it does not all depend upon the first glimpse; whether at the moment when he stampedes to the rail they appear as a jumble, like boxes piled on boxes, or fall into one of their super-compositions.

Gorky, "Boredom," p. 311

The city, magic and fantastic from afar, now appears an absurd jumble of straight lines of wood, a cheap, hastily constructed toy-house for the

amusement of children. Dozens of white buildings, monstrously diverse, not one with even the suggestion of beauty.

The residents of the high-rent apartment houses that lined the Manhattan side of the East River had never gotten much of a view for their money. Opposite them—to the east and dragging off to the south—was scenery done in Early Industrial Era Midlands, the grimy warehouses, factories, tenements, oil tanks and open storage depots of Astoria and Long Island City. Its dreariness broken only by the gaudiness of occasional monster billboards painted large enough so that their messages could be seen clearly across the river, that vista stretched away without a break (there were no housing developments or parks there then) beneath a pall (the word "smog" had not yet gained currency) cast over it by belching smokestacks. And the scene to the north where Ward's Island lay, low in the water with Randall's behind it, had not been any prettier. Dull-colored and lifeless in the distance even when fog didn't shroud them, the two islands had been adorned only by the squat red and gray industrial buildings that failed to block out the scenery behind the islands: the South Bronx, Long Island City's spiritual descendant. Since 1932, the piers erected for the first, abortive attempt to build the Triborough Bridge had been part of the scene, but, dun-colored, featureless and, without a bridge on top of them, seeming in the distance like a succession of walls to play handball against, they did little to relieve its drabness. The view had not been inspiriting.

Caro, p. 396

It's a well-known fact that you can live in Manhattan all your life without ever seeing it from the water.

Trebay, p. 221

Queens had been moribund and torpid, Manhattan was effervescent. The lights had come on in the midtown skyscrapers, the pavements were crowded, the yellow cabs bumped their ways over the potholes of the great avenues, and the peddlers displayed their wares and yelled their street cry: "Check it out!"

Brook, pp. 4–5

It seems an odd thing to say of creations so massive and magnificent as the sky-scrapers; but they have a strangely elusive beauty. Seen from one point of view, they are a meaningless jumble, justifying every charge the foreigner used to bring against them; seen from another, they fall into a composition, as though a Michelangelo or some other super-artist had designed the whole group for a single creation.

Irwin, p. 13

In "From An American Place, Looking North" (1931) a building is under construction opposite Stieglitz's window. At present he can see through the girders. When it's complete, it will block his view. Even from this height, his visual dominion is threatened.

Conrad, p. 83

The Gothic quirks of the church spire on West 23rd Street are partly obliterated by the bare rectangle of an office block.

Ibid., pp. 111–12

Hotel New Yorker, which has eight thousand rooms, each with an inside view.

Gooch, p. 189

Scale, Magnitude

The city is too big, and they have to touch too much, and touch it too rapidly. From the sheer impossibility of doing it justice they fall into conventionalism. Literature is nipped by the wealth of opportunity.

Hapgood, p. 97

Corbusier, p. 77

America has given us that sensation: magnitude which is noble, which can be very noble, as it often was in the past.

Federal Writers, *Panorama*, p. 312

The city as merely an accumulation: the largest size, the greatest number (even of units of quality), and the highest speed.

Fitzgerald, *My Lost City*, p. 110

We felt like small children in a great bright unexplored barn.

Atkinson, p. 94

The biggest world is Manhattan; the smaller world is in this case this tip of the island, the smallest one of all is the world of shops and restaurants that cater to it.

Gopnik, p. 296

The rush of emotion that rises as the car pulls down the Hudson Parkway, as the cab comes across the Triborough Bridge from La Guardia, the sense of a scale too big to be credited and of a potential too large to be quite real— all that remains available, which is the most you can say of any emotion. The other emotions—the daily frustrations, the long-term fears—remain available, too. The city we are in, the home we have made, and the other city we long for all remain in existence.

Ground

Gopnik, p. 122

The city looks one way from a distance, a skyline full of symbols, inviting pilgrims and Visigoths, and another way up close, a city full of people.

Caro, p. 555

First there was steelwork and concrete in the sky, immense towers, thick cables, a roadbed above the water—the George Washington Bridge, looking above the leaves, casting a dark shadow over the parkway so that the reporters' limousine rolled across it as if it were a gigantic welcome mat to a gigantic city. Then, above the parkway to the left, there were apartment houses of Riverside Drive. Far away to the left, there were the spires of the Empire State Building and the Chrysler Building, canyons of skyscrapers toward which the limousine was headed. Ahead of the reporters was the panorama of the harbor, serene water turned busy, churned by the giant screws of giant ships, dented by piers jutting from shore.

Donleavy

North across fourteen bridges and three tunnels. Under the flat tarred roofs. In the buildings zigzag with iron-staired fire escapes. Stacked on the hills, brick hives of grey and brown. Packed with ginneys, micks, kikes and coons.

Jackson and Dunbar, p. 678

The dome of the Manhattan Savings Bank over Chinatown at the entrance to Manhattan Bridge, and then in Brooklyn again, after we had traveled from light into dark, dark into light, along the shuddering shadowy criss-cross of the pillars.

Ibid.

Along Queens Boulevard. The stacks and stacks of apartment houses. Boxes and boxes of little homes down all the crosshatched streets.

Brook, p. 2

I gazed out the window, past the crawling traffic, those battered ungainly cars, past the cemeteries that cover hillside after hillside of suburban Queens, and looked idly at the Manhattan skyline just becoming visible through the late afternoon haze.

Panorama — Ground

"That," he reflects, "is the way you ought to come into Manhattan. See the black heart before you were dazzled by the chromium-plated wings and turrets."

Conrad, p. 281

If you will stand at any of the cross-streets that lead east from Second Avenue you will obtain a splendid panorama, window after window ornamented with a red or green or orange iron balcony and hung, in the summertime, with an array of green vines and bright flower-pots.

Dreiser, p. 269

You sit down on a piling and look out over the river. Downriver, the Statue of Liberty shimmers in the haze. Across the water, a huge Colgate sign welcomes you to New Jersey, the Garden State.

McInerney, *Bright Lights*, p. 10

New York reveals itself only at a particular sight, a particular distance, a particular speed. These are not the height, the distance, or the speed of the pedestrian. This city is strikingly like the great Andalusia plains— monotonous when you pass through on foot, superb and varying when crossed by car.

Sartre, p. 123

But if here I look up amid the shadows and out into the backyard I see nothing—a cement floor, an incredibly begrimed glass roof of an open shed. And it is just as well; except for soot, clean but eternally Cimmerian. As well— for although the house I have chosen to live in is old and relatively low, on the other three sides that surround my yard there tower up the skyscrapers, and I live either in funereal shadows or in artificial light … Where a sparrow *can* lodge a sparrow will lodge—but on the faces of these immense cliffs there is not lodgment even for a sparrow—except maybe skywards. You see, I have been gradually raising my eyes towards the tops of these cliffs by way of the backyards and the shadows.

Ford, *America*, pp. 64–5

River

Time on the river had become irrelevant—walking down into the darkness of the side streets and avenues, crossing the highway, cars burning in lines going uptown and downtown, waiting beneath the overpass, papers skidding along the loading docks, some character standing beside a solitary car in darkness, over by the river a series of cars easing from parking spots on the asphalt runway, others turning off along the waterfront, circular motions of vehicles, burning headlights acting like beacons that sweep over the surface of the river, the river looks like clouds, the rafts of ice driven together by currents, spread from the shore to the center of the river, protected from being swept away by the piers. When the headlights swing away from the surface of the river, everything is settled into a calm easy darkness, ice merges into a slow illuminated color of night, the bare ridges of the ice floes exposed, like arctic childhood memories, waiting for the polar strides and windy howls of desolation.

Wojnarowicz, p. 135

Out along the waterfront asphalt strip, more cars are turning and circling. Headlights like lighthouse beacons drift over the surface of the river, swinging around and illuminating men, strangers, men I might or might not have known because their faces were invisible, just disks of black silhouette outlined briefly as each car passes, one after the other, pale interior faces turned against the windows, then fading into distance.

Ibid., p. 147

Coda

Fitzgerald, *My Lost City*, p. 115

Then I understood—everything was explained: I had discovered the crowning error of the city, its Pandora's box. Full of vaunting pride the New Yorker had climbed here and seen with dismay what he had never suspected, that the city was not the endless succession of canyons that he had supposed but that it had limits—from the tallest structure he saw for the first time that it faded out into the country on all sides, into an expanse of green and blue that alone was limitless. And with the awful realization that New York was a city after all and not a universe, the whole shining edifice that he had reared in his imagination came crashing to the ground.

Skyscrapers were unknown until 1900. Britt, p. 5

New York's character is to be unfinished ... its very essence is to be Bender, *Unfinished*, p. xi
continually in the making, to never be completely resolved.

New York refuses a single logic and it declines any notion of completeness. *Ibid.*

Whitman's unfinished *Leaves of Grass* as a parallel to NYC's state of *Ibid.*, p. xii
incompletion.

Man's rush to the nth floor is a neck-and-neck race between plumbing and Koolhaas, p. 130
abstraction.

Unrealized

Early in 1906 advertisements appear in New York papers announcing "a Koolhaas, p. 71
ground floor chance to share profits" in "the largest steel structure ever
erected ... the greatest amusement enterprise in the whole world ... the best
real estate venture," the Globe Tower. It will cost $1,500,000 to erect. The
public is urged to invest. The stock will pay 100 percent interest annually.
The most voluminous building ever proposed in the history of mankind, it
combines in a single gestalt the opposites—needle and sphere, Trylon and
Perisphere—that have been the extremes of Manhattan's formal vocabulary
ever since the Latting Observatory and the balloon of the Crystal Palace
were juxtaposed in 1853. It is impossible for a globe to be a tower. A sketch
illustrating the ad—of a skyline dominated by a blob—reveals the Globe
Tower's concept: the sphere is to be so colossal that simply by resting on the
earth it can claim—through the height of its enormous diameter—also to
be a tower, for it is at least "three times as high as the Flatiron building, the
present marvel of New York."

The tower's blueprints showed a gigantic steel planet that had collided onto Stanton
a replica of the Eiffel Tower. As a whole it was 700 feet high, three times as
high as the Flatiron Building, New York's marvel at the time. The Globe
Tower would be the largest building in the world, with enormous elevators
to carry visitors to its eleven completely different floors. It would be an
agglomeration of Steeplechase, Dreamland and Luna Park, all contained in a
single interior volume.

Friede leased a small corner of the Steeplechase property on Surf Avenue
to erect this colossal structure. The structure would be supported by eight
enormous *socles* (pedestals) whose foundations would be thirty-five feet deep.
Underground was planned as a multi-level interchange of various modes of
transport: a combination parking garage, subway and railroad station with a
branch heading out towards sea to connect with the boat pier.

The Globe would be divided into eleven floors, beginning 150 feet above
the ground and spaced at intervals of fifty feet. The lowest or first level would
feature a Pedestal Roof Garden with a popular priced restaurant, continuous
vaudeville theater, roller skating rink, bowling alley, slot machines, etc. At
the 250 foot level there would be an Aerial Hippodrome seating 5000 people.
It would feature four large circus rings and four immense animal cages, each
ring representing a different continent. Performances would be continuous
and a miniature railroad would circle the arena's perimeter. The Globe's Main
Hall would be located at the 300 foot level. Here would be the largest ballroom
in the world and a moving restaurant enclosed in glass. A revolving strip
twenty-five feet wide would carry tables, kitchens and patrons around the

outer edge of the Tower to give the effect of eating in an airborne dining car. Diners would have a moving panoramic view of Coney Island, the countryside and Greater New York.

Friede, who envisioned continuous twenty-four-hour use of his Globe Tower by its 50,000 temporary residents, planned a hotel floor at the sphere's equator. Rooms would be small but luxuriously equipped and padded with soundproofing for undisturbed sleep.

[...]

Friede's floor layout implicitly used social stratification. The facilities were increasingly refined and elegant the higher one would ascend. The level above at 350 feet would feature an Aerial Palm Garden, a more expensive restaurant with tables scattered in a palm garden with cascades of running water screened from each other by shrubbery. It was to be arranged on the Italian Garden plan.

The Observatory platform was at the 500-foot level. At the highest platform in New York visitors could use coin-operated telescopes to see more than fifty miles. There would also be a souvenir stand and various small concessions. Near the tower's top at the 600 feet level would be the United States Weather Observation Bureau and Wireless Telegraph Station. It would be equipped with modern weather recording devices. And at the very top would be the largest revolving searchlight in the world. The tower itself, lit by thousands of electric lights, would resemble a gigantic tower of fire.

There was a cornerstone-laying ceremony on May 26, 1906. It was complete with speeches, band concerts and fireworks. There was a rush of investors at the Globe Tower Company office built next to the first *socle*. But by the end of the 1906 season, when the foundations were still incomplete, investors became anxious.

Another ceremony was held on February 17, 1907. A band was on hand when they put the first piece of steel in position. The company claimed they were driving 800 concrete foundation piles, each 30 feet long and five feet in circumference. They promised that half of the eleven-floor structure would be open to the public on May 15th and the remainder would be fully operational the following year.

Meanwhile in March, George Tilyou, tired of the endless delays, threatened an injunction. A Brooklyn Supreme Court judge prevented it. Nonetheless, by 1908 it became clear that the most impressive architectural project ever conceived was a fraud. Tilyou was left with the problem of removing thirty foundation piles on his property.

The Friede Tower, if it had been built, would have been the first single building in the world to claim the status of resort.

Panchyk, p. 40

The Globe's treasurer was convicted of embezzlement.

Conrad, pp. 258–60

Harvey Wiley Corbett in 1923 proposed for the New York of the future a segregation of vehicular from pedestrian traffic, which would consign cars to ground level and raise people onto elevated walkways.

Raymond Hood in 1929 conjectured that apartment houses for three million people could be built on the East River bridges. These would be doubly abstracted from earth, placed over water and hung from the air by cables.

Hugh Ferriss, who after 1915 renounced architectural practice and contented himself with the graphic rendering of unbuildable fantasies, saw buildings as landing stages for futuristic visitors from the upper air and planned airport terminals on the upper shelves of skyscrapers. He was sure that the New Yorkers of the future would live in the sky, and his imaginary dwellings are terraced with aerial golf courses, hanging gardens, and swimming pools. Rather than traveling horizontally to the country, New

F Architecture — Unrealized

Yorkers find it upstairs. Those heights are dizzy pleasances: Ferriss drew masked balls and carnivals atop his skyscrapers. What he called in 1936 "the air age" had reoriented architecture. Buildings, dangling from the sky into an abyss, should be designed to be seen from above. Following his own advice, Ferriss drew the United Nations Headquarters from a helicopter.

At the World's Fair in 1939, Norman Bel Geddes laid out a city while hovering in midair. For the Futurama metropolis of 1960 in the General Motors pavilion, which was to be seen from sound-chairs traveling above it, Geddes relied on the drastic aerial perspectives he'd become accustomed to when looking down from theater catwalks during his period as a stage designer. Geddes places you in the future, patronizing the present from a steep vertical distance of foresight. The Futurama passengers disembarked at a street intersection in Tomorrow. As they stepped into "the wonder world of 1960" they were reminded that "1940 is twenty years ago!" and admonished "ALL EYES TO THE FUTURE."

One of the biggest standing sets on the Fox lot in Beverly Hills was an East River vehicular tunnel under construction, an interior tube of raw, exposed steel plating. Built for a 1933 picture called *Under Pressure*, the set remained on the lot for decades, forever "unfinished," a testament to the city as an ongoing work in progress.

Sanders, *Celluloid*, p. 400

Buckminster Fuller envisioned cutting people off from the elements entirely by building domed cities, which, he claimed, would offer free climate control, winter and summer: "A two-mile-diameter dome has been calculated to cover Mid-Manhattan Island, spanning west to east at 42nd Street," he observed. "The cost saving in ten years would pay for the dome."

Kolbert

Fuller calculated that the single one-mile-diameter dome enclosing the mid-Manhattan area between Twenty-second and Sixty-second Streets and between the Hudson and East Rivers would have a surface area of only 1/84 of all the buildings it would enclose. That dome would reduce the heating and cooling requirements of the buildings it covered to 1/84 of the current requirements. In addition to regulating the temperature, such a dome would also control the precipitation and the air quality within the enclosed environment.

Sieden, p. 363

Suppose that there existed, between Madison Square and Central Park, an avenue three hundred feet in width, planted with trees on either side of a spacious roadway, with broad sidewalks, and a continuous series of flower beds, clumps of shrubs and patches of well-kept grass—in fact, something similar to the Avenue des Champs-Élysées in Paris; and suppose, further, that this avenue was bordered by the palaces of American millionaires—Silver Kings, Petroleum Kings, and other monarchs. In that case New York would possess a central artery worthy of the city and the renown of which would be worldwide.

Jackson and Dunbar, p. 439

King's "Dream of New York" (1908). A drawing of the imagined future. Lower Broadway has been transformed into a stepped range of tall buildings, linked here and there by aerial walkways and finished off with small pantheons, cupolas, statuary, or flags. Dirigibles are casting off from lofty mooring masts (according to their labels, bound for Japan, Europe, the Panama Canal, the North Pole); several unidentifiable flying structures veer about like strange mechanical birds. The upper atmosphere teems with activity; it is not mere space but a realm of great potential drama, and

Hawes

it appears to be almost within arm's reach, for the hypothetical viewer is perched aloft, thirty or forty stories above the street.

Glass Box

White, *Here*, p. 163 — Architecture is capital.

Morris, *Manhattan '45*, p. 261 — The word "skyscraper" originally meant the topsail of a clipper ship.

Kingwell, p. 56 — The very name, initially a mixture of irony and awe, confesses its own transcendent ambition and awareness of failure. Though we long to scrape it, the sky always retreats from our touch. And the building, once tall, feels its inadequacy. Not least, perhaps, because another building, somewhere else, a few blocks or an ocean away, is ascending just a little bit higher.

Ibid., p. 83 — They are not buildings, they are concrete realizations of thought.

N. cit. — Euphemisms for skyscrapers: "tombstones," "jealous bitches," and "granite cocks."

Rabinowitz, p. 155 — Skyscrapers and the men who built them may have represented the zenith of a modernist masculinity; yet there is something distinctly modern and female about them too.

Douglas, pp. 442–6 — The model is Jamesian rather than Freudian; James had his own ideas about the return of the repressed … The male-female presence, the realized alliance of masculine and feminine impulses, was crucial to the special euphoria of top promises fulfilled, the sense of heaven here on earth that the skyscrapers inspired in those who designed and viewed them. Only when the masculine and feminine elements are present in equal strength, only when the genders collaborate rather than compete, only when they come fully abreast or flush of each other, can the artifact or culture involved be, by a process of simultaneous gender reinforcement and gender cancellation, both gender-doubled and beyond gender and so satisfy the deepest needs of the human heart, mind, and psyche. Houdini remarked that "if the wish is father to the thought, it is mother to the hallucination." The New York skyline, "built with a wish," was that thought and that hallucination.

Sartre, p. 124 — Sartre: "When we were twenty, we heard about skyscrapers. We discovered them with amazement in the movies. They were the architecture of the future, just as cinema was the art of the future."

Ibid., p. 125 — Sartre: "To the man who strolled through New York before 1930, the high-rise buildings towering over the city were the first signs of an architecture destined to radiate over the entire country. Skyscrapers were then living things. Today, for a Frenchman arriving from Europe, they are already mere historical monuments, witnesses to a bygone age. They still rise up into the sky but my spirit does not soar with them, and the New Yorkers pass by at their feet without so much as a glance. I cannot think of them without melancholy; they speak of an age when we believed in peace. They are already a little run-down; tomorrow, perhaps, they will be demolished. At any rate, to build them took a faith we no longer possess."

Crisp, p. 217 — Quentin Crisp: "When I was young, no one who visited Manhattan talked about anything but its skyscrapers. Now every city has skyscrapers."

The aesthetics of skyscrapers have long passed the point of diminishing returns; there is nothing to say about a new skyscraper tower except that it is another skyscraper tower.

Mumford, *Sidewalk*, p. 81

What is astonishing about the skyscraper is that it does not astonish. When we actually see one (but do we ever see one, actually), the feeling it inspires is: *why not?*

Barthes, *Eiffel*, p. 150

By the late 1940s, as the swaggering individual entrepreneur of the past was transformed into the team-playing corporate man in the gray flannel suit, so the instantly identifiable cathedrals of commerce that exemplified the city's architecture from 1900 to 1929 gave way to an architecture that celebrated repetition to the point of anonymity.

Bennett, *Deconstructing*, p. 63

The architect-hero, Howard Roark, commonly believed to be modeled on Frank Lloyd Wright, had made generations of young women swoon. Roark is portrayed as a brilliantly creative, fiery genius, embattled by the establishment, who defiantly blows up his consummate work of art, a skyscraper, rather than see his talent and integrity compromised.

Berliner, p. 43

The terror of a city of architectural individuality.

Monson, p. 31

A physically sordid agglomeration of endlessly repeated submediocre typologies and overblown engineering stunts with little history and a dubious future.

Kunstler, p. 2.

The skyscraper appeals not only because of its combination of imposing form and enticing lights; there is also the magnetic pull of its human interior—and perhaps an underlying relief that one is not imprisoned there too.

Sharpe, p. 230

Such buildings do not shelter or isolate men as do those of Europe. They gather and shuffle them.

Still, *Mirror*, p. 298

Batman could not function in a city of sheer glass towers, for what would his hooks tie into, and how would he scale their sides?

Sanders, *Celluloid*, p. 104

Glass is the only material in the building industry which expresses surface and space at the same time.

Friedberg, p. 119

The UN building: the first building in the city with an all-glass curtain wall.

N. cit.

Glass gives a new, uncertain, meaning to the wall.

Boorstin

Mies is basic to the miracle: "Can anyone stand unmoved at the top of a steel-framed skyscraper today, looking out across a city's glittering twentieth-century towers, glass walls reflecting clouds, sky and structures in a massed, changing pattern of light and color? This architecture is not static, any more than life is static. Can anyone fail to recognize and react to this miracle of our time?"

Huxtable, *Goodbye*, p. 165

The Seagram Building is New York's ultimate skin building. The wall is held unrelentingly flat; there are no tricks with projecting or extending mullions; thin and flush, they are used only to divide the window glass. The metal spandrel facing, in one smooth piece, echoes the placing of structural steel and seeks no "artful" plasticity. The taut, shiny-dark sleekness of matte black

Ibid., p. 114

aluminum and gleaming bronze glass is an architectural statement of positive excellence as well as a foil for the ornate masonry around it.

Bennett, *Deconstructing*, p. 63

The anti-individualistic aesthetic of the Seagram building, which Mies himself described as "completely opposed to the idea that a specific building should have an individual character."

Huxtable, *Goodbye*, p. 162

The proportions of a Mies design are so sensitively adjusted, his understating of the richness of marble, the brilliance of glass and the substantiality of bronze so sensuously sure, his feelings for the materials of our time so overwhelmingly rich and yet so far from vulgar, that no one has matched the precise and timeless beauty of his buildings. The Seagram Building, for example, is dignified, sumptuous, severe, sophisticated, cool, consummately elegant architecture—architecture for the twentieth century and for the ages.

The Miesian example is a lesson of principle. But in too many cases, the Miesian principle has been ignored and the Miesian example simply "knocked off" in the cheapest Seventh Avenue terms.

Without fine materials and meticulous details, Mies's diamond-sharp doctrine of "less is more" becomes a most ordinary formula. Raised about the shoddy and speculative, however, it is a competent and appropriate formula and it is here that Mies's signal importance, as the source of a genuine popular style, has been so much misunderstood.

Kingwell, p. 33

"We will build no cathedrals." Buildings, Mies said, are "mere carriers" of "the will of the age." It is worth noting that, when it comes to literal cathedrals, Mies was correct: a longstanding project to build a new cathedral in New York has exhibited none of the speed and efficiency of commercial and residential building, and still stands unfinished.

Bennett, *Deconstructing*, p. 9

O'Hara explicitly challenges the functionalist pretensions of International Style Modernist architecture by imagining dysfunctional, ludic spaces where he can drop a "hot dog" into "one of the Seagram Building's / fountains."

O'Hara, p. 476

I get a cinder in my eye
 it streams into
 the sunlight
 the air pushes it aside
and I drop my hot dog
 into one of the Seagram Building's
fountains

Kingwell, p. 92

The refusal of decoration should lead, finally, to the building that is pure manifest functionality, an exercise in verticality (the smooth flat surfaces of the elegant foursquare slab) that is also a negation of it (the dark finish now making a blank screen, absorbing light rather than reflecting it). In its way, the Seagram Building is the architectural equivalent of an Ad Reinhardt painting, a rectangle of pure black pigment that simultaneously celebrates and destroys the blank canvas.

Mencken, pp. 186–91

Even triumphs of modernism could look bewildered or bereft against the backdrop of early postwar New York. On Park Avenue in midtown, Lever House and the Seagram Building, photographed before they've aged into the streetscape, seem wet behind the ears, just blocks away from a Third Avenue still holding on to the grubbiness it would soon lose under high-rise development. The whole atmosphere of the city in the 1950s was a blend of energy and enervation. In retrospect it looks—and the culture that

surrounded it seems—incomplete, either half-built or half-decayed, with
energy seeping away even where it seemed abundant.

Oppen often specifically asked why we must look to Lever Brothers to provide Friedberg, p. 133
the missing center that the city lacked. As Oppen's imagery suggests, Lever
House cannot center the city's urban typology because it is merely a local
address: it covers a single square block, containing some "thousand lives /
Within that glass."

The lights that blaze and promise Oppen, "Tourist," p. 27
Where are so many—What is offered

In the wall and nest of lights?
The land

Lacked center:
We must look to Lever Brothers

Based in a square block.
A thousand lives

Within that glass. What is the final meaning
Of extravagance? Why are the office

Buildings, storehouses of papers,
The centers of extravagance?

The "glass box" is the most maligned building idea of our time. It is also one Huxtable, *Goodbye*, p. 163
of the best. Whatever its deficiencies, and there are many, due to the complex
factors of architects who are less than perfectionists and businessmen who
are less than philanthropists or sociologists, it is the genuine vernacular of
the mid-twentieth century. It derives legitimately from Mies's masterful and
meaningful innovations, and it serves legitimately the needs of a commercial
society that builds on an industrial scale. It does this with sheer and brilliant
modern magic and with as much validity and suitability as the last great
vernacular style, the Georgian.

It is now possible to live in Mies apartment houses in Chicago, Detroit, *Ibid.*, p. 164
Newark, Montreal and Baltimore. It is not possible to do so in New York.
(It remains a mystery how New York's status-symbol-conscious rich can
continue to accept, at the nation's highest prices, residential architectural
trash.)

Corbusier: "The skyscrapers of New York are too small." Corbusier, p. 51

On the morning after my arrival in New York the New York Herald Tribune *Ibid.*
printed in big type, over my caricatured newspaper photograph:

FINDS AMERICAN SKYSCRAPERS MUCH TOO SMALL
Skyscrapers not big enough
Says Le Corbusier at first sight
Thinks they should be huge and a lot farther apart.

The cardinal question asked of every traveler on his arrival is: "What do you *Ibid.*
think of New York?" Coolly I replied: "The skyscrapers are too small."

Ibid., pp. 138–9

Though its buildings are fabled to be awesomely tall, for Le Corbusier they're not tall enough. Because it's an unplanned city, the skyscrapers flaunt themselves as brainless exhibitions of physical prowess, mere "acrobatic feats."

Irwin, p. 16

Carl Ruggles, the futurist musical composer, whose immoderation in speech is the delight of his friends, made his first visit to New York some twenty years ago. When he returned to Cape Cod someone asked:
"What did you think of the sky-scrapers?"
"By the Lord," he replied, "I wished they were twenty times higher!"

Hawes

Schuyler criticized the tall new commercial buildings for being too tame, which was a reminder that the new technological advances were breeding certain expectations, encouraging invention and originality.

Corbusier, p. 51

The New York skyscrapers are out of line with the rational skyscraper which I have called: the Cartesian skyscraper.

Ibid., p. 161

Jazz, like the skyscrapers, is an event and not a deliberately conceived creation. They represent the forces of today. The jazz is more advanced than the architecture. If architecture were at the point reached by jazz, it would be an incredible spectacle. I repeat: Manhattan is hot jazz in stone and steel.

Sartre, p. 125

Skyscrapers were the architecture of the future, just as cinema was the art of the future and jazz the music of the future. Today we know all about jazz; it is more a music of the past than of the future. It is a popular black music, capable of limited development, but in gentle decline. It has had its day. And the talkies have not fulfilled the promise of the silent films: Hollywood is stuck in a rut.

Corbusier, p. 51

The skyscraper is a light radiator.

Rock, Moore, and Lobenstine, p. xix

Abstracted isolation.

Koolhaas, p. 21

Architecture is Manhattan's new religion.

Corbusier, p. 56

Skyscrapers: new white cathedrals. They are sublime, naive, touching, idiotic.

Rock, Moore, and Lobenstine, p. xix

Ethereal lyricism.

Koolhaas, p. 281

Corbusier undoes Manhattanism with this "tower-in-the-park" concept, as best expressed in the UN and Lincoln Center.

Corbett, p. 225

Corbusier: "Skyscrapers are machines for making money."

Federal Writers, *Panorama*, p. 13

An aseptic skyscraper city, an immense machine for living.

Wark, *Beach*, p. 20

For Chtcheglov, Corbusier's city was not modern, it was already out of date. It was a product of a retrograde culture, lagging behind science. The physical world is no longer understood as an orderly geometry, but culture has yet to catch up. The purpose of technology is not to make a city purified of complexity, a Platonic form gleaming in the sun. Spirit is earthy, not heavenly; spirit is movement, not an ideal.

Bennett, *Deconstructing*, p. 68

At the same time that its gridded exterior and glass-and-steel box structure finally realized the thirty-year-old utopistic ideas of Mies van der Rohe and Le

Corbusier … At full scale, its primary building slab was also lifted on a base and turned at a right angle to the grand axis of Park Avenue, the traditional street—the *rue corridor*—so loathed by Le Corbusier, to create a new urban order of individual, object-like buildings liberated in space and set apart from one another.

Le Corbusier's ineffable space [*espace indicible*].

Richards, p. 141

You are in it.

Corbusier, p. 90

On a sunny day, Jones Beach transports us into the great romance of the Mediterranean, of Apollonian clarity, of perfect light without shadows, cosmic geometry, unbroken perspectives stretching onward toward an infinite horizon. This romance is at least as old as Plato. Its most passionate and influential modern devotee is Le Corbusier.

Berman, *Solid*, p. 297

Not the rational city but the playful city, not the city of work but the city of adventure. Not the city that conquers nature, but the city that opens towards the flux and change of the universe.

Wark, *Beach*, p. 19

The skyscraper as a form has encouraged every species of romantic extravagance.

Mumford, *Sidewalk*, p. 68

The Beaux-Arts Ball of 1931, "Fête Moderne—a Fantasie in Flame and Silver": In the main ballroom of the Hotel Astor … A small-town Main Street was built as a midway but redesigned in the Cubist style, with modernist trees dotting the village green. An orchestra directed by the architect Kenneth Murchison consisted of pneumatic riveting machines, live steam pipes, ocean liner whistles and sledgehammers. A puppet show designed by the puppeteer and children's book illustrator Tony Sarg presented robots on strings with bodies of metal coils. Ballet dancers rendered a modernistic impression of the blues.

Gray, "Beaux-Arts"

[…]

At least two dozen architects came dressed as buildings they had recently designed. These included Chester Aldrich as the Union Club, at 69th and Park, and William F. Lamb as the Empire State Building. Arthur J. Arwine, a heating contractor, came as a "low-pressure heating boiler." Murchison came as a model tenement.

But most architecture aficionados are familiar with only the well-known image of William Van Alen as his Chrysler Building.

But they all wore helmet-like constructions of the tops of the buildings they had designed.

A. Stewart Walker was completely hidden under the black and white ziggurat at the top of his Fuller Building, at 57th and Madison; Leonard Schultze wore the rocket-shaped crown of one of his Waldorf-Astoria towers; Ely Jacques Kahn peeked out from under the castlelike top of his Squibb Building, at 58th and Fifth; Ralph Walker wore the Art Deco tower of his building at 1 Wall Street; and Joseph Freedlander—one of the heads of the costume committee—looked pretty silly under the horizontal neo-Georgian pavilions of the Museum of the City of New York, at 103rd and Fifth.

They all played supporting roles to Van Alen, the star of the group, whose attire included a Buck Rogers-style cloak and boots, both made of patent leather and flame-colored silk, with flexible inlays of the same exotic woods used on the Chrysler Building's elevators. Indeed, his cloak was designed to emulate the design of the doors, and two shoulder ornaments replicated the eagle heads at the sixty-first-floor setbacks. On his head rose a strikingly

dangerous-looking crown, the graduated layers of the Chrysler tower itself rising to a spire, the ensemble at least four feet above his scalp.

O'Connell, p. 141 — It's the top of the world. All we can do is go round and round in a squirrel cage.

Sharpe, p. 123 — The skyscraper appears through a tracery of tree branches that domesticate the rude force of American capitalism.

Ibid., pp. 134–5 — Skyscrapers are not by day remarkable for grace or beauty of line, but by night under the electrician's skill, they were shown to be capable of transformations which suggested rather palaces and dreams than the sober realities of the modern Land of the Dollar.

Ibid., p. 250 — Skyscrapers turn into sky shapers.

Rock, Moore, and Lobenstine, p. 205 — Bernice Abbott: "Poetry in our crazy gadgets, our tools, our architecture."

Conrad, p. 257 — Once the city is geared for and goaded to transport itself into the future, its buildings begin to resent their anchorage to the earth.

N. cit. — Gertrude Stein: "It isn't the way they rise into the sky. It's the way they spring out of the ground."

Corbusier, p. 89 — Skyscrapers are an architectural accident. Imagine a man undergoing a mysterious disturbance of his organic life: the torso remains normal, but his legs become ten or twenty times too long.

Rosenfeld, p. 471 — Day after day in gray and desperate weather even, one can see its mystic aspiration above the skyscrapers of New York. Over our melancholy it rises high. It seems that we have taken root. The place has gotten a gravity that holds us. The suction outward has abated. No longer do we yearn to quit New York. We are not drawn away. We are content to remain in New York.

Ginsberg, Howl, p. 6 — Moloch whose skyscrapers stand in the long streets like endless Jehovahs!

Conrad, p. 131 — They are the expression of "great movements"—the social and economic tug-of-war of those "pull forces"—and they in turn discharge movement to their jagged or jittery surroundings. Their surfaces are warped or rippling. The Brooklyn Bridge is seen swaying … The World Trade Center towers twist in the wind.

Ibid., p. 85 — A skyscraper with a facade of oblong glass eyes. No longer blind, the building has become an ocular eminence.

Douglas, p. 438 — They were Manhattan's Rosetta Stone, the hieroglyphics of the modern American nation; skyscraper Manhattan offered the spectator the biggest sculpture, the largest-scale self-portrait yet seen in the world, a case study, one might say, set in stone.

Corbusier, p. 59 — The skyscrapers are greater than the architects.

Koolhaas, p. 296 — In the metropolitan archipelago, each skyscraper—in the absence of real history—develops its own instantaneous "folklore."

They aren't just gigantic; in an immense act of impersonation and appropriation, they play at being "giants."

Douglas, p. 447

Like airplanes, they offer a concrete expression of human ambition, an ambition to transcend the mundane, dirty, or slow. If the airplane or racing car was the era's purest expression of speed, the desire to overwhelm and annihilate space, the skyscraper was a materialization of pure direction.

Kingwell, p. 62

Image literally outdistances actuality. They won't defer to our imagery; the best we can hope for is that we might be allowed to become images of them. The skyscraper betokens the re-arising of prostrated man. Its upper tiers reclaim the sky from which he has been hurled. Whereas the image tentatively reaches out toward the infinite, the skyscraper boldly reaches up to it. Its architecture is a ladder of evolutionary elevation.

Conrad, p. 209

The perfection of cast iron in the middle of the nineteenth century, and the super-perfection of steel in the twentieth.

Kingwell, p. 77

Every tycoon was a nascent skyscraper. Frank Woolworth and Frank Taft clambered to the tower of the Woolworth Building, shinnying up ladders to scrawl their names on the rafters.

Conrad, p. 209

The tall skyscraper is the businessman's toy, his plaything, his gewgaw; in an expansive mood, he calls it alternatively a temple or a cathedral, and he looks upon the romantic altitudinous disorder of a modern city with the same blissful feeling that the Victorian industrialist had for his factory chimneys, belching forth soot and foul gases. The skyscraper makes him feel prosperous even when he is losing money on it. In the interests of congestion, the businessman is willing to make the streets impassable, lose thousands of dollars a day in lost motion and delay, waste millions in building more subways to promote more congestion, and in general to put up with any and every sort of nuisance, so long as he can feed his inflated romantic dream.

Kingwell, p. 83

Walking so small with the distant windowed mountains all around pointing in the sky. Climb up there and be rich.

Donleavy

It seems a misty architectural shape taking up into itself like individual building stones the skyscrapers, tenements, thoroughfares, and people; and with the mass of them erecting a tower higher than any of them, even the highest, toward the sky.

Rosenfeld, p. 470

I wish the word "skyscraper" had not been invented for them; its suggestion is one of ugliness that makes the superior European hug himself for his superior virtues. He does not do anything ugly to the skies, he says. But these great, beautiful pinnacles aspire to the skies and the clouds caress them. It would indeed be better if the European would regard them as cloud-houses, though the term is too clumsy for everyday New York to use, the initial of the word in common use taking the sound along faster.

Ford, *America*, p. 74

The violence of the name—gashing nature—gives permission for unbridled and unstoppable American ambition.

N. cit.

The American Will inhabits the skyscraper; the American Intellect inhabits the colonial mansion.

Hawes, p. 176

White, *Here*, p. 31

Manhattan has been compelled to expand skyward because of the absence of any other direction in which to grow. This, more than any other thing, is responsible for its physical majesty. It is to the nation what the white church spire is to the village—the visible symbol of aspiration and faith, the white plume saying that the way is up.

Depero, "24th Street," p. 429

At the base of these
square mountains
luminous boxes
there burst onto
the streets colored hair

Conrad, p. 209

The age of the skyscraper is gone. This is the age of the housing project. Which is always a prelude to the age of the cave. This will be the last skyscraper built in New York … the last achievement of man on earth before mankind destroys itself.

Setback

WPA Guide, pp. xxiv–v

To a remarkable degree, New York's buildings have been shaped by its zoning code, and it by them. It was New York, indeed, that initiated the practice of zoning back in 1919, and it has continued to be the most innovative of cities in that respect—ahead of all others, for ill or good, by about a decade. It is the shift from one zoning innovation to another that gives us our key to the city's postwar architecture: If you know the sequence of the shifts, you can look at a building and gauge its history with some accuracy.

In the late 1940s, zoning was quite prescriptive. Builders could pile up about as much bulk as they wanted to, but there were strict rules governing how the building had to be set back as it went up. Architects were customarily instructed to fill in the zoning envelope. They did so faithfully, producing a series of nearly identical buildings in the wedding cake, or ziggurat, form. Then, in 1958, a building came along that was to have a profound new influence on architecture and zoning: the Seagram Building, designed by Mies van der Rohe in collaboration with Philip Johnson. It was a pure tower, rising straight up and set at the rear of a broad plaza. The plaza, fronting on Park Avenue between Fifty-second and Fifty-third streets, proved—to the surprise of everyone, including the architects—to be immensely popular with lunchtime crowds searching for a place to sit, picnic, or sunbathe. New York City's planning commission thought it would be good to prod other architects and builders to provide similarly elegant structures and public spaces. Thus was born New York's incentive zoning. For the next ten years every builder who put up an office tower went for the plaza bonus, which allowed them to build higher as compensation for leaving more space open at ground level. In the process, more new open space was created than in all the country's other cities combined. Unhappily, many of the plazas were sterile and empty, neglecting such essentials as a place to sit. In 1975, however, zoning laws were changed so that essentials would be included. Before long, though, plazas were old hat; arcades, through-block corridors, covered pedestrian areas, and rooftop parks were in. Atriums were especially popular, in part because of the success of the atrium within the Citicorp Center at Lexington Avenue between Fifty-third and Fifty-fourth streets. Before long, Midtown was awash with atrium projects. Some turned out well—indoor parks, essentially, with "waterwalls," cafés, and occasional entertainment. Others looked very much like big office building lobbies. Either way, the builders got lots of extra office space to rent.

Excess piled on excess. As more big buildings went up, east Midtown seemed as if it must soon tilt into the East River. One solution would have been for the builders to head elsewhere—to the neglected west Midtown area, for example. But they didn't. Instead, they got the planning commission to modify the rules so that they could put up bigger buildings on smaller sites. This was done on a case-by-case basis, with much haggling back and forth. In the planners' lexicon, this came to be known as "fine tuning" or "sophisticated zoning." When you see an oversized building adorned with lots of greenhousery and skylights, you can bet it was built sometime between 1977 and 1981.

With bonuses for this and bonuses for that, and air rights as a kicker, developers began putting up "sliver" buildings. Ordinarily, very thin, tall buildings are uneconomical, amounting to mostly elevator banks and stairwells. But space was at a premium and the developers prevailed. If you see such a sliver—some thirty stories high but no wider than a brownstone, you can date its construction as 1981–1982.

Building setback laws occur the same time Cubism does.
N. cit.

The club sandwich is probably one of the best products of the synthetic meal mentality, the gastronomic equivalent of the skyscraper in architecture.
Beaton, *New York*, p. 53

The setbacks imposed by zoning regulations made the architect a carver. He must, Ferriss said, "cut into the mass to admit light into the interior." Architecture is thus the ventilation of a geological solid, the erosion of a granite lump. When Ferriss declared that the skyscrapers were a "Grand Canyon," he meant the tribute quite specifically: both have been made by reduction, emptying, a sculptural discarding of matter.
Mumford, *Sidewalk*, p. 66

The city has been blossoming cantilevered fronts this past year.
Sanders, *Celluloid*, p. 249

Unlike the recent, harder-edged profiles of New York and other cities, the profusion of setback terraces softened the skyline, and textured it, but above all, gave it *life*, making it the public extension of ten thousand private—even intimate—realms.
Ibid., p. 250

The tradition of these wide, setback terraces was about to come to an abrupt end; the city's new 1961 zoning law tossed out the older, stepped design for a new and very different model. Based on the same modernist prototype as the city's boxy new office buildings, apartment houses would now be fashioned as monolithic slabs, rising from sidewalk to roof in a straight line, with little or no variation from top to bottom. Just one element marked them as residential rather than commercial towers: the narrow balconies that were pasted onto the facade at every floor, running up the length of the building. Small and mean, open not to the sky but to the concrete underside of the identical balcony of the floor above, these appendages offered none of the amenities of traditional terraces; indeed, their endless repetition worked to make each apartment (and by extension its occupants) feel like an interchangeable cog in some vast, anonymous machine. If the traditional setback terraces brought profuse signs of human life to the top of each apartment house—while at the same time giving it a distinctively idiosyncratic and highly sculptural shape— the long vertical rows of pasted-on balconies worked only to emphasize (on the very face of the building, for all to see) an interminable, inhuman repetition of units within; an artless, mechanistic stacking of floors; a cookie-cutter mentality that made every new apartment house look just like every other one.
Koolhaas, p. 82

Baudrillard, *America*, p. 17 Architecture should not be humanized.

de Torre, "Mental Diagram," p. 459 Poetry says Epstein along with me is no longer in mythology, not in the lives of saints nor in the museum
It's right at hand in railway stations and piers

Huxtable, *Goodbye*, p. 81 Huxtable's quote is in line with the idea that nobody knows the names of the architects of the Empire State Building: "It is perhaps inconsistent that New Yorkers, who have such a love for celebrities, do not know the names of their most brilliant architects. But it is the fault of the architect … He has succeeded in making some of the biggest buildings in the world ordinary and inconsequential."

Koolhaas, p. 178 Rockefeller Center is a masterpiece without genius.

Huxtable, *Goodbye*, p. 85 All that solid brick and stone means nothing. Concrete is as evanescent as air. The monuments of our civilization stand, usually, on negotiated real estate; their value goes down as land value goes up … In addition to land economics, buildings, even great ones, become obsolete. Their functions and technology date. They reach a point of comparative inefficiency, and inefficiency today is both a financial and a mortal sin.

Hawes My father and most "sound" businessmen considered the purchase of an apartment, which they called "a hole in the air," to be a gambling venture as unwise as playing the market.

N. cit. Space has no meaning without scale, containment, boundaries and direction.

James, "American," p. 373 The loose nosegay of architectural flowers.

Wellmer, p. 277 Adorno: "[Great] architecture asks how a specific purpose can become space, through which forms and materials, all these moments are reciprocally related to each other. Architectural fantasy would thus be the ability to articulate space through the sense of function, and let the sense of function become space; to translate purposes into formal structures."

Gasche, p. 13 The turning away from any straightforward consideration of buildings and from the immediacy of such an experience toward a consideration of the very experience in which buildings are given.

Huxtable, *Goodbye*, p. 86 Builders, notoriously, are not urbanists.

McInerney, *Bright Lights*, p. 66 On Madison you pass a construction site, walled in by acres of plywood on which the faces of various rock stars and Mary O'Brien McCann are plastered. Thirty stories above you, a crane dangles an I-beam over the street beside the skeleton of a new building. From the sidewalk the crane looks like a toy, but a few months back you read about a pedestrian who was killed at this site when a cable broke. DEATH FALLS FROM SKY, the *Post* said.

Atkinson, p. 37 An army of men, bare to the waist, operate pneumatic drills that shatter the seemingly unshatterable air. The men, raising their voices above the voices of the drills, shout angrily at one another and enter into vigorous altercations with the foremen. Others pour lakes of hot tar, or some mixture that looks and smells like hot tar. Smoking-hot tar spreads menacingly all over the place. Steam rollers, driven by irate men who peer out furiously and shout at

everybody, roll with a horrible clanking and groaning and steaming. Nobody in the neighborhood can remember when these construction men were not in the process of constructing. The whole area settles down, grits its collective teeth and tries to endure.

Skyscrapers exist in time—complete even to renting offices—months before they appear in space!

Josephy and McBride, p. 60

That is, after the ghostly first building is all completed, on a time schedule, the pig iron to be used in the more tangible version still lies in the mill yards and the limestone in the quarries. Even the bricks are only red clay at this juncture.

Yet every joining of stone and steel, every laborer and exact payment, every delay has been accurately blue-printed.

Moreover, the real structure moves upward exactly as its paper shadow has prognosticated.

Something had been torn down; something was being put up, but the steel structure had only just risen above the sidewalk fence and daylight poured through the gap.

Cheever, "Five-Forty-Eight," pp. 28–34

The buildings make way for the sky, and the frame of a tower under construction, ignited by the sun on its steel, seems to catch fire.

Conrad, p. 83

The light from the street yellowed faintly a big sign on which was a picture of a skyscraper, white with black windows against blue sky and white clouds. SEGAL AND HAYNES will erect on this site a modern up-to-date TWENTY-FOUR STORY OFFICE BUILDING open for occupancy January 1915 renting space still available inquire.

Dos Passos, p. 192

Machine Age Temples

Rockefeller Center is the fulfillment of the promise of Manhattan. All paradoxes have been resolved.

Koolhaas, p. 207

From now on the Metropolis is perfect.

Beauty, utility, dignity and service are to be combined in the completed project. Rockefeller Center is not Greek, but it suggests the balance of Greek architecture. It is not Babylonian, but it retains the flavor of Babylon's magnificence. It is not Roman, yet it has Rome's enduring qualities of mass and strength. Nor is it the Taj Mahal, which it resembles in mass-composition, though in it has been caught the spirit of the Taj—aloof, generous in space, quieting in its serenity.

The Taj Mahal lies in solitary grandeur on the shimmering bank of the Jumna River. Rockefeller Center will stand in the mid-stream rush of New York. The Taj is like an oasis in the jungle, its whiteness tense against the gloomy greenness of the forest. Rockefeller Center will be a beautiful entity in the swirling life of a great metropolis—its cool heights standing out against the agitated man-made skyline. And yet the two, far apart in site and surroundings, are akin in spirit.

The Taj, in tribute to pure beauty, was designed as a temple, a shrine. Rockefeller Center, conceived in the same spirit of aesthetic devotion, is designed to satisfy, in pattern and in service, the many-sided spirit of our civilization. By solving its own varied problems, by bringing beauty and business into closer companionship, it promises a significant contribution to the city planning of an unfolding future.

Ibid., pp. 213–14

Radio City Music Hall: Its elaborate facilities include dormitories, a small hospital, rehearsal rooms, a gymnasium, an art department, costume workshops. There is Radio City Symphony and a permanent troupe of 64 female dancers—the Roxyettes, all between 5'4" and 5'7"—a scriptless chorus line without any action to sustain. Furthermore, there is a menagerie—horses, cows, goats and other animals. They live in ultramodern stables, artificially lit and ventilated; an animal elevator—dimensioned to carry even elephants—not only deposits them on the stage but also on a special grazing ground on Radio City's roof. Finally, there is Roxy's own apartment fitted in between the roof trusses of his theater. It is round, all white plaster and the walls describe a parabola to meet in a domed top. The whole thing is really breathless—vague, spaceless, timeless. Makes you feel like an unhatched chicken looking up at the top of his eggshell. To make the whole thing even more fantastic, there are telephone dials in the walls. When you turn a dial, a red light starts to flash on and off—something to do with radio. But most painfully inactive is the colossal theatrical machine, the most complete mechanical installation in the world, including a revolving stage; three manipulable sections of stage flooring; a power-driven orchestral dais; a tank; an electrically draped curtain; seventy-five rows of fly lines for its scenery, ten of which are electrically operated; a cyclorama 117 feet by 75; six horns for motion pictures and two motion picture projection sheets; a fountain in the middle of the revolving stage which can be used for water effects while the turntable is in motion; a public-address system for amplifying speech and producing thunder and wind effects (played from records with fifty-four ribbon type); semi-invisible microphones on the stage, in the footlights, in the orchestra pit and in the sub-basement and an amplifier and six loudspeakers concealed above the proscenium; a monitor system in connection with the public address system which reproduces words spoken on the stage in the projection booths and the director's office and even in the foyer and lobbies if desired, and which also carries the directions of the stage manager to the dressing rooms and electrical stations; an elaborate lighting system with six motor-operated light bridges over the stage, each 104 feet long, from which lens units and floods can be used for special lighting; eight portable sixteen-floor lighting towers; four spotting galleries, two on each side of the stage, and a spotting booth in the auditorium ceiling; a cyclorama strip in the floor and a floor battery of self-leveling, disappearing footlights; six projection machines, four effect machines and the usual, or rather more than usual, complication of controls.

Ibid., p. 89

Almost without seeing daylight it would be possible to breakfast, shop, visit the consulates of six different countries, procure a passport, visit the Science Museum, lunch, enjoy movies projected on to the largest screen in the world, watch the radio performances of the National Broadcasting Company, have a hair-cut, skate, dine and dance here all in one day … from now on each new building … strives to be "a City within a City."

Mumford, *Sidewalk*, p. 58

It was by the canons of Cloudcuckooland that Radio City was designed.

Koolhaas, p. 197

Rockefeller Center is the most mature demonstration of Manhattanism's unspoken theory of the simultaneous existence of different programs on a single site, connected only by the common data of elevators, service cores, columns and external envelope.

Conrad, pp. 83–5

Beyond, however, is the new pinnacle of Rockefeller Center, lit from below, from within, and from behind by the setting sun, which also gilds the clouds.

Reading from right to left, the eye advances from black by way of Rockefeller Center's gray to the white of the sky. Its passage is a triumphant ascent toward the heavenly city, hovering there in midair on the other side of Fifth Avenue.

Rockefeller Center has now reached a convenient halfway point in its construction. The mice have labored, and they have brought forth their mountain. It was the Rockefeller Center building that pleased me most ... Alice Toklas said it is not the way they go into the air but the way they come out of the ground that is the thing.

Sharpe, p. 247

The name Radio City derives from the fact that, at an early stage in the project, someone had the notion of dedicating this site to radio broadcasting, and with the prospect of television not very distant, had conceived of putting vaudeville theatres and the Metropolitan Opera House on the same site.

Mumford, *Sidewalk*, p. 54

In the first announcements about Radio City it was pointed out that Mr. Rockefeller, after a winter out in Egypt, had suggested an Egyptian style of architecture for the steel-framed skyscrapers which the practical men assigned to the site ... No one thought of a Pyramid or tried to render it, to suit modern urban conditions, as a Babylonian zikkurat.

*Ibid.*, p. 56

When the plans for Radio City were first announced a healthy reaction expressed itself: no one liked them.

*Ibid.*, p. 54

Architecturally, in short, Rockefeller Center is much ado about nothing. It lacks the distinction, the strength, the confidence of good architecture just because it lacks any solidity of purpose and sincerity of intention. On the one hand, the projectors have eaten into a colossal fortune with a series of bad guesses, blind stabs, and grandiose inanities; on the other, they have trimmed and played for a decent mediocrity. And the whole effect of the Center is mediocrity—seen through a magnifying glass.

*Ibid.*, p. 109

The elemental divinities of wind and wave that romp along Radio City are its messengers, through whom it will radiate into the air.

Conrad, p. 257

At last I have found something to admire in Rockefeller Center, and I hasten to express my feelings before any changes are made.

Mumford, *Sidewalk*, p. 137

Radio City's air conditioning was laced with ozone, to make the audience feel more happy. But not with laughing gas as its creator Samuel Rothafel had originally proposed.

Morris, *Manhattan '45*, p. 222

An early name for Rockefeller Center was Rockefeller City.

N. cit.

But the apogee of his cleansed and hermetically sealed New York is Radio City, where he goes with Léger to make a broadcast. As its name proclaims, it's a city within—and immunized against—the city. It's installed "in one of the skyscrapers of Rockefeller Center," safe from the savage, infested outdoors.

Conrad, pp. 137–8

Radio City is a machine age temple installed in one of the skyscrapers of Rockefeller Center.

Corbusier, p. 33

The Center is the apotheosis of the Vertical Schism: Rockefeller Center = Beaux-Arts + Dreamland + the electronic future + the Reconstructed Past

Koolhaas, p. 207

F Architecture — Machine Age Temples

+ the European Future, "the maximum of congestion" combined with "the maximum of light and space," "as beautiful as possible consistent with the maximum income that should be developed."

City Under One Roof

Koolhaas, p. 174

The tendency is toward related communities in the city—communities whose activities are confined within certain areas whose traffic does not need to travel distant streets to collect supplies and orders. It seems to me that the salvation of New York depends on the wider application of this principle … In Hood's "City Under One Roof," all the movement that contributes to congestion—horizontally across the surface of the earth—is replaced by vertical movement inside buildings, where it causes decongestion.

Hood, p. 195

Every business man in the city must at some time have realized what an advantage it would be to live in the building where his office is located … Put this worker in a unified scheme and he need hardly put his feet on the sidewalk during the entire day. His business, his lunch, his club and his apartment are all in the same building. The time he saves goes either into recreation or into greater production.

Douglas, p. 451

Sounding much like Bix Beiderbecke, Raymond Hood pledges not to build the same building twice.

Ibid., p. 453

Hood builds what Hood feels; it's the jazz ethos; his large office staff resembled a jazz band more than a bureaucracy; work was done in the ferment of creative chaos.

Ibid.

He welcomed the absence of tradition manifest in the skyscrapers. He was New York—its people and buildings crowded every which way on an irregular non-gridlike grid, constantly shoved into instant closeups and surprising long-shot vistas—as an unending exercise in shifting perspectives as stimulation … Pressed to define his style, he responded "I am as much in the air about style as I am about everything else." Hood wore his hair cropped; it looked, in the words of *The New Yorker*, like "a shock of amazing gray-black bristles sticking straight up in the air." He built and flew endless kites and he loved to set off firecrackers and watch their aerial pyrotechnics. "In the air," in the American air, was just the place Raymond Hood wanted to be.

Koolhaas, p. 289

In postwar Manhattan, Lincoln Center is doomed to be one project only. It has no Beaux-Arts basement, no parks on the tenth floor—no tenth floor—and missing most of all are the commercial superstructures of the skyscrapers.

Mayakovsky, *America*, p. 48

City as building: "The girders and the roofs of the elevated railways often amount to a continuous awning, running the whole length of a street, and you can see neither the sky nor the houses to the side. There is just the thundering of the trains above your head, and the thundering of the heavy traffic in front of your nose—chunterings, of which you really can't make out as much as a word. In order not to lose the art of moving your lips, it only remains to chew silently the American cud—chewing gum."

My ideal city would be one long Main Street with no cross streets or side streets to jam up traffic. Just one long one-way street. With one tall vertical building where everybody lived with:

Warhol, *Philosophy*, p. 156

One elevator
One doorman
One mailbox
One washing machine
One garbage can
One tree out front
One movie theater next door.

City Under One Roof: Hotel

These facilities are atomized and scattered throughout the structure in optimal locations for serving the farthest reaches of the building. Instead of a kitchen, the Waldorf has a *system of kitchens*. The main station is located on the second floor; "from there octopus-like tentacles in the form of service pantries are extended in all directions providing contact with all the Rooms and innumerable private dining rooms on the third and fourth floors." On the nineteenth floor, in the residential part, is a Home Kitchen where all the cooking is done by women … "Suppose that you want a dinner in your own language? Instead of the exotic masterpiece of a French chef, you may pine for your country ham and eggs, or Vermont cakes and maple syrup … It is for that reason that I put a home kitchen in the Waldorf. There are times that we all long for everyday food, so for instance if you wake up feeling hungry for chicken dumplings, or cherry pie, you simply call the American kitchen …"

Koolhaas, p. 148

The concept of Room Service is also elevated. For the benefit of those guests who choose to remain in the tower rather than descend to the living floors, it is transformed into a transcendental service that offers each visitor a choice between remaining a provincial or becoming a cosmopolite without ever leaving his room. All these services are orchestrated and coordinated by means of the telephone, which becomes an extension of the architecture. "The volume of telephone calls and special services rendered by telephone to the Waldorf's guests requires equipment that is extensive enough to serve a city with a population of more than 50,000."

Through all these revolutionary arrangements and the facilities that "take care of elaborate private or public functions—balls, banquets, expositions, concerts, theatrical performances—all of them in self-contained spaces that include halls, theater, restaurants, cloakrooms, dance floors, etc., the Waldorf-Astoria becomes the social and civic center which it is today …"

Manhattan's first Skyscraper House.

The munificence of its culture-loving patrons has finally made possible the subsidized existence of an opera *only*, a theatre *only*, a philharmonic *only*. Culture lovers have paid for the dissolution of Manhattanism's poetic density. Through its amnesia, Manhattan no longer supports an infinite number of superimposed and unpredictable activities on a single site; it has regressed back to the clarity and predictability of univalence—to the known.

Ibid., p. 289

At the turn of the century, the hotel emerges as the mode of public discourse.

N. cit.

With the Waldorf, the Hotel itself became a movie, featuring the guests as stars and the personnel as a discreet coat-tailed chorus of extras.

Sanders, *Celluloid*, p. 293

Hawes — The hotel as glittering theater.

Koolhaas, p. 289 — The evolution of the Empire State Building site from dual private homes, to joined home, to hotel, to Empire State Building. Waldorf-Astoria becomes early example of isolated self-contained island of congestion.

Douglas, p. 437 — The old Waldorf Astoria, which was demolished to make way for the Empire State Building, was dumped into the sea five miles off Sandy Hook. The destruction of the Waldorf was planned as part of the construction of the Empire State Building.

Conrad, p. 258 — The electrically retractable Starlight Roof rejected a building's need to be and to have a sheltering canopy. Since the Waldorf was conceived to be in motion, its roof became a disposable hood, like that of a convertible car, rolled back to allow union with the element through which the building fancied itself to be speeding.

Ibid., p. 261 — The Waldorf had its own hedonistically revolving cosmic totem, a rug by Louis Rigal inside the Park Avenue foyer representing "The Wheel of Life." You climbed aboard its dizzy circle, metaphorically at least, when you checked into the hotel. Such items of decor cast the buildings as autonomous worlds voyaging through space. Veined with pneumatic tubes, internally wired by 2,700 telephones and a switchboard which was said in 1939 to be "large enough for a good-sized city," transmitting messages through itself by electrical impulse, receiving dictation on its clattering teletype machines or dispatching radio signals to the air, the Waldorf seemed to have encompassed first New York and then the planet.

Warhol, *Philosophy*, p. 165 — "We've sat in hotel lobbies all over the world, and it's always nice," I said. The lobbies are always the best-looking place in the hotel—you wish you could bring out a cot and sleep in them. Compared to the lobby, your room always looks like a closet.

Josephy and McBride, p. 195 — Some of the Plaza suites have been done over by occupants of days gone by and the decorations remain for transients to enjoy. One gentleman, whose fortunes melted away over night, left a fireplace transplanted from a Florentine Palace.

Office

Irwin, pp. 49–50 — Since I began rightly to understand this cliff city, I look upon every casual visit to an unknown office as an adventure. There they stand, window after window up a thrust of thirty or forty stories, just alike. The elevator doors, opening to discharge passengers, reveal only white corridors and uniform doors of mahogany or oak or green-painted steel. As Gertrude Stein, futurist poet, says in her masterpiece on the Bon Marché, "One, one, there are many of them. Each is like the other." Within, you feel, must be the same neat, sanitary uniformity—steel or near-mahogany desks and chairs of the latest fashion in office furniture; rows of scrubbed clerks and well-powdered stenographers, all cut from the same pattern.

Mumford, *Sidewalk*, p. 68 — It is just an office building, capable of being divided into a maximum number of cubicles.

F Architecture — Office

Seen as terrain, the office floor resembles a series of concentric rings, nestled one into another. The innermost space, the building's core, held only the elevators and mechanical areas and is thus not contested. Surrounding the core is a ring of open floor area—"the bullpen"—given over to junior employees. Open and undivided (except by low partitions), it is noisy and lacks privacy. It offers no windows or view, looking out only upon the walls and doors of the floor's third and outermost ring: the private offices reserved for the corporate elite. These offices have actual walls. They are quiet. And occupying the perimeter of each floor, they—and only they—have authentic windows, and real views … After the war, central air-conditioning, fluorescent lighting, and a new zoning law allows office floors to become as large as desired—which turns out to be large indeed. Broad interior vistas became common with the advent of "open office" design with its low, flexible partitions. The same wide office floors that cause the building's exterior to balloon from a slender pinnacle to an ungainly box has an additional consequence: creating a vast interior field of space in which to play out a shot of stories. The scene suddenly shifts, from the outside in.

Sanders, *Celluloid*, pp. 136–7

For a while our 1,200,000 square feet of rentable area seemed almost like a new continent, so vast and vacant were its many floors.

Koolhaas, p. 88

In the winter you can almost hear the tides of information flowing through the rooms and corridors.

Atkinson, p. 214

I swam into the swift current of stenos and clerks and moved along with them as though my destination was still the same as their own. I felt that I could enter any building, go up in any elevator and get off at any floor. Then I could enter any office, go to the files and put my hand immediately upon that folder of correspondence that had been missing for days. I felt that with no effort I could dictate a soothing letter to that irate customer in Omaha that would make all serene once more. I felt that more than likely the girl at the switchboard, catching sight of me, might say, "Thank God, you're back! Here, take the board a minute. I'm dying for a butt."

Ibid., p. 100

You can smell the newness, and it looks like a floor in any modern office building: polished vinyl-tiled corridors under a string of skylights; beige-painted walls with stenciled black arrows indicating groups of office numbers; looped fire hoses behind glass; occasional drinking fountains; numbered flush doors each with a black-and-white plastic name-plate fastened to the wall beside it.

Finney, p. 30

The corporate epicenter is moving north, to Midtown—a place so far away, in commercial terms, that it might as well be a separate city. The new corporate showplaces in Midtown—with their enormous windows, wide-open floor spaces, and, perhaps the most glorious, central air conditioning—leave the downtown towers looking like quaint but shopworn antiques.

Glanz and Lipton, p. 9

In Guglielmi's "Nocturne" (1931), the navigator on his column in Columbus Circle plaintively confronts the featureless pile of the General Motors Headquarters.

Conrad, p. 112

515 Madison Avenue
door to heaven? portal
stopped realities and eternal licentiousness
or at least the jungle of impossible eagerness
your marble is bronze and your lianas elevator cables

O'Hara, p. 325

swinging from the myth of ascending
I would join
or declining the challenge of racial attractions
they zing on (into the lynch, dear friends)
while everywhere love is breathing draftily
like a doorway linking 53rd with 54th
the east-bound with the west-bound traffic by 8,000,000s
o midtown tunnels and the tunnels, too, of Holland

"DuMont Building"

515 Madison, DuMont Building. A 1931 art deco office building on 53rd and Madison ... One of the building's most distinctive features is a broadcasting antenna that traces back to the building's role in the first television broadcasts of WNYW in 1938. In 1938, Allen B. DuMont began broadcasting experimental television W2XWV from the building. In 1944, the station became WABD, named for his initials. The station was one of the few that continued to broadcast through World War II. The broadcast of news about the dropping of the atomic bomb on Nagasaki in 1945 was considered the beginning of the DuMont Television Network.

Verticality

Koolhaas, p. 82

In the era of the staircase, all floors above the second were considered unfit for commercial purposes, and all those above the fifth, uninhabitable. Since the 1870s in Manhattan, the elevator has been the great emancipator of all horizontal surfaces above the ground floor. Otis's apparatus recovers the uncounted planes that have been floating in the thin air of speculation and reveals their superiority in a metropolitan paradox: the greater the distance from the earth, the closer the communication with what remains of nature (i.e., light and air). The elevator is the ultimate self-fulfilling prophecy: the further it goes up, the more undesirable the circumstances it leaves behind. It also establishes a direct relationship between repetition and architectural quality: the greater the number of floors stacked around the shaft, the more spontaneously they congeal into a single form. The elevator generates the first aesthetic based on the absence of articulation. In the early 1880s the elevator meets the steel frame, able to support the newly discovered territories without itself taking up space. Through the mutual reinforcement of these two breakthroughs, any given site can now be multiplied ad infinitum to produce the proliferation of floor space called Skyscraper.

Corbusier, p. 62

You enter: when you are three feet away from the entrance you have chosen, the door opens of its own accord. You are going out; the door opens again. What is the intelligence breathed into so many doors across the entrance? They explain: notice the glass bulb which appears in front of each door, on the level of your hips; an invisible infrared ray radiates from it horizontally; when you step within three feet of the door, your body intercepts the invisible ray; an electric circuit is established which operates an opening mechanism. It will open thus, automatically, ten thousand times a day if necessary.

Riesenberg and Alland, pp. 74–5

Obviously there is no limit, within the realm of practical possibility, to the velocity at which an elevator can travel ... from the view point of a passenger, boxed in a car running on well-aligned, well-lubricated guides. It seems no different to him whether he be traveling at 200 feet per minute or 2,000 feet per minute, provided only that the velocity be constant.

High speed vertical transportation differs from high-speed horizontal transportation in two important items. The distance we travel horizontally,

Architecture — Verticality

at a given velocity, is not a matter of movement. But, due to the effect of variable air pressure, the distance we travel vertically, at a given velocity, may be a matter of considerable momentum, particularly to people with weak hearts or otherwise sensitive to such changes … The question is how fast can we safely drop a man through a given change in air pressure? At the present time it is possible to travel a thousand feet vertically at 1,000 feet per minute with no more discomfort than may be cured by one or two swallows to relieve the pressure on the ear drums. It is interesting to note, however, that a few immediate successive round trips in such an installation result in violent seasickness to those who are either not immune or not accustomed to continuous seesawing between one air pressure and another, though the difference may be only ½ inch of water pressure, as between the eightieth and the ground floors of the Empire State Building.

Everything about the vertical—aspiration, hierarchies, the Chrysler Building—is being replaced by the modular ideation in the immense Los Angeles interlock. We still dream in and of New York, but the paramount aggregate has gone to L.A.

McCourt, p. 39

The infinity of crystal buildings—vertical villages—capped by domes of agricultural stations, traverses convulsive dynamism of clear rectilinear avenues.

de Torre, "Upon Landing," p. 58

In America the elevators do work, just as the water in the pipes, the lighting of the streets work, as do the trains in the stations, etc. … It is something that has been accomplished; there is no longer any discussion about it.

Corbusier, p. 62

I live at an altitude of seventy-two feet while my friend Harrison works at a height of eight hundred and twenty feet in Rockefeller Center. And when we take the elevator at the same moment, we arrive at our doors at the same time, in forty-five seconds.

Ibid., p. 58

Dwelling Machines

The New York house: 20 or 25' wide, but two rooms deep.

Huxtable, *Architecture of NY*, p. 31

If an Englishman's home is his castle, a New Yorker's apartment is his fallout shelter.

Blandford, p. 34

Vogue magazine runs an article entitled, "The Rise of the Walkup." People who once lived in Fifth Avenue town houses or Park Avenue apartments have moved into tenements, says *Vogue*, and praises them for "living gallantly in simplicity and liking it."

Trager, p. 479

If the modern apartment building was, in Le Corbusier's terms, a "dwelling machine," it was also a viewing machine.

N. cit.

The wonder, really, is that there are any low buildings at all in Manhattan. Many of them were restricted not by desire but by material constraint. The six or eight stories of many residential blocks in Lower Manhattan is a function of human fatigue, since a walk-up—the casual-sounding name, as if everything to do with it were a sort of stroll, for a building without an elevator—cannot demand too much from its tenants' legs and lungs.

Kingwell, p. 65

Federal Writers,
Panorama, p. 286

Often the dwellers in other American cities may escape to a small garden plot, to the open road, to playing fields, even to mere restful idleness among quiet houses and streets whose tree-lined aspect offers relief from the grimness of factories and the austerity of office buildings. The New Yorker lacks such workaday variety. The end of his day's work, or his day's search for work, brings no relief. On the contrary, it intensifies his feeling of oppressive concern.

The sense of physical confinement that lurks in a removed corner of his consciousness during the day becomes overwhelming as he goes down into the crowded subway. Even his cramped living quarters offers no room for the unbending of his weary spirit. The apartment houses in which he lives are as closely packed as the office buildings where he works. The tenements look as grim as the factories. His mild but recurrent claustrophobia is fully roused by the time he has finished his evening meal; and the habit of a narrow but intense physical activity urges him like a drug. Where to go?

Hawes

Eventually, when New York was built and its population was settled, individual apartment buildings would not catch the attention like odd or flamboyant people. The eye would have grown nonchalant. The mind would be preoccupied. Apartment houses would be simply housing or real estate.

Ibid.

The rule of thumb seemed to be the more modest the building, the more esoteric the name and claim. Exotic names of early apartment buildings: The Sunnycrest and The Ogontz, The Veronique and The Hyperion; The Sandringham, The Bertha, The Marimpol Court; a block comprised of The Fanta, The Huldana, The Helena, and The Sigfried; The Nottingham, The Mannados, The King, The Zenobia, The Clifden, The Dreadnaught.

Josephy and McBride,
p. 235

The townhouse, built on East 38th Street as a swank cooperative and charming in its exterior and interior modernism, doesn't go at all until some blurb writer has the inspired idea of naming the apartments and describing them as though they were human. Immediately crowds come to view—and rent—"Harry" and "Creighton."

Hawes

People living in apartments, continually glancing up at the rising masses of residential buildings, or glancing out at a strange new geometry, were quietly revising their psyches. They were beginning to realize the advantages of height.

Ibid.

Once it had been the tall and ungainly new apartment house that was a self-conscious presence in the urban landscape. Now it is the old brownstone manse that is beginning to look awkward and isolated, like a survivor—brave, vulnerable, and no longer indomitable.

Mumford, *Sidewalk*, p. 74

The fear of sunlight and air, which we quaintly think of as confined to the French, is beginning to disappear among the well-to-do, who have so often been content with dark, back-to-back houses and apartments which differed only in price, space, and internal cleanliness from our worst slums.

Ibid., p. 117

When one thinks of their airless back rooms, untouched by daylight, whose hangings are always drawn in order to keep the occupants from staring at the blank wall ten feet away, one wonders that more murders are not committed there. Or perhaps that's the reason so many murders are committed there.

Mumford, "Intolerable,"
pp. 283–93

To overcome the base deficiencies of the building, we shall call in the services of a fashionable architect, he will arrange the scenery to persuade his client

that he is a Spanish ambassador, an Italian prince, or a medieval English baron—but woe to the poor client if he takes it into his head to draw back the hangings and look out the window. The chances are that he will find himself facing directly a blank honeycomb of windows: the virtues of a Park Avenue apartment are those of an honest barracks.

Sutton Place building code: no windows north are allowed. Hawes

The skyscraper should not have offices on the north side. Corbusier, p. 51

The apartment house as an expression of "modernized existence." Hawes

You can still call down to a neighbor through the dumbwaiter shaft. Hamill, "Lost"

The meaning of the doorway. Arnett

For two and a half months I did not *see* a stairway in America! They are Corbusier, p. 61 something that has been buried. They exist nevertheless, off each corridor, but hidden behind a door that you are not supposed to open. There is a lighted sign above the door: Exit. The stair can be used in case of panic or fire. But there are no fires in skyscrapers. Already they are large enough to have their own public services, including firemen. And there are fire extinguishers, hydrants, all the necessary preventive devices. How beautiful, clean, gleaming, this apartment is, and always kept in good order and ready to use!

What makes New York so dreadful, I believe, is mainly the fact that the vast Mencken, p. 191 majority of its people have been forced to rid themselves of one of the oldest and most powerful of human instincts—the instinct to make a permanent home. Crowded, shoved about and exploited without mercy, they have lost the feeling that any part of the earth belongs to them, and so they simply camp out like hoboes, waiting for the constables to rush in and chase them away. I am not speaking here of the poor (God knows how they exist in New York at all!): I am speaking of the well-to-do, even of the rich. The very richest man, in New York, is never quite sure that the house he lives in now will be his next year—that he will be able to resist the constant pressure of business expansion and rising land values. I have known actual millionaires to be chased out of their homes in this way, and forced into apartments. Here in Baltimore, of course, the same pressure exists, but it is not oppressive, for the householder can meet it by yielding to it half-way. It may force him into the suburbs, even into the adjacent country, but he is still in direct contact with the city, sharing in its life, and wherever he lands he may make a stand. But on Manhattan Island he is quickly brought up by rivers, and once he has crossed them he may as well move to Syracuse or Trenton.

Nine times out of ten he tries to avoid crossing them. That is, he moves into meaner quarters on the island itself, and pays more for them. His house gives way to a large flat—one offering the same room for his goods and chattels that his house offered have vanished. A few years more, and he is in three or four rooms. Finally, he lands in a hotel. At this point he ceases to exist as the head of a house. His quarters are precisely like the quarters of 50,000 other men. The front he presents to the world is simply an anonymous door on a gloomy corridor. Inside, he lives like a sardine in a can.

The seasoned families will never live on apartment-house terms, like larvae in Irwin, p. 221 a honey-comb.

Hawes The very rich do not wish to live in apartment houses, nor near apartment houses, and they do not like their effect on the city so they go about buying up lots to protect against projected development. Even talk of an apartment house in the vicinity throws the old guard into a panic.

Ibid. The apartment house as destroyer of social order: "Bring together in a single tenement-house a score of families enjoying equal incomes, each of which has hitherto lived in comfort and contentment in an isolated dwelling, and then add a family whose heads enjoy a better income, or, being of a more reckless nature, are willing to take all sorts of risk for the sake of cutting a dash, shortly thereafter, peace and comfort will vanish from most of the other twenty families, each of whom, disliking to be outshone, will also try to make a splurge and will sacrifice its children's rights to a 'plush rocker,' a piano, or a too expensive dress. That means debt, sooner or later, and debt too often means drink."

Leavitt, p. 109 At a party Paul meets a novelist he has long admired. "When I'm working," she tells him, "I can disappear into my study and not come out … for days." As it happens the novelist is married to a stockbroker, and lives on Central Park West. How enviously Paul envisions her study, its walls upholstered in some quieting damask fabric, its capacious oak desk overlooking the Park.

Bahrampour, p. 101 A friend tells me of his grandmother, who lived in a tiny Bronx apartment, dreamed of opening her linen closet and stepping into a paradise of clean, well-lighted space.

Cage, Indeterminacy One evening when I was still living at Grand Street and Monroe, Isamu Noguchi came to visit me.
There was nothing in the room (no furniture, no paintings).
The floor was covered, wall to wall, with cocoa matting.
The windows had no curtains, no drapes.
Isamu Noguchi said, "An old shoe would look beautiful in this room."

Hawes The architects of the Alwyn were so pleased with their floor plans that they cautioned the industry against plagiarism under the threat of lawsuit.

Ibid. Developers of Rosario Candela's luxury buildings called their offerings "country houses."

Gross, p. 38 Rosario Candela did the crossword puzzle in ink.

Ibid., p. 40 Candela's windows are perfectly framed in doorways, allowing maximum daylight.

Conrad, p. 316 Oldenburg: "New York is my favorite room."

Spillane, p. 323 The lobby was done in plush, gilt and leather. From the ceiling ancient gas fixtures had been converted to electricity whose yellow bulbs did little to brighten the mortuary effect of the mahogany-paneled walls. The pictures spotted around the place showed the city of long ago when it was at peace with itself.

Blandford, p. 31 Once all the rental buildings along the street had brass accessories, upholstered armchairs in their downstairs lobbies and thick, rich carpets leading to wood paneled elevators. Now but one carpet remains, cherished by the proud super to whose care it has been entrusted, while the rest must

F Architecture — Dwelling Machines

accept a life of plastic-covered banquettes, rubber mats and bare stone floors dictated by those who gather the rent.

October 1: Moving Day.

Morris, *Incredible*, p. 292

It never ceased to astonish me that some of the most luxurious apartments in the world are being constructed in the east and west 80s and 90s, while a few hundred yards away fester the slums of Harlem. New Yorkers blinker themselves against this, unless they travel by the commuter trains that slice through the ghetto at high speed. Drivers leaving the city to the north to reach the Westchester suburbs or New England are more likely to speed up one of the riverside highways than drive through Harlem. As long as the service industries prosper, and the glitter and glamour of the city are constantly refueled by fresh injections of talent and money, Manhattan will continue to gleam and shine and beckon as the prince of cities, welcoming acolytes who can make their contribution to it. That this prosperity and sophistication sours with every step that you take north of 96th Street doesn't concern affluent New Yorkers. They simply don't see it.

Hawes

The building where we have been accommodated is enormous, dense with so many kinds, a layer cake of the original inhabitants, who began as renters back in the sixties, were part of the original co-op, and now are the stunned (and imprisoned, really; where can they go?) inheritors of million-dollar apartments, schoolteachers and cookbook writers who contribute the odd recipe to the Wednesday *Times* and really believe in City Opera; true yuppies of the eighties generation, still in sneakers and skirts, upwardly mobile; single men in studios and lonesome Eleanor Rigbys who have occasional shouted telephone conversations with distant children, audible at seven o'clock in the morning and then again at the same time that night.

Gopnik, pp. 91–2

It is small and dark, but you like the imperfectly patched pressed-tin ceiling, the claw-footed bath in the kitchen, the windows that didn't quite fit the frames.

McInerney, *Bright Lights*, p. 9

The apartment has become very small.

Ibid., p. 170

The method of acquiring an apartment in those days was this. The *Village Voice* was published on Wednesday, but advance copies were delivered to Sheridan Square around noon on Tuesday. One waited as a nervous pad-junkie for the delivery truck and when it arrived, grabbed a copy and ran rudely, without even opening it, to the cigar store, where there were phone booths. Once inside the booth and the door was closed, one read the pad ads, and made immediate phone calls.

Sanders, *Beatnik*, p. 144

They had the coolest pad, large for the East Side, with three separate bedrooms. Everything was haphazard yet carefully chosen. They collected art. Somehow, without paying one dime, they packed the walls of that one slum living room/kitchen with a Joe Brainard, a Rauschenberg, a Mike Goldberg, a Louise Adams, a Larry Rivers, an Oldenburg, a Marisol, a Schneemann, *et alia moochifica*.

Ibid., p. 364

Shortly before he died, we were invited to dinner at Merce Cunningham's loft on Sixth Avenue. Upon entering, we were astonished to see numerous priceless works of art lining the walls. When we inquired "Is that … ?" we were unceremoniously cut off and told that everything here is what you think it is. There were Johnses, Rauschenbergs and even a little Duchamp

Goldsmith, *Theory*

Tzank Check framed in a '70s plexiglass frame close the floor, covered in cooking grease, dust and cat piss. Over many valuable works of art were leaky skylights. During dinner we asked Merce what would happen if one of these works were damaged. He smiled and said, "But of course our friends would just make us another."

Wilson, "Leaving NY," p. 477

Furniture imprisoned in the fortress of the Manhattan Storage Company is running up enormous bills.

N. cit.

Soon will come the no-room apartment, with all sleeping on the same floor, all listening to the same radio speeches by the same bland speaker.

Blandford, p. 205

There is no subject dearer to the heart of an upwardly mobile New Yorker than real estate. It has everything: romance, sex, status, fantasy, the security of deep love, the fever of grand passion.

Huxtable, "Sometimes We Do It Right"

The moment in the late seventies when, at parties, artists stopped talking about art and began talking about the value of their lofts.

Bahrampour, p. 97

Among people my age, from wealthy lawyers to struggling musicians, I never attend a party where the subject of real estate doesn't come up. The head-shaking. The low clucks of the tongue. The "Oh, it's so horrible," and "If I didn't have my place, I'd have to leave the city." I slink away from these conversations and wonder how the demographic makeup of the city might be different in a softer market … I imagine older people in rent-controlled digs, whose parties are free from this obsession. Unless they're going through divorce, they tend to be settled. They might have slummed it in their youth, but they had room to grow out of it.

Ibid.

A couple of weeks ago I was talking to a self-described 60s activist.
"Don't take this wrong," she said, "but I don't understand your generation. Why aren't you all in the streets fighting for the environment?"
"It is because we are fighting for real estate," I replied.

Braly, p. 399

Another reason I want to sell my apartment: I loathe my fellow neighbors.

McInerney, *Bright Lights,* p. 134

You pass the Helmsley Palace—the shell of old New York transparently veiling the hideous erection of a real estate baron.

Haden-Guest, p. 156

Leona Helmsley: The Queen of Mean.

Dos Passos, p. 29

How's all the big money in New York been made? Astor, Vanderbilt, Fish … In real estate of course.

Aerie, Mansion

Federal Writers, *Panorama*, p. 224

Final touch of strange luxury is the roof-house, the "cote"; sometimes merely a super-cottage surrounded by painfully cultivated gardens, but often a veritable mansion. Here, twenty inhabited stories above ground, the circle swings full turn; the tenant has achieved a detachment impossible to any dwelling set on the earth. There are no neighbors to his right and left; only the tinted air above Manhattan. Though hundreds of strangers dwell just underfoot, his only connection with his six million fellow-citizens is the opening to his private elevator-shaft.

F Architecture — Aerie, Mansion

Bette Davis's penthouse loft in *Deception*, all skylight view and grand piano, is said to be modeled on Leonard Bernstein's first New York loft apartment.

Hawes

The reason that then-Mayor John Lindsay did not send snowplows to Queens during that much publicized blizzard was that he lived on Gracie Square, where on the day in question he was lying on his terrace taking in the sun.

Lebowitz, p. 102

On top of a distant building perches a house. Here, for our admiration, is the city penthouse, theoretical habitat of slim gazelles who dress by Schiaparelli and lunch lightly at Voisin.

Riesenberg and Alland, p. 96

A city without chimneys.

Maffi, p. 26

The result has been an aerial landscape less picturesque perhaps than the chimney-pots of London or the slate roofs of Paris, but one whose essentially horizontal surfaces can accommodate all kinds of human pursuits and become, in effect, a series of open-air rooms.

Sanders, *Celluloid*, p. 251

At first, real penthouses were simple, single-story affairs placed atop the flat roofs of early apartment houses, taking their name and style from the utilitarian structures that contained the buildings' elevator machinery and other rooftop equipment. But they quickly sprawled and grew elegant as New Yorkers realized the value of their superior views and light, and soon architects were treating penthouses as an integral part of apartment-house design. The city's 1916 zoning law, which mandated that the upper portion of buildings be stepped back in order to provide more light and air for the streets below, turned out to have an important side benefit: the creation of habitable terraces and the encouragement of freer variation in apartment layouts on the upper floors. The tops of New York apartment houses no longer consisted of carved stone cornices and other inanimate architectural devices, but terraces, plantings, windows, doors, and awnings that were clearly signs of life—a whole way of life, in fact, that could become the object of fantasy for those below. By the mid-1920s, traditional society-page accounts of Fifth Avenue mansions were being quickly replaced with stories of chic penthouse parties held on expansive terraces high above Park Avenue.

Ibid., pp. 245–6

Even Babylon had its roof-gardens—far away and long ago. And it is a mere commonplace that where space is very valuable the rooftops will be utilized be they four stories high or a hundred and fifty.

Ford, *America*, p. 68

Senator Copper of Tonapah Ditch
Made a clean billion in minin' and sich,
Hiked fer Noo York, where his money he blew
Buildin' a palace on Fift' Avenoo.

Irwin, "Regal," p. 40

Forty-eight architects came to consult,
Drawin up plans for a splendid result;
If the old Senator wanted to pay,
They'd give 'em Art with a capital A,

 Pillars Ionic,
 Eaves Babylonic,
Doors cut in scallops, resemblin' a shell;
 Roof wuz Egyptian,
 Gables caniptian,
Whole grand effect, when completed, wuz—hell.

Hawes

When Mrs. E. F. Hutton, for example, was reluctant to sell her town-house property at 1107 Fifth, the builder contracted Rouse and Goldstone to re-create her fifty-four-room mansion atop the apartment structure. To ensure her autonomy, they cut a private *porte cochere* into the side of the building, which gave entrance to a private elevator that ascended directly to a three-story suite that filled its crown. In appearance, that crown might have been a grand house, planted like a dizzy fiefdom on a huge pedestal. The heavy band course above the lower floors might have been a garden wall. Like a great portal, a Palladian window at the center of the twelfth floor opened into a main foyer, with separate men's and women's coatrooms. From there, the apartment, decorated in the manner of a Newport estate, spread through a drawing room, a library, dining room, breakfast room, kitchen, and a servants' wing up to the bedrooms, sitting rooms, workrooms, sun porches, and on the roof, a laundry, children's bedrooms, a playroom, and gardens that changed with the seasons. It included a self-contained guest suite with maid's rooms and a private elevator, a silver room, cold-storage rooms for flowers and furs, and valets' workrooms, ten fireplaces, gown closets, cedar closets and bedroom balconies.

Josephy and McBride, p. 193

A feature is numerous entrances—one for the ballroom, another for the dining room, still others for transient guests, so that Mrs. Vanastorbilt may go direct to her own party, avoiding the stares of curious outsiders.

Ibid., p. 224

The largest apartment of which we found record was sold to John Markell—forty-one rooms and seventeen baths at 1060 Fifth Avenue for $375,000. The story goes that shortly after Mr. Markell moved in, a servant unlocked a door that nobody had noticed and discovered ten rooms they didn't know they had.

Hawes

The Very Rich Man set an elaborate example, involving numerous residences, each one adapted to a season of the year (Thanksgiving until the New Year in a mansion in New York, spring on a farm on Long Island, summer in Newport, fall in the Berkshires, a winter interlude in Aiken, South Carolina) and each involving domestic machinery worthy of English nobility. The Rich Man lived in only two or three permanent homes; the Prosperous frequently didn't own either his New York town house, his summer house, or his carriage, and retained fewer servants. More industriously, the Well-to-Do Comfortable Man adjusted the facts of his existence, boarding in the country for the summer months, leasing a row house on a cross street of the city, as did the Well-to-Do Uncomfortable, who had "a certain fashion to maintain, but … not the means to do it with either comfort or decency."

Gross, p. 25

The sort of apartment the mere thought of which ignites flames of greed and covetousness under people all over New York, and for that matter, all over the world.

Hawes

As early as 1921, Park Avenue is hailed as the new Fifth Avenue.

Ibid.

Park Avenue offers a new and revised version of well-to-do urbanity; it spells out how the modern aristocracy intends to live now: lavishly, privately, but also cooperatively and efficiently, well served and well serviced, "near 'business'" (and yet not actually, in their homes, on a business street). From a Park Avenue address, it is walking distance to the new "Little Wall Street" of Madison Avenue, to the theaters and clubs of the West 40s, to Grand Central and points north and west. The city encircles, but it does not encroach.

The luxury apartment is house-like, but does not feel exactly like a house, *Ibid.* however. It is a question of more than the verticality or common stairs or even the doorman and gilded lobby. The apartment has a different character. Almost in spite of itself, it has developed different virtues. It is social rather than domestic, pretentious rather than practical. More than a sequence of spaces programmed for family-oriented activities like reading or sewing or games playing, it seems to have been conceived for more sophisticated, more courtly behavior. The majestic entryways, carriage turnabouts, and gilded lobbies set the tone. Inside an apartment, the most prominent spaces are designed for entertaining on a grand scale, almost like Fifth Avenue mansions. Rooms en suite that sweep through fifty or sixty feet of elegant contiguous space and oversized windows that look down on busy city streets put one in the mind of theater people, literary soirees, the cosmopolitan gatherings that are described in novels and newspaper columns.

The interior decoration of an apartment, too, conjures up a world of wealth and refinement. It is lavish but specific—parquet floors, marble or carved fireplaces, painted beams, plaster friezes, elaborate lighting fixtures—and is intended to render rooms "artistic."

City Homes for Those with Country Houses. *Ibid.*

The specifics of the Dorilton are as carefully chosen as a lady's wardrobe: *Ibid.* mahogany, oak, white enamel, and bird's-eye maple trim throughout; high wooden wainscoting carried under a Dutch shelf molding for the dining room; five feet of marble wainscoting for the kitchen; French plate glass above French tiles in the bath; glass doors between major rooms. In most buildings, there are extra little touches here and there like signposts of taste—a sculpture niche, a Wedgwood frieze, a pair of silver wall sconces, a Delft-tiled fireplace.

The new apartment houses, which look like mansions blown into ridiculous *Ibid.* proportions.

In the past decade Greenwich Village, Washington Square, Murray Hill, *Ibid.* the châteaux of Fifth Avenue have somehow disappeared, or become unexpressive of anything. The city is bloated, glutted, stupid with cake and circuses, and a new expression "oh yeah?" sums up all the enthusiasm evoked by the announcement of the last super-skyscrapers.

Kingwell, p. 19

The Empire State Building is both sign and ambassador of New York, capital of the world—or, as we should better say, after Walter Benjamin's characterization of Paris and its epoch, capital of the twentieth century.

Ibid., p. 61

The world surveyed from the Eiffel Tower is no longer the world to be owned. That site has shifted, and its new coordinates are Thirty-fourth and Fifth.

Ibid., p. 111

This was no mere practical result; rather, it was the thin edge of a massive theoretical wedge that dramatically changed American social thinking. The Empire State, that sweeping gesture in the positional-goods race of height, is also an expression of coordinated technocratic ambition, a foreshadow of American megaprojects to come, from the Hoover Dam to the space program. The central-command progressivism of the 1930s morphed, over the course of the Second World War, into what used to be called the military-industrial complex.

Ibid., p. 35

A cathedral not merely of architecture but of Americanness.

Conrad, p. 211

Empire State Building site: in 1827 it was farmland, and William Backhouse Astor was able to acquire it for $20,500.
1856—free-standing brownstone
1893—The Waldorf Hotel opens
1897—becomes Waldorf Astoria
1925—site bought by real estate speculator
1928—sold to Bethlehem Engineering Corporation for a sum rumored to be between $14 million and $16 million.

Kingwell, p. 6

The groundbreaking of the Empire State Building—eight years ago, a short time when one stops to think, that this land was part of a farm.

Ibid., p. 100

The hotel at Fifth Avenue and Thirty-fourth Street represents a transitional moment, regrettable commercial enterprise corrupting, however luxuriously, a venerable Manhattan site. When it, in turn, made way for a skyscraper, and moreover a skyscraper explicitly organized around ideals of speed and efficiency, clearly the past world of New York was gone forever. Manhattan is finally, and irreversibly, what most of us now consider it, a thick palimpsest of newness and sometimes greatness, a city forever erected anew on the bones and dust of the past.

Koolhaas, p. 141

Mechanized construction: Down below, in the streets, the drivers of the motor trucks worked on similar schedules. They knew, each hour of the day, whether they were to bring steel beams or bricks, window frames or blocks of stone, to Empire State. The moment of departure from a strange place, the length of time allowed for moving through traffic and the precise moment of arrival were calculated, scheduled and fulfilled with absolute precision. Trucks did not wait, derricks and elevators did not swing idle, men did not wait.

Kingwell, p. 116

On each floor, as the steel frame climbed higher, a miniature railroad was built, with switches and cars, to carry supplies. A perfect timetable was published each morning. At every minute of the day the builders knew what was going up on each of the elevators, to which height it would rise and which gang of workers would use it.

Douglas, p. 436

As automatic architecture, there was nothing that was not easy.

So perfect was the planning, so exact the fulfillment of the schedule that workmen scarcely had to reach out for what they next required. As if by magic, their supplies appeared at their elbows.

Kingwell, p. 116

The Empire State Building rose so fast it seemed to appear by magic, downloaded from the ether of technological possibility.

Ibid., p. 97

At one point the "velocity" of this automatic architecture reaches 14½ stories in ten days.

Koolhaas, p. 141

This was the captivating technology of the Ford-hatched assembly line married ingeniously to the old-world appeal of haptic materials such as polished marble and carved granite.

Kingwell, p. 9

It was not only built using assembly-line principles, it was itself the product of an assembly line that, in the event, produced just one product. Construction is here reduced, or rationalized, to the point of simple assembly. The building is unique, yes, but only as a mere matter of fact: there could easily be other tokens of the exquisitely precise design erected elsewhere.

Ibid., p. 160

"Sky boys" and "poet builders" conjuring the Empire State out of thin air.

Conrad, p. 211

The finished Empire State Building is a sign, a representation in built form, of the logic of construction.

Kingwell, p. 94

Fed by spooling assembly lines and thrusting upward in the middle of exurban Manhattan, a mega-project motivated by equal parts grandiose rhetoric and profit motive, it is a great machine work that sweeps away its surroundings, obliterating in a moment not just the previous occupants of its site but all previous conceptions of Manhattan, New York, and America.

Ibid., p. 110

Empire State is not a new load placed on bedrock. Instead, the inert load of earth and stones put there by Nature has been dug away and a *useful* load in the form of a building has been placed there by man.

Koolhaas, p. 139

Every building is an implied hymn to what lies beneath its surface, the plumbing and electricity and telephone lines, but none more so than the implausible Empire State, erected on the very cusp of capitalism's worst ever spasm, what economists like to call a market correction and other people call, simply, a crash. The building goes up just as the market goes precipitately down, a living challenge, in its very uprightness, its physical assertion of height created and maintained, against the possibility of downfall.
 The building's design communicates this message, but it is delivered even more tellingly in accounts of the building that emphasize its gargantuan appetite for materials, like those still distributed by its in-house publicity department. It is, in this way as in so many others, a fitting synecdoche for New York itself, the city of self-conscious massiveness in consumption and production. Unlike the signature buildings of a more recent architectural moment, the Empire State makes itself a kind of organic genius of destruction (of raw materials and money) and creation (of office space and ... money). In this way, it utterly fulfills the structural and commercial drives of its creators, realizing along the way the inner logic of all hyper-technological modernism.

Kingwell, p. 112

Upon the completion of the Empire State Building: The familiar skyline, so much the stuff of future cinematic fantasy and youthful ambition, was now substantially done. The city's grid was set, its compression of desire

Ibid., p. 7

and energy made into a presumptive ideology of constant circulation and exchange.

Mumford, *Sidewalk*, p. 69 When the scaffolding was still up around the mooring mast of the Empire State tower it was far better in design than the structure that was finally revealed.

Douglas, p. 460 In 1932, the journalist Elmer Davis described the "newest New York" as a "sixty-story city unoccupied above the twentieth floor. Some nicknamed the Empire State Building the "Empty State Building."

Trager, p. 468 After it is built, it stands unlet and can only pay its taxes by collecting dollars from the sightseers who ascend to its eyrie for the stupendous view.

Kingwell, p. 143 "As a commercial building, it has never stood out and has never made sense," a broker with Helmsley-Spear, the building's manager, told me, sitting at a desk on its twenty-ninth floor surrounded by images of the exterior we could not see. "It's more about being gorgeous to look at."

Ibid., p. 128 One longtime tenant, descending to the lobby coatless one winter day, overheard a visitor say, "Hey, do you think there are offices in this building?" "Well, yes. I mean, it's not like the Eiffel Tower, where you can see that there's nothing there," the tenant said, shaking her head and laughing. "Do they think it's all an empty façade, with just a tourist shunt running people from bottom to top?"

Ibid., p. 35 Most people, when asked, cannot name the architects of the Empire State Building, nor do they much care.

Ibid., p. 16 Like all contemporary principles of the project, Lamb always refers to the building simply as "Empire State" rather than, as both visitors and native New Yorkers tend to do today, with the full title of "The Empire State Building."

Ibid., pp. 34–5 It is beautiful, certainly, but not revolutionary in its looks the way buildings by Corbusier, Mies, or Gropius, some of them going up at the very same time, are. Its American solidity contrasts with the European flights of fancy that make the French and German designers into visionaries, social planners, utopian philosophers.

Ibid., p. 106 In 1932, the year after the Empire State Building opened, Philip Johnson organized a landmark show, "The International Style," at the Museum of Modern Art declaring the Empire State Building's obsolescence by promoting the architecture pioneered by Le Corbusier and others. The show established the sleek glass-curtain skyscraper as a central modernist ideal.

Ibid., p. 112 Not for the Empire State, or New York, the historically conditioned grandiosity of Albert Speer's almost exactly contemporary structures. Speer famously advised Hitler to construct massive buildings with traditional load-bearing masonry rather than steel or concrete frames. Such edifices would be longstanding but noble, such that when they eventually crumbled, a thousand years hence, their broken columns and tumbled-down stone walls would convey a message of glorious achievement followed by decay. Steel frames would simply topple and tangle, breaking into a refuse pile of rusted beams and glass shards—the very images we now associate with the chaotic scenes of the postwar imagination. Speer instinctively sensed that the Nazi desire for ostentatious posterity, the dreams of a new Roman imperium and millennial

Reich, would be served better by classicism than by the sleek modernism of the architectural moment. The architect Otto March had designed for the 1936 Olympiad what Speer called "a concrete structure with glass partition walls"—a scheme Hitler furiously rejected, calling for the cancellation of the games. Hitler, Speer wrote, angrily vowed "never [to] set foot inside a modern glass box like that," a perverse endorsement of at least some of the revolutionary ideas of architectural modernism.

The Empire State embodies its own kind of technotopian dream: not the genocidal Nazi fantasy, of course, but an extended celebration of machine logic and the forces of capital. The building achieves, in its smooth and hygienic Huxleyan fashion, a totalitarian ideal of command and control, the inexorable logic of assembly line and social engineering. The building is all about vertical space, and in Manhattan's force-grown grid, space is money: upward is not upward for its own sake, but for the sake of possibility and profit. On the cramped Manhattan street plan, there is nowhere else to go, and so the skyscraper was born. The Empire State's relation to the grid is therefore symbiotic, born of its pressures but also exploiting its conduits, the streets and pipes and gas lines that tangle beneath its surface. It is a node growing, massing, developing in the entire network of power and commodity, rising like a magic tower from sheer force of energy concentrated below.

Ibid., p. 114

It is another cold day, a weekday in the last sunny dregs of fall, the city gathering itself for the giddy push of the holidays and the long wet months of the New Year. The lobby prep space and ticketing zone are filled and jostling, the lines at each way station of the elevated pilgrimage long, and long-suffering. You are yourself impatient to get to the top, for you have only a little time. Not for you the bovine sluggishness of the sight-seeking tourist, that slowing of the soul that comes, and finds its gait, with the gallery shuffle, the cathedral crawl. You have just left the jaywalked grid, the laced and scored streetscape, and still have the knifing urge to cut through the crowd.

Ibid., p. 201

You get to the top faster than ever, faster than anyone. And here there is a small crowd, as usual, and you are surprised, as usual, to remember how small it is here, really. Just a balcony, a gift shop, the dimensions of a not so grand apartment, especially in this city of grand apartments.

Skin, Shadows, Reflection, Light

It doesn't stand on earth, rather it's an anchor for the sky.

Conrad, p. 213

The Empire State's dirigible mast announced its new upside-down ambition. Rather than being founded on earth, it was tethered to the clouds. Buildings that couldn't fly transmitted themselves to the air by broadcasting themselves.

Ibid., p. 257

Its foundations are firmly planted in bedrock; its stairwells are encased in thick concrete, and its steel interior, married to the limestone cladding, is more like a vertical radiator than the spindly framework typical of newer towers.

Kingwell, p. 124

The rock and earth removed in digging the foundation of the Empire State Building weighed three-quarters as much as the building itself. This fact caused Henry Ford to worry about the building's potentially disastrous effect upon the rotation of the earth itself.

Feininger and Von Hartz, *Forties*, p. 8

Kingwell, pp. 9–16 Pure product of process, Empire State can have no content. The building is sheer *envelope* … The building is process, not a fixed state.

Koolhaas, p. 141 The skin is all, or almost all.

Kingwell, p. 161 The truth of the building lies in its entire universe of use and meaning: the webs of relation and work that spin through its webs of plumbing and wiring; the shunting workers and tourists who find themselves here today, or tomorrow, and carry away memories and postcards; the entire palimpsest of history, of events and moments over seventy-five years, which together embed the site, rising in layers with each passing year to a soaring height of lived reality equal to the physical span.

The truth of the building is me sitting here right now, thinking these thoughts, my models before me, experiencing the building as a place and not just a space—not just an orientation in three dimensions, in other words, but an orientation to how I walked here this morning, and who is nearby and what they said as I came in, and how I will leave, too soon, always too soon, and walk up Fifth Avenue to another Shreve, Lamb & Harmon creation, the brick-clad little brother at 500 Fifth, with its similar setbacks and funny family-resemblance familiarity, where I will stop in at the ground floor and buy some cigars at Nat Sherman, a shop that has been here since the year before the Empire State opened its doors, and then walk along Forty-second Street to Grand Central Terminal, where I will order a manhattan—because, today, what else?—and drink it looking over the Grand Concourse and think of those ethereal, iconic black-and-white pictures of the same place, from another era, with hatted men and gloved women.

Ibid., p. 15 The automonument is not the monument as described, for example, in Aldo Rossi's structuralist architectural theory: the building that becomes prominent over time, defining a crossroads of arranging an urban fabric around itself via use. Rather, the automonument simply *asserts* its monumentality, makes itself its own argument. No architectural program is necessary, or even desirable. The paradox of the automonument is that, as a building, it is both there and not there; it is dream architecture.

Koolhaas, p. 141 Empire State will gleam in all its pristine beauty, for our children's children to wonder at. This appearance comes from the use of chrome nickel steel, a new alloy that never tarnishes, never grows dull.

The disfiguring shadows which so often come from deeply recessed windows, to mar the simple beauty of line, in Empire State are avoided by setting the windows, in thin metal frames, flush with the outer wall. Thus, not even shadows are allowed to break the upward sweep of the tower.

Kingwell, p. 19 One dramatic feature of the Empire State Building is its tendency to disappear—that is, as Wittgenstein said of language, to "lie hidden in its obviousness." All icons are more than themselves; it is worth remembering that they are, likewise, less than themselves.

Ibid., p. 35 The Empire State Building is, at once, always a building and never a building. It is always present, always absent; forever full and empty; unignorable and virtually invisible. When, fifty years into its existence, it passes from being an architectural achievement and becomes historic, a landmark, a site of preservation, it becomes more treasured yet harder to appreciate. Now, a quarter century later still, we may be forgiven for confessing that we sometimes wonder if we have ever really seen it.

The structure of transcendence does not much guide the business conducted within its elevated walls.

Ibid., p. 83

In an age overwhelmed by science and its instrumental application, technology, we somehow find it unacceptable to emphasize anything other than the use-value of even so obvious an illustration of human desire. Al Smith, singing the transcendental pleasures of the Empire State Building in his 1934 souvenir pamphlet, *Above the Clouds*, could not resist doing the very same thing. "The Tower has served many purposes besides that of a platform to look out on the world beneath," he said of the building's summit. "Aviation authorities, many times each week, telephone to learn the wind velocity and the height of the ceiling above its pinnacle. Scientists have used it as a laboratory for the study of radio transmission; for the study of wind velocity and pressure; and for the study of electrical action."

Ibid., p. 59

The building even becomes, after the fashion of all perverse cultural physics, a mythic unit of energy.

Ibid., p. 132

Sufferers from hay fever and sinus afflictions sought relief in its vast elevator shafts. "One dear old lady rose up and down for hours on the fast-moving elevators in an effort to cure or reduce the intensity of approaching density."

Ibid., p. 59

Reproduction, Replication

The Empire State Building may be the most reproduced building in America.

Kingwell, p. 122

Guy de Maupassant may have wanted to lunch in the Eiffel Tower café in order not to look at what he regarded as a cast-iron monstrosity, but workers in the Empire State Building seem to want multiple images of their tower around them, toys and photos and paintings, perhaps because they are virtually the only New Yorkers who cannot look up, or out a window, and see it. They feel deprived, perhaps, of that sense of connection, the linked sightlines of the shared nodal view—I see it and see you seeing it too—that is offered to every other New Yorker. It may be that a model or a poster, held near, allays the sense of interior blindness, a felt invisibility of one's identity with the building when inside.

Ibid., p. 128

Not long ago, taking a wrapped thirty-inch model of the building into the elevator, the product of some inspired haggling in a tourist shop across Fifth Avenue, I was stopped. "The supervisor thinks that's a drill," the young guard said, pointing to his exposed X-ray view of the building's familiar pinnacle, which did indeed resemble a power tool if not quite a deadly weapon.

 Standing there on the security threshold, off the street but not yet quite inside the building, I said, "It's the building." Meaning, of course, not that it was the building, since we were standing inside that, but a model of the building. Actually, an X-ray image of a model of the building. "Obviously it's the building," I said, pointing at the screen. Of course it was not obvious at all. It was the opposite of obvious.

 "Obviously it's the building," the guard repeated, nodding in what he probably did not realize was agreement in a strange metaphysical bargain.

Ibid., p. 129

There is a scale model of the building in the lobby itself complete with lighting that stands in a glass case next to the ground-floor information desk.

Ibid., p. 136

All the multiple reproductions of the building, especially when keyed to size and greatness, which on the surface appear to constitute an extended exercise in type-token metaphysics and so affirm the superlative nature of the building, actually work to diminish, and then eliminate, the physical reality of the building. They and it are caught in a new, simulacral economy typical not only of the twentieth century's image-proliferating visual culture but also of the culture of tourism more generally. New York becomes suffused with visual memory, images and dreams entertained before. The Empire State is, in this sense, just one of a series of much-reproduced images that cycle through our collective experience, a thing whose materiality shimmers and goes out of focus with each added postcard or tchotchke.

These would not be models or copies, just late-model examples of the same. We cherish the building's uniqueness in part because, as we think more deeply, we realize how contingent it is! There could be any number of Empire State Buildings—how wonderful that there is only this one! Of course any such desire for duplication is absurd, and misses the point. A second full-scale building, fancifully called a "model," would no more make the first "building" definitive than a six-inch-high model does. Neither edifice can escape the logic of their shared subjection to cycles of image-making. Like a Borgesian library of self-collapsing taxonomy, the entire set of feedback loops of the Empire State Building is just part of its relation to all other buildings, both those literally around its space and those surrounding it in time, themselves including both the precursors of the past, which are set into a different position and meaning by its greatness, and those that will come after it, unable to ignore that achievement.

Images obscure as well as celebrate, and cultural icons shoulder a heavy burden of metaphysical speculation in the very act of being represented.

Proliferation

An anonymous man from Tacoma, Washington, used 135 decks of playing cards to construct a house of cards in the form of the Empire State. Another man carved a four-foot-high version out of soap. Students from Kelvedon Hatch Primary School in Brentwood, England, closed the distance between them and the New York landmark by constructing a seven-foot eight-inch model that used 3,212 matchboxes. T. B. Wu fashioned a ten-foot-high model out of plaster and powdered sugar. Models have been built at all scales from Lego blocks, carved out of cheese, chocolate, and butter, stitched into crochet samplers and embroidered onto jackets, made into abstract prints and decorative batik wall coverings. It has been mimicked in stacked champagne glasses in its own lobby, and there is at least one headstone carved in its likeness, marking the grave of a man who worked on its construction.

Officials estimate that more than a billion postcards featuring its image are produced every year. These are supplemented by commemorative posters, pennants, place mats, and eventually, the billboard of the late century, T-shirts.

By the fiftieth anniversary of the building in 1981 it was estimated that some 80,000 miniatures of all kinds had been sold, making the building the most replicated structure of all time. By the seventy-fifth anniversary in 2006 the number will likely have reached 150,000 or more.

Such items are still to be found in the shops scattered around the base of the building, along with crystal, steel, plastic and rubber models of the building, ineffective pencil erasers in its image, and even pewter salt and pepper shakers in the shape of the respective summits of the Empire State and the Chrysler buildings—a fitting counterpart to the sphere and obelisk shakers designed for the 1939 World's Fair.

Ibid., p. 134

The spire of the Empire State Building reflected in a pool on the sidewalk.

Conrad, p. 175

I see a shot of the summit, apparently taken from a helicopter; I remember the sight of soaring planes of limestone when I paused very briefly to look up while crossing Thirty-third Street at lunchtime; I recall the last time I walked over the Brooklyn Bridge at night, after eating pizza in Park Slope, and noticed that the building's signature lights were not red, white, and blue, though I can't now remember what they were; I visualize the opening sequence of a popular television show, now in reruns, that uses a titled time-lapse image of the building against a cerulean sky.

Kingwell, p. 153

Empire State seemed almost to float, like an enchanted fairy tower, over New York. An edifice so lofty, so serene, so marvelously simple, so luminously beautiful, had never before been imagined. One could look back on a dream well planned.

Ibid., p. 15

The Empire State Building, though not an artwork—not, that is, created first and foremost to be viewed with rapt attention—nevertheless has acquired such a status.

Ibid., p. 142

a sight of Manahatta in the towering needle
multi-faceted insight of the fly in the stringless labyrinth
Canada plans a higher place than the Empire State Building

O'Hara, p. 325

Scale

Al Smith, the former governor of New York who became a mascot for the Empire State, demonstrated that the building was a prodigy by having himself photographed on the observation deck looking up through a telescope at a 6'7" giant, reputed to be the world's tallest man.

Conrad, p. 209

"Stone of this size will be used all the way to the top of the building, in keeping with its massiveness," Lamb told reporters a month before steelwork began on the building.

Kingwell, p. 110

I reach such states, in which my brain feels so open, so full of light, it feels huge. It feels as big as the Empire State Building.

McNeil and McCain, p. 161

View

Some tourists seem to think the whole thing is there just to support the view.

Kingwell, p. 124

The observation deck becomes a kind of safety valve or ritual space of avoidance. Visitors are herded (sometimes, alas, literally) along vertical chutes of permitted access, deposited into the controlled space of the uppermost view, a platform far smaller than most people usually imagine, and then ushered back down to the street from which they have come.

Ibid., p. 59

Ibid., p. 153 Sitting here, in the office on the twenty-ninth floor, we are all at sea.

Ibid., p. 160 That is one reason I write from a position of actually sitting in the building, touching the nose on my face you might say.

Ibid., p. 60 The right building for New York, for the New World, for the Empire State, for the American empire itself. Joyful but tough, a place to think big thoughts and survey worlds to conquer. From here, I look down at the city, and the world, I will overcome. Poems are not written for this building.

Empire

Watson, *Factory*, pp. 244–5 The inspiration for *Empire* came from an eighteen-year-old named John Palmer, while he was camping out on the roof of the Film-Makers' Cooperative. Seen from Palmer's sleeping bag each night, the Empire State Building six blocks away dominated the New York skyline. Palmer had come to New York from Hartford, Connecticut, with an art background and an interest in film. He knew about Warhol's *Sleep*, although he had not seen it. "It occurred to me, after Man Ray, what about a movie of a building?" Palmer wrote. "As a movie. Not as time lapse or National Geographic but as MOVIE?"

One day while he and Jonas Mekas were lugging copies of *Film Culture* to the post office branch at the Empire State Building, Palmer suggested, "We should tell Andy. This is a perfect icon, a perfect image for Andy." Mekas presented the idea by talking to Andy Warhol and Marie Menken.

By the summer of 1964 Andy Warhol had moved away from the editing of *Sleep*, the multiple camera setups of *Haircut*, and the narrative of *Batman/ Dracula*. *Empire* required only a handful of decisions: where to point the camera, and when to turn it on and off. Around this time the Empire State Building's spire was floodlit by master lighting designer Douglas Leigh, just in time for the opening of the 1964 World's Fair. Before, it would have been too dark to film.

Jonas Mekas had recently rented a large Auricon sound camera, to film a movie of the Living Theater's production of *The Brig*. He shot the play in real time, and two days later, Diane di Prima showed the movie at the New York Poets Theater. The sound was crude and the process simple, so Warhol decided to shoot the Empire State Building with an Auricon. Marie Menken, who worked in the Time-Life Building, arranged with Henry Romney that Warhol, Jonas Mekas, John Palmer, and Gerard Malanga could set up the camera in Romney's Rockefeller Foundation office on the forty-first floor of the Time-Life Building. On the evening of July 25, 1964, while the sun was still visible, Mekas set the camera on the tripod and framed a shot of the world's largest building. Warhol looked through the lens, said yes, and turned the camera on at 8:10 P.M., about ten minutes before sunset.

In the background, dwarfed by the Empire State Building, the Metropolitan Life Insurance Tower was topped by a light that flashed every quarter hour, so that in the film the audience can not only feel time going by but see it as the lights flash. The passing of time and the change of light are the only dramatic events in the film, with the exception of a brief glimpse of Warhol and John Palmer reflected in the window at the beginning of reel seven. (This image of the filmmaker had never been mentioned until Callie Angel noted it in restoring the film—which suggests how few people had actually watched the legendary film in its entirety.)

Surviving bits and pieces of description from Jonas Mekas's column suggest the jovial tone of those long hours of filming. When Andy gazed at

the building, he repeatedly said, "An eight hour hard-on!" Henry Romney jokingly tried to goad Andy into making the movie more action-filled: "Andy?! NOW IS THE TIME TO PAN!" John Palmer occasionally noted, "The lack of action in the last three twelve-hundred-foot rolls is alarming." At one moment the group makes a string of campaign promises, and Andy contributes, "Jack Smith in every garage."

After the night of shooting, 654 feet of film were delivered to the lab. But when John Palmer went to pick them up, the lab would not release the film without payment. He called Warhol from a phone booth. "Ohhh, John, I don't have any money to pay for thaaaat," he said. "It will just have to stay in the lab." Palmer suggested he could try to get the $350 from his mother; if so, he would have to appear on the credits as co-director. The phone went silent for fifteen seconds, Palmer recalled, and then, "Andy, in a voice I never heard and will never forget, said, 'Now you're learning.'"

The result is a moving picture of a stationary object, a silent film shot on sound equipment. Whatever the circumstances of its communal creation, *Empire* became an indelibly Warhol image. "Andy was so taken with the Auricon," recalled Mekas, "that he abandoned the silent camera. Unfortunately, I am guilty of that."

Gerard Malanga: "It was John Palmer who came up with the idea for *Empire*. John, Jonas Mekas and I changed the reels for Andy. He barely touched the camera during the whole time it was being made. He wanted the machine to make the art for him.

Bockris, *Warhol*, p. 207

We started shooting around 6 p.m.—it was still daylight—and completed around 1 a.m. The first two reels are overexposed because Andy was exposing for night light, but it was all guesswork. What happens in the course of the first two reels, and partway through the third, is the building slowly emerges out of a twilight haze, balancing out the exposure for the darkness that slowly blankets the sky."

Andy looked through the lens, composed the shot and told Mekas to turn it on, while he encouraged Henry and John to "say things intelligent." Later, on seeing the rushes, he opted for the purity of silence in the movie.

Most people thought Andy was really crazy when they heard he had made a film of the Empire State Building from dusk till dawn, but Andy was excited. "The Empire State Building is a star," he announced. "It's an eight-hour hard on. It's so beautiful. The lights come on and the stars come out and it sways. It's like Flash Gordon riding into space."

Gerard Malanga: "I remember once—this happened so many different times and in varied contexts—we were attending the premiere screening of *Empire* at the Bridge Cinema in New York. We were standing in the rear of the auditorium. Andy was observing the audience rather than the film, and people were walking out or booing or throwing paper cups at the screen. Andy turned to me, and in his boyish voice said, 'Gee, you think they hate it ... you think they don't like it?' *Empire* was a movie where nothing happened except how the audience reacted."

Like the death-and-disaster series, *Empire* was a work inspired by an amphetamine vision. "Among the younger artists Andy was involved with, alcohol got almost completely phased out by marijuana in 1964, and then three months later by LSD, which made alcohol seem gross," recalled one observer. "But while everyone else mixed speed and grass and LSD, which made everything softer and more confused, Andy didn't give up the speed for a second."

Kingwell, p. 144

At about the six-and-a-half-hour mark, the floodlights illuminating the building are dimmed, and for the remaining ninety minutes of the film its ostensible subject is invisible.

Malanga, "EMPIRE," pp. 54–8

(The following interview was recorded with Andy Warhol at 4:30 A.M. on the 43rd floor of the Time-Life Building, just 30 minutes after the completion of the shooting of the 8-hour "underground" movie, EMPIRE, in the summer of 1964.)

Gerard Malanga: *Could you tell me how you felt as you were being taken up into the building?*

Andy Warhol: The actual elevator ride to the top of the Empire State Building took as little as one minute, but a visit to Empire State is an experience that each visitor will remember all his life.

My thrills began the moment I stepped aboard a modern express elevator which whisked me to the 86th floor Observatory at a speed of 1,200 feet per minute. A special elevator took me to the 102-story peak.

GM: *What did you see once you reached the top?*

AW: Once atop the Empire State Building, the most spectacular view in the world was spread at my feet. From the outdoor terraces or the glass-enclosed, heated Observatory on the 86th floor (1,050 feet or 320 meters), other buildings are dwarfed by this engineering marvel.

The view is even more amazing from the circular, glass-enclosed Observatory on the 102nd floor (1,250 feet or 381 meters). Here I was often at cloud level nearly a quarter of a mile above the streets.

I could distinguish landmarks as far away as twenty-five miles and was able to gaze as far as fifty miles into five states … Massachusetts, Connecticut, Pennsylvania, New Jersey and New York.

GM: *What were some of New York's landmarks that you were able to see from atop Empire State?*

AW: To the north the RCA Building stands out against the 840 acres of Central Park. The Hudson River to the left leads to upper New York State and New England. The Bronx is in the background.

From the northwest corner of the 86th floor Observatory, visitors look into Times Square (center) and the bustling piers along the Hudson River, where giant ships from all over the world tie up.

Looking northwest from the top of Empire State, the visitor looks down on such landmarks as the United Nations Building (center) on the bank of the East River and the Chrysler Building (left). The Borough of Queens is in the background.

By night, New York becomes a honeycomb of light, dazzling and unbelievable in its beauty. This view from the northwest corner of the 86th floor observatory looks down into Times Square and the heart of the theatre district.

GM: *What do you know about Empire State's TV Tower?*

AW: At the 102nd story level of the Empire State Building—on a space the size of a pitcher's mound—a 22-story, 222-feet, 60-ton mast-like structure stretches upward to a height of 1,472 feet into the clouds. It is the world's most powerful and far-reaching TV tower. From here all seven of the New York area's television stations transmit their programs to a four-state sector in which 15 million persons live and own more than 5,200,000 TV sets. Programs transmitted from the Empire State Building, in other words, reach an area in which one of every ten persons in the United States lives.

GM: *Andy, can you brief me on some of Empire State's vital statistics in comparison with other structures of similar nature?*

AW: The internationally known Empire State Building is the world's tallest building. Comparative statistics show that the 1,472-feet-high Empire State

Building towers over such other international structures as the 984-feet-high Eiffel Tower, the 555-feet-high Washington Monument, the 480-feet-high Pyramid of Cheops, and the 179-feet-high Leaning Tower of Pisa.

GM: *What can you tell me about Empire State's huge floodlights?*

AW: The spectacular lighting of the tower portions of the Empire State Building allows the world-famous silhouette of the world's tallest building to occupy the same dominant position on the horizon of nighttime New York as it does during the day. Basic light source for this gigantic floodlighting task is a 1,000-watt, iodine-quartz lamp which is in the same family of lamps as those used to illuminate missile launching pads at Cape Kennedy. The floodlights, which are distinguished for their high intensity, long throw and fine beam control capabilities, are strategically located on various setbacks of the building so as to do the best job of illumination without interfering with the famous nighttime view from the Observatory.

GM: *Before the floodlights were installed to coincide with the World's Fair, was there a time when Empire State had four powerful beacons?*

AW: Yes, you are quite correct. Visible from the Observatory are the four Freedom Lights, the world's most powerful beacons, which have made the Empire State Building the tallest lighthouse in the world … a landmark to sea and air travelers alike. A bronze plaque inscribed with famed author MacKinley Kantor's 168-word tribute to the Freedom Lights is located on the western terrace of the 86th floor Observatory.

GM: *What about Empire State's interior decoration?*

AW: "The Eight Wonders of the World," the eight original art works in the lobby of the Empire State Building, which were created by artist Roy Sparkia and his wife Renee Nemerov, have become a prime additional attraction at Empire State since their unveiling in 1963. Employing a new technique which permits the artist to paint with light as well as color, the subjects include the Seven Wonders of the Ancient World as well as the Eighth Wonder of the Modern World … the Empire State Building.

GM: *Can you tell me about the exterior of the Empire State?*

AW: Not only the highest building in the world, Empire State is also one of the most beautiful. The exterior is of Indiana limestone trimmed with sparkling strips of stainless steel which run from the sixth floor all the way to the top. Whether seen in sunlight or moonlight, the effect is magnificent.

Marble in the cathedral-like lobby was imported from four different countries, France, Italy, Belgium and Germany. Experts combed these countries to get the most beautiful marble, and in one case, the contents of an entire quarry were exhausted to insure matching blocks of exactly the right color and graining.

GM: *Do you feel that Empire State is a popular subject?*

AW: The Empire State Building has been featured in many movies, Broadway plays and several big-hit musicals. Hardly a day passes that it isn't mentioned in one television program or the other. It's been included, too, in popular songs—and many, many books.

GM: *Who are some of Empire State's celebrated visitors?*

AW: Each year the Empire State Building plays host to many Heads of State or dignitaries and celebrities. Had you been here on the right days in the past, you might have seen Queen Elizabeth II and Prince Philip of England, or the King and Queen of Thailand, or Princess Birgitta and Desiree of Sweden, or Queen Frederika of Greece or even your favorite movie actor.

GM: *Oh, by the way, that reminds me, who is your favorite movie actor?*

AW: My favorite movie actor is Troy Donahue.

GM: *In closing, do you know what others think of Empire State?*

AW: Of the many publications that have commented on Empire State, the following superfluous praise has been said (I hope I get the quotes right.):

"Empire State … one of the USA's 7 engineering wonders."—*Time Magazine*

"The unbelievable Empire State Building."—*Reader's Digest*

" … see New York from the top of Empire State. There's nothing like it." —*Dorothy Kilgallen*

"From Empire State you can see 50 miles."—*Allentown Sunday Call Chronicle*

"No visitor should miss Empire State"—*New York Times*

"Empire State's best view is at night"—*Glasgow (Scotland) News*

"Empire State's view is breathtaking"—*Britain's Queen Mother*

"New York's most visited building"—*NBC*

Quantification

Kingwell, p. 130

Child's Restaurants estimated that two days' servings of its popular pancakes would make a stack as high as the building.

Ibid.

Scribner's Magazine informed the world that the copies of Margaret Mitchell's potboiler *Gone With the Wind* sold in 1933 would, if piled one on top of the other, form a stack 250 times taller than the Empire State Building.

Ibid.

If all the materials which came to the corner of Fifth Avenue and Thirty-Fourth Street for the construction of Empire State had come in one shipment, a train fifty-seven miles in length would have been needed. When the locomotive of such a train would have entered New York, the caboose on the rear end would have come to a halt in Bridgeport, Connecticut.

Ibid.

Ten million bricks were used in building Empire State. A single workman, had he continued at it every day, would have had to work for twenty-five years before he could have finished mortaring these bricks.

Ibid.

Wiring expressed in miles, marble in acres, plaster in the form of an imaginary sidewalk that Starrett Brothers estimated would run from central Manhattan to the Capitol Building in Washington, D.C.

Ibid., p. 131

Kelvinator officials estimated that the 6 million square feet of porcelain tile they used in 1933 would clad the Empire State seven times over.

Ibid.

Once every eight hours Kellogg's Cereals used enough Waxtite paper to encase the building.

Ibid.

All the fresh linens stocked aboard the French Line cruise liner *Normandie*, sheets, tablecloths, and napkins included, would completely cover the building in snowy white material.

Ibid., p. 132

"The energy women use in a year to wash clothes," a contemporary ad for Oxydol detergent said, "would move the Empire State Building a block if translated into moving power."

A Sinclair gasoline ad shows the building being picked up by a crane: "Amazing as it may seem, there is enough energy stored up in a single gallon of the powerful new H-C gasoline, if it could be fully utilized, to hoist the world's tallest building one-quarter inches in the air."

Ibid.

The building is as high as all the original Seven Wonders tacked together.

Ibid., p. 31

The total volume of one day's worth of trash produced by McDonald's packaging would fill the total interior space of the Empire State Building.

Ibid., p. 132

In the Empire State lift-up, 102 stories to the sightseeing platform, 80 to the top service landing in the tower rental section, the elevators can, assuming the building to be fully occupied, carry 15,000 well drilled inmates to street level in a half an hour. This would mean fifteen full regiments suddenly assembled on Fifth Avenue and 34th and 33rd St. in thirty minutes—a regiment delivered at the curb every two minutes. Hitler can't beat that.

Riesenberg and Alland, pp. 77–8

There is nothing like having to change elevators three times to remind you that cable does not stretch infinitely far.

Kingwell, p. 192

Such imaginative equivalences, the stuff of a gee-whiz worldview ("amazing as it may seem"), were so neatly parodied by Dorothy Parker: "If all the young ladies who attended the Yale promenade dance were laid end to end, no one would be the least surprised."

Ibid., p. 132

King Kong, Simulacrum, Death

The Empire State Building, which to the photographer Lewis Hine is a trapeze for supermen, finds itself within two years assailed by King Kong, who from its spire briefly rules the city as a debased and tyrannized jungle.

Conrad, p. 207

In 1969, Fay Wray herself wrote, "When I'm in New York, I look at the Empire State Building and feel as though it belongs to me, or is it vice versa?"

Kingwell, p. 167

During a visit to the building, Wray refused outright to be photographed next to one of the building's nameless gorillas—a rare moment of abruptness in an afternoon of sophisticated good manners and good feeling. And yet, when she lay dying just a few months later, on a sticky Sunday afternoon in August, she asked her companion and caretaker to put the film on her video recorder. She fell asleep watching it, and paid her second final visit to the top of the building, this time in the virtual reality of celluloid and magnetic tape.

Ibid.

A scheme to place an inflatable Kong on the Empire State Building's side in 1983 collapsed when, larger and heavier than expected, the balloon Kong itself collapsed, hanging in deflated puffs and flaps off one side of the great building.

Ibid., p. 166

The Empire State Building bends out of the path of a low-flying jet airplane.

Valenti, p. 29

A B-52 Mitchell bomber struck the Empire State Building, driving a hole into both the seventy-eighth and seventy-ninth floors. Most of the wings sheared off at once and dropped into the street, though the propeller remained embedded in the wall. One of the two engines plowed straight down the

Moorhouse, pp. 53–4

corridor on the 78th, went through the wall at the other end, and crashed onto somebody's roof on 33rd St. The second engine plunged down one of the Empire State elevator shafts, taking the elevator with it. Some sections of the fuselage were blown—by the impact and by the explosion of the plane's fuel tanks—up to the observation platform on the 86th floor. Other parts remained sticking out of the hole in the wall. People on the street said that an orange glow spread eerily up the side of the building behind the mist. Inside, flames were everywhere, as blazing aviation fuel began to pour down stairwells and across office floors. The shock of the impact was felt several blocks away. The Empire State itself was said to rock a couple of times before settling very gently down. Then it stood fast.

Glanz and Lipton, p. 130

The Empire State Building swayed back and forth like a whipsaw ... People on the streets heard two rumbling booms. A brilliant orange mushroom of flame rushed up the side of the building to the Observation Deck on the 86th floor ... Plane parts from the fire weakened an elevator cable, which snapped, the car plummeting seventy floors into a subcellar ... One man was either blown out of a window or jumped to escape the inferno, and he died when he landed on a terrace seven floors below ... The next day the ragged hole that the plane had torn in the world's tallest building drew crowds on Fifth Avenue ... the mangled remnants of the plane's tail sticking out.

Ibid.

"It seems, to some extent, fortunate that if the crash did have to occur, that it was so squarely into such a well-constructed building. It is difficult to fully visualize what the result would have been if the plane had crashed into a less sturdy building."—NYC Fire Department report on how the building survived the July 1945 crash.

Ginsberg, *Howl*, p. 3

jumping down the stoops off fire escapes off windowsills off Empire State out of the moon

O'Hara, p. 85

"When you're ready to sell your diamonds
it's time to go to the Empire State Building"
and jump into the 30s like they did in 1929.

Conrad, p. 140.

The Empire State Building, in whose polished stones and mournful black lobby Le Corbusier finds a tragic gloom and grandeur: it, too, like the wax museum, is a mortuary.

Sanders, *Celluloid*, pp. 97–8

His goal is the highest point on this island, a manmade mountain called the Empire State Building. His rise to the top was illusory, short-lived. In the end, the city has defeated him.

Kingwell, p. 59

To pogo or walk backward up the stairs, rappel or BASE jump off the building, or otherwise subvert its businesslike efficiency.

Ibid., p. 32

H.G. Wells in *The Shape of Things*: published in 1933 just two years after construction tools were laid down, the Empire State Building, eighth wonder of the world, grows despised and neglected, and is finally torn down in the year 2016.

Ibid.

As opposed to World Trade Center, from the start it has been an architectural winner, a class star; it has also become, with the passage of time, a national treasure.

G Empire State Building — King Kong, Simulacrum, Death

It is a poignant detail that Lamb avoided the gala opening of the building by sailing to Europe that very day. Three miles out, and so past the Prohibition boundary, he poured two martinis from a chrome shaker, pointed at the building visible in the distance, and said to his wife, "Isn't this marvelous? Here we are and we don't have to go to the party and listen to all those speeches."

Ibid., p. 16

Chrysler

If Chrysler produced a new model every year, why shouldn't architects do the same? The skyscrapers were not only technology soon to be junked as obsolete, but pop and mass art, and whatever else it may be, mass art is transient, disposable, replaceable.

Douglas, p. 437

At first the Empire State was to be only four feet taller than the Chrysler, and John Jacob Raskob worried that Walter Chrysler might cheat by hiding a mast in his spire and suddenly raise it to win the race. For these men the buildings symbolize a power over mortality and over the human body which, for all their wealth, they themselves don't possess.

Conrad, p. 209

By 1929, construction was already under way on Walter Chrysler's tower at Forty-second Street and Lexington Avenue, with a planned height that would overtop the Woolworth Building. Developers of another downtown structure at 40 Wall Street briefly tried to keep the prize in Lower Manhattan by making plans to build their tower just a few feet higher than Chrysler's. What they did not know was that Walter Chrysler had been planning a little trick: a 185-foot metallic spire that was secretly being assembled inside the fire shaft of his new building. Only once the new Bank of Manhattan tower had been topped out did Chrysler have it hoisted into place, giving the building a height of 1,048 feet when it opened in May 1930.

Glanz and Lipton, p. 27

He pomades his hair with bear's grease until it shone like the silver tip of the Chrysler Tower.

Conrad, p. 201

Bourke-White photographed the Chrysler under construction during the winter of 1929–30. As the handmaiden of the machine, she had to learn its hardihood. She worked on a tower eight hundred feet in the air, which swayed eight feet in gales. Often the temperature was below freezing. Descending from open scaffolds, she had to negotiate flights of unfinished stairs. After the building's completion, she decided she must have a studio on its sixty-first floor, level with the stainless-steel gargoyles. She often crawled out onto those gargoyles to photograph the city and was herself photographed on this perch by her assistant Oscar Graubner; Walker Evans too had been photographed by his helper Paul Grotz kneeling underneath his tripod on a parapet of the building next to the Chrysler during its construction in 1929, peering perilously into the gulf of the street. Bourke-White declared her new premises to be "the world's highest studio."

Conrad, pp. 210–11

The brick friezes of cars along the sides of the Chrysler Building employ it as a runway and take to the air at the corners. With hubcaps, fenders, and radiator covers around its shaft and murals of airplanes and automobiles in its lobby, the Chrysler seems straining to lift off.

Ibid., p. 257

The Empire State and Chrysler buildings exist as symbols of thirties materialism and as abstract ideas of skyscrapers and as big dowdy office

Gopnik, p. 122

buildings—a sign and then a thing and then a sign and then a thing and then a sign, going back and forth all the time. (It is possible to transact business in the Empire State Building and only then nudge yourself and think, *Oh, yeah, this is the Empire State Building.*) The World Trade Center exists both as a thrilling double exclamation point at the end of the island and as a rotten place to have to go and get your card stamped, your registration renewed.

108

Restless machine and body parts: torrents of legs that mow each other down, herds of cars that move in close formation with shivers of disciplined brilliance, confetti-crowd, ants-crowd, human cage that runs, unlaces, slides, picks, thins and thickens with exasperating order and continuity; and comes and goes, and comes and goes, and comes and goes, andcomesandgoesandcomesandgoes.

Depero, "24th Street," p. 429

Nothing could be more intense, electrifying, turbulent and vital than the streets of New York. They are filled with crowds, bustle and advertisements, each by turns aggressive or casual. There are millions of people in the streets, wandering, carefree, violent, as if they had nothing better to do— and doubtless they have nothing else to do—than produce the permanent scenario of the city.

Baudrillard, *America*, p. 18

Crowd rushes by with a kind of hallucinated step, very staccato, monotonous, almost disciplined.

Jolas, p. 472

The crowd sways rhythmically. There is a feeling of erotic mass-insanity in the air.

Ibid., p. 473

Space is exploding on all sides.

Lefebvre, *Stage*, p. 190

As the flow of polyrhythmic human tide jostles with noisy machines and telegraphic gestures
Sensory perceptions flow out osmotically.

de Torre, "Upon Landing," p. 58

Compounding bodies, packing them together or piling them in orgiastic heaps.

Conrad, p. 97

hurtful crush of hateful bodies smashed into buildings one on another on another (heap overproduction)

Jones, *Modernism*, p. 228

There is just such a bombardment to the senses here that it gets taxing. Even walking out on the street for a leisurely stroll can be hair-raising. Car horns blare, people scream at you, you walk in dogshit, your feet get tangled in garbage, people bump right into you and don't even say excuse me, buses will mow you down, bicyclists will play chicken with you, taxi cab doors open in your path and some people will even laugh at your shoes.

Mueller, p. 240

Thousands are hurrying in every direction. The street cars which ply this area are packed as only the New York street car companies can pack their patrons, and that in cold, old, dirty and even vile cars. There are poor dresses, poor taste, and poor manners mingled with good dresses, good taste and good manners. In the glow of the many lights and shadows of the evening they are hurrying away, with that lightness of spirit and movement which is the evidence of a long strain of labor suddenly relaxed.

Dreiser, p. 278

Infatuated with the rush and roar of a great metropolis, fascinated by the illusion of pleasure. Broadway, Fifth Avenue, the mansions, the lights, the beauty. A fever of living in their blood. An unnatural hunger and thirst for excitement is burning them up. For this they labor. For this they endure a hard, unnatural existence. For this they crowd themselves in stifling, inhuman quarters, and for this they die.

Ibid., p. 275

I think of the crowds out there swarming over the streets with their minds clicking and buzzing and yawning with schedules and breakfast table slights

Hell, p. 26

H Crowds

and anticipations of the boss' reactions and big hopes and my mind goes blank the way it does when a mathematical problem gets too complicated.

Springer, p. 332

Monster crowds in Brooklyn, across the East river; monster crowds in New Jersey, across the Hudson River.

Joshi and Schultz, p. 101

Rushing and slithering human vermin.

Yeoash, p. 407

Shining top hats and a whirl of straw hats.

Gorky, "Boredom," p. 311

The people huddled together in this city actually number hundreds of thousands. They swarm into the cages like black flies. Children walk about, silent, with gaping mouths and dazzled eyes. They look around with such intensity, such seriousness, that the sight of them feeding their little souls upon this hideousness, which they mistake for beauty, inspires a pained sense of pity. The men's faces, shaven even to the mustache, all strangely like one another, are grave and immobile.

Ibid., p. 312

Everything rocks and roars and bellows and turns the heads of the people. They are filled with contented ennui, their nerves are racked by an intricate maze of motion and dazzling fire. Bright eyes grow still brighter, as if the brain paled and lost blood in the strange turmoil of the white, glittering wood. The ennui, which issues from under the pressure of self-disgust, seems to turn and turn in a slow circle of agony. It drags tens of thousands of uniformly dark people into its somber dance, and sweeps them into a will-less heap, as the wind sweeps the rubbish of the street. Then it scatters them apart and sweeps them together again.

WPA Guide, p. 49

The crowd increases with the light, a black moving mass, workbound; a million pale faces; a clicking of heels that swells to one sustained roll of thunder.

Dreiser, p. 7

Huddling together in thick, gummy streets.

Yeoash, p. 407

White necks, clumps of powdered bodies.

Céline, p. 562

The people surging in the direction of lights suspended far off in the darkness, writhing multicolored snakes. They flow from all the neighboring streets. A crowd like that, I say to myself, adds up to a lot of dollars in handkerchiefs alone or silk stockings! Or just in cigarettes for that matter!

Parland, p. 347

Eyes that have seen too many people,
a brain jazzing wearily.

Puzo, p. 5

Children cover the pavement, busy as ants, women, almost invisible in black, make little dark mounds before each tenement door. From each mound a buzzing hum of angry gossip rises to the summer, starry sky.

Riesenberg and Alland, p. 67

Bull-like men back off and plunge against walls of flesh, denting in and being pushed home.

Beauduin, p. 3

They're like a gray mass
with bubbling eyes

H Crowds

Women are pinned, their faces a few inches from those of strangers, their make-up running. It is a mingling and crushing of body to body, and close indecent contact.

Riesenberg and Alland, p. 67

People are hurrying along the sidewalk; hurrying, hurrying from work, from tea, from the theater, from their dentists; hurrying to the busses, the subways, calling for taxis; hurrying, hurrying.

Atkinson, p. 41

The streets are filled, with magical quickness, by hundreds of thousands, who chatter, and shout, and laugh, and shake hands, and ask questions, and tell their experiences, and demand if anybody has ever heard of such a thing before, and wonder what it is, and what it means, and whether it will come back again.

Serviss, p. 64

The garment factories, which have steadily inched their way northward to 42nd Street; in the evening their workers pour out of the tall buildings and place a blight on the streets like so many ravening grasshoppers.

Peretti, p. 106

Below the buildings, on the streets we find the crowded mass of "tired and scattered" people (wearing "cynical masks of struggle and tiredness—faces of iron—hearts of iron—tongue of iron—crowd of iron … ") pressed together with more goods (slicing down and across the corner of 24th Street and 7th Avenue: "real furs and fake furs by the million: mountains of the most delicate breasts to cover millions of PINK-WOMEN; BROWN AND BLACK WOMEN")

Depero, "24th Street," p. 429

The faces of the people themselves seem unreal, like freaks come to life from a dreadful nightmare: Cauliflower ears, beggars, sleazy crones, skinny girls, twisted old men, sleek youths with pale faces, the blind and the maimed.

Walker, *Night Club*, p. 205

Faces coming into and out of view.

Amin and Thrift, p. 38

One searches vainly in the crowd on Broad Street for a smiling face.

Talbot and Lehnartz, p. 32

Cigars in big overseeing fat faces.

Donleavy

Walking up Broadway, he avows that "each face [is] beautiful and individual," and on another promenade with his wife he restores individuality of character to the avenues which have been rendered uniform by their numerical naming, differentiating unscrupulous Sixth ("tenderloin, fast") from demure Eighth ("real lower class, honest") and piteous Third ("poor, foreign").

Koolhaas, p. 123

Full-length figure: all people appear at a distance, the face becomes unimportant, the overall gesture of the figure; silhouette, the figure always appears in relation to the background or frame of the composition.

Turner, *Backward*, p. 101

So I joined the line of pedestrians entering one of the neighboring streets. We progressed by fits and starts because of the shop-windows, which fragmented the crowd.

Céline, p. 558

The eyes of them! The bodies! The hats, the coats, the shoes, the motions! How often have I followed amazedly for blocks, for miles even, attempting to pigeonhole in my own mind the astonishing characteristics of a figure before me, attempting to say to myself what I really thought of it all, what misfortune or accident or condition of birth or of mind had worked out the sad or grim spectacle of a human being so distorted, a veritable caricature

Dreiser, p. 155

H Crowds

of womanhood or manhood. On the streets of New York I have seen slipping here and there truly marvelous creatures, and have realized instantly that I was looking at something most different, peculiar, that here again life had accomplished an actual chef d'oeuvre of the bizarre or the grotesque or the mad, had made something as strange and unaccountable as a great genius or a great master of men. Only it had worked at the other extreme from public efficiency or smug, conventional public interest, and had produced a singular variation, inefficient, unsocial, eccentric or evil, as you choose, qualities which worked to exclude the subject of the variation from any participation in what we are pleased to call a normal life.

McMahon

Vito Acconci: "*Following Piece*, potentially, could use all the time allotted and all the space available: I might be following people, all day long, every day, through all the streets in New York City. In actuality, following episodes ranged from two or three minutes when someone got into a car and I couldn't grab a taxi, I couldn't follow—to seven or eight hours—when a person went to a restaurant, a movie."

McInerney, *Bright Lights*, p. 160

Everyone on the sidewalk looks exactly seventeen years old and restless.

Hapgood, p. 156

The crowds are beginning to prey on my nerves.

Federal Writers, *Panorama*, p. 312

His life is spent among great crowds of his fellows, herded together in search of happiness or trains. He belongs at one time to the subway public, at another to the theater audience or the fight mob. But he always belongs to a crowd, and except at rare moments (in telephone booths or shower baths) he is only one of the faces one sees without recognition in such crowds.

Blandford, pp. 93–4

New Yorkers are huddlers. In streets, on buses, in shops, they crowd together so that they may talk and feel the reassuring closeness of other bodies. Even the arguments that break out so fiercely and so quickly between strangers are an expression of that need for contact—that compulsion to break the silence of aloneness.

White, *Here*, p. 52

The city has never been so uncomfortable, so crowded, so tense. Money has been plentiful and New York has responded. Restaurants are hard to get into; businessmen stand in line for a Schrafft's luncheon as meekly as idle men used to stand in soup lines. (Prosperity creates its bread lines, the same as the Depression.) The lunch hour in Manhattan has been shoved ahead half an hour, to 12:00 or 12:30, in the hopes of beating the crowd to a table. Everyone is a little emptier at quitting time than he used to be. Apartments are festooned with No Vacancy signs. There is standing-room-only in Fifth Avenue buses, which once reserved a seat for every paying guest. The old double-deckers are disappearing—people don't ride just for the fun of it anymore.

At certain hours on certain days it is almost impossible to find an empty taxi and there is a great deal of chasing around after them. You grab a handle and open the door, and find that some other citizen is entering from the other side. Doormen grow rich blowing their whistles for cabs; and some doormen belong to no door at all—merely wander about through the streets, opening cabs for people as they happen to find them. By comparison with other less hectic days, the city is uncomfortable and inconvenient; but New Yorkers temperamentally do not crave comfort and convenience—if they did they would live elsewhere.

H Crowds

In aboriginal America a person moving within the ten-mile circle could potentially make only 313 different contacts with other human beings. In contrast, the density of the United States as a whole today would make possible 15,699 contacts in the same land area. The density of the average central city in the United States would permit over 2.5 million contacts, the density of Chicago over 5.3 million contacts, the density of New York City over 7.8 million contacts, and the density of Manhattan over 23.5 million contacts in the same land area.

Hauser and Schnore, p. 12

If you take the population of a small town, say thirty thousand souls who are usually spread over houses bordering on several miles of road—I believe that if you wanted to walk over all the roads of London Town it would take you two hundred years at four miles per hour!—if you take that population and crowd it all into one house having a frontage of say sixty feet of say sixty-foot road, you will find that that road-space is singularly little for the needs of that population when another population of the same size is housed just a foot away along that same road. You will increase the bewilderment if you consider that of the population of a rural township of thirty thousand, about two-thirds—the children and the housekeeping women—use the roads very little, whereas your thirty thousand will all be active movers using their sixty feet of sidewalk and the sidewalks of their neighbors at least four times daily and all at about the same hour of the day—in tides. The congestion between—to be liberal—eight and ten of mornings and four and seven in the evening will be terrible. In addition there is the lunch hour. That is the situation of New York.

Ford, *America*, pp. 73–4

Living in New York City gives people real incentives to want things that nobody else wants—to want all the leftover things. There are so many people here to compete with that changing your tastes to what other people don't want is your only hope of getting anything. For instance, on beautiful, sunny days in New York, it gets so crowded outside you can't even see Central Park through all the bodies. But very early on Sunday mornings in horrible rainy weather, when no one wants to get up and no one wants to get out even if they are up, you can go out and walk all over and have the streets to yourself and it's wonderful.

Warhol, *Philosophy*, p. 93

This sense of dispossession, to be brief about it, haunted me so, I was to feel, in the New York streets and in the packed projectiles to which one clingingly appeals from the streets, just as one tumbles back into the streets in appalled reaction from them, that the art of beguiling or duping it became an art to be cultivated—though the fond alternative vision was never long to be obscured, the imagination, exasperated to envy, of the ideal, in the order in question; of the luxury of some such close and sweet and whole national consciousness as that of the Switzer and the Scot.

James, pp. 380–1

New York's most congested time was 1904.

Riesenberg and Alland, p. 54

I had to get used to it, but now that I have, nowhere do I feel freer than amid the crowds of New York. This light, ephemeral city, which every morning and evening, beneath the curious rays of the sun, seems a mere juxtaposition of rectangular parallelepipeds, never opposes or depresses. You can feel the anguish of solitude here, but not of being crushed.

Sartre, p. 124

Shared spatial consciousness.

Jacks, p. 34

H Crowds

Hughes, *Collected*, p. 427

I've seen them come dark
 wondering
 wide-eyed
 dreaming
out of Penn Station—
but the trains are late.

WPA Guide, p. 52

It's a tight little island.

Ibid., p. 51

And in the Upper West Side fifty thousand families will be reading the newspaper by the sitting room table; fifty thousand Upper East Side families will be finishing a quiet game of bridge or sitting at the library table; and among the thousand already asleep on the Lower East Side will be a large number of old timers who have never seen Broadway.

Douglas, p. 453

New York is the first place in the world where a man can work within a ten-minute walk of a quarter of a million people.

Kingwell, p. 65

An island is, after all, no place for sprawling; so many people, so little space.

Conrad, p. 199

No time for consciousness.

Marsh, p. 109

This city is full of self-conscious high achievers who strive to appear as confident and fearless as New York itself. Claustrophobia, which involves both the fear of being unable to escape the crowd and the feeling of being painfully self-aware and isolated by one's own limitations.

Ibid., p. 39

You may point out a street, correctly enough, as the abode of washerwomen; but, in that second floor, a man may be studying chaldee roots, and in the garret over the way, a forgotten artist is dying by inches.

Lefebvre, *Stage*, p. 202

A new contradiction appears on the horizon: that between flows (the moving, the ephemeral) and fixities (established centers, decision-making positions, institutions, various "properties," etc.).

Van Vechten, p. 245

On the sidewalk pedestrians of every class in every kind of dress of every color swept past Hamish or walked by his side. The show-windows on the bright spring day were resplendent with temptations for strollers.

Gopnik, p. 119

The streets and parks were thinned of people, but New York is so dense—an experiment in density, really, as Venice is an experiment in water—that the thinning just produced the normal density of Philadelphia or Baltimore. It added to the odd calm.

Koolhaas, p. 10

Manhattanism is the one urbanistic ideology that has fed, from its conception, on the splendors and miseries of the metropolitan condition—hyper-density—without once losing faith in it as the basis for a desirable modern culture. Manhattan's architecture is a paradigm for the exploitation of congestion.

Ibid., p. 125

The Culture of Congestion is *the* culture of the twentieth century.

Kilham, p. 188

Raymond Hood: "Congestion is good."

Hardened Arteries

The traffic is heavy this time of the evening.

Hollander, p. 164

The congestion on the streets gets heavier and heavier.

Lobas, p. 141

Traffic is tied up, and horns are blowing urgently on a crosstown street in the distance.

Cheever, "Five-Forty-Eight," p. 3

At that very moment, hundreds of thousands of cars are pouring into Manhattan island over twelve bridges and through four tunnels. Once they finally reach the city, they end up in more traffic snarls; and they instantly wish, at all costs, to break out of Manhattan again.

Lobas, p. 132

Vehicles jumping the lights often block intersections, inspiring whole symphonies of honking and hooting from frustrated drivers facing a green light and obstructed crossings. Spillback causes gridlock.

Brook, p. 144

Trucks jam along the gutters.

Donleavy

A savage confusion in the streets of New York. A great tidal counterpoint of traffic noises flows across a strange, roaring undertone that never ceases, night or day. It jangles the nerves of the people of the city, and creates tensions and strains that make everything a crisis.

Atkinson, p. 19

Fifty-ninth Street is almost solidly filled with two heavy, sluggish streams of traffic moving in opposite directions.

Ibid., p. 41

The traffic on Seventy-ninth Street has thickened into a querulous, honking rush-hour crowd.

Gopnik, p. 53

Getting around town by any means except by subway is virtually impossible.

Atkinson, p. 23

Trying to get through the side streets of New York in an automobile is like trying to thread a maze.

Ibid.

Blue exhaust chuffs steadily from heated cabs that line the curb. Drivers are huddled behind the wheels. Taxis desert the line. They U-turn with a violent protest of tires and tear away with a rush.

Berger, *Eight Million*, pp. 166–7

November seventh there is a heavy rain; the streets become slippery; traffic is completely tied up.

Corbusier, p. 69

12:01 Well, in conjunction with the big holiday weekend, we start out with the Hudson River horror show right now. Big delays in the Holland Tunnel either way with roadwork, only one lane will be getting by. You're talking about, at least, twenty to thirty minutes worth of traffic either way, possibly even more than that. Meanwhile the Lincoln Tunnel, not great back to Jersey but still your best option. And the GW Bridge your worst possible option. Thirty to forty minute delays, and that's just going into town. Lower level closed, upper level all you get. Then back to New Jersey every approach is fouled-up: West Side Highway from the 150's, the Major Deegan, the Bronx approaches and the Harlem River Drive are all a disaster, the Harlem River Drive could take you an hour, no direct access to the GW Bridge with roadwork. And right now across the East River 59th Street Bridge, you've gotta steer clear of that one. Midtown Tunnel, Triboro Bridge, they remain in better shape. Still very

Goldsmith, *Traffic*, p. 1

slow on the eastbound Southern State Parkway here at the area of the, uh, Meadowbrook there's a, uh, stalled car there blocking a lane and traffic very slow.

Conrad, p. 208

A million people surly with traffic.

Lobas, p. 156

For tardiness, sloppiness, and straining the nerves, you are sentenced to the maximum punishment—the Belt Parkway.

Paumgarten

Whatever our differences, we agreed that the Cross-Bronx Expressway, a deep, eternally sluggish river of brake lights and diesel exhaust coursing through a waste of twisted rebar and abandoned scrap, is as gruesome a stretch of highway as exists in these parts.

Brook, p. 144

About a million cars prowl around Manhattan each working day, and three-quarters of them leave the island every evening. Saturation point is frequently reached.

Mayakovsky, *Discovery*, p. 51

Fifty minutes is needed at this time of day for a journey that in the morning would take a quarter of an hour, and pedestrians have to stand and wait for two minutes, deprived of any hope of an immediate crossing.

Ibid.

On the most crowded street, Fifth Avenue, which cuts the city in half, from the height of the upstairs of the hundreds of trundling buses, you can see tens of thousands of cars, racing in six or eight lanes in either direction. Drenched in the rain that had just fallen, they are now gleaming with a lacquer finish.

Goldenberg, p. 19

Mayor William J. Gaynor, astounded by the automobile traffic he saw snarling Fifth Avenue, called for a broad new thoroughfare to be carved out of Midtown, just west of Fifth Avenue.

Van Vechten, p. 245

The sun illuminated a gracious picture on Fifth Avenue. At the corner the traffic policeman held up his hand and the black and white cabs, the yellow cabs, the cherry cabs, the green and silver cabs, the Chryslers, the Rolls-Royces, the Fords, the Packards, lined up restless for the signal to press onward, for all the world like a row of Roman charioteers behind the tape waiting for the race to begin.

Sieden, p. 167

Buckminster Fuller was driving through New York with a group of editors from the *New Yorker* and *Fortune* when he was stopped by a traffic officer at Fifty-seventh Street and Fifth Avenue. While the officer demanded to know exactly what Bucky was driving, Bucky cleverly turned the steering and slowly rotated the entire Dymaxion car around the stationary police officer. That maneuver backfired because, upon witnessing the traffic-stopping event one block away, the next officer demanded a similar demonstration. The incident was then repeated at almost every successive corner, causing Bucky and his guests to spend nearly an hour traveling one mile down Fifth Avenue.

Clapp, p. 390

Broadway is the main artery of New York life—the hardened artery.

Conrad, p. 232

Broadway as a river with no bridge to detain it.

Atkinson, p. 262

Our traffic snarls irritate us, but the sleighs on lower Broadway caused such tangles a hundred years ago that people used to get out and walk "in a huff" rather than try to get anywhere behind horses.

By the late nineteenth century, the Brooklyn Bridge had become clogged with traffic.

Hawes

Motor trucks average less than six miles per hour in traffic, as against eleven miles per hour for horse drawn vehicles in 1911.

Goodman, "Banning Cars"

Manhattan traffic congestion returns by late July 1945 to its prewar levels.

Trager, p. 549

The traffic problem in New York seems insoluble. Like some backwater of a lazy, powerful stream, it has eddied slower and slower until of late years it hardly moves at all.

Atkinson, p. 23

In 1911, the architect Henry Rutgers Marshall suggested a broad, gently curved boulevard linking the old Pennsylvania Station with Fifth Avenue and 42nd Street.

Goldenberg, p. 19

We propose banning private cars from Manhattan Island.

Goodman, "Banning Cars"

Corbett's "solution" for New York's traffic problem is the most blatant case of disingenuity in Manhattanism's history. Pragmatism so distorted becomes pure poetry. Not for a moment does the theorist intend to relieve congestion; his true ambition is to escalate it to such intensity that it generates—as in a quantum leap—a completely new condition, where congestion becomes mysteriously positive.

Koolhaas, p. 120

Anytime one attempts to insert speed into any system, slowness results. The traffic jam was the old proof of this truth.

Gopnik, p. 232

The new roadways are expected to ease traffic on the Southern and Northern State parkways, but they are quickly as jammed as the older roadways.

Trager, p. 495

The city designates all of Manhattan below 96th Street a tow-away zone for illegally parked cars.

Ibid., p. 621

Oldenburg's Broome Street expressway was a tube for traffic in the form of a cigarette extending across Manhattan. He says, "you would be driving inside a cigarette and wouldn't even know it was a cigarette."

Conrad, pp. 318–20

By the late '80s, I'd discovered how relatively easy it was to get a parking space on the street in Manhattan. Greenwich Village, the Upper East Side, and even the Theater District—areas that I would previously never have dreamed of driving to—began yielding spots pretty quickly.

McLoughlin, p. 198

Movement

Oh (cosmic sensation of speed!

Parland, p. 5

Lefebvre's rhythmanalysis, a concept that interweaves cyclical and linear rhythms in the everyday. The linear, which can be made totally uniform and quantifiable, has more and more eliminated the qualitative from time and space. The disappearance of rhythms and cycles engenders in turn a need for rhythms, exemplified by the growing significance of music in social life or the commercialized and recuperated fête.

Lefebvre, *Writings*, p. 31

Finney, p. 156 — And now the traffic was dim shapes and moving shadows visible only in bits and pieces.

Lobas, p. 158 — Park Avenue is one of the most dangerous thoroughfares in the city; one should never try to beat the lights there. The traffic lights on Park Avenue change at intervals that allow a driver to cross about five streets at city limits. If you hustle you make a sixth.

Fitzgerald, "My Lost City," p. 109 — There was already the tall white city of today, already the feverish activity of the boom, but there was a general inarticulateness.

White, *Physical History*, p. 121 — The Grand Concourse was also known as The Speedway Concourse, a route originally planned for Manhattanites to reach the open parks of the Bronx … When only a boulevard without dwellings or boulevardiers, the Speedway was an engineer's dream.

Berrigan, *Collected*, p. 522 — Peeling rubber all the way up
SECOND AVENUE into Harlem Heights
Our yellow Triumph took us out of Manhattan tenement hells
Into the deer-ridden black earth dairylands.

H Crowds — Movement

Corrupting the rational spaces of modernity through a kind of material or virtual "street haunting."

Jones, *Modernism*, p. 222

If you laid all New York's paved streets end to end they'd bridge the Atlantic.

Conrad, p. 249

Street Names

The junction of Grand and Center Streets was Bayard's Mount, or Bunker's Hill; East Thirteenth Street at Avenue D was Burnt Mill Point; just north of City Hall stood Windmill Hill, and around that spot were Gallows Hill, Potbaker's Hill and Cowfoot Hill. The inlet that cut into Seventy-fourth Street from East River was Sawmill Creek and the great dimple east of Riverside Drive between 129th and 132nd Streets was Mother David's Valley.

Berger, *New York*, p. 204

Abattoir Place was the former name of West 12th St. between 11th Ave. and the Hudson River.

Brown, *Valentine's No. 7*, p. 66

Art Street was the former name of Astor Place. Originally it was a lane leading from the Bowery to a part of the Stuyvesant Farm. It was known as Art St. in 1807.

Ibid., p. 69

The lower end of William Street has probably undergone more changes of name than any other street in the city. It has been known as: The Glass Makers' Street, The Smith Street, Smee Street, Smit Street, Suice Street, De Smee Street, Burghers Path, Burger Jorisens Path, King Street, Berger Joris Street, and Borisens Path.

WPA Guide, p. 89

Dirty Lane was the former name of South William St. This street was opened 1656 and was called by the Dutch Slyck Steegh, meaning Dirty Lane. In 1674 it was called Mill Street Lane; name changed to South William St. about 1832.

Brown, *Valentine's No. 7*, p. 77

Jew's Alley was the former name of South William St. between Broad Street and Mill Lane. Jew's Alley formerly ran from Madison St. between Oliver and James Sts.

Ibid., p. 90

Smell Street Lane was the former name of Broad St. between Exchange Place and Wall St.

Ibid., p. 106

On naming and utopianism.

Buse, p. 67

Street name changes: "The Street That Leads to the Pie Woman's" to Nassau Street, "Windmill Lane" to Cortlandt Street, "Smell Street Lane" to Broad Street, "Tinpot Alley" to Edgar Street, "Sugarloaf Street" to Franklin Street. A country road that wound around the west end of what is now Times Square toward the river was Verdant Lane.

Berger, *New York*, p. 25

She says she knows that she lives at 126 "Boddeh Stritt." Even this isn't correct, since her husband demands that she call it "Bahday Street," which she reconverts to German where it means, meaninglessly, "bath street." When David gets lost, he claims to live on "Boddeh Stritt." A passerby chucklingly translates this into Potter Street, and an Irish policeman into "Body Street—sounds like the morgue" or "Barhdee Street."

Conrad, pp. 122–3

David says he lives at "S-sebm fawdynine N-nint' Street," which someone in the crowd alternately locates as "on de cunner Evenyuh D."

Ibid., p. 123

Conrad, p. 284; Maffi, p. 109

A lexicon of pseudonyms for Broadway: the Illuminated Thoroughfare, the Modern Appian Way, the Rue of Roués, the Gay Lit-Up Canyon, Golden Gulch, Orange Juice Gulch, Beer Gulch, Mazda Lane, Fraudway, Via Lobsteria Dolorosa, Neon Boulevard, Tungsten Territory.

Conrad, p. 285

Stripty-Second Street.

Berger, *New York*, pp. 279–80

Maybe men will remember that Wall Street was named for a real wall that the mynheers built to keep out Indians. Maybe they will recall that Mill Lane took its name from an old Dutch mill; that Marketfield Street was Petticoat Lane, the Hausvrows' road to Bowling Green market; that there were once aromas and trades and events identified by every name that will then be only a signpost.

Kostelanetz, *Soho*, p. 29

SoHo was one of the few New York City places whose streets were named for American generals from the Revolutionary War: Lafayette, Crosby, Greene, Wooster, along with Thompson, Sullivan, and MacDougal, whose names grace streets to the west of SoHo. The current exception, West Broadway, was originally named Laurens Street after Henry Laurens (1724–1792), a president of the Continental Congress.

Lebowitz, p. 110

I had barely recovered from the appellative blow struck by SoHo (*So*uth of *Ho*uston Street) when I received a quick left to the sensibility in the form of NoHo (*No*rth of *Ho*uston Street) … I've come to the conclusion that this crazed naming of extremely specific areas of the city has yet to come to full flower … It is abundantly clear that such vague terms as Midtown will no longer suffice; it will only get worse.

Maffi, p. 15

As early as the mid-nineteenth century, a Russian visitor noted that the roads cutting through Broadway down to Washington Square bore historical names, while those beyond were numbered, as if history has dried up and stopped nursing imagination.

Carter, p. 13

Christopher Street became so gay in the 1970s that some gay men wrongly assumed that Gay Street had been named in their honor.

Street Numbers

Brown, *Valentine's No. 7*, pp. 153–4

We have also a deplorable habit of naming our streets and avenues in numerical order. There is no reason why we should not bestow on these streets the names of some of our great statesmen, authors or littérateurs—anything that would save us from this humdrum, prosaic one, two, three stuff would be a relief—and the beauty of it is that all these new names would be suggestive and lead to further inquiry regarding the accomplishments of the men and women so honored.

Conrad, p. 197

Too distracted to read the street numbers from the northbound bus he's caught on Fifth Avenue, he mistakes 127th Street for 137th. He tells himself that "two and three look alike," then admits that they don't really.

Lobas, p. 24

Sixty-sixth Street, which muddles the general odd-even rule for Manhattan, leads westward.

Morris, *Manhattan '45*, p. 172

89 East 42nd Street, the official address of Grand Central Station.

Ask me why they change Eleventh Avenue to West End at Fifty Ninth Street, and Tenth Avenue to Amsterdam and Ninth to Columbus, and Eighth to Central Park West. Because people thought they were big hot shit up there. That's why.

Donleavy

The fundamental reality of streets, as with all public space, is political.

Blomley, p. 16

Your streets are narrowing and must be widened.

Riesenberg and Alland, p. 205

The street widths of Manhattan were designed, in 1811, for buildings of one to four stories.

Goodman, "Banning Cars"

Corner

The ecology of the street corner.

N. cit.

Only the meeting of two different street names makes for the magic of the corner.

Buse, p. 67

Outdoor corners may be instructively contrasted with interior ones.

O'Neill, p. C1

The freedom of corners may be expressed thusly: A corner is where travel options are multiplied, usually by two. (Rare is the New York corner that is not one of a quartet.)

Ibid.

The pedestrian traffic accordingly doubles at corners, and because corners are where pedestrians are held up by stoplights, corners are also where temporary groups of people form.

Ibid.

On the phenomenon of corner boys: "A corner boy is a loiterer up to no good, a brazen article who hangs around hoping for action. The action may be narcotic, it may be sexual (in the case of corner boys who are girls or, indeed, boy/girls), or it may be more innocently risqué."

Ibid.

This corner is a paradise for semiologists. There is a very cluttered pole on which are mounted two pedestrian lights and a vehicular traffic light; a one-way sign; a sign alerting us to the possible presence of blind persons; a no-left-turn sign; a chirping yellow gadget (presumably for the blind); and, at the pole's overhanging extremity, a streetlight.

Ibid.

Go to the intersection of Fifth and Fiftieth.

Donleavy

Looking upon a street intersection the corner of Fifth Avenue and 42nd St., we can imagine the scene, in large to a vast size, a mural in some future museum, showing maximum surface pressure, pedestrian and motor, into this crude city of today.

Riesenberg and Alland, p. 64

The lion and the tiger passing, as Tom Wolfe used to say about certain types passing that corner.

Jackson and Dunbar, p. 753

Suddenly a psychopathically worried policeman appears on the corner and tells everybody to go away.

Kerouac, *Lonesome*, p. 108

I stood at the corner waiting for the light to change to get across to the subway and was overtaken again and started crying.

Wojnarowicz, p. 45

Carter, p. 13

Waverly Place achieves the distinction that makes it unique among the streets of New York City: the only street in the city to wrap around itself, it does so where it crosses Christopher Street, throwing itself around the three-sided Northern Dispensary (as a New Yorker once put it, "Where Waverly intersects Waverly intersecting Waverly"). From this point, as if having succeeded in confusing itself, Waverly takes a sudden sharp bend like the irregular path of a drunk and continues east to Sixth Avenue. But not before running into Gay Street on its northern side, a surprisingly short street that in its own diminutive existence of one block cannot keep itself straight, veering back upon itself at an odd angle, only to turn back into Christopher Street.

Sidewalk

Blomley, pp. 57–9

Sidewalks first appeared in Paris in the 1760s. By the mid-nineteenth century, they became common in major cities and began to be elevated about the road. Yet early sidewalks were tentative in nature: graveled edges, footbridges over muddy streets. In the 1880s, they were poured concrete. Once produced and identified as a space, the sidewalk became an object of urban governance.

Haden, p. 53

The first laying down of hot asphalt was in 1871 at the Battery, and as this practice spread it presumably greatly aided the early bicyclists. Concrete was first used as a base for pavements in New York in 1888. In 1889 the city fathers decided to implement a general project for the improvement of the pavements and sidewalks, seemingly after an especially hard winter which had led to an issue of bonds to help pay for road repairs.

Stevens and Swan, p. 105

Arshile Gorky, in the early thirties, often spoke of the cracks in the sidewalks as something that could interest and excite the eye.

Loukaitou-Sideris and Ehrenfeucht, p. 86

Sites of both domination and resistance.

Blomley, p. 19

Central to the drama of "life and death" in the city. Sidewalks, their bordering uses and their users, are active participants in the drama of civilization versus barbarism in cities.

Ibid.

The sidewalk ballet.

Ibid., p. 68

Pests of the pavement.

Ibid.

Inanimate bandits of the sidewalk.

Ibid., p. 19

A constant succession of eyes.

Loukaitou-Sideris and Ehrenfeucht, p. 87

Micro-politics on public sidewalks.

Pope.L, p. 75

When you are crawling on a sidewalk there is no proscenium: no front, no back.

Freeman, p. 102

Concrete excited him most.

Blomley, p. 74

Passing and repassing.

Loukaitou-Sideris and Ehrenfeucht, p. 189

Bodies as urban forests.

Tomlinson, p. 137

sidewalks into catwalks

Street — Sidewalk

The scourge of street encumbrance.

Blomley, p. 61

Amiable disorder.

Ibid., p. 41

Friction risk.

Ibid.

Calculus of delay.

Ibid.

Their emotional nature.

Ibid.

These same slates. Scratched with marks hoboes made.

Donleavy

In the New World of pavements, asphalt and cement.

Ibid.

They're of cut stone, not concrete.

Finney, p. 326

The side of the street with the most obstructions and slowest going is the side that attracts people.

Blomley, p. 22

Here falls a well-dressed woman and her dinner spills from a bag and onto the sidewalk.

Barry, p. xiv

Someone sweeps his portion.

Lees, p. 223

Attempts at sidewalk control: pedestrians were advised to keep to the right. Advisory placards were set up, but soon vandalized or destroyed. In the 1920s, painted white lines as to separate the two streams of pedestrians.

Blomley, p. 70

Impediments to the free flow of pedestrian traffic are a hallmark of city life.

Ibid., p. 93

Narrow and crowded; the pavements are cracked, full of holes and subway gratings; they're obstructed by a host of badly designed light standards, parking signs, mailboxes, trash containers; much of the surface is in permanent use for temporary storage of crates, newspapers, displays of merchandise, signs and what not. Further obstructing the flow is a host of street operators: handbill passers, demonstrators, hustlers for second-floor establishments, pitchmen for stores, pushcart food vendors, knickknack vendors, and barkers.

Ibid., p. 22

Most of us take sidewalks for granted. An undervalued element of the urban form, this public ground connects points of origin and destination, and few people go through the day without traversing at least one sidewalk. Sidewalks are unassuming, standardized pieces of gray concrete that are placed between roadways and buildings, and their common appearance belies their significance and history as unique but integral parts of the street and urban life. A commercial terrain for merchants and vendors, a place of leisure for flâneurs, a refuge for homeless residents, a place for day-to-day survival for panhandlers, a space for debate for political activists, an urban forest for environmentalists … Like streets, sidewalks are ubiquitous and difficult to avoid. Motorists observe them from their vehicles, and pedestrians walk along them from point of origin and destination or from car to building.

Loukaitou-Sideris and Ehrenfeucht, pp. 3, 6

On a warm and blue early October day, I walk half a block from my home and investigate this question at West 23rd Street and Seventh Avenue, an intersection I constantly but heedlessly use. There are no other lingerers,

O'Neill, p. C1

and partly out of embarrassment I pay attention, for the first time ever, to the street furniture.

Sanders, *Celluloid*, p. 198

By the early twentieth century, the canopy had supplanted the row-house stoop as the common signature of the middle-class New York residence—yet its importance was far more than symbolic. As the apartment house's clearest gesture to the street, it revealed the interlocking of domestic and public realms that made the New York apartment house, for all its layers of remove from the city, a profoundly urban form of housing. The canopy engaged the street—literally—by passing over a portion of the sidewalk and claiming it for the building; yet it simultaneously allowed free passage for the city's street life beneath. In this overlap the film city found enormous dramatic possibility.

Huxtable, *Architecture of NY*, p. 32

Street Furniture The difference between "street architecture" and "landmarks": built as part of street, they continue to live as a part of it, even in incongruous transformations; in isolation they lose their meaning.

Finney, pp. 227–8

I walked along for half a block staring up at a gray winter sky actually darkened, or so it seemed, by literally hundreds and hundreds of black telegraph wires on both sides of the street and running across it in bunches of sometimes several dozen, an astonishing mess. Every few yards wooden telegraph poles sprouted from the walk, some of them—I stopped and counted—with as many as fourteen crossarms loaded with wires, each pole, I noticed, marked with the name of whatever competing company had put it there.

Donleavy

Street lamps hang, two big tears above signs. No parking no commercial traffic.

McInerney, *Bright Lights*, p. 13

Waiting for a light at Forty-second, you scope among the announcements of ancient upcoming events, strangling the lamppost like kudzu.

O'Neill, p. C1

These white stripes form the rungs of a "ladder" crosswalk, where two parallel white lines serve as the side rails. A "continental" crosswalk, by contrast, is not bordered by rails, and its bands simply float on the blacktop. Some crosswalk markings have side rails but stripes that run diagonally: "zebra" crossings.

Hapgood, p. 76

In all his thoughts and actions, there is a flavor of asphalt.

Donleavy

Look down and see all the bottle tops embedded in the asphalt.

Berrigan, *Collected*, p. 44

Harum-scarum haze on the Pollock streets

Ellis, *Epic*, p. 460

Because of the building boom and the quickening thrust of the population toward the north, streets were ripped up much of the time.

Warhol, *Diaries*, p. 710

I think I forgot to tell about the girl on 57th at Park who took off all her clothes and peed in the middle of the street and then walked over and put her clothes on again. In front of that luggage store that I never see anybody in. The southwest corner, you know? Everybody pretended like nothing was happening. She had high heels on. (Tuesday, January 21, 1986)

Gooch, p. 74

In 1961 Frank and I were walking along First Avenue and noticed the funny steeples of St. Bridget's Church on Tompkins Square Park in the

distance—one steeple curved limply … The steeple of St. Brigid's on Tompkins Square which is "leaning a little to the left."

How funny you are today New York
like Ginger Rogers in *Swingtime*
and St. Brigid's steeple leaning a little to the left

O'Hara, p. 370

What, in fire escapes, do I admire? Their universality; their economy of design; their rugged skeletal strength and transparent utility; their spontaneous novelty; the simple sturdy curves overlapping when viewed from a given vantage, filtering the masonry or brick; their constancy; sound as a dollar, firm as Gibraltar, unshaken by the aged, neglected yet shouldering their vital charge, clinging, like Ulysses to his barque, through hurricanes, freezing gales of winter; safely conducting bolts of lighting; supporting, as Atlas, the gravid snows of winter.

Deyo and Leibowitz, p. 103

Signs to Maspeth, Flatbush and Ozone Park.

Donleavy

These are the hands that paste posters and notices on lamppost and wall. Over the course of time, one poster is pasted over another and each in its turn crumbles and peels and fades away. But bits of each remain to form collages which are subject to change whenever the wind blows hard or another hand puts up a fresh poster.

Binzen

Character of Streets

Every street and avenue should be studied as an individual artistic problem.

Goodman, "Banning Cars"

The use and purpose of streets: history.

Turner, *Backward*, p. 101

Rear Window is set on a fictitious 125 West 9th Street, nonexistent because West 9th has a career of only a single block.

Conrad, p. 293

Eighth Avenue: the greater lower middle class highway of New York.

Hawes

Allen Street: the Riviera of the bums.

Conrad, p. 285

Fifth Avenue automatically denotes a gentleman while Central Park West a commoner.

Hawes

People on Lexington Avenue are wishing that they lived in a more cheerful street.

Wilson, "Leaving NY," p. 477

In the Hunter's Gate and out the Miner's Gate and down Fifth Avenue.

Donleavy

The curve of lower Broadway around Bowling Green Park when you went up to Wall Street.

Jackson, p. 678

The Bowery alive outside the window with its traffic and muttering winos, inside a house with alley cats chasing each other through the dimly lit room.

Wojnarowicz, p. 184

Broadway has a kind of island in the center, with strips of grass and a green bush or two, and at each street crossing there are a few benches on this island where the real hard-bitten city dwellers sit, in the very center of the rushing traffic, happily relaxed and cheerfully chatting.

Atkinson, p. 25

Ellis, *Epic*, p. 526	Riding up Broadway amid the soft hail of ticker tape.
Donleavy	Socked in on Park Avenue.
Bennett, *Deconstructing*, p. 9	These streets are constantly stalked by high buildings.
Brook, p. 16	Where every street is a dead end and in which the sluggish rivers trap the island like a moat.
Bennett, *Deconstructing*, p. 9	all these streets leading so crosswise, honking, lengthily, by avenues
Maffi, p. 50	The streets are always disappearing around here.
Huxtable, *Goodbye*, p. 17	The brutal breaking of the streetscape, both historically and aesthetically.
Gold, p. 19	The East Side street could not be banished with a leather strap.
Donleavy	Leaving the island of Manhattan. Arrive on the mainland of the Bronx.
Trebay, p. 80	Truth to tell, Sixth and Eighth at the best of times is no cozy byway of the Village. Back when the Women's House of Detention occupied the site of the fenced neighborhood garden some neighbors refer to as "Pansies in Bondage," the streets veritably rang with conversations between inmates and loved ones six stories apart. The traffic island dividing Sixth and Greenwich avenues is an *old* haunt of brass bands partial to Souza medleys. And the intersection itself—can you try to imagine a sleazy incensed souk run by people in Mohawks, leather boots, and jackets that say "Stormtroopers of Death, Speak English or Die"?
Ellis, *Psycho*, p. 3	Abandon all hope ye who enter here is scrawled in blood red lettering on the side of the Chemical Bank near the corner of Eleventh and First and is in print large enough to be seen from the backseat of the cab as it lurches forward in the traffic leaving Wall Street and just as Timothy Price notices the words a bus pulls up, the advertisement for *Les Misérables* on its side blocking his view, but Price who is with Pierce & Pierce and twenty-six doesn't seem to care because he tells the driver he will give him five dollars to turn up the radio, "Be My Baby" on WYNN, and the driver, black, not American, does so … Price calms down, continues to stare out the cab's dirty window, probably at the word FEAR sprayed in red graffiti on the side of a McDonald's on Fourth and Seventh … Like in a movie another bus appears, another poster for *Les Misérables* replaces the word—not the same bus because someone has written the word DYKE over Eponine's face.

Subjective Streets

Walker, *Night Club*, p. 200	The street gets you.
Auster, "Fogg," p. 104	As time went on, the streets were what I came to dread most, and I was willing to do almost anything to avoid them.
McNeil and McCain, p. 299	I remember my favorite nights were just getting drunk and walking around the East Village kicking over garbage cans. Just the night. Just the night. Just that it would be night again. And you could go out, you know? It just seemed

glorious. And you'd be humming these great songs and anything could happen, and it was usually pretty good. You'd pick up some chick. You'd have an adventure. You'd go to some fantasy where you'd never been before.

My heart would just be racing every time I did that block. And then the doors would open and I'd be there. I was so excited every night I went. Everything was new, and it was so exciting because I knew I was walking into the future.

Ibid.

"The streets," Cory would say with a flash in his eye, "are *mine*."
 As if to prove it, he stopped me one evening under a lamp at the corner of Christopher and Seventh Avenue.
 "Kiss me," he commanded.
 Well, I was out of the closet and all that, but the corner of *Seventh Avenue and Christopher* with traffic going by like there was no tomorrow … ?
 "Here?" I said.
 "Here," he said.

Hamilton, pp. 14–15

And it's midafternoon and I find myself standing at a phone booth on a corner somewhere downtown, I don't know where, but I'm sweaty and a pounding migraine thumps dully in my head and I'm experiencing a major-league anxiety attack, searching my pockets for Valium, Xanax, a leftover Halcion, anything, and all I find are three faded Nuprin in a Gucci pillbox, so I pop all three into my mouth and swallow them down with a Diet Pepsi and I couldn't tell you where it came from if my life depended on it.

Ellis, *Psycho*, p. 148

Streets coming fast,
 One after the other.

Lowell, p. 54

I find myself walking through the antique district below Fourteenth Street. My watch has stopped so I'm not sure what time it is, but probably ten-thirty or so. Black guys pass by offering crack or hustling tickets to a party at the Palladium. I walk by a newsstand, a dry cleaners, a church, a diner. The streets are empty; the only noise breaking up the silence is an occasional taxi cruising toward Union Square. A couple of skinny faggots walk by while I'm at a phone booth checking my messages, staring at my reflection in an antique store's window. One of them whistles at me, the other laughs: a high, fey, horrible sound. A torn playbill from *Les Misérables* tumbles down the cracked, urine-stained sidewalk. A streetlamp burns out. Someone in a Jean-Paul Gaultier topcoat takes a piss in an alleyway. Steam rises from below the streets, billowing up in tendrils, evaporating. Bags of frozen garbage line the curbs. The moon, pale and low, hangs just above the tip of the Chrysler Building. Somewhere from over in the West Village the siren from an ambulance screams, the wind picks it up, it echoes then fades.

Ellis, *Psycho*, p. 128

This is not hell, but the street.

Lorca, *Poet*, p. 123

University Place: nothing of interest comes to mind about this minor thoroughfare of drab commercial buildings and boring apartment houses, with equally drab and boring bars, delis, and coffee shops interspersed, from shoddy, ugly Fourteenth Street down to what was then the staid and quiet corner of Eighth and University, where one found, inexplicably, completely out of place, the misnamed Cedar Street Tavern.

LeSueur, p. 165

Another night, deep in the summer, the heat of my room sent me out into the streets. I walked down Third Avenue to Fifty-first Street, where there was an antique store with an object in its window I admired: a palace of a

Capote, p. 13

bird cage, a mosque of minarets and bamboo rooms yearning to be filled with talkative parrots. But the price was three hundred and fifty dollars. On the way home I noticed a cab-driver crowd gathered in front of P. J. Clark's saloon, apparently attracted there by a happy group of whiskey-eyed Australian army officers baritoning, "Waltzing Matilda." As they sang they took turns spin-dancing a girl over the cobbles under the El; and the girl, Miss Golightly, to be sure, floated round in their, arms light as a scarf.

Frisa and Tonchi, p. 167

There's nothing better than taking a walk through the seedy part of downtown Manhattan during the steamy summer nights. I distinctly remember the smell of cigarettes, alcohol, garbage and cheap perfume. On the way to Keith Haring and Juan Dubose's cluttered apartment on Broome Street, hookers lined the blocks of Chrystie Street. We always knew that we were near because we could hear the sound of their vinyl hot pants snapping back and forth and their heels clicking.

McInerney, Bright Lights, p. 134

At the corner of Jones and Bleecker a Chinese restaurant has replaced the bar whose lesbian patrons kept you awake so many summer nights when, too hot to sleep, you lay together with the windows open.

Creeley

Q: What were your early influences?
 A: The sidewalks of New York. East 11th Street, West 12th Street ... so many side streets one doesn't think of when not in town.

Girdner, pp. 51–2

A six-year-old boy was recently asked at the kindergarten to name the principal use of the streets of New York. He promptly replied that the streets of New York were made for the cable-cars to run over. If this boy spends his life on Manhattan Island, the chances are he will never have occasion to amend this answer, and never think what the streets of New York are really for, and to whom they really belong.

Bushnell

Riding a bike in Manhattan is indeed perilous sport ... "You ride through red lights, you ride against the traffic. You can be a felon," said Chester ... "There's a freedom in being on your bike in the city. You feel like you're floating above the masses. I'm pretty fearless on my bike, in ways that I can't be in the rest of my life. I feel like I'm the best on my bike, the most in tune with myself and the city."

Streetscape

Hawes

Montgomery Schuyler reviewed the streetscape of New York, pronouncing buildings appropriate or innocent or adventuresome or conformist, as if they were interesting characters or coded bits of behavior. He always seemed to sense where these buildings had come from, from the heart or the mind or the ego, born of ambition or pretension, nostalgia, or sheer mechanical ingenuity. His pronouncements applied as aptly to the citizens of the city as to their structures. As the new Fifth Avenue buildings were "amusing," so, in a way, were their pretentious owners. The older generation of houses, by contrast, were "primeval venerable things"—"dull" but innocent.

Manville, p. 345

A walk first: past the rich people eating chicken dinners on the sidewalk terraces of the Fifth Avenue Hotel ... past the Young Marrieds, determinedly buying lousy paintings under the street lamps to take them back to the three-and-a-half out in Queens ... past the glittering stream of

Street — Streetscape

lion tamers, pirates, hoods, Englishmen, movie stars, poets, motorcycle riders, citizens, ingénues, bright young urine-analysts and beards on Eighth Street. Then through the park and under the dark, rustling trees, and the young lovers eating cantaloupe on the black lawns, and out onto Fever Street, MacDougal Street and then around, taking Sixth Avenue back (stopping often to have our silhouettes drawn on soft copper "by genuine artists"), then west on Greenwich Avenue and into the Picador.

He's now on Second Avenue, in the Yorkville section of Manhattan. He stops running for a moment to catch his breath. Once again he tries to hail a cab in the truck-filled street. No luck. He starts to run again. The music continues. The camera shows an empty phone booth; Ike runs over to it. He puts a dime into the slot and dials. The number is still busy. He drops the receiver back and leaves the booth quickly. He continues to run, now past Gramercy Park, oblivious to the passers-by, the traffic, everything but getting to where he desperately wants to go. The camera shows the lobby of Tracy's apartment house, looking outside from its interior. A limousine is parked at the curb. The music changes to "But Not for Me" as Ike runs onto the screen. He looks inside the glass doors, breathing hard. He looks pleased. *Allen and Brickman, Manhattan, p. 269*

Just rain, black squares of windows, a drunk that weaved up the sidewalk. *Spillane, p. 267*

Onward: across the park and out into Fifth Avenue: stampeding against the noonday traffic, taxis, buses that screechingly swerved. Past the Duke mansion, the Frick Museum, past the Pierre and the Plaza. *Capote, p. 70*

Every day on this corner, summer or winter, spring or fall, a small group of men meet. They have no steady employment, nothing they can speak of; they do, however, have the gift of gab. These man can talk, talk, and mo' talk, and when a bottle is going round and they're feeling "nice," they get philosophical. These men become the great thinkers of the world, with solutions to all its ills; like drugs, the homeless, and AIDS. *Lee and Jones, p. 12*

A distant street corner seen between two buildings. The traffic is very light at this hour, but a Sanitation Department truck moves through the intersection spraying water out behind it to cool the pavement and keep the dust down. Three little kids in bathing suits run behind the truck, playing in the water. *Hayes and Woolrich, p. 2*

Hasidim hurry up and down the street, holding their hats, stopping to confer with one another, taking care not to eyeball the women in miniskirts. *McInerney, Bright Lights, p. 68*

Empty cabs keep rolling past and you and Vicky continue to talk. *Ibid., p. 97*

While lighting a gargantuan joint, camcorder guy shoots out the huge expanse of French windows, the lens staring at a view of a leafless Union Square Park, at a truck with a massive Snapple logo driving by, limousines parked at a curb. *Ellis, Glamorama, p. 12*

Cabs lumber by silently, someone dressed exactly like me crosses the street, three beautiful girls pass by, each maybe sixteen and eyeing me, trailed by a thug with a camcorder, the muted, dissonant strains of Moby float from the open doors of the Crunch gym across the street where on the building above it a giant billboard advertises in huge black block letters the word TEMPURA. *Ibid., p. 107*

Lopate, *Waterfront*, p. 202

You take in the street by layers: this guy with the hat stepping too close to your shoulder; the storefront signs and window displays prompting impulse purchases; the stone-cut ornaments just above your head (cornices, cherubs, lions), and sometimes a whole second-story tier of retail or an upstairs restaurant; the wall posters on construction sites selling movies, politicians, rock stars; and, finally, the tops of buildings, for which the best touches are often saved: Babylonian roof gardens, green copper domes, medieval castle turrets, Mayan setbacks, Greek temples, and all manner of pointy needles symbolizing the heavenward aspirations of commerce.

Stevens and Swan, p. 119

By the mid-thirties the stores and entertainment palaces had long since closed, becoming empty-eyed witnesses to an earlier prosperity. When de Kooning moved in, the side streets were lined with graceless loft buildings that contained small factories and manufacturing spaces. Each was four or five stories high—sometimes as tall as eight—and without much enlivening decoration, careful proportion, or, indeed, any regaining architectural quality. The treeless streets, city canyons devoid of much light and space, were narrow. After dark, the area was deserted and grim. Few buildings were legitimate residences. Most were cold-water lofts, home to artists, dancers, and others.

Ibid.

Traces of an earlier era, before the lofts, could be seen in the rows of ornate, wrought-iron stoops that were never torn down.

Ibid., p. 420

In one night scene on the streets of New York, he depicted de Kooning as a haunted, brainy figure emerging from the abstract flicker of the city.

Binzen

Greenwich Avenue is dishing up some of the sexiest girls and gayest boys in town. The former gaze at the boutiques and the latter at each other, all with shameless rapaciousness.

Spillane, p. 290

The light changed and I saw my street coming up. I had to circle the block because it was a one way, then squeeze in between a decrepit delivery truck and a battered sedan. The number I wanted was a weather-beaten loft building, with an upholstery shop fronting on the street. On one side was a narrow entrance with a service elevator in the rear and a sign announcing the available vacancies hanging on the door.

Ibid., p. 189

New York had its sinkholes, too, and the number of this one placed it smack in the middle of the slime. It was a one-way street of rats' nests with the river at one end and a saloon on each corner, peopled with men and women that had the flat, vacant look of defeat stamped on their faces.

Ibid., p. 171

On one corner was a run-down candy store whose interior was obscured by flyspecked signs, but for all its dirt it served as a neighborhood hangout. In front of the paper stand were three young punks in sharp two-tone sports outfits making dirty cracks at the girls passing by. A husky blonde turned and slapped one across the jaw and got a boot in the tail for her trouble. This time she kept on going.

Ibid., p. 174

I wasn't going anywhere … just driving, taking it easy along the main stem, following anybody that was ahead of me. Somehow we got to the approach of the Manhattan Bridge and it was easier to go across than to cut out of traffic. This time I was behind a truck that led the way down Flatbush Avenue at a leisurely pace. Evidently he was in no hurry, because he didn't bother going through light changes and never jumped the reds. He set such a nice pace

I Street — Streetscape

that when he parked at Beverly Road for ten minutes I sat behind him and waited until he came back and followed him some more. The first thing I knew we had the lights of the city behind us and were skirting Floyd Bennett Field, and the air was carrying the salty tang of the ocean with it. We crossed the bridge then and he turned left, but I didn't follow. The winding macadam on the right led in the direction of the breezes and I took it to a gate and on into Rockaway Point.

Sanders, *Celluloid*, p. 406 The grid reproaches the flâneur.

Tallack The flâneur seemed out of place in a city growing so rapidly and reconstructing itself every ten years, as buildings within the grid were pulled down and replaced.

Trebay, p. 63 Who's going to write the history of the streets? And, anyway, what will it matter? Is there anyone around who can say, with calendar accuracy, when the solitary and quiet length of pavement and curb on which you walk every day became, let us say, a hooker's stroll?

Maffi, p. 13 The moment you decide to go in search of the city is fraught with difficulties. Magical, yes, but also very tricky, because it is precisely in that moment that you determine your relationship with it: where and how to begin.

Hapgood, pp. 216–17 I have contracted the habit of wandering. This great town, with its infinite modifications of nationality and external form, holds me in the afternoon and evening, when I am through work, in a vise. But, somehow, altho there is movement and life in plenty, there is nothing vivid, or exciting about it, nothing irritating as are one's own little affairs. Life is lived in big masses by the common people. The rhythm of life is low because it is big and important. That street moving with quiet energy is more peaceful than a country scene. It lulls like the perpetual breaking of waves. I start out on one of my long wanderings because I want diversion in my loneliness and usually end up with feeling that it is deep folly to desire diversion at all. The contented masses of humanity gently vibrating through the broad street flooded with warm and liquid light, make me hate my individuality, despise my intelligence and my ambitions, and minimize the importance of everything except the essentials of life.

Kasson, p. 61 Momentary disorientation, intimate exposure, physical contact with strangers, pratfalls, public humiliations—conditions that in other circumstances might have been excruciating—become richly entertaining.

McCourt, p. 7 Think about what happens to you during any two minutes spent walking on a city street—the flood of sensations, perceptions, and feelings that courses through you, most of them hardly deserving your attention. The multiplicity and density of detail is far greater than even the richest collection of verbalized thoughts or conversations with yourself that may have been going on at the same time. The process by which the world impinges on us at all times and the constantly shifting apprehension of our relation to it are too enormous for us to fully grasp.

Auster, *Glass*, p. 4 More than anything else, what he liked to do was walk. New York was a labyrinth of endless steps and no matter how far he walked, it always left him with the feeling of being lost. Each time he took a walk, he felt he was leaving himself behind. By giving himself up to the streets, by reducing himself to a seeing eye, he was able to escape thinking. All places became equal, and on his best walks, he was able to feel that he was nowhere. This was all he ever asked of things: to be nowhere. New York was the nowhere he had built around himself and he had no intention of ever leaving it again.

Miller, *Sexus*, pp. 535–7 Walk down any street in the soft violet light. Make the mind blank. A thousand sensations assault you at once from every direction. Here man is still furred and feathered; here cyst and quartz still speak. There are audible, voluble buildings with sheet-metal visors and windows that sweat; places of

J Flâneur

worship too, where the children drape themselves about the porticos like contortionists; rolling, ambulant streets where nothing stands still, nothing is fixed, nothing is comprehensible except through the eyes and mind of a dreamer. Hallucinating streets too, where suddenly all is silence, all is barren, a fevered temple, streets to die on and not a soul takes notice. Strange frangi-panic streets, in which attar of roses mingles with the acrid bite of leek and scallion. Slippered streets, which echo with the pat and slap of lazy feet. Streets out of Euclid, which can be explained only by logic and theorem.

A lyrical expectancy and openness, expressed through a mixture of the poetic and the factual. Amin and Thrift, p. 11

A man must make a great effort not to lose himself in the crowd, not to be overwhelmed by his amazement—an amazement in which there is neither transport nor joy. But if he succeeds in individualizing himself, he finds that these millions of fires produce a dismal, all-revealing light. Tho they hint at the possibility of beauty, they everywhere discover a dull, gloomy ugliness. Gorky, "Boredom," p. 311

On a mild October day, sunshine is said to be loitering in the cross-streets. The avenues won't even permit the light to dawdle. If it wants to be idle, it must do so around the corner. But the avenues can be won over if you stroll on them at leisure, rather than hurrying like the preoccupied men of business. Conrad, p. 196

Twice I had passed through it, but this was really my first visit to New York; and as I walked about that evening, I began to feel the dread power of the city; the crowds, the lights, the excitement, the gaiety, and all its subtler stimulating influences began to take effect upon me. My blood ran quicker and I felt that I was just beginning to live. To some natures this stimulant of life in a great city becomes a thing as binding and necessary as opium is to one addicted to the habit. It becomes their breath of life; they cannot exist outside of it; rather than be deprived of it they are content to suffer hunger, want, pain, and misery; they would not exchange even a ragged and wretched condition among the great crowd for any degree of comfort away from it. Johnson, *Autobiography*, pp. 86–7

Walking affirms, suspects, tries out, transgresses, respects, etc., the trajectories it "speaks." Jacks, p. 35

In the crowd he is sublimely reminded of his own paltriness and finitude, as against the annihilating infinitude of nature. Conrad, p. 84

The trialectics of being: historicality, sociality, and spatiality. Jacks, p. 34

Enter the reflexive walker who engages in a two-way encounter between mind and the city. Amin and Thrift, p. 10

The constant physical closeness of mutually anonymous strangers needing to deal with each other in daily life. Reinicke

When bored we took to our city with a Huysmans-like perversity. Jackson and Dunbar, p. 607

Commander Thomas J. Keane, sixty-five years old, hopes to complete next Sunday afternoon, if the weather is bright, a project he started a little less than four years ago—to walk every street, avenue, alley, square and court on Manhattan Island. Berger, *New York*, p. 116

He started at the island's tip, taking all the east-west streets. He has had to weave and backtrack a lot in the crooked lanes and alleys in the financial district and in Greenwich Village.

He worked the flanks of Central Park as solid east and west blocks—took them from Fifty-ninth to 110th and then resumed his river-to-river hikes north of that point. The going was roughest where the marginal motor highways block easy access to the rivers' brims.

All told, the commander has covered 3,022 city blocks, which add up to roughly 502 miles. After he had done all the side streets he took the avenues, working from east to west. He left Broadway for the last, because it is the only avenue that runs the island's full length.

The most curious things he saw were a goat farm, or stable, at 128th Street near the East River and the shacks on stilts on Harlem River around 223rd or 225th Street.

WPA Guide, p. 50 | The first man to walk the length of Manhattan backwards.

Jacks, p. 43 | Walking every street in the grid temporarily unearths an apparently comprehensive collection of memories in physical things.

Moscow, p. 105 | The only people ever to walk through the 8,500-foot Holland Tunnel for pleasure were members of the throngs (20,000 people) that attended the dedication ceremonies on November 12, 1927, at the Broome Street entrance plaza to Jersey City. After the speeches had ended and President Calvin Coolidge had pressed a button in the White House, thousands crowded into the tubes to make the first crossing of the Hudson River on foot; one enthusiast walked the tunnel—a mile and a half from portal to portal and at the time the longest underwater tunnel in the world—seven times before asking a tunnel policeman in Jersey City for directions to the nearest ferry.

Mayakovsky, *America*, p. 52 | From about six or seven, Broadway lights up—my very favorite street, the only one that capriciously and brazenly butts through streets and avenues as regular as prison bars. It's harder to get lost in New York than it is in Tulsa. From north to south run the avenues, and from east to west the streets. Fifth Avenue divides the city in half, between West and East. And that's all there is to it. I'm on Eighth Street, on the corner of Fifth Avenue. I want to get to the Fifty-third Street and Second Avenue corner. That means I have to go forty-five blocks, and turn right to the corner of Second.

Morris, *Manhattan '45*, p. 69 | To find the nearest street if you only have an Avenue address, drop the last digit of the building's number, divide it by two and add specified numerals—for 500 Fifth Avenue—for instance, you add 18 to 25 and discover that your destination stands near the corner of 43rd St.

Lopate, *Waterfront*, p. 202 | In Midtown Manhattan you walk as though on a conveyor belt, the grid pulling you along … you keep moving, you feel purposeful, wary, pointed, athletic. You can gauge your progress to an appointment by the rule of thumb that a block takes roughly a minute on foot.

Conrad, p. 196 | The avenues may be ladders of ascent, but the cross streets at right angles to them are exits to dalliance, resorts of indolence.

Morley, *New York*, p. 66 | I have often walked it at night, scanning the rectangles of lighted panes and wondering.

J Flâneur

134

Hunter the millionaire walks up Fifth Avenue at 4 a.m. from a nightclub on 53rd Street to his home on 71st and ponders as he goes his ancestral ownership of New York, marking "the mounting numbers, significant as names, of the marching streets." He receives the salutation of the reeling avenue.

Conrad, p. 195

After the party I walked around the city, beginning my farewells. The customary tinder lights beat up from the streets onto the low clouds overhead. On a sidewalk somewhere in the Eighties I saw a Cuban going through the steps of a rhumba, holding a baby in his arms. A dinner party in the Sixties was breaking up and men and women were standing in a lighted doorway calling good-by and good-night. In the Fifties I saw a scavenger pushing an enormous English perambulator—a carriage for a princess—from ash can to ash can.

Cheever, "Moving Out," p. 979

I know the deep night ballet and its seasons best from walking long after midnight to tend a baby and, sitting in the dark, seeing the shadows and hearing the sounds of the sidewalk. Mostly it is a sound like infinitely pattering snatches of party conversation and, about three in the morning, singing, very good singing. Sometimes there is a sharpness and anger or sad, sad weeping, or a flurry of search for a string of beads broken. One night a young man came roaring along bellowing terrible language at two girls whom he had apparently picked up and who were disappointing him.

Rorem, pp. 813–14

The men were passing, too, mostly young ones with faces that seemed to be made of pink wood, with a dry, monotonous expression, and jowls so wide and coarse they were hard to get used to … Well, maybe that was the kind of jowls their womenfolk wanted. The sexes seem to stay on different sides of the street. The women look only at the shopwindows, their whole attention was taken by the handbags, scarves, and little silk doodads, displayed very little at a time, but with precision and authority. You didn't see many old people in that crowd. Not many couples either. Nobody seemed to find it strange that I should sit on that bench for hours all by myself, watching the people pass. But all at once the policeman standing like an inkwell in the middle of the street seemed to suspect me of sinister intentions. I could tell.

Céline, p. 168

I liked to walk up Fifth Avenue and pick out romantic women from the crowd and imagine that in a few minutes I was going to enter into their lives, and no one would ever know or disapprove. Sometimes in my mind, I followed them to their apartments on the corners of hidden streets, and they turned and smiled back at me before they faded through a door into warm darkness.

Fitzgerald, *Gatsby*, p. 45

Daydreaming on a country road is one thing. Daydreaming on Fifth Avenue with hundreds of other people striding down the same sidewalk is quite another. But because we are so crowded here, active recognition of other people has become mostly a matter of choice. Even so, compliments, insults, banter, smiles and genuine conversations among strangers are part of the city's noise, its stimulus, its charm.

Hustvedt

I left the hotel and walked down Broadway. The pursuit of my type gave a pleasant savor of life and interest to the air I breathed. I was glad to be in a city so great, so complex and diversified … I strolled along with my heart expanding at the thought that I was a citizen of great Gotham, a sharer in its magnificence and pleasures, a partaker.

Henry, "Man About Town," p. 88

J Flâneur

Turner, *Backward*, p. 102	The endless feeling of one street leading to another, an ancient chain of physical communication.
Conrad, p. 302	The pedestrian soils the pavement as he walks; his eye likewise stains or fades what he looks at.
Ford, *America*, p. 80	I prefer New York with soiled pavements to other cities set upon floors like those of Heaven.
Dreiser, p. 3	Broadway at Forty-second Street, on those selfsame spring evenings when the city is crowded with an idle, sightseeing cloud of Westerners; when the doors of all shops are open, the windows of nearly all restaurants wide to the gaze of the idlest passer-by.
Dos Passos, p. 253	All these April nights combing the streets alone a Broadway skyscraper has obsessed him—a grooved building jutting up with uncountable bright windows falling onto him out of a scudding sky.
Keller, p. 298	As I walk up Broadway, the people that brush past me seem always hastening toward a destination they never reach. Their motions are eager, as if they said, "We are on our way, we shall arrive in a moment." They keep up the pace— they almost run. Each on his quest intent, in endless procession they pass, tragic, grotesque, gay, they all sweep onward like rain falling upon leaves. I wonder where they are going. I puzzle my brain; but the mystery is never solved. Will they at last come somewhere? Will anybody be waiting for them? The march never ceases. Their feet have worn the pavements unevenly. I wish I knew where they are going. Some are nonchalant, some walk with their eyes on the ground, others step lightly, as if they might fly if their wings were not bound by the multitude. A pale little woman is guiding the steps of a blind man. His great hand drags on her arm. Awkwardly he shortens his stride to her gait. He trips when the curb is uneven; his grip tightens on the arm of the woman. Where are they going?
	Like figures in a meaningless pageant, they pass. There are young girls laughing, loitering. They have beauty, youth, lovers. They look in the shop windows, they look at the huge winking signs; they jostle the crowds, their feet keep time to the music of their hearts. They must be going to a pleasant place. I think I should like to go where they are going.
Hapgood, p. 220	On Broadway I am not accustomed to find the "real thing." Judge of my delight, therefore, to find an atmosphere and an assemblage which were, in their way, the realest of the real. Here were men and women who combined qualities rarely found in conjunction on Broadway. They were not merely riotous. They were not really riotous at all, for they evidently didn't try to be. It was natural. And then they were all intelligent—and oh! word that covers a multitude of sins—artistic!
Conrad, p. 196	The streets shunt him along, and from his privileged platform he reviews the city as a performance staged to divert him.
Hapgood, p. 366	Flown were the real things. Flown was the world of expression.
Maffi, p. 20	Suspended in time and space, an interruption in the whirlwind of urban rhythms, an Arcadia carved out of the heart of the metropolis.
Turner, *Backward*, p. 102	The watching of streets: the old, chance meetings, the insecurity of being in an open place, of vulnerability.

] Flâneur

I started off from South Ferry one night upon a zigzag walk. Sleepless tramps were huddled in the seats in Battery Park; others were lying on the grass, flat and dazed as if they had fallen from balloons. There were hoots and howls from across the river, red lights and green lights, the hum-grum of machinery, and the strange electric-light cascade of moving elevated trains. 'Twas one by the clock. Syria slept. Greece slept.

I walked by Front Street to Moore Street, to Water Street, to Broad, to Pearl, to Coenties Slip, to Stone, to Mill Lane, to South William Street, to Broad again, past a blank empty lighted telegraph office, to Exchange Place, to New Street, to Wall Street. Thus I arrived at the financial anvil of the world. But all was still, no hammering, no bellows blowing, no flying sparks. Yellow stars looked down on the deserted Exchange. But I saw what appeared to be some Pagan temple, a stark altar of human sacrifice, and it proved to be a famous Christian Church, none other than Holy Trinity on Broadway, and as I stood by the strange little graveyard the church clock struck half past one. The little white headstones looked like the dead popping up from the tomb. There was heard the resounding hoot of a steamer on the river—yea, the last trump. Fast cars scooted along wet empty Broadway as if fleeing the wrath to come and all were going uptown.

Then I went on by Little Thames Street, and felt for a moment as if I were in part of the City of London. It also is deserted in the regions of Capel Court at that hour of the night. There are no nightshifts in stockbroking. You do not see a relief of stenographers being marched up Wall Street by a Managing Clerk; the stenographer's relief is prancing in the White Friars and Tangoland.

I was in Cedar Street and Greenwich Street, walking under the "El" like a rat, and came to Liberty Street—O Liberty, most empty was thy street—and to Washington above that sleeping Syria and sleeping Greece, and so, going by Cortland Street, I came to West Street and its great market. It was two o'clock, and New York here was very much alive.

There were horse waggons and motor waggons, cases and baskets of vegetables and fruit, and porters innumerable hurrying hither and thither with gleaming white-wood boxes on their shoulders. I emerged from the dead city where never a blade of grass twinkles before square toes and came into a fairyland of cucumbers and corn, cabbages and melons and Malaga grapes. Refreshing fruit odors invaded the nostrils.

Heaps of small black grapes looked in the dim light like exaggerated caviare. I kicked a peach as I walked along. What largesse in the night, peaches are like stones in the roadway! They tumbled from wooden troughs and buckets uncovered and overfilled. There were South Mountain oranges and California lemons. There were crates of greens stacked higher than men. There were cabinets of blackberries and raspberries. The nose whispered to the heart "Raspberries, raspberries" as it tasted the air. Colored porters with perspiring gleaming faces shouldered boxes of green varnish-surfaced peppers along narrow alley ways between piles of other boxes. Carrots peeped out of their ventilated crates like brown ribbons. Side streets were blocked with potatoes and yams. Activity, activity, activity—and quietude. The workers do not help themselves along with foul expletives and abuse as in London. They seem to be conserving their energy, or imitating the electric lamps which do their job and say nothing about it. But it is a big market, bigger than Covent Garden in London, and I reflected that New Yorkers eat more fruit and vegetables than we do. There is more for them to eat. Their reserves are greater.

The quayside beyond the market is long and spacious and empty. The freer air seems to be minus something—is it the mental ozone of New York? West Street is a long backyard. It has no mechanical turnings on the left. If

you wish to take a turning on the left, the way of the heart, you must take a ship. There are ships in the wharves still as birds dozing head on wing in a covert at night. Not a rustle nor a whisper comes from the giant Cunarder. West Street is the landing stage of the Atlantic ferry. You stand on West Street and you think Southampton. You stand in West Street and you think Havana, San Juan, Cristobal, Panama, Valparaiso. You stand on West Street and think Cherbourg, Naples, the Piraeus. But now no one is thinking anything. The gangways may be down, but no one is on them. Eastward New York's luminosity lies in layers like masonry of light and darkness built from the rocks to the night-sky. Westward lies the beautiful river flowing away to the calm ocean. And on the wide roadway of the quay laden lorries rush and crash bearing produce to the market or away.

I sought a turning on the left and did not find one till Fourteenth Street. It was a lonely walk. A drunken man sitting on a bit of paving addressed me vaguely. He was looking at the heavens with lackluster eye.

"There's only one star left. How far's that from here?" he queried.

I passed an empty "Goulash Kitchen," passed standing freight cars, passed the embarkation for Tampa and Mobile, passed the Boston and Providence pier, passed the R.M.S.P., passed the Hoboken Ferry and entered the Gansevoort market stirring feebly. A black and white cat was squatting in the roadway fastidiously eating melon.

My turning to the left proved to be the virtual one of Eleventh Avenue where it starts North near West Fourteenth Street, and there, like a derelict trolley car left stranded on the ooze after the subsidence of a flood, was a windowed shed with the explicit word LUNCH printed on it. This was kept by a lonely Greek.

"Where do you come from?" I asked, perched on my revolving stool at the counter and munching pie.

"Island," he answered.

"What? From Ireland? You don't look it."

"No. Island. Crete. Greek, yes."

"Fine country."

"No. Some nations go up. Some nations go down. The great Alexander thousand year ago take whole world. Then Venetians come. Before Jesus. Romans. Yes, the French. Napoleon. Germans. Now English, I guess."

"Not Americans?"

"No, English now. But in two hundred year maybe England go down. Other nation rise up."

"How d'ye like New York?"

"Not like it. Bad place here. Kill you for a dime. Want woman; cost ten dollars. Take her hotel two more. Drinks bad poison. Good drink cost big money. Not like New York."

A friend from the island of Rhodes rolled in for his morning coffee on his way to work at the National Biscuit Factory. "Rhodes no good. Italians there. They turn out Greeks. New York fine. Plenty money. Rodos bad."

I said Good Morning and Good-bye, and walked out on to Fourteenth Street, turned into Tenth Avenue and then into West Fifteenth Street where the "fleet" of the Biscuit Company was waiting in the dark like a string of camels before dawn on the outskirts of Baghdad.

Biscuits are not made all night. They are evidently partly compounded of daylight. But here was where my friend from Rhodes belonged, or in local parlance here the islander "held down his jahb."

Ninth Avenue was drear. Orion up above the roofs was striding hastily across Sixteenth Street. On Eighth Avenue a big fruiterer's stood wide open, very still and empty. What zest for trade!

West Seventeenth Street, Seventh Avenue, West Eighteenth, Sixth Avenue, West Nineteenth, passed as one. I was thinking of London and did not notice them. At Fifth Avenue I paused, for the speedway had had its nightly wash and was all aswill with water like a bathhouse floor.

I zigzagged across to Lexington and saw an iceman dragging blocks of ice into a large clean-swept and ready but empty cafeteria.

On Twenty-third Street I stopped at a shop window which was stacked with dollar shirts. A tall notice said "FORCED TO SELL." The shop was closed but it was flooded with electric light. I saw many offices and barber shops where the lights had been left on all night. And on Twenty-ninth Street I paused in front of a locked undertaker's where a white-lined baby's coffin was exposed, charmingly illuminated.

On Avenue A, the ashpan of the other avenues, there were notices which struck an Englishman as strange. The words TRANSIENTS met my eye. We advertise "Short Garage" but New Yorkers talk of "Transients." What poetry there is in the word! In some streets all other lighted signs have been put out and the one word remains brilliantly enshrined, now here, now there, "Transients!" "Transients!"

After all, every one in the great caravanserai of New York is a transient. Every one in the caravanserai of the world is a transient. The world itself is a transient. Look up among the stars; you will see it as a celestial sky sign. There it is pricked out all over the dark deep of space—TRANSIENTS.

I am a transient in the city of New York at night. I am gyrating across the fitfully sleeping city from the Hudson to the East River. No other great city can be got across so quickly. One could run across it in less than half an hour. I was soon out at the water edge on the other side of the island, listening to the ceaseless Edison works. Oh, what is Edison contriving there, are they engines of death or of life? The wonder name of Edison stirs the imagination as if he were an arch wizard, the Michael Scott of the New World. The river of Time flows by and the great works climb upward on its banks.

It is five a.m. Something of the burden of the city has been lifted. The air is light. The heart seems freed. I feel happy to be walking. I love the space and the quietness. I have got rid of the idea of going to bed, got rid of the routine of daily life. New York and its millions, its wealth, its mysteries, are mine. There is a sense of conquest. The bustle has died down and I am still walking. The majority of people are asleep—but I am not the least sleepy. It seems as if life has just begun. I am dancing on a springed floor. The stones of the side-walks help me to leap along First Avenue, grim, empty, gloomy Avenue One, which has no turning to the right except little bottle-neck lanes which go down to the edge of the water of the East River.

I spent many nights in this way wandering about the city and returning at dawn, resuming next night at the point where I had left off the night before.

Whoever would know the poetry of New York must walk it in the after-midnight hours, see the red light come out on the Metropolitan tower preliminary to the striking of the hour; one is too pre-occupied and diverted to observe it in the livelier hours; enter the Central station at four a.m. and see it anew, deserted, silent, beautiful as on the morning of Opening Day; see the City Hall at dawn hanging down from on high like the sky's apron.

Queensboro Bridge, seen from the foot of East Fifty-third Street late at night, is a marvelous spectacle. There is light in the sky above and wandering light on the river below. There is all the grandeur which circumambient shade can give. "What have I come to?" you ask, astonished after the sordidness of the Avenue, with its many garbage cans. Suddenly you see a mirage. It is called Queensboro Bridge. It takes the mind to the finest parts of the Seine and the Thames. You feel you must be at the center of a great city, near its Parliament, its palaces, its pontifical grandeurs. But this is Rome without a

Pope—a mere bridge, beautiful and awe-inspiring by accident, a convenience whose formal magnificence goes unheeded in the daytime, when business absorbs all the interest and takes the first and only place in men's eyes.

Still as I walk on I find the influence of the bridge expressed in men's habitations. As I approach the great viaduct of the bridge the poor district smartens up dramatically. The massive piles of the viaduct and the lofty exaggerated attendant factory chimneys, the vague Colossus of a gas works, all suggest more spacious living, and Sutton Place is the reply.

But I descend rapidly a long straight empty street nameless here for evermore, and it becomes Avenue A—the old ashpan once again. People of no social prominence are herded in grim unremarkable blocks. Fire ladders disfigure the houses, or do they merely hide them like black veils, the ravaged faces of elderly ladies. Perhaps the houses look worse than a similar variety in London. But imagine Bow and Whitechapel all festooned with rusty fire ladders! There is something queer about these ladders. They look like the old black ladders of tramp steamers let down to the wharves. The immigrant never gets away from the debarkation gangway. All New York is a quay. I see all the vessels that have arrived there—then the population swarming on the streets are all people who have come off ships.

But it is the most extraordinary shore in the world. It is well to have arrived there sometime or other on life's voyage.

Solitary walking along the empty streets seems to attune the mind to the city. True thoughts flow like music from the mind. I came to another outside street happily named Exterior Street. It has a Venetian view of river, lights, ferries, and small boats. Away beyond the river the sparse lights of Welfare Island diamond the dark. On the right is the grandeur of the bridge. But Exterior Street is below New York. It is bounded by the great grey cliff of the original Manhattan Island. Somewhere up above there are houses and gardens. Children perhaps come and drop pebbles down into Exterior Street or on to the shaggy tufts of old grass. It is like a bit of mountain road. There are hunks of uncontrolled rock. The shoulder of the world juts out. The silence is only accented by the rustling of the wind. No, there is another sound which is part of the silence, it is the undying whirr of rotary machines. I am walking towards a huge factory and from its little doors strange dwarfs with darkened faces come out, look round, and go in again—the workers, they don't belong. I sit on the grass under the cliff and look over the water. It is Exterior Street: I am outside New York.

To understand any experience you must get outside of it.

King Canute went to Exterior Street and bade the waves keep away from his toes. The gentry from Park Avenue and Upper Fifth might well make a pilgrimage to Exterior Street at four in the morning and sit there in the grass, outside the scene of their wealth and their power.

I left this curious street by smart residential East Seventy-ninth, thence by East End Avenue to East Eightieth. I had been outside; soon I was very much inside. I came to a steaming curtained window, lighted and murmurous. The one word STUBE was explanatory. I went inside and asked for cider. This seemed to amuse the bar-tender who, however, poured out two mugs of it at once and set them before me. There was a big notice on one of the walls, NO GAMBLING, and under it a vociferous throng were throwing scarlet dice.

"Splitz!" "Splitz!"—every one at the bar was asking for "Splitz."

I was invited to join the "Wilhelm Union." No one spoke a word of English. Mine host kept saying something about *zwei kasen Scotch verkauft*. I had a glass of whisky with a red-faced and puffing, very drunken man who showed me an iron cross and very paradoxically wanted to kiss me. I pointed to the only girl in the establishment, sitting sulkily in a corner. He took me over to a poster depicting the American Unknown Soldier which was

inscribed—"Work for the Living," and he nodded his head sententiously. A fig for unknown soldiers; all German soldiers were unknown. At least, so I surmised.

In this tavern ended another night and when next I resumed I quickly reached luxuriant, spacious, Southern-looking Fifth Avenue, the Avenue, as it is affectionately called. Curious fact about the avenues—the word avenue means approach; in England avenues are usually bordered with trees; in order to make a road into an avenue you plant trees. An avenue's trees are its guard of honor leading to the portals of country house, castle, or palace. But the avenues of New York do not lead anywhere. They are paved rivers which go on and on through various districts to lose themselves eventually in wildernesses, to be dried up in social deserts. But Fifth Avenue for one hundred and ten streets does preserve its character of grandeur, and it is one of the most exhilarating ways to walk in any city.

With Central Park on one side and fine houses on the other, I walked twenty blocks, the Harlem moon standing over the street and raising gleaming reflections all the way. Moonlight also glinted from the highly polished varnish of fast moving automobiles. No one was walking except myself, and many men and women passed in cars and taxis, mostly lovers indulgently petting one another in course of transit from one night-club to another, or from a dance to their homes.

I turned with the park railings along Hundred-and-Tenth Street and came to the gay base of Lenox Avenue, then went in a circle through the Morningside district back to Fifth Avenue. I came to Harlem all aflare with the lure of pleasure—cabarets, night-clubs, dance-halls, chop-suey restaurants, parlors. At three in the morning I watched a bevy of colored girls operating a barber shop, cutting the fuzzy hair of Harlem dandies in a brilliantly lighted hairdressing saloon. I strayed into Capitol Club and saw white women dreamily trotting with Negroes in slow jazz, strange women who defy the custom of night to enjoy the sensual thrill of the black man's dance.

By the cross-streets I passed through Africa. Street after street was entirely black, housing swarms of families, all black. Banjoes still throbbed in some; the ukuleles gurgled dance music, but most houses were silent. They were sleeping and snoring. They were bathed in the deep physical ardor of Negro sleep—only in doorways here and there petting couples lingered awake, oblivious of the clock.

I left Harlem by Edgecombe Avenue and St. Nicholas Avenue, the road dug up and dotted with red lanterns, and came to a substantial quiet and English-looking neighborhood, Hamilton Terrace, 144th Street and Convent Avenue, very respectable.

But respectability only held a strip, and having crossed it I was in Amsterdam Avenue. Then I came to Broadway still very much Broadway and, making a sharp descent by 147th Street, came once more to the end of New York—the grandest backway of all—Riverside Drive. The view was very beautiful. I could imagine that the Hudson River was the Danube and that I was in Bratislava again. The esplanade was high, serene, and wind-blown, fresh with raindrops flickering across the eyes. Little boats, like sleeping ducks, lay upon the surface of the water. The automobiles which whirled along the drive seemed unreal; the river is the great reality. It is on view here. It knows it was before all the rest and will survive it, with thousands of years both before and after.

A ferry boat crosses the river like a tram on the sea—transients once more, transients. Three shooting stars follow and pass over New Jersey—transients, transients. All is transient. New York is a setting for a drama that is being played, a spectacle which is being rehearsed. At four in the morning I am

walking along like the Wandering Jew, but my taste is shared by two lovers in a solemn closed car drawn up overlooking the river. Through the misty glass I see them in one another's arms, in close embrace.

Through silver-tinted clouds the moon seems to beat her way, keeping coming out, keeping going in, and as I climb Washington Heights I seem to be making another exit from the city, upward to the stars. All the way from South Ferry to the sky—I have skated the stairways of the city. I have gone from outside to inside, by Exterior Street to the heart. The mystic closes his eyes that he may see better. The curtain which comes down gives leisure to the mind to consider the hidden springs of drama. Night reveals the day.

Johnson, *Black Manhattan*, p. 163

Strolling is almost a lost art in New York; at least, in the manner in which it is so generally practiced in Harlem. Strolling in Harlem does not mean merely walking along Lenox or upper Seventh Avenue or One Hundred and Thirty-fifth Street; it means that those streets are places for socializing. One puts on one's best clothes and fares forth to pass the time pleasantly with the friends and acquaintances and, most important of all, the strangers he is sure of meeting. One saunters along, he hails this one, exchanges a word or two with that one, stops for a short chat with the other one. He comes up to a laughing, chattering group, in which he may have only one friend or acquaintance, but that gives him the privilege of joining in. He does join in and takes part in the joking, the small talk and gossip, and makes new acquaintances. He passes on and arrives in front of one of the theatres, studies the bill for a while, undecided about going in. He finally moves on a few steps farther and joins another group and is introduced to two or three pretty girls who have just come to Harlem, perhaps only for a visit; and finds a reason to be glad that he postponed going into the theatre. The hours of a summer evening run by rapidly. This is not simply going out for a walk; it is more like going out for adventure.

LeSueur, p. 15

Map in hand, walking fifty, sixty blocks a day that first heart-pounding week, resorting to the subway only to get to far-flung parts of Manhattan, I eagerly surveyed the reaches of the island I'd so long ago decided would one day be my home. Yet the place I'd envisioned paled beside the reality—an understandable reaction for me to have, since all I ever knew, all I could compare the city of my dreams with, were dismal suburban sprawls where nobody walks because there's nothing to see, where there is no spring, summer, fall, or winter, only unchanging days of humdrum sunshine that lull you into thinking comfort is all that matters in life. Small wonder I was agog over what I instantly recognized as the cosmopolitan atmosphere of a true city, whose want of any hint of provincialism thrilled me to the quick and whose awesome scale, ceaseless roar, and pounding tempo at once stunned, stirred, and seduced me. God, how the place bustled with people and activity! And it was now my home, it was where I should live.

Van Vechten, p. 242

Feeling a little cool, for the heat of the season was not yet excessive, he rose to stroll once more, now towards Fifty-ninth Street where over the tops of the greening trees myriad towers rose against the sky, creating an amazing spectacle which confirmed his desire to go somewhere, were it only for the pleasure of coming back to New York, a pleasure of which he never seemed to tire. Then the cock on the Heckscher Building reminded him of the storks of Strassbourg and Strassbourg reminded him of Germany.

Conrad, pp. 303–4

Rauschenberg: a flâneur who becomes a bricoleur. The bricoleur is Crusoe on his island. He is also Rauschenberg in New York, scavenging on the beaches of Staten Island and among the downtown gutters and the junk shops of

Canal Street for the urban jetsam which is to be the raw material of his art. The artist's compact with the city requires him to behave as if, like Crusoe, he were the first and only man there. He must adapt to its random order by limiting his range of choices.

Rauschenberg had a rule, when on the lookout for objects to make art from, that he'd go once around the block in quest of them. If that didn't yield enough, he could go one further block in any direction; then no more.

Ibid., p. 304

On his forays Rauschenberg picked up ventilation ducts, bicycle wheels, rubber tires, packing cases, cardboard, corrugated paper, and a stuffed angora goat.

Ibid.

Rauschenberg takes a snippet of the Manhattan telephone directory, recesses it, frames it in an expanse of paisley shawl, and renames it "Hymnal."

Ibid., pp. 304–5

Getting out of the labyrinthine West Village is easy only for those who know the neighborhood. Turning from one alleyway into another, I wandered around in search of a familiar thoroughfare and could not find either Sixth or Seventh Avenue, both of which were somewhere quite close by.

Lobas, p. 50

The streets as a place of danger: a place of crime, of confusion, movement, speed, noise, many fleeting images confront the walker of the streets. A place where anything can happen.

Turner, *Backward*, p. 101

There is a sleepy, melancholy charm for the wanderer, stranger or native, among these hangovers of a bygone day, especially on weekends when they are silent, barred and shuttered, staring with dust-covered, bleary panes on the narrow thoroughfares.

Berger, *New York*, pp. 279–80

automatons and somnambulists

Roche, p. 404

By this time the 3,126 electric lights on the Rialto were alight. People passed, but they held me not ... Diners, heimgangers, shop-girls, confidence men, panhandlers, actors, highwaymen, millionaires, and outlanders hurried, skipped, strolled, sneaked, swaggered, and scurried by me; but I took no note of them. I knew them all; I had read their hearts; they had served.

Henry, *Complete*, p. 83

There is a type of "Man About Town" in New York ... The term is quite familiar to me, but I don't think I was ever called upon to define the character before. It would be difficult to point out an exact specimen. I would say, offhand, that it is a man who had a hopeless case of the peculiar New York disease of wanting to see and know. At 6 o'clock each day life begins with him. He follows rigidly the conventions of dress and manners; but in the business of poking his nose into places where he does not belong he could give pointers to a civet cat or a jackdaw ... He is always on the scent of something new. He is curiosity, impudence and omnipresence. Hansoms were made for him, and gold-banded cigars; and the curse of music at dinner. There are not so many of him; but his minority report is adopted everywhere.

Ibid., pp. 85–6

He haunts the department stores, he does not buy. He consumes the city at one remove, savoring the display without expenditure, financial or emotional. All the women in the street belong to his personal harem. He need not choose, and he need not pay. Of course, he *could* choose and he *could* pay. This illusion of disinterest, of disinvolvement with the commercial, can only be indulged by men "of leisure and wit."

Tester, p. 28

Ibid., p. 31	The *flâneur*—once a full-time job—today is merely a pleasurable suspension of social claims, a temporary state of irresponsibility.
Ibid., p. 149	The street level is a dead space … It is only a means of passage to the interior.
O'Hara, p. 257	Tonight you probably walked over here from Bethune Street down Greenwich Avenue with its sneaky little bars and the Women's Detention House, across 8th Street, by the acres of books and pillows and shoes and illuminating lampshades, past Cooper Union where we heard the piece by Mortie Feldman with "The Stars and Stripes Forever" in it and the Sagamore's terrific "coffee and, Andy," meaning "with a cheese Danish"— did you spit on your index fingers and rub the CEDAR'S neon circle for luck? did you give a kind thought, hurrying, to Alger Hiss?
Brainard	I remember Delancey Street. The Brooklyn Bridge. Orchard Street. The Staten Island Ferry. And walking around the Wall Street area late at night. (No people.)
Schulyer, p. 693	I've been living at Broadway and West 74th for a week and still haven't ventured on a stroll in Central Park, two bizarre blocks away.
Conrad, p. 196	Since the street is ambling along at your bidding, you are free to sidle off it at any point.
Hapgood, p. 365	At midnight I turned up at the place. I had been, earlier in the evening, wandering on the Bowery, where I had been looking for "real things."
Bennett, *Deconstructing*, p. 72	Always at night he walked the streets alone, always the horn in his ears.
Conrad, pp. 137–8	On his nocturnal rambles, the street seems to be murmurously snoring, like the horse in the dormitory of buses; but it's only a drill at work early—the travail of a mechanical and therefore enviably immortal body.
Turner, "Red Friday," p. 18	I went out, shaken, and I wandered, dazed, often muttering to myself, once or twice even overturning children as I strode throughout those horrid crowded, superheated streets. Finally, when I cared to look, I found myself on the far East Side, well toward the East River, and I was compelled to turn back and retrace steps to the Bowery and the Third Avenue Elevated in that intense heat. I was all but exhausted when I reached it, and though I cooled my scarlet face and reduced my throbbing pulse beats somewhat in the breeze of my transit uptown, yet when I finally reached my quarters I was almost prostrated. A raging headache held me, with a not unnatural fear of heat exhaustion. Try as I would, I could neither think nor act. There was but one thing for me to do: I took to my bed, and finally sleep intervened upon my physical misery. It was night before I awoke again, and leaned out my window to see a city asleep—or struggling to sleep in the heat. I went back and, falling heavily on my disheveled bed, passed once more into a half stupor.

Off we reeled into the night streets. It was a difficult journey because the streets kept moving under our feet.

Hamilton, p. 7

Feet of passers-by become epileptic.

Jolas, p. 472

Walking around absentmindedly.

Maffi, p. 19

City of orgies, walks and joys.

Turner, *Backward*, p. 119

I have long been convinced of the unattractiveness and disagreeableness of people. I have noticed how they always turn the sharp side of their shoulders toward you when you pass them in a crowd. I have noticed how two or three walking together remain steadfastly side by side in spite of the narrowness of the pavement and the fact that some persons are going in the opposite direction.

Hapgood, p. 192

Three men wearing hats walk by, two toward our left, one the other way. In this chance cluster, a leg that stretches down to the bottom right is obscured at the knee, which makes us uncertain as to the direction it is going, let alone to whom it belongs. A view of his foot would be enlightening, but it is withheld.

Kozloff

I know two or three men of education who whenever they want to have a good "temperamental" time, go out at night alone, and wander for hours about the lowliest streets in the city. They go in search of anybody whose face shows that he has been subjected good and hard to what Henry James calls the "irregular rhythm of life" ... In these tours through the side streets there is not only temperamental satisfaction to be derived but also undoubted material for literature.

Hapgood, pp. 23–4

Linking chewing gum to the rhythm of the city—it's rather like humming, something that is particularly suited to walking the streets.

Turner, *Backward*, p. 103

Then there's time in the street, when you run into somebody you haven't seen in, say, five years, and you play it all one level. When you see each other and you don't even lose a beat, that's when it's the best. You don't say "What have you been doing?"—you don't try to catch up. Maybe you mention that you're on your way to 8th Street to get a frozen custard and maybe they mention which movie they're on their way to see, but that's it. Just a casual check-in. Very light, cool, off-hand, very American. Nobody's fazed, nobody's thrown out of time, nobody gets hysterical, nobody loses a beat. That's when it's good. And when somebody asks you whatever happened to so-and-so you just say, "Yes, I saw him having a malted on 53rd Street." Just play it all on one level, like everything was yesterday.

Warhol, *Philosophy*, p. 111

All modern metropolitan persons who compete in our fierce struggle are hypocrites when they pretend to enjoy anything. The nearest we can come to enjoyment is to see what we miss. When I look now at the mob passing along the avenue they mean nothing to me. The mood has passed.

Hapgood, p. 219

and for Mike I just stroll into the PARK LANE
Liquor Store and ask for a bottle of Strega and
then I go back where I came from to 6th Avenue
and the tobacconist in the Ziegfeld Theatre and
casually ask for a carton of Gauloises and a carton
of Picayunes, and a NEW YORK POST with her face on it

O'Hara, p. 325

J Flâneur

James, pp. 83–4

The weather, for all that experience, mixes intimately with the fullness of my impression; speaking not least, for instance, of the way "the state of the streets" and the assault of the turbid air seemed all one with the look, the tramp, the whole quality and *allure*, the consummate monotonous commonness, of the pushing male crowd, moving in its dense mass—with the confusion carried to chaos for any intelligence, any perception; a welter of objects and sounds in which relief, detachment, dignity, meaning, perished utterly and lost all rights. It appeared, the muddy medium, all one with every other element and note as well, all the signs of the heaped industrial battle-field, all the sounds and silences, grim, pushing, trudging silences too, of the universal will to move—to move, move, move, as an end in itself, an appetite at any price.

Girdner, p. 121

The walls of the high buildings which line the streets effectually limit the field of vision. The only opportunity for using the eyes for distant vision is to look up at the sky.

Ford, *America*, p. 180

For it was a couple or so of days afterwards when walking along the opposite side of the Avenue between Twenty-Second and Twenty-Third that looking across at the Flatiron and remembering something that had been said on that particular walk there came into my head a sudden, half-philosophical, half-literary idea that has ever since formed the chief basis of my technical stock in trade and the mainspring of my actions.

It would be superfluously biographical at this point to dilate on that idea. It is sufficient to say that very early on an October morning of strong damp shadows, looking across at the almost forbidding, dumb, purplish column of the Flatiron whose side towards me was in the deepest shade and feeling at the moment a mood of intense loneliness, I suddenly conjured up on that then deserted opposite sidewalk the figure of the companion who the day before or so had been walking with me at the foot of that same Flatiron that now seemed a barrier of gloom between myself and a desirable sunlight. And it occurred to me to think how the imagination of that figure made the Flatiron suddenly alive for me whether as an architectural mass or as a figurative barrier between myself and the sun.

Sanders, p. 400

But he isn't staying. "I've been in New York four days," he says, "and I'm lost already."

Amin and Thrift, p. 11

The gifted meditative walker, purposefully lost in the city's daily rhythms and material juxtapositions.

Maffi, p. 13

Walter Benjamin once wrote that we need to learn how to get lost in the city as in the forest. But, as in the forest, it is also nice to learn how to find ourselves, how to find the paths and trails across the city.

Ibid., p. 22

At this point, you really *can* get lost in the city.

Ibid., pp. 18–19

Where getting lost is child's play, where the roads become anonymous, directions are almost nonexistent, the small gardens become a mirage, and the mighty buildings (colonnades, roof gardens, spires, entablatures, streets) explode with architecture that seem Assyro-Babylonian, removed from any time or space, or like a dreamlike distillation of the subconscious.

Ibid., p. 107

I will tell you
how to get there:
walk 3 blocks down

& 8 blocks across
& 4 blocks backwards
& 7 blocks around
& 6 blocks up
& 9 blocks down
& 5 blocks across
& 1 block backwards
& 2 blocks sideways
& 3 blocks wherever
& you will get there
sooner or later

Hordes of people bustle all about you, and once again it feels like you are back in a village in the metropolis. Perhaps you are stuck on the corner, unsure of where to go next. *Ibid.*, p. 57

The invisible web of laws that guides people's behavior. Inam, p. 21

Central Park and Fifth Avenue are crowded with people who do not wish to hurry. They walk in the shade. Talese, p. 42

Lovecraft lived in that paradisiacal age of the pedestrian, which lay somewhere between the decline of the horse in large cities and the pestilence of mass car ownership. Haden, p. 9

In the 1920s cars were not dominant over pedestrians in the city, especially during the evenings and night. *Ibid.*, p. 55

The sight of a horse had become rare by the late 1920s. *Ibid.*, p. 57

As Lovecraft threaded his way through a maze of tenuous and delicate mental impressions, in the night shadows and dawn glimmerings of New York City he found a new dream-city that could function simultaneously as an inspirational fever-dream, as a text, as an antiquarian reliquary, and as a sort of psychic comforter to aid him in his battle against the mundane and horrifyingly noisy reality of its daylight hours. *Ibid.*, p. 9

Lovecraft and his circle spent several years, on and off, exploring the city by night, and from these experiences he shaped and sold the thrill of unspeakable fears and nightmares. His walking was not in the rural "tromping" style, or that of the rambling clubs then newly in vogue. Rather it was walking of fits and starts, of zig-zags and jumps, of adventuresome following of intuition, of stopping to see, hear, and consider, to fondle the past and also any passing kitty-kat that might come with range. *Ibid.*, p. 11

He and his friends delved into the slums, the ancient wharfs and graveyards, the neglected back courtyards, the crumbling churches and graveyards, the eerie wharfs, the winding alleys, plumbing the depths of the rapidly-widening civilization chasm opening between the hoary past and the brash new modernity. Out of this chasm he dredged the elements of what would, in time, establish his own weirdly dark and now seemingly eternal empire of the fantastic. *Ibid.*, pp. 11–12

Lovecraft found walking useful for working up a mood suitable for creation, and the plot for the famous "The Call of Cthulhu" was written directly after a marathon all-night walking session in the city. *Ibid.*, p. 12

Ibid., pp. 12–14

Lovecraft's expeditions into the night of New York City were near-contemporaneous with the more well-known night walks of the Surrealists in Paris. In a city just a few years away from the brink of a new car-borne hostility to the pedestrian, his walking, Lovecraft's cross-cutting of histories, his seeking out of little known routes, his stopping to look up at the buildings instead of into shop windows, his stepping back into the street for a better view—all these acts can be seen as implicit varieties of subversion of the "normal" commercial experience of the modern city. His actual techniques, and those of his companions, interestingly anticipated some of those used in the walks of the Situationists in the 1950s and early 1960s. His antiquarianism and attention to the old vernacular of the streets, and to the layered and confused pasts of the city edge-lands, has many parallels with the "London turn" in the modern psychogeography of the 1990s and 2000s. He was not simply being "a tourist" or some fogeyish daytime architectural train-spotter. Like the classic Paris flâneur, Lovecraft perceived modernity well enough—he marveled at its flow of seductive images when done well, enjoyed its childishly garish ice-cream parlors, ate at the coffee shops and the automats (all-night self-service cafes), went on the amusements at Coney Island, and visited its vast new cinemas and theatres. To illuminate this, Christopher Morley usefully gives a vivid glimpse of the New York streetscape in 1935 with modernity crowding in, seemingly from the edges:

"Walking on crowded city streets at night, watching the lighted windows, delicatessen shops, peanut carts, bakeries, fish stalls, free lunch counters piled with crackers and saloon cheese, and minor poets struggling home with the Saturday night marketing […] the great symbols of our hodgepodge democracy: ice cream soda, electrical sky-signs … "

But in turning his back on the modern and on the legendary American "compulsory cheerfulness," he became for a moment something that now seems a crucial addendum to New York's literary history—a conscious "anti-collector" collecting impressions of overlooked places rather than objects, righting wrongs being done upon the city by modernity through a kind of psychic collection and excavation of dark places, seeking out the obverse of modernity and making it into highly subjective fictional detours that nevertheless rested very much on his experiences in real places …

" … hidden in cryptical recesses which no street, lane, or passageway connects with the Manhattan of today!"

In short order he succeeded in powerfully reimagining city as haunted by its suppressed "other," the hoary and hidden past. He did not so much "re-enchant places"—as the Romantics had tried to do, and the neo-Romantics in Britain were then still trying to do—as to "re-nightmare" them. He succeeded in doing this, not for any one place in the city, but for the whole of New York City.

Ibid., p. 14

He also engaged in the typical bohemian modus operandi of "anti-consumption," happiest with the idea of the city as garden and as museum, as basically free and pleasurable—the free pleasures of the parks, pet shops, the public libraries and museums, the art galleries, street cats, even the joy of lingering in a café over a cheap coffee in the small hours so as to be able to read the free morning-edition papers, and talking with like-minded friends on long night walks. Such free pleasures are, of course, one of the rights and prerogatives of the talented artist. If society refuses to pay now for what it will value only after one's death, then one is perfectly entitled to sponge upon it mercilessly. Lovecraft did just that, becoming a lifelong expert at getting a free ride and then walking away leaving everyone smiling.

J Flâneur

Lovecraft's extreme sensitivity to the cold meant that walking was, with a few notable exceptions, a passion only enthusiastically undertaken in pleasant weather.

Ibid., p. 15

What awesome images are suggested by the existence of such secret cities within cities! … The active imagination conjures up endless weird possibilities … having seen this thing, one cannot look at an ordinary crowded street without wondering what surviving marvels may lurk unsuspecting beneath the prim and monotonous blocks.
 It is a mistake to fancy that horror is associated inextricably with darkness, silence, and solitude. I found it in the glare of mid-afternoon, in the clangour of a metropolis.

Lovecraft, "Cool Air"

I walked slowly southward by the light of a waning misty moon […] amongst the curious houses, imagination-kindling streets, & innumerable kitty-cats … Long all-night solo walk of early August 1925.

Haden, p. 15

Lovecraft: "I always have a supply of catnip on hand."

Ibid.

Lovecraft is exploring without map and guide as early as August 1924. At the end of September 1925 he spends several days and evenings without a map, exploring the furthest outer suburbs and boundaries of New York. "I had no map, & knew nothing of the country—trusting to chance with a very agreeable sense of adventure into the unknown."

Joshi and Schultz, p. 210

I didn't buy a map; that would have spoilt it, somehow; to see everything plotted out, and named, and measured. What I wanted was to feel that I was going where nobody had been before.

Machen, *Megapack*, p. 72

If these ancient spots were fascinating in the busy hours of twilight, fancy their utter and poignant charm in the sinister hours before dawn, when only cats, criminals, astronomers, and poetic antiquarians roam the waking world! … truly we had cast the modern and visible world aside … the fever of the explorer was upon us.

Joshi and Schultz, pp. 65–6

Lovecraft adored cats and made almost a game of his very serious attempts to encounter as many street and garden cats as possible on his walks. There were then a great many cats to encounter, as his good friend Loveman commented, "One of the quaintest features of all colonial New York is the number of cats seen at large … "

Ibid., p. 74

Promenade—dressing up and promenading up and down a street engaged in witty and intellectual conversation to see its effect on ordinary people.

Haden, p. 48

Lovecraft on an August 1925 nocturnal ramble: "I could go where I darned please and when I darned please … I set forth on a nocturnal pilgrimage after mine own heart; beginning at Chelsea … & working south toward Greenwich … south along Hudson St. to Old New York … under Brooklyn Bridge [then back] toward The Battery [and as dawn broke, onto] a Staten Island ferry."

Joshi and Schultz, p. 170

Navigation was aided by the illumination of shop display windows and signs at night, by which one might read a finely printed map or a pocket notebook without the aid of a flickering match.

Haden, p. 61

J Flâneur

Ibid., p. 64

Only once, attempting to explore the outlying suburb of Jamaica, did Lovecraft find that he did not have enough light to walk by at night.

Turner, *Backward*, pp. 59–60

What is it about the city that stimulates? Surely that altogether special blend of closeness and distance, crowd and flickering, surface and gaze, freedom and danger. Others are defenseless vis-à-vis your gaze and you yourself are on display to theirs; you come so close to them that you can actually touch them, yet ought not to: a distance that incites you to overstep yet still maintain it; surfaces intercept gazes and turn into signals, and the flickering vibrates; the crowd generates feelings of supply and possibilities; the anonymity and the absence of immediate social control amplifies the feeling, and the risk of nevertheless being monitored and uncovered increases the tension. You sense this omnipresent, diffuse sexualization of the city and confirm it by designing your surface accordingly and by taking up a position, perhaps also by engaging in cruising and brief encounters.

de Torre, *Mental Diagram*, p. 459

Oh! marvels of the fleeting moment, only for a moment seized.

Henry, "The Making of a New Yorker," p. 1098

He studied cities as women study their reflections in mirrors; as children study the glue and sawdust of a dislocated doll; as the men who write about wild animals study the cages in the zoo. A city to Raggles was not merely a pile of bricks and mortar, peopled by a certain number of inhabitants; it was a thing with a soul characteristic and distinct; an individual conglomeration of life, with its own peculiar essence, flavor, and feeling. Two thousand miles to the north and south, east and west, Raggles wandered in poetic fervor, taking the cities to his breast. He footed it on dusty roads, or sped magnificently in freight cars, counting time as of no account. And when he had found the heart of a city and listened to its secret confession, he strayed on, restless, to another. Fickle Raggles!—but perhaps he had not met the civic corporation that could engage and hold his critical fancy.

Riesenberg and Alland, p. 27

The citizen, about his occasions, butts ahead into on-rushing traffic, his eyes level or sweeping the sidewalks for dimes. He never looks up, unless he sees a crowd gazing at a window washer or a jumper.

Ibid., p. 100

Mayhap you like to roam in the rusty shadows of the Third Avenue El as trains roar overhead on a broiling day in the holy month of Ramadan, drinking cool beer in the corner places with infidel dogs.

Ibid., p. 153

Traffic lights flash; the street-crossing crowd starts and stops as if ordered by a corporal of marines. But there is always the disobedient citizen, the nonconformist. A mad adventurer dashes against the lights.

Tester, p. 13

First there is the problem of traffic; if the *flâneur* does not pay attention when he crosses roads he too will become a victim of it.

Jolas, p. 471

I walk quickly wondering how to say urinate in slang.

Donleavy

That night walked crosstown on Fifty Seventh Street and turned left up the tiny hill into the automat. For the two dollar bill I gave the woman in the little booth she swept into the hollow of her marble counter a fistful of nickels, dimes, and quarters.

Took deep breaths of air along the big shadowy darknesses of Fifth Avenue to bring back my appetite. Went back and forth examining the thicknesses of meat between the bread sitting in these glass tabernacles. Dreamt all my young life of moments like this. When I could shove in the nickels and open

up all the doors on all the doughnuts and pies I wanted. And show my little brother that I was magic.

To walk up one side and down the other of a people-flooded pale grey Fifth Avenue.

Ibid.

Now head north up Fifth Avenue. More canopies. Into the stacked palaces of the rich. Turn east. Between the shadows of the grey stone town houses. And come to an empty space in the sky.

Ibid.

Under its influence he could fall asleep in construction sites, play "chicken" with buses on Second Avenue, run naked into the ocean at night during a lightning storm.

Gooch, p. 436

I was once afraid of nothing … I'd walk home those sixty blocks alone all those years. I *loved* the fur district, that's where I'd walk when I finished working.

 These are the war years I'm speaking about now … believe me, there were no cabs; I'd walk these *long, long* blocks. We were practically in a blackout—what they called a brownout—the lights were very dim. I was absolutely *freezing.*

Vreeland, *DV*, p. 8

The city is so accommodating for the exploration of identity that it is a place of doubles, where the individual can be both self and other, where he can become an underground man and go unnoticed and where his secrets can remain secrets.

Turner, *Backward*, p. 127

] **Flâneur**

Dizzily he staggered up into the air and the blinking block of lights. Upper Broadway was full of people. Sailors lounged in twos and threes at the corner of Ninety-sixth. He ate a ham and a leberwurst sandwich in a delicatessen store.

Dos Passos, p. 148

Take a walk through junky littered downtown streets to that pier on the East River where they pile the great beams of mahogany, breakfast all alone at the Lafayette, coffee and crescent rolls and sweet butter, go shopping at Lord & Taylor's early before everything is stuffy and the salesgirls wilted.

Ibid., pp. 240–1

She dresses in a hurry and goes out, walks down Fifth Avenue and east along Eighth Street without looking to the right or left.

Ibid.

Walked along the West Side Highway structure, roaring autos and grainy darkness, filthy streets with the tugboat strike, a few transvestites out hooking in the shadows of the girder stanchions.

Wojnarowicz, p. 115

the flat drift of sensations gathered from walking and seeing and smelling

Ibid., p. 144

There's a discreet pleasure I have in the walking of familiar streets, streets familiar more because of the faraway past than for the recent past, streets that I walked down odd times while living amongst them. Each time different because of the companions I had previously while walking those streets.

Ibid., p. 145

Walking downtown in the rain, a quick bite at Tiffany's restaurant on Fourth Street and down into SoHo via Italian neighborhoods, all-night bars, neon in the drizzle, we're talking friendly and I'm feeling mellow and I say, I feel like I've really lost my innocence, now that I finally have fucked with needles, the

Ibid., p. 153

whole romantic attachment to them being blown with the first shot. Now it's just down to the simple level of intake and warmth. Whatya mean? he says. You think we'd be walkin' in this fuckin' rain talkin' like this if we'd lost our innocence? And he was right. We walked through Chinatown checkin' out kung-fu movie posters and over into his old neighborhood where we caught the train, shook out our wet jackets, and made it home.

Ibid., p. 133

Went out walking around the neighborhood along the river where the dark streets are gently illuminated, pools of light slipping down brick and stone and iron walls and easing over the smooth surfaces of cobblestones.

Ibid., p. 177

We headed west down the street glittering with lamps and pools of broken glass an emptiness in the dark air, a taxi in the distance bouncing over a hole in the street.

Ibid., pp. 223–4

I crossed Broadway and 7th Avenue in the midst of heavy traffic, dodging vehicles, drivers with feet on the gas pedals, heavy traffic mayhem like rush hour. I remember fragments of other people in the middle of the avenues dodging the cars as well, I got to the other side. I had to go back, dodged the traffic again barely missed by cars. Found myself at 42nd and 7th Avenue facing west, rows of movie houses and the streets were filled with people moving in different directions. Intensity from all the movements around me but I'm surrounded by anonymity and a sense as if the streets of the entire city were empty, emptied of people, houses, automobiles, mobiles, movements, and sounds. I'm magnified and I'm seeing the movie view of myself from behind. I'm seeing my upper body, the back of my head almost silhouetted against the intensity of dusk, light blowing from the west across 42nd Street, and I begin to scream. I see the grillwork of the movie marquees and the lettering of the current shows. I see the glimmering of the asphalt between 8th Avenue and 7th Avenue in the bleached out blind light as if the street were wet after a brief spitting rain and all that light is reflecting off it turning it lakelike in pools of light and I am screaming. I am screaming so loud and so deep I am inside my body and I feel the scream and it is as if I have a ten-year-old's body and that body is as full of life, full of flesh and muscle and veins and blood and energy and it all produces and propels this scream, this scream that comes from twenty to thirty years of silence. It is a sad great deep scream and it goes on forever. It lifts and swells up into the air and the sky, it barrels out into the dusk, into the west and my head is vibrating and the pressure of it makes me blind to everything but the blood running in rivers under my skin, and my fingers are tensed and delicate as a ten-year-old's and all my life is within them and it is here in the midst of that scream in the midst of this sensation of life in an uninfected body in all this blurry swirl of dusky street light that I wake up.

J Flâneur

Crane, "The Tunnel," p. 95

Of shoes, umbrellas, each eye attending its shoe.

Jackson and Dunbar, pp. 497–8

heavy walking shoes

Cheever, "Five-Forty-Eight," p. 3

Walking in the city, we seldom turn and look back.

Mumford, *City in History*, p. 546

The whole organization of the metropolitan community is designed to kill spontaneity and self-direction. You stop on the red and go on the green. You see what you are supposed to see, and think what you are supposed to think … To choose, to select, to discriminate, to exercise prudence or continence or forethought, to carry self-control to the point of abstinence, have standards other than those of the [mass] market, and to set limits other

than those of immediate consumption—these are the impious heresies that would challenge the whole megalopolitan myth and deflate its economy. In such a free society Henry Thoreau must rank as a greater public enemy than Karl Marx.

I was gripped by the horror at the thought of what it would be like to stroll aimlessly through this part of Manhattan. Always have a purpose and walk rapidly between appointments, to work, and on errands. In this way you cannot be overwhelmed, overtaken, enveloped by the mammoth emptiness of square grey spaces and buildings. Your tiny remnant of a soul, crushed into a minute fragment of itself by traveling the streets of New York—your soul can't be obliterated if you keep walking. Walk briskly, ride, escape if it's over fifty degrees, wear dark glasses if the sun is out, stay near Central Park on the Upper East Side, never go to a business district on weekends, never even be in New York on the weekend. Even a Friday is not safe—don't let yourself try to imagine what it would feel like to be on Park Avenue and Forty-sixth Street on a Sunday in the summer. You would be the only one there—maybe a lost tourist or a derelict in some state of delirium tremens would be someone to share the empty corner with.

Hecht, p. 320

I hired a hack to Wanamaker's, cut over to Third, walked up to Fourteenth. At Twelfth a mink-faced jasper made up as a street cleaner tailed me for a block, drifted into a dairy restaurant. At Thirteenth somebody dropped a sour tomato out of a third-story window, missing me by inches. I doubled back to Wanamaker's, hopped a bus up Fifth to Madison, and switched to a cab down Fourth, where the second-hand bookshops elbow each other like dirty urchins.

Perelman, p. 21

Go to a pulp novel in the late 1950s and learn which streets in the Village to walk, which corners in particular to pass, and where to linger.

Turner, *Backward*, p. 127

Wandering along the familiar but long-lost streets of my native Greenwich Village some June day.

Atkinson, p. 40

But everything I can really tell you I will have said before we reach Fifty-sixth Street.

Finney, p. 10

drunks somnambulist strutters lolling by cab-stands

Stefanile, p. 32

What people call love is small compared with that orgy, that holy prostitution of the soul that gives itself totally, in all its poetry and charity, to the unexpected that appears, to the unknown that passes by.

Berman, *Town*, p. xxiii

Moments excluded from histories of the day, a counterpoint within the time, space, and place governed and regulated by the logic and commerce of economic rationality and the structures of political rule.

Peretti, p. 8

The Rounder is merely a hardened specimen of the man about town anywhere. He is the man who frequents the club, the theater, the saloon, the restaurant, who turns up at every habitual place regularly.

His habits are stiffened into the inevitableness of reflex action. So stiff are they that he is stripped of all initiative and carried automatically every day into the same old haunts. He may have his business and his family, but they are the accidents of his career. His heart is not with them. His real life is the life of the theater, the restaurant, the society of other Rounders. It is this life

Hapgood, pp. 74–9

J Flâneur

which forms his ideals and determines his habits of thought. In it he moves and has his moral and intellectual being.

The Rounder is thoroughly a public man. He holds no public office and does no public work, but he is yet as public as the street. All the world is admitted to his inner life, which is the glittering apparent life of the city. He is occupied solely with what is in the common gaze, and has less of a private life even than the excellent actor, for the actor's genius secures for him an inner life into which the public can not enter. But the more excellent the Rounder the more completely are his interests confined to the most public of things, the more completely does he sink his individuality in the glare of the hard thoroughfare.

Broadway indeed is the external symbol of the Rounder's life. Everything in this brilliantly lighted street suggests the concentrated publicity of metropolitan life—the stranger eager to investigate the Tenderloin; the restaurant with its breath of hospitality; the flaunting show of dress in the passers-by; the music hall luring to a vision of the ballet or the topical song satirical of the country or illustrative of the streets; the theater in which a new farce, a new comic opera, is bidding loud for the undiscriminating favor of the crowd.

Of this unpleasant aspect of the street the Rounder is the interpreter. He realizes the street's ideals and rejects all else. In all his thoughts and actions, there is a flavor of asphalt. In what is only the occasional pastime of the ordinary human being, the Rounder is absorbed. He is the embodied spirit of Broadway. There his tastes are formed. He hates with the special hatred of a highly differentiated type whatever is foreign to the basic instincts of the Tenderloin. Filled with the feeling of the street, the Rounder hates poetry above all else. The light that never was on sea or land he sees not and believes only in the lights of Broadway. He looks with suspicion upon a man who thinks, for thought is a private privilege. The reformer in politics, the optimist, the lover, anybody with emotion or enthusiasm, fills him with loathing, for such he regards as fakes or fools, or at best as snobs in excellence. In politics he sees nothing but patronage, stares at a principle, which to him is as unreal as a poem. The word literature means pretension and reform is synonymous with hypocrisy. Sentiment is unpractical and love a name for something worse or the sign of a private life.

Pinned to the fact, blasé to the core, the Rounder is the modern soul in its narrowest aspect. So narrow is he that it is only generically that he can be said to have a soul at all. In the metaphorical sense he has none. Even for the latest happening in the trodden centers of the city's external life he has no enthusiasm. He merely recognizes its excellence, states it, and passes on to the next manifestation of the mundane.

The Rounder, limited to a hard and fragmentary fact, is as thoughtless as he is definite. There is no "fringe" to his ideas, no light and shade, only the hard perception of a limited line of facts. Each thing as he experiences it is finished and has no meaning beyond. There is nothing vague about him, except perhaps a vague distrust of anything intellectual or poetic, which he looks upon as amateurish or insincere.

Perhaps the Rounder is dry because his "rounds" bring him only to the street in one form or another, and for a soul to strike its roots for nourishment through the asphalt is a desperate proposition.

Jackson and Dunbar, p. 568

He flees from one desolation to another, he escapes by buying a seat "at some show," or snatching at food in a cafeteria, he lashes about the huge streets of the night and he returns to his cell having found no doors that he could open, no place that he could call his own.

O'Hara, pp. 257–8

It's my lunch hour, so I go

for a walk among the hum-colored
cabs. First, down the sidewalk
where laborers feed their dirty
glistening torsos sandwiches
and Coca-Cola, with yellow helmets
on. They protect them from falling
bricks, I guess. Then onto the
avenue where skirts are flipping
above heels and blow up over
grates. The sun is hot, but the
cabs stir up the air. I look
at bargains in wristwatches. There
are cats playing in sawdust.
[…]
And one has eaten and one walks,
past the magazines with nudes
and the posters for BULLFIGHT and
the Manhattan Storage Warehouse,
which they'll soon tear down. I
used to think they had the Armory
Show there.
 A glass of papaya juice
and back to work. My heart is in my
pocket, it is Poems by Pierre Reverdy.

Whenever I walked out among crowds, I was quickly shamed into an
awareness of myself. I felt like a speck, a vagabond, a pox of failure on the skin
of mankind. Each day, I became a little dirtier than I had been the day before,
a little more ragged and confused, a little more different from everyone else.

Auster, "Fogg," pp. 101–2

Today's flâneurs are mere shadows of their former selves. Today the very
notion of a "walking city" begins to sound precious, or curated … What if
walking ceased to be a form of entertainment, and became a cultural duty,
something "good for you"? Will all future literary mediations take place from
behind the wheel?

Lopate, Waterfront, p. 209

Around this time I began to appreciate the performance art of pedestrianism.
Each New Yorker can seem like a minor character who has honed his or her
persona into a sharp, three-second cameo. You have only an instant to catch
the passerby's unique gesture or telltale accessory: a cough, hair primping,
insouciant drawing on a cigarette, nubby red scarf, words muttered under the
breath, eyebrow squinched in doubt. Diane Arbus used to say that in that split-
second of passing someone, she looked for the flaw. I would say I look for the
self-dramatizing element. How often you see perfectly sane people walking
along grimacing to themselves, giggling, or wincing at some memory.

Ibid., pp. 202–3

The walk becomes a technique to deal with, act out, dramatize, defend,
or deplore one's solitude. With solitude, of course, comes a danger:
self-preoccupation. The literary walk inscribes the struggle between self-
absorption and self-forgetting, between the poison of ego-brooding and
the healing parade of sensory stimuli. One of the classic preoccupations of
peripatetic literature is how a mood changes in the process of traversing
a city on foot. In the meantime, perception is sharpened, by charting the
precise movement between interior monologue ("the daily fodder of my mind"
is how Rousseau put it in The Reveries of the Solitary Walker) and outward

Ibid., p. 200

Flâneur

attentiveness, like the rack-focus in movies that pulls first the foreground, then the background, into clarity.

Ibid. Some walks follow habitual routes, and are intended to reassure; others are undertaken to disorient oneself in a strange neighborhood—to court, as in childhood, the sensation of being lost and afraid, albeit in safe, small doses.

Ibid. Idlers and literary bohemians, looking down on nine-to-five "wage slaves," try to swallow their guilt toward the worker and promote walking into a sacred vocation.

Ibid., p. 204 The mind relaxes through the calming, repeated movement of a stroll, while the legs' cadences trigger the rhythms of poetry.

Ibid. Charles Reznikoff was a great walker, putting in twenty miles a day, usually starting from his home on the Upper West Side of Manhattan.

Ibid. Self-dislike is the doppelganger dogging the flâneur who must evade it at all costs by immersion in the present.

Ibid., p. 206 I walked, I walked.

Ibid., p. 207 There is about this walking (usually in the case of men, though not exclusively) an imperialistic vanity, as though you could possess a city by marking it with your shoe leather, side-by-side with a conviction of incurable solitude, that stems from early feelings of powerlessness: mind-locked, onanistic, boastful, defensive, and melancholy (as all flirtations with the infinite must be).

Stevens and Swan, p. 141 When beset by his demons, de Kooning would pace the dark streets for most of the night … walking as far south as Battery Park at the southern tip of the city and then back. Often he went on these prowls alone, but friends occasionally accompanied him. Denby said: "I can hear his light, tense voice saying as we walked at night, 'I'm struggling with my picture, I'm beating my brains out, I'm stuck.'"

Ibid., pp. 147–8 It was on one such evening that de Kooning, restlessly roaming the streets late at night, first met Mark Rothko, who rarely went to the artists cafés … And so, one night in the park, it was late, wasn't a soul around. I walked around—thought I would sit a little bit on a bench. I was sitting way on the right side of the bench and kind of a husky man was on the left end of the bench, and I thought maybe I ought to move and sit on another bench. Maybe people would think we were a couple of queers or something. I didn't know what I was thinking. We were just sitting there—there wasn't a soul around … and we just sat there until Mark said something like it was a nice evening. And so I said, "Yes, a nice evening," and we got to talk.

I guess he must've asked me what I did. I said, "I'm a painter." He said, "Oh, you're a painter? I'm a painter, too." And he said, "What's your name?" I said, "I'm Bill de Kooning." I said, "Who are you?" He says, "I'm Rothko." I said, "Oh, for God's sake," and said it was very funny. Then we talked and a couple of days later he came to visit me in my studio.

WPA Guide, p. xxx Average pedestrian speed: three hundred feet per minute.

Brook, p. 144 Before the light fades I went for a walk and headed towards Sixth Avenue. The rush hour was building up. It was my favorite time of day, when immobilized

cars buzz and growl across six lanes of avenue while pedestrians, free as air, thread between them. The liberty of the unmechanized is deliciously intensified by the sorrowful captivity of the motorized.

Sometime in the evening, getting on kind of late. This is a Thursday night. Second Avenue full of people, the kinds of people I never really notice anymore when walking down a street, not quite tourists but something like that (characters like middle-aged couples going into Abe's delicatessen or off to see some harmless show), lots of these people, nameless, faceless, almost uninteresting.

Wojnarowicz, p. 186

In the streets, everything is bodies and commotion, and like it or not, you cannot enter them without adhering to a rigid protocol of behavior. To walk among the crowd means never going faster than anyone else, never lagging behind your neighbor, never doing anything to disrupt the flow of human traffic. If you play by the rules of this game, people will tend to ignore you. There is a particular glaze that comes over the eyes of New Yorkers when they walk through the streets, a natural and perhaps necessary form of indifference to others. It doesn't matter how you look, for example. Outrageous costumes, bizarre hairdos, T-shirts with obscene slogans printed across them—no one pays attention to such things. On the other hand, the way you act inside your clothes is of the utmost importance. Odd gestures of any kind are automatically taken as a threat. Talking out loud to yourself, scratching your body, looking someone directly in the eye: these deviations can trigger off hostile and sometimes violent reactions from those around you. You must not swagger or swoon, you must not clutch the walls, you must not sing, for all forms of spontaneous or involuntary behavior are sure to elicit stares, caustic remarks, and even an occasional shove or kick in the shins. I was not so far gone that I received any treatment of that sort, but I saw it happen to others, and I knew that a day might eventually come when I wouldn't be able to control myself anymore.

Auster, "Fogg," pp. 101–2

Body space is carefully apportioned so that even elbows never jar, bare flesh is never thrust before another's eyes which, in any case, would be carefully averted.

Blandford, p. 115

Pedestrians can twist, duck, bend, and turn sharply, and therefore, unlike motorists, can safely count on being able to extricate themselves in the last few milliseconds before impending impact. Should pedestrians actually collide, damage is not likely to be significant, whereas between motorists collision is unlikely (given current costs of repair) to be insignificant. Further, a pedestrian who walks aggressively or drops in his tracks or collides with another can hardly produce a traffic jam, although, of course, he can produce a considerable audience.

Goffman, pp. 28–9

A popular maneuver in busy traffic (to avoid collision) is the "step-and-slide"—a slight angling of the body, a turning of the shoulder and an almost imperceptible sidestep, all of which is reciprocated by the oncoming pedestrian.

Ibid., p. 35

One pedestrian trips over another, says "Sorry," as he passes, is answered with "Okay," and each goes on his way.

Ibid., p. 172

A pedestrian has a buffer, a "no-touch" zone.

Ibid., p. 42

Bodies that may impede and obstruct other bodies.

Ibid., p. 89

J Flâneur

Ibid.	Bodies and objects are viewed as interchangeable.
Ibid., p. 42	The pedestrian as object in motion, rather than a person.
Ibid., p. 43	The spatial needs of two persons walking side by side is four-and-a-half feet (known as "spatial bubbles").
Lofland, p. 152	Their movements are such that they appear to be headed for a collision.
Blomley, p. 45	The freedom to choose desired speeds and to bypass others. The ability to cross a pedestrian traffic stream, to walk in the reverse direction of a major pedestrian flow, and to maneuver generally without conflicts and changes in walking speed.
Ibid.	The successful sidewalk is wide and largely empty, devoid of "pedlock."
Ibid., p. 59	City walkers who could be pushed along by a variety of causes and impulses, lagged and sped along, shopped and rushed to work, depending on the neighborhood and hour of day. They stopped and crossed streets at random: an order was not yet imposed on how they moved, stood, leaned or squatted under haunches, waiting in line … Absent traffic signals and police, anything resembling a full system of sidewalks, and a shared sense of etiquette, walkers, as individuals and groups, were undisciplined and unruly. At any one moment they might vary their pace and direction as they darted from one place to another, swerved to avoid a vehicle, circled to pass an unobstructed walk or made a beeline to greet an acquaintance.
Ibid., p. 70	In cities walkers were organized around narrower and tighter regimes … Gathered together by hundreds of thousands in cities … The walking public—by force, law and regulation and manners—must be coordinated in its everyday actions … Issues that might seem trivial to us, who have long ago learned the ways and etiquette of city walking or rarely walk at all, surround the proper use of sidewalks, stairs, escalators, ramps, doorways and fenced walkways. These issues include questions about who can walk them, in what ways (circling, going arm in arm, or with an unleashed dog), and with what things (long poles, big swords, or big picket signs). These issues consist of matters pertaining to the right to approach, sell and solicit passersby or stop traffic by not moving, by entertaining, or by lying down.
Maffi, p. 118	Then there are some very special niches within the city, where time seems to slow down as if suspended, to allow you a moment to reflect anew on the paths you have already trodden, reorganize the sensations you have felt, and think over the faces, voices, and stories you've come across.
Sennet, p. 17	The paradigm of the "self-sustaining" city incorporates a certain degree of disorder.
Lefebvre, *Critique*, p. 20	To look at things from an alien standpoint—externally and from a reasonable distance—is to look at things truly.
Trager, p. 601	New York installs "Walk / Don't Walk" signals at busy intersections beginning April 19, 1955. Park Avenue is exempted.
Chin	If a Chinese woman has nothing to do she never walks aimlessly through the streets.

J Flâneur

We spent entire evenings together during which we exchanged less than a hundred words; once, we walked all the way to Chinatown, ate a chow-mein supper, bought some paper lanterns and stole a box of joss sticks, then moseyed across the Brooklyn Bridge, and on the bridge, as we watched seaward-moving ships pass between the cliffs of burning skyline.

Capote, p. 67

You start north, holding a hand over your eyes. Trucks rumble up Hudson Street, bearing provisions into the sleeping city. You turn east. On Seventh Avenue an old woman with a hive of rollers on her head walks a German shepherd.

McInerney, Bright Lights, p. 9

You walk across town, east on Forty-seventh, past the windows of the discount jewelry stores. A hawker with an armful of leaflets drones in front of a shop door: "Gold and silver, buy and sell, gold and silver, buy and sell."

Ibid., p. 67

The evening is cool. You find yourself walking the Village, pointing out landmarks and favorite townhouses. Only yesterday you would have considered such a stroll too New Jersey for words, but tonight you remember how much you used to like this part of the city. The whole neighborhood smells of Italian food. The streets have friendly names and cut weird angles into the rectilinear map of the city. The buildings are humble in scale and don't try to intimidate you. Gay giants stride past on hypertrophied thighs, swathed in leather and chains, and they do intimidate you.

Ibid., p. 94

Down on the street, you clamp your sunglasses to your face and wonder where to go. An old question, it seems to come up more and more frequently.

Ibid., p. 107

You want to go somewhere, do something, talk to someone, but it's only eleven-thirty in the morning and everyone else in the world has a job.

Ibid.

You expect people to gaze at you, horror-stricken, yet nobody pays any attention. On the corner a fat man in a Yankees cap is selling pretzels from a pushcart. A woman in a fur coat holds her right arm erect, hoping to conjure a taxi. A bus roars past. Cautiously, as if you were entering a swimming pool for the first time in years, you ease yourself into the ranks of pedestrians.

Ibid., p. 127

At Fiftieth you get off and walk up the stairs to the street. Walking east, you cross abrupt thermoclines as you move between the cool shadows of tall buildings and brief regions of direct sunlight. At Fifth Avenue you stand on the corner and look over at the long row of windows fronting Saks. You cross the street to the third window down from the uptown corner.

Ibid., p. 77

You walk up Fifth Avenue along the park. On the steps of the Metropolitan Museum, a mime with a black-and-white face performs in front of a small crowd. As you pass you hear laughter and when you turn around the mime is imitating your walk. He bows and tips his hat when you stop. You bow back and throw him a quarter … You go to the Egyptian wing and wander among the obelisks, sarcophagi and mummies. In your several visits to the Met this is the only exhibit you have seen. Mummies of all sizes are included, some of them unwrapped to reveal the leathery half-preserved dead. Also dog and cat mummies, and an infant mummy, an ancient newborn bundled up for eternity.

Ibid., p. 52

You're not sure exactly where you are going. You don't feel you have the strength to walk home. You walk faster. If the sunlight catches you on the streets, you will undergo some terrible chemical change.

Ibid., p. 180

Conrad, p. 209 You like to prowl your own uncompleted buildings at night, treading on shivering planks hung over emptiness ... to the open edges where girders stuck out like bones through broken skin.

Howells, *Selected*, p. 305 Their impressions of New York remained the same that they had been fifteen years ago: huge, noisy, ugly, kindly, it seemed to them now as it seemed then. The main difference was that they saw it more now as a life, and then they only regarded it as a spectacle; and March could not release himself from a sense of complicity with it, no matter what whimsical, or alien, or critical attitude he took.

Henry, *Trimmed*, pp. 105–7 One day Raggles came and laid siege to the heart of the great city of Manhattan. She was the greatest of all; and he wanted to learn her note in the scale; to taste and appraise and classify and solve and label her and arrange her with the other cities that had given him up the secret of their individuality. And here we cease to be Raggles's translator and become his chronicler ... Late in the afternoon he drew out of the roar and commotion with a look of dumb terror on his countenance. He was defeated, puzzled, discomfited, frightened. Other cities had been to him as long primer to read; as country maidens quickly to fathom; as send-price-of-subscription-with-answer rebuses to solve; as oyster cocktails to swallow; but here was one as cold, glittering, serene, impossible as a four-carat diamond in a window to a lover outside fingering damply in his pocket his ribbon-counter salary.

The greetings of the other cities he had known—their homespun kindliness, their human gamut of rough charity, friendly curses, garrulous curiosity and easily estimated credulity or indifference. This city of Manhattan gave him no clue; it was walled against him. Like a river of adamant it flowed past him in the streets. Never an eye was turned upon him; no voice spoke to him. His heart yearned for the clap of Pittsburgh's sooty hand on his shoulder; for Chicago's menacing but social yawp in his ear; for the pale and eleemosynary stare through the Bostonian eyeglass—even for the precipitate but unmalicious boot-toe of Louisville or St. Louis.

On Broadway Raggles, successful suitor of many cities, stood, bashful, like any country swain. For the first time he experienced the poignant humiliation of being ignored. And when he tried to reduce this brilliant, swiftly changing, ice-cold city to a formula he failed utterly. Poet though he was, it offered him no color similes, no points of comparison, no flaw in its polished facets, no handle by which he could hold it up and view its shape and structure, as he familiarly and often contemptuously had done with other towns. The houses were interminable ramparts loopholed for defense; the people were bright but bloodless spectres passing in sinister and selfish array.

The thing that weighed heaviest on Raggles's soul and clogged his poet's fancy was the spirit of absolute egotism that seemed to saturate the people as toys are saturated with paint. Each one that he considered appeared a monster of abominable and insolent conceit. Humanity was gone from them; they were toddling idols of stone and varnish, worshipping themselves and greedy for though oblivious of worship from their fellow graven images. Frozen, cruel, implacable, impervious, cut to an identical pattern, they hurried on their ways like statues brought by some miracles to motion, while soul and feeling lay unaroused in the reluctant marble.

Gradually Raggles became conscious of certain types. One was an elderly gentleman with a snow-white, short beard, pink, unwrinkled face and stony, sharp blue eyes, attired in the fashion of a gilded youth, who seemed to personify the city's wealth, ripeness and frigid unconcern. Another type was a woman, tall, beautiful, clear as a steel engraving, goddess-like, calm, clothed like the princesses of old, with eyes as coldly blue as the reflection of sunlight

on a glacier. And another was a by-product of this town of marionettes—a broad, swaggering, grim, threateningly sedate fellow, with a jowl as large as a harvested wheat field, the complexion of a baptized infant and the knuckles of a prize-fighter. This type leaned against cigar signs and viewed the world with frappéd contumely.

Theater is a metaphor for the city because it renders experience unreal, abstracts you from yourself. Dreading the vulnerability of self-exposure, we all devise protective false fronts and wear them on the street as a defense against the crowd's assault.

Conrad, p. 107

New York provides not only a continuing excitation but also a spectacle that is continuing. I wander around, re-examining this spectacle, hoping that I can put it on paper.

White, *Here*, p. 38

Boredom, Loafing, Sloth

On mild sunny days the drifters sit along the docks with their "junk bags," sharing cigarette butts, and stare endlessly into the water.

WPA Guide, p. 81

I have never been bored since I came to live in Manhattan, but, inevitably, I am gradually becoming permanently tired.

Crisp, p. 124

New Yorkers do nothing.

Conrad, p. 199

Two policemen work two hours on the Lincoln Tunnel catwalks and two hours in open air at the tunnel plazas. They have an eight-hour day. There are no health hazards in the job. It's the monotony that gets them. The constant stream of cars seems to have a dulling effect on a man if he's on the catwalk too long.

Berger, *Eight Million*, p. 204

Theater patrons settling themselves into the otherwise empty stalls and studying the program of a nonexistent, putative show, though they know it never will.

Conrad, p. 106

I was sitting on the steps of the Metropolitan Museum at quitting time, watching people head home. It was nearly evening, too warm for the season, and the sky was Parker's inky blue. Men walked by with the slanted carriage you associate with dads in *New Yorker* cartoons. Fifth was weirdly vacant— one of those lulls after a herd of buses has taken off … The museum was closing, so I dropped down the steps and sat, the only person going no place besides a chauffeur in a Rolls and a curbside Santa.

Trebay, p. 150

Free countries are great, because you can actually sit in somebody else's space for a while and pretend you're a part of it. You can sit in the Plaza Hotel and you don't even have to live there. You can just sit and watch the people go by.

Warhol, *Philosophy*, p. 146

Sunday in the city: a term of compulsory inoccupation.

Conrad, p. 106

The girl on the El gazes at a procession of chimney pots, but her motive is boredom, not curiosity or yearning.

Ibid., p. 104

Ibid., p. 106	The painter, shuttled past on the El, can't wait for a narrative to ensue. Nor do his people have stories to tell about themselves. They're seen waiting for something to happen.
Ibid., p. 121	New York animates the plastic universals in a jittering, nervous, constant motion, yet it stays always the same.
Ibid., p. 102	People disconsolately accept their placement in the composition because, sweltering in their rooms or moping behind the counter of an all-night diner, they have nothing else to do.
Gorky, "Boredom," p. 314	Blinded by the gleam of the light, lured by the cheap, but glittering sumptuousness, intoxicated by the noise, they turn about in a slow dance of weary boredom.
Kasson, p. 108	Gorky on Coney Island: "a marsh of glittering boredom."
Philips, p. 6	To old people whose dwellings are tiny or dreary or places of endless boredom, the waiting room is a kind of indoor park. It never rains in the Port Authority bus terminal.
Lofland, p. 127	After seven-thirty in the evening, in order to read a book in Grand Central or Penn Station, a person either has to wear hornrimmed glasses or look exceptionally prosperous. Anyone else is apt to come under surveillance. On the other hand, newspaper readers never seem to attract attention and even the seediest vagrant can sit in Grand Central all night without being molested if he continues to read a paper.
Reay, pp. 265–6	A man who sat in a 42nd Street cafeteria for eighteen hours a day, sometimes for twenty-four when there was nowhere else to go, his expression always weary, indifferent, somehow astonished too, aware of everything. He had the look of a man who is sincerely miserable in the world.
Huxtable, *Goodbye*, p. 116	Downtown, the days of small shops for fresh-ground coffee or odd electronic gadgets or conviviality in a not-too-pure circa 1827 bar are past and numbered. It's not very convivial in the personal credit department of a bank and the place smells of computers, not coffee. If New Yorkers survive the rape of the city, or just crossing the street or breathing the air, there is one last, lethal urban hazard: boredom.
Auster, "Fogg," p. 107	Later on, after I had been rescued, they kept asking me how I managed to do nothing for so many days. Hadn't I been bored? they wondered. Hadn't I found it tedious? These were logical questions, but the fact was that I never became bored. I was subject to all kinds of moods and emotions in the park, but boredom wasn't one of them.
Tester, p. 13	The mysteries of the city could well become just banal and boring.
Finney, p. 266	But there was also an *excitement* in the streets of New York in 1882 that is gone.
Brainard	I remember awkward elevator "moments."
Pinder, p. 127	Chtcheglov: "We are bored in the city, there is no longer any Temple of the Sun … We are bored in the city, we really have to strain still to discover the mysteries on the sidewalk billboards … "

J Flâneur — Boredom, Loafing, Sloth

Loafing is a subject often talked about in the journals of New York. Man usually thinks and dreams a lot about what he does not experience. In the ideal world he insists on what hard fate shuts away from him in the actual world of the setting and the rising of the sun. Thus it comes about that loafing, which in the actual world of New York does not exist among the decent classes, is exhaustively treated in literature and the press. Man's intense longings, and man's conscience smothered by the dusty ordeal of daily life, is eased by the contemplation in print of all that ought to be.

Hapgood, pp. 193–4

Therefore no apology is needed for a few more melancholy remarks on loafing. If I were in Paris or Berlin or in Rome or in the languid East, I should consider such a subject a superfluous impertinence. But in New York I know the subject is in the minds of all idealists and you can always talk about a big subject, no matter how shabbily and tritely, without being very rudely sat upon.

Bohemianism combined loafing and agreeable companionship to form a philosophic and artistic habit of mind. Bohemianism was foreign to the American experience because in New York, a very swift town, contemplation was shut out of the life of its residents. In choosing bohemianism, and few men did, one endured social reprobation, for when a man is not busy in America, he is generally a bum or a foreigner.

Humphrey, p. 61

I know a common loafer, or "bum" or "gorilla," as they call such on the Bowery, who in his spoken language has the elements of literature. His phrases are not frozen, but adequately and originally and temperamentally express his thought.

Hapgood, p. 20

It was swelteringly hot in Washington Square. Wherever there was a bit of shade the benches were crowded, for it was Sunday, and the number of the New York Sunday afternoon loafers in the open air increases with the age and cosmopolitanism of the city.

Ibid., p. 151

Two men sat in a café on Second Avenue—one of those open-air cafés, characteristic of Europe and of the broadest, lightest, and handsomest streets in New York. It was on a Sunday afternoon and they watched the sauntering Teutonic crowd pass—men, women, and children in easy domestic fashion. Around them in the little garden sat several men, some playing cards some in almost complete silence staring sturdily at their beer all seeming to be fixt there, settled comfortable with no nervous consciousness of the uncompleted task or the unkept engagement. They belonged to the happy crowd of the unnoticed and the unambitious; and to a race that prefers calm and almost sensuous contemplation to "getting there" in any sweaty form. The day was warm and the sun shone through an atmosphere rendered heavy by a recent shower; the hot, bright globules of moisture marking the path of the rays.

Ibid., pp. 215–16

Perhaps it was the pacifying weather and the undulating rich quiet of the street that put the two nervous Americans into unusual mood. For a long time they were silent. They sipped the repose-inducing beer and almost felt that they were a part of their surroundings. Ultimately, however, being of expressive character, they must need give vent to what was an unusual and delightfully literary sensation, and talked of many things, through the heterogeneity of which, however, there was a strain of unity—the tone of the place and the mood of the day being subtly manifest in the diverse things they said.

He was born with a genius for doing nothing.

Ibid., p. 247

Ibid., p. 274 The people there sat long hours and did not hurry. It did not seem like New York.

Ibid., p. 280 He began adult life as an esthete. He was not an actor, or a musician, or anything like that. He was just a loafer, well born, with keen senses and much joy in life.

Mayakovsky, *America*, pp. 50–1 You will see crowds of people loafing around the streets with nothing to do. They will all stop and talk to you about any subject. If you raise your eyes to the heavens and stand still for a minute, you will be surrounded by a mob which a policeman would be hard to put to disperse. Their capacity for entertaining themselves with something beyond the stock market goes a long way towards reconciling me to the crowds of New York.

Sante, "Commerce," p. 112 When S. inherited his father's estate, although it was not a major sum, he promptly retired. That is, he quit his job, moved into a room in the George Washington Hotel on 23rd Street, and took his meals at the donut shop on the corner. He read, wrote, strolled, napped. It was the life of Riley. He might have continued in this fashion indefinitely had he not made the acquaintance of cocaine.

Tallack

On his visit to New York in 1930, Sergei Eisenstein found numbered streets confusing or else he could not remember addresses full of numbers. And so he attached images to the streets and street corners. He then found that, armed with his images, the rectangular, numerical experience of walking New York, and the shocks and collisions of its intersections, confirmed and refined his theory of cinematic montage.

Brook, p. 90

A number of places I had come to think of as mere sights were restored as memories. A familiar corner became not just an intersection, but a spot where I anxiously waited for her all those years ago. Places, bricks and mortar, rang with an emotional resonance they hadn't had before.

Bennett, *Deconstructing*, p. 6

In an episode that sounds like familiar fiction, but was in fact quite true, a father in my building went home by mistake to the identical building across the way. He went upstairs in the identical elevator, got off at his floor, went to his apartment, where the door was unlocked (this was in the fifties: doors were unlocked during the day so the kids could run freely from one apartment to another) and walked in. He wondered if his wife had gotten new furniture, shouted "hello!" to her, and a strange woman screamed in the bathroom.

Ibid., pp. 9, 20

O'Hara's "lunch hour" poems explore what the city can be like—and in fact what it is like—for urban subjects who are not confined, either spatially or psychologically, by the city's homogenous spatial grid … O'Hara laid the seeds for an urban aesthetic based on New York City's socio-spatial geography.

Gooch, p. 218

O'Hara used the cityscape constantly in his wishful need to transmute life into game or art. "Once we were walking down Fifty-seventh Street. There were all these grand antique shops, but small, each one with a window that would be arranged as a little Louis Quinze salon or a Victorian *fumoir*. One night Frank and I stopped and looked and a game began spontaneously where this was our living room and we were inviting all our idols in. He would say, "Tab, how nice to see you," and I would say, "Sugar Ray, I'm so glad you could come." We played the game the length of Fifty-seventh Street. This sort of thing happened every time you were with him.

Ford, *America*, p. 100

Then we strolled along Fifth Avenue northward, still discussing Style. Writers do sometimes do that. At the southeast corner of the intersection of the Avenue and Fourteenth Street, just as he was stepping off the curb to take his trolley-car he halted with one foot in the air and said: "I have read your books: I like them very much." So I said: "Well, I have read your books and I like them very much, too."

 So that angle of that street has its pleasant association for me. Crossing onto the corner immediately opposite on a very slippery day I once had a very bad fall—so that corner, too, has its clothing of memory.

Lopate, *Waterfront*, p. 201

The urban connoisseur is also an amateur archaeologist of the recently vanished past. Not surprisingly, an elegiac tone creeps into this genre, as personal memories intersect with what had formerly existed on a particular spot. The walker-writer cannot help seeing, superimposed over the present edifice, its former incarnation, and he/she sings the necropolis, the litany of all those torn-down Pennsylvania Stations.

Conrad, pp. 305–6

A famous crozier-shaped lamppost on Union Square, dating from the 1890s. Reginald Marsh could see it from his studio and sketched it in 1954. By then it was a signifier which signified so much that it polymathically contradicted

itself, asking to be read not as use but as ceremonial beauty. Traffic lights, street signs, embargos against parking, warnings against turns, and even a mailbox had been hung on it. Pointing every way at once, it offered itself as an all-purpose guide to the city, which it had transliterated in symbols, signs, and numerals referring to streets, postal zones, and periods of the day. It can cope with one symbol's sudden metamorphosis into another, as when East 14th Street unexpectedly renominates itself as Union Square or (since the pole, like a bemedaled veteran, also bears a highway shield) as N.Y. Route 22. As well as a many armed and all-wise directory, it's a tribal elder, a symbol of the city whose contradictory symbols it regulates. In Marsh's sketch, someone mails a letter in the box tethered to the post, not so much using it as gravely consulting it and trusting it to care for and relay a personal message, treating it as a clearinghouse for prayers. New York's policemen totemize their bodies in the same way as that lamppost, attaching to their sagging belts an armory of guns, whistles, truncheons, and handcuffs, with their clanking bunches of keys announcing their right to open every door in the city. Walkie-talkies crackling, they are human radio stations, absorbing and giving off information like the plurally gesturing lamppost.

Ibid., p. 315

Oldenburg reconstitutes the frugal and dexterous economy of Crusoe's island in a block-long studio on 14th Street at First Avenue. He reads the city as a landscape, of which he, like Crusoe, is the sole proprietor. A note in 1963 effects a sequence of beautiful metamorphoses, seeing urban objects as flora and fauna—people, Oldenburg says, are single trees, vehicles are animals, stores are collective forests, streets are plains or rivers.

Ford, *America*, p. 82

Apart from that, Wall Street might, for all I care, emigrate to Norfolk, Va. And yet it mightn't.

Conrad, p. 299

In *The Wiz* (1978) the yellow brick road is rerouted across the Brooklyn Bridge to the World Trade Center.

Sanders, *Celluloid*, p. 114

"Americans have practically added a new dimension to space," a British journalist wrote in 1899, "when they find themselves a little crowded, they simply tilt a street on end, and call it a skyscraper."

Delany, p. 5

Jenny Holzer on a Forty-second Street marquee: "In Greenwich Village / a tourist asks directions / to Greenwich Village"

Federal Writers, *Panorama*, p. 48

Superimposed on a map of midtown Manhattan, the World's Fair plan would reach from the Central Park menagerie deep down into Greenwich Village; and the transverse Central mall, lying approximately over Forty-Second Street, would extend from Times Square to Tudor City.

Ibid., p. 83

A map of Europe superimposed upon the map of New York could prove that the different foreign sections of the city live in the same proximity to one another as in Europe: the Germans near the Austrians, the Russians and the Rumanians near the Hungarians, and the Greeks behind the Italians. People of Western Europe live in the western side of the city. People of Eastern Europe live in the eastern side of the city. Northerners live in the northern part of the city and southerners in the southern part. Those who have lived on the other side near the sea or a river have a tendency to live here as near the sea or the river as possible. A reformation of the same grouping takes place every time the city expands. If the Italians move further up Harlem, the Greeks follow them, the Spanish join them, with the French always lagging behind and the Germans expanding eastward.

The private map turns out to be as provisional as the public one—not one on which our walks and lessons trace grooves deepening over the years, but one on which no step, no thing seems to leave a trace. The map of the city we carried just five years ago hardly corresponds to the city we know today, while the New York we knew before that is buried completely.

Gopnik, p. 4

Lay a Central Park map of the early eighteen eighties beside a map of today, and there on both maps are all the old names and places: the reservoir, the lake, North Meadow, the Green, the pool, Harlem Mere, the obelisk. We've photocopied some of the old maps to precisely the size of a modern one, then superimposed one over the other between glass sheets, and shot a good strong light through them. Allowing for small mapmakers' errors, they've coincided, the sizes and shapes of the things in the park unchanged through the years … the very curve of this road, and nearly all the roads and even the footpaths, are unaltered.

Finney, pp. 76–8

The city is a map of the hierarchy of desire, from the valorized to the stigmatized.

Califia, p. 216

One morning, with the sun at your back illuminating everything in front of you, you might, then, take 14th or 23rd or 42nd or 57th on the eastern side of the island and walk toward the Hudson River in the extreme west. Your steps will follow another map, and this will allow you to cut across the metropolis transversely—thus sharpening your perception of the city—land that openly proclaims, on the one hand, its monumental immensity, and on the other, at the same time, its insurmountable limits.

Maffi, p. 18

A new agenda for geography, where geographers would explore the *terra incognitae* of the simultaneously real, experiential and imaginary, and profoundly personal world.

Goodman, *Secret*, p. 14

Even if we must have a vertical city instead of a horizontal one, why have a West Street bordering the North River, which isn't the North River but the Hudson, and a South Street bordering the East River, which isn't any river at all?

Collins, *Money*, p. 8

As she always has, when we have a long way to go downtown at night, Martha will ask cab-drivers to take the "East Side Highway"—and no matter how often, or how obnoxiously I tell her that there is no East Side Highway, that it is called the FDR Drive, or just the Drive or the FDR, she persists. The East Side Highway is a sacred place for her somehow, the Yellow Brick Road of her mind and heart, never really settled in New York, still dreaming of Canada or Paris and a road to take you there.

Gopnik, p. 79

Fifth Avenue, by virtue of ghetto blasters usually no larger than refrigerators, was a temporary trade outpost of Japan.

Trebay, p. 136

271 West 52nd Street is the easiest of all addresses to find, but the hardest of all addresses to remember.

Conrad, p. 120

Transversed by seven parallel avenues, and on the grid by any number of names, letter and number streets, all out of sequence and Oz-like willy-nilly.

McCourt, p. 6

The city itself could be read, interpreted, and signified upon even by writers and artists who were unable to alter its physical topography.

Bennett, *Deconstructing*, p. 18

Maffi, p. 19

Observe the island, measuring it, superimposing one view over another, following its contours.

McCourt, p. 29

The street evolves over decades into a post-modern, non-linear cluster fuck event construction.

White, *Here*, p. 19

I am twenty-two blocks from where Rudolph Valentino lay in state, eight blocks from where Nathan Hale was executed, five blocks from the publisher's office where Ernest Hemingway hit Max Eastman on the nose, four miles from where Walt Whitman sat sweating out editorials for the Brooklyn Eagle, thirty-four blocks from the street Willa Cather lived in when she came to New York to write books about Nebraska, one block from where Marceline used to clown on the boards of the Hippodrome, thirty-six blocks from the spot where the historian Joe Gould kicked a radio to pieces in full view of the public, thirteen blocks from where Harry Thaw shot Stanford White, five blocks from where I used to usher at the Metropolitan Opera and only a hundred and twelve blocks from the spot where Clarence Day the Elder was washed of his sins in the Church of the Epiphany (I could continue this list indefinitely); and for that matter I am probably occupying the very room that any number of exalted and some wise, memorable characters sat in, some of them on hot, breathless afternoons, lonely and private and full of their own sense of emanations from without.

Lovecraft, "Pickman's," p. 505

What do maps and records and guide-books really tell [of the city, for] these ancient places are dreaming gorgeously and overflowing with wonder and terror and escapes from the commonplace, and yet there's not a living soul to understand or profit by them.

Morris, *Manhattan '45*, p. 18

The civic orientation is inexact, north-south avenues running twenty-eight degrees out of true, west-east streets really running northwest to southeast.

Gopnik, p. 3

I went downtown and met a man who was making a perfect map of New York. He worked for the city, and from a set of aerial photographs and underground schematics he had turned every block, every highway, and every awning— every one in all five boroughs—into neatly marked and brightly colored geometric spaces laid out on countless squares. Buildings red, streets blue, open spaces white, the underground tunnels sketched in dotted lines … everything in New York was on the map: every ramp to the Major Deegan Expressway and every abandoned brownstone in the Bronx.

The kicker was that the maniacally perfect map was unfinished and even unfinishable, because the city it described was too "dynamic," changing every day in ways that superseded each morning's finished drawing. Each time everything had been put in place—the subway tunnels aligned with the streets, the Con Ed crawl spaces with the subway tunnels, all else with the buildings above—someone or other would come back with the discouraging news that something had altered, invariably a lot. So every time he was nearly done, he had to start all over.

Queens Museum, "Panorama"

Built by Robert Moses for the 1964 World's Fair, in part as a celebration of the City's municipal infrastructure, The Panorama of the City of New York, a 9,335 square foot architectural model includes every single building constructed before 1992 in all five boroughs; that is a total of 895,000 individual structures. After the Fair the Panorama remained open to the public, its originally planned use as an urban planning tool seemingly forgotten. Until 1970 all of the changes in the City were accurately recreated in the model by Lester's team. After 1970 very few changes were made until

1992, when again Lester Associates changed over 60,000 structures to bring it up-to-date.

In his Brooklyn Heights apartment, Norman Mailer constructed a Lego-block model of his 15,000-unit apartment building in the pure-geometry style International Modernism, as an act of protest. After a year or so of slamming away at the modern "Kleenex box" school of architecture, Mailer decided to demonstrate the kind of city he thinks architects should be building. Using children's building blocks with aluminum beams here and there to provide structural support, he built a six-foot sculptural model of his dream city. Nichols

 In the summer, Mailer says, his city would be a tropical paradise "with all sorts of wonderful bright colors, beach umbrellas on terraces, people sunning themselves, all sorts of music." Mailer's city would be extraordinary in winter, too. "Think of it after a snowstorm," said Mailer ecstatically. "You'd think you were living in the Alps."

The real is produced from miniaturized cells, matrices, and memory banks, models of control—and it can be reproduced an indefinite number of times from these. Baudrillard, *Selected*, p. 167

A city of accommodations and of many maps. We constantly redraw them, whether we realize it or not, and are grateful if a single island we knew on the last survey is still to be found above water. Gopnik, p. 5

And yet both shape the city's maps, for what aspirations and accommodations share is the quality of becoming, of not being fixed in place, of being in every way unfinished. An aspiration might someday be achieved; an accommodation will someday be replaced. The romantic vision ends up harmonizing with the unromantic embrace of reality. *Ibid.*

We can't make any kind of life in New York without composing a private map of it in our minds—and these inner maps are always detailed, always divided into local squares, and always unfinished. *Ibid.*, p. 3

Ever since its beginnings, the New World constantly demanded and presumed that real and metaphorical adjustments be made to its topography, and so New York maps are potentially unlimited. Maffi, p. 22

Other cities that share NYC's latitude—40 degrees north—Beijing and Madrid. Mittlebach and Crewdson, p. 4

The middle of Central Park lay at latitude 40°46'56" N, longitude 73°57'57" W. Morris, *Manhattan '45*, p. 6

The invention of all manner of strange mappings—the network, the fluid, the blank figure. Amin and Thrift, p. 4

This confused knot of streets could certainly be termed, however anachronistically, a queer geography. Carter, p. 13

In New York, even monuments can fade from your mental map under the stress of daily life. I can walk to the Guggenheim if I want to, these days, but in my mind it has become simply a place to go when the coffee shops are too full. Another day, suddenly turning a corner, I discover the old monument looking just as it did the first time I saw it, the amazing white ziggurat on a city block, worth going to see. Gopnik, p. 6

K Psychogeography

Federal Writers, *Panorama*, p. 415	Charles Scott Landers' 1929 sub-surface map of Manhattan, on which subway lines in use or projected are shown against the original hills, swamps, watercourses and made land.
Amin and Thrift, p. 2	Fashioned and refashioned through commentaries, recollections, memories and erasures, and in a variety of media—monumental, official and vernacular, newspapers and magazines, guides and maps, photographs, films, newsreels and novels, street-level conversations and tales.
Brook, p. 211	Set Riker's Island adrift.
Ford, *America*, p. 84	Or the filling in of the East River nearly as far as Brooklyn Suspension Bridge might solve the problem.
Dos Passos, p. 15	Why the time will come—and I firmly believe that you and I will see it—when bridge after bridge spanning the East River have made Long Island and Manhattan one, when the Borough of Queens will be as much the heart and throbbing center of the great metropolis as is Astor Place today.
Simpich, p. 281	What if a super-tugboat could cast a line about Long Island and haul it out to sea! Left exposed would be the broken ends of all the bridges and the under-river tunnels that now tie it to Manhattan. Riding off on the runaway island would go more than 4-½ million people—but only if the start were made at night, for in the daytime a large share of these people work in New York.
Abelli, "Hudson," p. 38	PLUG up the Hudson River at both ends of Manhattan … divert that body of water into the Harlem River so that it might flow out into the East River and down to the Atlantic Ocean … pump out the water from the area of the Hudson which has been dammed off … fill in that space … ultimately connecting the Island of Manhattan with the mainland of New Jersey … and you have the world's eighth wonder—the reconstruction of Manhattan!
Ibid.	A plan to fill in the Harlem River and eliminate the East River entirely.
Brown, *Valentine's*, p. 241	The startling plan to fill up the Harlem River, in order to make more space for the city's expansion, was never fulfilled. It still ebbs and flows.
Ford, *America*, p. 68	So I am certain that, in the end, the East River will be covered in, since sooner or later, New York must either succumb or find more breathing space.
McCourt, p. 43	The East River is not a river at all, but a turbulent strait.
Philips, pp. 129–31	It is a peculiarity of Manhattan that it has two rivers running more or less parallel and one of them is called the East River, while the other is called the North River. The North River is like a broad avenue, smoothly paved. The East River is more like a narrow side street, clogged with traffic and badly pitted.
"Plan to Drain," p. 47	Increasing traffic congestion … recently called forth this vast plan of draining the East River and converting what now is a busy waterway into a five-mile system of automobile and motor-truck highways, subway lines, parking spaces, and city centers … The project calls for erection of two concrete dams—one at lower Manhattan near the Williamsburg Bridge, the other where the Harlem River joins the East River near Hell Gate. The river then would be drained, and the 500 feet between the Manhattan and the Brooklyn docks bridged with levels supported by steel uprights.

Psychogeography

In 1853, foresighted Charles E. Appleby purchased from the city a grant of Morris, *Incredible*, p. 355 land then mainly under the waters of the Hudson River between 39th and 40th Street. According to the terms of his grant, Appleby was required to fill in streets and build wharves and bulkheads. This work was left undone by Appleby and his heirs. Eventually, the city filled in the area, built streets, constructed piers. As a result, in 1928 Appleby's descendants sued the city for trespass, and ultimately received more than three million dollars in awards, interest and damages. They still own the property, which today—largely because of the city's trespass—is valued at more than 150 times what it cost their ancestor.

A view of the Wall Street skyscrapers through the masts and rigging of a Conrad, p. 167 schooner moored at Pier 11; the past is visually canceled by the efficient present as it is by the refrigerated containers for bananas parked in front of the arches of the Brooklyn Bridge.

Of only one thing about Henry Hudson's visit can we be sure: when he landed Collins, *Money*, p. 3 on Manhattan Island in 1609 he received no shower of torn-up phone books from skyscraper windows.

The patient thinks in a circle bounded by the confines of Manhattan Island. Girdner, p. 54

Central Park not as a landscape but—with its model yacht basin and its Conrad, pp. 256–7 boating lake— as a surrogate landlocked sea, mimicking the maritime commerce of New York.

The difference between the Upper East Side and the Upper West Side used Beller, p. 129 to be substantial. Now it is a question of gradations. The lack of delineation is one of the weirdest changes to the psychic landscape of New York in the last twenty-five or so years. Today a visitor might wander through the park from one side to another and feel it was a kind of oasis in the midst of a continuous fabric, but in recent decades it also served as a kind of moat, a Maginot Line that separated two worlds and worldviews. And if the park was a kind of DMZ in which one could wander, there was also means to cross the border from one side to the next. No one asked for your passport. It was an interval of stopped time: the Central Park Transverse.

People use the cross streets, imaginatively projecting them across the Park, Buford, p. 179 like latitude lines, as a way of imposing a New York grid on this bit of New York gridlessness.

At auction in 1973, Matta-Clark bought some small pieces of land in Queens Walker, *Matta-Clark*, p. 135 and Staten Island … which had reverted to the ownership of the City due to non-payment of taxes by previous owners. Each property was a small, irregularly shaped plot between buildings, known as a "kerb property" or "gutterspace." These were aberrations within the property system, for which Matta-Clark paid between $25 and $75 each. He described how he was drawn to the auctions by the description of the properties as "inaccessible": "When I bought those properties at the New York City Auction, the description of them that always excited me the most was 'inaccessible.' They were a group of fifteen micro-parcels of land in Queens, left over properties from an architect's drawing. One or two of the prize ones were a foot [wide] strip down somebody's driveway and a square foot of sidewalk. And the others were kerbstone and gutterspace that wouldn't be seen and certainly not occupied. Buying them was my own take on the strangeness of existing

Psychogeography

property demarcation lines. Property is so all-pervasive. Everyone's notion of ownership is determined by the use factor."

"Odd Lots" Matta-Clark died in 1978 at the age of 35 without realizing his plans for *Fake Estates*, and ownership of the properties reverted to the city. The archival material that he had assembled went into storage and was not rediscovered until the early 1990s, when it was assembled into exhibitable collages. Thus, *Fake Estates* has emerged not only as a mordant commentary on issues surrounding property, materiality, and disappearance that marked the whole of Matta-Clark's career, but as artifacts of his own estate, reminders of the powers of absence and presence that govern our relationship to the past.

Conrad, p. 87 An avenue is defined by its having been planted. It's a trail through a landscape, not a mere route for traffic.

Ibid., p. 314 For his "Automobile Tire Print" in 1951, Rauschenberg glued together twenty sheets of paper, then inked the pavement on Fulton Street. John Cage drove a car through the ink and along the paper.

Granick, p. 139 Sixth Avenue which Mayor LaGuardia, in a pixie moment, renamed the Avenue of the Americas.

Goodman, "Banning Cars" The length of a tennis court fits across Ninth Avenue.

Gopnik, p. 78 Pedestrians cross the street even earlier than I recalled, treating Second Avenue as a country lane.

Irwin, p. 323 The Times Tower, a Northern Flatiron.

Conrad, p. 133 The bisected Flatiron. Halved, it is set in motion, mounted on wings in readiness for flight, or sharpened into a prow which slices its way nautically out of the space where it has been tethered.

Hawes An apartment house called Stadium View, which claimed a western vista to a sports arena in New Jersey that was never built.

Franck and Stevens, p. 8 An overhang or bridge becomes the roof of a temporary home; lampposts can be used to lean against.

Myers, pp. 73–4 In the distance was a small old-fashioned brick building, probably a pump house. By cutting off the surrounding environment, it became a Swiss chalet nestling among trees. It looked like the kind of romantic vista one sees in an old engraving.

Conrad, p. 167 An elderly brownstone has as its neighbor a new residence fronted in glass brick, vitreously and metallically immaculate, all right angles and streamlined curves. Like different generations, they sit together amiably enough, but they're biologically at war. Even so, the victory of the present is temporary. It too will soon enough be the past. Indeed, it already is, for the glass-faced newcomer is the identical twin of its senescent companion and has simply had cosmetic surgery. Both were built about 1860; one was remodeled in 1934.

Ibid., p. 174 Rooftops deputized as beaches.

K Psychogeography

In the summer, windowsills, fire escapes, and parked vehicles are annexed as dormitories.

Ibid., p. 69

From the Woolworth Building you can take your vacation menially in the circumambient states.

Ibid., p. 202

The steel frame-work of the old Madison Square Garden was preserved and is languishing in storage in anticipation of the day when it will be set up again in another city.

Bennett, "Smashing," pp. 52–3

The façade of the Bank of the United States was cunningly tucked away as the south façade of the American Wing of the Metropolitan Museum of Art when the rest of the bank was demolished. This fine and important front is now a kind of a rear at the back, visible to the facing stone walls and the most diligent and dedicated searcher. Preservation can be an act of polite disposal.

Huxtable, *Architecture of NY*, p. 68

Given the proper investment of time and money, no two apartments needed to look alike.

Hawes

At the Grand Central Station's center stood the Main Concourse, the great room at the heart of the complex. "Nice looking city," observes the country bumpkin upon entering the space. "Pa, this is the station," his daughter explains.

Sanders, *Celluloid*, p. 282

The very things that are objectively wondrous, the rising towers and majestic bridges, must go unnoticed in order that the street dweller can maintain his obligatory demeanor of weary cool. It is famously goofy, by local standards, even to look up at the awesome structures stretching away above the sidewalk. This is the act of a rube, one likely to fail at the other cognitive imperatives of the real New Yorker, like checking the time, noticing an attractive stranger, and thinking about dinner even while crossing against the light. The rube, by contrast, notices all the wrong things: he or she is that person likely to take notice of a streetside entreaty, for example, and yet be unable to jaywalk successfully.

Kingwell, p. 53

On the Waldorf-Astoria: "Its site does not really exist: the entire hotel is built on steel columns wedged between the railroad tracks."

Koolhaas, p. 145

The tunnel to an invisible city depicts that city as an area of self-extermination, a subway to nowhere or to the ultimate estrangement and abstraction of death.

Conrad, p. 108

It is the symbolic city that draws us here, and the real city that keeps us.

Gopnik, p. 123.

You become a connoisseur of negative space. These spaces are refuges, tiny oases, sought after, multipurpose. They are meditative temples. They are moments of rest. Where nothing is happening. These places become little pockets of possibility. They are unidentified, off the grid, the staging areas for trysts, seductions, encounters. They are the places where crimes are committed, of one kind or another. The most conspicuous, hiding-in-plain-sight negative space in New York is Central Park.

Beller, p. 122

The degree of change each day is usually too slight to perceive much difference. Yet those tiny daily changes have brought us from a time when what you'd have seen down there, instead of traffic lights and hooting fire engines, was farmland, treetops, and streams; cows at pasture, men in

Finney, p. 66

tricornered hats; and British sailing ships anchored in a clear-running, tree-shaded East River. It was out there once. Can you see it?

Talese, p. 126

And near the old Medcef-Eden farm today, in Forty-second Street's subway station, are pinball machines and boys with narrow, cuffless pants who wiggle their hips and snap their fingers at each other.

Tallack

In the guidebook which I use, the visitor to New York is given advice on how not to look like an out-of-towner. And wandering slowly around with no obvious purpose, standing on street corners gazing in a detached manner at skyscrapers or at commodity fetishism in action (or at the crazies), breaks rules 1, 2, 5 and 8 on how to avoid getting mugged.

Federal Writers, *Panorama*, p. 3

A Harlem band playing *Young Woman's Blues* from a phonograph as the safari breaks camp in Tanganyika under a tile-blue morning sky as intensely lighted as the panorama closed by mountains in the ceiling dome of the African section at the American Museum of Natural History.

Trebay, p. 157

From a balcony in One Times Square I gazed down on Broadway last week and mentally erased the crowds.

K Psychogeography

Le Corbusier whitens New York; Dalí proclaims it to be a sanguinary, intestinal red.

Conrad, p. 145

Business, mass transit, is the circulation of that flood through the urban body, and he admires the El as an exact solution to the problem of traffic in New York.

Ibid., p. 183

Each of these huge constructed and compressed communities throbbing, through its myriad arteries and pores, with a single passion, even as a complicated watch throbs with the one purpose of telling you the hour and the minute, testified overwhelmingly to the *character* of New York—and the passion of the restless analyst, on his side, is for the extraction of character.

James, p. 377

Urban affrays are pathological symptoms. Traffic jams resemble blood clots or coronary obstructions, and the tonic of the street life is an overdose of surplus vitamins to keep the frenetic body working.

Conrad, p. 297

Congested roadways as hardened arteries.

Ibid.

A single organism and its parts should be read in order.

Ibid., p. 185

Le Corbusier dismisses the Brooklyn Bridge with faint praise, calling it "strong and rugged as a gladiator." He prefers the unornamented, severely exact George Washington Bridge, which is "a young athlete," beautiful but regressive, still trusting in the athletic training of the body. Whenever Le Corbusier employs anatomical imagery for the city, it's mocking or defamatory, characterizing New York as a messy overfed organism.

Ibid., p. 139

The city feeds on people to fuel its mechanism, the organism is a contraption of fleshly engineering.

Ibid., p. 117

The city as living organism, an enormous dragon curled up inside the guts of the metropolis, a mysterious and powerful energy to be released in small doses, smoke signals of a people hidden away beneath the sidewalk: fantastic images come to mind.

Maffi, p. 26

The division of the island by Fifth Avenue reminds him of the spine of a sole (which, in any case, you prize out and discard in order to get at the soft and yielding flesh), and the traffic-clogged avenues are costive digestive tracts, their excretory exits blocked.

Conrad, p. 139

The ridge of rock running in the general direction of Broadway is the backbone of the island.

Straubenmüller, p. 35

The markets and the warehouses are not the belly of the city, as Zola has called them in his own Paris. The digestive processes of a great city are worked out later and in a million homes. The markets are the heart of the city, pumping the life fuel to themselves from across the rivers and the seas and pumping them out again by drayloads and cartloads through the streets.

Strunsky, p. 699

The city mashes, melds, and recomposes substances, as a percolator circulates fluids in its hiccups.

Conrad, p. 125

L Body

Granick, p. 4

For even as your brain, nerves, heart, lungs and stomach are hidden from view, so it is with the City. Its nervous system, the vital organs which provide it with heat, water, light and air, its intestines, which like yours eliminate its wastes, its great arteries of its body, all these and more that makes it possible for eight million to live together, are out of sight under the pavements and the waterways.

But why is this complicated machine buried under tons of concrete and water where it is so hard to get at? Well, do you wear your heart upon your sleeve? No. It beats under the protection of a cage of ribs and muscle. The mechanism of the City also is too delicate and too vital to be placed out in the open.

Smith, *Charcoals*

New York City, below its man-piled coverings, is a huge stone lizard sprawled flat on its belly, its head erect at Spuyten-Tuyvel, its arms and legs touching the two rivers, its tail flopping the Battery.

All along the spine and flanks of this Reptile of Gneiss tormenting men dig and bore and blast: driving tunnels through its vitals; scooping holes for sub-cellars five floors under ground; running water pipes and gas mains; puncturing its skin with hypodermics of steam; weighting it with skyscrapers, the dismal streets below dark as sunless ravines; plastering its sides with grass bordered by asphalt into which scraggly shrubs are stuck—and as a crowning indignity—criss-crossing its backbone with centipedes of steel, highways for endless puffing trains belching heat and gas.

This has been going on in constantly increasing malevolence since the Dutch landed, and will continue to go on until three or four, or perhaps six, brand-new cities, each one exactly above the other, are piled on top of the poor beast. What will happen then, especially if it loses all patience and some fine morning gives an angry shiver, as would an old horse shaking off flies, a lucky survivor near the Golden Gate may know, but no one questions that it would be unpleasant for the flies.

White, *Here*, p. 55

Trucks will appear late at night to plant tall trees surreptitiously, their roots to mingle with the intestines of the town.

Conrad, p. 137

The postal tubes in skyscrapers as ducts traveling through the city's frigid, nonvisceral body. Letters posted on the fiftieth floor would catch fire from static irritation before they reached the ground; to guard against this, the conduits are iced.

Brook, p. 63

Burrowing through the innards of a prestigious skyscraper.

Jones, *Modernism*, p. 224

Fresh raw effluence flowing from the city's body.

Conrad, p. 117

New York is subject to a kind of alimentary decomposition. In its transit through the body the city has been ingested impressionistically and regurgitated abstractly, consumed as material or sensual food but transformed into an innutritious idea or a conceit.

Ibid., p. 181

An uncladding of the orifices, its excretory back door which shunts off the rejected to the river, the asylums, the potter's field.

Mumford, "Intolerable," pp. 283–93

The mouths of our great cities are gigantic hoppers. Into them pour the foods we coax from the earth, the energy we snare from the sun, the metals we disembowel, the men and women we draw from the sampler communities.

∟ Body — City as Body

What now is the container of multitudes? A gormandizing maw, able to ingest all those edibles; an overstocked store; a groaning garbage truck. The city swells to offer bodily hospitality to all the things which chance to be in it at the moment. The epic motive of the city's founder was to prove the necessity of the place. Now, however, the city is content to seem a product of happenstance.

Conrad, p. 323

His eyes penetrate the Empire State Building's skin, "paring / The white shaft stark to its thrusting steel."

Sharpe, p. 240

The skyscrapers of the city are a collection of hard-ons zeroing in on Brooklyn.

Flaherty, p. 64

But [Joseph] Stella, who called the city "she," and who said, "New York is my wife—I always come back to her," refuses phallic skyscraper imagery.

Sharpe, p. 204

Since the city's architecture is grisly biology, not celibate mechanism, Dalí interprets the skyline priapically. From the ship, he sees Manhattan as the rearing multiple erection of some couchant, many-phallused monster. After sunset, lights burst on in the skyscrapers as if in response to a libidinal massage, which caresses the prongs until, Dalí says, they void themselves in the sky's vagina. Traveling on the subway also inserts you, through the door of a gash into that body. Dalí declares that the cars run "not on iron rails" but "on rails of calves' lungs."

Conrad, p. 146

Suffering from "an edifice complex."

Federal Writers, <i>Panorama</i>, p. 13

Christo, suggesting that the outer garments matter more than what's beneath them, has fetishized the skyscrapers. We enjoy them by dressing them up, not by unclothing them. So long as we don't violate their casing, they'll guarantee us that joy forever. Without satiation there can be no wearying. He's reconciled to the consumability of his projects, which he calls temporary monuments.

Conrad, p. 312

The streets of New York pulse with warm blood and a feeling of animal love, symbolized by the throbbing fountain in Madison Square with its eruptive, ejaculatory spurts.

<i>Ibid.</i>, p. 92

Manhattan, as they neared it from the north, looked like the coda to the urban-erotic, the garter and stocking-top patterning of its loops and bridges now doing service as supports and braces, hernia frames. Above it all, the poised hypodermic of the Empire State.

Kingwell, p. 89

If skyscrapers get people excited, what kind of bodies do they have?

Sharpe, p. 240

Longing made concrete.

Kingwell, p. 56

The reason people look longingly at a sparkling skyscraper is because the beauty of the human form has inspired it.

Sharpe, p. 240

My City, my beloved,
Thou art a maid with no breasts,
Thou art slender as a silver reed.

Pound, <i>Personæ</i>, p. 58

The gaze is likely to be male, and the city as object is likely to be female.

Sharpe, p. 233

Quan, p. 8

Leaving the East Seventies is like getting squeezed out of a grid-shaped womb into wide-avenued *anarchy*.

Henry, *Four Million*, p. 135

He sees a congested flood of wagons, trucks, cabs, vans and street cars filling the vast space where Broadway, Sixth Avenue and Thirty-fourth street cross one another as a twenty-six inch maiden fills her twenty-two inch girdle.

Conrad, p. 90

New York anatomized as a plumply appetizing woman's body.

Jobs, p. 139

Newspapers referred to New York as a "she" or sometimes as the soldiers' mother.

Black, *Thrust*, p. 39

Now the skyscraper, stroked in graphite and color
On the thin whiteness of woven paper
Flamed suddenly like the mounting stillness
Of thighs, loins, breasts, lips,
Not steel but flesh, its straightness softened
By slight curving until it rose
Newly whole, like a woman poised
Meaningless and serene, her feet pressing the earth.

Conrad, p. 90

The city is lovingly stripped of the defenses in which it's clad and shown to be a body, warmly comforting and carnally needy.

Blandford, p. 148

The city has a gaunt look. The buildings are stark; they jab at the heavy skies.

Kittler, p. 718

It is common in the open spaces of the city to see the skeletal infrastructure on the backside of a building.

N. cit.

The city has such big feet and such small hands.

Conrad, p. 232

South Street beats time with bony hands.

Ibid., p. 277

The city's deposit of grime and dust is its membrane of complicity. He is taking New York's fingerprints.

Huxtable, *Goodbye*, p. 85

It isn't that New York has no muscle; it has no vision.

Jones, *Modernism*, p. 180

Subways being carved out of the flesh of the city.

Conrad, p. 203

Dozing on Riverside Drive, the buildings of lower Manhattan trudge uptown. They are the city's ghoulish spirits, departing from the gargantuanly lustful body which has been snuffed out that night. The Statue of Liberty has doused her torch, and the Brooklyn Bridge crawls along, rattling skeletally, its cables making a most unearthly racket.

Ibid., p. 92

The searchlight from Madison Square Garden scratching the belly of the sky and tickling the buildings.

Gorky, "Boredom," p. 311

The skyscrapers are built of wood, and smeared over with peeling white paint, which gives them the appearance of suffering with the same skin disease.

Peretti, p. 107

He professed to understand why skyscraper massiveness might have driven others to street level. "There is no question but that a body breaks of its own weight."

L Body — City as Body

The city relaxes into what Léger calls *la vie méchanique*, freed from the importunings of the perishable human organism. He notes that in New York everyone smokes, even the streets. He couples the human habit with the mechanical exhalation of subterranean steam because smoking, properly understood, chastens the body's cravings. It subdues greedy organism to disciplined machine: a girl tells Léger that it's good to smoke during a meal because it distracts your appetite and saves you from getting fat … The city ought to learn the appetite-suppressing wisdom of Léger's girl with her cigarettes between courses.

Conrad, pp. 137–8, 139

A broad chest usually means healthy lungs. Now, Manhattan Island is notoriously narrow-chested. Her scanty space across is not redeemed by greater length. Crowded with humans and their houses, there is consequently little space for the expansion of her normal breathing powers. Her lungs, i.e., her parks, are contracted and not enough of them; there never will be. But more than some people think.

Huneker, p. 396

It was Edmund Burke who first coined the famous description of parks as "the lungs of the city."

Rybczynski, p. 50

The subway mined through a neurotic individual brain.

Conrad, p. 233

I love this hairy city.
It's wrinkled like a detective story
and noisy and getting fat and smudged
lids hood the sharp hard black eyes.

O'Hara, p. 198

The Elusive Tenderloin: the cavity that had been drilled in the city's tooth, soon to be filed with the new gold subway.

Conrad, p. 90

West 42nd Street is the "inflamed appendix" of Broadway, while Bryant Park with its inexplicable excavations is a carious mouth.

*Ibid.*, p. 296

Windows are the eyes of buildings, the outlets of consciousness. If you can see in through them, you live in a city of commonality.

*Ibid.*, p. 103

In what part of the body of a Manhattan Islander is the New York located?

Girdner, p. 28

The economy of New York exists to cater to the exigent, opulent body. The streets are loud with advertisements for tattoos, permanent waves, and cosmetic aids.

Conrad, p. 97

The tribal fetishes of the two cities float into propinquity. El stations and sidewalk cafés are ranked as interchangeable amenities, and the lean needle of the Chrysler Building, tilted on its side, aims itself in the direction of a shapely Parisian leg.

*Ibid.*, p. 125

Both the body and the city are intensifying grids for simultaneously social and psychic meanings, produced in the mobile, conflictual fusion of power, desire and disgust.

Jones, *Modernism*, p. 169

His nervous system gets intertwined with that of the Metropolis.

Koolhaas, p. 164

In a taxi on Lafayette Street, Charley Anderson in U.S.A. travels on a stream of metal, glass, upholstery, overcoats, haberdashery, flesh and blood … moving uptown.

Conrad, p. 195

Henry, *Voice*, pp. 4–5 I have a fancy that every city has a voice. Each one has something to say to the one who can hear it … Chicago says, unhesitatingly, "I will"; Philadelphia says, "I should"; New Orleans says, "I used to"; Louisville says, "Don't care if I do"; St. Louis says, "Excuse me"; Pittsburgh says, "Smoke up." Now, New York—

Ibid., p. 8 Now, you can't put New York into a note unless it's better indorsed than that. But give me an idea of what it would say if it should speak. It is bound to be a mighty and far-reaching utterance. To arrive at it we must take the tremendous crash of the chords of the day's traffic, the laughter and music of the night, the solemn tones of Dr. Parkhurst, the ragtime, the weeping, the stealthy hum of cab-wheels, the shout of the press agent, the tinkle of fountains on the roof gardens, the hullabaloo of the strawberry vender and the covers of *Everybody's Magazine*, the whispers of the lovers in the parks—all these sounds must go into your Voice—not combined, but mixed, and of the mixture an essence made; and of the essence an extract—an audible extract, of which one drop shall form the thing we seek.

The Body in the City

Conrad, p. 296 Estimating the nervy, toxic toll of the city on its people, who inhale poisonous air, are squeezed and stifled in the subway, and have their organs nauseously rearranged in elevators.

Didion, "Goodbye," pp. 168–77 I could feel the soft air blowing from a subway grating on my legs.

Conrad, p. 239 It shuddered at the vibration of passing trains, and his body shivered with it.

Ibid., p. 296 The city lunges from boom to crash as one's entrails become tight and metallic. Blood and guts change to ethyl and duralumin.

Ibid., p. 95 The modern city so discourages our physical existence that improving on your body becomes a fanatical specialism, and once you have labored to perfect it, you're trapped inside it.

Talese, p. 2 New Yorkers blink twenty-eight times a minute, but forty when tense.

Ibid. Most popcorn chewers at Yankee Stadium stop chewing momentarily just before the first pitch.

Ibid. 150,000 walk though the city wearing eyes of glass and plastic.

Ibid. A Park Avenue doorman has parts of three bullets in his head—there since World War I.

Ibid., p. 3 Each month one hundred pounds of hair are delivered to Louis Feder at 545 Fifth Avenue, where blond hairpieces are made from German women's hair; and brunette hairpieces from French and Italian women's hair.

Ibid., p. 26 Each weekday over 4,000,000 riders pass these money changers who seem to have neither heads, faces, nor personalities—only fingers.

Ibid., p. 2 Gum chewers on Macy's escalators stop chewing momentarily just before they get off—to concentrate on the last step.

The male body begets a girder.

Unselfconscious New Yorkers stripping in their rooms.

Ibid., p. 95

Alone
in the empty streets of New York
I am its dirty feet and head

O'Hara, p. 228

You could hear his toenails scraping along the sidewalk.

Wolfe, *Bonfire*, p. 15

Punching a keyboard in disgust, or pressing too hard on a pen in our anxiety.

Amin and Thrift, p. 86

On Edward Hopper: "New York in *dishabille*, its shop windows bulging with corsets and ample brassieres, its inhabitants disheveled in their furnished rooms or sleeping undressed on rooftops during the summer or baring themselves at their windows or cheerily urinating in the gutter or ogling the legs of girls whose skirts flare in the hot drafts on the subway stairs."

Conrad, p. 89

The overly angular architect is seated at his desk with rectilinear lighted buildings visible through the window behind him. With a blueprint spread before him, he stares straight ahead; he holds out a T-square in his left hand and makes a right angle of the fingers on his right hand. Reflected in the window glass on the left we can see the object of his measuring gaze: a naked man stands before him in a life-class pose, at once natural and monumental. The skyscraper that rises in the background distance above the architect's head is the consummation of his vision, the supple proportions of the male body transformed into soaring glass and steel. As an emblem of male-male desire, both its yearning and fulfillment, the homosexual tower avoids the woman question entirely, along with the transgenderings that entangle the heterosexual lover of tall buildings.

Sharpe, p. 240

The rubbery elasticity of the jazz-dancing body, liquidizing its limbs and curvaceously grooving, corresponds to the fluctuant nature of De Casseres's city. To him New York is a sensorium of fickly migrating pleasures. The centers of nervous or erogenous sensitivity aren't fixed; they float about in quest of new intensities, like Baudelaire's drunken boat … This mobility of pleasure zones suggests to De Casseres a New York whose body is rendered fluid by desire, its internal organs spurning allocation to a single place and function but circulating in a hedonistic flux. The gambling centers are constantly on the move, the outlets for whiskey change once a month, the fashionable social precinct moves steadily north.

Conrad, pp. 205–6

The understanding of space cannot reduce the lived to the conceived, nor the body to a geometric or optical abstraction. On the contrary: this understanding must begin with the lived and the body, that is, from a space occupied by an organic, living, and thinking being. This being has (is) its space, circumscribed in its immediate surroundings, but threatened or favored by that which is distant. Within the reach of the body, that is, of the hands, it is what is useful or harmful to it; beyond this proximity begins a social space that stretches out without well-defined limits into physical and cosmic space. Three indistinct spheres and zones: the mental, the social, the cosmic—the lived body, the close, the distant.

Lefebvre, *Stage*, p. 229

Survival in the city isn't biological engagement with it but a blissful capacity not to hear, see, or smell it.

Conrad, p. 187

Crane, "The Bridge," p. 76

And to be ... Hereby the River that is East—
Here at the waters' edge the hands drop memory;
Shadowless in that abyss they unaccounting lie.

Conrad, p. 97

The only bodies the city can supply Reginald Marsh with are, unlike those girls of Sloan who bathe near open windows or lift their skirts to leap over fire hydrants, bulbous and bovine. Or else dead. Sloan understood in advance the miscegenation of the urban body, predicting its mechanization, when in 1908 he paused to watch a crowd on Sixth Avenue admiring a dummy in a shop window. The mannequin sported a sheath gown slit to the knee. Through the slit, however, she extended a wooden leg.

Ibid.

A watercolor of 1944, looking out from [Marsh's] studio window on Union Square at S. Klein's "Fat Men's Shop," derives a political reassurance from the body's sated placidity. The store's banner depicts a leering gourmand, his naked belly and thighs distending his swimming trunks. Underneath is printed his Falstaffian philosophy of pastoral nonaggression: "If everybody was fat there would be no war."

Ibid., pp. 115–16

Picabia's first act of abstract defiance was his refusal to paint what his eye saw in New York. His city forfeits this anecdotal abundance. Picabia absorbed impressions only to overcome them. He had passed, he explained, "entirely beyond the material, therefore there is nothing materialistic in my studies of New York nor anything sensual." He painted what his brain saw, a conceptual, not an actual, New York, a huddle of jostling oblongs and aspiring triangles plastically corresponding to the élan he felt in the buildings, bridges, and hurrying avenues. As he says in the title of a 1913 watercolor, his is a "New York seen through the body."

O'Connell, p. 137

A week in New York is like being rolled naked in metal filings.

Mumford, *Sidewalk*, p. 26

Men and women, if they survived in this environment, did so at the price of some sort of psychical dismemberment or paralysis. They sought to compensate themselves for their withered members by dwelling on the material satisfactions of this metropolitan life: how fresh fruits and vegetables came from California and Africa, thanks to refrigeration, how bathtubs and sanitary plumbing offset the undiminished dirt and the growing tendency toward constipation, how finally the sun lamps that were bought by the well-to-do overcame the lack of real sunlight in these misplanned domestic quarters. Mechanical apparatus, the refinements of scientific knowledge and of inventive ingenuity, would stay the process of deterioration for a time.

Gopnik, p. 228

Exercise from the seventies through the nineties, for a certain class of New Yorkers, was what communion and confession were for Italian peasants—not means but ends, not paths to heaven but the Godhead itself. If you "worked out," you did not need to succeed at it—in fact, no one *did* succeed at it, really, no one seemed much thinner or stronger or (aside from a few gay men and professional athletes) truly altered.

Considering the total number of hours spent in the gym, one would have expected a city of Samsons, a metropolis of Babe Didriksons. Instead, people went on dieting, and the gym existed as the church does in a Sicilian village, as a gathering place, an intermediate institution, where fitness, like grace, would eventually descend on your head just from being there—and if it didn't, what of it, death was a long way off, and the body, like the Mediterranean God, was forgetful, largely forgiving.

On a balcony five stories above the street, a man lying on his back with his hips in the air was being put through his morning exercises by a Swedish masseur. The tired middle-aged legs went up and down like pistons. Like pistons, the elevators rose and fell in all the buildings overlooking the park.

Maxwell, p. 402

Gothamites prefer to eschew extravertical wall climbing, trail biking, or parasailing.

Deák, p. 374

I've just returned from Berlin where my fingernails grew the longest that they've ever grown. Now I don't chew my nails or pick them but they never grow as rapidly in New York City.

Mueller, p. 240

I've noticed that my hair and nails grow better whenever I leave New York for extended periods.

Ibid.

I had come to New York to seduce a girl—but when I got to New York I didn't recognize her, because she'd changed her face. She had gotten plastic surgery.

McNeil and McCain, p. 149

Monitoring the city's financial health by studying the flailing, thrashing exuberance of the urban body.

Conrad, p. 92

Bowery skin peckers.

Talese, p. 100

A forest of hands, picking their way across keyboards, clicking mice, gripping steering wheels.

Amin and Thrift, p. 86

AIDS

Having this virus and watching guys have sex and ignoring the invitation to join in is like walking in between raindrops.

Wojnarowicz, p. 244

When I've gone to a movie house periodically to jerk off, there are at times men who approach me and begin to lick my throat or kiss my hands or jerk off next to me or try to kiss me and I sometimes allow a measure of touch and suddenly this guy's head attempts to go further and with the weight of my hand I prevent him. I feel comfortable to take responsibility to prevent him from doing anything that is dangerous to himself, but I also recognize in that moment that he has released himself from responsibility for himself. He submits to desire which negates death for him, which negates the possibility of death. The virus is invisible to the eye for both of us in that moment, but the pushing motion of my hand against his forehead even if he struggles with all his might in order to force me to let him do what he wants, my hand is like iron, I won't let him pass this line of desire. If I were to speak and tell him I have this virus in my body, he might flee or he might be angry because he kissed my neck or licked my chest, or he might not care and want to chance doing what he wants, which is to suck my dick. Sometimes a guy will get angry at me for not allowing him to do what he wishes and then go off down the aisle and immediately start blowing someone who will let him do what he wants. Some of these guys stay all day in the movie house and blow dozens of men. Everything is in motion inside the dark confines of this theater that shows blurry porno flicks on a cheap unfolded screen, and life and death is simultaneously being hatched, structures of life and death, plans of life and death are being made by physical communications and gestures. This guy doesn't trust the idea

Ibid., pp. 233–4

or concept of death enough to take his own precautions, or else maybe he feels it's too late to worry because of his history and the possibility that he already has the virus and that in the mechanics of sex many people don't believe it is highly possible to transmit the virus orally if they refrain from swallowing semen. I don't know what it is he thinks but I feel safe in what I allow or don't allow in terms of touch by fingers or tongue, all of it confined to the external and the areas free of seminal contact, but it also makes me wonder about the machinations of the world and the fragmentations of social order and disorder, all shifting simultaneously and creating designs and patterns that we call the world, that we call life. And I'm still wondering what that twelve years makes in terms of a difference beyond the frail human structure we call society and the world and personal activities that make up our lives. I guess I'm still trying to understand some concept of life in measurement against the universe and life/death cycles or capsules. What does that twelve years mean? to him? to me? to all whom we interact with? What does it mean outside the time we refer to as life? What does it mean to our selves? What does it mean?

Haring, pp. 162–3 For I am quite aware of the chance that I have or will have AIDS. The odds are very great and, in fact, the symptoms already exist. My friends are dropping like flies and I know in my heart that it is only divine intervention that has kept me alive this long. I don't know if I have five months or five years, but I know my days are numbered … I'm not really scared of AIDS. Not for myself. I'm scared of having to watch more people die in front of me … I refuse to die like that. If the time comes, I think suicide is much more dignified and much easier on friends and loved ones. Nobody deserves to watch this kind of slow death … most artists have this understanding of the world that separates them from it, but only some of them are truly special in a way that they can touch other peoples' lives and pass through them. I'm sure when I die, I won't really die, because I live in many people.

McCourt, p. 327 Some realized the cruel irony of the obviating ubiquity of "I Will Survive," the disco anthem, at a time when the dancers were already succumbing to amoebiasis and taking every drug there was in the world to go on dancing.

Ibid., p. 435 "I Will Survive" and "I'm Gonna Live Forever" slow to dirge tempo, as if the DJ were leaning on the needle. Disco dies. A mourner laments in form.

Ellis, Psycho, p. 34 "Yeah, but they think AIDS is a new band from England," Price points out.

McCourt, p. 435 On the public response in the early days of the epidemic: the great smear of mortality across the picture, the dirty mark of pain and horror, found in few quarters a surface of spirit or speech consenting to reflect it.

Meltzer, p. 189 Great Moments in Irrational AIDS Fear. Buy a paper at *any newsstand* in Manhattan, try to give 'em exact change, aim specifically for their hand, and they will not take it.

Atkins, p. 238 "On me, not in me" became a mantra of safer sex.

McCourt, p. 327 A virus has no morals.

Murphy, "7 New Yorkers" John was at the dentist and under the hygienist's vigorous scraping, his gums started to bleed and wouldn't stop. The hygienist applied gauze, but nothing seemed to stanch the flow. The dentist became quite perplexed and admitted John to Bellevue for tests.

"It seems my blood has lost the ability to clot," John told me over the phone from the hospital. "They want to check me for all kinds of things. They're testing my blood for platelets, whatever they are."

"Well, I'm sure it's no big deal," I lied, vaguely aware of some disturbing rumors that had been afoot about some gay men who were sick. "I'll come by later today and visit."

Surely this "gay cancer" could only affect older West Village mustached disco queens who went to the baths every day, not youthful smooth-faced East Village anarchist performance artists in skinny neckties.

I was wrong about that.

One gentleman, James Johnson, worked in the publicity department at Paramount Pictures and would invite me to movie screenings. By the end of the summer, he and the other two black guys in the building were dead. I would run into each of them frequently enough, but I never saw any of them deteriorate. It was that fast. So fast that the landlord was having trouble turning over the rent-stabilized apartments, so I was able to secure one for another college buddy. *Ibid.*

A couple of years later, the *Times* obits section was commonly referred to as the Gay Sports Page, because we would count the number of apparent AIDS-related deaths before checking the other news. *Ibid.*

Over scrambled eggs, Rupert casually said, "I guess you've heard about Robert," referring to someone I was fond of and had dated. *Ibid.*

I felt a chill. "No, what about Robert?" I asked.

"I heard he's got it," was all Rupert needed to say.

Then my attention fixed on a small oblong purple spot near Patrick's left earlobe. It was about as wide as the tip of a pencil eraser and about the same color … Rupert took a peek, and his face changed. "I don't think that was there a couple of days ago," he said. Patrick, who could be prickly, said belligerently, "What? Now you think I have AIDS? Thanks a lot!" *Ibid.*

He left the table to look in the bathroom mirror and returned with an ashen face. I felt guilty, like it was my fault for having noticed the spot.

I actually, by the way, saw five or six "AIDS beggars"—emaciated, scabby guys moaning, "I've got AIDS … feed me." *Ibid.*

Everyone designed rituals around AIDS: Rituals for a Cure, rituals for understanding, rituals to send energy to distant Positives, rituals to zap coven members in travail, rituals to build T-helper cells. McCourt, p. 437

Demonstrators "died" in front of the 5:33 to Harrison. They "died" on the steps to Vanderbilt Avenue. They formed a human chain to prevent commuters from reaching trains. They skeined red tape across the platform doorways. They splashed bags of blood on the terminal floor. Trebay, p. 257

THE THING THAT'S IMPORTANT ABOUT MEMORIALS IS THEY BRING A PRIVATE GRIEF OUT OF THE SELF AND MAKE IT A LITTLE MORE PUBLIC WHICH ALLOWS FOR COMMUNICATIVE TRANSITION, PEELS AWAY ISOLATION, BUT THE MEMORIAL IS IN ITSELF STILL AN ACCEPTANCE OF IMMOBILITY, INACTIVITY. TOO MANY TIMES I'VE SEEN THE COMMUNITY BRUSH OFF ITS MEMORIAL CLOTHES, ITS GRIEVING CLOTHES, AND GATHER IN THE CONFINES OF AT LEAST FOUR WALLS AND UTTER WORDS OR Wojnarowicz, p. 206

SONGS OF BEAUTY TO ACKNOWLEDGE THE PASSING OF ONE OF ITS CHILDREN / PARENTS / LOVERS BUT AFTER THE MEMORIAL THEY RETURN HOME AND WAIT FOR THE NEXT PASSING, THE NEXT DEATH. IT'S IMPORTANT TO MARK THAT TIME OR MOMENT OF DEATH. IT'S HEALTHY TO MAKE THE PRIVATE PUBLIC, BUT THE WALLS OF THE ROOM OR CHAPEL ARE THIN AND UNNECESSARY. ONE SIMPLE STEP CAN BRING IT OUT INTO A MORE PUBLIC SPACE. DON'T GIVE ME A MEMORIAL IF I DIE. GIVE ME A DEMONSTRATION.

Ibid., p. 211

I don't want to think of death or virus or illness and that sense of removal that aloneness in illness with everyone as witness of your silent decline that can only be the worst part aside from making oneself accept the burden of making acceptance with the idea of departure of dying of becoming dead.

Ibid., p. 213

I fight this weariness from drugs and take a glimpse of sunlight as a conducive shot of movement of excitement of living but these drugs make me weary and frustrated.

Ibid., p. 220

(that's the thing about watching someone die, you turn from the deathbed or the sidewalk and then look out the window or down the street and the world is still in motion and that's both a tragic and beautiful part of it)

Ibid., p. 232

I thought of the "AIDS Monster" headlines of the *New York Post* a few years ago: some guy on Long Island with AIDS paid a few dollars periodically to suck the dicks of teenagers.

Ibid., p. 235

The body is a conduit, a receptor of symbols or energy or merely moving forward drifting through the urban scenery waiting for a dozen signals to intersect the right way as to surprise, open the eyes, stir the senses, find me, and unexpected hard-on.

Ibid., p. 263

All your faces, the faces of those who are not dying have become echoes.

Bytsura

I was arrested in clown attire while throwing condoms + confetti in the middle of 5th Avenue.

Blotcher

WHEN I JOINED ACT UP, I WAS A NICE JEWISH BOY FROM THE SUBURBS, AND I WAS FORCED TO UNLEARN THE PRETTY LIES THAT SOCIETY DRILLS INTO US TO KEEP US IN CHECK: THAT THE POLICEMAN IS OUR FRIEND, THAT THE GOVERNMENT WILL TAKE CARE OF US, AND THAT "GOOD" PEOPLE DON'T LIE DOWN IN THE MIDDLE OF THE STREET AND GET ARRESTED.

Lott

AIDS isn't a disease anymore, it's a media event.

Mueller, p. 242

And don't worry about AIDS, for God's sake … if you don't have it now, you won't get it. By now we've all been in some form of contact with it … not everybody gets it, only those predisposed to it. If everyone got it that was introduced to it, half the population would be on death's door by now.

McCourt, p. 332

Herpes and hepatitis; *everybody* is getting transfusions, as if indeed Dracula were loose in Gotham.

L Body —— AIDS

Next year I predict a change in what is considered fashionable as far as body size goes. No longer will people want to be svelte and lean. Fat will be in because where there is fat you can be sure there is no AIDS. People by then will be terrified to align themselves with skinny people. Fashion, as we all know, is based on sexual attractions. Mueller, p. 245

You don't get AIDS through the air, or from even looking into the eyes of a victim or even from shaking their hand. You don't have to put yourself in a plastic bag. You could just as easily be hit by a car and die while you're not looking where you're going when fleeing a very skinny person you think has it. Everybody now living in this city takes their chances every day. Ibid.

Fortunately I am not the first person to tell you that you will never die. You simply lose your body. You will be the same except you won't have to worry about rent or mortgages or fashionable clothes. You will be released from sexual obsessions. You will not have drug addictions. You will not need alcohol. You will not have to worry about cellulite or cigarettes or cancer or AIDS or venereal disease. You will be free. Ibid., p. v

Larry Kramer and I disagree on almost everything, especially on his use of holocaust imagery, but he lost an entire life network. He would say that he had five hundred friends and acquaintances who had died. If you think about it, that's the size of a small town in Germany. Ingram

All the advertising on the subways in New York was about women taking condoms with them in their purse. It would say, "Don't forget these when you go out," as if women wore condoms. Ibid.

We began to throw around crazy ideas. One woman was absolutely panicked. She had absolutely never had anything to do with sports. But everybody else in the room was taking off on it. Two of the women were baseball nuts, so we finally decided this was the best idea we ever had, and we sat down and really worked out a plan. We were gonna get tickets in blocks. Shea Stadium is U-shaped. We planned to get seating in blocks in the three different areas of the "U" and that we would do "call-and-response" like you do at college football games. We called up Shea Stadium and found out that in fact there was a ball game that night and that we could get blocks of seats and that if you bought sixty seats, you could even get a message on the message board! And we thought, "Wow, this is fucking amazing!" Ibid.

When we came to the floor of ACT UP and we presented the Shea Stadium Action as our Nine Days of Action thing, the room became dead silent. Panic was in the air, absolute panic. So people started to stand up and speak. First, we got the "class" stuff. "We're gonna get beaten to death there," and we're standing there very calmly saying, "Do you know who goes to Shea Stadium? We go to Shea Stadium. Kids go to Shea Stadium on Friday nights to pick each other up. Queers go to Shea Stadium." And in the room all of a sudden the closeted baseball queers started standing up. All these gay men who wouldn't tell anyone they were baseball nuts because it's not the "thing to be," and they started saying, "Yeah! I go to Shea Stadium." So we finally got people to go.

We had reconnoitered the Stadium beforehand, found the seats we had just bought, measured them all out. We had rulers so that we could make banners that were exactly the right length. We also went to a night game to check out the lighting and to figure out how big the letters would have to be to be seen.

Word of this got out. In the beginning we could hardly get anybody to buy seats. By the last day, I was getting phone calls from people I hadn't heard from

in years from the left because the word had gotten out that this was gonna be the most amazing thing that had ever happened, and people were acting like I was their connection for a seat in the orchestra. They'd say, "Do you have seats at Shea Stadium?" and I'd say, "No, I don't." So it actually turned out to be quite amazing because we ended up selling around 400 tickets.

At Shea Stadium we had people spread in three different sections and there was also a whole big issue about standing outside and handing out these leaflets. Because Shea Stadium is owned by the City of New York, but the Mets rent it, anything that happens in Shea Stadium is in relationship to the Mets. The parking lot is owned by Kinney or was then. That's private property. They can decide what happens in the parking lot. But there's a whole space that is not really either publicly or privately owned or leased—almost like a street or plaza that goes around the entrances to the stadium, that looks like a sidewalk but a big sidewalk and that is not the parking lot and is not the stadium. We could not find out for weeks who it belonged to. We wanted to know, if we were going to get arrested, what it was we would be getting arrested for. Were we on private property or public property? Who knew? And we kept trying to get in touch with Shea Stadium. We also wanted to get in touch with them because we wanted the Mets to declare this National Woman and AIDS Day, and we left them many messages and they never called us back. And by that time, ACT UP had a reputation for doing things. Especially the women, because we had just done another demonstration in January, and the police nearly went crazy because we did not ask the city and the police for permits.

We had coming up on the LED screen a message that said "Welcome the National Women and AIDS Day Committee," and we did not think we'd have any trouble getting in because we had tickets. But giving out these flyers outside, that we thought we would end up getting arrested for. About a week and a half before this whole thing was going to happen, some guy wrote a story in the *Village Voice* about ACT UP that mentioned we were going to Shea Stadium. A friend of mine who was actually working with Shea Stadium on a totally different thing—she was working with them on a performance art thing that was going to be happening in their parking lot, and they did not know that she had anything to do with ACT UP—was there one day when the guy she was working with was talking to the community/police liaison. The officer was saying, "Did you hear? These crazy people are coming to the ballpark next week—these ACT UP people—and they're going to rip up the turf and they're going to do this and we're going to do that." And we thought, "Holy shit, we're going to show up, and they're going to be in riot gear!" And we weren't even doing anything that provocative, from our point of view. I mean we saw this as an educational action. There was nothing we wanted from Shea Stadium. So we actually thought of this as a lighthearted but hard-hitting educational action because it would be in a place where no one would ever expect us to be.

So we got one of the women to call up the cops—not to ask for a permit. She said, "You know, we've been trying to get in touch with Shea Stadium for three and a half months and nobody has called us back. We just wanted to let you know that we're going to be out there on Wednesday night, and we just did not want you to maybe get freaked that we were coming." And of course, when he started asking questions like "How many?" she just said, "Well, I don't know, but we just wanted you to know." So it wouldn't be this kind of riot gear kind of thing. When we got there, they had spoken to the people at Shea Stadium, and the head of their public relations department came out and put our leaflets in every one of their press packets, and he made sure that we could stand at every single doorway and give out all of our stuff. It was great, but we hadn't negotiated; we just went.

It was the most amazing thing because we had made these banners with a black background and white lettering. We had six long rows in each area and each row had a set of banners, and we only opened them up when the visiting team was up because we did not want to upset the New York Mets fans. At a certain point, I do not remember what inning it was, the first banners opened up. They started at the top of the group and they were always three lines. And the first one opened up and it said, "Don't balk at safe sex." And then across the stadium, opposite them, in the seats above the other field, three banners rolled open and they said "AIDS kills women," and then in the center, behind home plate, the next three opened up and they said "Men! Use condoms."

And then, people from ACT UP got so into having these banners that people started swaying back and forth, up and down, and the visual effect was incredible because it was at night, totally dark, and the lighting from the ballpark totally reflected the white letters of the banners. An inning and a half later, we opened the next set of banners. They said "Strike out AIDS," "No glove, no love," and the final one said "SILENCE=DEATH" and it had a huge triangle and ACT UP! This was on C-Span. We not only got to the twenty thousand people who were in the ballpark, but it was televised around the country and we gave out leaflets. We reached an incredible number of people in an audience that we'd otherwise never have been able to get to. Most of the people came from ACT UP, but many people from other groups got wind of it and thought it was the most exciting thing.

I mean, some people got all decked out and dressed up, and people were making out in the bleachers of Shea Stadium.

Schulman and Hubbard, "Katz"

A friend of mine in New York City has a half-fare transit card, which means that you get on buses and subways for half price. And the other day, when he showed his card to the token attendant, the attendant asked what his disability was and he said, I have AIDS. And the attendant said, no you don't, if you had AIDS, you'd be home dying. And so, I wanted to speak out today as a person with AIDS who is not dying.

Russo

Thank you for coming to New York City, the epicenter of the AIDS epidemic.

Finkelstein

Gregg, when you go to New York, there will be people who tell you that you can get cancer from certain kinds of gay sex. That's not true. They just want us not to be able to have sex. So you can't get cancer from anal sex. There's no such thing as gay cancer.

Schulman and Hubbard, "Bordowitz"

The feeling of ACT UP in its heyday—this was like 1988—when the room was packed, and you could hardly get into the ground floor of the Gay Community Center. If the weather was nice, the meeting spills out into the courtyard. There is business happening all over the place. It's very difficult for the people who are actually running the meeting to get the attention of the group. There is all kinds of sexiness going on, as well. There is all kinds of cruising going on on the sides, and eye catching, and chattiness. There was an energy in the group that was amazing, because it was filled with people who had ideas, filled with people who had energies, filled with a kind of erotic energy. And all that came together. It was in some ways like a bazaar of desires. So it was amazing that anything got done. An enormous amount got done.

Ibid.

You know, you would walk around down on Delancey Street, and if you would see someone—it's like dealing, basically. If you see someone who you think

Ibid.

might use needles, you just kind of whispered to them as they passed, "Do you get high?" They would stop, maybe, because they didn't know necessarily what you were offering.

Ibid.

But in ACT UP, you had to kiss everybody, because you couldn't be afraid of people with AIDS. So you had to demonstrate that you were not afraid of people with AIDS. So you had to kiss everyone you met.

Ibid.

It was at Sheridan Square and then we marched down to Sixth Avenue. We stopped traffic and kissed. It was pouring rain.

Lawrence, p. 64

In Brooklyn, there were problems when my friends' mothers would be crying because funeral parlors would not accept the bodies of those people that died from AIDS. Everybody had to come up to 110th Street or something, because nobody in Brooklyn would do it. So the funeral parlors in Harlem were like, "We know you can't catch it." But there was a time when they didn't want to bury people with AIDS in the ground. They thought once they buried a body with AIDS in the ground, you would grow flowers with AIDS.

Frisa and Tonchi, p. 404

How can we forget the clouds of Felix Gonzalez-Torres, the flowers of Nan Goldin or Jack Pierson, the delicate sketches of David Wojnarowicz, profound, simple adherence to the world in the diaries and words of Keith Haring? The illness modifies the body and is accepted by it.

Ellis, *Glamorama*, p. 11

"What about AIDS?"
"Passé. Passé."

Wojnarowicz, p. 211

At times I feel like there's nothing to be afraid about dying. I mean, look at how many people have done so before me.

Pathology

Trager, p. 540

The French freighter Wyoming arrives at New York from Casablanca with a cargo consisting of chiefly wine and tobacco. Casablanca and other Moroccan cities have had an outbreak of bubonic plague in December, but the Wyoming's crew is apparently healthy and she is allowed to unload some bags of mail at Brooklyn's Pier 34. When she begins to discharge cargo at Pier 84 on the Hudson River, however, some longshoremen spot rats: health inspectors find rat droppings. Twenty rats are promptly autopsied. Indications of plague infection show up, tests with guinea pigs confirm that the ship's crates carried the Black Death, but news of the incident is kept from public to avoid any panic. Evidently no rats got ashore.

Caldwell, p. 209

1899: a dog show held in the Metropolitan Opera House a few weeks prior to its opening left a major infestation of fleas in the auditorium's plush seats.

Berger, *New York*, p. 13

The importing of leeches for medicinal use continued in New York City until the mid-1950s.

Haden, p. 132

In 1908 Franz Boas began using "physical anthropology" methods, measuring the skulls of Jewish children in New York, moving on to measuring the heads of new arrivals at the Ellis Island immigration center in New York. He then recruited assistants and spread out to measure head size in New York's immigrant districts.

A comparison of individuals born in Europe with those born in America shows that the change of head-form is almost abrupt at the time of immigration. The child born abroad, even if it is less than one year old at the time of arrival, has the head-form of the European-born. The child born in America, even if born only a few months after the arrival of the parents, has the head-form of the American-born.

Boas, pp. 99–103

Immigrants believed in the medicinal value of blood, and when illness came they went to the abattoirs and bought blood for five cents a glass.

WPA Guide, p. 211

New York's two medicinal industries cater to the extremities of the longsuffering human body, selling pills for throbbing heads and, on a cross street in the 305 between Fifth and Madison, rectifying fallen arches.

N. cit.

Manhattan is an island of cannibals. Here people feed on other people for all their stimulation, information and satisfaction. The eagerness to expose all to another is also the desire to be allowed in return to creep into the other's skin.

Blandford, p. 93

Encephalitis in the New York region: twelve million men dedicated to hard labor.

Corbusier, p. 111

Elevator sickness: "The resulting movement of the organs, and the accompanying pressure of such organs against other parts more rigidly attached to the frame, is the cause of discomfort."

Riesenberg and Alland, p. 75

Getting home, if it's spring or summer, you close the windows to keep out mosquitoes and gnats, you wash out your ears and your nostrils, and cough up the coal dust.

Mayakovsky, *America*, p. 55

L Body — Pathology

Conrad, p. 200 — Things as innocuous as the interior remodeling of houses or traffic jams become polymorphously sexy.

Ibid. — A traffic jam catches two vehicles in the act of coupling: on Broadway near 28th Street a heavy truck had become entangled with a taxi-cab in so intimate a manner as to completely obstruct the pavement.

Ibid., p. 98 — The subway is a tunnel of love. Traveling on it inducts you into the city's erotic underground.

Ibid. — The subway is New York's id, able to trump the competing elevated railway. The El, being above ground, is less duskily sexy.

Ibid. — A romping bacchanal, a feast of blowsy, corpulent, promiscuous gods.

Wolfe, *Bonfire*, p. 53 — It was in the air! It was a wave! Everywhere! Inescapable! … Sex! … There for the taking! … It walked down the street, as bold as you please!

Conrad, p. 200 — The skyscrapers, for instance, are places of business. Their height is strictly utilitarian, a device for maximizing space and increasing revenues. It's therefore necessary to deny their dour usefulness and make them a sensual amenity as inducements to sexual delight: a skyscraper is the most exquisite setting for a passionate love affair which has yet been devised by man.

Ibid., p. 208 — Artists persist in describing their infatuation with New York as a courtship or a wedding.

Ibid. — Joseph Stella connubially declared, "New York is my wife." His paintings of it were their offspring.

Blandford, p. 81 — New York is not a romantic city. It does not choose to be. Romance is soft; so are Paris, Venice.

Conrad, p. 213 — New York is a zoo of lubricity.

Ibid., p. 202 — The eyes of the lions in front of the library on Fifth Avenue are heavy-lidded with the load of sensual experience granaried inside the building.

Ibid., p. 226 — The Brooklyn Bridge symbolizes a stern determination of restraint. It arrests the deliquescent sexual expenditure of the self, opposing to the fluidity of the river and of urban society its solid piers of stone.

Ibid., p. 95 — A celebration of the physical democracy of New York—its undressing of its inhabitants and of its own lusty, greedy urban body.

Conrad, p. 92 — The impressionist city renders sex pastoral, absorbing it into the budding fecundity of nature.

Gooch, p. 329 — That he was already projecting a destiny for the two of them as grand as the approaching skyline of Manhattan was an indication of the eagerness and poetic inspiration that he brought to bear almost instantly on this much-longed-for romance.

Sex M

Coming back from the laundry down First Avenue I and two other inmates, as usual, had to step over sleeping bodies in various positions on the sidewalk. About twenty yards from the halfway house, lying on his back in the middle of the sidewalk, someone was masturbating intensely, straight up to the sky. His eyes were squeezed tightly shut. It should have been amusing, but it was not. None of us could laugh although we tried to see humor in it.

Abbott, "Bowery," p. 84

The last function of the New York pub is to cater to the needs of a serious drinker.

Petronius, p. 14

Bell hops and elevator boys were known to be available for paid sex.

Reay, p. 104

The subway cowboy with a midnight tan.

Roditi, p. 427

Broads who stroll the boardwalk, while often easy, usually have housemaid's knee.

Mortimer and Lait, p. 141

Now that the days are warm again, sex is back on the streets of New York. Outside is no longer a mere conduit for wooly-bundled travelers scurrying between over-heated boxes hoping to achieve some miraculous arrangement of face and form in trundling elevators at their destination. Street life has resumed with all its buzzing excitement; sex has made its annual reappearance.

Blandford, p. 114

Body contact with strangers is to be had only with the battery of doctors or nurses to whom one turns over the machine for its biannual check-up.

Ibid.

kissproof world of plastic toiletseats tampax taxis

Bennett, *Deconstructing*, p. 8

It is dirty
does it look dirty
that's what you think of in the city.

O'Hara, p. 337

does it just seem dirty
that's what you think of in the city
you don't refuse to breathe do you …

General

I remember a rather horsy-looking girl who tried to seduce me on a New York City roof. Although I got it up, I really didn't want to do anything, so I told her that I had a headache.

Brainard

I never think of sex anymore, being wrapped up in work.

Riesenberg and Alland, p. 202

In the burlesques, women with dazzling skin have golden locks, like metal chiseled by a goldsmith, with the vividness of something cut by a chisel. Incisive casques (not vaporous!), clean, curly, dense, lively, full in style. Along with that the woman is a healthy, beautiful animal, a very beautiful animal.

Corbusier, p. 110

Kinsey spent a lot of time in Ross Bar interviewing some of the boys; I was there the night his assistant came, in 1945. Huncke and Allen were interviewed.

Kerouac, *Road*, p. 242

Harris, *Diary*, p. 10

Within the past few months, I have slept with an Italian journalist, a Hispanic teenager from Queens, a NYPD detective who investigates terrorist threats, a Jewish philosophy student attending Northwestern, a graphic artist for an advertising firm, a truck driver, a freelance copy editor, an architecture student at Pratt, a construction worker who specializes in concrete floors, an electrician, a vendor of tickets for local rock concerts, a supervisor at a research laboratory, a luggage inspector at an airport, a "male escort" who claimed to have read Housman and Yeats, a dispatcher for a cab company, and a mad Albanian who nearly kissed me when I mentioned that I had read and liked the novels of Ismail Kadare.

Conrad, p. 92

Watching some girls on swings in Stuyvesant Square who are themselves being ogled at by a fat man.

Petronius, p. 12

There's another female idiosyncrasy peculiar to New York that bears mentioning. Many girls go through periodic withdrawals and isolation. Suddenly extremely prudish, proper, sanctimonious and horrified at their pasts … they take on the responsibility of voluntary self-punishment. They wish to rid themselves of all their old loose living, racy friends and corrupt ways.

Morrison, p. 34

The woman who churned a man's blood as she leaned all alone on a fence by a country road might not expect even to catch his eye in the City. But if she is clipping quickly down the big-city street in heels, swinging her purse, or sitting on a stoop … dangling her shoe from the toes of her foot, the man, reacting to her posture, to soft skin on stone, the weight of the building stressing the delicate, dangling shoe, is captured. And he'd think it was the woman he wanted, and not some combination of curved stone, and a swinging, high-heeled shoe moving in and out of sunlight.

Conrad, p. 92

In one of Sloan's subway etchings, a girl, baring a solid length of leg, sits reading a book. Behind her an advertisement smirkingly recommends "Rub with Sloan's liniment."

Trebay, p. 6

A city of cheater panties and people who know how to use them, a puritan place some of whose famous prelates have been nicknamed Fanny and Joan, a city where a billboard shows a woman sipping from a bottle of brandy beneath the legend, "I could suck on this all night," a city of fugitive sex on phone lines, an electronic territory of states called raunch-and-sleaze, hardcore, discipline, daddy and span.

Conrad, p. 306

Woman eating at 2nd Ave Deli (E 10th St) Fri aft at 4. You had small Barnes & Noble bag w/ you. I'm the man you saw getting his check when you turned around. Call 777-5291 anytime after 2 pm, or 11/11/80, 8:45 PM, Times Sq RR. You were boarding train, we smiled, you seemed interested. Wearing blue jacket, tan pants, brown hair, beard. Tel: 201-648-2306. Mark.

Miles, p. 342

Oh for my New York bed full of teenage boys and lost wandering Tibetan Amphetamine girls of twenty.

Delany, p. 12

On the street, other than to note that he's probably homeless, you wouldn't give him a second look. In a public rest room, at Penn Station or at Port Authority, however, when he stands before a urinal, slouched a leisurely eight to ten inches back from the porcelain fixture, I've never seen anyone *not* at least glance in his direction—astonished, with opened mouth and blinking eyes.

M Sex — General

Suits will stand outside the peep show entrance and give the appearance of casually waiting for someone in a place that just "happens" to be in front of the shop. At other times they may loiter, standing near the curb as if waiting for a cab or bus. The person will stand in these places until it seems that "the coast is clear" and then quickly enter the shop.

McNamara, p. 63

Another technique involves walking by the shop and stopping, appearing to be a curious observer. The customer first looks through the window of the shop and then enters. Hence there is no sense of rushing since, after all, the individual is simply a curious passerby.

He was reputed to be the best gay lay in New York.

Hamilton, p. 143

His eyelashes were long enough now to catch in the boughs should he go for a walk in Washington Square.

Reay, p. 149

All I have to do is step outdoors alone to have boys drop from the sky and roll under his feet; they look up at one (I am told on reliable authority), flutter their lovely black eyelashes, and the deal is made.

Ibid., p. 11

In New York nobody paid any attention to you except now and then a man tried to pick you up in the street or brushed against you in the subway, which was disgusting.

Conrad, p. 189

A woman idling on the street is to be "consumed" and "enjoyed" along with the rest of the sights that the city affords.

Tester, p. 28

The parks of New York were their boudoir. They planked in them all. They were the only ones who had ever made love under the streetlight in the midpoint of the arching stone bridge near the Central Park Zoo, according to the policeman who broke up their coupling at a most urgent mutual moment of just-before-groinflash oblivion; ears aware of the approaching footsteps of Eros, but not of gumshoe.

Sanders, *Beatnik*, p. 6

They tried it, lying up against the little jungle-gym park in Washington Square after the park was closed. They planked on the cinder riding track near 72nd St. on the west side of Central Park and were interrupted by police horses—again at a critical moment. They planked sports-car style on a bench at 72nd on the east side of the park (the same night as the cinder track interruption).

They loved to make it in Inwood Park. One New Year's Eve they climbed high in the rocks above the Columbia University boat basin at the north edge of Inwood, and were lean/lying on a steep icy incline between huge boulders—when, right in the middle, they began to slide, were unable to break it, but still kept fucking, and her buttocks were treated to fifteen feet of thrillies down the twiggy glaciation.

"The condom killed romance, but it has made it a lot easier to get laid," said a friend. "There's something about using a condom that, for women, makes it like sex doesn't count. There's no skin-to-skin contact. So they go to bed with you more easily."

Bushnell

The talk turned to the inevitable: What kind of people go to a sex club? I seemed to be the only one who didn't have a clue. Although no one had been to a sex club, everyone at dinner firmly asserted that the clubgoers would generally be "losers from New Jersey."

Ibid.

Ibid. Le Trapeze was located in a white stone building covered with graffiti. The entrance was discreet, with a rounded metal railing, a downmarket version of the entrance to the Royalton Hotel … What did we see? Well, there was a big room with a huge air mattress, upon which a few blobby couples gamely went at it; there was a "sex chair" (unoccupied) that looked like a spider; there was a chubby woman in a robe, sitting next to a Jacuzzi, smoking; there were couples with glazed eyes (*Night of the Living Sex Zombies*, I thought); and there were many men who appeared to be having trouble keeping up their end of the bargain. But mostly, there were those damn steaming buffet tables (containing what—mini—hot dogs?), and unfortunately, that's pretty much all you need to know … The problem, in the clubs, anyway, always comes down to the people. They're the actresses who can never find work; the failed opera singers, painters, and writers; the lower-management men who will never get to the middle. People who, should they corner you in a bar, will keep you hostage with tales of their ex-spouses and their digestive troubles. They're the people who can't negotiate the system. They're on the fringes, sexually and in life. They're not necessarily the people with whom you want to share your intimate fantasies.

Ibid. Or is there a darker side to threesomes: Are they a symptom of all that's wrong with New York, a product of that combination of desperation and desire particular to Manhattan?

Ibid. Lured perhaps by the promise of free drinks, free joints, and free honey-roasted peanuts, seven men joined me on a recent Monday evening in the basement of a SoHo art gallery to talk about threesomes.

Coleman, p. 274 The most popular place where strangers agree to meet, it seems, are outside the main branch of the New York Public Library, beside the Washington Square Arch, under the clock at the Biltmore and by the information booth in Grand Central Station. At any of these places and many others, says my friend, pretty girls will always be waiting, with at least of few of them waiting for men they've never met.

Ibid. (Incidentally, if you want to invest in a white carnation for your buttonhole, that's fine, but you don't really need it. Research has proved that the most common identification symbol among blind dates is a *New Yorker* magazine tucked under the arm.)

Bushnell And in this city, with all the lawyers and all the overcrowded niche structures, you have incredible pressure. Pressure fucks up the hormones; when the hormones are screwed up, there are more homosexuals; and homosexuality is nature's way of cutting down on population. All of these unnatural things we're talking about exponentially expand.

Turner, *Backward*, p. 127 Man meets woman, man fucks woman … again and again and again.

Bushnell And you go into the bathroom, and you get a blow job from someone in the fashion industry.

Quan, p. 99 In the Ninety-third Street two-bedroom—Carnegie Hill—he pulled my hair to one side and kissed my neck slowly, with a masterful flourish … Then he took my hand and pulled me gently into … the master bedroom. Sunlight. Space. New marble bathroom. Just as promised.

Sex — General

I remember queer bars. Brainard

I remember leaning up against walls in queer bars. *Ibid.*

I remember standing up straight in queer bars. *Ibid.*

I remember suddenly being aware of "how" I am holding my cigarette in *Ibid.*
queer bars.

I remember not liking myself for not picking up boys I probably could pick up *Ibid.*
because of the possibility of being rejected.

I remember deciding at a certain point that I would cut through all the bullshit *Ibid.*
and just go up to boys I liked and say, "Do you want to go home with me?"
and so I tried it. But it didn't work. Except once. And he was drunk. The next
morning he left a card behind with a picture of Jesus on it signed "with love,
Jesus" on the back. He said he was a friend of Allen Ginsberg.

I remember tight white pants. Certain ways of standing. Blond heads of hair. *Ibid.*
And spotted bleached blue jeans.

I remember "baskets." *Ibid.*

I remember "jewels" neatly placed down the left pantleg or the right. *Ibid.*

I remember pretty faces that don't move. *Ibid.*

I remember loud sexy music. Too much beer. Quick glances. And not liking *Ibid.*
myself for playing the game too.

I remember a boy I tried to pick up once. As an opener I told him he had a *Ibid.*
nice nose and he said he was thinking about having it "fixed" and I said no
he shouldn't. He said he was busy that night but he took my phone number.
(Never did call, though.) Maybe I put him off by saying that I thought
psychology was a bit silly. (He was a psychology major.) "Too self-indulgent." I
remember saying. (I was drunk.) Actually his nose was a bit too big.

I remember coming home from queer bars and bawling myself out for not *Ibid.*
having more confidence in myself.

After an unsuccessful night, going around to queer bars, I come home, and *Ibid.*
say to myself, "Art."

14th Street is drunken and credulous, O'Hara, p. 182
53rd Street tries to tremble but is too at rest.

He said, "There's a special train. After you've done the Third Avenue bars, Gooch, p. 194
you take it at Fifty-third and Third and it goes right to West Eighth Street.
And then you have all of Eighth Street."

Names for Third Avenue: Third Sex, Third Leg, Three-Dollar Bill. McCourt, p. 6

The Bird Circuit of gay bars: The Blue Parrot on Fifty-third between Third Bowes, p. 105
and Lexington, the Golden Pheasant on Forty-eighth Street, the Swan—all

in the neighborhood of the Third Avenue El. The East Side bars tended to be dressy, and their customers were conservatively dressed in bow ties, blazers, or fluffy sweaters. The "bird bars" usually started coming to life between eleven-thirty and midnight when the plays let out. Often the men in the bar could be found shoulder to shoulder dancing, singing tunes from such Broadway musicals as *South Pacific* or *Kiss Me, Kate* in unison with the jukebox.

Ibid., pp. 105–6

I'd walk down Third Avenue. In the East Sixties, guys stood casually on street corners, paused significantly in doorways, gave sidelong glances: all very discreet. Eyes tracked me from the windows of the bird bars … In those bars Piaf sang on the jukebox, men in suits sat at the bar … Down the Avenue from the bars at Fifty-Third and Third was a world famous chicken run. Young boys stood in the cold in sneakers and thin jackets, waited under awnings, stared out the windows of seedy coffee shops and knew just who I was.

Auden, "September," p. 72

I sit in one of the dives
On Fifty-second Street
Uncertain and afraid

Delaney, p. 77

The bars of Third Avenue, where *The Lost Weekend* was filmed.

McNeil and McCain, p. 175

The Ramones' "53rd & 3rd" is a chilling song. It's about this guy standing on the corner of Fifty-third and Third trying to hustle guys, but nobody ever picks him. Then when somebody does, he kills the john to prove that he's not a sissy.

Van Dorston

"The song '53rd & 3rd' speaks for itself," said Dee Dee Ramone. "Everything I write is autobiographical and very real. I can't write any other way."

McNeil and McCain, p. 174

I remember driving by Fifty-third Street and Third Avenue and seeing Dee Dee Ramone standing out there. He had a black leather motorcycle jacket on, the one he would later wear on the first album cover. He was just standing there, so I knew what he was doing, because I knew that was the gay-boy hustler spot. Still, I was kind of shocked to see somebody I knew standing there, like, "Holy shit. That's Doug standing there. He's really doing it."

Kaiser, p. 107

Eighth Street gay bars of the 50s: Mary's, Main Street, the Eighth Street Bar, the Old Colony.

Little, p. 79

Regent's Row: "piss-elegant" Upper East Side gay bar.

Strausbaugh, p. 517

The Mineshaft, the Anvil, Ramrod, the Spike, Crisco Disco, the Cock Pit, the Toilet, Hellfire, Papicock, Clit Club.

Bockris, *Warhol*, pp. 104–5

Late in the afternoon [Warhol] usually dropped by a new favorite hot spot, Serendipity, to have coffee and pastries. Serendipity … was located in a basement on East 58th Street and specialized in serving ice cream, cakes and coffee and selling fashionable knick-knacks in a tasteful, all-white setting. It was a mecca for celebrities like Gloria Vanderbilt, Cary Grant and Truman Capote.

Hamilton, pp. 19–20

The Silver Dollar Bar with its selection of wonderful hustlers, the more upmarket possibilities of the Astor Bar (hustlers with ties) and the young white and Puerto Rican men of 42nd Street available for $5 or $10. I couldn't

believe that these beautiful, magnificent specimens of manly beauty would be so pliable and agreeable in bed.

The Back Room was an arcane practice that has since, apparently, gone out of fashion in Village bars. In its heyday, it was a walled-off area, pitch-black, adjacent to the bar, that served as an arena for any variety of catch-as-catch-can sex. Sometimes two guys would meet at the bar and, after preliminaries, repair to the Back Room to do their thing. In other cases, singles who had not much luck at the bar or pool table would drift into the Back Room and wait for a body—any body—to find them in the darkness … what closed down the Village Back Room was not fastidiousness, but the rumor of a "mad Slasher" who was said to go around from one back room to another playing havoc on penile musculatures with a razor blade.

Ibid.

Gay

1910s–1940s

In 1912, agents of the Pennsylvania Railroad cut holes in the ceiling of the men's room at their Cortlandt Ferry house in order to spy on men using the facilities.

Chauncey, p. 198

East Fourteenth Street between Third Avenue and Union Square was a gay cruising area known as the Rialto from the 1890s into the 1920s.

Ibid., p. 190

The sexual topography of the capital of the homosexual world continually shifted but did so around recurring axes. In the 1920s, the centers had been Riverside Drive, Fifth Avenue, and Battery Park. In the early 1930s, the focus had moved to Bryant Park and Lexington Avenue. In 1940, it was Times Square and lower Central Park.

Reay, p. 85

Van Vechten's flat in Harlem for his affairs with men was painted black with silver stars on the ceiling for nocturnal trysts.

Barnet, p. 141

Charles Henri Ford and Parker Tyler on Harlem's drag balls of the 1920s: "A scene whose celestial flavor and cerulean coloring no angelic painter or nectarish poet has ever conceived."

Lawrence, p. 3

The elaborate display windows that department stores began installing in the late nineteenth century quickly became the locus of one of the few acceptable street cultures for middle-class women, who could stroll down the street looking at them and conversing with other browsers, their loitering in public space legitimized by its association with consumption. As men, gay men had less need to justify their presence on the streets, but they took advantage of the same legitimizing conventions. One man who had indicated his interest in meeting another might stop before a window and gaze at the display; the second could then join him and strike up a conversation in which they could determine whether they wanted to spend more time together. "Fairies hang out in the saloon opposite Bloomingdale's," a Macy's saleswoman claimed in 1913, and, she added, the blocks of Third Avenue in the East Fifties, a marginal retail strip under the El, were "their favorite beat." A study of arrests for homosexual activity in 1921 provides further evidence of the extent to which cruising was concentrated in retail shopping districts, for it revealed that the subway stations at Lexington and Fifty-ninth Street (where Bloomingdale's stood), Union Square (the site of numerous cheap retail

Chauncey, p. 190

outlets), and Herald Square (where Macy's, Gimbels, and Saks–34th Street were located) each accounted for more arrests than any other station, and together accounted for three-quarters of the arrests reported in all subway stations.

Ibid., p. 198

A man who expressed interest in another could stop in front of a window display, and the other, if interested, could begin a conversation without attracting attention.

Reay, p. 85

The floating center of hustlers moved from one street corner to another or from the north to the south sides of the street, depending on the popularity of a given bar or the frequency of policing.

Chauncey, p. 204

The Fruited Plain, Vaseline Alley, Bitches' Walk.

McCourt, p. 199

The senescent, semi-derelict pensioned-off civil servant queer from one of the many residential hotels in the neighborhood is sitting on the bench a mere two blocks south in Madison Square, at six on a summer morning. Sex still rages in the bushes and up against the trees, and particularly significantly in the thicket behind the Saint-Gaudens statue of Admiral Farragut ("Damn the torpedoes—full speed ahead!") with his flaring long coat, pedestal and chair.

Califia, p. 20

There is always some kind of physical barrier—some bushes, a bathroom door, or a car—between the participants of public sex and the outside world. This barrier screens out the uninitiated. If more than two people are present, one of them usually acts as a lookout … People sitting behind the closed door of a bathroom or of a movie booth in an adult bookstore can reasonably assume that they have privacy.

Chauncey, p. 189

Clustered in theater and retail shopping districts, where many gay men worked and where heavy pedestrian traffic offered cover, such as Union Square, Herald Square and Harlem's Seventh Avenue and 135th Street; along the socially less desirable avenues darkened by elevated trains thundering overhead, particularly Third and Sixth Avenues, where few powerful interests would notice them; close to the parks where men gathered, such as Fifth Avenue in the twenty blocks south of Central Park (and, in later years, Central Park West in the Seventies); along Riverside Drive and other parts of the waterfront, where many seamen and other unmarried or transient workers were to be found; and, in general, in the same "vice" areas where other forms of disreputable sexual behavior, particularly prostitution, were tacitly allowed to flourish, or that for one reason or another provided a measure of privacy and "cover" to gay men seeking to meet.

McCourt, p. 31

In which Central Park becomes a fantasy dancing ground for sailors.

Carter, p. 30

Every night after dinner we go walk on Central Park West and we run into all of our friends, the people we work with, and half the West Side gay people—which were thousands—on Central Park West between 59th and 86th. In those days, there was one long bench from corner to corner, solid with gay men. Hundreds and thousands of them walked back-and-forth singularly, in couples, and in groups.

Reay, p. 55

Where homosexuals gather, hustlers will gather and during the 1920s and early 1930s Riverside Drive at about 96th Street was a hive of homosexual activity every mild evening and even during the winter.

■ Sex — Gay

Riverside Drive was the haunt of Navy and Army men looking for prostitutes. *Ibid.*

Hart Crane makes frequent references to his fondness for sailors in New York: *Ibid.*, p. 7
"If it weren't for the Fleet I should scarcely be able to endure it."

In the 1930s, painted faggots were to be found on the blocks above and below *Ibid.*, p. 56
72nd Street between Central Park and Broadway—because the end of 72nd
Street was where the sailors disembarked.

And here on Broadway and 72nd Street *murderpiss beautiful boys grow out of* *Ibid.*, p. 40
dung … They push flesh into eternity and sidestep automobiles. I bemoan
them most under sheets at night when their eyes rimmed with masculinity
see nothing and their lymphlips are smothered by the irondomed sky. Poor
things, their genitals only peaceful when without visiting cards.

Gay male residential and commercial enclaves developed in the Bowery, Chauncey, p. 136
Greenwich Village, Times Square and Harlem in large part because they were
the city's major centers of furnished-room housing for single men.

Opposite the piers, along the entire length of highway, nearly every block *WPA Guide*, p. 69
houses its quota of cheap lunchrooms, tawdry saloons and waterfront
haberdasheries catering to the thousands of polyglot seamen who haunt
the "front." Men "on the beach" (out of employment) usually make their
headquarters in the barrooms, which are frequented mainly by employees of
lines leasing piers in the vicinity.

In the 1920s and 1930s, the flaming homosexual was a common sight on the Reay, pp. 57–8
streets of mid-town New York. There were blatant, painted, "flaming" young
homosexuals (older ones seldom try to flame) with marcelled hair quite long
and held into place with innumerable hair pins, with mascaraed eyelashes,
powdered cheeks, lipsticked mouths, and riotously colored fingernails, their
fingers vulgarly ornamented with large rings, their clothing femininely soft
and loudly colored, their shoes suede, their whole appearance and manner
calculated to attract the attention of normal men. These were to be seen any
night in Times Square.

In 1930, Fifth Avenue from 42nd Street to Central Park at 59th Street was *Ibid.*, p. 85
popular homosexually, but only one side of the street—the west side.

Well-dressed, "mannered," and gay-identified hustlers serving a gay- Chauncey, p. 191
identified clientele generally met their customers as the latter left the theater
and walked home on the west side of Fifth Avenue from Forty-second to Fifty-
ninth Streets.

1930s hustler tactics: telling a john that he is menstruating so he can have Reay, p. 59
anal or provide oral sex; the use of breast pads and a girdle to hold up tell-tale
testicles and penis; the strategy never to strip; the employment of a rubber
vagina or the technique of slipping the penis into the anus instead of the non-
existent vagina.

La Guardia began closing Bryant Park at night in 1944 in order to "prevent Chauncey, p. 183
undesirables from gathering."

One man often served informally as a sentry who could warn the others *Ibid.*, p. 197
about the approach of strangers, and, given the possible consequences
of approaching the wrong man, even two strangers alone in an isolated

washroom usually sought to confirm their mutual interest in an encounter through a series of nonverbal signs before overtly approaching each other. The most popular tearooms had elaborate and noisy entrances, which alerted men to the approach of another and gave them time to stop whatever they were doing. To reach one tearoom famous among gay men in the 1940s, located on the eighth floor of the RCA Building at Rockefeller Center, for instance, those arriving had to pass through several doors in a long corridor, thus providing the men in the room ample warning of their approach.

Reay, p. 8

Gore Vidal, who had an appetite for trade, recalled the Astor Bar in New York's Times Square in the 1940s as "the city's most exciting meeting place for soldiers, sailors, and marines on the prowl for one another." "I did enjoy my daily meetings with strangers, usually encountered in the streets," he wrote of 1946. "We would then go to one of the Dreiserian hotels around Times Square. Most were poor youths my own age, and often capable of an odd lovingness, odd considering the fact that I did so little to give any of them physical pleasure. But then, even at twenty, I often paid for sex on the ground that it was only fair."

Ibid., p. 7

John Cheever was not above paid sex with young men.

Ibid., p. 9

Tennessee Williams: "I went out cruising last night and brought home something with a marvelous body it was animated Greek marble and turned over even. It asked for money and I said, dear, would I be living in circumstances like this if I had any money?"

Ibid., p. 47

The pansies stared and tightened their grip on their dandies. The dandies tightened their hold on themselves. They looked the favored Jake up and down … Dandies and pansies, chocolate, chestnut, coffee, ebony, cream, yellow, everybody was teased up to the high point of excitement. Brown girls rouged and painted like dark pansies. Brown flesh draped in soft colorful clothes. Brown lips full and pouted for sweet kissing. Brown breasts throbbing with love.

Walker, *Night Club*, p. 207

Ima Pansy from Central Park.

Chauncey, p. 183

Harvey Milk arrested in a Central Park cruising area sweep in 1947.

1950s

Miles, p. 64

Ginsberg's first sexual experience with Kerouac: They were walking by the waterfront where the elevated West Side Highway passed Christopher Street. The area beneath it was used as a truck park and would later become the center of the New York gay scene. They stopped between two trucks and jacked each other off. "I don't know why there should be some erotic spirit of a place," Ginsberg commented. "I think it was just the industrial isolation, and we were horny." However, the next time they walked through the area they did it again.

Reay, p. 20

In the 1950s, he described a movie theatre in Spanish Harlem where fellators operated as a cooperative, some keeping watch on the stairs, the others observing the fellating. One was a horrid, campy, swishy, noisy old faggot who irritated them all; another was a tough, rough, muscular, truck-driverish youth who nonetheless was also a fellator and who said to the faggot, "Thank God I'm just a cocksucker and not queer!"

M Sex — Gay

The buff boys of the Chelsea night, ripped
all, like Alpha-male delicatessen, work
of Paul Cadmus, and Charles Demuth.

McCourt, p. 24

I remember another early sexual experience. At the Museum of Modern
Art. In the movie theater. I don't remember the movie. First there was a
knee pressed to mine. Then there was a hand on my knee. Then a hand on
my crotch. Then a hand inside my pants. Inside my underwear. It was very
exciting but I was afraid to look at him. He left before the movie was over
and I thought he would be outside waiting for me by the print exhibition but I
waited around and nobody showed any interest.

Brainard

1954 Times Square hustler uniform: T-shirt and turned-up jeans.

Reay, p. 80

Idlewild—gay name, for sure.

McCourt, p. 155

Eighth Street in the summer of '57. The Eighth Street Bookshop, the Whitney,
the Bon Soir, and the Village Barn. The Walgreen's on the northeast corner
of Eighth Street and the Avenue of the Americas. The Eighth Street (at
Broadway) men's toilet (the uptown side).

Ibid., p. 80

The Rialto. The waterfront. The Lunts. Cardinal Spellman. Dorothy Kilgallen.
Hitchcock. The Old Met, the old Pennsylvania Station. Maria Meneghini
Callas. Judy. Merman.

Ibid., p. 39

Every queer coming of age in America, who developed the ambition to be
metropolitan, was instructed in the same way: the goal is the "penthouse"
overlooking the river, or the Park, or midway between the two, but uptown, far
away from the 14th Street fault line.

Ibid., p. 108

M Sex — Gay

Washington Square Park hustlers in the late 50s: lined up in close-fitting
jeans with a clear emphasis on certain body parts—in Levis, t-shirts, leather
jackets (every taste is provided for), and a cigarette dangling from the corner
of the mouth.

Reay, p. 112

One Sunday he circled a block on Greenwich Avenue. He had circled the
block twice already and he hadn't met anyone. In the early 60s it could be
hard to meet someone, the encounter was so ritualized. The shops were
closed on Sundays, but he circled the block looking at the shop windows; then
he walked by without looking. Then he went around the block again, passed
an attractive man, and stood and feigned a studious interest in the goods
displayed in the window. Would the good-looking fellow stop and also stare?
Maybe the other man would signal his interest by tapping his foot as they
both window-shopped. Then he could ask the other man if he knew the time
or had a light for a cigarette? They started the long, drawn-out procedure of
approach. Did you live here? What did he think of the village? And so forth.

Carter, pp. 16–17

The shadowy parks, subways stations, and ship docks of the city were a
libidinal landscape for the young poet, their furtiveness part of a mischievous
midsummer night's game.

Gooch, p. 197

Frank O'Hara's sexual exploits: His regularly making out with a guard at the
UN during its construction, right there in the small, temporary station house,
always after midnight, or like the time he boarded the subway, blind drunk,
missed his stop and ended up in Queens, where he blew the Negro in the
change booth before catching his train back to Manhattan.

LeSueur, p. 40

O'Hara, p. 257

There are several Puerto
Ricans on the avenue today, which
makes it beautiful and warm.

1960s

McCourt, p. 24

The early years: Eighth Street, Greenwich Avenue, the Cherry Lane, Lenny's
Hideaway; Mary's, Julius's, Danny Monk's, The Modern, the Ninth Circle; the
St. Marks Baths, the Everad Baths, the Metropolitan Opera standing-room
line between 39th and 40th on Broadway, the Astor Bar "Flit" Side—and the
infiltrated "Straight" Side at the opposite end—the other side of the mirror.
Dozens of subway and Department of Parks mens' toilets, the "tea rooms,"
the Ramble in Central Park, the Metropolitan Museum of Art, MoMA, the
Frick Collection, Duff's and the Sea Shack in Cherry Grove, on Fire Island,
the Belvedere (the grandest beach house in the Grove), the Cherry Grove
Playhouse.

Turner, *Backward*, p. 128

If I had sex, say, with an average of three different partners a week from
1962 to 1982 in New York, then that means I fooled around with 3,120 men
during my twenty years there. The funny thing is that I always felt deprived,
as though all the other fellows must be getting laid more often. A gay shrink
once told me that that was the single most common complaint he heard from
his patients, even from the real satyrs: they weren't getting as much tail as the
next guy.

Warhol, *POPism*, pp. 281–2

Most people would probably think of the following year, '68, as the time we
were getting involved with the drag queens who were around downtown,
because it wasn't until then that they first cropped up in our movies, when
Paul used Jackie Curtis and Candy in *Flesh*. Of course we'd had Mario Montez
in a few of our early films, but since Mario only dressed up as a woman for
performances—out in the world, he would never be in drag; he was more like
a show business transvestite than the social sexual phenomenon the true
drags were.

As late as '67 drag queens still weren't accepted in the mainstream freak
circles. They were still hanging around where they'd always hung around—
on the fringes, around the big cities, usually in crummy little hotels, sticking
to their own circles—outcasts with bad teeth and body odor and cheap
makeup and creepy clothes. But then, just like drugs had come into the
average person's life, sexual blurs did, too, and people began identifying a
little more with drag queens, seeing them more as "sexual radicals" than as
depressing losers.

In the sixties, average types started having sex-identity problems, and
some people saw a lot of their own questions about themselves being acted out
by the drag queens. So then, naturally, people seemed to sort of want them
around—almost as if it made them feel better because then they could say to
themselves, "I may not know exactly what I am, but at least I know I'm not a
drag queen." That's how in '68, after so many years of being repelled by them,
people started accepting drag queens, even courting them, inviting them
everywhere. With the new attitude of mind-before-matter / where-your-head-
is-at / do-your-own-thing, the drags had the Thing of Things going for them.
I mean, it was quite a thing, it took up all of their time. "Does she tuck?" the
other queens would ask Jackie about Candy, and Jackie would say something
oblique like "Listen, even Garbo has to rearrange her jewels."

Candy herself referred to his penis as "my flaw." There was always that
question of what to call the drags— "him" or "her" or a little bit of both. You

usually just did it intuitively. Jackie I always called "him" since I'd known him before he went into drag, and Candy Darling and Holly Woodlawn were "her" because they were already in it when I met up with them.

But if in '68 the drag queens were incorporated into the fun of the general freak scene, in '67 they were still pretty "queer."

Poet Charles Henri Ford was still paying for sex in the 1960s.

Reay, p. 9

Hustlers stood on the curb facing inwards on the sidewalk so that they could see those passing by and be seen … In the 1960s, they stood on the opposite side of the sidewalk against the wall or a shop window, easily approached by potential johns who could always say that they were window shopping.

Ibid., pp. 84–5

New York *was* the gay capital of the US. Things happened here.

Atkins, p. 253

New York's male homosexuals are the smartest, best-dressed, most glamorous, jaded, wittiest, most attractive, most successful, vicious, shrewd, influential and desirable queens in the world. They are also the sickest, most desperate, most ridiculous and dullest in the world.

Petronius, p. 79

Ginsberg visiting the Stonewall Inn after the riots: "The guys there were so beautiful—they've lost that wounded look that fags all had ten years ago."

Caldwell, p. 326

June 27, 1969: Judy Garland's funeral was held at Frank Campbell's Upper East Side mortuary the day of the Stonewall Riots.

Atkins, p. 253

Out of the mass of people on the dance deck, strands of lives reached out in time and place, in anguish or fulfillment or just a quiet gentle drift toward death. Post-Stonewall liberation? What did it mean? How would the people on the dance deck differ in their lives from those quiet gray-haired gay couples who ghosted around the Village and shared their little amusements during genteel evenings at Carr's, a West Village gay bar of antique vintage, or at home with the television set and two toy poodles?

Hamilton, p. 56

… their torments in the city and their ecstasies at Cherry Grove … their safe haven in a rent-controlled two-bedroom on Charles Street.

Ibid.

1970s

Short of hair, mustaches neatly clipped, T-shirts tight over big muscles, heavy key chains jangling, feet shod in bulky leather workboots.

Blandford, p. 157

Vaseline, Stevedore, Partouze, Dexamyl, Amyl, Mascara, Revenge, Judy, Balenciaga, Syphilis, Penicillin and Frottage.

McCourt, p. 74

Over the strains of WKTU 92 FM disco, they sigh for his gleaming black hair, his broad shoulders, the cowboy moustache.

Blandford, p. 78

Here in Manhattan were a hundred or so men in leather or lumberjack shirts or other varieties of Western gear, though for a certainty no more than one or two had so much as laid eyes on a cow, let alone rounded one up. A shiny saddle hung from the center of the ceiling and across the middle of the bar a rustic wooden fence had been constructed, the kind of fence Dale Evans sits on while she watches Roy Rogers breaking in a four-legged friend. A few

Brook, pp. 160–1

tightly jeaned men in check shirts and bristling moustaches sat on this fence, and there was a little manly smooching going on.

Delany, p. 15

In the Forty-second Street area's sex theaters specifically, since I started frequenting them in the summer of 1975, I've met playwrights, carpenters, opera singers, telephone repair men, stockbrokers, guys on welfare, guys with trust funds, guys on crutches, on walkers, in wheelchairs, teachers, warehouse workers, male nurses, fancy chefs, guys who worked at Dunkin Donuts, guys who gave out flyers on street corners, guys who drove garbage trucks, and guys who washed windows on the Empire State Building.

Ibid.

For a dollar forty-nine in the seventies, and for five dollars in the year before they were closed (several less than twelve months ago), from ten in the morning till midnight you could enter and, in the sagging seats, watch a projection of two or three hardcore pornographic videos. A few trips up and down the aisle while your eyes got accustomed to the darkness revealed men sitting off in the shadows—or, sometimes, full out under the occasional wall lights—masturbating … if someone hadn't stood up on the seat and unscrewed the bulb. Sit a seat away from one, and you would either be told to go away, usually fairly quietly, or invited to move closer (if only by the guy's feigned indifference). *Should* he be one of *your* regulars, you might even get a grin of recognition.

Occasionally men expected money—but most often, not. Many encounters were wordless. Now and again, though, one would blossom into a conversation lasting hours, especially with those men less well off, the out-of-work, or the homeless with nowhere else to go.

McCourt, p. 209

Nobody gets what they want, pet, on Fire Island, except the deer. Check the faces on the ferry on the way back: there ought to be a branch of the Department of Welfare with a passport photo apparatus to snap headshots on the Friday afternoon and again on the Sunday evening—before and after, as in the ads for Ayds, the reducing candy. The idea that candy can lead to weight reduction is no crazier than canonizing the idea that a weekend in Island Pines can lead to happiness. Never have I seen so much unavailing untold want, such fruitless longing as on the dance floor, along the meat rack and in the drugged hollows of Island Pines.

"Ayds"

Ayds (pronounced as "aids") was an appetite-suppressant candy which enjoyed strong sales in the 1970s and early 1980s and was originally manufactured by The Campana Company. It was available in chocolate, chocolate mint, butterscotch, and caramel flavors, and later a peanut butter flavor was introduced. The original packaging used the phrase "Ayds Reducing Plan vitamin and mineral Candy"; a later version used the phrase "appetite suppressant candy." The active ingredient was originally benzocaine, presumably to reduce the sense of taste to reduce eating.

By the mid-1980s, public awareness of the disease AIDS caused problems for the brand due to the phonetic similarity of names. While initially sales were not affected, by 1988 the chair of Dep Corporation announced that the company was seeking a new name because sales had dropped as much as 50% due to publicity about the disease. While the product's name was changed to Diet Ayds (Aydslim in Britain), it was eventually withdrawn from the market.

Carter, p. 36

There was no fence. The trucks would back right up to the river and it was pitch-dark in there. Every now and then you could see somebody with a cigarette in the back of the truck. There would sometimes be 200 or 300 people in them.

Christopher Street is sedate and quiet, more like the block I first saw in 1970, when I wondered if the man walking down the street in front of me knew there was a hole in the seat of his jeans.

Holleran, "Anniversary," p. 12

Later heading back we walked along the highway, the motorheads from the cycle bars spilling out in beery crowd onto the streets. Musclemen packed into tight T-shirts and this one albino kid about nineteen or twenty flirting with some of them as he walked in front of us. A group of ten transvestites sitting on car hoods or standing by the sides of gleaming autos, fixing their faces, powdering noses, rubbing on lipsticks and showing each other their clothes, bending down into car mirrors to work with cosmetics. Couple of more reserved joes hanging out with them staring around and looking a bit faded.

Wojnarowicz, p. 116

We walked down Christopher Street in the night, crowds of bar characters, homeless cowboys and street sleepers, the roughneck crowds and the junkies on the stoop next to Boots & Saddles and dollah joints ooo-eee good shit here now dollar joints, mesc, etc., etc. Passed the Silver Dollar with the semitransvestites primping in the side mirrors, day-old leather guys lounging in plastic seats and across tables.

Ibid., p. 117

Turned the corner at Badlands bar and walked uptown, racing night traffic and glitter of lamps and glass broken on the street and the tittering of transvestites in front of Peter Rabbit bar and the ocean roll of traffic and hiss of wheels the shooosh of bypassing autos and the glimmer of the river not too far away—we crossed and took various pisses and sat on the waterfront boardwalk and watched the characters easing in and outta the shadows of the pier warehouses, along the brick walls like rats and emerging into the phosphorescent shine of bathing street lamps along the lapping posted walls through various darkness and passing no one—once inside it was difficult to see, a few dim shapes of white T-shirts or the pale gleam of white skin in the darkness, and standin' still for a while our eyes adjusted and we walked toward the back of the pier warehouse where there was one middle doorway shining with a contained section of river and lights, we passed back, John said it was hard to see the ground, we moved directly in the center of the doorway line, seeing two bright spherical yellow lights like car headlights anchored on Jersey cliffs sending vertical lines of light, gold breathin' light across the surface of the dark roiling river, like two railroad track lines laid out into some hobo's heaven, it's a giant Chevy parked against the Jersey coastline, images come from the river, the solitude and great sense of foreign remote excitement, all road images coming back from distant places and watchin' these ferryboat barge ships drift by with loud echoing rollin' music coming from their stompin' interiors, party people on a latenight drift, we turned and walked back in the deep darkness of the pier warehouse and stood against a side wall talking quietly and watching the movements of anonymous characters driftin' back and forth and up and down staircases against the back wall, occasional voices from upstairs and then we strolled back out and onto the bank street pier and towards the end of the pier, avoiding the large gaping holes that open onto the river, my foot almost disappeared down a large pipe aperture, over to the side materializing in the darkness were two men, one giving the other a desperate blow job, Jesus, I said, and John went, Whew … and further on were two men one bent over getting rammed by another guy, the fucking was brutal and fast and almost violent but both were into it and then at one point the guy getting rammed was rammed so hard he flew over and his palms landed on the surface of the pier boards and he continued in that position and I just recalled that

Ibid., pp. 118–21

before in the warehouse we were upstairs walkin' around through hallways and rooms and there was this guy who slid outta the dark and had his shirt removed and positioned himself on the wall and then slid after us as we moved along, he rushin' from door to door and leaning back to caress his chest and crotch and I asked John would he mind waitin' a little bit to the side in the main large room, he did and I went in after the guy, he turned from the wall and ran his tongue over his lips, could feel the dryness of them just by lookin', he whipped out this bottle of amyl and held it under my nose and groped me and I rubbed his chest, his nipples, and he moaned in that hollow darkness, held the amyl under my nose and I placed my hand behind his neck to draw him down to his knees but he turned and slipped away into the darkness and disappeared—I went back to John and we split into a series of rooms windows bordering the river and four perfect diamonds of exterior lamplights laid out on the floor, if ya stand in the middle of the side doorway and walk forward the doorframe empty of door evolves into another room with diamonds of gold light with shadows crossing window frames into another doorway you're still moving forward it's like a film, another set of diamonds on another floor, and the tips of each set of light diamonds appearing less and less in each room, easin' into full view as ya pass forward, eyes on one spot in the unseeing distance, moving like you're on rails— everything relegated to the senses, use of sense like a vehicle, moving forward at regulated pace, something otherwise so unexplainable yet the wounding nature of these visual scenes … we watched on the bankstreet pier the fucking until the guys separated and went their various ways, we sat on the far edge next to lapping water and posts and talked about the sense ya get in these scenes that although it's public sex ya still have the sense that ya should respect their privacy and not go over and watch, though watching from a discreet distance can only be expected as it is an intense visual to be confronted with and then another boat went by with characters milling and shoutin' in the din of music, you could barely make out their voices—and the timeless photographical nature of the scenes way back at the beginning of the pier, the trucks lined up silver and motionless, the numerous autos from Jersey and other parts all filled with motionless drivers waiting for someone of their private dreams to walk along softly and open the side door with a click and slide heavy and denimed into the front seat and the pale flash of belly and the motion of the tongue and the slide of hands and the sleeplessness of it all, the bright lights and lampposts burning continuously beneath the Westside Highway structures, the trucks barreling downtown and the two smokestacks to the side in a factory building, squealing autos and the light pale rise of smoke.

Conrad, p. 100

A skein of torsos unravels into the Hudson, with a liner passing and the skyscrapers on parade. The bodies might be boys diving; they might just as well be gods thunderously alighting.

Atkins, p. 255

I found New York's gay sex scene appealing primarily for the novelty of outdoor sex to be had in Central or Riverside Parks, on Fire Island, or on the piers or trucks of the Village and Meatpacking districts.

McCourt, p. 328

At Westbeth, gazing down on what remained of the Morton Street Pier, a blackened slab, like an enormous Anselm Kiefer canvas year by year dismantled further, until the blackened surface had been torn away and the pilings had almost completely sunk into the North River, like the Sunken Cathedral and the Kingdom of Y's.

O'Hara, p. 85

Sodom-on-Hudson.

Waterfront fuck pits.

McCourt, p. 328

Dank black holes, full of creeping murmur and the poring dark.

McCourt, p. 332

You cross under the rusting stanchions of the old elevated highway and walk out to the pier. The easterly light skims across the broad expanse of the Hudson. You step carefully as you approach the end of the rotting pier. You are none too steady and there are holes through which you can see the black, fetid water underneath.

McInerney, *Bright Lights*, p. 10

The succeeding four nights have proven that New York is still a Babylon and a Sodom—if not more so.

Reay, p. 67

I had a copy of William Burroughs's *The Algebra of Need* balanced on the ledge of the closed unloading dock door next to where we stood as we started getting it on we got involved, the situation becoming more and more intense and hot, the idea that if I was ever gonna make it with a guy that I loved and knew previously as a traveling buddy that this place in the predawn hours had to be the one right place in this fuckin' city to do it.

Wojnarowicz, p. 123

Remembering how when I was younger and was rejected by the sturdy rogue men ten years older than me whom I met within the dark avenues of the river, how I came close to telling them it didn't matter, I had their images, their faces, and bodies and all the associations in my head to go home at leisure and lay down upon the warm sheets of a summer room and lay my hand to myself and have them anyway.

Ibid., pp. 140–1

And I swung down over him, placed his hard cock in my mouth and immediately he began coming and I heard soft sounds come from his mouth and the darkness in the room moving, stirring with the low breeze over the sill.

Ibid., p. 160

I'm sitting in the park up on 15th Street, long after the sun's gone down. I'm sitting there in the darkness under some trees on a bench and this seedy red-haired man in a cheap business suit suddenly walks over and slides onto the bench next to me, simultaneously mumbling something.

Ibid., p. 173

At some point a couple of bums walked by and I heard one yell, Hey you homos … get outta there.

Ibid., p. 178

Early in the morning in a coffee shop on 2nd Avenue and 11th Street, this dive coffeehouse where gunshots occasionally ring out and pimp types are murdered, drug stuff, petty gangsters, I'm sitting there in the fluorescent light watching the dawn come up, this strong sunlight over in the trees of the church on the uppermost parts of buildings yet the asphalt street below, the cool stone walls of the cemetery of St. Mark's Church, everything cool blue like early dawn, a clarity that's unreal, and these drag queens, three of them lifting their skirts up to the traffic, wind billowing up beneath the skirts, their brown slender arms waving, pulling the skirts almost over their heads, shaking their pantied asses at passing cars, laughing loudly, small shrieks: Oh baby! Lips painted and stretched against white teeth, one guy in the coffee shop, a fat white guy with faded blue tattoos on his huge sagging arms: Lookit them faggots. They get desperate after the sun comes up. One queen comes in assuming this overly feminine posture at the counter, leans towards the fat man: Order me a cup of tea, baby. I'll be right back. Pats the place on the counter where she wants her tea and walks out, cuts up in the street laughing,

Ibid., pp. 194–5

M Sex — Gay

fat man says to the Greek behind the counter: A cup of tea, she'll be right back in … cup of tea, y'hear me? And she comes back in and sips at the tea after pouring a pound of sugar in and a dash of milk and her friend comes in and takes a few sips patting their lips with napkins, first one points to this cute counterman and says, What's he, Puerto Rican? Says something in Spanish. Naw, says the fat man, Egyptian. Oh, says the drag queen. Oh, I've always wanted to take a trip up the Nile.

Lawrence, p. 63

For gay people in the 1970s it was like one person per 50 blocks, north, south, east and west.

McCourt, p. 325

Marlboro Man clones, with tattoos, cockrings, tit-clamps, cigars and ritual hot-ash frolics in cavernous back cellar rooms in the Meat Packing District, a program of order and conformity whose power to contain was surpassed only by its ability to define.

McNeil and McCain, p. 275

Gay liberation had really exploded. Homosexual culture had really taken over—Donna Summer, disco, it was so boring. Suddenly in New York, it was cool to be gay, but it just seemed to be about suburbanites who sucked cock and went to discos.

Hamilton, p. 19

He would retire to the arms of a bevy of black drag-queens as some hotel on Eighth Street. The drag-queens would salve his wounds with an ego-satisfying flutter over his lily-white flesh.

Ibid., p. 33

Here was this kid with dance training coming out of his ears and he wasn't doing a damn thing about it except running up and down Christopher Street, shrieking it up with other queens.

Reay, p. 25

One walked by doorways and saw young men in tight pants with their whole profile on display. And there were the many flagrant queens that used to fly up and down the street, not to mention the more sinister types that could be noticed if one paid attention.

Hamilton, p. 172

The street queens did a little better. One I knew spent months working his way through the NYU faculty. It was geology one night, chemistry the next, and English literature for two nights running. He got quite a groove out of it. "They even *talk* to me once in a while! Of course, I don't know what the hell they're talking about, but it's nice to hear them talk." Too bad. With concentration he might have gone through all the freshman survey courses in the school!

Ibid., pp. 44–5

The headquarters of the Gay Activist Alliance was an old firehouse on Wooster Street in SoHo. Dances were held there on Saturday nights as a manifest of "Our Place" as opposed to the Mafia-run gay bars in other parts of the city. For two dollars' admission one could spend an evening immersed in tribal rites, with all the soda or beer one could drink. The street floor of the firehouse was the dance floor, with a circular staircase to the second-floor lounge and soda bar. The basement, in Stygian darkness, included chairs, tables, and another soda bar.

The whole building, on Saturday nights, pulsed with the beat of rock music, but the main action was on the dance floor. When Lamont, Vernon, Michael, and I were going over there, it was early June, 1971, and hot, since the Firehouse didn't have air conditioning. The higher the temperature went, the more clothes came off, down to the briefest of hot pants. The music blasted. The bodies writhed. The sweat poured. And the beat went

M Sex — Gay

on. Observing the melee from halfway up the circular staircase left no doubt in my mind about what was happening. It was a war dance. The contrast to the dancing at Christopher's End and other dance bars was obvious. At the bars dancing was, by and large, part of the whole cruising process and had a sense of display about it. People danced for other people to see them and hopefully appreciate what they saw. Although plenty of cruising went on at the Firehouse, the dance floor wasn't the place for peacock displays, but a celebration of post-Stonewall identity. "We are. We are together. And if you don't like it, fuck off."

Arms around each other, we wove our way to Christopher Street, steadying the trees and lamp posts as we went. We sang a little, sighed a lot, and exchanged incoherent profundities.

Ibid., p. 165

On weekend evenings, when there was sometimes a line out in front of Your Father's Mustache and the smell of new-mown hay was in the air, gays I knew would take some pleasure in walking slowly past the place hand-in-hand or arm-in-arm, pause at the corner, and go into some deathless swoon of an embrace—just to let the folks know whose territory it was. It was kind of silly in a serious kind of way.

Ibid., p. 192

It started out pleasantly enough, wandering through a Middle Earth poster, but in the middle of a field he had the sudden sensation of falling down through the earth into a vast vaulted cavern, dimly lit with street lamps that he recognized as Central Park West. The floor of the cavern was covered with male bodies, still as they lay there. Still as he had seen them on beds all over New York. Young bodies and old, fat and thin, black and white, stretched and huddled, a great, slow-breathing carpet of flesh that extended out until it was lost in the shadows of the chamber. He moved slowly between the bodies, searching. He'd see faces; some of them he'd remember but others were strangers. At least he thought they were strangers. Maybe he'd slept with them once, but he couldn't remember. So many bodies. He could feel the heat of them in the chill of the cavern. He wanted to lie down and warm himself. But he had to keep hunting.

Ibid., pp. 107–8

You should see this guy's place. Apartment building with a doorman all dressed up. And you go up in the elevator, way up. His pad, it's got a big living room and it looks out over the Park, with rugs all over, and this big stereo, and a bar with all kinds of bottles, and a color television set in the bedroom. He's in some kind of thing down on Wall Street. He's old, maybe even thirty, and he's got it all together. He says like he's bisexual, you know, and he likes guys and girls both. He gave me a drink. Then we smoked some grass and played a lot of his records—he's big on Dionne Warwick—and he told me I had a nice body. After a while I was feeling real good and he let me take a shower. It was one of those crazy showers where the water comes out all around you, and being stoned, I felt like I was all alive—everything—and then we went into the bedroom to watch television, and he talked to me. I never had anybody talk to me like that, I mean, him being older, but talking to me just like I was, you know, his friend. Then he put his arms around me, and I was going to tell him I was straight, but he said he liked girls too, so it didn't matter, and … after a while I came back home.
 Heady stuff for a couple of kids from Queens.

Ibid., pp. 100–1

The mating habits of gays, as Paul Goodman has pointed out, are highly democratic. A gay who is living with a coterie of addicts on welfare in some far reach of the East Village might move from there to some professional's

Ibid., p. 38

opulent pad on the Upper West Side. A street freak I knew who was a masochist found heaven-for-two with an industrialist on Park Avenue in the Eighties. "You better know it, he ties me up in *velvet* every night! It's getting so I come just touching velvet!"

Holleran, "Anniversary," p. 11

The St. Mark's Baths, a plaque outside the door proclaims, is the site of the last townhouse of James Fenimore Cooper.

Brook, pp. 96–7

A few recreational facilities were provided for the blasé and the detumescent; the rest of the building was devoted to sex. There were nine floors. The first floor was the entrance, the second contained offices, the third the lockers; the next three floors housed the "rooms" and a TV room and gym; the floor above consisted of a communal shower and sauna; up more stairs to the Truck Stop, and the top floor contained so-called Fantasy Rooms.

If "baths" is a misnomer, so is "rooms." They were no more than cubicles, a double row of them encircled by a corridor, at least 30 on each floor. On the outer side of the corridor was blank wall—no windows anywhere, one was boxed in, secluded, secure—and the occasional uninviting lavatory and washroom. A cubicle was only large enough for a mattress and a chair. Most of the doors were closed, either because the tenant was busy elsewhere or because the room was occupied by a couple at work.

But some of the doors were open. In some cubicles the dim light exhibited a man languidly staring out into the corridor while he fondled his penis or otherwise displayed his best features to those who passed by. Some of these men looked battle-weary, but they must have been game for another bout, or else they'd have closed the door and taken a recuperative nap. In others men lay on their stomachs baring their buttocks. I was puzzled by the constant availability of the inmate of one cubicle. He was a lithe creature, with a mop of very dark hair and a shapely bottom—but his door was always open and it was clear no one wanted him. *Chacun à son gout*, of course, but he seemed a good deal more desirable, qua meat, than some of the other morsels that were more readily snapped up. Perhaps the cruisers knew something I didn't: piles or an unattractive disposition.

Although these sexual invitations are transparent enough, they are not of course entirely open. The prospective partner lingers on the threshold and the two men look each other over and decide whether or not to commit unnatural acts. The succession of opening and closing doors implied considerable sexual athleticism, a determination to cram in as many sex acts as your body can take and muster. The silence in the air was punctuated with the grunts and cries of the compatible, but was also filled with the stillness of the undesired, hopelessly exhibiting their negligible charms to a parade of passers-by. In odd recesses stood couples of more exhibitionist inclination. One youth, with an ineffably bored expression, leaned against the wall gazing down onto the mobile head of another man who was energetically sucking him off. It spoke of a vast sexual indifference that was, if anything, more dispiriting than the meat market around the cubicles. Look on, stranger, I'm only making love.

Ibid., p. 100

The streets were deserted and the snow had blanketed the city. It was a dangerous time to be out alone on the streets but it didn't feel that way. How sweet even the grimy night air of New York seemed, now fresh and pastoral after the sour sweat-heavy atmosphere of the baths.

McCourt, p. 40

Dark places and groping, almost certainly unsanitary hands.

M Sex — Gay

The Continental Baths, where *chanteuse* / gay icon Bette Midler performed poolside.

Atkins, p. 254

The thing about the Everard is, it was just rooms and beds, tiny rooms and tiny beds. No tile and marble glories, no "fetish rooms." Barebones bodies. A little steam, for tradition's sake. But they made their own heat.

You could imagine boys coming here to bathe—the tub in the kitchen being full of dirty dishes.

There was *no music*—so one could sleep … And the walls of the rooms did not reach the ceiling—you could hear everything—you couldn't *not* hear everything. Slurping and moaning and everybody's dish about everybody else … The entrance is a dream of cartoons … That a whole culture's mating, food-finding, navigational and social behavior should converge at a single point on West 28th Street in New York City is certainly notable.

McCourt, pp. 189–94

In reaction to the mustaches, flannel shirts, construction-worker boots, faded Levi's, leather-tongued key rings and color-coded handkerchiefs, they, the old proud, dress in pressed chinos, button-down shirts and striped ties, and in rumpled pebble-weave tweeds, drink bourbon old fashioneds, stingers, brandy alexanders and awfully good old vintages. They smoke Lucky Strikes, Chesterfields, Pall Malls and Kents, and play and sing the golden oldies.

Ibid., p. 324

It was Gay Day parade day. Got in a cab and the driver was a happy faggot, he said, "Hi! Did you go to the parade?" and I just said, "What parade?" and he dropped the subject, talked about the weather (cab $5). (Sunday, June 30, 1985)

Warhol, *Diaries*, p. 659

New York seemed to be a sea of men: all 28, all dark-eyed, all handsome, and all named Luis.

Holleran, "Anniversary," p. 10

Sunday afternoons the mob of men spilling out of the waterfront bars was so huge it left you wondering why, with such numbers available, you still could not detail just one.

Ibid.

'80s–'90s / Drag Balls

1981: Gay is in, didn't you know?

Morrisroe, *Mapplethorpe*, p. 255

It was the queens' most baroque fantasies of glamour and stardom, all run on Singer sewing machines in tiny apartments.

Lawrence, p. 4

One girl, a sexy Puerto Rican pre-op with luscious pouting lips who advertises her self as "DA MOST BEAUTYFULL TS IN DA BRONX."

Harris, *Diary*, p. 96

At one event, Cleopatra arrived on a ceremonial float flanked by six servants waving white, glittering palm leaves; and at another, a 2,000-watt incandescent lamp was lit just as a fashion model flung open her Mylar-lined feathered coat, leaving the front rows momentarily blind.

Lawrence, p. 3

The negro homosexuals still appear at intervals dressed in a baffling impersonation of their opposite sex. Sometimes a "Drag" (or costume ball) is announced … The raised stubble of chin and neck is pitted with a power that creates a blue bloom. The row of pearls accentuates, rather than camouflages, the Adam's apple. Kid gloves cover the veined hands, but the feet are always a "give-away."

Ibid.

McCourt, p. 258	Going to the annual Greenwich Village Halloween Parade as Mother Teresa.
Ibid., p. 257	Holly Woodlawn and Candy Darling; Charles Ludlam, Charles Pierce, and Charles Busch; Ethyl Eichelberger; Dame Edna Everage; Lypsinka.
Lawrence, p. 4	House of Dupree, House of Corey, House of Wong, House of Christian, House of Plenty, House of LaBeija, House of Xtravaganza, House of Omni.
Ibid., p. 5	Voguing evolved into a contorted, jerky, slicing style of dance when drag queens incorporated kung fu aesthetics into their routines, having become familiar with the swift, angular movements of Bruce Lee and his co-stars while working trade inside Times Square's porn cinemas, or heading there after a night's work to get some rest.
Ibid., p. 6	In broad daylight, voguers headed to the abandoned stretches of the West Side piers, where they would hang out and practice moves, or to the clandestine space of gay-driven dance venues such as Better Days, the Paradise Garage and Tracks.
Ibid., p. 11	Beautiful femme queens and famous voguers, taken in their youth. Founding mothers Dorian Corey, Pepper LaBeija, Avis Pendavis, Angie Xtravaganza, Paris Dupree, Duchess LaWong.
Ibid., p. 61	In the early 1980s, leaving my house to go to balls at 3:30am was really just a bit too much. My family argued with me about going out, they were like, "Are you crazy? Where you going at this time?" And I would reply, "I'm leaving Brooklyn, riding the West Side Highway up to Harlem, looking at the sunrise, and then I'm going to a ball." It was like a drug, you had to go, and you had to wait to the end for the grand prize. It was like, "You have to see Miss Avis come out there, honey."
Ibid.	Not because I didn't appreciate the Harlem Renaissance or my roots, I just didn't like that 4 o'clock, 5 o'clock in the morning lifestyle. It almost felt to me like it was as if gay people shouldn't be seen, so let's go out in the wee hours of the morning and play around and do our thing, then run home before people can see us. I think it was a little safer for some of the drag queens back then, because they liked coming out when it was dark. But when they came downtown, I picked an area where people could feel safe, wear their fur coats and didn't have to worry about this, that and the other.
Ibid., p. 63	I walked in Brooklyn, in the worst neighborhoods, in red leather pants, red leather shoes, beige sheepskin, beige shoes, finger-wave hairstyle and Gazelle glasses.
Ibid., p. 86	Light versus dark for butch queen face.
Ibid., p. 87	The top voguers were Ronald LeMay, Jose Xtravaganza, Jason Overness, Aldona Fields, Jerome Pendavis, and Brian Omni.
Califia, p. 221	Park Slope in Brooklyn is a nascent "lesbian ghetto."
Gopnik, p. 10	The cross-dressers in the Village sniff at the influx of nuclear families as the fleeing nuclear families once sniffed at the cross-dressers.
Harris, *Diary*, pp. 53–4	Late one drunken December night, did I bundle myself up and go to a corner bodega for a beer run in my makeup, wig, and heels, but I have

M Sex — Gay

never repeated this foolhardy excursion. In fact, I dread stepping out of my apartment in my getups as much as vampires dread stepping out into sunlight. I live in terror that my neighbors should discover what I am doing, that I should forget that I am made up (a surprisingly simple oversight) and come to the door to take a package they have accepted for me, or, horror of horrors, that I should be caught in the hallway or the elevator when, after the outside doors to the buzzers lock at 10:00 P.M., I am forced to go down to meet a trick in one of my clownish disguises. For these fantastic voyages, I wear sunglasses and hooded sweatshirts pulled tightly over my face, the costumes of a hysterical actress bent on avoiding the attention of her intrusive fans, but only attracting more of it by virtue of her ostentatious stealth. The building's 10:00 curfew, imposed when the neighborhood was at the mercy of drug pushers and crack addicts, instills me with dread on those nights that I go on a drag bender, drunk and horny. To leave my apartment is to enter a war zone of unexpected encounters, ambushes by astonished families returning late from Grandma's or packs of black teenage boys who smoke pot in the stairwells. I tell my tricks to hurry, to get here before 10:00, to do everything they can to arrive before the building's security timer turns the bolt.

Cruising

Turner, *Backward*, pp. 13–14

Let's suppose you are in a real city and you are a man and you are walking down the street, in the thick of the crowd. Glancing up from the pavement, for just a moment, you notice a man walking in your direction and he's staring straight at you. Not every man fixes his stare before his feet at this violet hour, it seems. You don't. His stare hits you right between your eyes. And not for the first time. You recognize him. He has looked at you in this way before—and he has seen you see him do this before. Let's say he is about your age (whatever age that is) and he is wearing a suit, like you. You two could be twins, in the dark.

You don't know why, or rather, you don't at this particular moment ask yourself why, but you hold the gaze of this man who is now walking closer to you and who refuses not to look. Seconds pass, perhaps as many as five or six, but it seems like longer. Time slows down for you, as it always does in situations like these. In an instant, the gaze between you two is broken—you look down, or perhaps he looks away. Maybe someone passes between you, or something else diverts your attention. It's noisy, with the sound of horns and motors, but it could be anything. As quickly as the moment came upon you, it is lost. Almost. You look back, behind you, and see that he, too, is looking back behind him.

You are hurrying … in order to catch a train because you have a family to go home to, a ready-made microwave meal awaits, probably kids, the lot. You don't want to be late, not again, not again this week anyway. You look forward to your train journey, because this is your time, your very own time, the time between two lives, someone might say.

On the train home, settled into your seat, and for reasons you cannot explain to yourself or for reasons you really don't understand, the man on the street—your man on the street, handsome with a nice suit—comes back into your mind. He was never very far out of your mind, if truth be told. You are going a little red in the cheeks at the thought of it, even now. Did you go red in the cheeks when he was looking at you? Was it the blush of shame or the blush of desire? Do you know the difference between shame and desire? These are questions you could ask yourself, but don't.

Instead, you wonder if one day this man will speak to you. Speak to me, you think. Why do you never speak? What are you thinking? I never know what you are thinking.

Ibid., p. 123

Can we talk about a network of cruisers rather than occasional and seemingly isolated, if not accidental, encounters?

Ibid., pp. 129–30

While walking the street, my gaze would be riveted on stalwart adolescents, and I would have to look back at the handsomest that passed. If a street-car conductor happened to be youthful and good-looking, I became almost irrational. With a look of despair I would gaze insolently and imploringly into the face of the blue-clad youth as if I would compel him to read my thoughts, since I did not dare give them expression. When in a crowded car he brushed against me in passing, a tremor would pass over my body. Youthful policemen also at this time particularly fascinated me. Blue clothing and brass buttons have always made a young man appear to me as at his best.

Ibid., p. 148

"So we are taking off our masks, are we, and keeping / our mouths shut? As if we'd been pierced by a glance"—that later leads us to "the merits of each / of the latrines. 14th Street is drunken and credulous, / 53rd tries to tremble but is too at rest."

Ibid., p. 43

What does it mean when two men look at each other in the streets of the modern city?

Ibid., p. 61

Mere eye contact and an exchange of words.

Ibid.

Reciprocal gazes may hold their own pleasures for some, and the dynamics of the gaze may be erotic and stimulating precisely because it does *not* end in sex.

Ibid., p. 89

This chance encounter—"the magnetism of our meeting."

Ibid., p. 62

The cruiser queers the *flâneur*.

Ibid., p. 46

Cruising is a practice that exploits the ambivalence of the modern city, and in so doing, "queers" the totalizing narratives of modernity, in particular, *flânerie*.

Ibid., pp. 56–7

There's an art to cruising and it has a lot to do with timing and with the eyes. Take eyes first. You're walking down the street and you pass a man going in the opposite direction. Your eyes lock but you both keep on moving. After a few paces you glance back and see that the man has stopped and is facing a store window but looking in your direction. If he's not exactly the partner you're searching for you'll probably register the compliment his stare is paying you but leave it at that.

But if he does catch your fancy you may go through the little charade of examining the shop window nearest you. After a bit, the frequency and intensity of exchanged glances will increase and one of you will stroll over to the other. There are a few safe and stock opening lines banal to the point of absurdity ... After these preliminaries you may extend your hand, introduce yourself, ask him his name and suggest you have a drink together.

Brainard

I remember when I lived in a storefront next door to a meat packing house on East Sixth Street. One very fat meat packer who always ate at the same diner on the corner that I ate at followed me home and asked if he could come in and see my paintings. Once inside he instantly unzipped his blood-stained

white pants and pulled out an enormous dick. He asked me to touch it and I did. As repulsive as it all was, it was exciting too, and I didn't want to hurt his feelings. But then I said I had to go out and he said, "Let's get together," and I said, "No" but he was very insistent so I said, "Yes." He was very fat and ugly and really very disgusting, so when the time came for our date I went out for a walk. But who should I run into on the street but him, all dressed up and spanking clean. I felt bad that I had to tell him that I had changed my mind. He offered me money but I said no.

Port Authority Bus Terminal's "meat rack," near the departure gates. *McNamara, p. 27*

For open secret tea-room ceremonies. Tea ceremonies are properly held in tea *McCourt, p. 92* *houses*, true, but the tea room at Port Authority was the side of a half-floor in the fabled Dakota Apartments overlooking Central Park West. Two seemingly endless rows of urinals, as many as at Radio City Music Hall—with as many semaphoric penises as a full kick line of Rockettes' legs … and in the stalls, you might say, apropos tea ceremonies, there was a kind of Zen operating insofar as the mediator was summoned to contemplation of a symmetry without the burden of any attendant meaning.

So he's in the tea room at 59th and Lexington, of course on the uptown side, and he sees scribbled on the stall wall, *For a nice acomodation* [sic], *call Regent 4—*, and for the first time in his life is impelled to scribble a reply: *There are two c's and two m's in* accommodation, *Mary.*

To cater to the flood of tourists, dozens of self-consciously picturesque *Burns, p. 327* tearooms sprang up, with names that suggested … "a tinted zoology"—the Black Parrot, the Purple Pup, the Green Witch, the Vermillion Hound.

Old cops always called the tea rooms the nickelodeons. *McCourt, p. 94*

One's social performance in subway toilets. *Ibid., p. 93*

I've never understood how anybody can do business in such places, with *Ibid., p. 96* express trains roaring by at regular intervals.

I get vertigo in the Ramble, dear—all those precipitous declivities. *Ibid., p. 103*

Moving along at warp speed from a single encounter on Eighth Street. *Ibid., p. 106*

Santos measures his success by his earnings. He is sure that he has done as *Reay, pp. 58–9* well, if not better, than most of the boys who loiter around Forty-second Street between Broadway and Eighth Avenue, a street known by homosexuals as the "Meat Market." Here hoodlum homosexuals meet prospective customers and arrange the details of payment, the form of sex play, and the place where it is to occur. Santos says that his usual fee is $1. On one evening he took in as much as $6 for three sexual experiences.

A few flagrantly exhibitionistic fairies are able to make a living through the sexual gratification of men who are interested in their type of service. Ordinarily, however, the hustler is the one who is paid by the "queen," "bitch," "fag," or "fairy"—that is, by an effeminate exhibitionist who not only brazenly proclaims his homosexuality to the interested, but attempts to force it on the notice of others. Like the female prostitute, the effeminate male prostitute has a more masculine male prostitute somewhere in the offing to whom he contributes and who serves as his protector. Sometimes these protectors are gangsters. Emotional attachments between fairies of Santos' type and their protectors are ephemeral affairs.

Warhol, *POPism*, pp. 372–3

The big nude theater craze hit in '69. It was only the year before that police had stood by in San Francisco to arrest the Living Theater performers if they so much as started taking their clothes off. Then all of a sudden the new thing was for performers to take all their clothes off and dance around completely naked on stage in long-playing well-advertised shows like *Oh! Calcutta!* and *Dionysus in '69.*

During this period I took thousands of Polaroids of genitals. Whenever somebody came up to the Factory, no matter how straight-looking he was, I'd ask him to take his pants off so I could photograph his cock and balls. It was surprising who'd let me and who wouldn't.

Personally, I loved porno and I bought lots of it all the time—the really dirty, exciting stuff. All you had to do was figure out what turned you on, and then just buy the dirty magazines and movie prints that are right for you, the way you'd go for the right pills or the right cans of food. (I was so avid for porno that on my first time out of the house after the shooting I went straight to 42nd Street and checked out the peep shows with Vera Cruise and restocked on dirty magazines.)

I'd always wanted to do a movie that was pure fucking, nothing else, the way *Eat* had been just eating and *Sleep* had been just sleeping. So in October '68 I shot a movie of Viva having sex with Louis Waldon. I called it just *Fuck*.

At first we kept it at the Factory, screening it occasionally for friends. Then, when we opened *Lonesome Cowboys* in May and it began to die pretty quickly, we had to think about what to replace it with, and I wondered if it should be *Fuck*.

I was still confused about what was legal in pornography and what wasn't, but at the end of July, what with all sorts of dirty movies playing around town and dirty magazines like *Screw* on every newsstand, we thought, oh, why not, and put *Fuck* into the Garrick Theater after changing the title to *Blue Movie*. It ran a week before getting seized by the cops. They came all the way down to the Village, sat through Viva's speeches about General MacArthur and the Vietnam war, through Louis calling her tits "dried apricots," and through her story about the police harassing her in the Hamptons for not wearing a bra, etc., etc., etc. and then they seized the print of our movie. Why, I wondered, hadn't they gone over to Eighth Avenue and seized things like *Inside Judy's Box* or *Tina's Tongue*? Were they more "socially redeeming," maybe? It all came down to what they wanted to seize and what they didn't, basically. It was ridiculous.

Ibid., p. 289

I knew that we were probably going to have more trouble with the censors soon—at least if our movies kept getting attention and I guess I must have known in the back of my mind that it would be a smart idea to have at least one really articulate performer in each movie. The legal definition of "obscenity" had that "without redeeming social value" phrase in it, and it occurred to me that if you found someone who could look beautiful, take off her clothes, step into a bathtub, and talk as intellectually as Viva did ("You know, Churchill spent six hours a day in his tub"), you'd have a better chance with the censors than if you had a giggly teenager saying, "Let me feel your cock." It was all just silly legal strategy, though, because to me they were all great, all just people being their real selves on camera and I liked them all the same.

Wornov, pp. 89–107

The Factory was dark. It took me a moment to figure out what was going on, and when I did I knew Ondine wasn't there. Andy was torturing several people, several rich people judging by the little gleam of jewelry at

everyone's throat and wrist, and by the smell; the rich have a certain smell when they are upset, like good food going bad. I saw little screams for help shine in the ladies' eyes, and heard the soft groans from their husbands as they twisted in their chairs. Oblivious, Andy calmly loaded another reel of his twenty-four hour movie called *Fuck*. He knew they were unhappy, but he always thought if he just showed them a little more they would finally understand or maybe even like it. Tonight he was projecting two separate scenes and soundtracks onto the same screen at the same time. The result was excruciating; the very air was turning black with pressure as the bright flickers of pain shot through it. To make matters worse, one of the uncomfortable women sat very near a famous art critic who was watching this mess with a cigar in his mouth and an anonymous dick in each of his hands, the owners of which lay stoned on either side of him on the silver couch. I was happy to see the rich had to go to hell too, and I would have stayed to enjoy their discomfort but I was more interested in finding Ondine. I told Andy I had to run.

The Bryant (that had featured "Live Sex Shows," which, at five performances a day between ten and ten, were exactly that: a brown or black couple spent twenty minutes on a bare blue-lit stage, first the woman stripping for the man, then fellating him, then his performing cunnilingus on her, and finally the two of them screwing in two or three positions, finishing—with pull-out orgasms for a few of the after-six shows—to polite applause from the largely forty-plus male audience, before the porn film started once more. At the back of the chest-high wall behind the last row of orchestra seats, usually some guy would give you a hand job or sometimes a blow job; there for a couple of weeks I gave my quota of both) was simply a south-side vacant lot. *Delany, pp. 17–18*

Just as Manhattan liberals of a few years before had sought to rub elbows with student revolutionaries and Black Panthers (a trend satirized by Tom Wolfe as "radical chic"), so now the smart set indulged in "porn chic," joining the raincoat brigade at Times Square theaters to see *Deep Throat* and such films as *The Devil in Miss Jones* (1972) and *Behind the Green Door* (1972) in order to claim front line credentials in the sexual revolution. *Turner, NYC Sex, p. 11*

Prostitution

"The capital of dangerous love." *Berman, Town, p. 112*

Where the girls with thirsty eyes go by. *Teasdale, p. 50*
[…]
With the man I love who loves me not
 I walked in the street-lamps flare—
But oh, the girls who can ask for love
 In the lights of Union Square.

Reformers: think of prostitution not as a social evil but as an answer to a human need. *Peretti, p. 29*

If *Crane, Complete, p. 109*
you don't like my gate why did you
swing on it, why *didja*
swing on it
anyhow

Conrad, p. 226	Crane vows to withdraw from "beckonings and all that draws you into doorways, subways, sympathies, rapports and the City's complicated devastations."
Peretti, p. 43	Preludes to solicitation: A woman on Times Square acted very suspiciously, but she explained, "The reason I winked at you was that I didn't want anybody else to see me. You have to be somewhat careful around the City of New York."
Ibid.	The detectives tried to glean conclusions from the most ambiguous female body language.
Ibid., p. 44	At the Dreamland dance hall in Harlem in 1931, a hostess exposed her breast to detective "B" and suggested that he kiss it. On his second visit in 1932 to a massage parlor on West 70th Street an investigator disrobed for a session. A masseuse removed the towel from his loins, put oil on her hands, and tried to "stimulate his private parts," while another offered him a "tongue bath."
Gold, p. 15	The girls winked and jeered, made lascivious gestures at passing males. They pulled at coat-tails and cajoled men with fake honeyed words. They called their wares like pushcart peddlers.
Ibid.	The girls were naked under flowery kimonos. Chunks of breast and belly flashed. Slippers hung from their feet; they were always ready for business.
Ibid.	Earth's trees, grass, flowers could not grow on my street; but the rose of syphilis bloomed by night and by day.
Petronius, p. 71	… old New York hookers rarely retire. They just move to Chicago or Duluth.
Ibid., p. 72	New York is the hooker melting pot of the world … New York features at least 3,000 hookers. Each grosses an average of between $15,000 and $20,000 a year. Mostly tax free … Very few girls come to New York exclusively to pursue hookerdom. In fact, no more than 3% of New York's hookers came here with hustling in mind as their destined career. Most usually land with some more noble aspiration in mind … and then gradually settle down to pursue this most classical and traditional career for as long as possible.
Ibid., p. 76	The majority of New York's vice girls are *foreign*. They're often superbly shrewd beauties who have maneuvered their way to the United States through various methods. Many of them were war brides, temporarily charming the lonesome GI and dumping him shortly after marriage and citizenship. It takes a special cunning for the ones who get here … But the foreign girl who was so desirable overseas loses much of that notorious European femininity in the process. The men who rave about those "magnificent European women, so much better, more understanding than U.S. girls" would swallow those fatuous words if they examined the relocated product once she has settled in New York or points west.
Ibid.	Hunter College, New York University and Columbia all contribute their share of educated ladies of leisure to the sexual vortex of the city. There has also been a contingent of college girls who hook for prestige. They actually brag about their sexual adventures as an index of their social emancipation. Paid pros regard them with great distaste.

Sex — Prostitution

The garment, jewelry, furniture, hardware, fur districts and many other centralized industries abounding in New York all have a need for hookers. For themselves and hundreds of customers from all over the world who pass through for business.

Ibid., p. 77

… there has been a larger call for colored girls, and shortage of same. The quality of the colored girls who hook has gone down … the top colored hookers in New York are always quite light, unusually beautiful and rarely have dealings with Negro men … except for those in very high and powerful stations.

Ibid., p. 79

The United Nations is one of the largest users of hookers. They have an assembly of choice prostitutes at their disposal. A girl considers a UN diplomat or any foreign emissary a genuine prize. They are all exceedingly generous with their nation's money and extra gifts; most court the prostitutes extravagantly. They're also all great leads for the wealthier members of their countries who drop in on the States and like to meet a nice girl. Have tons of money, want to swing.

Ibid., p. 85

Times Square: "There may never have been such a vast variety of women thrown together in any one place before. A small proportion of these women were prostitutes, professionally offering many varieties of sex, and appealing to customers in every class. Other women, sexual amateurs (though often fairly sophisticated), offered themselves to coworkers, bosses, or customers, sometimes in hope of a respectable marriage, other times settling for cruder satisfactions like furs, jewels, and rent money. Some would have died rather than give up their premarital virginity, yet sought alluring ways to present their sexuality in the ways they dressed and moved and spoke."

Berman, *Town*, p. 110

On sunshiny days the whores sat on chairs along the sidewalks. They sprawled indolently, their legs taking up half the pavements. People stumbled over a gauntlet of whores' meaty legs.

Gold, p. 15

Walked along the West Side Highway structure, roaring autos and grainy darkness, filthy streets with the tugboat strike, a few transvestites out hooking in the shadows of the girder stanchions.

Wojnarowicz, p. 115

I tell the chauffeur to head over to the meat-packing district just west of Nell's, near the bistro Florent, to look for prostitutes.

Ellis, *Psycho*, p. 168

Manhattan go-go bars are really sleazy. The owners sometimes want you to go into the back rooms to do hand jobs on the creeps.

Mueller, p. 147

Tricks at the St. Regis.

Quan, p. 97

Down on the West Side Highway, a lone hooker totters on heels and tugs at her skirt as if no one had told her that the commuters won't be coming through the tunnels from Jersey today. Coming closer, you see that she is a man in drag.

McInerney, *Bright Lights*, p. 9

Hookers and office workers do not wear the same kind of high heels, stockings, skirts, foundation garments, wigs, or makeup, and these items do not mean the same things, either.

Califia, p. 219

The Tenderloin was represented by persons who seemed to forget for a moment the trade that brought them there.

Hapgood, pp. 369–71

Spillane, p. 186 They don't start walking the streets until midnight, if that's what you're after.

Coda

Van Vechten, p. 70 The only happy people left in New York are the Lesbians and pederasts, and they are so happy they are miserable. Nobody else has anything.

Harris, *Diary*, p. 99 I was too unnerved by the ominous sounds of distant sirens and the honking horns of cars confused by the failure of the traffic lights to enjoy the sex, which seemed distinctly ill-omened, as if it were our last fuck, the last desperate gropes of a couple doomed to die before sunset, the twilight of Western civilization as we knew it.

Coney Island is the dress rehearsal for Manhattan.

Koolhaas, p. 27

Electric Eden.

Sanders, *Celluloid*, p. 30

I, poet without arms, lost
in the vomiting multitude

Lorca, "Landscape," p. 426

For Lorca, Coney Island becomes "Landscape of the Vomiting Multitude"
and Battery Park "Landscape of the Urinating Multitude."

Walton, p. 22

What would a Jones Beach of the mind be like?

Berman, *Solid*, p. 297

Reginald Marsh on Coney Island: "I'm nauseated by the smell of stale food,
but after that I get so I don't notice it."

Kasson, p. 93

Unreality is as greedily craved by the mob as alcohol by the dipsomaniac.

Ibid., p. 96

It attracted people because of the way in which it mocked the established
social order. It in effect declared a moral holiday for all who entered its gates.
Against the values of thrift, sobriety, industry, and ambition, it encouraged
extravagance, gaiety, abandon, revelry. Coney signaled the rise of a new mass
culture no longer deferential to genteel tastes and values, which demanded
a democratic resort of its own. It served as a Feast of Fools for an urban-
industrial society … As a city of festivity and play, Coney Island challenged
conventional categories of social description. It appeared to be a new kind of
cultural institution, and commentators groped for analogies to describe it:
"an almost uninterrupted French *fête*," "a medieval street fair," a "fiesta and
mardi-gras," a "charivari," and, again and again, a "carnival" … In Coney's
permissive environment customers felt a giddy sense of irresponsibility.
Among the most popular attractions … were booths with imitation china
dishes, objects to throw at them, and a sign: "If you can't break up your own
home, break up ours!" … Factory "girls" pretended they occupied loftier
positions and played the parts of stenographers and private secretaries for a
day; and a Brooklyn shopkeeper would don her best clothes and act the part of
a *grand dame*. More dramatically, a prim-looking "schoolmarm," accustomed
to curbing the childish excesses of others, surrendered to her own at Coney
Island and walked fully dressed into the sea.

Ibid., pp. 49–50, 59

Arriving as separate, isolated figures, they became actors in a vast,
collective comedy. The flamboyantly expressive surroundings had the effect
of garbing customers in costumes and eliciting their own theatricality. At
various moments on rides they might briefly grab the spotlight and attract
the attention of the multitude; at other times they might sit in the balconies
and watch their fellow revelers. The lines between spectator and performer,
between professional entertainer and seeker of amusement, blurred at Luna
Park.

Ibid., p. 65

My analyst says I exaggerate my childhood memories, but I swear I was
brought up underneath the roller coaster in the Coney Island section of
Brooklyn. Maybe that accounts for my personality, which is a little nervous, I
think.

Allen and Brickman,
Annie Hall

A ferry ride to Coney became for middle- and working-class people a
substitute for a steamship cruise abroad and Luna Park a Cook's tour in
miniature.

Ibid., p. 70

Ibid., p. 82

Though Luna Park provided benches, the owners hated to see customers sitting on them, for in effect they were removing themselves as actors in the spectacle and becoming a potentially detached and critical audience. When people sat down, they would immediately dispatch a band of musicians to the scene in attempt to rouse their customer's spirits and thus bring them to their feet.

Ibid.

The importance of sustaining the illusion of anarchic freedom and heedless release beneath the underlying reality of control underlay all of Luna Park and Coney Island as a whole. The various rides were based upon the ability to coordinate mass activity through technology, to assemble and disperse crowds at will without making such efforts oppressive.

Ibid., pp. 73–4

All of Coney Island's intricate machines and amusements were unproductive, promising customers nothing more than the pleasure of the event itself; that was central to their character as play. But the particular forms this play took were significant. In the effort to suggest a dream or nightmare world, Coney abstracted features from the larger society and presented them in intensified, fantastic forms. Instruments of production and efficiency were transformed into objects of amusement, and life around them lifted from dull routine to exhilarating pageantry.

This process is particularly striking in the case of the mechanized rides at Luna and elsewhere in Coney Island. These marked the culmination of a desire, evident throughout the nineteenth century and into the twentieth, not simply to view technology in utilitarian terms but to value it as spectacle. Generations of Americans had thrilled in viewing huge steam engines, thundering locomotives, and other powerful machinery as sublime creatures harnessed to do their bidding. Mechanical amusement rides allowed them to cultivate the delight, awe, and fear of the technological sublime still more intensely.

Barnes, *New York*, p. 145

If an embargo were placed on noise at Coney, if silence were required, there would be a lot of people who would lose their jobs. If the transactions of the mongers were carried on in the sign language, there would be money in manicuring.

Kasson, p. 66

Luna appealed to popular notions of magnificence. Illusions of extravagance and ostentatious display provided a holiday compensation for the plainness and thrift required of everyday life … Before the mansions of the rich on New York's Fifth Avenue they might feel humbled and excluded, but here they could feel assured. Luna Park, in effect, democratized the hunger for aristocratic splendor that was driving rich industrialists to construct palatial houses at the turn of the century. It provided a Newport for the masses.

Ibid.

Luna turned night into day, a feat which symbolized its topsy-turvy order. Its buildings dramatically altered their appearance [via colored lights] to achieve an even more festive air and invited visitors to do the same.

Sanders, *Celluloid*, pp. 30–1

Coney Island's nighttime landscape complements the plaster architecture of days: not rectangular signboards propped above modest, boxy, commercial buildings, but a delicate tracery of bulbs, draped like glittering necklaces over the romantic structures of a shimmering fairyland.

Goldenberg, pp. 17–18

The Infant Incubator exhibit, at Luna Park in Coney Island, among midway attractions like the Streets of Delhi and Trip to the Moon, was a consistently popular attraction from 1903 until the exhibit closed 40 years later. Stranger

still is that the exhibit was, by all accounts, medially and ethically sound. Visitors to the exhibit viewed rows of tiny infants dozing in their incubators while a lecturer explained the workings of the life-saving machines. The Incubators closed when the cost of maintaining the exhibit became too great amid the general cheapening of Coney Island entertainments.

Luna Park's "Human Toboggan."

Kasson, p. 78

A Luna Park ride in the shape of a huge tobacco pipe, in which patrons entered at the mouthpiece and slid out the bowl.

Ibid.

steep mountains for tolling at absurd speeds

Depero, "Coney Island," p. 422

climb descend climb descend

Abril, p. 432

Such rides served in effect as powerful hallucinogens, altering visitors' perceptions and transforming their consciousness, dispelling everyday concerns in the intense sensations of the present moment. They allowed customers the exhilaration or whirlwind activity without physical exertion, of thrilling drama without imaginary effort.

Kasson, p. 82

Coney Island is a problem for interpreters of the city because it can be a lesson in the glad democracy of human fates or in their individual insignificance. It aggravates the psychological problem of the city: are we akin to our neighbors, or do we dissever ourselves from them in gloating at them?

Conrad, p. 96

Dreamland contained a Lilliputian village inhabited by 300 midgets.

Kasson, p. 86

Midgets, giants, fat ladies, and ape-men were both stigmatized and honored as freaks … Their grotesque presences heightened the visitors' sense that they had penetrated a marvelous realm of transformation, subject to laws all its own. The popular distorting mirrors furnished the illusion that the spectators themselves had become freaks. Thus it seemed charged with a magical power to transmute customary appearances into fluid new possibilities.

Ibid., pp. 50–1

Coney boasted its own "Streets of Cairo." Visitors stared at camels and warily fed elephants, not in a circus setting but as participants in a drama that attempted within its means to suggest the mysteries of the Orient.

Ibid., p. 53

Showmen vied with one another in re-creating such famous disasters as "The Fall of Pompeii," simulating the eruption of Mount Vesuvius and the death of 40,000 people, the eruption of Mount Pelée and devastation of Martinique in 1902, Pennsylvania's Johnston Flood of 1889, and Texas's Galveston Flood of 1900. For the first live disaster spectacle Luna chose a scene closer to home. In "Fire and Flames" a four-story building was repeatedly set ablaze, the fire battled by heroic firemen while residents leaped from upper windows into safety nets below.

Ibid., pp. 71–2

The day that Luna Park burned to the ground. The year was 1944. There was a sudden stirring on the beach, a movement away from the surf to the boardwalk, and then great clouds of black smoke piling into the cobalt sky. You could hear voices: Luna Park's on fire. People were running then, and we could hear the sirens of the Fire Department and saw high arcs of water rising in a beautiful way and falling into the flames. We watched for hours, drawn

Hamill, "Lost"

as New Yorkers always are to the unity of disaster, and saw the rides and buildings collapse into black, wet rubble until there was no more Luna Park.

Kasson, p. 112

Following the great fire that destroyed Steeplechase Park, a sign appeared: "Admission to the Burning Ruins—10 cents."

Sex

Conrad, p. 95

In the mechanical metropolis, the body is cordoned off from exhibition and discloses itself either tawdrily at burlesque shows or in a wrestling adipose mass on the beach.

Ibid., p. 252

Sunday, July 28, 1940, Coney Island, 4 p.m. A sweaty compendium of overlapping limbs. Standing or sitting on one another's shoulders, an undiscriminating family of flesh. They're all just meat.

Ibid., p. 96

There may be a million bodies on the beach, but none of them is much concerned about any of the others.

Mortimer and Lait, p. 141

Time was when Coney's transgressions were crimson and its sinners wore silks and sables.

Conrad, p. 252

On the beach: "crowd of over a MILLION … (I wonder who counts them)" has no order except the carnal common denominator. We all have bodies ("undressing is permitted on the beach"), and we're all therefore voyeurs.

Ibid., p. 96

Coney as alfresco life class; Reginald Marsh carried anatomy textbooks with him to the beach, where a million near naked bodies could be seen at once, a phenomenon unparalleled in history.

Ibid., p. 98

Marsh was ambitious to paint murals, reinterpreting the city's public spaces as idylls of surfeit and athletic sensuality. His Coney Island with its wrestling musclemen is a tribute to Michelangelo's bathing soldiers; his Luna Park with its barrage of indiscriminate bodies is an orgiastic heaven based on the hell of Michelangelo's "Last Judgment"; his nocturnal Central Park in a painting of 1932, with patrolling sailors and tempting girls trailing off to couple in leafy alcoves, is a scene of unprotesting ravishment that corrects Rubens's "Abduction of the Daughters of Leucippus."

Chauncey, p. 184

A male beauty contest held at Coney Island's Washington Baths in the summer of 1929 took an unexpected turn. To the surprise of a *Variety* reporter who served as one of the judges, most of the people who gathered to watch the contest were men. Add to her further surprise, most of the men participating in the contest wore paint and powder. On a packed beach on a hot summer afternoon, gay men had taken over a male beauty contest, becoming its audience, its contestants, its stars.

Ibid., p. 210

1939–40: "Coney Island has one truly amazing bath … It gives the visitor the impression of being exclusively homosexual. If one visits the roof there is the spectacle of at least a hundred naked males practically all of them homosexuals, with a few hustlers and kept boys about, lying around in the sun. The more direct homosexual expression is reserved for the steam rooms. There, in an atmosphere murky with steam—so murky, indeed, that one cannot see more than a few feet ahead—with benches around the walls, fellation and pedication are not at all uncommon. If one stumbles over

a pair in the act, one mutters a hasty apology and goes on quickly in another direction."

The body discloses itself at the cost of a licentious vulgarization. Spectators glimpse underwear on the slippery slides at Luna Park with a roar of natural "vulgar mirth," and on the beach the women look like soft sandstone sculptures, full of the real "vulgar" human life.

Conrad, p. 96

Bert Savoy, famously struck by lightening on that very Coney Island promenade when during a summer storm he talked back to a thunderbolt, declaring, "That'll be enough out of you, Miss God!"

McCourt, pp. 19–20

Gay men gathered on the city's beaches, which were enormously popular in the decades before air conditioning. A large group of deaf gay men regularly gathered on one of the city's beaches in the 1940s.

Chauncey, p. 197

Body-builders at Coney Island as pagan gods.

Conrad, p. 114

Coney Island has been a Paradise for me that way—as it would be: my type goes there—the rough, tough proletarian; they dress for Coney Island in fetish clothing (to me), and they proceed to reduce that clothing to a fascinating minimum. And on the beach, ah the beach, with its beautiful Italians!

N. cit.

Instead of the burlesque show, he frequented the locker room at the West Side YMCA on 63rd Street and the changing sheds at Jones Beach where, in 1933 and 1935, he watched the boisterous divinities of his agora at play. Those at the Y soap and deodorize their toned-up bodies, erotically fraternizing, as the conventions of that room allow them to do, without suspicion; those at Jones Beach, with the grins of proletarian satyrs, flick each other with wet towels.

Conrad, p. 99

Coney

Samuel Gottscho's stunning photograph *Luna Park, Coney Island* (1906) shows hundreds of dazzling lights but only two words—"WILD ANIMALS."

Sharpe, p. 191

This particularly long, thin slice of island-peninsula was so densely populated with rabbits in the seventeenth century that the Dutch called it *Conyné Eylant* (the "island of rabbits").

Maffi, p. 7

The elephant, Topsy, belonged to the Forepaugh Circus and spent the last years of her life at Coney Island's Luna Park. Because she had killed three men in as many years (including a severely abusive trainer who attempted to feed her a lit cigarette), Topsy was deemed a threat to people by her owners and killed by electrocution on January 4, 1903, at the age of 28. Inventor Thomas Edison captured the event on film. He would release it later that year under the title *Electrocuting an Elephant*.

"Topsy (elephant)"

A means of execution initially discussed was hanging. However, the American Society for the Prevention of Cruelty to Animals protested and other ways were considered. Edison then suggested electrocution with alternating current, which had been used for the execution of humans since 1890.

To reinforce the execution, Topsy was fed carrots laced with 460 grams of potassium cyanide before the deadly current from a 6,600-volt AC source was sent coursing through her body. She was dead in seconds. The event was

witnessed by an estimated 1,500 people and Edison's film of the event was seen by audiences throughout the United States.

When Luna Park burned down in 1944, the fire was referred to as "Topsy's Revenge."

The wires were dragged over. Topsy immediately complied when she was instructed to raise her right foot for the first death sandal.

"Not so vicious," a reporter remarked aloud.

Topsy seemed less a wild animal than a mild one. Another reporter later wrote, "She stood still in the application as quietly as could be asked, obeying all commands of the men even when telling her to get down on her knees."

After the second electrode was fitted on her rear left foot and she was again standing, Topsy did become mildly bothered. She shook off the electrode on her forefoot, but soon it was secured again and there she stood, nearly three decades after being torn from her mother and smuggled into America, where she had traveled tens of thousands of miles in perpetual servitude, endured innumerable beatings, and survived more than a dozen train wrecks. Her big dark eyes with their extravagant elephantine lashes glimmered with what a reporter discerned to be still at her core.

"There was real benevolence in her eyes and kindness in her manner," the *Tribune* reported.

The amusement park's press agent stepped up to act out the ultimate metaphor for his profession, feeding Topsy three carrots filled with a total of 460 grams of potassium cyanide. She took and gobbled one after another, playfully curling her trunk.

The motion picture camera had been shifted around so that Topsy was in center frame and one of the cloth banners on the platform was in full view over her left shoulder.

If the gobbling of the carrots was filmed, it never made public view. The Edison crew was there to film, and the Luna Park people were there to stage, an electrocution, not a poisoning. The big worry was that the cyanide might cause her to collapse before the electricity brought her down. The third carrot was no sooner swallowed than the Edison plant got the awaited signal on the phone.

"All right!"

The camera was running and recorded Topsy again trying to shake off the electrode on her right forefoot. The electrode stayed in place. She set her foot back down and was standing motionless when the 6,600 volts coursed through the wires and the electrician, Thomas, closed the switch at the park. There were flashes and small blue flames and then smoke began to curl up from where copper met foot. Some would describe the smell as that of burning flesh, others that of burning hoof. The pain must have been excruciating and her huge form shook violently.

"Turn the current off!" a Luna employee cried out.

The smoke rose up around her flanks and she pitched forward into it, tipping to the right as her right foreleg buckled. The chain on her left leg grew taut with the fall, restraining her even in her last instant, drawing the limb straight out, displaying the electrode at the bottom of the foot. The electrode had stopped smoking. The current had been turned off after ten seconds.

Once the motion picture camera stopped filming, the donkey engine was set to work, cinching the noose tight around Topsy's neck and holding it tight for a full ten minutes. Only then, when she had been triply killed and there was not the slightest chance that she was alive, did the three veterinary surgeons approach and pronounce her dead.

Topsy was measured and it was recorded that she was ten feet tall and ten feet, eleven inches long. The autopsy was then performed on the spot. The heart and stomach were removed for the biology department at Princeton University. The taxidermist Hubert Vogelsang began skinning her. Some of the hide would be used to cover Thompson's office chair and two of the legs would be fashioned into umbrella holders. Thompson would tell people that the hide and leg came from the world-famous Jumbo. The head was buried in a remote, unmarked patch behind the stables.

The many witnesses to the electrocution concurred that Topsy had died without making a sound. There is no way of knowing if, in those final instants, she had made one of those cries below the level of human hearing, which a scientist of the next millennium would term a contact call and explain as a simple message elephants in the wild send to other elephants across great distances of savannah and jungle. Such a cry would have carried past the gawkers and across the grounds and the beach beyond and out over the sea, fading to an unheard whisper over the waves.

"Here I am! Here I am! Where are you?"

Three elephants escaped from Coney Island's Luna Park in June 1904. One swam across the Lower Bay to Staten Island and was captured. The other two elephants, which allegedly had headed for Quogue, on Long Island, never were sighted.

Moscow, p. 95

Elephants were brought to the sands of Long Beach in the 1920s to haul pilings for the boardwalk.

Kornblum, p. 58

Freedomland opens in the Bronx, June 1960. Billed as the "world's largest entertainment area" (bigger than Disneyland), but quickly turns dystopian: A fire destroys several buildings before the opening and three gunmen have taken $28,000 from the amusement park's office, escaping by boat up the Hutchinson River. Displays include replicas of Old New York and a Kansas Cornfield. Freedomland lasts only four years before being demolished to make room for Co-Op City in 1970.

Schiavi, p. 14

Under any other conditions the Seaside Hotel would have been a flophouse. Because it had sand around the foundations and sometimes you could smell the ocean over the hot dogs and body odors, they called it a summer hotel. The corridors were cramped and warped, the carpet on the floor worn through in spots. Doors to the rooms hung from tired hinges, eager for the final siege of dry rot, when they could fall and lie there. I went down the hallway, keeping against the wall, the flash spotting the way. To one side a flight of stairs snaked down, the dust tracked with the imprints of countless rat feet.

Spillane, p. 337

Coney Island had several Communist party clubs, collectively known as the Coney Island section.

Ellis, *Epic*

The problem the Coney Island entrepreneurs faced by the 1920s was that the rest of the culture was catching up. A long-time Coney Island resident would observe, "Once upon a time Coney Island was the greatest amusement resort in the world. The radio and the movies killed it. The movies killed illusions."

Kasson, p. 112

And this is Coney Island on a quiet Sunday afternoon … a crowd of over a MILLION is usual and attracts no attention (I wonder who counts them).

Weegee, *Naked*, p. 176

Sharpe, pp. 192–3 The summer crowd sleeping on the Coney Island beach after the lights went off: A muggy moon shown intermittently over us, its bleached rays painting in ghastly tone, the upturned faces of the sleepers.

Weegee, *Naked*, p. 180 It was after midnight and jet black. One of those nights when the moon forgets to come out … but the sweethearts like that. I took my shoes off not to get sand in them and went walking in my stocking feet on the beach, being careful not to bump into any couples. I wouldn't want to disturb them for the world. Once in a while I would hear a giggle or a happy laugh, so I aimed my camera and took a picture in the dark using invisible light.

It was so still. Once in a while there would be a flicker of a match lighting a cigarette. Love making is so exhausting … a happy kind of exhaustion … and a cigarette gives one a chance to rest up and hear the heartbeat of one's partner.

I walked nearer to the water's edge and stopped to rest against a Life Guard look-out. I thought I heard a movement from above so I aimed my camera high and took a photo, thinking it was a couple who liked to be exclusive and do their love making nearer the sky. When I developed the picture, I saw that the only occupant on the look-out had been a girl looking dreamily towards the Atlantic Ocean.

What was she doing there alone among all the lovers?

Ibid., p. 186 … Came the zero hour, 9 P.M. "Lights Out" and they did go out … In Coney Island the freaks inside the museums got a well-earned rest … what with doing a new show every fifteen minutes inside, and the bally outside … In Steeplechase Park the power was shut off the machine that throws up the girls' skirts as they pass … At the Baby Incubator the side-show doctor was glad … he was slowly but surely being driven crazy by lady customers who kept pestering him with questions like "Where do you get the eggs from?" "How can I get a ticket for a premature?" "How can I have intercourse with this machine?" So Coney Island was dark … But the saloons remained open for business as usual. The patrons remained inside in the dark … and kept ordering fresh drinks by lighting matches so the waiters could see them … Someone sat down at the piano and started fooling around with the keys … "Play God Bless America," someone shouted … the melody started on the piano and everyone joined in the chorus … but loud … people like to sing loud in the dark …

New York, I tell you, was drunk to begin with. And man has done little to compensate for this original inebriety.

Collins, *Money*, p. 8

New York landscapes express an amnesiac fluency, rendering everything liquid so as to carry it into oblivion.

Conrad, p. 232

Robert Ripley liked to remind his readers that the word "Manhattan" in the language of the Indians who were its original inhabitants means "Place of Drunkenness."

Douglas, p. 24

Manhattan *is* the place where we all got drunk.

Collins, *Money*, pp. 8–9

Fitzgerald ended an alcoholic rampage of his own on Fifth Avenue early one Sunday morning in 1919, and instigated a giddy parade by rolling empty champagne bottles down the roadway.

Conrad, p. 195

wine drunkenness over the rooftops

Ginsberg, *Howl*, p. 3

Oh mixologic cryptogram
It's the Manhattan-Cocktail!
Manhattan! Manhattan! Gechy Manitou!

Meyer, "Manhattan-Cocktail," pp. 295–6

The cocktail is the product of a period when drinking is equated with style and art. The purpose remains the brain's annihilation; but the means to that obtuse end must be fantasticated and ritualized. Nature and its thirsty cravings must succumb, as at Van Vechten's Coney Island, to artifice. The same mutation occurs when Fitzgerald says the New York skyline is fabricated not from which is ordure, but from sugar. The cocktail is a liquid symbol of decadence in its contradiction between function (getting drunk) and form (doing so by tippling grenadine or honey or maple syrup). It corresponds to the sexual habits of Firbank's New Yorkers, who administer sadistic slaps with bouquets or with checkbooks. The instinctual urge, complicated by optional extras and fetishistic detours, turns toward perversity.

Conrad, p. 203

During Van Vechten's "splendid Drunken Twenties," New York undergoes an imaginative liquidation.

Lerner, p. 50

Once de Kooning and Marisol drank together all night; and then about six in the morning, de Kooning thought the pebbles in the street were floating about.

Stevens and Swan, p. 369

In New York it is the cocktail hour. You have cocktails at the homes of various friends after your day's work in the city. Thirty people, fifty people, even more. You stand up. It is impossible to carry on a conversation standing up, for, in the middle of a phrase, a third person intervenes, taps you on the shoulder and says "Hello!" It is useless to go on trying, conversation is out of the question. One cocktail leads to another, your blood warms up, voices rise; the noise, annoying at first, becomes intolerable. Everyone shouts and has an alcoholic smile. Cudgel blows on spirits wearied by hard work in the city. Decidedly, conversation is impossible.

Corbusier, p. 103

The bar is the center of their apartments, and in its shuttered and black-mirrored laboratory they toil over the invention of new cocktails.

Conrad, p. 204

Alcohol

Now, admittedly, mixed drinks are not paintings, sculptures, novels, or poems. They are disposable and, frankly, not a little bit disreputable, standing roughly in the same relation to the culinary arts that American motor sports do to automotive engineering or hot jazz to musical composition: they smack of improvisation and cheap effects and even the most august of them lack the cachet accorded to fine wines, old whiskies, and cognac brandies. They are easily abused; they can degrade lives and even destroy them. Even if appreciated in moderation, they are appreciated in surroundings that rarely lead to detached meditation on truth and beauty (if those are not the same thing) or constructive engagement with the great moral and social questions of the age.

Larry Rivers once said to me, "I've often asked myself, what is a bar? It's a space that has liquor that's usually fairly dark, where you go for a certain kind of social interaction. It's not a dinner party. It's not a dance. It's not an opening. You move in a certain way through this space, over a period of time, and you begin to recognize faces that begin to recognize you. And you may have had experiences with some of these people before which you kind of pick up on in another way in this space."

The Angle Bar with one door on Eighth Avenue and the other on 43rd Street.

The Zero Zero Club was a cellar joint off Sixth Avenue that buried itself among the maze of other night spots with nothing more than two aughts done in red neon to proclaim its location. But it was doing a lively business. It had atmosphere; plenty of it ... that's why they called it the Zero Zero. Both visibility and ceiling were wiped out with cigar smoke ... Unlike most joints, there was no tinsel or chromium. The bar was an old solid mahogany job set along one wall and the tables were grouped around a dance floor that actually had room for dancing. The orchestra was set into a niche that could double as a stage for the floor show if necessary. The faces around me weren't those of New Yorkers. At least those of the men. Most could be spotted as out-of-towners looking for a good time ... Yeah, the atmosphere was great, what you could see of it. The Zero Zero Club took you right back to the saloons of a Western mining camp and the patrons loved it.

I found him in a dirty bar near Canal Street, his one hand cupped around a highball and his other hooked in his belt, in earnest conversation with a couple of kids who couldn't have been more than seventeen. Both of them looked like high-school seniors out to spend a week's allowance.

Even from bars, like a Third Avenue bar—4 P.M. the men are all roaring in clink bonk glass brassfoot barrail "where ya goin" excitement.

The British novelist Ford Madox Ford found that in New York, "few people object to your getting far drunker than a lord at any [European] social gathering," while Lois Long noted Manhattanites' preference for "drinking without interruption in the smokiest place they could find."

If you have never before seen a luxurious modern bar, this one of Tony's will interest you. It is a huge oval, occupying almost the entire front portion of the second floor space. Its polished black top, rimmed with stainless steel, rests on a base of contrasting natural woods. Little swivel stools, covered in beige leather, to match the color of the walls, are set all around. In the center, the oval back-bar, also done in beige and black, is a sparkling pyramid of vari-colored bottles. Eight bartenders in the white jackets of tradition are already

(margin notes, left column)
Wondrich, p. 10

Warhol, *POPism*, p. 234

Reay, p. 269

Spillane, p. 215

Ibid., p. 186

Kerouac, *Lonesome*, p. 105

Peretti, p. 12

Hilder, p. 596

(right margin, vertical) 0 Alcohol

busy, shaking and mixing. We are lucky to get seats. In a few minutes more customers will be clustered here three deep.

Then one night I happened into a strange, equivocal place on Twelfth Street at Second Avenue. It was called the Clock Bar. The Clock had no regular crowd. It was not Bohemian or tough or Bowery. It was a place that anyone could happen in. The place was empty—except for you.

Reay, p. 92

Crowd with alcoholic eyes

Beauduin, p. 283

Albee on Julius's: "There was a saloon—it's changed its name now—on Tenth Street between Greenwich Avenue and Waverly Place … and they had a big mirror on the downstairs bar in this saloon where people used to scrawl graffiti. At one point back in about … 1954 I think it was—long before any of us started doing much of anything—I was in there having a beer one night, and I saw 'Who's Afraid of Virginia Woolf?' scrawled in soap, I suppose, on this mirror."

Edmiston and Cirino, p. 99

The camera shows the word "Elaine's" drawn on the glass of the restaurant, and moves inside, past patrons being shown to their seats, past the crowded, noisy, smoky tables.

Allen and Brickman, *Manhattan*, p. 182

Nightlife

By 1920 the term "nightlife" was coined.

Peretti, p. 4

A museum and a factory, New York in the 1910s and 1920s was a modern scene in action crying for comment, tantalizingly ready to express and be expressed. It was a photo shoot inviting models and masqueraders, a play in the vast business of being cast, a movie set calling those ready to live inside their own movie of New York.

Douglas, p. 59

In 1945, only one in fifteen New Yorkers had ever been to a nightclub and 92 percent were in bed by 10:30 p.m.

Morris, *Manhattan '45*, p. 166

Five thousand people in New York go out several times a week.

Haden-Guest, p. xii

An army of tens of thousands were moving through Nightworld.

Ibid.

Thursday is New York's night out.

Trebay, p. 273

Life in New York only begins to get really amusing around two-thirty. In Harlem the club Bamville was deserted on Sunday nights until about four A.M. when hordes began arriving for the Monday morning breakfast-dance.

Peretti, p. 7

The whole mystique of the place was to make a person struggle to find it.

Haden-Guest, p. 5

The nocturnal behavior centering on the nightclub districts posed a new challenge to the daytime norms of "respectable" New York culture. The presence of homosexuals and prostitutes was the most blatant indication that the night was a culturally alternate, liminal, or "inverted" time.

Peretti, p. 8

Fitzgerald: "It was characteristic of the Jazz Age that it had no interest in politics at all."

Douglas, p. 18

Mitchell, *Ears*, p. 233	In this agitated metropolis nightlife joints sprout like jimsonweeds after a spring rain.
Peretti, p. 10	Most clubs had no windows at all.
Ibid., p. 16	The nightclub disenchants New York. You pass the portals of a guarded house, leave the throngs in the Avenue, and straightaway you are transported to another clime. You are in a village street in Millen, Georgia, with wisps of cotton blowing about. There is dancing in the village square … Old wooden lamp-posts stand round the square, with smoky kerosene lamps in the quaint lanterns above. Lamp-dazzled Emperor moths are on the wing, and float above in the dim light. Men and women sit about at tables, talking or listening or merely existing. Inside all is unreality, sentiment, indulgence and relaxation. New York has been banished.
Lerner, p. 140	By stepping into one of New York's nightclubs, one could suddenly be transported to an ocean liner, a Hungarian village, a pirate's den, an antebellum plantation, an old-fashioned Parisian café, an ultra-modern European casino, a bohemian tearoom, or a luxurious country club.
Peretti, p. 12	A smart girl in black with silver flowers on her hips selling dolls, the four strolling guitarists, and Guinan's "near-naked girls" who sang "a song about cherries."
Ibid., p. 10	The magician at one nightclub "enthralls New Yorkers so sophisticated that they, apparently, have never been to a county fair in Dubuque and seen the shell game put over on the yokels."
Ibid., p. 17	Ethnic motifs in the decor, personnel, and entertainment of nightclubs reflected the insecurities of native-born white Americans in an increasingly diverse society. These portrayals both fulfilled white customers' taste for exotic escapism and expressed their anxieties about the world outside nightclub walls.
Walker, *Night Club*, p. 209	The lower type of dance-hall, the closed joint, is a direct lineal descendent of the old mining camp dive. Its main purpose is to give the unattractive man a chance to have a good time. And how unattractive some of them are! Some of the old sourdoughs could pass for Apollos beside them. To these places come the crippled, the outcasts, the pockmarked, and frequently Filipinos, who are extremely fond of the dance.
Lerner, p. 143	Cool, cruel faces, gray with the night-club pallor, red, bloated faces, indicative of overstrained hearts, brown faces of outdoor men and alabaster faces of indoor ones. Faces of women, young faces and old ones, ugly and beautiful, stupid and daring. Keen, sophisticated faces beside blandly innocent ones.
Conrad, p. 232	Van Vechten believes that the architectural mutability of New York contradicts the solid stony permanence most cities aim to possess. New York commits itself to a more promiscuous, truant element—"if a city may conceivably be compared to a liquid, it may be reasonably said that New York is a fluid: it flows" … Pleasures well and gush there in streamy succession, catering to the insatiability of urban appetites. Among the most liquidly unstable sites mentioned by Van Vechten are those which trade in the watery elements, speakeasies and the business places of the bootleggers.

The night of January 16, 1920. Prohibition begins. As midnight approached Walker, *Night Club*, p. 2
the weather became terribly cold. A blistery wind swept around the corners.
Derelicts huddled in hallways, tried to sleep under piles of old newspapers.
The blanketed horses arched their backs and hobbled along the icy
pavements. Snowplows crunched through the streets. After midnight the
temperature in the city went down to six degrees above zero.

On the last night of legal drinking, New Yorkers crowded into corner saloons, Morris, *Incredible*, p. 294
into the cafes and supper rooms of hotels, into hot spots along Broadway's
roaring Forties, joylessly awaiting the midnight hour that would inaugurate
a future of deprivation and drought. Prosperous citizens had stocked up on
liquor at soaring prices, but even millionaires could not acquire supplies
adequate to last a lifetime. As midnight approached, people drank copiously
but solemnly. Some shed tears over the extinction of all gaiety. Some pleaded
for souvenirs of an epoch about to pass into history—a champagne glass, an
ice bucket.

In New York City, before Prohibition, there had been 15,000 places where a Collins, *Money*, p. 301
man could get a drink. Shortly after Prohibition began, there were 32,000.
Before Prohibition ended, there were more drinking places in the city than
there had previously been in all New York State. Office bars appeared.
Daytime drinking became the accepted thing in the Wall Street counting
rooms. The twenty-four-hour consumption of the average downtown New
Yorker rose during Prohibition from four fingers to fifteen.

Official estimates of the number of speakeasies in New York City as a whole Peretti, p. 10
ranged from twenty-two thousand to one hundred thousand.

In one week during Prohibition, the Anti-Saloon League claimed, New Lerner, p. 14
Yorkers consumed 30 million quarts of draft beer, a million quarts of bottled
beer and ale, a half-million quarts of whiskey, 75,000 quarts of gin, 76,000
quarts of brandy, 500 quarts of absinthe, 40,500 quarts of champagne, 60,000
quarts of wine, and nearly 500,000 quarts of other miscellaneous beers and
liquors.

The Adams Gum Company appealed to New Yorkers to try chewing gum *Ibid*, p. 50
as a replacement for their cocktails. Waving "Good-bye, Old Pal!" to the
mixed drink, Adams's advertisements in the New York dailies promised
that Chiclets, with their "exhilarating flavor that tingles the taste," would let
drinkers forget all about alcohol.

Names of alcohol-free "near beers" marketed during Prohibition: Bevo, Famo, Lerner, p. 150
Kippo, Yip, Bone Dry.

Saloons were selling alcohol disguised in soda bottles with fictitious names *Ibid.*, p. 58
like "Moonland Moss."

Prohibition transformed the familiar landscape of the city as bars disappeared *Ibid.*, pp. 51, 54
from hotel lobbies to be replaced by lunchrooms, bank branches, and shops
… Saloons were converted into grocery stores, cigar shops, or dry goods
stores.

Many restaurants considered watering down their famous wine selections to *Ibid.*, p. 53
legal strength.

Ibid., p. 58	Liquor was being sold openly from taxicabs.
Ibid.	Bartenders were hiding miniature flasks of whiskey in cigar boxes, or concealing it in bottles attached to their belts like holsters.
Ibid.	Though many hotels had closed their bars, their lobbies had become very popular with patrons desiring suspicious brews of "coffee" or "tea," curiously served without cream or sugar.
Ibid.	In restaurants, patrons were seen drinking liquor out of teacups.
Ibid.	Waiters had quickly mastered the art of exchanging flasks under tablecloths.
Ibid.	A candy shop on Wythe Avenue in Brooklyn sold chocolate bunnies filled with whiskey.
Ibid.	Farm trade journals reported 17,000 trainloads of grapes being shipped to New York, and estimated that only 20 percent were consumed as fruit.
Ibid., p. 107	Wine-making was so common in the Italian quarters of New York that every fall the gutters in front of tenements and storefronts would be stained red by the dregs from the process, and the women who worked in the local grocery stores would apologize for their grape-stained hands.
Ibid., p. 58	A Staten Island hearse was stopped carrying 60 cases of liquor.
Ibid.	An olive oil dealer on Chrystie Street actually turned out to be selling rye in olive oil tins.
Ibid.	Pharmacies, which could legally dispense prescription whiskey.
Van Vechten, p. 174	One day in late winter which was so heavenly bright, all of New York with one accord pulled down the shades, illuminated its rooms with artificial light, and manufactured synthetic gin in a thousand bathtubs.
Lerner, p. 86	See what Prohibition has done—driven hard working, honest men to drinking wood alcohol.
Ibid., pp. 100, 108	"Dry Americans" and "wet foreigners" … "Most of the aliens are lovers of wine, which they are unable to get under present conditions. As a result, they are changing their minds about America being the free country they thought it was and are going back now where they will be able to get their wine and beer unmolested."
Ibid., p. 152	"wet" propaganda
Ibid., p. 101	The defiance of Prohibition could be seen all over the city. In Little Italy, Greenwich Village, East Harlem, and sections of the Bronx, Italian workers still gathered in cafés to drink wine. In Jewish neighborhoods, cafés and restaurants freely sold wine, beer, and liquor to their patrons. In Harlem, grills and cafés remained open for business, with the traditional walnut or mahogany screens still covering their plate-glass windows to obscure the goings-on inside. One reporter argued that the only discernible difference between these Prohibition-era saloons and their legal predecessors was that the traditional free pretzels had been replaced by potato chips.

According to Manhattan lore, the originator of the interwar nightclub was a tall, sad-faced Irish-American named Larry Fay. A native to the island, Fay was a taxicab driver with a long record of traffic and parking violations who dabbled in controlling his own fleet of cars. In 1920 Prohibition had begun and speakeasies had sprung up to sell illegal liquor. That year, legend has it, Fay took on a bootlegger as a fare. They drove 400 miles to Montreal, where the passenger picked up a crate of liquor. Earning a sizeable wad of bills for his effort, Fay decided to buy his own cache of Canadian whiskey. On his return to Manhattan he sold it to speakeasies and scored a large profit. Fay first poured his liquor earnings into an effort to build the most distinctive taxicab fleet in the city. He outfitted his cabs with blinking lights, tune-playing horns, polished metallic trim, and inlaid black swastikas. His personnel director, a recently paroled thief named Owney Madden, hired tough and aggressive drivers and ran the racket, using threats to scare other cabbies away from railway stations and prestigious hotels.

Peretti, p. 1

Most of all, New Yorkers drank during Prohibition because drinking was a form of cultural rebellion against the heavy-handed moralism of the dry lobby and its insistence that all Americans adhere to the same social mores.

Lerner, p. 130

Tex Guinan began wearing a charm bracelet made of tiny gold padlocks in a spirited show of defiance.

Ibid., p. 158

Jimmy Walker called moral reformers "the side-burned shock troops of reform."

Ibid., p. 163

Under the initial terms of the Volstead Act, all households in the United States were entitled to an annual allowance of ten gallons of sacramental wine for religious use.

Ibid., p. 117

Fraudulent rabbis inflated the sizes of their congregations to get more wine; sold wine to saloons; forged wine permits; took kickbacks from wineries; set up elaborate schemes to import wine illegally; or sold wine to gentiles using fake Jewish names.

Ibid., p. 121

Newspaper headline: "Jews of City without Wine for Passover."

Ibid.

The Dearborn Independent, a Michigan newspaper published by Henry Ford, in a 1921 article claimed that "bootlegging is a 95 percent controlled Jewish industry in which a certain class of rabbis have been active." Mocking the provisions of the Volstead Act that allowed the use of sacramental wine, the paper insisted that "rabbinical wine" is a euphemism for whiskey, gin, Scotch, champagne, vermouth, absinthe, or any other kind of hard liquor.

Ibid., p. 122

Robert Benchley had his first cocktail in 1921 in a speakeasy with playwright Robert Sherwood and Zelda and F. Scott Fitzgerald … Benchley once visited thirty-eight speakeasies and clubs in a single night.

Ibid., pp. 128–9

Prohibition transformed Dorothy Parker into a drinker as legendary as Benchley.

Ibid., p. 129

Men would surreptitiously ask for "ginger ale" in bars, hoping the bartender would respond with a wink and the query, "Imported or domestic?" If the customer wants imported ginger ale, and he is the right kind of customer, and he gets a regulation pre-Prohibition highball … When the diners requested two highballs, the waiter asked, "Do you know anybody?" The one guest

Ibid., p. 134

pointed at his companion and replied with a smile, "I know him, and he knows me." With that, the waiter fetched the drinks, for these, unmistakably, were true New Yorkers, qualified to be served.

Ibid., p. 135

Have you observed, of late, how fastidious everyone has become in the matter of liquor? Not only a particular brand, but a definitive vintage and especially shaped bottle are now almost always demanded.

Ibid., p. 138

Some speakeasies were tucked away in construction sites, hidden in apartment back rooms, disguised behind receptionists' desks in office buildings, or brazenly situated across from police precinct houses.

Ibid., p. 139

Six white-coated fellows … lining the shakers up and down lustily to the tune of rattling ice … while the faintly sweet aroma of gin floated back through the crowd pressed against the rail.

Ibid.

"Gin" was often industrial alcohol mixed with glycerin and oil of juniper, while "scotch" was made from grain alcohol colored with prune juice, creosote, or Moxie.

N. cit.

Prohibition song titles: "How Are You Going to Wet Your Whistle (When the Whole Damn World Goes Dry?)," "I Must Have a Little Liquor When I'm Dry," and Irving Berlin's "You Cannot Make Your Shimmy Shake on Tea."

Mitgang, p. 33

The inlets of Long Island served as ports of call for small boats unloading liquor. Once in a while, bathers at Coney Island heard the boom of small cannon as the Coast Guard fired warning shots across the bows of unregistered speedboats suspected of carrying contraband whisky. Sometimes the whisky was dumped to lighten an unregistered vessel so it could make a fast getaway. To the delight of beachcombers from Coney Island to Montauk Point, 120 miles away from the eastern tip of Long Island, cases of whisky sometimes washed up on the sands.

Lerner, p. 156

New York will be on a strict "water diet" within sixty days.

Ibid., p. 200

Ladies' department stores in the district hawked whiskey and gin under code names like "red stockings" and "white stockings."

Ibid., p. 201

Many African Americans looked to Prohibition as an important opportunity to prove the decency and "respectability" of their race.

Ibid., p. 200

The community's moral guardians were called "Black Victorians."

Ibid., pp. 202–3

One African American politician in neighboring Jersey City went so far as to suggest that if the Eighteenth Amendment were ever repealed, it would open the possibility for a repeal of the Thirteenth Amendment and a return to legal slavery in the United States.

Ibid., p. 203

Gin was considered the new "Aframerican national beverage."

Morand, pp. 509–17

Open a book or newspaper of a few years ago and you will seek the term "speakeasy" in vain. It was born of Prohibition, but later than Prohibition. The speakeasy (the name suggests a whispered password) is a clandestine refreshment-bar selling spirits or wine. They must be visited to understand present-day New York. One must see a speakeasy, if only to avoid the places for the future—I know nothing so depressing. There are a few in the

Alcohol — Prohibition

downtown streets, but they are mainly set up between Fortieth Street and Sixtieth Street; they are usually situated downstairs, and are identifiable by the large number of empty cars standing at their doors. The door is closed, and is only opened after you have been scrutinized through a door-catch or a barred opening. At night an electric torch suddenly gleams through a pink silk curtain. There is a truly New York atmosphere of humbug in the whole thing. The interior is that of a criminal house; shutters are closed in full daylight, and one is caught in the smell of a cremation furnace, for the ventilation is defective and grills are prepared under the mantelpiece of the fireplace. Italians with a too familiar manner, or plump, blue pseudo-bullfighters, carrying bunches of monastic keys, guide you through the deserted rooms of the abandoned house. Facetious inscriptions grimace from the walls. There are a few very flushed diners. At one table some habitués are asleep, their heads sunk on their arms; behind a screen somebody is trying to restore a young woman who has had an attack of hysteria, while an old gentleman with spectacles is dancing all by himself. The food is almost always poor, the service deplorable; the staff regards you with the eyes of confederates and cares not two pins about you. The Sauterne is a sort of glycerine; it has to go with a partridge brought from the refrigerator of a French vessel; the champagne would not be touched at a Vincennes wedding-party.

Yet the speakeasy pervades Manhattan with a fascinating atmosphere of mystery. If only one could drink water there! Some speakeasies are disguised behind florists' shops, or behind undertakers' coffins. I know one, right in Broadway, which is entered through an imitation telephone-box; it has excellent beer; appetizing sausages and Welsh rabbits are sizzling in chafing-dishes and are given to customers without extra charge; drunks are expelled through a side-door which seems to open out into the nether world, as in Chicago Nights. In the poorer quarters many former saloons for the ordinary people have secretly reopened. All these secret shrines are readily accessible, for there are, it is said, 20,000 speakeasies in New York, and it is unlikely that the police do not know them; I think myself that they are only forced to close down when they refuse to make themselves pleasant to persons in authority, or when they sell too much poison. Spirits have their market-quotations in New York, as fluctuating as those of the Stock Exchange; champagne averages forty dollars, cognac and gin twelve dollars, the bottle. The speakeasy is very popular in all classes of society; women go there gladly, even a few young girls, who at least provide a diversion for the Frenchman, who is not accustomed to American habits of drinking.

It isn't very exciting here? No, it's not supposed to be; in fact, it's supposed not to be. But what sort of excitement did you expect? A shooting? They do have shootings at some speakeasies, not in the best ones; at least, not as a general thing.

Hilder, p. 591

The Manhattan anchorage of the Brooklyn Bridge was used as a storage place for European liquors. The cellars, entered from 209 William Street, were sealed during Prohibition.

WPA Guide, p. 314

City records for 1901 show that the "Luyties Brothers" paid $5,000 for wine storage in a vault on the Manhattan side. "A. Smith & Company" paid $500 a year from 1901 until 1909 for a vault on the Brooklyn side.

Schneider, "Chateau"

The Brooklyn Bridge's arches' interiors are damp, gloomy vaults and are weirdly medieval in appearance, especially the abandoned wine cellars behind the studded heavy steel doors in the arch at North William Street,

Morris, *Incredible*, p. 355

just off the rear of the old World Building. The arches and the crooked little streets that bend and twist around them give that part of town something of the look of medieval Prague. When you get down into the wine cellars and away from the sound, you're in a "Cask of Amontillado" setting. The damp drips, walls glitter, footfalls echo, shadows distort on ancient vaults.

There's a brief history of the bridge wine cellars on one of the deep inner walls. It's patchy and flaked, with painted vine trellises all around it crawling up the wet walls. It says: "Legend of Oechs Cellars: These cellars were built in 1876, about seven years prior to the official opening of Brooklyn Bridge in 1883. From their inception they housed the choicest wines in New York City."

"Historic," p. 24

Historic Wine Cellars Reopened After Dry Era

Corks Pop in Vaulted Passageways Far Below Roaring Traffic as Liquor Firm Is Handed Keys in Ceremony.

NEW YORK, July 11—You step off the subway at Brooklyn Bridge, turn sharp left through an underground passageway and pass through a cave-like door into medieval France.

As far ahead as you can see stretch vaulted passageways, dimly glowing in a subdued light, and from floor to ceiling are stacked cases upon cases of champagne, sparkling Burgundies, brandies, liqueurs, rare vintages of the old world.

These are the wine cellars of Anthony Oechs & Co., under the roaring traffic of Brooklyn Bridge, under the trolleys and elevators, the brass-buttoned policemen and shrieking newsboys, the hurrying millions that scuttle back and forth on the surface.

A few hundred lucky citizens were invited to visit the historic cellars today to witness the ceremony in which Aldermanic President Bernard S. Deutsch turned over the key to the Oechs company. Since Prohibition the ancient cellars have been used for storing city tools. And before that they were used by the now defunct "Evening World" for storing newsprint.

New Yorkers of another generation remember the cellars, which were built in 1876, seven years before the erection of Brooklyn Bridge, and which housed the wine stores of Rackey's wine establishment and Luyties & Co. In a niche at the entrance is a shrine of the Virgin Mary, brought from the Pol Roger cellars in Epernay. The walls of the vaulted labyrinths are embellished with mottos in French, German, and Italian.

And on the arched entrances to the various cellars are titles—Avenue Sichel Bordeaux, Avenue Les Deux Oefs, Avenue Regoud, Avenue Des Chateaux Haut Brion.

Visitors crowded the taproom this afternoon, musicians played Viennese waltzes, champagne corks popped and nobody remembered that above the trolleys and the elevators, the automobiles and the rushing pedestrians still hurried back and forth across Brooklyn Bridge.

Wilson, "Leaving New York," p. 478

Corner drug-stores will supply bad gin to people who are well enough known to them.

Conrad, p. 213

The hazards of Sumatra are no worse than the poison liquor and the automobiles here in New York.

Charyn, *Gangsters*, p. 68

Bootleggers were the real modernists.

N. cit.

Names of speakeasies: The Bombay Bicycle Club, The Town and Country Club, Tony's, Michael's, Louis', 300 Club, El Fey Club, Landmark Tavern, Club Intime, Casa Blanca, Connie's Inn, Jack and Charlie's, The Red Head, Club Frontón.

Almost without exception, every house, on both sides of the street, was a speak, and the after-dark traffic on this single block was always more congested than that on any so-called "residential" cross street in Manhattan.

Morris, *Incredible*, p. 325

The "21" Club: the atmosphere was one of aristocratic elegance, and you would not have surmised that this dignified resort concealed defenses as elaborate as those of a fortress, or electrically controlled devices of such remarkable ingenuity that, in the event of a raid, strategic sections of wall could be made to turn and disappear.

Ibid., p. 326

At the 21 Club during Prohibition a button was pressed when the premises were raided, and all the bottles in the bar would at once crash through a trapdoor and shatter on rocks. A sandpit absorbed the spillage.

Conrad, p. 288

One establishment decorated its walls "with a translation of the skyline of New York into terms of bottles."

Peretti, p. 10

Spy-holes, moving shutters, padlocks, chains, bars, [and] a password might be used. False wall panels, electric dumbwaiters, and drains underneath the bartender's work space allowed for the quick disposal of liquor in case of raids.

Ibid., p. 11

I hope you enjoyed the dinner as much as I did. Considering that it was prepared and served by the outlaw employees of a pair of outlaws, it seems to me to have been a not uncivilized production. The barbaric feature was the fact that Prohibition, which is supposed to make it impossible, and protection which made it possible, combined to make it three times as expensive as it should've been.

Ibid.

La Guardia: "I'm making beer."
Patrolman Mennella: "All right."
La Guardia: "Why don't you arrest me?"
Mennella: "I guess that's a job for a Prohibition agent if anybody."
La Guardia: "Well, I'm defying you. I thought you might accommodate me."

Ibid., p. 257

Sales of beer are legalized after 14 years of Prohibition. Schaefer Brewing company has anticipated Repeal by launching an advertising campaign with the slogan, "Our hand has never lost its skill."

Trager, p. 480

Parties

I want to give a really bad party. I want to give a party where there's a brawl and seductions and people going home with their feelings hurt and women passing out in the cabinet de toilette.

Fitzgerald, *Tender*, p. 30

Nobody had time to sleep. Everybody had about five careers. What I learned from them was the Dickens Principle—it was the best of times, it was the worst of times, but it was *our* times, and we owned them with our youth, our energy, our good will, our edginess. So let's party. Under the Dickens Principle everything was a party. Poetry was a party. Work was a party. When I put out a new issue of *Fuck You / A magazine of the Arts* and there was a night-long collating session at Peace Eye, sitting lotus posture in front of stacks of pages with Peter and Julius Orlovsky and Barbara Rubin—that was a party. Fugs rehearsals were a party. Even demonstrations and long meetings planning the revolution.

Sanders, *Beatnik*, p. 365

Mueller, p. 286	It was a good party, you could tell by the party barometer man, Andy Warhol. All the stars were crushing in, bubbly, perfumed, crackling with sparks, but the host was just looking melancholy. And when he wasn't looking wistful he was looking bored and sullen. He even yawned a few times.
Van Vechten, p. 63	Rosalie Keith was celebrated for giving the worst parties in New York, but despite this undesirable reputation she never ceased giving them and people continued to go to them. It is impossible to persuade people not to go to a party in New York, particularly if there are uninvited and English.
Douglas, p. 4	Who could tell anymore what was fashionable and what was fun?
Ibid., p. 22	A swirl of excited nothingness.
Conrad, p. 193	Now it's New York itself which is being consumed—worn, drunk, eaten by a populace of partygoers.
McInerney, *Bright Lights*, p. 2	Tad's mission in life is to have more fun than anyone else in New York City, and this involves a lot of moving around, since there is always the likelihood that where you aren't is more fun than where you are.
McCourt, p. 106	The trouble with inviting every suspect in New York to a party is that they tend to come.
Irwin, p. 222	The labor of social supremacy is no longer worth the scant glory.
Riesenberg and Alland, p. 95	Is great New York to become the final citadel of an enduring youth, the only creatures strong enough to live in it?
LeSueur	At a large party, Frank lost his temper when a former friend, an art critic, pursued him all evening in an effort to get back in his good graces. "Listen," Frank finally exploded, his voice loud enough so that half of the party heard him, "there are eight million people in New York and I like about ten of them and you're not one of them."
Naumann, p. 6	In an era when parties were a way of life, all I could think of was: "Too bad I missed this one."

Studio 54

Haden-Guest, p. xiii	Over the dance floor, tubes studded with light bulbs, Flash Gordon style, were rising and descending and, higher yet, the spoon made its rhythmic journeys to the insatiable nose of the Man in the Moon, discharging a fizz of light.
Ibid.	The beat of disco, which is very close to that of the human heartbeat.
Ibid.	Dancers washed in the surf of sound, dappled and splashed by light, shedding the dull gravitational tug of quotidian life, losing themselves in what was at once a voyeuristic jostle, like a fairground, and a domain of the self-absorbed.
Ibid., p. xiv	Vladimir Horowitz on the floor of Studio 54, protecting his valuable eardrums with wads of cotton.

Fashion models and demi-señoritas who could be counted upon to pop a perky nipple as they threw themselves into choreographed frenzies on the dance floor; also those who had painted themselves silver, or gold, or costumed as pharaohs, cucumbers, or Angels of Death; to say nothing of such Studio-famous characters as Rollerena, supposedly a prim Wall Streeter by day, a dreamboat by night in a wedding dress and roller skates; and the man who danced with the lifelike marionette; and Miriam, the woman (by day a substitute teacher) in the see-through wedding-dress; and the septuagenarian pretty girl, Disco Sally. Finally, there would have been, as always, a handful of souls who felt that the sight of their naked genitalia should be a source of wonder and delight.

Ibid.

You would look around and you'd see somebody's back. And then you'd see little toes twinkling behind their ears.

Ibid.

A warm body and a toot of cocaine.

Ibid., p. xii

To me it was about freeing the body. The girls would take off their tops and dance.

Ibid.

I don't know if I was in heaven or hell. But it was *wonderful*.

Ibid.

Here are Elizabeth Taylor and Betty Ford, each wearing something diaphanous, each with a bodyguard, wearing Truly Bad Hair; here is Michael Jackson with an Afro in pale shantung and an ascot; here is Steve Rubell dancing with Margaret Trudeau, her eyes wide and heavy-lidded, like those of a succubus; here are Barry Diller and Rod Stewart in the DJ booth; and here is Christie Brinkley, with permanently sideswept hair, as though being escorted by her own personal wind tunnel.

Ibid., p. xiii

They seldom looked happy. They passed one another without a word, in the elevator, like silent shades in hell, hell-bent on their next look from a handsome stranger. Their next rush from a popper. The next song that turned their bones to jelly and left them all on the dance floor with heads back, eyes nearly closed, in the ecstasy of saints receiving the stigmata. They pursued these things with such devotion that they acquired, after a few seasons, a haggard look, a look of deadly seriousness. Some wiped everything they could off their faces and reduced themselves to blanks.

Ibid.

Before it was Studio 54, it was owned by CBS and called Studio 53 … The concept of the studio—moveable sets, the actors being the audience, the audience being the actors … A former theater as a club.

Ibid.

It is a Manhattan myth, a chunk of urban folklore, that Studio 54 never had a dull moment after Bianca rode the horse.

Ibid.

Andy Warhol's fashionable silkscreen portraits of the 70s had been widely pooh-poohed by the high art world and he was wistfully aware that he wasn't seen as being in the same league as his fellow popsters like Roy Lichtenstein. In Studio, Andy was the famous artist. Halston, once a household name at a grandee level, now became a household name in trailer camps and retirement homes. The vehicle for Halston's re-ascent was Studio 54.

Ibid., p. 56

You would see a little piece of glitter in her hair and you knew she had been at Studio 54 the night before.

Ibid., p. 51

Ibid., p. 57	People would say to me, "Where do you live?" I would say, "I live at Studio 54."
Ibid., p. 59	The lords of the door were aware of their might.
Ibid., p. xx	Barry White, yeah. Isaac Hayes, sure. James Brown, absolutely.
Ibid., p. 4	With gardenias behind their ears and Tuinal smiles.
"She'll Be"	A Chinatown Mall is a Chinatown Mall. When you enter the fluorescent lights glare at you and suddenly you're surrounded by hundreds of brightly colored posters of happy Chinese women, children and cartoons. The place smells like musty plastic and everything looks old. There are trinkets everywhere. Up the escalator everything gets darker and the bass is pumping. Even early on everyone is dancing to a familiar beat, and they can't help it. That's what Disco does.
Haden-Guest, p. 18	A very Queens-type club. The problem was the landing pattern at Kennedy Airport. The jet planes would go right the hell over this place and there would be this tremendous noise every fifteen seconds. So they just pumped up the music.
Ibid., pp. 12–13	The sheer look of things was going to be important in the new disco palaces. Some elements would be nostalgic, like the disco balls themselves, and some, like Infinity's neon penis, would be borrowed from the gaudy over-the-topness of burlesque shows, the Vegas aesthetic. Others would be taken from Nightworld's arsenal of special effects, like the strobe, borrowed from fashion photography, which caught dancers in a snowblind dazzle, freezing them, moment by moment, like a Muybridge photo strip, and like the luminescent spermatozoa that used to slip over the walls, ceiling, and revelers during the classic light shows of the sixties.
Ibid., p. 13	The "Translator" coded music into electrical pulses that activated a flashing light system, fulfilling a project of the Decadents of the nineteenth century, who had dreamed of sense swapping—Rimbaud's colored vowels and the scent organ of Huysmans.
Frisa and Tonchi, p. 167	Paradise Garage was a gigantic warehouse off Varick on King Street. One has to walk awhile before one gets to the entrance, like walking on an airport tarmac during the night. Once inside there would be a blue haze of smoke amidst tons of sweaty people either socializing or dancing. It was a place where our mental state and the music created that tingle that lasts awhile.
McInerney, *Bright Lights*, p. 172	The elevator door opens directly into the loft, which is roughly the size of a Midwestern state and at least as populous. There are windows on three sides and mirrors on the fourth. A bar and buffet is set up at one end. The dance floor is down at the other end, somewhere near New Jersey.
Ibid., p. 5	Lots of sniffling going on in the stalls.
Haden-Guest, p. xxi	At four-thirty in the morning, when I played "Last Dance," the people were in tears. In tears.

Burroughs: "Heroin was $28 an ounce in the 1920s. Actually there was more morphine on the street rather than heroin. In the 1920s they brought in morphine. Then heroin came in in the late 1920s. Heroin is now about $9,000 an ounce, so imagine from $28 an ounce to $9,000 and junk turns out to be a model for inflation, being the most inflated item. A friend of mine ... who did time on Rikers Island in the thirties, told me the guards came in every morning with a shoebox full of heroin decks at fifty cents a deck. On one deck you could stay loaded all day and do the time standing on your head. With junk you are immune to boredom and discomfort ... Now there's good heroin on the street again and you can maintain a habit for $12 a day."

Bockris, *Burroughs*, pp. 111–12

In the 1930s, the word *smack* for heroin originates on the Lower East Side from *schmecker*, the Yiddish word for taste.

Patterson, *Resistance*, p. 240

It was in 1948—January—during a siege of severe New York winter weather. It had snowed for several days—stopped—clearing up—growing milder, the snow melting into dirty slush then becoming intensely cold—snowing again ... At night the city streets became even more deserted with only a few to be seen on Forty-second Street—probably one of the busiest streets of any city in the world—a few like myself living in cafeterias—sleeping in the all-night movies—staying away from the cops on their beats—who were angry to be out ... walking through the underground tunnels down toward Penn Station—through the station into the rest rooms—sitting on the toilets sleeping—sometimes writing—looking to pick up someone who had money and wanted sex—and was willing to pay for it—anxious only for a place to sleep take a bath—shave—obtain clean clothing—even food. Maybe steal a suitcase—roll a stray drunk—meet a friend—talk—make it until the morning and a cheap movie. I had been living in this manner since shortly after the beginning of the New Year. I was broke—hungry most of the time—poorly clad for contesting the rage of the elements—staying awake using Benzedrine inhalers—occasionally smoking pot—somehow maintaining a junk habit—just managing to keep straight enough not to collapse completely—stealing—ready to make a dollar at anything—always looking for a good take—something big enough to allow me a chance for a bed of my own—a place to live or at least die in out of the cold—not to be found crouched—a corpse in the doorway. I wanted to die and I felt I was dying—could observe death feeding on me—see it in the pallor of my skin— the patches of oozing sores on my chin and face—the tiny red flecks in the whites of my eyes—in the way my skull showed through my skin at the temples—and I could smell it from my dirt-coated bleeding feet—from my crotch—from my clothing.

Reay, p. 226

Smack was in effect the avant-garde of drugs, the ultimate high, the total rejection of the square world and its bustling work ethic ... It was no coincidence that jazz and heroin appeared in the same place. The common factor was the Mafia, who both ran the international heroin trade and owned or backed many of the jazz clubs ... Heroin's reputation as the coolest complement to the coolest new music would carry through the rock and punk rock decades.

Strausbaugh, p. 285

The brands of heroin most actively hawked Wednesday afternoon, June 9, 1982, on 3rd Street east of Avenue C were Red Tape and Yellow Tape and Buddha.

Trebay, p. 202

P Drugs

Burroughs, p. 227

As the geologist looking for oil is guided by certain outcroppings of rock, so certain signs indicate the near presence of junk. Junk is often found adjacent to ambiguous or transitional districts: East Fourteenth near Third in New York.

Jacobson, p. 108

There's no night (except for Sunday, when the Street is eerie and dead) when you can't walk from Fourth Avenue to Second Avenue on Fourteenth Street without at least half a dozen ballcap-wearing, pinpoint-eyed junkies asking you if you want downers. The price list fluctuates with supply: Placidyl usually go for $2.50; Valium, 75 cents; Tuinal, $3; Elavil, $2 on Fourteenth Street, with a 25 percent markup for rock show nights.

Wojnarowicz, p. 25

Avenues of pushers and between 3rd and 2nd Avenues—it's hot like wall-to-wall body tension, like people waiting for a connection somewhere in that wall of sound and flash.

Sante, "Commerce," p. 111

One day when L. went to buy heroin on 3rd Street, as he often did, he was hijacked. That was not unusual either, but this time the thieves maneuvered him into an abandoned building and took not just his money but also every shred of his clothing. He was forced to make his way home naked. Fortunately he only lived about ten blocks away.

McNeil and McCain, pp. 209, 210

About that time, it was getting very, very popular to be a junkie on the Lower East Side. In the morning you would see people lined up, like for a hit movie—in a line fifty feet deep—with people that sold the dope running up and down the line saying, "Have your money ready, we'll be open in ten minutes." You know, "No singles, you gotta have fives or tens." And they would have a menu, like, "Today we have brown dope, white dope, and cocaine." You know, "Got somethin' special today, you're all gonna be real happy" … Sometimes it was very scary copping at the dope house—you'd go to these abandoned buildings, you'd go in, it was completely dark, and you'd climb a stairway where half the steps were missing. You can't see ANYTHING at all, complete darkness, then you'd get to the landing and there'd be one candle on each floor. You'd climb two or three stories, then suddenly, BAAM, you'd run into someone—there's all these people—there's now a line of two hundred people going up the stairs. So you'd wait in line in complete darkness, while some motherfucker would say, "Stay in line!" Everybody would be real quiet, because they wanted their dope. When you finally got to the top of the stairs, there would be a guy behind the door. There'd just be a little hole in the door. You'd put your money in the hole, and say the initial, C or D, if you wanted either coke or dope. Then you'd get a little bag back, and get the fuck outta there, hoping they'd say, "Green light." That meant you could walk out, there was no cops on the street. If they said, "Red light," then you had to stay in there and that was really scary, but it wasn't until years later I realized that was a big part of the rush.

Schmitz, pp. 270–4

I'd walk through abandoned buildings where the Stations of the Cross had been set up or where people were having sex, creeping by headless animals, half-humans doing all kinds of drugs, used condoms, used tampons, discarded panties, *Naked Lunch*–sized cockroaches.

Hamilton, p. 96

The outer chaos was considerable. When I first moved in, a soda joint called The Haven was in full operation in the neighborhood as probably the largest downtown retail distribution center for every known variety of drugs. Sunday mornings, going out to get the paper at nine or ten o'clock, I'd see the flotsam and jetsam of the night before strewn around Sheridan Square and West

P Drugs — Junk

Fourth Street, kids barely able to walk, kids draped over fenders or nodding out in doorways, blank, lost looks on their faces. I had a sunlit vision of hell.

The junk scene was just like the sex, it was all a lark. I mean, it still had this "nice" taint of the forbidden, yet at the same time nobody really thought of it as dangerous.

McNeil and McCain, p. 210

You could get a bag of dope for three bucks. That's what the standard price was. We'd cop on the corner of Twelfth Street and Avenue A. There was a crowd of about ten or twenty Puerto Rican children, about the age of thirteen, who were the runners. So we'd give them three bucks and they'd bring back a bag.

Ibid., p. 212

Junkies were always the hungriest, the hurtingest; they almost kind of *defined* New York Despair.

Meltzer, p. 188

By 1989, heroin had become my sole occupation as well as my one solace in the nonstop clang of a city that clearly had no use for me.

Kopasz, p. 243

One day something fell out of an old book, the business card of a beauty parlor that had stood on Avenue C near Third Street, probably in the 1920s. I marveled at it, unable to picture something as sedate as a beauty parlor anywhere near that corner, by then a heroin souk.

Sante, "My Lost City"

Heroin: "If Alphabet City was a candy store, then Harlem was a supermarket."

Kopasz, p. 250

Those cold, junk-sick mornings in Alphabet City and East Harlem, crying, crying in the gray rain, begging me to get my white ass back out on the street and hustle, scratch up some money or back a few bags or get to work, but for Christ's sake, do something … those mornings when every tree was bare even if the air was warm … those sickly mornings of rain and grinding noise held a terrible, immutable, extracting beauty that I cannot accurately describe. It was something close to the pain of pure desire.

Ibid., p. 252

People were either gay or sharing needles or both.

Schmitz, p. 270

This particular party was for his birthday, at the apartment he shared with his lovers, Alice and Tom. All his loyal friends were there, the famous, the infamous, the washouts, the successful rogues, and the types who only have fame after they die. They were the representatives of the New York alternative subculture, the people who went to sleep at dawn. And never held a nine to five job because they were too odd looking, or sassy, or over-qualified. Because Sam had an MFA degree, he never had any money, but he always gave great parties … never pretentious ones, always wild ones. He wasn't short handed with the food or liquor.

It wasn't even midnight but the party was already jamming and jumping. Alice hadn't even gotten around to lighting the candles on her attempted Cordon Bleu birthday cake when I noticed Sam thanking a rock star for a very small birthday present, one of the many very small presents he'd received all night, yet another glassine bag of heroin, his drug of choice.

Mueller, p. 155

Heroin makes you real smart, huh?

McNeil and McCain, p. 164

Using heroin was like taking a vacation a few days a week.

Ibid., p. 166

She was a prostitute, I was a Ramone, and we were both junkies.

Ibid., p. 200

McNeil and McCain, p. 381

And the worst thing is, the worst thing about junkies, is they are so BORING. They sit around and talk about junk. As if there were anything to say about it.

Warhol, *POPism*, pp. 213–14

"They call this a light show?" Paul said, looking at the stage during the Airplane's act, where they had projections from the glass with fluid on it. "I'd rather sit and watch a clothes dryer in the laundromat."

A lot of friction developed between Bill Graham and us. It was just the difference between New York and San Francisco attitudes. What was funny was that Graham's business style was New York—the fast, loud-mouth operator kind of thing—but then what he was saying were San Francisco flower child things. The end came when we were all standing around in the back of the Fillmore watching some local band onstage. Paul was continuing the same type of LSD put-down commentary that he'd been making all day—comments that I could see were really rubbing Graham the wrong way.

"Why don't they take heroin?" Paul suggested, pointing to the group on stage. "That's what all the really good musicians take." Graham didn't say anything, he just fumed. Paul knew he was driving him good and crazy so he kept it up. "You know, I think I'm really all for heroin, because if you take care of yourself, it doesn't affect you physically." He took a tangerine out of his pocket and peeled it in one motion, letting the peels fall on the floor. "With heroin you never catch cold—it started in the United States as a cure for the common cold."

Paul was saying everything he could think of to offend Bill Graham's San Francisco sensibility, but in the end it was dropping the tangerine peels on the Fillmore floor—which he had done totally unconsciously—that brought on the showdown. Little things mean a lot. Graham stared down at the peels, and he got livid. I don't remember his exact words, but he started yelling things like:

"You disgusting germs from New York! Here we are, trying to clean up everything, and you come out here with your disgusting minds and whips!" Things along that line.

Speed

Warhol, *POPism*, pp. 73–4

By then he was taking so much amphetamine. He had the classic symptom: intense concentration, but only on minutiae. That's what happens to you on speed—your teeth might be falling out of your head, the landlord might be evicting you, your brother might be dropping dead right next to you, but you would have to, say, get your address book recopied and you couldn't let any of that other stuff "distract" you.

Wornov, p. 93

We cut across the black underbelly of the Manhattan animal, and wherever we cut, its colorful guts tumbled out: hippies, hustlers, hookers, heroin users, they trickled into the streets collecting in pools at the corners waiting to be pumped through the veins of the city. When we stumbled onto the sidewalk I had no idea where we were. I don't even think we paid the driver, he was so happy to get rid of us. My teeth were banging on my gums—we want out, we hate you. As he pulled me into an expensive brownstone I wondered if Ronnie could hear my teeth yelling.

Inside, all the queens and queers were in one room. It was painted gold, and it was vibrating, humming like a great nest of wasps. Beads of every description were all over the floor, in different-sized containers on the tables, and hanging on the walls in every kind of necklace imaginable. The electric lights were blaring, forcing the occupants of the room to wear sunglasses that

only added to their insect-like appearance. Each bug held a big fat needle, and you knew they were shooting up; but every time you looked at them, they pretended to string beads, with smiles that fooled nobody. Rotten Rita grinned, and a rotten tooth fell out of his head. Without missing a beat, he strung it onto his necklace. Orion was wearing jeweled chicken bones about her throat. She also had glued her hand to the arm of a chair and with a smile, she removed it like a glove.

"Don't go near the windows," they hummed, laying out two giant lines of white powder that I greedily snorted. *Ibid.*, p. 97

"Beware of the windows, darling," they smiled, laying out two more big fat lines. I couldn't believe my luck.

"No, no, don't touch those windows," they snickered as the drug took hold and stringing beads became my life.

Oh yes, the bead stringing was absolutely fierce, with the necklaces growing in size. Yes, yes, this was a very competitive group—who could make the biggest collar. The buzzing increased, the weak dropped back, pushed into corners where they were relegated to gathering and sorting stray beads. I heard them talking about me out of the corner of my ear.

They were after me, but I just kept stringing. It didn't matter anyway. I wasn't even thinking of them—what I was worried about were my teeth. What happens to them when they come out? Is there much blood? I mean, blood shooting from the empty sockets in my gums, or will they simply drop out with a little dust? I've had dreams about this, where my teeth were loose and I spent all night holding them in place.

I hadn't said anything for four hours, afraid to unclench my jaw. The race to string the biggest necklace intensified. Silverware, records, anything was pounced on and incorporated into the decorative noose we were all weaving for our group suicide. Along with squeals of humming and droning, huge beads were rolled across the floor. Shiny gelatinous encrusted goo hung from the walls in various lengths.

I stopped drifting. What was it? I had seen something. Everything was still, just the dry bead stringing noises, the scraping needles, the insects were happy; then I saw it again. *Ibid.*, p. 104

Ondine, master seamstress that he was, leaned into the mirror before me and shot up right in his eyeball. I almost puked into the sink. *Ibid.*

Murmurs fluttered, the word was passed, "Shot up in his eye," and we all took it as an omen that a particularly intense high was ahead of us—all except Andy. He was oblivious, buzzing along on his own little yellow pills. He liked to be next to things, feel the energy, but he didn't want to know what was really going on, and we were very discreet. Yes, to the normal eye it looked as if everybody simply had an extreme bowel disease, but to us a bathroom became a temple of porcelain and tile, the inner sanctum of bodily functions where only the initiated were allowed, where the dealer held communion, and ritual held sway.

We called them gray people, unfortunates who had lost their souls to get high. All they wanted was to be the one closest to the door, but one twitch from the animal and they scattered along the ground like wingless birds, scuttling into the corners of the room where they tried to look like furniture so no one would throw them out. We had no sympathy for them. To regain their human form all they had to do was leave, the only thing they could not do. Instead they hovered, searching our eyes for the flicker of recognition that would turn them from ghosts into people again. *Ibid.*, p. 150

Ibid., p. 156

"You promised me a shot." No one looked at anyone. No one spoke. "You promised me a shot!" Quickly everyone moved away, leaving Ann's exposed mouth opening and shutting on the floor. It was unheard of for a ghost to speak. "Where's my shot?"

Only Rita moved towards Ann, smiling cordially. "Oh, did I promise you that? Thanks for reminding me." He pulled out a giant horse syringe. I had never seen anything so big—the needle itself must have been nine feet long.

"You're right, I have your shot right here. Shall we?" His other hand pointed to the bathroom.

Most people used only one word to describe Rita, and that word was evil. He was the dealer, and a lousy dealer at that. Trying to cop from Rita was a nightmare. His apartment was a bare room with several glaring sunlamps and one black chair that he would sit in, telling you to make yourself comfortable. In the dead of winter people would be sweating in there. If you didn't have sunglasses it was hard to stay, but he would start insisting that before you score you might like to watch his lover, Birdie, sit on a Coke bottle.

Warhol, POPism, pp. 79–81

The Factory A-men were mostly fags (they knew each other originally from Riis Park in Brooklyn), except for the Duchess, who was a notorious dyke. They were all incredibly skinny, except for the Duchess, who was incredibly fat. And they all mainlined, except for the Duchess, who skin-popped. All this I only found out later, because at the time I was very naïve—I mean, if you don't actually see a person shooting up, you don't believe they could really be doing it. Oh, I'd hear them call someone on the wall pay phone and say, "Can I come over?" and then they'd leave and I'd just assume they were going to pick up some amphetamine. But where they went I never knew. Years later I asked somebody who'd been around a lot then where exactly all the speed had been coming from, and he said, "At first, they got all their speed from Rotten, but then his speed got so bad he wouldn't even touch it himself, and from then on, everybody got it from Won-Ton." That was a name I'd heard a lot, but I'd never laid eyes on him. Won-Ton was really short and barrel-chested and he never left his apartment—he always answered the door in the same shiny satin latex royal blue Jantzen bathing suit. That was all he ever wore. "Was he a fag?" I asked. "Well"—this person laughed—"he was living with a woman, but you got the idea he'd do anything with just about anybody. He worked in construction—he had something to do with the Verrazano Bridge." But where did Won-Ton get the speed? "That was something you just didn't ask."

Amphetamine doesn't give you peace of mind, but it makes not having it very amusing. Billy used to say that amphetamine had been invented by Hitler to keep his Nazis awake and happy in the trenches, but then Silver George would look up from the intricate geometric patterns he was drawing with his Magic Markers—another classic speed compulsion—and insist that it had been invented by the Japanese so they would export more felt-tip pens. Anyway, they both agreed that it hadn't been invented by any Allies.

Ibid., pp. 87–8

Generally speaking, girls were still pretty chubby, but with the new slim clothes coming in, they all went on diets. This was the first year I can remember seeing loads of people drink low-calorie sodas. (Amazingly, lots of the people who got thinner looked better and younger ten years later at the end of the sixties than they had at the beginning. And of course, tits and muscles were on the way out along with fat, because they bulged too much in clothes, too.) Since diet pills are made out of amphetamine, that was one reason speed was as popular with Society women as it was with street people. And these Society women would pass out the pills to their whole family, too—to their sons and daughters to help them lose weight, and to their husbands to help them work harder or stay out later. There were so many people from

every level on amphetamine, and although it sounds strange, I think a lot of it was because of the new fashions—everyone wanted to stay thin and stay up late to show off their new looks at all the new clubs.

who chained themselves to subways for the endless ride from Battery to holy Bronx on Benzedrine

Ginsberg, *Howl*, p. 10

If you lived on the East Side, and spent much time mixing with the street culture, the A-heads were unavoidable. They roamed the streets, bistros and pads compulsively shooting, snorting or gobbling unearthly amounts of amphetamine, methedrine, dysoxin, bennies, cocaine, procaine—all of them burning for the flash that would lead to FLASH!
 Everybody from Washington Square to Tompkins Square called the streets "the set"—as in, "I've been looking for you all over the set, man. Where is my amphetamine?" With a generation readily present and future life as on a set, there was no need to hunt too far for actors and actresses. What a cast of characters were roaming the Village streets of 1962!

Sanders, *Beatnik*, p. 201

Amphetamine altered sex. Some under A's spell waxed unable in Eros or sublimated their desire beneath the frenzy of endless conversation or art projects. Others with strong natural sensual urges experienced this: that the erogenous areas became extended under A to include every inch of bodily skin. "No piece of skin where you can't cop a riff of flash, man."

Ibid., p. 202

Within fifteen minutes, the A-heads began to flock, and the sounds of the trilling flute was heard in the hallway of 28 Allen Street, 'phet-freaks banging most urgently upon the door.

Ibid., p. 205

Huncke was sharing an apartment on East Sixth Street. The occupants and habitués of that apartment were shooting amphetamine on an hour-by-hour basis and had been doing so for six weeks, with disastrous effects. Not only were they dropping like mallards into the jails and looney bins of Manhattan, but Beauty was besmirched, and even Huncke was becoming a nervous wreck.

Reay, p. 269

Those treks up to Myrtle sometimes took forever as I was loading up on all that good shit the neighborhood had to offer: grass, plantains, Cafe Bustelo, various hot peppers, chorizo, fake opium, those ubiquitous incense bundles, pizza, occasionally some coke.

Kopasz, p. 244

It was 1983, and between Jay Street and the end of the line at Myrtle and Steuben, I might have heard Grandmaster Flash's "White Lines" a dozen times: Freeze! Rock!

Ibid.

Diane was seventeen—and six months removed from the Bronx—sitting with the others on the mattress and floor of the bedroom, yakkety-yakking. Amphetamine had possessed her. She wore her long black tresses swept back into a vague tangled knot behind her. Her eyes were huge and dark—capable of fixing a baleful glazed gaze upon a partner of shoot-up, art or grope. She wore a black short-sleeved scoop-neck bodystocking. Her shoes and other clothes were in a brown bag on the window ledge between the rooms. There was a hole in the stocking's toe. "See that abscess?" wiggling her white toe which bore a pink sore on the outer tarsal—"Zack shot me up with methedrine. A foot flash!"—breaking into giggles.
 Diane drew eyelashes with ink and brush above her lips so that her mouth babbling torrentially had the look of a convulsing cyclops. Next,

Sanders, *Beatnik*, pp. 206–7

P Drugs — Speed

her twitching Rapidograph pen began to work on her toe. She drew flower petals around her shoot-up sore. Then she ripped at the toe-hole and peeled the stocking up to her thigh and spent the next hour drawing a maze of stick-figures all over the leg. Soon, she had cut a jagged circle out of the stomach of the bodystocking with a razor blade. She studied her stomach, craning her head down, and then began to shave each pale stomach hair with the blade. Sometimes a meth mini-spasm would occur and the steel would nick the skin, leaving a thin red slice. Ouch. She drew an ink sun in the Mayan style rising from the top of her pubic hair. This done, she stood up and said, "Hey, somebody said you were going to bring some amphetamine."

McNeil and McCain, p. 14

He said, "Oh, I took a shot of speed and I couldn't stop brushing my hair for three days."

Dr. Roberts

Stein and Plimpton, pp. 260–4

There were other father figures in New York at that time—the acid doctors. A friend of mine—well, an ex-friend of mine—told me about this terrific doctor where you'd get these vitamin shots—Dr. Charles Roberts. I used to run into Edie there. I went one night, got this shot, and it was the most wonderful shot in the world. I had the answer: I mean, it gives you that rush. There were vitamins in it, and a very strong lacing of methedrine. I'd never heard of methedrine or speed. They never told you what was in the shot anyway. It was a slow evolution. I went there first and got a shot. I went a week later and got another one. And maybe one week later I was feeling kind of down, and I went twice a week. Eventually I was going there every day, and then I was going two or three times a day. Then I went four times a day. Then I started shooting up myself.

Dr. Roberts was the perfect father image. His office, down on Forty-eighth Street on the East Side, was very reputable-looking, with attractive nurses, and he himself looked like a doctor in a movie. He was always telling me of his wonderful experiments with LSD, delivering babies, curing alcoholics … and he was going to open a health farm and spa where all this was going to go on … and naturally he was stoned all the time, too. He wasn't a viper. I just think he was so crazy, he truly thought he was going to help the world. He wasn't out to kill anyone. We were the ones going in and getting the shots. I mean, anyone can set up a booth on the side of the road reading: I'M GIVING ARSENIC SHOTS HERE, but you have to stop and take them.

Over the years that he was riding high, tons of people went to see Dr. Roberts. But there was a little crowd of favorites. When you were a favorite, it meant that you were allowed special privileges. Even if the waiting room was filled with twenty people, you got right in. When you were addicted, being able to get right in was very important. You got bigger shots; you got shot up more than anybody else, and you became more of an addict. It was wonderful to be part of this special group. Edie fit right in. The minute she hit there, she became a special Dr. Roberts person.

I'll give you a description of what it was like to go to Dr. Roberts. The time is two-thirty in the afternoon. I'm going back for my second shot of the day. I open the door. There are twenty-five people in the waiting room: businessmen, beautiful teenagers on the floor with long hair playing guitars, pregnant women with babies in their arms, designers, actors, models, record people, freaks, non-freaks … waiting. Everyone is waiting for a shot, so the tension in the office is beyond belief.

Lucky you, being a special Dr. Roberts person who can whip right in without waiting. Naturally, there's a terribly resentful, tense moment as you rush by because you're going to get your shot.

You attack one of the nurses. By that I mean you grab her and say, "Listen, Susan! Give me a shot!" You're in the corridor with your pants half off, ready to get the shot in your rear. Meanwhile Dr. Roberts comes floating by. Dr. Roberts has had a few shots already, right? So in the middle of this corridor he decides to tell you his complete plan to rejuvenate the entire earth. It's a thirteen-part plan, but he has lots of time to tell it to you, and as the shot starts to work—Susan having given it to you—you have a lot of time to listen.

In Dr. Roberts's room would be Edie … so thin that she cannot be given her shot standing up; she has to be down on her stomach. It was a big shot—all those vitamins, niacin, methedrine, God knows what else—for a little girl, so she had to take it lying down.

Meanwhile everyone who's back in the corridor for the second or third time that day complains that the shots they received that morning haven't worked. Out in the waiting room you can hear the people complaining that they haven't even received their first shot yet.

And Dr. Roberts is still going on. In the middle of his thirteen-part plan he decides to tell you about a movie he saw on television … in detail. You, however, are telling him your ideas for whatever you're going to do. But then Dr. Roberts begins to describe his idea for a plastic Kabuki house. Someone else is showing his sketches for redesigning the Boeing 707 with a psychedelic interior. Big doings at Dr. Roberts's all the time.

Now you decide to go back out through the waiting room, right? Now you have all the time in the world. Life is a breeze. You've used the sun lamp. I mean, you were in a great rush when you came in; now, finally, you decide you'll leave.

But there in the room are all these people who are not Dr. Roberts's special people and who still haven't been serviced. They're there to spend as much money as you have, but they're not part of the "in" crowd. So they're drifting off into craziness because they haven't gotten their shots. A couple of people are wandering around … their poor systems are so riddled with the methedrine they got half an hour ago they feel is not working that they've come back for what Dr. Roberts calls "the booster." The basic Dr. Roberts shot goes from ten dollars to fifteen dollars. As your resistance to the drug gets to the point of diminishing returns, you move on up. There is a big shot for twenty-five dollars, and if it doesn't work, you go right back and get "the booster" for five dollars. That's what some of these poor people are doing—standing out there waiting for the booster. But you … you are flying high, having just had your twenty-five-dollar special, and you walk out into the outer office and say: "Hi. Oh, hi! What a beautiful sweater! Gee, you look wonderful! How are you? Oh, hi! Isn't it wonderful to see you! What's happening?"

Before leaving, I'd often go and find Edie in Dr. Roberts's sauna. If we'd been up all night on drugs, the sauna and steam bath were wonderful things. We'd go out and walk for blocks and blocks … just be together, because we didn't know what we were saying half the time.

The speed thing was so wonderful because everyone was walking around scared to death … scared because they couldn't sustain that pace. And so these shots from Dr. Roberts and all those other speed doctors gave you a false sense of being together. You could face everybody when you went out at night. You could dance all night. It was like "the answer." Nobody knew much about speed in those days.

Once Edie's mother came to Dr. Roberts's. I remember she was on crutches. She looked like Betty Crocker—gray hair with a little hairnet, a blue print dress, and little glasses. She looked like a librarian from the

Midwest standing next to Edie with her cut-off blond hair with the dark roots, thigh-high boots, a mini-skirt, and a kind of chubby fur jacket that looked like it was made out of old cocker spaniels. There they were—the two of them. Mrs. Sedgwick had come to see if Dr. Roberts was taking good care of her little girl … and I guess he must have conned her, because Edie kept going there. I guess the parents paid for her treatment: it cost a lot for those shots.

Falter

Paul McCartney: "We'd hear people say, 'You can get anything off him, any pills you want.' It was a big racket. The song was a joke about this fellow who cured everyone of everything with all these pills and tranquilizers. He just kept New York high." John Lennon paid sardonic tribute to an actual New York doctor. His real name was Charles Roberts, whose unorthodox prescriptions had made him a great favorite of Andy Warhol's entourage and, indeed, of The Beatles themselves, whenever they passed through town.

In fact, the name was based on the New York Dr. Feelgood character Dr. Robert Freymann, whose discreet East 78th Street clinic was conveniently located for Jackie Kennedy and other wealthy Upper East Siders from Fifth Avenue and Park to stroll over for their vitamin B-12 shots, which also happened to contain a massive dose of amphetamine. Dr. Robert's reputation spread and it was not long before visiting Americans told John and Paul about him.

German born Robert Freymann, sometimes known as Dr. Robert or "The Great White Father" (reportedly because of having a tuft of white hair), continued his practice in New York for many years, administering legal amphetamines in larger than needed doses to mostly well-to-do clients. "I have a clientele that is remarkable, from every sphere of life," he has stated. "I could tell you in ten minutes probably 100 famous names who come here." He continued his practice until he was expelled from the New York State Medical Society in 1975 for malpractice. His book *What's So Bad About Feeling Good?* was published in 1983. He passed away in 1987.

Stein and Plimpton, p. 260

Often people got introduced to Dr. Roberts as a present. Going to him was the great gift of the time. If you really loved someone, you took him to Dr. Roberts as a gift and let him feel the feeling. Or if you were trying to make somebody, you'd go around to Dr. Roberts, and after the shots you'd get very oversexed and you'd fuck. People used him in that way. His office was a social focal point.

I've forgotten who took me there first. Someone said, "Hey, Cherry Vanilla, let's go over to Dr. Roberts." Cherry Vanilla is a name I thought up when somebody asked what I'd call myself if I wrote a column for a rock magazine, and I said, "Cherry Vanilla … scoops for you!" Everybody loved it. Anyway, someone said, "Come on, Cherry Vanilla," and we went over to Dr. Roberts. I was fascinated. All these freaky people were sitting around, rapping their brains out in the office, in the middle of the day.

Then Dr. Roberts moved his office. He had a sauna and a big mirrored room with a dance floor. Four floors. Never completed. You'd get your shot in the hallway, sometimes from the nurse. You and your friend could go in together and both get them at once, and even give each other shots. It was all big fun-and-games.

I became like an acid queen. I loved it. My looks got crazier and crazier. I started getting into things like pink wigs, teasing them up to make them real big and like bubbles. I'd wear goggle glasses and real crazy make-up: spidery lashes and white lips, and micro-minis. I saw a micro-mini on Edie and immediately started cutting everything off. Kenneth Jay Lane earrings. Big Robert Indiana LOVE earrings, giant love paintings on my ears. Little bikini undies, a band around the top; and we made these silver dresses that were just silver strings hanging on us. I was surrounded by a lot of gay boys in

designing and decorating who would always give me a hand in pulling some look together. I would go out half naked with see-through things. You took a scarf and wrapped it around you and thought you were dressed.

I gave Dr. Roberts a shot once. In the ass, in his office about five o'clock in the morning. I had been playing records at Aux Puces—I was the disc jockey there—and he had come around to visit and said, "If you come back to my office with me, I'll give you a shot." It was a freebie, which was nice because those shots were not cheap.

I really got into having a needle in the ass. Just the feeling of it. I got into the pain of it. You got the shot, then this taste in your mouth, and you got a rush and you knew you were getting high. It was all very sexual in a way, and very "in" and social and stylish to do it. So I went back to his office with him and I gave him one and he gave me one.

I don't know what he shot me up with, but it was something I had certainly never had before. I was really very numbed. Maybe it was cocaine. Sometimes he would shoot you with LSD. You never knew what he was going to shoot you with. He'd throw a little surprise in every once in a while. So we got involved in a rather heavy sex encounter.

Dr. Roberts says, "Hello, girls … how are we today? Are you all ready? Okay. Hop up. Put all your weight on this leg. Okay? Ready? My god, this rear end looks like a battlefield." *Ibid.*, p. 267

You want to hear something I wrote about the horror of speed? Well, maybe you don't, but the nearly incommunicable torments of speed, buzzerama, that acrylic high, horrorous, yodeling, repetitious echoes of an infinity so brutally harrowing that words cannot capture the devastation nor the tone of such a vicious nightmare. Yes, I'm even getting paranoid, which is a trip for me. I don't really dig it, but there it is.

It's hard to choose between the climactic ecstasies of speed and cocaine. They're similar. Oh, they are so fabulous. That fantabulous sexual exhilaration. Which is better, coke or speed? It's hard to choose. The purest speed, the purest coke, and sex is a deadlock.

Speeding and booze. That gets funny. You get chattering at about fifty miles an hour over the downdraft, and booze kind of cools it. It can get very funny. Utterly ridiculous. It's a good combination for a party. Not for an orgy, though.

Speedball! Speed and heroin. That was the first time I had a shot in each arm. Closed my eyes. Opened my arms. Closed my fists, and jab, jab. A shot of cocaine and speed, and a shot of heroin. Stripped off all my clothes, leapt downstairs, and ran out on Park Avenue and two blocks down it before my friends caught me. Naked. Naked as a lima bean. A speedball is from another world. It's a little bit dangerous. Pure coke, pure speed, and pure sex. Wow! The ultimate in climax. Once I went over to Dr. Roberts for a shot of cocaine. It was very strange because he wouldn't tell me what it was and I was playing it cool. It was my first intravenous shot, and I said, "Well, I don't feel it." And so he gave me another one, and all of a sudden I went blind. Just flipped out of my skull! I ended up wildly balling him. And flipping him out of his skull. He was probably shot up … he was always shooting up around the corner anyway.

The next day, the Duchess told us she'd been in her pill doctor's office on Fifth Avenue when the lights went out. A lot of people used to go to this one particular doctor—he gave them what they wanted. Warhol, *POPism*, pp. 137–8

"I was in Doctor Pill's office and I was thrilled. I thought 'This is it, the big haul.' I stuffed as much as I could get my hands on into my pocketbooks while he went out to see what was happening, and I ran out of there across to the park and sat down by the Met. I couldn't wait to see what I'd gotten. It turned

out to be some green iron pills, some Phisohex, and lots of that green soap doctors use. I didn't get *anything*, my dear. But oh, what a place to be in the dark … "

"Is he a *legal* doctor?" I asked, because I knew all the kids got drugs there and I'd heard that some drag queens were getting hormone shots from him—I mean, it sounded like a big social club there.

"Well, naturally he's not legal when he does abortions, but yes, he's a legal doctor."

"And he's never gotten in trouble with the police?"

"Oh, they *know* about him, but it'll take years to get him. They've got to have proof—they've almost got to catch him doing it … "

"But why would a real doctor take a chance like that?"

"He needs the money, he gambles. He bets on the trotters every day—that's where it all goes. So he has to do abortions and charge a fortune for pills. But if I give him, say, an old invitation to a debutante ball or something—one of those fancy engraved ones—he gives me a bottle of amphetamine for free because he wants to impress his friends."

"Oooo," I said, "he must be creepy. Is he?"

"No. Actually I adore him."

"How much did your abortion cost?" I asked her.

"A lot. Eight hundred dollars. But he followed up on me that night, and they don't usually do that, you know? They usually just dump you afterward. He brought me home and gave me orange juice and tea, and every day for five days he came over to give me penicillin injections. Believe me, it was worth the eight hundred dollars. His office has paintings by movie stars who are too famous to mention." She laughed, and then she mentioned them.

Ibid., p. 136

Whatever anyone may have thought, the truth is I never gave Edie a drug, ever. Not even one diet pill. Nothing. She certainly was taking a lot of amphetamine and downs, but she certainly wasn't getting any of them from me. She was getting them from that doctor who was shooting up every Society lady in town.

Petronius, p. 46

Dr. Bishop's Waiting Room: 420 E. 51st. Diet doctor of the moment! Fashionable party ever-present for daily, nightly treatments. Includes sauna. Good for all contracts.

Opium

Beck, pp. 154–6

The hands of a clock prominently displayed in the window of a Chatham Square jewelry store point to 2 o'clock in the morning. The boulevard of the East Side is thronged with pedestrians. Night brings them over here when the rest of the city is asleep, recalling the old adage, "One half of this great city knows nothing about the other half." Within half a dozen doors from the shop where the clock hangs is Pell Street, a narrow, dark, gruesome thoroughfare. This portion of the Chinese quarter is given over to the occupancy of loose women and men who are, if anything, on a lower scale morally than their wretched consorts. The houses are old and dilapidated veritable rookeries swarming in the daytime with Mongol-American children who give place, as night draws near, to the frowsy haired and foul-mouthed women who make the dark halls a rendezvous. No. 10 is a house much like the rest, with possibly the exception that an air of quiet pervades it in the daytime. Visitors are few, occasionally a man or woman better dressed than those of the neighborhood. They come from the Tenderloin, and in the early part of the night are frequenters of the Empire, the Bijou on Sixth Avenue,

the Haymarket, and similar places. They climb up the steps leading from the cellar and hurry away. These steps lead down to a little square bit of standing room, built about with boards nailed firm and strong, as if an attack was expected. Little pencils of light sift through cracks made by inequalities in the timber, and from a knothole in the door a single red eye in the forehead of a very watchful demon confronts you. If you would enter, knock, wait, and presently you will hear the rattle of a chain, the shifting of a bolt and the door is opened by an attendant who peers out into the gloom, bringing with him a smell pungent and heavy. If he knows you, or concludes that you look all right, the chain is loosened and you enter the opium "joint."

Near the door is an apartment very much like a booth at a country fair or like an enclosure in Central Park where the sacred bull or some other animal is kept to be stared at. In the booth is a platform which takes up nearly all the available space. It is two feet from the floor, and is covered with Chinese matting. In the center is a square black walnut tray holding a variety of articles familiar to the opium smoker. By the tray is the pipe itself. This particular pipe is a good one and brought on here from San Francisco by Mo Iling. It is used only by the Celestial proprietor. A piece of bamboo about fifteen inches long, so soaked by repeated smokings that it looks like ebony, is the stem. Two-thirds of the distance from the ivory mouthpiece is the bowl, made of red clay and marked around the sides with Chinese characters. The top of the bowl is flat, but in the center is a pin hole over which the cooked pill is placed. This particular pipe is worth $50. The value increases with age. A Chinaman is smoking. He is Sing, the proprietor. His lips are fixed against the mouthpiece and he draws steadily. While the smoke is ejected through his nostrils, the pill makes a crackling noise as it turns over the flame and as it is gradually drawn into the little hole.

Pass between the folds of a calico curtain to the joint proper and this is what you will see. It is a room about thirty feet long by about twelve wide. Beginning at a point about three feet from the floor are several separate and distinct strata of smoke which rise and fall like the bosom of the sea disturbed by a swell. The pungent odor which greeted you at the door is intensified a hundredfold and is heavy and sensuous. A score of little lamps dot the place here and there and are burning bravely as if they were trying to light up the surroundings. Their attempt at illumination is a failure. They were not intended to illuminate, hence their failure in that regard. Vice loves gloom and goes hand in hand with darkness. Here is vice of the vilest kind: imported vice. On either side of the room there is a row of board bunks, as habitués say, erected about two feet from the floor and covered like the platform in the outer room with matting and dotted with wooden head rests or little wads of straw covered with green gingham which serve as pillows. This is the hour for the fiends, and there is little unoccupied space on the bunks.

A party of four is the usual company with one lay out and one pipe. Two lie, one on either side of the tray, and use the head rests. The other two lie on their companions so that no space is wasted. One acts as cook and the pipe goes around in turn between choice bits of conversation and morsels of gossip. Hop fiends do not stand on ceremony nor among them is regard paid to personal appearance while in the joint. There is a knock at the door and a party of newcomers is announced.

When the Chinese in 1875 began migrating in numbers from the Pacific coast to this city they brought with them their opium pots well filled, and the paraphernalia for its use. But while they settled in an isolated locality by themselves, the noxious fumes of their opium pipes pervaded the entire city and rapidly won devotees to its use. And so it happens that to day we are debarred from pointing a finger at Chinatown and saying, "There that

Ibid., p. 139

degrading, disgusting, and soul-destroying habit of opium smoking is indulged, therefore we must drive the Chinese out." Opium is smoked today in all quarters of the city and by all classes of the community alike. The number of hop fiends, as opium smokers are called, is far greater in New York than people have any idea of and seems to be growing rapidly.

Ibid., p. 144

There are about twenty or more places in Chinatown in which opium is sold in twenty-five and fifty cent portions. The gum, which is bought from wholesale druggists, is spread out thin in a baking pan and baked slowly over a mild fire until almost crisp. It is then dissolved in water over night and strained through a piece of fine flannel. Then it is again boiled over a slow fire until the liquid becomes of the consistency of molasses. This is known as No. 1 opium.

Ibid., pp. 146–8

The places where opium smoking is provided for and may be indulged for a price by all comers like liquor drinking in a saloon are called "joints." There are a great many of these joints scattered throughout Chinatown, the most of them hidden in obscure places and all more or less surrounded with mystery, out of deference to or fear of the police … To gain an entrance to it you will have to go along a narrow, unlighted, dingy alley to a barricaded door. Upon the signal given by your guide the door will be opened, leading through a Chinese wood yard, up a narrow rickety stairs, along a narrow creaky porch, to the second flight of stairs, leading down to door No. 2. On gaining an entrance there by signal you will find yourself in a dimly lighted underground room where from fifteen to twenty people, Chinamen and white women, will be found hitting the pipe. Others may be seen sitting at tables gambling away the few pennies they may have.

The place is dark, gloomy, and filthy. Along the sides of the apartment are ranged a number of slightly raised platforms which serve as bunks for the smokers. They are without furniture save a block of wood which serves as a head rest or pillow. The paraphernalia or lay out for smoking is brought to the bunk on order by the proprietor or attendant. This lay out consists of the following essential articles:

The *Yen Tsiang* (opium pipe), *Ow* (opium bowl), *Yen Hock* (a thin wire used for dipping out the opium and holding it over the light while cooking), *Yen Hop* (a box containing the opium), *Yen Dong* (opium lamp), *Kiao Tsien* (scissors), *Sui Pow* (a sponge to wipe off the bowl of the pipe when soiled), *Dao* (a cleaning knife), *Yen tau Kar* (a box or bureau used for setting the bowl on), *Yen Shee Hop* (a box for keeping the ashes in).

For all this you make payment and are then at liberty to proceed with your smoking and when satisfied or overcome, sleep and dream as long as you please or can survive in the close, fetid atmosphere of the room. The person who smokes opium always does so reclining, usually stretched across the hard wooden bunk, which is simply carpeted with straw matting, a small stool or a beveled block of wood serving as a pillow. Resting on his left side the smoker takes up a little of the treacle-like mass upon the steel needle *yen hock* and, holding it about the flame of a lamp, watches it bubble and swell to six or seven times its usual size. In doing so it loses its inky hue and becomes a bright golden brown color giving out a pleasant creamy odor much admired by old smokers. Poor opium does not yield so pleasant an odor and is liable to drop from the needle into the flame of the lamp and rarely gives so handsome a color, the yellow being here and there streaked with black. This process is known as cooking the hop or opium. Having brought it to a proper consistency the operator, with a rapid twirling motion of the fingers holding the long needle, rolls the mass upon the smooth surface of the bowl, submitting it occasionally to the flame and now and then catching it on the

edge of the bowl and pulling it out into strings in order to cook it through and more thoroughly. This is called *chying*—the mass or pill.

Rolling it again upon the surface of the bowl until the opium is formed into a small pea-sized mass with the needle as a center, the needle is thrust into the small hole in the center of the bowl, thus leveling off the bottom.

There are many Chinamen in Chinatown who make a living buying *Yen Shee* or opium ashes. They collect these ashes from all available sources. This refuse is dissolved in water, when it is subjected to a process by which whatever of the original drug may be retained in it is recovered and remanufactured. This is known as No. 2 opium. It is then mixed with No. 1 and becomes what is called *Yen She Cow*, or half and half, and is sold at a reduced price to the lower class of joints and to those smokers who cannot command the price of the pure drug. Fortunes or what are esteemed such among the Chinese have been made from this business.

Ibid., pp. 152–3

waiting for a door in the East River to open to a room full of steamheat and opium

Ginsberg, *Howl*, p. 15

On the wall of the squat at 8th and Avenue C was written, "Opium is the religion of the people."

Kopasz, p. 242

Various

I was scared now and tripping my brains out. I crawled out the window onto the fire escape, which faced south and offered a perfectly framed view of the World Trade Center, where I'd worked as a foot messenger just a few years earlier. The two towers hovered over me changing color from blue to purple to pink and cycling back through again and again.

Kopasz, p. 246

The primary colors of crack vial tops decorated the sidewalks.

Schmitz, p. 270

I tried to look away politely, but all I could find to stare at were three spent crack vials floating in the puddle of urine that almost inevitably adorns the corners of New York City Housing Authority elevators in El Barrio at 2:00 a.m. on Saturday nights.

Courgois, p. 258

In 1907, the cost of cocaine on New York City streets, as revealed by newspaper and police accounts after the law's enactment, was typically 25 cents a packet, or "deck" … Packets, commonly glassine envelopes, usually contained one to two grains (65 to 130 milligrams), or about a tenth of a gram. The going rate was roughly 10 times that of the wholesale price, a ratio not unlike recent cocaine street prices, although in the past few years the street price has actually been lower in real value than what it was in 1910.

Musto, pp. 40–7

"You've got some blow?" she says.
"Is Stevie Wonder blind?" you say.

McInerney, *Bright Lights*, p. 7

Every time we played New York, this guy would come by our show and give the Stooges a little bottle of coke, completely on his own volition. So we're sitting backstage with Miles Davis, and this guy finally arrives and just throws down a big old pile. We already had the straws ready. Imagine that great scene—Miles Davis's head right next to all the heads of the Stooges going "SNNNORRRT!"

McNeil and McCain, p. 65

Ibid., pp. 177–8 I never really sniffed glue or Carbona. I never got really heavy into the paper bag. I did it, but I didn't get into it like Johnny and Dee Dee did. They used to go up on the roof and sniff Carbona and sniff glue and shit. It was this sensation, like "Bzzzz, bzzz, bzzz."

Haring, p. 166 Leave New York at 7:30 PM for Paris. Came to airport in limo with Adolfo Arena. Smoking pot all the way to the airport.

McNeil and McCain, p. 269 Quaaludes were great, the Love Drug, they made you real horny. You just wanted to rip off your clothes and scream, "Suck my dick!"

Haden-Guest, p. 103 A Quaalude nirvana.

Young, *Stonewall*, p. 104 The original, medicinal form of poppers was amyl nitrate, a "vascular dilator" used by people with angina.

Ibid., pp. 103–4 In the gay ghettos of the Seventies and early Eighties, poppers were always at the center of the action. On any given night at, say, the Anvil in Manhattan, a large percentage of the men on the dance floor would have poppers in hand, and many of the rest would be helping to pass the bottles around. Some disco clubs would even add to the general euphoria by occasionally spraying the dance floor with poppers fumes … permeated with that particularly inert, greasy odor of poppers. Wherever you went, the musky chemical smell of it was constantly in your nostrils. He found himself heading to the single, small window, in order to gasp a few breaths of something other than the cold, kerosene smell of amyl.

Ibid., p. 103 I was visiting friends in The Pines, and was spending a couple of hours at the disco one night. Across the room, I noticed an acquaintance of mine … dancing up a storm and inhaling liberally from a poppers bottle which he kept in the pocket of his jeans. Somehow in the course of the evening, the bottle broke, and the contents spilled all over [his] leg, giving him a terrible and very unsightly burn. It made me wonder what kind of damage inhaling the stuff must do.

Ibid., p. 104 A brand of poppers called Cum showed its bottle as a dripping cock and balls.

Sanders, *Beatnik*, p. 57 It was a cold and bitter night. The wind was nearly as exhilarating as the amyl nitrite they were popping in the taxi.

"She'll Be Good" At the Paradise Garage: "In the morning empty poppers and ethyl rags lay strewn about the dance floor. Morning, it is worth noting, was after 7 AM."

Bockris, *Burroughs*, pp. 95–6 At Burroughs's apartment, Ter emptied the bag of drug samples onto Bill's big parlor table, and as I turned on the tape and fired up the bomber, Bill motioned us to fix our drinks, donned his reading glasses, and settled in for a good scrutiny of the dope labels, using a magnifying glass like a jeweler examining precious stones.

BURROUGHS: Now then, what is all this shit, Terry?

TERRY SOUTHERN: Bill, these are pharmaceutical samples, sent by the drug companies to Big Ed Fales, the friendly druggist, and to Doc Tom Adams, the writing croak. Anything that won't cook up, we'll eat. Give them good scrutiny, Bill.

BURROUGHS: Indeed I shall.

SOUTHERN: We'll get them into the old noggin one way or the other! On double alert for Demerol, Dilaudid, and the great Talwin!

BURROUGHS: Pain—I'm on the alert for the word pain … [murmuring, as he examines the label]: Hmm … yes … yes … yes, indeed [reading from a label]: "Fluid-control that can make life livable." Well, that could apply to blood, water … [reading another label].

SOUTHERN: All our precious bodily fluids!

BURROUGHS: I'll just go through these methodically. Anything of interest I'll put to one side … [makes a separate grouping].

SOUTHERN [getting a paper bag]: We'll put rejects in here.

BURROUGHS [gesture of restraint]: I'm just picking out what might be of interest … [examining a label]: Here's a possible [sets it aside].

SOUTHERN: Now a lot of these are new synthetics, Bill—names you may not be familiar with, because they're disguising the heavy drug within! This could warrant some serious research, and a good article for one of the dope mags—on how the pharmaceutical companies connive to beat the FDA—you know, and get Cosonal back on the shelf!

BURROUGHS [scrutinizing a bottle]: I don't really know what this one may be …

SOUTHERN [enthusiastically]: Well then, down the old gullet with it, Bill! Better safe than sorry!

BURROUGHS [dryly]: I think not.

SOUTHERN [picks up a bottle and reads]: "For pimples and acne" [throws it aside in disgust]. Now here … "Icktazinga" [handing it to Bill]. Ring a bell?

BURROUGHS [examining it]: "Chewable." I'm not much interested in anything chewable … [makes a wry face].

Half the people in this city can't sleep without pills.

Conrad, p. 276

The down of the day was Darvon. Then Black Beauties, Christmas Trees. The downs were to take the pain away that was always there. The ups were to keep them going so that they could go out on tears all night. They never slept.

Carter, p. 59

(*sotto voce*: "Loose joints, Valium, black beauties … 'Ludes … Sen'similla … ")

Delany, p. 7

On Forty-second near Fifth a kid falls into stride beside you.
 "Loose joints. Genuine Hawaiian sens. Downers and uppers."

McInerney, *Bright Lights*, p. 108

In Washington Square Park, a pot dealer walked around holding up notebook pages covered with scribble. "These are testimonials from my satisfied customers!" he crowed.

Sante, "Commerce," p. 108

Three thousand persons selected at random from the phone book were sent a well-rolled marijuana cigarette with a card saying, "Happy Valentines Day" … (in case you're curious, Jimi Hendrix financed the entire marijuana mailing).

Hoffman, *Autobiography*, p. 111

That summer, for the first time really, pot was all over the place. But acid still wasn't being dropped out of helicopters yet. You still had to "know somebody."
 Not that much dope was being handed around on the Village streets yet, although the Duchess had a friend who hung out around Washington Square with the M taken off the M & Ms and told the kids from the boroughs, "It's dynamite dope, only *don't chew it* because if you do you'll die. See, it has to dissolve *after* it gets to your stomach." He'd deal sugar to little girls from Brooklyn—he wouldn't even bother to mash it up, he'd just take a box of granulated Domino out of his jacket and pour it into something. How did he get away with it? "I'm a spade, man," he'd explain. "They *worship* me. They want to shoot up, I say, 'You girls should sniff it, stay high longer, ask somebody.'"

Warhol, *POPism*, p. 147

Kids were so naïve about drugs in '65. Nobody knew how to buy dope yet—but a lot of people sure knew how to sell it.

Sante, "Commerce," p. 106 Once, while visiting my parents in New Jersey, I ran into a high-school classmate I hadn't seen in years. When he found out where I lived, he told me he visited the neighborhood sometimes in his capacity as freight agent for a large-scale marijuana importer. The outfit rented an apartment a few blocks away from me that was employed as a depot for goods being moved from one distant city to another. Years later, a friend who was a musician and a carpenter told me he had spent the previous three months refitting a nearby apartment for a pot dealer. The circumstances were different, though. Prices had increased significantly and so, correspondingly, had apprehension. This dealer, a wholesaler for local traffic, had engaged my friend to put in numerous false walls and invisible compartments and sliding panels, as well as a booth by the door for the guard, with a hole through which he could poke the muzzle of his piece.

Ibid., p. 105 For many years there were numerous commercial establishments that sold marijuana. Summer candy stores, some social clubs, some *bodegas*. But what they had in common was a slot in the rear wall into which you would push your money, generally $10, and from which you would collect your little manila envelope. The most famous were probably the Black Door and the Blue Door which glared at one another from opposite sides of 10th St. One was an empty room, the other featured a pool table; one marked its bags with the Maltese-cross stamp, the other didn't.

P Drugs — Various

Remarkable, unspeakable New York.

James, p. 527

A city of people talking, to themselves, to their gods, to dead parents, to errant lovers and doomful doctors, to the friends who come and go. A city of people acting out, folks talking loud to no one or to everyone at once on the IRT—thanking you for your generosity before it's offered, biting your pant leg with their maladies and tales of hard luck. A city of menacing bargains struck by strangers, who ask charity in return for not mugging you or robbing you blind. A city of people speaking in tongues. Some of them are talking to space aliens who control their brains from the antenna atop the World Trade Center. You've heard these people muttering in strange syllables. The aliens may have heard them, too.

Trebay, p. 3

But what is the voice of New York? Has this voice changed now that the elevated no longer cuts across *all* Manhattan with his fire-breathing steel structures, and the agonizing siren songs of massive ocean liners along the East River and Hudson are no more? Someone, perhaps Walt Whitman in 1842, wondered what had New York—noisy, trembling, bustling, stormy, turbulent New York—to do with silence.

Maffi, pp. 103–5

True, there are (though they do exist) very few pockets of silence where sound is a kind of continual comment on everyday life, a genuine leitmotif that sums up the thousand contradictions of the city—strident, aggressive, and violent, or sweet, soothing, and amicable. In certain subway stations, the thunder can be frightening in the extreme, a rolling rumble that almost induces feelings of panic as the train draws near. J. D. Salinger was right when he wrote "New York's terrible when somebody laughs on the street very late at night. You can hear it for miles. It makes you feel so lonesome and depressed." With its honkings, sirens, skiddings, and breakings, the traffic is a constantly grating presence. But the streets of New York reverberate with an incessant variety of sounds and noises: the voices—full, high-pitched, and rhythmic—of those with the streets, the witty remark of a young black leaning against the wall, the rustling of squirrels in the grass or among the branches above, the hurried scurrying along the massive sidewalk stones, the wooden thud of skateboards leaping up stairs, the intermittent whirring of helicopter blades, the metal frizzle of police car radios, the full-throated singing of the passerby … a succession of sounds that demands our attention, that creates a tension all of its own.

Once removed from the fortuitous and fleeting condition—their fluctuating consistency—they are sounds that, like the images we have of New York, tell a great deal about the history and culture of the city. For example, someone whose name escapes me for the moment once said that the sound of the jackhammer typifies New York the same way the chiming of Big Ben typifies London: and its resounding centrality—its sheer physical everyday reality—cannot but remind us (yet again) of the mainsprings hidden away in the depths of the metropolitan mechanism.

But the experience of sound of New York is extremely various in nature. I remember the first night I spent in Queens, many years ago. I was awoken by a peculiar hissing sound continually wailing away and changing pitch; sleepless from jet lag, I simply had to satisfy my curiosity. Unable to resist the temptation of discovering where the noise came from, I got up from the sofa bed in the sitting room where I was temporarily being lodged, afraid of turning a light for fear of waking my hosts. Hand stretched out in front of me, I started fumbling about the house in search of where the sound was coming from, and on reaching the kitchen I let out an almighty yell: I had grabbed hold of the massive, boiling-hot pipe of the steam heating system.

Q Sound

The sound had given me a sharp—and decidedly palpable!—lesson in the history of the city.

Since that time I have learned to recognize (and live with) the variety of sounds that fill the apartments with an almost physical density and bulk: the vibration of the air as it sneaks its way about the stairways of the high-rises, crying out in the corridors and shaking the doors; the howling of the wind whistling through cracks in the guillotine windows; the deep droning of that air-conditioning system of the supermarket below the house; the sound of a phrase muttered in the narrow streets that echoes all the way up to the top floor … It is difficult not to be reminded of something that Fitzgerald wrote in "My Lost City": "The gentle playing of an oboe mingled with the city noises from this brief outside, which penetrated into the room with difficulty through great barricades of books … " But this sparks off memories of another night in New York (again, after I had just flown then), when a typically frenzied block party lulled me off to sleep at five in the morning with an extremely limited and aggressive mix of salsa and merengue being played at a nearby corner turned into a square and dancing hall.

All this music making in the city's public places … Of course, it is not an exclusively New York experience, but I do not think it is an entirely casual phenomenon either. It has as much to do with a very direct relationship with the metropolis, its spaces and its rhythms.

Warhol, *POPism*, p. 172
I sit there and listen to every sound: the freight elevator moving in the shaft, the sound of the grate opening and closing when people got in and went out, the steady traffic all the way downstairs on 47th Street, the projector running, a camera shutter clicking, a magazine page turning, somebody lighting a match, the colored sheets of gelatin and sheets of silver paper moving when the fan hits them, the high school typists hitting a key every couple of seconds, the scissors shearing as Paul cuts out E.P.I. clippings and pastes them into scrapbooks, the water running over the prints in Billy's darkroom, the timer going off, the dryer operating, someone trying to make the toilet work, men having sex in the back room, girls closing compacts and makeup cases. The mixture of the mechanical sounds and the people sounds make everything seem unreal and if you hear a projector going while you are watching somebody, you feel that they must be a part of the movie, too.

Conrad, pp. 117–18
Audited correctly, New York can be heard speaking the Esperanto of abstraction.

Ibid., p. 122
Linguistically, New York's nearest approach to the world language of abstraction's Esperanto is in its bastardizing of tongues. Sometimes more than one language is spoken in a single word. The pidgin English which results comically gestures toward monoglot Babel. Vladimir Mayakofsky, visiting New York in 1925, hears the émigrés on Broadway conversing in mispronounced English catchphrases which he transcribes as Russian neologisms "chuingam" for chewing gum, "Mek monei" for the admonition to get rich.

Ibid., p. 124
Language as ascetically abstract as the skeletal New York grid.

Ibid., pp. 117–18
Picabia is delighted by the conflict of tongues in New York because his art wants to reach the plastic or grammatic universals that those clashing tribal dialects have in common.

Ω Sound

Since Babel, the only language that remains globally (but abstractly) intelligible is music, and this too can be heard in New York, in the mechanical *bruit* of the streets.

Ibid., p. 118

Has a history of metropolitan sound ever been written? A study of all the different elements involved, the transformations that take place with each passing epoch, the effects on the life of the city and the way in which culture recorded and incorporated it?

Maffi, p. 103

It is almost impossible at any season of the year or in any quarter of the city to escape the sound of blasting, which reminds one that Manhattan, like the church of Rome, is built on solid rock, or the sound of riveting, that process by which molten bolts are urged to bind steel girders together. Sometimes these sounds are imminent and ear-splitting, sometimes they are dull rackets in the distance, but their permanence seems fairly secure. So does that of the rumble of the elevated railways, the clanging of bells on the trolley-cars, the shrieking of the taxi sirens, the explosions of exhausted gas from automobiles, the late evening cries of *Extra!* (usually unheeded), proclaiming another edition of the tabloids, the song of the radio, Crying for the Carolines, through so many open windows or through the fragile floors or frail walls of apartment houses, the beating of the steam in cold radiators, Rudy Vallee and Duke Ellington, and in the morning, the hurling of tin trash-receptacles by the refuse man against brick walls or the clatter of milk bottles upon cement floorings. These are a few of the predominant contemporary New York sounds, most of which did not exist twenty years ago and many of which may have departed in favor of newer dins in 1950.

Van Vechten, p. 141

Q Sound

Sounds burst forth, they move in the streets, rebound off the walls, build houses. You can almost touch them. The day will be full of them: the intermittent wail of fire trucks rushing by, the scream of police cars, the long, drawn-out screeching of breaking yellow taxis, the dull thud of cars landing on the huge metal sheets thrown down to cover up the roadworks, the excessive chanting of antitheft devices, the roaring of the subway, the machine gun–like chorus of jackhammers, the rhythmic pounding of drills tearing up the earth to lay the foundations of a new tower block, the guttural shrieking of the poor wretch hobbling along the sidewalk, and the vibrations emanating from a radio sitting on the shoulder of some ghetto boy … A blend of longings and frustrations, tenderness and harshness—less a contemporary babel than a polyphony—a concert of ostensibly discordant sounds that eventually settles and amalgamates, and tells the metropolis.

Maffi, pp. 112–13

 Hence, when I am at home in the evening, the windows tinged with red and yellow as the city at last catches its breath, I know I will shortly hear the ice-cream truck coming from afar, almost as if in a dream. The sounds of the city continue to clash and overlap even at that hour, but the sweet melody of the approaching truck—like that of an immense music box—is a charm able to dialogue with these sounds, almost reconciling them one to the other. The truck reaches the corner, then it stops for a few minutes down below, filling my house with familiar notes and affectionate melodies, hypnotic in their undulating movement, and enfolding every other sound—every other noise— of the pulsating city at dusk.

 At that moment I stop whatever I'm doing, and smile: that dainty music box melody is my very own private New York "Nocturne."

Air, Wind

Irwin, p. 41

The slashed canyons of lower Broadway play curious tricks with sounds as with air currents. At some points the echoes seem to collide and burst into a noise like the booming of a great gun.

Girdner, p. 128

The high walls of the houses also play an important part in producing this symptom, for they reflect the noise and cause the sound-waves to reverberate back and forth many times, thus greatly increasing the evil effects of a single discordant sound on the ears. The capacity of city streets for transmitting and intensifying sounds is shown in the great distance at which the rap of a policeman's club on the pavement can be heard.

Corbusier, p. 66

One can rigorously control the placement of skyscrapers in such a way that no reflective surfaces are offered to street noises, and thus the desired silence can be secured.

Silence, Quiet

Mitchell, *Ears*, p. 196

The financial streets are deserted. It is so quiet one can hear, walking through a narrow street, the staccato noise of a typewriter in one of the few offices in which people are still working. No flags fly from the plentiful flagpoles. The jewelers on lower Broadway have removed their prim window displays for the weekend and pulled their shades. All the restaurants are closed. They will not open again until Monday morning. In these narrow streets of corporations and tickertape there is no life.

Botkin, p. 257

In a high wind tenants sometimes hear ghost "typewriters" tapping away like mad in empty offices—but this is only the building's steel skeleton creaking and groaning.

White, *Here*, p. 42

On weekends in summer the town empties. I visit my office on a Saturday afternoon. No phone rings, no one feeds the hungry IN-baskets, no one disturbs the papers; it is a building of the dead, a time of awesome suspension. The whole city is honeycombed with abandoned cells—a jail that has been effectively broken. Occasionally from somewhere in the building a night bell rings, summoning the elevator—a special fire-alarm rings. This is the pit of loneliness, in an office on a summer Saturday. I stand at the window and look down at the batteries and batteries of offices across the way, recalling how the thing looks in winter twilight when everything is going full blast, every cell lighted, and how you can see in pantomime the puppets fumbling with their slips of paper (but you don't hear the rustle), see them pick up their phone (but you don't hear the ring), see the noiseless, ceaseless moving about of so many passers of pieces of paper: New York, the capital of memoranda, in touch with Calcutta, in touch with Reykjavik, and always fooling with something.

Caldwell, p. 2

Stores close, the smaller ones with crashes of steel security gates, and the quieter stretches of commercial avenues turn into rows of illuminated grillwork.

Maffi, pp. 112–13

At this time of the day, it's almost as if there are no sounds of the city: perhaps they have all been carefully wrapped in the cotton wool of morning, or hidden away somewhere beneath the sidewalk in their very own Pandora's box.

Q Sound — Air, Wind

All of a sudden it is silent out there on the street. All those damnable millions who come careening into Manhattan all week aren't there. The town is empty.

Wolfe, "Sunday," p. 240

It was this frightful silence of the streets, and of all the outer world, that terrifies people, cooped up in their houses, and their rooms, by the walls of darkness, more than almost any other circumstance; it gives such an overwhelming sense of the universality of disaster, whatever that disaster is. Except where the voices of neighbors can be heard, one cannot be sure that the whole population, outside of his own family, had not perished.

Serviss, p. 61

The city is silenced by the softer and richer symphony of the night, its racking noises quelled.

Conrad, p. 73

Night workers, their footsteps sharp, irregular on the quiet streets, return home.

WPA Guide, p. 49

In the long, lonely hours of early morning in Times Square, the beggar's tin cup does not rattle; the target guns go silent in the slot-machine parlors; loud speakers do not pour scratchy melodies into the ears of passersby; curbstone evangelists shout final affirmations above the chorus of their hecklers and go home.

Philips, p. 21

The blanked-out street now ends in a terminal emptiness.

Conrad, p. 112

Absences begin to ventilate urban narrative.

Ibid.

The city has emptied itself in deference to abstraction. The shop fronts are identical, colleagues in empty-headed vacancy, windows which resemble moronic faces harboring a nullity behind their eyes.

Ibid., p. 105

Abstraction, entering the city, evacuates and disassembles it. Its people are sent into retreat, its buildings are flattened or else sliced in half. It becomes beautiful by being rendered humanly unintelligible and uninhabitable.

Ibid., p. 105

For a moment the summertime city hushed, one of those pauses and its roar more imaginary than real.

Riesenberg and Alland, p. 50

No traffic noises penetrate to the court. Its nocturnal silences have dimension. Lying in their beds under the ancient rooftops and chimney pots, the tenants get only the heartbreak wait of groping river traffic on foggy nights.

Berger, New York, p. 116

The automobiles slide through the esophagus of silence.

Seifert, p. 462

Mrs. Mattie Dechner has three rooms with five windows, all facing the street. She has a tape recording she made one day, which she calls, "A Quiet Sunday Afternoon."

Philips, p. 42

The sounds of traffic are barely audible inside the great Park Avenue residential palaces.

Hawes

The noise is bad everywhere, but in some of the finer apartment-houses on the better streets you are as well out of it as you can be anywhere in the city.

Howells, Eye, p. 12

Q Sound — Silence, Quiet

Burroughs, p. 1566	Boy walks into an Italian social club on Bleecker Street. A moment of dead ominous silence, dominoes frozen in the air.
Finney, p. 115	The walls of this building are thick; from the outside I never hear any but the loudest sounds, and they are muted. But now I can't hear even these; no horns, air brakes, tire squeals. The silence is absolute.
Corbusier, p. 103	Restaurants are devoid of conversation.
Hilder, p. 595	A thick carpet deadens the footsteps of waiters and busboys.
Conrad, p. 123	They walk along 86th Street toward Fifth Avenue and, remembering the "avalanche of sound" on Avenue D, he notices that the further they get from Third Avenue, the more aloof grow the houses, the more silent the streets.
O'Hara, p. 327	the breeze is cool barely a sound filters up through my confused eyes
Riesenberg and Alland, p. 208	City of silent laughter.
O'Hara, p. 332	even the sun must rest and air and the noises of Manhattan
Riesenberg and Alland, p. 202	You are the refuge of silent people rubbing elbows and afraid to talk.
Corbusier, p. 33	The silent elevators unloading passengers.
Irwin, p. 47	The strange silence of it all. When I first noticed this—as a man will notice suddenly an obvious phenomenon he has been ignoring for years—I wondered if it were not a trick of acoustics; perhaps these depths absorbed sound. Then a pair of truckmen, unloading a safe, laughed; and the noise came out as clearly as the crying of a child in church. The cause may be that half-light, whether of sun or fire, to draw conversation out of people; or it may be the absorption of brain-workers. This is only the overflow of nearly a million people who cram for seven hours a day the caves in the great cliffs aloft; and ninety-nine per cent of them work furiously at a thinking job.
Kinkead, *Chinatown*, p. 11	For most of its history, Chinatown has been silent.
Maxwell, p. 16	With the first hint of morning, this beautiful quiet comes to an end.

Snow

Crisp, p. 169	One morning at the beginning of last month, I stood for a moment at the open window of my room and, except for the very faint wail of a distant police car siren, there was no sound to be heard. I thought it was the snow that had hushed the usually strident city … At last it dawned on me that I had become almost totally deaf … I like the noise of Manhattan.
Warhol, *Diaries*, p. 628	I hear snow shovels hitting the pavement at 6 A.M. (Thursday, January 17, 1985)
Donleavy	Sound of snow shoveling in the street.

When day breaks after a heavy snowfall, Manhattan wakes up to the clanging of shovels on sidewalks and the spatter of salt on newly cleared and shiny concrete.

Blandford, pp. 111–12

Snow white this Monday morning. Began falling in the night. Traffic sounds faint on the avenue the end of the street.

Donleavy

We turned on to a side street, and as the traffic sounds faded, the snow became audible. It was an incredibly delicate sound. Imagine the softest, lightest rain you have ever heard, and then imagine that the sound is not taking place on an umbrella right over your head, but about 20 feet away. Something like that. In any case, it sounded great, and we just listened to the snow for a block or two.

Johnson, *New Music*, pp. 269–70

 Later, as I began thinking about the sound of snow, and considering writing about it, I found myself listening to my feet as I walked along snow-packed sidewalks. That sound is familiar to all of us who live in snowy climates, and writers in English even seem to have agreed on a word for it. I haven't taken any surveys, but I'm fairly sure that "crunch" is by far the most common word to describe the sound of footsteps in the snow. But as I listened, really listened, I began to hear something else. It's something much more gentle than that. "Crunch," after all, is something you do when you bite down on a piece of celery, and the word sounds very much like "crush." Our feet don't do anything that violent to the snow, they just pack it down a bit. It isn't exactly a crunch, it's a ... Well, I guess there isn't any word for it, which explains why writers have made do with the wrong one, and which also shows how linguistic approximations can distort our perceptions. For years I have assumed that my feet really did crunch when I walked in the snow. I trusted language conventions instead of really listening.

Rain

He listens for a minute—foolishly as he walks, as if he can distinguish her footsteps from the worlds of sound in the city at the end of a rainy day.

Cheever, "Five-Forty-Eight," p. 285

It has been raining all day, and he notices how much louder the rain makes the noises of the street.

Ibid.

From the sides, numerous minor tones from the narrow side streets howl in accompaniment to the storm, just as evenly cutting their swaths across Manhattan—from one water's edge to the other.

Mayakovsky, *America*, p. 47

River

Gone from the upper harbor around Manhattan are the thousands of large and small vessels whose whistles (especially on a foggy day) have always been a reminder to New Yorkers of their maritime past.

Allen, *NY, NY*, p. 295

Ship's whistle from the river.

Donleavy

The low cry of dark shapes and winking lights that are ships echo and re-echo through the canyons of the avenues.

Spillane, p. 220

The whistlings of the ferries.

Roche, p. 404

Berger, *Eight Million*, p. 84	Ferry blasts shatter and break on the Wall Street skyscraper fronts.
Conrad, p. 239	From under the bridge tugboats moan in pain.
WPA Guide, p. 51	There are no steamship blasts but loud now are the hoarse piping of tugs, the yap of ferries with homeward-bound crowds.
White, *Here*, p. 22	I hear the Queen Mary blow at midnight, though, and the sound carries the whole history of departure and longing and loss.
WPA Guide, p. 69	The broad highway, West Street and its continuations, is, during the day, a surging mass of back-firing, horn-blowing, gear-grinding trucks and taxis. All other water-front sounds are submerged in the cacophony of the daily avalanche of freight and passengers in transit.

Nature

Mitchell, *Ears*, p. 196	The fat pigeons that roost in the eaves of the Custom House fly down, making ugly noises in their throats.
Maxwell, p. 3	They make bubbling noises in their throats as they strut on windowsills high above the street.
Philips, p. 135	Seagulls screech outside his window and sometimes when he wants to call an important person, he waits until the seagulls come near to supply an authentic background.
Brooks, *In the City*, p. 7	Occasionally, in the morning, the delicate sounds of small birds cut through the aural clutter. For a moment the city becomes the country. It's unsettling, a confusion of contexts.
Gold, p. 15	Girls gossip and chirp like a jungle of parrots. Others hum.
Wojnarowicz, p. 178	It is cool quiet, the occasional sounds of a faraway city, the wet tips of grass and the warmth of him through his clothes.
Finney, p. 177	As I stand sketching, I hear the lowing of cows, the baaing of sheep, hear pigs squeal, geese honk, and at the same time the distant, familiar, incongruous clatter of the El.
Glanz and Lipton, p. 185	Skilled construction engineers during the building of the World Trade Center learn to strike the stone with a bar and, as the heavy equipment nearby stands silent, listen to the ring. A sound with a certain muffled overtone means the rock can have faults, or be too soft, or have a gap underneath. A clear melodic ping means the rock is solid. Swinging the rebar and listening, a first violinist searches for a perfect A amid the mighty walls of the excavation. A Stradivarius couldn't have sounded prettier. "Pour the concrete," he barks.

El, Train, Subway

Dos Passos, p. 129	Morning clatters with the first L train down Allen Street. Daylight rattles through the windows, shaking the old brick houses, splatters the girders of the L structure with bright confetti.

They are walking down Sixth Avenue. An L train roars above their heads, leaving a humming rattle to fade among the girders after it passes.

Ibid., p. 39

Jagged oblongs of harsh sound break one after another as an elevated passes over.

Ibid., p. 158

The Bowery by day … where only the El makes music.

Weegee, Naked, p. 156

His laughter develops into a sneer. It grows into an insane cackling that resounds above the noise of the elevated train just passing.

Jolas, p. 474

Vaguely I hear the purple roar of the torn-down Third Avenue El
it sways slightly but firmly like a hand or a golden-downed thigh

O'Hara, p. 331

An Elevated Railway train passes. It bounds between two streets like a cannonball filled with quivering flesh, jolting from section to section of this lunatic city. You could see it far away, its carcass trembling as it passes over a torrent of steel girders, which goes on echoing from rampart to rampart long after the train has roared by at seventy miles an hour.

Céline, p. 560

Elevated train roaring by on its iron trestle at the end of the street.

Donleavy

The click click of the turnstile. Money drops down.

Ibid.

Coins-in-cups make a pretty good rattle.

Meltzer, p. 188

Shout Kools to the man over the crashing rumble of an elevated train and he hands across a pack. Says mentholated. With a free book of matches. In Europe they make you pay.

Donleavy

I stop for a moment so as to listen to the sounds of the tunnels. We stand very still, and there is silence here, deep under the city. Irregular drops of water reverberate and I also pick out, far off, a faint hum.

Brook, p. 132

The subway rumbles underneath as man in homburg in vest but coatless executive changes from right to left foot.

Kerouac, Lonesome, p. 107

Now and then, with a long and fading reverberation, a subway train passes under their feet. Perhaps they think momentarily of two green eyes tunneling violently through the earth without apparent propulsion or guidance, as though of their own unparalleled violence creating, like spaced beads on a string, lighted niches in whose wan and fleeting glare human figures like corpses set momentarily on end in a violated grave yard leaned in one streaming and rigid direction and flick away.

Faulkner, p. 613

A long, dirt-crusted train screeches into the station, running past his nose, stopping with a hundred decibel scream of brakes.

Riesenberg and Alland, p. 66

Uncovered tracks meant a never-ending clanking, from the couplings of railroad cars, and periodic bawling, from the cows and other animals being transported south to the slaughterhouses, unless the people who live in the apartments above keep their windows closed.

Caro, p. 557

Listen: You might even hear the Pan Am Clipper leaving from Floyd Bennett for Lisbon.

Hamill, "Lost"

Q Sound — El, Train, Subway

Bohan, *American Art*, p. 207

Joseph Stella: "The shrill sulphurous voice of the trolley wires."

Traffic

Ellis, *Epic*, p. 462

It is hardly possible to conceive the appearance of a crowded wholesale street in the day of the automobile vehicle. In the first place, it will be almost as quiet as a country lane—all the crash of horses' hoofs and the rumble of steel tires will be gone.

Arce, p. 330

The hymn of the heavy trucks.

WPA Guide, p. 81

The rumble of speeding trucks, the blasts from nearby steam shovels, and the intermittent whistles from passing river traffic join in crescendos of dissonance.

Lobas, p. 54

I move along the streets in a constant screech of brakes, while a torrent of curses and abuse rain down on me.

Irwin, p. 315

Only sometimes of an afternoon keen ears detect over the rattle and roar of traffic on Seventh Avenue a humming which is the voice of a hundred thousand sewing machines.

Bahrampour

One apartment has a picture-window view of the Gowanus Expressway. "Ah, listen," the realtor says as the cars zoom toward the living room. "To me, the sounds of a freeway are like the sound of the ocean. In fact, I like it better."

Finney, pp. 104–5

We can hear the sound of our own tires on the asphalt, and at Amsterdam Avenue, waiting for a light, I hear someone cough half a block or more away.

Lebowitz, p. 139

When one is walking down Fifth Avenue, one does not expect to hear a string quartet playing a Strauss waltz. What one expects to hear while walking down Fifth Avenue is traffic. When one does indeed hear a string quartet playing a Strauss waltz while one is walking down Fifth Avenue, one is apt to become confused, and imagine that one is not walking down Fifth Avenue at all but rather that one has somehow wound up in old Vienna. Should one imagine that one is in Old Vienna one is likely to become quite upset when one realizes that in old Vienna there is no sale at Charles Jourdan. And that is why when I walk down Fifth Avenue I want to hear traffic.

Dreiser, p. 3

Fifth Avenue, that singing, crystal street.

Serviss, p. 60

The noise of the collision had been heard in Fifth Avenue, and its meaning was understood; but amid the universal terror no one thought of trying to aid the victims. Everybody was absorbed in wondering what would become of himself.

Jolas, p. 473

Auto claxon roars crescendo.

Brook, p. 254

We bounce and dance over every pothole on the avenue.

Donleavy

Thick iron manhole cover clanks and rocks under the passing wheels.

Ibid.

Taxis squeal by as doormen's whistles blow.

Q Sound — Traffic

And right in the middle of my little moment of beauty some crass fucker stops his car to honk his horn. *Ibid.*

"Taxi!" people wail. *"Taxi!"* But there are no taxis. Or if one comes along there is somebody in it. Maxwell, p. 17

Pedestrian and motor traffic thins and the din slowly fades. Berger, *Eight Million*, p. 166

Noise of sliding automobiles and hunger of their eyes. Galwey, p. 422

The sound of tireless traffic in the wet streets. Wojnarowicz, p. 129

From somewhere off toward Amsterdam Avenue comes the sound of a siren. Conroy, p. 44

The siren subsides. Car doors slam outside. Donleavy

I hear the siren scream, but that is all there is to that—an eighteen-inch margin again. White, *Here*, p. 22

Streets of clanging ambulances. Riesenberg and Alland, p. 203

Just south of the statue of Father Duffy at 46th Street between Broadway and Seventh Avenue is a large subway grating on a pedestrian island. If you walk over it, you will hear a steady sound, not unlike that of a conch shell held up to the ear. If you stand still for a long enough time, you will notice that the sound changes gradually and subtly … It does not pollute the air nor force itself on one, the way Muzak does in restaurants and other public places, but rather steals into one's consciousness, and by its uniqueness it makes one listen to the sounds—chiefly traffic noise—with a greater appreciation of special textures. Ericson, p. 113

Garbage

The garbage men come waltzing along. Clanging, clattering and strewing the sidewalk and gutters with a new debris. Donleavy

Muffled sound of the garbage men approaching. Radio says temperature twenty two degrees. *Ibid.*

The "CHIFF-CHIFF" of hydraulic brakes (like steam escaping from a narrow fissure), the scrunch of clashing gears, the thump of wooden boxes being unloaded, the blaring of a loudspeaker system, the growl of trucks being jockeyed in and out of position, the slamming shut of metal doors hardly ever stop … There are two reverse gears. The second one is the noisy one, but it's faster. VRRRRROM! they gun the motors to get out, then CHUME! into gear, CHUME! into the next gear, then they slam on the brakes at the corner. Philips, p. 43

Stopping and starting, making noises like an electric toaster, the Department of Sanitation truck makes its way down Eighty-fourth Street murdering sleep. Crash. Tingle. More grinding. Bump. Thump. Voices. A brief silence and then the whole thing starts up again further down the street. This is followed by other noises—a parked car being warmed up, a maniac in the sports car with no muffler. Maxwell, p. 18

Philips, p. 41

The apartments facing the largest express depot in the world are living in acute distress. They have the mercantile equivalent of all-news radio—"all noise, all the time"—the difference being that there's no knob to shut it off with.

Radiator

Federal Writers, *Almanac*, p. i

We hear the first paint-roasting thump of the radiator, which tells our conditioned ears that Autumn is here.

Donleavy

Tingling and banging in the pipes along the wall.

Riesenberg and Alland, p. 207

City of clanging radiators.

Donleavy

If the clatter, blast, clang and boom ever quiets.

Philips, p. 26

There is a cracking sound. Strong fumes come up. Someone has dropped a bottle of ammonia at the curb.

Crisp, p. 92

When real winter arrives, the radiators of Manhattan begin to clank and hiss and tenants know that happiness—or, at least, heat—is on the way, but at this time of year while in the street it is still warm, indoors it is cool—occasionally too cool.

Construction

WPA Guide, p. 50

A rivet overhead pierces the sultry sky; another shakes the earth.

Wojnarowicz, p. 133

The slow lights of barges and the bleak iron giantcy of a crane that in the morning sunrise are pummeling away at the hard earth amidst the clang of hammers and cries of workmen.

Donleavy

Scaffolding down five stories into murky ear splitting darkness. Red hatted carpenters hammering. Under floodlights. Men bending wire and cutting steel. Huge crane rearing from a truck up into the sky.

Van Vechten, p. 77

Outside there is a prodigious honking of motor-horns and the hammering of a riveter as it flattens the headless ends of bolts in a steel construction across the way. Through the window men, poised perilously at a high altitude on the cross-beams, might be observed catching these bolts as they are tossed molten from the furnace.

Dos Passos, p. 185

Steam riveters rattle incessantly; now and then a donkeyengine whistles and there is a jingle of chains and a fresh girder soared crosswise in the air.

WPA Guide, p. 50

Looms, shears, jackhammers, trolley cars, voices, add to the din.

Ibid.

A deep blast rises, drowning the sound of hawkers, children, automobiles.

Atkinson, p. 37

Street repairs and upheavals, buildings being razed and buildings being constructed keep the streets of New York in a constant hell of noise and dirt and inconvenience.

Q Sound — Radiator

I am sitting in my room one night, listening to the sounds that float vaguely about this curious little unit of metropolitan life. Dreiser, p. 190

On a hot summer night, I can measure the lively progress of small boys down Tenth Street by the clanking of sticks on the garbage cans along the way. They charge the air with strident sounds that no symphony would dare to match. Binzen

The sounds of my street lift like the blast of a great carnival or catastrophe. The noise is always in my ears. Even in sleep I could hear it; I can hear it now. Gold, p. 14

From the twenty-first floor, I hear all the noises, precisely and in detail, amplified even! I am stupefied. I cannot sleep with the window barely half open. Corbusier, p. 65

Sounds drift up from the street. Honking horns. Squeals of tires. Sirens wailing along the avenues. Drone of an airplane. Donleavy

I don't even hear any planes except a couple of westbound commercial airliners that habitually use this air shaft to fly over. White, *Here*, p. 22

The wail of fire trucks and police sirens is now added to the night. Lee and Jones, p. 85

Off in the distance a fire engine screams, demanding room, behind it another with a harsh, brassy gong backing up the order. Spillane, p. 318

Horse cars jingle by. A tinker hammers at brass. Junkbells clang. Gold, p. 14

A sound like electric waves cuts into the nerves of the passers-by. Jolas, p. 472

I listen to the burbling of water in the fountain, the thunder clapping its way across the skylight, the organ music. Maffi, p. 72

Shouting screaming kids fill the streets playing baseball, football, hopscotch, jump-rope, dodging swift-moving trucks and taxis. WPA Guide, p. 50

Jackhammers, horns, sirens, breaking glass, recycling trucks, whistles, booming bass from the new Ice Cube, unwanted sound trailing behind me. Ellis, *Glamorama*, p. 18

We hear the familiar tune from the Mister Softee truck as it comes down the street. Lee and Jones, p. 60

Now and again, though, in a quiet moment, the high sound of the iced drink vendor's bell rings across the corner. Blandford, p. 30

The clatter of riveting-guns, the sigh of the weary, the shrill warnings of policemen's whistles, the sunny chatter of perambulating nursemaids, the jittery laconisms of waiters, countermen, cabbies, musicians, busboys on the run, doctors, lawyers, nurses, thieves and radio entertainers. Federal Writers, *Panorama*, p. 152

The sounds of the city are best heard from without. In the city the screeches of police whistles, the gongs of ambulances, the terrifying sirens of fire engines, balance out, but they swing off together over the pure heads, just as foghorns blare inland up the city streets in thick weather. Off on the stream Riesenberg and Alland, p. 199

one notes the cries of children playing games, the sound of whistles at noon, and on Sunday the ringing of church bells. But, for the traveler coming to New York by ferry, the most haunting charm of all is the saucy tinkle of iron pawls merrily spanking the mooring wheels of ferry slips.

Kasson, p. 49

The din of barkers, brass bands, roller coasters, merry-go-rounds, shooting galleries, and hundreds of other attractions—above all, the shouts and laughter of the crowd itself.

Gorky, "Boredom," p. 311

But no human voice is heard. The monotonous hissing of the arc lights fills the air, the sounds of music, the cheap notes of the orchestrions, and the thin, continuous sputtering of the sausage-frying counters. All these sounds mingle in an importunate hum, as of some thick, taut chord. And if the human voice breaks into this ceaseless resonance, it is like a frightened whisper. Everything 'round about glitters insolently and reveals its own dismal ugliness.

Gopnik, p. 91

Yet the background noise, like the incidental sweetness, is overwhelming: the rumble of buses, the constant whistles, a kind of white hush very different from that in other places. No hushed Sunday-morning moments when church bells ring from a distance … A fight over noise is a displaced fight over space. You struggle so hard to claim a few hundred, a bare thousand, square feet that anything intruding—a take-out menu, a neighbor's piano—becomes an affront to your privacy, to your selfhood. The dancing overhead, the barking down below, however harmless, encroach on your dearly bought and long-fought-for solitude. We fight about noise as people in Venice might have fought—did fight—about water rights at the Palazzo. As we do, they blamed the malice of their neighbors for the fact of their circumstances. The annual flooding, the damp mold creeping into your basement, the certain fatality of wet; it all got referred to an argument with your neighbor about where he left his gondola.

Ibid., pp. 81, 99

Noise is *the* New York issue, yet why should it be so? Surely all cities are equally noisy, but I have never heard anyone in Paris complain about the noise … yet Paris is as loud as it gets: the streets with traffic, the families with dogs; and in San Francisco, they play the stereo all night long. Noise in New York is, must be, a symbol, a referred pain, for something else. It is an issue on which no compromises seem possible. The anger comes from elsewhere, even if (as they claim, and as we refute at length) the noise comes from upstairs … Is it noisier here than it is elsewhere? I listened on the street and think that, yes, it is noisy here, though I had never really noticed before. The situation can even be said to have improved somewhat, for everything has gone indoors, inside, been internalized.

Wojnarowicz, p. 43

The 8th Avenue wind from the river blowing the dirty curtains out over the Avenue—street sounds and prostitute clatter of heels mixed with traffic flowing in.

Douglas, p. 17

A dissonance comprised of a thousand noises.

Ibid.

You can *see* the noise.

Ibid.

I can't hear me.

Barnes, p. 294

And yet the city gives out only a faint sound of fabric being rent: one-half of the mass pulling one way and the other half in an opposing direction.

Q Sound — Street

This is what you hear along the sidewalks when the sun is shining and when the city's roving bootblacks are lived up like buzzards for business—sometimes lurking in corners, sometimes perched at the curb, sometimes wandering through crowds whispering *"shine, shine"* like a peddler of dirty postcards.

Talese, p. 39

This strange dim street, still clattering steel against cobble in a blackness relieved by squares, rectangles and cones of vague light whose very color was strange.

Finney, p. 156

It's hard to lose yourself in the fog of art when you can't afford an air-conditioner, and the erratic thrum of a jackhammer rises up from the street. Through the thin walls comes the sound of the radio played too loudly. Babies and sirens cry.

Leavitt

We lived on East Ninth Street, in a second-floor apartment so close to the street that it seems an extension of it, a cacophonous symphony of ugly urban sounds that play fortissimo outside our window, punctuated regularly by the sound of the Ninth Street crosstown bus making its stop next to the downstairs doorway—incredibly, these distractions not only fail to impede but seem to spur the steady stream of words rushing from his teeming brain to his two nimble index fingers that decisively, at full tilt, strike the keys of his trusty, overburdened Royal portable. It is, then, wide of the mark to say that he is tuning out, doing what I try in vain to do under the same trying circumstances—"I can't hear myself think!" I shout, and toss aside the book I am endeavoring to read, while Frank appears unwilling or unable to shut out the world that engulfs us.
 "Is everything grist for your mill?" I ask him, impatiently.
 "What?" he asks, as he continues typing.
 "The city! The noise outside!"

LeSueur, pp. 82–3

the life of the city
at all hours
the polyphonic concert of
cables
of rat-a-tats
a "honneger pacific"
of the sewer-pipe

Stern, "Europe," p. 520

Restless walks filled with coasting images of sight and sound, cars buckling or bucking over cobblestones down quiet side streets, trucks waiting at corners with swarthy drivers leaning back in cool shadowy seats and windows of buildings opening and closing, figures passing within the rooms, faraway sounds of voices and cries and horns that roll up and funnel in like some secret earphone connecting me to the creakings of the city.

Wojnarowicz, p. 145

On the dropping of the New Year's Eve ball: "It's a giant animal mass that heaves and emits this *unbelievable* sound."

Trebay, p. 156

Music

O city
full of music
built all out of mechanical rhythm.

Arce, p. 19

Baudrillard, *America*, p. 18	There is music everywhere; the activity is intense, relatively violent, and silent (it is not the agitated, theatrical activity you find in Italy).
Amin and Thrift, p. 16	The "music of the city" that needs to be "discovered by reflection."
McReynolds, p. 346	When the mode of music changes, the walls of the city shake.
Maffi, p. 106	Music and the spoken word meet, intermingle, and blend as one here, and the dialogue between the two is continual.
Atkinson, p. 80	When I come to Trinity Church I hear organ music rising against the roar of traffic.
Riesenberg and Alland, p. 202	Cats singing at night, cornetists wailing by day.
Arce, p. 333	And now a "Jazz-Band" from New York; vice blossoms and engines thrust in synchronous seaports Nuthouse of Hertz, Marconi, and Edison!
Jolas, p. 472	A sound of jazz from jug-band.
Wojnarowicz, p. 111	bebop clatter familiar sounds
Ginsberg, *Howl*, p. 5	who sang out of their windows in despair
Cheever, "Moving Out," p. 97	Bessie Smith is singing Jazzbo Brown from a radio in the orange drink stand at the corner. Halfway down Sutton Place a blind man is playing "Make Believe" on a sliding trombone. Beethoven's *Fifth Symphony*, all threats and revelations, is blowing out of an upstairs window.
Ellis, *Glamorama*, p. 129	The sidewalks on 14th Street are empty, devoid of extras, and above the sounds, I can hear someone singing "The Sunny Side of the Street" softly to himself.
Smith, "Postscript," pp. 306–7	On Christmas Eve, Dorothy Day returns to the Women's House of Detention where she had spent almost a month this summer. With her are fellow members of the Catholic Worker Movement, pacifists, individualists—several of whom have also gone to jail for refusing, because of their convictions, to take shelter during an air-raid drill. They have come to Village Square to sing carols to the women inside. They stand in the freezing street opposite the towering building, and sing.

It seems hard for the unknowing, like this reporter, to believe that anyone can reach the girls in that dismal place.

The singing starts with a kind of unsure sincerity. After the first song, they pause. Against the windows, silhouettes of the watching girls can be seen. Then, from behind the heavy windows, they began to shout. "More … sing another one!" One girl yells, in a throaty Puerto Rican accent that seems to make standing in the cold wind worth it: "Please? Please sing another one, you good people … God bless all of you!"

The group really catches fire and sings with such zeal that they sound good enough to be in Saint Patrick's. Every time they pause, the inmates think they are stopping, and plead for more.

Q Sound — Music

The carolers circle the prison, giving each side a chance to hear, and each side responds like the others. Every time a girl calls down, the singers seem to take on a new fervor.

Some passersby approach with the wry smile of sophistication, but no one sneers when he gets close. In fact a great many stop to join in.

A slightly bald priest who looks very much like Barry Fitzgerald notices that I am standing apart, and smiles in my direction. A few minutes later he smiles again, comes over, and says to me with warmth: "You can join us if you'd like. That is—if you really want to."

So I sing right along with the group. I am singing with Catholic Workers, tourists, sailors, Villagers, actors, and a drunken woman who also feels the magnetism. We sing ourselves to tears to a bunch of tough girls we will never see.

After a long time in the cold the carolers start to split up. "God bless all you girls ... we know next Christmas will be merrier," shouts the drunken woman in a blurred, tipsy voice, while she looks around thinking that perhaps she has made a mistake. Believe me, she hasn't.

Music is playing from upstairs apartments in this year before air-conditioning silenced the New York night: Symphony Sid or Jazzbo Collins, Alan Freed or Murray Kaufman (*Mee-a-zurry, Mee-a-zurray, all through the night*) ... even, in memory, Jack Lacy on WINS before it became an all-news station (*Listen to Lacy, a guy with a style, of spinning a disk with finesse, yes, yes*). Hamill, "Lost"

The cornetist steps forward for a solo, begins, "Drink to me only with thine eyes ... " In the wide, warm night the horn is startlingly pure and magical. Then from the North River another horn solo begins—the Queen Mary announcing her intentions. She is not on key; she is a half tone off. The trumpeter in the bandstand never flinches. The horns quarrel savagely, but no one minds having the intimation of travel injected into the pledge of love. "I leave," sobs Mary. "And I will pledge with mine," sighs the trumpeter. White, *Here*, p. 41

The gentle playing of an oboe mingles with city noises from the street outside, which penetrates into the room with difficulty through great barricades of books. Fitzgerald, "My Lost City," p. 107

The elevator stops, and we clamber out, blinking at the light and noise. There is a party going on, for sure. Some of the guys are playing a horn duet—I can't tell an oboe from a trumpet from a frog, so I'm not sure exactly what instruments they are using, but they sound like enemy herds of elephants preparing for battle. Tucker, p. 140

Deep in the night, I am almost unaware how many people are on the street unless something calls them together, like the bagpipe. Who the piper is and why he favors our street I have no idea. The bagpipe just skirls out in the February night. Rorem, p. 814

a grindorgan fills the street with shiny jostling coils of the Blue Danube Dos Passos, pp. 240–1

Varèse hears the din of the city as improvised modern music, spurning the assuagement of tone and harmony. Conrad, p. 118

The sirens change from scientific hypothesis to urban commonplace when fire engines—which can be heard in Varèse's "Deserts" (1954) and in his "Ameriques" (1926)—shrill by. *Ibid.*

♫ Sound — Music

"Music is made of sound," Varèse insists, and New York's foghorns, piercing police whistles, rattling hammers, percussive El, ground bass of automobiles, and stuttering radios are an organization of sound, mechanically emitted and (in the orchestra) mechanically imitated.

American sounds. Varèse hears them from his room on West 14th Street.

Mid-1920s, Varèse's *Amériques* is played at Carnegie Hall. An anonymous reviewer of the *Evening World* says, "A pretty little shindig of boos and hisses broke last night … after Edgard Varèse's symphonic genuflection to the Fire Department and the Pneumatic Riveters' Union."

Composer George Antheil, the self-styled "bad boy of music," presents the US premiere of his *Ballet mécanique* [at Carnegie Hall] on April 10.

Conducted by Eugène Goossens, the performance featured xylophones, electric bells, anvils, airplane propellers, sirens, assorted percussion instruments, player pianos, and regular pianos, including one played by a 26-year-old Aaron Copland.

According to *The New York Times*, some members of the audience cheered, some hissed, and "one beleaguered man" even tied a white handkerchief to his cane, "hoisted it over his head and waved it from side to side in a token of surrender."

He hears the electric light as the ringing of a "silvery alarm."

The music does not melodiously happen through time. Rather it accumulates in and deafeningly congests space as the city does, tiered vertically in layers of battering sound. It is cubism in music, a piling-up of solid masses.

The trumpet in a Harlem band is a turbine, a tireless self-repetitive dynamo, and admires tap-dancing for similar reasons, because it's the choreography of the factory, "as mechanical as a sewing machine."

Cage: "I'm just crazy about the noise of New York. I consider it musical."

When I hear what we call music, it seems to me that someone is talking. And talking about his feelings or about his ideas, of relationships. But when I hear traffic, the sound of traffic here on Sixth Avenue for instance, I don't have the feeling that anyone is talking, I have the feeling that a sound is acting, and I love the activity of sound. What it does, is it gets louder and quieter, and it gets higher and lower. And it gets longer and shorter. I'm completely satisfied with that, I don't need sound to talk to me. And this silence, almost anywhere in the world today, is traffic. If you listen to Beethoven, it's always the same, but if you listen to traffic, it's always different.

I love living on Sixth Avenue. It has more sounds, and totally unpredictable sounds, than any place I've ever lived.

I wouldn't dream of getting double glass because I love all the sounds. The traffic never stops, night and day. Every now and then a horn, siren, screeching brakes—extremely interesting and always unpredictable. At first I thought I couldn't sleep through it. Then I found a way of transposing the sounds into images so that they entered into my dreams without waking me up.

Margin notes (left column):
Ibid.

Ibid.

Varèse, p. 246

"1927 George"

Conrad, p. 239

Ibid., p. 118

Ibid., p. 138

Ibid., p. 119

Cage, "About Silence"

Cage, *Conversing*, p. 25

Ibid.

Margin note (right column):
Q Sound — Music

280

Now I don't need a piano. I have Sixth Avenue, the sounds. I translate the sounds into images, and so my dreams aren't disturbed. It just fuses. There was a burglar alarm one night and I was amazed because the pitch went on for two hours, was quite loud. It seemed to me to be going slightly up and slightly down. So what it became in my dreams was a Brancusi-like shape, you know, a subtle curve. And I wasn't annoyed at all.

Ibid.

When the weather was good the windows were open, and the airplanes leaving La Guardia flew directly overhead, drowning out from time to time whatever he had to say. He never repeated what had been said during the passage of the airplane. Three lectures I remember in particular. While he was giving them I couldn't for the life of me figure out what he was saying. It was a week or so later, while I was walking in the woods looking for mushrooms, that it all dawned on me.

Cage, *Indeterminacy*

Planes flew over the city around me; I heard them.

Finney, p. 113

O'Hara working at 326 East Forty-ninth Street between First and Second Avenues, listening to the three or four albums he owned: works by Poulenc, Milhaud and Rachmaninoff's Second Symphony—and an antiquated little radio which he kept tuned to one of the two classical radio stations, WQXR or WNYC.

Gooch, p. 193

Listening to free concerts under the stars at Lewisohn Stadium.

Hamill, "Lost"

In 1955 Muzak was tested in the NYC subways.

Basile, p. 217

On this blue May night, it is music. It is not the Prologue to Pagliacci, which rises ever and anon on hot evenings from an Italian tenement on Thompson Street, with the gasps of the corpulent baritone who gets behind it; nor is it the hurdy-gurdy man, who often plays at the corner in the balmy twilight. No, this is a woman's voice, singing the tempestuous, over-lapping phrases of Signor Puccini, then comparatively new in the world, but already so popular that even he recognized his unmistakable gusts of breath. He looks about over the roofs; all is blue and still, with the well-built chimneys that were never used now standing up dark and mournful.

Cather, p. 11

It is Saturday, toward the end of the afternoon. I turn through West 48th Street. From the open windows of the drum and saxophone parlors come the listless sounds of musical instruction, monstrous insect noises in the brooding field of summer. The Cort Theater is disgorging its matinee audience. Suddenly the whole block is filled with the mighty voice of a street singer. He approaches, looking for an audience, a large, cheerful Negro with grand-opera contours, strolling with head thrown back, filling the canyon with uninhibited song. He carries a long cane as his sole prop, and is tidily but casually dressed slacks, seersucker jacket, a book showing in his pocket.

White, *Here*, p. 39

I craved the memories of the smells and sounds of then-exotic Caribbean vegetables at La Marqueta, the indoor market at 115th Street and Park Avenue, and the salsa jams throbbing from the Casa Latina record store on 116th Street.

Morales, p. 19

The Beatles' Sgt. Pepper music was the main strain you heard all through the summer; you'd hear it playing absolutely everywhere.

Warhol, *POPism*, p. 216

Q Sound — Music

Trebay, p. 67
Sometimes a turntable just gets an urge to walk out the window and down to Eighth Street.

Brook, p. 4
In Harlem lanky youths in t-shirts amble past uniform public housing blocks swinging monstrous transistor radios that blare rock and reggae into the air as palpably as the exhaust from the groaning buses.

Frisa and Tonchi, p. 167
One night she came down in a green sweat suit and carrying a boom box on her shoulder blaring "Rapper's Delight"! We didn't go anywhere. We just walked around the city. It was our playground and her hood.

Courgois, p. 33
A loudspeaker pulses salsa music from a tenth-story housing project window so that everyone on the street below can step in tune for free.

Gopnik, pp. 81, 99
Once there were kids with boom boxes, declaring the strength of their shoulders and their indifference to middle-class opinions by hoisting huge radios to create insulating, almost visible clouds of defiant sound … Now everyone walks with headphones.

Blandford, p. 30
This is the only difference between this latest summer and those that have gone before it. The blaring tape decks are fewer. The big black noise machines gave way to Sony Walkmen. Now each person skips and dances along to an unheard, inner tune. It would be a welcome relief were it not that the thunder of traffic goes on, the blast of exhaust continues.

Goldsmith, *Theory*
Back in the early 90s, I was working in my studio on Houston St. with the window open. In those days, people were still playing music on the streets from oversized ghetto blasters balanced on their shoulders and, more often than not, playing hip hop. From outside the window came an array of sheer white noise, which quickly morphed into what sounded like the electronic whooshes of *musique concrète*. I was stunned and rushed over to see what was going on. But by the time I got there, the noise had changed again, this time into light Daisy Age beats. It took me a few minutes to realize that what I was hearing was a noisy break in what was a rare and unique moment for experimental hip hop; a moment that passed quickly once gangsta rap took over.

Radio

Irwin, p. 38
The phonograph and radio have all but exterminated the Italian organ-grinder.

Seferis, pp. 303–4
At every corner a gramophone shop
in every shop a hundred gramophones
for each gramophone a hundred records

Riesenberg and Alland, p. 206
City of telephone flirtations, Dictaphones, microphones, and loud-speakers.

Léyeles, p. 405
A gramophone
will play (in-e-luc-ta-bly)
the Afternoon of a Faun;

Bercovici, pp. 53–4
Radio and victrola shops relay a never-ending program of "fanfare" music. Rifle-shots thrash the air with monotonous explosions as the pageant of ducks floats by in the side-show, or a ping-pong ball balances precariously on a water jet. And you can hear music streaming out from every window.

Q Sound — Radio

The sound from a grand piano on which some one is essaying Beethoven's "Appassionata" or Sarasate's undying and hackneyed "Gypsy Airs," played on a violin to a very inadequate accompaniment. Song, music, and color, whichever way you turn.

Somewhere in the quiet, sparsely developed outskirts of Los Angeles, an artificial New York would arise. It would be a New York where sound could be controlled, a New York distant from any unwanted traffic background noises … The rise of a genuine *mythic* New York on film was the unexpected consequence of a second revolution brought on by sound—a consequence, in fact, of the single most crucial fact about talking pictures. They talked.

Sanders, *Celluloid*, p. 275

The lack of directionality in early microphones ensured that every background sound—car horns, pneumatic drills, tugboat whistles, and always, somewhere, the roar of a distant elevated train—would find its way on to the recordings track.

Ibid.

On the radio district which was replaced by the World Trade Center: And what an area it was, especially in its sounds. A walk down the streets presented a constantly shifting cacophony, as most of the shop owners had mounted big cone-shaped vibrating speakers over their doorways, blasting out everything from the teariest opera to big-band orchestral music to step-right-up sales pitches that ran over and over. Piercing through all that noise was the a-ooga of car horns on the street, the whistle of the ferries that docked in the slips right at the foot of Cortlandt Street, and the much deeper bellow from the tugboats plying the river. There was the occasional clop of horses—in the late 1920s there were still a few horse-drawn drays moving small loads of cargo or scrapwood, and they could be seen negotiating the widest of U-turns at the Cortlandt intersections.

Glanz and Lipton, pp. 74–5

Radio has introduced many new expressions into the city's language. Easily recognizable are hog the mike, wanna buy a duck?, check and double-check, are ya listenin'? Equally colorful is an inside (professional) lingo which employs killie loo bird for a flighty coloratura, old sexton for a bass with a sepulchral voice, talking in his beard for a muffled voice, fax for facilities, town crier for one who sings too loud, fighting the music for lack of ease in singing, down in the mud for very low reproduction volume, line hits for occasional chirps on transmission circuits, fizzy for an unclear voice, fuzzy for an unclear program, and on the nose for ending a program on schedule to the second. Staples surviving the introduction of microphones include nervous pudding for Jello; burn the British or toasted Wally for a toasted English muffin; smear one, burn it for a toasted cheese sandwich; bottle o' red for catsup; one to go for an order to be taken out; one cow for a glass of milk; stretch it for a large glass; burn one with a feather for a chocolate malted milk with an egg in it; and the strident eighty-six, a warning to the cashier that a customer is trying to leave without paying his check.

Federal Writers, *Panorama*, p. 159

Radio jazz-splashing on pavement.

Jolas, p. 471

The far end of the dial. Move the pointer away from NYC and QXR some night late and start fishing around between the loud local stations at the high-frequency end of the band. Where the static level is high and the living is not easy.

Shepherd, p. 156

The obliviousness to low sounds, the indifference to cacophony which makes the ideal radio listener of present-day America, was part of the original

Mumford, "Metropolitan," p. 22

acquisition of Manhattan in the Brown Decades. This torment of noise-troubled sleep lowered waking efficiency, depleted vitality; but it was endured as if it were an irremediable fact of nature. In the lull of the elevated's thunder, the occasional tinkle of the cowbells of the ragman on a side street, or the solemn I-I-I cas' clo's of the second-hand clothing buyer, would have an almost pastoral touch; while Carmen, on an Italian's clanking hand organ, could splash the sky with color.

Hamill, "Lost"

If it's warm enough, and the right year, you can hear the ball games too: Ernie Harwell and Russ Hodges bringing us the Giants (with Frankie Frisch the Fordham Flash on the post-game show), or Red Barber and Connie Desmond with the Dodgers, or hear the simulated crack of a bat and the simulated roar of a crowd, and *Today's baseball, with Bert Lee and Marty Glickman, and the absent Ward Wilson, who is ailing* ... Ward Wilson was always absent. Ward Wilson was always ailing. And nobody listened to the Yankees.

Conrad, pp. 137–8

Radio City as a bloodless cathedral. Inside the studio he sees another room made by muting and insulation: a glass aquarium for spectators, who can chatter at will without being heard because their booth is soundproofed.

Fitzgerald, "My Lost City," p. 114

"What's news from New York?"
 "Stocks go up. A baby murdered a gangster."
 "Nothing more?"
 "Nothing. Radios blare in the street."

Speech

Girdner, p. 127

The exposure to the din and roar, the screams and yells, which go on in the streets at nearly all hours of the day and night.

Binzen

People talk with their hands, their mouths, their bodies—most of all their hands.

Riesenberg and Alland, p. 50

Then, all of a sudden, piercing shrieks volley from high office windows.

Brown, *Manchild*, p. 120

But somebody's always screaming.

Brooks, p. 59

A woman shouts into a pay phone, as if she wants the whole city to hear.

Dreiser, p. 3

Life bubbles, sparkles; chatters gay, incoherent stuff.

McCourt, p. 31

In summer, other voices in other rooms spilled out into the street.

Jolas, p. 472

A voice chants a Congo song.

Mitchell, *Ears*, p. 186

All of a sudden you realize that most of these humans are talking. The sound is like the sound in a theater just before the curtain goes up. Shut your eyes and listen. It is almost overpowering.

Conrad, p. 278

There are now so many stories gabbling simultaneously in New York that none of them can be made audible.

Maffi, p. 108

The confusion of strange tongues, babbling heedlessly.

Conrad, p. 122

Survival requires linguistic assimilation.

Q Sound — Speech

284

The Voice of the City, implies that the painting is a direct expression of a city that speaks for itself. Stella may have got both his title and idea from O. Henry's book *The Voice of the City* (1908). In the eponymous lead story the narrator searches all over New York, at night, for "the composite vocal message of massed humanity," to "interpret its meaning" since "it must have a key." New York's voice, O. Henry imagined, would have to be "a mighty and far-reaching utterance … the tremendous crash of the chords of the day's traffic, the laughter and music of the night … the rag-time, the weeping, the stealthy hum of cab-wheels."

Sharpe, p. 201

The composite vocal message of massed humanity. In other words, of the Voice of a Big City.

Henry, *Voice*, p. 13

We can compare space to a language and study its dimensions: the paradigmatic (relevant oppositions: inside/outside, above/below, verticality/horizontality, etc.)—the syntagmatic (sequences and linkages: roads, avenues and boulevards, routes, etc.)—the symbolic (the meaning of monuments, special places, etc.).

Lefebvre, *Stage*, p. 230

Words and expressions are whipped off the street only to be deformed or interpreted anew, and linguistic borrowings taking their origins from the provinces and small towns are remolded on (and for) the metropolitan experience.

Maffi, p. 110

In everyday speech, dominated as it is by its rhythm and speed, this language—"language of the city"—often becomes pure sound continually remodeled and modified by pronunciation, accent, and forever-changing outside influences.

Ibid.

While walking around the metropolis, new and hybrid linguistic forms echo all around you, confirming the sensation that this is very much an ongoing process.

Ibid., p. 111

It is a world of echoes and ricochets, observed from angles that emphasize the flatness and miscellaneous presences in the urban space.

Kozloff

The familiar utterance of words derived from unfamiliar lexicons.

Federal Writers, *Panorama*, p. 292

The vendors call out their wares in what seems at first a tongue all their own. But a trained ear soon discovers that it is English, or rather that English is the essential component of the chemistry of their language; the rest being words of their own creation, or scraps from a dozen other languages which stuck to the people of woe in their two thousand years' peregrination from land to land.

Bercovici, p. 14

If you sit in Bronx Park on a Sunday or walk down Sixth Avenue below Twenty-third Street on almost any evening you will not hear a word of English—but it will be a very New York Yiddish or Italian or German that you will hear.

Ford, *America*, p. 96

You can sip coffee at the Cafe Royal on 12th Street at Second Avenue and listen to the sound of Yiddish.

Hamill, "Lost"

Anyone who listens attentively enough on a Friday morning may hear as he strolls down Washington Street an oratorical flow of rhythmic speech

Irwin, p. 35

Q Sound — Speech

piercing the rumble and chatter of the pavements. It is the reading of the Koran.

Bercovici, pp. 224–5

From Houston to Rivington Street ... fruit is sold in the open air by howling venders to bargaining customers, each one yelling his offer on the top of his voice; quarreling, disputing, cursing, using what is most spicy in the gutters of the street lingo.

Donleavy

Who rose triumphant out of Brooklyn and the Bronx with that ritzy accent.

Mayakovsky, *America*, p. 55

At first I made manic efforts to manage to speak English inside a month. Just as my efforts were beginning to make some headway, the near-at-hand (or even near-at-foot, or to boot) shopkeeper, milkman, laundryman, and even the policeman—they all began speaking to me in Russian.

Lobas, p. 70

It's slang. Instead of "thank you," they say "fuck you."

Blandford, p. 148

In the wintry hush, the babble of the city's languages carries through the clear, biting air—a whisper of English, as often the soft rise and fall of Spanish.

Abbott, "Bowery," p. 220

The windows are opened and all our neighbors can hear us. We often lay there ourselves listening to the desperate fucking, and the curses in English, but in Spanish too, which was the language of that part of the city. For seven hours the deluge is unceasing.

Maffi, p. 108

New Yorkese is the common speech of early nineteenth century Cork, transplanted during the mass immigration of the South Irish a hundred years ago.

McCourt, p. 106

It is not a joke, the great clang of New York. It is the sound of brassy people at the party, at all parties, pimping and doing favors and threatening and making gassy public statements and being modest and blackmailing and having dinner and going on later.

Federal Writers, *Panorama*, p. 153

The emphasized articulation of the so-called "dental consonants"—"d," "ts," "z," "sh," "ch," and "n."

Ibid., p. 284

Popeye, gnarled knight of the clenched fist and the corncob pipe, speaks Tenth Avenue's indigenous tongue. Betty Boop, epitome of short-skirted innocence in the 1920's, scolds her little dog and sings her copyrighted ditties in exaggerated New Yorkese.

Ibid., p. 157

So you say to the waiter, "Gimme the chicken and vegetables but portostat with the chicken with the fustatis on it." So he says "What?" and you say "You know, the portostat, and moonsign the savina on the top, with the vegetables."

Ibid.

"Sure ya got pressed in the third, kid. You done all right, but your trouble is ya fonnastat when you go forward with your left hand. That's a pretty bad fault. All ya have to learn is ya come forward when ya fest 'em up on the referee with the old sedda m'credda."

Liebling, p. 17

"He's after painting two swans on deh kitchen windes. Wan is facin' wan way and d'oder is facin' d'oder way.—So dat is so help me God dis day you'd tink deh swans was floatin' in a garden! And deh garden was floatin' in through deh winda! And dere was no winda!"

"Hey, hoo pie, howza clock on 'at stonecrusher?"
 "It's the ice-breaker; see you on the show-break." Federal Writers, *Panorama*, p. 158

kibitzer, shikse, schnorrer, schlemiel, schmegeggie, nebach, chiker, mazuma, *Ibid.*, p. 153
meshuggah, kishkes, inazzaltov, shaslik

The Dorgans, Conways, Lardners, Winchells, Baers, O'Haras, Kobers, *Ibid.*, p. 155
Durantes and Runyons have given the nation scram, lay an egg, palooka,
belly-laugh, Reno-vate, yes we have no bananas, twenty-three skiddoo,
Alcoholiday, Park Rowgue, wisecrack, applesauce, you said it, hard-boiled,
pushover, click, laugh that off, yes-man, middle-aisling it, socko, step on the
gas, kiss the canvas, throw in the sponge.

New York so worships names that it recites them as free-standing—and thus Conrad, p. 120
inane—spells, which no longer need refer to things.

In the 1926 Manhattan telephone book "Smith" fell to second place behind Peretti, p. 17
"Cohen" as the most common surname.

Liang, Lang, Leong. Seto, Soo-hoo, Szu Tu, Yuan, Goon. Moy, Mei, Mui, Hu, Chin
Woo. Huie, Huey. Choy, Toy. Tom, Hom. Hoo, He. Fung, Feng. Gee, Chee.
Lum, Lin. Chin.

Wellington Koo. Alfred Sze. *Ibid.*

Thalia Stitch, Iancu Posmantir, Albino Ong, Chidilim Onyiagha, Richard Brook, p. 147
Ooms, Siegmund Kiwi, Brian T. Kivlan, Fleurin Eshghi, Ida Ipp, Oy Turoa,
and Babington A. Quame.

Finian, Peyzer, Ladiges, Tahmes, Pinzonas, Freechtermas, Cicarella, Riesenberg and Alland, p. 207
Aboutfour, Zugried, Bodnor, Powder, Vdonin, Firker, Fatseas, Yartin, Peskin,
Frant, Conconeff; Sanfilippo, Schmidt, Smith, Jones, and Brown.

Papito, Papi, Papo, Nene, Pops, Negro, Junior. Courgois, p. 216

Pipe the pushover, he thinks he's a click with his doll because she told him Federal Writers, *Panorama*, p. 155
she'd lohengrin and bear it, but all she wants is a stand-in to pinch hit for the
last heart, who lost all his what-it-takes in an under-the-bridge-at-midnite
payoff.

Somebody Loves Me, Baby Divine, You're in Kentucky fuss Shu' As You're Dos Passos, p. 291
Born, bruised notes of foxtrots go limping out of doors, blues, waltzes (We'd
Danced the Whole Night Through) trail gyrating tinsel memories.

The Rock & Roll for the RR. C for Charlie. The J is Johnny, the M is Mary, N Groce, p. 74
for Nancy. Boy train is the B; A is Apple; E is Echo. Most of the names that
would be hard to distinguish on the radio … N and M would be difficult …
Nancy, Mary … so that's why they do that. A lot over the radio would be very
difficult … And then the number trains are no problem.

In the 1920s, the introduction to polite society of the full spectrum of long- Douglas, p. 54
tabooed profanity such as the "lowdown," the "scoop," the "dope," the "dirt,"
"bunk," "bogus," "baloney," "applesauce," "balls," and "bull[shit]." They
tried to eliminate from their lexicon all the words like "sacred," "sacrifice,"
and "soul" that their Victorian predecessors had disfigured by overuse and
misuse. Slang in the 1920s was the speech of bootlegging criminals and

fast-talking vaudevillians, people who knew how to "fix" everything, from the World Series to bathtub gin.

Ibid., p. 101

Edmund Wilson listed more than a hundred terms for "drunk" in his "Lexicon of Prohibition" (1927): lit, squiffy, oiled, lubricated, owled, edged, jingled, piffed, piped, sloppy, woozy, happy, half-screwed, half-cocked, half-shot, half seas over, fried, stewed, boiled, zozzled, sprung, scrooched, jazzed, jagged, canned, corked, corned, potted, hooted, slopped, tanked, stinko, blind, stiff, under the table, tight, full, wet, high, horseback, liquored, pickled, ginned, shicker (Yiddish), spifflicated, primed, organized, featured, pie-eyed, cock-eyed, wall-eyed, glassy-eyed, bleary-eyed, hoary-eyed, over the Bay, four sheets in the wind, crocked, loaded, leaping, screeching, lathered, plastered, soused, bloated, polluted, saturated, full as a tick, loaded for bear, loaded to the muzzle, loaded to the plimsoll mark, wapsed down, paralyzed, ossified, out like a light, passed out cold, embalmed, buried, blotto, lit up like the sky, lit up like the Commonwealth, lit up like a Christmas tree, lit up like a store window, lit up like a church, fried to the hat, slopped to the ears, stewed to the gills, boiled as an owl, to have a bun on, to have a slant on, to have a skate on, to have a snootful, to have a skinful, to draw a blank, to pull a shut-eye, to pull a Daniel Boone, to have a rubber drink, to have a hangover, to have a head, to have the jumps, to have the shakes, to have the zings, to have the heeby-jeebies, to have the screaming meemies, to have the whoops and jingles, to burn with a low blue flame.

Trager, p. 460

Damon Runyan invented the argot of NY streets, calling money *potatoes*, Lindy's restaurant *Mindy's* and complimentary tickets *Chinee* (because they are punched with holes like Chinese coins).

Douglas, p. 451

"Wauf!" "Pow!" "Wham!" "Socko!" "Glug!" "Zowie!" and "Bam!"

Fitzpatrick, *Parker*, p. 9

The first documented use of the following words, terms, and phrases can be attributed to Dorothy Parker: art moderne, ball of fire (said of a person), with bells on, bellyacher, birdbrain, boy-meets-girl, chocolate bar, daisy chain (in the sexual sense), face-lift, high society, mess around (to potter), nostalgic, one-night stand (in the sexual sense), pain in the neck (said of a person), pass (sexual overture), doesn't have a prayer, queer (gay), scaredy-cat, shoot (expletive), the sky's the limit, to twist someone's arm, what the hell, and wisecrack.

Douglas, p. 357

They wanted "nuthouse" not "madhouse," "drugstore" not "chemist's shop," "radio" not "wireless," "frame" not "put-up job."

Collins, *Money*, p. 291

On the sidewalks of downtown brokers and brokers' clerks are talking strange words and stranger phrases: conscientious objectors, hyphens, camouflage, T.N.T., profiteers, enemy aliens, the bridge of ships, swivel chairs, strafing, gasless Sundays, heatless Mondays, meatless Thursdays, somewhere in France, "Lafayette, we are here!"

Conrad, p. 287

Each precinct has its own idiosyncratic cry, voicing its collective unconsciousness. The Lower East Side gave out a subdued, suffering "Oh-hh, O-h-h. O-h-h," Broadway a shriller "Eeee-eee-eee," Harlem a throaty, ululating "Ooo-oooooo."

Milford, p. 163

So we sat darning socks on Waverly Place and practiced the use of profanity as we stitched. Needle in, shit. Needle out, piss. Needle in, fuck. Needle out, cunt. Until we were easy with the words.

Q Sound — Speech

In the gale of brassbands and trampling horses and rumbling clatter of cannon, shadows like the shadows of claws grasp at the taut flags, the flags are hungry tongues licking twisting curling. Dos Passos, p. 271

Oh it's a long way to Tipperary ... Over there! Over there!

The harbor is packed with zebrastriped skunkstriped piebald steamboats, the Narrows are choked with bullion, they're piling gold sovereigns up to the ceilings in the Subtreasury. Dollars whine on the radio, all the cables tap out dollars.

There's a long long trail awinding ... Over there! Over there!

In the subway their eyes pop as they spell out APOCALYPSE, typhus, cholera, shrapnel, insurrection, death in fire, death in water, death in hunger, death in mud.

Oh it's a long way to Madymosell from Armenteers, over there! The Yanks are coming, the Yanks are coming. Down Fifth Avenue the bands blare for the Liberty Loan drive, for the Red Cross drive. Hospital ships sneak up the harbor and unload furtively at night in old docks in Jersey. Up Fifth Avenue the flags of the seventeen nations are flaring curling in the shrill hungry wind.

O the oak and the ash and the weeping willow tree. And green grows the grass in God's country.

The great flags flap and tug at their lashings on the creaking goldknobbed poles up Fifth Avenue.

Chuck's readiness is proverbial on the Bowery. He is always prepared to say something characteristic and original. One day he was in a philosophic mood, and talked to me disjointedly, over his beer, as follows: Hapgood, pp. 36–9

"A bloke wat ain't go no money can't git a gal, and if he does git her, den it's all up in de air wid de money wat he's got. But dere are some good gals wat a bloke's a junk if he don't treat right. A bloke ain't go no show wid a gal if he ain't goo-lookin', wid good clothes, with a fence around his neck. I ain't handsome, and I ain't rich, so sometimes a bundle will give me a ticket to go across de ferry wid but she'll give me a ticket to go back see. Now, if I was handsome and rich I'd git a ticket to cross de ferry but I wouldn't git no ticket back, see? Anyway, a gal don't make no difference ter me. All coons look alike ter me. Dere's no difference between a gal and a lady except dat de lady has got a fine dress and de gal ain't. De lady has got de boodle, de rocks, see? and de gal ain't, see? Dat's all. Wat's a gent, did yer say? A gent, wat you call a gentleman, is a bloke wat ain't a junk. A gent is a man wat shakes hands wid yer; wat don't wear no fence around his neck, wat don't wear no tall hat, wat don't call yer a bum. When a bloke wat ain't got a nickel asks a junk for a nickel, the junk wat ain't a gent, calls him a bum. You can always tell a junk that way. A junk ain't no gent, that's all, see? A gent is a dammed good man, a good man that ain't looking fer no good advice. A bloke wat takes good advice ain't no gent. I hate a man wat takes good advice. A gent takes no advice, particly no good advice. He's too good a feller, yer know. A chump is a good, good man. A chump is slang for a sucker. If you fetch him a jab in the wizard, he'll grin, feeble like. An' if you tell him you didn't mean it he'll shake yer hand as friendly as yer like. He's a good, good man, a chump is, which is slang for a sucker, but he ain't no gent tho he is a lot better than a junk. A junk is the worst thing there is. A chump is good to yer, but he's mean to himself. He does himself all the harm he does, and that's why he is a sucker. But a junk is a down bad man, real bad, yer know, wid a fence around his neck. Am I married did yer say? I'd like to see the gal wat could hitch up ter me. If I ever do hitch up, she might as well hitch up ter a post. But I booze too much and I may hitch up sometime. It's a wonder I ain't dead. I've done it all, yer know, up all night full of booze and fight, yer know, and dey say that when a bloke

hitches up it's easy to stop the booze. But I'd like to see the girl wat could hitch up ter me. If I ever do hitch up she'll think I am a post sure. I get into a lot of troubles 'cause of other blokes. I ain't had ten fights fer myself in my life. Some bloke'll come up to me'nd say, Chuck, that fellow wants ter fight me and den I fight. See that scar, and dat? and dat? dey's all got fer other fellows, not fer me, but I am tired of it, and I am going to quit. I wonder I ain't dead. Maybe I'll hitch up. I thot I'd have a sloon of my own, but that would not pay, fer all the old blokes would come in and say: Chuck I'm dead broke, gimme a drink, Chuck, and I'd give em a drink of course, but dat don't pay. I'd be in the air every night, right up in the air, yer know. But I am going to get a place right here in this here bar, and I tell you ther'll be lots old blokes wat'll come and when other men are around p'raps they'll pay, but when I am alone then there ain't no use. Be on the level and watch de play. It's a blue day to-day but de play of life goes on. Some blokes—good fellows too—kill demselves when dey get blue. Why? Why not see de next act? I know a bloke wat cut his throat 'cause his wife ran away from him. Dat's all nonsense. He ought to go and cut a figur' and his wife'd would come back, all right, all right. If she didn't it wouldn't cut no ice, but she would, yer know. Wat's the use of being as blue as dis wedder? I'm always happy. Whenever I have de rocks, I'm all right, an' I'm all right when I ain't got 'em. Some odder feller can cut his throat. Dat's all right, but I won't, Chuck Connors won't. I want ter see de next act. I want ter see de play out. I'm me own friend bloke, me best friend, and it's only an easy mark wot'd cut his throat or give a rip wat happens so long as de play goes on."

290

When I'm walking around New York I'm always aware of the smells around me: the rubber mats in office buildings; upholstered seats in movie theaters; pizza; Orange Julius; espresso-garlic-oregano; burgers; dry cotton tee-shirts; neighborhood grocery stores; chic grocery stores; the hot dogs and sauerkraut carts; hardware store smell; stationery store smell; souvlaki; the leather and rugs at Dunhill, Mark Cross, Gucci; the Moroccan-tanned leather on the street-racks; new magazines, back-issue magazines; typewriter stores; Chinese import stores (the mildew from the freighter); India import stores; Japanese import stores; record stores; health food stores; soda-fountain drugstores; cut-rate drugstores; barber shops; beauty parlors; delicatessens; lumber yards; the wood chairs and tables in the N.Y. Public Library; the donuts, pretzels, gum, and grape soda in the subways; kitchen appliance departments; photo labs; shoe stores; bicycle stores; the paper and printing inks in Scribner's, Brentano's, Doubleday's, Rizzoli, Marboro, Bookmasters, Barnes & Noble; shoe-shine stands; grease-batter; hair pomade; the good cheap candy smell in the front of Woolworth's and the dry-goods smell in the back; the horses by the Plaza Hotel; bus and truck exhaust; architects' blueprints; cumin, fenugreek, soy sauce, cinnamon; fried platanos; the train tracks in Grand Central Station; the banana smell of dry cleaners; exhausts from apartment house laundry rooms; East Side bars (creams); West Side bars (sweat); newspaper stands; record stores; fruit stands in all the different seasons—strawberry, watermelon, plum, peach, kiwi, cherry, Concord grape, tangerine, murcot, pineapple, apple—and I love the way the smell of each fruit gets into the rough wood of the crates and into the tissue-paper wrappings.

Warhol, *Philosophy*, pp. 152–4

I usually know what city I am in by the odors. There are as many smells as there are philosophies. I have never had time to gather and classify my olfactory impressions of different cities, but it would be an interesting subject. I find it quite natural to think of places by their characteristic smells.

Keller, pp. 296–7

The night is scented with the odor of decaying foliage: it reeks of ambergris, menthol, powder, rouge, and the neoprene smell of slickers and galoshes.

Carco, p. 220

Its aliveness is certified by the hearty and versatile stench it exudes, an olfactory cloud of hot asphalt, underground caverns, gasoline, patchouli, orange peel, sewer gas, Albany grabs, Egyptian cigarettes, mortar and the undried ink on newspapers drifts across Gramercy Park: the city's body odor.

Conrad, p. 90

For years it reeked with trapped breaths, the fuming of paper-box scrap fillers, trade-marked cigarettes, blended bottle alcohol, and the fry smell of half-done hot dogs grilled at the downstairs lunch counter. A certain rectification was achieved by bubbling coffee urns, adding a Brooklyn aroma while humidifying the winter cold with jets of steam.

Riesenberg and Alland, p. 103

The faint odor of horse-dung, so prevailing in the nineties, has of course been supplanted by the aroma of gas. The other odors of New York depend upon the locale and the seasons: in the summer, the smell of hot asphalt, a distinct smell of chop suey and occasionally even of cooking opium on Broadway and the adjacent streets; in the winter, the aroma of roasting chestnuts; in the theaters, the churches, and the restaurants the mingled odors of Guerlain, Houbigant, Hudnut, and stale tobacco.

Van Vechten, pp. 141–2

R Smell

Conrad, p. 199 Coney Island's greasy air with its confusion of artificial and natural odors: the fishy, salty smell of the sea; the aroma of cooking-oil, steaming clams, sausages, frying pork.

Mortimer and Lait, p. 141 The air, despite the good zestful salt sea breeze, reeks with the acrid smoke of potato knishes, garlic and frying frankfurters.

Gopnik, p. 28 The essential New York smell twenty years ago was still Italian and WASP: tomato and olive oil and oregano, acid and pungent, mingled with the indoor, Bloomingdale's smell of sweet perfumes. Now, inside the giant boxes that have arrived from America, from the malls (the Gap and Banana Republic and Staples), there is a new, clean pharmacy smell, a disconcerting absence of smells, the American non-smell.

Berger, *Eight Million*, pp. 205–7 Spice odors came downwind two blocks from the spice mills in the weathered brick plant on Franklin Street. The closer you trod the sharper the odors seemed. The inner brick walls, once white, were a melancholy yellow and coated with fine spice dust, mostly brown and red, something like brick dust.

Mr. Weyer said, "That yellow you see is from volatile spice oils. It has settled on the walls through the years. It's on everything; all six floors."

My sense of smell became, in a manner of speaking, somewhat hysterical. It struggled frantically to identify individual pungent odors but made no headway. Mr. Weyer peered down the length of the gloomy loft as if he could *see* the odors. His nose wiggled like a rabbit's over a carrot.

"Can't say for sure," he said. "But I'd guess what we're getting right here is mostly caraway. Some kummel, maybe."

He felt his surefooted way between high mounds of enshadowed bales and bags of spices. The place was ill-lighted and spice dust hung in the half-light like red fog. We clumped along the rough wooden flooring, past silent gnomish men who toiled at fragrant bales. Their faces seemed inordinately grave, had the rust-and-yellow tint of the walls.

Mr. Weyer stepped into another cavernous loft, darker than the one below. Gyrators throbbed and pulsed in the shadows, grinding and sifting red pepper, cayenne, cloves, caraway, cardamom, mace. These ponderous devices, distorted in the weak dust-infiltrated light, ground the crude stuff and dropped it through fine silk mesh. Cloth bags at the bottom bulged and breathed as the spices blew through.

He brought out African ginger, Granada mace, allspice from Jamaica, red pepper from Japan, coriander from Morocco, curry from India, cloves from Madagascar, cardamom from the Malay archipelago. My eyes smarted and I looked wistfully at the clean air beyond the dusty windows.

On the mill floor, below, leather belting slapped at great iron wheels lost in deep upper gloom. Great galvanized pipes and middle-sized pipes ran through the flooring, carrying off milled nutmeg, cayenne. A dusty-red miller patiently scooped crushed nutmeg from a mound on the floor and fed it into a hopper.

Strunsky, p. 699 Walk out of the crush of Gansevoort Market and Greenwich Street and Hudson Street, a good mile and a half south through silent warehouses all crammed with food, a solid square mile of provender. The contents of these grim weather-beaten storehouses are open to appraisal by the mere sense of smell as you pass through successive strata of coffee and sugar and tea and spices and green vegetables and fruits … Discern where the pepper merges into the cloves, and the heavy odor of banana into the acid aroma of the citrus.

R Smell — Food

As we walked down Greenwich Avenue we stopped to enjoy the smell of hot bread outside of Cushman's bakery.

Cowley, p. 49

de Kooning could not stand the smell of fresh bread constantly wafting upward from a bakery just beneath him in his loft.

Stevens and Swan, p. 119

On Bleecker Street you catch the scent of the Italian bakery.

McInerney, *Bright Lights*, p. 9

As you turn, what is left of your olfactory equipment sends a message to your brain: fresh bread. Somewhere they are baking bread. You can smell it, even through the nose-bleed. You see bakery trucks loading in front of a building on the next block. You watch as bags of rolls are carried out onto the loading dock by a man with tattooed forearms. This man is already at work so that normal people can have fresh bread for their morning tables … As you approach, the smell of bread washes over you like a gentle rain. You inhale deeply, filling your lungs. Tears come to your eyes, and you feel such a rush of tenderness and pity that you stop beside a lamppost and hang on for support.

Ibid., p. 180

The warm smell of the bakery on the corner of Eighth Street, a blessed repository of doughnuts, cookies, cream-cakes and pies, the slow passing by which, on returns from school, must have had much in common with the experience of the shipmen of old who came, in long voyages, while they tacked and hung back, upon those belts of ocean that are haunted with the balm and spice of tropic islands.

James, p. 91

At her feet a squirming heap of small boys, dirty torn shirts, slobbering mouths, punching, biting, scratching; a squalid smell like moldy bread comes from them.

Dos Passos, pp. 240–1

Near Eighth Avenue, before Fortieth Street. The smell of garlic and tomato sauce warns the passer-by that the inhabitants are from Piedmonte, but on the street one hears the Irish brogue. The bales of cotton in front of the warehouses and the smoke from the chimneys reek after Liverpool, but the smell of rope, tar and fried smelts that comes from the wharves near by remind one of Fiume and Marseille, as the swaying masts and the spread-out sails outline themselves against the glowing sky.

Bercovici, pp. 209–10

The aroma of oregano, tomato, and garlic filled the elevator.

Tucker, p. 140

The smell of garlic in the rear of a Mulberry Street church.

Talese, p. 24

The hot air is tinged by garlic, by the offensive breath of cigarettes.

Riesenberg and Alland, p. 67

Cheese shops give Fulton Street its racy aroma; second office furniture fills in between the gorgonzola.

Ibid., p. 18

Close your eyes, take a deep breath. You are on the west side of the street, in the Forties. A smell of rich fried chicken assaults your nose.

Ibid., p. 30

acrid pungence spreads from a picklestand

Dos Passos, pp. 240–1

The steam escapes through the little copper pipe on the peanut roaster, making a cheerful sound, and the hot peanuts smell good.

Mitchell, *Ears*, p. 196

Beaton on Roseland: "the smell of double-mint gum permeates the atmosphere of this monstrous paradise of black, orange and pink."

Caldwell, p. 264

Kinkead, *Chinatown*, p. 3 The crooked streets of one of New York's oldest ghettos smell of salt and fish and orange peel … Ice water dripped from the profusion of produce, and among the gagging smells rising from the sidewalk and the gutters, where the food was cleaned, was a whiff of orange peel.

Bercovici, p. 174 The odor of cooked cabbage and burned fats dissolves into the stronger odors of the oiled high boots and the numerous Russian steam baths of the district. Ah, these steam baths! From the looks of them and the smell, one comes to think of them more as sewers than baths.

Neighborhood

Barnes, p. 225 Why has Washington Square a meaning, a fragrance, so to speak, while Washington Heights has none?

Riesenberg and Alland, p. 180 Third Avenue is easily identified by its smells—malt and hops in the Nineties, burning rubber in the Fifties, and ripe hides, when the wind blows from the east, under Brooklyn Bridge.

Keller, pp. 296–7 Fifth Avenue, for example, has a different odor from any other part of New York or elsewhere. Indeed, it is a very odorous street. It may sound like a joke to say that it has an aristocratic smell; but it has, nevertheless. As I walk along its even pavements, I recognize expensive perfumes, powders, creams, choice flowers, and pleasant exhalations from the houses. In the residential section I smell delicate food, silken draperies, and rich tapestries. Sometimes when a door opens as I pass, I know what kind of cosmetics the occupants of the house use. I know if there is an open fire, if they burn wood or soft cola, if they roast their coffee, if they use candles, if the house has been shut up for a long time, if it has been painted or newly decorated, and if the cleaners are at work in it.

McKay, *Home*, p. 30 the tenacious odors of service and the warm indigenous smells of Harlem

Buford, p. 185 There was also a smell: a dampness, a kind of rotting fecundity. And the stream was very loud: this was the sound of nature, true, but it was all a bit too incongruous. Olmsted or not, I knew I was in Harlem.

Nature

Talese, p. 98 John Muhlhan sniffs hay by the hour, and he is believed to be one of the nation's top connoisseurs of hay for horses. The odd thing is that he has been selling hay in the heart of Forty-second Street for forty-five years.

Kasson, p. 49 We must try to imagine the smells of circus animals.

Haden, pp. 57–8 The smell of a dead old horse in the night air was said to be appalling.

Irwin, p. 322 The smell of raw furs permeating Seventh Avenue and Thirtieth Street.

Riesenberg and Alland, p. 18 Salted hides smell under the damp approachment arches of Brooklyn Bridge.

Caro, p. 557 And in the summer, when it was too hot to keep windows closed, uncovered tracks meant not only noise but odors, the stench of the animals.

Outside the air smells of crowds, is full of noise and sunlight.

Dos Passos, p. 17

It smells of the sun.

Lichtenstein, p. 513

If you want to quit the world for a moment, head east on Sixth Street and pass through a gate between avenues B and C. First stand at the threshold and take a breath. The smell—what some people think of as the sweet, fresh-scented essence of summer—is honeysuckle, of course. Its slightly druggy aroma drifts down from a big, bosomy vine that partly conceals a hideous chain-link fence. Covering the vine itself are tiny butter-yellow flowers that look like trumpets with flicking tongues. There are good street smells in New York (and even more foul ones) but few smells that have the power to take you away from where you are.

Trebay, p. 214

Snow

When the city air smelled of snow.

Cheever, "Country," p. 147

Dry snow has that heavenly smell that comes of purity, like the smell of a healthy well-washed baby.

Riesenberg and Alland, p. 185

In the rotunda, where the people appeared as small and intent as ants, the smell and sense of snow still lingered.

Ibid.

Perfume

The flask of perfume which brings Fifth Avenue to a hacienda in the Argentine.

Federal Writers, *Panorama*, p. 3

I could smell lilac and garbage and expensive perfume.

Didion, "Goodbye," p. 170

For a lot of the time I was in New York I used a perfume called *Fleurs de Rocaille*, and then *L'air du Temps*, and now the slightest trace of either can short-circuit my connections for the rest of the day. Nor can I smell Henri Bendel jasmine soap without falling back into the past, or the particular mixture of spices used for boiling crabs. There were barrels of crab boil in a Czech place in the Eighties where I once shopped. Smells, of course, are notorious memory stimuli.

Ibid., p. 173

I noticed the aroma and sheen of very rich women, or women with very rich husbands or lovers.

Brook, p. 253

At 9 A.M. the bus is filled with secretaries and receptionists and the smell of perfume.

Talese, p. 32

Drugs

Sharp whiffs of marijuana hit the nose.

Brook, 165

The smell hit me first: dampness, the sharp whiff of amyl nitrate, and the equally pungent aroma of piss.

Ibid., pp. 162–8

The place smelled of the usual telltale mix of Crisco, poppers, and smoke.

Fritscher, p. 36

Braunstein " … the smell of poppers and the sweat off a stranger's body."

Hell, p. 26 Spring had a smell to it too, even in New York. It smelled like just-cooked heroin. It was the exhaust fumes mixed with the wet air that still carried subtle hinted promises of voyage and growth. Sea air and foliage.

Industrial

Dreiser, p. 3 The very gasoline contributes a distinct perfume.

de Amat, p. 404 Its parks smelled like warm bitumen and gasoline

Maxwell, p. 5 He raised his head and sniffed, hoping for a breath of the sea, and smelled gasoline fumes instead.

Dos Passos, p. 158 Trucks grated by along the avenue raising a dust that smelled of gasoline and trampled horsedung. The dead air stank of stores and lunchrooms. He began walking slowly uptown towards Fourteenth Street. At a corner a crinkly warm smell of cigars stopped him like a hand on his shoulder.

Caldwell, p. 2 The acrid fumes of diesel combustion, the flash of wheel sparks, and the chemical-industrial reek of brakes follow the commuter trains out into the suburbs. The later the hour the swanker the passengers: the loud workers peak at four or five, to be followed by the sweet-voiced bourgeois at six, seven, and eight.

Beauduin, p. 284 symphony of electric aromas

Riesenberg and Alland, p. 93 The sneering city curls brown smoke from its chimney censers; the bitter incense carries a faint odor as of burning sacrificial flesh.

Kerouac, *Lonesome*, p. 106 Smells of Moody street exhaust river lunch in road of grime.

Jackson and Dunbar, p. 566 The life of subways, of rebreathed air, of the smell of burnt steel.

Bellow, "Father," p. 26 The stony, odorous, metallic, captive air of the subway.

Stink, Sweat, Garbage

Dos Passos, p. 51 He crossed Sixth Avenue and followed the street into the dingy West Side, where there was a smell of stables and the sidewalks were littered with scraps of garbage and crawling children.

Ashbery, p. 133 A scent of garbage, patchouli and carbon monoxide drifts across it, making it the lovely, corrupt, wholesome place New York is.

Conrad, p. 320 Oldenburg's design for an electric fan for Staten Island to dwarf the Statue of Liberty and disperse the city's odors, and to cope with more solid wastage, a vacuum cleaner for the Battery.

Ibid., p. 93 The possibility of smelling the humid city's odors of human life and sweat.

Ibid., p. 52 He smelled of tobacco and sweat.

R Smell — Industrial

Summertime, all ya can smell is the garbage. Stink overpowers everything, especially soft sweet smells like flowers. Lee and Jones, p. 57

You just don't know how I love it—how I get up every morning and want to kiss the pavement … Hollywood smells like a laundry. The beautiful vegetables taste as if they were raised in trunks, and at those wonderful supermarkets you find that the vegetables are all wax. The flowers out there smell like dirty, old dollar bills. Fitzpatrick, *Parker*, pp. 109–10

So the first time I went to CBGB's, the whole place stunk of urine. The whole place smelled like a bathroom. McNeil and McCain, p. 201

I'd sniff deep and see the *cuchifritos* and hot dogs, stale sweat and dried urine. I'd smell the worn-out mothers with six or seven kids, and the non-patient fathers beating the hell out of them. My nose would get a high-pitch tingling from the gritting wailing and bouncing red light of a squad car passing the scene like a bat out of Harlem, going to cool some trouble, or maybe cause some. Thomas, *Streets*, p. 106

Given the heat, people smelled, of course, but some smelled a lot worse than others. Miller, "Air Conditioning"

Something all a piece of dirty rags and stench picked up in the street. McKay, *Home*, p. 59

The city that Sunday morning was quiet and those trapped there gasped in foul humid air that smelled and felt like water in which too many soda-water glasses had been washed. Conrad, p. 291

Water

Beyond the Battery, which is the prow of Manhattan, lies the waterfront with its smells of salt, tar, rope, seaweed and decaying fish. Beaton, *New York*, p. 128

The smell of the ozone, the ghostly wails of old boats passing down the Island, and the opalescent skies. *Ibid.*, p. 250

The smell of the salt air in the rotting planks floating on the green scummy waters of the Hudson. Jackson and Dunbar, p. 678

The watery floor of the Aquarium that smelled of the eternally wet skins of the seals in the great tank. *Ibid.*

The rancid smell of the wet gutters and pavings. Cheever, "Five-Forty-Eight," p. 4

The rancid smell of the wet dusk outside. *Ibid.*, p. 5

Now on summer nights the smell of the city sometimes drifts northward on the waters of the Hudson River, up to the wooded, inland banks where we live. The odor is like the stales from some enormous laundry, although I expect that an incurable evacuee could detect in it Arpége, stone-cold gin, and might perhaps even imagine that he heard music on the water; but this is not for me. Cheever, "Moving," p. 981

Hudson's report to his employers must have been an unfavorable one, at least on the practical side, which was the side in which they were interested. They hadn't sent him across the ocean to find out how Staten Island smelled. Collins, *Money*, p. 10

Williams and Noël, p. 149 — He ushered me into his West Broadway apartment. It was a steamy, New York summer day, but the apartment was cool. It smelled like straw mats.

WPA Guide, p. 51 — In courtyards smelling of backhouses.

Wojnarowicz, p. 43 — We went up to the hotel on 44th Street or 45th up the rank rickety swaying leaning staircase paid seven dollars for a room and opened the windows to let the musty smell out.

Ibid., p. 111 — the smell of the four cats in this apartment

Morris, *Manhattan '45*, p. 240 — There are still books I bought more than thirty years ago which can still, by a single sniff of their pages, transport me instantly over the ocean to New York. Books don't smell like that any more.

Sanders, *Beatnik*, p. 5 — And the Fourth Avenue bookstores! How many hundreds of afternoons they spent in the twenty or so dusty stores with the worn wood floors; noses whiffing that excellent store-air, a mixture of dust and floating minutiae of antique leather bindings and frayed linen.

Oldenburg's New York is an indulged infant, gobbling a diet of fast food. He plans to set up at Times Square an overripe, wilting banana, and on Ellis Island a colossal frankfurter with a tomato on top, impaled by a toothpick. A supplementary island of pizza will bob in the bay; the blades of the fan that unseats the Statue of Liberty are made by unpeeling and softly mechanizing the Times Square banana. If the monuments themselves can't be ingested, Oldenburg locates restaurants inside them. Visitors would alight from helicopters on top of the East Side ironing board and eat in a cabin hanging beneath it. He allows his structures to boast of the ravages of appetite. A bite has already been chewed from the Good Humor bar on Park Avenue; through the gap, cars could be driven. The city's catastrophes are to Oldenburg soft tragedies, like the fate of our provender inside us.

Conrad, p. 140

As Dalí sees it, the surreal nature of New York is evinced by its maggoty carnality: uncooked meat and cheese.

Ibid., p. 145

When Dalí wakes up in the Hotel St. Moritz, the city confirms the bloodthirstiness he has excited in it by the temptation of meat, for the first thing he hears is the roar of hungry lions in the Central Park zoo.

Ibid., p. 146

When Dalí sees the skyline from his boat, he likens it to an immense Gothic Roquefort cheese, adding, "I love Roquefort."

Ibid.

Dalí perverts New York, dressing one of its skyscrapers in kinky furs and setting a gargantuan lamb chop on its pinnacle.

Ibid., p. 149

New York as candy or confectionery: a building on West 58th Street as one slice in a long white cake of apartment-houses.

Ibid., p. 201

New York seen from the Queensboro Bridge rises in white heaps and sugar lumps all built with a wish out of non-olfactory money. Money is smelly, guilty refuse. Amassing it not in cloacal hoards but in an arrangement of sugar lumps sanitizes it, for sugar symbolizes a romantic inutility.

Ibid.

The New York skyline first deodorizes wealth, then makes it sweetly edible.

Ibid., p. 202

The lemon-yellow shades of the lamps on Fifth Avenue give the street and everybody the color of champagne in the evening.

Ibid.

The Belly of New York

Every day in New York, they slaughter
four million ducks,
five million hogs,
two thousand pigeons to accommodate the tastes of the dying,
one million cows,
one million lambs,
and two million roosters
that smash the sky to pieces.

Lorca, "Office," p. 11

Fried sleeve buttons; a plate of summertime; a band of music with the leader; soaked buns; stack of browns; slaughter in the pan; drop one on the brown;

Grimes, p. 117

eggs in the dark; white wings, with the sunny side up; two shipwrecked; a sheeny funeral with two on horseback; hot and viscid sinkers.

Ibid., p. 118

walking lunchrooms

Gopnik, pp. 75–6

Luke, hostage to Parisian food, cannot believe the range of cheap takeout, the empire of menus. You press a button, and all the world's spices come obsequiously to your door: Indian food, Chinese food; the baby loves chicken in pancakes, the boy loves steak fajitas, and without saying so, I see that he likes the sweetness of New York food, the way that, as I had forgotten, Americans put sugar in everything, in ketchup and mustard and cereal and bread. The incidental sweetness of American life is, to an unaccustomed palate like his, overwhelming and quickly addictive.

Ibid., pp. 7–8

I can't walk into a housewares store in Manhattan without feeling myself the victim of a complicated confidence trick, a kind of cynical come-on. We're really going to use a toaster and a coffee-maker every morning?

Dos Passos, p. 314

"Egg sandwich, coffee and doughnuts." "Cup of boullion." "Chicken broth." "Chocolate icecream soda." People eat hurriedly without looking at each other, with their eyes on their plates, in their cups. Behind the people sitting on stools those waiting nudge nearer. Some eat standing up. Some turn their backs on the counter and eat looking out through the glass partition and the sign HCNUL ENIL NEERG at the jostling crowds filing in and out the subway through the drabgreen gloom.

Ibid., p. 200

A blast of grey heat hit their faces. They passed the stationary store, the red A. and P., the corner drugstore from which a stale coolness of sodawater and icecream freezers drifted out under the green awning, crossed the street, where their feet sank into the sticky melting asphalt, and stopped at the Sagamore Cafeteria. It was twelve exactly by the clock in the window that had round its face in old English lettering, TIME TO EAT. Under it was a large rusty fern and a card announcing Chicken Dinner $1.25.

Bockris, *Warhol*, pp. 144–5

The next morning Andy told Julia to buy one of each of the thirty-two varieties of Campbell's soup at the local A & P and he started to work on his idea. First he did a series of drawings. Then he made color slides of each can, projected them on to a screen and began experimenting with different dimensions and combinations … Finally he hit upon his format for the soup cans. A lot of pop artists used supermarket food images in their work but they crammed their pictures with them. Andy decided to do one portrait of each of the thirty-two cans as exactly as possible alone against a white background … "He made us feel that even in the simplest of commodities and the most commonplace of subjects there was a great deal of poetry and meaning … "

Williams and Noël, p. 187

In 1962 you could live in New York on a $5-a-week food budget. He bought from the discount shelves in the supermarket all the canned foods without labels. At that time labels were printed on paper and wrapped around the items. When those papers got ripped off, the cans came up on the bargain counter and people, poor people, used to buy them as a kind of blind date.

Trager, p. 626

Häagen-Dazs Ice Cream is introduced by Polish-born Bronx entrepreneur Reuben Mattus, 47, who since age 17 has been peddling his family's homemade ice cream to small candy stores and neighborhood restaurants, initially with a horse and wagon. Finding that most commercial ice cream

has become cheaper, he puts more butterfat in his product than government standards require, uses less air filler, comes up with a Danish-sounding name (even though the umlaut does not exist in Danish), packs the ice cream in cartons adorned with maps of Scandinavia, creates a new category that will be called super-premium ice cream, and begins what will become a multimillion-dollar company.

Mattus invented the "Danish-sounding" "Häagen-Dazs" as a tribute to Denmark's exemplary treatment of its Jews during the Second World War, and included an outline map of Denmark on early labels. The name, however, is not Danish, which has neither an umlaut nor a digraph zs, nor does it have any meaning in any language or etymology before its creation. Mattus felt that Denmark was known for its dairy products and had a positive image in the U.S. His daughter Doris Hurley reported … that her father sat at the kitchen table for hours saying nonsensical words until he came up with a combination he liked. The reason he chose this method was so that the name would be unique and original.

"Häagen-Dazs"

Business girls who bought their food in the ubiquitous delicatessen stores and prepared it on electric plates concealed on closet shelves.

Morris, *Incredible*, p. 299

The silk-skirt factory girls who came to eat their lunch in Washington Square.

Cather, p. 17

Big theatrical men with their mistresses, both shaped like well-stuffed ottomans, are eating sandwiches at sandwich places.

Wilson, "Leaving New York," p. 123

For the men who labor in the night, primarily for the city's breakfast, must themselves be fed. Clustered around the markets and around the railway-junctions and car-barns or the popular and brilliantly illuminated Delmonico's of the industrial underworld. What places of warm cheer they are, on a winter night, these long rows of Lunches, whose names are a perpetual lesson in the national geography! They all have tiled floors and white walls and spacious arm-chairs … a sirloin steak selling for twenty cents, with bread, butter and coffee, at three in the morning.

Strunsky, p. 702

A whole section of Elizabeth Street is given up to the sale of stale fish at ten and fifteen cents a pound, and the crowd of Italians, Jews and Bohemians who are taking advantage of these modest prices is swarming over the sidewalk and into the gutters. A four- or five-pound fish at fifteen cents a pound will make an excellent Christmas dinner for four, five or six. A thin, ice-packed and chemically-preserved chicken at fifteen or twenty cents a pound will do as much for another family. Onions, garlic, old cast-off preserves, pickles and condiments that the wholesale houses uptown have seen grow stale and musty on their shelves, can be had here for five, ten and fifteen cents a bottle, and although the combination is unwholesome it will be worked over as Christmas dinners for the morrow. Cheap, unsalable, stale, adulterated—these are the words that should be stamped on every bottle, basket and barrel that is here being scrambled over. And yet the purchasers would not be benefited any thereby. They must buy what they can afford. What they can afford is this.

Dreiser, p. 277

The old men, the ones who have been doing it for years, are too resigned to boast about the wizened bits of meat they sell, too tired to move fast and, anyway, couldn't—hampered as they are by the thick, heavy coats they wear no matter how hot the day.

Blandford, p. 29

Gopnik, p. 168

After years of Paris markets, with their abundance and bad faith, I confess that I found the pickings at the Union Square green market on a spring morning a little scrappy.

Ford, *America*, p. 150

Take celery. It is monstrous to eat blanched celery with olives as an *hors d'oeuvre*. For God surely meant celery to be eaten along with Stilton cheese at the end of a full meal, just before the port ... Yet in New York—*horresco referens*—blanched celery is continually eaten as I have described. I may add that in Paris the idea of eating celery raw at all causes a shudder to run down the French spine.

Ellis, *Epic*, p. 460

In the winter of 1900 Bernarr MacFadden opened a restaurant, at 487 Pearl Street, where most items sold for one cent.

Ibid., p. 474

Perplexed by the diversity of dietary habits and helpless in the face of grafting food contractors, Ellis Island staff members often fed the immigrants little more than prunes and bread. One employee brought out a big pail filled with prunes. Another walked into the mess hall carrying sliced loaves of rye bread. A third plunged a dipper into the pail, slopped prunes onto a big slice of bread, and cried to the bewildered immigrants, "Here! Now go and eat!"

Huxtable, *Goodbye*, p. 116

The area was "redolent" of old New York, and equally redolent of garlic and pearly onions, and gleaming with the fresh color of avocados, tomatoes and eggplants. It was filled with the bustle of early dawn activity for a city still stonily asleep. Hopelessly nonfunctional for the 20th century and, we assume, now happily transferred to safe, sanitary and totally sterile in every sense of the word new accommodations in the Bronx, the old market had Hogarthian energy and Georgian style.

Beaton, *Portrait*, p. 44

The Automat has a clinical cleanliness—the tables are washed continuously, even the slot through which the nickels pass are polished many times a day. Around the marble wall are rows of dishes, an infinite variety of food, each a still-life framed in chromium.

Grimes, p. 193

Around Times Square, and across from Bryant Park, the Horn & Hardart Automats, free from supervision, developed into prime cruising grounds for gay New Yorkers.

Mayakovsky, *America*, p. 50

The thirty-five-a-week lot go to a huge mechanized eating point. Having shoved in their five cents, they press a knob and an exactly measured quantity of coffee splashes out into a cup. And for another two or three nickels they can open one of the little glass doors to the sandwiches on the huge shelves piled with comestibles.

Kerouac, *Lonesome*, p. 110

"Let's go down to the Automat."
 "Just a minute, I've got to shine my shoes on top of a fire hydrant."

Ibid.

Shall we go down by the Automat and watch the old ladies eating beans, or the deaf-mutes that stand in front of the window there and you watch 'em and try to figure the invisible language as it flees across the window from face to face and finger to finger ... ?

Riesenberg and Alland, p. 153

We hear a warlike clash of ten thousand heavy dishes storming washing machines in the energetic Automat.

But of first importance to the American is the cleanliness of his food. Sugar is hermetically sealed, biscuits are done up in cellophane, sandwiches wrapped in greaseproof paper. The waiters at Childs look like dentists or operating surgeons in their white overalls.

Beaton, *Portrait*, p. 41

Around the small cafés, single men start getting their body machinery into gear, cramming the first fuel of the day into their mouths—a hurried cup of rotten coffee and a baked bagel, which right here, in samples running to hundreds, the bagel-making machine is slinging into a cauldron of boiling and spitting fat.

Mayakovsky, *America*, p. 47

In the summer a stand is a breakaway soft drink place; in the winter it is a nuttery.

Walker, *Night Club*, p. 203

More than eight hundred hospital patients in New York City had been without sugar for a week.

Ibid., p. 23

Bodegas sold mysterious little bags of dime-sized cookies decorated with pastel florets of frosting. The bags cost a quarter, and every time I went to a birthday party I would buy one and tape it to my present. As far as I know, nobody ever ate even one, and no wonder: while they looked soft, they had all the resilience of marble.

Sante, "Commerce," p. 108

Day and night the cash registers ring, frankfurters twirl over hot rollers, orangeade gushes forth into glasses and the air is filled with sizzling pork and tangling tension.

Talese, p. 95

men are wiping off the marble counters of softdrink stands

Dos Passos, pp. 240–1

It's been estimated that if a customer smoked a cigarette in Nedick's on Thirty-fourth, the store would lose about $2 in turnover. Nedick's is believed to pay $95,000 rent annually for the tiny corner stand and, with its salaries and other expenses, it must sell thousands of hot dogs and orange drinks each day to break even. All this food is pushed over a 61-foot-long counter, and only thirty-two customers can be crushed against it at one time. Behind the counter, Nedick's twenty-six employees sidestep each other, collect coins, flip hamburgers, jab hot dogs, and pour orange drink into coolers. The famous drink is 20 percent orange juice mixed with water, lemon and sugar.

Talese, pp. 95–6

A tally of the millions of eggs cracked each morning, of the thousands upon thousands of gallons of hot coffee drawn.

Riesenberg and Alland, p. 30

Ten million stomachs eat 15 percent of the national production of perishable food commodities.

Ibid.

As they do little physical labor, the result is stimulated glands or overdeveloped midsections and jowls.

Ibid.

This street of large signs and large portions, feeds its fortunates to the point of bursting.

Ibid.

Skinless franks, smeared with canary-yellow chemical mustard, pinched in last week's fresh-laid rolls, are doing a moderate forenoon business.

Ibid., p. 142

Dry ice is being shuffled into milkless jumbo malted-milk containers.

Ibid.

Ibid., p. 153	A noontime mob refuels in a double-decked commercial cafeteria.
Donleavy	Then go to the Sixth Avenue Delicatessen. Order a hot pastrami on rye, use plenty of mustard, a dish of coleslaw, a bottle of beer.
Kerouac, *Lonesome*, p. 105	Like Dublin at 4:30 P.M. when the work is done, but this is great New York Third Avenue, free lunch.
Kasson, p. 49	… the taste of hot dogs, beer, and seafood …
Capote, p. 52	Hamburg Heaven was empty. Nevertheless, he took a seat right beside me at the long counter … He ordered a cup of coffee, but when it came he didn't touch it. Instead, he chewed on a toothpick and studied me in the wall mirror facing us.
O'Hara, p. 258	I stop for a cheeseburger at JULIET'S CORNER. Giulietta Masina, wife of Federico Fellini, *è bell' attrice*. And chocolate malted. A lady in foxes on such a day puts her poodle in a cab.
Quan, p. 97	I'm just going out to Sarabeth's Kitchen to pick up some more fucking scones, dear.
Blandford, p. 120	The croissant is Manhattan's national dish.
Capote, p. 44	The rest of the afternoon we were east and west worming out of reluctant grocers cans of peanut butter, a wartime scarcity; dark came before we'd rounded up a half-dozen jars, the last at a delicatessen on Third Avenue. It was near the antique shop with the palace of a bird cage in its window, so I took her there to see it, and she enjoyed the point, its fantasy: "But still, it's a cage."
McInerney, *Bright Lights*, p. 134	You pass Ottomanelli's Meats, where the corpses of small animals hang in the window: unskinned rabbits, hairless fetal pigs, plucked fowl with yellow feet.
Ibid., p. 135	Why are all the vegetables in the city sold by Koreans?
Donleavy	Passing a vegetable shop, green peppers, bulging red and yellow tomatoes, purple eggplants and fruits stacked out on the pavement. Buy myself an apple. With one nickel. Make a phone call with another.

S Food — Dining

Dining

Grimes, p. 146	Murray's, the city's first theme restaurant. Located on Forty-second Street, its exterior was modeled on the residence of the Cardinal de Rohan in Paris. Electric stars twinkled in the ceiling, while underneath the tables electric lights radiated a romantic pink glow. Extensive use of mirrors compounded the sense of dislocation—gaping patrons often walked straight into their own reflections. Not just a restaurant but a portal to another world … The menu included a porcelain dolphin stuffed with flambéed crabmeat, oysters, and lobster, planked lamb a la Ramses II, and American Beauty roses stuffed with cheese covered in mayonnaise dressing. The centerpiece of the dining room table was a scale model of Peking's imperial gardens, with a miniature railroad that delivered dishes to each place setting.

The Waldorf Hotel was the first dining room where old New York wealth dined on public display. *Ibid.*, p. 147

Healy's opened a beefsteak dungeon. *Ibid.*, p. 151

Rooftop gardens swelter during the summer. One trick was to heat the elevator so that sweltering guests stepping out on the roof, felt the blessed relief of cooler air. *Ibid.*, p. 156

At the Paradise Roof atop the Republic Theater on Forty-second Street, Oscar Hammerstein created a mock country village, with a windmill, a ruined castle, bridges, boats, and stone houses to complement an open-air farm where swains and milkmaids tended live animals. Fitted with colored electric lights, his spinning windmill threw vibrant colors onto the night sky. *Ibid.*

On the Waldorf-Astoria roof-garden, the management installed a giant Victrola. As Caruso recordings played, a twenty-five-piece orchestra provided the accompaniment, creating the illusion of a live operatic performance. *Ibid.*, p. 172

The itchy palm of the waiter. *Ibid.*, p. 161

Large restaurants: the distance between the kitchen and the tables was so great that the food tended to arrive cold. *Ibid.*, p. 167

The restaurant operated by Gustav Stickley on the 12th floor of his retail house furnishings store on 39th street in NYC was a brave but brief experiment in pure food, sanitation, and "progressive living." It opened in May of 1913 and was out of business a few months short of three years later when the entire retail business failed … The Workshop's ambitions were captured in the motto which appeared on furniture labels and the restaurant's china: "Als ik kan." In its quaint Dutch formulation, it was a pledge to do one's very best work. When applied to food this meant pure and fresh ingredients straight from the source, simply prepared by cooks using modern appliances in a pleasant work environment, and consumed slowly in a restful setting … Provisions such as eggs, dairy products, vegetables, and spring water served for lunch[eon], teatime, and dinner at the Craftsman Restaurant were trucked in daily from Stickley's 600-acre Craftsman Farms in Morris Plains, NJ … It was a haven for people of "good taste" wishing to avoid the show-off culture of champagne and loud music exemplified by lobster palaces and cabarets … The dining room was decorated in earth tones: browns, deep reds, oatmeals, and creams. Plates, bowls, and cups were rimmed with a pinecone design. Bread was served in handmade willow baskets. The wood floor was mostly left bare while the tables were covered with criss-crossing Irish linen runners. A focal point of the room was a Germanic-looking hearth covered in Grueby tiles, with a hammered copper hood … The store and restaurant closed early in 1916. In August the entire stock of the Craftsman Workshops store was sold at Gimbels Department Store at reductions of 35% to 50%. Whitaker, *Service*

In the teens, the Department of Health ran an experimental lunchroom, where the calorie count and protein content of each dish were printed on the menu. *Ibid.*, p. 178

As calorie-counting became widespread in the teens and twenties with the pencil-thin flapper ideal, restaurants suffered. *Ibid.*, p. 199

S Food — Dining

Ibid., p. 198 The Volstead Act harmed restaurants, where many sauces could not be made without wine.

Ibid., p. 194 First vegetarian restaurant, Vegetarian Restaurant Number One, opens in 1895 on Twenty-third Street.

Berger, *New York*, p. 203 Keene's English Chop House in West Thirty-sixth Street has three-dimensional menus, now—stereoptician color slides showing all available courses, including desserts. The diner studies them through a viewer.

Ellis, *Epic*, p. 506 No meat was served in New York on Tuesdays during World War I.

Hamill, "Lost" If it's very late and you are hungry, you can take a cab to the Belmont Cafeteria downtown or the Garfield on Flatbush Avenue. Better: Wait till tomorrow; there's a 99-cent hot lunch at the Tip Toe Inn on 86th and Broadway. Have the brisket and then drop a nickel in the subway and go downtown and take a walk. The old socialists are still discussing the imminent collapse of capitalism with the writers from the *Forvetz* at the Garden Cafeteria. In Union Square, they are arguing about surplus value, the Spanish Republic, and the true meaning of Marx's *Grundrisse*.

Ibid. If it's a sultry August evening, you will be able to hurry down to Sheepshead Bay and step up to the Clam Bar at Lundy's. Or you can drive out to Rockaway, get on the rides at Playland, drink cold beer and eat pig's feet at Fennessey's, Gildea's, or Sligo House, McGuire's or the Breakers, and look at the girls outside Curly's Hotel at 116th and the ocean.

Williams and Noël, p. 153 In the late 50s and early 60s there was a restaurant on West 50th (or was it 49th?) Street, in New York, between Fifth and Sixth Avenues, called Stokholm (without the "c"). As one may guess, it was a Swedish restaurant.

It was George who first told me about it. Actually he was telling all his friends about it. "You pay $3 and you can eat and eat and eat, as much as you want," George said. And it was true. That was the restaurant's policy. Swedish and Italian dishes.

The funny thing about this was that George used to very carefully prepare himself for the trips to Stokholm. For two or three days prior to going, he practically starved. He ate nothing. I never followed that rule—which he advised—but George followed it religiously. On the subway, up Sixth Avenue, he could barely contain his anticipation of stuffing himself full. And I tell you, he ate and ate and ate, incredible amounts, his belly barely holding all the Swedish and Italian stuff, and he laughed, and had a terrific time, and we all had a terrific time. He never went to Stokholm alone: it was always a Fluxus gorging party. I don't think I will ever forget those trips.

Ibid., pp. 150–1 Maciunas's diet consisted of ripe cheese and canned fish. The fish and the cheese were washed down with liberal amounts of Russian vodka … He used to say that, as long as the cheese did not walk away, he would eat it.

Ibid., p. 150 In 1960, Maciunas decided that one could become a millionaire by importing very special European foods. So he sent hundreds of form letters to European special food exporters and producers, offering to be their agent / salesman; and "Please, send me some samples of your special foods." And samples he got! Thousands of canned food samples began arriving at his home … We were very poor and very very hungry … So he brings and dumps in our place maybe a thousand cans of the most expensive, very very special *pates*, nightingale tongues, all very very special stuff. So we ate and ate, and we fed

all the hungry Lower East Side poets for a year or two, and everybody was amazed when we used to pull out these French delicacies that you could get only at the Waldorf-Astoria. I don't have to tell you that George couldn't sell any of it. He ate it all himself, with our help.

"Oh, but baby, I want to go to Nobu tonight," she whines from the closet. "I want a baby shrimp tempura roll."

Ellis, *Glamorama*, p. 26

Florent: a narrow, bleak 24-hour diner in the meat-packing district and I'm feeling grimy, slumped at a table near the front.

Ibid., p. 191

The glittering, curvilinear surfaces inside Odeon are reassuring. The place makes you feel reasonable at any hour, often against bad odds, with its good light and clean luncheonette-via-Cartier deco decor. Along the bar are faces familiar under artificial light, belonging to people whose daytime existence is only a tag—designer, writer, artist.

McInerney, *Bright Lights*, p. 44

New York in 1982 will probably be fed on concentrates—pills at so much per box or bottle. Restaurants, cafés, and dining places generally, will probably be passé. Meals will largely consist of various pellets according to the hunger of the masses.

Chase, p. 13

Chinese

Li Hung Chang, the last Premier in the Tsing dynasty under the Manchus, left China on a good will tour. He sailed first to Europe and then to New York. On the strength of his friendship with the then ex-President U.S. Grant, whom he had met while the latter was touring the Orient, he was heartily welcomed at the dock and escorted by a jubilant throng down to the Astor Hotel, where he was stopping.

Chin

Socially he was a huge success. He was invited everywhere. Much to his dismay, wherever he dined his meals always consisted of meat in one form or other. The meat was good, but it didn't agree with his stomach because he was not used to such a steady diet of it. He was faced with the grave problem of cancelling all of his dinner engagements or bringing his own chef along wherever he went, to personally supervise and prepare his meals. He decided to try the latter idea. It was a huge success because of the novelty of it.

Americans looked on with wonder and asked him what the name of the food was that his chef was preparing. His answer was "Chop Suey," which meant that it was a combination of mixed foods. He explained that it was a meal consisting of bean sprouts, celery and Chinese greens, plus many more vegetables, with a touch of meat, usually pork. The guests begged him to let them taste it. They did. Immediately they clamored for more. Overnight, Chop Suey won widespread popularity.

Chinese residents in New York soon found a new field of endeavor open to them. They opened restaurants and called them "Chop Suey Houses." Many of these original Chop Suey Houses still exist.

Several years later there was a trend in American appetites. The Chinese restaurant owners introduced a new dish to their patrons. They called their concoction, Chow Mein. This dish consisted of a layer of fried noodles smothered with onions, Chinese greens, a touch of chicken or pork, and gravy.

Most Americans, even today, cannot distinguish the difference between Chop Suey and Chow Mein. The easiest way to remember it is to know the

following rule. "Without noodles it is Chop Suey. With noodles it's Chow Mein."

Allen, *Slang*, p. 151

chow-meineries

Chin

It is a revelation to walk into a real Chinese kitchen and watch the chef prepare a meal. It is plainly evident that he thoroughly enjoys his work and that he would not be happy at any other occupation. Although a chef seldom works less than from 10 to 12 hours a day he is never tired because of the buoyancy his "songs" give him.

Every stroke of the cleaver is done with perfect rhythmic timing, "Chop. Chop. Chop Chop Chop." The beats seem to say over and over, "I am happy. I am cheerful. The food smells very good!"

Even the Chinese diner who partakes of this food smacks his lips in delight at every mouthful to signify his enjoyment and pleasure. To refrain from smacking one's lips and to eat in silence as is the American custom is an insult to the chef because it means that the diner is not enjoying his food.

Chinese family restaurants may seem drab and colorless to many tourists and visitors, but they should keep in mind that when Chinese go into a restaurant they do so to eat, not to look at the scenery. The delicious foods are enough scenery for them.

A chef never talks about his technique in preparing his dishes. A true chef is like the proverbial sailor on a holiday. He spends his spare time in perfecting his "kitchen music."

The Chinese chefs in the Broadway sector or in any other Chinese-American restaurants are different from the chefs in Chinatown because they do not specialize in Chinese foods for the Chinese.

Ibid.

Chinese do not like rare meats. They like to eat hard apples and hard peaches. They eat freshly killed chickens instead of first putting them in an icebox for a few days or a few months like most Americans do. They dislike bread.

Grimes, p. 203

Chinese restaurants move into Times Square during Prohibition and open chop suey joints. Low food overhead and cheap labor, they undercut the nightclubs and large restaurants.

Conrad, p. 322

The jaundiced cooks of Chinatown leer as they slice off the heads of fishes or the snouts of pigs.

N. cit.

Sing Wu—Chinese restaurant on Second Avenue everyone went to after art openings.

Food

Morris, *Food*, p. 12

Food restaurant opened at 127 Prince Street on the corner of Wooster Street in October of 1971 and was run by the original founders for three years.

Ibid., p. 29

Matta-Clark held a sculptor's dinner—for sculptors by sculptors. All the utensils were screwdrivers, hammers, chisels.

Ibid.

Famous Sunday night guest artist meals at *Food*. One was the serving of live brine shrimp in hollowed out hard-boiled eggs. The other was Matta-Clark's "Bone Meal," consisting of a variety of bone-based dishes such as chicken bones, beef bones stuffed with wild rice and mushrooms, frog legs, marrow bones. The meal started with Gordon-made aspic, went on to oxtail soup, and

then the bone platter. Richard Peck was in the back scrubbing bones that people had finished eating and Hisachika Tasahashi drilled holes through the bones, which were hung on rope and handed to the customers as necklaces so they could wear their dinners home.

"You have to realize at that particular time in New York," Mr. Sonnier added, "people did not eat bone marrow." Kennedy, "Meals"

The same year, 1971, Alice Waters founded Chez Panisse in Berkeley, Calif., as "a simple little place where we could cook and talk politics," sparking a fresh-and-seasonal-foods revolution in America. In 1973 a collective of artists and communal farmers founded the Moosewood Restaurant, the vegetarian standard-bearer, in Ithaca, N.Y. Ibid.

Menu items: used car stew, alka seltzer chili, velvet chicken in satin sauce, city chicken, lumberjacks, hobnails. Morris, *Food*, p. 52

Food was one of the first places in NYC to serve sushi. It was the idea of Hisachika Tasahashi, assistant to Robert Rauschenberg. One early menu simply described it as raw mackerel with wasabi sauce. Walrod, p. 57

Matta-Clark cooked a lovely whole sea bass, but it emerged from the kitchen encased in a block of aspic nearly three feet long. He unmolded it, then gave the table a good kick, so that the aspic wobbled wildly and the bass seemed to fishtail upstream … "All the guests looked at it with this sort of horror and amazement. In the end my mundane chicken stew got eaten and everyone was too afraid to touch the fish." Kennedy, "Meals"

Edible flowers were served to guests who came dressed as flowers. Ibid.

"I had the ridiculous idea of serving a glass of milk for 5 cents for pure nostalgic reasons." Ibid.

At one dinner performance, Matta-Clark served live brine shrimp swimming in broth in the middle of a halved, cooked egg white. "Some nonartist customers were furious and claimed there should be a law against us," she wrote. "We told them guest chef days were no holds barred days and they could leave if they wished. So they did." Ibid.

About 60 artists are estimated to have worked at the restaurant as cooks, waiters and busboys over the first three years. Ibid.

The restaurant was becoming an increasingly fashionable scene, a precursor of the SoHo to come. Ibid.

Corbusier, p. 101	Le Corbusier: "If I were in authority, I would forbid advertising."
Irwin, p. 30	This city knows how to advertise.
Morris, *Manhattan '45*, p. 10	Manhattan is its own best logo.
Sharpe, p. 195	Outdoor advertising, where the mere idea of a commodity could shine without any reference to the actual object.
Morand, p. 191	History is forgotten. "Nature, gods, the sea, are replaced by new words that must be mastered. In Paris there is but one which the skies spasmodically teach us—Citroën. In New York there are Lasky, Ziegfeld, Goldwyn, Mayer."
Barnes, p. 183	Innermost, decisive significance of the advertisement: "An electric sign stands up against the sky, advertising some brand of chewing gum, and beside it the steeple of a church. Great warehouses and grain elevators support flaring advertisements; it looks as though the whole of Manhattan is for sale. And somewhere in all this tangle of lives and tangle of buildings, inland out of sight of the sea and fog, there is my own particular little studio called home."
Conrad, p. 170	The statue of Christopher Columbus in Columbus Circle has been upstaged by a hotel, the Mayflower, which hoists its plaque into the sky in celebration of another voyage. The new gods the city has installed in its heaven are the theatrical stars named on its billboards: Beatrice Lillie, Ethel Waters, and Eleanor Powell are appearing in *At Home Abroad* just off Columbus Circle.
Sanders, *Celluloid*, p. 352	Like so many others, a young woman named Gladys Glover has come to New York to make a name for herself. Unable to do so by dint of talent or determination, she hits upon a simpler expedient, using her hard-earned cash to rent a huge billboard overlooking Columbus Circle, with her name painted on it in ten-foot-tall letters. Eerily prophetic in its vision of celebrity as a self-fueling phenomenon—Gladys becomes famous for being famous—offering deep insight into the nature of urban spectacle. New York is a city of crowds, of course, but it is also an instrument by which certain individuals distinguish themselves from the crowd, commanding the attention of everyone else. Incapable of activating New York's publicity machine in an institutional way, Gladys taps the city's physical urbanism, which turns out to be shaped along much the same lines: giant signs, placed on buildings facing large public spaces, seek to draw the notice of the thousands of pedestrians below.
Sharpe, p. 197	In 1910, the famous Roman Chariot Race sign debuted atop the Hotel Normandie at Broadway and Thirty-eighth Street. The thirty-second show, at seven stories high and ninety feet wide, was astonishing enough to stop traffic. Twenty thousand incandescent bulbs gave the impression of toga'd drivers snapping their whips over galloping horses as the wheels of their chariots spun through the night. Like Oscar Wilde at the New York Customs office, the sign had nothing to declare except its own genius. It sold nothing, but advertisers—up to ten in a minute—could bask in the glory of the spectacle by time-sharing a space for their names on the top of the billboard. Chariots came back to Broadway in 1925 when the first neon tubes were used to advertise the movie *Ben-Hur*.
Trager, p. 476	A billboard for the new St. Moritz Hotel goes up at Fordham Road and Corona Avenue in the Bronx. Alabama-born sign creator Douglas Leigh,

26, has persuaded the owners to advertise on the site, he is paid $50 per month and a room at the hotel (the Central Park South address looks good on his letterhead), and by year's end he has sold A&P on the idea of putting up a sign with a steaming cup of coffee, 15 feet wide at the southeast corner of Seventh Avenue and 47th Street. Leigh will soon have a giant penguin blinking its eyes to promote Kool cigarettes, an animated cartoon for Old Gold cigarettes, a clown tossing quoits in the shape of the three-ring Ballantine Beer logotype, and by 1941 will have created 32 large signs with more than 75,000 light bulbs for Times Square, Columbus Circle, and other venues.

In general, the close connection between advertising and the cosmic awaits analysis: "In a Buick ad of the late 1920s, an athletic larger-than-life young man seems to be rising over the Manhattan skyline; his eyes are raised, his face bathed in light, and he is lifting a Buick in the palm of his hand, as offering it to heaven." Douglas, p. 68

Electric billboards are more efficient than the moon. Goll, p. 5

In a city in which the illusion of its advertising is mistaken for its reality, those who muddle along in the unkempt and ordinary way know themselves to be failures. Blandford, p. 56

Red, white, green, yellow, blue, orange, purple, they urge, solicit, press, command you to go somewhere or buy something. Bottles of beer appear on the firmament and transform themselves into dwarfs drinking; showers of gold peanuts fall from the skies; dragons breathing smoke become a film title; cigarettes are ignited; automobiles materialize. Mountains, towns, lamaseries, men with top hats, nude women with teeth, spring into existence on the façades and are wiped off into oblivion … dwarfs and dragons, beer and nuts, spiffy men, naked women, and far-off landscapes—this fairy tale hodgepodge. Sharpe, pp. 210–11

In New York Asta electrifies, astral
 The flickering signals on the rooftops give off sparks. Behrens, p. 315

At a yellowpainted drugstore at the corner of Canal, he stops and stares abstractly at a face on a green advertising card. It is a highbrowed cleanshaven distinguished face with arched eyebrows and a bushy neatly trimmed moustache, the face of a man who has money in the bank, poised prosperously above a crisp wing collar and an ample dark cravat. Under it in copybook writing is the signature, "King C. Gillette." Dos Passos, p. 11

The evenly chiseled windows are like a stenciled advertising poster. Mayakovsky, *America*, p. 47

Grand Central has become honky-tonk, with its extra-dimensional advertising displays and its tendency to adopt the tactics of a travel broker. I practically lived in Grand Central Terminal at one period (it has all the conveniences and I had no other place to stay) and the great hall seemed to me one of the more inspiring interiors in New York, until Lastex and Coca-Cola got into the temple. White, *Here*, p. 49

In 1949, Grand Central tries to boost revenues by broadcasting advertising messages over its public address system, stopping only after a vociferous protest led by *New Yorker* editor Harold Ross. Trager, p. 569

Ibid., p. 578 The Eastman Kodak Colorama unveiled in the main concourse of Grand Central Terminal will remain there for 40 years, presenting spectacular scenic views 18 feet high and 60 feet long. Other commercial displays follow.

Douglas, p. 66 Marianne Moore delighted in advertising copy as a girl, later appropriating its fast, exact shifts and splices for the collages of her poetic art. "If you fear that you are reading an advertisement," her poem, "The Arctic Ox (or Goat)" concludes, "you are."

Ibid., p. 67 Scott Fitzgerald spent only three months in the advertising world but learned how to drop flamboyantly quotable lines such as: "All women over thirty should be shot."

Ibid. Scott had shrewd ideas about pushing his books. In a 1923 essay entitled "How I Would Sell My Book," he urged the dealers to fill an entire store window with nothing but copies of his latest book, then station "a man with large spectacles sitting in the midst of them, frantically engrossed in the perusal of a copy." Brash but incandescent self-promotion was one of the motive springs of young Fitzgerald's art. "I am a fake," he liked to explain in a half-conscious homage to the values of Madison Avenue, "but not a lie."

Ibid., p. 68 The fascination and familiarity with advertising on the part of New York's leading performers, publishers, and writers did not represent an artistic compromise or sellout on their part.

Venturi, p. 6 I.M. Pei will never be happy on Route 66.

Meyer, "Cocktail," p. 294 Cocktails
and signs of
"ads"

flashing,
light's waterfalls,

Bacchae
among electric lights

will swarm the crowds
streamers of the lighted

skyscrapers

Sharpe, p. 21 The electrical sublime in art and literature ultimately threatened to become a form of the advertising that gave it birth—not advertising products, for people knew from the start how fleeting that effect was—but selling light and spectacle in and of themselves.

Debord, *Spectacle* The spectacle is capital accumulated to the point that it becomes images.

Depero, "Coney," p. 422 All obsessing electric capitals
Warner's Sugar
And on the Palisade cliff
Surf Bathing

Sharpe, p. 188 As I look at the great incandescent signs along the Jersey Shore, blazing across the night the names of beer and perfumes and corsets, it occurs to me

that, after all, that kind of thing could be overdone; a single name, a single question, could be blazed too far.

Stuart Davis's paintings treat words like trade names, and his surfaces are, at bottom, a form of prospectus for corporate enterprises. Later, nesting in Pop trade names are figments such as those earlier thought to be hidden in the cache of "poetic" vocables. N. cit.

Advertising is the art of mass communication, the only art, if it is one, that assumes that all knowledge is transmittable, and takes its audiences to be literally everyone. This is a position shared in one form or another by the artists working in New York in the 1920s; they, too, believe that everything is capable of popularization. Douglas, p. 69

A year after the Singer Building opened, the Metropolitan Life Insurance Building usurped its place as the world's tallest building, the world's largest advertisement. Sharpe, p. 188

When Woolworth's designers apologized to him that his building's cost was unlikely to be recuperated by enough income-producing floor space, he confided that it was as an enormous advertisement that the building would pay for itself. *Ibid.*, p. 234

It is an office building, not a cathedral, an advertising symbol, a monument to prosperity, an unusable landing place for illusory dirigibles, or a pathological symptom of somebody's repressed desires. Mumford, *Sidewalk*, p. 68

Symbol dominates space. Architecture is not enough. The sign is more important than the architecture. Venturi, pp. 8, 13

An ad campaign for beer features pictures of the New York skyline over the slogan, "The night belongs to Michelob." Sharpe, p. 323

Madison Avenue

To be white, male and healthy in New York in the 1950s was to be as blessed as any individual at any time in history. Cracknell, p. 16

The well-shined Oxfords of the comfortable WASP account executives patrolling the Madison Avenue sidewalks. *Ibid.*, p. 71

The world of commercial art was high-powered and snobbish—the crowd was the smuggest, meanest, drunkest bunch of people you ever saw. Bockris, *Warhol*, p. 80

Contrary to popular belief, drinking on agency premises was comparatively rare, although not unknown. Cracknell, p. 148

who were burned alive in their innocent flannel suits
on Madison Avenue amid blasts of leaden verse
& the tanked-up clatter of the iron regiments
of fashion & the nitroglycerine shrieks
of the fairies of advertising & the mustard gas of sinister
intelligent editors, or were run down by the
drunken taxicabs of Absolute Reality Ginsberg, *Howl*, p. 16

Roman, p. 8	Ghost writing, as in advertising.
Ibid., p. 7	Rosser Reeves: "Originality is the most dangerous word in the advertiser's lexicon."
Ibid., pp. 8, 9	David Ogilvy deplored "creativity," a word he professed not to understand: "When I write an ad, I don't want you to tell me you find it *creative*."
Ibid., p. 104	"Paper clips are dangerous. When they are used to fasten papers together they frequently pick up papers which don't belong. Staples or bulldog clips are much safer and more efficient."
Cracknell, pp. 32–3, 41	Ogilvy was English, at a time when an English accent was still rare and hugely prized in New York. Ogilvy's was "a particularly well-modulated accent, and with his long, lean figure, foppish hair and ever present pipe, he was every bit Hollywood's idea of the perfect English gentleman, a character he fully exploited … He dressed for his parts. He didn't wear a business suit. Sometimes he dressed as the English country gentleman with his brogues, a tweed jacket and lapels on his vest. Sometimes he wore a kilt, before anyone had seen one. Sometimes, at big state occasions, he put on this kind of purple vest that looked vaguely ecclesiastical. But he never wore a normal business suit, never … In that era in New York, where in the face of the brash, loud, busy new world he retreats into a caricature of his real self and becomes even more English, brittle and refined."
Ibid., p. 52	Bill Bernbach on naming Doyle Dane Bernbach: "Nothing will come between us, not even punctuation."
Ibid., p. 53	In 1935 when Grover Whalen was put in charge of organizing the New York World Fair that was to open in 1939, he took the young Bill Bernbach with him to work in his offices in the Empire State Building and at the site in Flushing Meadows.
Ibid., p. 55	Jewish advertising firms were known as "Seventh Avenue" agencies.
Ibid., p. 84	On DDB's Volkswagen account: "We have to sell a Nazi car in a Jewish town."
Ibid., p. 66	"You don't have to be Jewish to love Levy's real Jewish rye." It was advertised as "Levy's real Jewish Rye," itself a little contrived as there's nothing particularly Jewish about rye bread … Subway passengers became aware of posters with large, engaging pictures of the people you'd least expect chewing through a hunk of Levy's. And if they looked authentic, that's because they were authentic: "We wanted normal-looking people, not blonde, perfectly proportioned models. I saw the Indian on the street; he was an engineer for the New York Central. The Chinese guy worked in a restaurant near my midtown Manhattan office. And the kid we found in Harlem. They have great faces, interesting faces, expressive faces."

It would be easy now to dismiss the whole campaign as stereotypical, even condescending, but not then—far from it. These ads were startling for the simple reason that such people weren't usually seen starring in advertising. New Yorkers reveled in it, demanding copies of the Levy's posters as well as the bread. It reflected and celebrated their contemporary multiculturalism, and for the immigrants it helped "normalize" their status simply by making them seem an accepted, normal part of society.

I Wuv Wevy's.

Ibid., p. 65

Early in 1965, a beer company launched a major television and radio advertising campaign, in which it pointed out how many different nationalities live in New York City and, of course, how each of them preferred that company's beer.

Gottehrer, p. v

Charles Gillett created the Big Apple tourism campaign, which was conceived during the 1964–65 World's Fair, and most of the bureau's publications carried "Come to the Fair" or similar slogans in large type. Gillett proposed that after the Fair, the city was The Big Apple, named after jazz musicians' nickname for the city because that's where they'd get the best jobs.

Cohen and Popik, *Apple*, pp. 91, 92

I've heard great singing Negroes call it "The Apple!"

Kerouac, *Traveler*, p. 105

In the mid-1950s an art director at Benton & Bowles asked the name of the hopeful blonde female illustrator who'd just shown her folio to a colleague in the office next to his. "That wasn't a chick," he laughed, "I've got his name somewhere … er … Andy Warhol."

Cracknell, p. 74

On his second day in New York, Andy went to see the art director of *Glamour* magazine, Tina Fredericks, in the Condé Nast building in the heart of Madison Avenue's "ad alley." He held himself in a loose way, with his hands hanging limp from his wrists, and talked in a breathless whisper.

Bockris, *Warhol*, p. 80

When shopping his drawings to Madison Avenue, Andy wore a bohemian uniform of chino pants, cotton T-shirts and worn sneakers, which he had appropriated largely from Marlon Brando, and carried his drawings in a brown paper bag, looking, one friend remembered, "as if he had written his own part in a play by Truman Capote."

Ibid., p. 81

A 1994 Gap ad featured a black-and-white photo of Warhol during his illustrator days on Madison Avenue with the tagline: "Andy Warhol wore khakis."

N. cit.

One of the climactic moments in the Raggedy Andy saga occurred when he presented his drawings to the elegant *grande dame* of the fashion magazines, Carmel Snow at *Harper's Bazaar*, and a roach crawled out with the pictures. "She felt so sorry for me," Andy told everyone, "that she gave me a job."

Bockris, *Warhol*, p. 82

In 1953, Andy won his first Art Director's Club gold medal—the Oscar of the advertising industry.

Ibid., p. 88

On an *Esquire* cover, Warhol falls backward into a can of Campbell's tomato soup to signify the end of pop art. Warhol was excited; he thought they were going to make a giant can and fill it with soup. Fischer shot the picture in two parts, dropping a marble into a can of thinned soup to make the splash and then stripping in a separate shot of Warhol.

Cracknell, p. 166

Warhol was contributing illustrations to practically all of the fashion magazines, including *Mademoiselle, Glamour, Vogue*, and *Harper's Bazaar*, as well as doing covers for *Dance Magazine* and *Interiors*. His work could be seen in many of the city's fanciest stores: he designed greeting cards for Tiffany & Co., stationery for Bergdorf Goodman, and placemats for the Bird Cage restaurant at Lord & Taylor. He whipped up sketches for album covers for RCA Victor and Columbia records and dust jackets for New Directions,

Bourdon, pp. 33–4

including one with a typically Warholian composition of rows and rows of faces and a suggestively impish cupid with arrow for the cover of *Three More Novels* by Ronald Firbank, the outré English writer and pillar of camp sensibility. Warhol also devised illustrations for the corporate image-building campaigns of the Upjohn and Rexall companies. He drew newspaper ads for the National Broadcast Company and created title cards for the prestigious television show "Studio One." For a while, he was even the "hands" on the Will Rogers Jr. Sunday morning TV show, drawing clouds, raindrops and whatever else the meteorologists predicated.

Art directors showered Warhol with assignments because he worked fast, met deadlines, and displayed a properly submissive attitude when they demanded revisions. "If they told me to draw a shoe," he said, "I'd do it, and if they told me to correct it, I would—I'd do anything they told me to do, correct it and do it right. After all that correction, those commercial drawings would have feelings, they would have a style. The attitude of those who hired me had feeling or something to it; they knew what they wanted, they insisted; sometimes they got very emotional. The process of doing work in commercial art was machine-like, but the attitude had feeling to it."

Andy cleverly ingratiated himself with almost anyone who was in a position to give him work. He made and gave away numerous personalized artworks, including hand-colored wrapping paper, ornately decorated Easter eggs, and whimsical drawings of butterflies. This endeared him to art directors, many of whom treasured every drawing he sent their way.

Smith, *Warhol*, p. 100 Warhol brought his clients drawings in paper bags.

Koestenbaum, p. 28 He wanted to call himself Andy Paperbag.

Billboards

Berman, *Town*, p. 109 The development of electric power in the 1900s made it feasible to install enormous electric signs, sometimes mounted on the roofs of shorter, older buildings, sometimes on the façades of big new ones. Years of conflict between Broadway and Fifth Avenue owners' associations led to a plan to restrict electric signs in most of Manhattan, but to concentrate them around Times Square. In 1909, a state court overturned a city law that limited their size. Nearly overnight, a new generation of huge, bright, kinetic signs came to life.

Charyn, *Gangsters*, p. 51 In 1916, the Broadway Association and the Fifth Avenue Association—collections of combative merchants—battle it out over where projecting signboards can and cannot be placed. Broadway wants unlimited access. But the Fifth Avenue merchants, who are wealthier and more aggressive, insist that projecting signs be banned from Washington Square to 110th, along Fifth Avenue. Fifth Avenue wins the war. Its long elegant vistas will be unharmed. Broadway fights back. A new zoning law grants the unlimited use of giant billboards, but only on the Main Stem. One of the peculiarities of American capitalism is to concentrate and confine such activity [billboards] to a limited space, while at the same time *liberating* it to an unparalleled degree.

WPA Guide, pp. 170–1 The phrase, the Great White Way, is supposed to have been coined in 1901 by O.J. Gude, an advertising man, who is also said to have been the first to see the tremendous possibilities of electric display. A modest sign at Broadway and Twenty-third Street advertising an ocean resort was New York's first experience with this phenomenon.

At Broadway and Twenty-third Street, where later, on this and some other ground, the once famed Flatiron Building was placed, there stood at one time a smaller building, not more than six stories high, the northward looking blank wall of which was completely covered with a huge electric sign which read:



SWEPT BY OCEAN BREEZES
THE GREAT HOTELS
PAIN'S FIREWORKS
SOUSA'S BAND
SEIDL'S GREAT ORCHESTRA
THE RACES
NOW—MANHATTAN BEACH—NOW



Dreiser, p. 119

Each line was done in a different color of lights, light green for the ocean breezes, white for Manhattan Beach and the great hotels, red for Pain's fireworks and the races, blue and yellow for the orchestra and band. As one line was illuminated the others were made dark, until all had been flashed separately, when they would again be flashed simultaneously and held thus for a time. Walking up or down Broadway on a hot summer night, this sign was an inspiration and an invitation. It made one long to go to Manhattan Beach. I had heard as much or more about Atlantic City and Coney Island, but this blazing sign lifted Manhattan Beach into rivalry with fairyland.

BILLBOARDS ARE ALMOST ALRIGHT.

Venturi, p. 6

Everything about a Times Square sign, from its supporting framework to the image it displays, is big—indeed enormous. But it is not just big. Unlike a dam or aircraft hangar or similarly oversized structure, a Broadway sign is not simply large in the abstract: because its subject is almost always a person's face, or figure, or name, it plainly represents an enlargement, a scaling-up from ordinary human dimensions to something else, something that is distinct from—yet also related to—the individual on which it is based.

Sanders, *Celluloid*, p. 298

In 1955, James Rosenquist moves to New York to study. The next year he quits school and paints billboards in Times Square.

Dickerson

 Rosenquist: "I wanted to paint the Sistine Chapel, and so where do you learn that? So, maybe that's in billboard painting, or outdoor sign painting. So I went to General Outdoor Advertising, and I said, 'I can do that!' It was painting great big macaroni noodles as big as firehouses for Kraft Foods. 'Oh, we don't let anybody do that until they've been here 20 years.' I said, 'Well, I can do that.' So, they gave me a job to paint two heads for Coca-Cola … "

Rosenquistian gigantism into abstraction … But one sign, dead center, especially catches our attention—not least because, seeing it from behind, we have no idea what it is for. It is a giant top hat, outlined in lights and slowly tipping its brim every minute or so. Glamorous, larger than life, ultimately unknowable, it is a symbol not of any particular celebrity, but of celebrity itself, a construct of popular culture that grows from and yet transcends individual personality in a way that not even the stars themselves fully understand.

Sanders, *Celluloid*, p. 299

A giant smoker in a Times Square spectacular begins blowing five-foot-wide smoke rings (created by steam from Con Ed) every 4 seconds to promote Camel cigarettes. The sign requires no lighting.

Trager, p. 528

Sanders, *Celluloid*, p. 297	Harpo Marx enters the signage of Times Square, riding a neon Pegasus across the giant Mobil sign, as if he has himself been somehow transmuted into the evanescent stuff of neon.

Barnes, p. 36	A blank array of electric globes crusting every building's side like the very skin of some immense and glowing thing that has left its shell behind.

Berman, *Town*, p. 7	The allure springs from the totality, the superabundance of signs, rather than from any one.

Ibid.	One important way in which people have always experienced Times Square, and still do, has been to adopt a favorite sign, to be alone with it, to make it part of their inner lives. This means uncoupling the sign from whatever commodity it was meant to promote and placing it in a different system of meaning all our own.

Irwin, p. 325	Do you remember the lady in an electric rain-storm with her long skirt blowing to show the binding? Do you remember the kitten eternally unrolling a spool of silk thread? Then there was the golfer, making at two-minute intervals a perfectly grooved drive, and the chariot race, with teams of fours galloping all night.

Berman, *Town*, pp. 7–8	One of Times Square's most arresting early spectaculars was the fifty foot-tall Miss Heatherbloom, promoting *Heatherbloom Petticoats, Silk's Only Rival*. The product seems to have been a typical garment-center knockoff of a high-fashion item, marketed to millions of young women of the sort who passed through the Square every day: typists and switchboard operators, schoolteachers and young wives. The sign was built in the 1900s (different sources give different dates) by O.J. Gude, the Square's first great commercial artist, who painted in bursts and undulations of electric power. It had an elaborately programmed sequence where the heroine walked through a driving rain "depicted by slashing diagonal lines of lamps." The wind whipped at her dress, lifted her skirt, and revealed the petticoat clinging to her legs and her hips and her thighs. The gale receded, her clothes fell into place, she resumed her high-heeled, mincing walk—only to be swept up in the wind and rain again, and again and again.

This sign attracted big crowds, and the crowds included plenty of women—not the most affluent women, who would surely have stuck with silk, a warm and voluptuous material that has been a symbol of class since ancient times—but seamstresses and switchboard operators on their way to work, or schoolteachers and stenographers going to plays. What the ad promised is something that the New York garment industry, just a few blocks south, knew how (and still knows how) to deliver: cheap knockoffs of expensive fabrics and designs; aristocratic fantasies that a plebeian mass public can afford. It was structurally similar to the electrified mass culture embodied in its sign. It sought and found a large body of respectable women who would respond to a public, flamboyant sexual display, and would buy a garment that they hoped would help them change.

Benjamin, p. 171	The advertisement is the ruse by which the dream forces itself on industry.

Irwin, p. 325	The Prince of Wales visits Times Square to just look at and admire the electric signs.

T Advertising — Billboards

On the corner is a gargantuan sign, "DRINK THE WIGGIN FAMILY RYE." An acre of blood and green fire shows a huge bottle of the Wiggin Family pouring everlastingly into a glass that never fills.

Riesenberg and Alland, p. 156

The waterfall, a city block long, had a tremendous seething flow. At night, everything in the Square seemed to flow toward it. If you stood there and looked at it for a while, it could put you in a kind of trance, you could lose track of everything around you. The falls were high off the ground, but was there a way you could fall in? Could kids fall in? Was there something there that we couldn't see but that could pull us in? On the northern and southern fringes of the waterfall, there were giant bronze statues of a man and a woman. Looking at photos today, I see I was right about them: They were naked! No clothes at all! And yet they were totally unsexy. Not that my cousins and my friends and I knew much about sex, but still we could feel its absence. The compelling thing about these statues was their solemnity … Were the bronze statues so solemn because they were guarding us from the edge, from falling in, from fatal currents and hidden rocks that we couldn't see or even imagine, but that they knew all too well? Did the danger come, in some weird way, from the smart clothes themselves and from the BOND?

Berman, *Town*, pp. 9, 10

The Camel sign just below the waterfall was something else. Here was another giant adult, and a man in uniform, too—which meant, in the 1940s, somebody who was risking his life to protect us all from Hitler … this Camel smoker was ready to take Hitler on. How did he fight? He blew smoke rings in the dictator's face … The smoke rings were collected from the building's heating system; they signified not only American bravery, but American cool.

This week or next, depending on when the first sharp frost hits Times Square, crews will add 3,000 gallons of anti-freeze to the waterfall display in the square. The anti-freeze goes in every year about the same time. A 1,000 gallon tank of the chemical is kept on the roof behind the waterfall to make up for evaporation loss, which varies from 250 to 500 gallons a week.

Berger, *New York*, p. 281

A new Times Square sign advertising Bond Stores men's and women's apparel features a waterfall five stories (27 feet) high and 120 feet long. Sign impresario Douglas Leigh … has persuaded Bond Stores to let him put up the most sensational sign ever and it will continue until 1954. Running a full 200 feet from 44th to 45th Street, the $350,000 sign has 65-foot-tall male and female figures flanking the waterfall, which recycles 50,000 gallons of water while a zipper flashes the news; a circular sign with a digital clock rises above the word "BOND" with a message reading, "Every Day 3,490 People Buy at Bond."

Trager, p. 564

Most signs are likely to be much smaller and more nuanced. The Square's ecology is such that the smaller signs are experienced in relation to the big ones. The manager of the Arrow Shirts shop said, "We're just below the waterfall." They make limited claims on the universe, but "Side by side, they're glorified" by the unlimited claims being made just above and around them.

Berman, *Town*, p. 5

I cannot pass by the luminous advertising on Broadway. Everyone has heard about that incandescent path cutting diagonally across Manhattan in which the mob of idlers and patrons of motion pictures, burlesque shows and theaters moves. Electricity reigns, but it is dynamic here, exploding, moving, sparkling, with lights turning white, blue, red, green, yellow. The things behind it are disappointing. These close-range constellations, this Milky Way in which you are carried along, lead to objects of enjoyment which are often

Corbusier, p. 102

mediocre. So much the worse for advertising! There remains a nocturnal festival characteristic of modem times. I remember that the light filled our hearts, and that the intense, powerful color excited us and gave us pleasure. And on Broadway, divided by feelings of melancholy and lively gaiety, I wander along in a hopeless search for an intelligent burlesque show in which the nude white bodies of beautiful women will spring up in witty flashes under the paradisaic illumination of the spotlight.

Venturi, p. 3

Learning from the existing landscape is a way of being revolutionary for an architect. Not the obvious way, which is to tear down Paris and begin again, as Le Corbusier suggested in the 1920s, but another, more tolerant way; that is, to question how we look at things.

Berman, *Town*, pp. 6–7

Many American cities, especially in the Sun Belt, developed prosperity based on highways and cars, and created spaces with signs as big and bold as Times Square's. But those spaces tend to be strips (Las Vegas, Los Angeles, Mexico City) where people come in cars and drive straight through. Their signs are laid out in straight lines, meant to be seen one or at most two at a time by drivers or passengers on the road. The deployment of signs in Times Square is far more complex. Here people are on their feet, enveloped by crowds of walkers in a hundred directions, impeded from moving straight ahead even if they want to. The signs come at us from many directions; they color the people next to us in complex blends, and we become colored, too, all of us overlaid with the moving lights and shadows. We metamorphose as we turn around, and we have to turn around to make any headway in this crowd.

The development of Cubism in the early twentieth century was made for spaces like this, where we occupy many different points of view while standing nearly still. Times Square is a place where Cubism is realism. Being there is like being inside a 1920s Cubist experimental film: *The Man with the Movie Camera* as a home movie. Signs are the essential landmark, yet generally what grips our hearts is less any one sign than the complex, the totality, the superabundance of signs, too many signs, a perfect complement for the Square's too many people.

Since the 1890s, being attuned to Times Square's powerfulness has been one of the basic ways of being at home in New York. Even the most wretched people can feel at home with the Square's signs. "I'll just go down Broadway," Hurstwood says. "When he reached 42nd Street, the fire signs were already blazing bright." This man is starving, freezing, dressed in rags, delirious, one foot in the grave. But he can't stay away from the "fire signs." He is drawn to their warmth and light like a moth to a flame.

Caldwell, p. 213

A five-story-high plaster and wood arch over Fifth Avenue at Madison Square, built to commemorate the Spanish-American War, featured a garland of electric lights. But it looked stodgy beside a 45-foot-long Heinz pickle blaring out across the square, outlined in rapidly blinking green bulbs with 577 GOOD THINGS FOR THE TABLE flashing beneath it in a riot of color.

Berman, *Town*, pp. 16–17

Tibor Kalman's (1949–99) Fire Sign. A spectacular ad for *Colors*, a glossy magazine put out by the Italian sportswear company United Colors of Benetton. The sign was on display in 1992 and 1993. It was fifty feet high, maybe twice as long; it curved around the corner of 47th Street and Broadway, and it showed full frontal nude photos of six teenagers. Actually, they weren't quite teenagers: Two of them looked closer to twenty-five, another two seemed more like fifteen. And they weren't quite nude; they were holding small signs over their genitals, something like the fig leaves in Renaissance paintings of Adam and Eve …

The color contrasts among the kids were striking: One was clearly Asian, one clearly African (Afro-American? Afro-European?), two clearly Caucasian, and two unclear or mixed; for that matter, it was very likely that all of them were mixed. The contrasts in ideas were striking, too. At the far left, a punklike blond boy with an Axl Rose look held an ATTITUDE placard. Next, a voluptuous Asian girl held RACE. An olive-skinned boy carried a TRUTH sign. A black girl had a POWER sign. A short, compact Asian man signed LIES. At right, the youngest-looking of the six, a girl with a gamine aura, covered herself with FIRST DATE. It was impossible (or let's say very hard) for a spectator not to enjoy the near nakedness of these kids, to feast our eyes on them. At the same time, the way the sign was crafted, it was impossible not to feel guilt and embarrassment. The sudden vision of their bodies was revelatory and shocking. There was something about the way they stood, the ambient light and color, the innocence on their faces when innocence was mixed with defiance—that made them seem vulnerable and overexposed; they looked more like suspects in a police lineup than participants in an orgy. But what was their crime? There was human depth in this sign, it drew us into the action. Before the picture could mean anything, we spectators had to imagine actively, to "write the book." My wife and I imagined a strip search after a drug raid on a club. We noticed that at least two of these kids were "underage," but we couldn't tell what the age spread was supposed to mean. Was the point that age meant nothing? (But then, I thought, shouldn't there be some older people with wrinkled or sagging bodies in the scene?) We never figured out their genital signs, fig leaves in print. Were we meant to think of those tags as social labels imposed by the powers that took their clothes and lined them up? Was this a generation of kids caught in the crossfire of adult big words? Yet wasn't "victim" another adult big word?

The eighties begin with this story. Photographer Bruce Weber shot a water-polo player lying bare-chested on an unmade bed with his hands playing "inside-outside" in his long johns, which persuaded Calvin Klein to hire him. Against a backdrop of a whitewashed house on a Greek island, with the muscles and detail of the male anatomy heightened by the low camera angle, the image of the athlete, transformed into a demigod in undershorts, was blown up into an immense poster measuring twenty by thirty meters on a billboard in Times Square. It was stolen overnight. In the month following, the sales of Calvin Klein underwear reached record highs. ^{Frisa and Tonchi, p. 90}

Weber's gaze annulled all vulgarity, all sex-shop temptation, to reveal the aspect of a masculinity wounded by centuries of sexophobic obscurantism, in which heterosexual men can also recognize themselves. *Ibid.*

In the Whitney Museum of American Art's 1987 Biennial, Weber's work, flanked by Julian Schnabel, Barbara Kruger, Jeff Koons, and others, was described as "the comfort of myths," precisely because his photos reinvented an athletic body whose precedent is still found in the classicism of the myth of Olympus. *Ibid.*

Signs

The neon in the streets made its way into the new interiors in the indirect Deco cove lighting, casting a subdued yet emphatic glow across ceilings, walls, and mirrors. Caldwell, p. 262

A hundred, a thousand electric signs will blink and wink. Dreiser, p. 3

Hapgood, p. 76 — The light that never was on sea or land he sees not and believes only in the lights of Broadway.

Berman, *Town*, p. 124 — The 1920s also saw a tremendous brightening of Times Square: a "bath of light."

Beaton, *Portrait*, p. 80 — Broadway on a clear night—this is the "Great White Way," when colored lights soar high and a floodlit clock seems to hang in heaven.

Loy, p. 509 —
the eye-white sky-light
white-light district
of lunar lusts

Dos Passos, p. 192 — Taxis honked and rasped outside the hoarding, the sky shimmered with gold powder from electric signs.

Lobas, p. 152 — I drove toward the twilight descending on the city, into a very different New York, beckoning with the evening glow of the streets. But I entered the neon fairyland of Times Square embittered and gloomy.

Wojnarowicz, p. 25 — At night the whores come out along with pimps and everyone struts in high-heeled regalia under the glitter of a half-dead moon and fluorescent lights and lamp poles.

Berman, *Town*, p. 125 — Marshall McLuhan will suggest that this great array of machinery, programmed to "blind people with false daylight," can inadvertently endow them with a second sight, an insight into "the truth of the night" that is deeper than the truth of the working day.

O'Hara, p. 257 —
On
to Times Square, where the sign
blows smoke over my head, and higher
the waterfall pours lightly. A
Negro stands in a doorway with a
toothpick, languorously agitating.
A blonde chorus girl clicks: he
smiles and rubs his chin. Everything
suddenly honks: it is 12:40 on
a Thursday.
 Neon in daylight is a
great pleasure, as Edwin Denby would
write, as are light bulbs in daylight.

Peretti, p. 16 — Broadway, he argued, "is not reality, it is transfiguration" of the mind and body. "Broadway is a great place of health. It is a free electric ray treatment. It is a tonic light-bath. Here voices are clearer, eyes brighter, and the whole body more vivid than anywhere else in New York." "Poe's man in the crowd," he continued, "is walking there every night, back and forth, forward and back again, his eyes lit by some dream." He acknowledged that it all is "the artifice of night." Everyday life in Manhattan "is almost intolerable," so "a great deal of New York night life is purely escape from New York."

McNeil and McCain, p. 89 — Glitter was the gaudiness of America, that's what I interpreted it as. And it was pretty. Glitter was makeup. I used it because it was shoving America back into the American faces. It was the gaudiness of Times Square. You know, take away the lights and what do you have in Times Square? Nothing.

Like Tristan and Isolde obliterating day, the denizens of Broadway subsist in a permanent dimout. Conrad, p. 288

Then they both looked up the ramp and through the arcade, toward the doors on Seventh Avenue. Beyond the doors lay a thick, moribund light that seemed to fill the arcade with the smell of snow and of cold, so that for a while longer they seemed to stand in the grip of a dreadful reluctance and inertia. Faulkner, p. 624

the flash lighting of Pizza stand clattering character, dark night over grainy red buildings' rooftops, the glimmer of the chrome in windows Wojnarowicz, p. 111

Garcia Márquez, writing of Macondo, manages to see Times Square: "In that state of hallucinated lucidity, not only did they see the images of their own dreams, but some saw the images dreamed by others." Berman, *Town*, p. 121

In 1985 the Municipal Art Society helped create a ruling, put into effect in 1987, that developers had to preserve the world-famous signage by making sure that the base of new office buildings would be covered with eye-assaulting advertising. In so doing they ensured a great light show, but also took a decisive step in turning the night city into a museum. With electric signs no longer an essential form of economic communication—the brands and shows are already known from media that travel farther than a flashing light—what counts is status, the fact of having one's product blazoned at the center of light. Sharpe, p. 325

The red neon sign was a blur through the rain, and when I cruised past I could see a bar with a handful of people on stools huddled over their drinks. Spillane

Berman, *Town*, p. 124 Today, on a winter evening, I arrive in Times Square about six o'clock. It is Broadway's finest hour. Here, until midnight, New York takes its bath of light … tumbling, running, turning, zigzagging, rolling, vertical, perpendicular, dancing, epileptic; frames are whirling, letters flash out from the night … In 42nd Street it is a glowing summer afternoon all night, a world of undiscovered prisms, of rainbows squared.

In rain, or when there are mists floating around, it is still more beautiful; the rain becomes golden water; the skyscrapers vanish halfway up, and nothing more can be seen but the haloes of their cupolas suspended in a colored mist … The great searchlight atop the Times Building is sweeping up the remains of the sky.

Here the class war no longer has any meaning. This is victory! The electric lamp is no longer a lighting device, it is a machine for fascinating, a machine for obliterating … This weary throng is determined not to go home, determined to spend its money, determined to blind itself with false daylight … 42nd Street is a conspiracy of commerce against night … there is only one latitude left, the latitude of pleasure.

Berger, *Eight Million*, p. 166 The Crossroads of the World were cold and windswept. The subway gratings breathed mustily and strongly when trains came by. Each sudden exhalation scattered cellophane wrappers, cigar bands, and grimy papers on the sidewalk in front of the United Cigar store.

Kerouac, *Lonesome*, p. 112 Depends how high you are by now—assuming you're picked up on one of the corners—say 42nd Street and 8th Avenue, near the great Whelan's drug store, another lonely haunt spot where you can meet people—Negro whores, ladies limping in a Benzedrine psychosis—Across the street you can see the ruins of New York already started—the Globe Hotel being torn down there, an empty tooth hole right on 44th Street—and the green McGraw-Hill building gaping up in the sky, higher than you'd believe—lonely all by itself down towards the Hudson River where freighters wait in the rain for the Montevideo limestone.

Ibid., p. 108 Or bemused drunken businessmen with their hats tipped awry on their graying heads staring catatonically upward at the signs floating by on the *Times* Building, huge sentences about Khrushchev reeling by, the populations of Asia enumerated in flashing lightbulbs, always five hundred periods after each sentence.

Conrad, p. 121 Times Square is a Catholic anathema.

Morris, *Manhattan '45*, p. 238. The Times Square Motogram, spelling out the news in its thousands of bulbs. A blind man would know he was in New York from the endless chatter of it.

Weegee, *Naked*, p. 45 Broadway at 42nd Street. Mother has stopped to read the flashes of the latest news on the Times Building … but baby wasn't curious about that and fell asleep … but the girl was interested as she ate an eskimo pie.

Reay, pp. 85–6 Like lost souls emerging from the purgatory of the trains (dark rattling tunnels, smelly pornographic toilets, newsstands futilely splashing the subterranean gray depths with unreal magazine colors), the New York faces push into the air: spilling into 42nd Street and Broadway—a scattered defeated army. And the world of that street bursts like a rocket into a shattered phosphorescent world. Giant signs—Bigger! Than! Life!—blink off and on. And a great hungry sign groping luridly at the darkness screams F*A*S*C*I*N*A*T*I*O*N.

Why does Times Square feel like a big room?

Kerouac, *Lonesome*, p. 111

Hart Crane: Time squared.

Mariani, p. 233

Broadway's deliberate ephemerality. For the first time a landscape changed every few seconds.

Sharpe, p. 215

Right off Broadway where the Rialto is at its intensest, where the American spirit is abroad at night, and where the crude emphasis of the lobster and the rarebit with its chappy accompaniment would excite a stare on the boulevards.

Hapgood, p. 364

This is the quiet hour; the theaters
 Have gathered in their crowds, and steadily
 The million lights blaze on for few to see,
Robbing the sky of stars that should be hers.
A woman waits with bag and shabby furs,
 A somber man drifts by, and only we,
 Pass up the street unwearied, warm and free,
For over us the olden magic stirs.
Beneath the liquid splendor of the lights
 We live a little ere the charm is spent
This night is ours, of all the golden nights,
 The pavement an enchanted palace floor,
And Youth the player on the viol, who sent
 A strain of music thru an open door.

Teasdale, p. 50

The jungle of West Forty-second Street. This inflamed appendix is noisier, more noisome, and more punk than Broadway, exposed at midsummer noon.

Riesenberg and Alland, p. 154

We misappropriate Walter Benjamin when we assimilate his arcades to Times Square, either before or after Disney.

Bender, *NY Intellect*, p. 223

Do we overdraw Times Square history, make it more epic than it ought to be? Picadilly and Soho, in London, and Place de Clichy, in Paris, are similar places, have known similar kinds of decline and similar kinds of pickup, but without gathering quite the same emotion. We make Times Square do more work than it ought to.

Gopnik, p. 221

From my office window, as I write, my constant companion is a small Beaux Arts skyscraper directly across on 42nd Street. It is elegantly composed and decorated, with three elongated, vertical bands of round-arched windows dominating a delicate, five-bay arrangement, topped with a crown of carved stone. The street at its feet is porn-country; the neighborhood around it is a disaster area. But the finesse with which the building proposes that skill and order are not only justifiable but desirable is somehow reassuring. I raise my eyes for an architecture break in a city that is as heartbreaking in its beauty as it is in its poverty and decay.

Huxtable, *Goodbye*, p. 134

Times Square, in the 1960s: the place that removed the need for drugs because it was a psychedelic trip in itself.

Berman, *Town*, p. 11

The X-rated movie houses and porno parlors had yielded to cartoon figures and toy stores.

Sharpe, p. 325

Peretti, p. 107

Penny arcades, peepshows, shooting-galleries, flea circuses, and burlesque theaters, shooting galleries, fake doctors ... freak-shows and hot-dog stands and Hindu yogis have moved their tents from Coney Island to Broadway. The seaside carnival had decamped on the Great White Way within the shadow of the Empire State Building. Charlatan yogis pretended to mend people and wristwatches in storefront tent theaters, and automatic moving-picture booths allowed the customer to "see herself as she would look on the silver screen."

Ibid.

Hubert's Times Square Museum epitomized the presence of Coney Island in Midtown. Famed for its flea circus, in which the insects kicked balls and walked on wires, Hubert's also featured lectures on human conception, transvestitism (delivered by a practitioner), and boxing, the latter given by Jack Johnson, the destitute former world heavyweight boxing champion. A pig and a monkey in a baby carriage, Siamese twins, Asian dancers, slot-machine films, and freak exhibits, including "Doraldina," "half man and half woman," also graced the museum.

Caldwell, p. 264

"The Spanish Inquisition," an exhibit of nineteen oil paintings of torture in Times Square by Franz Vinck (Belgian, 1827–1903), which stayed open until one in the morning.

Berman, *Town*, p. 138

The Astaires, the most aristocratic act in the history of American popular culture, could fly through the air amid crashes of downward mobility and smells of fast food.

Walker, *Night Club*, p. 209

Fantastic postures, such as the Strangler Lewis hold around the neck, are barred from the more tony places.

Hamill, "Lost"

Maybe you'll get a sandwich at Reuben's or stroll through Times Square and look at the Camel sign with the guy blowing smoke rings into the night or the two huge nude statues flanking the waterfall of the Bond Clothes sign and then slip into Toffenetti's for coffee or head east to Glennon's for a few final beers.

Cafeterias, Bars, Hangouts

Kerouac, *Lonesome*, pp. 111–12

Bickford's is the greatest stage on Times Square—many people have hung around there for years, man and boy searching God alone knows for what, maybe some angel of Times Square who would make the whole big room home, the old homestead—civilization needs it ... What's Times Square doing there anyway? Might as well enjoy it.—Greatest city the world has ever seen.—Have they got a Times Square on Mars? What would the Blob do on Times Square? Or St. Francis? A girl gets off a bus in the Port Authority Terminal and goes into Bickford's, Chinese girl, red shoes, sits down with coffee, looking for daddy. There's a whole floating population around Times Square that has always made Bickford's their headquarters day and night. In the old days of the beat generation some poets used to go in there to meet the famous character "Hunkey" who used to come in and out in an oversized black raincoat and a cigarette holder looking for somebody to lay a pawn ticket on—Remington typewriter, portable radio, black raincoat—to score for some toast, (get some money) so he can go uptown and get in trouble with the cops or any of his boys. Also a lot of stupid gangsters from 8th Avenue used to cut in—maybe they still do—the ones from the early days are all in

jail or dead. Now the poets just go there and smoke a peace pipe, looking for the ghost of Hunkey or his boys, and dream over the fading cups of tea. The beatniks make the point that if you went there every night and stayed there you could start a whole Dostoevski season on Times Square by yourself and meet all the midnight newspaper peddlers and their involvements and families and woes.

Remember how we went to a year of movies on 42nd Street, seeing successions of nothing pictures about nobody people while we waited for our friend to finish work. Or sat in Bickford's forming patterns on the table top, our fingers pushing through the spilled sugar, our feet scraping on the tiled floor? We listened to the parade of pushers and passers who stopped at our table or sat there with us, drinking hot water and ketsup.

Sullivan, "Liza"

Bickford's Restaurants were a mainstay of early to mid-20th century New York. It all started in 1902 when Samuel L. Bickford opened his first restaurant. Within two decades he owned a chain offering quick food at affordable prices. In those pre-Depression days, the company described itself saying, "The lunchrooms operated are of the self-service type and serve a limited bill of fare, which makes possible the maximum use of equipment and a rapid turnover. Emphasis is placed on serving meals of high quality at moderate cost."

Ibid.

The little building at 488 8th Avenue made the newspapers in 1932 when Bickford's replaced glass windows using non-union glaziers. In retaliation union members drove past while a passenger shot out the plate glass with a slingshot.

The appeal of Bickford's, as well as their rival Horn & Hardart, was good food served quickly in a pleasant environment at an affordable cost. The working class of the nearby 34th Street office buildings flocked in at lunchtime for lamb stew or chopped steak, followed by apple pie or rice pudding. The 24 lunchrooms in the 1920s doubled to 48 by 1960.

who sank all night in submarine light of Bickford's

Ginsberg, *Howl*, p. 3

Emerging from the Seventh Avenue subway on 42nd Street, you pass the john, which is the beatest john in New York—you never can tell if it's open or not, usually there's a big chain in front of it saying it's out of order, or else it's got some white-haired decaying monster slinking outside, a john which all seven million people in New York City have at one time passed and taken strange notice of—past the new charcoal-fried-hamburger stand, Bible booths, operatic jukeboxes, and a seedy underground used-magazine store next to a peanut-brittle store smelling of subway arcades—here and there a used copy of that old bard Plotinus sneaked in with the remainders of collections of German high-school textbooks—where they sell long ratty-looking hotdogs (no, actually they're quite beautiful, particularly if you haven't got 15 cents and are looking for someone in Bickford's Cafeteria who can lay some smash on you) [lend you some change].

Kerouac, *Lonesome*, p. 108

Coming up that stairway, people stand there for hours and hours drooling in the rain, with soaking wet umbrellas—lots of boys in dungarees scared to go into the Army standing halfway up the stairway on the iron steps waiting for God Who knows what, certainly among them some romantic heroes just in from Oklahoma with ambitions to end up yearning in the arms of some unpredictable sexy young blonde in a penthouse on the Empire State Building—some of them probably stand there dreaming of owning the Empire State Building by virtue of a magic spell which they've dreamed

up by a creek in the backwoods of a ratty old house on the outskirts of Texarkana.

Ibid., p. 112

Still hungry, go out down to the Oriental Cafeteria—"favored dining spot" also—some night life—cheap—down in the basement across the street from the Port Authority monolith bus terminal on 40th Street and eat big oily lambs' heads with Greek rice for 90¢—Oriental zig-zag tunes on the jukebox.

Wojnarowicz, p. 59

Hot sooty neon and hotels.

Talbot and Lehnartz, p. 47

A Saturday night scene in Times Square included young men standing around waiting for something interesting to happen.

Kerouac, *Lonesome*, p. 108

We were sitting in Ross Bar on Eighth Avenue when he proposed the idea; we'd spent an hour walking Times Square looking for Hunkey. Ross Bar is the hoodlum bar of Times Square; it changes names every year. You walk in there and you don't see a single girl, even in the booths, just a great mob of young men dressed in all varieties of hoodlum cloth—from red shirts to zoot suits: it is also the hustler's bar, the boys who make a living among the sad old homos of the Eighth Avenue night. Neal walked in there with his eyes slitted to see every single face. There were wild Negro queers, sullen guys with guns, shiv-packing seamen, thin non-committal junkies, and an occasional well-dressed middle-aged detective posing as a bookie and hanging around half for interest and half for duty. It was the typical place for Neal to put down his request. All kinds of evil plans are hatched in Ross Bar—you can sense it in the air—and all kinds of mad sexual routines are initiated to go with it. The safecracker not only proposes a certain loft on Fourteenth Street to the hoodlum but that they sleep together.

Crime

Peretti, p. 9

Broadway: the clip street of the world, the slaughter house of Moronia.

Mitchell, *Ears*, p. 253

At no time in the history of the world have there been so many damned morons together in one place as here in New York right now. The town squirms with them.

WPA *Guide*, p. xxxi

The heartland of undesirable New York is the block of Forty-second Street between Seventh and Eighth avenues. Here is the national cesspool, so bad, New Yorkers can take perverse pride in it, overflowing with pimps, whores, transvestites, male prostitutes and the like. At night, roving bands of toughs appear. Saturdays, they take over the subway station at Eighth Avenue, the most dangerous place in the city.

Berger, *Eight Million*, pp. 187–8

Broadway supports more low forms of life today than a primordial swamp; it swarms with types beside which the old-school gold-brick peddler, the cutpurse, and the square-rigged streetwalker seem like dimpled cherubim. But the chiselers are not like any of these. They are artists, living by chiseling with no thought of profit, to hear them tell of it, and all the others are sordid mercenaries. While the others prey on small and helpless game, chiefly gullible peasants from Oneonta and Painted Post, the chiselers practice their skullduggery on fair-sized victims: the Telephone Company, subway interests, the Automats, big hotels, and the owners and backers of slot and vending machines. These corporations have spent and are still spending tens of thousands of dollars and no end of corporate wrath in futile

attempts to eliminate them, but the chiselers carry on. Private detectives and new automatic safeguarding gadgets only quicken their ingenuity.

In Damon Runyon's stories, Broadway secedes from New York. Although Runyon's people are society's idle or criminal rejects, he punctiliously refers to them as citizens. Their citizenship is their presence on the street: joining its shiftless after-dark world, they have opted out of workaday New York.

Conrad, p. 283

The beer and alky runner, the junk pusher, the cannon mob and the booster; the hoop dropper, the fire-proofer, the stock-steerer; also the tat-man and the hijacker plied their trades, all targeting the half-smart eggs who thinks he is three jumps ahead of Broadway himself.

Peretti, p. 9

"morons" and "half-smart eggs"

Ibid.

fuckin' nighttime in Times Square waiting for a friend who's scoring some heroin …

Wojnarowicz, p. 151

Broadway has its moments of glamorous beauty when it shines forth, but for every one of these moments there are long dull hours of the day and night when it is as tawdry as Coney at its worst. At three in the morning the dreary street sprawls slant-wise across the town in all the ugly meanness of disuse.

Peretti, p. 26

"Someday," she says, "I'm going to take a pick-ax and rip up Broadway from end to end."

Berman, *Town*, p. 198

This very Broadway,
its astonished melon-mouth smeared
with your explosive fists
and your trendy patent leather shoes …
is the same Broadway
stretching its chops with a huge wet tongue,
to greedily lick up
all the blood of our cane.

Guillén, p. 466

Phony acting academies that bilked investors in nonexistent theatrical shows.

Peretti, p. 9

Detectives and tarts in collusion are framing victims in the upper Forties.

Wilson, "Leaving New York," p. 478

Last night Kenny and I went to Times Square to do Polaroid photographs after seeing Barbara Buckner's videotape—Pictures of the Lost—at the Donnell Library. We watched this incredible black woman in a fluorescent orange poncho playing an electric organ. She was the best organ player I've heard in a long time. She would go through these incredible abstract chord changes. She was totally unaware of the preconceived structures of songs and the only way you could tell what she was playing was by listening to the words. She did the most far-out version of "Blue Suede Shoes" I ever heard. We were the only people watching except for two other men.

Haring, p. 88

Sex

If one visits a sex zone at the wrong time of day, it may be unrecognizable. This type of marketplace is usually tolerated only between the hours of sunset

Califia, p. 218

and dawn … This gives all other neighborhoods in the city double meaning, a hidden semiotic, since their relationship to the sex zone remains uncharted.

Berman, *Town*, p. 18 Sex gave the Square its allure; sex was the primal force that leaped across all the color lines and all the national borders, and created the family of man.

Chauncey, p. 66 Whenever the fleet comes into town, every sailor who wants his d— licked comes to the Times Square Building. It seems to be common knowledge among the sailors that the Times Square Building is the place to go if they want to meet any fairies.

Charyn, *Gangsters*, p. 226 —Who has the biggest prick on Broadway?
—Fanny Brice.

Chauncey, p. 197 Privacy in public: Times Square subway station washrooms were used so frequently for sexual encounters that they became widely known among gay men as the "Sunken Gardens" (possibly an allusion to the song by Beatrice Lille about the fairies at the bottom of *her* garden, a name subsequently sometimes applied to other underground washrooms).

Ibid., p. 192 In the Depression the Square swarmed with boys. Poverty put them there. Transient boys went to Times Square to play the queers, forcing the fairy prostitutes to move east of Sixth Avenue to Bryant Park.

Ibid., p. 421 Tennessee Williams cruising Times Square in the early 40s where he made "very abrupt and candid overtures to groups of sailors or GIs, phrased so bluntly that it's a wonder they didn't slaughter me on the spot … They would stare at me for a moment in astonishment, burst into laughter, huddle for a brief conference, and, as often as not, would accept the solicitation, going to my partner's Village pad or to my room at the 'Y.'"

Reay, pp. 93–4 "Corner of 42nd Street and Broadway," Charles Henri Ford wrote in his diary in 1948, "meatmarket in the rain: a seaman wearing tight light blue jeans and dark knitted cap. If I had gone up to him and said, 'How much' and he'd have said, 'For what?' and I'd have replied, 'You know for what.'"

Ibid. At the corner of 42nd Street and Broadway in 1951 to 1952: Like everyone whose life is conditioned by luck they had some brilliant streaks of it and some were dismal. For instance, that first week they operated together in Manhattan. That was really a freak; you couldn't expect a thing like that to happen twice in a lifetime. The trade was running as thick as spawning salmon up those narrow cataracts in the Rockies: head to tail, tail to head, crowding, swarming together, seemingly driven along by some immoderate instinct. It was not a question of catching: it was simply a question of deciding which ones to keep and which ones to throw back in the stream, all glittering, all swift, all flowing one way, which was toward you!

Rechy, p. 30 The world pours into Times Square like lost souls emerging from the purgatory of trains.

Kerouac, *Lonesome*, p. 108 Ashamed of being seen going into the dirty movie (what's its name?) across the street from the New York Times.

Ibid. Strange duos of girls coming out of dirty movies.

The diamond-district shop windows on Forty-seventh Street, heaped with gold and precious stones, gave way rapidly to the skyscrapers of Rockefeller Center, followed by the theaters of Broadway. Ten squads of prostitutes, crummy movie houses with Xs on their signs, and cheap joints where, fliers promised, satisfaction was guaranteed for seven dollars. Past houses whose windows were boarded up with plywood, catching occasional glimpses of ruins that looked like bomb sites. The white faces vanished. And then a stunning white girl stands in the middle of the sidewalk, shirt unbuttoned, breast bared. She lifts her elegant skirt, and, squatting down, urinates. Two men bustle around her, one with a camera, the other with a reflector.

Lobas, p. 44

There is a broken heart for every light on Broadway.

Miller, "Festive"

A street of synthetic romance, of phony titillation.

Walker, *Night Club*, p. 199

Leaning against that cigar store with a lot of telephone booths on the corner of 42nd and Seventh where you make beautiful telephone calls looking out into the street and it gets real cozy in there when it's raining outside and you like to prolong the conversation, who do you find?

Kerouac, *Lonesome*, p. 108

Times Square is extinct during the day, and almost so at night.

Petronius, p. 19

Eighth Avenue

Eighth Avenue is a sad, sick street whose neon lights dangle over the dandruff of bartenders.

Talese, p. 116

Eighth Avenue begins at a defunct public bathroom off West Twelfth Street.

*Ibid.*

Eighth Avenue is where hoodlums attacked a longshoreman named Clifford Jordan and knocked his glass eye into a sewer.

*Ibid.*

All around Eighth Avenue are cut-rate drugstores, some of which have telephones that are so sticky you hate to press them to your ear.

*Ibid.*, p. 118

… and in 1925 huge holes were dug into Eighth Avenue.

*Ibid.*, p. 125

On a June day in 1927, workmen scooped up six coffins on Eighth Avenue about Forty-fourth Street—coffins with expensive wood and nails. But the workmen quickly cleared the area of coffins and installed chewing gum machines.

*Ibid.*, p. 126

Conrad, p. 145	Apollinaire imagined that the New York Public Library was made of white marble and owed its present soiled hue to being washed each day with brown soap.
Ibid., p. 311	Gay Talese sees the whole city as engaged in this famished consumption and excretion, ridding itself daily of tons of trash, leaving unclaimed umbrellas in the lockers of the Port Authority bus station, and distributing dead animals through the streets.
Jones, *Modernism*, p. 224	Skimming the fouled streets of Greenwich Village in blacknight the stench of uncollected garbage newly cut wood steamy stinking tar fills the air—New York—filled with influenza rot—expands with Europe desolately warruined.
Conrad, p. 314	Writing in 1961 about a novelty shop on the Lower East Side, Oldenburg equates it with the wealthy museums uptown. The store is a "place full of objects," and thus a demotically livelier version of the art mausoleum. "A refuse lot in the city," he argues, "is worth all the art stores in the world." His dream is to inhabit the street as a studio and to define the pavement as a canvas.
Ibid., p. 311	Oldenburg in 1966 marveled that "the chief production of New York is garbage."
Berman, *Solid*, p. 391	Oldenberg: "Dirt has depth and beauty. I love soot and scorching." He embraced "the city filth, the evils of advertising, the disease of success, popular culture."
Ibid.	The essential thing, Oldenburg said, was to "look for beauty where it is not supposed to be found."
Ibid., p. 320	Oldenberg: "I am for an art that tells you the time of day, or where such and such a street is. I am for an art that helps old ladies across the street."
Conrad, p. 95	The ashcan, which had been the emblematic trophy of the realists who scavenge among and rejoice in the city's refuse, undergoes conscription. The waste cans on Fifth Avenue are marked "It's against the law to throw litter into the streets—use this can." Imagine the Anarchist joy in plunging into the can and scattering the waste over the avenue!
Atkinson, pp. 17–18	There is a low door at the back of the sanitation truck and a kind of conveyor belt that bangs away endlessly as it turns. The men hurl the contents of the ash barrels and garbage cans in the general direction of this maw, and a little of it is caught and conveyed into the truck. A wild dense cloud of ash floats out and settles on passers-by and drifts into open windows. Cinders rain down, and bottles smash, and broken glass tumbles crazily to rest under the tires of the parked automobiles. The smell of old, disturbed vegetables and ancient fruit hangs heavy between the buildings, and masses of old fruit and vegetables are ground into slippery paste by the heavy, hurrying boots of the sanitation men.
Ginsberg, *Howl*, p. 3	ashcan rantings
Reitano, p. 111	Ashcan school: a Hester street pushcart is a better subject than a Dutch windmill.

Realism enables him to tolerate, even to delight in, the physical soiling of New York.

Conrad, p. 92

Sloan's subway etching sees paint as a sensual lubricant. But it's also dirt. The painter is a licensed mess-maker. Sloan can enjoy the soiled and stained reality of New York because his own profession contributes to that festal grime. When writing his diary, he takes pleasure in his new fountain pen "which is making these marks" and sullying the paper. With the same comically scatological thrill, he records having taken delivery of an expressed box of printing ink. Part of Robert Henri's teaching was a messy and incontinent liberation of pigment. His students were taught to be unashamed of the filth they dabbled in, just as they were unembarrassed by urban ugliness. At the New York School of Art on West 57th Street they flung the leftovers from their palettes at a wall, which soon became impasted with an iridescent murk. Sloan concedes the alliance between paint and dirt when, on a walk through the East Side slums in 1906, he comments that the "grimy and greasy door frames" of the tenements look "as though huge hogs covered with filth had worn the paint away and replaced it with matted dirt." Here paint and dirt compete, but they're allies all the same. Paint is the accretion of sentiment, the varnishing of age and affection; dirt, too, testifies to use, wear, long familiarity. Dirt, like the spot on Yeats's vest, vouches for the reality of things, as paint is trying to do. One of Sloan's pictures—his scrubwoman in the Astor Library in 1910—shows the city being scoured and cleaned. Yet the artist undoes the woman's labor by muddying the scene all over again in paint.

Ibid., p. 94

Sloan's impish pleasure in the city's uninhibited disorder, which makes him dream of overturning those waste cans, will turn when the surrealists arrive into a calculated assault from beneath on the normality and reality which the official city purports to uphold.

Ibid., p. 95

"Six O'clock, Winter" (1912) is somberly toned. An El train flares against a lurid sky, a compressed and perhaps oppressed mob surges beneath its tracks. On the day Sloan began the painting he had twice been involved in the panic of an agitating mass, first at Grand Central, where some socialists from the west had missed their train and blamed a capitalist plot, then at the Labor Temple.

Ibid., p. 94

Convinced that city dwellers reveal themselves in what they discard, literally giving themselves away in their garbage, Capote in April 1979 tested his expertise at trash decipherment by accompanying his cleaning lady on her rounds. In the empty apartments she services, he guesses at the character of the occupants. Fatty snacks cram the freezers of the rich Jewish couples. An airline pilot has, strewn through his apartment, a flotsam of miniature vodka bottles; between his seamy sheets is impasted a gooey collage of mayonnaise, chocolate, chewing gum, cigarette butts, and lipstick.

Ibid., p. 307

Once the rubble has been cleared up and the vile smells it gave off have drifted away, its version of the city is benign, for it arrives at ecological peace. Tinguely carried his machine's members back to the dumps of Plainfield and Summit: earth to earth, garbage to garbage.

Ibid., p. 310

W.B. Yeats, on the pier from which rubbish is shipped, watching the barges being loaded with the offal the city has evacuated.

Ibid., p. 92

Huxtable, *Goodbye*, p. 132	Vincent Scully on the new Penn Station: "One entered the city like a god ... one scuttles in now like a rat."
Trager, p. 628	Penn Station: the majestic station's pink walls, once sparkling, are now covered with grime.
Huxtable, *Goodbye*, p. 49	Six murals by Jules Guérin, huge topographical maps of Pennsy territory in sky blues, pale browns and yellow, high in the reaches of the massive walls, gradually disappeared under layers of the same soot. Generous deposits turned the exterior Massachusetts granite from warm pink to dingy gray. Now marble pomp has been reduced to rubble; stone to dust.
Corbusier, p. 78	Grand Central Station is kept clean constantly by an army of excellent Negroes who are polite, attentive, and never obnoxiously grasping.
Severo	A hunk of fetid ham fat from 1984 that remains as disturbingly plump and supple as the day it was trimmed from somebody's dinner; a July 10, 1982, front page from *The Daily News* announcing a jet crash and looking surprisingly crisp, even after seven years of foul entombment; and assorted shards and snippets of plastic and paper, innards and once-edibles, oddments long forgotten by the New Yorkers who bought them, consumed them, then unceremoniously discarded them.
Oatman-Stanford	If you do a core sample of Fresh Kills, which has been done, and you pull up these early layers, you can still read the newspapers from that era. I've seen slide shows from archaeologists who've done this work and the hotdogs look like you could throw them on the grill. But they're from the 1953 layer of Fresh Kills.
Hughes, "Culture"	One of the peculiarities of a place like the city dump is that it makes you realize that New York throws away in the course of a week probably more manufactured goods than were produced in 18th century France in the course of a year. The motto was replacement, not maintenance, disposability and not durability.
Morris, *Manhattan '45*, p. 53	The garbage thrown away in this city every day—every day—would feed the whole of Europe for a week.
N. cit.	An investigation conducted in July, 1932, showed that in 50,000,000 cubic feet of New York City air there was one pound of dirt.
Weberman	Each square mile of Manhattan produces 375,000 pounds of garbage per day, 80% of which is paper.
Hoffman, *Autobiography*, p. 97	Two thousand people joined in a sweep-in, and one cross street in Manhattan was made to sparkle.
Ibid., p. 98	Years later Reverend Moon appropriated the tactic, sending out smiling moonies in spotless white coveralls to clean up New York. The sight of them coming down the street with their brooms was chilling.
Thomas, "Brave"	In Colonial days New York City got rid of its garbage by letting pigs roam freely about the streets to eat it. But even an army of starving pigs couldn't digest the six million tons of refuse the city now produces each year—enough to fill the 102-story Empire State Building, the world's tallest, 30 times. In a city where 30 tons of trash are carted out of the cavernous subway

V Dirt

system alone each day, 14,000 sanitation workers battle the daily garbage problem.

Before New Yorkers burned or buried their waste, they pitched garbage out their windows onto city streets, where it was consumed by scavenging pigs and dogs.

Royte

Sometimes as many as twenty thousand, were the street cleaners. Charles Dickens did not like New York because of them.

Granick, p. 16

Weegee's photographs define the dead as the city's rubbish. They litter and stain its pavements, or (in one of his crime shots taken in a restaurant) lie under tables on which the chairs have been stacked, waiting to be swept up by the janitor.

Conrad, p. 277

New York is great only while still growing. Of its unending self-revision, the symbol is litter.

Ibid., p. 300

As the evicted litter blows or rambles down the streets, so people drift through New York, never to return. You daren't pretend to belong there. Urban wisdom demands that you accept the randomness of your apparition in and disappearance from the city.

Ibid.

Our thrown-away plastic bags are their suitcases, and the heat we expel from our buildings provides them with hearths: they curl up to sleep over warm outdoor gratings. They're parsimonious feeders on the city's second helpings.

Conrad, p. 311

Plastic bags twisted around branches of trees become year-round foliage, transforming bare winter oaks into everblues and everreds, technicolor displays that make New England Octobers pale by comparison. Seasonal narratives take on a rogue character: older bags, their shape deformed by sunlight and rough weather, disintegrate into fluttering flaglike shreds before being blown off the trees by gales. Those same gales attach fresh bags to the trees, blossoming anew each day.

Goldsmith, "Displacement"

The illusion that there's an "away" to which we can throw things, then it's all sort of magic. It just goes "away."

Oatman-Stanford

There was a gigantic dung heap somewhere in the '40s on the East River. It created a horrific stench for anybody down wind of it. The pile was illegal, but it had been there for years and years. The owner sold it as fertilizer.

Ibid.

Miss Foley, the Waldorf housekeeper, has over two thousand rooms in her household; with 30,000 face towels and 54,000 sheets in her linen cupboard, her laundry bill must surely be excessive. Each day over 60,000 pieces of linen are sent to the wash. In this vast, modern, efficient hotel, that employs "every possible comfort-bringing, labor-saving device," it would seem that even used razor-blades must find some utilitarian fate. What becomes of them once they are dropped into those accommodating slots in the bathrooms? Perhaps they reach the world again as part of the steel chassis of a motor-car or add just one more steel drop to the ocean that goes to make a girder, forcing the world higher still to the sky? But no, enquiry reveals that Miss Foley allows the blades to lie idle behind the slots, waiting for the day when the cavities have been filled up before finding a use for the discarded relics.

Beaton, p. 43

Blandford, p. 51 Most family apartments are old and awkward, with floors that encourage polishing and windows that have been painted over so often that opening them becomes a mighty feat. Should they open, the dirt that flies in is of a character associated with a nineteenth-century mill town. It is a six-hour job vaguely to clean such an apartment.

Riesenberg and Alland, p. 67 Windows half open or unwashed.

Corbusier, p. 46 People who wash their shirts, paint their houses, clean the glass in their windows, have an ethic different from those who cultivate dust and filth.

Douglas, p. 48 Robert Ripley seemed to live in excrement. Anyone could smell the fact that he seldom bathed; his nails were black with dirt, he gobbled and sucked his huge meals; and he actually ruled a "harem" of girls of every nationality near his private zoo on a Citizen Kane–scale estate in Mamaroneck, New York.

Fritscher, p. 42 New York is a dirty city of a dirty present and a dirtier future.

Hollander, p. 217 The city was at its ugliest then. The buildings were all covered in soot and in various states of disrepair. Access to the sky was severely restricted by the ludicrous height of these block-shaped edifices.

Caldwell, pp. 300–1 As Manhattan's last elevated line began coming down in 1955, Third Avenue emerged from beneath its tracks and girders like a hungover drunk waking up in the sunlight: it was disheveled, grimy, unsure where it had been or where it was going. The el had been running overhead 24 hours a day since 1878, depressing real estate values but also offering cover to seedy bars and a vital if shady street life. When the rows of dingy brick tenements, their begrimed windows, and their aged storefronts emerged into the harsh Manhattan light, for a time they remained a mocking contrast to the new, clean, and spare International Style skyscrapers that were beginning to rise in midtown.

Huxtable, *Goodbye*, p. 26 The area was encrusted with the dark and gritty sediment of endless seasons of concentrated use and abuse that no rain or garbage removal ever touches.

Sanders, *Celluloid*, p. 27 Film by Edwin S. Porter for Edison: *Sorting Refuse at Incinerating Plant, New York City.* (1903)

Conrad, p. 185 Their only means of communication is the service shaft. The flats are united by the mute mediation of the dumbwaiter: doors open into this empty column from every apartment on each floor, so commingling is confined to the chute reserved for the delivery of groceries or the disposal of garbage.

WPA Guide, p. 51 Streets littered with papers, bags of garbage shooting out of windows, lines of pushcarts selling food, neckties, pictures, bric-a-brac.

Trebay, p. 63 I am thinking now about Eighth Street, in particular the stretch off Broadway that's perpetually bathed in the warm greasy breeze of the Riviera Cafe's exhaust fan, a cheeseburger sirocco. It's a short, drab block with truck loading bays on its north side and, on the south, the blank rear wall of a large union building. A nothing street you hurried down on the way to the IRT. Empty, as far back as I can remember, except for the odd drunk, or a dozer in a box.

V Dirt

Then one day—and what would be the timetable on this? Two years ago? More?—the street was full of people unloading onto flattened cartons and unwound bedrolls what looked like their worldly possessions. "Jerks selling junk," a friend called them, although by the time she made the remark the nature of what was offered for sale on Eighth Street had evolved in a quantum way.

Where at first the vendors hawked bric-a-brac and very used clothes, over time other merchandising veins were opened. Not that the stock of mateless plates, ceramic Bambis, and cheap suit jackets dried up. These things exist in inexhaustible supply. They were just joined by other bits of sham and gimcrack in amounts that doubled, quadrupled, multiplied until on a summer afternoon Eighth Street (and, for accuracy's sake, I should mention that the phenomenon leaps Lafayette Street to a patch of parking lot sidewalk and then crosses Fourth to Cooper Union) is littered with profligate quantities of flea-bitten unassimilable junk, all of it for sale. And selling.

Usable objects not worth selling could be disposed of easily. You just put them out on the street and they would disappear, within minutes, as if they had been thrown into a river. Depending on the building, a similar result might be obtained by putting the stuff in the lobby or a stairwell. When I finally threw out my old green couch, though, nobody would touch it. I felt personally insulted. It was admittedly a little ragged, but its springs were all present and intact, and it was long enough to serve as a comfortable spare bed. The cushions, of course, were nabbed immediately, but the rest of it lingered on the sidewalk until someone stuffed it awkwardly through the back door of an abandoned car and set it on fire. Sante, "Commerce," p. 107

Everybody's seen them, parked and plateless, belly up or sitting on their rims, hoods propped open, innards gutted. "People think nothing of abandoning a car at curbside, but what we're talking about basically is 3000 pounds of litter in the street." He refers to the picked-over automobiles as an "eyesore condition." In some neighborhoods, car dumping is so popular it creates entire eyesore regions. Riverside Park is one. So is Marine Park near the Belt Parkway. Stretches of Third, Fifth, and Eighth avenues in Harlem. Eighth Street between B and C. The popular reeds and cattails of the Crossbay Boulevard shoulder. Bruckner Boulevard. The Newton Creek. The Gowanus Canal. Any part of the East River with an open pier. Trebay, pp. 321–2

Like most dead things in New York, abandoned cars have their own municipal Charons. Ibid., p. 322

In Manhattan, the wife of a movie magnate threw two Rolls-Royces and a Hispano-Suiza automobile into the WWII ammunition heap. Diehl, p. 166

Coins, paper clips, ballpoint pens, and little girls' pocketbooks are found by workmen when they clean the sea lions' pool at the Bronx Zoo. Talese, p. 2

In Rockefeller Center where, after all the wastepaper has been dumped in baskets, it is stored for forty-eight hours in warehouses. Even vacuum cleaners are held for twelve hours before being emptied, a practice that has paid off in the recovery of jeweler's gold dust, diamond rings and many tiny gems. Ibid., p. 35

Women leave tissues behind in the subways and think nobody notices. Ibid., p. 102

I burrow the trashcan in the Square pigeon alighting on my breadcrust. Jones, *Modernism*, p. 227

Auster, "Fogg," p. 105 I began giving funny names to the garbage cans. I called them cylindrical restaurants, pot-luck dinners, municipal care packages.

Mayakovsky, *America*, p. 53 Bins filled with every kind of garbage stand there, and from these the poverty-stricken pick out any not entirely nibbled bones and pieces. Stinking puddles from today's and the day before yesterday's rain lie there cooling. Litter and putrefaction lie about ankle-deep—not just figuratively ankle-deep, but literally and for real. And this is within a fifteen-minute stroll, or a five-minute ride, of sparkling Fifth Avenue and Broadway.

Philips, p. 23 The litter baskets—they look like volcanoes of trash that have just erupted—are overloaded from a Sunday's use. Debris is strewn over the pavement and in the gutters. A wind stirs up scraps and creates a funnel of newspaper that swirls up in a mad ballet.

Atkinson, p. 16 When trash containers were first put on street corners, they were stolen.

Ibid., p. 17 Barrels of ashes and garbage stand bulging along the sides of the buildings, spilling their contents. Passers-by unwittingly brush against them, and loose papers and rags float on the breeze. Bad little children amuse themselves by kicking the unsavory stuff. The automobiles that stand solidly head to tail at the curbs fine hide-outs for fruit peelings and old vegetable under their wheels.

Riesenberg and Alland, p. 28 Business buildings clean only the first story of their premises.

Ibid., p. 142 People who clean up, working largely for the love of it, are picking cigarette butts and removing chewing gum from under marquees, dark with turned-off lights.

Binzen And under the chess tables, at the end of a long day, matches, papers, butts, broken bottles, Vietnam leaflets, junk galore, all to be swept up by little men in green uniforms at the dawn of a new day.

Donleavy Sanitation department truck, grey lumphing insect vehicle squirting water and spinning a big brush along the gutter.

Mitchell, *Ears*, p. 136 Outside, in East Twenty-fifth Street, the wind blew, the cold wind from the dirty river. The wind blew dirty scraps of newspapers along the dirty street.

Dreiser, p. 10 Here comes a chip, there goes a wisp of straw. A tomato box comes leisurely bobbing upon the surface of the stream.

V Dirt — Strike

Strike

Binzen During the Great Garbage Strike, the residents on Tenth between University Place and Fifth Avenue, once their garbage cans were full, put the excess in strangely vulgar-looking see-through plastic bags. But whatever their appearance, they were effective, and the sidewalks remained clean.

Further east on Tenth Street the garbage just piled higher and higher in great smelly pyramids that soon threatened to engulf entire city blocks in as pungent and surrealistic a happening as this city ever held. One night, between Avenues B and C, someone started throwing his slop out of the window. This immediately developed into a block project. Two hours later that

section of Tenth Street was ankle-high in wall-to-wall garbage. It proved to be a swift and altogether satisfying solution to the problem, though, for the city saw fit to remove the mess during the night, and the next morning that block was cleaner than it had ever been before.

With many once-clean sections of New York looking like a vast slum as mounds of refuse grew higher and strong winds whirled the filth through the streets, Mayor Lindsay made a brief inspection tour and reported grimly that, "the situation is getting very serious." "When City"

A sanman's annual salary ran from $6,424 to $7,956. DeLury wanted a $600 hike. The city was offering $400. Ten thousand persons walked off their jobs. Rubbish fires flamed nightly. Storm sewers backed up. Hungry rats swarmed in by the battalion. The grim specter of deadly disease stalked the streets. *Ibid.*

Said Health Commissioner Edward O'Rourke, "There's no need to wait until somebody dies, comes down with typhoid fever, breaks his neck falling over a pile of garbage, burns to death in a fire or comes down with dysentery or hepatitis."

A corner is piled with black-bagged garbage, rising in a mound between a lamppost and a mailbox. There are no people on the pavement. The city seems to belong to the trash. At the corner, angled toward the street, sits an abandoned armchair. Some bags of litter repose in it to watch the world go by. Refuse here provides an amenity for its own kind: a park bench for the city's rejects. Conrad, p. 305

The city grows its totems, as on this street corner. They accumulate, like garbage, by haphazard accretion. *Ibid.*

Well, last Sunday I walked after lunch from 36th Street along Sixth Avenue to 16th and I have never imagined that such filth could be found in a city street as there we had to walk on. The paper repositories in all the side streets were piled high with *immondices* of an intimate and unmentionable kind and these with every conceivable other disgusting object overflowed from the side-streets onto the Avenue itself. And the queer thing was that although I was hardly able to desist from retching and wished incontinently to take a taxi, my companion—of a normally more delicate nature—said, no, the exercise would do us good and accepted the garbage as being all in the day's journey. Ford, *America*, pp. 79–80

Debris was everywhere in the street and sidewalks. Third Avenue traffic had not yet started. The streets were deserted. Hollander, p. 79

Dark, dirty streets littered with trash and garbage, but trash from what usage? And garbage from what foods and what containers? The smell of death and rot is here, from decay of unfamiliar offal. Burroughs, p. 1745

At the end of the 1975 garbage strike: "Today the city had enough garbage to construct two piles the height and width of both towers of the 110-story World Trade Center." Maull, p. 2

Riesenberg and Alland, p. 71	The dredging and washing out of the polluted silted rivers. The bottom blanket of rare old vintage germs, if spread by machinery, would fertilize a Desert of Sahara.
Ibid.	And some day gigantic liners—floating cities—will no longer empty their sanitary waste into our beautiful harbor.
Caro, p. 393	If Charles Dickens had been looking for an illustration for an American edition of *Hard Times*, he could have stopped looking when he got to that riverfront. The stretch between Ninety-second and 125th streets was a catalogue of the unlovely by-products of industrialism; scented with raw filth pouring from open sewers into the river below was a long row of small, grimy factories, used-car lots, auto-repair shops, junkyards, coal pockets and oil-storage depots. Hogarth could have found a whole gallery of models in the occupants of the bars, whorehouses and tenements that mingled with them.
Trebay, p. 332	The joke on Hylan Boulevard last week went that if you held a syringe to your ear, you could hear the ocean. Beginning with a high tide over the previous weekend, medical waste had been washing up on Staten Island's shore almost daily. Each new cycle brought fresh harvests of pill bottles, blood vials, and needles. As if that weren't enough, a city sewage treatment plant overflowed on Thursday and added 20 million gallons of bilge to the nightmare soup.
Mumford, *Empire*, pp. 32–3	During the 1900s, the city was losing its sense of the rivers, despite the extension of Riverside Park. Sewage pollution had driven the North River shad away and made all other kinds of fish that might be caught noxious; so that the old gaffers with their set-lines and bells had disappeared from the Hudson, along with the groups of happy naked swimmers, and another link with nature was broken, even as later, because of pollution from the oil-burning steamers, the waters of the Lower Bay lost the bluefish and weakfish that had once been so plentiful there.
Spillane, p. 252	A breeze was blowing up from the water, carrying with it the partially purified atmosphere of a city at work. It was cool and refreshing, but there was still something unclean about it. The river was gray in color, not the rich blue it should have been, and the foam that followed the wake of the ships passing by was too thick. Almost like blood. In close to shore it changed to a dirty brown trying to wash the filth up on the banks. It was pretty if you only stopped to look at it, but when you looked too close and thought enough it made you sick.
Trebay, p. 333	"No way am I going in the ocean and catch AIDS."
Ibid., p. 332	77 hypodermics plucked from the sand since Saturday afternoon, a number that topped 200 by the end of the week.
Ibid., pp. 332–3	An unreported truth is that few people swim at Staten Island beaches, they've become so foul: New York harbor meets the Atlantic above the south shore, and the water there is a scientifically diverse and constant scum.
Ibid., p. 333	Tide-composed still lifes of tampon applicators, fireworks, glass shards, and chicken bones.

Dirt — Water, River, Beach

The hypodermics were easiest to spot. Plungers jutted up from tangles of seaweed … The syringes were pencil-thin, sand-caked, and of a type used to administer insulin or skin-pop illegal drugs.

Ibid.

Needles on the beach are part of the ecology of New York, as much as crack vials are part of the ecology of Washington Square.

Ibid., p. 334

The surf between the shore and the end of a jetty was glazed with a 40-yard coating of oily filth. Cork, straws, and cigarette butts swirled in meteor shower patterns. Spent condoms waved in the wash.

Ibid.

Here at the waterfronts, barges heaped with the city's garbage swayed in the greasy, dark water, great mounds of a city's refuse suspiring in the sun like a glutton lolling after an orgy. One felt that, had one listened sharply enough, one would have caught its thick, throaty breathing; the mounds seemed to move, rising slowly, falling slowly, a great stomach on a couch.

Barnes, p. 290

An enormous pancake of dirt spread beside the Manhattan Bridge, mostly surrounded by river.

Wojnarowicz, p. 133

The river was dirty and coming towards me in the wind, a smooth chest trembling with sweat.

Ibid., p. 137

The Gowanus used to freeze at times in winter and tugs had to break the channel clear. Now, its antagonists suspect, the chemicals in it act as their own antifreeze.

Philips, p. 137

It's said that you can't judge an ocean by what washes ashore. Or perhaps the proper verb is shouldn't. If the composition of the Atlantic was to be inferred from the myriad pink tampon applicators that adorn Jones Beach, would anyone ever go in? I would not like to venture an opinion. So it is with the tidemark of detritus on Eighth Street. You pick your way along and avoid any sweeping conclusions about the culture.

Trebay, p. 66

New Yorkers would never drink Hudson water, even if it were made twice as pure as Catskill water (as it could be). The stuff is "psychologically unpalatable."

Perrin, pp. 76–81

The water used in New York is soft water.

Atkinson, p. 227

Do not imagine that I scampered around those velvet sewers completely unscathed.

Wornov, p. 169

Broad St., near Wall St., began as a brook. The Dutch, homesick for Holland, widened it into a canal with a roadway and it became the City's first "common seuer."

Granick, p. 40

Mid-twentieth century New York still uses some brick sewers put down in the early nineteenth century. They're mostly below Canal Street. Parts of the Canal Street sewer carry their twentieth century load after 145 years.

Berger, *New York*, p. 21

As late as 1900 there were still thousands of toilets which led to cesspools.

Granick, p. 40

In 1902, Mayor Seth Low embarked on what may have been the world's first instance of driving a car through a sewer, causing the *New York Times* to proclaim that "automobiling through sewers is the very latest thing." Two

Solis, p. 45

cars were lowered into a 15-foot-wide conduit beneath 64th Street in Bay Ridge, which had been atmospherically lit with candles. The mayor and his entourage climbed down a ladder at Fourth Avenue and drove through the finish stretch of a pipe that, at a length of 300 miles, was intended to be the largest sewer in the world.

Granick, p. 40

Open sewers ran alongside Canal St. as late as 1918.

Ibid., p. 42

In 1938, Department of Public Works took over responsibility for sewage treatment in time to service the 1939 World's Fair.

Ibid., p. 40

First sewer gutter drains made of wood, then of stone, later of brick.

Ibid., p. 43

The sewage from buildings leaves through six-inch pipes that connect with the street sewer. The street sewer is twelve inches in diameter, laid eight to twelve feet below street level. Its sewage flows into a collecting sewer that is usually five feet or more in diameter.

Atkinson, p. 226

Nobody knows how many toilets there are on Manhattan Island. Since it takes five gallons of water to flush a toilet, there's another ocean used up every day.

Granick, p. 43

All the solids in sewage amount to no more than a spoonful in a big barrel of water. NYC's sewage is about a billion gallons a day, containing one thousand tons of solids.

Ibid.

Five Boroughs, 17 drainage areas, each sloping toward a waterway. Sewers follow the banks of the city. All sewers are built at downgrades.

Ibid.

Sewage plants at the extreme western end of Canal St. are completely underground and below water level; remaining sewage flows into the Hudson. Coney Island into the ocean.

Ibid., p. 46

Large quantities of digested sludge are used as fertilizer in City parks. Sludge dumped ten miles out in the ocean.

Trager, p. 506

The city's first sewage treatment plant is constructed on Coney Island. New York has been pouring nearly 1.5 million gallons of raw sewage into the harbor each day.

Galwey, p. 421

Huge naked breast of water
Saturated lead by sewers—

Garbology

Weberman

One day in September, 1970, Ann Duncan and I were on our way to the Cafe Gaslight on MacDougal Street and we happened to pass Bob Dylan's townhouse. For four long years I had been studying Dylan's poetry, trying to crack the code of his symbolism. As I eyed the home of the reclusive poet I wondered what went down behind the door that Dylan had slammed in my face when I had tried to discuss my work with him. Just then I noticed Dylan's shiny new steel garbage can. My mind flashed back to a Lord Buckley riff from Johanna and Whale: "I ain't outside anymore, I'm inside now," and said to myself, "Now, there's something that was inside and it's outside now." I lifted the lid, I opened Pandora's can, I reached in and the first thing, THE

FIRST THING, that I pulled out of Dylan's garbage was a half-finished letter written by Bob Dylan to Johnny Cash. "Holy Moley," I said, "Ann, this is no ordinary garbage-can, this is a gold mine!"

After my initial discovery in Dylan's garbage I realized that this method of research had great potential as a clandestine method. The lives of the rich, famous and powerful could be penetrated, great secrets revealed, plain truths brought to light from beneath the glittery facade. Garbology was a new weapon in the war against lies, injustice and faceless bureaucracy. The study and analysis of garbage could possibly alter the course of history! I resolved at once that aided by this valuable science I would leave no stone unturned, no garbage can lid unturned, in my quest for truth.

Ibid.

One night I went over D[ylan]'s garbage just for old time's sake and in an envelope separate from the rest of the trash there were five toothbrushes of various sizes and an unused tube of toothpaste wrapped in a plastic bag. "Tooth" means "electric guitar" in D's symbology …

Eisen, p. 179

My fantasy was that I would find first drafts of Dylan's poetry (Dylan eventually published some stained first drafts in his book *Poetry & Drawings*, published by Knopf) or a Rosetta stone that would unlock the secrets of his symbolism. But the reality, as I began sorting through the bags, was a harsh one, especially when I hit a layer of disposable diapers. It reminded me that Dylan and his wife Sara had just recently had their fourth child. I made my way down through a layer of kitchen refuse—vegetable cans, Blimpie wrappers, coffee grounds. His eating habits seemed normal enough. No evidence of "brown rice, seaweed or a dirty hot-dog." Underneath the kitchen stuff a new layer came to light, composed of rock-and-roll magazines. There was *Rock*, *Rolling Stone* and even an issue of *Crawdaddy* which contained an article that I had recently written. I was deeply hurt by this. Why had Dylan insulted me by throwing it away rather than filing it in his "Weberman" file?

Weberman

After about ten excursions through Dylan's garbage can over a two-week period in September 1970, I began to piece together a very clear picture of the person he really is and the life he was living at that time. Essentially, the mythic Bob Dylan—romantic, revolutionary, visionary—was dispelled forever by thorough garbanalysis. Instead, he was revealed to be a typically upper middle-class family man with very ordinary day-to-day household concerns. From his pail I gathered bills from the vet concerning treatment of Sasha's upset stomach; invitations to Sara to attend private sales at exclusive department stores; dozens of mail-order cosmetic offers; all the high fashion magazines, addressed to Sara; a package from Bloomingdale's addressed to one of Dylan's many pseudonyms, and charged to Sara Dylan's account. I also found a bill from the Book-of-the-Month Club, and a memo to Bob Dylan regarding the upcoming monthly meeting of the MacDougal Street Garden Association.

Ibid.

The only remotely political piece of trash I was able to find in his garbage was a poster from upstate New York with a personal note on it from a local folksinger in Woodstock, asking Dylan to please vote in the upcoming election for this particular Democratic county committeeman. It was true, though, that despite the fact that he was a millionaire, Dylan's garbage was not extravagant. There were no empty caviar tins, no drained bottles of rare wines. The typical shopping list for the Dylan household included items such as cookie mix, liverwurst and granola.

Ibid.

Jackie Onassis's trash: There were two Brut Champagne bottles (Vintage 1966) and one Cole De Beaune Villages bottle (Vintage 1969). Typically, there were empty perfume bottles—Estée Lauder Sport Fragrance Spray, perfumed lavender bath scent, a refillable spray container of Chanel No. 5 and an Avon Fashion Figurine that once held Field Flowers Cologne. There was dental floss, toothpaste and five empty packs of Ambassador cigarettes; Wella Care herbal shampoo, Instant Quaker cereal, Melba toast, etc., etc. I also found one of her famous leather gloves, plastic wrappers from pantyhose, a perfectly good scarf and two pairs of Jackie's pantyhose, one of which I am wearing proudly at this very moment as I type this chapter. I also found some ribbons with "Happy 13th, John" and "Sweet Sixteen, Caroline" written on them in glitter along with a piece of stationery with John Kennedy, Jr. printed on the bottom of it. There was a wrapper from a famous European jeweler, marked "To Mr. Onassis" and another marked "To John."

Walrod, p. 51

Super-picker Robert Loughlin once found a Salvador Dalí portrait at the Salvation Army on Spring Street in 1994. He bought the painting for $40, and later sold it at a Sotheby's auction for $78,000.

Purity, Whiteness, Cleanliness

Conrad, p. 137

To purify New York, one must blanch it.

Ibid.

Contrasting the crystalline White World of the ideal, therapeutic New York with the befouled Brown World of the past.

Ibid.

The whiteness of New York's mercantile cathedrals signifies their clinical disinfection, free from the soiling patina of age. Glass, with which New York walled its buildings, is a medium of moral superiority, hiding nothing, not straggling back into mud and murk like brick and stone.

Ibid., pp. 137–8

Appropriately, Le Corbusier's first view of New York was from his liner while it was anchored in quarantine. He sees it from within a sanitary cordon and admires its gelid beauty. Disembarking, he finds it to be carnally real and repellent. Before he can approve of it, it must be pristinely repackaged, insulated from the bacterial atmosphere. He commends the cellophane casing of sandwiches, the polished bar tops, and the trains in Grand Central, which are kept spick and span by legions of black janitors. But the apogee of his cleansed and hermetically sealed New York is Radio City, where he goes with Léger to make a broadcast. As its name proclaims, it's a city within— and immunized against—the city. It's installed "in one of the skyscrapers of Rockefeller Center," safe from the savage, infested outdoors. He likes the claustral hush of its elevators and corridors and gratefully breathes its filtered and tempered air. Radio City is one of his bloodless cathedrals. Inside the studio he sees another room made by muting and insulation: a glass aquarium for spectators, who can chatter at will without being heard because their booth is soundproofed.

Ibid., p. 139

New York's remade whiteness is fantasticated by Léger, who reports that scientists have found a way of making glass from curdled milk and imagines the cows of America laboring for the reification of the city and its conversion to transparency.

Corbusier, p. 46

Cleanliness is a national virtue in America. No filth, no dust.

344

There is a style, a true style, in American cleanliness. *Ibid.*

The offices are clean; the bath tubs, the shops, the glistening hotels; the *Ibid.* dazzling restaurants and bars. The immaculate personnel, in shirt sleeves, is shining white. Food is wrapped up in bright cellophane. There is no more real dust than there is symbolic dust, everything is new and spotless.

In New York you have to clean so much, and when you're finished, it's not- Warhol, *Philosophy*, p. 159 dirty. In Europe people clean so much, and when they're finished, it not just not-dirty, it's clean.

Tehran, in Iran, is cleaner than New York. Atkinson, p. 15

New York is too big to be kept clean. *Ibid.*, p. 18

Corbusier, p. 72 If the precious ground of Central Park is valued at from two thousand to four thousand dollars per square yard, the commercial value of these granite rocks amounts to anywhere from ten billion to eighteen billion dollars.

"If 'Improvement'" If the various persons who have sought to invade Central Park in the last sixty years, for projects in themselves often worthy, oftener grotesque, and frequently purely commercial, had had their way, there would now be nothing left of the park except a few walks and drives, and a lake upon which steamboats and full-rigged ships would be plying.

The Park was a new institution in 1860, but already it had become apparent that there were plenty of people in New York who saw in this large expanse of ground only room for profitable private enterprise. The Board of Commissioners for Central Park reported in that year that "the demands of people who wish to advance their business interest by means of the park are most astounding."

Following are some of the more audacious projects:

An outdoor theater, proposed in 1911, which would have seated anywhere from 25,000 to 100,000 persons.

A street railway.

The use of the lake for the voyagings of a full-rigged ship or steamboat.

It was suggested that the park should be used as a burial ground for the city's distinguished dead.

In 1904, Robert B. Roosevelt wanted to cut the whole park into building lots.

Perry, p. 70 Were apartment houses built as thickly and as tall in Central Park as elsewhere on Manhattan Island, the Park could handily domicile the populations of Austin, Texas, or Springfield, Illinois, or all the citizens of the State of Nevada.

Buford, p. 215 Imagine there's no Central Park.

Finney, p. 76 This park itself is something of a miracle of survival, too. Right here in the heart of what must be the world's most changeable city are, not just acres, but several square *miles* that have been preserved practically unchanged for decades.

Perry, p. 70 A reminder of what the earth is really like before it is paved, pressed into brick or smelted into metal.

Tonkiss, p. 131 *Sous les pavés, la plage!*

Koolhaas, p. 23 A synthetic Arcadian Carpet.

Rybczynski, p. 53 It was conceived with a very specific function, but it has not been static. It is a historical place, but it is also a place with a history, a changing history. It took a long time before the park was open at night, for example. A hundred years ago letting automobiles use the carriage drives must have seemed like a good idea; today it feels, and sounds, like an imposition.

Goodman, *Secret*, p. 10 Every tree, every rise, every dip, every vista as carefully conceived as a museum show, yet all somehow maintaining the illusion of spontaneity.

Caro, p. 332 By 1932, the paths, walks and roadways in New York's parks were miles of broken pavement. The lawns, seldom mowed, sometimes looked more like meadows. So many trees were dying that some of the loveliest tree-bordered

walks were bordered mostly by stumps—the result of allowing unskilled and unsupervised workers to prune trees by simply climbing up to the top of their ladders and sawing trees off at that height, since they were reluctant to risk their own limbs by climbing out on trees. According to a Park Avenue Association survey, there was not a single structure in any park in the city that was not in need of immediate repair.

The faces of statues were masses of bird droppings. Obscenities had been written on—and never erased from—their chests. Their identifying plaques had been torn off. Swords were missing from sheaths, laurel wreaths from brows. Poets plucked at broken harps, saints stood on cracked pedestals. An Indian hunter had lost his bow. The tiger in Central Park was slipping off his rock. The bayonets had been stolen off the rifles of the soldiers in the Seventh Regiment Memorial on Fifth Avenue.

Ibid.

Central Park was not then the barren waste it became in the nineteen-twenties.

Mumford, *Sidewalk*, p. 37

The park's lawns, unseeded, were expanses of bare earth, decorated with scraggly patches of grass and weeds, that became dust holes in dry weather and mud holes in wet. Its walks were broken and potholed. Its bridle paths were covered with dung. The once beautiful Mall looked like the scene of a wild party the morning after. Benches lay on their backs, their legs jabbing at the sky. Trash baskets had been overturned and never righted; their contents lay where they had spilled out. The concrete had been stripped off drinking fountains so completely that only their rusting iron pipes remained. And nine out of every ten trees on the Mall were dead or dying.

Caro, p. 334

In the zoo, the lion's cages were so flimsy that animal keepers carried shotguns to protect children if the beasts escaped.

Ellis, *Epic*, p. 551

Around the Arsenal squatted the twenty-two ancient wooden animal houses of the Central Park Menagerie, crumbling away beneath their yellow paint. So rotted were their walls that park department officials feared that a single charge from a large animal, perhaps maddened by fire, might tear the cage bars right out of them. Instead of rebuilding the animal houses, the department had stationed keepers in front of the lion and tiger cages with rifles and had instructed them to shoot the big carnivores if fire broke out.
 The Menagerie was filled with surprises. Because it gratefully accepted any gift that would fill a cage, and people therefore donated their unwanted family pets, it was housing in 1932, alongside the hyacinth cockatoos and the vulturine guinea fowl, several dozen canaries, and, in a large cage between the mountain lions and the leopards, an Airedale. Because the Menagerie did not adequately care for its animals or dispose of them when they grew old, its exhibits included such old pensioners as a senile tiger, a puma with rickets and a semi-paralyzed baboon. Its most fearsome exhibits were rats, which roamed it in herds and had become so bold that they were stealing food from the lions' feeding pans. The most vivid memory carried away by many visitors was of the sickening stench that rose from the dung-heaped Barbary-pen.

Caro, p. 335

Almost directly across the Park, off Central Park West, was Jacob Wrey Mould's sheepfold, considered by some critics the finest existing example of the full-blown architecture of the mid-nineteenth century, and from a distance the sheep who grazed opposite on the Green or Sheep meadow, under the care of a resident shepherd who twice a day held up traffic on the park's West Drive to herd his flock across, made a picture as pretty as Olmsted

Ibid.

had envisioned. But a closer look disclosed that, because for generations the sheep had been allowed to inbreed, every one of them was malformed.

Wynn, p. 165

Moses was getting tired of waiting for the sheep to cross the streets on his drives through Central Park.

Caro, p. 335

The aged biddies in charge of park comfort stations were widows of Tammany ward heelers and they understood that no work was required of them. According to one reporter: "Some had curtained off all but, say, two of the eight toilet compartments, had imported chairs, tables and hangings into the cozy space, and frequently had in their friends to afternoon tea." The lady in charge of the comfort station perched on a rocky bluff overlooking the Metropolitan Museum of Art spent her time there removing much of the plumbing and then building herself a cozy little sitting room, in which she had installed a grand piano. The chords of a Chopin nocturne startled more than one woman who entered the comfort station in good faith.

Ibid., p. 336

The Depression added its own touches to the parks: the shack towns named, bitterly, "Hoovervilles," in which homeless men sought refuge. One of the largest was a collection of more than two hundred hovels of old boards, flattened gasoline tins and pieces of sheet iron and cardboard in the dried-out bed of the abandoned Central Park Receiving Reservoir behind the Metropolitan Museum of Art; at night its inhabitants ate birds they caught in the park's bird sanctuary.

Caldwell, p. 253

The park is developed by the homeless in the Depression. A twenty-foot-tall building is erected with an inlaid tile roof; it was in front of a boulder, so they called it the Rockside Inn.

Trager, p. 457

22 men are arrested for vagrancy in July, 1930 following complaints by Fifth Avenue residents that "hobos" are sleeping in Central Park, but a sympathetic judge suspends their sentences, gives each one $2, and sends them all back to the park, which by autumn has 17 chimneyed shacks, all furnished with chairs and beds.

Caro, p. 488

Dogs wandered into the playgrounds and urinated and defecated in the sandboxes and the sandboxes had to be removed. Drunks crept into the tunnel segments at night and fell asleep, to be discovered by children the next morning sleeping in their own vomit. The tunnel segments had to be removed. Drunks wandered into the striped guardhouse "play booths" during the day and urinated in them. Perverts used them as hiding places from which they could watch the playing little girls and boys at close range and masturbate. Vandals pried loose the light lumber out of which the play booths were constructed. The play booths had to be removed. Then the drunks slept and the perverts hid in the trees and shrubbery behind the benches, so this landscaping had to be removed. Still drunks kept wandering into the playgrounds at night.

Ibid., p. 332

Park concessions sold substandard food; there were recurring reports of sickness among children who ate the hot dogs they sold.

Trager, p. 486

Municipal parks have degenerated into weed-filled dumps, some of them occupied by squatters. What will be Central Park's Great Lawn is rid of 200,000 rats in one week.

Bryant Park, too: "Six priceless acres of green amid the concrete masses of midtown, had been allowed to become a haven for drunks and idlers."

Caro, p. 332

By 1934, under Moses, every structure in every park had been repainted. Every tennis court had been resurfaced. Every lawn had been reseeded. Eight antiqued golf courses had been reshaped, eleven miles of bridle paths rebuilt, thirty-eight miles of walks repaved, 145 comfort stations renovated, 284 statues refurbished, 678 drinking fountains repaired, 7,000 wastepaper baskets replaced, 22,500 benches reslatted, 7,000 dead trees removed, 11,000 new ones planted in their place and 62,000 others pruned ... Generations of New Yorkers had believed that the six miles of granite walls around Central Park were a grimy blackish color. Now they saw that sand blasting had restored them to their original color, a handsome dark cream ... And a thousand plots in the parks, plots which as long as New Yorkers could remember had contained nothing but dirt and weeds, were gay with spring-blooming flowers.

Ibid., pp. 372–3

While seven hundred men were working day and night to build the Bronx Zoo, another thousand were transforming the dried-up reservoir bed that had been called "Hoover Valley"—Moses had torn down the shanty town there—into a verdant, thirty-acre "Great Lawn," laying flagstone walks around it and planting along them hundreds of Japanese cherry trees.

Ibid., p. 374

Henry James: "The Park was too narrow, and too short, and was overwhelmed by an obligation to 'do.'"

Buford, p. 181

On Central Park: "New York itself must have been built to afford some kind of relief from it."

Morris, *Manhattan '45*, p. 217

Without the intervening park, the Upper East Side would blend into the Upper West Side—unthinkable. Without its enchanted setting, Tavern on the Green would be just another tourist eatery, and the site of the Bethesda Fountain would be simply an ordinary street corner. New York City without Central Park would be like Chicago without the lake, San Francisco without hills or Los Angeles without sunshine.

Rybczynski, p. 49

Inside Central Park the film's hippies and war resisters could exist in a world of their own, a place wrenched out of time. The park we see in *Hair* is an urban arcadia, an artfully improved nature, dedicated to the renewal of the human spirit. The film's characters celebrate the "Age of Aquarius" in a grassy meadow where police horses mirror their dance steps; they ride along the park's bridle paths and take a midnight swim in its pond; they move to choreography on the stage-like steps of Bethesda Fountain and eventually gather at the Sheep Meadow for a peace festival.

Sanders, *Celluloid*, p. 356

The Easter Sunday Be-In in Central Park was incredible; thousands of kids handing you flowers, burning incense, smoking grass, taking acid, passing drugs around right out in the open, taking their clothes off and rolling around on the ground, painting their bodies and faces with Day-Glo, doing Far East–type chants, playing with their toys—balloons and pinwheels and sheriff's badges and Frisbees. They could stand there staring at each other for hours without moving. As I said before, that had always fascinated me, the way people could sit by a window or on a porch all day and look out and never be bored, but then if they went to a movie or a play, they suddenly objected to being bored. I always felt that a very slow film could be just as interesting as a porch-sit if you thought about it the

Warhol, *POPism*, p. 207

same way. And now all these kids on acid were demonstrating the exact same thing.

Capote, p. 43

We giggled, ran, sang along the paths toward the old wooden boathouse, now gone. Leaves floated on the lake; on the shore, a park-man was fanning a bonfire of them, and the smoke, rising like Indian signals, was the only smudge on the quivering air. Aprils have never meant much to me, autumns seem that season of beginning, spring; which is how I felt sitting with Holly on the railings of the boathouse porch.

N. cit.

No one is buried there.

Auster, "Fogg," pp. 101–2

I slept in the park every night after that. It became a sanctuary for me, a refuge of inwardness against the grinding demands of the streets. There were eight hundred and forty acres to roam in, and unlike the massive gridwork of buildings and towers that loomed outside the perimeter, the park offered me the possibility of solitude, of separating myself from the rest of the world. By contrast, life in Central Park allowed for a much broader range of variables. No one thought twice if you stretched out on the grass and went to sleep in the middle of the day. No one blinked if you sat under a tree and did nothing, if you played your clarinet, if you howled at the top of your lungs. Except for the office workers who lurked around the fringes of the park at lunch hour, the majority of people who came in there acted as if they were on holiday. The same things that would have alarmed them in the streets were dismissed as casual amusements.

There is no question that the park did me a world of good. It gave me privacy, but more than that, it allowed me to pretend that I was not as bad off as I really was. The grass and the trees were democratic, and as I loafed in the sunshine of a late afternoon, or climbed among the rocks in the early evening to look for a place to sleep, I felt that I was blending into the environment, that even to a practiced eye I could have passed for one of the picnickers or strollers around me. The streets did not allow for such delusions. Whenever I walked out among crowds, I was quickly shamed into an awareness of myself. I felt like a speck, a vagabond, a pox of failure on the skin of mankind. Each day, I became a little dirtier than I had been the day before, a little more ragged and confused, a little more different from everyone else. In the park, I did not have to carry around this burden of self-consciousness. It gave me a threshold, a boundary, a way to distinguish between the inside and the outside. If the streets forced me to see myself as others saw me, the park gave me a chance to return to my inner life, to hold on to myself purely in terms of what was happening inside me. It is possible to survive without a roof over your head, I discovered, but you cannot live without establishing an equilibrium between the inner and outer. The park did that for me. It was not quite a home, perhaps, but for want of any other shelter, it came close.

Ibid., p. 108

I usually spent some time ambling through the park, exploring areas I had not visited before. I enjoyed the paradox of living in a manmade natural world. This was nature enhanced, so to speak, and it offered a variety of sites and terrains that nature seldom gives in such a condensed area. There were hillocks and fields, stony outcrops and jungles of foliage, smooth pastures and crowded networks of caves. I liked wandering back and forth among these different sectors, for it allowed me to imagine that I was traveling over great distances, even as I remained within the boundaries of my miniature world.

W Central Park

Because night loiterers are excluded from Central Park, I supposed that all its awakening loveliness must go for naught. But if the first impingement of the sun on the massed verdure of the Park, on its lakes, its alpine views, its waterfall, and the fresh, sweet meadows, does find a rare spectator, it must again be one of the homeless who has eluded police regulations to find a night's rest in the great green inclosure. Possibly there may be a poet or two wandering about in Central Park at dawn, but the poets are early risers only in the country. To them the city is only the monstrous, noisy machine of the full day.

Strunsky, p. 705

I then set off into the park. It is a thick and hilly wood, a forest of century-old trees, an intricate network of roads and trails, rising and falling then meeting before departing again, squirrels poking about the bushes and scattering up the trees. Yet it is in a sorrowful mess: the brush is littered with wizened branches, leaves, and fallen trees, bottles and wastepaper are scattered here and there, and not one of the streetlamps has been left intact—some of them have even been torn out of the ground, and now lie there like cast-iron trunks uprooted during a storm. There are no signs to tell you where you are, and it's easy to get lost and you just have to trust your luck in finding the odd passerby who can put you back on the right track.

Maffi, pp. 10–11

Whole sections of the city had grown rather poisonous, but invariably I found a moment of utter peace in riding south through Central Park at dark toward where the façade of 59th Street thrusts its lights through the trees. There again was my lost city, wrapped cool in its mystery and promise.

Fitzgerald, "Lost City," p. 576

The warning, "Don't go into the Park after dark," is more than just a simple notice of potential physical danger. It is also an acknowledgment of the shift in the park's function—which takes place when the sun goes down—from a place where nature lovers eat lunch and children feed squirrels, to a place where one can buy drugs or get one's cock sucked.

Califia, p. 216

For light relief I went up to street level to take a walk in the park. On top of a boulder in the sunshine, eight guys wearing lipstick sitting in a circle jerking off. Waved and invited me to join. As one marked time with a tambourine. And coming along the path, in nice linen suit and white spats, an elderly man passing me said welcome to the asylum.

Donleavy

Certainly, homosexuals cruising Central Park for partners must accept the possibility of ending up dismembered in the bushes.

Blandford, p. 156

One of the most frightening things in the Park at night was a man on his own.

Buford, p. 180

For all at once, like savage members of a jungle ambush, a band of Negro boys leapt out of the shrubbery along the path. Hooting, cursing, they launched rocks and thrashed at the horse's rumps with switches.

Capote, p. 69

Two days ago, I was riding through Central Park at ten at night, when I was surrounded by a "wilding" gang on rollerblades. They were almost children. They tried to capture me in a flank maneuver, but I was able to bicycle away even faster.

Bushnell

1,477 Big New Lights for Central Park: Lovers' Lanes Will Be Illuminated and Also the Danger Spots.

Sharpe, p. 170

Stone It's possible Chambers took Levin to the park because he thought it would be romantic …

Ibid. Chambers and Levin entered at 86th Street at around 4:50 A.M. and walked to a grassy area across the park drive from the Metropolitan Museum … She flew into a rage, he said, yelling at him and hitting him and scratching his face. He retreated and sat down in the grass a short distance away. She then went over to a nearby tree to urinate. When she came back, Chambers continued on the tape, she started being nice to him. He was sitting with his hands behind his back, and she playfully tied her panties loosely around his wrists and pushed him back to the ground. She straddled him, facing away, Chambers said. She undid his shirt and pants, he said, and began to masturbate him. Chambers said he grew tired of her efforts and told her to let go, but she wouldn't. Instead, she squeezed his testicles, hurting him. Freeing his hands, he reached up with his left arm and pulled back on her neck as hard as he could, eventually flipping her over him. Levin is estimated to have died at about 5:30.

Smith, "Revisited" On Wednesday, April 19, 1989, at about 9 p.m., reports began filtering into the Central Park precinct that a marauding gang of youths was beating up joggers and bicyclists … The victim was white and middle-class and female, a promising young investment banker at Salomon Brothers with a Wellesley–Yale–Phi Beta Kappa pedigree. The suspects were black and Latino and male and much younger, some with dubious school records, some from fractured homes, all from Harlem. That the crime took place in Central Park, mythologized as the city's verdant, democratic refuge, played right into the theme of middle-class violation.

Atkinson, pp. 41–2 The mothers and the nursemaids and the babies and the laughing children who fill the park all the daylight hours were gone now. In their place lurked muggers and thugs, perverts, dope addicts, a twisted world of evil, desperate people.

Donleavy Looking out the window over the tree tops. The cars snaking on the curving drives through the park. And night when lights sprinkled across the whole grey vista. To put the heavens down below. With the stabbings and stompings. You watch from windows safe and warm.

Sanders, *Celluloid*, p. 255 Over the tops of Fifth Avenue's proud apartment houses, showing exactly how abruptly they rise from the edge of the dark forest at their feet—the very embodiment, in urban terms, of the troubling closeness of "chaos" and "control."

W Central Park

People move about in granite chasms; if not mastered, they are no longer the masters.

Rock, Moore, and Lobenstine, p. xvi

Rivering under streets and rivers.

Conrad, p. 232

The train
hammers its hard rhythm
in the blood.

Parland, p. 346

A monotone of motion.

Conrad, p. 232

The new subway system would quickly be characterized in the press as an antechamber of Hell.

Haden, p. 89

An underwater ferry, disposing of people in its sluice.

Conrad, p. 232

The hottest station in the summer of 1905 was Astor Place.

Brooks, p. 70

To cool the subway platforms in 1905, the Interborough turned off all but a few incandescent lights in each station.

Ibid.

It brought ordinary office fans on to the station platforms.

Ibid.

It takes a subway about seven years after building to equal the surface temperatures.

Granick, p. 194

A New York City subway passenger wouldn't be assured of riding in an air-conditioned train until well into the 1990s.

Basile, p. 218

Tremulously I stand in the subways, absorbed into the terrible reverberations of exploding energy. Fearful, I touch the forest of steel girders loud with the thunder of oncoming trains that shoot past me like projectiles. Inert I stand, riveted in my place. My limbs, paralyzed, refuse to obey the will insistent on haste to board the train while the lightning steed is leashed and its reeling speed checked for a moment. Before my mind flashes in clairvoyant vision what all this speed portends—the lightning crashing into life, the accidents, railroad wrecks, steam bursting free like geysers from bands of steel, thousands of racing motors and children caught at play, flying heroes diving into the sea, dying for speed—all this because of strange, unsatisfied ambitions. Another train bursts into the station like a volcano, the people crowd me on, on into the chasm—into the dark depths of awful forces and fates. In a few minutes, still trembling, I am spilled into the streets.

Keller, p. 299

Indescribable scenes of crowding and confusion, never before paralleled in this city, marked the throwing open of the subway to the general public last night. The old 6 o'clock Brooklyn Bridge car crush paled into insignificance when contrasted with the deadly suffocating, rib-smashing subway rush which began at 7 o'clock tonight. Men fought, kicked and pummeled one another in the mad desire to reach the subway ticket offices or to ride on the trains. Women were dragged out, either screaming in hysterics or in a swooning condition; grey haired men pleaded for mercy, boys were knocked down and only escaped by a miracle from being trampled under foot. The presence of the police alone averted what would undoubtedly have been panic after panic, with wholesale loss of life.

"Birth"

Brooks, *Subway*, p. 70

The controversy over "subway air." Within days of the opening reporters found passengers complaining of headaches, attacks of vertigo, dizziness, and occasional fainting spells. The *New York Times* reported on a woman who fainted on a train. "Foul air and nervousness due to the excitement of the trip" was the judgment of a physician who happened to be in the car. The Interborough responded by hiring Professor C. F. Chandler of Columbia University to prepare a scientific study. When his report of November 1904 declared the air perfectly safe, the company quickly issued its own pamphlet. Its cover proudly bore the claim, "SUBWAY AIR PURE AS IN YOUR OWN HOME."

Ibid.

In 1905, it was proven that there were only half as many microbes per cubic foot in subway air as on the street.

Lovecraft, "Lurking"

I cannot see a well or a subway entrance without shuddering.

Haden, p. 91

In his letters Lovecraft refers to some types of closed New York buses as "prepayment suffocation chambers," so how much more trepidation might he have felt about suffocation on the subways?

Ibid., p. 146

Hart Crane seems the key progenitor for the future mythologizing of the subway, with his poem "The Tunnel" (the writing of which appears to have been started around late 1925 and with development continuing into 1926) in which the overcrowded and claustrophobic city subways become the nightmare haunt of the ghost of Edgar Allan Poe. Crane presents Poe as a covert symbol of an "underground" queer culture, linking his deathly status with the persecutions that normalcy inflicts upon the artistic.

Crane, "Bridge; Tunnel," p. 95

Whose head is swinging from the swollen strap?
Whose body smokes along the bitten rails,
Bursts from a smoldering bundle far behind
In back forks of the chasms of the brain,—
Puffs from a riven stump far out behind
In interborough fissures of the mind … ?
And why do I often meet your visage here,
Your eyes like agate lanterns—on and on
Below the toothpaste and the dandruff ads? —
And did their riding eyes right through your side,
And did their eyes like unwashed platters ride?

Riesenberg and Alland, p. 67

Above the swaying heads, near smarting myopic eyes, are bands of clashing color, battering down sales lag. Liquors, cosmetics, legs, vermin exterminators, hair restorers, depilatories, purges, gums, and swim suits scream their obnoxious messages.

Ginsberg, *Howl*, p. 5

fell out of the subway window

Maloney, p. 109

In March 1912, a 27-year-old Irish-American subway engineer went to see Dr. C.P. Oberndorf, an Upper West Side neurologist, complaining of claustrophobia so severe that he had to quit his job because he could no longer enter the subway shaft. He had suffered his first attack of claustrophobia three years earlier while watching vaudeville at the American Theater.

There is an actual sickness that affects mass-transit users […] overcrowding leaves people wedged in place with blood accumulating in their feet, leading to faintness […] the claustrophobia and dreads combine to push people from unease to panic.

Norwood, pp. 39–41

who howled on their knees in the subway

Ginsberg, *Howl*, p. 4

It is disappointing to hear that travellers on the New York Subway are complaining of imperfect ventilation and other discomforts which were not anticipated.

The Electrician

Somehow, the way life works, people usually wind up either in crowded subways and elevators, or in big rooms all by themselves. Everybody should have a big room they can go to and everybody should also ride the crowded subways.

Warhol, *Philosophy*, p. 155

Usually people are very tired when they ride on a subway, so they can't sing and dance, but I think if they could sing and dance on a subway, they'd really enjoy it.

The kids who spray graffiti all over the subway cars at night have learned how to recycle city space very well. They go back into the subway yards in the middle of the night when the cars are empty and that's when they do their singing and their dancing on the subway. The subways are like palaces at night with all that space just for you.

Four steps past the turnstiles everybody is already backed up haunch to paunch for the climb up the ramp and the stairs to the surface, a great funnel of flesh, wool, felt, leather, rubber and steaming alumicron, with the blood squeezing through everybody's old sclerotic arteries in hopped-up spurts from too much coffee and the effort of surfacing from the subway at the rush hour.

Wolfe, "Sunday," p. 293

It is not exactly an inspiring sight, this subway car on the W train—our usual car filled with a look so full of exhaustion that you might think we had been riding on this car forever. But one senses that if you look hard enough, you can see the things that draw people to cities, that drew my grandfather here seventy years ago and drew me here, too: possibility, and plurality, keep us riding still. I suppose that possibility is just as possible in the suburbs of Dallas or Phoenix, in some edge city near Atlanta, some floating island of residence levitating between two malls, but I don't quite believe it. Possibility still, in some significant part, depends on density; hope is the thing in a sweatshirt, riding the W train and reading the *Daily News*, a bird of another feather.

Gopnik, p. 295

[close together; touching]

Mumford, "Intolerable" pp. 283–93

At 96th Street the IRT was jammed. This was not unusual. Quite often New Yorkers at that station indulge fantasies of commutation, pantomimes that to the uninitiated must seem strange.

Trebay, pp. 328–9

A train pulls into the station, crowded with people, who then get off. The train, which had been southbound, retreats into the tunnel. Another empty train comes, slowing down as it enters the station, which by now is dangerously crowded, and halts. It pauses, engine humming, while people push to the doors, then accelerates and hurtles away. Perhaps a third train comes and if it does perhaps it is brimful of people. Perhaps, too, these people press closer under the pressure of newcomers who board the train and wait. Ten minutes? On occasion the train moves ahead to another station, 86th

Street, where the announcement is made: "This train is going out of service, all passengers please get off."

Riesenberg and Alland, p. 65

We have had our New York subways for 34 suffocating psychopathic years.

Lefebvre, *Critique*, p. 28

The subway, Archer thought, was the only place to read today's newspapers. Underground, in a bad light, at an increased fare, with all the passengers fearing the worst about each other. Everyone suspecting the man next to him of preparing to pick a pocket, commit a nuisance, carry a lighted cigar, pinch a girl, ask for a job, run for a vacant seat, block the door at the station at which you wanted to leave the train. Archer put the paper down and looked around at his fellow passengers. They do not look American, he thought; perhaps I shall report them to the proper authorities.

Leipzig and Böhmer, p. 13

Once the train doors close, people seemed to sink into their own private worlds, and it was easy to see their concerns played out on their faces.

Riesenberg and Alland, p. 65

Always more crowded are the subways, more rusty, more ill-kept, more dense with dull, ox-like throngs winding in the stations, following green, or black, or red stripes to their destinations; dust and papers and dirt swirling on every hand. He has become immune to the filth and orders of subway lavatories; he accepts unseeing the cheap additions to old decoration schemes at station platforms lengthened to accommodate ten-car, two-guard trains. He accepts as normal nuisances the brash crowd herders who act as station guards or pushers-in. His ears are deaf to club turnstiles, clapping around nerve-wracking collections. He goes, uncomplaining for machines that count him and take him like meat in a grinder.

Galwey, p. 421

Strap clutching subway stench, screaming "L"

Hughes, *Collected*, p. 68

Mingled
breath and smell
so close
mingled
black and White House so near
no room for fear.

Sexuality

Donleavy

The air fuming. A man sitting with a smile staring at a girl. Then someone vomited on the floor of the train.

Ibid.

The rush hour crush of tired silent faces. Breathing all over each other. Someone's hands trying to open my fly. Easing fingers in under the foreskin. All the way to the Bronx, didn't know who to punch. For borrowing my privates without permission.

Mumford, "Intolerable," pp. 283–93

The Swedish Massage of the Subway ... the pulping mill of the subway.

Brooks, *Subway*, p. 69

G.W. Bitzer filmed at 2 a.m. in the Subway in June 1905, showing a lady and gentleman behaving scandalously (she raises her voluminous skirt above her knees so that he can tie her shoelace) and being ejected from the train by a guard.

One of the few places where body contact—at least the unavoidable rush-hour kind—is more acceptable than eye contact.

Peter, p. ix

Relationship is a friction of bodies in passing: a messenger boy is squeezed against an odorous blonde.

N. cit.

Thoughts very often grow fertile, because of the motion, the great company, the subtlety of the rider's state as he rattles under streets and rivers, under the foundations of great buildings.

Brooks, *Subway*, p. 169

The city breathes eroticism, from noon on. Even in the subway you can sense men and women angling, sizing each other up.

Keillor, p. 298

In the repellent intimacy of the subway, silence is protection. Strangers might crush together, miles apart in mind.

Riesenberg and Alland, p. 67

The entire island [of Manhattan] will be honeycombed by swiftly running [subways] … The first day I [went down to the subway] it would not have been a difficult task to send me flying upstairs again. I wasn't exactly frightened, rather nervous. The hustling on the platform didn't give me much chance for reflection, and I entered the first train that I was shoved into—the magnetism of the mob, as [Gustave] Le Bon would say … New York is full to the brim … yes, pretty girls, a bit too rouged, too flimsily attired …

Huneker, pp. 51–2

I remember my first sexual experience in a subway. Some guy (I was afraid to look at him) got a hard-on and was rubbing it back and forth against my arm. I got very excited and when my stop came I hurried out and home where I tried to do an oil painting using my dick as a brush.

Brainard

She took off her clothes at 4:00 in the afternoon in the doorway of the F train at Rockefeller Center at rush hour.

Groce, p. 85

On crowded subways, where women have had reason to accuse standees of mashing, a man may hold on to a center post, with both hands fixed to the pole high so everyone can see that, whatever happens, his hands did not do it. An individual moving someone else's parcel from one seat to another when it is not clear who the owner is may feel he must show he has no designs on the other's personal property and is not overruling maliciously the claims of a possession marker; he handles the article very gingerly and at its edge, thus contaminating it minimally.

Goffman, pp. 165–6

A person walking down the aisle of a subway car, accidentally stepping on the toe of a seated passenger, can maintain his rate of movement, turn his head back and hold out his arm and hand while he verbally excuses himself. The held-out hand, in effect, holds the offender in the remedial encounter even while his body is rapidly leaving it.

Ibid., p. 38

A principle of stranger interaction is "civil inattention." This "sine qua non of city life" is familiar to all of us who have, for example, travelled on the subway. A brief acknowledgment through body language that the other person is there and then, please, no staring or conversation.

Ings

Kennedy, *Subwayland,* p. 113	In the fall of 1902, one Charles F. Allaire, Civil War veteran, accidentally rode his bicycle into an open subway tunnel at Amsterdam Avenue and 65th Street, breaking his right leg. Edward Morris drove a whole car in, at Broadway and 43rd Street.
Brooks, *Subway,* p. 69	On the subway's second of day of operation, holes had been pounded in the tile walls so that advertising posters could be put up.
Hamill, "Lost"	The el with its rusting potbellied stoves in the waiting rooms.
Brook, p. 129	Some subway entrances can't even be shut: they have no gates.
Jackson and Dunbar, p. 678	The yellow wicker seats facing each other in the middle of the El car.
Ginsberg, *Howl,* p. 3	Heaven under the El … horrors of Third Avenue iron dreams
Goll, p. 5	The elevated rail is more intoxicating than the heavenly cathedral.
Conrad, p. 104	El stations abstractly dislocate the city.
Ibid., p. 124	A system of "impersonal dynamics": not a convocation of people but a continuum of objects, activated by the impatience of the urban eye, as are the fire escapes, cast-iron pillars, barbers' poles, and light fixtures which bounce through the visual field of his "Sixth Avenue El."
Trager, p. 508	The Sixth Avenue El ceases operations. After the last northbound train from Rector Street arrives at 53rd Street and Eighth Avenue, revelers strip the cars for souvenirs, taking electric bulbs, destination signs, and straps, throwing seat cushions out of windows, pulling safety cords to bring the train to a series of jolting stops, and smoking in defiance of the No Smoking signs.
Kozloff	Elevated train platforms, about to be torn down, have a nostalgic glow about them.
Conrad, p. 169	"Its lease won't expire 'till 2878; and no doubt by then all the 'Els' will be torn down." In fact, they didn't last much more than a decade, let alone the anticipated thousand years.
Norwood, pp. 39–41	The horrors of socialism in the subway: Everyone paid the same fare, there were no "first class" tickets, no separate entrances or seating areas. Everyone was dragged down to the same level in the same mundane and deeply uncomfortable "cattle car" experience.
Manrique, p. 3	After it leaves Manhattan, the number seven train becomes an elevated, and crosses a landscape of abandoned railroad tracks, dilapidated buildings and, later, a conglomerate of ugly factories that blow serpentine plumes of gaudy poisonous smoke. As the train journeys deeper into Queens, the Manhattan skyscrapers in the distance resemble monuments of an enchanted place— ancient Baghdad, or even the Land of Oz. The sun, setting behind the towers of the World Trade Center, burnishes the sky with a warm orange glow and the windows of the towers look like gold-leafed entrances to huge hives bursting with honey.

Walk about the subway station
in a grove of steel pillars;
how their knobs, the rivet-heads—
unlike those of oaks—
are regularly placed;
how barren the ground is
except here and there on the platform
a flat black fungus
that was chewing-gum.

Reznikoff, p. 97

Gum holds subway floors together.

Talese, p. 102

I went home, had a good cry, and towards nightfall, was collected by an unknown man who had been dragooned by an unknown woman into taking me to her home in Brooklyn. Apart from Mr. Cherry-Garrard's voyage to the South Pole, this was the worst journey in the world. Though we implored eight of them, no taxi driver would take us on such a desperate trek. I couldn't blame them. Brooklyn is a terrible place and all who live there know they have entered an enclosed order. In desperation, we walked to the subway station at the corner of Broadway and Houston Street where we waited for a train that did not come for a long and dangerous time. When it did appear, we forced our way on to it and stood swaying perilously but unable to reach any fixture on which to hold. I have to report that this motley throng of strangers, though pressed into disturbing proximity, remained surprisingly calm—even cheerful. Arriving at our station we still had a long, dark way to walk over pavements that have not been repaired in a hundred years. Had we not been delayed by so many difficulties on our journey, we would have been compelled to stand in the bitter desolation of a Brooklyn street for some time.

Crisp, pp. 160–1

You wait fifteen minutes on the downtown platform … An announcement is made that the express is out of service. The tunnel smells of wet clothing and urine. The voice comes over the speaker again to say that the local will be delayed twenty minutes because of a fire on the tracks. You push through the crowd and ascend to the street.

McInerney, *Bright Lights*, p. 86

At the subway station you wait fifteen minutes on the platform for a train. Finally a local, enervated by graffiti, shuffles into the station.

Ibid., p. 11

But someone in the back is holding one open for a man who is running up the platform. The doors open again. You step onto the train. The car is full of Hasidim from Brooklyn—gnomes in black with briefcases full of diamonds. You take a seat beside one of them. He is reading from his Talmud, running his finger across the page. The strange script is similar to the graffiti signatures all over the surfaces of the subway car, but the man does not look up at the graffiti, nor does he try to steal a peek at the headlines of your *Post*.

Ibid., p. 56

Oh you age when streetcars make elegant spirals curving around City Hall.

N. cit.

I ride the A train out from Manhattan to my summer bungalow in the Rockaways. Crossing Jamaica Bay, I get a little lightheaded. The subway car, which has been chugging along over the bay, plunges downward with a jerk, as if it's headed straight for the bottom. Then abruptly, almost at the waterline, the car seems to skim right across the top of the waves. It's as if a gust of wind could swirl up and tip it over. Hitting open water in a crowded New York City subway car is one of the strangest satisfactions of metropolitan life.

Maloney, p. 109

McInerney, *Bright Lights*, p. 12

The train shudders and pitches toward Fourteenth Street, stopping twice for breathers in the tunnel.

Ibid., p. 57

At Fourteenth Street three Rastafarians get on, and soon the car reeks of sweat and reefer.

Ibid., p. 56

The doors close with a pneumatic hiss.

Talbot and Lehnartz, p. 73

The KK train from Manhattan crosses the Williamsburg Bridge.

Crane, "Bridge; Tunnel," p. 110

For Gravesend Manor change at Chambers Street.
[…]
The train rounds, bending to a scream,
Taking the final level for the dive
Under the river—

Groce, p. 83

We had a full train. Well, the next stop is Fifth Avenue. And this fellow gets on—twenty, twenty-five years old—fit and trim as a marine. In fact, he was in marine fatigue uniform—except the hat that he had on, he had a pacifier hanging down, and a feather in the back. As we were moving out of Fifth Avenue … he took off his jacket, rolled it up very tightly. And then proceeded to get down on the floor of the subway car with this tightly rolled jacket between his elbows, and he starts doing a belly crawl along the floor! You'd think there were live bullets going across—he literally slithered across the floor. And he would go and he would look at people, just like a snake. And, of course, New Yorkers, you learn not to make eye contact. And here it is: it's after 12:00 at night and people are getting scared.

Brooks, *Subway*, p. 69

The subway films of G.W. "Billy" Bitzer: *A Rube in the Subway* (1905). A country bumpkin gets off the subway. His pocket is picked. He tries to jump back on the departing subway car, but hits the electrified third rail.

Caro, p. 66

The railroad tracks wended their way between the buildings, making several sharp curves, and then emerged on Eleventh Avenue, along which, at street level, trains inched their way in a straight line down to the foot of the island. In front of every train, to warn pedestrians and drivers, rode a cowboy on a horse, waving a large red flag. Since the trains came at frequent intervals and moved extremely slowly along the avenue, traffic was frequently backed up for blocks. Often, a driver would become impatient and ignore the warning flag. For that reason, Eleventh had become known as "Death Avenue." For years, the city had tried without success to find a solution to the problem posed by the presence of the railroad along the West Side.

McCourt, p. 100

In a late-night cop raid, after the opera, the ballet and the theater crowd had long gone home, as the pursued felons dispersed, hurrying down platforms, leaping over turnstiles, jumping down on to the tracks and disappearing in the tunnels full of sewer rats, where they hoped to be spared death by oncoming local trains, one voice calling wildly, "Stay alive—I'll find you!"

Groce, p. 81

I saw Batman walking across the tracks. Someone just walking the tracks in a Batman costume! OK. I have a radio. My rule book says I'm supposed to call in anything unusual. I'm going to call control center and say "Batman just walked across West 4th Street, across three tracks?" So as long as the train was in the station, this man just went across four tracks, flinging his cape back and forth 'til he got tired of it and then he went upstairs.

X Subway — Various

If there is a memorable bus scene in literature, or an unforgettable moment in a movie that takes place on a New York City bus, I have not found it. It isn't that buses are intrinsically inimical to symbolism: The London bus has a poetry as rich as the Tube's—there is Mary Poppins, there is Mrs. Dalloway. In Paris, Pascal rides the bus, Zazie dreams of riding the Métro. In L.A., Keanu Reeves rides the bus, round and round in desperate Dennis Hopper–driven circles. But as a symbolic repository, the New York City bus does not exist. The only significant symbolic figure that the New York bus has had is Ralph Kramden, and what he symbolizes about the bus is that being stuck in one is one more form of comic frustration and disappointment; the bus is exactly the kind of institution that would have Ralph Kramden as its significant symbolic figure. Gopnik, p. 145

Skidaddling crosstown. Donleavy

Every time I see a groaning bus coughing fumes as it lumbers across three traffic lanes, I long for the trolley cars. Hamill, "Lost"

This bus with a great engine roaring, swaying from stop to stop. Donleavy

Lumbering, smelly vehicles. Walker, *Night Club*, p. 203

The buses totter spilling the jammed shadows. Galwey, p. 421

On a bus a simple citizen in search of transportation will find himself often reduced to the shakes. Atkinson, p. 19

The bus roaring past a statue of a man on a pedestal. Donleavy

In the late 70s, the MTA began to notice riders sitting on the back bumpers of city buses. In 1981, all new buses ordered by the authority featured "anti-ride bumpers." Instead of offering a flat surface upon which a person could get a foothold, the new bumpers slanted away from the bus at a 45-degree angle. Also redesigned was the grille on the back of the bus, which the bumper riders held on to. The grille itself was made smaller and the slats were put so close together that a hand cannot fit between them and get a grip. Boland

Another bus pulls over and disgorges passengers. The sheltered mob clutch umbrellas, purses and briefcases, prepared to fight for seats; but once the bus unloads it's nearly empty. The driver, a massive black man with sweat rings under his arms, says "Take it easy," and his voice commands respect. McInerney, *Bright Lights*, p. 87

You sit down up front. The bus lurches into traffic. Below Fortieth Street the signs on the corners change from Seventh Avenue to Fashion Avenue as you enter the garment district. *Ibid.*

At the Thirty-fourth Street stop there is a commotion at the door. "Zact change," the bus driver says. A young man standing by the change box is trying to work his hand into the pockets of his skin-tight Calvin Kleins. Peach Lacoste shirt, a mustache that looks like a set of plucked eyebrows. Under one arm he clutches a small portfolio and a bulky Japanese paper umbrella. He rests the umbrella against the change box. "Step aside," the bus driver says. "People getting wet out there." *Ibid.*

Everyone watching titters and guffaws. The bus hasn't moved. *Ibid.*, p. 86

Donleavy Catching a bus by a white stone building.

Blandford, p. 176 Seen from a crowded bus on a steamy wet winter's afternoon. As the M3 bus jolts its way along Madison Avenue from the fifties up towards the nineties, each fantasy stares out through the window and fulfills itself.

Car, Taxi

Schneider, "Sign Language" The 1908 New York to Paris auto race was by definition over land. The six competing teams rolled up Broadway, then turned their backs on the Atlantic and set off for France on a westerly course. The chosen route crossed the continental United States, Alaska and the frozen Bering Strait, continuing through Siberia, Russia, Poland, Germany, and finally to France. The length of the trip, which took about six months, was 19,877 miles. As the canvas-topped cars set out from the *New York Times* building that uncommonly cold February morning, a crowd of more than 150,000 lined the streets to watch. The eventual winner was George Schuster, an American mechanic. He piloted his Tomas Speedway Flyer into Paris on July 30—and was promptly stopped by a policeman for driving without a headlight.

Lobas, p. 152 It is not the beauty of the city at night, or the shimmer of its multicolored lights, that enthralls the cab driver. Over twelve bridges and through four tunnels, hundreds of thousands of cars were leaving the island of Manhattan, freeing up the hammed, narrow streets, opening up for me the wide avenues, where the itching of my meter was now much livelier than in the daytime. The fewer the cars remaining in the city, the greater grew the number of people who need a taxi.

Fearing, "Twentieth-Century," p. 66 Or your taxi rolls and rolls through streets made of velvet, what is the feeling, what is the feeling when the radio never ends, but the hour, the swift, the electric, the invisible hour does not stop and does not turn.

O'Connell, p. 147 Fast taxi ride through New York streets when you are drunk: impression that you are plunging through all obstacles at exhilarating giddy speed; nothing can interfere with your progress.

Donleavy Slam the door shut of this yellow black checkered cab.

Jackson and Dunbar, p. 607 Through strange doors into strange apartments with intermittent swings along in taxis through the soft nights.

Lobas, p. 141 Even with the meter on there is no pleasure in driving around the city at five miles per hour, and it is even harder to pick your way through the crowds of pedestrians streaming around the cab; but it is unbearable to hang around in traffic jams empty.

Ibid., p. 53 Kennedy Airport! Half of the soul, half of the life of a New York cabbie belongs here, in this inexhaustible well of fabulous driving dollars.

Ibid., p. 132 Down in the mines of the streets and the avenues, we extracted our nickels and dimes, but we never stopped keeping a lascivious eye out for an airport.

Toth, p. 9 All the way down, he muses, are layers upon layers upon layers of tunnels, with no bottom.

362

New York is a dream of a song, a feeling of aliveness, a rush and flow of vitality Ellington, pp. 65–7
that pulses like the giant heartbeat of all humanity. The whole world revolves
around New York, especially my world. Very little happens anywhere unless
someone in New York presses a button!

New York is its people, and its people are *the city*. Among its crowds, along
its streets, and in its high-piled buildings can be found every mood, sight,
and every sound, every custom, thought, and tradition, every color, flavor,
religion, and culture of the entire earth. It is as if each of the world's greatest
chefs had sent a pinch of his nation's most distinctive flavoring to contribute to
the richness of taste of this great savory *pot au feu* called New York.

The miracle of the city is that this concoction, with its multitude of
dissimilar ingredients, can sometimes come to the boil, and sometimes
simmer away contentedly on the back of the stove. Since it is at the mercy of
so many cooks, it is often stirred up, and, too often, of late, over-seasoned by
some heavy-handed pepper wielders. But this gorgeously aromatic pot never
burns or sticks to the bottom! Instead, New York presents itself as a proper
feast to each human being of healthy appetite who hungers for soul food.
Whether his needs are nutritional or merely "gourmet," the hungry one is
fed, for in New York it is all there on the menu, that something to satisfy every
taste: exotic, traditional, or adventuresome. Perhaps it is at this very moment
of finding his soul food listed on the menu that the next New Yorker is born.
For the "real New Yorker" is not always born in New York, you know. He
becomes one at the very instant when he discovers that his own ingredients
are completely compatible with the city's soups and salads.

I am that kind of New Yorker, for I was born in Washington, D.C. And if
I am asked to describe New York, I must think in musical terms, because
New York is people, and that is what music is all about. This incredible city
embraces all humanity within its structure, whether resident or visitor, and
joins each new heartbeat with her own throbbing pulse. For personified, New
York is a woman, and as such she is a little of everything. Certainly, she is
a sophisticate. Sometimes she is a lady of the evening. To her cosmopolitan
visitors, she is always a gracious hostess deferential to their differing points of
view. And like a true Earth Mother, she rests but never sleeps. She is the last
to retire at night and the first to rise with each new day, for she suffers from
an exhaustingly active energy called Anticipation!

In his ideal image, the real New Yorker is seen at the newsstand after
midnight with the *News* under his arm, but it is also considered extremely
prestigious to be seen reading the *Times* on the subway in the morning.
On his way home from work in the later afternoon, always with the *Post* in
his pocket, the New Yorker looks as though he has been some place, and
knows it.

It is impossible to enter New York without feeling that something
wonderful is about to happen. Whether you arrive by plane, ship, train, car or
bus, bridge or tunnel, you feel the immediate excitement of starshine. For to
this great city come the world's Beautiful People; men of wisdom and good
intent; people of cultures older than our own, with highly cultivated tastes;
creative geniuses in all fields of endeavor; exquisite women of fashion; great
ladies of all ages, whose beauty lies in their genuineness; and all are essential
parts of the melody line in this dream of a song that is New York. This is a
city of talented performance. Everyone in New York is a performer, down to
the most casual visitor. Perhaps Shakespeare had a vision of Manhattan in
mind when he wrote that "all the world's a stage," for most certainly we all get
caught up in the plot!

There is a kind of highly contagious fever of backstage communication
about New York. The opportunities to rub elbows with the "stars" are so many
and frequent that a little of that glamour dust of starshine clings to everybody.

Y Poetic Empire

There are almost no "bit players" on Manhattan Island. Everybody is a star. If this statement seems extravagant, then just consider the taxi driver. No greater Solon exists than the New York cabbie. He knows something about everything, and his is the only gossip column worth reading. He is part of the pulse of the people, of the beat and throb of the city, for he knows, he really *knows* what is happening in New York, from his own point of view and everyone else's. He speaks a "people" wisdom and at the heart of this great cosmopolitan city is a vital, small-town "peopleness." Have you ever been in New York during a disaster or a blizzard? It becomes the friendliest place in the world! That blew fuse, the blackout, was the friendliest of all, because nine months later the stork flew in over the horizon with a bumper crop of babies.

So amid all her tickertape and traffic, New York is the dream of a song. New York is a place where the rich walk, the poor drive Cadillacs, and beggars die of malnutrition with thousands of dollars hidden in their mattresses.

Morris, *Manhattan '45*, p. 69

It was an unusually organic kind of city. Its sewage mostly went into its surrounding waters, to be swept away by the tides. Its garbage mostly went to make landfill. Its corpses were nearly all removed from the island. Its indigent old and its incurably sick were housed on an offshore island, Welfare Island, in the middle of the East River. The daily migration of its commuters, in and out, in and out, over the bridges, on the ferries, through the subaqueous tunnels, was like a great tidal movement, and the ships that were docked all around the shore, fitted so neatly into its multitudinous piers, made the whole island seem God-made, rather than man-developed, for its own particular functions.

White, *Here*, p. 25

There are roughly three New Yorks. There is, first, the New York of the man or woman who was born here, who takes the city for granted and accepts its size and its turbulence as natural and inevitable. Second, there is the New York of the commuter—the city that is devoured by locusts each day and spat out each night. Third, there is the New York of the person who was born somewhere else and came to New York in quest of something. Of these three trembling cities the greatest is the last—the city of final destination, the city that is a goal. It is this third city that accounts for New York's high-strung disposition, its poetical deportment, its dedication to the arts, and its incomparable achievements. Commuters give the city its tidal restlessness; natives give it solidity and continuity; but the settlers give it passion. And whether it is a farmer arriving from Italy to set up a small grocery store in a slum, or a young girl arriving from a small town in Mississippi to escape the indignity of being observed by her neighbors, or a boy arriving from the Corn Belt with a manuscript in his suitcase and a pain in his heart, it makes no difference: each embraces New York with the intense excitement of first love, each absorbs New York with the fresh eyes of an adventurer, each generates heat and light to dwarf the Consolidated Edison Company.

Hapgood, pp. 114–15

There is very little Bohemian atmosphere in New York for it is a very "swift" town. Even the rapid man from Chicago notices that there is a peculiarly strident character to the nervous haste of the metropolis. The rumbling "L," the shrieking trolley, overflowing with people all having an expression of wild eagerness on their faces, these are the most fitting external expressions of the jumping unrest at the heart of our city. We are palpitant, eager in the functions of life. We hurry our business in order to get at our pleasure, and hurry our pleasure in order to get at our business. We all have occasional backaches and headaches, and anything slow, from a thoughtful play to a provincial, brings to our nerves the shock of the unfamiliar. Contemplation

is the one thing completely shut out of the life of a New Yorker who is thoroughly saturated with the most American spirit of the town. Thought with him is a nervous impulse, quickly over, having no genial, philosophic fringe, looking not before nor after, but pinned to the exciting moment. To use a rather undignified figure, the man who is "in it" in New York is like the nervous system of the frog of the psychological laboratory which the operator, by the application of acid, galvanizes into vivid but unmeaning activity.

One way in which philosophy and art are found is in books, but the nervous New Yorker is too busy to read. Through books, therefore, he comes only very incompletely into contact with the contemplative, the eternal, the artistic. The only practicable means of subjecting the typical city American to the contemplative is therefore through some influence which is connected with his daily, practical life and amusements. Now, this element is partly found in what is contributed to our metropolitan existence by the foreigners.

Good old New York! The same old wench of a city. Elevated racketing over you' head. Subway bellowing under you' feet. Me foh wrastling round them piers again. Scratching down to the bottom of them ships and scrambling out. All alongshore for me now. No more fooling with the sea. Same old New York. Everybody dashing around like crazy … Same old New York … But the sun does better than over there. And the sky's so high and dry and blue. And the air it—O Gawd it works in you' flesh and blood like Scotch. O Lawdy, Lawdy! I wants to live to a hundred and finish mah days in New York.

McKay, *Home*, p. 25

Its isolated faces, its loose fragments and time warps surround us and (with their reserved silences or boisterous chatterings) tell the city; and from these metropolis hypertext windows one can observe important stories and inconsequential events, reasons, and causes lost in time, revelations and unexpected epiphanies. Perhaps it is precisely this alternation of continuity and discontinuity—of the overall picture and the separate parts that go to make up that picture—that makes it difficult to get a grasp and puzzle out what it really is. And so every departure from the city necessarily implies a return, for is there not always a niggling unconscious suspicion that something has been omitted? It is at this stage that the sides of the prism become as important for understanding as the in-depth and in-width maps.

Maffi, pp. 115–16

In a weed-filled vacant lot in Riverdale just north of the Harlem River stood a marble column a hundred feet high with a strangely unfinished look about its top. There was supposed to be a statue up there, a statue of Hendrick Hudson, for the vacant lot had been purchased by the city as the northern bridgehead of a "Hendrick Hudson Bridge" that was supposed to ease the congestion on the Broadway drawbridge, and a statue of the Great Navigator was supposed to look down on the span that bore his name. But although the lot had been purchased, and the column erected, in 1909, in 1932 work had still not started on the statue—or the bridge.

Caro, p. 331

What I marvel is that the gorgeous, voluptuous color of this greatest of world capitals makes so little showing in the lovely letters of the United States. If only as spectacle, it is superb. It has a glitter like that of the Constantinople of the Comneni. It roars with life like the Bagdad of the Sassanians. These great capitals of antiquity, in fact, were squalid villages compared to it, as Rome was after their kind, and Paris and London are today.

There is little in New York that does not issue out of money. It is not a town of ideas; it is not even a town of causes. But what issues out of money is often extremely brilliant, and I believe that it is more brilliant in New York than it

Mencken, *Chrestomathy*, pp. 189–90

has ever been anywhere else. A truly overwhelming opulence envelops the whole place, even the slums.

The slaves who keep it going may dwell in vile cubicles, but they are hauled to and from their work by machinery that costs hundreds of millions, and when they fare forth to recreate themselves for tomorrow's tasks they are felled and made dumb by a gaudiness that would have floored John Paleologus himself.

Has any one ever figured out, in hard cash, the value of the objects of art stored upon Manhattan Island? I narrow it to painting, and bar out all the good ones. What would it cost to replace even the bad ones? Of all the statuary, bronzes, hangings, pottery, and bogus antiques? Or the tons of bangles, chains of pearls, stomachers, necklaces, and other baubles? Assemble all the diamonds into one colossal stone, and you will have a weapon to slay Behemoth. The crowds pour in daily, bringing the gold wrung from iron and coal, hog and cow. It is invisible, for they carry it in checks, but it is real for all that. Every dollar earned in Kansas or Montana finds its way, soon or late, to New York, and if there is a part of it that goes back, there is also a part of it that sticks.

What I contend is that this spectacle, lush and barbaric in its every detail, offers the material for a great imaginative literature. There is not only gaudiness in it; there is also a hint of strangeness; it has overtones of the fabulous and even of the diabolical.

The thing simply cannot last. If it does not end by catastrophe, then it will end by becoming stale, which is to say, dull. But while it is in full blast it certainly holds out every sort of stimulation that the gifted literatus may plausibly demand. The shocking imbecility of Main Street is there and the macabre touch of Spoon River. But though Main Street and Spoon River have both found their poets, Manhattan is still to be adequately sung. How will the historian of the future get at it, imagining a future and assuming that it will have historians? The story is not written anywhere in the official records. It is not in the files of the newspapers, which reflect only the surface, and not even all of that. It will not go into memoirs, for the actors in the melodramatic comedy have no taste for prose, and moreover they are all afraid to tell what they know. What it needs, obviously, is an imaginative artist. We have them in this bursting, stall-fed land—not many of them, perhaps—not as many as our supply of quacks—but nevertheless we have them. The trouble is that they either hate Manhattan too much to do its portrait, or are so bedazzled by it that their hands are palsied and their parts of speech demoralized. Thus we have the dithyrambs of Manhattan—but no prose.

I hymn the town without loving it. It is immensely amusing, but I see nothing in it to inspire the fragile and shy thing called affection. I can imagine an Iowan loving the black, fecund stretches of his native State, or a New Englander loving the wreck of Boston, or even a Chicagoan loving Chicago, Loop, stockyards and all, but it is hard for me to fancy any rational human being loving New York. Does one love bartenders? Or interior decorators? Or elevator starters? Or the head-waiters of night clubs? No, one delights in such functionaries, and perhaps one respects them and even reveres them, but one does not love them. They are as palpably cold and artificial as the Cathedral of St. John the Divine. Like it, they are mere functions of solvency. When the sheriff comes in they flutter away. One invests affection in places where it will be safe when the winds blow.

But I am speaking now of spectacles, not love affairs. The spectacle of New York remains—grand and gorgeous, stimulating like the best that comes out of goblets, and none the worse for its sinister smack. The town seizes upon all the more facile and agreeable emotions like band music. It is immensely trashy—but it remains immense. Is it a mere Utopia of rogues, a vast and

complicated machine for rooking honest men? I don't think so. The honest man, going to its market, gets value for his money too. It offers him luxury of a kind never dreamed of in the world before—the luxury of being served by perfect and unobtrusive slaves, human and mechanical. It permits him to wallow regally—nay, almost celestially. The Heaven of the Moslems is open to any one who can pay the *couvert* charge and the honorarium of the hat-check girl—and there is a door, too, leading into the Heaven of the Christians, or, at all events, into every part of it save that devoted to praise and prayer. Nor is all this luxury purely physiological. There is entertainment also for the spirit, or for what passes for the spirit when men are happy. There were more orchestral concerts last Winter than anywhere else on earth. The town, as I have said, is loaded with art to the gunwales and is steadily piling more on deck. Is it fecund of ideas? Perhaps. But surely it is not hostile to them. There is far more to the show it offers than watching a pretty gal oscillate her hips; one may also hear some other gal, only a shade less slightly, babble the latest discoveries in antinomianism. All kinds, in brief, come in. There are parts for all in the *Totentanz*, even for moralists to call the figures. But there is, as yet, no recorder to put it on paper.

I like to think of all the city microcosms so nicely synchronized though unaware of one another: the worlds of the weight-lifters, yodelers, tugboat captains and sideshow barkers, of the book-dutchers, sparring partners, song pluggers, sporting girls and religious painters, of the dealers in rhesus monkeys and the bishops of churches that they establish themselves under the religious corporations law. It strengthens my hold on reality to know when I awake with a brandy headache in my house which is nine blocks due south of the Chrysler Building and four blocks due east of the Empire State, that Eddie Arcaio, the jockey, is galloping a horse around the track at Belmont while Ollie Thomas, a colored docker of my acquaintance, is holding a watch on him. I can be sure that Kit Coates, at the Aquarium, is worrying over the liverish deportment of a new tropical fish, that presently Whitey will be laying out the gloves and headguards for the fighters he trains at Stillman's gymnasium, while Miss Ira, the Harlem modiste, will be trying to talk a dark-complexioned girl out of buying herself an orange turban and Hymie the Tummler ruminates a plan for opening a new night club. It would be easier to predicate the existence of God on such recurrences than on the cracking of ice in ponds, the peeping of spring peepers in their peeperies and the shy green sprigs of poison ivy so well advertised by writers like Thoreau.

Jackson and Dunbar, p. 620

There is something strangely affecting about the last hours of long-lived and famous City institutions. Everything almost exactly as it has always gone on right up to the last minute and then suddenly it stops, never to be again. Whatever such places meant in the lives of many people is only a memory from that moment on. Perhaps it is the sheer ordinariness of such an occasion, observed with the knowledge that it is just about over, that gives it that quality. Or perhaps it is the courage of those who, knowing what is about to happen, go about their jobs almost exactly as they have always gone about them, performing their small functions to the end.

Philips, p. 223

Be that as it may, the time wasted in New York over waiting for people who are late for their dates, over waiting for elevators, during traffic jams, and over answering purely frivolous telephone calls must amount to a very considerable expenditure if it could be represented in money. Let us put it in another way: If I go to London, or if I go, in Paris, from the South to the North Bank, in both cases on business, I expect to—and I do—get in at least three, but not unusually four, business interviews before lunch and at least two, but

Ford, *America*, pp. 76–7

quite frequently three, afterwards. In New York if you can manage two before lunch and one afterwards you are lucky, simply because of the difficulty of transit and of synchronization.

Ibid., pp. 70–1

There is *no* gauging the time of your arrival at any given point on the ground level of the city. Having an engagement for half-past four in Sixty-fifth Street, I took a taxicab one afternoon at four in Madison Square and arrived at five minutes past five, having traveled at the rate of practically a minute and a half to a block. The same evening I had a date for eight o'clock in the same street. I took a taxi at the corner of Sixteenth Street and Sixth Avenue at seven o'clock and arrived at Sixty-fifth Street at seven-twenty—having to cool my feet for forty minutes outside the house where I was dining and having covered the ground at the rate of practically fifty blocks in twenty minutes.

And this goes millionwise: there must be at present thousands of millions of business hours lost in the city of New York every year, on the surface of the ground alone.

Caldwell, p. 279

Manhattan demographic dislocations: fluctuating populations from night to night and week to week as the servicemen tided through on their way abroad.

Donleavy

Like all big cities, it consisted of irregularity, change, sliding forward, not keeping in step, collisions of things and affairs, and fathomless points of silence in between, of paved ways and wilderness, of one great rhythmic throb and the perpetual discord and dislocation of all opposing rhythms, and as a whole resembled seething, bubbling fluid in a vessel consisting of the solid materials of buildings, laws, regulations, and historical traditions.

Hawes

By the end of the nineteenth century, New York was too big and too diverse to be measured in traditional ways. It was impossible to cover its length in a walk, to keep up with the shops and the social events, to follow all the threads of its daily life.

Mencken, *Chrestomathy*, pp. 185–6

What will finish New York in the end, I suppose, will be an onslaught from without, not from within. The city is the least defensible of great capitals. Give an enemy command of the sea, and he will be able to take it almost as easily as he could take Copenhagen. The strategists of the General Staff at Washington seem to be well aware of this fact, for their preparations to defend the city from a foe afloat have always been half-hearted and lacking in confidence. Captain Stuart Godfrey, U.S.A., is at pains to warn his lay reader that the existing forts protect only the narrow spaces in front of them that "they cannot be expected to prevent the enemy from landing elsewhere," *e.g.*, anywhere along the reaches of the Long Island coast. Once such a landing were effected, the fact that the city stands upon an island, with deep water behind it, would be a handicap rather than a benefit. If it could not be taken and held, it could at least be battered to pieces, and made so untenable. The guns of its own forts, indeed, might be turned upon it, once those forts were open to attack from the rear. After that, the best defenders could do would be to retire to the natural bombproofs in the cellars of Union Hill, N.J., breweries, and there wait for God to deliver them. They might, of course, be able to throw down enough metal from the Jersey heights to prevent the enemy from occupying the city and reopening its theaters and bordellos, but the more successful they were in this enterprise the more cruelly Manhattan would be used.

Altogether, an assault from the sea promises to give the New Yorkers something to think about. Any invader who emptied New York and took the line of the Hudson would have Uncle Sam by the tail, and could enter upon

⋎ Poetic Empire

peace negotiations with every prospect of getting very polite attention. The American people, of course, could go on living without New York, but they could not go on living as a great and puissant nation. Steadily, year by year, they have made New York more and more essential to the orderly functioning of the American state. If it were cut off from the rest of the country the United States would be in the hopeless position of a man relieved of his medulla oblongata—that is to say, of a man without even enough equipment left to be a father, a patriot and a Christian.

Nevertheless, it is highly probable that the predestined enemy, when he comes at last, will direct his first and hardest efforts to cutting off New York, and then make some attempt to keep it detached afterward. This, in fact, is an essential part of the new higher strategy, which is based upon economic considerations, as the old strategy was based upon dynastic considerations. In the Middle Ages, the object of war was to capture and hamstring a king; at present it is to dismember a great state, and so make it impotent. The Germans, had they won, would have broken up the British Empire, and probably detached important territories from France, Italy and Russia, besides gobbling Belgium *in toto*. The French, tantalized by a precarious and incomplete victory, attempted to break up Germany, as they broke up Austria. The chances are that an enemy capable of taking and holding New York would never give it back wholly—that is, would never consent to its restoration to the Union on the old terms. What would be proposed, I venture, would be its conversion into a sort of free state—a new Danzig, perhaps functioning, as now, as the financial and commercial capital of the country, but nevertheless lying outside the bounds politically. This would solve the problem of the city's subsistence, and still enable the conqueror to keep his hold upon it.

It is my belief that the New Yorkers, after the first blush of horror, would agree to the new arrangement and even welcome it. Their patriotism, as things stand, is next to nothing. I have never heard, indeed, of a single honest patriot in the whole town; every last man who pretends to kiss the flag is simply a swindler with something to sell. The indifference to the great heartthrobs of the hinterland is not to be dismissed as mere criminality; it is founded upon the plain and harsh fact that New York is alien to the rest of the country, not only in blood and tastes, but also in fundamental interests—that the sort of life that New Yorkers lead differs radically from the sort of life that the rest of the American people lead, and that their deepest instincts vary with it. The city, in truth, already constitutes an independent free state in all save the name. The ordinary American law does not run there, save when it has been specifically ratified, and the ordinary American *mores* are quite unknown there. What passes as virtue in Kansas is regarded as intolerable vice in New York, and *vice versa*. The town is already powerful enough to swing the whole country when it wants to, as it did on the war issue in 1917, but the country is quite impotent to swing the town. Every great wave of popular passion that rolls up on the prairies is dashed to spray when it strikes the hard rocks of Manhattan.

As a free state, licensed to prey upon the hinterland but unharassed by its Cro-Magnon prejudices and delusions, New York would probably rise to heights of very genuine greatness, and perhaps become the most splendid city known to history. For one thing, it would be able, once it had cut the painter, to erect barriers and conditions around the privilege of citizenship, and so save itself from the double flood that now swamps it—first, of broken-down peasants from Europe, and secondly and more important, of fugitive rogues from all the land West and South of the Hudson. Citizenship in New York is now worth no more than citizenship in Arkansas, for it is open to any applicant from Arkansas. The great city-states of history have been far more fastidious. Venice, Antwerp, London, the Hansa towns, Carthage, Tyre,

Cnossus, Alexandria—they were all very sniffish. Rome began to wobble when the Roman franchise was extended to immigrants from the Italian hill country, *i.e.*, the Arkansas of that time. The Hansa towns, under the democracy that has been forced upon them, are rapidly sinking to the level of Chicago and Philadelphia. New York, free to put an end to this invasion, and to drive out thousands of the gorillas who now infest it—more, free from the eternal blackmail of laws made at Albany and the Methodist tyranny of laws made at Washington—could face the future with resolution and security, and in the course of a few generations it might conceivably become genuinely civilized. It would still stand as toll-taker on the chief highway of American commerce; it would still remain the premier banker and usurer of the Republic. But it would be loosed from the bonds which now tend to strenuously drag it down to the level of the rest of the country. Free at last, it could cease to be the auction-room and bawdy-house that it is now, and so devote its brains and energy to the building up of a civilization.

The decade lost to Scott Fitzgerald's hero—that period of architectural reconstruction between 1929 and 1939—is the one when New York most irrevocably transforms itself. The raising of the Chrysler Building (1930), the Empire State (1931), and Rockefeller Center (completed in 1940) demanded that the city conceive of itself anew. Its heights are the lookouts of scientific prediction, from where it can espy a future designed in its own image. The decade ended with the provisional building of that future, at the New York World's Fair of 1939–40. Going there was time-travel. The Pennsylvania Railroad undertook to speed you "From the World of Today to the World of Tomorrow in ten minutes for ten cents." The route stretched from actual to envisioned New York: the Fair was the city's perfected dream of itself.

Conrad, p. 248

This Fair, more than had any previous effort, promoted as a major purpose the availability of consumer goods and services. It was a Fair that from the very start viewed the people not only as observers but as potential customers of the products it displayed. Thus, the advertising potential of the Fair and its promotion of the growing consumer culture of the time marked a subtle change in the role of the Fair.

Queens, p. 181

There was no cynicism. There was no black humor. The human condition, or one's awareness of its problems and inequities, had not reached the point where a sense of the absurd became salvation. It was an absurd world, in its own way, but we loved its flashy, streamlined promises of better things … And so there is more to the sudden passion for the memorabilia of the recent past than mere nostalgia. Nostalgia is a sadly desperate game, an instinctive gut reaction to the fact that we have gone through, and are still going through, a period of shattering change, a destructive, antiheroic, anti-beautiful phase of smashing beliefs, idols and ideals, in a world that offers none of the certainties and standards that kept earlier generations stable in adversity.

Huxtable, *Goodbye*, pp. 140–1

The Fair was one of the conceptual crucibles in which the socio-spatial ideology of post-WWII American urbanism was forged … Probing beneath the Fair's clean, shiny, streamlined surfaces, many cultural representations of the Fair exposed various cultural and political contradictions in the Fair's socio-spatial ideology … its techno-rational designs promoted an evolution of democracy that excluded both ethnic minorities and the economically disenfranchised … its streamlined, machine-age aesthetics functioned as an ideological mask for the economic and political interests of corporate capitalism … the Fair's own complex, marginal spaces—such as Salvador Dalí's Dream of Venus exhibit or the Amusement Area—were models for developing alternative counter-hegemonic spatial, political, and urban agendas … Through its numerous, elaborate urban displays, the Fair exposed fairgoers to many trends in architecture and urban planning that would subsequently play a dominant role in the post-WWII restructuring of American cities. It also attempted to endow this new urban ideology with a brilliant utopian aura, fascinated with New York City's newly emerging role as an international capital.

Ibid., p. 30

The assertion of New York City's importance as a global city. As one advertisement for the exhibit explained, New York City itself was an expression of the future because "no other city had advanced nearly so far along the road that leads to the world of tomorrow." Convinced both that New York City would play a prominent role in defining the world civilization of the future and that the Fair would help design the new urban practices that would make this new world civilization possible, the Fair's designers envisioned

Ibid.

Z 1939 World's Fair

the Fair as a place where New York architects and urban planners could "as members of a great metropolis … think for the world at large" and "lay the foundation for a pattern of life which would have an enormous impact in times to come." Thus the Fair's designers endowed the Fair's urban ideology, the ideology that would dominate the spatial restructuring of post-WWII New York City, with the bold utopian significance. In addition to exalting New York City as a paradigmatic city of the future, the Fair also developed bold, futuristic, techno-rational urban utopias that would eventually serve as models for restructuring post-WWII New York City itself.

Ibid., p. 35

The 1939 Fair's urban utopias expressed a deep strain of optimism among fairgoers themselves.

Riesenberg and Alland, p. 52

Aside from an enormous amount of tearing down, these last forty-five years have added stylish and mechanical complications to our hysterical society: motion pictures, silent and sound; photoelectric cells; electron beams; radio direction beams; wire photos and electronic television; oil cracking; internal combustion engines, gas, gasoline, and Diesel; automobiles; airplanes; X-rays, gamma rays; radioactivity; the gyrocompass; turbine engine; steam boilers carrying pressures of over 2,000 pounds to the square inch; high speed steel and a thousand new and marvelous alloys; vast improvements in the generation and distribution of electricity; synthetic rubber and silk. The colloids and the vitamins have arrived, and we have set foot on a new continent of discoveries in medicine and in the art of surgery. Fantastic inventions have been made in the design and the use of automatic machinery, of gang drills and precision jigs. The breaking down and the synthesis of matter become an accomplished fact. We see the crystal structure of the atom. Also, the cyclotron has arrived, two hundred and fifty tons of power set to stretch the spectrum, to beat the speed of light. The atom is smashed, and its parts fly to the ends of the universe; an idea thrown into the machine will explode with the kick of a lightning bolt. Many of these things will be shown at the New York World's Fair.

Bennett, *Urban*, pp. 65–6

Jack Womack's *Terraplane: A Futuristic Novel of New York, 1939* sends twenty-first century African American and Russian time travelers back to New York City in 1939. Representing different racial and political ideologies than those of the Fair's designers, these characters frequently point out late-1930s Americans' racist and exploitative practices, such as its xenophobia, ethnic violence, legalized segregation, and prejudiced legal system. Womack's dehumanized, violent, futuristic characters—who kill people as if they were just "fixing breakfast"—also critique late-1930s America's techno-rational metanarratives … By plotting an alternative, dystopic history of twentieth-century America that extends from the racially segregated streets of 1939 New York City to futuristic, dehumanized extensions of twentieth-century America's military-industrial complex, Womack challenges the Fair's utopian ideology.

Construction

Monaghan, p. 18

Originally known, in popular parlance, as the "Corona Dumps"—1,216 ½ acres of primeval bog, spongy marshland, and the accumulated debris and ashes of many years … The appearance of the site was enough to daunt many of the most optimistic of the officials who fought their way to the ceremonies through the accumulated junk of many decades. It once presented a scene of stagnant pools and muddy runlets, a source of evil odors that threatened

asphyxiation to the distressed inhabitants for miles around. Mountains of ashes rose to a height of 100 feet; the topmost peak, waggishly named "Mount Corona," dominated the dismal panorama. A creek called Flushing River meandered through the bog, virtually undisturbed since President Washington crossed it in 1790 to Flushing Bay. The preparation of the site was the largest single reclamation project ever undertaken in the eastern United States. The mountains were leveled and the bogs filled in with almost six million cubic yards of ashes. Over the marshes thus filled in, hundreds of thousands of cubic yards of top soil were deposited and leveled ... A massive tide gate and dam were built to regulate water levels of the Fair-created lakes and the lagoon and to control the tide waters of Flushing Bay. By the end of March 1937 the area was leveled, filled and graded, ready for construction and planting. "From dump to glory."

For the landscaping of the Fair grounds, a forest of trees began moving toward the site. Experts, equipped with large books giving the sizes, shapes, and kinds of trees required, had been scouring the country for hundreds of miles around. They had catalogued upward of 10,000 available trees. In the largest mass movement of the kind on record, railroad flat cars and motor trucks began rolling toward New York bearing a wide variety of full-grown trees, some weighing as much as twenty-five tons and having a height of more than fifty feet. Following one-way streets and guided by police cars, most of the trucks passed through New York City in the early hours of the morning, reaching their destination before daylight.

Teale, p. 36

Trylon and Perisphere

The *needle* and the *globe* represent the two extremes of Manhattan's formal vocabulary and describe the outer limits of its architectural choices. The needle is the thinnest, least voluminous structure to mark a location within the Grid. It combines maximum physical impact with a negligible consumption of ground. It is, essentially, a building without an interior. The globe is, mathematically, the form that encloses the maximum interior volume with the least external skin. It has a promiscuous capacity to absorb objects, people, iconographies, symbolisms; it relates them through the mere fact of their coexistence in its interior. In many ways, the history of Manhattanism as a separate, identifiable architecture is a dialectic between these two forms, with the needle wanting to become a globe and the globe trying, from time to time, to turn into a needle—a cross-fertilization that results in a series of successful hybrids in which the needle's capacity for attracting attention and its territorial modesty are matched with the consummate receptivity of the sphere.

Koolhaas, p. 27

The Perisphere has hollowed out Hood's globe and made it habitable. Now people can enter it and travel within it into the future. Implantation makes the globe an egg. The Perisphere is the womb of time, engendering the future. Its ovoid shape offers us, when we enter it, the safety of regression and the comfort of going round in circles. Everything in it was constructed circularly. Democracity was laid out in concentric rings, its outer edges expanding from a downtown area called Centerton, and visitors saw it from cradling, revolving balconies. The Perisphere has, however, interrupted the present in order to give it rebirth as the future.

Conrad, p. 264

A sphere and a pylon like a cock and balls. An erection in Flushing Meadow Park. Imagined it so green with milk and honey and all the people of the world

Donleavy

walked around with white angels landing on their arms and sticking lollypops of any flavor they wanted right in their mouths.

Trager, p. 519 The Trylon and Perisphere: based on a pair of gas storage tanks at the corner of York Avenue and 62nd Street.

Monaghan, p. 43 The Trylon: 700 feet high; The Perisphere 200 feet in diameter, 18 stories high, broad as a city block, its interior more than twice the size of Radio City Music Hall.

Ibid. Trylon: from "tri," the three sides of the structure, and "pylon," indicating its use as the monumental gateway to the Theme Building. Perisphere: from "peri," meaning "beyond, all around."

Ibid. Inside the Perisphere: "Democracity," a panorama. Daylight bustling city, broad highways traverse expansive areas of vivid green countryside, connecting outlying industrial towns with the city's heart. After two minutes, night comes; workers march to the strains of a symphony and grow larger. The workers symbolize a group which makes the creation of a city possible.

Ibid., p. 65 The Perisphere's theme music is composed by William Grant Still—jazzy, tonic, light. The selection committee, in searching for a composer, listened to recordings on file at CBS radio without knowing who the composer was. The judges narrowed their choices to two works, "Lenox Avenue" and "A Deserted Plantation," which turned out to be by the same composer, William Grant Still. The theme song, "Rising Tide," was played continually in the Perisphere by an orchestra that was assembled and directed by André Kostelanetz.

"William Grant Still" William Grant Still (May 11, 1895–December 3, 1978) was an African-American classical composer who wrote more than 150 compositions. He was the first African-American to conduct a major American symphony orchestra, the first to have a symphony (his first symphony) performed by a leading orchestra, the first to have an opera performed by a major opera company, and the first to have an opera performed on national television. He is often referred to as "the Dean" of African-American composers.

Color and Light

Monaghan, p. 24 Only the Perisphere and Trylon, at the center of the Fair, are in pure white.

Harding, p. 193 From almost any point of entrance, the New York World's Fair assaults the beholder as a carnival of color in architecture. Great stretches of eye-filling hues, canary yellow, orange, blue, green, and rose, carry the eye along unbroken wall surfaces, set among fountains and lawns, and softened by long vistas of tree-lined avenues. From the central axis, dominated by the pearl-white Perisphere and the slender, sky-piercing Trylon, more than five hundred tints and shades contribute to the palette which the Fair has devised to depict the World of Tomorrow.

N. cit. Fourteen buildings, including the flood-lighted Perisphere in the Fair's theme center, were thrown into partial darkness and several lost the service of their air-conditioning equipment when a main feed line supplying the power failed. Democracity, the exhibition in the Perisphere, was unaffected, but the globe's exterior lost a good part of its purple glow.

In the Fair's color scheme, an unstained whiteness was reserved for the Conrad, p. 270 Trylon and Perisphere. The rest of the Theme Center had dimmed into off-white. From there, the white radiance of this eternity was fractured into the variegation of the world. Each of the red, gold, and blue avenues that set out from the Theme Center, like rays from a white-hot but also lucidly cool sun, had its own color. At their ends these thoroughfares converged in the prism of Rainbow Avenue. The Fair's layout follows the career of light from white immanence on high at its center to the polychrome hues of this world around the edges. This white city prohibited fear, anxiety, and mystery, the incubi of the dark. The Con Ed diorama boasted of their abolition: "This is / The City of Light, / Where night never comes." This confidence was soon daunted. Even before the Fair had been dismantled, New York was subscribing to another image of itself—as a defiled and enshrouded place, a guilty city of immitigable night.

Visual restrictions: "There shall be no signs in neon lights, no red lighting on Harding, p. 193 any part of the building, and no names of exhibitors more than fifteen feet off the ground." The result is that the Fair controls absolutely the integral effect of its own night-lighting and its own skyline as the designers conceived it. The crude glare of the average American city by night and the blatant hodgepodge of the skyline by day are, therefore, entirely subordinated to as civilized an effect of power and beauty, of significantly emphasized highlights, as any American has ever seen in any city in the United States.

The first general exposure to fluorescent lights. Throughout the grounds, Brox, p. 212 white fluorescent tubes lit pathways. Colored fluorescent light backlit murals, illuminated signs, and highlighted walls. Whether concealed, recessed, or ghosting structural details, they created sleek, striking effects.

Throughout the Fair, gas is used extensively in the form of open flames to Monaghan, p. 39 secure that lambent movement and ruddy softness obtainable in no other way.

Preeminent among all the satisfying beauties to the average beholder is Harding, p. 199 the lavish use of color. Under its spell great areas of wall surface lose their monotony and the flatness of buildings seldom more than fifty feet high is enlivened vitality and beauty. At night capillary mercury tubes and mercury vapor lamps are used on a scale that revolutionizes all our ideas of the use of light. A softened but brilliant radiance, with no glare or concentrated intensity, diffuses light over color in a way that makes the color produce its own life. The beauty of the central Ballet of the Fountains, where living flames play among the water jets, and streams of water fifty feet into the air as a hidden symphony orchestra plays, color adds the final touch—one of the most superlatively beautiful sites we shall ever see. The fountains, played like a great organ, change from rose to amber to a rainbow of all colors to purest white again, in forms of dramatic and indescribable beauty.

Architecture, City

On the day the World's Fair opened, Mayor La Guardia nominated New York Kriendler and Jeffers,
p. 119 itself as one of the exhibits.

In view of the proximity of the Fair site to New York City with its towering Monaghan, p. 20 skyscrapers, it was deemed absurd to build a "skyscraper" Fair. By way of contrast a "flat" exposition, consisting largely of one-story structures, was constructed.

Ibid.

There is an absolute conviction that buildings must be made to look what they are—temporary exhibit structures. No imitations either of historic architecture or imitations of permanent materials were permitted.

Ibid., p. 21

Since it was decided to emphasize the frankly temporary nature of the buildings, they were constructed with large blank wall surfaces and without the superposition of meaningless architectural forms. The barren aspect of the blank surfaces was overcome through the application of sculpture, murals, and shadows cast by vines and tree groups arranged near the buildings ... The Board of Design wished to achieve "unity without uniformity."

Ibid., p. 20

There are no windows in Fair-built buildings ... because of the great amount of space that would be "lost" as exhibit space in the buildings if windows were installed. Another factor to be considered was that the huge areas of glass in buildings in this climate would render them insufferably hot in summertime. Virtually all Fair-erected buildings are artificially illuminated and ventilated.

Conrad, p. 295

Both New York's combustible summer and its libidinal night are laboratories for metamorphosis—of staid daytime citizens into savages of uncontrollable id; of the city, which the World's Fair promised would be an electronic heaven, into our mutual hell, where the dark is aglow with flame, not light.

Ibid., pp. 74–5

Here a Glass House under a microscope shows how plumbing fixtures operate, how heat is created and conveyed through the house, and how you get water from faucets. The relationship of valves, fittings and piping to modern living.

Harding, p. 193

Coming in, let us say, from the Interborough gate, on the northwest side, you get a breath-taking first impression of the amazing uses to which the architects of the Fair have put the tools of the present in projecting, on these once flat and dreary marshes, their ideals of the city of the future. Tall pylons carry the eye over the flat roofs of the exhibition buildings. Great domelike structures, bisected and connected on the flat side with huge ramps to the ground, invite you to the massive buildings of the big exhibitors. Arclike roofs resembling huge railway stations loom in the transportation section. Bold masses of color catch the light everywhere. Dominating the skyline, as you look from the adjacent Perisphere toward the massive bulk of the United States Government Building far down the central axis of the Fair, protrude the heroic statue of star-bearing young Russia, Italia seated on a pyramid throne, the bronze-hued glass tower of Poland, and the solid, superbly located mass of the British building. To the far left rises, like a rococo mausoleum, the beautifully proportioned little turret of the League of Nations building; on the far right, across Fountain Lake, are the gemlike roofs and tortured ironwork of the Amusement Zone.

Politics

Monaghan, p. 84

Palestine Exhibits, Inc.: Because of its significance as an answer to the charge of unproductiveness leveled against the Jew, the Palestine Exhibit has received the united support of the Jews of America.

Bennett, *Deconstructing*, p. 38

In his dedication of the Palestine Pavilion at the 1939–40 New York World's Fair, Albert Einstein criticized how the Fair "projected the world of men

like a wishful dream" by exhibiting modern civilization's "creative forces" while hiding its "sinister and destructive ones which today more than ever jeopardize the happiness, the very existence of civilized humanity."

La Guardia proposed a Chamber of Horrors be built for the 1939 World's Fair, depicting all that was evil in Nazi Germany.

Diehl, p. 19

Mayor La Guardia announces that he will not allow Germany to mount an exhibit at the World's Fair next year, and if somehow Germany is able to have an exhibit that he will put a wax effigy of Adolf Hitler in a Museum of Horrors; he calls Hermann Goering a "perverted maniac." Goering vows to bomb New York from Governors Island to Rockefeller Center "to stop somewhat the mouths of the arrogant people over there." The German consulate in Manhattan demands police protection against possible attacks from angered Jews, and La Guardia sends Jewish cops to stand guard.

Trager, p. 506

Conspicuously missing from the Hall of Nations is Germany. USSR, Italy and Japan are included.

Monaghan, p. 67

A bomb that had been taken from the British Pavilion at the World's Fair exploded in the faces of four detectives, killing two of them. Bundists, Fascists or members of the Christian Front were suspected.

Duffy, *Double Agent*, p. 172

Virtually all of the new urban and suburban spaces, from Levittown to Stuyvesant Town, were racially segregated. Futurama and Democracity neither acknowledged nor attempted to redress these kinds of racial issues. Just as the Fair presented a brave new vision of the world of tomorrow, but only to those who could afford its steep admission fees and concession charges, post-WWII American urbanism also enabled the predominantly white middle-class to escape a little farther from the city while trapping other lower-class and racial minorities within embattled inner-city ghettos. Thus the Fair's utopian promises were both selectively made and selectively fulfilled.

Bennett, *Deconstructing*, pp. 36–7

Seminole Village Indians recognize no authority other than that vested in their chiefs, and consequently are permitted to have their own police force and jail at the Fair.

Monaghan, p. 50

The American religion paraded its eschatological predictions and deep utopian faith most memorably and definitively at the 1939 New York World's Fair. The Fair was a credo in stucco and steel … as such that World's Fair is important to any credible effort at deciphering modern America … it is essential that we understand Democracity city if we are to understand the Fair … Democracity's utopian world of tomorrow amounts, in essence, to the modern suburbs.

Bennett, *Deconstructing*, p. 27

La Guardia's pre–World's Fair crackdown on gay bars in the 1930s.

Chauncey, p. 182

Exhibit

Here are strange people from remote lands which you have read about: pygmies, for instance, from the dark forests of central Africa, where mysterious rivers flow in the eternal shadow of impenetrable foliage; Ubangi tribesmen from French Equatorial Africa, strange black beings with enormous distended lips; headhunters, too … fierce savages from Masambo

Monaghan, p. 33

and the Congo; and here you may stare in awe at the giraffe-necked women from Padeung, in the mysterious north of India.

Ibid., p. 41

Frank (Bring 'em Back Alive) Buck has made his greatest capture. He has brought the whole jungle back alive to the Fair. Here are thousands of rare specimens of wild life from the jungles … 1,000 rhesus monkeys living on a miniature mountain … Apart from the jungle camp inhabited by native hunters there is a special feature exhibit of trained animals where it is shown to what extent savage beasts can be "educated."

Ibid., p. 46

Nature's Mistakes: An assemblage of animal freaks from all corners of the world … housed in an auditorium with a maze-like pit area where the freaks move about in seeming freedom. There you see a hog without any ham, a bull with elephant feet, a steer with its heart in its neck, a cat with 28 toes and 28 claws, a bull with human skin (so transparent that veins are visible, insured by Lloyd's of London for $15,000) … None of these animals have been mutilated to make freaks.

Ibid., pp. 51–2

Strange As It Seems: Founded on the familiar publications of John Hix in newspapers throughout the country, the show comprises thirty-two acts featuring the strange people depicted in the cartoons by Mr. Hix. Here also are showcases filled with curious objects obtained from all over the world. The show includes genuine Igerots, savage natives from North Luzon, Philippine Islands; pygmies from Batwa, Central Africa (the smallest human beings known); genuine Duckbill Ubangis from Shari country, French Equatorial Africa; headhunters from Congo and Masambo; the Jivaro and Phantom Indians of Ecuador; two genuine natives of the Cameroons, their faces covered with tribal markings; six Icelandic albinos, with white hair and pink eyes; giraffe-necked women from Padeung, north-eastern section of India; and two Romanian sister giantesses, the tallest women in the world.

Ibid., p. 57

The Infant Incubator Company Building (Skidmore and Owings, John Moss) was a structure designed to take care of premature babies. 8,000 babies are brought into the World's Fair to live for the first few weeks of their lives.

Ibid., p. 64

We Humans: This is neither a mystery show nor one offering gruesome thrills, but its nature is such that it mustn't be divulged ahead of time. This much may be said, however: you'll enjoy We Humans, a biological surprise exhibit.

Ibid., p. 82

A galaxy of midget stars dressed in immaculate white costumes … offering a variety of entertainment. Between performances they are kept busy packing giant cartons of "Krispy Crackers" and other Sunshine products.

Ibid., p. 44

Living Magazine Covers: Jack Sheridan's eight-minute show presents beautiful girls in person whom the artists for magazine covers have made nationally famous. The show is accompanied by music and trick lighting. Titles identify the magazines represented.

Ibid., p. 82

In a block of ice appears a living model who tells the story of refrigeration of tomorrow.

Ibid., p. 35

Clad in an abbreviated bathing suit, a beautiful girl is entombed in a solid cake of crystal-clear ice weighing 1,400 pounds. Without resorting to legerdemain or any special preparations this young woman is able to remain for long periods at a time in her frigid prison. Special lighting and the clearness

of the ice enable you to observe the Arctic Girl closely, and by means of a microphone and amplifiers you may converse with her. Only her ability to produce self-hypnosis makes possible this seeming, icy contradiction.

True enough, stalwart Amazons do not stalk militantly over a gigantic, legendary country but pursue arts and sports … young athletic women whose sole purpose is to display the harmony and beauty of the perfect feminine physique in action. Dressed as gladiators they perform. *Ibid.*, p. 34

Famous industrial designer Norman Bel Geddes uses one-way mirrors in a circular room thirty feet in diameter. A single dancing girl appears to be a whole chorus of World's Fairettes. Six hundred people are able to see the show from three levels through the transparent-reflecting glass walls, which repeat the image at least sixty times. *Ibid.*, p. 35

The Consumers Building is, indeed, the most nearly empty shell of all. Harding, p. 196

The nickel is a coin no one recognizes at the Fair. *Ibid.*, p. 197

The Fair pipes in city water free and charges what the concessionaires consider a stiff price for it. *Ibid.*, p. 198

For the first time the salesman is subordinate to the industrial designer, engineer, the architect, scientist, and the research man. *Ibid.*, p. 195

Celotex Traffic Top, a "new material that takes the strain out of walking" covers the Fair. "It is safe to say that this innovation has done its part to reverse the familiar expression often heard at previous fairs—'I'm too tired, let's go home' to 'Let's stay and see the show.'" *Ibid.*, p. 56

The Borden exhibit sells Mel-o-rols, highly engineered ice cream cones, flat on the bottom, designed to accept a horizontal cylinder of vanilla, chocolate or strawberry ice cream on top. Bennett, *Deconstructing*, p. 28

Simulacra

The Fair's urban dioramas simply expressed an already existent, widespread, popular desire for their utopian urbanism without adequately considering how the Fair's spectacular urban simulacra also helped construct and produce that desire. Bennett, *Deconstructing*, p. 37

The predominance of nostalgia in 1939: "The tintype photographer is on hand to portray visitors as they would have looked in 1853, 1876, 1893 and 1915. The mustachioed soda fountain clerk dispenses the soda delights of bygone eras." Monaghan, p. 41

Under the supervision of George Jessel, famous actor, Old New York presents an entertainment program staged and styled in the manner of The Gay Nineties. Here is New York of a bygone era, its streets lighted by gas; horsecars, hansom cabs, and patrol wagons clatter over its cobblestones … In the ghetto restaurant, short orders of food are relayed to the cook in the most amusing manner, while "Nigger" Mike features a score of singing waiters similar to those from among whom Irving Berlin rose to fame. Other attractions include … a police station and night court where rowdies and petty offenders are tried. *Ibid.*, p. 48

Z 1939 World's Fair — Simulacra

"George Jessel (actor)"

Jessel sometimes appeared in blackface in his Vaudeville shows. By the late 1960s he had gained a reputation as being overly indulgent in reminiscing about former companions who were little known by younger audiences. Walter Winchell once said of him, "That son of a bitch started to reminisce when he was eight years old."

Monaghan, p. 44

Morris Gest's Little Miracle Town, occupying 36,000 square feet, was brought over from Europe by a specially chartered ship. A miniature community, complete in every detail even to the diminutive organ in the church, its one hundred and twenty-five midget inhabitants have their own tiny restaurant, their city hall, their own theatre, art gallery, and railroad station. Other features include a midget circus, motion picture studio, garage, radio station, ballroom, guard barracks, Punch and Judy show, and toy and doll factory. Morris Gest toured all Europe to secure the greatest "little people" for Little Miracle Town.

Ford, "How Jews"

In February of 1921, Gest filed a $5,000,000 damage suit against Henry Ford for an article, "How Jews Capitalized a Protest Against Jews," which had referred to him as "a Russian Jew who has produced the most salacious spectacles ever shown in America," and which accused him of abandoning his Russian parents. Mr. Gest was livid, saying to the press, "I'll make that Peace Ship Henry pay dearly for what he said, and more, I'll make him eat his own words." In an official response, Liebold responded simply, "Mr. Gest will be ignored." The suit was eventually abandoned.

Monaghan, p. 86

Located in the rear of a Fair building is the only wheat field sown and cultivated in New York City in 68 years.

Ibid., p. 66

Sun Valley: Here, throughout the summer, a snowstorm is realistically depicted every evening.

Brox, p. 211

The road to Tomorrow leads through the chimney pots of Queens. It's a long familiar journey, through Mulsified Shampoo and Mobilgas, through Bliss Street, Kix, Astring-O-Sol, and the Majestic Auto Seat Covers ... through Musterole and the delicate pink blossoms on the fruit trees in the ever-hopeful back yards of the populous borough, past Zemo, Alka-Seltzer ... and the clothes that fly bravely on the line under the trees with the new little green leaves in Queens' incomparable springtime.

Bennett, *Deconstructing*, p. 39

For E.B. White, the Fair seemed to be "merely Heinz jousting with Beech-Nut—the same old contest on a somewhat larger field with accommodations for more spectators, and rather better facilities all around."

Art

Bennett, *Deconstructing*, p. 54

The New York cultural avant-garde almost unanimously opposes International Style modernist corporate skyscrapers on both aesthetic and political grounds. What others see as a brave, new utopian city—the rationalized, radiant, rectilinear city of tomorrow promised by the World's Fair—the avant-garde attacks as a brutal inscription of the political economy of post–World War II corporate America.

Monaghan

1939 marks the appearance of William de Kooning and Arshele Gorky [*sic*] as muralists at The Fair.

1939 World's Fair — Art

de Kooning receives a commission to design one of three murals for the Hall of Pharmacy at the World's Fair … The Hall of Pharmacy is allotted an auspicious location just off the Long Island Expressway, which skirts the fairgrounds.

Stevens and Swan, pp. 149, 151

Salvador Dalí's Living Pictures: A series of living pictures, executed in three dimensions … In front of the spectator is a long animated panorama that includes a thirty-foot glass and steel tank filled with water, at the bottom of which is a room from a "Dream House." Lovely diving girls plunge into the tank and by their actions seem to reveal the secrets of some dreams. The representations includes Dalí's famous "Soft Watches," "Piano Women," "Anthropomorphic Seaweed," "Exploding Giraffes," a cow at the bottom of the sea, a couch in the shape of Garbo's lips, and of course his "Living Liquid Ladies."

Monaghan, p. 49

Dalí's "Dream of Venus" provides a prototype for the complex aesthetic strategies that the post-WWII New York avant-garde developed to deconstruct the neo-Corbusian restricting of post-WWII New York City. The opposition between the Fair's techno-rational urban dioramas and Dalí's surrealistic architecture not only illustrates an incipient form of the cultural antagonisms that subsequently emerged, but it also helps demonstrate how the historical evolution of the post-WWII New York avant-garde was intimately connected to an on-going intellectual discussion about the nature of both space in general and urban space in particular.

Bennett, *Deconstructing*, p. 48

Replica of Harlem's Savoy Ballroom. Performers include Chick Webb, Erskine Hawkins, Duke Ellington and Johnny [*sic*] Lunceford.

Monaghan, p. 49

Conducted by The Academy of American Poets, the contest for the Official Poems of the New York World's Fair closed on March 15, 1939. 6,175 manuscripts were received. These came from every state and from American citizens living in Great Britain, Italy, France, Finland and Peru … The poem was judged by William Rose Benét, Theodore Roosevelt and Louis Untermeyer.

Academy

The names of the final poems: "World of Tomorrow," "The World of Tomorrow," "The World of Tomorrow," "Tomorrow," and "Tomorrow, America."

Ibid.

The official poem was "World of Tomorrow" by Pearl E. Levison (P. Earl), later known as Pearl London. The poem was read on the radio by Orson Welles, with whom she was photographed.

Ibid.

"World of Tomorrow" by Pearl E. Levison

Ibid.

Here on island (*O connect here for all points of your travel*)
With many bridges extending: Triborough, Queensboro
Brooklyn, Manhattan, Whitestone, iron harps suspended:
Here at hub of island with many spokes converging:
Radio, cable, wire bearing more than sparrow;
Train, bus, tug, trawler, clipper with bellied sail,
This is the achievement: this is tomorrow.

Probably more kinds of beauty were concentrated in the World of Tomorrow (1939–40) than had ever been seen by mortal eyes.

Rodgers and Rankin, p. 345

Berger, *Eight Million*, p. 247

Sometimes at night I lie awake in the dark and try to recapture the vision and sound of The World of Tomorrow. I try to remember how the pastel lighting glowed on Mad Meadow in Flushing: soft greens, orange, yellow, and red; blue moonglow on the great Perisphere and on the ghostly soaring Trylon. I think with a sense of sweetened pain of nights when I sat by Flushing River and saw The World of Tomorrow reflected on its onyx surface, in full color, and upside down. I try to recall the sounds, the carillon from the Garden of the Netherlands, chimes from Belgium's Tower. I know now that under the white carnation won by Grover Whalen, Great White Father of The Fen, beat the heart of a major poet. I muse, sometimes, on the distant day when archaeologists shall dig up the Time Capsule where the Westinghouse Building stood on the Fair Grounds. I wonder if they will be able to reconstruct the Great White Father's World as it really was, if they will be able to picture it swarming with pilgrims awed by his handiwork, if they will realize it was a place somewhat more astonishing than the world into which Alice stepped on the far side of the looking glass.

N. cit.

Externally, the Grand Central Terminal resembled a Palace of Industry in some nonexistent World's Fair. But was not New York itself becoming the universal exposition, the world's international playground?

Riesenberg and Alland, p. 64

It is possible that the final city, the City of Tomorrow only faintly visible in the embryo of New York, will be so constructed that the cost, in energy, to maintain life, will be less than at an outside point. On an average, people assembled in cities eat too much, if statistics are true. In the future city this may be changed. Ideal air and temperature balances will reduce the desire for caloric feeding. There will be less close eating and more idealistic drinking, not necessarily alcoholic; maybe a matter of skin absorption through gaseous as well as liquid painting. The common plate of ham and beans will eventually go into the garbage can, to the delight of billions of unborn hogs and the abolition of our reeking slaughterhouses.

Diehl, pp. 67–8

Within a few days after Pearl Harbor, the Japanese Pavilion at the World's Fair was dismantled … The famous Japanese Garden in Brooklyn's Botanical Garden would be renamed the Oriental Garden … A Japanese garden, one of the twelve that made up Rockefeller Center's "Gardens of the Nations" located on a setback on the eleventh floor of the RCA Building, was shorn of its chrysanthemums and replaced by a Chinese garden dedicated to Madame Chiang Kai-shek.

Ibid., p. 165

Con Edison's "Edison Man," a quarter-ton brass, copper and aluminum sculpture that was a part of the "City of Light" exhibit at the 1939 World's Fair was sacrificed during WWII.

Samuel, *End*, p. 18

The Trylon and Perisphere were demolished and melted down to make weapons during World War II.

Berger, *New York*, pp. 263–4

At dawn, now, night herons flap over the marshes to feed in the waters on Grover Whalen's vanished World of Tomorrow on Flushing Meadow. Pheasants light in tall, swaying meadow grasses to hunt for weed seeds and for insects. Cottontails break from brush and hedge; show their white flags in hoppity flight. Beside the rustic summer house on the edge of the old Gardens on Parade—the Queens Botanic Gardens now—a wild duck has laid seven large eggs in ground ivy. A few weeks ago majestic swans sailed down

from April skies to light in Flushing Creek. Wee things creep in the grass. Wild birds whistle and flute in old Fair-ground trees. Fishermen plod to the meadow to dangle bait in the creek, in old Fountain Lake and in Willow Lake just beyond the stretch where the Amusement Center made brazen clamor nineteen years ago. The anglers catch carp, catfish and sunnies. In twilight, frogs swell their throats in batrachian chorus. From early morning into early evening, from fifty to sixty old men and women come each day to the Meadow with burlap bags slung from their shoulders to search in dandelion-starred greensward for dandelion greens and for button mushrooms. They look like Millet's rustics—figures in "The Gleaners" and "The Angelus." Park Department foresters prune the Meadow's pin oaks, red maples and weeping willows on the 1,200 odd acres where Mr. Whalen's gardener-army planted them nineteen years ago. The paved roads that ran between glowing World Fair pavilions are carefully patched, but weeds grow in the cracks as in a ghost city. The new World's Fair in Brussels seems to have made people think of yesterday's World of Tomorrow. They wander on the Meadow in vain search for the buildings that wrote lambent loveliness against the sky there in 1939 and 1940. Only two structures still stand: the Building of the City of New York and Billy Rose's Aquacade. The city operates roller- and ice skating rinks in the New York building at night and police rookies study there by day. On summer nights, water shows are staged in the Aquacade and children use the pool up to noon. But of the dream houses that stood in the meadow—the Futurama, the pallid Trylon and Perisphere, all the pastel pavilions—there is no sign. Local hausfraus set up easels and paint the gardens and the lakes. Amateur botanists, including women deep in the winter years, look after the rock-garden plantings. One great patch near the old Gardens on Parade throbs with the color of 12,000 enormous tulips, a gift of Louis Dupuy, a greenhouse man in Whitestone. Azaleas flame at wide intervals over the whole meadow. No other green spot so close to granite-towered Manhattan has quite the sylvan lure of the old Fair grounds. It is a place to dream on a spring or summer day among the grasses, beside the creek or on the lake banks, with bird music pulsing all about. El train rumble comes in like mild thunder from the Roosevelt Avenue trestle, but only after wide silences. By-and-by you come upon a dark marble cylinder that reaches up out of the meadow. Its inscription says: "This Time Capsule deposited fifty feet beneath this spot by the Westinghouse Electric and Manufacturing Company on September 23, 1938. Preserving for The Future a record of the History, Faiths, Arts, Sciences and Customs of the People then alive … Scientists and Engineers designed it, Scholars chose its contents … to endure for 5,000 years."

1960 not only seemed like a brilliant, glittering dream from the perspective of 1939, but looking back, 1960 *was* a brilliant glittering dream. The Fair kept its promises. So many of its predictions came true.

Bennett, *Deconstructing*, p. 36

383

Allen and Brickman,
Manhattan, p. 271

And the "Rhapsody in Blue" orchestration swells. The film cuts to a magnificent skyline of Manhattan, the early-morning sun casting it almost in silhouette; the sun sets in another, a different, skyline, and, finally, Manhattan is shown at night, its buildings and bridges illuminated with thousands of lights. "Rhapsody in Blue" reaches a crescendo as the film cuts to a black background, white credits popping on and off the screen.

Z Postscript

Interlude

Talese, p. 9	At 5 A.M. Manhattan is a town of tired trumpet players and homeward-bound bartenders. Pigeons control Park Avenue and strut unchallenged in the middle of the street. Most *night* people are out of sight—but the *day* people have not yet appeared.
Ibid., pp. 9–11	At 5 A.M. the Broadway regulars have gone home or to all-night coffee shops where, under the glaring light, you see their whiskers and wear ... You also see cleaning ladies going home, always wearing kerchiefs.
Didion, "Goodbye," p. 174	We would watch the sky lighten and have a last drink with no ice and then go home in the early morning light, when the streets were clean and wet (had it rained in the night? we never knew) and the few cruising taxis still had their headlights on and the only color was the red and green of the traffic signals ... I liked the bleak branches above Washington Square at dawn, and the monochromatic flatness of Second Avenue, the fire escapes and the grilled storefronts peculiar and empty in their perspective.
Caldwell, p. 2	Toward dawn, as if released at the rasp of iron hinges, succubae and incubi fly out: nightmare thoughts, in check during the day, point with skeletal fingers to remorse, death, and vanity, their victims everywhere—tossing alone in bed, staring at the ceiling beside a snoring stranger, or plodding home after the bartender jerks on the lights and watches the deflated customers file out.
Strunsky, p. 706	As late as even five o'clock the milk man in the quiet streets is a symbol and mystery. By six o'clock he is a common purveyor.
Mayakovsky, *America*, p. 47	Down below, there flows the stream of humanity. At first, before dawn, there is a blackish-purplish mass of Negroes, who carry out the most arduous and dismal tasks.
Talese, p. 11	At 5 A.M. it is mostly quiet. New York is an entirely different city at 5 A.M.
Graham, pp. 36–52	It is five a.m. Something of the burden of the city has been lifted. The air is light. The heart seems freed. I feel happy to be walking. I love the space and the quietness. I have got rid of the idea of going to bed, got rid of the routine of daily life. New York and its millions, its wealth, its mysteries, are mine. There is a sense of conquest. The bustle has died down and I am still walking. The majority of people are asleep—but I am not the least sleepy. It seems as if life has just begun. I am dancing on a springed floor.
Weideman, p. 9	Five A.M. and waiting for the light at Times Square, a black guy runs up to my window.
Weegee, *Naked*, pp. 30–1	Open Air Canteen at Broadway and 47th Street at five in the morning. Bryant Park ... same time.
Philips, p. 28	5:23 A.M. The sky is gray-blue now. Empty buildings stand like cardboard cutouts against the slowly brightening day. A sleeper on one of the benches stretches slowly. The day is at hand.
Ibid., p. 111	The sun has barely come up even with the rooftops.
Mittlebach and Crewdson, p. 1	Few city residents awake to see the sunrise. Almost no one notices the daily rise and fall of the tides on the Hudson River.

Z Interlude

The sunrises (I saw them) are admirable: in a violet fog or dull atmosphere the solar fanfare bursts forth like a salvo, raw and clean, on the surface of one tower, then another, then many others. An Alpine spectacle which lights up the vast horizon of the city. Rose crystals, rose stone. There are tiaras over it, sometimes gold-colored, and not at all comic in effect but often beautiful.

Corbusier, p. 66

It is about five-thirty in the morning. We drive down lower Broadway. There are two black doors at 653. We go in the door. It was Infinity. There are two thousand guys.

Haden-Guest, p. 16

Creatures of the night, they cower and dissolve the incoming of the light. The yellow glare of their oil-torches and the ghastly violet-blue of their vacuum tubes pale, flicker, and go out before the onrush of dawn.

Strunsky, p. 697

When the long attended hour of sunrise approaches, they are appalled by the absence of even the slightest indication of the reappearance of the orb of day. There is no lightening of the dense cloak of darkness, and the great city seems dead.

Serviss, p. 60

Dawn in New York groans
on enormous fire escapes

Reznikoff, p. 97

At 6 A.M. the early workers begin to push up from the subways. The traffic begins to move down Broadway like a river.

Talese, p. 11

Have you ever arisen at dawn or earlier in New York and watched the outpouring in the meaner side-streets or avenues? It is a wondrous thing. It seems to have so little to do with the later, showier, brisker life of the day, and yet it has so very much. It is in the main so drab, or shabby-smart at best, poor copies of what you see done more efficiently later in the day. Typewriter girls in almost stage or society costumes entering shabby offices; boys and men made up to look like actors and millionaires turning into the humblest institutions, where they are clerks or managers. These might be called the machinery of the city, after the elevators and street cars and wagons are excluded, the implements by which things are made to go.

Dreiser, p. 5

Six in the morning. Thunder and rain. It's dark, and it'll stay dark until midday.

Mayakovsky, *America*, p. 46

The gray of dawn overtakes the armies from the markets, the car-barns, and the excavation pits in full retreat from the ferries, the bridges, and along the main arteries to the crowded sections where the early risers live. They scatter in every direction, weary, heavy-eyed, with no sense of defeat in their souls. They throng to the ferries to lose themselves in the mysterious wilds of Jersey. Their cavalry and train rumbles down empty Broadway to South Ferry. They pour eastward toward the bridges where they lose themselves in the sellers and ramshackle corner booths of the East Side. They plunge into the subway and, stretched out at full length in the illuminated spaciousness of the Interborough's cars, they pass off into the sleep which falls alike upon the just and unjust, contrary to general supposition ... The beauty of New York rising to meet a new day is for these lowly workers, and for the unfortunates who stay out in the night not to work but to sleep, because nights in the open are their refuge.

Strunsky, pp. 704–5

As daylight begins to fall on the city, their buckets will clatter in the halls, and downstairs their hollow voices will echo through the marble corridors.

Talese, pp. 33–35

Wojnarowicz, p. 175

He says, I wonder what the red sky means. I look up and the sky has a red pale glow on the bellies of clouds. It is getting towards dawn.

Strunsky, p. 704

The tremulous milky gray of the firmament followed by the red flush of daylight is reserved in New York for the truck-farmer from the suburbs, the drayman, the food-vendors, and the early factory hands. For them only is the beauty of New York as it heaves up out of the shadows.

McInerney, *Bright Lights*, p. 180

The first light of the morning outlines the towers of the World Trade Center at the tip of the island. You turn in the other direction and start uptown. There are cobbles on the street where the asphalt has worn through. You think of the wooden shoes of the first Dutch settlers on these same stones. Before that, Algonquin braves stalking game along silent trails.

Wojnarowicz, p. 123

The slow dawn is beginning to be apparent on the outer traces of horizon, I am thinking mass energy, white fields of light, protective energy, the voices get closer, feel claustrophobic on the edge of the great river on the edge of the great city, massive distances come and gone, the great endless sky and feels claustrophobic, like no place to run.

Weegee, *Naked*, p. 19

It is now almost six in the morning ... it is still dark ... but the church is open ... and the early morning worshippers find solace inside ... except for this tired Sunday traveler who, a few blocks away, finds a resting place under the canopy at number 711 Amsterdam Avenue ... This avenue is full of saloons, and they are called just that ... no fancy foreign names like Cocktail Lounges ... So sleep on stranger ... no one will bother you ... not even the cops ... Sunday is a good day for sleeping—so is any other day— when one is tired.

Wojnarowicz, p. 124

The dawn is on its way up with lightening colors of sky, a rusty tinge of red-orange coming up behind the factory across the way, the one past the next pier, the two simultaneous stacks almost merged with one another in the perspective of sight and growing a brown brick color, emerging from the darkness into the coming dawn, shadows slowly easing away, the water with small almost indiscernible flickering lines, like schools of fish just beneath the surface racing along and surging but not yet moving further but where they are, turmoils of water.

Berrigan, *Collected*, p. 149

What moves me most, I guess
of a sunlit morning
is being alone
with everyone I love
crossing 6th and 1st
at ice-cold 6 a.m.
from where I come home
 with two French donuts, Pepsi and
the New York Times.

Wojnarowicz, p. 124

Watch the intense visuals of dawn, the elevated structure of the Westside Highway and the burning lampposts, the incineration of the dawn, the backdrop domelike sky over the city lightening and the water turning to an azure blue, to turquoises and silvers, the merging of blood rust reds into the surfaces as if dawn were a flaming vehicle come rolling down across the plains and highways to step slowly into the river of time, the Indian giver of moments, the pulling in and the pushing forward, the continuance of senses, the changes that have rolled up and in and pulled me along since my return

from the quiet city of Paris, the lonesome city and the darkness that shuts off my sense of abandonment in that faraway place.

The sun heaves up from its sleeping-place somewhere in the vicinity of Flatbush, an extremely early riser.

Strunsky, p. 697

Across Times Square while the sky shows its first real signs of light, I see the clock on the *New York Times* building: 6:16.

Goodman, *Secret*, p. 9

Already at six and six-thirty in the morning they have begun to trickle small streams of human beings Manhattan or cityward.

Dreiser, p. 7

dragging themselves through the negro streets at dawn looking for an angry fix

Ginsberg, *Howl*, p. 3

In the now gathering dawn and somewhere out there are two huge metal barges filled with stuff I can't make out, bobbing and drifting in the river as huge waves pulled in from passing tugs and barges and small ships and the moon long gone and the open doorways of the warehouse across the way revealing orange.

Wojnarowicz, pp. 124–5

Maybe it is the dark light of dawn just as the sun is rising in the east but buried behind buildings, maybe it's midnight, the light qualities fluctuate.

Ibid., p. 223

Cold rosy dawn in New York City

Berrigan, *Collected*, p. 127

We lay there for some slow minutes with our hands beneath our heads staring up: large mobile clouds with reddish tinge to their bellies and the jigsaw sections of turquoise sky behind them, shuttering for moments until they were once again covered, one spire way up catching the gradually warming light of dawn way east of the river and tenements. The yard was still filled with a descending night, like some old Magritte scene.

Wojnarowicz, p. 177

A new day dawns living.

Donleavy

Toward seven, it's an uninterrupted flow of lights. On they go, in the direction of their hundreds of thousands, to their places of work. But their resinated yellow waterproofs sizzle and glitter like innumerable samovars in the electric light—running wet, yet inextinguishable, even under this rain.

Mayakovsky, *America*, p. 47

Look at them flowing into the city's lower parts in the morning rush. The downtown region sops them up as dry bread lifts the gravy from a platter.

Riesenberg and Alland, p. 28

By seven and seven-fifteen these streams have become sizable affairs.

Dreiser, p. 7

Movement of the city regiments and the commuting storm troopers, in and out of the business citadels, takes a fifth of the "working" day.

Riesenberg and Alland, p. 70

Alternating magnet and ejector of commuters.

Ibid., p. 207

Great silent weeping stream of people in the canyon streets.

Donleavy

No rush, no hurry. Only slow movement. Yet all are surely and gradually slipping away.

Dreiser, p. 10

By seven-thirty and eight they have changed into heavy, turbulent rivers.

Ibid., p. 7

Maxwell, p. 3

With the morning sun on them, the apartment buildings far to the west, on Lexington Avenue, look like an orange mesa.

Berrigan, *Collected*, p. 116

It is 7:53 Friday morning in the Universe
New York City to be somewhat exact
I'm in my room wife gone working Gallup
fucking in the room below
 had 17½ milligrams desoxyn

Conrad, p. 249

A Scarsdale commuter station where the passengers, reading newspapers to use the time in waiting, line up at the spots on the platform where they know the doors of their train will open; once aboard, they return to their papers, and each car becomes an informal study-group in current events.

Dreiser, p. 7

At eight-thirty they are raging torrents, no less. They overflow all the streets and avenues and every available means of conveyance. They are pouring into all available doorways, shops, factories, office-buildings—those huge affairs towering so significantly above them.

Berrigan, *Collected*, p. 117

It's 8:54 a.m. in Brooklyn it's the 26th of July and
it's probably 8:54 in Manhattan but I'm
in Brooklyn I'm eating English muffins and drinking
Pepsi and I'm thinking of how Brooklyn is New
York City too how odd I usually think of it
as something all its own like Bellows Falls like
Little Chute like Uijongbu

WPA Guide, p. 86

Wall Street and Broadway, shortly before nine o'clock in the morning. The empty streets fill suddenly with swift-moving clerks, tellers, stenographers, and office boys pouring from subways, ferries, and elevated trains; while bankers and brokers arrive almost as promptly in chauffeured automobiles or by planes landing at a ramp near the foot of Wall Street.

Mayakovsky, *America*, p. 48

By 9:30, the crowd flows along, inundating the apertures to the underground protruding into the covered thoroughfares to the airborne trains, and racing through the air at a height in double- and triple-decker parallel overhead trains.

Dreiser, p. 7

Here they stay all day long, causing those great hives and their adjacent streets to flush with a softness of color not indigenous to them.

McInerney, *Bright Lights*, p. 14

It's ten-fifty when you get to Times Square. You come up on Seventh Avenue blinking. The sunlight is excessive. You grope for your shades. Down Forty-second Street, through the meat district. Every day the same spiel from the same old man: "Girls, girls, girls—check 'em out, check 'em out. Take a free look, gentlemen. Check it out, check it out." The words and rhythm never vary. Kinky Karla, Naughty Lola, Sexsational Live Revue—girls, girls, girls.

Conrad, p. 110

If your eyes could penetrate the opaque masses of the façades at 11 a.m., they would see an incredible spectacle: three hundred thousand, five hundred thousand men and women—perhaps more—at work in a pool of space at the same time. A humanity having broken its millenary destiny which was to be attached to the ground, which is suspended between heaven and earth, going up and down at high speed in clusters of twenty and in sheaves of two hundred. Is it a new scene in purgatory?

At the hour of noon light suddenly broke overhead. Beginning in a round patch enclosed in an iridescent halo, it spread swiftly, seeming to melt its way down through the thick, dark mass that choked the air, and in less than fifteen minutes New York and all its surroundings emerged into the golden light of noonday.

Serviss, p. 63

… It is 12:10 in New York. In Houston
it is 2 p.m. It is time to steal books.

Berrigan, *Collected*, p. 114

The lunchtime crowd churns Park Avenue.

McInerney, *Bright Lights*, p. 126

It is 12:20 in New York a Friday
three days after Bastille day, yes
it is 1959 and I go get a shoeshine
because I will get off the 4:19 in Easthampton
at 7:15 and then go straight to dinner
and I don't know the people who will feed me

O'Hara, p. 325

From twelve noon until about two-thirty, there is a carnival. Since the place has an appetite like a hundred anacondas, food is eaten by the carload; beauty shops and barber shops seethe; merchandise is purchased and sold in staggering amounts and the sound of money changing hands can be heard all over the place.

Atkinson, p. 95

Standing in the waterfront bar, having stopped for a beer in midafternoon, smoky sunlight fading in through the large plate-glass windows and a thumping roll of music beating invisibly in the air …

Wojnarowicz, p. 138

The city traffic in the afternoon, people standing on street corners, streets filled with cars and buses humming, and even though it was overcast there was some startling nature to the light, everything graphic in detail, a heavy sense of rain in the cool air.

Ibid., p. 179

After two-thirty the restaurants gradually become empty, the shops are vacant, the streets sparsely filled.

Atkinson, p. 95

At three o'clock, an air of suspended animation between the morning and evening rush hours.

Morris, *Incredible*, p. 299

in the warm New York 4 o'clock light we are drifting back and forth between each other like a tree breathing through its spectacles

O'Hara, p. 360

I remember "four o'clocks." (A flower that closes at four.)

Brainard

Already, at four o'clock, the somber hues of night are over all. A heavy snow is falling, a fine, picking, whipping snow, borne forward by a swift wind in long, thin lines. The street is bedded with it, six inches of cold, soft carpet, churned brown by the crush of teams and the feet of men. Along the Bowery men slouch through it with collars up and hats pulled over their ears.

Dreiser, p. 228

And of an early winter afternoon—the time for which I most lovingly remember the El, for the color of the sky as it fell through those painted windows, and the beauty of the snow on the black cars and iron rails and tar roofs we saw somewhere off Brooklyn Bridge—when the country stove next to the change booth blazed and blazed as some crusty old woman with a pince-nez gave out change, and the heavy turnstiles crashed with a roar

Jackson and Dunbar, p. 678

inside the wooden shed—then, among the darkly huddled crowds waiting to go out to the train, looking out on Brooklyn Bridge all dark sweeping cable lines under the drifts of snow, I pretended those were gaslights I saw in the streets below.

Capote, p. 45

Late one afternoon, while waiting for a Fifth Avenue bus, I noticed a taxi stop across the street to let out a girl who ran up the steps of the Forty-second Street public library.

Morand, p. 513

At five p.m., at the foot of the buildings the revolving doors are whirling like crazy wheels, each fan blowing out human beings on to the sidewalk. In Europe there are no crowds. One must go to Asia or come here to get the feel of that air-current, that unsubstantial monster, impersonal and cowardly and tender, calling for the death of a black boxer, writhing for love before the coffin of Valentino, mourning a father before the bier of Lincoln, welcoming a bridegroom in Lindbergh.

Sharpe, p. 229

It is growing dark. Great white lights are throwing a magic glare over streets and buildings. All the windows of the palaces and great buildings glow with light. Mysterious shadows come and go. Nothing seems real. Am I awake or am I dreaming?

Ellis, *Glamorama*, p. 18

It's a Wednesday but outside feels Mondayish and the city looks vaguely unreal, there's a sky like from October 1973 or something hanging over it and right now at 5:30.

Morand, p. 513

The flood streams up Broadway, washes over Brooklyn Bridge, invades the "L"—as the Elevated Railroad is called—and swamps the subway stations. Then an individual order follows this momentary chaos; some stop before the newspaper display windows where the fleeting news-strips announce that Trotsky is going to settle at Monte Carlo, or congregate round the special editions which pile up at the street-crossings, or make for suburban repose, for the cottage or bungalow with its aerial on the roof and its artificial flowers, or for supper at the Y.M.C.A., while others seek their aspirations in the great luminous halo of the cinemas and theaters of Times Square and the Forties.

Mayakovsky, *America*, p. 51

From five until seven is the most boisterous, the most congested time. To those who have finished work, there can also be added the shoppers, male and female, and simply the *flâneur*.

Lovecraft, "He," p. 295

I have seen it in the sunset from a bridge, majestic above its waters, its incredible peaks and pyramids rising flowerlike and delicate from pools of violet mist to play with the flaming clouds and the first stars of evening. Then it lights up window by window above the shimmering tides where lanterns nod and glide and deep horns bay weird harmonies, and has itself become a starry firmament of dream, redolent of faery music, and one with the marvels of Carcassonne and Samarcand and El Dorado and all glorious and half-fabulous cities.

Atkinson, p. 95

One more slight spasm of trade after five o'clock when the commuters begin passing on their way to the suburbs. But after that everywhere is as dark and silent as the grave.

Dos Passos, p. 169

The sun's moved to Jersey, the sun's behind Hoboken.
Covers are clicking on typewriters, rolltop desks are closing; elevators go up empty, come down jammed. It's ebbtide in the downtown district, flood in

Flatbush, Woodlawn, Dyckman Street, Sheepshead Bay, New Lots Avenue, Canarsie.

Pink sheets, green sheets, gray sheets, *FULL MARKET REPORTS, FINALS ON HAVRE DE GRACE*. Print squirms among the shopworn officeworn sagging faces, sore fingertips aching insteps, strongarm men cram into subway expresses. *SENATORS 8, GIANTS 2, DIVA RECOVERS PEARLS, $800,000 ROBBERY*.

It's ebbtide on Wall Street, floodtide in the Bronx.

The sun's gone down in Jersey.

That most magical moment of the day when the buildings around Central Park are still visible in a blue mist, the lights simultaneously shining at every window.

Beaton, *New York*, p. 53

Evening falls. The skyscrapers, these great presses of humanity, disgorge their exhausted contents. The vertical arrangement of individuals will now give way to the new, horizontal arrangement for night-time.

Morand, p. 513

At six, they are going, pouring forth over the bridges and through the subways and across the ferries and out on the trains, until the last drop of them appears to have been exuded, and they are pocketed in some outlying side-street or village or metropolitan hall-room and the great, turbulent night of the city is on once more.

Dreiser, p. 7

Near sunset, the clouds, the long bridges, the tops of some of the structures on the Queens shore, and the bridges of the ships are brushed with rose, while the grayish water turns slowly to ink.

Philips, p. 136

The sky is bleeding now
 onto 57th Street
of the 20th Century &
 HORN & HARDART'S

Berrigan, *Collected*, p. 157

A setting sun sending shadows east.

Donleavy

Tonite I walked out of my red apartment door on East Tenth Street's
 dusk—
Walked out of my home ten years, walked out in my honking
 neighborhood
Tonite at seven walked out past garbage cans chained to concrete
 anchors
Walked under black painted fire escapes, giant castiron plate
 covering a hole in ground
—Crossed the street, traffic lite red, thirteen bus roaring by liquor
 store,
part corner pharmacy iron grated, past Coca Cola & Mylai posters
 fading scraped on brick
Past Chinese Laundry wood door'd, & broken cement stoop steps
 For Rent hall painted green & purple Puerto Rican style
Along E. 10th's glass spattered pavement, kid blacks & Spanish oiled
 hair adolescents' crowded house fronts—
Ah, tonite I walked out on my block NY City under humid summer
 sky Halloween

Ginsberg, *Collected*, p. 633

Outside a premature dusk is settling over the city as the gray haze of rain clouds blow in from the southeast. I cross the street and walk north to a

Spillane, p. 288

subway kiosk. Before I reach it the rain starts again. A train pulls out of the station, giving me five minutes to six to wait.

395

Talese, pp. 33–5

Early in the evening, as thousands of New York secretaries go heel-clacking and swishing out of office buildings, another large army of women prepare to move in. And from twilight to sunrise these women will seemingly control New York … They will keep skyscraper lights burning all night, and along the windows their silhouettes and brooms will be reaching and touching like a ballet of witches.

Riesenberg and Alland, p. 209

Darkling perfumed city of fair women passing closely in the dusk; crowds hurrying away and returning.

Dreiser, p. 82

The streets are pouring with them at six o'clock. They are a great tide in the gray and dark.

Jolas, p. 472

Sultry July dusk.

Hughes, *Collected*, p. 426

dusky sash across Manhattan

Blandford, p. 111

There is a certain yellow, white and green complexion that can be seen every night around 6 o'clock, swaying and faint on the Madison Avenue bus. It is the face of a physically and emotionally overheated society.

Atkinson, p. 42

Twilight over terrible Manhattan. The New York sky that had been a twanging blue when I entered the hotel is now a tender violet. The street lights are golden bubbles, golden fruits, hanging from their wrought-iron trees. From the doorway where I am standing I can see a forest of jeweled towers rising serene and magical against the lovely sky. They are the hotels and apartment houses that light their windows against the coming dark. To the west a varicolored mist hangs low—that is Columbus Circle with its neon signs and its whirligig of traffic lanes. And everywhere the people hurry through the gloom.

Conrad, p. 234

Hart Crane arranges a landscape of impressionist imprecision inside the frame of his window: "At twilight on a foggy evening … it is beyond description," he says of the harbor—beyond description because beyond perception, atmospherically smudged, the top of the Woolworth Building swallowed by a cloud.

Nabokov, p. 226

When they emerge from the thunder and foul air of the subway, the last dregs of the day are mixed with the street lights.

Atkinson, p. 41

Across the way in the twilight stretches the dark jungle of Central Park.

Hapgood, p. 189

It is 6:30 when I leave my room. I walk slowly down Broadway. The lights are twinkling, and the hurrying crowds tell of universal impatience for the pleasures of the evening. How many of these people are going to the theater? How many are hastening home to domestic comforts? Many a man is going to meet an old friend for a long sweet dinner and a longer and sweeter talk. Many a girl is hurrying to meet the man she has known for so long that meeting him after hours has become a pleasant habit. Others, like myself, are merely vaguely looking forward for something amusing or affecting to happen.

7 Interlude

A twilight hour in early spring—it is March—when, starting from the Brooklyn end, I face into the west wind sweeping over the rivers from New Jersey. The ragged, slate-blue cumulus clouds that gather over the horizon leave open patches for the light of the waning sun to shine through, and finally, as I reach the middle of the Brooklyn Bridge, the sunlight spreads across the sky, forming a halo around the jagged mountain of skyscrapers, with the darkened loft buildings and warehouses huddling below in the foreground. The towers, topped by the golden pinnacles of the new Woolworth Building, still catch the light even as it begins to ebb away. Three-quarters of the way across the Bridge I see the skyscrapers in the deepening darkness become slowly honeycombed with lights until, before I reach the Manhattan end, these buildings pile up in a dazzling mass against the indigo sky. *Mumford, Sketches, p. 129*

The early part of the night on Broadway, which is but the bedraggled fringe of day. *Strunsky, p. 698*

Workdays repeat themselves: night reinvents itself with every sunset. After the commute, and as full darkness is accomplished, first restaurants come to life, then theaters, bars, and clubs, then after-hours dives—all of them venues for drama, rewritten every second it plays. Glamour, lust, license, and crime emerge from the shadows and parade under the lights, high life and low life, polished veneer and sweaty beastliness. *Caldwell, p. 2*

When I finish eating and climb behind the wheel of the car it is almost eight. The evening shadows have dissolved into night, glossy and wet, the splatter of the rain on the steel roof an impatient drumming that lulls thoughts away. I switch on the radio to a news program, change my mind and find some music instead. *Spillane, p. 318*

The foreground is thickly dark, obfuscated by the looming stump of a building. There are some lights below, like gems in a mine, but they don't help, since you can't tell to what they belong. *Conrad, p. 85*

Dark between these buildings. *Donleavy*

That's part of the magic of the night, the way that the moon and the stars, though invisible, smothered in the contaminated skies of big cities, nonetheless manage to charm silver and gold out of the pockets that are zippered shut in the daylight. *Haden-Guest, p. 4*

Men and women who work in New York skyscrapers by day never meet the men and women cleaners who take over at night. They form independent tides that never rip or cross. *Berger, New York, p. 42*

The sempiternal New York night. *McCourt, p. 21*

After dark, consciousness is no longer on sentry duty. Sleep is the city's restitution. At night the body is consigned to its own metabolic devices. No longer required to do things for its demanding mental employer, it fantasizes about its longed-for liberty. *Conrad, p. 272*

Below Canal Street, night covers a dark blot, except for the scrubbers' dim lights. *Riesenberg and Alland, p. 29*

It's 8:30 p.m. in New York and I've been running around all day old come-all-ye's streel into the streets. *Berrigan, Collected, p. 28*

Ibid.	Wind giving presence to fragments.
Strunsky, p. 698	The dealers of the night are concerned with bread, flesh, milk, butter, cheese, fruits, and the green offerings of the fields.
Dos Passos, p. 326	Outside the broad office windows the night is gray and foggy. Here and there a few lights make up dim horizontals and perpendiculars of asterisks.
Weegee, *Naked*, p. 37	Night … a black velvet curtain has dropped over the white sky… a few mothers went looking for their kids … found them here … dragged them home for supper … but they are back again … but that's the same Empire State Building in the Background …
Dreiser, p. 217	It is nine o'clock on a summer's night. The great city all about is still astir, active, interested, apparently comfortable. Lights gleam out from stores lazily. The cars go rumbling by only partially filled, as is usual at this time of night. People stroll in parks in a score of places throughout the city, enjoying the cool of the night, such as it is.
Brook, p. 17	It's a wintry night and the clouds are low. Walking through the midtown streets my chin is thrust into my coat, my hands are chilled inside my fur-lined gloves.
Wojnarowicz, p. 177	On the way up Broadway we passed the church around 11th Street, which has a front yard with a large urn the size of four men side by side and dark green lawns and some trees and flowers that had recently lost their petals. The entire yard is bathed in night shadows but over the roofs and spires the sky is turning a deep cobalt. I turn to him and say, I haven't lain down on grass in ages … We stopped and rest our hands on the wrought-iron fence, white against gleaming back. Then, I say, There's too much dog shit in the parks to lay down.
Conrad, p. 272	The city at night is taken from those who think they run it and handed over to its amoral aborigines—the sexually hungry, the larcenous, the violent, all of them agents of somnambulistic id.
Atkinson, p. 40	A couple resting from dancing in the Mall in Central Park some starry summer night.
Conrad, p. 284	It is maybe ten-thirty of a Wednesday night, and I am standing at the corner of Forty-eighth Street and Seventh Avenue.
Depero, "24th Street," p. 428	Who roams Manhattan's midnight range From neonrise to neonset?
Mayakovsky, *America*, p. 55	At midnight, those coming out of the theatres drink a last soda, eat a last ice cream, and crawl home at one, or at three, should they hang about for a couple of hours foxtrotting, or in the final yelling of "Charleston." But life does not come to a stop. In the same way, shops of all sorts are open, the subway and the elevated are still running, you can still find a cinema which will stay open all night, and sleep there as long as you like for your twenty-five cents.
Riesenberg and Alland, p. 158	A clock chimes midnight. The last few news watchers leave. The lights go out. Then, of a sudden, the sign flashes again, you stand transfixed. What now? Words trip before you. THE NEW YORK TIMES WISHES YOU GOOD NIGHT. The pavement seems a little less hard. Somewhere, up behind the

screen, is a dash of kindness. A strictly practical sign would just shut off its light and save that extra watt of current.

The hands of the lighted city clock
Climb one on top of the other
Like a street dog on his accidental mate—
Twelve.
Now the hoarse song of blood rises
To the night ears of the city.
Now the whole city sings the song of two.
Now the whole city cries the cry of one to one.
And the lighted city clock replies:
Twelve.

Glashteyn, p. 498

Behind Midnight's screen on St. Mark's Place

Berrigan, *Collected*, p. 594

At midnight New York is dead-deadd-deadd. It is won-derr-ful.

Conrad, p. 288

At midnight Jack raises his window and sits close to it. He catches his breath at what he sees, though he has seen and felt it a hundred times.

Henry, "Duel," p. 386

 Far below and around lies the city like a ragged purple dream. The irregular houses are like the broken exteriors of cliffs lining deep gulches and winding streams. Some are mountainous; some lie in long, monotonous rows like the basalt precipices hanging over desert canons. Such is the background of the wonderful, cruel, enchanting, bewildering, fatal, great city. But into this background are cut myriads of brilliant parallelograms and circles and squares through which glow many colored lights. And out of the violet and purple depths ascend like the city's soul sounds and odors and thrills that make up the civic body. There arise the breath of gaiety unrestrained, of love, of hate, of all the passions that man can know. There below him lies all things, good or bad, that can be brought from the four corners of the earth to instruct, please, thrill, enrich, despoil, elevate, cast down, nurture or kill. Thus the flavor of it comes up to him and goes into his blood.

On the subway, a girl who has fallen asleep, her head lolling, her mouth slightly agape.

Conrad, p. 174

We need urgently a vindication of the Night, and especially of night in the city.

Strunsky, p. 697

The streets at one A.M. are very very dark up in the 30's, as if all the lights are concentrated in 42nd Street. Everything else dims in the radius spreading out from that street. Everything, each surface has a glittering quality. There is so little light that touches anything directly, as signs of life, little granules of glass in the asphalt, the sidewalks, pools of wet stuff, occasional faraway streetlights, pools of black darkness where it's hard to discern grates and barricades and doorways and burglar gates and occasionally the dim light of what seems like a fifty-foot-high streetlamp illuminating a sphere of sidewalk, piles of large cardboard boxes from factories and sweatshops hidden behind the fashion/garment district facades and showrooms. Nothing but the sound of skittering newspapers, pieces of cardboard dragging down the street, garbage spread everywhere, rotten produce in the gutter, sounds of traffic on the main avenue, occasional side street cabs bumping potholes, indiscernible click of traffic lights on empty streets, vague silhouettes of mannequins behind dark windows and solder gates, poor versions of American fashions for overseas. On 8th Avenue there's rarely a living being below 40th Street—it's maybe too dangerous or the pickings too slim to draw any interest.

Wojnarowicz, pp. 236–7

Suddenly darkness moves and a human is sliding along the storefronts close to the windows and doors moving bent over with intent or with loss—something in the body language or the clothing, broke, in pain, weary, hopelessness. Cars come in twos or threes burning up the Avenue with foot pushing the gas springing from a red light that's finally changed, charging uptown giving the impression there's nothing here to stop for, people rushing from one location to another and I wish at times I could read the entire history and intentions and structure of a person to know what sad destinations they have before them in that moment.

On 37th Street on the west corner of 8th Avenue, there was an illuminated window, gates half down, a donut shop, and the apparition of a man naked above the waist mopping the floor around the horseshoe counters. I stood on the opposite corner—the image was kind of beautiful, in the periphery of sight it was just six-story buildings and empty streets, everything buried in black shadows and gritty low-level light, newspapers lifting gently in the warm breeze, the skip of occasional car wheels over manhole covers, the metallic hum of circuitry in the traffic lights and the sky that weird charcoal blue gray where night is softly illuminated from the city below. And in the midst of all this desolation a bright rectangle ten feet by twenty feet fluorescent unreality and thousands of fresh donuts stacked into the racks and a sexy Puerto Rican man, his muscular body just beginning to fade from youth softening up at the edges sweeping motions of the mop from side to side, white kitchen pants and athletic shoes and he's totally unaware of being watched.

Ibid., p. 148

One A.M. on the corner of Sheridan Square—across from the unlit triangle of park benches streaming in the night, neons as far as you can see, then the shell of darkness beyond, and back there over that indiscernible line drawn by lack of lights is the whole pocket of memory and a sense of the past few hours, past days, seeds of weariness brought on by the crashings of black beauties.

Berger, *Eight Million*, pp. 166–7

At two A.M. the Spearmint sign blacked out and plunged Times Square into sudden darkness. One by one the neons died: the Cadillac, the bars and grills in the deeper Forties. Store windows darkened and theater lights drained off. The Square huddled in ever-deepening shadow.

Gamble, p. 391

The streets of Harlem make an unreal scene of frightened silence at 2 A.M.

Carpenter, p. 341

2 AM it was the hour for "taking you home," "going home," and the teenagers and sailors walked arm in arm with their "women," and the women giggled. At 2 AM in the morning, it seemed, to me, one of the lonely souls, that everybody was walking in pairs, and every smart woman had found her man, and any man worth his pants had managed to hook up with a woman … Only the poets are free.

Philips, p. 26

In a few minutes the lights on the marquees start going off and by 2:00 A.M. the street is dark. The moving news sign on the tower a block away is out, and the big advertising signs in the Square are switched off, too.

McInerney, *Bright Lights*, p. 1

The night has already turned on that imperceptible pivot where two A.M. changes to six A.M.

Reay, p. 271

For sheer beauty—don't miss the breaking of dawn across the East River—or a full moon—bathing Avenue C in magic light at two or three in the morning.

And the great city sleeps, its pulse scarcely disturbed by the feverish activity of the hosts of darkness. Or if the city catches a rumble of their movements and stirs in its slumber, it is only to turn over and go to sleep again. No hypnotic spell will account for this indifference of a city of five million to the presence of an army in its gas-lit streets. It is merely habit. If here and there in the cubical hives where New York takes its rest an unquiet sleeper tosses in his bed and resents the disturbance, it is not to wish his prowlers of the night were caught and sent to jail, but only to wish that they went about their business more discreetly—this great host of market-men, groceries, butchers, milkmen, push-cart engineers, and news-vendors would've engaged since soon after midnight on the enormous task of preparing the cities breakfast.

Strunsky, p. 697

For this, of course, Is the real nightlife of New York—the life that beats at rapid pace the great water-front markets, and the newspaper press-rooms around Brooklyn Bridge, under the acetylene glare over excavations for the new subways, and in the thousands of bake shops that line the avenues and streets.

At three in the morning the dreary street sprawls slant-wise across the town in all the ugly meanness of disuse.

Peretti, p. 26

The markets on the water-front are the heart of the city's night life, but in all five boroughs there are local centers of concentrated vitality—the milk-depots, the street-railway junctions, the car-barns. Where elevated or subway meets cross-town and longitudinal surface lines you will find at three in the morning as active and garishly illuminated a civic center as many a city of the hinterland would boast at nine o'clock in the evening. Groups of switchmen, car-despatchers, conductors, motormen, and the casual onlooker whom New York supplies from its inexhaustible womb even at three in the morning, stand in the middle of the road and discuss the most wonderful mysteries—so it seems, at least, in the hush before dawn. And because the cars which they switch and side-track and despatch on their way depart empty of passengers and lose themselves in the shadows, their business, too, seems one of impressive mystery.

Strunsky, p. 700

A car-conductor at 3 o'clock in the morning is the most delightful of people to meet. His hands are grimy with the dirt of alien nickels and dimes. His temper isn't as yet unworn by the day's traffic.

Ibid.

A trip down Amsterdam Avenue in a surface car at 3 A.M.

Ibid., p. 703

The night is primarily the time of the innocent industries, employing simple, innocent, primitive men—slow-speaking truck-farmers; brawny slaughterers in the abattoirs; stolid German bakers; apathetic milkmen.

Ibid., p. 698

Rise at three in the morning and walk a mile between the rows of wagons and stalls in Gansevoort or Wallabout Market, drawing strength from the piles of sweet, green produce, dewy under the lamplight and learning patience from the farmers' horses … When you stroll through the markets, between lines of wagons, stalls, crates, baskets, and squads of perspiring men, you need not force the imagination to call up the solid square miles of brick and stone barracks in which New York's five million, minus some thousands, are asleep, outside the glare of the arc-lights and kerosene-torches.

Ibid., pp. 698–9

Little girl … what are you doing out at three in the morning … you should be home asleep.

Weegee, *Naked*, p. 28

Z Interlude

Philips, p. 23	There is a point past 3 a.m. when the loudest noise a stray visitor hears in Times Square is the click-click of the inner workings of a traffic signal, switching lights.
Ibid., p. 27	3:10 A.M. You can walk a block in Times Square and not see a soul.
Strunsky, p. 699	There it sleeps, the big, dark brute, and in another three hours it will yawn and sit up and blink its eyes and roar for its food.
Lichtenstein, p. 513	Night creeps into the cellars, musty and dull. Tuxedos totter through the rubble of the street. Faces are moldy and worn out. The blue morning burns coolly in the city.
Talese, p. 5	When street traffic dwindles and most people are sleeping, some New York neighborhoods begin to crawl with cats.
Berrigan, *Collected*, p. 70	it is 3:17 a.m. in New York city, yes, it is 1962, it is the year of parrot fever.
Ibid., p. 68	Then I walk out in the bleak village in my dreams, for they are present! I wake up aching from soft bed Back to books. It is 3:17 a.m. in New York city
Brainard	I remember the clock from three to three-thirty.
Dreiser, p. 5	Take your place on Williamsburg Bridge some morning, for instance, at say three or four o'clock, and watch the long, the quite unbroken line of Jews trundling pushcarts eastward to the great Wallabout Market over the bridge. A procession out of Assyria or Egypt or Chaldea, you might suppose, Biblical in quality; or, better yet, a huge chorus in some operatic dawn scene laid in Paris or Petrograd or here. A vast, silent mass it is, marching to the music of necessity. They are so grimy, so mechanistic, so elemental in their movements and needs.
Strunsky, p. 697	It is amazing how a great city can snore with equanimity while entire regiments and squadrons carry on operations in the streets, quietly, but with no attempt at concealment.
Berger, *Eight Million*, p. 169	The Square, north of the Crossroads, is a black pit now. It is almost four o'clock. Only one or two neon signs glow redly through the dark.
Reay, p. 12	Rewarding myself with a hustler at 4 am.
Ginsberg, "Howl," p. 19	the last door closed at 4. A.M.
Berrigan, *Collected*, p. 493	Crossing Park Avenue South; 4:14 a.m.; going West at 23rd; September 1st, 1971
Strunsky, p. 698	The milkman alone is enough to redeem the night from its undeserved evil reputation. A cartload of pasteurized milk for nurslings at four o'clock in the morning represents more service to civilization than a truckload of bullion on its way from Sub-treasury to the vaults of a national bank five hours later.

Z Interlude

Part 2

Ellis, *Epic*, pp. 456–7

J. Pierpont Morgan dealt himself another hand of solitaire and listened for the twentieth century. It was the night of December 31, 1899, and Morgan sat in the library of his Madison Avenue mansion. Logs crackled in the fireplace. To the left of the hearth stood a bookcase holding two metal statues of knights in armor, a clock perched between them. From time to time Morgan may have lifted his dark-hazel eyes to glance at the clock.

The hulking six-foot financier sat at his desk in his usual flat-footed position, toes turned out. With strong and well-formed fingers, he laid out the cards, playing almost automatically, as he did when he had something on his mind. A long cigar protruded from the paper cigar holder clenched in his teeth under his mustache.

Although it was almost midnight in Morgan's mahogany study, it was the high noon of capitalism in America, and no American stood out so starkly as he. Morgan was centralizing the control of industry and credit. He was the capitalist's capitalist. President William McKinley of the large head and barrel torso sat in the White House; but businessmen guided the nation's destiny and Morgan guided the businessmen. Indifferent to social reform and defiant of public opinion, Morgan felt that he owed the public nothing.

The clock began tolling the hour of midnight. Morgan may have raised his massive head at the very first bing. So the twentieth century had arrived? Very well. Within a little more than a year Morgan was to create the first billion-dollar corporation in history, the United States Steel Corporation. Bong!

Haden-Guest, p. 273	Uptown is uptown. Downtown is downtown. It's sort of a voluntary apartheid.
Ibid., p. 108	There were not many *ideas* uptown.
Holiday, p. 77	I found out the main difference between uptown and downtown was people are more for real up there. They got to be, I guess. Uptown a whore was a whore; a pimp was a pimp; a thief was a thief; a faggot was a faggot; a dike was a dike; a mother-hugger was a mother-hugger.
	Downtown it was different—more complicated. A whore was sometimes a socialite; a pimp could be a man about town; a thief could be an executive; a faggot could be a playboy; a dike might be called a deb; a mother-hugger was somebody who wasn't adjusted and had problems.
Warhol, *POPism*, p. 69	It's always surprising to me to think how small the downtown New York City avant-garde scene was in relation to how much influence it eventually had. A generous estimate would be five hundred people, and that would include friends of friends—the audience as well as the performers. If you got an audience of more than fifty, it was considered large. South of 14th Street things were always informal.
Bower, "Village Girl," p. 19	Greenwich Village girls move to the East Side when they get more money; the East Side girls move downtown when they get more money.
Crane, "The Tunnel," p. 60	Somewhere above Fourteenth TAKE THE EXPRESS
McInerney, *Bright Lights*, p. 160	All of uptown seems to be headed downtown for Saturday night.

Dwellings

Hawes	The first apartment dwellers were artists, and their needs had shaped early apartment buildings, sometimes quite directly and explicitly.
Ibid.	Artists were responsible for large, light-drenched double-height rooms.
Ibid.	A typical uptown artists' apartment was hung with tapestries and Turkish drapery, which provided atmospheric background for portraiture.
Ibid.	An artist carving out an appropriate space to activate his life was not unlike the wealthy industrialist demanding chandeliered reception rooms and paneled libraries to achieve his own social ends. It was a sound urban idea and a particularly sane solution to a particularly exotic style of living.
Ibid.	The first New York co-op was formed by a group of ten well-known artists, led by the landscape painter Henry Ward Ranger and including Childe Hassam, who banded together to finance a fourteen-story apartment house on West 67th Street. The block quickly became known as a bohemian enclave. It conveyed its sense of fraternity physically, for a passerby was drawn in by the similarity of the facades on the front, the banks of double-height windows on the back. Its ingenious use of space was appealing. In volume alone, its studios were sumptuous. And to a populace who had only recently been swept off its feet by the premiere of Puccini's *La Bohème*, its very *raison d'être* was romantic.
Kostelanetz, p. 5	Anyone with an eye for fashion in 1908 might have predicted that the Houston Street style at the time I noticed in certain upper-story windows houseplants

a Downtown

408

or interior lights shining into the night, signifying that someone might be residing there.

Plants are to SoHo what lawns are to suburbia.

Ibid., p. 140

The development of SoHo is often cited as a Maciunas legacy, contributing on a smaller scale, as a gardener, to the greening of SoHo. A beautiful potted forest of very healthy rubber trees flourished under his vigilance, as well as the baby trees he planted—illegally—in front of the building at 80 Wooster Street that are over two stories high today.

Williams and Noël, pp. 194–5

He was interested in revealing the cast-iron detailing in the structure and cleaned off a lot of old paint. In the front of the building he worked on restoring the cast-iron sidewalk panels with lenses that let light down into the basement, and he took delight in finding a large quantity of these lenses at bargain prices. In front he planted some Ailanthus trees (the Tree of Heaven), to cover up some illegal electrical work.

Ibid., p. 177

In my twenties, when I passed through SoHo late at night after some party, I would detour by his block to see the light shining in his window. I would feel oddly secure in the thought that he was up in his loft working, revolving like a planet through his self-created cosmology of painted shapes and plaster structures.

Pinchbeck

Over many an artist's loft, one can still hear the machines banging away, slamming out their products.

Anderson-Spivy and Archer, p. 13

de Kooning's studio: "The loft was just too large; it wasn't good for an apartment. There was heat until five or six p.m. each day provided by the large radiators in the front and back, an amenity that many rough lofts of the time lacked. And there was a hot-water boiler in the kitchen. But there was no stove and no tub, and the overall condition of the loft was poor. There was no flooring, only subflooring. It was a wooden floor, but it was unfinished and gray."

Stevens and Swan, p. 195

In those studios, the heat used to go off after five o'clock because they were commercial buildings. de Kooning would be painting with his hat and coat on. Painting away, and whistling.

Ibid., p. 198

As long as he lived there, friends said, de Kooning would knock off work early on Saturdays in order to scrub down his loft.

Ibid., p. 147

Westbeth nicknamed Deathbeth and Westdeath.

Strausbaugh, p. 499

SoHo has good and bad artists, brilliant and dull minds, saints and frauds. Still, the collective life is there, and that it should so much resemble, well, anybody's life, strikes me as worth mentioning. For a very long time, the life of the artist has served as an emblem in the middle-class conundrum of how to live authentically. If SoHo, taken as a community, has any meaning, it is that this myth—of the artist's emblematic, sanctified, ridiculed struggle—has passed out of its heroic phase. Of course, the myth, if it is a myth, not only has reality, but also vast power, and that power is installed in the minds of almost everyone. It is institutionalized in SoHo. Yet actual life there seems to demonstrate something slightly different: the thirst for community itself—and that despite the ferocious rivalries, the intensely high-powered ambitions at work there, despite its grand and often arcane intellectual

Anderson-Spivy and Archer, p. 17

a Downtown — Dwellings

tradition. SoHo has become a major community, not only a community in which art is being made, but also (and not quite the same thing) a place where the notion of what it means to be an artist is being tested and enacted. What happens there will one day be important not merely because of the art that has been produced by artists living there, but also for the version of the artist's identity which it creates. Any community creates its own pressures and promises. For an entire generation of art students now pouring into it, SoHo has become the place to be, a place where the heroic, heady task of self-creation is to be performed.

Ibid., pp. 16–17

One does not live well or badly in SoHo; one *works* well or badly. Doing work—one's "own," of course—overcoming obstacles to work, living with work, and one's partner's work, these are the insignia of authentic living. At moments, even routine banalities like "How have you been?" seem replaced by "How's your work been going?" or, more politely, "What have you been doing?", it being understood that the only thing really done is work. What's happening in SoHo is that the artist's identity—his social definition of himself—has become completely saturated with the idea of work, while romantic visions of free spirits fall into desuetude. The ethos clamps its defining power over the very layout of the lofts. Those immense rectangular spaces would be ruined by subdivision into lots of little rooms. And so the space is organized, instead. The principle of organization is that of "work space" as distinguished from "living space." Almost invariably, the work space arrogantly overwhelms the living space, which is scrunched into some small corner where one sits feeling primarily the irrelevance of whatever amenities are supposed to take place there. Not that SoHo lacks its amenities—but one glances up from a serenely appointed dinner table to look directly into an environment replete with drafting tables and power tools.

SoHo's impulse to wed the space of work and living, like its impulse to live where no life was ever intended to be lived, is a variety of elegance. That elegance is of course connected to the taste for incongruity which is among the oldest modernist principles of style. But a deeper logic reveals itself here, for adopting the identity of an artist almost always means adopting a special set of attitudes toward the middle class. It remains the great alternative identity. In SoHo, those of America's children who have chosen that identity reveal themselves. Childhood's hated suburban distinction between home (i.e., life) and work (located not only in a different place but a different city) is resolutely eliminated. In a single stroke all the mortifying pettiness of the American "home" is ripped away; everything about making art that feels possibly tainted by that cozy triviality is demolished. One lives in work— that's what's wanted. The inevitable, and unnatural, sexual resonances of having been raised in Mom's town (where real life is lived), remote from work in Dad's town (the unseen, meaningless, uninhabitable city) are also dramatically refused. Suburbia and its wall-to-wall alienations have led to a new image for the ancient one of the artist as androgyne, and after the misadventures of the 60s, it finds itself taking a social, rather than specifically sexual, expression. True enough, an industrial look has been important to the image of the modern artist's virility. But the style's stronger aim is to resolve the sexually laden contradictions of a recent American childhood. In SoHo, working and living are at last reunited, and work becomes real.

Hudson, p. 49

This was a place where hard work was done and respected. Artistic production requires intensive labor, and there was a recognition by the blue-collar workers that artists did work hard, even if they worked odd hours. There were no distinctions made by those who worked in SoHo based upon social status or occupation—at least among those who "toiled."

Until the mid-seventies, the answer to the question "What do you do?" would refer to an actual job, such as "I'm a teacher, lawyer, worker," etc., but by the end of the seventies (and especially from 1977 onwards), the replies became "I work in cinema, music, writing, art … " One replied, in other words, by citing one's "hobby" or, better, one's elective affinity. This was a sign of changing times that saw the shift from a culture based on the Marxist idea of work—an idea linked to the industrial era—to the post-Ford one, in which work and the factory receded to the background, to the benefit of the theory of the needs and desires of postindustrial society.

Frisa and Tonchi, p. 382

A performance is the word used when referring to any event in SoHo in which people do things in front of an audience. Whether a performance is good or bad, interesting or not, it is always a major SoHo social event. For some reason, one must always climb stairs to reach a performance. The ascent is the same to reach the most modest dump, with battered floors and grimy windows, or the cool sanctum of the Castelli Gallery. And when you've gotten to the top of whatever stairs you climbed, you will find yourself not in a theater, but in a "space." (*Space*, like *work*, is one of SoHo's cherished words. For example, the correct compliment for a new loft is "What a beautiful space.") The space will be crowded with people milling around the pieces of electronic equipment, which generally have been arranged in the most conspicuous manner possible. While edging around the video monitors and stepping over cables, the waiting audience begins to spin the web of acquaintance with the customary small nods, waves, smiles, flashes and raised eyebrows. There is likely to be a great deal of sitting on the floors along with perching on windowsills and leaning against pillars.

Anderson-Spivy and Archer, p. 77

They want to climb those vertiginous loft building stairs on Howard Street that go up five flights without a single turn or bend—*straight up*! like something out of a casebook dream—to wind up with their hearts ricocheting around in their rib cages with tachycardia from the exertion.

Wolfe, *Painted*, p. 17

It's a rainy Thursday evening when I step out of a cab at the corner of Broadway and Franklin streets in lower Manhattan on my way to dinner with William Burroughs.

I gaze down a line of warehouses with a haphazard mixture of small trucks and old cars parked in front of them, spot Burroughs's four story building, hurry diagonally across the street, push open the door and step into the foyer. The hall light is out and I feel cautiously for the banisters as two bottles of cold white wine clink in the crook of my arm. Warped wooden stairs lead to the top floor past a series of wall paintings.

The loft is impeccably clean. The old wooden floors beam with polish, the bed is neatly made, all surfaces are devoid of other than essentials … I notice an efficient-looking brand new kitchen has been installed. The loft feels warm and lived in whilst remaining concisely organized.

Bockris, *Burroughs*, p. 83

Not in SoHo. The naïve but powerful doctrine of art as self-expression and therefore self-discovery swings precious little weight in those elegant lofts. It is dismissed as a trivial adolescent fantasy.

Anderson-Spivy and Archer, p. 15

SoHo on Saturdays resembles an enormous, floating party which begins in the galleries and ends up in local bars, restaurants and lofts.

Ibid., p. 21

SoHo fashion: "Flamboyance is out: the standard uniform consists of work clothes, jeans and a T-shirt or sweatshirt are usually considered best (and

Ibid., p. 16

they should be worn, by preference, without any asinine inscriptions or decals)."

Allen and Brickman, *Manhattan*, p. 197

They probably sit around on the floor with wine and cheese and mispronounce "allegorical" and "didacticism."

Wolfe, *Purple*, pp. 325–6

Oh, to be young and come to New York and move into your first loft and look at the world with eyes that light up even the rotting fire-escape railings, even the buckling pressed-tin squares on the ceiling, even the sheet-metal shower stall with its belly dents and rusting seams, the soot granules embedded like blackheads in the dry rot of the window frames, the basin with the copper-green dripping-spigot stains in the cracks at the bottom, the door with its crowbar-notch history of twenty-five years of break-ins, the canvas-bottom chairs that cut off the circulation in the sural arteries of the leg, the indomitable roach that appears every morning in silhouette on the cord of the hot plate, the doomed yucca straining for light on the windowsill, the two cats nobody ever housebroke, the garbage trucks with the grinder whine, the leather freaks and health-shoe geeks, the punkers with chopped hair and Korean warm-up jackets, the herds of Uptown Boutique bohemians who arrive every weekend by radio-call cab, the bag ladies who sit on the standpipes swabbing the lesions on their ankles.

Anderson-Spivy and Archer, p. 14

Canal Street: "For generations, it has served as an immense, ten-block-long hardware store and junk shop for the surrounding industry. For the artists of SoHo, it has become a vast, luxurious, tangled garden of the real. Through its pathways, one strolls in the cool of the evening. There are crates of power tools, barrels of pliers, rack upon rack of Plexiglass, whole floors crammed with cheap office furniture. Here on Canal Street, lofts are furnished, works and careers are conceived, souls are soothed. From Canal Street and its like, the improbable elegance of the place has been assembled."

Jones, "Canal Street"

I first found Canal Street in the late 50s, early 60s. You see, at that time, the small business people were moving out of the lofts, going to New Jersey or Philadelphia because New York all of a sudden had a very high tax rate for them. So they moved out. That left a lot of empty lofts in the Canal Street area. So, we artists started moving in. The rents were cheap, about $65 per thousand square feet. Naturally, we were living illegally because we could not pass the fire inspection laws or the housing department laws. So during the day, we would stay locked in our lofts, fearing to answer the doorbell, that it might be a housing inspector or a fire inspector, but after six o'clock when we knew that would be no more inspectors, we would all come out like, just coming all of the lofts and going to a nice restaurant that was called Canal Street Bar—its other name was Dave's Place, because Dave owned it—and there we would meet, and talk over about what we were doing, or what we planned to do, or what shows we hoped to get, or what shows were planned for us. And this was a good period. Everyone felt like comrades. We were fighting everybody. This was the Canal Street I loved.

And there were so many beautiful stores on that street, so many beautiful stores. There were junk stores, electronic stores—you could find anything there. And this is how Pop Art really got going, because all the material was right there on the street: you didn't have to go anywhere. That's where I started making my music machines with sound motors for 25 cents apiece. There was a toy store that only sold broken toys so I got all the cheapest guitars I could find. It was a good time. That was my Canal Street.

Then came what I call the Canal Street Blues. You see, we had a mayor—a Burgomaster—called Mr. John Lindsay, who decided to make living in lofts

legal. Now, what really happened was the real estate speculators bought the buildings, so now if you wanted a legal loft—the same loft that used to cost you $65 a month—you had to buy it. So that meant that you had to pay at least, at that time, $25,000 for the loft and then $2,000 a month for maintenance fees. Yes, that was Canal Street Blues, and what hurts more is—you know what really happened?—artists could not afford it. They moved out, they couldn't pay that kind of money. Many went to Brooklyn, some to Staten Island, some just left New York completely. And guess who moved into these beautiful lofts? Lawyers, doctors, Wall Street brokers. Oh yeah, yeah, yeah. It became so chic, this Canal Street: fancy boutiques, French restaurants, even had its own newspaper. This is when I left Canal Street. A long, long time ago.

I got the Canal Street Blues. Canal Street Blues. I got the Canal Street Blues. Canal Street, I still think of it. Can't help it. I remember the good times on Canal Street and I want to keep on remembering it, but it's not the same, not the same at all. In fact, I never want to see Canal Street again. It's gone. There is no more Canal Street for me. Sorry about that but … let's face it, there is no Canal Street anymore.

Bars

Cedar, San Remo

LeSueur, p. 18

A list of their names, when I reel them off, is for me like a mantra that magically evokes the essence, spirit, and soul of the downtown New York I knew in 1949 and on into the early fifties: Julian Beck, Judith Malina, Parker Tyler, John Ashbery, Willard Maas, Marie Menken, Dorothy Van Ghent, Edouard Roditi, John Bernard Myers, Harold Norse, David Sachs, John Button, Alvin Novak, Jean Garrigue, Marguerite Young, Oscar Williams, Gene Derwood, John Cage, Merce Cunningham, Lou Harrison, Irving Feldman, José Garcia Villa, Anaïs Nin, Ned Rorem, Edwin Denby, Harold and May Rosenberg, Percival Goodman, Irving Howe, Dwight Macdonald, George Dennison, Fritz and Laura Pens, Isadore From, I. Rice Pereira, Robert Motherwell, Jackson Pollock, and, if we forget that prior meeting through John Ashbery, Frank O'Hara. Some of these names are now forgotten and will be recognized only by readers who were on the scene at that time.

Gooch, p. 203

Regulars at the Cedar Tavern: David Smith, Philip Guston, Mark Rothko, Isamu Noguchi, Barnett Newman, Norman Bluhm, Howard Kanovitz, Aristodemis Kaldis, Michael Goldberg, Herman Cherry, Jack Tworkov, John Cage, Edwin Denby, John Gruen, Morton Feldman, Harold Rosenberg, Clement Greenberg, Alfred Leslie, Arnold Weinstein, Robert Rauschenberg, Jasper Johns, Irving Sandier, and Milton Resnick; among the few women in the classic "men's bar" were Helen Frankenthaler, Grace Hartigan, Joan Mitchell, Jane Wilson, Barbara Guest, Elaine Mercedes Matter, and Ruth Kligman.

Ibid.

Clement Greenberg: "At the Cedar, everybody looked unattractive."

Stevens and Swan, p. 361

The Cedar smelled of spilled beer and tobacco smoke. The air was thick, the light a "bilious yellow-green," said one Cedar regular, "that made everyone look worse than they already looked." In the low light, you could not be sure, at first, who was sitting in the booths along the wall. The Cedar … was a working-class bar entirely without distinction. And that, in the New York of the 1950s, was precisely its distinction. It appealed to the downtown painters because it was *not* French, *not* tasteful, *not* smooth, *not* witty, not, that is,

a Parisian café where artists chatted and sipped. These were important "nots" to painters determined to declare their independence from Paris: the Americans were hard drinkers at a dive whose existential aura owed more to Brando on the docks than to Sartre at Deux Magots. The Cedar represented a perfect blend of high and low, of proletarian circumstance and intellectual aspiration. English hunting prints in elegant black frames hung, absurdly, on the dingy walls.



Gooch, p. 202



The Cedar, which Rivers described as a "verbal news shop," was nondescript, with flaking green plaster walls bare except for a few Hogarth prints, glaring white ceiling lamps dangling overhead, a long bar in the front and a honeycomb of brass-studded leatherette booths in the rear. Looming from its back wall was a round industrial clock whose hands sometimes turned backward like a prop in a Cocteau movie.

N. cit.

The notable absence of collectors at the Cedar Bar.

Gooch, p. 203

Helen Frankenthaler posts a sign, "No Beatniks," in the Cedar Tavern, then rats out Kerouac for urinating in a sink outside the men's room.

Stevens and Swan, p. 365

Pollock was celebrated for ripping the men's-room door off its hinges at the Cedar. He would glower into his drink, greet men with "Fuck you" and women with "Wanna fuck?" and often pick fights … In the middle-fifties, the New York art world … was still in the two-drink stage of its party. Pollock was regarded as the pioneer, the man who broke the limits of conventional European practice not only in his painting but also in his cowboy-on-a-spree drunks.

Ibid.

At the Cedar, de Kooning and another painter once took turns slapping each other as hard as they could across the cheek, the idea being to take the hit without flinching.

Ibid., p. 204

The atmosphere of the Cedar was very much that of a saloon, its Wild West rowdiness only increased by the presence of Pollock, who usually appeared on Tuesday nights after coming in from the Hamptons for his weekly psychiatric session. Pollock tried to overcome his extreme shyness by drinking inordinate amounts of whiskey, which then allowed him to release his Cody, Wyoming, cowboy persona. Pollock's two-fisted swagger set the bar's somewhat paradoxical tone, filled as it was mostly with macho men who were in truth hypersensitive artists who sometimes had trouble relating to the women in the bar with their black stockings, black eyeliner, and very long hair. "Most of those guys you couldn't even sit and have a cup of coffee with because they could barely socialize with anyone, men or women," recalls Al Leslie.

The din of the Cedar regularly hit a high note with Pollock's explosions of fist-fighting or shouting. Once when he and Kline had a brawl he tore the door off the men's room and smashed a few chairs. Pollock thrived on such angry confrontations. To a black man he said, "How do you like your skin color?" To a lady painter, "You may be a great lay, but you can't paint worth a damn." He made licking motions with his tongue at John Myers, whom he leeringly asked, "Sucked any good cock lately?" To Larry Rivers, who was then in a phase of using heroin, he pantomimed shooting-up. On at least one occasion he called O'Hara a "fag" to his face and was enough of a menace that O'Hara fled the Cedar one night when he heard that Pollock was on a drunken rampage. But this unpleasantness was always forgiven in the name of genius and art. As O'Hara later wrote, "If Jackson Pollock tore the door off the men's

**a Downtown — Bars**

room in the Cedar it was something he just did and was interesting, not an annoyance. You couldn't see into it anyway, and besides there was then a sense of genius. Or what Kline used to call *the dream*."

In a way, Jackson Pollock had to die the way he did, crashing his car up, and even Barnett Newman, who was so elegant, always in a suit and monocle, was tough enough to get into politics when he made a kind of symbolic run for mayor of New York in the thirties. The toughness was part of a tradition, it went with their agonized, anguished art. They were always exploding and having fist fights about their work and their love lives. This went on all through the fifties when I was just new in town, doing whatever jobs I could get in advertising and spending my nights at home drawing to meet deadlines or going out with a few friends.

Warhol, *POPism*, pp. 15–18

I often asked Larry Rivers, after we got to be friends, what it had really been like down there then. Larry's painting style was unique—it wasn't Abstract Expressionist and it wasn't Pop, it fell into the period in between. But his personality was very Pop. He rode around on a motorcycle and he had a sense of humor about himself as well as everybody else. I used to see him mostly at parties. I remember a very crowded opening at the Janis Gallery where we stood wedged in a corner at right angles to each other and I got Larry talking about the Cedar. I'd heard that when he was about to go on "The $64,000 Question" on TV, he passed the word around that if he won, you could find him at the Cedar Bar, and if he lost, he'd head straight for the Five-Spot, where he played jazz saxophone. He did win—$49,000—and he went straight to the Cedar and bought drinks for around three hundred people.

I asked Larry about Jackson Pollock. "Pollock? Socially, he was a real jerk," Larry said. "Very unpleasant to be around. Very stupid. He was always at the Cedar on Tuesdays—that was the day he came into town to see his analyst— and he always got completely drunk, and he made a point of behaving badly to everyone. I knew him a little from the Hamptons. I used to play saxophone in the taverns out there and he'd drop in occasionally. He was the kind of drunk who'd insist you play 'I Can't Give You Anything but Love, Baby' or some other songs the musicians thought were way beneath them, so you'd have to see if you could play it in some way that you wouldn't be putting yourself down too much … He was a star painter all right, but that's no reason to pretend he was a pleasant person. Some people at the Cedar took him very seriously; they would announce what he was doing every single second—'There's Jackson' or 'Jackson just went to the john!' … I remember he once went over to Milton Resnick and said, 'You de Kooning imitator!' and Resnick said, 'Step outside.' Really." Larry laughed. "You have to have known these people to believe the things they'd fight over." I could tell from Larry's smile that he still had a lot of affection for that whole scene.

"What about the other painters?" I asked him. "Well," he said, "Franz Kline would certainly be at the Cedar every night. He was one of those people who always got there before you did and was still there after you left. While he was talking to you, he had this way of turning to someone else as you were leaving, and you got the feeling of automatic continuity—sort of, 'So long … So this guy comes over to me and … ' and while you may have flinched at his indiscriminate friendliness, he did have the virtue of smiling and wanting to talk all the time. There were always great discussions going on, and there was always some guy pulling out his poem and reading it to you. It was a very heavy scene." Larry sighed. "You wouldn't have liked it at all, Andy."

He was right. It was exactly the kind of atmosphere I'd pay to get out of. But it was fascinating to hear about, especially from Larry.

"You didn't go to the Cedar 'to see the stars,' though," Larry added. "Oh, sure, you may have liked being in their aura, but what you came back for night

after night was to see your friends ... Frank O'Hara, Kenneth Koch, John Ashbery."

The art world sure was different in those days. I tried to imagine myself in a bar striding over to, say, Roy Lichtenstein and asking him to "step outside" because I'd heard he'd insulted my soup cans. I mean, how corny. I was glad those slug-it-out routines had been retired. They weren't my style, let alone my capability.

Larry had mentioned that Pollock came in from the country every Tuesday. That was part of the big out-of-the-city-and-into-the-country trend that the Abstract Expressionist painters had started in the late fifties when they were beginning to make money and could afford country places. Right in the middle of the twentieth century, artists were still following the tradition of wanting to get out there alone in the woods and do their stuff. Even Larry had moved to Southampton in '53—and stayed out there for five years. The tradition was really ingrained. But the sixties changed all that back again—from country to city.

Gooch, p. 378

O'Hara might get himself started in the morning with a filterless cigarette and a glass of bourbon and orange juice. Arriving at the office in the late morning, he worked and talked on the phone for an hour or so before heading off for lunch, which often began with a martini or a negroni at Larré's French restaurant on West Fifty-sixth Street. In the evening O'Hara could drink several vodkas or bourbons without falling down or losing control.

*Ibid.*, p. 327

Like the San Remo a few years earlier, the Cedar had been picked up by the media and was now overcrowded with tourists on the lookout for Pollock-like painters and young guys cruising for loose art girls.

Stevens and Swan, p. 423

At the Cedar Tavern, suddenly it seemed that every art student in America was arriving at the bar to get drunk with Bill and Franz. Slumming uptown celebrities and Hollywood stars—including Elizabeth Taylor—passing through dropped in regularly.

Warhol, *POPism*,
pp. 69–70

Two major feeders of personalities and ideas into the early Factory were the San Remo / Judson Church crowd and the Harvard / Cambridge crowd. The San Remo Coffee Shop on the corner of MacDougal and Bleecker streets in the Village was where I met Billy Name and Freddy Herko. I'd been going there since '61, when it was a lot artier—a few poets and a lot of fags coming down from the 53rd Street and Third Avenue area. It was a big thing in those days to "go to the Village," to places like the Gaslight and the Kettle of Fish. But around '63 when you walked into the San Remo through the frosted glass doors with flower designs, past the long bar and the booths, it was all full of hustlers who usually sat on the railing of Washington Square Park who'd been taken to the San Remo for one-draft beer. All the amphetamine men—"A-men"—fags on speed who would howl laughing at the very thought of going to a "gay bar," loved the San Remo because it wasn't really a gay bar, there were very few gay-world clichés there.

Not everyone at the San Remo was gay, of course, but the stars of the place certainly were. Most of the customers were just there to watch the performance. A lot of the San Remo boys used to write for a mimeographed sheet called The Sinking Bear (named after a poetry magazine that was around then called The Floating Bear), which was one of the first underground newsletter papers. One of these was Ondine—or "Pope Ondine," as he was occasionally called. Ondine would sit in a booth with his Magic Markers and write replies to people with sex queries / problems for his column, "Beloved Ondine's Advice to the Shopworn," and the "problems"

would be coming to him on notes passed from the other booths as fast as he could reply. One afternoon Ondine rushed in with an "appalled" look on his face, and as he put his flight bag down on the table, he pointed back toward Washington Square Park and said, incredulously, "A guy just said to me, 'Would you like to go to a gay bar?'" Ondine shook his head, laughing in disbelief, "Horrible experience."

The San Remo was almost entirely A-men. I say "almost entirely," because I remember being introduced to the Duchess for the first time there, and a few minutes later, the owner came over and asked me, "Do you know her?" and when I said yes, he told me, "Then take your friend and get out." I never did find out what she'd done, she was such a terror. She was a well-known New York post-deb, a part-time lesbian on speed who could put even the A-men in their places. I hung around the San Remo a lot and got to know some faces and bodies I'd be seeing drift in and out of the 47th Street Factory day and night during the next few years.

The San Remo's success was founded upon, like that of so many Parisian cafés, the discomfort of the tiny apartments in which many of its patrons were living. Among those who could regularly be found drinking its fifteen-cent beers, or martinis, were Tennessee Williams, John Cage, Paul Goodman, Dylan Thomas, Allen Ginsberg, William Burroughs, Judith Malina and Julian Beck, Miles Davis, Merce Cunningham, Dorothy Day, and James Agee.

Gooch, p. 202

On the San Remo: "The place is an ordinary hash house during the day, serving truckers, garage men, postal clerks, and others who work in the area. At night, the place goes into outer space. By two or three in the morning, there usually isn't a customer in there who isn't on something, more likely a combination of somethings, nodding out, speeding, tripping, and, in the case of the reactionaries, just plain drunk.

Hamilton, p. 96

On entering, it looked ordinary enough, with groups clustered in booths and others hunched over the counter. Only when I looked at the groups closely did I realize that it was a drug-induced caricature of every other hash house in the country. People were speaking, but they weren't talking. They were looking at each other, but they weren't seeing. Their hands and bodies moved, but their selves were motionless. At the core was solitude."

At the San Remo we argued and gossiped: in the Cedar we often wrote poems while listening to the painters argue and gossip. So far as I know nobody painted in the San Remo while they listened to the writers argue.

Gooch, p. 202

Stanley's Bar at 12th and Avenue B was *the* bar of the time; as through its doors passed a steady stream of artists, poets, filmmakers, musicians, and every type of radical publisher and nuclear-disarmament peaceworker. Avenue B between 10th and 12th, in those days, was a sacred road. In addition to Stanley's, there were several other artists' bars, and above the bars were cheap pads, and there was the Charles Theater where there were regular showings of underground films. The filmmakers met at Stanley's after the screenings and there was a great sense of energy and excitement.

Sanders, *Beatnik*, p. 198

Greenwich Village folk scene bars: Gaslight, Gerde's Folk City, the Kettle of Fish, Izzy Young's Folklore Center, the Village Gate, Café Figaro, Rienzi's, the Tin Angel, Café Reggio, the Wha, the Night Owl, San Remo, the Bizarre, the Derby, Mills Tavern, Minetta Tavern, the Borgia, the Other End.

N. cit.

Stevens and Swan,
pp. 148–9

The most popular meeting place for local artists was Stewart's at Twenty-third Street and Seventh Avenue … There were also two additional artist meeting places in the otherwise dark and deserted neighborhood. One was the Oasis Bar, across the street from Stewart's. The other was a Horn & Hardart Automat. Together, said Milton Resnick, the three places constituted "the center of the art world at that time."

For artists who painted alone all day, the late evenings at Stewart's offered a kind of vigorous release, a lively and ever-changing round of debate, jokes, and discovery. Hunched over in their chairs, cigarettes in hand, the regulars at Stewart's would pick apart the history of modern art, trying to understand what worked … Often, after the cafeteria closed around one or two in the morning, the debaters would return to de Kooning's loft "and talk some more and make coffee," said Denby.

McGuigan

As an artist's hangout, the elegant cream-lacquered interior of Mr. Chow's is light-years away from the Cedar Tavern, that grubby Greenwich Village haunt of the artists of the New York School 30 years ago.

LeSueur, p. 128

The crypto-queer San Remo, the macho Cedar Street Tavern, and the blustering White Horse.

Max's

McCourt, p. 244

The businessmen who came to Max's Kansas City in the afternoon.

Ibid., p. 246

Why was Max's never raided for much the same activity they went after at the Stonewall? Because of those front room businessmen.

Ibid., p. 244

As Five Points make a star in the American flag, so was Max's that American.

Ibid., p. 245

Adversity on spindly legs, creatures at Max's might have been renamed Maxine.

Huffa

Forrest "Frosty" Myers's laser sculpture, which he called "From My Place To Max's a/k/a Good Vibrations," in which he ran a laser beam from his studio two diagonal blocks to Max's, where it hit a mirror attached to a speaker wired to the jukebox. When the jukebox played, the mirror vibrated and created a light show on the back room wall.

Kane, p. 39

Mickey Ruskin co-owned Les Deux Mégots, but by 1962 had had enough of the business … "He wanted to make more money. We used to walk in there, bring our bottle of wine, buy a cup of coffee, drink the coffee, and then pour the wine in. So we weren't even buying the coffee … they weren't making any money. It was a poetry hangout." At that point, the coffee shop had been robbed twice. Ruskin quit to open what would turn out to be a very successful restaurant, the Ninth Circle; he would ultimately open the legendary Max's Kansas City.

Warhol, *POPism*, p. 234

In September we started going regularly to a two-story bar / restaurant on Park Avenue South off Union Square that Mickey Ruskin had opened in late '65. It was called Max's Kansas City and it became the ultimate hangout. Max's was the farthest uptown of any of the restaurants Mickey had ever operated. He'd had a place on East 7ᵗʰ Street called Deux Mégots that later became the Paradox, and then he'd had the Ninth Circle, a Village bar with a

format similar to what Max's would have, and then an Avenue B bar called the Annex. Mickey had always been attracted to the downtown art atmosphere— at Deux Mégots, he'd held poetry readings—and now painters and poets were starting to drift into Max's. The art heavies would group around the bar and the kids would be in the back room, basically.

Max's Kansas City was the exact place where Pop Art and pop life came together in New York in the sixties—teeny boppers and sculptors, rock stars and poets from St. Mark's Place, Hollywood actors checking out what the underground actors were all about, boutique owners and models, modern dancers and go-go dancers—everybody went to Max's and everything got homogenized there.

When I wasn't getting laid elsewhere I went to Max's Kansas City every night. It was a bar and restaurant two blocks away from where I lived and you could sit there all night and bring yourself coffee. It was free. And you always signed the check and never paid the bill. I felt so guilty, I had an unpaid bill of about two or three thousand dollars. I guess that was a lot in the sixties. I had friends that would sign the check "Donald Duck" and "Fatty Arbuckle." It was just so wonderful and all the waitresses were beautiful … and all the busboys … You could have sex with all the busboys. I mean, not right there, but later. And anybody who walked into the room, you could fuck, because they all wanted to be in the back room. And you would say, "You'll have to fuck me and I'll let you sit at a good table." So it was wide open, but it wasn't gay, thank god. We hated gay bars. Gay bars? Oh please, who wanted to go to gay bars? At Max's you could fuck anyone in the room, and that was what was sweet about it.

McNeil and McCain, p. 27

It was fabulous! It was very *Satyricon*. There was a lot of acid being taken, and everyone would … I would just run around in rags. At one point, I had a purse that was a suitcase, and, you know, just the way people would dress. Oh! They were just very, very crazy. Very "up." And Mick Jagger and Bianca … people would just walk in. I mean Salvador Dalí and Veruschka and her sisters would be at the round table. It was … You see, I started going there towards the end of '69, '68, '69. I mean, Max's was in its heyday in '66, '67, '65, and so I was going there. Andy very seldom went there. At one point, he would go there every night to eat.

Smith, *Warhol*, p. 244

I went to Max's every night. Every single night. At first it was full of Warhol people. During that period you'd see Andy Warhol there with his entourage: Viva, Jane Forth, Joe Dallesandro. Taylor Mead would be hanging out in the corner, drinking. Or some crazy girl with dreadlocks, holding a baby doll, talking to herself. Warhol's Factory had been up on Forty-seventh Street, but then they moved it to Seventeenth Street, right off of Union Square Park, a few blocks away from Max's. So you could just walk across the park and hang out at the Factory when Max's closed. And that was usually the place where everybody had video cameras following them. It was pretty much like that scene in the Doors movie where they meet Nico and go off and do heroin … The back room was vicious. Vicious. Everyone was on a different drug, and if you got up to use the bathroom you didn't dare turn your back. The bathroom was on your left, and you had to back out of the back room to get there, because if you turned your back, people would talk about you. People would say horrible things about you the minute you got up.

McNeil and McCain, pp. 96, 98

In a way you could feel the generations change at Max's … the Warhol crowd who helped invent Max's … but as the seventies progressed, the rockers took it over, and the order changed.

Ibid., p. 106

Max's were evil. All

the lips only partly closed something of the irresolution of will often married to intellectual delicacy. Instead of buoyant optimism there was in this face refined fatigue, which lent a kind of distinction to his manner.

"Old fellow, you have lost the feeling for the imperceptible. I have to hit you on the head now to convey an idea. You are so definite. You are so energetic that nothing but a bellows or a hammer can make any impression on you … You have learned to think that there is nothing real that isn't prominent, nothing beautiful that isn't effective."

The American even when he is a Bohemian is seldom the "real thing": he always retains an element of strenuousness. He not only occasionally works hard, but it is his common practice to "talk hard." He even talks extremely; a real Bohemian, however, does nothing in excess; he avoids stress of any kind. Then again the American Bohemian is not entirely careless and disreputable and the foreign Bohemian generally is. *Ibid.*, p. 120

The supernatural darkness of cold-water flats floating across the tops of cities contemplating jazz Ginsberg, *Howl*, p. 3

Never had I seen a dwelling of its kind before. With a sinking sensation, I wondered if this was what lay in my future. There was no refrigerator, I remember, and only the barest necessities—a pinched, woebegone scene, to be sure. But because of the presence of books, hundreds of them, and an upright piano, it was inevitable that I would romanticize the whole thing, and that I'd do it in hackneyed, bohemian terms: the struggling artist, his humble garret, a life of high-principled sacrifice. LeSueur

His pad on East 4th Street was a three-room citadel of verminous grime. Sanders, *Beatnik*, p. 143

Must watch for police—tombs stay avoided by leap from trolleyback, running back with dogs to huddle safely—home? heartfilled wandering, more like it—apartment is dirthole with rats, mice, and other friends—they at least don't talk back. Jones, *Modernism*, p. 228

He located an apartment at 28 Allen Street, a few blocks south of Houston. It was a typical two-room tub-in-the-kitchen slum apartment painted dogtongue green. The human who had previously lived there had somehow caused the walls to become streaked with long lines of gray brown grease furry to the touch because of the trapped soot. The plaster was tumbling from the ceiling and the front window, opening on Allen Street, had been bashed in and replaced with the door of a cigarette vending machine. What a crummy apartment. Sanders, *Beatnik*, p. 205

Outside the door of her loft are steep threatening steps and total ugliness. Blandford, p. 175

In recollections of the 1950s, in films, and in photographs, perhaps the most striking feature of Manhattan that emerges again and again is its emptiness—the abandoned look of even its most important arteries. Third and Sixth Avenues had the excuse of sudden exposure after decades under the shadow, soot, and screech of their elevated lines. But much of the rest of New York looked similar—beaten up and exhausted by hard use. This comes out most poignantly in photographic records of Greenwich Village. The streets are void of traffic, both vehicular and pedestrian: parking spaces abound; the signs are handmade and amateurish. Café and restaurant interiors resemble grammar school classrooms, a clutter of junk and a creativity more childish than avant-garde. Exteriors seem forgotten, Caldwell, pp. 300–1

embalmed: in a 1960 photo of the White Horse Tavern on Hudson Street, now a sidewalk café overrun by models and stockbrokers, it looks like what it then really was: a seedy bar on the corner of fire escapes and walkup apartments.

Bennett, *Deconstructing*, p. 6 Allen Ginsberg denounces the city's robot apartments, invisible suburbs, and sphinxes of cement and aluminum not simply for the pure machinery of their homogenous spatial aesthetics but also for the psycho-social damage that they inflict upon urban subjects by bashing open the skulls, eating up the brains and imagination, and destroying the best minds of his generation.

Ginsberg, *Howl*, p. 7 Moloch! Moloch! Robot apartments! invisible suburbs! skeleton treasuries! blind capitals! demonic industries! spectral nations! invincible madhouses!

Tucker, p. 140 All young, all poor, all sloppy, all artists, and all interesting, smart, and fun to be around. Hooray for us, and fuck the doctors, lawyers, dentists, and accountants our parents wanted for us!

Bennett, *Deconstructing*, p. 9 Eccentric urban experiences that exist beneath the surface, on the margins, or along the interstices of the city's more homogenous urban center. They explore aberrant spatio-temporal dimensions, heterogeneous urban topographies, and deviant urban paradigms, but they explicitly associate these anomalous urban spaces with some kind of alternative, counter-hegemonic city-within-city or some marginalized urban space that is dominated, opposed, stalked, haunted, or repressed by the corporate city that surrounds it.

McNeil and McCain, p. 4 When you went over to La Monte and Marian's place, you were there for a minimum of seven hours—probably end up to be two or three days. It was a very Turkish type scene. It was a pad with everything on the floor and beads and great hashish and street people coming and scoring—and this droning music going on. La Monte had this whole thing where he would do a performance that would go on for days and he would have people droning with him. Droning is holding a single note for a whole long time. People would just come in and then be assigned to drone.

Ibid. La Monte Young was the best drug connection in New York. He had the best drugs—the best! Great big acid pills, and opium, and grass too.

Ibid. La Monte Young: "I was—so to speak—the darling of the avant-garde. Yoko Ono was always saying to me, 'If only I could be as famous as you.'"

Kane, p. 18 James Schuyler: "It's a remarkably dreary day out here and I think I'll soon be staying more at my New York pad, on East 35th—a nice blah sort of neighborhood, unostentatious middle class, my dish exactly. I admire my friends who have the courage to live on the Lower East Side; I certainly haven't.

Fitzgerald, *Crack-up*, p. 25 As I hovered ghost-like in the Plaza Red Room of a Saturday afternoon, or went to lush and liquid garden parties in the East Sixties or tippled with Princetonians in the Biltmore Bar I was haunted always by my other life—my drab room in the Bronx, my square foot of the subway, my fixation upon the day's letter from Alabama—would it come and what would it say?—my shabby suits, my poverty, and love. While my friends were launching decently into life I had muscled my inadequate bark into midstream.

In our century, nostalgia not for displaced immigrants but for displaced bohemians.

Waterman, p. 12

The Village

If you want to get out of America, go to Greenwich Village.

Dylan, *Chronicles*, p. 55

Let's make the Village or go to the Lower East Side and play Symphony Sid on the radio—or play our Indian records—and eat big dead Puerto Rican steaks—or lung stew—see if Bruno has slashed any more car roofs in Brooklyn—though Bruno's gentled now, maybe he's written a new poem.

Kerouac, *Lonesome*, pp. 112–17

Or look at Television. Night life—Oscar Levant talking about his melancholia on the Jack Paar show.

The Five Spot on 5th Street and Bowery sometimes features Thelonious Monk on the piano and you go on there. If you know the proprietor you sit down at the table free with a beer, but if you dont know him you can sneak in and stand by the ventilator and listen. Always crowded weekends. Monk cogitates with deadly abstraction, clonk, and makes a statement, huge foot beating delicately on the floor, head turned to one side listening, entering the piano.

Lester Young played there just before he died and used to sit in the back kitchen between sets. My buddy poet Allen Ginsberg went back and got on his knees and asked him what he would do if an atom bomb fell on New York. Lester said he would break the window in Tiffany's and get some jewels anyway. He also said, "What you doin' on your knees?" not realizing he is a great hero of the beat generation and now enshrined. The Five Spot is darkly lit, has weird waiters, good music always, sometimes John "Train" Coltrane showers his rough notes from his big tenor horn all over the place. On weekends parties of well-dressed up-towners jam-pack the place talking continuously—nobody minds.

O for a couple of hours, though, in the Egyptian Gardens in the lower West Side Chelsea district of Greek restaurants.—Glasses of ouzo, Greek liqueur, and beautiful girls dancing the belly dance in spangles and beaded bras, the incomparable Zara on the floor and weaving like mystery to the flutes and tingtang beats of Greece—when she's not dancing she sits in the orchestra with the men plopping a drum against her belly, dreams in her eyes.—Huge crowds of what appear to be Suburbia couples sit at the tables clapping to the swaying Oriental idea.—If you're late you have to stand along the wall.

Wanta dance? The Garden Bar on Third Avenue where you can do fantastic sprawling dances in the dim back room to a jukebox, cheap, the waiter doesn't care. Wanta just talk? The Cedar Bar on University Place where all the painters hang out and a 16-year-old kid who was there one afternoon squirting red wine out of a Spanish wine skin into his friends' mouths and kept missing …

The night clubs of Greenwich Village known as the Half Note, the Village Vanguard, the Cafe Bohemia, the Village Gate also feature jazz (Lee Konitz, J. J. Johnson, Miles Davis), but you've got to have mucho money and it's not so much that you've got to have mucho money but the sad commercial atmosphere is killing jazz and jazz is killing itself there, because jazz belongs to open joyful ten-cent beer joints, as in the beginning.

There's a big party at some painter's loft, wild loud flamenco on the phonograph, the girls suddenly become all hips and heels and people try to dance between their flying hair.—Men go mad and start tackling people, flying wedges hurtle across the room, men grab men around the knees and lift them nine feet from the floor and lose their balance and nobody gets hurt,

blonk.—Girls are balanced hands on men's knees, their skirts falling and revealing frills on their thighs.—Finally everybody dresses to go home and the host says dazedly.—"You all look so *respectable*."

Or somebody just had an opening, or there's a poetry reading at the Living Theater, or at the Gaslight Cafe, or at the Seven Arts Coffee Gallery, up around Times Square (9th Avenue and 43rd Street, amazing spot) (begins at midnight Fridays), where afterward everybody rushes out to the old wild bar.—Or else a huge party at Leroi Jones's—he's got a new issue of Yugen Magazine which he printed himself on a little cranky machine and everybody's poems are in it, from San Francisco to Gloucester Mass., and costs only 50 cents.—Historic publisher, secret hipster of the trade.—Leroi's getting sick of parties, everyone's always taking off his shirt and dancing, three sentimental girls are crooning over poet Raymond Bremser, my buddy Gregory Corso is arguing with a New York *Post* reporter saying, "But you dont understand Kangaroonian weep! Forsake thy trade! Flee to the Enchenedian Islands!"

Let's get out of here, it's too literary.—Let's go get drunk on the Bowery or eat those long noodles and tea in glasses at Hong Pat's in Chinatown.—What are we always eating for? Let's walk over the Brooklyn Bridge and build up another appetite.—How about some okra on Sands Street?

Shades of Hart Crane!

[...]

"LET'S GO SEE if we can find Don Joseph!"

"Who's Don Joseph?"

Don Joseph is a terrific cornet player who wanders around the Village with his little mustache and his arms hangin at the sides with the cornet, which creaks when he plays softly, nay whispers, the greatest sweetest cornet since Bix and more.—He stands at the jukebox in the bar and plays with the music for a beer.—He looks like a handsome movie actor.—He's the great super glamorous secret Bobby Hackett of the jazz world. What about that guy Tony Fruscella who sits cross-legged on the rug and plays Bach on his trumpet, by ear, and later on at night there he is blowing with the guys at a session, modern jazz—

Or George Jones the secret Bowery shroud who plays great tenor in parks at dawn with Charley Mariano, for kicks, because they love jazz, and that time on the waterfront at dawn they played a whole session as the guy beat on the dock with a stick for the beat. Talkin of Bowery shrouds, what about Charley Mills walkin down the street with bums drinkin his bottle of wine singing in twelve tone scale.

"Let's go see the strange great secret painters of America and discuss their paintings and their visions with them—Iris Brodie with her delicate fawn Byzantine filigree of Virgins—"

"Or Miles Forst and his black bull in the orange cave."

"Or Franz Klein and his spiderwebs."

"His bloody spiderwebs!"

"Or Willem de Kooning and his White."

"Or Robert De Niro."

"Or Dody Muller and her Annunciations in seven feet tall flowers."

"Or Al Leslie and his giant feet canvases."

"Al Leslie's giant is sleeping in the Paramount building."

There's another great painter, his name is Bill Heine, he's a really secret subterranean painter who sits with all those weird new cats in the East Tenth Street coffeeshops that don't look like coffeeshops at all but like sorta Henry Street basement secondhand clothes stores except you see an African sculpture or maybe a Mary Frank sculpture over the door and inside they play Frescobaldi on the hi fi.

AH, LET'S GO BACK TO THE VILLAGE and stand on the corner of Eighth Street and Sixth Avenue and watch the intellectuals go by.—AP reporters lurching home to their basement apartments on Washington Square, lady editorialists with huge German police dogs breaking their chains, lonely dikes melting by, unknown experts on Sherlock Holmes with blue fingernails going up to their rooms to take scopolamine, a muscle-bound young man in a cheap gray German suit explaining something weird to his fat girl friend, great editors leaning politely, at the newsstand buying the early edition of the *Times*; great fat furniture movers out of 1910 Charlie Chaplin films coming home with great bags full of chop suey (feeding everybody), Picasso's melancholy harlequin now owner of a print and frame shop musing on his wife and newborn child lifting up his finger for a taxi, rolypoly recording engineers rush in fur hats, girl artists down from Columbia with D. H. Lawrence problems picking up 50-year-old men, old men in the Kettle of Fish, and the melancholy spectre of New York Women's prison that looms high and is folded in silence as the night itself—at sunset their windows look like oranges—poet e. e. cummings buying a package of cough drops in the shade of that monstrosity.—If it's raining you can stand under the awning in front of Howard Johnson's and watch the street from the other side.

Beatnik Angel Peter Orlovsky in the supermarket five doors away buying Uneeda Biscuits (late Friday night), ice cream, caviar, bacon, pretzels, sodapop, TV Guide, Vaseline, three toothbrushes, chocolate milk (dreaming of roast suckling pig), buying whole Idaho potatoes, raisin bread, wormy cabbage by mistake, and fresh-felt tomatoes and collecting purple stamps.— Then he goes home broke and dumps it all on the table, takes out a big book of Mayakovsky poems, turns on the 1949 television set to the horror movie, and goes to sleep.

And this is the beat night life of New York.

The monkish Mondrian took up jazz dancing while in New York as a tribute to the spirit of the place.

Conrad, p. 121

All here is intimidation, if you are young and recently arrived in the Village: Kafka and Brecht, Artaud and Ionesco glower from book jackets; the clerks look through you; Eli Willentz, the owner, sighs when you mispronounce a writer's name. But look: There is James Baldwin, home from Europe, talking near the counter to Eli—a man like any man, not a statue in the park; Robert Creeley is in from Black Mountain College; the small, dark man looking at the book of drawings by Heinrich Kley is Alfred Andriola, who draws "Kerry Drake" in the *Mirror*; the thick-bodied man with the face of a disappointed stevedore is Franz Kline; and walking past the store, waving diffidently, is Harold Rosenberg. To make this a perfect New York evening, the next strolling New Yorker would have to be Sal Maglie.

Hamill, "Lost"

There, wandering up from MacDougal Street: That's Joe Gould, who has translated Rimbaud into the language of seagulls and is writing the oral history of the world.

*Ibid.*

You have come up out of the subway from Brooklyn or Queens or the Bronx and are engulfed by swarming crowds, lining up for Bergman or Fellini at the 8th Street or the Art, and the very air seems thick with sensuality.

*Ibid.*

You are once again at the bar of the Five Spot on St. Mark's Place. You are listening to Monk, of course, and working hard at being hip.

*Ibid.*

Dylan, *Chronicles*, p. 47	You could sit on a bar stool and look out the windows to the snowy streets and see heavy people going by, David Amram bundled up, Gregory Corso, Ted Joans, Fred Hellerman.
Brainard	I remember when Ron Padgett and I first arrived in New York City we told a cab driver to take us to the Village. He said, "Where?" And we said, "To the Village." He said, "But where in the Village?" And we said, "Anywhere." He took us to Sixth Avenue and 8th Street. I was pretty disappointed. I thought that the Village would be like a real village. Like my vision of Europe.
Weegee, *Naked*, p. 229	This is an unexposed film of Greenwich Village because nothing ever happens there … The artists have all gone in for still life … because the models are working in defense plants and eating regular … A girl who doesn't wear moccasins and slacks is considered anti-social … the favorite meeting place is at the "Cercle de la Paix"—the circle of peace—that's Washington Square Park … When it gets colder the rendezvous is at the Waldorf Cafeteria at 6th Avenue and 8th Street … You can tell the artists by their berets and beards … and frustrated looks.
Weegee, *The Village*	I love the Village … the most sensitive spot in town … the soul of the city, where people are friendly, understanding, and approving—there are no lonely-hearts clubs there. Up to the time this book went to press I continually photographed the Village … compiling a memento of a place that seemed to be fast disappearing. New York University is tearing down all the old buildings and putting up more classrooms so they can teach Ceramics, Square Dancing, and primitive Painting à la Grandma Moses. (Where do they get all the money?) The old landmarks are going the way of all brick—threatening a severe shortage of cold water flats. But there is a counter movement to tear down all the modern half-room apartment houses … and a petition is making the rounds in the better bars and espresso coffee houses to move N.Y.U. out to the Yucca Flats in the Arizona Desert so the soldier boys can practice dropping H-bombs. On the site of N.Y.U. will be erected cold water flats, the greatest blessing to modern civilization.

People flock to the Village to escape … to be different … or even just to be themselves and to meet kindred souls. A weekly visit to your analyst is a must (an analyst can be seen toting a collapsible couch through Washington Square Park, on his way to a house call). Freud is the favorite author. The Village is full of creative talent: painters, actors, dancers, writers, waiting to be recognized. However, if you meet a guy who composes songs, flies a plane, reads *The New Yorker*, cooks spaghetti, wears a bow tie and a goatee, and smokes a pipe … he's no genius.

There's plenty of nightlife in the Village. Broadway is now called "Cinderella Land" because everything shuts off at midnight. But that's the hour things start humming in the Village.

The best time to start on a tour of Bohemia is 10 o'clock at night (stay away Saturday night—that's when the tourists from the Bronx flock to the Village, and the Villagers flee to the Bronx). Sheridan Square is the place to start—you can tell it's Sheridan Square because that's where you'll find the couples kissing hello and goodnight at the subway station. At Sheridan Square look into the window of the Limelight, maybe two or three times an evening. Then across the Square and into the Riviera—the friendliest spot in town … then go to Louis's for a beer—very crowded, and on to the Montmartre for another beer—only 15¢ a glass, and refreshing and the exercise is good for you. But don't stay in any one spot too long … travel … move …

The shops on West 4th Street have good windows to look into: handmade leather goods, jewelry, paintings, sculpture, etc. Stop in at Jon's Scandinavian

Shop for wine on the house. Take a look at the people around you too … the men with beards, the girls sans makeup and ponytails—both in dark jerseys, blue jeans and sandals.

Walk along MacDougal Street and peek into the window of the Caricature Coffee House—just peek, you don't want to mix coffee and beer. Drop in at the Kettle of Fish Bar … then up to Rienzi's for a quick look at the bulletin board, where you see that you can get a model to pose in the nude for $2 an hour, in case you want to take up art … People advertise for room-mates, soul-mates, helicopter pilots (probably for the girls who found a cold-water flat on the sixth floor). Then you can stop in, say, at the San Remo bar—see what's going on there.

If by 4 o'clock, the witching hour, you have not met anybody, something is wrong with you—maybe you should go to the nearest analyst. But don't give up hope—last stop is Lenny's Hideaway, on West 10th Street. But be careful … a lonely ponytail all by herself is okay … stick close to her … in the Village it's all right to talk to a stranger without an introduction from Emily Post. But beware of the girl tourists from the Bronx and Brooklyn … they make the rounds of the Village in wolfpacks, tightly corseted and copiously petticoated, flashily dressed in tailor-made suits from the Thrift Shoppe, and $20 Shoes. You can tell the immigrants by their orange pancake makeup and purple lipstick … they usually chew chlorophyll gum and carry a copy of *Confidential*. These are the career girls looking for Johns (Suckers) to wine and dine them and take them home in cabs … they offer nothing in return … they refuse to give … These are the liberated females who have sold their souls for a weekly paycheck … they hold on to stupid, dopey, uninteresting jobs, and dine at Chock Full O' Nuts. Their real career begins when they leave their jobs at 5 to attend evening courses at N.Y.U.—where they hope to meet a Jocko who will marry them and free them from the monotony of 9 to 5.

Monday nights they take courses in BALLET … SKIING … HEAD SHRINKING and SKIN DIVING … Wednesdays: PLUMBING … INTERIOR DECORATING and HOW TO BE A DISC JOCKEY … Thursdays: HOW TO BE A HOSTESS AT SCHRAFFTS TEA SHOPPE … HOW TO HAVE A NERVOUS BREAKDOWN & HOW TO MEET YOUR ANALYST … Friday, Saturday & Sunday nights they hang around outside Louis's Bar on West 4th Street waiting for someone to buy them a drink, their favorite being Scotch with Ginger Ale, mixed.

At least once a week someone throws a part in the Village—a rent party … admission usually 50¢ … probably in a loft where everybody sits on the floor, with dark circles under their eyes and listens to bongo drums. Bring your own liquor and your own girl, if possible … Guys go to parties to find girls, but usually they're all taken. Village girls don't dress up for parties … just the usual pony tail, dungarees, black jersey … no bra, no makeup. The Village girl seems to be from another planet … she could walk through walls … she seems to have an inexhaustible capacity for beer—sometimes she round trips to all the places … You never see anyone eat in the Village—the steady diet is beer.

Sunday is a big day in the Village. In the afternoon everyone meets at the fountain at Washington Square Park—you can tell it's a fountain because there's no running water … Kids come with their banjos and harmonicas and sing folksongs … and folks wander about—maybe looking at the outdoor art show … People sit in the sun and look out for friends.

Evening falls, and in ones, twos and threes, lamplit figures drift away, leaving the park almost deserted … except for a couple here and there sitting close together. The solitary lonely ones, startled out of their reveries by the silence, awake to the reality of the evening meal and the approaching Monday

morning … and to postpone lonely reality, they start their weary rounds …
looking … searching.

Bower, "Village Girl," p. 20

Q. Do you think Greenwich Village girls come to a good end?
No they don't. The ones that came here were very sick in the first place.
After staying here, they're either sicker or not so sick. If they're sicker, they're
interesting, but not all right. If they're not sick, they're not interesting.
Q. What do you mean by sick?
Neurotic.

Ibid., p. 19

Toreador pants, flat ballet slippers (if she isn't wearing Murray Space Shoes),
a pony tail or a short man-styled hair cut.

Ibid., p. 23

A penchant for woolen knee-socks.

Bower, "Village Men,"
p. 29

Properly faded blue jeans that are reasonably tight; a fashionable seedy white
sweatshirt; a Paisley scarf, moccasin-type shoes.

McDarrah, "Letter," p. 33

Listens to Bob and Ray, to music on NYC and QXR, and hates Dorothy and
Dick. She faithfully reads *Time*, the *New Yorker*, the *Village Voice*, occasionally
the *Reporter*, the *Saturday Review*, and *Partisan Review*. For hours she gloats
over *Vogue*'s fashion pictures. She can write, paint, decorate, make pottery,
make strange earrings and even dance to tom-tom music. There is at least one
philodendron plant in her apartment.
Her job is less creative that she would like. Her office associates talk about
her as if she were a cultured prostitute.
She smokes Pall Malls or Marlboros, is a moderate drinker, prefers Scotch,
likes gin, but settles for beer.

Balaban, p. 40

"There is no room for youth and vitality in New York," said Gregory Corso. "It
is a city full of guilty academicians."
"Too big, too multiple, too jaded," chanted Jack Kerouac.

Coleman, p. 206

At one time in the past it was said that they danced on the Arch and spoke
and swung from trees and stumbled round the Square over grass, into grass,
and ran and fell on top of each other on the grass, and once too the grass was
full with not too many dirt spots, brown and lifeless with bits of grey showing
through where the earth had been worn right down to the rock on which
everything stood.

Reitano, p. 128

I flutter down the jocund aisles, the plaintively garish corridors of New York,
bumping into solemn-eyed, three-fourths happy poets, drained, humorous
futurist-artists, wives of poets who have short strings to which their husbands
are attached, enormous-bearded, bubbling sculptors, prostitutes who are not
prostitutes, and Emma Goldman … Goldman: marriage enslaves women;
schools stifle children; prisons breed crime; private property perpetuates
wars; and religion lulls people into passivity.

Barnes, p. 225

The greater part of New York is as soulless as a department store; but
Greenwich Village has recollections like ears filled with muted music and
hopes like sightless eyes straining to catch a glimpse of the beatific vision.

Jones, *Modernism*, p. 224

Greenwich Village dark and shining and hands reach my way as I traipse
thinking they are worse off than I.

a Downtown — The Village

Perhaps it would be wise, the night before the General Strike, to have small McReynolds, pp. 345–9 beat groups scatter throughout the city, pasting up manifestos. Then, on the appointed day, events can begin with a motorcycle corps roaring in from the far reaches of the Bronx, from Long Island, from New Jersey, and by ferry from Staten Island, scattering leaflets on their way. Harlem, which was born hip, would swing down in a night march, augmented by roving bands of boppers from Spanish Harlem who would have sheathed their weapons in honor of the occasion. I would suggest that a skiffle group start at 59th Street and jazz its way down Madison Avenue, preaching great New Orleans truth into every door and window of that sad tense street.

Meanwhile, special contingents would be gathering at every coffee shop in the city, each such contingent to be led by a poet and two bongo drummers. Man, in my mind's most inner eye I dig that sound as it rocks down the great tenement avenues! These groups would all converge on Washington Square, picking up thousands of curious citizens as they bopped along, singing and dancing in the streets. It would be a dramatic sight as the column of Harlem hipsters was joined constantly by new coffee-shop contingents. The folk singers would have already met at Washington Square, where a fantastic morale-building hootenanny would be in full swing. Special hip agents who for months had worked on Madison Avenue under the cover of shaven faces and Dacron suits (and who had even written advertising copy to prove they were square) would be seizing control of the TV and radio stations in order to broadcast good jazz during the daytime, thus alerting the city to the Revolution at hand.

By this time I assume the hipsters would have assembled a crowd of vast proportions. The poets, strange angels of death and of life: improbable possessors of such impossible insane hallucinations as brotherhood, compassion, God—they would lead the line of march. I can see that wonderful assemblage now—folk-singers and dancers, bongo-drummers and poets—the whole mighty column marching joyous through the streets, past the Tishman project, right down to City Hall. And there, finally, sustained and inspired by magic horns of jazz, the hip population of our city would march seven times around the City Hall while we stand by the hundreds of thousands to watch. Perhaps—just perhaps—the walls of indifference would crumble, injustice fall broken to the ground. Perhaps Wagner, dressed in his usual confusion, would flee. Perhaps Moses would agree to be sheathed in concrete and set in Central Park as a monument of some kind or for pigeons to breathe on. DeSapio, being a shrewd man, would doubtless take off his dark glasses and join the line of march. And thus at last the back of the Tammany Tiger would be broken.

Alas and unfortunately, this is all nothing but fantasy. I'm sure the beats would be no more effective with their General Strike than we politicos have been with our General Elections. Still—they might be more interesting.

In any event, having spoken my piece, I am now waiting for the first warm day of spring.

Great things are still being said and done in Greenwich Village today, if you'll Riesenberg and Alland, p. 114 have the patience to wait until some aged scribe sets them to music in the year 1989.

East Village

Tompkins Square Park: in those pre-hippie days it was a bleak and forbidding Waldman, p. 295 place frequented by disgruntled old people.

Mueller, p. 256

Suppose, just for a moment, that everything physical and tangible was an art trend. Everything: food, clothing, shelter, water, trees, animals, sex. This is a wild thing to imagine. But if it were so, the sun, which normally hatches hot from the East River and falls at dusk into the Hudson, would come to an abrupt stop right above Tompkins Square Park. Geographically, this is the dead center of the little hamlet known as the East Village.

Johnson, *Minor*, p. 973

I loved the slums, my slums, the sweet slums of Bohemia and beatnikdom, where sunflowers and morning glories would bloom on fire escapes in the summer and old ladies weighed down by breasts leaned on goosedown pillows in windows, self-appointed guardians of the street, and Tompkins Square with its onion-topped church had the greyness of photos of Moscow.

Sanders, *Beatnik*, pp. 186–90

He rented a two-room apartment at 521 East 11th Street in December of 1961 for fifty-six dollars a month. It was on the third floor. One room was a combined kitchen and living room. The other was supposed to be a bedroom. There were no closets, only a five-pronged clothes rack nailed to the wall in the bedroom. The rooms were tiny and both had lumpy metal ceilings stamped with leaf-like patterns in six-inch squares.

The two living-room windows opened onto a fire escape which protruded rustily upon a back courtyard crisscrossed with clotheslines and wet clothes getting gritty from the anus of Satan, otherwise known as the Consolidated Edison smokestacks belching a few blocks away. Some mornings he would awaken with the inside of his nose black-caked with fallout.

Spanish music floated in from the courtyard by day by night by dawn. Someone close by had a rooster and occasionally he heard a faint baaaa. On the roof of the building directly opposite his fire escape there was a five-tiered pigeon warren which was used ostensibly to supply food for a family in the building. The super, however, swore up and down that the birds were shipped downtown to a Chinese restaurant for squab gobble.

The backroom or bedroom had a single window to the outside which was sealed shut, its panes painted lightless with many coats. When he pried the window open he saw why. The vista was of a gray-streaked solid brick wall about five feet away and a sheer drop to the rubble of the alley dotted with dropped garbage bags, a common disposal method on the East Side.

Like many dinky New York apartments, there was a window between the kitchen and the so-called bedroom. This too was completely covered with years of paint, the newest being avocado green. The icebox was strictly early American and rattled as the motor struggled to propel the refrigerant. The door was almost as cold as the interior and a piece of rubber insulation hung down from the top and prevented it from closing properly. Next to the icebox was a large, low sink which apparently had been originally intended also for use as a washtub. Next to the sink was the bathtub with a removable porcelain-glazed metal covering. Above the bathtub were the kitchen cabinets whose crooked doors could never quite be shut and whose interiors were a sour-smelling barrenness of decayed oilcloths, cockroach egg cases, kernels of roach-chewed rice, coffee grounds, and greasy dust.

The watercloset was jammed into a small booth in the hallway. There was something wrong with the light fixture so he placed a candle on the ledge. Either the user left the hall door open, or lit the candle, or voided in darkness. The toilet gurgled with spilling water twenty-four hours a day. Roaches loved the watercloset. There were hundreds of them. He gave up at once trying to maintain the watercloset with the result that his friends, even the funkiest among them, were loath to lower any exposed skin upon the seat.

There were eight layers of linoleum on the floor. These he chopped up and carted away by the armload. The bare floor itself had never been painted or

varnished. It was raw wood. He wondered if he should leave it the way it was. Enough paint splashed on it when he was working on the ceiling and walls, however, that he decided to make it black also.

He wound up painting the entire apartment, floor, ceiling, walls, door, black except for one wall which he painted white intending to cover it with murals. The living room was red orange when he rented the place. There were many buckles, cracks and ridges in the plaster. When painting, he left the cracks and ridges red orange so that there were these groovy abstract red lines and patterns running through the black expanses, man. As for the long white wall, he spent the next few months carefully painting it with multi-colored cuneiform stanzas of Sumerian poetry which he had studied in college.

In those days the Lower East Side on Wednesday nights was a free department store. For it was then that residents would place upon the pavement old furniture, kitchen cabinets, smashed TVs, mattresses tied up with cord, etc., for the refuse department to cart away. Sometimes, as when an elderly person without family would die, the sidewalk outside an apartment would be jammed with trunks full of old clothes, boxes of books, lamps, utensils, and the debris of fifty years. This produced a grab scene almost as if someone had thrown money on the ground. Citizens were thrilled to seize from an old trunk a sport shirt from Honolulu or a photo album dated 1923.

The very first Wednesday he forayed and found a large, lidded packing crate from Japan which he lugged home, painted black, and added to the pad as a table. Some things he had to purchase. One such item was a ten-foot-by-ten-foot bamboo mat edged with black cloth. This was the living room fun-rug. Floor pillows he obtained from old sofas found on the streets. He hung another smaller bamboo mat in the doorway between the two rooms. He rigged a string from the bottom up over a nail at the top of the doorjamb so that the bamboo curtain could be raised or lowered by a tug on the string.

He walked the side streets looking for a throwaway mattress. It was a poor day for freebies. Finally he spotted an old mattress tied up into the shape of a jelly roll with rope and leaning against garbage cans at 9th and Avenue C.

The first thing to ascertain, when checking out a free street mattress, was why it was that the owner had discarded it. He regarded the mattress. Even as a throwaway, it was rather a pitiful specimen. In the first place, the prior owners had not been the most continent of humans as evinced by several widespread spills, so to speak, all over the middle of it. But, when given the firmness and bounce tests, it seemed very substantial. To the nose it was not particularly offensive and he could find no indication thereon and therein of cootie, tick, crab or roach. Therefore, all considered, he grabbed the mattress upon his back and staggered toward 11th Street to his apartment.

I do remember that everything in the East Village begins and ends on street level. It was like that in the misty, idealistic '60s, when I first moved here and sat with thousands of hippies right where the homeless now sleep. We listened to Jefferson Airplane playing from the bandshell. And through all the fires and muggings and the heroin of the '70s to the present—our empty, deadly '80s.

Kapralov, p. 88

I remember Second Avenue and strawberry shortcake at "Ratner's."

Brainard

I remember the St. Mark's movie theatre (45¢ until six). The red popcorn machine. And lots of old men.

Ibid.

Ibid. I remember "Le Metro." (A coffeehouse on Second Avenue that had poetry readings.) Paul Blackburn. And Diane di Prima sitting on top of a piano reading her poems.

Ibid. I remember how beautiful snow made the Lower East Side look.

Ibid. I remember "Folk City." "Man Power." And selling books at "The Strand."

Hamilton, p. 17

I sat at the bar with some middle-aged accountant-looking type: glasses, thinning hair, business suit, the works. He just didn't look right on Avenue A.

Sanders, *Beatnik*, p. 480

He spent nothing until he passed Gem Spa at St. Mark's and Second Avenue, where he plunked down fifteen cents for a chocolate egg cream and ten cents for the *Village Voice*.

Warhol, *POPism*, pp. 66–7

Jimmy made all his own costumes out of beads and feathers, just putting the materials together as he went along. He lived on Tompkins Square on the Lower East Side where you could still rent whole floors of rooms for just thirty or forty dollars a month. I'd lived in that part of town myself when I first got to New York, on Avenue A and St. Mark's Place. Even just a little bit of work a month could pay your rent down there. Right up till the summer of '67, before drugs came in, the East Village was, in a way, a very peaceful place, full of European immigrants, artists, jazzy blacks, Puerto Ricans—everybody all hanging around door stoops and out the windows. The creative people there weren't hustling work, they weren't "upwardly mobile," they were happy just to drift around the streets looking at everything, enjoying everything: Ratner's, Gem's Spa, Polish restaurants, junk stores, dry goods stores— maybe go home and write in a diary about what they'd enjoyed that day or choreograph something they'd gotten an idea about. They used to say that the East Village was the bedroom of the West Village, that the West Village was the action and the East Village was the place you rested up in.

By the early sixties the Judson dance concerts were a fulltime dance theater. They could stage a whole ballet for no more than fifty dollars—the kids in the company would ransack friends' apartments for props and go down to Orchard Street and pick through materials for costumes. The same went for the plays done at places like the Café La Mama and the Caffe Cino, where a lot of the Judson dancers performed when they weren't waiting on tables.

Segal, p. 76

Back in the 1970s, an urban eccentric named Adam Purple (born David Wilkie) built the Garden of Eden on Manhattan's Lower East Side. An oasis of agriculture amidst a sea of bricks and steel, the garden was a stunning design of plants and flowers, brilliantly organized into concentric circles around a central Yin-Yang symbol. Purple had miraculously transformed five abandoned city lots into a wonderland of raspberry bushes and roses. Dressed entirely in purple, he would bicycle up to Central Park to collect horse manure and then ride back downtown with fertilizer in tow … For eighteen years Purple lived an astonishingly ascetic life, with no heat, no electricity, and no plumbing. He spent his days scavenging for wood (a wood-burning stove cooked his only food, a tofu-based vegetarian stew), collecting cans (an income of $2,000 a year from recycling sustained him) and tending to the dilapidated building.

Small

Long after midtown office towers have been deserted for the day, as many New Yorkers snuggle into bed in their high-rise apartments, another world comes to life in the seedier districts of Lower Manhattan. From 11 p.m. to

5 a.m., Monday through Sunday, the young and the active pack into musty East Village basement bars, cavernous lofts in warehouse districts, or short-lived speakeasies that, because they lack liquor licenses, tend to fall prey to police raids. Disdaining the laser lights and droning beat of '70s discos, these clubs offer an '80s alternative: riotous after-hours vaudeville complete with drag shows, art auctions, raunchy comedy revues and theme parties celebrating such diverse topics as sexual obsession and Tupperware. The purpose, believe it or not, is art. For many of the city's thousands of working artists and countless aspiring actors, shunned by conventional artistic outlets like uptown galleries and Broadway, the clubs offer a congenial, supportive alternative—a brave new world wilder than the dreams of the sleeping city. This outlandish scene has its own celebrities (John Sex and Gracie Mansion), fashions (spike cuts and crew cuts) and rules for conduct (regulars rarely dance, even in clubs with constant rock music). Says one club-hopper, "It encompasses Berlin before and after the war—the decadence of before, the look of after." Weekend tourists from the 9-to-5 world, unlike in-crowd members, wait in lines at club doors, pay $3 to $15 cover charges and rarely get free drinks. All in all, a small price to pay for an eccentric evening out.

One Wednesday around midnight a woman named Philly and her friend *Ibid.* Stephen Tashjian, both in their 20s, scuttle around the basement of a onetime Ukrainian blue-collar bar revamped in 1982 as the Pyramid Cocktail Lounge. Philly, who dropped her given name when she moved to the East Village from Philadelphia, smears on the same apple-red lipstick that Stephen wears. He is draping himself with plastic oranges and cherries for his Carmen Miranda act; she is stuffing tiny rotten bananas under layers of shawls and rags that transform her into a "monkey/woman/creature." Finally, clad to fruitarian perfection, they climb up a wooden stairway and emerge into a tiny, windowless room where a solid mass of sweaty kids flail to the beat. A spotlight hits the stage, where a sign bears the name of tonight's extravaganza, Flying Down to Rio. Shaking his hips to a calypso beat, Stephen takes center stage carrying a trombone. Combining the best of Tiny Tim and Shecky Green, he sings in falsetto, toots his horn, treats his fans to a few raunchy jokes and exits. Philly comes on next to the tune of the Belafonte hit "Day-O." "I love bananas, big yellow bananas," she screeches as she spits some on the cat-calling audience. Five minutes later she curtsies primly and exits.

"That was sort of a throwaway performance," Philly admits afterward. She and Stephen, who play the clubs as often as four times a week, usually perform in more literate skits—such as I Love Ruthie, their version of I Love Lucy '80s-style and In Praise of Java, a show for coffee believers. That's as legit as they get. "Boy George is interesting but he's too polished. You need a bit more slime and a bit more trash than that," says Philly. Mark Phred, who appears with Philly in some of her other performances, details the logistical realities of their profession: "They call us up and say, 'Can you be South American sun gods showing a synthesis of Egyptian and Polynesian cultures and the space theory in a sort of go-go dance?' And we do it—because that's how we pay our rent."

On the downtown nightclub circuit, where most performers earn about $50 a night—with occasional gusts up to $1,000—Philly and her partners are far from unique. As actor Kestutis Nakas puts it, "Working the clubs is much more exciting and vital than hustling your resume to get a bit part on a soap opera." John Sex agrees. Best known for his straight-up hairdo and slimy nightclub act, John, a former male stripper, now supports himself singing hits like his R-rated version of "That's Life." "I've been a hustler, a hooker, a honcho, a hero, a dike and a queen," John sings to the classic Sinatra tune.

Sex, who has been 24 for years, just landed a recording deal with Island Records. "I'm a nice Catholic boy from Long Island and everything my mother didn't want me to be," he admits.

Joe Bernard, alias Zette, earns $110 a night acting out Area's regularly changing themes, often behind glass in an enclosed stage resembling a department store window. For the theme of Confinement, Zette, 25, impersonated Rapunzel, Quasimodo, Anne Frank and various women under hair dryers. (Area nixed his crucifixion act because he wanted to do it during Easter week.)

In 1979, seasoned pro Ann Magnuson, 27, ran the now-defunct Club 57, a low-budget, high-energy cabaret where almost all of today's scene makers first displayed their talents. Now Ann presents 25 or so characters, including an evangelist named Alice Tully Hall, "a combination of Loretta Lynn and Lotte Lenya," in comic half-hour vignettes. About the growing club circuit, Ann says, "Most of the people here are trying to make sense of what they grew up with in the '60s and '70s. We take all those elements and put them back together in different configurations and try to make people laugh. And we make them think."

Gracie Mansion, who named herself after the New York mayor's residence, used to show her friends' artwork in her bathroom. Now she owns one of the East Village's most successful galleries. To stay in touch, she regularly attends clubs whose walls are covered with the work of artists she represents. Who first thought of showing art in nightclubs is a point of endless contention, but the best guess is now-well-known artist Keith Haring, who curated a show in 1979 at Club 57 during its heyday. Anyway, all the right places now do it—and some even specialize in it. Haoui (pronounced Howie) Montaug, 32, a veteran clubgoer who helps run Danceteria, explains the phenomenon: "Everybody who used to be a musician in a band is now a painter. For the locals, art is a bigger draw than anything else, including music. And the clubs have to go with what people want." Neophyte fashion designer Michael Wylde, 23, praises the clubs for the same reason most painters do: "Showing there makes my clothes more accessible to the people who buy them. Nobody I know would go to a fashion show at noon."

Kamikaze, in a warehouse next to the Hudson River, runs the most elaborate art shows. Every other Thursday curator Stacie Teele, 23—or one of her friends—opens a new exhibit with an average of 20 contributors. During the past nine months about 1,000 young artists have hung their works for as many as 1,500 art lovers per opening. Says Stacie, "In a gallery you look at a painting for two seconds. In a club, you look at it several times a night." It was probably Limbo, a two-year-old art bar now closed for a move to a larger space, that ran the first club art auctions. Once 80 works were sold in a single night for $40 to $575 apiece. Moreover, the benefits are not merely monetary. "The first go-round you look at the paintings," says one faithful viewer, "the second go-round you look at the people."

On any given night the four floors of Danceteria might house an art exhibit, a live band, a dinner party and a fashion show. Across town, 8 B.C.—located in a deteriorating 1850s farmhouse with a large stage (and a slight cockroach problem) on a burned-out street—sometimes presents five short theater pieces a night. Area, an immaculate space in New York's old Pony Express building, celebrates its complete redecoration every six weeks with a special Wednesday bash. On Mondays exotic performers invade the Area dance floor for Obsession nights to act out such compulsions as "pets" and "body oddities." Limelight, a traditional disco on many nights, despite its location in a former Episcopal church, also sponsors wild theme parties. Recently art director Malcolm Kelso, 34, recreated scenes from different Fellini movies there; another night he threw a pajama party for 1,600 people. Meanwhile, the

Limbo crew runs a production company called Anonymous Productions that books about 100 acts (including the Pop Tarts) into various clubs.

All this activity does not go unappreciated. Desirable patrons are under steady—though imaginative—emotional siege. Stephen Saban, 38, who writes a column about the clubs for *Details*, a fashion and nightlife magazine, jokes that they send him invitations every 15 minutes. Danceteria and the Pyramid print newsletters every two weeks, Area invitations come with a dog bone, a beach thong or other prizes. Of course, the hippest club-hoppers—like Saban and Dianne Brill—don't need invitations to know which way the wind is blowing. Dubbed the Queen of the Scene, fashion designer Brill, 25, goes out midweek—weekends are too crowded—but this Florida native knows New York's nightlife better than most. "A 'scene person' has to be involved in art, fashion and music and have a pretty good understanding of what's fresh in these mediums," says Dianne of the hundreds of club-goers she sees nightly. "You also have to be active—at least go to the key parties once a week. It takes discipline to know when to go out and when to stay in. Believe me, having fun is work." Then, with an appropriately dramatic sigh, she adds, "What a life."

The Pyramid on Avenue A was the haven and birthplace of a whole new breed of drag queens: Ethel Eichelberger, Hapi Phace, John Kelly, RuPaul, Lypsinka, Lady Bunny, Taboo!

Frisa and Tonchi, p. 167

The Palladium: "What I was most interested in was that the discotheque as a building type almost extends beyond the conventional idea of architecture and that even substance is lost in its space. Needless to say, however, its space is naturally built and affected by forms and their material composition as in a usual traditional building, nevertheless, these greatly lose their importance in a disco space, and, instead, momentarily passing lights, sounds and visionary images come to the fore. Although lighting, video and music are elements of an architectural space, they come to play the main roles in a discotheque. Each of these elements is the material and media of a new type brought forth by the technology of this age. If it is confirmed that space can be transformed by such elements, it will be quite a rare case in the sphere of contemporary architecture, where a field of experiment has been lost. Above all, in a discotheque, such technologies pour over the whole body of a person like a shower and stimulate all the senses. It is as if hidden desire is evoked. Rather it would be better to say that a shower of technologies gives birth to successive desires."

Ibid., p. 178

Tinkerbelle, an underground celebrity who had written for *Interview* and had starred on cable TV. Her whole life revolved around nightclubs. The worst was when she couldn't get into the Palladium. That was such an enormous blow to her. She talked about it for weeks and weeks and weeks, and didn't let up, and went back to it, and niggled away. It just devastated her. It blew her ego away. On January 22, 1986, she leapt to her death from a fifth-story window.

Haden-Guest, p. 277

We couldn't wait for it to open. It was going to be the most sophisticated club in New York: the one with space done by an architect and the decor done by artists. It was going to have more speakers, more video screens, more lights, more DJs, more space than any other club in New York. It does. It has more speakers and video screens and lights and DJs and space than any other club in New York. But who has more than one perfect body to take it all in? Who has more than one pair of eyes to see it all? Who has more than one pair of ears to hear it all? Who has more than one brain to sift through it all? Who can see another's face in that kind of machine gun light? Who can talk to

Ibid., p. 178

another in that kind of industrial noise? Who can find a friend in that dark smoky factory of entertainment?

Are the seventies already being revived? Who's heard your joke? Who touches your elbow? Who can see you dancing? Who knows it's you? Who is the man sitting at the bar? Where is the man who was sitting at the bar a minute ago? Look at that green hair. Look at the scenery going up. Look at the video screens coming down. Look at the tiny people swarming up and down the stairs. Look at those people like fluttering confetti on the dance floor. Who are you here? A feverish molecule in a disco dictatorship trying to catch desire by the tail. But dictatorships think only of the masses (consisting of all those who think more is better and that it's the only place to be if you have to line up outside to get in). It's like a large department store: they have everything but you can't find what you are looking for. It's like an airport, or a train station (without planes or trains to take you places): a space so huge you become anonymous in it. It's like the first day at school, only at night, and in a class of 3000. That's entertainment in the post-Orwell metropolis. Rumor has it that Big Brother furtively swings at the old El Morocco.

Kornbluth, "Area," p. 34 At Area: "The silver bar is where worlds collide. Andy Warhol might be brushing up against Malcolm Forbes, Keith Haring and Jean-Michel Basquiat against David Byrne or Giorgio Armani, Scavullo and Joan Rivers against Phoebe Cates or Henry Geldzahler. And if no one's mixing, Stephen Saban, the Boswell of the night, will push them together, later to remind them what happened in his column in *Details*."

Frisa and Tonchi, pp. 274–6 I can't exactly remember when the world stepped out of the underground and entered the unceasing flux of consensus. It happened, I guess, around 11 o'clock on the evening of December 8, 1980, uptown New York, on the sidewalk in front of the Dakota building. David Mark Chapman, twenty-five years old, from Hawaii, popped out from the underground of his mind and fired five shots at John Lennon. When Lennon died at St. Luke's-Roosevelt Hospital Center, the underground ended and the eighties began. The seventies were the subsoil of our culture, maybe not really the sub-soil but only a sad basement, one of those with windows at sidewalk level, from where you can see people's ankles passing by. The ankle is that part of the body that more than any other reveals how unsexy the seventies were. From the basement the world was seeking out for some form of deliverance. From their ankles the seventies wanted to climb up as far as to the shoulders.

Honestly, the true underground was finished by the end of the sixties, with the livid turmoil of the '68 movement making mincemeat of it. The seventies, by contrast, were a pimple on the face of Western society. The underground was the smell of cigarette smoke, unmade beds, bodies naked, not bundled up, dark glasses even at night, spend not thrift, personal not collective risk, vulgarity not malaise, personality not insecurity. The bullets that smacked into John Lennon's body arrived from the seventies' awkwardness, shattering what was left over from the sixties. Those bullets made a breach in the sewers of the Western world's underground, from which it poured out the excessive effluvium of a decade in which success and excess swapped places continually, softening even the hardest dwellers of sewers, cellars and miserable basements.

The eighties were a blaze of fireworks in the sky of the history of our still 100% pure Western world … The third world, the real underground of our civilization, appeared in the streets of New York ennobled by the collarless shirt of Francesco Clemente, the forerunner of all the rebels who since then have been splashed on the covers of the best reviews, flushed out of their

cellars and hosted on cozy couches of Soho's lofts. The eighties wiped off the sweat of India, blew away the dust of Mali, sweetened Mexican chilies. The apartheid society of success and consensus was born.

Underground dwellers were no longer allowed into restaurants, clubs, bars, exhibitions, everything was now reserved for "the people" of the rowdy eighties. To be against meant simply and solely being lonely on the outside, devolution was no longer sexy but simply the "ankle" of society. AIDS began to devour excess but not success, and strikingly even illness became mainstream. As the eighties wore on, the difference between the opening of a gallery and a funeral service became increasingly slender. Dying is better, when all's said and done, than sliding downstairs into the basement. Basquiat was the dark side of Warhol, Mapplethorpe of Haring. The damned no longer existed or at least no one really wanted to meet them. Everyone who used to be part of the culture of the underground simply became losers in the eighties. The underground disappeared because it had lost its charm and the eighties were the time when defeat was no longer an alternative but an antisocial gesture, a time when the individual no longer offered any energy to the flux and hence had to be isolated, forgotten, abandoned and eventually terminated.

Those who died as losers died twice over in the society of the eighties. While the seventies brought about the genocide of individual ideas and identities, the eighties saw the genocide of those who were "different," not sexually or racially different but economically different and marginal. The eighties saw the extermination of those who failed to enter the flux of consensus, of success and excess. The eighties saw the massacre of those who for one reason or other survived the final demolition of the underground. The eighties poured layers of concrete into the subsoil and it's still hard to see what survived underneath. In an imaginary world of sci-fi archaeology, when someone will dare to dig into the crust of the twentieth century, they'll reach a point in which a void will appear, like an air chamber: they will have uncovered the civilization of the eighties, an era when a whole society was erected on top of a void surface. Religion, politics and rebellion arrived drained by the violence of the seventies and, passing the border of the new decade, let themselves be disarmed by a generation that no longer saw in the night a darkness where to disappear into, but the fight shining off a perverse but unrotten hedonism. Shooting up unknown substances, the eighties' society no longer rotted, it exploded. As in Antonioni's final film, *Zabriskie Point*, the explosion of the eighties still continues today, though increasingly in slow motion and with less and less energy. Work has resumed again on rebuilding basements, cellars, undergrounds, where a new generation seems to have holed up once again to rediscover the stimuli, ideas, and reactions, to hide from a bulimic world, which seeks to digest everything and immediately in the juice of consensus. The true underground, however, is holed up there, in those societies still desperately in quest of their modernity. The eighties projected a corrupt image of the West onto the world: they unwittingly caused gangrene in the wounds of those worlds where the underground does not simply conceal the desire for an alternative transformation but also hides the violence of a barbarism that is trying to sink the whole world into an abyss of darkness, where no mainstream will ever succeed in welling up again. The five bullets that hit John Lennon in the darkness opened the terrible, dazzling and unavoidable, necessary eighties.

Jones, *Modernism*, p. 3 Dada cannot live in New York because all New York is dada, and will not tolerate a rival.

Conrad, p. 115 Picabia called it a Cubist city in 1913, and on his return in 1915 credited it with his conversion to the mechanomorphic style, for America shows that "the genius of the modern world" resides in machinery. The Cubist Albert Gleizes told a reporter, "New York inspires me tremendously." Duchamp declared, "I adore New York."

Ibid. In Duchamp's America, art had been supplanted by engineering. The country's creativity, he thought, went into its plumbing and its bridges; all art had to do was make selections from its utilitarian stock, as he did when he tagged the Woolworth Building as a ready-made. Because New York was already "a complete work of art," it absolved Duchamp from the necessity of creating new works of art. Its gift to him was that it silenced him. "I have not painted a single picture since coming over," he boasted.

"A Complete Reversal," p. 5 New York itself is a work of art, a complete work of art. Its growth is harmonious, like the growth of ripples that come on the water when a stone has been thrown into it. And I believe that your idea of demolishing old buildings, old souvenirs, is fine. It is in line with that so much misunderstood manifesto issued by the Italian Futurists which demanded … the destruction of museums and libraries. The dead should not be permitted to be so much stronger than the living. We must learn to forget the past, to live our lives in our own time.

Marquis, p. 127 Duchamp suggests the Woolworth Building as a monumental readymade, merely awaiting the proper title.

Myers, p. 33 One day I ask Marcel Duchamp how many people he thinks *really* liked avant-garde art and he replies, "Oh, maybe ten in New York and one or two in New Jersey."

Yau, p. 278 There were around two hundred artists in New York in 1960 and one could meet them all in a relatively short period of time.

"French Artists," pp. 2–3 "I came over here not because I couldn't paint at home, but because I hadn't had anyone to talk with."

Myers, p. 34 Duchamp himself remains completely elusive. One day I meet him at the elevator of the *View* office. He arrives a bit earlier than I and is waiting for me. I notice he has in his hand a pocket chess set, the black and white men arrayed against each other. I ask him whom he might be playing against and he answers, "Marcel versus Duchamp."

Jones, *Modernism*, p. 58 Marcel Duchamp perfectly adapts to the violent rhythm of New York. He is the hero of the artists and intellectuals, and of the young ladies who frequent these circles. Leaving his almost monastic isolation, he flings himself into orgies of drunkenness and every other excess.

Ibid., p. 9 Duchamp's relationship to masculinity in his New York Dada period parallels the "Warren Beatty effect in *Shampoo*"—the less macho man adopting feminine attributes in order to seduce women.

b Art

Arriving at 7:30, we find Duchamp sitting in a corner of the small living room by a window overlooking University Place where he remains—serene, utterly at ease, seldom speaking although in no way aloof—until nearly three o'clock in the morning. His participation in the evening's social intercourse takes the form of a twinkle in his eye and a barely perceptible hint of a smile, and yet his presence charges the room. Brown, *Chance*, p. 269

He has the presence of a "smiling corrupter." Marquis, p. 110

Duchamp tells a reporter that he had tried to obtain a studio in a skyscraper, "one of the highest," but was dismayed to learn that "people are not allowed to live in them." Ibid., p. 113

Duchamp calls America a one-class country and marvels that people who can afford chauffeurs go to the theater by subway. Ibid.

His occupation of the Washington Square arch ratifies Washington Square as a monument of the avant-garde. Banes, p. 15

The Republic of Washington Square takeover of the arch, Gertrude Drick aka Woe reads her Declaration, which consists of the word "Whereas" repeated over and over, and nothing else. Miller, *Greenwich Village*, p. 59

A rumor that Duchamp's original Bottle Rack has been found complete with signature, date, and forgotten inscription, on a New York junkman's truck. Marquis, p. 127

One evening in January 1916, during dinner with the Arensbergs at the Cafe des Artistes at 1 West 67th Street, Duchamp leaps up and impulsively signs his own name to a huge old-fashioned battle scene painted on the wall behind him. The gesture, he explains, makes the mural his own readymade; it has "everything except taste." Ibid., p. 128

"My capital is time, not money." Ibid., p. 246

In the 1940s Duchamp was so poor that he traveled all the way to Brooklyn for some dental work at a free clinic. The dentist pulled a whole group of teeth, and on the way home Duchamp collapsed on a street curb … He paid for treatment by his dentist, Daniel Tzanck, with a beautifully hand-lettered check for $115, drawn on "The Teeth's Loan and Trust Co., Consolidated, 2 Wall St., New York." Ibid., p. 143

Jimmy Ernst, the son of Max Ernst, dined with him one evening in 1967 at "a swank New York restaurant." He asked Marcel, "as a connoisseur who had dined all over the world," to pick the wine. While the wine steward waited patiently, Duchamp perused each item on the extensive wine list, occasionally asking details about a particular year or cru. Then he ordered "a little white and a little red." Somehow, this incident found its way into a popular newspaper column. He was also deliberately unpretentious in his choice of favorite foods: pastrami and French fries. Ibid., p. 289

threw potato salad at CCNY lecturers on Dadaism Ginsberg, *Howl*, p. 18

William Carlos Williams describes Duchamp during the 1940s as "idling in a telephoneless 14th Street garret." Marquis, p. 246

Jones, *Modernism*, p. 8

From the Baroness's point of view, Duchamp and Williams exemplify the tendency among male avant-gardists to make radical art in their free time, while living more or less bourgeois lives, driven by neurasthenic fears of the modern challenges to their coherence as male subjects.

Ibid., p. 8

William Carlos Williams on The Baroness's apartment: "The most unspeakably filthy tenement in the city. Romantically, mystically dirty, of grimy walls, dark, gaslit halls and narrow stairs, it smelt of black water closets, one to a floor, with low gasflame always burning and torn newspapers trodden in the wet. Waves of stench thickened on each landing as one moved up … I saw them [her dogs] at it on her dirty bed."

Ibid., p. 2

Paris has had *Dada* for five years, and we have had Elsa von Freytag-Loringhoven for quite two years. But great minds think alike and great natural truths force themselves into cognition at vastly separated spots.

Ibid.

In Elsa von Freytag-Loringhoven, Paris is mystically united [with] New York.

Ibid., p. 3

The Baroness is the first American dada; she is the only one living anywhere who dresses dada, loves dada, lives dada.

Ibid., pp. 3–4

The Baroness used detritus she found on the street as well as items stolen from department stores to craft elaborate costumes which she would then wear, complete with black lipstick, shaved head or brightly dyed hair, and other body adornments, to the legendary Greenwich Village balls or (notoriously, and surely far more noticeably) through the streets of New York.

Ibid., p. 208

Djuna Barnes, writing c. 1933: "Baroness Elsa von Freytag-Loringhoven … was one of the terrors of the district which cuts below Minetta Lane … The lip of a burnished coal scuttle for a helmet strapped to her head with a scarlet belt which buckled under the chin, Christmas tree balls of yellow and red as ear rings, a tea strainer about her neck, a short yellow skirt barely covering her legs, and over the precision of her breasts a single length of black lace she would walk the city … She made a great plaster cast of a penis once, & showed it to all the 'old maids' she came in contact with."

Ibid., p. 222

The Baroness, with her leaky, smelly, grotesque body and flamboyant costumes cobbled together from urban detritus and stolen commodities, performed an irrational, antimasculinist, and radically queer subjectivity against the grain of New York's abstracting spaces and phallic skyline.

Ibid., p. 180

audacious modernity

Ibid., p. 30

How do we construct a legitimate or convincing history when we only have a pile of disconnected anecdotes (anecdote being, as Djuna Barnes put it, "the skeleton of life")?

Trager, p. 623

"My uncle's garage, that Frank Lloyd Wright thing on Fifth Avenue," said Peggy Guggenheim.

Monson, p. 31

One would never expect to see another "Guggenheim" aped somewhere down the Avenue.

Ibid.

No one can now deny the uniqueness of the plain apartment blocks behind the Guggenheim, for it was the Museum building which gave them a reality which themselves they had not had until its construction.

For the Mexican muralist J. C. Orozco in 1929, New York constituted a challenge to the modernizing artist. Its architecture stood as a rebuke to the inequity and fatuity of ancestral Europe, and where the buildings had boldly led, Orozco proclaimed, "painting and sculpture must certainly follow." Mondrian too saluted the city's overthrow of a tyrannical past, a liberation symbolized by its engineering, its electricity, its jazz, and the displays in its shop windows.

Conrad, p. 115

Joseph Cornell, who located the oddments he reverently boxed in the shabby arcades of Times Square, the musty bookstores of Fourth Avenue, the flower stalls on West 28th Street, and the curiosity shops above Madison Square.

Ibid., p. 311

Cornell remembered passing a shop window displaying compasses, then, two blocks farther, a window full of boxes. "It occurred to me to put the two together." He is the *bricoleur* as an elegiac wanderer in memory, a votary of the souvenir.

Ibid.

Presently we went through the kitchen, where Cornell's mother was sitting reading the Sunday paper. It could have been any kitchen on Utopia Parkway—ruffled curtains on the windows, some plant cuttings on a sill. I glimpsed the pantry, which seemed to be filled with bags of birdseed, for the good reason that Joseph had in his backyard a birdbath, birdhouses, bird feeders. He explained that he enjoyed the visits of sparrows, pigeons, robins or any other bird that came by. There was a wire fence in the rear of the yard. Other backyards stretched to the left and right, all fenced off, each with a garage. It was to the Cornell garage that I was led, and when the doors were swung open, I felt as though I were entering Aladdin's cave. There were shelves and more shelves lining the garage on which were stored objects, constructions, materials for new boxes, dolls. I cannot say which boxes I liked the most. I cannot say if I understood the meaning of them. I only knew that these creations were among the most beautiful and mysterious things I had ever seen, the total embodiments of *le merveilleux*.

Myers, pp. 73–4

After a light lunch of cottage cheese, toast, bologna, jello and milk (Joseph picked at his food as though eating were a nuisance), I was invited to go for a bicycle ride. There were two bikes in the garage and off we went on a tour of the neighborhood. But the sights most memorable were pure Cornell. "Stand here," he said at one spot, "and hold your hands to the right and left of your eyes so that you see only what is in front of you." In the distance was a small old-fashioned brick building, probably a pump house. By cutting off the surrounding environment, it became a Swiss chalet nestling among trees. It looked like the kind of romantic vista one sees in an old engraving. The next spot provided a spectacular view of New York, the whole of it stretched out and illuminated by the silvery gray light of the afternoon. I had never seen New York from such a vantage point. Its skyscrapers became minarets, it seemed to float on a low-lying mist. It was Baghdad. When we got back to the house, I was not shown the attic, where more treasures were stored, or his cellar, which serves as a studio. Instead, we went upstairs to Joseph's room—as austere as a monk's cell—where there was a large collection of Victrola records and a wind-up Victrola. I was shown a portfolio devoted to an early nineteenth-century opera singer called Malibran. In it were programs, engravings, sheet music, reproductions of letters, a host of memorabilia through which Cornell could summon the presence of the celebrated diva. (Cornell had already put his vast collection of this sort of visual material, plus several thousand silent movie stills, to practical use. He conducted an archives service rather like the huge-scale Bettmann Archive; commercial art

ᴅ Art — New York Dada

directors who needed a picture of, let us say, a kitchen stove circa 1846 would call Cornell and invariably he would have the sought-after image.)

While I was looking through this sheaf of material, selections on various recordings were played on the wind-up Victrola. These were not necessarily operatic arias or overtures. Some of the music evoked a Malibran who might have lived in another period—music by Erik Satie and Debussy, for instance. It became clear, however, from glancing at the covers of many of the record albums, that Joseph's passion was for the Romantic composers—Schumann, Schubert, Berlioz, Chopin.

It was time for me to leave, but Mrs. Cornell insisted I have a cup of tea and some Lorna Doone cookies. Her deafness prevented much conversation, and I felt I had stayed too long, although Joseph assured me I hadn't. I said goodbye to his brother, Robert.

Wolfe, *Painted*, pp. 86–7 Suppose the greatest artist in the history of the world, impoverished and unknown at the time, had been sitting at a table in the old Automat at Union Square, cadging some free water and hoping to cop a leftover crust of toasted corn muffin or a few abandoned translucent chartreuse waxed beans or some other item of that amazing range of Yellow Food the Automat went in for— and suddenly he got the inspiration for the greatest work of art in the history of the world. Possessing not even so much as a pencil or a burnt match, he dipped his forefinger into the glass of water and began recording this greatest of all inspirations, this high point in the history of man as a sentient being, on a paper napkin, with New York tap water as his paint. In a matter of seconds, of course, the water had diffused through the paper and the grand design vanished, whereupon the greatest artist in the history of the world slumped to the table and died of a broken heart, and the manager came over, and he thought that here was nothing more than a dead wino with a wet napkin. Now, the question is: Would that have been the greatest work of art in the history of the world or not?

Talese, p. 19 When an equestrian statue of a general has both front hoofs off the ground, it means the general died in battle; if one hoof is off the ground, he died of wounds received in battle.

New York Schools

Stevens and Swan, p. 292 As 1950 approached, a feeling akin to manifest destiny began to course through the art world. This was "the American century," the Luce magazines constantly trumpeted, and Americans had a heroic role to play in resisting totalitarianism and celebrating Western values. Buoyed by the new optimism, the downtown artists decided to stage a Christmas party at the Club. Most of the charter members spent several evenings creating one or two huge collages apiece. In the end, the collages—"daring and dazzling" to look at— covered almost every inch of the Club's walls and ceilings. The partying mood did not end after Christmas. The biggest day of all, New Year's 1950, was approaching. Bridge tables were covered in paper tablecloths and lined up in a long row for a communal dinner. After dinner the dancing began.

[...]

And then it was midnight and 1950. And then it was morning, and still no one went home. Many artists simply broke for breakfast and a new bottle. The partying lasted for three days. Sometime during the marathon, Philip Pavia stood up and delivered a ringing proclamation. "This is the beginning of the next half century," he announced. "The first half of the century belonged to Paris. The next half century will be ours."

De Kooning's "Excavation" had none of the monkish reserve of Parisian cubism, but seemed brash and pulsing, like a blinking sign in New York. A black and white city that glinted with occasional color, New York was itself a kind of synthesis of cubism and surrealism, a combination of strict grids and liberating gestures in which order and chaos, reserve and craziness, appeared locked in a tense balance. New York in 1950 was not the bland caricature later known as "the fifties." It celebrated the exaggerated self and the strut of personality. And yet, the city could also be cold and detached, a place of gritty grays and inhuman scale … No other American painting—not even Stuart Davis's pictures—conveyed with comparable force the jazzy syncopation of the city.

Ibid., p. 296

New York School art works with titles about New York: Jane Freilicher, *Early New York Evening*, Larry Rivers, *Second Avenue*, Grace Hartigan, *Grand Street Bridges*, Allan Kaprow, *George Washington Bridge (with Cars)*, Franz Kline, *Third Avenue*.

N. cit.

De Kooning joked that he thought of the fiercely totemic *Woman* of his 1950–52 series as "living" on Fourteenth Street.

Gooch, p. 191

Publicity had not been an issue with artists in the Forties and Fifties. It might come as a bolt from the philistine blue, as when *Life* made Jackson Pollock famous, but such events were rare enough to be freakish, not merely unusual. By today's standards, the art world was virginally naive about the mass media and what they could do. Television and the press, in return, were indifferent to what could still be called the avant-garde. "Publicity" meant a notice in the *New York Times*, a paragraph or two long, followed eventually by an article in *Art News* which perhaps five thousand people would read. Anything else was regarded as extrinsic to the work—something to view with suspicion, at best an accident, at worst a gratuitous distraction. One might woo a critic, but not a fashion correspondent, a TV producer, or the editor of *Vogue*. To be one's own PR outfit was, in the eyes of the New York artists of the Forties or Fifties, nearly unthinkable—hence the contempt they felt for Salvador Dalí.

Bockris, *Warhol*, pp. 116–17

Splatters of paint from the brushes of Arshile Gorky can be found on the floor of a 14th Street studio still occupied by a painter.

McDarrah, *Beat*, p. 15

Harold Rosenberg and Dwight Macdonald for twenty-five years lived in the same four-story whitestone on East Tenth Street in the Village and rarely spoke to one another, often barely grunting hello.

Jumonville, p. 140

The ultimate dream of any Painting and Design person was to go to New York and get a studio. That word "studio" was enormously charged, it was much more charged than "sex" or "fuck," because it implied this whole life, I mean, this was it! The most talented and independent people would come to New York in the summer and sublet somebody's studio with an outdoor toilet for $18 a month.

Bockris, *Warhol*, p. 78

I remember the first time I met Frank O'Hara. He was walking down Second Avenue. It was a cool early Spring evening but he was wearing only a white shirt with the sleeves rolled up to his elbows. And blue jeans. And moccasins. I remember that he seemed very sissy to me. Very theatrical. Decadent. I remember that I liked him instantly.

Brainard

Ibid. I remember Frank O'Hara's walk. Light and sassy. With a slight bounce and a slight twist. It was a beautiful walk. Confident. "I don't care" and sometimes "I know you are looking."

Ibid. I remember one very cold and black night on the beach alone with Frank O'Hara. He ran into the ocean naked and it scared me to death.

Gooch, p. 191 O'Hara matched the spirit of his new artist friends by trying to create a poetic city of New York. Other poets had certainly written about Manhattan— Whitman, Crane, Lorca, Auden. But over the next fifteen years, O'Hara composed a fragmented epic of the city, focusing particularly on the humor and chaos of the growing metropolis and using his experiences as a trail through an ever-changing urban labyrinth rather on the scale of Joyce's Dublin or William Carlos Williams's Paterson.

Ibid. From the moment Frank O'Hara arrived in New York, the twenty-five-year-old poet began absorbing the images, smells, and sounds that appeared in his work—newspaper headlines, subway bathrooms, yellow construction helmets, taxi honkings, funeral home signs, painters' lofts, instant coffee, negronis, abandoned storefronts, lunchroom tables, smoke-filled bars, liquor stores, and tobacconists.

Ibid., pp. 395–9 O'Hara was vexed by Warhol's rise. They had both arrived in New York at about the same time. But Warhol's acceptance by the art world in which O'Hara was so celebrated was peripheral at best. Of Warhol's first show at the Hugo Gallery in 1952, an unimpressed *Art News* reviewer had written that his drawings of young boys' heads and women dressed in the style of the twenties were "airily" reminiscent of the novels of Truman Capote. As a curator, O'Hara had visited Warhol's studio in 1959. "He was very unkind to Andy," says the poet John Giorno. "This was when Andy was still drawing shoe ads and making all that money. Frank O'Hara and two other people came to visit Andy in that house on Eighty-ninth Street and Lexington Avenue. It was very chicly decorated at the time—black vinyl walls, a horse from a carousel. I remember Andy saying that Frank walked into that front room and just started laughing and putting him down for being chi-chi. That's not what they wanted to see or what they thought was important. He told me, 'Frank was so meeeean.' That carried through when he became a famous artist. But then at some point Frank made a change and thought that what Andy was doing was valid."

Warhol had begun doing drawings of feet long before the shoe as an expression of his fetish. Introduced to O'Hara by Willard Maas at Charles Henri Ford's, Warhol asked O'Hara if he could draw his feet. Well aware of the eroticism in the suggestion, O'Hara refused. "But you let Larry Rivers draw your feet," complained Warhol, who had early on bought a Rivers drawing from John Bernard Myers on an installment plan of five dollars a month for five months. "Well that's Larry Rivers!" O'Hara exclaimed. O'Hara was not nearly so difficult with Jasper Johns, who made a sculpture of wood, lead, metal, brass, and sand in 1961 titled "Memory Piece (Frank O'Hara)," in which a rubber cast of a foot in the sand was taken from a plaster mold of O'Hara's foot. "I remember casting his foot on Front Street in my studio," says Johns. "I cast his foot and did a drawing for the piece, which included a cabinet with the drawers full of sand. At that time I had a house in South Carolina. I needed a carpenter but could never find anyone to do it. I think it was done after his death. But I gave Frank the drawing for it." This was the piece referred to in O'Hara's letter-poem to Johns, written in 1963: "Dear Jap, when I think of you in South Carolina I think of my foot in the sand."

Masterful at the art of manipulation and careerism, Warhol had targeted O'Hara at first as someone who could open doors for him. "Andy wanted Frank's respect, I think," says Gerard Malanga. "But Andy was not getting it, so he was kind of two-faced about the situation. He actually was not that impressed by Frank. But he would get hurt by these negative reactions from people he thought he could look up to." Soon enough, of course, doors opened without O'Hara. Warhol's one-man show in November at the Stable Gallery, which included his Marilyn diptych, 100 Soup Cans, 100 Coke Bottles, and 100 Dollar Bills, set him at the head of the pack, which O'Hara would rather have seen him trailing. Bill Seitz, the chief curator of the Museum's Department of Painting and Sculpture, bought a Marilyn for himself for $250. Philip Johnson bought the Gold Marilyn for $800. Yet when Warhol gave him one of the Marilyns, O'Hara instantly put it in his closet. Jim Brodey, a poet from O'Hara's New School class, recalls a cocktail party at O'Hara's at which Warhol gave O'Hara an imaginary drawing of the poet's penis, which he crumpled up and threw away in annoyance.

O'Hara's antagonism toward Warhol was mixed with art politics and sexual politics. Warhol was relegating the Abstract Expressionists to the past. By threatening O'Hara's allies, he was threatening O'Hara's own vanguard status, a position he had enjoyed since he was a teenager. He offended O'Hara as well by rejecting the brushstroke, with its touching, personal, humanistic implications, in favor of silkscreening and mechanical reproduction. Larry Rivers's commissioned billboard for the first New York Film Festival in 1963 included a camera, strips of celluloid, a Rudolph Valentino cameo, a leopard, a figure of Jane Russell in her briefest costume from *Gentlemen Prefer Blondes*, and stenciled letters. When it was mounted at the corner of Broadway and Sixty-fifth Street, O'Hara wrote to Joan Mitchell, "You can make out what the message is through a few well-placed letters here and there, but mostly it is pure Rivers—no Andy Warhol he. It's quite funny that they do all those paintings that look like billboards, and when a billboard is finally commissioned it looks like a painting, or rather is one."

"In his love of objects in his poetry and in his association with Larry Rivers he certainly wasn't antirealist," says the painter Wynn Chamberlain. "On the other hand he was very much anti-Death, which is what Warhol signified to him I think. And to all of us at that point. He was the prophet of doom. There was a complete division between the Warhol-Geldzahler camp and the O'Hara-Rivers-de Kooning camp. Frank was at the Museum of Modern Art, and that Museum was the thing to be overcome by the younger Pop painters." Among his fellow curators at the Museum, O'Hara was actually relatively open to some of the "New Realists," if not always to Warhol. "Like a lot of people who were involved with Abstract Expressionism I was very resistant to Pop," says Waldo Rasmussen. "It really seemed trivializing to me. And in some aspects of it he was too. But he was much more open to it than I. He became very quickly a good friend of Claes Oldenburg. He liked Lichtenstein's work." (The painter Al Leslie recalls a panel discussion at the Skowhegan School of Painting and Sculpture in Maine at which O'Hara savagely "devastated" an art historian who criticized Lichtenstein, beginning his tirade with his trademark insult, "You big sack of shit!")

Some of O'Hara's peeves with Warhol were personal. Paramount was a friendship of Warhol's with Freddy Herko—the young dancer who had roomed with Vincent Warren after rooming with Diane DiPrima. Warhol had filmed the struggling dancer roller-skating all over New York on one bleeding foot in a sixteen-millimeter film titled *Dance Movie* in September 1963. In October 1964, Herko killed himself tripping on LSD by dancing out the fifth-floor window of a friend's Greenwich Village apartment while Mozart's *Coronation Mass* played on the record player. When he heard the

news, Warhol reportedly said, "Why didn't he tell me he was going to do it? We could have gone down there and filmed it!" O'Hara, who attended the memorial service organized by Diane DiPrima at Judson Church, reacted to Herko's death with his usual overblown mourning and sorrow. Warhol's response cinched O'Hara's opinion of him as cold-blooded. As he wrote to Mike Goldberg, "How did you know incidentally about my being so depressed about Freddie? I was, very, but when this girl told me that Andy Warhol and Alan Marlowe had found it 'beautiful' and I said that I hoped they would both be locked into a Ben Hecht movie and left to starve, I felt greatly relieved."

O'Hara was first brought to Warhol's "Factory," which was then located in a warehouse and factory building at 231 East Forty-seventh Street, by Joe LeSueur in 1964. (LeSueur had appeared eating a banana that year in *Couch*, a lightly pornographic movie filmed in July on an old red couch in the middle of the Forty-seventh Street Factory with cameo appearances by Malanga, Ginsberg, Corso, Orlovsky, Kerouac, Mark Lancaster, and Baby Jane Hoizer.) O'Hara half-heartedly agreed to write, with LeSueur, a segment for a plotted movie (conspicuously missing until then in the Warhol canon) to be called *Messy Lives*, but he never did it. His only contribution was an episode written with Frank Lima called "Love on the Hook." "Frank left the Factory that day not very impressed with what Andy was doing," says Malanga of O'Hara's only visit. "But there was a weird homosexual climate there at that point. Maybe he felt Andy was too sissified for his tastes."

Warhol's style of homosexuality was counter to O'Hara's, who preferred the artist cowboys of the Cedar. Warhol felt alienated by such aesthetic roughhousing. As he later wrote of the Cedar, "I tried to imagine myself in a bar striding over to, say, Roy Lichtenstein and asking him to 'step outside' because I'd heard he'd insulted my soup cans. I mean, how corny. I was glad those slug-it-out routines had been retired—they weren't my style, let alone my capability." The Factory was Warhol's attempt at a party he could control, and the scene's infiltration of Max's Kansas City in 1966 changed the life of artists at least as much as the Janis show. Max's—with its red velvet booths and black vinyl walls covered with works by Frank Stella, Donald Judd, Dan Flavin, and Richard Bernstein—became the new Cedar. The dividing line O'Hara had described as so "New York" in his letter to Warren from Madrid, between the heterosexual painters who liked him and the effete homosexuals who didn't, had been erased.

Eventually O'Hara, like the rest of the art world, made room for Warhol. As the painter Joe Brainard wrote, "I remember Frank O'Hara putting down Andy Warhol and then a week or so later defending him with his life." In 1964 Warhol, using his Bolex, shot movie footage of O'Hara giving a poetry reading at Café Le Metro—a subbasement coffee shop and antique furniture store on Second Avenue between Ninth and Tenth streets that was the hangout of the East Village poets until the founding of the Poetry Project at St. Mark's Church in-the-Bowery in 1966. In an interview with a British journalist in October 1965, O'Hara found kind words to say about Warhol: "I went to Boston recently and saw the full mounting of the picture of Mrs. Kennedy … It was never shown in New York full scale. And it's absolutely moving and beautiful. Not sarcastic, and it's not some sort of stunt. It really is compelling work when shown in the way he wanted it to be shown. When it's as big as it's supposed to be and there are that many images of her and the color somehow works from image to image. And I think that he—you know, just as one knows that Duchamp's serious—I think Andy is a terribly serious artist rather than an agent to make everything lively, which he sometimes is taken for in the United States. The European evaluation of him is much more exact." In a memo written shortly before his death, on a Pollock retrospective he was organizing, he proposed a panel of five critics and artists he thought would

be "pentagonally opposed"—Harold Rosenberg, Clement Greenberg, Barnett Newman, Alfonso Ossorio, and Andy Warhol.

To Capote himself, New York was "like living inside an electric lightbulb." Bockris, *Warhol*, p. 78

Warhol wrote fan letters to Truman Capote and Judy Garland … Throughout his first year in New York, he had written Capote almost daily fan letters, announcing he was in town and asking if he might draw Truman's portrait. *Ibid.*, pp. 86, 91
 "I never answer fan letters," Capote would later recall, "but not answering these Warhol letters didn't seem to faze him at all. I became Andy's Shirley Temple. After a while I began getting letters from him every day! Until I became terrifically conscious of this person. Also he began sending along drawings. They certainly weren't like his later things. They were rather literally illustrations from stories of mine … at least that's what they were supposed to be. Not only that, but apparently Andy Warhol used to stand outside waiting to see me come in or go out of the building."

Capote on Warhol: "He seemed one of those helpless people that you just know nothing's ever going to happen to. Just a hopeless born loser, the loneliest, most friendless person I'd ever seen in my life." *Ibid.*, p. 91

The city was changing. De Kooning's New York was hot and fervent; now a more iconic and cool city, which Andy Warhol would soon symbolize, was developing around him. The contemporary art world was becoming increasingly remote from his inner life as an artist. The constant parties, the bright young faces, and the air of fashion took him far from his own roots. There seemed to be no center any longer. Stevens and Swan, p. 422

The multiplicity of learned traditions, the diverse institutional bases of learning, popularization, and vernacular cultures, make it no easy task to identify either elite or popular culture. A simple "high" / "low" scheme is utterly inadequate. The cultural life of the modern city, of New York City in particular, has been divided and subdivided along both historical and vertical axes—with no universally recognized principle of hierarchy or priority. Bender, *Unfinished*, p. 61

If anybody wants to know what those summer days of '66 were like in New York with us, all I can say is go see *Chelsea Girls*. I've never seen it without feeling in the pit of my stomach that I was right back there all over again. It may have looked like a horror show—"cubicles in hell"—to some outside people, but to us it was more like a comfort—after all, we were a group of people who understood each other's problems. Warhol, *POPism*, p. 233

I remember the day Frank O'Hara died. I tried to do a painting somehow especially for him. (Especially good.) And it turned out awful. Brainard

Warhol: "One night I happened to be at Max's when Larry came in. That afternoon Frank O'Hara had been buried in Springs, Long Island, with Jackson Pollock's grave in the distance, and half the art world had gone out there for the funeral. Larry came over to my table holding a drink and sat down. He looked terrible. He'd been really close friends with Frank. After he was hit by a car, they took him to the nearest hospital, Larry told me, where they didn't realize he was bleeding internally until the next morning, and by then he'd been losing blood for eight hours. Frank's best friends, Larry and Kenneth Koch and Joe LeSueur and Bill de Kooning, were all called to the hospital, and de Kooning and Larry went up to his room to see him. 'He Warhol, *POPism*, p. 234–5

thought he was at a cocktail party,' Larry said. 'It was a dream conversation. And three hours later he was dead. I made this speech at the funeral today— I was practically in tears. I just thought I'd describe what Frank looked like that afternoon, the marks on his body, the stitches, the tubes coming out of him. But I didn't get to finish because everyone was screaming at me to shut up.' Larry shook his head. It sounded like a very Pop eulogy to me—just the surface things. It was just what I hoped people would do for me if I died. But evidently death wasn't something the people out there in Springs that afternoon wanted to be Pop about.

'It's very selfish of me, I know,' Larry said, 'but all I can think is that there'll never be anybody who likes my work as much as Frank did. It's like that poem of Kenneth's—"He Likes My Work."'

It was scary to think that you could lose your life if you were taken to the wrong hospital or if you happened to get the wrong doctor at the right hospital. It sounded to me like Frank wouldn't have died if they'd realized in time that he was bleeding.

I'd known Frank, too. He was kind of small, and he always wore tennis shoes, and he talked a little like Truman Capote, and even though he was Irish, he had a face like a Roman senator. He'd say things like 'Listen, Circe, just because you've turned us all into pigs, don't think we're going to forget you're still our queen!"'

Berrigan, *Collected*, p. 620 Frank O'Hara's dead & we are not.

Haring, p. 156 It's hard to imagine what N.Y. will be like without Andy. How will anybody know where to go or what is "cool"?

Literature

Kerouac, *Lonesome*, p. 109 W. H. Auden himself may be seen fumbling by in the rain—Paul Bowles, natty in a Dacron suit, passing through on a trip from Morocco, the ghost of Herman Melville himself followed by Bartleby the Wall Street Scrivener and Pierre the ambiguous hipster of 1848 out on a walk—to see what's up in the news flashes of the *Times*.

Malanga, *Archiving*, pp. 23–4 Wystan Auden could probably be considered one of the first modern poets to homestead in the East Village.

Reay, p. 11 W. H. Auden's parties in his apartment in the Village, attended by an incongruous mix of high-powered literary figures and street scum boys, who Auden and his partner had picked up.

Kane, p. 8 I was living in New York when my early poems were written, and the thing then was to be experimental. We thought that using slashes and "wd" instead of "would" was experimental writing. I finally asked Joel Oppenheimer, who was well known for this, why he used slashes instead of apostrophes and he told me that it was because he was a typesetter and the typesetting machines had no apostrophes. So I guess it wasn't all that avant-garde after all.

Ibid., p. 19 The cowboy look extended into the poetry and writing coming out of the Lower East Side scene.

Kane, p. 64 "Edited, published & printed by Ed Sanders at a secret location on the Lower East Side, New York City."

The New York poets seem to be nourished by a reservoir of attributes including, mainly, wild, improbable juxtaposition, diction that turns corners sharply, put-ons, very mock ingenuousness and urbane faggotry.

Kane, p. 175

John Giorno's benefit for Ron Gold at the Poetry Project in January of 1970 included setting up a guerilla pirate radio station called Radio Free Poetry that could reach a radius of ten blocks, a light and sound show, perfumed air, fog machines and a bowl of LSD punch that was distributed at the church's altar.

Ibid., pp. 184–5

The St. Mark's Poetry Project
is closed for the summer. But
all over the world, poets
are writing poems. Why?

Berrigan, *Collected*, p. 592

On January 10, 1968, Kenneth Koch read at the Poetry Project. His reading was interrupted by the poet Allen Van Newkirk yelling out "Stop!" followed immediately by the sound of a pistol. Newkirk had quietly walked from the rear exit of the parish hall up to the front of the stage, pulled out a pistol, and fired two blanks directly at Koch. Rod Padgett remembers: "A tall, somewhat scraggly white man, in his mid-to-late 20s and wearing Dostoveskyan overcoat, emerged from the door behind the podium and took a few steps toward Kenneth, on Kenneth's left side, and he aimed a small revolver at Kenneth and from close range fired several shots. It was quite loud and stunning. Kenneth cringed and lurched. The audience jumped. I jumped too, but I kept my eye on Kenneth and saw that he was not shot. Around this time there were a lot of Happenings, and other unusual art events with pranks set up to fool the audience, so you never knew. But it was very unlikely that Kenneth was going to set up a thing like this. When I saw Kenneth wasn't in fact hurt, and I realized that this must be some kind of a stunt, I was mightily relieved. Meanwhile, the assailant walked down the center aisle toward a cohort who was distributing leaflets from the back—it turned out to be Andrei Codrescu, who had recently arrived in this country. The two were told to leave—by Ted Berrigan, I think—and they did, shouting slogans."

Kane, pp. 171–3

Koch sounds a little shaken as he states, "that was a benefit shooting." This comment elicited what seemed like relieved laughter from the audience, and Koch resumed reading his poem. He stopped his reading to say in a sardonic tone, "poetry is revolution." Then Koch is heard to sigh, "well," as he looked at one of the flyers Newkirk and his cohorts was circulating throughout the parish hall. After some period of silence, Koch stated, "Well, now, I don't want the congregation to get upset by these hijinks. These young people have a fine cause that they're working for, and this seems to be about Leroi. Now, I don't think the judge should've put Leroi in jail because he wrote a poem. If that's the point these people wanted to make they could've made it in a better way it seems to me. So why don't you stop interrupting the reading." At this point Newkirk heckled Koch again, to which Koch responded by shouting, "Scram!" In response to Koch, Newkirk shouted, "Fuck you!" Koch again yelled out, "Get out!" The heckler then intoned, "Revolution—the only solution!" Some audience members could be heard laughing rather contemptuously in response to the slogan. Koch said, "Grow up!" And then, in an indignant if amused tone, muttered "revolution."

What happened with the "assassination" of the poet Ken Koch in 1968?

McIntyre

Ben Morea: Koch was a symbol to us of this totally bourgeois, dandy world. Myself, Dan Georgakas, Alan Van Newkirk and some of the other Black Mask people went to one of his readings at St. Marks Church. I think

I came up with idea to shoot him with a blank pistol. Alan looked like the classic image of the bomb-throwing anarchist. He was about six foot three, long and thin with a gaunt face and always dressed in black—the anarchist incarnate. So we decided "You're the one, you're going to shoot him." (laughter) We printed a leaflet and all it had on it was a picture of Leroi Jones with the words "Poetry is revolution." On the night when Alan shot the blank Koch fainted and everyone in the audience assumed he was dead and started screaming. Some people threw the leaflets from the balcony into the crowd and then we all left.

Reactions after the event were split between people who thought it was the greatest thing they'd ever heard and those that thought we were a bunch of sophomoric assholes. Which was great because so much of what Black Mask and The Family was about was pushing people to decide "Do I belong with this group of people or this one?" We were determined to be outrageous in order to force people to decide where they stood on things. We wanted to push people, force them to think. "Why shoot Koch? He's just a nice poet."

Bockris, *Burroughs*, pp. 85–7, 89–91

On an average day in New York, William S. Burroughs gets up between 9:00 and 10:00 and shaves. In a dream note made on 13th August 1975 he wrote: "Things needed. Shaving mirror. Anyone used to shave feels deterioration if he cannot." From Retreat Diaries. Burroughs associates shaving with civilization and throughout his travels has never grown a beard or mustache.

Then he takes a 100 milligram capsule of vitamin B1 because he believes it replaces the B1 that alcohol removes from the system. He dresses, washes last night's dishes, and eats breakfast. He likes coffee with a donut, English muffin, or angel food cake.

Around 11:00 he goes down four long flights of stairs to get his mail (5–10 pieces daily). Between 11:30 and 12:30 he putters around the loft looking at notes, writing notes, and checking through various books.

Between 12:30 and 1:00 Bill often goes out shopping for groceries or, lately, new clothes. He's usually back by 1:00, eats no lunch and writes between 1:00 and 4:00 in the afternoon.

If James Grauerholz is working with him on a manuscript or a reading, James will arrive around 4:00 in the afternoon and will stay through dinner. This happens, on the average, three times a week. They go over the work between 4:00 and 6:00 when Burroughs often relaxes, sitting in a rocking chair by the window. "It's a very beautiful sight," James says. "I'll be working at the other end of the loft. I'll look up, and there will be William just sitting perfectly still in his chair looking kind of serene."

At 6:00 P.M. Burroughs pours himself a drink. Dinner is between 7:30 and 8:30.

All his life Burroughs has eaten in restaurants. Today, he shops and cooks for himself, often having friends over, or going to their places nearby for dinner. After dinner, conversation continues until 11:00 or 12:00 and then usually home or to bed. Occasionally he stays up talking till dawn.

An average Burroughs day produces six pages. Sometimes he'll write as many as fifteen. When he started *Cities of the Red Night* he produced 120 pages in two weeks. "William's very good at knowing when to leave things alone and when to go back to them. He knows when enough is enough," James reports. "Sometimes I may try to push him on something—looking at a manuscript when 600 pages have been written and saying, 'We should begin editing that'—and he'll say, 'No … that'll take another couple of years.' He's seen enough time pass that he knows how to pace himself."

[…]

Burroughs currently lives on the Bowery in a large three-room apartment which used to be the locker room of a gymnasium. He calls it the Bunker.

b Art — Literature

Going to the Bunker can be a hazardous experience, and in fact William personifies more than any other man I have ever met a person aware of the hazards surrounding him. He has recently equipped me with a cane, a tube of tear gas, and a blackjack. "I would never go out of the house without all three on me," he says pointedly.

In fact, walking down the street in a dark blue chesterfield, his homburg pulled down over one eye, a cane swinging alertly from his right hand, Bill steps right out of a Kerouac novel ... I was constantly struck by the similarity of Kerouac's portraits of Bill to the William who was slowly becoming revealed to me during the time I was constructing this portrait.

It wasn't until late 1975 that Burroughs found what would become his HQ in New York City. The Bunker is an elegant old red brick building. One of the first people I ever brought over to visit him was the British writer Christopher Isherwood, whose novels and travel books Burroughs had read and admired as well as used, and his companion, the artist Don Bachardy. I turned on my tape recorder just as the cab pulled up in front of the locked iron gate of the Bunker on the chilly, deserted, windswept Bowery.

BOCKRIS [on the street]: A foreboding entrance. It's rather hard to get in here sometimes; it depends on whether the gate's open or not. Bill will come down and unlock the gate.

DON BACHARDY: Is that because it's a bad part of town?

BOCKRIS: I don't think that's the reason. It's a big building and they lock the gate. Bill doesn't personally lock it. [We walk across the street to a bar half a block away. Icy wind. People wrapped in blankets leer out of doorways.] Now this bar's perfectly safe, we'll call Bill and he'll come down. [Open door, go into bar, loud noises of laughing, shouting, breaking glass, screams. Christopher and Don run very close behind. Voices from various conversations appear on tape: "That's my two dollars," etc.] Is there a telephone in the bar?

BARTENDER: Nope. There's one right across the street.

CHRISTOPHER ISHERWOOD [gleefully]: It's so Eugene O'Neill! [Open door into second bar. Repeat of above atmosphere. Voices drift in and out of the tape: "You and me are gonna meet tomorrow, you better believe it! When your friend ain't around. I've had enough of your shit! All your goddam friends!"]

BOCKRIS: This is part of visiting William Burroughs though, isn't it? [On phone]: Hi! James! We're down on the corner here ... [Hangs up.] They're coming down. [Walks out into street.] Is it worse to be a drug addict or an alcoholic do you think?

ISHERWOOD: God, I don't know. I never tried either.

BOCKRIS: You do see more alcoholics in the world. It seems that drug addicts either die or else they don't get in such bad shape.

ISHERWOOD: I've drunk rather a lot during my life, but I never came anywhere near to being an alcoholic.

BOCKRIS: [Burroughs's secretary, James Grauerholz, appears behind the iron door with a key. We walk up a flight of stone steps.] I'll lead the way. [They walk into William Burroughs's spacious apartment.] I'll introduce everyone. [They shake hands, nod, smile.]

BURROUGHS: Why don't you take off your coats, gentlemen. [All put coats in Bill's room next to his pyjamas, which are lying neatly folded on his bed, come back into living room and sit in a series of office-style orange armchairs around a large conference table that Burroughs has in the kitchen section of his apartment.]

GRAUERHOLZ: Can I get you a drink?

EVERYBODY: YES!

ISHERWOOD [looking around]: This is a marvelous place.

BURROUGHS: There are no windows. On the other hand, there's no noise. This whole building was a YMCA. This used to be the locker room. The man upstairs has the gymnasium and downstairs is the swimming pool. It's a furniture shop now.

BOCKRIS: Why did you move from Franklin Street to the Bunker?

BURROUGHS: I was very dissatisfied with walking up those stairs in Franklin Street; also they were putting up the rent. The "in" was John Giorno, who has a place upstairs. The landlord showed me this place. No one wanted it because it didn't have any windows. It was used for storage then. The sink was already in and the shower and toilet. I decided to take it. It was originally one space so we put up these partitions. James moved in first for about six months, and then I moved out of Franklin Street. I was trying to sell it because I'd spent a good deal of money on Franklin Street. It was in a pretty bad state when I moved in and by the time I had bought a refrigerator and put in a sink and a set of cabinets and some reflooring, it cost me $7,000. But nobody would give me anything for it, so I finally gave it to Malcolm McNeil, who lives there now. I happened to hit the market at the wrong time. Also, nobody wanted it because it was a three-story walkup. Now it's a hell of a thing to have a refrigerator brought up three flights. It costs you a lot extra.

BOCKRIS: What gave you the idea to paint the Bunker's floors white?

BURROUGHS: When I first moved in it was battleship gray and it looked dingy. It's obvious you need all the light you can get in here since there isn't any natural light and I was very pleased with the results. There is of course no view, but what kind of view did I have at Franklin Street? I had some buildings to look at. Also I have four doors between me and the outside and I have people down there in the daytime. It's pretty impregnable.

BOCKRIS: This entry via telephone system is good. No one can come knock at the door unexpectedly and bother you.

BURROUGHS: I think it's better this way. I am very comfortable here.

White, *Physical*, p. xxvi

Have you ever noticed that no American writer of any consequence lives in Manhattan? Dreiser tried it, but finally fled to California.

Ford, *America*, p. 155

There arises sporadically and from time to time in American literary circles a sort of patriotic fervor which is not so much a Xenophobia as a sort of determination that all matter printed in America shall be marked: *Written and manufactured in the United States.*

Riesenberg and Alland, p. 75

So far no "Elegy Written in a High-Speed Elevator" has appeared among modern masterpieces.

Conrad, p. 193

Whitman the housebuilder and (as a newspaperman) manufacturer of literature works to construct an epic city. After him, no one seems to work there. At best they have careers.

Federal Writers, *Panorama*, p. 15

"He who touches the soil of Manhattan and the pavement of New York," said Lewis Mumford, "touches, whether he knows it or not, Walt Whitman."

Conrad, pp. 108–9

The ghost of Whitman still presides. He sits naked, bearded, wearing a sun hat, and watches the gymnastic revels of a crowd he might have invented. A female bather—his muse perhaps—studies him from her deck chair.

Stettner, p. 11

Whitman's commonplace sighting of eagles, horses, and boats "sparkling" on the Hudson "as thick as stars in the sky"—cannot be remembered by anyone still alive.

Serious reading was the order of the day. Downy-haired flappers tucked up their bobs and rolled down their stockings and went to it.

Collins, *Money*, p. 297

O. Henry was forty years old before he ever saw New York and he lived there only eight years (1902–10).

Patterson, "The City of NY," p. 207

Pepys was better off when he lived than if he had lived today. He was an artist in life, but if he had tried to shape his way in this world of Manhattan his artistic job would have been a bigger one.

Hapgood, p. 259

Waverly Place is a writing street; no other spot in America produces so much real literature.

Irwin, p. 123

Willa Cather wrote her greatest novels of the prairie and the Southwest in a small house on Bank Street in Greenwich Village.

Lopate, *Writing*, p. 194

Asked to recite her poetry at a party, Edna St. Vincent Millay would toss back her hair, bare her long white neck—she speculated in an early poem that she would someday be "strangled"—and launch into full declamation.

Douglas, p. 55

Gertrude Stein is long dead but under cover rides the torn down El.

Bennett, *Deconstructing*, p. 18

James Thurber, drunk and legally blind, kept setting himself on fire with his cigarettes in the Algonquin Hotel.

Douglas, p. 23

The Four Seasons restaurant. Joseph Baum will claim to have been inspired by reading haiku poetry in planning the new restaurant.

Trager, p. 626

Mark Rothko was engaged to paint a series of works for the restaurant in 1958. Accepting the commission, he secretly resolved to create "something that will ruin the appetite of every son-of-a-bitch who ever eats in that room."

"Four Seasons"

There are several totally uneducated men on the east side of New York who write literature of a high order. They present simple truth in misspelled and almost illegible manuscripts.

Hapgood, pp. 18–19

One night J. and I were walking along when we saw, carefully lined up in the glow of the spots, the complete works of Wilhelm Reich, in chronological order of publication. We each took two books, feeling a bit guilty about it, since they seemed intended for some purpose. We joked that they were meant to greet visiting flying saucers.

Berman, *NY Calling*, p. 27

Among the peddlers on Astor Place, the same set of the works of Khrushchev (Foreign Language Press, Moscow) circulated from hand to hand for at least a year. Nobody ever bought it, but every day it would appear in someone else's stock.

Sante, "Commerce," p. 111

Imagine, if you will, a rainy Sunday afternoon in New York. All over town, writers are lying in bed, their heads under their respective pillows. They are of varying heights and builds, races, religions, and creeds, but they are as one: whining. Some of them are whining to themselves. Some to companions. It matters not in the least. Simultaneously they all turn over and reach for the phone. In a matter of seconds every writer in New York is speaking to another writer in New York. They're not talking about writing.

Lebowitz, p. 174

Ibid., p. 175	Now on this particular Sunday afternoon a phenomenon has occurred. Every single writer in the city of New York is not writing.
Cheever, "Country," p. 146	My father was writing stories for *The New Yorker* magazine and hoping that one day he would be able to write a novel. He was an artist, but he liked to keep up appearances. In the morning he got dressed in a business suit from Brooks Brothers with a rep tie and felt hat with a grosgrain band and rode down in our building elevator with all the other men dressed the same way on their way to work. They got off at the first floor and left the building through the lobby on their way to Wall Street and midtown. My father crossed the lobby and walked down the back stairs to the basement, where he wrote all day in a windowless storage room in his boxer shorts, with his suit carefully hung against the wall.
Riesenberg and Alland, p. 101	The parts of New York are as the pages of a money's-worth best seller.
Fritscher, p. 284	The notorious mutual masturbation of that Manhattan clique called "The Violet Quill."
Burroughs, p. 1489	This poem was wroted by Kim Carsons after a shoot-out on Bleecker Street, October 23, 1920.
Hamill, "Lost"	You can spend an entire Saturday among the used bookshops along Fourth Avenue.
Sanders, *Beatnik*, p. 5	And the Fourth Avenue bookstores! How many hundreds of afternoons they spent in the twenty or so dusty stores with the worn wood floors; noses whiffing that excellent store-air, a mixture of dust and floating minutiae of antique leather bindings and frayed linen. What a heaven of data, to stand on a rickety ladder at the top of a fourteen-foot wall of out-of-print verse!
Philips, pp. 78–84	In 1969 there were just twenty-one bookstores in five blocks in a rather quaint sector south of Union Square, running from Ninth to Fourteenth Streets. In 1947 there had been thirty stores. There is a fear among dealers that the book center may become just a footnote in the City's history.
	Some dealers think that the grip of the electronic media on young people has hurt the book business and may eventually do it in. "Young people have been so conditioned by the lighted box that their attention span is oriented to it. They are not very friendly to the book. While the printed book has lasted 500 years, there's no guarantee it will last another 500. It will last the century. Someday you'll have a telephone with a screen and you'll be able to dial a book. They'll put you in instant contact with thousands and thousands of books."
Sanders, *Beatnik*, p. 5	On occasion they gathered their first editions of poetry and novels and sold them to rare-book dealers. They were always getting writers to sign their books. At poetry readings at the 92 Street Y, they usually managed to hang out backstage grabbing the 'graphs, man. A *signed* first edition, ahhh that was a pleasure.
Goldsmith, *Theory*	Ted Berrigan stole books by famous authors and forged their autographs. He then sold them back to the dealers he stole them from at greatly increased prices.

b Art — Literature

454

An intense intellectual from the Upper West Side, earnestly reading the *New York Review of Books* on the train, just to make sure I knew what everyone was talking about that week.

Hamilton, p. 6

The House of Mirth – Edith Wharton (1905), *The Melting Pot* – Israel Zangwill (1908), *Ashes of Roses* – Mary Jane Auch (1911), *The Custom of the Country* – Edith Wharton (1913), *The Rise of David Levinsky* – Abraham Cahan (1917), *The Age of Innocence* – Edith Wharton (1920), *The Beautiful and Damned* – F. Scott Fitzgerald (1922), *Old New York* – Edith Wharton (1924), *Bread Givers* – Anzia Yezierska (1925), *The Great Gatsby* – F. Scott Fitzgerald (1925), *Manhattan Transfer* – John Dos Passos (1925), *The Island Within* – Ludwig Lewisohn (1928), *Plum Bun* – Jessie Redmon Fauset (1929), *Jews Without Money* – Michael Gold (1930), *Doc Savage* pulp fiction series – Kenneth Robeson (1933–1949), *Miss Lonelyhearts* – Nathanael West (1933), *Call It Sleep* – Henry Roth (1934), *The Thin Man* – Dashiell Hammett (1934), *Turn, Magic Wheel* – Dawn Powell (1936), *Laura* – Vera Caspary (1943), *A Tree Grows in Brooklyn* – Betty Smith (1943), *The Fountainhead* – Ayn Rand (1943), *The Big Clock* – Kenneth Fearing (1946), *The Deadly Percheron* – John Franklin Bardin (1946), *The Street* – Ann Petry (1946), *Three Bedrooms in Manhattan* – Georges Simenon (1946), *I, the Jury* – Mickey Spillane (1947), *Invisible Man* – Ralph Ellison (1947), *The Last of Philip Banter* – John Franklin Barden (1947), *The Victim* – Saul Bellow (1947), *Consider Her Ways* – Frederick Philip Grove (1948), *East Side, West Side* – Marcia Davenport (1947), *A Walker in the City* – Alfred Kazin (1951), *The Caine Mutiny* – Herman Wouk (1951), *The Catcher in the Rye* – J. D. Salinger (1951), *Go* – John Clellon Holmes (1952), *The Caves of Steel* – Isaac Asimov (1953), *Marjorie Morningstar* – Herman Wouk (1955), *Cities in Flight* (series) – James Blish (1955–1962), *Bunny Lake Is Missing* – Merriam Modell (writing as Evelyn Piper) (1957), *Atlas Shrugged* – Ayn Rand (1957), *Breakfast at Tiffany's* – Truman Capote (1958), *Brown Girl, Brownstones* – Paule Marshall (1959), *Franny and Zooey* – J. D. Salinger (1961), *Another Country* – James Baldwin (1962), *Raise High the Roof Beam, Carpenters and Seymour: An Introduction* – J. D. Salinger (1963), *The Group* – Mary McCarthy (1963), *Joy in the Morning* – Betty Smith (1963), *The Bell Jar* – Sylvia Plath (1963), *New York* – Brendan Behan (1964), *Joe Gould's Secret* – Joseph Mitchell (1964), *A Singular Man* – J. P. Donleavy (1964), *Last Exit to Brooklyn* – Hubert Selby, Jr. (1964), *The Doorbell Rang* – Rex Stout (1965), *Make Room! Make Room!* – Harry Harrison (1966), *A Queer Kind of Death* – George Baxt (1966), *The Butterfly Kid* – Chester Anderson (1967), *The Chosen* – Chaim Potok (1967), *Rosemary's Baby* – Ira Levin (1967), *Swing Low, Sweet Harriet* – George Baxt (1967), *My Sister Eileen* – Ruth McKenney (1968), *The Godfather* – Mario Puzo (1969), *Topsy and Evil* – George Baxt (1969), *Mr. Sammler's Planet* – Saul Bellow (1970), *Time and Again* – Jack Finney (1970), *The Taking of Pelham One Two Three* – Morton Freedgood (1973), *Enemies* – Isaac Bashevis Singer (1972), *Umbrella Steps* – Julie Goldsmith Gilbert (1972), *A Bomb Built in Hell* – Andrew Vachss (1973), *A Fairytale of New York* – J. P. Donleavy (1973), *Great Jones Street* – Don DeLillo (1973), *Sheila Levine Is Dead and Living in New York* – Gail Parent (1973), *Looking for Mr. Goodbar* – Judith Rossner (1975), *Sophie's Choice* – William Styron (1976), *Players* – Don DeLillo (1977), *An Armful of Warm Girl* – W. M. Spackman (1978), *A Contract with God* – Will Eisner (1978), *Dancer from the Dance* – Andrew Holleran (1978), *Faggots* – Larry Kramer (1978), *Happy All the Time* – Laurie Colwin (1978), *The Stand* – Stephen King (1978), *The Dark Tower: The Gunslinger* – Stephen King (1982), *A Brother's Touch* – Owen Levy (1982), *Last Angry Man* – Gerald Green (1983), *Winter's Tale* – Mark Helprin (1983), *Bright Lights, Big City* – Jay McInerney (1984), *Duplicate Keys* – Jane Smiley (1984), *Neuromancer* – William Gibson (1984), *Blood Music* – Greg

"List of Books Set in NYC"

Bear (1985), *Flood* – Andrew Vachss (1985), *The Hyde Park Murder* – Elliott Roosevelt (1985), *The New York Trilogy* – Paul Auster (1985–86), *Banana Fish* (manga series) – Akimi Yoshida (1985–1994), *The Bachelor's Bride* – Stephen Koch (1986), *Dreams of an Average Man* – Dyan Sheldon (1986), *Money* – Martin Amis (1986), *Social Disease* – Paul Rudnick (1986), *War Cries Over Avenue C* – Jerome Charyn (1986), *The Bonfire of the Vanities* – Tom Wolfe (1987), *The Dark Tower II: The Drawing of the Three* – Stephen King (1987), *Ice and Fire* – Andrea Dworkin (1987), *Knight Life* – Peter David (1987), *Paradise Man* – Jerome Charyn (1987), *Stars and Bars* – William Boyd (1987), *Strega* – Andrew Vachss (1987), *The Year of Silence* – Madison Smartt Bell (1987), *Blue Belle* – Andrew Vachss (1988), *Little Odessa* – Joseph Koenig (1988), *People Like Us* – Dominick Dunne (1988), *The Crazy Kill* – Chester Himes (1989), *Emma Who Saved My Life* – Wilton Barnhardt (1989), *A Fairy Tale of New York* – J. P. Donleavy (1989), *Hard Candy* – Andrew Vachss (1989), *I Pass Like Night* – Jonathan Ames (1989), *Billy Bathgate* – E. L. Doctorow (1990), *Children of the Night* – Mercedes Lackey (1990), *A Home at the End of the World* – Michael Cunningham (1990), *The Mambo Kings Play Songs of Love* – Oscar Hijuelos (1990), *Moon Palace* – Paul Auster (1990), *Our House in the Last World* – Oscar Hijuelos (1990), *Skinny Legs and All* – Tom Robbins (1990), *Sniper's Moon* – Carsten Stroud (1990), *American Psycho* – Bret Easton Ellis (1991), *Aftershock* – Chuck Scarborough (1991), *Day of Atonement* – Faye Kellerman (1991), *Sacrifice* – Andrew Vachss (1991), *Sliver* – Ira Levin (1991), *The First Wives Club* – Olivia Goldsmith (1992), *The Blindfold* – Siri Hustvedt (1992), *Good Fairies of New York* – Martin Millar (1992), *Sweet Liar* – Jude Deveraux (1992), *The Kaisho* – Eric Lustbader (1993), *A Mother's Love* – Mary Morris (1993), *Nude Men* – Amanda Filipacchi (1993), *Banished Children of Eve* – Peter Quinn (1994), *Closing Time* – Joseph Heller (1994), *Down in the Zero* – Andrew Vachss (1994), *A Feather on the Breath of God* – Sigrid Nunez (1994), *Just Like That* – Lily Brett (1994), *The Alienist* – Caleb Carr (1995), *The Lady Who Liked Clean Restrooms* – J. P. Donleavy (1995), *Footsteps of the Hawk* – Andrew Vachss (1995), *Full Stop* – Joan Smith (1995), *One Coffee With* – Margaret Maron (1995), *World's Fair* – E. L. Doctorow (1996), *The Book of Night with Moon* – Diane Duane (1997), *A History of Violence* – John Wagner (1997), *Martin Dressler: The Tale of an American Dreamer* – Steven Millhauser (1997), *Off Season* – Naomi Holoch (1997), *Sewer, Gas and Electric* – Matt Ruff (1997), *Sex and the City* – Candace Bushnell (1997), *Lives of the Monster Dogs* – Kirsten Bakis (1997), *Snow in August* – Pete Hamill (1997), *The Waterworks* – E. L. Doctorow (1997), *Underworld* – Don DeLillo (1997), *Always Hiding* – Sophia G. Romero (1998), *Wrong Information Is Being Given Out at Princeton* – J. P. Donleavy (1998), *Bringing Out the Dead* – Joe Connelly (1998), *Eating Chinese Food Naked* – Mei Ng (1998), *The Extra Man* – Jonathan Ames (1998), *Herb's Pajamas* – Abigail Thomas (1998), *The Hours* – Michael Cunningham (1998), *Last Days of Summer* – Steve Kluger (1998), *New York Graphic* – Adam Lloyd Baker (1998), *Of Kings and Planets* – Ethan Canin (1998), *Safe House* – Andrew Vachss (1998), *Solo Variations* – Cassandra Garbus (1998), *The Willow Tree* – Hubert Selby, Jr. (1998), *The Broken Hearts Club* – Ethan Black (1999), *Choice of Evil* – Andrew Vachss (1999), *Downsiders* – Neal Shusterman (1999), *Glamorama* – Bret Easton Ellis (1999), *Liberty Falling* – Nevada Barr (1999), *Morningside Heights* – Cheryl Mendelson (1999), *Motherless Brooklyn* – Jonathan Lethem (1999), *The Silk Code* – Paul Levinson (1999), *Vapor* – Amanda Filipacchi (1999).

b Art — Literature

McInerney, *Bright Lights*, p. 68

You examine the wares in the window of the Gotham Book Mart, and take note of the sign: WISE MEN FISH HERE.

Gould called this book "An Oral History," sometimes adding "of Our Time." As he described it, the Oral History consisted of talk he had heard and had considered meaningful and had taken down, either verbatim or summarized—everything from a remark overheard in the street to the conversations of a roomful of people lasting for hours—and of essays commenting on this talk. Some talk has an obvious meaning and nothing more, he said, and some, often unbeknownst to the talker, has at least one other meaning and sometimes several other meanings lurking around inside its obvious meaning. He professed to believe that such talk might have great hidden historical significance … He told people he met in Village joints that the Oral History was already millions upon millions of words long and beyond any doubt the lengthiest unpublished literary work in existence but that it was nowhere near finished … "As soon after my demise as is convenient for all concerned," he specified in the will, "my manuscript books shall be collected from the various and sundry places in which they are stored and put on the scales and weighted, and two-thirds of the weight shall be given to the Harvard Library and the other third shall be given to the library of the Smithsonian Institution" … One evening in June, 1942, for example, he told an acquaintance that at the moment the Oral History was "approximately nine million two hundred and fifty-five thousand words long, or," he added, throwing his head back proudly, "about a dozen times as long as the Bible."

Mitchell, *Hotel*, pp. 624–5

Henry Miller declared it the most horrible place on earth.

Morris, *Manhattan '45*, p. 23

Crane confessed to having to stitch together for "The Tunnel" the hundreds of notes he'd written while swinging on the subway straps as he passed under the East River, the wheels screeching against the rails, the agate lights blinking in the midnight tunnel, the car deserted, as he rode back to his apartment after a night in Manhattan.

Mariani, p. 233

Hart Crane was financed by banker Otto Kahn.

Trager, p. 450

During his first trip to New York City in 1964, Samuel Beckett went to a doubleheader at Shea Stadium with his friend Dick Seaver, who explained the game of baseball to the Irish writer. Halfway through the second game, Seaver asked, "Would you like to go now?" To which Beckett replied, "Is the game over, then?" "Not yet," said Seaver. Beckett concluded, "We don't want to go then before it's finished." The Mets won both games, unlike their double loss two months earlier in what had been the longest doubleheader in Major League history, clocking in at nine hours and fifty-two minutes.

"Samuel Beckett"

Music

The afternoon following Pearl Harbor, the Metropolitan Opera announced that it would not perform *Madame Butterfly* until Japan was defeated.

Diehl, p. 67

The antique shops of Madison Avenue are selling even to this day those Jennie Lind rum-bottles out of which our rustic chivalry used to drink to her health.

Irwin, p. 9

Tin Pan Alley: "In Twenty-seventh or Twenty-eighth Street, or anywhere along Broadway from Madison to Greeley Squares, are the parlors of a score of publishers, gentlemen who coordinate this divided world for song publishing purposes. There is an office and a reception room; a

Dreiser, p. 245

music-chamber, where songs are tried, and a stock room. Perhaps, in the case of the larger publishers, the music-rooms are two or three, but the air of each is much the same. Rugs, divans, imitation palms make this publishing house more bower than office. Three or four pianos give to each chamber a parlor-like appearance. The walls are hung with the photos of celebrities, neatly framed, celebrities of the kind described. In the private music-rooms, rocking-chairs. A boy or two waits to bring professional copies at a word. A salaried pianist or two wait to run over pieces which the singer may desire to hear. Arrangers wait to make orchestrations or take down newly schemed out melodies which the popular composer himself cannot play. He has evolved the melody by a process of whistling and must have its fleeting beauty registered before it escapes him forever. Hence the salaried arranger.

Into these parlors then, come the mixed company of this distinctive world: authors who have or have not succeeded, variety artists who have some word from touring fellows or know the firm, masters of small bands throughout the city or the country, of which the name is legion, orchestra-leaders of Bowery theaters and uptown variety halls, and singers.

Reublin

The name is attributed to a newspaper writer named Monroe Rosenfeld who, while staying in New York, coined the term to symbolize the cacophony of the many pianos being pounded in publisher's demo rooms which he characterized as sounding as though hundreds of people were pounding on tin pans.

"Tin Pan Alley"

The persistent image of the "Gay Nineties" as one of the happiest and least troubled times in American history has been derived largely from these songs … Regardless of the happy times the music connotes, we cannot forget that Tin Pan Alley was not about love, peace, and happiness, it was about selling songs … There were no altruistic desires on the part of the publishers to solve the problems of society nor were they attempting to create a happy world. They were simply about trying to create and sell music that people bought.

Ibid.

Tin Pan Alley composers and lyricists: Milton Ager, Thomas S. Allen, Harold Arlen, Ernest Ball, Irving Berlin, Bernard Bierman, George Botsford, Shelton Brooks, Nacio Herb Brown, Irving Caesar, Sammy Cahn, Hoagy Carmichael, George M. Cohan, Con Conrad, J. Fred Coots, Buddy DeSylva, Walter Donaldson, Paul Dresser, Dave Dreyer, Al Dubin, Dorothy Fields, Ted Fio Rito, Max Freedman, Cliff Friend, George Gershwin, Ira Gershwin, E. Y. Yip Harburg, Charles K. Harris, James P. Johnson, Isham Jones, Scott Joplin, Gus Kahn, Bert Kalmar, Jerome Kern, Al Lewis, Sam M. Lewis, F. W. Meacham, Johnny Mercer, Theodora Morse, Ethelbert Nevin, Bernice Petkere, Maceo Pinkard, Lew Pollack, Cole Porter, Andy Razaf, Harry Ruby, Al Sherman, Lou Singer, Sunny Skylar, Ted Snyder, Kay Swift, Albert Von Tilzer, Harry Von Tilzer, Fats Waller, Harry Warren, Richard A. Whiting, Harry M. Woods, Jack Yellen, Vincent Youmans, Joe Young, Hy Zaret.

Ibid.

Tin Pan Alley hits: "After the Ball" (Charles K. Harris, 1892), "The Man Who Broke the Bank at Monte Carlo" (Charles Coborn, 1892), "The Little Lost Child" (Marks & Stern, 1894), "The Sidewalks of New York" (Lawlor & Blake, 1894), "The Band Played On" (Charles B. Ward & John F. Palmer, 1895), "Mister Johnson, Turn Me Loose" (Ben Harney, 1896), "There'll Be a Hot Time in the Old Town Tonight" (Joe Hayden & Theodore Mertz, 1896), "Warmest Baby in the Bunch" (George M. Cohan, 1896), "On the Banks of the Wabash, Far Away" (Paul Dresser, 1897), "At a Georgia Campmeeting" (Kerry Mills, 1897), "Hearts and Flowers" (Theodore Moses Tobani, 1899),

"Hello! Ma Baby (Hello Ma Ragtime Gal)" (Emerson, Howard, & Sterling, 1899), "A Bird in a Gilded Cage" (Harry Von Tilzer, 1900), "Mighty Lak' a Rose" (Ethelbert Nevin & Frank L. Stanton, 1901), "Bill Bailey, Won't You Please Come Home" (Huey Cannon, 1902), "In the Good Old Summer Time" (Ren Shields & George Evans, 1902), "Give My Regards to Broadway" (George M. Cohan, 1904), "In the Shade of the Old Apple Tree" (Harry Williams & Egbert van Alstyne, 1905), "Shine Little Glow Worm" (Paul Lincke & Lilla Cayley Robinson, 1907), "Shine on Harvest Moon" (Nora Bayes & Jack Norworth, 1908), "Take Me Out to the Ball Game" (Albert Von Tilzer, 1908), "By the Light of the Silvery Moon" (Gus Edwards & Edward Madden, 1909), "Down by the Old Mill Stream" (Tell Taylor, 1910), "Come Josephine in My Flying Machine" (Fred Fisher & Alfred Bryan, 1910), "Let Me Call You Sweetheart" (Beth Slater Whitson & Leo Friedman, 1910), "Alexander's Ragtime Band" (Irving Berlin, 1911), "Some of These Days" (Shelton Brooks, 1911), "Peg o' My Heart" (Fred Fisher & Alfred Bryan, 1913), "The Darktown Strutters Ball" (Shelton Brooks, 1917), "K-K-K-Katy" (Geoffrey O'Hara, 1918), "God Bless America" (Irving Berlin, 1918; revised 1938), "Oh by Jingo!" (Albert Von Tilzer, 1919), "Swanee" (George Gershwin, 1919), "Whispering" (1920), "The Japanese Sandman" (1920), "Carolina in the Morning" (Gus Kahn & Walter Donaldson, 1922), "Lovesick Blues" (Cliff Friend & Irving Mills, 1922), "Way Down Yonder in New Orleans" (Creamer & Turner Layton, 1922), "Yes, We Have No Bananas" (Frank Silver & Irving Cohn, 1923), "I Cried for You" (Arthur Freed & Nacio Herb Brown, 1923), "Everybody Loves My Baby" (Spencer Williams, 1924), "All Alone" (Irving Berlin, 1924), "Sweet Georgia Brown" (Maceo Pinkard, 1925), "Baby Face" (Benny Davis & Harry Akst, 1926), "Ain't She Sweet" (Jack Yellen & Milton Ager, 1927), "My Blue Heaven" (Walter Donaldson & George Whiting, 1927), "Happy Days Are Here Again" (Jack Yellen & Milton Ager, 1930).

The popular conception of Tin Pan Alley, a conception aided by Hollywood and its talent for hyperbole, is still that of an uninhibited madhouse, with composers and their lyricists in the role of zanies who nail the reluctant publisher to a chair while he listens to the year's (unpublished) smash hit. A sober tour of the district, however, is enough to convince anyone that the glamor-and-screwball atmosphere has long been concealed behind polite but firm secretaries; executives who, aside from their Broadway tastes in haberdashery, might as well be in the cream separator business; mahogany desks and, more often than not, photo-murals in place of the old-time collection of autographed pictures of stars who plugged the firm's songs. Here and there, of course, an office typical of the Alley in its halcyon youth can still be found. Here the telephone girl reads *Variety* as she hums one of the firm's numbers; zanies scramble hither and thither; and from innumerable cubbyholes fitted out with antiquated uprights come (with or without words) the unpublished and, alas, often never-to-be-published smash hits of the season.

Statistically, the shorter-lived hits of today are written by fewer songwriters as the new century's downbeat sounds its accent. A closer concentration of the music business, the decline of the sheet music and phonograph record industry, and the rise of radio and moving pictures— these factors augured ill for the many. The lucky few among the nation's songwriters were rewarded with air-conditioned bungalows in the glamour City of Celluloid. The less lucky stay-at-homes obligingly ground out "You Ought to Be in Pictures" and continued to take schnapps with their schmaltz (cheaply sentimental sweet music) in the depths of the Fifty-second Street underground.

Federal Writers, *Panorama*, p. 244

Douglas, p. 430 "I never read Shakespeare in the original."—Irving Berlin.

Hapgood, pp. 86–9 Vaudeville puts together what does not fit … The charm of vaudeville lies in its health and naturalness, the result of being determined by that healthy autocrat, the common man. Only the "real thing" is represented, and consequently the average man and the philosopher find in the vaudeville stage their common account … Everything is calculated to cradle the mind, to please by an appeal to what is always present in human nature. All the senses are taken care of. Tobacco throws a thin blue veil about the hall, which lends an easy grace to the movements on the stage … The attractive side of vaudeville is well brought out by a comparison with the artificial farce of the day—the senseless mechanical performance which has a strong hold on some legitimate theaters on Broadway … In this farcical swirl of artificial complications all the easy genuine humorous quality of less compactly constructed vaudeville is lost. Pleasant unction, droll characterization, sentimental appeal, is shut out of the swiftly moving farce. Farce is artistic for its own sake. Vaudeville, nothing as form, presents the real stuff of life.

Huxley, p. 330 Maciunas described Fluxus as striving "for the monostructural and nontheatrical qualities of a simple natural event, a game or a gag. It is the fusion of Spike Jones, Vaudeville, gag, children's games and Duchamp."

McCourt, p. 111 The Old Met: the Yellow Brick Brewery on Broadway.

Diehl, p. 28 Modernist refugee composer Paul Dessau worked on a New Jersey chicken farm upon arriving in the US.

Jackson and Dunbar, p. 567 the jerky automata of jazz

Douglas, p. 451 What better acoustic chamber could jazz musicians have had than a city built *of* solid stone and *on* solid stone? (Chicago rests on mud, not stone.)

Ibid., p. 434 If the blues were the roots of American's modern sensibility, jazz was its oxygen; if blues were buried treasure under the ocean's floor, jazz was the deep-sea diver bursting back up into the air. The generation that invented jazz was the first "to get our feet off of the ground!", as the expatriate poet Harry Crosby put it, the first to defy gravity and colonize space. It coined the word "airmindedness" and advertised its day as "the Aerial Age." Radio shows were "on the air," planes toured the heavens, and buildings competed with clouds. Everywhere people were netting the sky and finding in the air what seemed an androgynous free-for-all of spiritual energy.

Holiday, p. xiv I spent the rest of the war on 52nd Street and a few other streets. I had the white gowns and the white shoes. And every night they'd bring me the white gardenias and the white junk.

Ibid. Holiday's overview of the working conditions for musicians in New York: "You can be up to your boobies in white satin, with gardenias in your hair and no sugar cane for miles, but you can still be working on a plantation."

Ibid. But another time, on 52nd Street, I finished a set with "Strange Fruit" and headed, as usual, for the bathroom. I always do. When I sing it, it affects me so much I get sick. It takes all the strength out of me.

Ibid., p. 110 Take 52nd Street in the late thirties and early forties. It was supposed to be a big deal. "Swing Street," they called it. Joint after joint was jumping. It was

this "new" kind of music. They could get away with calling it new because millions of squares hadn't taken a trip to 131st Street. If they had they could have dug swing for twenty years.

By the time the ofays got around to copping "swing" a new-style music was already breaking out all over uptown. Ten years later that became the newest thing when the white boys downtown figured out how to cop it.

Anyway, white musicians were "swinging" from one end of 52nd Street to the other, but there wasn't a black face in sight on the street except Teddy Wilson and me.

[…]

But 52nd Street couldn't hold the line against Negroes forever. Something had to give. And eventually it was the plantation owners. They found they could make money off Negro artists and they couldn't afford their old prejudices. So the barriers went down, and it gave jobs to a lot of great musicians.

As I write I still have no New York police card, and this keeps me from singing in clubs in New York.

Ibid., p. 194

… and Leroi comes in
and tells me Miles Davis was clubbed 12
times last night outside BIRDLAND by a cop

O'Hara, p. 335

On the evening of September 7, 1964, Frank O'Hara held a small party to watch the arrival of the Beatles at Kennedy Airport where they were met by a screaming crowd of ten thousand.

Gooch, p. 420

The thing that gave me hope for the future of poetry was this Rolling Stones concert at Madison Square Garden that I saw in 1974. Jagger was real tired and fucked-up. It was a Tuesday, he had done two concerts and was really on the brink of collapse—but the kind of collapse that transcends into magic.

McNeil and McCain, p. 159

Jagger was so tired that he needed the energy of the audience. He was not a rock & roller that Tuesday night. He was closer to a poet than he ever has been, because he was so tired, he could hardly sing. I love the music of the Rolling Stones, but what was foremost was not the music but the performance, the naked performance. It was his naked performance, his rhythm, his movement, his talk—he was so tired, he was saying things like, "Very warm here / warm warm warm / it's very hot here / hot, hot / New York, New York, New York / bang, bang, bang."

Street

It started with JOHN GIORNO and BURROUGHS at the Nova Convention in December 1978. It's reading CAGE and starting my first recording with four cassettes at SVA in February. It's the poetries of video-tape and BARBARA BUCKNER. It's BURROUGHS and GINSBERG and GIORNO upstairs at the MUDD CLUB. It's living with DREW B. STRAUB, who was reading BURROUGHS thoroughly. It's VIDEO CLONES with MOLISSA FENLEY. It's ART SIN BOY and CLUB 57 POETRY READINGS EVERY WEDNESDAY NIGHT THIS SUMMER. It's reading SAINT GENET by SARTRE on the subway going to work in QUEENS. It's books from SVA library all summer and tape recorders from SVA for most of the summer. It's BOOKS THAT YOU JUST FIND IN A LIBRARY … BOOKS THAT FIND YOU. It's PATTI SMITH ON THE BIG EGO ALBUM with GIORNO, MEREDITH MONK, GLASS, etc. It's reading RIMBAUD, KEATS, JEAN COCTEAU, JOHN CAGE,

Haring, pp. 62–6

HEGEL, JEAN GENET, TALKING POETICS FROM NAROPA INSTITUTE. It's meeting another like you and sharing everything including your body but mostly your ideas. It's POETIC UNDERSTANDING AND JUSTIFIABLE HATE. It's July 4 on the top of the Empire State Building after reading an ART SIN BOY mimeograph at Club 57 watching fireworks and thinking about the smile exchanged on the street and nothing but a second glance and lots of dreaming. It's KLAUS NOMI at Xenon. READING GINSBERG'S JOURNALS, READING SEMIOTEXT, READING GERTRUDE STEIN, READING "HOWL" FOR THE FIRST TIME. It's NOW-NOW-NOW and paintings I did in the fall of 1978. It's Chinese pattern paintings in KERMIT'S HOUSE. BARBARA SCHWARTZ ON 22ND STREET AND DREW AT JOHN WEBER GALLERY BUILDING A ROBERT SMITHSON. DREW'S RAIN DANCE IN LITTLE ITALY. It's listening to JOHN GIORNO read GRASPING AT EMPTINESS for the 27th time. It's letting records skip for ten minutes and thinking it's beautiful. IT'S HAVING DINNER ON AVENUE C WITH DINA, DOZO, AND FUGACHAN (A MAN). It's thinking about SEX as ART and ART as SEX. It's continued situations and controlled environments, B-52s, BATHS, AND SEX WITH FRIENDS. IT'S PAPA AND JOHN MCLAUGHLIN AND OUTER SPACE AND JET SET AND DELTAS AND THE ASTRO TWIST AND KENNY SCHARF AND LARRY LEVAN. It's being heckled reading what may be my favorite mimeograph piece with two tape recorders and being called a FAGGOT. IT'S LISTENING TO OTHER POETS AT CLUB 57. TALKING TO POETS. BEING A POET AT CLUB 57. It's painting on ST. MARKS outside of STROMBOLI PIZZA. It's having one night at Club 57 when everyone in the open reading was in top form and everyone knows it and everyone is smiling. It's HAL SIROWITZ READING. IT'S BEING QUOTED IN HIS POEM AS SAYING, "'I CONSIDER MYSELF MORE OF AN ARTIST THAN A POET,' SAID KEITH." IT'S MAKING XEROXES and mimeographs. IT'S MEETING CHARLES STANLEY AND BEING APPREHENSIVE. IT'S TAPING UP XEROXES WALKING HOME DRUNK. It's looking in the window at BUDDHA. It's seeing a TRUCK THAT SAYS "BETTER METHODS." IT'S BUYING JEROME ROTHENBERG'S BOOK TECHNICIANS OF THE SACRED that BARBARA BUCKNER had lent to me in spring and now TIM MILLER has it out of the library and now I'm reading references to it in a new book I bought. IT'S ALL THOSE THINGS THAT FIT TOGETHER SO PERFECTLY THAT IT APPEARS PREDETERMINED. IT'S DREAMS OF FALLING INTO WARM WATER HOLE WITH EXOTIC FISH CREATURE AND ENOUGH LIGHT TO SEE EVERYTHING. It's finding HANDBILLS ABOUT SIN that are poems in themselves. It's painting on walls in the suburbs. It's the bridge in LONG ISLAND WITH 1958 AND 1980 on parallel poles. IT'S FINDING OUT THE SPACE AGE BEGAN IN 1958. It's STEVE PAXTON dancing in the sculpture garden at MOMA. It's CARL ANDRE POEMS IN THE MOMA SUMMER SCULPTURE SHOW. It's JONES BEACH ON SUNDAYS. It's MATISSE. IT'S MATISSE. It's listening to old cassettes I made in winter and understanding them for the first time. A NOTION OF PROPHECY. IT'S DOUGLAS DAVIS'S ARTICLE IN THE VILLAGE VOICE about postmodern art. "POST-ART." It's pornographic pictures and black feathers. It's GERMANY. It's JAPAN. It's hearing DOW JONES AND THE INDUSTRIALS. It's loose joints and conversations. IT'S THE SAME THING, THE SAME THING. It's understanding painting. IT'S SOMEONE YELLING "LICK FAT BOYS." IT'S CONVERSATIONS ABOUT ALL ART BEING PRETENTIOUS. It's not going to look at ART in the galleries all summer. It's seeing drawings by KEVIN CRAWFORD AND DREW B. STRAUB and thinking about the relationship. IT'S THINKING ABOUT THE RELATIONSHIP BETWEEN SEEMINGLY UNRELATED OBJECTS AND EVENTS. It's an art "context."

It's thinking about poetry on as many different levels as I can. It's thinking about myself. It's companions and ratios and mathematical principles. IT'S THE POETRY OF NUMBERS. Language, culture, time, spirit, universe. IT'S THE PAST PRESENT FUTURE ALL TIME NO TIME SAME THING. It's systems within systems that evoke systems. ORDER-FORM-STRUCTURE-MATTER. It's seeing TRISHA BROWN DANCE. IT'S ITALIAN FILMS FROM 1967. IT'S LAURIE ANDERSON AT MUDD CLUB. It's NEW MUSIC, NEW YORK at the KITCHEN for a week. IT'S CHARLIE MORROW'S PIECE FOR 60 CLARINETS AT BATTERY PARK IN CELEBRATION OF THE FIRST DAY OF SUMMER AT SUNSET. It's the BRONX ZOO. Reading RIMBAUD'S LETTERS. Reading RIMBAUD'S ILLUMINATIONS ON THE SUBWAY AND IN A CAFE EATIN' CREMOLATA AND DRINKING PER RIER. IT'S FELLINI FILMS WITH TSENG KWONG CHI. It's finding things on the street. IT'S CONVERSATION WITH LYNN UMLAUF ABOUT THE NOW NOW NOW TAPES A.J. WEBER GALLERY SHOW. IT'S XEROXES PUT UP IN the West Village for Gay Pride week end and hearing people that had seen them months later. IT'S THE NINTH CIRCLE AFTER THE GAY PRIDE MARCH TALKING ABOUT APATHY AND MILITANCY. It's wearing and distributing red-and-white stripes for one evening. IT'S READING AT CLUB 57 WHILE THIS WOMAN who I later found out was GLORIE TROPP is saying things like AHHH and DO IT and YEAH while I'm reading and it feels good. IT'S XEROXES at GRAND CENTRAL STATION IN A HURRY. It's the poetics of chance. IT'S GOING TO THE POETRY SECTION INSTEAD OF THE ART SECTION WHEN YOU GO INTO A BOOKSTORE. It's a panel about performance art with MEREDITH MONK, LAURIE ANDERSON, JULIE HEYWARD, CONNIE BECKLEY, AND ROSELEE GOLDBERG. IT'S GRAFFITI IN THE SUBWAY. It's riding the BUS FROM KUTZTOWN TO N.Y.C. WITH CONNIE BECKLEY. It's BRIAN WARREN'S NEW PIECES. It's reading BRIAN'S journal and feeling close to it. IT'S A SHORT POEM CALLED "ART BOY." It's feeling real good about being an artist. It's depression that can kill. It's telling other people that depression can be productive and talking to yourself. IT'S KOZO'S BIRTHDAY PARTY AND SPANISH AND JAPANESE AND HEBREW. It's "Running on Empty." It's delivering tropical plants in Manhattan. IT'S MANHATTAN IN THE SUMMER. It's reading *NAKED LUNCH*. IT'S DISEASE XEROXES. It's JOSEPH KOSUTH AT CASTELLI ON CONCEPT AND CONTEXT. IT'S JOAN JONAS'S "JUNIPER TREE." It's CONNIE BECKLEY'S INSTALLATION in the VIDEO ROOM AT MOMA. IT'S KERMIT'S NEW DRAWINGS. It's playing CROQUET in Kutztown. It's talking about epileptic fits in an art context. It's suicide. It's ART AS SIN AS IF NO ART AS ART. It's MOHOLY-NAGY. It's JEAN COCTEAU WRITING ON "THE ORIGINAL SIN OF ART." IT'S ANONYMOUS SEX. IT'S RE-READING DREW STRAUB'S "UNI-VERSE" WHILE LISTENING TO THE "UNI-VERSE" cut-up tapes we did in February or March IN AUGUST. IT'S READING BURROUGHS'S TALK ABOUT WORK WITH CUT-UPS ON TAPE IN AUGUST MONTHS AFTER WE HAD READ THE THIRD MIND AND DID THE SAME THING. It's the most logical step. LOGICAL DOESN'T MEAN RATIONAL. It's science-fiction films. It's reading SARTRE'S SAINT GENET ALL SUMMER with much else in between. It's 40 postcards sent to KERMIT OSWALD 172 W. MAIN ST. KUTZTOWN PA. 19530. It's not painting all summer except maybe once or twice. IT'S UNDERSTANDING WHY I SHOULDN'T TRY TO UNDERSTAND. IT'S "NEGATIVE CAPABILITY"—AS SAID KEATS. DIANE DI PRIMA ON "LIGHT AND KEATS." It's wanting to know more. It's an accumulation of information. IT'S AN IDEA FOR TOTAL THEATRE. It's a

new understanding. IT'S A BEGINNING A SEED A GARDEN IT'S THE BIG **463**
CHUNK CALLED POETRY.

Frisa and Tonchi, p. 383

New York art styles of the eighties: Julian Schnabel, whose surfaces were covered with broken plates and fragmented images, David Salle, whose works emphasized collages of images related to film editing, Eric Fischl with his film-like realism, Jean-Michel Basquiat and his tribal expressionism, Robert Longo with his *Men in the Cities*, the so-called "graffiti artists," such as Keith Haring with his electric radiating line, or Rammelzee of "iconoclastic futurism."

Sharpe, p. 200

Who shall paint New York? Who?

Freeman, p. 275

The first graffiti writer: In 1971, a young Greek-American began writing his nickname, Taki, followed by 183, for the street he lived on in upper Manhattan, on subway cars and station walls all over the city.

Haring, p. 87

LOOKING AT
JEAN (SAMO)'S
WINDOW AT
PATRICIA FIELD'S.

PAINTED BOXES
PAINTED CLOTHES

LOOKING AT PAINTINGS
HANGING ON A RACK

I like looking at paintings in a clothing store.
SAMO in Patricia Field's.

Conrad, p. 308

In a 1974 essay Mailer cheers the existential pluck of the graffiti daubers in the subway. Defacement is their faith, and Mailer finds in their slapdash virtuosity the same idolatry of gesture that excited the critics of Abstract Expressionism. The angry adolescents with their spray cans are mute, inglorious Pollocks, whose dribbles, flicks, and whorls of paint scribble psychic signatures. They willfully affront the blank theater of the canvas or the impersonal metal of the city's surface. They're prepared to risk their lives to make art. They climb along a cliff above the Harlem River to get to the A train yard at 207th Street, paint through the winter with frostbitten fingers, and triumphantly decorate inaccessible areas of wall on the wrong side of the electrified rail.

Gopnik, p. 192

When the wild-style cars came roaring into a station, they were as exciting and shimmering as Frank Stella birds.

Fillia, p. 48

A city undefiled by scabby walls!

Mueller, p. 247

New York is becoming the New El Dorado, but instead of streets paved in gold, the streets are paved in art. On black paper on subway platforms people look for new Keith Harings to tear off and take home.

Ibid., p. 257

80 percent of all East Village art looked the same; 70 percent of it was inspired by money; 60 percent of it was rendered by impostors; and 50 percent of it was expendable.

b Art — Street

Yes, our host, Jean-Michel Basquiat, the bright graffiti artist turned suddenly *Ibid.*, pp. 286–7 wildly successful genius painter, was in a ho-hum kinda mood.

Watching him, I filled in the blanks myself. Maybe he was, for the first time, thinking what a sham this success nonsense was. Maybe he was asking himself if this was all there was. Where was the joy that's supposed to come with fame and money? Wasn't life supposed to be fun and glamorous and fulfilling after one was successful and rich and had a beautiful home, famous friends, lovers, esteem, respect? When was the real deal going to start? When came the Fun at the Top stuff? When was the panorama up there going to look better than any other vista? When was it going to mean something?

It was later in the evening, around 3 A.M., after people had eaten and drunk and were whipped up and sweating in samba frenzies, when I looked up from my dancing partner's face and saw Jean quietly slipping out the door. No one noticed that the host himself was leaving. No one noticed because the party was that good, it was ripping, one of the year's best. No one noticed and half the crowd, the hollow party people, the ones that appear uninvited at every party not even knowing who the host might be, didn't care an iota.

The host had had enough of his own party. Let them eat cake, the guests, let them laugh and dance and slop drinks all over the floor, whatever. The host was going out into the night. A guest of wind bearing a few gold and red leaves and a stray piece of newspaper blew in after him and that was all.

Young, gifted, and black, it was clearly destined for the history books. Already his paintings were selling furiously, even still wet and oily. Fresh from his studio he was making hotcakes. His name was on all the buyers, gallerists, and arts students' lips. Already he was considered an old master, soaring to the ranks of a Constable. He was dancing in the dizzying heights of fast becoming a great 20th-century artist. It was a school of basement imitators, but no one could top the master, no one could paint this prolifically or beautifully with such incredibly shocking ease. He even outdistanced himself by being so prolific. He turned out a few canvases a day sometimes.

He was becoming internationally famous, he was having shows all over the world. A photograph of him sitting in a chair with his sweet eyes and luscious café au lait coloring graced the cover of the *New York Times Magazine*, and he was doing collaborative work, sharing canvases with Andy Warhol. Warhol had become a close friend. They phoned each other every day.

When asked how Warhol has influenced him, Basquiat says, "I wear clean McGuigan pants all the time now."

Five years ago, he didn't have a place to live. He slept on the couch of one *Ibid.* friend after another. He lacked money to buy art supplies. Now, at 24, he is making paintings that sell for $10,000 to $25,000. They are reproduced in art magazines and also as part of fashion layouts, or in photographs of chic private homes in *House & Garden*. They are in the collections of the publisher S. I. Newhouse, Richard Gere, Paul Simon and the Whitney Museum of American Art.

Eugene Schwartz, for example, who, along with his wife, Barbara, amassed an *Ibid.* important collection including Frank Stella, Morris Louis and David Smith, stopped collecting altogether in 1969. One day in 1980, he saw a painting by the artist Julian Schnabel in a dealer's gallery. "It brought us from the '60s to the '80s in about 14 seconds," he said.

One dealer, visiting his loft and noting his fondness for health food, went away *Ibid.* and came back with a big jar of fruits and nuts. "But what she really wanted

were my paintings," he says. "She tried to tell me that her chauffeur, who was black, worked with her in her gallery, not that he was her driver." As she walked out of his door in defeat, Basquiat leaned out his window and dumped the contents of the jar on her head.

Ibid.

"The black person is the protagonist in most of my paintings," he says. "I realized that I didn't see many paintings with black people in them."

Ibid.

Once when he was trying to sell his photocopied postcards on a SoHo streetcorner, he followed Andy Warhol and Henry Geldzahler into a restaurant. Warhol bought one of the cards for $1. Later, when Basquiat had graduated to painting sweatshirts, he went to Warhol's Factory one day. "I just wanted to meet him, he was an art hero of mine," he recalls. Warhol looked at his sweatshirts and gave him some money to buy more.

Ibid.

"He'll run in here in an $800 suit and paint all night," says his friend Shenge. "In the morning, he'll be standing in front of a picture with his suit just covered in paint."

Warhol, *Diaries*, p. 519

Paige stayed overnight with Jean-Michel in his dirty smelly loft downtown. How I know it smells is because Chris was there and said (laughs) it was like a nigger's loft, that there were crumpled-up hundred-dollar bills in the corner and bad b.o. all over and you step on paintings.

Abu-Lughod, p. 144

Miguel Algarín: "The poet sees his function as troubadour. He tells the tale of the streets … The voice of the street poet must amplify itself … A poem described the neighborhood of the writer for the reader … The Nuyorican poets have worked to establish the commonplace because they have wanted to locate their position on earth, the ground, the neighborhood, the environment."

Solis, p. 88

I'M FUCKIN ALIVE is the name of Revs's book, which consists of a series of autobiographical pages written on the walls of subway tunnels, and it was down here that I first encountered them. On large, light-colored panels, he would write dated entries on subjects ranging from childhood episodes to personal commentaries. Initially, he planned to write a page in every subway tunnel in the city; 235 were finished before he was arrested in 2000.

Fritscher, p. 287

In the 1970s a New York artist persuaded two street gangs to hold a rumble inside the Museum of Modern Art. Without warning, the gangs turned on the audience and beat and robbed them.

Tucker, p. 93

A group of women artists staged a feminist protest at the Whitney, leaving used tampons and smashed eggs in the stairwells.

McNeil and McCain, p. 16

We'd just come out, shoot up, lift weights, put flashlights in their eyes, whip giant bullwhips across their faces, sort of simulate fucking each other onstage, have Andy's films blaring in the background, and the Velvets would have their backs to the audience.

Reading the city as one would a text—from a distance.

Tester, p. 31

The city is a sentence, harsh, staccato, in an alien tongue.

Frank, p. 133

The city is a language, its people entries in a vocabulary.

Conrad, p. 123

The city rises in high hard words. Each building is a word.

Ibid.

The difficulty of reading a city that has made itself abstractly illegible. New York's readability has always been in doubt. It is too vast, too diverse for easy comprehension.

Ibid., p. 122

"New York, New York" designates the city of New York in the state of New York but has other meanings for those interested in the city as text. "New York, New York" suggests the repetitiveness of New York, its doubleness and its excessive, hyperbolic character. It is such an extraordinary city—from the top of the World Trade Center Michel de Certeau called it "the most immoderate of human texts"—that saying its name just once, simply would not do. "New York" is almost the only proper adjective for New York.

Tallack

The most salient characteristic of the city in modern literature is precisely its illegibility.

Brooks, *Subway*, p. 2

The act of walking is to the city what the speech act is to language.

Ibid.

Walking is a speech act.

Jacks, p. 44

They walk—an elementary form of this experience of the city; they are walkers, *Wandersmänner*, whose bodies follow the thicks and thins of an urban "text" they write without being able to read it. These practitioners make use of spaces that cannot be seen; their knowledge of them is as blind as that of lovers in each other's arms. The paths that correspond in this intertwining, unrecognized poems in which each body is an element signed by many others, elude legibility. It is as though the practices organizing a bustling city were characterized by their blindness. The networks of these moving, intersecting writings compose a manifold story that has neither author nor spectator, shaped out of fragments of trajectories and alterations of spaces: in relation to representations, it remains daily and indefinitely other.

de Certeau, p. 93

The long poems of walking manipulates spatial organization, no matter how panoptic they may be: it is neither foreign to them (it can take place only within them) nor in conformity with them (it does not receive its identity from them). It creates shadows and ambiguities within them.

Blomley, p. 26

Interpreting the city as a politically charged work of art or a species of ideologically laden poetry written in glass, steel, and concrete on texts twenty blocks wide and fifty stories high.

Bennett, *Deconstructing*, p. 18

Urban stories, it is clear, can be told only by those immune to the stress and the seductions of the city, who can turn those seductions to good account, that is, into a text that will exercise its own seductions.

Tester, p. 28

c **Textuality**

Ibid., p. 81

A kind of reading of the street, in which faces, shop fronts, shop windows, café terraces, street cars, automobiles and trees become a wealth of equally valid letters of the alphabet and together result in words, sentences and pages of an ever-new book.

Szeman and Kaposy, p. 264

To what erotics of knowledge does the ecstasy of reading such a cosmos belong? Having taken a voluptuous pleasure in it, I wonder what is the source of this pleasure of "seeing the whole," of looming down on, totalizing the most immoderate of human texts.

de Certeau, p. 92

The 1,370 foot high tower that serves as a prow for Manhattan continues to construct the fiction that creates readers, makes the complexity of the city readable, and immobilizes its opaque mobility in a transparent text.

Sharpe, p. 211

In 1928 a visitor said of Times Square: "Here the eye does not read any writing, it cannot pick out any shapes, it is simply dazzled by a profusion of scintillating lights, by a plethora of elements of light that cancel out each other's effect." Visual incapacitation.

Ibid.

Trivial as commercial lighting instantly became, the messages were so crude and powerful that legibility was unavoidable, even if, as Loti noted, their legibility was tied to their evanescence: "Everywhere multicolored lights change and sparkle, forming letters, and then dissolving them again. They fall in cascades from top to bottom of the houses, or in the distance seem to stretch in banners across the street."

Morand, p. 192

In Forty-second Street there are no more windows in the buildings—nothing but letters. It is a kindled alphabet, a conspiracy of commerce against night; in the sky, an advertising airplane.

Sharpe, p. 211

G. K. Chesterton visited New York in 1922, observing, "What a glorious garden of wonders this would be, to any one who was lucky enough to be unable to read."

Ibid.

"Let us suppose that there does walk down this flaming avenue a peasant, who is as innocent as Adam before the Fall. He would see sights almost as fine as the flaming sword or the purple and peacock plumage of the seraphim; so long as he did not go near the Tree of Knowledge." For Chesterton, reading was a fall from Edenic grace into a sorry understanding. The signs of the great republic do not, alas, say "Liberty, Equality, Fraternity" but rather "Tang Tonic To-day; Tang Tonic Tomorrow; Tang Tonic All the Time."

Ibid., pp. 210–11

Intensifying the color, lights, and excitement of Broadway by translating the commercial message into form and color, a wordless interpretation of New York.

Ibid., p. 211

But even if the signs cancel each other out, this apparent Babel is not meaningless.

O'Connell, p. xiv

As we read the text of the city—so extravagant in its tropes, so intense and varied in its rhythms, so bold in its presence, so encompassing in its reach, so firm in its grasp—it also reads us, or rather shows us how to read ourselves.

Finney, pp. 228–9

And everywhere I looked, there were signs, the names of firms occupying the buildings on which the signs hung. Most were black letters on white, or

gold letters on black, and they hung out over the sidewalks or were wired to building ledges just below rows of windows, slanting slightly downward so they could be read from the street.

The city was and remains object, but not in the way of particular, pliable and instrumental object: such as a pencil or a sheet of paper.

Lefebvre, *Cities*, p. 102

When we walk the city we are quoting the walkers who have come before us, and performing communal turns on each quotation.

Jacks, p. 44

No women were involved in designing NYC's skyscrapers of the 1920s; if the decade was engaged in "reading the phallus," Manhattan might supply the text. Storming the sky, the skyscrapers substantiated Freud's worst fears about a fatherless world, a paradoxical homage to a feminine principle that "blurred the issue of paternity."

Douglas, p. 442

The structure of the loft space is understood piece by piece as one glimpses fragments of the integrating text. The entire space has the effect of being a rare, isolated glimpse of some larger, usually invisible context of vectors, currents and coded messages.

Lyotard, p. 281

On the city street, hundreds of motor cars, electric trams and bicycles flash before my eyes every moment, yet I retain all of these in my mind at once; why, then, is the view commonly held that such disorder and speed in poetry makes it meaningless for the reader?

Shershenevich, p. 31

Reading in the City

A city of subway readers.

Mahler, p. 43

Her eyes never leave the pages of the book no matter how the train pitches and rolls as it thunders on.

Brooks, *In the City*, p. 10

A person who picks up the crumpled sections of newspaper in the subway and reads haphazardly until the next stop.

Ibid., p. 2

New Yorkers carry their solitude around with them and employ it as their protection, which is why it's improper—tantamount almost to trespassing—to read the newspaper over your neighbor's shoulder in the subway.

Conrad, p. 104

Driving down a Los Angeles boulevard, a billboard was legible from a half-mile away. It said one or two words. In Los Angeles, people are used to reading single words, very large at far distances, and passing by them very quickly. It's totally the opposite in New York, where we get our information by reading a newspaper over somebody's shoulder in the subway.

Goldsmith, *Theory*

I was on a subway somewhere in Brooklyn when I saw that headline. The paper that bannered it belonged to another passenger.

Capote, p. 59

Does the city read anything besides newspapers?

Brooks, *In the City*, p. 8

Tom Wolfe: "To me the idea of writing a novel about this astonishing metropolis, a big novel, cramming as much of New York City between covers as you could, was the most tempting, the most challenging, and the most obvious idea an American writer could possibly have."

Bloom, p. 151

Conrad, pp. 249–50

There are so many stenographers and typists in the city that if they joined in copying *Anthony Adverse* they would finish the job in ten seconds.

Rich, *How*, p. 4

Take a scenic boat ride around the island, but read *The Notebooks of Henry James* during the entire trip, never once looking up.

Lofland, p. 172

In the winter of 1962 to 1963, they attempted to access libraries and museums. He liked to station himself in the neuropsychology section of the New York Public Library's Main Reading Room and observe what books people were browsing, and wandering about, noting which books were being read. Upon finding a person involved in the book imagined to be "cosmic" in concern (books on psychology, religion or world affairs), he would stay close by the person, waiting for an occurrence that could bring about a conversation. He did much looking but he rarely found an opportunity to talk and often complained about the difficulties of striking up a conversation with strangers. Access was equally difficult to museums. While walking around looking at the exhibits at MoMA, his ploy was to station himself next to a co-patronizer and hope for a likely opening. He complained that it was difficult to make such an opening. If you looked at work while standing beside a stranger and said, "That is an interesting abstraction" (or whatever), they tended to "look at you as if you were some kind of nut" and walk away.

Koolhaas, p. 10

Movie stars who have led adventure-packed lives are often too egocentric to discover patterns, too inarticulate to express intentions, too restless to record or remember events. Ghostwriters do it for them. In this way *I was Manhattan's ghostwriter.*

Bender, *Unfinished*, p. 57

Is there a key that opens the cultural meaning of the modern metropolis? The proliferation of difference that characterizes metropolitan modernity is so great that it seems unlikely that there is a single "text of the city," the explication of which would reveal the city's cultural script. New York is particularly difficult; there are no equivalents of Balzac or Dickens who reached very far toward incorporating into their narratives the vast kaleidoscope of Paris and London. Whether it results from a deficiency in New York's literary culture or because of the peculiar difficulty of capturing the complexity of New York, the city has not had its Balzac. Whitman, who captured so much, relied upon his famous lists. Even he was unable to bring the many fascinations he found in the city into narrative form.

c Textuality — Reading in the City

Le Corbusier: The streets are at right angles to each other and the mind is liberated.

Fyfe, p. 3

Your mind is free instead of being given over every minute to the complicated game imposed on it by the puzzle of our European cities.

Corbusier, p. 47

New York lives by its clear checkerboard. Millions of beings act simply and easily within it. Freedom of mind. From the first hour, the stranger is oriented, sure of his course.

Ibid., p. 91

The streets and avenues never empty, but the neat, spacious geometry of the city is far removed from the thronging intimacy of the narrow streets of Europe.

Baudrillard, *Simulacra*, p. 61

The individuality of objects is heir to the formal possibilities of the grid, and it is the delineation of this orthogonality—its mathematics—which in turn elucidates the ideal of the road in Manhattan's placemaking. Movement is both parent and progeny in the process of making equality into form.

Monson, p. 32

Everything is determined with a Euclidean clearness. Thus you know instantly whether to walk, whether to take a taxi, or whether to catch the bus on the avenue or use the subway. I say that it is an immense and beneficent freedom for the mind.

Corbusier, pp. 47–8

Straight lines everywhere.

Still, *Mirror*, p. 298

The grid—in its peculiarly intense New York manifestation—influenced a mode of seeing, an urban imagination which eventually rivaled that which we associate with Paris, "capital of the nineteenth century," as Walter Benjamin called it.

Tallack

Thanks to the grid, New York disposes itself as a diagram. The tenements, however, mar this regularity, with dozens of rear houses huddled at odd angles on a single block.

Conrad, p. 71

The grid reproaches the flâneur.

Sanders, *Celluloid*, p. 406

The Grid is, above all, a conceptual speculation.

Koolhaas, pp. 20–1

In spite of its apparent neutrality, it implies an intellectual program for the island: in its indifference to topography, to what exists, it claims the superiority of mental construction over reality.

The plotting of its streets and blocks announces that the subjugation, if not obliteration, of nature is its true ambition.

All blocks are the same; their equivalence invalidates, at once, all the systems of articulation and differentiation that have guided the design of traditional cities. The Grid makes the history of architecture and all previous lessons of urbanism irrelevant. It forces Manhattan's builders to develop a new system of formal values, to invent strategies for the distinction of one block from another.

The Grid's two-dimensional discipline also creates undreamt-of freedom for three-dimensional anarchy. The Grid defines a new balance between control and de-control in which the city can be at the same time ordered and fluid, a metropolis of rigid chaos.

With its imposition, Manhattan is forever immunized against any (further) totalitarian intervention. In the single block—the largest possible

d Grid

area that can fall under architectural control—it develops a maximum unit of urbanistic Ego.

Since there is no hope that larger parts of the island can ever be dominated by a single client or architect, each intention—each architectural ideology—has to be realized fully within the limitations of the block. Since Manhattan is finite and the number of its blocks forever fixed, the city cannot grow in any conventional manner.

Its planning therefore can never describe a specific built configuration that is to remain static through the ages; it can only predict that whatever happens, it will have to happen somewhere within the 2,028 blocks of the Grid.

It follows that one form of human occupancy can only be established at the expense of another. The city becomes a mosaic of episodes, each with its own particular life span, that contest each other through the medium of the Grid.

Morris, *Manhattan '45*, p. 23

Frank Lloyd Wright on Manhattan's grid: "An affected riot."

Rapoport, pp. 51, 52

Rather than to speak of urban order as opposed to disorder or chaos, it is more appropriate to speak of different urban orders … That definition of order to which the opposite notion of chaos or disorder can be applied is the order of the world, a "categorical order," the opposite of which is an undifferentiated state of things. Chaos is thus a negation of such an order and is only a hypothetical state.

Monson, p. 30

Rockefeller Center as the "center in the grid," and the Guggenheim as the "thing illuminating the grid."

Sharpe, p. 199

Joseph Stella: "The depth of night tempers and renders mysterious the geometrical severity of the city."

Conrad, p. 255

Feininger believed that curves were a rarity in cities.

Krauss, p. 50

Its will to silence, its hostility to literature, to narrative, to discourse. As such, the grid has done its job with striking efficiency.

Conrad, p. 195

As a straight line, Fifth Avenue can be a social arbiter. Fifth and Sixth avenues are the uprights of a gigantic ladder stretching from Washington Square to Central Park.

Ibid., p. 196

The avenues may be ladders of ascent, but the cross streets at right angles to them are exits to dalliance, resorts of indolence.

Binzen

The flavor of any street is spiced by those streets that bisect it along the way.

Conrad, p. 196

If the grid is to be converted to the purposes of the epicurean, its numerical regularity must be confounded, because its plan presumes a linear rectitude in one's conduct.

Bender, *Unfinished*, p. xvi

The uniform grid has often energized New York by liberating the deviant.

Kittler, p. 719

The territory is simply the surface effect of its own topicality.

Conrad, p. 135

The city's giddy radiance is chastened by its steely rectilinear geometry.

Sharpe, p. 207

Geometry and anguish.

Geometry in this city maintains an inflexible civic discipline.

Conrad, p. 130

The circle can be squared.

Amin and Thrift, p. 56

The city survives in its relentless grid.

White, *Physical*, p. xxiii

A city is not a flattenable graph. In a city, networks overlap upon other networks. Every traffic light, every subway transfer, and every post office, as well as all the bars and bordellos, speak for this fact.

Kittler, p. 719

Flattened, geometricized, ordered, it is antinatural, antimimetic, antireal. It is what art looks like when it turns its back on nature. In the flatness that results from its coordinates, the grid is the means of crowding out the dimensions of the real and replacing them with the lateral spread of a single surface. In the overall regularity of its organization, it is the result not of imitation, but of aesthetic decree. Insofar as its order is that of pure relationship, the grid is a way of abrogating the claims of natural objects to have an order particular to themselves.

Krauss, p. 50

City walls are pulled down and filled in; once-rational grids are slowly obscured; a slashing diagonal boulevard is run through close-grained residential neighborhoods; railroad tracks usurp cemeteries and waterfronts; and wars, fires, and highways annihilate city cores.

Inam, p. 18

The grid's mythic power is that it makes us able to think we are dealing with materialism (or sometimes science, or logic) while at the same time it provides us with a release into belief (or illusion, or fiction).

Krauss, p. 55

The intersection of everything.

McCourt, p. 244

In the temporal dimension, the grid is an emblem of modernity by being just that: the form that is ubiquitous in the art of our century, while appearing nowhere, nowhere at all, in the art of the last one.

Krauss, p. 53

What matters most in the long run is not the mystique of the grid geometry, but the luck of first ownership.

Inam, p. 18

Urbanism itself, this checkerboard of nameless streets, is the price that has to be paid in order that the streets be useful and no longer picturesque, in order that men and objects circulate, adapt themselves to the distances, rule effectively over this enormous urban nature: the biggest city in the world (with Tokyo) is also the one we possess in an afternoon, by the most exciting of operations, since here to *possess* is to *understand*: New York exposes itself to intellection, and our familiarity with it comes very quickly. This is the purpose of these numbered streets, inflexibly distributed according to regular distances: not to make the city into a huge machine and man into an automaton, as we are repeatedly and stupidly told by those for whom tortuosity and dirt are the gauges of spirituality, but on the contrary to master the distances and orientations by the mind, to put at one man's disposal the space of these twelve million, this fabulous reservoir, this world emporium in which *all* goods exist except the metaphysical variety. This is the purpose of New York's geometry: that each individual should be *poetically* the owner of the capital of the world. It is not up, toward the sky, that you must look in New York; it is down, toward men and merchandise: by an admirable static paradox, the skyscraper establishes the block, the block creates the street, the street offers itself to man. New York is an anti-city.

Barthes, *Eiffel*, p. 151

d Grid

Monson, pp. 31–2	Americans would as readily number their cities as they do their streets.
Riesenberg and Alland, p. 21	It will be noted that the "squares" of the city are seldom parallelograms. The city's little alterations and fictions are part of its charm.
Conrad, p. 256	Rotary thrills, the violent circuitry of pleasure as opposed to the utilitarian drill of those lines, vertical and horizontal, diagonal and perpendicular, from which the workaday city is constructed … Urban people spend their lives traveling purposefully in straight lines. They come to Coney to enjoy the inane exhilaration of going around in circles. Elsewhere they trudge and plod; here they can whirl and rotate.
Ibid.	New York is overwhelmingly square, regular, and right-angled, so why not take advantage of those rare oblique views where roads seem to diverge almost on the spur of the moment, affording you glimpses of an unwonted three-dimensional nature—unconventional cut-and-thrusts indeed.
Maffi, p. 18	Most of all for its vast dimensions—the straight avenues ending in the sky, as they pursue some ultimately significant horizon.
Krauss, p. 53	The grid lands one in the present, and everything else is declared to be the past.
Ibid., p. 56	Grids are not only spatial to start with, they are visual structures that explicitly reject a narrative or sequential reading of any kind.
Conrad, p. 120	The gridded street plan is a plastic representation of pure equilibrium.
Krauss, p. 53	The grid is a transfer in which nothing changes place.
Koolhaas, p. 97	The block becomes a "park" in the tradition of Coney Island: it offers an aggressive alternative reality, intent on discrediting and replacing all "natural" reality. The area of these interior parks can never exceed the size of a block: that is the maximum increment of conquest by a single "planner" or a single "vision." Since all Manhattan's blocks are identical and emphatically equivalent in the unstated philosophy of the Grid, a mutation in a single one affects all others as a latent possibility: theoretically, each block can now turn into a self-contained enclave of the Irresistible Synthetic. That potential also implies an essential isolation: no longer does the city consist of a more or less homogeneous texture—a mosaic of complementary urban fragments—but each block is now alone, like an island, fundamentally on its own. Manhattan turns into a dry archipelago of blocks.
Jackson and Dunbar, p. 436	On a chess-board, imagine a line cutting the squares it traverses, into obtuse and sharp angles, all equally geometrically to right angles, doubtless, but in reality, so different: this is Broadway crossing New York.
Ibid.	In straight New York, Broadway runs riot.
Conrad, p. 283	Broadway is deleterious because it is diagonal, straying across Manhattan from east to west, and because it is nocturnal. Winchell called it New York's hardened artery.

Grid

"Broadway's on the diagonal!" somebody cuts in. So was he. The diagonal, they'd been taught in geometry, is in relation to the straight sides of irrational incommensurate, as is the square root of two.

McCourt, p. 80

Nothing is more tiresome than an infinite number of perfectly straight streets and avenues running on and on until they lose themselves in the sky. One goes along them without ever seeing an edifice closing the vista. There is a terrible monotony about a city each street of which is the counterpart of its neighbors. The idea for a city to aim at is not that the newly arrived stranger shall be able to dispense with map and find his road unaided.

Jackson and Dunbar, p. 438

This relentless set of right angles was like a brand on the wilderness of Manhattan's forests, hills, springs, and streams, ignoring them so that inevitably the forests were cut, the hills leveled, and the streams seduced into the underground pipery that bore them invisibly from source to sea.

White, *Physical*, pp. 112–13

It is like a general introduction to the whole surface of life. Every point of it is worth investigation, for every point leads far into ultimate meaning.

Hapgood, p. 100

Until medieval times European cities were circular structures arranged around a center, while American cities are mostly linear structures built along axes. European cities tend to be closed, while American cities tend toward a more open structure. This is true at least in the sense that city roads in Europe are centripetal/centrifugal, while in the United States, they tend to run and cut across. The European city is dominated by the square, but in America this role is taken by the "Main Street" that begins in the no-man's-land preceding the city, runs its course through the city, and peters out in the no-man's-land at the other end. In this way, instead of widening out in concentric circles, American cities "rise" from their original nucleus. Hence the reasoning between the tripartite division: *downtown, midtown,* and *uptown.*

Maffi, p. 15

The grid acts as a reassuring compass, always ready to orient you. It pulls your eye straight up the avenue, to those long, unimpeded vistas … and so your gaze keeps adjusting astigmatically between long distance and middle range, and all the while there is so much coming at you that you have to attend to the immediate surround, dodging bodies and seizing openings.

Lopate, *Waterfront*, p. 202

The RCA Building's sheer number of windows, its system of multiplication; the United Nations Secretariat is a decapitated pyramid with its edges chiseled against a darker sky, depthless and unornamented.

Conrad, p. 110

The grid appears in the form of windows, the material presence of their panes expressed by the geometrical intervention of the window's mullions.

Krauss, p. 59

There is no necessary connection between good art and change, no matter how conditioned we may be to think that there is. Indeed, as we have a more and more extended experience of the grid, we have discovered that one of the most modernist things about it is its capacity to serve as a paradigm or model for the antidevelopmental, the antinarrative, the antihistorical. This has occurred in the temporal as well as the visual arts: in music, for example, and in dance. It is no surprise then, that as we contemplate this subject, there should have been announced for next season a performance project based on the combined efforts of Phil Glass, Lucinda Childs, and Sol LeWitt: music, dance, and sculpture, projected as the mutually accessible space of the grid.

Ibid., p. 64

Wooster, p. 143–7

Dance by Lucinda Childs, Philip Glass and Sol LeWitt, was performed at the Brooklyn Academy of Music in December 1979. The collaboration was unusual because it brought together three individuals who since the '60s have been working with similar modular structures in their separate disciplines. Characteristic of this production (and in contrast to the discontinuity which characterizes the collaborations between Cunningham and Cage, Tudor, et al.) was the fact that its three parts—film, dance and music—were designed to synchronize with each other. The presence of the grid substantially changed the appearance and the meaning of Childs's dances. Though Childs has used geometric configurations as the basis of her choreography in the past, the existence of those structures—straight lines, triangles, arcs—often had to be intuited. When her dances were placed on a grid in the filmed segments of *Dance*, however, their mathematical foundation became immediately evident. The combination of dancers and grid had exactly the opposite effect for LeWitt's work: the figures served to humanize it. In the visual arts the inclusion of figures within a grid has been relatively rare. For LeWitt, the placement of figures in / on the grid stresses the underlying physical / anthropomorphic quality of his own structures. The dancers thus appeared to be dancing both within and on top of one of LeWitt's own sculptural grids, their movements transformed into a three-dimensional tic-tac-toe. They, in turn, completely revolutionized the meaning of the grid—changing its usual abstract, symbolic character to the more functional role of a high-tech piece of furniture. Together, the figures and grid seemed absorbed into the realm of painterly, illusionistic space and to move in some dimension beyond the reality of the stage on which we know they danced.

Abstraction

Conrad, p. 110

The city of realism is congested. Abstracted New York is empty. Human life has been expelled from it and its perimeters are blank walls, the screens for invisible vistas.

Ibid., p. 110–1

Whitewashed handball walls are the infinitudes of a negative sublimity, a pallor that appalls, like the incomprehensible whiteness of Moby Dick or the uncharted extent of American geography, which weary human beings have to trudge across and fill up.

Ibid., p. 109

A geometer's New York of sharpened edges and extreme angles, a city which, in the process of rebuilding, can be seen recomposing itself abstractly, purged now of Whitman's organic ferment. Even the city's mobility is belied.

Lefebvre, *Stage*, p. 187

Abstract space reveals its oppressive and repressive capacities in relation to time. It rejects time as an abstraction—except when it concerns work, the producer of things and of surplus value. Time is reduced to constraints of space: schedules, runs, crossings, loads.

Conrad, p. 109

Whitman is co-opted by the abstractors of New York.

Ibid., p. 117

New York invites re-formation because it's a world city. Abstraction is the universal regime of structure beneath the variety of local appearance; it confounds and then rationally rearranges the visible world just as New York draws from and then resynthesizes the old political world of quarrelsome nationalities.

The first task of the American painter is repletion of this emptiness; but his way of colonizing it is simply to color it white. Tom Sawyer has been sentenced to whitewash "thirty yards of board-fence nine feet high." He pauses, dismayed, to compare the few streaks he has accomplished with "the far-reaching continent of unwhitewashed fence" yet to be conquered. Tom's canvas, like the unsettled continent or the white paintings (fleetingly colored and inhabited by the shadows of viewers, travelers through this vacant infinity) made by Robert Rauschenberg in 1951, is a void. So too is the city once it has been abstracted: a clean, well-lighted place, its walls are as wide and as depressingly open as the continent they're meant to occlude.

Ibid., p. 111

The distanced rather than the proximate, the displaced rather than the placed, the intransitive rather than the reflexive.

Amin and Thrift, p. 5

Socially, politically, and ethnically, New York performs a benign reduction resembling that of the cubists, who see within all objects those ideal, ideational forms—the sphere, the cone, and the cylinder. It takes immigrants from every country and recomposes them as Americans. At the same time, New York devises an international language to accompany the visual universality of abstraction.

Conrad, p. 117

Constance Rourke saw all New York culture, past and present—politics, religion, advertising, *everything*—as "doubled"; "Everything doubled."

Douglas, p. 55

The sticky & slack human
nonhuman, inorganic
incorporeal, phenomena
phenomenal, banal
intense everydayness.

Amin and Thrift, p. 9

The tension between the similarities and differences among the façades along a block, and the repetition of such blocks along streets which themselves subtly differ in dimension.

Conrad, p. 123

Grid — Abstraction

Salinger, p. 81	New York's terrible when somebody laughs on the street very late at night. You can hear it for miles. It makes you feel so lonesome and depressed.
Brooks, *In the City*, p. 15	Occasionally, a single shoe is marooned in the city.
Huxtable, *Goodbye*, p. 52	A single human figure, equally isolated in a crowd, proceeds through the chill, bleak anonymity of the 20th-century transit catacombs (ancient catacombs softened even death with frescoes) in a setting of impersonal, ordinary sterility that could just as well be a clean, functional gas chamber. The human spirit and human environment have reached absolute zero.
Ford, *America*, p. 178	The hours of depression that I have passed in New York.
Lehman, *Selected*, p. 157	Of the cities I know New York wins the paranoia award
Oppen, *Collected*, p. 43	The solitary are obsessed. Apartments furnish little solitude.
Blandford, p. 95	There is no agoraphobia any more, there is, simply, no reason to go out.
Mariani, p. 234	Riding the subway escalator at 14th Street, each eye downcast, avoiding direct contact with anyone, each staring intently at his shoes.
Rosenfeld, p. 470	One is still alone; among people who are alone, scattered like seed or pebbles strewn.
Kinkead, *Chinatown*, p. 5	For months, I roamed the streets, trying to find people who would talk to me.
Roche, p. 404	delirium of empty streets
Blandford, p. 120	Perhaps because so many here are lonely, there is a sense of depression.
White, *Here*, p. 37	Summertime is a good time to reexamine New York and to receive again the gift of privacy, the jewel of loneliness.
O'Hara, p. 405	how sad the lower East side is on Sunday morning in May eating yellow eggs
Frank, p. 177	I am a bit of a man with a seven-syllabled name in the vastness New York.
Jones, *Modernism*, p. 226	I am unfit for this puffed city of gray dust and lost soldiers drinking lost battles in the chasms between buildings making artwar to assuage rather than fight.
Depero, "Coney Island," p. 422	The crypts of loneliness, The dreams and immundicities of the crowd.
Fitzgerald, *My Lost City*, p. 110	Later I realized that behind much of the entertainment that the city poured forth into the nation there were only a lot of rather lost and lonely people. The world of the picture actors was like our own in that it was in New York and not of it.
Conrad, p. 178	At first, the symbolic gesture of the novel in New York is its closure of a door.
Blandford, p. 95	Mingling is out; privacy is in.

e Loneliness

Once it has disallowed character, New York must rule out any narrative that grows from voluntary affinities. Its dwellings are constructed to enforce this denial.

Conrad, p. 185

For in the city, things were definitely outside you, apart from you; you were alien to them, it seemed, and for your part you could not move closer to them, no more than to the people who moved amongst them; even to those of the people you were supposed to know the best of all and with whom you had spent years. It was as useless trying to feel yourself through the crowding towers of the lower town, and feel a whole, as it was trying to feel yourself through the forbidding people in the streets. The towers were not a whit less hard, less mutually exclusive, less eager to crowd each other out, than the people who had made them. They snatched the light from each other; rough-shouldered each other; were loud, anarchical, showy … unfriendly; flaunting money; calling for money. Edges stood, knife after knife. Nothing ever came with the warmth of heaven to do the work of the sun and melt the many antagonistic particles.

Rosenfeld, p. 467

In the seventies, we used to dream of escaping to downtown New York to escape the draft. The labyrinth of forgotten streets made it seem like the perfect place to disappear into. We figured we'd go undercover for a few years there, and emerge later unnoticed by the draft authorities.

N. cit.

Only in a great city could an introvert give his overwhelming yearning free rein incognito and thus keep the respect of his every-day circle. In New York one can live as Nature demands without setting every one's tongue wagging.

Chauncey, p. 131

I began to cherish the loneliness of it, the sense that at any given time no one need know where I was or what I was doing.

Didion, "Goodbye," p. 174

New York. A walking exile here I will always be—alone.

Jones, *Modernism*, p. 227

It was a beautiful day. No one was around. So I was all by myself, but I had courage enough to go down to the office. I take a sharp stick with me in case the elevator doors stick, so I can pry myself out. And if I go over there alone on the weekend I always tell someone I'm going … No one was available to accompany me to the office, and I was afraid the elevator would get stuck, so I didn't go down.

Warhol, *Diaries*, pp. 521–2

The dark was coming quickly down, the dark of a February Sunday evening, and that vaguely perturbed him. He didn't want to go "home," though, and get out of it. It would be gloomy and close in his hotel room, and his soiled shirts would be piled on the floor of the closet where he had been flinging them for weeks.

He sits in the lobby drinking brandy and asking again if he's received any messages (he hasn't). Restless, he wanders out again. Finally after moping from bar to bar, he shuffles, drunk and maudlin, back to his hotel. It's three o'clock Monday morning; nothing awaits him but the night clerk and an absence of messages.

Caldwell, p. 261

I wonder if one person out of the 8,000,000 is
thinking of me as I shake hands with LeRoi

O'Hara, p. 336

Lovers still become radiant and breathless; honest workers shave wood, rivet steel beams, dig in the earth, or set type with sure hands and quiet

Mumford, *Modern*, p. 24

satisfaction; scholars incubate ideas, and now and again a poet or an artist broods by himself in some half-shaded city square.

Blandford, p. 95

Out there, beyond the world of the box, and the security of the hermit's shell, is sensed a gallery of losers.

Gorky, "Boredom," p. 310

Three Hundred Thousand People in Coney Island Yesterday. Twenty-three Children Lost.

Jones, *Modernism*, p. 176

The movies, the White Ways, and the Coney Islands, which almost every American city boasts in some form or other, are means of giving jaded and throttled people the sensations of living without the direct experience of life—a sort of spiritual masturbation.

Ibid., p. 208

New York of the teens is as soulless as a department store.

Conrad, p. 103

The city as a confraternity of minds, each of which illuminates a window with a sign of its sentience, sinister in their lidded blankness.

Lebowitz, p. 200

She stares out the window, across the freezing black river and into the bleakness of Queens.

Conrad, p. 103

A room without a window is a life denied consciousness of itself and contact with others … 300,000 inhabited, windowless rooms in New York.

Henry, "Making," p. 108

And then he said to himself that this fair but pitiless city of Manhattan was without a soul; that its inhabitants were manikins moved by wires and springs, and that he was alone in a great wilderness.

Riesenberg and Alland, p. 204

City of ardent spinsters and impotent Galahads.

Tester, p. 11

A dialectic of incognito observations.

Ibid., p. 77

A sociability of Ones.

Ibid.

An atomized form of association where individuals congregate in an anonymous crowd of randomly strolling people. Despite their proximity they keep their social distance from each other and preserve a discrete estrangement. This is the life of watching the world go by, not ever exchanging a word acknowledging the presence of an Other.

Lofland, p. ix

To experience the city is, among many other things, to experience anonymity.

Ibid., p. x

To cope with the city is, among many other things, to cope with strangers.

Ibid., p. 19

Strangers in the midst of strangers.

Ibid., p. x

A situation of pure anonymity would be intolerable.

Ibid., p. 3

A collection of relatively large numbers of people in a relatively small space.

Ibid., p. 4

There is nothing peculiar in the situation of living out one's life amid persons one does not know.

Ibid.

Pre-urban condition: the absence of anonymity.

There would appear to be a sheer biophysical limitation on the capacity of human beings to recognize, either by name or by face, an infinite number of their fellowmen.

Ibid., p. 10

Keep one's facial expression impassive. Look neither happy nor sad, angry nor peaceful.

Ibid., p. 151

Keep oneself to oneself. Avoid bumping into, brushing past, stepping on, or colliding with any strange persons. Keep alert to the speed with which, and direction in which, these persons are moving, so as to guide one's own actions appropriately. Follow the rule of generally staying to the right but do not assume that others will do the same.

Ibid.

Keep oneself apart. Avoid seating oneself in such a way as to suggest to a strange other that one wishes to interact.

Ibid., p. 153

Keep one's eyes to oneself. Avoid even accidental contact. Concentrate one's gaze on inanimate objects. If one wishes to gaze about, glance at surrounding persons only below the neck.

Ibid., p. 154

Wear sunglasses. One can then look people right in the eye without their being aware that one is doing so.

Ibid.

Keep oneself protected. Avoid coming close to anyone who either looks or behaves "oddly." Such persons are unpredictable, may accost one despite one's precautions, and may involve one in conspicuous interaction.

Ibid.

Keep oneself aloof.

Ibid., p. 155

People born and bred to life within earshot and eye glance of a score of neighbors have learned to preserve their own private worlds by uniformly ignoring each other, except on direct invitation.

Hayes and Woolrich, p. 1

Street empty. Save for a solitary trudging head down shielding a big brown envelope.

Donleavy

A stormy morning is the best time of all in New York—when there isn't a single loafer, not a spare person about. There are only the toilers of the great army of labor of the city of ten million.

Mayakovsky, *Discovery*, p. 48

Really it's this lawlessness and anonymity simultaneously that I desire.

Wojnarowicz, p. 128

Inhabited by 4,000,000 mysterious strangers.

Jackson and Dunbar, pp. 497–8

theme for an immense poem—collecting, in running list, all the things done in secret.

Turner, *Backward*, p. 110

Streets already emptied at night by television.

Freeman, p. 275

If he is dressed superbly well—there are a half a million people dressed equally well.

Jackson and Dunbar, p. 671

If he is in rags—there are a million ragged people.

Ibid.

If he is tall, it is a city of tall people.

Ibid.

Ibid.	If he is short, the streets are full of dwarfs.
Ibid.	If ugly, ten perfect horrors pass him in one block.
Ibid.	If beautiful, the competition is overwhelming.
Ibid.	If he is talented, talent is a dime a dozen.
Ibid.	If he tries to make an impression by wearing a toga—there's a man down the street in a leopard skin.
Ibid.	Whatever he does or says or wears or thinks he is not unique. Once accepted this gives him perfect freedom to be himself, but unaccepted it horrifies him.
Atkinson, p. 261	It is truly the city that nobody knows.
Ibid.	The most desired yet least beloved of cities.
Ibid., p. 264	Whoever wishes company can find company; whoever wishes to be alone will not be disturbed.
Ibid.	"Ladies of the Corridor"—widows with money and no inner resources who sit all day in hotel lobbies sadly watching life pass them by.
Ibid.	Elderly men, somehow alone in the world, or unwanted, sitting on park benches staring into the past.
Ibid.	A man I heard of whose sole social contact was going to the hat-and-shoe cleaners to have his hat cleaned. He had his hat cleaned a couple of times a week, just to sit waiting in the warm, bright shop, listening to the chatter of the proprietor and other customers.
White, *Here*, p. 22	New York blends the gift of privacy with the excitement of participation; and better than most dense communities it succeeds in insulating the individual (if he wants it, and almost everybody wants or needs it) against all enormous and violent and wonderful events that are taking place every minute.
Ibid., p. 19	On any person who desires such queer prizes, New York will bestow the gift of loneliness and the gift of privacy. It is this largess that accounts for the presence within the city's walls of a considerable section of the population; for the residents of Manhattan are to a large extent strangers who have pulled up stakes somewhere and come to town, seeking sanctuary or fulfillment or some greater or lesser grail. The capacity to make such dubious gifts is a mysterious quality of New York. It can destroy an individual, or it can fulfill him, depending a good deal on luck. No one should come to New York to live unless he is willing to be lucky.
Chauncey, p. 131	The main external check upon a man's conduct, the opinion of his neighbors, which has such a powerful influence in the country or small town, tends to disappear. In a great city one has no neighbors. No man knows the doings of even his close friends; few men care what the secret life of their friends may be. The young man is left free to follow his own inclinations.
Sanders, *Celluloid*, p. 395	Any taxi driver is a symbol of urban disengagement, a man who moves, works, walks and talks and yet somehow is invisible to the eyes of his fellow

e Loneliness

men. He is acknowledged briefly when the passenger enters the cab and then consigned to limbo, to nonexistence.

New York's bus driver remains largely anonymous and goes through life with only half of his face showing in the rear-view mirror. Talese, p. 31

People who have no terraces and no gardens long to escape from their own four walls, but not to wander far. They only want to step outside for a minute. They stand outside their apartment houses on summer nights and during summer days. They stand around in groups or they sit together on the front steps of their buildings, taking the air and looking around at the street. Sometimes they carry a chair out, so that an old person can have a little outing. They lean out of their windows, with their elbows on the sills, and look into the faces of their neighborhoods at their windows on the other side of the street, all of them escaping from the rooms they live in and that they are glad to have but not to be closed up in. It should not be a problem, to have shelter without being shut away. The window sills are safety hatches into the open, and so are the fire escapes and the roofs and the front stoops. Brennan, p. 32

A city for eccentrics and a center for odd bits of information. Talese, p. 1

Yeah if those floorboards could talk, if those streets could talk, if the whole huge path this body has traveled—roads, motel rooms, hillsides, cliffs, subways, rivers, planes, tracks—if any of them could speak, what would they remember most about me? What motions would they unravel within their words, or would they turn away faceless like the turn of this whole river and waterfront street, all of its people, its wanderers, its silences beneath the wheels of traffic and industry and sleep, would it turn away speechless like faces in dreams, in warehouses, pale wordless faces containing whole histories and geographies and adventures? Wojnarowicz, p. 147

Love in Manhattan? I Don't Think So. Bushnell

"Relationships in New York are about detachment," she said. *Ibid.*

When it comes to finding a marriage partner, New York has its own particularly cruel mating rituals, as complicated and sophisticated as those in an Edith Wharton novel. Everyone knows the rules but no one wants to talk about them. The result is that New York has bred a particular type of single woman: smart, attractive, successful, and never married. She is in her late thirties or early forties, and, if empirical knowledge is good for anything, she probably never will get married. *Ibid.*

What if, on the other hand, you're forty and pretty and you're a television producer or have your own PR company, but you still live in a studio and sleep on a foldout couch—the nineties equivalent of Mary Tyler Moore? Except, unlike Mary Tyler Moore, you've actually gone to bed with all those guys instead of demurely kicking them out at 12:02 a.m.? What happens to those women? *Ibid.*

There are thousands, maybe tens of thousands of women like this in the city. We all know lots of them, and we all agree they're great. They travel, they pay taxes, they'll spend four hundred dollars on a pair of Manolo Blahnik strappy sandals.

"Here's the deal," Jerry said. "There's a window of opportunity for women to get married in New York. Somewhere between the ages of twenty-six and *Ibid.*

thirty-five. Or maybe thirty-six." We agreed that if a woman's been married once, she can always get married again; there's something about knowing how to close the deal.

Ibid.

"But all of a sudden, when women get to be thirty-seven or thirty-eight, there's all this … stuff," he said. "Baggage. They've been around too long. Their history works against them."

Ibid.

"There's a list of toxic bachelors in New York," said Jerry, "and they're deadly."

Ibid.

Because if you're a successful single woman in this city, you have two choices: You can beat your head against the wall trying to find a relationship, or you can say "screw it" and just go out and have sex like a man.

Ibid.

The Bicycle Boy actually has a long literary-social tradition in New York. The patron saints of Bicycle Boys are white-haired writer George Plimpton, whose bike used to hang upside down above his employees' heads at the Paris Review offices, and white-haired Newsday columnist Murray Kempton. They've been riding for years and are the inspiration for the next generation of Bicycle Boys, like the aforementioned Mr. New Yorker and scores of young book, magazine, and newspaper editors and writers who insist on traversing Manhattan's physical and romantic landscape as solitary peddlers. Bicycle Boys are a particular breed of New York bachelor: Smart, funny, romantic, lean, quite attractive, they are the stuff that grownup coed dreams are made of. There's something incredibly, er, charming about a tweedy guy on a bike, especially if he's wearing goofy glasses.

Ibid.

John F. Kennedy Jr. is certainly New York's most famous and sought-after bike-riding bachelor.

Ibid.

On a recent afternoon, four women met at an Upper East Side restaurant to discuss what it's like to be an extremely beautiful young woman in New York City. About what it's like to be sought after, paid for, bothered, envied, misunderstood, and just plain gorgeous: all before the age of twenty-five.

Ibid.

He lives in a tiny studio that has white everything: white curtains, white sheets, white comforter, white chaise. When you're in the bathroom, you look to see if he uses special cosmetics. He doesn't.

Allen and Brickman, *Annie Hall*

Probably met by answering an ad in the *New York Review of Books*. "Thirtyish academic wishes to meet woman who's interested in Mozart, James Joyce and sodomy."

McInerney, *Bright Lights*, p. 57

Sometimes you feel like the only man in the city without group affiliation.

Wojnarowicz, p. 156

He slipped his hand into mine and my reaction to that was almost bewilderment insofar as people rarely do that in this city, much less when they hardly know you, and I really dug it. We left each other after an embrace on the corner of Christopher and Hudson Streets. After walking half a block I turned to look back, and he was standing there, hand in pocket, the other hand up waving. I waved back and turned towards the subway and home.

New York is a city that eats its history.

Solis, p. 9

Crowned not only with no history, but with no credible possibility of time for history, and consecrated by no uses save the commercial at any cost, they are simply the most piercing notes in that concert of the expensively provisional into which your supreme sense of New York resolves itself.

Brook, p. 284

In retropsect it seems to me that those days before I knew the names of all the bridges were happier than the ones that came later.

Didion, "Goodbye," p. 169

As speedily forgetful as the RR subway.

Conrad, p. 307

The lot is now a place of pictorial memory, a chimerical souvenir of the city before abstraction: on its blank wall is the imprint of a demolished house.

Ibid., p. 112

It is both novelty and recognition that pleases him: the novelty of its actual and amazing encompassment, the recognition of great shafts and crowds and thoroughfares remembered from a hundred motion pictures, rotogravures and advertisements.

Federal Writers, Panorama, p. 5

In these matters human psychology is very queer. I suppose that everybody who knows anything about them laments the decay of the ancient glories of … well, say Spain. It is sad to think that never again will the great galleons trail away into the golden sunsets. London to me today is nothing—or next to nothing. I know nobody of its seventeen or so millions—five people perhaps outside my own family. New York really means a great deal more: my memories of her are nearly all pleasant—full of clean air and white Flatirons.

Ford, America, p. 81

Everything's changed. I couldn't stand it here. I'd die. I belong to the Delmonico period. Ah, a table at the window, looking out on Fifth Avenue. Boxes with flowers, pink lampshades, string orchestras, and, yes, willow plumes. Inverness cape, dry champagne, and snow on the ground. Say, they don't even have snow anymore!

Sanders, Celluloid, p. 400

The tempo of the city had changed sharply. The uncertainties of 1920 were drowned in a steady golden roar and many of our friends had grown wealthy. But the restlessness of New York in 1927 approached hysteria. The parties were bigger—those of Condé Nast, for example, rivaled in their way the fabled balls of the nineties; the pace was faster—the catering to dissipation set an example to Paris; the shows were broader, the buildings were higher, the morals were looser and the liquor was cheaper … Everything there was to say about the boom days in New York that couldn't be said by a jazz band.

Fitzgerald, My Lost City, p. 112

To a New Yorker the city is both changeless and changing. In many respects it neither looks nor feels the way it did twenty-five years ago. The elevated railways have been pulled down, all but the Third Avenue. An old-timer walking up Sixth past the Jefferson Market jail misses the railroad, misses its sound, its spotted shade, its little aerial stations, and the tremor of the thing. Broadway has changed in aspect. It used to have a discernible bony structure beneath its loud bright surface; but the signs are so enormous now, the buildings and shops and hotels have largely disappeared under the neon lights and letters and the frozen custard façade. Broadway is a custard street with no frame supporting it. In Greenwich Village the light is thinning: big apartments have come in, bordering the Square, and the bars are mirrored

White, Here, p. 49

and chromed. But there are still in the Village the lingering traces of poesy, Mexican glass, hammered brass, batik, lamps made of whisky bottles, first novels made of fresh memories—the old Village with its alleys and ratty one-room rents catering to the erratic needs of those whose hearts are young and gay.

Ibid., p. 50

Police now ride in radio prowl cars instead of gumshoeing around the block swinging their sticks. A ride in the subway costs ten cents, and the seats are apt to be dark green instead of straw yellow. Men go to saloons to gaze at televised events instead of to think long thoughts. It is all very disconcerting. Even parades have changed some. The last triumphal military procession in Manhattan simply filled the city with an ominous and terrible rumble of heavy tanks. The slums are gradually giving way to the lofty housing projects—high in stature, high in purpose, low in rent. There are a couple of dozens of these new developments scattered around; each is a city in itself (one of them in the Bronx accommodates twelve thousand families), sky acreage hitherto untilled, lifting people far above the street, standardizing their sanitary life, giving them some place to sit other than an orange crate. Federal money, state money, city money and private money have flowed into these projects. Banks and insurance companies are in back of some of them. Architects have turned the buildings slightly on their bases, to catch more light. In some of them, rents are as low as eight dollars a room. Thousands of new units are still needed and will eventually be built, but New York never quite catches up with itself, is never in equilibrium. In flush times the population mushrooms and the new dwellings sprout from the rock. Come bad times and the population scatters and the lofts are abandoned and the landlord withers and dies.

Federal Writers, *Panorama*, pp. 421–2

Jules Romains visits NYC in 1924. An expert in the human resonance of great cities, he noted its equivocal ethics, at home in the guarded half-light of the speakeasy, its neurotic drive to make each moment pay in full, its violent emulation of the machine … He returns in 1936. There had been some extraordinary change in the face and character of the city. Its very streets were fresher, the sky had opened, there was a luster on the flanks of great clay shafts, the intimation of an unbelievable tranquility. True, it was summer; but the deeper signs were plain. They appeared in the faces of the people in every turn and feature. The old, abrasive will-to-action for its own sake was gone. These men and women were freer, more open, casually good-natured, even happy. They had time for a new and more relaxed gaiety. He felt in them a profound reinvigoration of the democratic spirit.

Brook, p. 284

This great city of perpetual change doesn't encourage nostalgia. Much that is precious in the memory will have vanished months or years later, and the returning traveler must rediscover the city each time. The scale of New York scorns the indulgences of personal sentiment. The towers of Manhattan are an embodiment of overachievement, a defiantly artificial megalopolis in which glass and stone and concrete overwhelm the human element. The lifelong sport of being a New Yorker is to overcome these extraordinary self-created obstacles. The art of doing so, which New Yorkers by definition have had to perfect, is urban living at its most extreme, most rhapsodic. Defying all the laws that sociologists lay down, impossibly overcrowded Manhattan functions as well, if not better, than most cities of the same size. Though individual buildings, even neighborhoods, decay and disappear, the city as a whole is inextinguishable. It is more than an agglomeration; it is an idea, an assertion. Because it is self-renewing it can never, superpowers permitting, be destroyed.

Publicity is, in essence, nostalgic. It has to sell the past to the future. Nostalgia is no simple longing for the past, however, not least because we can be made to feel it for experiences we did not, and could not, have ourselves enjoyed. Nostalgia literally means—from the Greek *nostos algos*—a painful longing for one's home harbor, and Odysseus may be considered by this token the most celebrated nostalgic in history or literature. It is a paradoxical pain even in its simplest form, since there is the pain of return as well as the pain felt as return is successively thwarted: you really can't go home again, because when you get there it is not the same as when you left.

Kingwell, p. 182

Seen from the ferry boat in the early morning, it no longer whispers of fantastic success and eternal youth. The whoopee mamas who prance before its empty parquets do not suggest to me the ineffable beauty of my dream girls of 1914.

Fitzgerald, *My Lost City*, p. 115

All over town the great mansions are in decline. Schwab's house facing the Hudson on Riverside is gone. Gould's house on Fifth Avenue is an antique shop. Morgan's house on Madison Avenue is a church administration office. What was once the Fahnestock house is now Random House. Rich men nowadays don't live in houses; they live in the attics of big apartment buildings and plant trees on the setbacks, hundreds of feet above the street.

White, *Here*, p. 49

From the confusion of the year 1920 I remember riding on top of a taxi-cab along deserted Fifth Avenue on a hot Sunday night, and a luncheon in the cool Japanese gardens at the Ritz, and paying too much for minute apartments, and buying magnificent but broken-down cars.

Fitzgerald, *My Lost City*, p. 110

The past is the only real thing. You can brood on the past, reflect about it, enjoy it. The present is mere activity and the future is nothing.

Hapgood, p. 215

History written in scratches and scars onto streets and houses.

Maffi, p. 56

The first New York I knew well, SoHo's art world of twenty years ago, is no less vanished now than Carthage; the New York where my wife and I first set up housekeeping, the old Yorkville of German restaurants and sallow Eastern European families, is still more submerged, Atlantis; and the New York of our older friends—where the light came in from the river and people wore hats and on hot nights slept in Central Park—is not just lost but by now essentially fictional, like Narnia.

Gopnik, p. 4

On the rare occasions when Old New York surfaces, the public is generally uninvited to the viewing.

Trebay, p. 130

The leaden twilight weighs on the dry limbs of an old man walking towards Broadway. Round the Nedick's stand at the corner something clicks in his eyes. Broken doll in the ranks of varnished articulated dolls he plods up with drooping head into the seethe and throb into the furnace of beaded lettercut light. "I remember when it was all meadows," he grumbles to the little boy.

Dos Passos, p. 249

She changes so fast that you cannot at any moment say: "This is my New York." And yet your New York it remains. The tobacco-store at the corner of Fourteenth Street vanished in next to no time after I had begun to use it as a means of communication with the outside world, but it collected an extraordinary crop of associations and became part of the Past with a rapidity such as could have been equaled in surely no other city. And you may say the same of all New York. Impressions are all there so vivid that what, in another

Ford, *America*, p. 180

place, would leave next to no impress on the mind becomes between the Battery and Central Park of almost epoch-making importance. So New York clothes herself.

Talese, p. 129

It is a city of silent movie stars and old fans who rarely recognize them. Although sometimes on Broadway an elderly man will swing around, stare at a passing figure and exclaim:
"Why, you're Nita Naldi!"

Riesenberg and Alland, p. 156

Confusion is in the city, and so is pure simplicity. One hour is like a minute, and the day wanes, for the more you see, smell, and hear, the less you know.

Holleran, "Anniversary," p. 11

In a city like New York it is easy to relive the past ten years by walking to the Laundromat.

N. cit.

The city has become a tissue of memories. I can't walk down any street after having lived here for thirty years without remembering a lover who lived on such-and-such a street or a long-vanished store that occupied a corner. The city can never be new again.

Wojnarowicz, p. 244

It's so odd trying to write about the past based on memory: the landscape and human particulars fall to the odd logic of time and emotional impression. The landscape of memory is as affected by time and personal structure as is landscape affected by light or darkness. At night when sources of light are curtailed, shaped, bent, deflected, erased, the distances can suddenly be elongated or shortened, physicality of self or landscape expands or contracts in the dark. 8th Avenue in memory can be a location or landscape no one else has ever traveled.

Jackson and Dunbar, p. 598

We walk the streets with a thousand legs and eyes, with furry antennae picking up the slightest clue and memory of the past. In the aimless to and fro we pause now and then, like long, sticky plants, and we swallow whole the live morsels of the past.

Finney, p. 66

And in spite of all the indistinguishable glass boxes and of monstrosities like the Pan Am Building and other crimes against nature and the people, there are fragments of still earlier days. Single buildings. Sometimes several together. And once you get away from midtown, there are entire city blocks that have been where they still stand for fifty, seventy, even eighty and ninety years. There are scattered places a century or more old, and a very few which actually knew the presence of Washington.

Peretti, p. 26

In the 1920s, nostalgia for the Gay 90s appeared. New Yorkers began to fight to preserve old buildings and to slow the pace of "creative destruction" in Manhattan. "Sentimental. Unjazzed. Jolly."

Finney, p. 113

And the New York of the eighties was dead.

Hamill, "Lost"

I suppose that 30 years from now (as close to us as we are to 1958), when I've been safely tucked into the turf at the Green-Wood, someone will write in these pages about a Lost New York that includes Area and the Mudd Club and Nell's, David's Cookies and Aca Joe and Steve's Ice Cream. Someone might mourn Lever House or Trump Tower or the current version of Madison Square Garden.

I confess to a feeling akin to sadness about the Gay Nineties. They record, in one sense, the last days of another Pompeii—the last days of little Old New York. The proud name which she had gallantly borne for three centuries was to be torn from her grasp. The last link that connected her with her days of romance, her Indians, her Pirates, her valiant struggle for freedom, her Raines Law sandwich was to be a thing of the past. No more was the little seaport at the mouth of the lordly Hudson to be called by the name which navigators, explorers and mariners had made known to the Seven Seas. In order to realize her manifest destiny—to become still greater—it became necessary to ally herself with Hunter's Point, Far Rockaway, Long Island City and the Bronx! The mantle of her shining greatness fell upon these benighted communities and now the traveller from Brooklyn is no longer ashamed to register from his home town, but gaily and at last truthfully inscribes himself from New York. The Borough of Manhattan may in time come to mean something. For the present it is a mouthing—a cymbal of brass. To the old New Yorker, the name New York will always mean the city on Manhattan Island at the mouth of the Hudson River and will never mean anything else. All the consolidations, annexations, combinations, etc., to the contrary notwithstanding. And now to the burden of my discourse. It is yet the early nineties and I am still in real old New York. Not till almost the closing years of this decade am I obliged to record this lamentable change. So till almost the last page I am speaking of New York and not of the contraption of five upstart Boroughs strutting around in unmerited splendor as part of that ancient and honorable commonwealth, the Empire City, little old New York.

Brown, *Valentine's*, p. 19

Here is D. W. Griffith, whose old Biograph Studio building still stands, solid but battered and neglected, at the Expressway's edge; here is Sholem Aleichem, seeing the New World and saying that it was good, and dying on Kelly Street (the block where Bella Abzug was born); and there is Trotsky on East 164th Street, waiting for his revolution (did he really play a Russian in obscure silent films? we will never know). Now we see a modest but energetic and confident bourgeoisie, springing up in the 1920s near the new Yankee Stadium, promenading on the Grand Concourse for a brief moment in the sun, finding romance in the swan boats in Crotona Park; and not far away, "the coops," a great network of workers' housing settlements, cooperatively building a new world beside Bronx and Van Cortlandt parks. We move on to the bleak adversity of the 1930s, unemployment lines, home relief, the WPA (whose splendid monument, the Bronx County Courthouse, stands just above the Yankee Stadium), radical passions and energies exploding, street-corner fights between Trotskyites and Stalinists, candy stores and cafeterias ablaze with talk all through the night; then to the excitement and anxiety of the postwar years, new affluence, neighborhoods more vibrant than ever, even as new worlds beyond the neighborhoods begin to open up, people buy cars, start to move; to the Bronx's new immigrants from Puerto Rico, South Carolina, Trinidad, new shades of skin and clothes on the street, new music and rhythms, new tensions and intensities; and finally, to Robert Moses and his dread road, smashing through the Bronx's inner life, transforming evolution into devolution, entropy into catastrophe, and creating the ruin on which this work of art is built.

Berman, *Solid*, p. 342

In the nineteenth century the nostalgic was an urban dweller who dreamed of escape from the city into the unspoiled landscape. At the end of the twentieth century the urban dweller feels that the city itself is an endangered landscape.

Lopate, *Waterfront*, p. 208

I came to the city as a stranger, and although I became a New Yorker, I left it finally as a stranger, too.

O'Connell, p. 304

Talese, *Serendipiter's*, p. 81

Friday, July 15, 1960 was a typical day in New York City. Seven new "Littering Prohibited" signs were added in Central Park. John T. Jackson became Vice-President in Charge of Management Planning at Remington Rand and got his picture on page 26 of the *Times*. The Home for Aged and Infirm Hebrews of New York announced that it received $2,000,000 under the will of Solomon Friedman, a cotton merchant. John's Bargain Stores leased a building at 184 West 213th Street, near Broadway, from one Louis Cella. The Fifth Avenue Coach Lines, Inc., brought a $500,000 damage suit against Michael J. Quill's union for an unauthorized bus strike. At 11:15 A.M., Joseph J. Marinello, 77, whizzed into Times Square on his bicycle, asked for a tomato juice, and remarked, "I just knocked off 671 miles on this bike." (A sleepy-eyed counter clerk was very impressed.) Nitrous oxide seeped through gas masks and overcame twenty firemen at a blaze in the twelve-story loft at 107-109 West Thirty-eighth Street. At 8 P.M. it was 79 degrees. Eleanor Steber sang *Il Trovatore* at Lewisohn Stadium and everybody liked it. A Polish cleaning lady was stuck for five minutes in a Wall Street elevator on the 37th floor. A car plunged 40 feet down into the East River with a man and woman after speeding over the Tiffany Street pier shortly before midnight. Nobody saw either of them again until Saturday night, July 16, when a stocky deep-sea diver, wading through the slippery slime, felt the bodies, attached a hook to the car's rear bumper, and then sent it up toward the surface again.

Rock, Moore, and Lobenstine, p. 287

Capture a piece of the street and make a history of the commonplace.

Barnes, p. 294

Somewhere, everywhere over there in that world that we had been around, actresses were getting their beauty sleep or were at school learning an arduous new dance. Somewhere a man was killing a gnat and somewhere else a man building a bomb. Someone was kissing, and someone was being born, and someone was dying. Some were eating and drinking and laughing, and others were starving. Some were thinking, and others were not. Waiters moved about in their great hotels, dragging their servility with them like trains. Pompous gentlemen in fat rings discuss politics amid spittoons, and handsome women read yellow-backed novels and gave their hands to be kissed by gallants. And there were some walking about, looking over at us as we looked back at them. The tall buildings threw their shadows down on little buildings, great men on small men, joy on sorrow.

Janowitz, p. 167

A man invited us to dinner. We went to his apartment. We looked at his paintings for a long time. He had painted them. We looked at each painting and said different things about them. We said nothing negative about any painting. Then the man said it was time for dinner. He offered us herbal tea. We sat down at the table. It was just the three of us. The man set the table and brought out a salad. It was a fairly large green salad. He gave us each some salad and we ate it. Then he asked if we would like some more. After a while we decided to have some more salad. Then a long time passed and we said we would have a bit more salad. Then the man brought out the herbal tea.

After a while longer we realized the meal was over and we went home.

Maxwell, p. 392

Yawning, stretching, any number of people got up and started the business of the day. Turning on the shower, dressing. Putting their hair up in plastic curlers. Squeezing the toothpaste out of tubes that were all but empty. Squeezing orange juice. Separating strips of bacon.

Dylan, *Chronicles*, p. 32

Across the way a guy in a leather jacket scooped frost off the windshield of a snow-packed black Mercury Montclair. Behind him, a priest in a purple cloak was slipping through the courtyard of the church through an opened gate on

f Mundane

his way to perform some sacred duty. Nearby, a bareheaded woman in boots tried to manage a laundry bag up the street. There were a million stories, just everyday New York things if you wanted to focus in on them. It was always right out in front of you, blended together, but you'd have to pull it apart to make any sense of it.

I used to get up in the mornings, shower, check the weather, dress accordingly, make sure the windows by the fire escape were closed, lock up, wait for the elevator, check whether the mail had arrived, say hello to the doorman. By the time I actually hit the street, the day was over and it was time to go home again.

Brook, p. 45

Why do I feel so happy when I take the Madison Avenue bus past Grand Central Station and down Park Avenue? I would get off at East Thirty-eighth Street and each time I descended from the bus, and stepped on the curb, I felt this inexpressible happiness. Every time. Was it Murray Hill? The station? The pretty trees on Thirty-eighth Street? Was it the sunset in winter, the skyscrapers in the strange cold air of autumn? Was it the elegant, parcel-laden ladies dashing out of cabs? Was it the light cast into the sky? I would walk across Thirty-eighth Street to Third Avenue, usually stopping at the Italian grocery store. I would climb the stairs to my third-floor apartment, put the food in the Frigidaire, sit down in a chair—and wait. The Third Avenue El rushed by. Silence for a while—and then I would wait again. What, I asked myself, am I waiting for?

Myers, p. 95

Time: the passage of time, the endlessness of time, the patter of repetition, of daily actions, the patterns of traffic (going to work, shopping, deliveries, children play in the street, coming home from work, the closing stores, etc.). The feeling of the day as a unit of time–awareness of time.

Turner, *Backward*, p. 101

He learns to tell the striking in utterly conventional form.

Hapgood, p. 99

The brooding emotional impact of what might have been ordinary evening occurrences: a trip to the corner store, a subway ride, a look at the newspaper on a park bench.

Sharpe, p. 282

Life is never free and easy in New York. One has too little to do or much too much. In no other city must existence be planned so carefully. Not to go out is to be forgotten, but one invitation leads to a dozen more. New York has too many cocktail acquaintances, and half the time people go out against their will and overtired.
 Yet one has the impression of being in much closer contact with everyday events in New York. The daily routine is more easily dispensed with. Everyone is more available and on hand. Somehow or other, everybody knows where and how the other person is spending his day and, without instructions having been left, you are successfully tracked down by the telephone, even in the most obscure restaurant that has been chosen for lunch. In Paris, to make a telephone call is an event. Here, telephoning is as easy as breathing ... Not only is it unwise, and even dangerous, to be listed in the telephone book, it has come to be considered inelegant.

Beaton, *New York*, p. 249

Do you have your name in the telephone book?
Cage: No, I don't, but that's not my wish. That's Merce's wish because he's involved with a large company of dancers and a school, so if his name were in the telephone book, it would be awful. Anyway, people find out what your number is whether it's in the book or not.

Cage, *Conversing*, p. 19

Finney, p. 104

I stood looking around for a moment at New York in the second half of the twentieth century. But there wasn't much to see besides the walls of the buildings around me, a long stretch of asphalt on which only a single cab was moving and a fragment of gray-black sky directly overhead too hazed for any stars to be visible. The day's car-exhaust seemed to have settled down here and was making my eyes smart; it had turned cold; and half a block down the cross street, on the corner of which I was standing, a group of young Negroes was walking toward Lex, so I didn't hang around to encounter them and explain how fond I'd always been of Martin Luther King. I walked on, up Lexington and then across town toward the warehouse; I felt tired, a little sleepy, yet so excited I was conscious of the beat of my heart.

Sante, "My Lost City"

For most people on the street—including, we liked to think, us—New York City was the only imaginable home, the only place that posted no outer limit on appearance or behavior.

Lefebvre, *Cities*, p. 94–5

Is the city the sum of indices and facts, of variables and parameters, of correlations, this collection of facts, of descriptions, a fragmentary analyses, because it is fragmentary?

Mumford, "Intolerable," pp. 283–93

Mr. Brown is proud of the fact that he keeps books or sells insurance on the eighteenth story of a skyscraper; but so much of the ground was used to build those splendid offices that Mr. Brown works most of the day under artificial light; and in spite of the slick system of ventilation, the middle of the afternoon finds him dull.

The journey home undoubtedly calls forth physical effort; unhappily it is not invigorating. The Swedish massage he receives at the hand of the subway guard does not improve his appetite; nor is it helped by the thick fumes of gasoline when he walks out upon the street. Eventually Mr. Brown sits down at his dinner table and looks out on an airshaft or a court where a dozen other kitchens have been busily preparing a dozen other meals; it never varies. No change in color, no hint of sunset or moonlight, no variation from season to season as the vegetation flourishes or shrivels: only the smells that creep through the windows tell the difference between Thursday and Friday.

Once upon a time Mr. Brown used to stretch his legs and play with the children; the six-room flat apartment was common in Boston and New York; the seven-room house flourished in Philadelphia and Chicago and St. Louis. Now the walls of the rooms have contracted: Mr. Brown pays so much for his four cubicles he is perhaps forced to harbor an ancient aunt or his wife's parents in the same narrow quarters; and, as likely as not, there are no children. When the Browns have put by a little they will have either a baby or a cheap car: it is hard to decide which, for the upkeep is high in both cases; but the car has this advantage—it would enable the whole family to get out into God's own country on Sundays.

This pursuit of God's own country would make the angels themselves weep: it means a ride through endless dusty streets, and along an equally straight and endless concrete road, breathing the dust and exhaust of the car ahead, and furnishing an equal quantum of exhaust and dust to the car behind; a ride with intervals spent at hot-dog stands, and long hours wasted at ferry houses and bridges and main junctions and similar bottlenecks, where the honking of impatient horns reminds Mr. Brown in the spring of the frog ponds he was not quite able to reach. As the main city grows, the country around becomes more suburban and the fields and hills and lakes are more difficult to reach. A generation ago Mr. Brown's father used to catch shad in the Hudson, or he might have spent the Sunday rambling with his youngsters along the bays and inlets of Long Island Sound. Today a vast load of sewage

f Mundane

has driven away the fish; and the expansion of great country estates for the lords of the metropolis has blocked and fenced off the rambler. Nor does New York alone suffer. Buffalo was forced to jump sixteen miles from the city line the other day to recover a paltry thousand feet of lake front for its citizens. By the time open spaces are set aside, however, the population has multiplied so furiously that, on a summer Sunday, the great parks are as congested as the city's streets—so much for solitude and natural beauty!

When dinner is over neither Mr. Brown nor his wife is in condition to listen to great music or to attend the theater. First of all, they are not in financial condition to do this because ground rents are high in the amusement district, and the price of seats has risen steadily to meet the increase in rents. Unless the occasion is important or Mr. Brown is willing to scrimp on the week's lunches, he cannot afford to go. Again, he is in no mental condition to participate in play that demands mental activity or emotional response above the spinal cord; and if this were not enough, the prospect of another hour in the subway kills most of the impinging [close together; touching] joys. The seventy theaters that exist in sophisticated New York are, really, only one to a hundred thousand people; there are a score of little towns in continental Europe that are far better provided with drama and music. The fact is that, with all New York's wealth, its cultural facilities are relatively limited: they would be insufficient were it not for the fact that only a minority can afford to enjoy them regularly.

But Mr. and Mrs. Brown have their amusements? Oh yes, they have the movies, that is to say, the same entertainment, served in almost the same form, as it comes in Peoria or Tuscaloosa or Danbury—no more and no less. If they are too tired to "drop around the corner" they have another consolation, the radio: this, too, works no better than it does in the despised, backward villages of the hinterland, and if the Browns happen to be situated in one of the mysterious "dead areas" it does not work nearly so well! In short, Mr. Brown travels through the pulping mill of the subway, endures the tawdry monotony of his flat, divorces himself from the natural environments he can never quite recover on Sunday—for what? For an occasional visit to the museum or the opera? He could have as much if he lived a hundred miles away. His sacrifices are in reality made for a much more mystical purpose: his presence increases the "greatness" of his city. By adding to its population, he raises the capitalizable value of its real estate; and so he increases rents; and so he makes parks and playgrounds and decent homes more difficult to obtain; and so he increases his own difficulties and burdens; and his flat gets smaller, his streets bleaker, and his annual tribute to the deities who build roads and subways and bridges and tunnels becomes more immense.

Mr. Brown grumbles; sometimes he complains; but he is only just beginning to doubt. His newspaper tells him that he is fortunate; and he believes it. He fancies that when another subway is built he will find room for his feet—if he leaves the office promptly.

A quiet couple sitting rapt and remote at a free concert at Yankee Stadium. Atkinson, p. 39

Young things in the cheapest seats at the Metropolitan. *Ibid.*, p. 40

And so the Madison Avenue car carries thousands past doors and gates that are marvels of loveliness in wrought iron, in perfect glass, in priceless bronze, and not an eye is lifted from the daily paper. Arnett, p. 98

The oft-quoted thumbnail sketch of New York is, of course: "It's a wonderful place, but I'd hate to live there." I have an idea that people from villages and small towns, people accustomed to the convenience and the friendliness White, *Here*, pp. 35–6

f Mundane

of neighborhood over-the-fence living, are unaware that life in New York follows the neighborhood pattern. The city is literally a composite of tens of thousands of tiny neighborhood units. There are, of course, the big districts and big units: Chelsea and Murray Hill and Gramercy (which are residential units), Harlem (a racial unit), Greenwich Village (a unit dedicated to the arts and other matters), and there is Radio City (a commercial development), Peter Cooper Village (a housing unit), the Medical Center (a sickness unit) and many other sections each of which has some distinguishing characteristic. But the curious thing about New York is that each large geographical unit is composed of countless small neighborhoods. Each neighborhood is virtually self-sufficient. Usually it is no more than two or three blocks long and a couple of blocks wide. Each area is a city within a city within a city. Thus, no matter where you live in New York, you will find within a block or two a grocery store, a barbershop, a newsstand and shoeshine shack, an ice-coal-and-wood cellar (where you write your order on a pad outside as you walk by), a dry cleaner, a laundry, a delicatessen (beer and sandwiches delivered at any hour to your door), a flower shop, an undertaker's parlor, a movie house, a radio-repair shop, a stationer, a haberdasher, a tailor, a drugstore, a garage, a tearoom, a saloon, a hardware store, a liquor store, a shoe-repair shop. Every block or two, in most residential sections of New York, is a little main street. A man starts for work in the morning and before he has gone two hundred yards he has completed half a dozen missions: bought a paper, left a pair of shoes to be soled, picked up a pack of cigarettes, ordered a bottle of whiskey to be dispatched in the opposite direction against his home-coming, written a message to the unseen forces of the wood cellar, and notified the dry cleaner that a pair of trousers awaits call. Homeward bound eight hours later, he buys a bunch of pussy willows, a Mazda bulb, a drink, a shine—all between the corner where he steps off the bus and his apartment. So complete is each neighborhood, and so strong the sense of neighborhood, that many a New Yorker spends a lifetime within the confines of an area smaller than a country village. Let him walk two blocks from his corner and he is in a strange land and will feel uneasy till he gets back.

Conrad, p. 189

New York as an assembly of cells or cadres which he must syndicalize, a hive of separate neighborhoods, each with its own economic specialism.

Berger, *New York*, p. 4

Storekeepers are particularly conscious of neighborhood boundary lines. A woman friend of mine moved recently from one apartment to another, a distance of three blocks. When she turned up, the day after the move, at the same grocer's that she had patronized for years, the proprietor was in ecstasy—almost in tears—at seeing her. "I was afraid," he said, "now that you've moved away I wouldn't be seeing you any more." To him, away was three blocks, or about seven hundred and fifty feet.

Jackson and Dunbar, p. 620

The city's microcosms, synchronized but unaware of one another.

Weekend

Weegee, *Naked*, p. 14

Sunday morning in Manhattan. This is the most peaceful time of the whole week. Everything is so quiet … no traffic noises … and no crime either. People are just too exhausted for anything. The Sunday papers, all bundled up, are thrown on the sidewalk in front of the still-closed candy stores and newspaper stands. New Yorkers like their Sunday papers, especially the lonely men and women who live in furnished rooms. They leave early to get the papers … they get two. One of the standard-size papers, either the *Times*

or *Tribune* ... they're thick and heavy, plenty of reading in them, and then also the tabloid *Mirror* ... to read Winchell and learn all about Cafe Society and the Broadway playboys and their Glamour Girl Friends. Then back to the room ... to read and read ... to drive away loneliness ... but one tires of reading. One wants someone to talk to, to argue with, and yes, someone to make love to. How about a movie—NO—too damn much talking on the screen. "But Darling I do love you ... RAHLLY I do," ... then the final clinch with the lovers in each others arms ... then it's even worse, to go back alone to the furnished room ... to look up at the ceiling and cry oneself to sleep.

Sunday morning is the only time these cuties get a chance to get cleaned up ... while the store is closed ... they are taken from the store window ... their garments with price tags removed ... and given a thorough scrubbing ... the mannequins are patterned after the current Hollywood movie glamour stars ... and are worth their weight in gold, each one costing a few hundred dollars.

Ibid., p. 15

The weekend is not so much longed for as tumbled across by accident.

Blandford, p. 119

Weekends are but a hiatus in money-making.

Ibid., p. 183

There is Saturday, but Saturday is not much better than Monday through Friday. Saturday is the day for errands in New York. More millions of shoppers are pouring in to keep the place jammed up. Everybody is bobbing around, running up to Yorkville to pick up those arty cheeses for this evening, or down to Fourth Avenue to try to find the Van Vechten book, *Parties*, to complete the set for somebody, or off to the cleaner's, the dentist's, the hairdresser's.

Wolfe, "Sunday," p. 295

I hate Sundays: there's nothing open except plant stores and bookstores.

Warhol, *Philosophy*, p. 133

On Sunday the city ceases to be anything, the streets being empty and the buildings deprived of their meaning ... Sunday is an astonishing touchstone which, for twenty-four hours, can cause the collapse of this magnificent city which, in its essence, is still a Babel.

Corbusier, p. xv

Sunday has come and with it creeps into the empty street all the life that for the other six days bides its time till night and gives no sign of existence.

Campbell, Knox, and Byrnes, p. 50

The grey depression of a musical Sunday afternoon at Carnegie Hall.

Jackson and Dunbar, p. 566

Chronicle

George Bellows, just before his death, patiently expounding his defense of an alleged indecent picture: "Art strives for form and hopes for beauty" ... Jed Harris, sitting at a prizefight and undergoing more intense agony than either man in the ring ... Dr. John Roach Straton, of the sepulchral voice, pointing to the rude chairs which he had made for his bride years before and declaiming, "You know, the Master was a carpenter" ... Owney Madden, turning to Walter Winchell and snarling, "You louse! You think you know so much about Broadway and you never heard of Doody Broderick!" ... Charles Francis Potter, the Humanist, and his admiring tales of the great deeds of Oom the Omnipotent ... William J. Guard, looking more like Robert Louis Stevenson than Stevenson looked, lying in his coffin ... Frederic MacMonflies, the sculptor of "Civic Virtue" in City Hall Park, defending his private opinion that it was the best of his works ... My first meeting with Edwin C. Hill, the great

Walker, *Night Club*, pp. 298–321

reporter, who mistook me for an office boy … A last train ride with James J. Corbett, obviously dying but able to growl in his rich barytone, "I'll be all right, boys" … Whit Burnett and the amazing brown beard which he brought back from Majorca … Texas Guinan, one afternoon in the old Stork Club, whispering to a friend, "I hear they snatched Big Frenchy last night" … J. Frank Dobie, the "Pancho" of the brush country in the Southwest, patiently enduring a literary tea … Walter Davenport the night in Jimmy Kelly's, when he believed the Apache dance was real and chivalrously rose to the defense of the girl … The old San Quentin graduate who gave me the friendly smile as I picked him out of a line-up at the Tombs for misdeeds that sent him on a long stretch to Sing Sing … Keats Speed, most understanding of managing editors, walking seventy feet to say a kind word to a reporter … Frederic F. Van de Water, tall and white-haired, and his formal greeting, "Good evening, Commissioner" … Joel Sayre, former bodyguard to Admiral Koichak, giving the supreme rendition of "Frankie and Johnny" … Captain Stephen Norton Bobo, leaping from his automobile to paint a landscape that had attracted him … Herbert Hoover, as Secretary of Commerce, reading in a dull monotone a speech he had written for a small gathering at the old Waldorf … Senator Huey Long, king of the canebrakes, sitting up in bed in the New Yorker Hotel eating peanuts … Don Skene's definition of an old cow-country word: "A maverick is a lamister dogey" … Dashiell Hammett's old assignment when he worked for the Pinkertons—to find a Ferris wheel which had been stolen in Sacramento, California … Cameron Rogers, in top hat, morning coat and striped trousers, touring the countryside on New Year's Day in a rented Rolls-Royce … A memory of Richard A. Knight, now the most amusing of New York lawyers: a little boy with a large head riding a bicycle down Guadalupe Street, Austin, Texas, and reciting Byron aloud … Henry L. Mencken, barging down Fifth Avenue during the dull days of the Coolidge administration and wishing for another war … Ruth Hale, wife of Heywood Broun and most articulate of the Lucy Stoners, denouncing me in Barney Gallant's for some ancient injustice … John Nance Garner, Vice-President of the United States, and his friend, Edward Angly, newspaper man and author of "Oh, Yeah!", taking a drink, which they called "striking a blow for Liberty" … James W. Elliott, of the old Business Builders, sitting at a table at the Algonquin and expounding the technique of selling cemeteries … James J. Montague's stories of his long service with the quixotic William Randolph Hearst … Alice Roosevelt Longworth giving her dinner-table parody of her cousin, Mrs. Franklin D. Roosevelt, speaking over the radio, a great bit of mimicry … The deadly, close-clipped command of Captain Patrick McVeigh of New York Police Headquarters as he turned to his strong-arm squad during a raid on a clip: "Toss this joint in the street" … The gentle Adolph, who cultivated tobacco plants on the roof-top speakeasy, now closed, where Dudley Field Malone once had had his penthouse … The proud terror of Herbert Asbury the week he thought he had been threatened by gangsters … The pathetic incredulity of Geoffrey Parsons when he was told that, in many parts of the country, cemeteries are the most popular spots of assignation … Ring W. Lardner, coming in drenched after the Dempsey-Tunney fight at Philadelphia and announcing that Tunney would be the most popular champion since Tommy Burns … Gene Buck, sentimental old songwriter, propounding his belief that when love is weighed against duty and all else, "one woman's hair is stronger than the Atlantic cable" … Gene Fowler joining me one Sunday afternoon in hiring an open hansom cab to convey us to a meeting of hoboes on the East Side, where James Eads How presided … William Muldoon, the Solid Man, sitting in his "hygienic institute" in Westchester and showing his sentimental side, his deep affection for Kid McCoy, the bad boy of pugilism … Owen Oliver, who, when past sixty,

smoked twelve cigars a day and walked from his office at 280 Broadway to his home in Yonkers … Robert Livingstone, New York's first bluestocking reporter, and his memories of Paddy the Pig, once-famous dive keeper … Martin W. Littleton, lawyer, eating at the Lunch Club of Wall Street and pointing to another lawyer with the remark that "there goes an astridulent zither" … Owen P. White, the grizzled plainsman, and his tales of the feuds and tangled politics of New Mexico … Hector Fuller, who was Jimmy Walker's writer of scrolls for distinguished guests during the years of the Great Madness, and his embarrassment when he erroneously referred to Queen Marie of Roumania as "Your Imperial Highness" … John Francis Curry, close-mouthed leader of Tammany Hall, in the days when he was a district leader and a writer of eloquent and bitter letters … William J. Fallon, criminal lawyer, putting on one of the greatest shows of his life conducting the defense in the Bronx of a little chauffeur named Fritz, on trial for killing his sweetheart, and getting an acquittal … Louis Bromfield, in the days when he worked for the Associated Press and toured the newspaper offices late at night checking up on dull items … Frank Sullivan, fresh from Saratoga Springs, in the precarious days when he and I were cubs under William A. Willis on the old Herald at Herald Square … Silliman Evans, Fourth Assistant Postmaster General under the New Deal, and the time he was almost fired from a paper for spelling "sergeant" correctly because his boss thought it was spelled "sargent" … The astonishingly pointed nose of Felix, major-domo at Madame Mon's place in Bleecker Street … Griffo, once the most scientific of fighters, sitting in his later days, bloated and coarse, catching live flies with his lightning-like paws and releasing them unhurt for the amusement of street gamins … William O. McGeehan, the old Sheriff, explaining to a young man who had been drinking too much that one particular specter, a sinister fellow with hip boots, dinner jacket and fireman's helmet, was a harmless fellow once you got to know him … The curious belief of many persons that Edward P. Mulrooney, former Police Commissioner and now in control of New York State's beer, is a heavy drinker, while the truth is that he never drank, not even 3.2% beer … Harry Staton, former circus press agent, singing hymns from 5 o'clock in the afternoon until 3 o'clock in the morning and getting them all perfect … Bob Clifford, managing genius of society funerals, arguing that William Jennings Bryan should not be buried in Arlington Cemetery … Leo Newman, the ticket broker, who, when meeting a new acquaintance, likely as not will pull out a new necktie and give it to him … Georges Carpentier and the beautiful women who lolled about him on the porch of his training camp at Manhasset the day after he was beaten by Dempsey in 1921 … Julius Tannen, the monologist, coming back to New York in 1933 with an iron-gray toupee making him almost unrecognizable … Abner Rubien, the great mouthpiece, telling about what a whale of a wrestler he was at Cornell … Nunnally Johnson, deeply moved at the funeral of Zip, the circus freak … Percy Hammond, quivering with fright the day after he had been gypped in a fly-by-night speakeasy, and his relief when the place was broken up … Chester T. Crowell, who can eat three heaping plates of tripe in an Italian restaurant, and who, though highly literate, pronounces it clen'th and stren'th … E. E. Paramore, author of the immortal "Ballad of Yukon Jake," sitting in a corner at the Brevoort … Beverly Smith, the old quarter-miler of Johns Hopkins, who, though the most cynical of men, writes success stories for a magazine … Armstead R. Holcombe, the good gray editor, at whose behest I once had the prostitutes chased off Riverside Drive … William Archer Sholto Douglas, author of "The End of Oofty-Goofty," who made himself an expert on the dialect and folkways of many parts of America … Clare Briggs, in the days before his last illness, when he wore a yellow coat, wing collar and stick, hat cocked on one side and was the life of the party … Richard Reagan, who

covers the New York waterfront, and his practically interminable recollection of the time when he almost became a Trappist monk … Enrico Caruso, the day he was able to leave the Vanderbilt after his long illness … Reginald A. Wilson, the Canadian, handsomest of all reporters, who dropped dead on the station platform in Albany … Charles B. Falls, proud of his lithograph of the old Everleigh Club in Chicago as it looks today … John F. Hylan, former Mayor, and his splendid denunciations of what he called "art artists" … Herbert Bayard Swope in a poker game with Gerhard M. Dahi, a battle to the death between the two greatest extroverts of the Western World … James Stephens, the Irish writer, drinking Irish whisky in the home of the late Cornelius J. Sullivan, New York lawyer … Nicholas Murray Butler, and his anger when it was called to his attention following a speech at the Metropolitan Opera House that he had said "neutrality don't" … Julian Starkweather Mason and his elegant long cigarette holders … Lucius Beebe and his Tattersall waistcoats … The touching grief of Thyra Samter Winslow at the death of her pet dog, Lobo, a superannuated Pomeranian … The explanation of Joab H. Banton, former District Attorney of New York County, that the initial "H." didn't stand for anything but was there merely because he liked it … Col. Oscar H. Fogg refusing to acknowledge the greetings of a man he didn't like at a dinner at the Astor, and remarking to no one in particular, "I like clean things" … James W. Barrett's lengthy song which he developed from a limerick based upon the doings of the late Chile Mapocha Acuna, stool pigeon of the vice squad … Silas Bent and his patronizing greeting of "Young man" … Julian Street Jr. being bawled out by his father-in-law, Frank A. Vanderlip, for being late at a lunch at the Union League Club … Laurence Stallings, before the days of "What Price Glory," expounding his theories of literature over a table at the Newspaper Club … Eddie Jackson, the photographer, and his almost reverential love for the memory of Woodrow Wilson … The jokes cracked by the late Harry Reichenbach, press agent, when District Attorney Edward Swann summoned him in connection with a fake drowning in the Central Park lake … Detective Edward T. V. Fitzgerald of Headquarters, who, when pressed, will exhibit a bullet imbedded just below the skin in the calf of his leg … Bruce Gould, sitting at the Rhinelander annulment trial in 1925, barely able to control his amusement at the fantastic evidence … Frank W. Wozencraft, once the boy Mayor of Dallas, Texas, learning the ropes of New York, from the University Club bar to Madison Square Garden … Earl Carroll, pale-faced, long-haired and smiling wanly, lunching at the Lambs … Joe Cook and his fabulous place at Lake Hopatcong, New Jersey, where, in the living room, are suspended every imaginable object that is no larger than a man's hand … Dexter Fellows, the great circus press agent, who, when told that the show was stupendous and dazzling, waved his hand deprecatingly and said, "I wouldn't go that far" … An afternoon in a New York apartment listening to the greatest tale of adventure of the twenties, the story of J. Frank Norfleet, the Texas rancher who lost his life's savings to a gang of confidence men and who trailed them to the ends of the earth and caught them all … Al Smith, on his way to a Democratic picnic in Chicago in 1925, sitting up most of the night on the train singing old songs … Walter Howey, drinking brandy in a drawing room on a Pennsylvania Railroad train and telling of the old days in Chicago newspaperdom, the days of "The Front Page" … The yachting parties of Larry Schwab and the fast set of the North Shore of Long Island … Steve Hannegan's tale of his wild, lonely drive through the Middle West to find his favorite surgeon and have his appendix removed … Kent Watson, who, in the early days of prohibition in New York, accompanied the agents on most of their liquor raids … Phil Stong, who once hung around the Criminal Courts Building but who later made money and had Young Otto come to his apartment to give him boxing lessons … Freddie

Wildman, now planning to import wine from France in large quantities, engaged in long conversation with John Perrona, proprietor of the old Bath Club in West Fifty-third street ... Father Wilfrid Parsons, one of the most articulate, engaging and realistic of priests ... Whitney Bolton, the most Broadway-struck young man who ever came from South Carolina ... Larry Smits, the bald lion of the tea parties ... B. O. McAnney and his realistic imitations of tree frogs, best performed late at night ... Stuart P. Sherman, who came to New York a shy professor from the Middle West and had begun to like the place before he was drowned ... Gene Tunney, delivering a lecture to a panhandler who had poked his head into Tunney's cab, and then giving the bum a quarter ... The late Harriette Underhill, motion picture critic, who came back to Broadway from Saranac to work and die ... The Rev. J. H. Randolph Ray of the Little Church Around the Corner and the ex-convict forger whom he sought to befriend, to no purpose ... Harold Ross and his almost pathological fear of crossing bridges in a cab ... Dan Williams, the crusading editor, and his gestures as he inveighs against evil ... Lulu Volimer, when she lived in Eighth Street before she wrote the play, "Sun-Up" ... The exciting wedding of Morris Gilbert in the old church in Hudson Street ... George Gray Barnard, hair waving, discoursing in organ tones in an apartment in West Seventy-second Street ... Holger Lundberg, the Swedish poet, who can say "Thank you" in more different ways than any man in New York ... Justice Peter Schmuck of the New York Supreme Court, explaining that he drew upon Carlyle for his amazing prose style, which is the marvel of the New York bar ... James Thurber, very tired, sitting quietly fondling a French poodle ... Ross Santee, the artist, as gentle a soul as ever came out of the desert ... Cornelius Vanderbilt, Jr., who, as a cub reporter on the old Herald, used to come to work in his automobile, a strange sight in those days ... Oliver H. P. Garrett, who is now wealthy in Hollywood, and his consuming fear the night before he left New York that he would not make good ... The spectacle of David Belasco and Benny Leonard in earnest conversation at a prizefight ... The Hahn girls from Chicago—Helen, Emily and Josephine— and how they captured New York ... Isabel Ross, who suffers dreadfully from seasickness but who passes most of her spare time on the ocean ... Dorothy Parker, the night she set out confessional sports, and his identification of a popular character, "Just a con man, but a nice guy" ... The night in the Park Avenue Club where I saw Bill Corum for the first time since 1920 ... The night in 1920 when Tris Speaker, then manager of the Cleveland Indians, came into Moore's restaurant with his ballplayers and all shucked off their coats because it was so hot ... The curious truth, probably of little importance, that there are two Tony Weirs; one Tony Weir, a big fellow, used to be a bartender at the Knickerbocker, while the other, a short man, has looked out for the public welfare both before and during prohibition ... Tim Shine, old saloonkeeper and the yarns of how he kept every cent he ever made ... Paul Mellon, son of Andrew W. Mellon, sitting in a café and planning to go to work for a bank ... Tony Muto, who got the "bends" by going down with the sand-hogs under the Hudson to write a story about it ... John Stewart Bryan, the tall, gray, Virginia publisher, and the night he was charged with being head of the Confederate Army ... William Macbeth and Wilbert Robinson, rotund and Rabelaisian, and great friends ... Sam Untermyer, Mephisto, flower-lover, great lawyer, riding through the Bronx in his Mercedes late at night and quoting Tennyson's "Locksley Hall" ... Lawrence Tibbett, fresh from one of his early triumphs at the Metropolitan Opera House, dropping in at a near-by oasis ... Larry Fay at 4 o'clock in the morning sitting with a beautiful woman in Reuben's ... Joseph Shalleck, criminal lawyer, reeling into a political headquarters in the old Hotel Marlboro one night, bleeding from a beating suffered at the polls ... Franklin D. Roosevelt, tall, lean, dark,

amazingly alert and eloquent, captivating a group of women in an uptown club with a speech just before he was stricken with infantile paralysis ... Marquis (Gimpy) Curtis, one of the smartest of criminals, being captured by Detectives under Inspector John D. Coughlin in an apartment on the West Side ... Dr. Francis Carter Wood, the cancer specialist, and his lifetime work of exposing fake cancer cures ... David Hirshfield, later a Magistrate, trying to joke with a waitress at the lunch counter of the Hotel Pennsylvania ... Mike Haggerty's terse description of a garment worn by one of the women involved in the murder of Joseph Bowne Elwell ... Artie Hitchman, the little ticket hawker, the freshest kid on Broadway ... John McHugh Stuart, the mysterious journalist who brought about the conference which resulted in the forming of the Irish Free State ... Richard Maney's first remark on recovering consciousness after having been knocked out by a Jew whom he had been chaffing in a barroom: "Custer in the Ghetto" ... Donald Henderson Clarke, returns come in on the night of the Roosevelt landslide ... Jack Johnson, the big smoke, giving an afternoon sermon on clean living in a Harlem Negro church ... William Travers Jerome, in his last fling in support of reform in the municipal election of 1921, smoking innumerable cigarettes and snarling his scorn of loose public officials ... Inspector John J. Sullivan, in charge of New York detectives, presiding at the line-up of criminals at Headquarters and tearing into each prisoner with a savagery that suggested that he must have done something to Sullivan personally ... An unfortunate brawl at Reuben's old place on Broadway, which ended with two beautiful women carrying out a battered and unconscious actor head first ... Morris Tremaine, Comptroller of the State of New York, having a glass of legal beer with the boys and discoursing upon the excellent quality of a forthcoming bond issue ... Detective Hugh Sheridan, gray-haired, probably the most suave and gentlemanly of all of New York's thug-hunters ... Harry Benge Crozier telling everybody that he had just rediscovered O. Henry and found him great ... The amazing energy of Grantland Rice, probably due to clean living ... Louis Fehr, heftiest of New York journalists, who can, and does, toss off a Scotch highball in one gulp, which is no mean trick ... The unimportant but rather curious fact that I have never met, or seen, or talked over the telephone with O. O. McIntyre ... The unbelievable face and the scrambled vocabulary of Phily Lewis (born Luigi Filippi) as he attempted, in Duffy's Tavern, to conceal the fact that he couldn't read ... The handsome mustaches of Stanley Sackett, manager of the Madison, who looks and acts like an improvement on the visions of Peter Arno ... Ned McIntosh, the misanthrope, and his insistence that he must live in a pent-house ... Eddie McBride, the veteran artist, and his high-pitched, complaining voice ... Dr. John C. Moorhead, great surgeon, and his tales of the broken bones of men from war time on ... John D. Rockefeller, Jr., walking with his boys down Fifth Avenue on an Easter morning ... Alva Johnston, best of all reporters, doing more work over the telephone in an hour than a dozen leg men could do in a month ... Burton Rascoe, stammering in his excitement, recalling the rough old days in Chicago ... Ward Greene, and his willingness to forget that he had been reported dead and his obituary printed in full ... Jimmy Walker on a Staten Island ferryboat giving advice to a consumptive who was about to go away: "Don't stand up if you can sit down; don't sit down if you can lie down" ... The Rev. Dr. Charles H. Parkhurst, at eighty-five, sitting in a hotel room just off Broadway and chuckling about how he could hold abiding cynicism of Joseph Mulvaney, Hearst's great rewrite man ... Mildred Paxton, the week before she went back to Texas to become the bride of Dan Moody, who later became Governor ... Earl Reeves, perfect householder, who can cook, do interior decorating and chop trees ... The infinite poses and the essential soundness of Franklin Pierce Adams ... Will James, the cowboy artist, puzzled and sick on his first trip to New York ...

500 John Bleeck, club owner, and his diatribes against crooked prohibition agents … Robert Barton Peck, who, though busy in New York for more than twenty years, still has his chief interest in the early Indian troubles in Western Pennsylvania … The blush of Joseph Phillips, who, excepting Irvin S. Cobb, is the only man ever to come from Paducah, Kentucky … Heywood Broun trying to disguise himself so he could pass the night in the Municipal Lodging House without being recognized, a palpably impossible feat … John W. Goff, New York's last Recorder, at the reception for Eamonn de Valera in 1920 … The dinner table banter of Alexander Woollcott … An evening with Frank E. Campbell, the undertaker, at Janssen's old place, and his straightfaced, blood-chilling jocosity … The girl who used to smuggle notes out of prison for her sweetheart, in the belief that, somehow, he might get out in less than ten years … Jack Sharkey, in his hotel room, yelling to a waiter to throw a raw steak through the transom instead of bringing in an ordinary dinner … A murderous appetite, and a breakfast of bacon and eggs near the water at Fire Island … A little island in Lake George, amid the clear water, where there are neither bucket shops nor clip joints nor traffic jams … A roof on Central Park South, very late at night, with no noise except distant music and the low hum of far-off motor cars … A walk along the Palisades at dawn, and the sight of New York's skyline unfolding and the city coming to life … The unforgettable sound of a human head hitting a concrete floor … Time for one more before we catch the train.

Morrisroe, *Mapplethorpe*, p. 181	Robert Mapplethorpe was the 1970s leather-clad equivalent of the great dandies and decadents of the nineteenth century—Beardsley, Oscar Wilde, Huysmans, Baudelaire. What made his personality so intriguing were the same qualities found in his work—the chilling contrast between the viciousness of his sexuality and the grace and finesse of his personal style. Mapplethorpe embodied both Dionysian and Apollonian qualities—Dionysus being the "god of frenzy" and Apollo "the god of proportion and form."
Ibid., p. 209	Verlaine, Rimbaud, Smith, Mapplethorpe; we are dealing here with a network of homage and swapped destinies, like Piaf and Cocteau, people who would die within minutes of each other.
Didion, *Some Women*	A Rimbaud of the baths.
Morrisroe, *Mapplethorpe*, p. 272	A perverse Oscar Wilde-meets-Duchamp reworking of the highly charged imagery of church and state.
Mapplethorpe Foundation	Of his childhood he said, "I come from suburban America. It was a very safe environment and it was a good place to come from in that it was a good place to leave."
Fritscher, p. 78	Robert will always be a figure of bizarre fascination. He's no Oscar Wilde. He never produced in photography, no matter how much his "perfect moments" are touted, anything as good as *The Importance of Being Earnest*, which is the perfect symbol of comedy.
Ibid.	Mapplethorpe is virtually a retroversion of *The Picture of Dorian Gray*. Certainly, in court and controversy, Mapplethorpe is this *fin de siècle*'s Wilde with a Hasselblad.
Ibid., p. 6	He was as fated as Byron, Shelley, and Keats to die prematurely, the same as James Byron Dean, Jimi Hendrix, Janis Joplin and his famous look-alike, the poet-singer of the perverse, Jim Morrison of The Doors.
Ibid., p. 171	Half in love with mournful death, Robert particularly worshipped rock star Jim Morrison, the pouty Botticelli lead singer of The Doors. Robert physically resembled Morrison and, after the singer's mysterious death in Paris, in July 1971, Robert, three years younger than Morrison, began to assume the dead singer's look, attitude, and doomed-angel leather-style straight out of auto-cide James Dean.
Ibid., p. 25	An androgynous Burton and Taylor.
Ibid., p. 72	The Diaghilev milieu would have suited Robert very well.
Ibid., p. 101	Patti Smith may have been his Mona Lisa odalisque, but Isadora Duncan is the woman most inherently presage of Mapplethorpe.
Ibid., p. 130	Mapplethorpe was typical of those deliberately artificial artists, somewhat like Gustav Moreau, who helped begat Art Nouveau. Moreau and that group admired in Michelangelo's figures what they took to be the "ideal somnambulism" of Michelangelo's figures.
Ibid., p. 184	Derivations: works reference the Bible, Baudelaire, Beardsley, Rimbaud, George Platt Lynes, and George Dureau, but all reimagined through the

identifiable Mapplethorpe Spin—that confrontational edge to render his sources more controversial and commercial.

He aspired to a code of conduct hardly typical of his times, somewhere between dandyism and gentlemanliness.

Danto, p. 24

He is fascinated by the satanic and confronts his night-based world with the elegant and melancholic stance of the dandy. He stumbles through the day like a sleepwalker, but comes alive and charged with energy after dark. He uses the photographer's lamp as though it were an artificial moon.

Chatwin and Mapplethorpe, p. 9

His classic narcissism was perfect for the seventies.

Fritscher, p. 102

Ezra Pound once wrote that "the age demanded an image of its accelerated grimace," and Mapplethorpe provided his age with the very image it required.

White and Mapplethorpe, p. 129

That crucial "moment," not yet a "perfect moment," was that nano-second when Robert "came out" from heterosexuality into the homosexuality that would certify him as genuinely avant-garde.

Fritscher, p. 70

He was his own greatest object.

Ibid., p. 99

Mapplethorpe seemed incapable of handling even the most basic tasks: he couldn't compose business letters, couldn't be bothered to eat lunch.

Morrisroe, *Mapplethorpe*, p. 255

Robert complains about people who say the word *apple* in Mapplethorpe; he hates worse when I call him "Nipplethorpe."

Fritscher, p. 59

Robert is so urbane and cool and classic.

Ibid., p. 62

Mapplethorpe would stamp his foot to get people to pay attention.

Ibid., p. 92

He likes cameras, Coke, kooks, and Crisco.

Ibid., p. 93

He was five feet ten inches and 150 pounds, hung about six inches and virtually without body hair.

Ibid., p. 92

Robert's wafer-thin, drug-waif body, adroitly abstracted by black leather, was unimportant, really, compared with his head. More specifically, his face, especially his eyes, and, despite his androgynous inability to grow a real beard, his triumph of black faun-hair and aggressive Pan-teeth captured people's attention.

Ibid.

Robert hated bodybuilding the way he hated blacks; he couldn't get enough.

Ibid., p. 220

He is, in fact, his Hasselblad. His camera eye peels faces, bodies, and trips.

Ibid., p. 93

He rearranges reality in his SoHo loft in Manhattan. His studio is his space for living, balling, and shooting. He lunches afternoons at One Fifth Avenue. He maneuvers after midnight at the Mineshaft. He photographs princesses like Margaret, bodybuilders like Arnold, rockstars like his best friend Patti Smith, and night trippers nameless in leather, rubber, and ropes. He's famous for his photographs of faces, flowers, and fetishes.

Ibid., pp. 93–4

Morrisroe, *Mapplethorpe*, p. 186 Never in his wildest imagination did he think his own son would embrace the holy trinity of parental nightmares: he was an artist, a homosexual, *and* a pornographer.

White and Mapplethorpe, p. 129 My life began in the summer of 1969. Before that I didn't exist.

Morrisroe, *Mapplethorpe*, p. 32 1964—Mapplethorpe works at the World's Fair, where he operated the games of chance at the Belgian Pavilion. Sees Warhol's *Ten Most Wanted Men*.

Ibid. Mapplethorpe on Warhol in 1964: "Someone who knew what he was doing."

Ibid., p. 297 In Mapplethorpe's loft, looming over the sitting room adjacent to his bedroom was the ultimate symbol of his success—a Warhol silkscreen portrait of Mapplethorpe himself.

Ibid., p. 140 The then-editor of *Interview* did indeed have a crush on Mapplethorpe. "He's so dirty," Warhol complained. "His feet smell. He has no money. And that horrible Patti Smith … " Mapplethorpe worried that Warhol was going to steal his ideas and viewed him, perhaps rightfully so, as someone who had sucked the life out of people.

Ibid., p. 317 January 16, 1978—Mapplethorpe attended a dinner for the artist David Salle at Mr. Chow's. Andy Warhol refused to sit next to him because, as he later recorded in his diary, "he's sick."

Ibid., p. 359 Warhol longed to be a machine; Mapplethorpe found comfort behind one.

Fritscher, p. 72 Robert charged into the scene and opened it up. He was young, fresh, and coyly abrasive. His bold condescension, his icy coldness to anyone who challenged him, was excitingly assaultive in a decade when theater loved cruelty. He broke the perceived taste of the avant-garde obeying Warhol's pontifications.

Ibid., p. 74 Warhol wrote the sort of book that was *Popism*, ghost-written, really. Mapplethorpe wrote only letters. Maybe he hadn't enough intellectual mass to write. He wasn't well educated. He was great at small talk: deflecting, derailing, trivializing, humoring. I remember him saying that primitive tribes who believed the camera sees the soul were right. Maybe that says everything he had to say about his photography.

Ibid., p. 77 Like Warhol, who let other people do his work, Mapplethorpe sometimes seemed more into product than art.

Ibid., p. 91 Andy's taste ran to the fashionable. Robert tilted more toward the arcane.

Ibid., p. 97 Robert's own messy life and formal art, enhanced by drugs and the rags-to-riches mystique of Warhol, defined itself by seesawing, through fashion and society, and from art to commerce. Mapplethorpe threw himself headfirst into this trendy world for his rites of passage.

Ibid., p. 118 At the beginning of 1994, Warhol's estate was block-priced at $220 million; Mapplethorpe's $228 million.

Ibid., p. 196 Mapplethorpe received no substantial cash from Warhol for his photographic work in *Interview*. He traded his photographs for Andy's endorsement.

Candy Darling, whom Robert shot in 1973, once complained to Robert that it was so dreadfully boring and difficult to find something famous to do everyday.

Ibid.

Andy and Robert would have loved fax.

Ibid.

Early Mapplethorpe collage of Warhol, found portrait. A tear bisects the right eye and a layer of spray paint delineates a ghostlike finger shape that seems to point to this torn area, emphasizing the fact that what Mapplethorpe selected, painted, and claimed as his own was a photograph of a damaged photograph. His recognition of a photograph as object.

Marshall, p. 8

Mapplethorpe codged drugs, sex, leather, superstars, and ideas from the underground movies of Warhol and Anger.

Fritscher, p. 274

I mean the fact that Warhol says, "anything can be art," and then I can make pornography art.

Kardon, p. 28

He smiled and introduced himself as "Robert Mapplethorpe, the pornographic photographer."

Fritscher, p. 181

I'm a male nymphomaniac.

Ibid., p. 30

The idea of the homomasculine man.

Morrisroe, *Mapplethorpe*, p. 164

Mapplethorpe once joked that he was just a "fag decorator."

Ibid., p. 179

Sex is the only thing worth living for.

Ibid., p. 127

I had many affairs during that period, but I was never into quickie sex. I've only slept with maybe a thousand men.

Ibid., p. 189

Near the bed hung a "masturbation machine," which he had designed by surrounding a mirror with dozens of white lights that blinked off and on, like a carnival roulette wheel.

Ibid., p. 126

No sex tonight? Then how about some photographs?

Fritscher, p. 177

Few admit to bedding him. Some who do, say it didn't work, usually because of the drugs. He was very affectionate, but he wasn't emotional sex; he was intellectual sex. Accepted for that novelty, he was a stimulating partner, if one likes to have rational sex, which to some is not as torrid as passionate sex. Mapplethorpe used every sexual fetish and gimmick he could find to try to ignite real heat and passion in himself and his work. That's why he turned to leather, and that's why he turned to black men, in his quest of the passion's soul.

Ibid., p. 180

Art and sex in the seventies are inextricably linked.

Ibid., p. 102

Mapplethorpe: "You're afraid to go as far into nasty sex as I want to take you."

Ibid., p. 28

S&M not as sadism and masochism, but as "sex and magic."

Morrisroe, *Mapplethorpe*, p. 145

Sex *is* magic. If you channel it right, there's more energy in sex than there is in art.

Ibid.

Sadomasochism was practiced by only a small percentage of the gay population, yet the uniforms and equipment were everywhere in the West Village. S&M accessories, such as studded cuffs, ropes, chains, and bondage masks, were sold at places like the Marquis de Sade and the Pleasure Chest. Artist Robert Morris publicized his April exhibit at the Castelli-Sonnabend Gallery by designing a poster that featured him in a Nazi helmet, his hands manacled to a thick chain attached to his neck. Susan Sontag in her 1974 essay "Fascinating Fascism" quotes Morris as saying he considered the picture to be "the only image that still has any power to shock." Six months later, Italian film director Lilana Cavani brought out *The Night Porter*, the story of an SS officer who carries on an S&M love affair with one of his former concentration victims. The following year S&M had so infiltrated American consumer culture that it was being used to sell everything from clothes to records.

Ibid., p. 147

What was so different about Mapplethorpe's work, and consequently more unsettling, was that instead of a woman being tied up in ropes—a standard pose in straight photography—he had the audacity to turn the tables and reveal a whole universe of submissive men. Helmut Newton could photograph a woman tethered to a bed by a chain around her neck, or another crouched on all fours, with a saddle on her back, and the images were vied as kinky and decadent, for they conjured up a privileged world of *Vogue* fashion shoots and jet-set society. In comparison, Mapplethorpe's S&M photographs made no reference to the outside world at all; his men were defined exclusively by their sexual predilections.

Ibid., p. 153

Mapplethorpe's signature colors, in his art, were red (blood), purple (the Church), and black (Satanism and the leather culture).

Fritscher, pp. 93–4

He's a man who knows night territory.

Morrisroe, *Mapplethorpe*, pp. 163–4

From his observations at the leather bars, he realized he was in a position to become the documentarian of the 1970s gay S&M scene, but unlike photojournalism, this was a niche that allowed his own sexual compulsions to flourish. He did not approach it as a voyeur, but as an active participant.

Ibid., pp. 201–2

Mapplethorpe's loft had become a port-of-call for men with every conceivable sexual perversion, and they arrived with suitcases, and sometimes doctor's bags, filled with catheters, scalpels, syringes, needles, laxatives, hot water bottles, rope, handcuffs, and pills. They dressed up as women, SS troopers, and pigs. One wore baby clothes and a bonnet, drank from a bottle, and defecated in his diapers. "Joe" appeared at the loft in a rubber body suit and Mapplethorpe took a picture of him kneeling on a bench; the tube inserted in his mouth was later connected to an enema bag.

Up until now Mapplethorpe had attempted to steer clear of the "crazies"— men whose sexual proclivities included bodily mutilation—but he had already documented most forms of gay S&M, and since he didn't want to keep repeating himself, he was open to meeting people with extreme tastes. "Ken," for example, enjoyed having people carve their initials into his skin. "I think he's probably dead now," said Mapplethorpe. "He was totally scarred, like a tree trunk, with initials. He'd just lay there like a piece of beef, and you could do anything you wanted to him. But there was no real energy there. He was a down trip."

At the time Mapplethorpe photographed "Ken," he received a call from an art critic who offered to introduce him to someone who derived sexual satisfaction by having someone slash his penis with a razor. Stoned on MDA,

Mapplethorpe arrived at the appointed apartment with his camera and met "Richard"—a "mathematician and computer person"—whose penis was strapped into a stock-like device, with a hole in the center and bolts on the side. "Then the scalpel came out. I was told I could be a participant or an observer. I managed to do both. It was hard to focus on the camera, but I found I really got off on this thing. Holding a scalpel in my hand and grazing a cock was a real turn-on. You could feel the energy in your fingers. Another guy went through his number. He came out of a bathroom with a wig, garish makeup, and leotards, but that wasn't my scene."

When he had finished taking pictures of Richard's "crucifixion," he waited for the other man to strap himself into the contraption so he, too, could submit to the ritual. "Then all of a sudden it was my turn. The other guys were older, and certainly as intelligent as I, and I had certainly been an active participant. But I thought, how am I going to deal with this?" He placed the device over his genitals and tried to divorce himself of the reality of the situation, which was that a man in a curly wig and tights, who was flying high on LSD, was holding a scalpel in his hands. "Okay," he said, panicking. "I'm not getting off on this. It's not my thing."

"I had exhausted the S&M thing. I had gone through it all both photographically and physically, and I was meeting too many guys like Richard. It was getting a little too crazy."

Mapplethorpe's "Censored" show drew the most colorful opening night crowd, with a cavalcade of leather men, in addition to the local chapter of the Hell's Angels, who roared up to the gallery on their motorcycles.

Ibid., p. 206

Initially, he was intimidated by Mapplethorpe's hardcore reputation and by his sinister loft—"I had never seen a black leather bedspread before."

Ibid., p. 398

His Morris chairs and Stickley settee had been upholstered in black leather, which, he believed, reflected an "amorous, masculine quality."

Ibid., p. 212

Chaps were held together on the inside seam by leather thongs. He had tied the thongs of the left leg to that of the right leg, so he could only walk a few inches. A cross-gartered figure hopping around the room. The two of them were as dandified and foppish as anything.

Ibid., p. 219

Tuxedo elegance and leather attitude.

Fritscher, p. 24

A mob scene of white ties, pearls, black leather, and New Wave funk.

Ibid., p. 25

Perhaps perversity, that last urban frontier, is avant-garde and retro-garde.

Ibid., p. 40

I want you to meet the most polymorphously perverse person I have ever met in my life.

Ibid., p. 67

He was not threatening to women or gay men in a decade in which "threat" meant "sexy."

Ibid., p. 92

Leather fetishists found his documentation fresh because he brought the leather world out of the closet. While S&M leathermen lionized his work for a time, they did not buy it. They themselves took hotter pictures of their own sex style. Perhaps his inability to achieve real eros, personally or on film, was the price fate charged him for his careerism.

Ibid., p. 180

A dirty jockstrap frames the buttocks.

Ibid., p. 185

Ibid., p. 188 The leather scene in the seventies was so wild that Mapplethorpe's work looks like still-life studies when compared to such classic period films as *Erotic Hands* (three-way handballing), *Sebastiane* (Derek Jarman's S&M version of the homoerotic martyrdom of St. Sebastian; a British film, dialogue in Latin, with English subtitles), Wakefield Poole's *Bijou* and *Moving*, and Dave Masur's *Skulls of Akron Fisting Ballet*, which was shot at the Mineshaft in New York.

Ibid. Robert deliberately tried to clean the leather scene up to acceptability to push his avant-garde following. He thought the genre legitimate. In fact, he envied director/porn star Fred Halsted, whose films *Sextool* and *L.A. Plays Itself* (with the S&M and fisting sequences intact) were purchased for the permanent collection at the Museum of Modern Art.

Ibid., p. 189 Robert could not sell the gristly reality of leather.
 The reality of leather would be too radical.
 He had to formalize leather to sell it.

Ibid., p. 218 When it came to real sex, Robert didn't have a clue about leather, fisting or fetish sex. He sometimes seemed like a scared heterosexual posing as a homosexual, putting on his alternate sexuality the way he pulled on his leather pants.

Ibid., p. 29 He pulled from his leather jeans pocket one of those little plastic MDA bags he was always dipping his finger into and shoving up my nose.

Danto, p. 8 We do not for the most part live our fantasies out, and so they never evolve. But the form of life Mapplethorpe had entered had made of sex a public practice, and this enabled it to evolve in ways quite beyond the power of private fantasy to anticipate. Whatever one might think of it, sex was probably lived more creatively in those years when the barriers to its enactment had fallen than at any other time in history. It had become as public as a language.

McCourt, p. 342 Yes, venerated and tongue washed—every limb and crevice of him.

Morrisroe, *Mapplethorpe*, pp. 145–6 Before going out at night, he made sure he put on his clothes in exactly the same order; he was careful not to wash beneath his underarms because he believed perspiration odor was vital to his sex appeal. He picked up men in bars by staring at them to see if he could detect "something" in their eyes; those who passed the eyeball test came home with him, but then he had difficulty maintaining an erection unless his partner stared into his own eyes. Sight, he believed, was the most important of all the five senses. If his partner reached a premature climax, Mapplethorpe considered the evening a failure, and no matter what time it was, he would put on his clothes—jeans or leather pants, sometimes a codpiece, shirt, vest, studded leather cuffs, black leather jacket—and return to the West Village.

Ibid., p. 190 The scene at the Mineshaft was not about conversation. In fact, you'd be told to leave if you were standing around too long talking about the opera or something. It was a stalking animal thing. I think what happened was that in one concentrated period of our history a whole group of people became addicted to this concept of going out every night and getting laid. It wasn't even a question of having an orgasm. Some of the ways one would end up doing that might seem tragic if viewed from the outside, but it was just to experience that feeling—like the release one gets from exercise—and then you could go home, go to sleep, and move on.

Mapplethorpe had a lifetime pass to the Mineshaft and was there so often he inspired the running joke "Who did you see out last night *besides* Robert?" Yet he rarely participated in any of the public orgies; he spent most of his time roaming the dimly lit passageways that led to rooms where men were being whipped and chained. There was a bathtub for "watersports" and a jail where "prisoners" were handcuffed or strapped to chairs, and leather slings to facilitate fisting. Mapplethorpe was constantly on the lookout for someone to take home, and the Mineshaft provided him with an opportunity to connect with other men who also venerated sexual excess. "If the average person had ever gone there," said an art critic and biographer, "they would have been horrified. You'd see these incredible models with these great bodies in a sling. They'd be completely drugged, their eyes rolled up in their heads … it would be two fists, three fists. In sexual terms, they saw themselves as Olympic athletes. The next day I'd see some of my female friends, and they'd tease me and say, 'I'm sure you were up to something terrible last night,' and I used to think, 'God, if they only knew, they would faint in horror at the extremities of it.'"

Most humans would fail miserably in this environment, designed for bats, hanging stark naked from the ceiling in caves cluttered with dung, catching insects in one's open mouth while flying at high speeds through the night. Not *them* however—they glory in it. McCourt, p. 332

The Mineshaft is in the heart of the meat-packing district, an eerie and fascinating corner of the city sandwiched between Greenwich Street and the Hudson, a strip of warehouses that only comes to life at night, as at most wholesale markets. The pavements are narrow here, as half the area next to the warehouses is raised to form a loading dock, so that when the huge trucks back towards the warehouse entrances, it's easy to send the carcasses swinging off the trucks and into the storage area. These loading docks are sheltered by rusty iron canopies. Metal rails are suspended from the canopies, and to them are attached evil-looking hooks from which dangle immense sides of beef that then rattle their way into the arctic depths of the warehouses. Brook, pp. 162–8

The street lighting is dim but illumination is provided by the warm glow beaming out of the warehouses, and by flaring fires lit in oil drums by the bums sleeping under the disused canopies—for even though the weather was unseasonably warm, a chill set in if one remained motionless for too long. The roughly paved streets are full of potholes; almost the only traffic here is that of heavy, multi-axled trucks that churn up the paving with their huge tyres. Rows of trucks were parked along the streets, their powerful engines and refrigeration units throbbing away.

This is the meeting place of meat.

We passed a burly driver unloading a bleeding carcass and wiping his scarlet hands on a dingy apron. We stepped gingerly to avoid the blood and grease underfoot; the smell rising from stacked garbage bags awaiting collection was rancid and sharp, pricking the nostrils. And then at the end of the journey, more meat, hunky men in leather and rough denim, their bodies taut with sexual anticipation.

We saw ahead of us a narrow doorway, its yellow welcome surprisingly warm against the blank walls of the deserted warehouses.

We sauntered into the back room. Near the entrance was a cloakroom where you can check your clothes, some or all, and here in the back and down in the basement there were quite a few men naked or wearing jockstraps. It was much darker back here and it took a while for my eyes to adjust. Cubicles lined the rear wall; they didn't have doors, but they did surround occupants

with three low walls so that their exertions wouldn't be in full view of the entire room. Slings and straps hung from the ceiling, but weren't in use. The night was still young.

Next to me was a man in black leather, in his 40s, heavy set. Facing him stood another piano mover, a bit younger, wearing a grubby white T-shirt (but then it's hard to keep your clothes whiter than white down the Mineshaft). They were tweaking each other's nipples and absentmindedly groping each other as they talked. The younger man was trying to date Mr. Leather. Why they didn't head for a cubicle and have it off, I didn't know, and they were talking so quietly that I couldn't catch all the sub clauses of their negotiation. But I did notice that every sentence uttered by the younger man ended with "sir": "Can I call you tomorrow, sir?" "I would like that very much, sir." Voluntary enslavement before my very eyes.

My attention was diverted by some activity on a curious wooden construction in front of us. It was not unlike an easel: two ladders at 45 degrees met at the top to form an apex, and two men were about to demonstrate its uses. A naked man leaned face down against the ladder, so that the length of his body was within easy reach. Behind him stood a Nazi. I use that term as shorthand for a standardized brute wearing jacket, trousers, boots, and a peaked cap, all in black leather; optional extras include studded gauntlets, bikers' insignia, and a chain or two. This Nazi was wielding a crop with which he was slowly whacking the buttocks before him. The slow beating went on for some time, after which the naked man heaved himself off the wooden frame. His place was taken by the Nazi.

We crossed the room, where there was a good deal of coming and going, coming and blowing, and descended a rickety staircase to what felt like a basement, but was in fact the street level. Down there were three or four rooms and passageways. I found it hard to keep my bearings. The smell hit me first: dampness, the sharp whiff of amyl nitrate, and the equally pungent aroma of piss. Sanitary facilities at the baths and bars leave much to be desired, and in the Mineshaft, or at least down at the coalface, bodily functions too are tendered as sexual coinage.

Here in this dank hole there were fewer clothes than upstairs, partly because of the warmth of the fetid atmosphere and partly because the sexual activity was in full spate. There were more cubicles, more slings, more leather thongs hanging on chains from the roof, and from dark corners came the sounds of slurping and the thwack of callused palm or leather strap coming down hard on undulating buttocks.

I had to sidestep deftly to avoid another Nazi going at it hammer and tongs. This thug was stocky and orange-bearded, and his jacket seemed to be delightfully decorated with ball bearings he'd probably split with his teeth. He was standing over a younger man, similarly attired, and with teeth clenched and head thrown back the Nazi was masturbating.

This, however, was harmless fun compared to what was going on in the next room. The smell alerted me, as did the slipperiness of the concrete floor. The room contained two deep metal bathtubs. In one of them crouched a plump and sodden man. Encircled by other men who were pissing on him, he kept shifting his position to catch the full steamy force of these arcs of urine. To my astonishment he was clothed, and his wringing wet T-shirt, by now blotchy yellow in color, was kneaded and pressed by many eager hands. So, never shake hands with anyone at the Mineshaft; you never know where they've been. Later on we passed the bathtub again and this time there were two men in it sharing the golden shower. Piss and sweat, piss and sweat.

It was four in the morning by the time we stepped out onto the pavement. I'd expected the street to be deserted here in the belly of the night, but not

a bit of it: there was a queue of cabs waiting by the kerb. It was odd to think of those sweaty, pissy, fucked-out men in uniform stumbling out of the Mineshaft in the wee hours and falling into waiting cabs that would take them back home.

I thought we'd try the Spike and so we headed up Eleventh Avenue along the river's edge. The street was full of men, some just walking to and fro, others plainly hustling as they leaned against parked cars or stood in doorways. A small group of what could have been mistaken for Hell's Angels without their bikes loitered outside the Spike. It had just closed. So we walked back down Eleventh and then down West Street as far as The Ramrod, probably the most notorious of the Village leather bars, since it was here that some years ago a trigger-happy goon who hated gays opened fire on a crowd similar to the one now gathered outside its door. Most of these men, it appeared, were simply hanging about nurturing the hope of finding a body and a bed for the night.

It was 5:15. Like a number of similar establishments in the West Village, it has a back room. As we walked into the shop I could hear a sound I had learned to recognize: leather against flesh, followed by the groans of the happy whackee. But I no longer wanted to look at more bodies in sexual travail. I wasn't tired, but I had decidedly had enough, and said so.

Are we talking, darling, about what is coming or came down at the Mineshaft? What flecks of gold in the sluice of the experience? McCourt, p. 322

Wally Wallace was founding owner of the Mineshaft, which was to male sex and drugs what CBGB was to punk music and drugs and what Studio 54 was to celebrity schmoozing and drugs. The three clubs' name lists overlapped. Not everyone went to CBGB or Studio 54, but sooner or later everyone came to the Mineshaft, where sex, not status, ruled. Fritscher, p. 209

The Mineshaft was opened in October 1976 and was closed on November 7, 1985, by the New York City Department of Health. Ibid.

Between 1979 and 1980, Robert was the "official" Mineshaft photographer. Wally Wallace asked Robert to shoot a party at the club. Robert worked dutifully but he was unable to shoot in the paparazzi style required so he hid or destroyed the party negatives. Robert, in an uncontrolled environment, could not shoot from the hip. In October 1979, he shot David O'Brien, that year's Mr. Mineshaft, at the bootblack's stand where inferiors shined the shoes and worshipped the boots of superiors. Ibid., p. 190

The place smelled of the usual telltale mix of Crisco, poppers, and smoke. The lights were low, throbbing disco pounded out from the large-reel tape deck. Candles, maybe a hundred of them, all different shapes and sizes, flickered across the room. Ibid., p. 36

One night, Robert, quite thrilled, said he had seen Mick Jagger turned away at the door, not because he was Mick Jagger, which counted for nothing once inside, but because he was with a woman. Women, disguised as men, often made it into the Mineshaft. In fact, more than one woman, aided in disguise by her escort Mapplethorpe, spent a splendid night of active orality and fisting at the Mineshaft. Ibid., p. 209

Mapplethorpe sometimes became so desperate for sexual contact that he prowled the Bowery picking up homeless black men. When asked about getting diseases, Mapplethorpe answered, "They're okay if you give them a Morrisroe, *Mapplethorpe*, p. 243

bath. And besides, they're the least likely people to have diseases because nobody else wants them."

Fritscher, p. 68

On Max's: "I hated going there, but I had to."

Haden-Guest, p. 105

Ogle the fist-fuckers and the Glory Holes, and then return to Xanadu.

Fritscher, p. 284

Cruising was completed, and, despite the "politically correct" changes, gave the best *cinéma vérité* take on the real seventies leather subculture of masculine-identified men ever seen in a commercial Hollywood film.

Anyone wanting to know the texture of all-male leather nightlife in the seventies will witness in *Cruising* the pop-sex world that Mapplethorpe cleaned up for museum consumption.

Available on video, the film can be scanned slowly, the VCR put on pause, and surviving denizens of that wonderfully decadent decade can recognize the faces of once-familiar friends and famous "Sex Stars of the NY Night" whom Friedkin hired as atmosphere extras.

Cruising is a virtual documentary of a night in the life of Robert.

Morrisroe, *Mapplethorpe*, p. 193

He boldly advertised his own coprophiliac tendencies by wearing a belt that spelled the word "SHIT" in metal studs, yet he was evasive with people he thought might be repulsed by his activities, and coyly referred to his own fetish as "dirty." He hinted at the origins of his fixations, in a 1978 self-portrait that was taken at the prompting of a German art director named Helmut, who, after agreeing to reveal his "secret," pressed the photographer to divulge his own. Mapplethorpe inserted the handle of a bullwhip into his anus and glared defiantly at the camera.

He developed a worldwide network of coprophiliacs who visited Bond Street whenever they were in town, and who spoke of excrement as the "ultimate sacrament." He often boasted of his sexual prowess and believed he had cultivated his senses to a far greater degree than anyone else he knew. Yet to reach a point where one can eroticize excrement involves a certain shutting down of the senses, and while Mapplethorpe proudly maintained he was not a voyeur, he derived his greatest pleasure from watching others consume his excrement—an act of perverse voyeurism. Perhaps his chilly detachment explains why many men found him to be utterly devoid of sensuality, a cold-blooded angel figure, curiously unisexual for someone who was supposed to be so sexual.

Ibid., p. 269

Dr. Larry Downs, Mapplethorpe's physician, repeatedly advised him to stop his coprophiliac obsession with feces, but since he failed to follow the doctor's advice, he was continually battling parasites and spreading them to his sexual partners. Worn down by stomach cramps and diarrhea.

Fritscher, p. 31

On May 21, 1978, he wrote: "It's midnight ... I almost forgot to tell you. I let some creep stick his hand up my ass. I've been fisted—even came—but I think I prefer being the giver. I can't help but to give preferential treatment to the feeding process. I want to see the devil in us all. That's my real turn on. The MDS is coming on stronger. I have to take a dump but I'll save it. I'm sure somebody out there is hungry. It's time to get myself together, pack my skin in leather. The package is always important. Goodnight for now. I feel the pull to the West Side. The night is getting older. Love, Robert."

Ibid., p. 41

Fisting, many think, is the last taboo to be incorporated into male sportfucking. They better think again. Scatology, from ritual to anointing to

communion, is the latest rage among sexual sophisticates who pay Robert court.

"With scat, I make myself invulnerable. I build up my resistance to everything."

Ibid., p. 172

Rear nudes, which have long been socially acceptable, were made very shocking by Mapplethorpe, esp. when one knows the existence of the scatological photographs.

Ibid., p. 186

Mapplethorpe had recently seen Pasolini's *Salo* and found it a brilliant piece of filmmaking.

Morrisroe, *Mapplethorpe,* p. 192

What Mapplethorpe (and Pasolini) found in sadism and scatology was a practice, a world, so revolting that even (or especially) other homosexuals were horrified by it.

White and Mapplethorpe, p. 132

Robert is quite frank about everything, even though he never really had sex in groups. He stated explicitly that the orgy would be scatologically satanic sadomasochism.

Fritscher, p. 40

"I feel like a vampire," Robert said. "I am a vampire."

Ibid., p. 194

"Blood is in the air. Love, Robert."

Ibid., p. 31

He became totally infatuated with the man he called "the serpent in Eden."

Morrisroe, *Mapplethorpe,* p. 164

Mapplethorpe was fully aware that he was breaking taboos, and the act of transgression was central to his work. He pushed his sexual partners to transgress their own boundaries by repeating the phrase "Do it for Satan." He wanted to bring to light previously hidden sexual secrets, and often taunted the various men by telling them, "You know you're dirty." Once he had succeeded in breaking down their reserve, he often photographed the "secrets" and made them public. He was careful not to reveal anyone's identity, and while he never dreamed of blackmailing his subjects, the pictures gave him the sense of control he craved. "Robert was really interested in photographing people's private desires," explained a model whose picture appears in the "X Portfolio." "He'd always tell you, 'Do it for Satan.' When he found out that I was into smells and odors, dirty jockstraps, and being submissive, he convinced me to wrap two jockstraps around my head for the picture. Actually, my photograph should have been the piss one, but he'd already done that."

Ibid., p. 192

"You can tell," he says, "who's interesting, who's sick by the way they say uh huh. You can tell who's dirty by their eyes. I look for dark circles. Interesting people have dark circles."

Fritscher, pp. 93–4

"You've got what I want. You've got perfect dark circles under your eyes. You know that's what I look for."
 "Robert Mapplethorpe's famous raccoon effect."
 "Actually, right now, your soul is outside your skin where I can shoot it."

Ibid., p. 45

When I have sex with someone I forget who I am. For a minute I even forget I'm human. It's the same thing when I'm behind a camera. I forget I exist.

Morrisroe, *Mapplethorpe,* p. 193

Fritscher, p. 33

Robert was a creature of the night. Take a walk down Greenwich after midnight. Peer in the windows of shops where we browsed for antiques. Robert was an offhand collector. He wrote impulsive, enormous checks for small bronze sculptures of the goat-footed devil.

Morrisroe, *Mapplethorpe*, p. 211

Whenever you make love with someone, there should be three people involved—you, the other person, and the devil.

Ibid., p. 212

Robert was one of the most tortured, tormented individuals I've ever met. He was a bundle of insecurities and always seemed ready to snap.

Ibid., p. 220

In *Civilization and Its Discontents*, Freud talks about artists who descend into what he calls the maelstrom, meaning the unconscious, and they come back and tell us what was there. Robert went into the maelstrom, no question about it, but he came back with an elegant picture postcard—"Having a wonderful time, wish you were here. Love, Robert."

Fritscher, p. 40

He likes to set people up to shock them into admitting to their own repressed desires.

Morrisroe, *Mapplethorpe*, p. 282

Ultimately he treated people the way he treated a statue or his collection of pottery. People were either subjects for his photographs, or they were in his life the way his collections were in his life.

Fritscher, p. 217

Robert clobbered anyone and everyone. He used money, fame, drugs, or whatever he needed to exert his will. Life was easy. Everyone was caving in to Mapplethorpe. How could he create a "perfect moment" without resistance? By the early Eighties, Robert was disdainful of everything and everyone, because whatever Mapplethorpe wanted Mapplethorpe got. He wanted people to resist him.

Chatwin and Mapplethorpe, p. 10

In his studio, a loft on Bond Street in lower Manhattan, there is a condition of perpetual night: the floor gray and grainy, mission-style furniture upholstered in black leather, the reflections of mirror or fauceted glass, a black bedroom behind a white wire-netting cage, and, ranged around, the paraphernalia of an irreverent perversity (a scorpion in a case, a bronze of Mephistopheles, and a much smaller bronze of the Devil with his toasting-fork).

Ibid.

People who remember the apartment remember a murky room full of Robert's sculptures—fetishes, rather—sexual, frontal, and, for the most part, black.

Kardon

"There's one particular person I photographed any number of times; as a person, he's horrible, but I couldn't take a bad picture of him. There was a sympathy in the studio, but outside I couldn't talk to him. He was disgusting."

Danto, p. 24

They were powerful and cruel, and though on the scale of suffering one witnesses every evening on cable news, the actual pain depicted was slight and of the imagination, the fact that it was voluntary and strange, that it was an exercise of spirit, gave it an edge of meaning that had to be dealt with in a different way from the meaningless, pointless, unwanted suffering of Rwanda or Bosnia.

Didion, *Some Women*

That romantic agony should have been revived as the downtown style in the greatest bourgeois city in the modern world at the moment of its decline was, in any historical sense, predictable, and yet Robert Mapplethorpe's work has often been seen as an aesthetic sport, so entirely outside any historical

or social context and so "new," as to resist interpretation. This "newness" has in fact become so fixed an idea about Mapplethorpe that we tend to overlook the source of his strength, which derived, from the beginning, less from the shock of the new than from the shock of the old, from the rather unnerving novelty of exposure to a fixed moral universe. There was always in his work the tension, even the struggle, between dark and light. There was the exaltation of powerlessness. There was the seductiveness of death, the fantasy of crucifixion.

Robert Mapplethorpe was no more shocking than his times.

Fritscher, p. 197

Shock was Robert's medium in the seventies: the shock of burning bras, the shock of abortion, the shock of sexual liberation, the shock of losing Vietnam, the shock of terrorist Olympics, the shock of Watergate, the shock of Americans hostage in Iran, the cumulative culture shock that led to the aftershocks in the eighties' shock of AIDS, IranContra, the Republican deficit, the destruction of the middle class, the meltdown of the nuclear family, the epidemic of drugs, the homeless, the savings-and-loan scandals, the blasphemy of television evangelists, the rise of shock-rock music, shock-trash television, and shocking U.S. policies in the Mideast.

Ibid., pp. 196–7

"I don't like that particular word, 'shocking.'" Robert Mapplethorpe told *ArtNews* in late 1988, when he was struggling with illness and asked one more time to discuss the famous leather photographs. "I'm looking for the unexpected. I'm looking for things I've never seen before. But I have trouble with the word 'shocking' because I'm not really shocked by anything … I was in a position to take those pictures. I felt an obligation to do them."

Didion, *Some Women*

Imagine the young Robert in the late sixties, early seventies, deliberately setting up avant-garde savants by showing them his fresh, shocking images. They had to lie about his work, because if they blinked in shock, they immediately lost their avant-garde status. His assault on them was an "invitation to a mugging" he could not lose. Robert wanted status and he achieved it by threatening their status. If they thought themselves far out, he presented himself as farther out.

Fritscher, p. 66

"All Robert wanted to do was to fuck his models, then photograph them," Baril said. "He was documenting his life and sticking it in front of everybody's faces, daring them to say something about it." Perhaps sensing Baril's hostility, Mapplethorpe confined him to the darkroom, but Baril, knowing his employer was too intimidated to confront him directly, delighted in disobeying him. Mapplethorpe, then, would send a message through a third party directing Baril to "stay in the darkroom." From Mapplethorpe's perspective, it was the ultimate putdown, as he derived great pleasure from having made a name for himself as a photographer without ever making a print.

Morrisroe, *Mapplethorpe*, p. 239

Mapplethorpe had confided to several friends that he blamed a black man for infecting him with the AIDS virus, but given his boast of having had sex with an estimated thousand men, he couldn't possibly know for sure. Still, he approached his task like an avenging angel, picking up one black man after another with the word "nigger." One man screamed at him to stop, but when Mapplethorpe still kept repeating the word, the man grabbed his clothes and ran out the door. "You're evil," the man shouted, in parting. "*Evil!*"

Ibid., p. 318

Mapplethorpe's "neo-fascist politics."

Ibid., p. 204

Ibid.　　　He often referred to Jews as being money-hungry and vulgar.

Ibid., p. 204　　　I think Robert liked me but he despised Jews, and I happened to be Jewish. We both felt uncomfortable with each other. I believed his pictures had to be shown.

Ibid., p. 240　　　Taking a cue from classical sculpture, he expected white skin to approximate marble and black skin the color of bronze. His printers were to selectively lighten the white faces to obscure any imperfections and selectively darken the blacks.

Fritscher, p. 249　　　Only sexually was Mapplethorpe multicultural.

Ibid., p. 212　　　Lesbian black women deemed him acceptable, because he at least made black people visible.

Ibid., p. 92　　　How can a biographer build him up as a modern hero and then tell the world that one of his turn-ons was to force his black sex partners to say, "I'm your nigger"?

Ibid., p. 210　　　Robert asked Wally, the source of all New York sexual information, about, in Robert's term, "nigger" bars.
"I told him about the black bars," Wally said, "but he was scared. He kept after me, so I took him there myself. I'd never seen Bob so nervous. He had shot a few black men previously, but they had been gay black men, some of them professional models. I knew Bob. He wanted the danger of the real thing.

Ibid.　　　Mapplethorpe: "I'm still into Niggers. I even have a button on my leather jacket that spells it out when I hit the bars. It seems to attract them."

Morrisroe, *Mapplethorpe*, p. 28　　　He asked if she knew how stimulating the word "nigger" was during sexual foreplay. "Let me get this straight," she said, dumbfounded. "You're looking for an intelligent, successful black millionaire who wants you—a white man—to call him 'nigger'?" Mapplethorpe patiently explained that she hadn't grasped the whole concept. "I wouldn't call him 'nigger' all the time," he said, offended. "Only during sex."

Ibid., p. 252　　　People who walked through the Miller Gallery to see such beautiful black bodies as "Ajitto" had no idea the man who took the pictures referred to his subjects as "niggers" or that he subscribed to racist ideas.

Fritscher, p. 214　　　Mapplethorpe's meeting with Leni Riefenstahl in Manhattan to discuss the mystique of blacks.

Marshall, p. 15　　　Riefenstahl's exotic forays to Sudan and East Africa. Piling gilt upon guilt, she brought back her naked-warrior images, thinking—and she was not alone—that they shone with the truth of her subjects' nobility. Instead, her theatrics, her kitschy choices and angles betrayed the fact that she saw these people through those Aryan glasses that seem to have only one end in sight—the creation of an *Übermensch*. Her reduction of the Nuba people or the Masai to picturesque members of an animal kingdom—there for the snapping of the paparazzi who want them in their "natural habitat."

Fritscher, p. 218　　　Blacks are only sporadically visible in the history of photography: Louise Dahl-Wolfe, Edward Weston, Eikoh Hosoe, George Dureau, Miles Everett.

516

There was something about the pictures, even the commercial ones, that did not lend itself well to American consumer culture.

Morrisroe, *Mapplethorpe*, p. 287

The unfortunate shift today away from an emphasis on sexual freedom to gay identity has made the explicit sexual content of Mapplethorpe's photos look sleazy, politically incorrect, even racist.

White and Mapplethorpe, p. 129

He coveted Butler's photographs of black body builders like Serge Nubret, Leon Brown, and Gordon Babb, displayed next to antique photographs of strongmen, including 1951 Mr. Universe, the black Monotosh Roy, who posed for fantasy photographs, not nude, but suggestive of the "Young Physique" magazines Robert had come out on in the adult bookstores on Forty-second Street.

Fritscher, p. 221

Mapplethorpe: "Black guys are hung bigger, except for the ones who date white chicks."

Ibid., p. 215

He hoped in the perfect moment of sex to find the perfect moment of death. He hoped someday a black would kill him.

Ibid., p. 218

By 1980, Mapplethorpe claimed that white men no longer interested him sexually.

Morrisroe, *Mapplethorpe*, p. 233

Mapplethorpe: "Once you go black, you can never go back."

Ibid., p. 233

Mapplethorpe's racism intensified with the progression of his disease, and Kelly Edey, who had presumably heard everything, was so startled by Mapplethorpe's venomous comments that he noted one incident in his diary. Mapplethorpe was standing outside Keller's on the evening of August 2 when he suddenly began to shout, "This is the sleaziest corner in New York. How can it be that I'm standing here in the midst of all this human garbage? They're so stupid, every last one of them is so unbelievably stupid." And yet he kept returning to Keller's, hoping his demigod might rise from the debris. "A lot of people yelled at him for continuing to go to the bars," Mark Isaacson explained. "But he looked at it, like, well, that's their problem—if they're not protecting themselves, why should I worry about it? When Robert first got sick, I said to him, 'You've got to stop your old lifestyle,' and he said to me, 'If I have to change my lifestyle I don't want to live.'"

Ibid., p. 325

Keller's Bar—West St., pickup spot for biracial sex. The whites had money; the blacks did not. What the blacks had, however—or so went the myth—was an exotic, "primitive" sexuality that lured the white men to Keller's the way affluent whites were once drawn to Harlem's Cotton Club. Mapplethorpe went at least four times a week.

Ibid., p. 233

Keller's on the waterfront was pure theater in the tradition of Genet's *The Balcony*. At the bar, and around the edges of the room, were the plumbing supply salesmen, electricians, furniture movers, and parking-lot attendants who were playing the sadist for the evening. They were in black leather caps, dark glasses, black leather jackets with a plethora of chains, studs, and emblems, black leather pants and boots, with heavy key rings hanging from their belts. They lounged around like lethargic tigers, drinking their beer and licking their chops as they observed the center-stage activity around the pool table. There were gathered the chemists, hairdressers, junior accountants, and college students who were playing the masochists for the evening, attired in black plastic jump suits, fetchingly unzipped. To watch one of those

Hamilton, p. 23

masochists take a stance with a pool cue was to know the full eloquence of
body language, right down to the twitch of the buttocks as the shot was made.
The tigers would stir languidly.

Morrisroe, *Mapplethorpe*,
pp. 234–5

Mapplethorpe's favorite subject: the physical superiority of the black male.
Once Mapplethorpe began photographing blacks, he found to his delight
that he could extract a greater richness from the color of their skin. "For
one thing, the texture of a black man's skin is different. The most beautiful
black bodies have a thin layer of fat all over them which gives an amazing
consistency to the musculature and to the surface of the body. Another thing
about black bodies at their best is the broadness of shoulders in proportion to
the narrowness of the hips. Then, of course, there's the size of the cock. The
average black cock is bigger." I don't think people realize how hard Robert
worked to find the perfect one. He examined thousands and thousands of
them.

George Stambolian once heard Mapplethorpe describe the perfect black
phallus in such detail that he had even worked out the ideal measurement
of the tiny opening at the tip of the glans through which the urethra carries
urine and semen. "Robert had drawn a picture of a penis on a chart,"
Stambolian recalled, "and he was like a surgeon, using medical terms like
'corpus spongiosum.' I was impressed by his dedication." But in those
rare instances when Mapplethorpe found the ideal phallus, he was usually
dissatisfied with another part of the man's anatomy. Perhaps he had too
much of a "prison build"—the upper body too large for the hips—or perhaps
his skin color was too muddy, or his legs too short. "When the ancients did
a painting or a sculpture of a god," Edey explained, "they often took parts
from different models—a hand, or a leg, or a face. Robert couldn't do that
as a photographer, so he needed to find everything in one person. He was
searching for the Platonic ideal."

Mapplethorpe's method of seduction varied little from night to night;
since black leather was not standard attire among black gays, he dressed in
jeans and a simple shirt, then, arriving at Keller's after midnight, he would
order a beer and stake out a position in front of the bar so he could watch
the men walk in the door. He had nicknames for all the regulars—"Pail and
Shovel," "Mutton Chops," "Pigeon." After twenty minutes of gossiping with
Kelly Edey and John Abbott, he would saunter to the far end of the bar, light
a cigarette, and fix his eyes on the most desirable person in the room, staring
so intently the chosen man was compelled to approach him. "Robert's eyes
just blazed whenever he saw a person whom he thought was spectacularly
beautiful," Edey said. "I was trying to find a word for that intense look on
Robert's face, and I finally realized it was the same word they used to describe
Michelangelo's eyes—*terribilità*."

Mapplethorpe's charisma was enhanced considerably by the vial of cocaine
he kept in his back pocket and waved at the appropriate moment. Some of the
men at Keller's were there for the sole purpose of procuring drugs, and even if
they weren't homosexual, they were amenable to trading sex for coke. Others
went home with Mapplethorpe because they knew he was a photographer
and they hoped they might be able to make some money modeling for him.
Curiously, while Edey maintained that both he and Mapplethorpe longed to
be "swept away by a black superstud," the men Mapplethorpe wound up with
were often small and slightly built.

Marshall, p. 10

The photographer's repeated assertion that it is the bodies of black men
which will take the light, and the darkness, with the most resolute formal
determination.

518

Morrisroe, *Mapplethorpe*, pp. 236–8

What happened when black men ceased to be "form" was a different matter entirely. Mapplethorpe referred to his Platonic ideal as "Super Nigger," and told John Abbott he longed to find a black man who was "free enough" to allow him to repeat the pejorative word in bed. "I've always liked to talk dirty," he explained. "It's like magic words, forbidden words. The idea that someone white would call them 'nigger' worked consistently with blacks. It made their cocks jump." When he discussed his work with art critics and journalists, he addressed the aesthetics of dark skin, but with friends at Keller's he talked about the way blacks smelled different from whites; the size of their lips and genitals; how he could always "catch a nigger with coke"; and which blacks were "gorillas." He and his friends weren't interested in middle-class blacks, because then, according to Abbott, "they weren't black anymore." Consequently it was nearly impossible for Mapplethorpe to find someone who could fit comfortably into his social world. "Robert's leitmotif was how unbelievably and impossibly stupid they all were," said Edey. "We called it 'the curse of beauty.' There was an inverse proportion between mental development and cock size. The most beautiful ones didn't seem to develop their brains much. Robert came to just accept it as a fact of life that the ones he was attracted to sexually and as a photographer weren't going to have much upstairs. So we did a lot of sitting around wringing our hands. And then somebody would walk through the door, and we'd say, 'My God, did you see that?' There was a sense of obligation. If somebody is that beautiful you have to capture them on film, like catching a total solar eclipse."

From the time Mapplethorpe entered his "black period," he made a concerted effort to study the work of other photographers who had taken pictures of black male nudes. He didn't regard this as "stealing" other photographers' ideas or techniques, but rather as creating a library of images in his subconscious from which he could occasionally borrow. "I like to look at pictures, all kinds," he said in *Portrait: Theory*. "And all those things you absorb come out subconsciously one way or another. You'll be taking photographs and suddenly know that you have resources from having looked at a lot of them before. There is no way you can avoid this. But this kind of subconscious influence is good, and it certainly can work for one. In fact, the more pictures you see, the better you are as a photographer." Photographic images of the black male nude, however, were relatively rare. Of the 134 images in Constance Sullivan's *Nude: Photographs 1850–1980*, the black male is not represented at all. Given the taboo against male nudity in general, white heterosexuals were not inclined to celebrate the erotic properties of the black male body. And since blacks rarely had the financial resources to become art photographers, it was left to gay white men to present their vision of the black male nude.

F. Holland Day, who had shocked nineteenth-century Boston with his staged crucifixion scenes, was one of the first Americans to photograph the black male nude. Day's fascination with male beauty was evident in the highly stylized portraits of black models that comprised the "Nubian series." His photograph of a black man dressed as an Ethiopian chief in a striped African robe and feathered headdress was featured by Alfred Stieglitz in the October 1897 issue of *Camera Notes*; Day's biographer, Estelle Jussim, cited the picture as "one of the first photographic embodiments of the idea that 'Black is beautiful.'" In his photograph "Ebony and Ivory," Day further explored the erotic properties of the black body by contrasting the model's dark skin with the white figurine he holds in his hand. Allen Ellenzweig, in *The Homoerotic Photograph*, emphasizes Mapplethorpe's debt to Day: "Certainly Day proffered the black male as a desirable sexual object, aesthetic in himself, worthy of admiration, and, to those open to the possibility, likely to spur sexual longing. What we have here is a forerunner of Robert Mapplethorpe."

In the years between Day and Mapplethorpe, the black male nude was largely invisible, and the pictures that existed were usually done in secret. George Platt Lynes took photographs of black nudes in the early 1950s, but these didn't surface until several decades later.

Marshall, p. 10

In most instances, Mapplethorpe's images of the nude male are isolated, solitary.

Morrisroe, *Mapplethorpe*, p. 238

Mapplethorpe eventually began to photograph his black models against black backdrop paper instead of gray, to enhance the skin's highlights.

Marshall, p. 11

The world of inorganic form is absent save as it is defined by the organic.

Ibid.

Black men perceived as physiognomies so symmetrical as not to admit those "accidentals" which for most of us constitute the recognizable self.

Morrisroe, *Mapplethorpe*, p. 246

Black lover / model Milton Moore wouldn't allow Mapplethorpe to take pictures of him until the photographer agreed that he would never show his face and genitals together in the same photograph. Disappearing into the bedroom, Mapplethorpe returned with a pillowcase, which he then placed over Moore's head before proceeding to shoot several rolls of film.

White and Mapplethorpe, p. 130

[Moore] was afraid family members would see the pictures and figure out he was gay.

Morrisroe, *Mapplethorpe*, p. 254

Robert kept complaining that Milton would only eat "nigger food" and that he couldn't stand it anymore. Robert's relationships with blacks were all terribly sexual, but he didn't actually *like* them. He constantly called them "niggers," and said they were stupid.

Ibid., p. 248

Mapplethorpe encouraged Moore to take advantage of his "natural rhythm" by presenting him with a pair of tap shoes.

Ibid., p. 257

Robert had this poor black kid from the South cooped up in what looked like a showroom for a glass company. It was like keeping a tiger on a leash in your apartment.

Ibid., p. 254

We drove to the beach and everyone was in bathing suits except for Robert and Milton, who were still dressed in black leather. This was not exactly a normal sight for the Hamptons …

Ibid., p. 287

Asked to photograph a pair of high heels for the German magazine *Stern*, for example, he balanced a shoe on the buttocks of a naked black man; for *Vogue Italia*, he accessorized a black model's body with diamond jewelry; later for a Japanese department store, he photographed the same black model bound by leather belts. The real message of the picture wasn't about fashion, but power and submission, especially as it related to black men, whom Mapplethorpe regarded as the ultimate accessory—a fetish equal to a high-heel shoe, or a diamond elephant pin.

Fritscher, p. 172

Mapplethorpe preferred models, both leather and black, who posed for little or nothing.

Ibid., p. 219

George Butler and Charles Gaines's *Pumping Iron: The Art and Sport of Bodybuilding*—Arnold Schwarzenegger and black musclemen.

Mapplethorpe's evident parodies of muscleman poses and *House Beautiful* arrangements.

Marshall, p. 14

I can remember that when I was interviewing black gay men in Atlanta in 1978 several told me that Mapplethorpe was virtually the only photographer who was giving them exciting and beautiful images of their race.

White and Mapplethorpe, p. 129

Blacks crossed over the same way gays crossed over. Race and sex: blacks and gays. To the mix, Robert carried camera and checkbook.

Fritscher, p. 211

In the gay seventies, women who were poets, singers, and performance artists were considered chic ornaments for gay men. They were not unlike straight men's trophy wives.
 Masculine-identified gay men, particularly, matched up with female partners who were not like female-identified gay men's sisters.

Ibid., p. 119

Robert, in the final analysis, spotlighted a primal masculinity contrapuntal to the seventies' emerging feminist consciousness.

Ibid., p. 276

Mapplethorpe's work gives some internal evidence that he clung to Smith as symbolic of some possibility he had lost.

Ibid., p. 75

Patti Smith: the grieving, about-to-be-widowed Mrs. Robert Mapplethorpe.

Ibid.

She was his alter ego. She was the light to his dark. I suspect his photographs of her are his best work.

Ibid.

Mapplethorpe's photos are always beautiful, but a Mapplethorpe photo of Patti Smith is, well, history.

Morrisroe, *Mapplethorpe*, p. 209

Patti Smith: Mapplethorpe's twin, his divining androgyne.

Fritscher, p. 68

Robert Having His Nipple Pierced. The scene was pure Warhol. Miss Daley's screening of her film took place in the very room where it had been shot. Some of the silver plastic pillows, their helium depleted, flitted through the film. Robert was there with Patti.

Fritscher, p. 69

"I just thought it would be an interesting idea, having a ring through your tit," he told the BBC about the early film "Robert Having His Nipple Pierced," the romance of the edge.

Didion, *Some Women*

In the film Robert and Patti were very like each other, outsiders, pretty, but hungry and skinny, and deathly intense. Patti had a slightly hysterical edge, which I think probably has to do with something in her childhood. She did the soundtrack of the movie. She spoke live; it was an improvised poem. Patti watches while Robert, having his nipple pierced, lies in the arms of a male lover. I think the film was supposed to be about the tensions in Robert's nature, about his attraction to Patti and his attraction to men. They seem to have come to some terms with the ambiguity, perhaps through the film. It encapsulated the moment from which they were all moving away.

Fritscher, p. 70

Rock music's merchandizing of androgyny.

Morrisroe, *Mapplethorpe*, p. 215

Literally, as well as metaphorically, pop culture success depends on who fucks whom.

Fritscher, p. 95

Ibid., p. 132	Pop art faces are generally blank.
Ibid., p. 114	The Pop couple, Robert Pop and Patti Pop, moved through their Pop Adolescence in the Pop Art World, influenced by the invitation of British Pop. In the Pop Speak of the sixties and seventies, Pop People often played "What movie am I in now?" Pop Urchins living at the Popularly Priced Chelsea hotel, Robert Pop and Patti Pop Popped Pills and listened to Pop Music (to make Pop Music) and watched Pop Movies (to make Pop Movies). Imagine Robert Pop and Patti Pop at a rock horror triple-feature picture show. Consider that the Pops are tropes turning in tandem periodicity to the light of the movie screen.
Ibid., p. 127	Robert, essentially, was a one-woman man and that woman was his mirror, Patti Smith, whose very existence fueled Robert's introspection.
Ibid., p. 136	If Mapplethorpe had lived longer, would he have come to his senses after a misspent youth, married Patti Smith (thus redeeming them both from sex, drugs and rock 'n' roll)?
Ibid., p. 128	Lisa and Patti represent in body type the Mapplethorpe female who is not in the tradition of the fecund female figure. Mapplethorpe's women straddle androgyny by their very slender builds.
Ibid.	Lisa Lyon was 5'3", 102 lbs.
Ibid., p. 136	The plot thickens when Lisa Lyon is cast as "the other woman" who comes between Mapplethorpe and Smith.
Morrisroe, Mapplethorpe, p. 231	Edie leaves the stage to be replaced by an inferior version of herself in Ingrid Superstar. Smith replaced by Lyon.
Ibid.	Although Lisa Lyon had won the 1979 First World's Women's Bodybuilding Championship, she was hardly a stereotypical athlete and regularly took angel dust, quoted Carlos Castaneda, R. D. Laing, and William Blake; she counted among her friends Henry Miller and former Black Panther leader Huey Newton.
Ibid.	Lyon was a gifted child who suffered from hallucinations. She developed compulsive rituals such as running around the house counterclockwise and tapping on furniture hundreds of times.
Chatwin and Mapplethorpe, p. 11	She was hurtled into the limelight by winning, in Los Angeles in 1979, the First World Women's Bodybuilding Championship. She had then enraged the new crop of women body builders by declining to defend her title at the Second World Championship, considering herself not so much an athlete as a "performance artist"—a sculptor whose raw material was her own body. Since this material was, in the long run, ephemeral, she was on the lookout for the right photographer to document it. "A mirror," she says, "is not an objective witness."
Ibid., p. 232	Driven by her compulsive behavior, she began rigorously counting bicep curls and leg lifts, and when she was too wired to fall asleep at night, she exercised on the trapeze hanging from the ceiling of her apartment. Instead of steroids, she used LSD, which she claimed help reprogram her cellular structure and made it possible for her to lift 265 pounds and squat 285. "I was using LSD to resculpt myself," she said. "Not only was I leaping forward in my body, but I

was having visionary experiences. I was going into zones you can't talk about to people."

Lyon's drug problems and emotional difficulties.

Ibid., p. 279

Lyon was a potential marketing goldmine, and plans were underway for an exercise book and a new perfume. Lyon, however, was unwilling to play the game for even a short time. She never dreamed of being an athlete in the first place. She saw herself as a sculptor who used her own body as raw material. Her meeting with Mapplethorpe, then, was serendipitous, for she was searching for a photographer to document her "work-in-progress." Mapplethorpe, coincidentally, was searching for ways to change his gay S&M image.

Ibid., p. 232

Mapplethorpe complained that Lyon hadn't capitalized on her bodybuilding career, and he couldn't understand why she persisted in labeling herself a "performance artist" when she could have been a female Conan the Barbarian.

Ibid., p. 279

On Wednesday, February 25, 1976, Schwarzenegger appeared live, as a performance artist, posing, one night only, at the Whitney Museum of American Art. Presenting Schwarzenegger with the bodybuilders Frank Zane and Ed Corney were *Pumping Iron* authors Charles Gaines and George Butler.

Fritscher, p. 221

They were all "Exhibit A" for the panelists debating a kind of pop culture wrestling chautauqua of "Mind versus Body." The panel included professors of fine arts from NYU, of English and comparative literature from Richmond College, and of the Art Department at Rutgers. They were all male and made legitimate by the gender of the assertive moderator, Vicki Goldberg.

That night at the Whitney was historical for itself and for its directly quoted reference of the night nearly 170 years before when Lord Elgin brought the Parthenon marbles to London.

"In June 1808," Goldberg said, "the famous prizefighter Gregson was induced to stand naked in the museum and pose for two hours in various attitudes so that his anatomy could be compared with that of the statues."

At the Whitney that night, Schwarzenegger and Ed Corney and Frank Zane posed on a revolving platform. The SRO crowd went wild. The scene was a gladiator-slave show "straight" out of a Fellini coliseum in ancient, decadent Rome.

As the symposium concluded, Robert worked his way to the green room, where the musclemen were holding court and signing autographs. He invited them to pose for him at his Bond Street studio. Schwarzenegger, the most self-promoting of the three, recognized a kindred soul in Robert Mapplethorpe.

Mapplethorpe confided that the female pubic region was so unattractive to him that he couldn't imagine photographing full-frontal nudes. Instead, he arrived at homoerotic aesthetic: a book entitled *Small-Breasted Women.* How to define small-breasted? Mapplethorpe wondered if women who wore bras should be automatically disqualified, or if "small" meant totally flat. He even worked out on a piece of paper the exact nipple-to-breast radio of the ideal candidate.

Morrisroe, *Mapplethorpe,* p. 232

Lisa Lyon: "These pictures are a little hard, like us."

Chatwin and Mapplethorpe, p. 12

Lisa Lyon: "I like weapons. They are a part of my reality."

Ibid.

Ibid.

She might explain her concept of the prototype for the woman of the eighties: The concept of a woman's body ("neither masculine nor feminine but feline"), her conceptual of body building as ritual, and her concept of the ritual as Art. She might tell how awkward it is to be a white woman in "a sport meant for black men"; how she learned to highlight her muscles by darkening her skin with liquid graphite; how she just ordered a further ten tubes of it from the Ace Lock and Key Store in Santa Monica ("graphite's a lock lubricant, you know"); how once, at a performance at a museum in California, anointed with this ceremonial patina, she drew a crowd of thousands to watch her perform a three-minute ritual in front of a chalk wall.

Marshall

In his studies of the bodybuilder Lisa Lyon, it is of course a reversal of stereotypes which Mapplethorpe effects. Precisely the kind of lyric stasis so lovingly studied in male bodies traditionally granted movement and power (in other words, a paradoxical anti-phallicism, if we take our lead from the culture's interpretation of the phallic as dominance, as inflexibility, as denial of the other's response) is withheld in the Lisa Lyon series: Lyon repeatedly subverts, in images of sleek force and definition, the conventions of female iconography she is made to criticize, to parody, to transform.

Chatwin and Mapplethorpe, p. 14

In session after session, Lisa posed as bride, broad, doll, moll, playgirl, beach-girl, bike-girl, gym-girl, and boy-girl; as frog-person, mud-person, flamenco dancer, spiritist medium, archetypal huntress, circus artiste, snake-woman, society woman, young Christian, and kink. She posed in Jamaica. She posed, naked on an arctic day, in Joshua Tree National Monument. One afternoon in New York, she posed flat out on a masseur's bench. "I think there is something of the slab in this one, don't you? The anatomy table? I don't find it morbid, though. I find it calm."

Fritscher, p. 95

In the seventies, Patty Hearst, everybody's Pop Debutante of the Decade, was Robert's favorite society child.

Deconstructed as a debutante and reconstructed as a revolutionary, Patty Hearst switched identities with an ease Robert envied. He referenced Hearst as Tonya, Queen of the SLA in his photograph of himself with a machine gun.

Robert loved the pop culture concept of Patty the Deb having her consciousness raised when kidnapped by the Big Black Buck, Cinque, leader of the Symbionese Liberation Army ... She was Mapplethorpe's dream girl: the rich bitch who is kidnapped and through force becomes the white sex slave of a dangerous black revolutionary who makes her betray her family and rob banks.

He wanted Patty to be his wild WASP heiress the way the doomed superstar Edie Sedgwick was Warhol's, so he could shoot his own underground movie.

In his black-and-white dreams of race, gender, and money, Robert's fantasy, because of Patty Hearst's mythic pop culture past, was to photograph the rescued heiress as a lacquered Bay Area society matron who had been forced into romance-novel adventures beyond her will to resist.

Ibid., p. 216

In the seventies, the decade of black music, black magic, Black power, Black Panthers, and the Symbionese Liberation Army, black males' inherent defiance was Robert's way of realigning hot spin on the cold axis of his formal work.

Marshall

Robert Mapplethorpe has been a society photographer in the largest sense.

He wanted to sell photographs to his target market, the radical chic, who had attended Leonard Bernstein's fund-raising party for the Black Panthers in 1970. Agnès Varda had made her films *Black Panthers* and *Lion's Love* (1969) back to back. *Lion's Love* starred Warhol superstar Viva, the authors of *Hair*, Gerome Ragni and James Rado, and filmmaker Shirley Clarke. Fritscher, p. 210

Tom of Finland meets Mapplethorpe in SF in the '70s. In the '80s in NYC. Pfanner and Khoury

Derek Jarman was Mapplethorpe's bête noire. Fritscher, p. 63

Jarman was the British Mapplethorpe and then some. *Ibid.*, p. 105

British film director Derek Jarman remembered that one night in the 1980s, at a party at Heaven, the disco, he was going down one stairway as Robert Mapplethorpe was climbing up another and Robert shouted out, "I have everything I want, Derek. Have you got everything you want?" *Ibid.*, p. 92

He assaulted the New York avant-garde with his camera. Robert Mapplethorpe was a cultural terrorist. *Ibid.*, p. 78

Love was impossible with him, because the only people he wanted in his life were the rich people, famous people, and people he could have sex with. Morrisroe, *Mapplethorpe*, p. 134

He hated the murder of the rich and famous because it cut into his model and client list. Fritscher, p. 112

He was conspicuously apolitical and obsessed with his own career, with a degree of self-absorption friends might have called anarchic individualism and enemies might have labeled narcissism. *Ibid.*, p. 114

He was the man who removed Yoko Ono's shades and presented her eyes to the world. *Ibid.*, p. 127

He liked dropping the names of Tom Wolfe and Joan Didion before he knew them. *Ibid.*, p. 99

He equated publicity with life itself. Following the show, when his name receded from the newspapers, he glumly said, "Well, I guess that's it." Morrisroe, *Mapplethorpe*, p. 351

He appeared in 1987 in an ad selling Rose's Lime Juice for Schweppes. Fritscher, p. 194

His surname became an answer on the TV game show *Jeopardy* in September 1990. *Ibid.*, p. 66

I had to sell a lot of photographs to make the kind of money a painter made from selling just one painting. Morrisroe, *Mapplethorpe*, p. 251

His real thrill was the kill, the sale. Fritscher, p. 183

Mapplethorpe: "My theory about creativity is that the more money one has, the more creative one can be." Morrisroe, *Mapplethorpe*, p. 286

He was an aerobic shopper. Fritscher, p. 79

Mapplethorpe ran himself like a department store. *Ibid.*, p. 80

Ibid., p. 97	He loved the surfaceness of haute couture.
Ashbery, p. 255	Their chic glossy-magazine ambience heightens the drama. We've all turned the pages of these magazines, ogled the luxury goods, envied the rich and famous, and then closed them, newly conscious of our own mortality. *Vanitas vanitatum.*
Danto, p. 19	The term "marketable" is an index to the transformation in attitude from formalism to a certain smooth, stylish, and [academically] marketable Marxism, which had come to replace it.
Morrisroe, *Mapplethorpe*, p. 165	Mapplethorpe demonstrated his talent for being a quick-change artist when he flew to London to do portraits of his English friends. From S&M call boys, he was now a photographer of Isabel and Rose Lambton, daughters of a former cabinet minister; Guy Nevill in his riding gear; Lady Astor's granddaughter, Stella; Colin Tennant's son, Charlie; John Paul Getty III; and beer heiress Catherine Guinness. This might indicate some schizoid nature in his work, a meretricious split approach and interest. In fact, although these subjects come from a universe of extravagant contrasts, Mapplethorpe casts them from the same mold. The polished world of high fashion and country-house living seems as hard and brittle as the underworld of burnished chains and studded leather.
Didion, *Some Women*	The familiar face of Grace Jones, as photographed by Mapplethorpe, suggests not the androgynous future for which it has come to stand but the nineteenth-century passion for the exotic, the romance with Africa, with Egypt.
Fritscher, p. 33	I wonder, do Richard Gere and Princess Margaret and Arnold Schwarzenegger feel somehow changed? Robert's tongue never licked their eyeball. Robert's lean body never made love to them.
Ashbery, p. 256	Aren't many of the other works that complete his oeuvre a hairbreadth away from classy commercial photography?
Fritscher, p. 175	Basically a commercial photographer with fine art aspirations. He gave good product.
Ibid., p. 74	So many gay photographers don't take portraits of nude men. They just shoot pictures of a cock which happens to have an appendage, a person attached to it.
Marshall	The penis, in all the images by Mapplethorpe, is never shown erect.
Fritscher, p. 95	Actually, I know no one, at least in California, who thought that Robert would be any more talented, famous, or controversial than the thousand other gay photographers.
Ibid., p. 80	Amazingly, Robert never received a really bad review from straight critics. The gays avoided comment. "I'm beyond them," Robert said.
Ashbery, p. 255	Ingrid Sischy once tried to interest a publisher of pornography in Mapplethorpe's work, only to have him refuse to look at it. "I know these pictures," she reports him as saying. "I've never liked them. They're so personal."

g **Mapplethorpe**

Patti Smith, Robert's girlfriend, would show his work to gay dealers who'd reject it; as he recalled, "Several of them told me, 'I think the work is really interesting, but how can I exhibit it without making a statement about who I am?'"

White and Mapplethorpe, p. 129

Paradoxically, Robert Mapplethorpe is both a link in a long photographic tradition and someone who was startlingly original, without precursors.

Ibid., p. 128

"If I were a movie, I'd be *I Am a Camera*."

Fritscher, p. 181

Every Mapplethorpe photograph is a single frame in a movie, which, if it existed, would be a series of dissolves:
the lily dissolves to the genitalia,
the face to the skull,
the skull to the lily.

Ibid., p. 129

A cover shot is always a signature shot.

Ibid., p. 132

Mapplethorpe often X-rayed subjects who interested him.

Ibid., p. 73

It [photography] was the perfect medium, or so it seemed, for the seventies and eighties, when everything was so fast. If I were to make something that took two weeks to do, I'd lose my enthusiasm. It would become an act of labor and the love would be gone. With photography, you zero in; you put a lot of energy into short moments, and then you go on to the next thing. It seems to allow you to function in a very contemporary way and still produce the material.

Morrisroe, *Mapplethorpe*, p. 133

If I had been born one hundred or two hundred years ago, I might have been a sculptor, but photography is a very quick way to see, to make sculpture.

Kardon, p. 27

People don't have time to wait for somebody to paint their portraits anymore, so the money is in photography. It's the perfect medium for our times, because it's of the instant.

Morrisroe, *Mapplethorpe*, p. 142

I went into photography because it seemed like the perfect vehicle for commenting on the madness of today's existence.

Ibid.

Portraits, flowers, and sex pictures.

Ibid., p. 130

He described a disconcerting image of a man inserting a finger in his penis as "a perfect picture, because the hand gestures are beautiful. I know most people couldn't see the hand gestures, but compositionally I think it works. I think the hand gesture is beautiful. What it happens to be doing, it happens to be doing, but that's an aside."

Ibid., p. 192

Mapplethorpe was not an intrusive photographer; he barely raised his voice above a whisper and gave directions by just flicking his hands.

Ibid., p. 211

The only way Mapplethorpe was able to discuss and evaluate his work; it was whether or not he liked the people, not the pictures.

Ibid., p. 279

He purposely wore a loose-fitting Katharine Hamnett jacket to the photo session, and while Mapplethorpe smoked a joint, the curator projected a mental image of himself as someone relaxed and friendly. When they moved from the sitting room into the studio area, however, Narine noticed

Ibid.

that Mapplethorpe no longer seemed stoned, and that his blurry eyes had assumed an expression of steely intensity. He began firing instructions at Narine is a soft but commanding voice: "Move your hands before your lapel ... turn your head to the left ... shift your eyes to the right." Before Narine had time to think about what was happening to him, he had abdicated control of his own body. "I was suddenly part of the process," he explained, "and I felt myself becoming stiff and formalized. Robert was sculpting me into a Mapplethorpe photograph as surely as I had been a piece of stone."

Marshall

Mapplethorpe, Sontag observes, could never become a photographer of accidents. He wants to photograph whatever can be made to pose.

Fritscher, p. 55

In fact, I was genuinely curious to see how Robert had Mapplethorped me. I'd seen his interpretations of other people I know and how their real faces were transformed into Mapplethorpe masks.

Ibid., p. 30

When Robert sent me a package with a print of his photo of me, or perhaps not-me, or, more, what I was then, I hesitated. I wanted to see what this magnificent visionary photographer had found in me. I had to see if I looked dirty: not from the inside out—that id I had always known—but from the outside in. I had to know if I had a gay face: the haunted, hunted, distorted, stereotypical kind. I had to find out if my face had become like the Fellini faces in the bars and baths: a dead giveaway of whatever night hunger it was that made us terminally different from other men. Had Robert exposed my soul?

Ibid., p. 184

F. Holland Day—photographer who dieted himself down to emaciation to play the Christus in his own 1898 self-portrait hanging on the cross, *Crucifixion*.

Ibid.

Joel-Peter Witkin, 1982 crucifixion photograph, *Penitent*.

Ibid., p. 185

Mapplethorpe's influences: Edwin Weston's vegetables, Cecil Beaton's fashion studies, Julia Margaret Cameron's portraits, the African-American work by George Dureau and Miles Everett, and male physique work by Eadweard Muybridge, Baron Wilhelm von Gloeden, Fred Holland Day, George Platt Lynes, and Leni Riefenstahl.

White and Mapplethorpe, p. 132

George Platt Lynes's pictures of erect penises, of black and white male couples, of a suffering man in bondage; he paired nude men with classical sculptures. In all these ways Lynes set an important precedent for Mapplethorpe. Lynes, too, isolated body parts and fetishized sexual organs.

Danto, p. 24

However modern its content, its severe classicism seemed to consign it to another age.

Ibid., p. 23

The photographs seem scarcely to belong to his own time at all. They are controlled, composed exercises in a classical mode. They fit, aesthetically, with the photographs of the nineteenth century, which Mapplethorpe admired and collected, far more than they do with the work of his contemporaries.

Chatwin and Mapplethorpe, p. 10

There were whiffs of Neoclassicism in the air: already, the orthodoxies of Modern Art were grating on people's nerves. No longer was it quite so retrograde for artists to shun the body beautiful; and photographers seemed to be showing the way. It was symptomatic of Robert's approach that he used the Hasselblad as though it were a nineteenth-century plate-camera, slowing down the shutter speeds for greater penetration of the subject.

In 1972, he took a long hard look at the history of photography; although some "great" photographs were anonymous and accidental (just as an *objet trouvé* can be called a "great" object), there were a few photographers with all the attributes of genius. To these pioneers he looked for inspiration; and when he took up portraiture, he turned to one of the greatest portraits of all time— Baudelaire's friend Gaspard-Félix Tournachon, better known as Nadar.

Ibid.

It was Nadar—the photographer of Liszt and of Sarah Bernhardt, of Delacroix and of Rossini—who, marveling at the variety of human expression, perfected the techniques of studio lighting and left a series of character studies unseen in Western art since the realistic portraits of the Roman Republic. And it was Nadar who, in a suit against his brother, explained to a French law court why his own pictures were inimitable, thus disposing of the theory, still held in some quarters by the ignorant, that the camera is an objective apparatus; that photography is not an art.

I think the greatest portrait photographer of all time was Nadar, and he was probably one of the most interesting, if not the most interesting, photographers ever. You can tell by the way the subjects are giving themselves to the camera that they're not sitting in the company of anyone other than their equal. They're not just doing something for a picture; they respect the photographer. Of course, in Nadar's time, it was often the first time they were being photographed, so that the whole experience was not just another photo session, which unfortunately is the case today, because everybody is so oversaturated with photography.

Kardon, p. 27

Partial views of bent-over nudes may bring to mind Edward Weston's still lives of single peppers.

Marshall

However wide his subject matter, he could never become a war photographer or a photographer of accidents in the street.

Ibid.

He is not really an outlaw; he is a preservationist.

Ibid.

He condensed whole feature-length films into single-frame elegance.

Fritscher, p. 45

Mapplethorpe differs perhaps from other artists in photography by this insistence upon the darkness: if other photographers are artists precisely insofar as they *see the light* and register its capacity to seize and transform our response to the world, Mapplethorpe would be the photographer who sees the darkness.

Marshall

I have presumed to say that he sees a particular darkness through three subjects: through flowers, through faces, through figures, discarding the prolixity, then, of the real and discarding the prolixity of the unreal. When we are not prolix (which means when we are not liquid), then we are concise (which means we are crystalline), and this indeed is Mapplethorpe's quality and goal: to restore potency to flowers, to restore aesthetic dignity to the genitals, and to restore form to identity—and in so doing to set his images before us in such a way that we realize that what might never have been seen at all can never be seen as anything but what it appears. What is, as Paul Valéry used to say, the realization of the beautiful.

Valery, speaking of the effect of light upon the sea, calls it "a mass of calm and visible reserve."

Ibid.

His friend Lynn Davis recalls him asking for stronger and stronger light, to the point where you felt boxed in by power packs if you sat for a portrait.

Ashbery, p. 255

White and Mapplethorpe, p. 30	Not for him the shadow-stealing of the unauthorized snapshot.
Ibid., p. 130	Sometimes their bodies are oiled, although Mapplethorpe himself disliked this look, believing it to be reminiscent of corny physique photography of the 1950s, and shot oiled bodies only when the subjects insisted.
Ibid.	Mapplethorpe was an adept of the cult of beauty and rejected the freakish photo à la Diane Arbus or the unmasked-celebrity photo à la Avedon.
Kardon, p. 28	Perfection means you don't question anything about the photograph. I often have trouble with contemporary art because I find it's not perfect.
Ashbery, p. 253	"I'm not after imperfections."
White and Mapplethorpe, p. 130	Objectify: the French word for "lens" is *objectif*.
Ibid., p. 131	Mapplethorpe usually gives us his subjects' names, or at least, depending on the model's preference, his first name.
Ibid., p. 130	… the way the images from the X portfolio were segregated off in specially marked precincts into which one could not possibly wander by accident, so that one had to make a moral decision whether or not to look at them.
Danto, p. 5	I confess to being a great deal more excited by Larry Clark's pictures, partly because of their heterosexual content, partly because I imagine the sexual fantasies of most of us are teenage formations that never especially change.
Ibid., p. 23	It is Dionysiac *and* Apollonian at once.
Ibid., p. 24	[uninhibited and austere, dirty and pure, wild and disciplined]
White and Mapplethorpe, p. 132	The book must enter into the very fiber of its reader, whereas the photograph can be glanced at without being assimilated.
Ibid.	"Let's face it, most photographers are living their lives vicariously by taking pictures. When they get into sex or pornography it's often a sort of cover-up for their own sexual inactivity or inadequacy. They'd rather do it through the camera and sublimate their desires in order to take pictures."
Ibid., pp. 132–3	If Mapplethorpe was linked to earlier photographers and painters, he was also genuinely original, especially in his simplicity, his directness, his unapologetic curiosity, the unwavering force of his regard. As any look at gay art, whether literary or plastic, reveals, nothing is so difficult, so recent, so *evolved* as the simplicity of unmediated vision. Early gay fiction, for instance, is set in ancient Greece or in another country or occurs between innocent schoolboys or touches on the subject of forbidden sexuality only on the last page or takes place between an aristocrat and a lord on a fog-swept island or involves a doomed couple living far from other gay people. Madness or suicide or accidental death is usually the conclusion. Similarly, the alibi of early gay photography is the classical world or ballet or mythology or "scientific" studies of motion or degeneration. Sleeping boys or the dead Christ or the martyred Saint Sebastian or mudlarks fishing coins out of the Thames or naked wrestlers or exotic Arab dancing boys dressed as girls—these are just a few of the pretexts for earlier gay photography.

What is extraordinary about Mapplethorpe is his abandonment of all these contexts, this window dressing for, if you will, the naked fact of sexual curiosity and erotic intensity.

Homosexuality has always been in a visual ghetto.

Marshall

The artificial atmosphere is often claustrophobic, which, subject matter aside, is even more shocking than that of the erotic pictures.

Ashbery, p. 255

Pornography ordinarily represents the sexual organs, making them into a motionless object (a fetish), flattered like an idol that does not leave its niche; for me, there is no *punctum* in the pornographic image; at most it amuses me (and even then, boredom follows quickly). The erotic photograph, on the contrary (and this is its very condition), does not make the sexual organs into a central object; it may very well not show them at all; it takes the spectator outside its frame, and it is there that I animate this photograph and that it animates me. The *punctum*, then, is a kind of subtle *beyond*—as if the image launched desire beyond what it permits us to see: not only toward "the rest" of the nakedness, not only toward the fantasy of a *praxis*, but toward the absolute excellence of a being, body and soul together.

Barthes, *Camera*, p. 59

"I am obsessed with beauty. I want everything to be perfect and, of course, it isn't. And that's a tough place to be because you're never really satisfied."

Morrisroe, *Mapplethorpe*, p. 182

George Dureau was another photographer whose work attracted Mapplethorpe's attention; Dureau, a resident of New Orleans, had a curious relationship to his models, many of whom were dwarves and amputees. "I ran a little kingdom where I was an esteemed patriarch," he said, "and the blacks were like natives of my village." Dureau often met his models by driving through the city in his pickup truck and offering to give them a ride; his photographs were strategically placed in the backseat. "They'd look at them and say, 'What a coincidence! I have a missing leg, too,'" Dureau explained. "Then I'd offer to photograph them. Almost everyone on earth wants to be remembered." When Mapplethorpe saw a picture of Dureau's longtime lover, Wilbert Hines, nicknamed "Wing Ding," whose left arm had been amputated at the elbow, he wrote to the photographer and asked if he could buy the photograph. He then invited Dureau to New York, where the two men discussed their approach to the subject of black men. Dureau explained that he viewed his models' handicaps as visual metaphors, and that despite their disabilities, he saw them as vibrant, sexual creatures. Dureau spent only a short time taking pictures; most of his efforts, he said, were directed at understanding the model as a human being. "Okay," Mapplethorpe interrupted, "but what's your feeling about their armpits?" Dureau was appalled by his single-minded focus on sex. "I was searching for the greatest universal truths," he said, "and Robert was searching for pungent armpits."

Ibid., p. 238

He almost always used coke during a shooting and frequently offered it to his sitters. The wide-eyed stare that became a distinguishing characteristic of his portraits was often the result of cocaine, and when it wasn't, he seemed to be aiming for a sharp "coke look."

Ibid., p. 267

As early as 1971, he made the astonishing confession—or was it a challenge, even a defiance?—about his work as a portrait-maker: "I often don't know who these people are. It's not that important to me. I never had heroes."

Marshall

In Mapplethorpe's portraits, almost no one is smiling.

Ibid.

Ibid. A remarkable exception to this general solemnity of regard is the portrait of Louise Bourgeois (one of three superb effigies of old women artists in *Certain People*, the others, Alice Neel and Lee Krasner, revealed as flaunting the damages of a lifetime like a shield before them, stoically endured). Sometimes exhibited or reproduced in a cropped version, the Louise Bourgeois portrait then seems no more than a rictus of mysterious complicity. Seen in the version Mapplethorpe prints in the book, the complicity is accounted for: under her arm (and she is wearing a shaggy monkey fur jacket which accentuates the spooky side of things), she carries like a sidearm her own sculpture of a two-foot phallus-and-testicles, lighted and held in such a way as to form the base of a sinister—castrational?—pyramid. The livid light on Bourgeois' face, explicitly tracing the seamed and wrinkled flesh, pronounces sentence on the entire composition: like some sibyl out of Petronius, the sculptor is on her way to a ceremony of puzzling erotic nature; she knows what she is about to do, as the shocking hand makes explicit: fingers can be taught, but that thumb was born knowing.

Ibid. The portrait of Roy Cohn made in 1981 is precisely the portrait of everything that name has come to signify, and the portrait is not so much a proleptic death mask as a Veronica's Veil of ill-omen, floating in a black void, bodiless and therefore soulless.

Ibid. Susan Sontag asked Mapplethorpe what he does with himself when he poses, to which he answered, "try to find that part of the subject which is self-confident."

Ibid. A Mapplethorpe portrait represents a power of the flesh as a Mapplethorpe flower constitutes an effigy of sacred assertion: it figures Being taken— posed, beguiled, inveigled by all the sortileges of darkness—to the very limits of itself, all that flesh is heir to without the connivance of circumstance.

Ibid. What we call the facial mask has momentarily triumphed over individuality, over the personal, the human, and all that the merely human hides. Indeed, in the face of such an image, I no longer know why we must praise an artist, a photographer, for being "human," when as Mapplethorpe shows us, all that fulfills and completes humanity is inhuman.

Ibid. Nothing of Diane Arbus's fascinated repulsion in Mapplethorpe's exploration of drastic erotic identities.

Ibid. Faces are transpicuous with energy, with appetite, yet there is always the gravity of the features, of the flesh which pulls, which ponderates, in the sense of bearing down what aspires to rise, to mount to expression, to identity.

Kardon, p. 25 I've tried to juxtapose a flower, then a picture of a cock, then a portrait, so that you could see they were the same thing.

Fritscher, p. 72 Robert gave people permission to be avant-gardistes with photographs of lilies in the dining room, because, as soon as everyone knew about his fisting photographs, his lilies gained an edge. The flowers opened up whispered avant conversations about his forbidden photographs, which, at first, not too many had been granted favor to see.

Edward Steichen said in 1963 that the custom in New York since the 1920s was to hang nude art, especially photographs, discreetly away in the bedroom.

"So the subtext of the flower photographs' popularity is the existence of the nude and leathersex photographs?"

"The forbidden photographs," Edward replied, "made the flowers desirable, salable."

"Did that same sexual subtext cause his celebrity portraits to succeed?"

"He definitely benefited from his private history. Of course, it was sexy to be shot by such a naughty boy."

Sam Wagstaff: "As an old-fashioned gesture I once sent Mapplethorpe some flowers at Easter which, to my chagrin, were greeted with snarls. 'I hate flowers,' he said and pretended to spit on them. Now, if you will, he still spits on them but with his Hasselblad, or he does something perverse to them that nobody else seems to have thought of before." *Morrisroe, Mapplethorpe, p. 182*

Many of Mapplethorpe's flowers appear to have lost their virginity, as though the photographer himself had defiled them in some exotic and unspeakable way. There was an air of the kidnapper about him as he rushed home from Gifts of Nature, a florist shop on Sixth Avenue, his arms laded with orchids, irises, and tuberoses. By the time he had finished photographing his "gifts of nature" they had no connection to nature at all and had become, in Mapplethorpe's words, "New York flowers"—hard edged and decadent. Like the hero of Joris-Karl Huysman's novel *Against Nature*, Mapplethorpe despised "bourgeois blooms" and preferred orchids and lilies—the "princesses of the vegetable kingdom," or in his case, the "princes." *Ibid.*

Flowers being the sex organs of plants, Mapplethorpe's view of botanical reproduction was colored by his own sexual interests; he transformed protruding pistils and stamen into male genitalia. "My approach to photographing a flower is not much different than photographing a cock. Basically it's the same thing."

Mapplethorpe treated his flowers no differently than the men who modeled for him. He didn't know what to do with the flowers once he had taken their picture, and since he didn't want the responsibility of watering them, he tossed them in his garbage bin before they wilted and died.

He always saved Robert his filthiest jockstraps and his best blooms for Robert's Baudelairean flowers-of-evil still lifes. *Fritscher, p. 27*

Janet Kardon: Do you think they're threatening? *Kardon, p. 25*

Robert Mapplethorpe: That's not the exact word. But they're not fun flowers.

The "expression" of the uncircumcised glans and the "assertion" of the cut flower. *Marshall*

In the heat of ardor, you might think, "That's an elegant cock." Normally, it's not a subject you would consider elegant. But you think of flowers as possessing an elegance, or refinement, and I think you treat the flowers like the cocks and the cocks like the flowers. *Ibid.*

These frozen bouquets are so exquisite that they might almost have us forget the fact that hours or days after they have posed here they will end up on the street waiting for the garbage trucks. *Sischy*

Flowers spring up against their own weight; engorged with juice, they are never shown attached to the cycle which would make their momentary victory more than just that. *Marshall*

Ibid.

Mapplethorpe: I don't love flowers and I don't like having them.

Q: What don't you like about living with them … the bother of watering them?

A: Watering them and dripping on the floor.

Q: And watching them die?

A: And watching them die and feeling guilty about them. I can't have part of my life devoted to flowers. But I can photograph them and get excited about photographing them … I'll sort of force myself to photograph them before they die because I know I can get a good picture of them.

Ashbery, p. 253

His concern for the flowers is almost touching.

Marshall

Flowers—just think of Emily Dickinson, of Georgia O'Keeffe, with their patient explorations of bloom—which have so traditionally been associated with female art and female organs, are here, in their engorged, erectile, anti-chthonic forms, identified with that "male" principle we so clumsily (and often so reductively) decry as "phallic."

Ashbery, p. 253

Taking revenge on the flowers for the transience of their perfection.

Ibid.

"I think flowers have a certain edge … I don't know if 'nasty' is the right word—if you look at the picture of the orchid, to me it is a kind of scorpion—it has a sharp edge to it. I get something out of flowers that other people don't get … I love the pictures of flowers more than I love real flowers."

Marshall

What is spoken, Heidegger says, is never—and in no language—what is said. I might add: not even in the language of flowers.

Chatwin and Mapplethorpe, p. 10

On bright days, when the rest of Manhattan scintillates in the sunshine, he will emerge onto the sidewalk, screw up his face, and say, "I hate the sun."

Ashbery, p. 253

Can one feel sympathy for an artist who hates not only flowers but sunlight too?

Ibid., p. 254

Because he is fashionable, because there is tremendous demand for his work, and because so much of it cannot be shown in public, these presumably innocent photographs of flowers have been summoned to stand in for the others. It is impossible to look at them and ignore their context, and so they have taken on a further ambiguity: They are, in effect, calling attention to the pictures that are hidden from view. Like fig leaves for absent genitalia, they point to the scandal of what is not there.

Marshall

Yeats: "the mystery which touches the genitals, a blurred touch through a curtain."

Ashbery, p. 255

This wasn't in the original plan: at most Mapplethorpe was trying to make some money with the flowers to finance other work that mattered more to him.

Ibid., p. 256

A vase of tulips, more disheveled and past their prime than he usually allows his subjects to get, is perched perilously on the edge of a table; one tulip at far left is about to swan-dive into the abyss.

N. cit.

The great white calla lily whose horizontal lines serve as a foil to its proud gold erection, strikes an uncharacteristic jubilant note. It is an invitation to pleasure that will not be rebuffed.

Nulle fleur du jardin n'égale ma splendeur,
Mais la nature, hélas! n'a pas verse d'odeur
dans mon calce fair comme un vase de Chine.
(No other flower of the garden equals me in splendor,
But nature, alas! poured no scent
into my calyx, shaped like a Chinese vase.)

Théophile Gautier

AIDS was too popular a form for Mapplethorpe to be excluded.

Fritscher, p. 216

Several photographers who have AIDS all said they'd speeded up their production.

Ibid., p. 77

Mapplethorpe, unlike Rock Hudson, wasn't a sympathetic AIDS victim.

Morrisroe, *Mapplethorpe,* p. 359

You know, faggots are dying.

Ibid., p. 270

Contrary to his fears that rumors of AIDS would ruin his career, the disease only served to increase his sales potential. He was already one of the most visible photographers in the world, and during the past decade his work had been the subject of sixty-nine one-person shows, five books, and fifteen catalogues. But AIDS would soon catapult him into another realm of celebrityhood; unfortunately, nothing enhanced his life more than the prospect of his leaving it. "I don't think it's impossible to sell a million dollars' worth of Robert's pictures," Howard Read boasted to dealer Peter MacGill. "He's ill."

Ibid., p. 323

Prices often escalate after an artist's death—"the deader, the better" goes the art world saying—so Mapplethorpe's terminal illness had, according to Read, created a "built-in market condition," whereby people purchased Mapplethorpe photographs in anticipation of his demise. "AIDS," Read said, "had a terrific influence."

Lisa Lyon recalled a photography dealer calling her up to see if she'd sell some of her Mapplethorpe photographs from *Lady.* "The dealer said, 'You know, Robert's dead,'" she explained, "so I immediately got crazy and said, 'What do you mean he's dead?' Then the dealer told me, 'Well, he's dead … in terms of the market.'"

Mapplethorpe's ability to discuss his work in terms of "just starting" was an example of how he truly believed in the magic power of his own creativity, and how, despite his deteriorating body, he was still capable of expanding the boundaries of his vision. Physically, however, he was like the photograph of Thomas Williams trapped in the circle. The neuropathy was spreading from his feet to his legs, and from his fingers to his hands. Since Mapplethorpe had long defined his identity in terms of sex, it must have terrified him to imagine a nerve disorder traveling to his genitals, and he obsessed on the idea that when it struck the center of his body, it meant he would no longer exist.

Ibid., p. 334

Yet AIDS had already diminished his sexual desire, and in response, he wasn't focusing on black nudes anymore. "I'm over that phase," he told Janet Kardon. "I'm not photographing anything naked these days. That isn't to say I won't again, but I haven't been concentrating on bodies recently." Instead, he turned his attention to marble statues—"chilly white icons of desire," as art critic Kay Larson described them.

In doing so, Mapplethorpe had come full circle, for having once excelled at transforming his models into pieces of sculpture, he was now attempting to breathe life into stone. Most of the statues he photographed were nineteenth- and twentieth-century reproductions of classical gods, which Dimitri Levas bought for him at Malmaison. Mapplethorpe purposely sought the

reproductions because the ancient classical figures were rarely in perfect condition, and he did not want to own them if they were missing "noses and things." Yet even his reproduction gods failed to measure up to his exacting standards, and discovering a slight mark on the bridge of Apollo's nose, he sent the statue out to be professionally cleaned. He then began sending all his statues out for cleaning until Levas finally put a stop to it. "This is ridiculous," he said. "You're ruining the beautiful patina and making them look like brand-new statues. It doesn't make any sense."

Fritscher, pp. 221–2

To legitimize itself from stigmas, bodybuilding often referenced classic statuary. Gaines's pop-seminal *Pumping Iron* called bodybuilders "living sculpture."

Morrisroe, *Mapplethorpe*, p. 232

John Russell Taylor, in a review of the show for *The Times*, attributed the sudden surge of interest in Mapplethorpe not to his talent, which he found to be on the level "of the average photographic graduate from art school," but to the elaborate myths surrounding his career: "Certainly no photographer of recent times—perhaps no photographer ever—has been so ruthlessly hyped, so skillfully merchandised." The issue of Mapplethorpe's impending death from AIDS only served to enhance the myth.

Ibid., p. 356

A late exhibition of Mapplethorpe's busts and religious icons. Gallery-goers meditated on his photograph of a crucified Christ figure as if they were studying the Pietà. One man swore he could see a real tear in the eye of an African bronze.

Ibid., p. 345

Mapplethorpe's Whitney retrospective, summer 1988. People poured into the exhibit by the dozens, until Mapplethorpe was nearly engulfed by a crowd that numbered sixteen hundred. The museum's air conditioning was malfunctioning, so the rooms were sweltering, and the fashionably attired guests were soon complaining that the museum felt like a sauna. Meanwhile, paparazzi encircled the couch hoping to capture what was fast becoming a new genre of celebrity portraiture—the AIDS shot.

Ibid., p. 354

Mapplethorpe's eyes were one of the few parts of his body relatively unaffected by the disease, and his compulsion to weed the ugly from the beautiful was the only way he could still exert control over his life. Fittingly, his last self-portrait was a picture of his eyes only.

Ibid., p. 359

Among the last images was a faint self-portrait, followed by his signature—"Robert Mapplethorpe … Robert Mapplethorpe … Robert Mapplethorpe"—until his name was reduced to a blur.

Marshall

I used to think Mapplethorpe's photography was grim with the restrictive occasions of obsession and fetishism; but after a certain meditation, pondering their reasons and their realizations, I discern these pictures—a good share of them—to be emblems of contested mortality, grave with the contradictions of organic life in their aspiration to ecstasy, as crystalline in terms of their own art as the sonatas of Scarlatti or the last paintings of Mondrian, but as problematic, as imprecatory as any representation of the body I know, fond enemy and ally.

Fritscher, p. 89

Mapplethorpe's final photo-sort profiles the homage he paid to photographers, historical or personal friends, who influenced him or whom he admired: F. Holland Day (*Orpheus Series, Return to Earth*), Adolph de Meyer (*The Opium Smoker* and *Portrait of Robert Stowitz in a Diaghilev Ballet*),

g **Mapplethorpe**

Harold Edgerton (*30 Cal. Bullet through an Apple*), George Dureau (assorted male nude studies), Peter Hujar (selected images), Clarence Kennedy (fashion and society sculpture studies), Angus McBean (male face portrait and reclining male nude), George Platt Lynes, Julia Margaret Cameron (*The Shadow of the Cross*), Edward Curtis (*Native American Portraits: Crow-Chief White Swan* and *The Potter, Hopi*), Edward Steichen (*Fashion Portrait*), Alfred Stieglitz (*Portrait of Marie Rapp*), three from Diane Arbus, two from Bruce Weber, seven from Joel-Peter Witkin (Lisa Lyon as Hercules, bearded, and Mandan, depicting the sun dance ritual enacted by Fakir Musafar), five from longtime friend and Mapplethorpe Foundation board member Lynn Davis (*Iceberg* and *Selected Images*), and two from Annie Leibovitz (*John Lennon and Yoko Ono*, 1980: Lennon nude, curled fetally across the reclining Ono whose hair flows across the floor; this photograph was taken the afternoon of the evening Lennon was shot).

Drawings, photographs and screens of Mapplethorpe, sold on the auction block: Patti Smith, *Robert Mapplethorpe and Patti Smith Go to Coney Island Together*, graphite and crayons, $400; David Hockney, *Portrait of Robert Mapplethorpe*, pen and black ink on paper, New York, June 1, 1971, $75,000; Francesco Clemente, *Untitled (Robert Mapplethorpe)*, watercolor on paper, March 1976, $15,000; Don Bacardy, *Portrait of Robert Mapplethorpe*, pen and black ink wash on paper, February 2, 1979, $1,500; Tom of Finland, *Portrait of Robert Mapplethorpe*, 1979, $600; Andy Warhol, *Portrait of Robert Mapplethorpe*, synthetic polymer silkscreen on canvas, unframed, 1983, $120,000. *Ibid.*, p. 90

After Mapplethorpe's death, magazine mail-order advertisements offered an edition of collectible "dinner" plates printed with his signature calla lily. T-shirts are sold in museum shops along with posters and greeting cards. His photographs appear on refrigerator magnets manufactured in places where copyright means nothing. *Ibid.*, p. 192

Three Mapplethorpe photographs were found, trashed in a dumpster in San Rafael. At the time vintage Mapplethorpe sold for $10,000. The photographs, all signed, were dated 1977. *Ibid.*, p. 187

The Vatican's art collection is rumored to have more than one "forbidden" Mapplethorpe. *Ibid.*, p. 185

Mapplethorpe's memorial service at the Whitney Museum was a "guests only" affair, and several of the photographer's friends who wanted to pay their respects had to sneak past the Mapplethorpe sentinels at the door. Music executive Danny Fields, who had been the first person to befriend Mapplethorpe and Patti Smith at Max's Kansas City, was confronted by a woman demanding "Where's your ticket?" When he confessed he didn't have one. "It's a memorial service," he said, "not a rock concert"—he was informed that without a ticket he couldn't have a seat, although standing room was still available in the back. "One of the ushers was a friend of mine," Fields recalled, "so I told him, 'This is embarrassing … get me a seat.' Then I looked around me, and I couldn't figure out what any of the people had to do with Robert's life. There were no black men, and I didn't see any of the gay crowd from the Eagle's Nest or the Mineshaft. It was mostly art dealers in suits and leaders of fashion society, and you could almost see prices climbing in everybody's heads. It was like an auction at Christie's." Morrisroe, *Mapplethorpe*, p. 368

Photographer Sheila Metzner was overheard saying, "I feel bad that Robert's dead, but I'm just glad to be alive." A photographer from British

Vogue was trying to get pictures of the memorial for the magazine, and the celebrity count was on the low side.

Fritscher, p. 79

He lovingly photographed his things in the glamorous, pricey style suited for beautiful commercial print ads for magazines to up their resale value.

When finally his precious objects were auctioned, he had, in addition, his beautiful photographs of them: sale objects selling themselves. The physical collectible might be sold, but he maintained ownership of the negatives of their photographs. Because he photographed the objects, they were worth even more, endorsed by his selection and enhanced by his take.

Every perfect object served double duty.

Through his camera, he multiplied his loot.

He not only sold the stuff.

He sold photographs of the stuff.

The Christie's auction was a collection of the relics of St. Mapplethorpe.

He endorsed his collection the way athletes endorse Wheaties. He upped the value. A George Sakier glass vase became even more important when collected, photographed, and signed by Mapplethorpe.

Ibid., p. 91

When Arthur C. Danto's overwhelming *Mapplethorpe*, created with the cooperation of Robert's estate, appeared with 280 duotones, London's Harrods, one of the world's largest department stores, declared the book pornographic. The same week in November 1992, Harrods sold out, in one hour, their entire allotment of Madonna's book, *Sex*, with heterosexual and lesbian photographs by Stephen Meisel.

Ibid., p. 92

Actually, the Mapplethorpe Truth is not going to match the Mapplethorpe Legend. And people will always prefer the legend.

Ibid.

Mapplethorpe would love the contretemps of corporate biography competing with personal reminiscence.

Morrisroe, *Mapplethorpe*, p. 368

Mapplethorpe had excluded his parents from his multimillion-dollar will.

Ibid., p. 369

No one claimed Mapplethorpe's ashes.

"New York," Zelda said, "is more full of reflections than of itself."

Douglas, p. 59

The reflecting surfaces, of the ironic, of the epic order, suspended in the New York atmosphere, have yet to show symptoms of shining out, and the monstrous phenomena themselves, meanwhile, strike me as having, with their immense momentum, got the start, got ahead of, in proper parlance, any possibility of poetic, of dramatic capture.

James, p. 83

City of a million mirrors, actual and unseen.

Riesenberg and Alland, p. 207

Self-consciousness has come to suggest a beam of light thrown back upon itself after impact with a reflecting surface.

Gasche, p. 16

Reflections and mirrorings, transparent and translucent building materials are carefully calculated and organized to focus divergent spatial vistas in one visual grasp.

Friedberg, p. 120

The vertical reflections on the sidewalk.

Sharpe, p. 125

A window-ledge refraction, where the curved surface of a brandy glass capsizes the skyline of Washington Square South, holding it afloat and inverted: the city acquiescently melts in the transparent *chambre claire* of the glass.

Conrad, p. 175

A viewer can't tell whether a pane of glass acts like a mirror or a cloth.

Kozloff

The street dies in the mirror.

Garfias, p. 305

The city rights and assigns, that is, it signifies, orders, stipulates. What? That is to be discovered by reflection.

Lefebvre, p. 102

Reflection is the structure and the process of an operation that, in addition to designating the action of a mirror reproducing an object, implies that mirror's mirroring itself, by which process the mirror is made to see itself.

Gasche, pp. 16–17

The metaphor of the mirror—producing substitutive, deceptive, illusory vision—and the metaphor of the window—producing direct, veridical, unmediated vision—imply very different epistemological consequences.

Friedberg, p. 15

New York was more full of reflection than of itself—the only concrete things in town were the abstractions.

Fitzgerald, *Waltz*, p. 68

Is there any other place where an entire cloud bank can be completely reflected in the windows of one wall of only one building, and with room to spare?

Finney, p. 10

Glass, in hues of plum to bronze to charcoal, that mirror their towering neighbors.

Klein, p. 124

The blackness somewhere gouged glass on a sky.

Crane, "The Tunnel," p. 63

In the large plate glass, he saw a clear reflection of himself and the crowds that were passing, like shadows at his back.

Cheever, "Five-Forty-Eight," p. 285

Imagine a city iridescent by day, luminous by night, imperishable! Buildings—shimmering fabrics—woven of rich glass—glass all clear or part

Friedberg, p. 116

opaque and part clear-patterned in color or stamped … Such a city would clean itself in the rain, would know no fire alarms nor any glooms.

Ellis, *Psycho*, p. 163

I start to stalk the dark, cold streets off Central Park West and I catch sight of my face reflected in the tinted windows of a limousine that's parked in front of Café des Artistes.

Ellis, *Glamorama*, p. 107

Stopping on the corner of East Fourth I catch my reflection superimposed in the glass covering of an Armani Exchange ad.

Conrad, p. 102

If you're left alone, you cheer up yourself by becoming an amusing stranger to yourself in the mirror, relying on it to supply you with company.

Gasche, p. 13

Reflection shows itself to mean primarily self-reflection, self-relation, self-mirroring.

Vreeland, *Papers*

We don't think about it. The girls keep looking in the mirror … which is all right by *me*. I loathe narcissism, but I *approve* of vanity.

Riesenberg and Alland, pp. 189–90

The sides of tall buildings on Forty-second Street reflect the lightnings and amplify the crashes.

Corbusier, p. 101

Boxes of various products, bottles, cars, always cellophaned and supplied with reflections.

Ellison, *Invisible*, p. 546

… the shattered glass glittered in the street like the water of a flooded river upon the surface of which I ran as in a dream …

"I'll Be Your Mirror"

Warhol suggested that the Velvet Underground's LP have a built-in skip so that the line "I'll be your mirror" would repeat infinitely.

Mayakovsky, *Discovery*, p. 47

With the inordinate length of the buildings, and the winking colors of the traffic controls, all the motions are doubled, tripled and magnified tenfold by the asphalt—which has been licked as clean as a mirror by the rain.

Scheerbart, Taut, and Sharp, p. 55

When glass architecture comes in, there will not be much more talk of windows either; the word "window" will disappear from the dictionaries … The window will effectively become the wall.

Bulletin of the American Meteorological, p. 88

Windows are much more expensive to build than blank walls; they occupy valuable wall space; they increase heating costs; their washing is a big item of expense; and the light they admit fades most kinds of hangings and decorations more rapidly than does artificial light.

Krauss, pp. 59–60

As a transparent vehicle, the window is that which admits light—or spirit—into the initial darkness of the room. But if glass transmits, it also reflects. And so the window is experienced by the symbolist as a mirror as well—something that freezes and locks the self into the space of its own reduplicated being. Flowing and freezing; *glace* in French means glass, mirror, and ice; transparency, opacity, and water.

Friedberg, p. 18

The metaphors of windows and mirrors fall into a slippery discursive tumble of synecdoche and displacement.

Ginsberg, *Howl*, p. 6

Moloch whose eyes are a thousand blind windows!

Brick culture does us only harm. Friedberg, p. 115

The 1920s had delighted in hard surfaces. Douglas, p. 470

The concept of transparency takes on a new set of meanings in the utopian turns of architectural modernism. Friedberg, p. 117

Transparency has an odd effect on the discursive "materiality" of glass. *Ibid.*

Transparency means simultaneous perception of different spatial locations. *Ibid.*, p. 119

dematerializing the corners *Ibid.*

Thermopane, a type of double glazed window with two pieces of glass separated by a sealed air space, invented in the 1930s, reduces the degree of air-conditioning ordinarily needed to counter the effect of the sun on so much skyscraper glass, thus making it possible for glass curtained buildings. Trager, p. 578

A complete visibility without exposure of the other senses. Friedberg, p. 117

All around you is a building unchanged from the day it was built, including the room you stand in and very possibly even the glass pane you look through. And this is what's unique in New York: *Everything you see outside the window is also unchanged.* Finney, pp. 74–5

The condition of the window implies a *boundary* between the perceiver and the perceived. It establishes as a condition for perception a formal *separation* between a subject who sees the world and the world that is seen, and in so doing it sets the stage, as it were, for that retreat or withdrawal of the self from the world which characterizes the dawn of the modern age. Ensconced behind the window the self becomes an observing *subject*, a *spectator*, as against a world which becomes a *spectacle*, an *object* of vision. Friedberg, p. 16

h Glass

One gloomy afternoon, millions were won and lost in bets over which raindrop would first reach the bottom of a window. Culbertson and Randall, p. 150

One window was streaked with something that looked like soy sauce. Kinkead, *Chinatown*, p. 18

Window cleaners charge very high prices and do a smeary, slovenly job of window cleaning. Atkinson, p. 30

Lever House: a traveling gondola suspended from its roof enables window cleaners to wash its 1,404 panes of heat-resistant blue-green glass, but the windows are sealed, the centrally air-conditioned building makes profligate use of energy, and it will be a model for energy wasting architectural extravaganzas that will be constructed throughout most of the world. Trager, p. 590

I looked out the windows, and they were dirty, very much the tonality of Rauschenberg's pictures. They were very much New York Lower Broadway windows. Kostelanetz, p. 5

Although New York has more windows than any other city in the world, it has no window life. In Italy, a large part of the day is happily spent leaning on the windowsill. When Spain was a land of peace, much of her social life was carried on from the balcony. A dance in a London square brings neighboring footmen, housemaids and passersby to see the waltzing figures pass lighted Beaton, *Portrait*, p. 30

windows. Tweenies in curl papers gaze dreamily down into lamplit squares before going to bed. Yet here, in New York, never a face is to be seen at the numberless windows. Only when one passes them in a train do these illuminated frames show any life at all—a family in shirt-sleeves, eating its evening meal in full view of the plumbing fixtures; a couple dancing halfheartedly to an unheard radio; a man, like a wax figure, studying an unseen mirror as he shaves his latherless face with an electric razor.

Hawes Rosario Candela: designer of irregular fenestration.

Mayakovsky, "Hell," p. 505 Windows split the city's great hell
into tiny hellets—vamps with lamps.

Stevens, *Letters*, pp. 67–8 Tall office buildings closed up for the night with drawn curtains, so that the faces of the buildings looked hard and cruel and lifeless.

Conrad, p. 103 Windows rather sinister in their lidded blankness.

Crane, "The Tunnel," p. 95 Blank windows gargle signals through the roar.

Voyeur, Exhibitionism

Parland, p. 346 Darkness whirls
streaks of light, shadows
against people's windows:
are you in?

Sharpe, p. 274 The odd idea that New Yorkers abhor shades or window treatment, content with the knowledge that everyone can (and does) see each other.

Blandford, p. 11 When we moved in, I acquired a pair of binoculars. Now, I stand in the kitchen, binoculars trained on the twenty-storey building next door. Any neighbors who don't like it, I reasoned at first, could simply draw their nets. Not one window opposite has net curtains; not one has any curtains that close for that matter.

 No one knows or apparently cares that I am watching. If you assume the world outside is hostile, you try to shut it out. If you assume that it's merely impersonal, that it doesn't give a damn about you either way, there's no point in bothering.

Metz, p. 62 Voyeurism rests on a kind of *fiction*, more or less justified in the order of the real, a fiction that stipulates that the object "agrees," that it is therefore exhibitionist.

Sharpe, p. 274 One night window offers the man sexual fantasy, the other domestic drudgery.

Ibid. How much undressing will the girl do by the window? Will she turn out the light or discover our presence before she is naked?

Metz, p. 60 All voyeuristic desire depends on the infinite pursuit of its absent object.

Riesenberg and Alland, p. 208 Town of snoopers, peepers, keyhole astronomers.

The voyeur is very careful to maintain a gulf, an empty space, between the object and the eye, the object and his own body ... the voyeur represents in space the fracture which forever separates him from the object.

Metz, p. 60

Edward Hopper, tireless street prowler and elevated snooper.

Sharpe, p. 277

Hopper used the vantage point of the nighttime elevated train to encourage viewers to fantasize about people never to be seen again—except in the picture frame, where they are frozen forever in the instant when their unknowability hovers on the edge of a giveaway act.

Ibid.

Racing up Third Avenue on the el, gazing into living rooms out of John Sloan or Edward Hopper.

Hamill, "Lost"

"Nighthawks," he once said, "seems to be the way I think of a night street."

Levin, p. 349

Bare interiors starkly lit by electric light spotlight the invisible desperation of motionless people in their supposed leisure hours.

Conrad, p. 102

From a position above the street, he looks in to an upper-story apartment. Three windows glow; the middle one reveals, in a patch of interior light, the buttocks, bare legs, and bare back of a slip-clad woman who bends forward into her room, away from the window. Her head and feet are cut off by the heavy masonry of her apartment building's walls. Her vulnerability—or is it availability?—to the implied male viewer is signaled by the open window on the left, whose thin curtain, echoing the curve of her torso, flutters out in the breeze. Meanwhile, the window on the right glares flame-like through a backlit red curtain ... The central window and the provocative posterior beckon at the cusp of the curve, open to the night air, while an exterior ledge wide enough to support a bold criminal or lover accentuates the rounding of the corner, the broachable interior, and the soft fall of light from inside outward.

Sharpe, pp. 278–9

The couple on the El have turned away, twisting awkwardly together in their desire to guard themselves from observation.

Conrad, p. 104

Hopper recalled that the picture "was probably first suggested by many rides on the 'L' train in New York City after dark and glimpses of office interiors that were so fleeting as to leave fresh and vivid impressions on my mind."

Sharpe, p. 281

He commented that his "East Side Interior" (1922) derives from "memories of glimpses of rooms seen from the streets in the eastside in my walks."

Conrad, p. 101

A Hopper interior is never a shelter. Seeing into his rooms, you see through them, as with that glass box which contains, as if in a cage or an aquarium, his "Nighthawks." No blinds mask the scenes of depression or sexual discontent he looks in on because the emotional lives of his people are as unfurnished as their rooms or the streets they frequent in the small hours.

Ibid., p. 105

The painter's surest way of knowing his fellow citizens is to spy on them.

Ibid., p. 101

[John Sloan] was offended when, in his new studio on West 4th Street, some Italians salaciously bored holes through the wall to peek at the artist closeted with his models.

Ibid.

Ibid.	Sloan's looking is a speculative sympathy, a guessing fascination with the lives of others, like the couple he observes across the backyards on West 24th Street. The woman has bleached hair, the man lacks a hand. "I have rather fancied," Sloan records, "the notion that he is something of an outlaw."
Ibid., p. 91	Sloan thinks of New York as a landscape populated by chubby healthy female nudes, who sun themselves on rooftops.
Ibid., p. 90	From his studio on West 23rd Street Sloan could spy on such women bathing in rooms across the backyard or sunning themselves on the roof, and he would often walk east to the Flatiron, where the impudent air currents between the buildings caused the skirts of passersby to blow around their knees. In adjacent Madison Square he would "soak up a little sunlight," his own urban body luxuriantly roasting itself.
Brown, *Valentine's*, p. 23	In these trailing skirt days it was nothing unusual to see a crowd of boys and young men, and men not so young, congregate around the sheltered doorways of the Flatiron Building. The gusts that were created by the peculiar position of this particular building were the cause of much embarrassment to the ladies caught unaware in a small-sized hurricane. The resultant effect—sometimes you could actually see a glimpse of hosiery—was the cause of much merriment among the cloistered group in the doorways.
Arce, p. 20	The afternoon shot full of windows.
Conrad, p. 101	On West 26th Street he sees "eyes between the slats of shutters" and hears soft voices inviting him.
Ibid.	In June 1906 he watches a baby die in a neighboring room and is as helplessly concerned as the men who can only clumsily force a drink on the distraught mother.
Ibid., p. 158	King Vidor, making *The Crowd* in New York in 1928, hides the camera inside a barricade of packing crates on a corner or mounted it on the back of a truck from where it peers out through a hole in the flap. Vidor loiters alongside, posing as an idler on the street, and mutters his instructions to the cameraman under cover.
Metz, p. 62	Voyeurism rests on a kind of *fiction*, more or less justified in the order of the real, a fiction that stipulates that the object "agrees," that it is therefore exhibitionist.
Conrad, p. 159	The filming of Dassin's "The Naked City" is organized with a devious skill worthy of the criminals whose activity it investigates. To allay the suspicions of passersby, diversions are staged: a juggler performs and a man propped on a thirty-foot ladder waves the American flag. Street smart imps relish the way the camera picks the pockets of the citizens by cheating them of their fees as extras. A shoeshine boy remarks to the producer, Mark Hellinger, that the crowd distracted by the juggler "should be getting twenty-five a day for being in the movies and they don't know it." Sometimes, while conducting surveillance, the camera unintentionally sees things it shouldn't—not breaches of the law but incriminating social details which Dassin is forced to cut from the release print, such as Bowery bums selling off their last possessions outside the Diamond Exchange.

The Naked City (1948): Two hundred thousand New Yorkers turned out to watch the camera crews; at one point the producers turned to a professional juggler to help distract the crowds while the actual shooting was completed.

Sanders, *Celluloid*, p. 330

Pleasure derived as much from the witnessing of lovely images as from any sexual embrace.

Wojnarowicz, p. 140

This is the city self, looking from window to lighted window
It is the city consciousness
Which sees and says: more: more and more: always more.

Schwartz, p. 4

After the day's work I climb up these stairs into the distant company of strange yet friendly windows burning over the roofs. I read a few hours, catch glimpses of my neighbors in their nightgowns, watch their lights disappear and then am swallowed up in the huge velvet October night.

Stevens, *Letters*, pp. 67–8

The fleeting intimacy you form with people in second- and third-floor interiors, while all the usual street life goes on underneath, has a domestic intensity mixed with a perfect repose that is the last effect of good society with all its security and exclusiveness. It is better than the theater, seeing those people through their windows: a family party of workfolk at a late tea, some of the men in their shirt sleeves; a woman sewing by a lamp; a mother laying her child in its cradle; a man with his head fallen on his hands upon a table; a girl and her lover leaning over the window-sill together. What suggestion! What drama! What infinite interest!

Sharpe, p. 271

Like spotlights, streetlamps create pools of light to direct the viewer's gaze; like stage sets, lit interiors framed glimpses of intimate life for strangers watching in the dark.

Ibid., p. 267

hazy brilliance of windows

Khlebnikov, p. 47

Hers is the only light in the apartment building, and I see her shadow pass the drawn curtains twice, then recede back into the room.

Spillane, p. 268

You stand at the corner of Bleecker and Cornelia and gaze at the windows on the fourth floor of a tenement.

McInerney, *Bright Lights*, p. 9

This evening, on my way to supper, I see the man again. He is standing across the street, leaning against a tree and staring up at Holly's windows. Sinister speculations rush through my head. Is he a detective? Or some underworld agent connected with her Sing Sing friend, Sally Tomato? The situation revives my tenderer feelings for Holly; it is only fair to interrupt our feud long enough to warn her that she is being watched. As I walk to the corner, heading east toward the Hamburg Heaven at Seventy-ninth and Madison, I can feel the man's attention focused on me. Presently, without turning my head, I know that he is following me. Because I can hear him whistling. Not any ordinary tune, but the plaintive, prairie melody Holly sometimes plays on her guitar: *Don't wanna sleep, don't wanna die, just wanna go a-travelin' through the pastures of the sky.* The whistling continues across Park Avenue and up Madison. While waiting for a traffic light to change, I watch him out of the corner of my eye as he stops to pet a sleazy Pomeranian. "That's a fine animal you got there," he tells the owner in a hoarse, countrified drawl.

Capote, p. 52

It's been a year since anyone occupied the apartment on the top floor of the little building tucked into a small street in the financial district. Its windows

Brooks, *In the City*, p. 53

are empty, pools of darkness in an area that is beginning to brighten as the neon sheen of night arises.

Wilcock, "New Neighbor," p. 155

The windows of a large studio apartment on Greenwich Avenue were flung open with a flourish last Thursday afternoon and a girl dressed in a black sweater and what looked like black tights peered out. There is nothing significant in either this item or any of the information that follows, and the only reason I mention it is that the apartment windows are across the street from this office, thereby catching my eye several times a day.

For the past two or three weeks, the apartment has been empty, its windows closed and blinds drawn. I went to have a look at it myself one day and though it would've been just the right location and size for me, its $80 rent was beyond my budget. I'm sure the new tenant will like it, however; apart from the big windows, it has a fireplace, an excellent view, and a fire escape suitable for a kitten.

The new girl, still in black, was pottering around most of Thursday evening—probably unpacking—but the light from three table lamps kept most of her face in shadow. From what I could see of her, she looked like a Shirley or possibly a Jennifer. I doubt if she has had the time to reach any conclusions about us.

Ibid., p. 169

The girl in the apartment across the street is a blonde called Kay. Born in Minneapolis, she works in a public-relations office uptown, and just got back from a Paris vacation. This information isn't from observation—a man in her office called me. In fact, since my peeping-john note of last week, my new neighbor has kept her blinds drawn.

McCourt, p. 31

Intrigue was largely an indoor business, an *acquis communautaire* negotiated behind the windows in the skyline's million slits.

Hayes and Woolrich, p. 6

While he is continuing his phone conversation, we see the object of his look. Two pretty girls have appeared on the distant roof. They are smiling and talking, although we cannot hear their dialogue. Each wears a terrycloth robe. With their backs to the CAMERA, they take off the robes, slipping them down over their shoulders slowly. Then, seductively, they turn—revealing the full beauty of their tanned and bathing-suited bodies. It is almost as if they want to be noticed, the center of neighborhood attention. They at least have all of Jeff's attention. Then they spread the robes in front of them, and lie down on the roof, and out of sight. He seems a little disappointed.

Ibid., p. 16

I can smell trouble right in this apartment. You broke your leg. You look out the window. You see things you shouldn't.

Ibid., p. 35

There is a slight, but warm, smile on his face as he looks at the drawn shade. His eyes move away from the newlyweds' apartment, and slowly explore the neighborhood to his right. He finds something of interest, and stops to stare at it. His face sobers at what he sees. He becomes completely absorbed with what he sees. He leans forward a little.

Ibid., p. 45

He returns to the window. He lights a cigarette and smokes it peacefully, as he contemplates the neighborhood.

Ibid., p. 46

From his viewpoint we see the first few drops of rain starting to fall. It is soft, gentle rain, not a downpour. There are still some windows lit in the neighborhood. The apartment house corridors all have small night lights burning.

h Glass — Voyeur, Exhibitionism

The couple who sleep on the fire escape. The increasing rain causes them to hastily gather their things to retreat inside.

Ibid.

He lowers the binoculars and there is an expression of exasperation on his face. He throws the binoculars down, and then looks about him. He backs his chair up quickly toward the main cabinet on his left. He leans down, opens a cupboard door and takes out a long-focus lens. Then from a shelf above he takes a small Exacta camera. He quickly takes off the existing lens and puts on the telephoto lens in its place. He wheels himself back to the window and raises the camera to his eye. He lowers the camera for a moment, and watches tensely. Suddenly he puts it up to his eye again.

Ibid., p. 57

We have been able to see all this because it has transpired in front of open windows, or on fire escapes or terraces. No one has bothered to shut themselves off from view by closing blinds, or using interior rooms, or avoiding outdoor areas. And these are clearly rituals, performed everyday in a casual, unthinking manner, without a trace of self-consciousness. If we really were a "race of Peeping Toms," would not people regularly try to hide themselves behind solid walls and shuttered windows? Instead, they reveal themselves to an astounding degree. It is no trivial point; in fact, it is an important lesson on how cities work.

Sanders, *Celluloid*, p. 233

Some of their behavior can be traced to the heat; in the days before residential air-conditioning became common, summer life in the city naturally gravitated toward open windows, or to outdoor spaces like fire escapes. But some of their behavior, it is fair to speculate, is encouraged by the space itself. Many of these people might feel far less comfortable performing the same actions on the street side of their buildings, in full view of strangers. Is there something about this courtyard that encourages them to feel comfortable treating it as an extension of their homes?

There is. The courtyard, as Hitchcock shows us, is a place of perceived privacy—a subtle yet enormously valuable quality for an urban space. Real privacy comes from actual isolation, from placing oneself behind closed doors and solid walls. Perceived privacy grows from the sense that, while others might be looking, it is reasonable to act as if they are not. Perceived privacy allows urban dwellers to go about their lives without the tiresome effort of constantly closing blinds and shades and shutting themselves off from the light, view, and air of windows, doors, terraces, and yards.

Privacy is undermined by the complexity of the sewer network … Sewers, like gas and electricity, involve the intrusion of an external institution into the private home.

Dennis, p. 326

Photography

The camera seemed made to record the velocity of urban existence: one machine competitively raced another.

Conrad, p. 154

People seen in New York appear as acute, as carelessly and permanently vivid as only images of themselves could be. New York is the camera town. Always the sharp but unnoticed click: the face caught in the store window, the short sounds struck from the pavements, the air broken by buildings, the quick discarded moment, the disconnected continuous opportunities for defining and defining without the solace or the dullness of meaning.

Douglas, p. 59

h Glass — Photography

Conrad, p. 155

The camera's presence in the city offends against that urban pact whereby we abide the congestion which has denied us privacy by politely ignoring one another. To be photographed is to be stared at, which urban etiquette forbids (except to out-of-towners, who have come to gape). The photographic image knows that it's accosting and perhaps defrauding its subject because its purpose in the city is to create visibility, to coerce reality out of hiding. Thus the photographic act becomes that rudest and (in a city) most perilous of denotations, a pointing of the finger. It's a visual citation: an image is compelled, maybe against its will, to bear witness.

Sharpe, p. 125

The photographer who "clicks" the avenue "into being" with his shutter.

Abbott and McCausland, p. 69

Over $40,000,000 worth of property has been compressed by the camera eye into one visual record.

Aycock and Scott, p. 169

Cinematic / photographic spectacle: Electric lights beamed down upon the boxers with such intense clarity that spectators in the galleries could see every move of their slick and gleaming bodies.

Conrad, p. 158

For work in New York, Paul Strand fixed a dummy lens to his camera and pretended to aim it while the real lens jutted out from under his arm.

Ibid., p. 235

Using a camera to heal the city's "brokenness."

Sanders, *Celluloid*, p. 26

For a decade, the first cameramen carried their cameras all around this remarkable setting—from street corners to rooftops to boats in the river—making a special kind of documentary-like film that they called "actualities." Usually only a few minutes long, actualities were merely views of actual events, people, or places. They had no plots. They had no stories. They had no characters. Filmmakers still didn't know how to tell a story; they hadn't yet discovered editing, the bringing together of two pieces of film to contract time. So these actualities could last only as long as the real event they showed: the cameraman just pointed his camera at something interesting and started cranking. They were simply glimpses, in what today might be called "real time," of the city and its life.

Their deadpan titles suggested just that. *Skating on Lake, Central Park*, or *Excavation for Subway*, these films were called. *East Side Urchins Bathing in a Fountain*, or *Panoramic View of Brooklyn Bridge*, or *New York City in a Blizzard*. One was named *At the Foot of the Flatiron*, and that is exactly what it shows: a stretch of sidewalk in front of the Flatiron Building, on a very windy day. During the course of the film, only two minutes and nineteen seconds long, pedestrians—ordinary, turn-of-the-century New Yorkers—simply walk down the street and past the camera, unaware for the most part that they are being photographed. The men grapple with their coats. The women clutch their long skirts. A well-dressed black man stares into the lens with curiosity and suspicion—until his hat flies off. (He disappears offscreen to retrieve it; the camera never moves from its position.) A streetcar can be noticed on the far right, crossing 23rd Street. Then two young women pass by, struggling gleefully against the strong wind. One of them turns and breaks into a wide, joyful smile. The film ends.

Kozloff

In the 50s … Saul Leiter used the camera as a thermometer just as much as an optical instrument … record[ing] the city through screens of evidently disparate temperature zones. From where he stands, often in the shade, to what he sees, the centigrade level is not the same.

h Glass — Photography

On Leiter: "He's fond of antique lamp-posts, balustrades, pawn shop windows, and vendor's carts. When revealed in color, they seem dusted with a tender recognition of their age. Just as there are after-images in his oeuvre, these are remainders from an earlier metropolitan scene. Here, the low-keyed chromaticism has a symbolic function, for it overlays a feeling for the past upon an urban environment that is otherwise contemporary. Not only do we have the weight of atmosphere in these image, but the weight of memory."

Ibid.

Coburn photographed industrial New York at the same time as the sublime nature of Yosemite, and for him the city and the landscape were equivalent in their demonstration that "nothing is really 'ordinary,' for every fragment of the world is crowned with wonder and mystery."

Conrad, p. 114

On 22 February 1893 he stood for hours in a blizzard on Fifth Avenue, awaiting "the proper moment" for photography. As soon as that moment arrived, he made it into ancient history. His snow scene doesn't look like an anecdotal instant: it seems to represent an arctic world, prior to human society.

Ibid., p. 166

"My dream," V. told me more than once, "is to come upon a parked truck transporting Kodak film. Think about it: film is small, light, untraceable, easy to dispose of, and proportionately expensive. It's the ideal score. A find like that could set you up for years to come." I lost track of V., so I don't know whether he ever fulfilled his dream.

Sante, "Commerce," p. 111

Man with a camera stopping another man with a small girl. As she stands with a flowered umbrella and raincoat. Just as it begins to rain. All delighted with smiles as the flash bulb pops. And people turn to look. A tiny moment like that.

Donleavy

Early photographers developed a pictorial mis-seeing of New York into a tricky smudging of sight. In their eagerness to render the city impressionistically molten, they'd jolt their cameras during exposure so the image trembled, or they'd grease their lens. Atmosphere was applied from without, as a shock or a lubricant smear.

Conrad, p. 74

The rise of rain-slicked night photographs of New York streets: Exposure time could be cut by a third if the pavement was covered with rainwater.

Caldwell, p. 274

Asking a friend to "[k]eep photographing the instant when you go down West Fourteenth Street." O'Hara explains that this way "I will know what it is like there," and "I will know you are at least all right" even if "my eyes seem incapable of the images I'd hoped."

Bennett, *Deconstructing*, p. 19

The El as an early form of the movies: the lighted windows flicker past in a tantalizing montage, while the dramatic-seeming tableaux have the advantage of being real, not staged. The proprieties of ordinary social life— not to mention the class barriers between spectators and spectacle—would never permit such access.

Sharpe, p. 272

The sensory roughage of New York life is softened and appears miraculously more coordinated than it is in reality.

Kozloff

Conrad, p. 77

Stieglitz reverts to a natural order by making it a rule never to work with artificial light.

Conrad, p. 83

Beauty may not belong to the skyscrapers; Stieglitz, however, can award it to them.

Douglas, p. 60

Modern photography began in America in the 1890s, when Alfred Stieglitz started taking pictures of New York's streets, parks, people, and buildings. Stieglitz had been living in Berlin, and when he came home at the age of twenty-six in 1890, he initially thought New York uninspiring, even photo-resistant. But Stieglitz underwent something like a conversion experience in the next year or two; he realized that New York was not so much inimical to photography as insistent on a new approach to it. He needed to stop imposing on the American metropolis photographic techniques and ideas worked out in the various very different circumstances of European cities, and to let New York itself call the shots. The way one perceives things when looking at New York was, then, the impetus and precondition of Stieglitz's art; New York was as important to photography as photography was to New York. The city changed forever the history of perception and the ways of recording it.

Krieger, pp. 64–71

Stieglitz urged his students to move in a little closer, to crop their scene a little tighter, *after* they composed a shot.

Conrad, p. 210

Stieglitz moves to the Shelton; Margaret Bourke-White establishes herself in the Chrysler Building; Lewis Hine, suspended in a derrick lift a quarter of a mile above the streets, records the construction of the Empire State.

Ibid., p. 81

Both Steichen and Stieglitz express their qualms about and hopes for New York by photographing it from their studio windows.

Stieglitz, Greenough, and Hamilton, p. 214

Alfred Stieglitz to Sherwood Anderson in 1925: "New York is madder than ever. The pace is ever increasing. But Georgia and I somehow don't seem to be of New York—nor of anywhere. We live high up in the Shelton … All is so quiet except the wind—& the trembling shaking hulk of steel in which we live."

Marquis, p. 116

Stieglitz was probably put off by Duchamp's aloofness from any kind of commitment, political or personal, though later he "repeatedly expressed regret" for not having exhibited the man's work.

Douglas, p. 155

In the 1900s, Alfred Stieglitz took picture after picture of New York's audacious new Flatiron Building … a breathtakingly unbroken and slender wedge of matter slipping gravity's laws. Stieglitz thought that the Flatiron was "to the States what the Parthenon was to Greece," and during one snowstorm he had something like a vision: "The Flat Iron impressed me as never before. It appeared to be moving toward me like the bow of a monster ocean steamer—a picture of new America in the making." The Flatiron, like the nation it emblematized, was to Stieglitz both a wonder of civilization and a "monster" whose course could not be known.

Conrad, p. 80

Stieglitz's father called the Flatiron Building hideous, and when he saw the photograph said, "I do not see how you could have produced such a beautiful thing from such an ugly building." The wonder that irradiated the structure during that first winter faded for Stieglitz. Later, he admitted, he found it

gloomy, no longer beautiful. Is the photographic imagination therefore only a capacity, like the picturesque, to deceive yourself about the incorrigible reality of things?

Ford Madox Ford sensed a meaning in the Flatiron: it symbolized the staid, genteel city's renovation of itself. He professes to find the Flatiron beautiful because to do so is to offend the pieties of old New York. "Very beautiful it used to look," he comments, "towering up, slim and ivory white when you saw it from the Fifth Avenue stage or from on top of a trolley descending Broadway." N. cit.

Ford: "New York, I think, has lost a little in impressiveness, if not in beauty. To-day the Flatiron is gray and the skyline along Fifth Avenue where it goes along Central Park is too uniform in height with the rest of the city to let you have any feeling either of entrance or of plunging down." Ford, *America*, p. 55

shiny flatiron, pleating their inhabitants Khlebnikov, p. 48
into crisp, unwrinkled folds of symmetry

The angled point of the Flatiron parts the traffic as if cleaving the ocean: the Mauretania stalked like a skyscraper through the harbor. Dos Passos, p. 734

As used by Steichen, the soft-focus lens dims and smoothes objects into images. His *Brooklyn Bridge* (1903) is a dark wedge inset with jewels against a furry gray sky. Structure is befuddled, and the span is pattern, not engineering. His dusky *Flatiron* (1909) withdraws into the sky, belying its own solidity and angularity, vanishing as we watch. Conrad, p. 80

Steichen's portrait of J. P. Morgan: The only thing that J. Pierpont Morgan could not control was Steichen's camera: the essence of a man called Jupiter because he was an omnipotent as an ancient Roman god … His left hand tightly clutched the arm of his chair as if symbolizing the intensity of his grip on the American economy. Morgan so hated the picture that he tore the first print to shreds. Reitano, p. 105

Stieglitz helped create night photography; Weegee almost bumped it off. Stieglitz wanted to show how beautiful the night city could be; Weegee tried to prove how wrong he was. N. cit.

Alfred Stieglitz became famous both in Europe and America as the master of the camera, and what did his fame get him? Weegee, *Naked*, pp. 233–4

On Madison Avenue in the fifties … morning … noon … and night a lone man walks the streets. He wears a black cape (Loden cape bought in Tyrol, Austria), white shirt, black tie (not bow), black hat. No one pays any attention to him. A few kids turn around. Just another character. I've noticed him many times … walking as if in a trance. I was afraid to disturb him … finally I walked up to him and said …

"You Stieglitz? I'm Weegee. You may have read about me in magazines, or seen my pictures in *PM*."

He stared at me as if I had waked him from a dream and told me that he never read about other people or himself. I apologized for the intrusion and told him that for a long time I had wanted to meet him. He became gracious and invited me to come up to his studio but first he stopped at a drug store, where he left a prescription to be filled … then up to No. 509 Madison Avenue where we took the elevator to the seventeenth floor. We stopped at a door. On the glass was painted AN AMERICAN PLACE. It wasn't locked and we

walked in. The place was fitted up as a gallery, with paintings hung on the walls … there was a smell of disinfectant like in a sick room.

In the back of the gallery, in a cubbyhole, Stieglitz slumped on the cot, half sitting and half lying, too exhausted to take his cape off. That was his home. We started to talk. I was at last talking not only to the most famous photographer in the world, but one who had also sponsored painters and sculptors … unknown once, but famous now.

I had so many questions to ask … hours went by fast … (I was wondering if I was going to find a ticket on my jallopy parked at the door.) Stieglitz pointed to the phone near the cot … "It never rings … I have been deserted … the paintings on the wall are orphans … no one comes up to see them." I switched the talk back to photography. Was he a success? No, he was a failure. What about the photographers he had known and started and helped? They were successful … why? … because they had wanted money and were now working for the slick-paper magazines … because they were politicians and showmen who knew how to sell themselves. As for himself … he hadn't made a photograph for the past ten years … had never used the products of one company, because they had advertised, "You push the button. We'll do the rest … " … that slogan was a bad influence on photographers because a picture needed careful planning and thinking and could only be captured on film at a certain fleeting fraction of a second … and that once that passed, that fraction of time was dead and could never be brought back to life again … that he had never compromised with his photography, for money or to please an editor. One had to be free to do creative work.

What about his influence on American photographers? Could he teach or influence them to do the same things he had accomplished? The answer was a firm no … I thought of a lecture which I recently gave at the Museum of Modern Art … and the questions which were asked of me there. I thought perhaps Stieglitz would have the answers.

He also told me that he was eighty-one years old. That the happiest time of his life was spent in Berlin at the turn of the century … it was free then and that when he returned to America he used to cry himself to sleep every night for two years thinking of the dirty streets here.

I asked Stieglitz how he lived and paid the rent. He told me that he had a private income of eighteen hundred dollars a year. That three hundred and fifty dollars went for income tax. (Not that he had to pay it but he felt that the government needed the money worse than he did), that the rent money and expenses, about four thousand dollars a year for the studio, was contributed by the artists when they sold the paintings which were on exhibit … That few paintings were being sold now … that the rent was not going to be ready and he was afraid he was going to be dispossessed.

Suddenly he slumped over in pain. "My heart, it's bad," he said in a whisper as he slumped over on the cot. I waited till he recovered then left quietly … wondering if that elusive fame I was after was worth while.

Rabinowitz, p. 164

Marking an age, the essence of perfection, the faces of Garbo and O'Keeffe were like giant skyscrapers: cold, gleaming, and modern … Garbo's face, elusive and yet available, private yet consumable, like the images of the city, white framed by black.

Ibid., p. 165

At the very moment Walter Benjamin was cruising the "one way streets" of Berlin and noticing the intrusion of signs like those that had caught the eye of Hart Crane as he crossed "the bridge" from Brooklyn, O'Keeffe's images—her portraits of flowers—grabbed the attention of gallery-goers as movie posters called forth movie-goers. After all, she had worked first in advertising and commercial art.

Changing from evocative / erotic abstractions and gigantic flowers to skyscrapers suggests new symbols for modernity—from interiorized attempts to depict states of mind and emotion and sexuality, or to reveal details of interior spaces secreted within flowers, the city paintings marvel at "something bigger, grander, more complex than ever before in history." Modernity has been exteriorized onto steel and concrete, industry and power, attributes of national pride.

Ibid., pp. 165–6

It was the scale of New York's buildings that had stimulated O'Keeffe in 1924 to begin painting her famous blowups of flowers: "I thought I'll make them big like the huge buildings going up. People will be startled; they'll have to look at them—and they did."

Sharpe, p. 249

In O'Keeffe's mural design *Manhattan* (1932) she paints flowers superimposed on skyscrapers.

Ibid., p. 250

"Lexington Avenue looked, in the night," Georgia O'Keeffe wrote, "like a very tall thin bottle with colored things going up and down inside it."

Ibid., p. 255

For these sons of well-off assimilated Jews, the avant-garde offered a new country; it was called Am/bition/erica and it was located in one city. In Europe, modernism was a territory deterritorialized—not tied to national identity—as artists migrated to cosmopolitan cities like Paris or Berlin or Prague. This was especially true for Jews, especially after the rise of Fascism and National Socialism sent them into exile. In America, however, an urban nationalism located in New York, the city of ambition, as a "unit," its panorama, found on one page of the daily tabloid, might include a Jewish baseball payer at the Polo Grounds and a prim ex-country schoolmistress in her Midtown skyscraper, or anything else in between.

Rabinowitz, p. 167

When Stieglitz and O'Keeffe moved into Room 3003 of the Shelton Hotel, the city's first skyscraper hotel on Lexington Avenue, they also became the first artists in America to live and work in that icon of the modern city, the skyscraper.

Ibid., p. 153

Contrary to the usual association of the Stieglitz group with Greenwich Village bohemianism, I would argue that the artists associated with the 291 Gallery, located above Madison Square, faced north, toward midtown. Few of that group lived in the Village. In the 1920s, for example, Stieglitz and Georgia O'Keeffe lived in midtown. The Sloan group, by contrast, lived mostly in the "extended Village." Each group depicted its own neighborhood.

Bender, *Unfinished*, pp. 119–20

Mumford, writing on Stieglitz's photograph, "Wall Street": "Stieglitz ironically shows the skyscraper—the mock city of the future—in the last state of mechanical perfection and human insignificance, devoid at last of even the possibility of earning money; financial liabilities, as well as the social liabilities their reckless misuse had already made them … These skyscrapers of Stieglitz's last photographs might be the cold exhalations of a depopulated world."

Rabinowitz, p. 154

The structure of the city's architectural space had been the subject of Atget's Paris photographs, images Walter Benjamin likened to the scene of a crime: the cityscape, a dead landscape poised in anticipation of corruption and danger, of commerce and seduction. Yet Stieglitz only worked with natural light, so his images reflect the harshness of daily life, rather than the dreadful fears accumulating at night.

Ibid.

Ibid., p. 156 The same year Henry James published his impressions of "New York Revisited," nineteen-year-old O'Keeffe had come to New York in 1907–8 to study art in what was just beginning to be America's art center.

Williams, *Ambition*, p. xi If Stieglitz's skyscrapers captured the ebullient commercialism of the early twentieth century, the New York of the thirties and forties was a city of "libraries and parks."

Riis

Sharpe, p. 149 In 1887, Jacob Riis read of magnesium flash powder: "There it was, the thing I had been looking for all those years … The darkest corner might be photographed that way."

Ibid. Riis saw photography as a form of war. His "raiding party … invaded the East Side by night."

Ibid., p. 150 Riis or an assistant fired an explosive round of magnesium-based "lightning powder" from a revolver, jolting the subjects, garishly illuminating every speck of dirt and every crack in the wall, and occasionally setting the room on fire. Once he accidentally ignited the wallpaper in a room full of blind men, up several flights of stairs—and he was painfully burned in putting out the blaze with his hands. Using military metaphors and flash pistols, Riis perfected his own form of the new art: photography as blitzkrieg. "It was not too much to say," recalled Riis, "that our party carried terror wherever it went."

Ibid. The poor became anthropological specimens, to be "shot" in their hovels by the crusading photojournalist … His flash functions like the police officer's bull's-eye lantern, but like the photographer, it remains concealed. We see only the target that the light hits.

Ibid. His determination to photograph "the darkest corner" involved a fundamental shift in nocturnal art. That is, he did not seek either to capture the elusive aesthetic qualities of darkness, as did Whistler and his photographic followers, or register the new look of an artificially lit cityscape, as did Hassam or Steichen. Rather, he wanted to bring to light— or bring light to—what usually dwelled in darkness. He was on the side of Light with a capital *L*. His aim was not to record but to alter. His photographs were literally exposures—exposures of greasy wallpaper and grimy skin, filthy bedding and soot-caked stoves that never saw the light of day. It was a vision created only for an instant by the flash camera. Displaying what even the poor themselves were unable to see, the full degradation of their environment, Riis hoped to destroy the world his flash fell on. Photography is often thought of as a form of preservation; for Riis it was an agent of demolition.

Ibid., p. 152 In the darkness, the magnesium flash ensured a certain spontaneity, since the photographer could not see his subject until he took the picture, and human subjects were surely unprepared for the violence of the flash powder's explosion. And then there was the element of surprise, as Riis and his assistants burst into the room with their "weird and uncanny movements," and then fired off "the blinding flash" before beating a hasty retreat.

Caldwell, p. 275 Photography is by nature ill-suited to night: it needs light, hence has to destroy darkness in order to represent it. Technology has over the course of

modern history transformed, even to some extent created the possibility of
life at night, and has repeatedly reinvented our perceptions of it.

What they saw was a ghostly tripod, three or four figures in the gloom, some
weird and uncanny movements, the blinding flash, and they heard the patter
of retreating footsteps and the mysterious visitors were gone.

Sharpe, p. 150

Presenting the photographs in the form of a guided tour, Riis asked his
spectators if they had the courage to follow him into the worst slums. When
they assented, he conducted them into various tenements, his commentary
accentuating the dirt, stench, and atmospheric poison through which the
visitor had to move. Out of the darkness, in unprecedented detail, came a
sooty man in a coal cellar, a gang of thugs in bowler hats lining an alley,
a withered hag with clawlike hands in a decrepit room. Viewers seemed
to be thrust up against these people; the encounter was brutal, repulsive,
claustrophobic. Some of the audience wept, others fainted—such are
contemporary accounts of Riis's lectures.

Ibid., p. 151

The sleepers indistinguishable from the piles of bedding and washing
piled around them in a ramshackle room in *Midnight in Ludlow Street
Tenement*.

Ibid., p. 135

The camera and flash trespass on their privacy and ingloriously turn them
into lumps under blankets, legless bare feet (there are at least four pairs in
Men's Lodging Room), and greasy heads with scarlike parts on the scalp.

Ibid., p. 154

Riis eventually shifted the ignition of his flash powder from a revolver to a
frying pan because "it seemed more homelike."

Ibid.

Riis's invasive photographs fling back the cover of night, claiming intimacy
without any kind of human engagement. By dispelling darkness, the flash
deprives the sleepers not only of privacy but also of a reason for sleeping in
the first place. The night has been dissolved, abolished.

Ibid.

These are the first night pictures without any trace of night—a moon, stars,
darkness, or any evidence of blazing lights. Nothing in the picture suggests
the hour, a reason for revelry or repose.

Ibid., p. 155

Why do the boys (who seem to be outdoors, in the daylight) sleep while
the grown-ups are awake? Are the boys—or both groups—posing? These
pictures disturb partly because of their voyeuristic quality—photographer
and viewers glimpse something meant to be hidden—but partly because
we can't tell if those unseeing faces are pretending to act unseen. Through
this uncertainty, the night's mystery sneaks back into Riis's photographs.
Someone is being manipulated, but we don't know whom.

Ibid., pp. 155–6

A step into the side streets and you felt set back by centuries.

Ibid., p. 156

In the 1930s and 1940s, the perfection of the flashbulb and fast film enabled
Weegee to bring Jacob Riis's nocturnal lowlife a few steps closer to the rest
of us. While Riis had to struggle to place his photos in front of the public,
Weegee's aim was to see his night's work in the papers the next morning. For
him, night was an exploitable frontier, the fertile soil from which he could
harvest a crop of corpses, evidence of his boldness and food for the sensation-
hungry urbanite.

Sharpe, p. 292

The flash explodes in the dark street, and its flare lights up a huge revolver suspended over the pavement to advertise the gunsmith's wares. The camera shoots on behalf of the gun, which will also emit light along with its missile when the trigger is pressed.

Le Corbusier, upon seeing NYC's skyscrapers in the 1930s: "In New York, then, I learned to appreciate the Italian Renaissance. It is so well done that you could believe it to be genuine." Corbusier, p. 60

This is all from another place, I thought, shocked by the derivativeness of Fifth Avenue architecture. I felt, I saw, for the first time ever, the adolescent absurdity of so many Manhattan monuments—the sad, wilderness, opera-house-in-the-Arctic and Amazon pathos of copying old European styles in a New World city. *This isn't a true Gothic cathedral*, I thought, staring at St. Patrick's. *There are such things, I've seen them, and this is just a …. copy, a raw inflated thing thrown up in emulation of a far-off and distant thing! That Renaissance palazzo on Fifty-fourth Street is no Renaissance palazzo—it's a cheap stage-set imitation!* Gopnik, p. 74

 This perception—of New York as a blown-up Inflato city, aspirational rather than achieved, gawkily imitating its models, the proper cities of Europe—which was once so obvious and embarrassing (to Henry James, much less to Tocqueville), has faded away now, and I no longer see it that way. For that single early morning, though, it seemed that the architecture of New York was not quite real, not organic, coming from elsewhere and imposed, a delirium of old styles and other people's European visions: the Gothic vision of sublime verticality, or, for that matter, the Bauhaus vision of the glass tower. For a moment New York seemed unnatural, the anti-matter city. "You're not real!" I wanted to cry out, to the city. "Yes, we are," the buildings cried back blankly. "It is the old thing that is the lie; the true thing is our re-creation of it." But the moment passed quickly, and now New York just looks like New York: old as time, worn as Rome, mysterious as life.

Between 1890 and 1940 a new culture (the Machine Age?) selected Manhattan as laboratory: a mythical island where the invention and testing of a metropolitan lifestyle and its attendant architecture could be pursued as a collective experiment in which the entire city became a factory of man-made experience, where the real and the natural ceased to exist … Manhattan as the product of an unformulated theory, *Manhattanism*, whose program—to exist in a world totally fabricated by man, i.e., to live *inside* fantasy—was so ambitious that, to be realized, it could never be openly stated. Koolhaas, p. 10

Every great law firm in New York moves without a sputter of protest into a glass-box office building with concrete slab floors and seven-foot-ten-inch-high concrete slab ceilings and plasterboard walls and pygmy corridors—and then hires a decorator and gives him a budget of hundreds of thousands of dollars to turn these mean cubes and grids into a horizontal fantasy of a Restoration townhouse. I have seen the carpenters and cabinetmakers and search-and-acquire girls hauling in more cornices, covings, pilasters, carved moldings, and recessed domes, more linenfold paneling, more (fireless) fireplaces with festoons of fruit carved in mahogany on the mantels, more chandeliers, sconces, girandoles, chestnut leather sofas, and chiming clocks than Wren, Inigo Jones, the brothers Adam, Lord Burlington, and the Dilettanti working in concert, could have dreamed of. Wolfe, *Bauhaus*, pp. 7–8

In your offices, however high they may be, these cottage windows are annoying. Corbusier, p. 67

A 345-year-old Jacobean room on the thirty-seventh floor of the Empire State Building. Linked by ancient doors with a Gascon chamber originally put together in a château near Dax in southwest France and a Georgian room made for the Guildhall in London in 1730. Installed by the Schenley Distillers Berger, *New York*, p. 171

i Simulacrum

Company. The Jacobean room has green mullioned windows threaded with lead and stained glass images of Louis II of Hungary and his Queen, Maria of Austria.

Hawes

The custom of assigning descriptive labels to domestic architecture was borrowed from the rural English, who named their manor houses and country estates to expedite the delivery of mail through uncharted countryside. In New York, no one used the Melba, the Sophomore, the Altoona, the Greylock, or the Pamlico as a mailing address. Nor did names necessarily have anything to do with physical realities: Les Chateaux was not castlelike; the courts of the Georgian Court, the Columbia Court, and the Chatham Court were aggrandized air shafts, and no one knew that the "arms" of the Washington Arms or the Clarendon Arms, among dozens of arms buildings, referred to a family coat of arms. They were used the way Beaux-Arts style was—to project an image of importance to the outside. Names, however preposterous, were yet another ornament, and tantalizing in that.

Ibid.

Hearst's apartment included tapestries, suits of armor, mummies, figurines, bronzes, and bibelots. It measured three-quarters of an acre of living space, excluding the roof garden, to which Hearst soon added two more floors, eventually purchasing the entire building. Within these walls, he fashioned a Georgian dining room, an Empire bedroom, a three-story galleria modeled on a vaulted Gothic cathedral, a two-story display room for his collection of silver salvers, and an office suite; he continued to redecorate, adding carved ceilings, choir stalls, stained glass from French cathedrals, redesigning to incorporate new possessions from his warehouse full of art treasures, until he left New York for his castle at San Simeon. Hearst, like other apartment dwellers, was engaging in a bit of make-believe, creating the illusion that he was living elsewhere than in a large new apartment house.

Huxtable, *Goodbye*, p. 20

It's sad and funny to see it done again by the Franklin National Bank at Madison Avenue and 48th Street. Watching this building being transformed from 20th century to 18th century was one of the top midtown acts of last season's Follies. First, there was the steel frame, strong, severe, handsomely rectilinear (the bones are best in most buildings), suggesting the logical shape and design that its covering surface might take, subject only to the architect's talent, imagination and respect for the inspiration of the structure. Painstakingly, brick by brick, the façade was laid up for anyone to observe.

Eighteenth-century arches were hung on the façade like theatrical scrim. Originally, of course, arches like these were carefully built up to be wedge-shaped, locking keystones to make openings in a brick wall without having the wall fall down. They were as natural and beautiful for masonry construction as the thin curtain wall is for the metal-framed building today.

Presto change. The hand is quicker than the eye. The arches aren't arches because the masonry is non-supporting. It's all backed by steel. Fooled you. What we have here is a kind of large architectural practical joke. It is tiresome, like most practical jokes.

But the undertaking was carried out in consistent comic spirit to the end. The opening luncheon, which featured authentic colonial cooking, was served by waiters in knee breeches. (Authentic Madison Avenue.)

Erenberg, pp. 44–5

To heighten the impression that their patrons were part of the world of wealth and opulence, the Broadway restaurants borrowed their décor from aristocratic Fifth Avenue and foreign homes. From the elaborate exteriors to the gilded interiors, the restaurants removed their patrons from the humdrum business activity of Broadway and brought them the fantasies of Europe

Simulacrum

558

and the past … Murray's Roman Gardens, which opened on Forty-second Street in 1906: Once leaving the busy street the visitor was "transported as though on the famous carpet of Mahomet, back into ancient Rome." There, in this American-created foreign world, the guest would "feast his eyes on artistically and authentically beautiful features of Rome's most ornate homes, of the palaces, villas and pleasure resorts of her wealthiest and most cultured citizens." While the interior was Roman, the exterior was French, reproducing for the lower two stories the ancient hotel of Cardinal de Rohan of Paris in Caen stone. A huge doorway marked the entrance, over which rested a copy of "Les chevaux du soliel" from the cardinal's stables. This regal imagery was not limited to Murray's. The Rectors decorated their restaurant in green and gold furnishings of the Sun King. The Hotel Martinique on Broadway and Thirty-second Street featured a main dining room modeled after the Apollo Room of the Louvre, with panels depicting Maurice de Saxe, Rosnard, Voltaire, Louis XV, the ladies of the court, and other great figures of the eighteenth century. Up two streets, the Hotel McAlpin had a Sun King Room while the Knickerbocker bar on Forty-second Street sported a Louis XIV design.

The elevator, going up and down like the mercury in a typhoid's thermometer, decorated with French *boiseries*, Renaissance brocades and an El Greco.

Beaton, *New York*, p. 218

Please, gentleman, no horse-drawn cars, no costumes, no wigs, no stage sets, no cute-old-stores, no "re-creations" that never were, no phone little-old-New York. There is a tendency in American restoration for corn to conquer all. In Europe old buildings are used naturally and normally, not reduced to cultural kitsch. That is perversion, not preservation. The past becomes real by its legitimate and handsome contrasts with the present.

Huxtable, *Goodbye*, p. 25

If the authentic city exists, it is as a mere shadow of itself, one that serves only to underline what has been lost.

Amin and Thrift, p. 32

A second New York is being built a little west of the old one. Each man works on the replica of the apartment building he lived in, adding new touches.

Berman, "NY, NY," p. 277

It is *impossible*, as impossible as to raise the dead, to restore anything that has ever been great or beautiful in architecture … Do not let us talk then of restoration. The thing is a Lie from beginning to end. You may make a model of a building as you may of a corpse, and your model may have the shell of old walls within it … but the old building is destroyed, and that more totally and mercilessly than if it had sunk into a heap of dust, or melted into a mass of clay.

Lowenthal, p. 249

For every Brooklyn Heights, which preserves a historical continuity of real buildings of the real past, there are numerous projects that will put up brand-new "aged" imitations mixed with a few dislocated victims of throughways or urban renewal for spuriously quaint little groups of instant history in sterile isolation. Across the country the genuine heritage of the 19th century is still being razed to be replaced by elaborately built synthetic 18th-century stage sets more pleasing to 20th-century tastes.

Huxtable, *Goodbye*, p. 171

This disease, which we have previously called galloping restorationitis, evades the sticky problem of saving the real thing by letting it be bulldozed and putting up a copy at a more convenient time or place … The result is a lot of sham history and sham art.

i Simulacrum

Huxtable, *Architecture of NY*, p. xiv

One can find a cast-iron-fronted building, shipped in sections from New York City, on a street in Halifax, Nova Scotia.

Yau, p. 277

The contents of Magoos, the famous 70s Tribeca artist bar, ended up in Japan, perfectly preserved.

Rooney, pp. 159–60

In the South Bronx, the Charlotte Street pastel-colored houses, which sit in the center of green lawns and are bordered by white picket fences, stand in splendid isolation from one another as abandoned tenements loom in all directions.

Berger, *New York*, p. 29

You go through a thin-barred iron gate down a long flagged corridor till you're midway between the north side of Forty-ninth Street, but perhaps forty feet short of Fiftieth, and you're in a cool, ailanthus-shaded garden restored to look much as it was, say, 150 years ago. White and gray cottages face each other across the court. The ground's neatly laid out in squares and oblongs that smell of rain and dew through lush fern growth and pachysandra. Lotus bowls and wrought-iron benches are cunningly placed in it and a wall sign reads "Boston Post Road, 1673."

Huxtable, *Architecture of NY*, p. 5

New York is not [Colonial] Williamsburg.

Fitzgerald, *My Lost City*, p. 107

I felt that no actuality could live up to my conception of New York's splendor.

Huxtable, *Goodbye*, pp. 191–3

How do you finish an anachronism? How do you complete a cathedral begun too late, beset by conflicts in symbolism, construction, art and costs, overshadowed by skyscrapers, clinging to obsolete crafts, mismeasured for glory and miscalculated for meaning in the modern world?

The Cathedral of St. John the Divine, on Morningside Heights, was conceived in 1891 as the world's largest and latest of the great medieval line that ran from Arles to Amiens. There was only one thing wrong. It was not the product of a cathedral-building age. The medieval cathedral was a superb structure, the creative flowering of a special confluence of forces at a particular moment in time. Its synthesis of technology, necessity, timeliness and expression is the basic formula of all great architectural art.

Out of context, the formula is not reproducible. The same moment and the same results never come twice. Archaeological copying will not make it so. This is an ineluctable reality of art and life. Until it is understood, we will continue to have the pious reproductions, the dead reconstructions, the vacuum-packed imitations and the false, nostalgic standards that, at best, evoke only the second-hand suggestion of the artistic glories of some other age, or at worst, throttle creativity and subvert values in our own.

When the design for St. John the Divine was projected, the church spire was already losing out to the commercial tower—a kind of symbolism, if one wished to look for it, that the cathedral was no longer the physical capstone of the city or of society and could no longer offer the comforting assurances of an older, more familiar symbolism merely by increasing the size of its traditional forms. The medieval cathedral already belonged to history.

And so the cathedral sits unfinished, not through the inexorable process of the evolutionary architectural change of the Middle Ages, but through conflicts over aims, objectives, symbolism and commitment of church funds in the 20th century.

What all this leads up to is the simple fact that it doesn't really matter now the cathedral isn't finished—a subject that has been the cause of some little rarefied furor. It is merely, again, a matter of taste. The forms and meanings of the building are so totally removed from the social, spiritual and aesthetic

i Simulacrum

mainstream of the 20th century that the result, whatever the decision, will inevitably be cold, thin stuff.

A careful and conscientious effort has been made by the firm of Adams and Woodbridge to solve the problems that exist. The cost of the central tower planned for the crossing and of the completion of the west towers would be prohibitive today, even if stonemasons were available for the work, which they are not. The "temporary" Guastavino dome, guaranteed for 10 years and going for half a century—a testament to that fascinating and now equally historic form of tile construction—is to be replaced.

The architects have been forced, ironically enough, by that same evolutionary process of art and history that the cathedral ignored, to go to modern concrete construction in the name of cost and practicality. They are providing elevators in the piers that will support the beams for a "modern Gothic" glass and concrete lantern to substitute for the unbuildable crossing tower, because labor to change an electric light bulb, for example, is too costly today to permit the bulb changer the inefficiency of toiling up stone steps. Count the anachronisms, architectural and otherwise, in that sentence. You can only finish a superanachronism like St. John the Divine with more of the same, and there is not much to be said in praise or blame.

If an impassable wall were built around this island which would prevent any one of its present inhabitants from leaving it, and would prevent any one from the outside from coming on it, it is only a matter of a few hundred years until its human inhabitants would become extinct, or be reduced to an insignificant remnant. In other words, the population of Manhattan Island is not self-supporting in the matter of reproducing itself, and but for the continual accessions from without, the race could not continue to exist here indefinitely.

Girdner, pp. 17–19

That physical conditions have something to do with bringing about this state of affairs there can be no question, but the principal cause is to be found in the habits and character of the inhabitants themselves, and in the artificial life they lead. By artificial life is meant the continual violation of those mental, moral, and physical laws which nature has imposed on mankind everywhere, and the observance of which is essential to its existence and continued well-being.

Psychoanalysis

New York is less a place than an idea or perhaps a neurosis.

Conrad, p. 107

A new agenda for geography, where geographers would explore the *terra incognitae* of the simultaneously real, experiential and imaginary, and profoundly personal world.

Pile, p. 14

For the moment, our unconscious architecture has gone *Surrealiste*: indecent and extravagant, like the dreams a dutiful patient prepares for a psychoanalyst.

Mumford, *Sidewalk*, p. 69

A psychoanalysis of space.

Pile, p. 15

Psychoanalysis is, after all, a spatial discipline.

Ibid., p. 77

Freud, on his one visit to New York in 1909, showed no interest in the city … No metropolis anywhere took up psychoanalysis so eagerly as New York. By the early 1920s, there were about 500 Freudian analysts in the

Douglas, pp. 124–9

city. Translations and articles popularizing his ideas poured from New York presses.

Greenwich Villagers were gripped by *mania psychological* and spent their time in "Freuding parties," "psyching" and probing each other's motives and dreams ... Vachel Lindsay found the New York enthusiasm for psychoanalytic ways torture: "I do *not*," he asserted, "have a matriarchal complex!"

John Barrymore's 1922 *Hamlet* with its self-consciously Freudian interpretation of the role. He prepared for the role by having extensive conversations with an analyst, Smith Ely Jeliffe, who later published three lengthy psychoanalytic critiques of Barrymore's pre-*Hamlet* roles in the *New York Medical Journal*.

The Freudian discourse, no matter how simplified or distorted, had by the mid-1920s eclipsed the Protestant pieties sovereign in America's official life until then. It had become *the* explanatory discourse, if not of America, then of New York.

For his part, Freud always acknowledged that America had been the first country to welcome psychoanalysis: "ex-communicated" in Europe, he had been "received [in America] by the best as equal," and American recognition had removed psychoanalysis from the realm of "delusion" and made it a valuable part of reality. Despite numerous invitations, however, Freud refused to go back to the United States; indeed, he developed a vehement, even obsessional, hatred for all things American. Americans might put their seal of approval on psychoanalysis, but they did not and could not understand it, he insisted. Psychoanalysis, he wrote a friend in 1924, "suits Americans [only] as a white shirt suits a raven." America was a "gigantic mistake"; his suspicion of its aims was "unconquerable." At the end of his life, in great peril as a Jew in Nazi Vienna, he refused to go to America for refuge, as most of his friends wished him to do. Stubbornly, predictably, he elected to finish his days in England, where his work had been far less influential and he himself far less revered, and he continued to hope that America would secede, or be expelled, from the ranks of psychoanalysis.

Freud saw only the simplification and distortions Americans wreaked in his "science." In his view, American versions of psychoanalysis were to the Viennese original what mass culture was to elite art, and he was a bitter enemy of the democratic tendencies endemic in the mass arts that America in general and New York in particular hosted. Further, attached as he was to modes of temporal sequence in his science and in his art, Freud gave his allegiance to the print culture, which the mass media were threatening to succeed. Whereas James had responded eagerly to New York's promise that "there was nothing that was not easy," whereas Stein loved the effortlessness and abundance created by the new technology of consumer-oriented mass production and saw her own art as its ally and analogue, Freud prized the arts, not of consuming or absorbing, but of mastering the world. He reified productivity and hard, unrelenting work; *"Travailler sans raisonner"* (Don't debate; work!) was his motto. The flow of curiosity by which James and Stein oriented themselves in a fast-modernizing culture was foreign to him. He rebuffed not only Sam Goldwyn's Hollywood offer to write a script but several others like it, avoided the telephone, seldom listen to the radio, and never, so far as we know, went to a movie.

Throughout his studies of what he called the "pathology of cultural communities" and his voluminous correspondence, Freud seldom missed a chance to jab at the values, or lack of values, of popular American culture. He hated the "uncultivated public" that put "quantity" above "quality," intellectuals incapable of "living in opposition to the public opinion as we [Europeans] are prepared to do," the insane "rush of American life" with its worship of the "almighty dollar," its "cheap" and "manic" promises of

instant gratification, and its "prudish" middlebrow moralizings. Most of
all, he detested the blind "optimism," the "noble intentions" and the utter
disregard of "facts," of those he took to be America's political and religious
spokespersons.

Freud's disciples, including Otto Rank, Alfred Adler, Theodor Reik,
Hans Sachs, Franz Alexander, Helene Deutsch, Erik Erikson, Fritz Wittels,
Sandor Rado, and Karen Horney all visited America and New York, and most
of them loved what they found. Deutsch thought the new skyscrapers "The
most beautiful architecture that one can imagine" and telegrammed her son:
"AMERICA IMPOSING REALLY NEW WORLD EVERYTHING GIGANTIC
MAD TEMPO." What Freud hated as cheap commercialism she saw as the
prosperity and energy of a people "striving forward," exciting evidence of
"hope" and "sheer life!"

Some of the émigrés lingered in this "really new world" for months,
years, decades, even life. Both Ferenczi and Rank used trips to New York to
signal their attempt to break from Freud. Rank, who fell in love with Harlem
dancing and occasionally signed his letters "Huck [Finn]," expatriated for
good in the 1930s. Jung stayed in Switzerland, but visited America often and
found his biggest following and surest funding there. If there were, as Freud
claimed, irreparable differences between the new discourse of psychoanalysis
and America, most of his followers refused, if not to see them, to condemn
them. Freud charged his American patients higher fees than he asked from
European patients and gave them less time and attention; Americans had no
value, he insisted, except their "dollarei." But those "dollarei" were critical to
his still-fledgling discipline. Psychoanalysis might have originated in Vienna,
but it was copied and Americanized, then marketed, and marketed on a scale
immeasurably greater than Europe could offer, in New York.

The Village's chief psychoanalysts: A. A. Brill, Smith Ely Jelliffe, and Samuel
Tannenbaum.

Humphrey, p. 227

Freud was attractive to Villagers because of the special status he assigned to
those who transformed primitive impulses into artistic creations. The artists'
gifts, originating deep within the unconscious, emerged only after a terrific
inner struggle. For some Villagers the presence of psychological problems
seemed to verify the existence of unmined talent. Failure to develop and
produce meant that repression had dammed up creativity.

Ibid., pp. 227–8

The Village popularized psychoanalytic theories and supplied American
psychiatrists with patients to treat. Seeing a psychiatrist was considered
avant-garde. While the rest of society ignorantly confessed their sins to
clerics, the modern Villager explored the psychic forces at work in the world.
Floyd Dell remembered:

"There must have been ... a half dozen or more people in the Liberal Club
who knew a great deal about psychoanalysis, and a score more who were
familiar enough with the terms to use them in badinage ... Everyone ...
who knew about psychoanalysis was a sort of missionary on the subject, and
nobody could be around Greenwich Village without hearing a lot about it."

Psychoanalysis was fascinating, Dell admitted, because "it [dealt]
with ourselves, a subject in which we are all deeply interested." While
psychoanalysis was embraced as a method of self-exploration, it enhanced
and expanded the practice of mutual evaluation. Margaret Anderson and Jane
Heap spent their evenings searching for "the Achilles heel of everybody's
psychic set-up." With its "recondite technical vocabulary" psychoanalysis
permitted "talk about morbid states of health without seeming to indulge in
a vulgar predilection." Psychoanalysis provided new topics of discussion and
a new form of entertainment. Liberal Club members played parlor games

of "associating" their thoughts to lists of words and tried to unravel dreams by following "the Freudian formula." Plain, everyday gossip was elevated to scientific analysis, and commonplace dreams were assigned intellectual and sexual significance.

Douglas, p. 144

Freud read his nephew Edward Bernays's book *Propaganda* and praised it as "clear, clever, and comprehensible," and Bernays in turn devoted considerable time and money to publicizing Freud's work in America. In 1920, Freud had asked him to peddle among New York publishers the idea of a popular book to be written by himself. For a title, he suggested the catchy "Scraps of Popular Psychoanalysis." *Cosmopolitan* was interested but Freud wanted more authorial freedom and money than *Cosmopolitan* was willing to give, so the project was dropped.

Ibid., p. 147

He was connected to modern white urban America less because Americans read him, though they did, than because they did not have to read him. Freud and America in the modern era were not just conversationalists on a common theme, critics working within the same interpretative project, but mutual mind readers at work in an age fascinated with all forms of mind reading and mental telepathy.

Ibid., p. 148

As powerful arrivistes, Freud and New York shared in its most acute form the adrenaline rush that was modernism.

McCourt, p. 106

The unholy alliance of the hardline New York Freudians and the McCarthy-Army State Department.

Talese, p. 48

Each day people go to a Fifty-eighth Street psychodrama studio to scream and curse at two masked dummies.

Fitzgerald, *Lost City*, p. 110

I, or rather it was "we" now, did not know exactly what New York expected of us and found it rather confusing.

Blandford, p. 112

For all that they are supposed to be "crisis-oriented" and boast of living under perilous conditions, New Yorkers actually fall apart under the slightest strain that has not been planned for.

Ibid., p. 120

On weekends psychotherapists are not available (there is a Manhattan condition known as Saturday anxiety).

Buzzi, p. 56

bone-drunk on starry metaphysics

McCourt, p. 243

It is part of the character of Manhattan that interior and exterior realities mingle recklessly.

Conrad, p. 309

When its fixative won't hold, collage cobbles together a schizophrenic, self-torturing machine. If you can entertain at once all those impossible contradictions, the machine may work. If not, it won't heed your efforts to restrain and order it and will fly derangedly apart.

Blandford, p. 69

Manhattan's children learn early that life here is but a series of fragments.

Jackson and Dunbar, pp. 497–8

Your opponent is the City.

Conrad, p. 227

Hart Crane begins to complain of a dejected exhaustion. The manic city depresses him. "The N.Y. life is too taxing," he admits in 1923, and has left

him insomniac and irritable. The summer heat sucks away his vitality and brings him near collapse. "New York takes such a lot from you that you have to save all you can of yourself or you simply give out."

I may be one of Manhattans therapized elite, I'm still coming to terms with some aspects of the process—like having my recently blown-out hair savagely *re*blown by the punishing wind off the Hudson.

Quan, p. 8

What are you depressed about?
 I missed my therapy. I overslept.

Allen and Brickman, *Annie Hall*

Jesus, last night it was some guy honking his car horn. I mean, the city can't close down. You know, what-whatta yuh gonna do, h-have 'em shut down the airport, too? No more fights so we can have sex?
 I'm too tense. I need a Valium. My analyst says I should live in the country and not in New York.
 Well, I can't li—We can't have this discussion all the time. The country makes me nervous. There's … You got crickets and it-it's quiet … there's no place to walk after dinner, and … uh, there's the screens with the dead moths behind them, and … uh, yuh got the-the Manson family possibly, yuh got Dick and Terry—
 Okay, okay, my analyst just thinks I'm too tense. Where's the goddamn Valium?

Ibid., p. 38

Alvy, you're incapable of enjoying life, you know that? I mean, your life is New York City. You're just this person. You're like this island unto yourself.
 I can't enjoy anything unless I … unless everybody is. I—you know, if one guy is starving someplace, that's … you know, I-I … it puts a crimp in my evening.

Ibid., p. 143

What's so great about New York? I mean, it's a dying city. You read "Death in Venice."
 You didn't read "Death in Venice" till I gave it to you!
 Well, you only give me books with the word "death" in the title.
 Alvy, you are totally incapable of enjoying life.

Ibid., pp. 148–9

¡ Simulacrum — Psychoanalysis

Behold this paper city, buried in its newspapers in the morning, intent through the day on its journals and ledgers and briefs and Dear-sir-in-reply-to-yours-of-even-date, picking at its newly invented typewriters and mimeographs and adding machines, manifolding and filing, watching the ticker tape flow from the glib automatons in Broad Street, piling its soiled paper into deep baskets, burying its dead paper in dusty alphabetical cemeteries, binding fat little dockets with red tape, counting the crisp rolls and bank notes, cutting the coupons of the gilt-edged bonds, redeemable twenty years hence, forty years hence, in paper that might be even more dubious than the original loan issue. At night, when the paper day is over, the city buries itself in paper once more: the Wall Street closing prices, the Five Star Sporting Extra, with the ninth inning scores, the Special Extra, *All-about-the-big-fight*, all about the anarchist assassination in St. Petersburg—or Pittsburgh.

The cult of paper brings with it indifference to sight and sound: print and arithmetic are the Bible and the incense of this religious ritual. Realities of the world not included in this religion become dim and unreal to both the priests and the worshipers: these pious New Yorkers live in a world of Nature and human tradition, as indifferent to the round of the seasons and to the delights of the awakened senses and the deeper stores of social memory as an early Christian ascetic, occupied with his devotions amid the splendid temples of a Greek Acropolis. They collect pictures as they collect securities; their patronage of learning is merely a premature engraving of their own tombstones. It is not the images or the thoughts, but the reports of their munificence in the newspaper, that justifies their gifts. The whole social fabric is built on a foundation of printed paper; it is cemented together by paper; it is crowned with paper. No wonder the anarchists, with more generous modes of life in mind, have invented the ominous phrase: "Incinerate the documents!" That would wreck this world worse than an earthquake.

The huge bundles of newspapers which at night and in bulk have the merit of a really great commodity—the dignity almost of a bag of meal or a crate of eggs—are now resolved into units on the stationers' stands, and if the new day be Sunday the newsman is busy sorting out the different sections of the Sunday paper and putting the comics section on top. Nor can I think of anything in human affairs which must be more futile in the eyes of the Creator than a stationer sorting out comic supplements in the full glory of early sunrise. With the newspaper waiting for it, New York of the ordinary life is ready to get out of bed.

On Sunday, with breakfast, comes a huge and sphinx-like bundle of papers, neatly folded, layer on wad. Breakfast waits the investigation … Reading this gigantic newspaper becomes a sort of game or endurance test, a task a Spartan mother might well assign her son if she lived in New York today … The bed is lost in the avalanche of paper … the bed, the breakfast tray, myself, utterly submerged by the Sunday *Times* … I contemplate helplessly the vast paper tent that envelopes me. The room is newspaper, the newspaper is room.

I leaped swiftly out of the car and presented her with the seven pounds of Sunday *Times* as if it were a basket of flowers.

Imagine being in New York City on the morning of Sunday, April 28, 1974, like I was, slipping into that great public bath, that vat, that spa, that regional

physiotherapy tank, that White Sulphur Springs, that Marienbad, that Ganges, that River Jordan for a million souls which is the Sunday *New York Times*. Soon I was submerged, weightless, suspended in the tepid depths of the thing, in Arts & Leisure, Section 2, page 19, in a state of perfect sensory deprivation.

To see a family reading the Sunday paper gratifies. The sections have been separated. Papa is earnestly scanning the pages that pictures the young lady exercising before an open window, and bending—but there, there! Mamma is interested in trying to guess the missing letters in the word N—w Yo—k. The oldest girls are eagerly pursuing the financial reports, for a certain young man remarked last Sunday night that he had taken a flyer in Q., X. & Z.

Henry, *Complete*, p. 28

I hate New York on a Sunday. At about ten o'clock, some office worker opposite, dressed only in lilac underwear, raises his blinds. Without, it would seem, putting on his trousers, he sits down at the window with his hundred-page edition of either the *World* or the *Times*, weighing two pounds. He'll read for an hour first the poetic and colorful section of big-store publicity (which forms the basis of the average American world outlook), and after the adverts he'll have a glance at the burglary and murder pages.

Mayakovsky, *Discovery*, p. 56

The radio, the Sunday *New York Times*, Pullman cars, fill up the voids and empty spaces.

Corbusier, p. 213

That Sunday, I'm reading the *New York Times* real estate ads—comparing my worth to everybody else's on the Upper West Side.

Braly, p. 399

In today's thirty-two page *Times* news section, twenty-one of them were taken up with advertisements of a life of looking gorgeous.

Blandford, p. 58

Rubbing shoulders with *New York Times* advertisements.

*Ibid.*, p. 13

A copy of the *New York Times* was spread out, unread, at her feet.

Van Vechten, p. 77

Hurrying to the subway, Rip is reminded to pick up his copy of the daily *Times*. He's an imp who flourishes in the remissness of time.

Conrad, p. 232

His daily paper must be highly spiced.

Girdner, p. 40

He prefers news to romance.

Hapgood, p. 78

Instead of making the commonplace interesting, the newspaper makes the exceptional commonplace. The striking becomes the daily thing.

*Ibid.*, p. 96

Those bundled Sunday newspapers strewn on the sidewalk at the beginning of *Naked City* could just as well be corpses, bagged in neat rows after a tenement fire. They contain corpses and will soon be corpses, or refuse. Sleepers in a mission use them for mattresses, and, in Weegee's photographs of a car crash, they double as a shroud: the dead man is sheeted with newspaper until the ambulance arrives.

Conrad, p. 274

A newspaper truck went from building to building dropping off heavy bundles of, for the most part, bad news, which little boys carried inside on their shoulders.

Maxwell, p. 391

Weegee, *Naked*, p. 43 — One woman kneels at the still-closed church on the way to work, while another girl checks off jobs in the help-wanted section of the *New York Times*.

Heckscher and Robinson, p. 10 — LaGuardia coatless, his eyeglasses pushed over his head, as he read the comics to children during a newspaper strike.

Talese, p. 134 — This is the way it is in New York, where 250 people die each day, and where the living dash for empty apartments. This is the way it is in a big, impersonal, departmentalized city—where on page 29 of this morning's newspaper are pictures of the dead; on page 31 are the pictures of the engaged; on page 1 are pictures of those who are running the world, enjoying the lush years before they land back on page 29.

Ellis, *Psycho*, p. 4 — Baseball players with AIDS, more Mafia shit, gridlock, the homeless, various maniacs, faggots dropping like flies in the streets, surrogate mothers, the cancellation of a soap opera, kids who broke into a zoo and tortured and burned various animals alive, more Nazis … and the joke is, the punch line is, it's all in this city—nowhere else, just here, it sucks, whoa wait, more Nazis, gridlock, gridlock, baby-sellers, black-market babies, AIDS babies, baby junkies, building collapses on baby, maniac baby, gridlock, bridge collapses—

Freeman, p. 57 — NYC left-wing newspapers, including at least five dailies: the *Daily Worker*, the *Forward*, *Morgen Freiheit*, the *China Daily News* (*Meizhou Huaqiao Ribao*), and *PM*.

Hamill, "Lost" — We can see three daily newspapers: the *Journal-American*, the *World-Telegram*, and *PM*; the magazines are *Liberty*, *Air News*, *Argosy*, *Song Parade*, *American*, *Judy's*, *Crack Detective*, *Phantom Detective*, *Cartoon Digest*, *American Astrology*, *White's Radio*, *Magazine Digest*, *Popular Science*, *Mechanix Illustrated*, *Die Hausfrau*, and *Die Welt* (must've been a Yorkville newsstand). We cannot see some other New York dailies that were publishing that year: the *Herald Tribune* and the *Mirror*, and in the outer boroughs, the Brooklyn *Eagle*, the Brooklyn *Times-Union*, the Bronx *Home-News*, the Long Island *Press*, the Long Island *Star-Journal*.

Behrens, p. 315 — The *News*, the *Tribune*, and the *American*
Between the *Evening Mail* and the *Morning Telegraph*
Between the *Morning Journal* and the *Evening Telegram*
From the *Times* to the *World*

Kerouac, *Traveler*, p. 109 — Let's go back to the corner newsstand. —SPACE BLAST … POPE WASHES FEET OF POOR …

Conrad, p. 302 — Yesterday's newspaper is a synonym for waste and the city's amnesia; and they, too, like the streets, can only be read nonhierarchically, since their columns adjoin stories without relating them, which is how the city randomly orders the lives entrusted to it. Those lives are in turn diminished, consumed and wasted by the paper.

Burroughs, p. 920 — This page, an experiment in newspaper format, was largely a rearrangement of phrases from the front page of *The New York Times*, September 17, 1899, cast in the form of code messages.

Fillia, p. 49 — Typography opens shouting at the crowd hungry for the future. newspaper-poetry, a mass of feelings and colors, dedicated to the miraculous new LIGHT.

j Media — Newspaper

Five floors down, a sheet of newspaper flutters across the cement at the bottom of the airshaft.

Eisenberg, p. 26

Newspapers wing, revolve and wing.

Lehman, *Oxford*, p. 443

In hundredstreet multithousand cities
every day thousands of newspapers come out,
long, black columns of words,
are announced loudly in all the boulevards
they are written by little middle-aged men in spectacles
wrong
they are written by the City
in the shorthand of thousands of accidents
in its rhythm, pulse, blood
long forty-column poems
ticked out by multithousand machines
which feel the pulse of the world millions of miles away.
[…]
all this the city writes in its forty-column poems
this is true gigantic poetry
the only one ever new, every twenty-four hours
one that affects me as a strong electric current
how ridiculous is all other poetry in front of it
poets you are superfluous.

Mehring, p. 34

He's as disposable as the daily paper.

Conrad, p. 232

In the smoking car, whose etiquette is that you keep quiet and let men read the morning paper, it occurs to the student that future historians might value a casual abstract of one day's marginalia on the book of life. I take a New York morning newspaper, on a Monday in August, 1928, and quote some of its minor items. It is not for me to offer comment; I leave that to the historian of 2028.

Morley, *Morley's*, p. 185

Perhaps grown-ups get somewhat that same feeling of reality—though not always of safe care and protection—by reading the newspaper. Once every two or three years I take a copy of the *New York Times* and sit down with it to study it intensively. The last time I did so was in 1928 when things were riding high. And now, cleaning up in my study in hope of a small vacation, I find the issue of May 29, 1931.

Ibid., p. 194

By purchasing a ragpaper copy of the *New York Times*, of which a limited edition is printed each day, "records of births, deaths, engagements may be preserved indefinitely." This special perdurable edition costs 75 cents on weekdays, $1.25 on Sundays.

Ibid., p. 198

The paper before me is the *New York Times* of Thursday, July 20. Giving ourselves the privilege of detachment, what can we deduce of the state of the world?

Ibid., p. 206

The transcontinental air mail left New York at 11 A.M., arrived Chicago 7 P.M., arrived Omaha 20 minutes after midnight, arrived Cheyenne 4:30 A.M., arrived Salt Lake City 10 A.M., arrived San Francisco 4:30 P.M.

Ibid.

An "overnight bag" containing a black coolie coat, a navy blue dress, and a typewritten manuscript was lost in a taxicab outside a restaurant on 58th Street.

Ibid., p. 208

Ibid.	Marathon dancers, the biological oddities of the year 1928, were still going strong. A pair of them had just reached the outskirts of New York after having danced down the Post Road all the way from Bridgeport.
Ibid.	Electric refrigeration was highly spoken of in the ads.
Ibid.	People in the Chrysler Building elevators were stalled for 41 minutes, suspended between floors.
Ibid.	Six circus lions housed in a barn on East 221st Street kept the neighbors awake.
Ibid.	Babe Ruth muffed a fly and the Yankees lost, ending their winning streak of 9 games.
Ibid.	Gimbel's has a few openings for elevator girls of good appearance; must be at least 5 feet 5 inches tall and under 25 years.
Ibid., p. 209	With an atlas, an encyclopaedia, and a shelf of histories one might adequately absorb one issue of a newspaper.
Ibid., p. 211	As one moves deeper into this fascinating maze of printed paradox we realize that only the merciful opium of habit makes it possible for the pensive citizen to skim all this every morning and not go haywire. Everywhere he turns is the perfection of astonishment.
McInerney, *Bright Lights*, p. 11	You get a seat and hoist a copy of the *New York Post*. The *Post* is the most shameful of your several addictions.
Ibid., p. 57	The *Post* confirms your sense of impending disaster. There's a Fiery Nightmare on page three—an apartment blaze in Queens; and on page four a Killer Tornado that ravaged Nebraska. In the heartland of the country, carnage is usually the result of acts of God. In the city it's man-made—arson, rape, murder.
Allen and Brickman, *Annie Hall*	There are people out there from *The New Yorker* magazine. My God! What would they think?
Ellis, *Glamorama*, p. 274	I proceed to various newsstands in desperate need of a *New York Post* or a *New York News* to check out what course my life is taking back in Manhattan, but I can't find any foreign papers anywhere.

Radio / TV

Hayes and Woolrich, p. 1	The time—7:15 A.M., WOR, New York. The temperature, outside, 84—Friends—is your life worth one dollar?
Walker, *Night Club*, p. 202	The decline of the street may be blamed upon several causes—the growth of radio and the motion picture.
Hamill, "Lost"	Television killed the supper and nightclubs. The movie houses began closing, too.
Lee and Jones, p. 64	As the evening slowly falls upon us living here in Brooklyn, New York, this is ya Love Daddy rappin' to you. Right now we're gonna open up the Love Lines.

570

New York's multitudes became acutely aware of a new miracle in the fall of 1947, on the eve of the World Series baseball games. In a remarkably short time practically every tavern in town displayed signs bearing the single word "Television."

Rodgers and Rankin, p. 311

In anticipation of the imminent application of TV technology, NBC conceives of the entire block (insofar as it is not punctured by RCA's columns) as a single electronic arena that can transmit itself via airwaves into the home of every citizen of the world—the nerve center of an electronic community that would congregate at Rockefeller Center without actually being there. *Rockefeller Center is the first architecture that can be broadcast.*
 This part of the Center is an anti–Dream Factory; radio and TV, the new instruments of pervasive culture, will simply broadcast life, "realism," as it is organized at the NBC studios.
 By absorbing radio and TV, Rockefeller Center adds to its levels of congestion electronics—the very medium that denies the need for congestion as condition for desirable human interaction.

Koolhaas, p. 200

The majority of chalk sidewalk art of Chelsea children in 1954 was identified as either television sets or characters and/or objects from popular television shows. None of the children's interpretations of their drawings included references to personal or group associations.

Arter, p. 26

Theater of protest expanded from the streets to the television studio.

Hoffman, *Autobiography*, p. 113

To claim that the city is defined as a network of circulation and communication, as a center of information and decision-making, is an absolute ideology; this ideology proceeding from a particularly arbitrary and dangerous reduction-extrapolation and using terrorist means, sees itself as total truth and dogma.

Lefebvre, *Cities*, p. 98

The Waldorf-Astoria (1931) had a web of radio antennae strung between its towers as a means of universalizing itself.

Conrad, p. 257

Sunshine still with us and temperature still climbing, and it should get to sixty, and even into the sixties today. It'll be coolest on the south shore of Long Island and the Connecticut coast with a southerly breeze coming in off the water. Then it clouds up tonight, could start to drizzle. We get drizzle and rain at times tomorrow, especially tomorrow night on into Sunday morning, could be some heavy rain and maybe a thunderstorm. The rain, um, er, probably at least the steady rain, ends Sunday morning, but there still may be some rain showers around Sunday afternoon, and it will be noticeably colder with temperatures no higher than the forties. Right now, though, uh, it is fifty-six degrees and sunny in Central Park, and the temperature today going up to, uh, about sixty.

Goldsmith, *Weather*, p. 41

I paid $258 for that durned TV set. I was sitting there watching a program and the thing went blooey. I got so doggone mad, I just picked up the set and threw it out the window. When it hit the pavement, the picture tube exploded.

Greenburg, p. 115

Why are you so hostile?
 'Cause I wanna watch the Knicks on television.

Allen and Brickman, *Annie Hall*

WBAI is kind of obscure, but you hear it from time to time if you take a lot of cabs.

Quan, p. 93

Radio traffic reports and local TV news are in a frenzy.

Caldwell, p. 2

j Media — Radio / TV

Well, we've been telling you how bad the rush hour's been in Midtown and through Manhattan and it's only getting worse right now. We've been, uh, checking out the FDR Drive just south of the Triboro. This delay goes straight on down to the Brooklyn Bridge. And the northbound side, there was a crash in the 40's with delays right off the Brooklyn Bridge going north. And the West Side, I'm telling you, it can take you upwards to two and a half to three hours to sit in this mess from the 120's all the way down to the Battery Tunnel. I'm not seeing any movement at all right now around the Chelsea Piers area, around the 40's, up in the 90's. It's just horrible on the West Side. Eighth Avenue's gonna be bad, Teens all the way up to Columbus Circle. You got a ton of traffic right now on Seventh Avenue out of, uh, the area of Central Park, all the way down, going past Times Square. Broadway's being impacted by that too. On the East Side steer clear of Second Avenue. Because of the dump-off off the 59th Street Bridge and coming out of the Midtown Tunnel, you've got delays on Second Avenue from the 80's all the way down to the Teens. And the East Side side streets through the 40's and 50's are an absolute mess. Big problems right now across the East River. The only thing south of the Triboro that's moving is the Manhattan-bound Manhattan Bridge. Other than that, forget it. And right now off the Verrazano we've got troubles, Brooklyn-bound lower level there's an accident. It's a flipped-over car, the Brooklyn-bound lower level of the Verrazano on the ramp to the Belt. This will impact the upper roadway too. So right now coming out of Staten Island coming off the Verrazano, it'll be very slow.

Technology

Lorca, *Poet in NY*, p. xi New York is Senegal with machines.

Kittler, p. 721 Entire cities are made of silicon, silicon oxide, and gold wire.

Mumford, *Sidewalk*, p. 65 The vernacular of the machine.

Ibid., p. 82 The Machine Age equals jazz equals triangles equals modernism.

Goll, p. 5 We need the new urban landscape,
the dance of turbines,
the oily atoms of machines

Granick, pp. 96–9 Pneumatic mail—1897. Tube system built from General Post Office to Grand Central and Brooklyn, from Battery to 125th St.

Tubes are cast iron. Cylinders are twenty-four inches long, with a 7-inch diameter. Pressure provided by rotary blowers and air compressors.

Fifty-four miles of tube to 23 post offices, traveling at a speed of 30 and 40 m.p.h.

Operated weekdays between 5am and 10pm, carrying 6 to 7 million letters a day. By 1947 the U.S. Post Office had stopped using pneumatic tubes in all cities except Boston and NYC.

Tubes displaced by teleprinters.

Reasons for blockage: messengers drop chewing gum, rubber bands and erasers into inlets. If a carrier jams, pressure is doubled and sometimes reversed. If that doesn't dislodge it, a heavy carrier may be shot against it, or it may have to be poked out with a steel rod.

New York office of The Associated Press snapped its dispatches to local offices by air chute.

Newspapers were delivered in chutes.

572

The streets of a city are alive in more ways than people usually imagine:
as we walk the streets millions of letters and thousands of telegrams are
shooting every which way under our very feet.

Instantaneous landscapes flit
through systems of pneumatic tubes.

Arce, p. 18

Telegrams sorted at 60 Hudson Street (The Western Union Building) by girls
on roller skates.

Granick, p. 105

the street is my electric lyre,
I walk in its midst, like string above me are wires

Młodożeniec, p. 324

1889 protest where a crew of men climbed 90-foot poles at the corner of
Broadway and 14th St. and sheared the lines to the ground.

Granick, p. 134

Overhead wires, dense as jungle vines, began disappearing in the 1890s, and
sky, both by day and night, returned to the landscape.

Caldwell, p. 209

wireless subways vacuum
cleaners pianolas funnygraphs skyscrapers an safetyrazors

Cummings, p. 85

The great forests of cedar and chestnut poles that once carried the telegraph
wires are now forgotten.

Granick, p. 105

Metro, metronome, mechanical, constructive: nickel,
express, radium, telephone, radio, cable,
elevator, thermometer, petroleum, integral
calculus, vermouth, speed, passport,
radiator, voltaic arc, pneumatic, motor,
alcohol, turbine.

Vinea, p. 54

The living units or houses in cities must be measured in terms of molecules
whose total surface area, even after having been reproduced millions of
times, barely fill a square millimeter. The technologic media miniaturize the
city, while magnifying the entropy of megalopolis.

Kittler, p. 721

In a shockproof vault below 60 Hudson are two pendulum clocks, each six feet
in diameter. These huge master clocks are regulated to tick off every sixtieth
of a second in perfect unison with the clock at the Naval Observatory. If
anything were to happen to the Observatory clock, the nation's radio station,
railroads, air fields, business houses and research laboratories would be able
to get the correct time during the emergency from the Western Union clocks.

Granick, p. 105

Everything whirls
towards its mechanical destiny.

Sánchez, p. 306

Is not the click of the telegraph, telephones, arc lights, elevators, cranes,
trains, airplanes not a blossoming of terrestrial monotony?

Bonnelycke, p. 10

They get scattered through all the floors of the downtown skyscrapers, around
the side corridors fed by the main entrance of dozens of lifts. There are dozens
of lifts for local connections, stopping at every floor, and dozens of express lifts,
going up without a stop until the seventeenth, the twentieth, or the thirtieth.
Special clocks show you what floor the lift is now on, lights indicating, in red and
white, descent or ascent. And if you have two calls to make—one on the seventh

Mayakovsky, *Discovery*,
p. 49

floor and another on the twenty-fourth—you take the local up to the seventh, and then, so as not to waste six whole minutes, you change to the express.

Dos Passos, p. 15

"We are caught up … on a great wave whether we will or not, a great wave of expansion and progress. A great deal is going to happen in the next few years. All these mechanical inventions—telephones, electricity, steel bridges, horseless vehicles—they are leading somewhere. It's up to us to be on the inside, in the forefront of progress … My God! I can't begin to tell you what it will mean … " Poking amid the dry grass and the burdock leaves he had moved something with his stick. He stooped and picked up a triangular skull with a pair of spiralfluted horns. "By gad!" he said. "That must have been a fine ram."

Goll, p. 5

You my century!
electrical gears,
speedway racer to the sun,
headlights on the stars,
I'm yours!

Mayakovsky, *Discovery*, p. 59

All the electricity belongs to the bourgeoisie, yet they eat by candle-end. They have an unconscious fear of their own electricity. They are embarrassed, like the sorcerer who has called up spirits he is unable to control.

Koolhaas, p. 87

To support the alibi of "business," the incipient tradition of Fantastic Technology is disguised as pragmatic technology. The paraphernalia of illusion that have just subverted Coney Island's nature into an artificial paradise—electricity, air-conditioning, tubes, telegraphs, tracks and elevators—reappear in Manhattan as paraphernalia of efficiency to convert raw space into office suites.

Conrad, p. 309

Canal Street, the city's graveyard of industrial mechanism.

Brown, *Valentine's*, p. 183

In 1879 there were only 17 residence telephones in New York and 5 in Brooklyn. The names of the owners were:

Barney, A. H.	101 E. 38th Street.
Barricklo, A.	52 Sedgwick St., Bklyn.
Borden, Wm.	411 W. 23rd Street.
Boncicault, D.	6 E. 15th Street.
Brown, Robert	280 Carlton Ave., Bklyn.
Buss, Geo.	54 W. 39th Street.
Byrne, C. A.	829 Seventh Ave.
Cheseborough, R. A.	17 E. 45th Street.
Dean, John H.	53 W. 54th Street.
Dickenson, E. N.	64 E. 34th Street.
Duryea, Miss A. A.	188 Washington St., Bklyn.
Duryea, S. B.	46 Remsen St., Bklyn.
Earle, F. P.	48 E. 53rd Street.
Elkins, S. B.	46 W. 58th Street.
Gorden, A. D.	210 E. 41st Street.
Hallgarten, Mrs.	5 W. 49th Street.
Hart, J.	71 Lexington Avenue.
Hays, A. N.	144 W. 47th Street.
How, R. W.	134 Columbia Heights, Bklyn.
Parke, T. W.	Buckingham Hotel.
Post, L. W.	247 W. 25th Street.
Sargent, H. J.	665 Bway (Tremont House).

Boys operated the first switchboards. They were succeeded by girls in the eighties.

Ibid., p. 184

1877—The first telephone subscriber in New York was Mr. J. H. Haigh, 81 John Street. His line, five miles in length, was laid across the then half-finished Brooklyn Bridge to his steel plant in South Brooklyn. Mr. Haigh had the distinction of being the first paid line in New York City.

Ibid.

22 million
telephone calls
a day that weave
the most intense
human electricity

Depero, "24th Street," p. 428

New York Telephone Co. installs outdoor telephone booths in 1960. The disappearance of candy and cigar stores since the 1940s has created a need for public phones, and the company sees an opportunity to profit from calls made on impulse by pedestrians, but the new booths will be vandalized, used as urinals, turned into shelters, and employed as offices by drug dealers; directories will be stolen and beginning in the 1970s the company will replace the booths with simpler, doorless enclosures.

Trager, p. 629

In the telephone booth passing a finger up and down the names. Write the number on the back of a business card. Pop in the coin, hear it go clink and bing down into the black box.

Donleavy

And how quiet the telephone operator's office is! It is like a strange library where the librarians sit before their shelves and silently reach for the conversations which their invisible public desires.

Granick, p. 129

Telephone billing—the practice of making monthly photographs of the phone meter.

N. cit.

Each day in New York 90,000 people dial WE6-1212 for the latest weather report; 70,000 dial ME7-1212 for the correct time.

Talese, p. 37

555-1212 for information wasn't introduced until 1959.

Lapsley, p. 53

The energy, time and money that go into preparing temporary political headquarters is astonishing. Early in September, on Republican order, Roosevelt Hotel housemen stripped the seventh floor of everything except the carpets, draperies and television sets. The sets were kept because Mr. Rockefeller wanted his staff to keep up with campaign developments.

Trager, p. 509

When the floor was cleared, brand-new office equipment was carried in by the carload. Countless reams of stationery were piled up. Three hundred telephones were hooked up with a special three-position headquarters switchboard. Forty more telephones will be installed in the Roosevelt's Grand Ballroom tomorrow. So will extra circuits for radio commentators and television men.

The Rockefeller men tried something new with good results. They set thirty telephones aside to carry Mr. Rockefeller's stand on major issues. His voice was recorded on tape. The numbers of the special telephones were advertised so that any voter who wanted to brush up on Mr. Rockefeller's platform could hear it in his own words, in his own voice.

j Media — Technology

Caldwell, p. 210

The *Herald* announces: "Residents of New York City and the country around will be able to read in the skies the result of the battle of the ballots to-morrow." A searchlight, placed atop the Madison Square Garden Tower, beamed out the results as soon as they came in, pointing southward to announce that the Democrats had won.

Trager, p. 485

La Guardia passes a bill describing slot machines as gambling devices that can be seized on sight, whether or not they are in use, and dumped into the Atlantic Ocean. Makers of the machines try to evade the law by placing an obscure knob that releases a cheap (and almost inedible) candy bar, claiming that their devices are vending machines.

Ibid., p. 575

May 26, 1950: Mayor O'Dwyer says that he will not approve parking meters until he has proof that their manufacturers are not linked to slot machines.

Ibid., p. 549

Ballpoint pens go on sale in 1945 at Gimbels for the price of $12.50 with the promise that the pens will write underwater. Some banks suggest that ballpoint pen signatures may not be legal.

Berger, *New York*, pp. 245–7

Ten years ago, in the early 1940s, the historian Allan Nevins of Columbia University saw a stumbling block ahead for historians of generations yet to be. Before the twentieth century, men had relied chiefly on letters to keep them in touch with associates in their calling, or in government. They wrote when they were on holiday; kept diaries.

When the telephone came into wider use and radio communications developed, the letter and the diary came to figure less and less in the daily scheme. Men could speak to one another though whole oceans lay between. Fast planes swept them in brief time to friends or kinsmen and that cut down a lot more on use of the written word.

Professor Nevins finally figured a way to build a source-material stockpile for tomorrow's historians: get competent researchers to make tape-recordings of interviews with men and women notable in law, medicine, the arts, government, journalism, industry, advertising in all fields.

The Oral History Research Office was created. It operates out of Columbia University's Butler Library. Finished tapes are transcribed there in triplicate—one copy for the subject, two for the files. The tapes are used over and over again, but small sections are cut off from time to time so the historian may hear the actual sound of the subject's voice.

In ten years Oral History Research has accumulated 100,000 pages of manuscript in interviews with some 450 persons. All are stored in the Butler Library. Some will not be available to historians while the subjects still live, some will stay closed to from fifty to eighty years after a subject passes; one or two are not to be opened to historians until the Year 2001.

Columbia University does not own the manuscripts; it merely has them in custody. Ownership, it is explained, might make the university liable if any libel action resulted from a historian's use of the material; mere custodianship would not. Each subject owns his own manuscript. At his death ownership passes to his estate. Closed items are locked away with rare books in the library's fireproof vaults. Open manuscripts may be scanned by qualified scholars.

Researchers and transcribers are carefully chosen. They must be persons who would not be likely to disclose restricted material. Only the other day a girl transcriber resigned. She was working on an almost legendary police case, which is still unsolved. She told Oral History Research executives, "I'm afraid I couldn't go on listening to this material without blurting some of it out somewhere." Her resignation was accepted.

The project owns seven tape-recorders. Their newest models will take up to twelve interview hours on a single reel. Wherever they're available, researchers pick up any diaries, pertinent documents, photographs or drawings and put them in with the Mss. Several open biographies already have gone into books, or into parts of books—J. M. Burns's "The Lion and the Fox," A. M. Schlesinger's "The Crisis of the Old Order," among others.

Columbia has hired its project researchers out for special projects to Book-of-the-Month Club, to the Ford Motor Company, Radio Pioneers, Weyerhauser Timber Company, McGraw-Hill. The material will probably be used for corporate or institutional histories. The fee comes to around $90 an hour, which leaves a small profit margin. The margin is applied to other projects, although most of the work is done on special grants.

Not all subjects want their names made public now, but among those who have left their material open are Sir Norman Angell, Nobel Prize winner; John W. Davis, the barrister; Senator William J. Fulbright; Edward J. Flynn, the late Democratic leader; John R. Gregg, the shorthand man; James W. Gerard, the diplomat; Mrs. Fiorello H. La Guardia, the former Mayor's widow; Mrs. Alice Roosevelt Longworth; Geoffrey Parsons, the late journalist; Keats Speed, the journalist; Norman Thomas; Henry A. Wallace; the Rev. George Barry Ward, parish priest. Frances Perkins's manuscript, more than 5,000 pages, is to stay closed until five years after her death.

One of the subjects, a minister, is 100 years old. Close to fifty of the persons interviewed since the project started have died since. "Some of us," one of the project people said the other day, "keep thinking of it, in some cases, as a race with death."

In early 1965, Norelco came out with the first affordable video recorder. "Andy called me up and said he had been making these underground movies and asked for a loaner on this Norelco video recorder for both a black & white and a color camera," recalled Ekstract. "I thought it would be good publicity for Norelco to lend him one and have a world premiere underground party for him."

Ekstract, p. 71

Ekstract had heard that there was an unused train tunnel beneath the Waldorf-Astoria Hotel and thought the location would be an ideal setting for the premiere of Warhol's videos made with the new equipment. The party was held on Friday, October 29, 1965. Entering through a hole in the street, denizens of the New York underground mixed with Park Avenue housewives, all dodging rats and roaches. The party was a success, but the exact content of the tapes, recorded on an obsolete one-inch format which makes playback virtually impossible today, remains unknown.

The party for the machine was held underground, on the abandoned New York Central Railroad track on Park Avenue under the Waldorf-Astoria. You went in through a hole in the street. There was a band and Edie came in shorts, but there were people all dressed up in gowns who were screaming and dodging the rats and roaches and everything—it was the real thing all right.

Warhol, *POPism*, p. 19

The purist refrigerators of New York.

Conrad, p. 136

The intent escalator lifts a serenade.

Lehman, *Oxford*, p. 443

I'm now living the way all outsiders think all New Yorkers live, i.e. under siege conditions, alleviated only a little by the shower with tension-soothing massage attachment, commercial meat slicer, automatic lettuce dryer and similar aids to lie. At least there's a sense of other human beings being nearby.

Blandford, p. 11

Goldenberg, p. 19

Cold War Radar–guided Nike missiles that once surrounded the city like a ballistic "ring of steel" were removed by the mid-1970s. Most of the missile batteries were positioned near sleepy towns on Long Island and in New Jersey and Westchester, but a couple were placed in now-abandoned military installations on the outskirts of the city itself.

Trager, p. 59

The first true Xerox image appears October 22 at Astoria, Queens. The electrophotographic image "10-22-38 Astoria" is imprinted on wax paper which has been pressed against an electrostatically charged two-by-three inch sulfur-coated zinc plate that has been dusted with lycopodium powder.

Ellis, *Psycho*, p. 4

"I could stay living in this city if they just installed Blaupunkts in the cabs. Maybe the ODM III or ORC II dynamic tuning systems?" His voice softens here. "Either one. Hip my friend, very hip."

Franzen, pp. 88–97

New York in the late 1990s, a seamless citywide transition from nicotine culture to cellular culture. One day the lump in the shirt pocket was Marlboros, the next day it was Motorola. One day the vulnerably unaccompanied pretty girl was occupying her hands and mouth and attention with a cigarette, the next day she was occupying them with a very important conversation with a person who wasn't you. One day a crowd gathered around the first kid on the playground with a pack of Kools, the next day around the first kid with a color screen. One day travelers were clicking lighters the second they were off an airplane, the next day they were speed-dialing. Pack-a-day habits became hundred-dollar monthly Verizon bills. Smoke pollution became sonic pollution. Although the irritant changed overnight, the suffering of a self-restrained majority at the hands of a compulsive minority, in restaurants and airports and other public spaces, remained eerily constant. Back in 1998, not long after I'd quit cigarettes, I would sit on the subway and watch other riders nervously folding and unfolding phones, or nibbling on the teatlike antennae that all the phones then had, or just quietly clutching their devices like a mother's hand, and I would feel something close to sorry for them. It still seemed to me an open question how far the trend would go: whether New York truly wanted to become a city of phone addicts sleepwalking down the sidewalks in icky little clouds of private life, or whether the notion of a more restrained public self might somehow prevail.

Gopnik, p. 107

"I mean, this is the Internet," he said, standing among the chattering switches. "You're looking at it. It smells like an old Lionel train set. It weighs a ton. It sits on the floor on Hudson Street. Virtual reality depends on the strength of this floor."

Media — Technology

Fitzgerald in *The Beautiful and the Damned* describes New York "struggling to approach the tremendous and impressive urbanity ascribed to it," in competition with its own publicity. Having already grandly imagined itself, it confronts the artistic imagination with a rebuff. The city promulgates values of its own: how can it then be made to speak for the different values of the artist? New York's monuments—the Empire State Building, the Statue of Liberty, the Brooklyn Bridge—defy the symbolizing faculty because they are already symbols, prepackaged and self-expounding. They therefore provoke in the artist a mischievous revisionism. If he is to capture the city, he must reinterpret them.

Conrad, p. 207

Statue of Liberty

The Statue of Liberty: she is an image alarmingly disproportionate to the idea she's meant to serve. Why is she so menacingly gigantic, and if she's Liberty, why does she frown so illiberally? Instead of a mother, is she another mechanized bogey? Those who are made uncomfortable by her rewrite the allegory and reassign the image. Her torch, for instance, is meant to enlighten the world. Yet she seems to be raising it as a weapon, in hostility or at least admonishment.

Conrad, p. 215

The torch is in reality a threatening club: "Get to work," it commands.

*Ibid.*

I am sorry to say that whenever I have returned from Europe, the first peep of lower Manhattan, with its craggy battlements, its spires splintering the very firmament, and the horrid Statue of Liberty, all these do so work on my spirit that I feel like repining. Not because I am home again—not, my friend, because the spectacle is an uplifting one, but, shame that I must confess the truth, because my return means back to toil, back to the newspaper forge, there to resume my old job of wordsmith. Why, the very symbol of liberty, that stupid giant female, with her illuminating torch, becomes a monster of hated mien, her torch a club that ominously threatens us: Get to work! Get to work!

Huneker, p. 22

The torch: the blackened hilt of a broken sword.

Conrad, p. 215

Christopher Isherwood remembers the Statue as "the Giantess," an overbearing and unnurturing mother.

*Ibid.*

Because the Statue is a woman, she's more the victim of interpretative impertinences than her male architectural colleagues.

*Ibid.*

Her cast-ironical welcome to the oppressed of other lands.

*Ibid.*

Max Beerbohm renamed her the Statue of Vulgarity. For Cecil Beaton in 1938 she appeared as a frumpish matron in last year's ball gown; for Beerbohm she is an overeager hostess.

*Ibid.*, p. 216

Beerbohm told Robert Ross that the Statue must come down.

*Ibid.*

Shaw once said that his reason for not going to the United States was that he couldn't bear to see the Statue, and when he did go, he denounced her as a Statue of Anarchy.

*Ibid.*

A monstrous idol which you call Liberty.

Conrad, p. 216

Ibid., p. 217

Czech Dadaist Jindrich Styrsky, who in 1939 drew the Statue in construction. For a torso she has girders and pulleys, but she flaunts a swollen human mammary.

Ibid.

Lady Liberty resembles a disturbed sleepwalker, wearing a bronze dressing gown and carrying a huge candlestick.

Ibid., p. 223

If you ponder the inner life of the Statue of Liberty, you discover a head empty of thought.

Ibid., p. 217

Why, Morand asks, is she turning her torch in the direction of Europe? Does she want to light her homeland first? Why has she been stranded on that islet? Are they afraid of her setting fire to things with her torch in the wind?

Ibid.

She's a symbol you can enter. But this erotic decipherment—reading the allegory by trespassing inside the body—ends in fear and frustration, as Liberty traps him within her. "From near by, the towering, green, abstract figure terrified me," Morand reports. He valiantly thrusts himself into the abstraction: "I penetrated her skirts by fortress casements." Once inside, he discovers a disquieting truth about her. Though she professes to be Liberty, her interior resembles a prison, and though she claims to be the impersonation of an idea, he finds, when he climbs to the top of her, that her head is empty.

Ibid.

Does Liberty have to be encircled by water because it's too incendiary a notion and may need a cautionary quenching?

Ibid.

When Mae West slinks into her garments in 1934, the Statue of Liberty is redefined as a statue of ignited libido. She earned the right to pose as the Statue because she's a superwoman contemptuous of the official morality. Kong on the Empire State characterized the city's mechanical monstrosity; if Mae West, mounting the Statue's pedestal, is a monster, she's at least a sacred one. Kong is the city's nightmare of itself, Mae West its lubricious daydreaming.

Ibid., pp. 218–20

In 1950 Weegee photographed the Statue through one of his distorting lenses and warped her strict uprightness. She bends lewdly at the waist, vampily redistributing her weight and acquiring a disheveled femaleness. The spikes of her crown, elongated and blurred by the lens, fly out of control like unraveled braids of hair. Though she's no longer an allegorical mentor, the new litheness of her body bestows a more up-to-date iconic status on her. She's as sinuous in her wreathings as a Coca-Cola bottle, and her torch, also squeezed out of shape by the lens, resembles a hot dog. Weegee has made her a deity for the age of advertising, the logo of a product, not the emblem of an idea. And her visual association with fast food—with Coke and frankfurters— revises her monumental meaning. Her virtue is her infinite reproducibility, like the commodities of junk food. She forfeits heroic singularity but gains in recompense repeatability and ubiquity, which augment her power: Coke and hot dogs are themselves symbols of the consumer economy, that great boon of American liberty.

Warhol, *Philosophy*, pp. 100–1

What's great about this country is that America started the tradition where the richest consumers buy essentially the same things as the poorest. You can be watching TV and see Coca-Cola, and you know that the President drinks Coke, Liz Taylor drinks Coke, and just think, you can drink Coke, too. A Coke

is a Coke and no amount of money can get you a better Coke than the one the bum on the corner is drinking. All the Cokes are the same and all the Cokes are good. Liz Taylor knows it, the President knows it, the bum knows it, and you know it.

In Rauschenberg's "Die Hard" (1963) she floats sideways, bobbing in the ocean with splashed-down space capsules, or lumbers like a dirigible across the sky above the water towers on the New York rooftops. Horizontality at once changes her meaning. It's a more democratic posture than standing up straight, though it also allies her with the cruising weaponry—submarines and planes—which supposedly exist to defend her. Tilted sideways, she's both an odalisque and a missile.

Conrad, p. 220

In the poster Rauschenberg designed for the exhibition of his work in 1977 at the Museum of Modern Art, she stands next to the Flatiron and is dwarfed by it—a crude figurine, one of the clichés the city merchandizes as a remembrance. Inherited symbols we consign to the junk heap; the only objects which are authentically symbolic for us are the tacky castoffs of the city's gutters or its dime stores. A cheap replica of Liberty is to him more truly iconic than the Statue itself.

Ibid.

Rauschenberg does a jokey version of a *Time* magazine cover, where she's ranked among the paraphernalia of patriotism, like the American flag and other symbols of a putative reference as cosmic as her own: the see-through globe from the 1964 New York World's Fair and an aerial map of the fair grounds.

Ibid.

Rauschenberg dreams of liberating Liberty from the arbitrary task of having to represent liberty, inviting her to step down from her pedestal. He delights in the city's free-for-all. Iconography shackles its helter-skelter, blown-about things to a system and chains each one to a meaning. Rauschenberg protests that art should consist, as do the streets of New York, of happenings with no particular order or significance. Deposed as a statue, Liberty is reclaimed as litter.

Ibid., p. 221

Rauschenberg, at exactly 12:18 am of a Sunday morning, balanced himself atop a ten-foot ladder, unscrewed a 500-watt light bulb, held his arm outstretched momentarily, and descended—thus completing his rarely performed Statue of Liberty happening.

Malanga, *Archiving*, p. 49

It used to be that the Statue of Liberty was the signpost that proclaimed New York and translated it for all the world. Today Liberty shares the role with Death.

White, *Here*, p. 55

The Liberty statue used to *épater les bourgeois* on the grounds of its height, many times eclipsed by the towering skyscrapers invented since.

Henderson, p. 21

The inside of the Statue of Liberty has been coated in Teflon.

Moorhouse, p. 25

A 1920 memorial at Green-Wood Cemetery in Brooklyn called the Altar to Liberty includes a bronze statue of the goddess Minerva in full regalia. She is positioned facing west with her left arm raised in perpetual salute to the Statue of Liberty, visible across the bay.

Goldenberg, pp. 11–12

The second Statue of Liberty—the obscure almost unnoticed statue that stands on top of the Liberty-Pac warehouse at 43 West Sixty-fourth Street.

Talese, p. 21

This reasonable facsimile, erected in 1902, at the request of William H. Flattau, a patriotic warehouse owner, stands 55 feet high above its pedestal, as compared with Bartholdi's 151-footer on Liberty Island. The smaller Liberty also had a lighted torch, a spiral staircase, and a hole in the head through which Broadway could be seen. But in 1912 the staircase became weakened and the torch blew off in a storm.

Glanz and Lipton, p. 45

When Port Authority Chairman Austin Tobin opened a new arrival terminal at Idlewild (later Kennedy International) Airport, he had it inscribed with four of the five lines from the Emma Lazarus poem immortalized on the Statue of Liberty. He had ordered the "wretched refuse" line expunged, presumably because he thought it sounded gauche at a modern airport terminal. "That line had meaning during the mass migrations of the nineteenth century," Tobin said when the criticism inevitably burst in his face, "but it has no meaning now. It might be offensive to the fine people of Europe—they might not regard themselves as 'wretched refuse.'" What really incensed Tobin, however, was the allegation that his omission had harmed the metrical pattern of the poem. "I didn't think I'd be criticized for *that*," he snapped.

Kilgannon

Liberty Island is now a tourist attraction, but in the 1930s, when it was called Bedloes Island—its official name until 1956—the section open to those visiting the statue was a comparatively small piece. Most of the island's dozen acres were occupied by Fort Wood.

The island was relatively isolated, with no stores or cars. There was a recreation center with two bowling alleys. Food had to be bought at the commissary at Fort Jay. The sole vehicle on Bedloes Island was an Army truck that delivered coal and ice to homes.

Their children recall having free run of the statue, often all the way up to the torch, 305 feet in the air. "We would get up to the torch, and we could actually rock it back and forth. We would walk around the torch—it was frightening but quite an experience."

Donleavy

That statue of a woman holding aloft a torch over the grey green harbor of New York. Two flat ferries pass, one to and one fro.

Jackson and Dunbar, p. 677

A garbage scow burning in the upper bay just under Liberty's right arm.

England, p. 20

Beatrice pointed out the fact that no longer Liberty held her bronze torch aloft. Save for a black, misshapen mass protruding through the tree-tops, the huge gift of France was no more.

Johnson, *Autobiography*, pp. 387–8

She sits like a great witch at the gate of the country, showing her alluring white face, and hiding her crooked hands and feet under the folds of her wide garments, constantly enticing thousands from far within, and tempting those who come from across the seas to go no farther. And all these become the victims of her caprice. Some she at once crushes beneath her cruel feet; others she condemns to a fate like that of galley slaves; a few she favors and fondles, riding them high on the bubbles of fortune; then with a sudden breath she blows the bubbles out and laughs mockingly as she watches them fall.

Bridge

Hawes

By the late nineteenth century, the Brooklyn Bridge had become clogged with traffic.

A bridge exists to pave water.

Conrad, p. 231

The skyline Stella observed from the bridge at night was a rain of meteors, a planetary holocaust. The lights resembled "suspended falls of astral bodies or fantastic splendors of remote rites." The bridge's structural responsibility is to cage light, to imprison an explosion.

Ibid., p. 239

Whitman's primary act of naming is followed by a series of impudent or insurgent renamings which announce a take-over. His biologically continuous Brooklyn Ferry becomes the tense, distraught Brooklyn Bridge of Hart Crane.

Ibid., p. 207

Crane hears the bridge harmonically singing, Stella transcribes its outcry as the high-pitched complaint of color. Both oracularly implant a voice in mechanism.

Ibid., p. 245

Crane writes of "the ecstasy of walking hand in hand across the most beautiful bridge of the world, the cables enclosing us and pulling us upward in such a dance ... "

Ibid., p. 228

In 1924 Crane removed himself to Columbia Heights, where he could be at a meditative distance from the city. Now, instead of living in it and being spent by it, he could look at it and understand it from afar. Across the river, it has receded into an image; between himself and it he has placed the Brooklyn Bridge, "the most superb piece of construction in the modern world," as he called it, which engenders or engineers that image. The bridge suggests a reconstruction of himself. The valor of structural steel is its resilient preparedness for stress and tension, the inner ailments (as Crane discovered when abraded by New York) of modernity. In its combination of stone piers and steel cables, the bridge dramatizes a change in architectural physiology. There's a difference in building materials between strength and stress, between plastic and elastic deformation. Iron is strong but breaks easily and can't be pulled about. It has to be cast or molded, fixed into a solid shape. But if you add carbon, you change the properties of iron and make steel, which is tensile and abides stress. Engineering is the calculated application of stress to a material. Steel is manipulable, and if you know it must withstand a certain stress, you can ensure that it will do so. It copes by flexing, by giving slightly, like the upper tiers of the Empire State swaying in a gale. The cables on the bridge are examples of those contrary "pull forces" that John Mann saw as the dynamics of cubism. Under pressure from both ends at once, they're stressed to maintain form despite that tug-of-war. Rather than snapping, they bend, because the big cords are woven of smaller ones which cooperate in the chore. When in 1930 Crane was commissioned by *Fortune* magazine to write about the construction of the George Washington Bridge, it was the plaiting of these cables which most impressed him.

Ibid., p. 227

The bridge posed a series of technical challenges to Bernice Abbott, who in 1943 lamented that "we cannot yet take a satisfactory photograph from the Brooklyn Bridge" because no film was fast enough to catch detail from the requisite distance, and the bridge's lateral swaying disrupted the exposure.

Ibid., p. 244

Comparing the Brooklyn Bridge with the noblest achievements of European architecture.

Ibid., p. 241

The bridge's roadway is gloomy, too, in the afternoon, but in the evening aglow with aureoles.

Ibid., p. 242

Moorhouse, p. 23

There is a Brooklyn Bridge sound, such as a million swarming bees might make, and it can be heard a mile away downwind for months on end, after which it is extinguished for a year or two before becoming audible again. It is caused by the tarmac on the bridge's roads having worn away to expose metal strips, which produce the high-pitched hum in the endless contact with tyres revolving at high speed; until workmen come to lay fresh tarmac again.

Donleavy

To play the harp of great cables strung sweeping the gothic arches of Brooklyn Bridge. Trembling a music solemn and sad. For all those down deep and listening in their street walking sorrow.

Conrad, pp. 246–7

Derelict after an air raid, the Brooklyn Bridge roadway still serves as a concert platform for an unheeding harpist. While the strings he plays on are taut and tuned, the bridge's cables have buckled, drooped, and twisted out of shape. The bricks crumble, the girders sag sickly.

Jackson and Dunbar, p. 599

One walks the street at night with the bridge against the sky like a harp.

Conrad, p. 245

The bridge's roadway is effaced by a row of featureless warehouses. No one travels across it, for like Hopper's exterminating railway tunnel it's a route to nowhere.

Ibid., p. 257

The Brooklyn Bridge vanishes in a fog in 1943, and the blizzard of 1947 immobilizes the city, icing up the riggings of the fishing boats and obstructing Fifth Avenue with the mounds of buried cars.

Fitzgerald, *Gatsby*, pp. 54–5

Over the great bridge, with the sunlight through the girders making a constant flicker upon the moving cars, with the city rising up across the river in white heaps and sugar lumps all built with a wish out of non-olfactory money.

Conrad, p. 224

For Mayakovsky the Brooklyn Bridge prophesies the advent of dialectical materialism, for its own constructive means, advancing beyond the stolidity of stone and suspending masses in the air by the agency of tense steel, take matter and raise it to spirit, as poetic imagery does. It's not a weighted, completed, obstructive thing, but a field of forces distributed through space. Not planted in earth, it unfolds in air, and the logic of its design suggests a similar engineering of society and history: man would be released from his servitude to material forces if only those forces could be operated on, directed, articulated. The bridge is built in time as much as in space. It's a passage into the future as well as a conduit across a river. Mayakovsky sees it as a prehensile predator, standing with one steel leg in Manhattan while extending a paw to grip Brooklyn.

He adopts the bridge's own method of segmenting in his poetic punctuation. Mayakovsky experimented with a punctuation that would array sentences in space, rather than hastening them through time toward a dying fall, with every comma an expression of reserve or hesitancy, every full stop an obsequy; and this new punctuation, stepped or tiered or zigzagging, works like the bridge, whose cables divide New York in order to rule it.

If the Eiffel Tower stays too long in wanton Paris, it will, he fears, get flabby and sell out to the frivolous values of Montmartre. Traveling home across the Atlantic in 1925, he worries about the same mechanical dysfunction in himself. He has been estranged from his activist purpose while abroad and feels himself to be tarnished, corroded: "steel words rust, blacken copper brass. why is it, under foreign rain, I get wet, and rot and rust?"

so I,
 in graying evening
 haze,
humbly set foot
 on Brooklyn Bridge.
As a conqueror presses
 into a city
 all shattered,
so, I
 from the near skies
 bestrewn with stars,
gaze
 at New York
 through the Brooklyn Bridge.
New York,
 heavy and stifling
 till night,
has forgotten
 its hardships
 and height;
and only
 the household ghosts
ascend
 in the lucid glow of its windows.
Here
 the elevateds
 drone softly.
And only
 their gentle
 droning
tell us:
 here trains
 are crawling and rattling
like dishes
 being cleared in a cupboard.

Mayakovsky, "Brooklyn
Bridge," p. 479

Mayakovsky's poem about the making of the bridge takes the bridge to pieces—unraveling its muscular wires, capsizing its building blocks—in order to refabricate it as a poem.

Conrad, pp. 225–6

Many nights, I stood on the bridge—and in the middle alone—lost—a defenseless prey to the surrounding swarming darkness—crushed by the mountainous black impenetrability of the skyscrapers—here and there lights resembling the suspended falls of astral bodies or fantastic splendors of remote rites—shaken by the underground tumult of the trains in perpetual motion, like the blood in the arteries.

Sharpe, p. 207

The Brooklyn Bridge is still to be observed, but the Hudson Tube is a more modern wonder.

*Ibid.*, p. 206

The skyscrapers are the children of the bridges.

Federal Writers,
Panorama, p. 215

The Brooklyn Bridge conjoins two worlds, fusing earth and heaven; the skyscrapers are a collective cathedral; New York is an angry cyclops, gesticulating with steel girders in defiance of the gods.

Conrad, p. 136

Brook, p. 15

With every step the lines of those cables shift, so that you are glimpsing the city through a constantly changing geometric design.

Dos Passos, p. 124

Picking his teeth he walked through the grimydark entrance to Brooklyn Bridge. A man in a derby hat was smoking a cigar in the middle of the broad tunnel. The arching footwalk was empty except for a single policeman who stood yawning, looking up at the sky. It was like walking among the stars. Below in either direction streets tapered into dotted lines of lights between square blackwindowed buildings. The river glimmered underneath like the Milky Way above. Silently smoothly the bunch of lights of a tug slipped through the moist darkness. A car whirred across the bridge making the girders rattle and the spiderwork of cables thrum like a shaken banjo.

Conrad, p. 239

On Brooklyn Bridge, color glowers from an inferno. The green and red glare of the traffic lights signals seething of the pit.

Ibid., p. 133

The central arch of the Brooklyn Bridge is cloven.

Ibid., p. 223

The object in New York which most keenly attunes itself to the subject is a bridge. If you anthropomorphize the skyscrapers, you get either an overweening ego or an ape; if you ponder the inner life of the Statue of Liberty, you discover a head empty of thought; but the Brooklyn Bridge seems to take on naturally the attributes of a human body. It's as vibrant as a body, receiving from and transmitting to your body as you walk across it the hum and clatter of the traffic using it, and it's a lucid mental apparatus as well. Being transparent, it segments the city with its cables and instructs you—if you look at New York through it—in a way of seeing it. The bridge's engineering is the effortful but gracious enforcement of synthesis, holding contraries together with the violence of spun steel. And its bravest feat of this kind is visual, not architectonic. It analyzes the city, proposing itself to the artist as a mediator between his subjective retreat and the throng of clamoring objects which is downtown Manhattan.

Jackson and Dunbar, p. 599

One looks down from the Brooklyn Bridge on a spot of foam or a little lake of gasoline or a broken splinter or an empty scow.

Berrigan, *Collected*, p. 32

And high upon the Brooklyn Bridge alone,
An ugly ogre masturbates by ear

"Steve Brodie"

Steve Brodie was an American from New York City who jumped off the Brooklyn Bridge and survived on July 23, 1886. The resulting publicity from the supposed jump, whose veracity was disputed, gave Brodie publicity, a thriving saloon and a career as an actor.

"A Leap"

Brodie swung to and fro in the breeze, and steadied himself as well as he could. When he hung perpendicularly over the river he let go his hold, and shot down like an arrow. It was but a few seconds before he struck the water. His body inclined a little to the right, and his legs were parted. He, however, struck with his feet and then on his side, disappearing from view as the water splashed up around and then closed over him. He was under water four seconds. When he came up he began floundering about, as though bewildered by the shock he had received ... Dr. White proceeded to examine him all over. He found a small contusion on the right breast, just below the shoulder, and another below the right nipple. He finally pronounced him in excellent condition, only suffering somewhat from shock. He could not find anything the matter with his internal organs. They were as sound as they

could be, and, in his opinion, Brodie was only shamming a little. Then Brodie called for more whisky ... The only other person who succeeded in jumping from the Brooklyn Bridge was Emmett Odlum, a Washington swimming teacher, who lost his life in his attempt in 1885.

"Steve Brodie" jumping nightly off a reproduction of the Brooklyn Bridge, 100 feet high at the Fair. Conrad, p. 265

who jumped off the Brooklyn Bridge Ginsberg, *Howl*, p. 5
this actually happened and walked away unknown and forgotten
into the ghostly daze of Chinatown soup alley
ways & firetrucks, not even one free beer

Ginsberg's description in *Howl* is fictional ... Tuli Kupferberg did jump from "Tuli Kupferberg" the Manhattan Bridge in 1944, after which he was picked up by a passing tugboat and taken to Gouvernor Hospital. Severely injured, he had broken the transverse process of his spine and spent time in a body cast. He told Thelma Blitz he feels it's important that people don't think they can emulate this leap and walk away unscathed as the poetic accounts suggest he did.

I asked Tuli Kupferberg once, "Did you really jump off of the Manhattan *Ibid.* Bridge?" "Yeah," he said, "I really did." "How come?" I said. "I thought that I had lost the ability to love," Tuli said. "So, I figured I might as well be dead. So, I went one night to the top of the Manhattan Bridge, & after a few minutes, I jumped off." "That's amazing," I said. "Yeah," Tuli said, "but nothing happened. I landed in the water, & I wasn't dead. So I swam ashore, & went home, & took a bath, & went to bed. Nobody even noticed."

The bridge, he said, "emerges victorious," subjugating the hellish "fluvial *Ibid.* abyss" of the torrent beneath.

As the New York City municipal bridge worker said to Ms. Sontag when, to McCourt, p. 250 mark a significant birthday, she once, with a companion, scaled the pylons of the Brooklyn Bridge, "You can do it, Sue!"

G. W. Bridge

No bridge has yet been built across the Hudson at New York. Stokes, p. 815

Corbusier: "The George Washington Bridge over the Hudson is the most Miller, *Supreme*, p. 479 beautiful bridge in the world. Made of cables and steel beams, it gleams in the sky like a reversed arch. It is blessed. It is the only seat of grace in the disordered city."

The anonymity of the G. W. Bridge shares its status with the Empire State Mumford, *Sidewalk*, p. 60 Building, the Chrysler Building, and Rockefeller Center. New York's major landmarks are faceless: "The George Washington Bridge now marks high water in current architecture. How many people know that this bridge was designed and built by Mr. Othmar Ammann for the Port of New York Authority?"

If all the wires in all the cables wrapped into the George Washington Bridge Conrad, p. 249 were stretched out lengthwise, they'd circumnavigate the world four times over.

Beaton, *New York*, p. 39

In intense cold, the metal framework of the George Washington Bridge contracts, creating a rise of three feet in the roadway, at the center of its span. In hot weather, due to the expansion of its giant cables, the center is twelve feet closer to the Hudson than in mid-winter. With its grey lines and trellises, its silver spokes and curving girders, this bridge is like an exquisitely complicated cat's-cradle of steel that leaps into the immensity. Connecting Manhattan Island with New Jersey, it is one of the most beautiful of man-made objects. To defray the cost of building, fifty cents is charged for crossing the bridge by car, and it cannot but be fortunate that funds ran out before the intended decorations could be added. Its extreme and unpretentious functionalism makes it a supreme example of modern engineering.

Talese, p. 19

From dawn to dusk to dawn, day after day, you can hear the steady rumble of tires against the concrete span of the George Washington Bridge.

Hamilton, p. 52

The boat passed under the massive darkness of the George Washington Bridge, turned around, and started back down the river. I was on the top deck, alone, while the kids were whooping it up on the dance deck. After the pack of people, it was good to be alone. The couples on the top deck kept very much to themselves. I watched the bridge, and played time games with myself. I could remember when the bridge was built, remember when I used to walk back and forth across it, remember seeing it from the Cloisters, remember the loom of it coming back from weekends in New Jersey. I was twelve. I was twenty. I was thirty-two. Things that had happened on the bridge were checkpoints through the years. Passing under it was another checkpoint; I'd never done that before.

Ibid., p. 53

As the boat passed under the George Washington Bridge, I began to play time games again. Every two minutes a year passed: that was the game. Ten minutes was five years. Twenty minutes ten years. Forty minutes, twenty. What was going to happen to those people on the dance floor as the minutes rolled by? Where would they be? What would they be doing? What would they look like? How would they feel? What would they think about themselves?

Talese, pp. 268–9

Many people opposed the name Verrazano because they could not spell it. Others, many of them Irish, did not want a bridge named after an Italian, and they took to calling it the "Guinea Gangplank." Still others advocated simpler names—"The Gateway Bridge," "Freedom Bridge," "Neptune Bridge," "The New World Bridge," and "The Narrows Bridge." One of the last things ever written by Ludwig Bemelmans was a letter to the *New York Times* expressing the hope that the name "Verrazano" be dropped in favor of a more "romantic" and "tremendous" name, and he suggested calling it the "Commissioner Moses Bridge."

Moses built the infrastructure that secured New York's place among the greatest cities in the history of the world. Alexander Garvin has said it succinctly: "Nobody, not even Baron Haussmann in 19th-century Paris, has ever done more to improve a city."

Ballon and Jackson, p. 71

Moses himself once said of the man who rebuilt the French capital in the 1850s and 1860s: "Baron Haussmann has been described as a talker, an ogre for work, despotic, insolvent, full of initiative and daring, and carrying not a straw for legality." Moses might have been describing himself. And so also Moses's conclusion about Haussmann: "Everything about him was on a grand scale, both good qualities and faults. His dictatorial talents enabled him to accomplish a vast amount of work in an incredibly short time, but they also made him many enemies, for he was in the habit of running roughshod over all opposition." Baron Haussmann operated under the tutelage of Napoleon III. Moses also operated in a special time, when most people thought that government could and should do grand things for ordinary families.

He had "the energy and enthusiasm of a Haussmann." This made him "uniquely equal, as Haussmann himself had been equal, to the opportunities and needs of the period," and uniquely qualified to build "the city of the future" in our time.

Berman, *Solid*, p. 302

He appeared as the latest in a long line of titanic builders and destroyers, in history and in cultural mythology: Louis XIV, Peter the Great, Baron Haussmann, Joseph Stalin (although fanatically anti-communist, Moses loved to quote the Stalinist maxim "You can't make an omelet without breaking eggs"), Bugsy Siegel (master builder of the mob, creator of Las Vegas), "Kingfish" Huey Long, Marlowe's Tamburlaine, Goethe's Faust, Captain Ahab, Mr. Kurtz, Citizen Kane. Moses did his best to raise himself to gigantic stature, and even came to enjoy his increasing reputation as a monster, which he believed would intimidate the public and keep potential opponents out of the way.

*Ibid.*, p. 294

The greatest intracity road development of modern times before Robert Moses was the boulevarding of Paris envisioned by Emperor Napoleon III and carried out by his Prefect of the Seine, the "brawny Alsatian" George-Eugène Haussmann, between 1852 and 1870. But the roads of Haussmann, impressive though they were, were nonetheless still roads designed for the carriage rather than the car.

Caro, p. 838

Moses made land.

*Ibid.*, p. 392

Moses would be the man who, patching together the rent torn in the earth millennia before by the glaciers rumbling down from Hudson Bay, reunited Long Island with the mainland of the United States.

*Ibid.*, p. 387

Great roads of the twentieth century: Mussolini's *autostrade*, Hitler's *Autobahn*, and Moses's Long Island parkways.

*Ibid.*, p. 838

From the pyramids of Egypt, the rebuilding of Rome after Nero's fire, to the creation of the great medieval cathedrals … all great public works have been somehow associated with autocratic power. It was no accident that most of the world's great roads—ancient and modern alike—had been associated with totalitarian regimes, that it took a great Khan to build the great roads of Asia,

*Ibid.*, p. 874

a Darius to build the Royal Road across Asia Minor, a Hitler and a Mussolini to build the *Autobahnen* and *autostrade* of Europe.

Ibid., pp. 458–9

"He was a man of vision … a giant … He saw Nature as a whole … He was a hero of old, always rushing into battle with Excalibur waving above his head. I always thought of the Park Association as Aaron and Hur … They were the soldiers in the Bible who stood behind Moses and held up his arms when he got tired (at the battle of Rephidim, at which 'Israel prevailed' so long as Moses held up his hands). Well, that's how I thought of the Park Association, as upholding the arms of Bob Moses."

Ibid., p. 6

Moses commented upon the building of Shea Stadium, "When the Emperor Titus opened the Colosseum in 80 A.D. he could have felt no happier."

Ibid., p. 9

[A] measure of his career is immortality. Men strive for a sliver of it; Robert Moses had it heaped upon him. Not only is there a Robert Moses State Park on Long Island, there is another Robert Moses State Park at Massena. There is a Robert Moses Causeway on Long Island, a Robert Moses Parkway at Niagara. The great dam at Niagara is named for him. And over the entrance to the dam at Massena, in letters of stainless steel each three feet high, gleam the words "Robert Moses Power Dam."

Ibid., p. 830

To compare the works of Robert Moses to the works of man, one has to compare them not to the works of individual men but to the combined total work of an era. The yardstick by which his public housing and Title 1 feats can best be measured, for example, is the Age of Skyscrapers, which reared up the great masses of stone and steel and concrete over Manhattan in quality comparable to his. The yardstick by which the influence of his highways can be gauged is the Age of Railroads. But Robert Moses did not build only housing projects and highways. Robert Moses built parks and playgrounds and beaches and parking lots and cultural centers and civic centers and a United Nations Building and a Shea Stadium and a Lincoln Center and the mid-city campuses of four separate universities. He was a shaper not of sections of a city but of a *city*. He was, for the greatest city in the Western world, the city shaper, the only city shaper. In sheer physical impact on New York and the entire metropolitan region, he is comparable not to the works of any man or group of men or even generations of men. In the shaping of New York, Robert Moses was comparable only to some elemental force of nature.

But if in the shaping of New York, Robert Moses was an elemental force, he was also a blind force: blind and deaf to reason, to argument, to new ideas, to any ideas except his own.

Ibid.

The life of a suspension bridge, engineers tell us, is measureless. Atomic attack or natural catastrophe could render all New York shapeless. Barring such monumental calamity in centuries to come, discerning historians will, if they look for it, be able to see writ plain throughout the great city and its suburbs evidence of the shaping hand of Robert Moses.

Roads

Caro, p. 838

The major roads in Rome, the widest paved highways in any ancient city, were only sixty-five and a half feet wide; the highways Moses was preparing to build were two hundred feet wide.

Moses: "What will people see in the year 1999? The long arteries of travel will stand out."

Ibid., p. 829

The roads of Rome stood for two thousand years and more; who would predict less for the roads of Moses? Who would predict less for his Shea Stadium, a structure consciously shaped to resemble Rome's Colosseum because he was afraid that his convention center-office tower "Coliseum" didn't make the comparison clear enough?

Ibid.

During the 1930s, Robert Moses had announced a program—of New York Bridge and arterial highway construction and park reconstruction—which, taken as a whole, as the single coordinated system it was, dwarfed any public work or coordinated system of public works built in any modern city, and, perhaps, in any ancient city as well. The program Robert Moses was announcing now—during the 1940s—would, if completed, dwarf those earlier programs. And, he said, there was no reason why it shouldn't be completed; it was, he said, no mere visionary dream; "The postwar highway era is here."

Ibid., p. 897

Moses's Northern and Southern State parkways, leading from Queens out to Jones Beach and beyond, opened up another dimension of modern pastoral. These gently flowing, artfully landscaped roads, although a little frayed after half a century, are still among the world's most beautiful. But their beauty does not (like that of, say, California's Coast Highway or the Appalachian Trail) emanate from the natural environment around the roads: it springs from the artificially created environment of the roads themselves. Even if these parkways adjoined nothing and led nowhere, they would still constitute an adventure in their own right.

Berman, *Solid*, p. 298

Blueprints were ready for widening the city's old boulevards—Horace Harding, Queens, Conduit, Northern, Eastern—and his old parkways—the Belt, the Gowanus, the Cross Island, the Laurelton—and for building close to a hundred miles of new, broader roads, "expressways" … Soon New York's newspapers began to be filled with names like "Bruckner," "Van Wyck," "Major Deegan," "Cross-Bronx," "Brooklyn-Queens," "Harlem River," "New England," "Richmond," "Willowbrook," "Clove Lakes."

Caro, p. 896

To build his highways, Moses threw out of their homes 250,000 persons—more people than lived in Albany or Chattanooga, or in Spokane, Tacoma, Duluth, Akron, Baton Rouge, Mobile, Nashville or Sacramento.

Ibid., p. 19

His highways and bridges and tunnels were awesome—taken as a whole, the most awesome urban improvement in the history of mankind—but no aspect of those highways and bridges and tunnels was as awesome as the congestion on them.

Ibid., p. 20

Moses: "Cities are created by and for traffic."

Ballon and Jackson, p. 125

Before they existed, four bridges had connected Long Island with the rest of the world, and they all had been jammed. Now six bridges connected Long Island with the rest of the world. And *they* were jammed.

Caro, p. 519

On August 17, 1936, a little more than a month after the Triborough Bridge opened, Long Island's parkways were the scene of what some observers called the greatest traffic tie-up in the history of the metropolitan area. Referring to it as a "cross-country traffic jam," the *Herald Tribune* was forced to conclude that the bridge had, at least indirectly, caused it. Apparently, the

Ibid., p. 516

"motoring residents of the Bronx" had all discovered at the same moment that the Triborough "brought them within easy time of Jones Beach and other cool and pleasant resorts on the south shore of Long Island" and had decided "at the same moment to head for the ocean by way of the new bridge and the Grand Central Parkway. And nearly all of them got stuck—as did countless other motorists going to and from Long Island."

Ibid., pp. 910–11

Within weeks of the opening of the Van Wyck Expressway, the road was jammed. The four miles of roadway which Moses had hacked across Queens looked like a four-mile-long parking lot. "Traffic will flow freely," Moses had promised … Drivers were chained to the Van Wyck; men who, commuting daily, had taken twenty minutes to cover the four miles had looked forward to the opening of the publicized new road; now, clocking their first trips on it, they could hardly believe their watches; where it had taken twenty minutes on local streets, it now took thirty minutes on the expressway—if conditions were good. And, so often, they were bad. The new road had not freed them from the trap of daily travel; it had closed the trap on them more firmly than ever, for new traffic, generated by the new road, was also jamming the local streets. With every passing year, congestion on the expressway worsened.

Ibid., p. 912

The *Times*, clocking travel time to the Lincoln Tunnel, found on one evening that it took a truck twenty-seven minutes to make a one-block-square circuit to the entrance plaza. Within the city, it seemed that there was not a crevice into which cars did not cram; traffic was piling up everywhere; on the crosstown side streets in midtown Manhattan, the *Times* found, motorists frequently spent forty minutes traversing the two and a half miles from one side of the island to the other.

Ibid.

And it wasn't only the bridges and highways that were jammed. As seen from the air, at rush hours, every street in the neighborhoods near the approaches to the East River crossings was a crawling mass of cars.

Ibid., p. 943

In 1955, you would have had to build sixty lanes of new highway just to keep up with the increase in traffic.

Ibid., p. 954

He had condemned *all* Long Islanders—for generations to come.

Ibid., p. 912

We learn to tolerate intolerable conditions.

Ibid., p. 913

People caught in intolerable traffic jams twice a day, day after day, week after week, month after month, began after some months to accept traffic jams as a part of their lives, to become hardened to them, to suffer through them in dull and listless apathy.

Ibid., p. 911

Traffic was "normal," which meant jammed.

Ibid., p. 913

New bridges jammed up without easing the jams on the old, as every lane of gleaming white concrete was filled with cars as soon as it was opened to traffic.

Ibid., p. 914

How come to grips in one's imagination with a situation in which a mighty expressway, a gigantic superhighway of dimensions literally almost unknown to history, could be opened one month—and be filled to absolute capacity the next?

He wanted to plow a 48-foot wide highway through the middle of Washington Square Park in a trench below grade, crossed only by a few pedestrian bridges.

Ballon and Jackson, p. 126

On the opposition to his road through Washington Square Park: "There is nobody against this—NOBODY, NOBODY, NOBODY, but a bunch of, a bunch of MOTHERS!"

Ibid., p. 125

Greenwich Village is sound. It needs no broad highways, no great projects, no straightening out of streets.

Abrams, p. 205

Stuart Constable, aide to Robert Moses: "I don't care how those people in Greenwich Village feel. They can't agree on what should be done. They're a nuisance. They're an awful bunch of artists down there." To which community activists responded, "Not only do we applaud Mr. Constable's outspokenness in this matter, but we feel he is right when he says that Villagers are a nuisance. Anyone who joins in community action to preserve local traditions and resources is always a terrible nuisance to The Authorities. We hope there are thousands of nuisances like that within a stone's throw of his office."

Ballon and Jackson, p. 126

Jane Jacobs was just a housewife.

Gratz, p. 20

Moses called people of tiny neighborhoods and small-scale streetscapes "little schnooks."

Glanz and Lipton, p. 73

It was in transportation, the area in which Robert Moses was most active after the war, that his isolation from reality was most complete: because he never participated in the activity for which he was creating his highways—driving—at all. Insulated in the comfortable rear seat of his limousine, unable to experience even once the frustration of a traffic jam, unable, unless he made an effort and put his work aside and leaned forward to look out the window, even to look at a traffic jam, Robert Moses did not know what driving in the modern era was. He did not know that the sheer weight of numbers of new cars changed the very nature of the activity for which he was creating facilities … He was making transportation plans based on beliefs that were not true anymore. He was making plans that had no basis in reality.

Caro, p. 836

His car, the most luxurious Detroit could provide (the richness of its leather upholstery gave one guest the feeling that he was not in a motor vehicle but the library of a fine men's club, an illusion reinforced by the placement of the limousine's side windows so far forward that the occupants of its deeper rear seat could see out only by leaning forward—"There was a feeling of isolation; normally when you ride in the back of a car people are able to look in and you're able to look out, but here it was as if you were isolated from the outside world"), rushed to him by Detroit at his command, stood at his call day and night; to ensure that it would, he had not one but three personal chauffeurs.

Ibid., pp. 812–13, 815

　　Of the tens of thousands of cars that passed daily through the empire's toll booths, that car alone did not stop. And when the big black limousine with the row of shields on its bumper and the license plate "2000" roared through a booth, not even slowing down, the uniformed officer inside jumping to salute and then staring after it, straining vainly to catch a glimpse of the living legend riding in the rear seat, the lieutenant or captain in charge at the toll plaza would hastily pick up his telephone—as hastily as the commission trooper, miles down the road, seeing the long black limousine looming out of the distance, would reach for his radio microphone—to keep the empire's

capital on Randall's Island appraised, minute by minute and mile by mile, of its ruler's progress, so that urgent messages could be delivered to him at the next toll plaza. If, in reply, he wanted to make a call—he would not allow a telephone in his car so that he could work in it uninterrupted—his chauffeur would pull in to the next police barracks, troopers springing up to escort him to a phone.

[…]

When the calls from the toll booths and the troopers out on the parkways indicated that Moses was headed toward one of his offices, that office would erupt into frenzied excitement. Grown men—men who were themselves in positions of authority over hundreds of men—would shout to each other: "RM is twenty-four minutes away!" "He's twelve minutes away!" "The boss will be here in one minute!"

Ibid., p. 834

Moses had never, aside from a few driving lessons thirty years before, driven a car. He didn't know what driving was. His chauffeured limousine was an office, to him a particularly pleasant office … Traveling by car had been pleasant for him in the 1920's; it was still pleasant for him in the 1950's. The nature of driving might've changed immensely for the people of the metropolitan area; it had not changed at all for him.

Ballon and Jackson, p. 71

I wish that Robert Moses had been in charge of the subways instead of the highways.

Caro, p. 931

At rush hour, the scenes at subway stations in the greatest city in history's richest and technologically most advanced civilization were incredible. At hundreds of stations, the traveler arrived each morning at the head of the stairs leading down onto the loading platforms beneath him, overflowing them, lapping precariously full to their very edges, a sea of humanity—a sea into which the traveler had no choice but to hurl himself.

To get inside the trains, men and women pushed and shoved like irritable animals, rushing for seats as animals rush for a food trough, for without a seat they would have to stand—body crushed against body, strangers' smells in their nostrils, strangers' breaths in their faces—in a press so dense that there could exist in it neither comfort nor dignity nor manners. Writers called subway cars "cattle cars"; they said people were crammed into them "like sardines"; and such nonhuman images were apt. For the crowding in New York subways—crowding to which hundreds of thousands of human beings were subjected day after day, year after year, for all the years of their working lives—was inhuman. Although most office workers were not due until 9 o'clock, on any weekday morning one could see around the subway stations in outlying areas of the cities—past the chain-link fences of the giant parking lots on Woodhaven Boulevard near the giant new Lefrak City housing development in Queens, for example—long lines of men and women, during the fall and winter huddling in their coats against the too early morning chill, hurrying for the stations at 7:45 or even 7:30, willing to forgo a half hour or more of sleep, willing to gulp down a coffee and danish at the office instead of breakfasting at home, to avoid the worst of that degrading ordeal. By eight, it was already too late.

Ibid., p. 933

When Moses came to power in New York in 1934, the city's mass transportation system was probably the best in the world. When he left power in 1968, it was quite possibly the worst.

Ibid.

With money, you could buy almost anything in mid-twentieth-century New York. But you couldn't buy a decent trip to and from work.

Robert Moses — Roads

To oppose his bridges, tunnels, expressways, housing developments, power dams, stadia, cultural centers, was—or so it seemed—to oppose history, progress, modernity itself.

Berman, *Solid*, p. 294

The public works that Moses organized from the 1920s onward expressed a vision—or rather a series of visions—of what modern life could and should be.

Ibid., p. 296

Thanks to Robert Moses, the modernity of the urban boulevard was being condemned as obsolete, and blown to pieces, by the modernity of the interstate highway.

Ibid., p. 295

Its most striking feature as a landscape is its amazing clarity of space and form: absolutely flat, blindingly white expanses of sand, stretching forth to the horizon in a straight wide band, cut on one side by the clear, pure, endless blue of the sea, and on the other by the boardwalk's sharp unbroken line of brown. The great horizontal sweep of the whole is punctuated by two elegant Art Deco bathhouses of wood, brick and stone, and halfway between them at the park's dead center by a monumental columnar water tower, visible from everywhere, rising up like a skyscraper, evoking the grandeur of the twentieth-century urban forms that this park at once complements and denies. Jones Beach offers a spectacular display of the primary forms of nature—earth, sun, water, sky—but nature here appears with an abstract horizontal purity and a luminous clarity that only culture can create.

Ibid., p. 296

Giedion compared Moses's parkways to cubist paintings, to abstract sculptures and mobiles, and to the movies. "As with many of the creations born out of the spirit of this age, the meaning and beauty of the parkway cannot be grasped from a single point of observation, as was possible from a window of the château at Versailles. It can be revealed only by movement, by going along in a steady flow, as the rules of traffic prescribe. The space-time feeling of our period can seldom be felt so keenly as when driving."

Ibid., p. 302

Culture

It was always Moses's ambition to write "cheap pulp" fiction.

Caro, p. 811

In the mid-1950's, short on cash as usual, [Moses] announced to aides that he was going to write "a trashy piece of pulp" that he was sure to sell. Ironically, when he finished it—a reportedly sex-filled novel titled *From Palms to Pines*— and sent it to various publishing houses under a pseudonym, not one would publish it.

Ibid.

Moses's own court musicians were Guy Lombardo's red-coated Royal Canadians, an orchestra whose banal, rigidly traditional arrangements complemented his personal philosophy.

Ibid., p. 819

Regarded in Russia as our greatest builder, was how he characterized Frank Lloyd Wright.

Ibid., p. 471

Walter Gropius, he said, was seeking to change the American system by advocating a "philosophy which doesn't belong here."

Ibid.

Ibid.
Planners, in general, he said, are "socialists" and "revolutionaries."

Peretti, p. 153
Moses: "I am in the position of an artist or a sculptor … I can see New York as it should be and as it can be … But now I am like the man who has a conception that he wishes to carve or to paint, who has the model before him, but hasn't a chisel or a brush." In certain respects, Robert Moses became La Guardia's "chisel."

Caro, p. 397
You could see avenues being widened as if a giant chisel was being rammed between them.

Walrod, p. 61
Moses hated Isamu Noguchi. In 1952, the artist was commissioned to create a privately funded, sculptured playground for the United Nations building on city property which was given a special international diplomatic designation. All parties were a go until Moses stepped in and criticized the design as little more than a "rabbit warren." He went so far as to threaten to not install the guard rail facing the East River to force the project's abandonment.

Berman, Solid, p. 291
When I heard Allen Ginsberg ask at the end of the 1950s, "Who was that sphinx of cement and aluminum?", I felt sure at once that, even if the poet didn't know it, Moses was his man.

Bennett, Deconstructing, p. 55
Moses contended that few writers knew intimately the New York of today so as to be able to appreciate it, and he criticized even the best writers for merely representing only "a quarter, a corner, phrase or facet, certainly not the essence of the city's totality."

Warhol / World's Fair

Gooch, pp. 423–4
During the spring of 1964, the incestuous fevered party of the art world was forced to contend, if only in passing, with the more institutionalized global festival of the World's Fair. O'Hara reacted to the event with a mixture of bemusement and anger. His irritation was partly due to the public glorification of the art of the Pop artists rather than the Abstract Expressionists. As the architect of the New York Pavilion at the Fair, Philip Johnson had commissioned murals for the outside wall of its concrete theatre almost exclusively from the New Realists contingent—Lichtenstein, Rosenquist, Indiana, Chamberlain, Rauschenberg, Warhol. Allan D'Arcangelo executed a Pop Art mural for the outside of the Transportation and Travel Building.

Haines
In 1964, architect Johnson invited the edgy up-and-coming artist Andy Warhol to produce one of ten commissions for the facade of the New York State Pavilion—Warhol's first and ultimately last public-art project. Working in the midst of his "Death and Disaster" depictions of car crashes and race riots, while taking his initial photobooth strips of socialites, friends, and, of course, himself, Warhol devised a work for the pavilion that would merge the profane and the portrait: blown-up silk-screened mug shots of the thirteen most-wanted men taken straight from the City of New York's police department. As the story goes, someone in power had objections, perhaps to its coarse aesthetics, thinly veiled homoeroticism, or simply the banal subject material. By the time the World's Fair opened on April 22, 1964, the *Thirteen Most Wanted Men* was covered in a thick coat of silver paint (a proposal to replace the work with twenty-five identical panels of a beaming World's Fair President Robert Moses was, alas, rejected out of hand).

Warhol contributed *Thirteen Most Wanted Men,* a silkscreened mural
of mugshots appropriated from the files of the New York City Police
Department. A week before the grand opening of the Fair on April 22,
1964, *Thirteen Most Wanted Men* was installed on the exterior façade of the
Pavilion's "Theaterama," a large, cylindrical movie theater. Within a few
days of the mural's installation, a work crew covered it with aluminum house
paint, thereby muffling it under a monochrome of silver. Warhol's mural, now
a visible absence on the New York State Pavilion, was left to stand in this
state throughout the opening festivities of the Fair and for several months
thereafter. Years later, Philip Johnson would claim that Governor Nelson
Rockefeller had insisted on the mural's removal. Other sources, including
Warhol himself, would hold World's Fair President Robert Moses responsible
for the mural censorship.

Meyer, *Outlaw*, p. 130

By April 17, Warhol had already written to the New York State Department
of Public Works authorizing them to paint over the mural "in a color
suitable to the architect." On April 18, both the *Journal-American* and Emily
Genauer in the *New York Herald Tribune* reported that Warhol had asked
to have the work removed because, as the *Journal-American* put it, "He did
not feel his work achieved the effect he had in mind, and asked that it be
removed so he could replace it with another painting." Philip Johnson was
quoted as follows, "He [Warhol] thought we hung it wrong. He didn't like it
the moment he saw it."

Frei, King-Nero, and Printz, p. 26

An aerial view in *Newsday*, dated April 21, shows Warhol's mural covered by a
dark tarp.

Ibid.

The World's Fair was out in Flushing Meadow that summer with my mural of
the *Ten Most Wanted Men* on the outside of the building that Philip Johnson
designed. Philip gave me the assignment, but because of some political thing
I never understood, the officials had it whitewashed out. A bunch of us went
out to Flushing Meadow to have a look at it, but by the time we got there, you
could only see the images faintly coming through the paint they'd just put
over them. In one way I was glad the mural was gone: now I wouldn't have to
feel responsible if one of the criminals ever got turned in to the FBI because
someone had recognized him from my pictures. So then I did a picture of
Robert Moses instead, who was running the Fair—a few dozen four-foot
squares of Masonite panels—but that got rejected, too. But since I had the
Ten Most Wanted screens already made up, I decided to go ahead and do
paintings of them anyway. (The ten certainly weren't going to get caught
from the kind of exposure they'd get at the Factory.) The thing I most of all
remember about the World's Fair was sitting in a car with the sound coming
from speakers behind me. As I sat there hearing the words rush past me from
behind, I got the same sensation I always got when I gave an interview—that
the words weren't coming out of me, that they were coming from someplace
else, someplace behind me.

Warhol, *POPism*, pp. 90–1

At a World's Fair devoted to the achievements of tomorrow, Warhol chose
to look backward by recovering criminal mugshots from the New York City
Police Department. Far from celebrating the promise of America's future,
Thirteen Most Wanted Men stood as a darkly sardonic commentary on its
past. The updated status of "most wanted men" would later be offered as a
defense of the mural's overpainting. Recall Johnson's comment that "it was an
old list, and a lot of them had been proven not guilty. And to label them, we
would have been subject to lawsuits from here to the end of the world." The
visible gap between the original context of the "most wanted men" as police

Meyer, *Outlaw*, p. 136

photography and Warhol's recycling of them as Pop art here serves to justify the censorship of *Thirteen Most Wanted Men*.

Ibid., p. 133

"One of the men labeled 'wanted' had been pardoned, you see," said Mr. Warhol the other day, "so the mural wasn't valid anymore. I'm still waiting for another inspiration."

Ibid., p. 130

Prior to its overpainting, the mural had been reproduced by both the *New York Times* and the *New York Journal American*, the latter on page one … The three New York newspapers that covered the incident each informed their readers that *Thirteen Most Wanted Men* had been overpainted at Warhol's own request.

Ibid., p. 136

More forcefully than any other painting from this period, the World's Fair mural bridges Warhol's interest in celebrity, death, and criminality. Each of the men pictured in the mural was a kind of low-level star, one whose image was reproduced across the nation, albeit in post offices and police stations rather than films and fan magazines. By endowing the mug shot with the grandeur he typically reserved for Elvis Presley or Marilyn Monroe, Warhol insisted on the most wanted man as a mass-cultural icon and, by implication, as an object of desire for a mass audience.

Ibid.

Warhol himself would later write of the alignment of "criminal" and "star" within the space of popular culture: "Nowadays if you're a crook you're still considered up there. You can write books, going TV, give interviews—you're a big celebrity and nobody even looks down on you because you're a crook. You're still really up there. This is because more than anything people just want stars."

Ibid., p. 135

In portraying the criminal as iconic American antihero, Warhol acidly mocked the official ethos of the Fair.

Ibid., p. 137

Warhol posed the following question to his viewers: If the police is no longer pursuing the outlaws pictured here, by whom are these men most wanted now? One answer is, by Warhol himself; another is, by the viewer of the mural; the third is that the men are now wanted by one another.

Ibid., pp. 145–6

Although most visitors to the World's Fair did not know that a set of mug shots lay underneath the silver monochrome, Warhol and the officials who censored his mural certainly did. Through this knowledge the mug shots continued to haunt the scene of representation after their evacuation from it, dismaying Fair officials even when muted under aluminum house paint.

Frei, King-Nero, and Printz, p. 26

Mark Lancaster remembered stretching a series of canvases printed with the faces of the *Most Wanted Men* in early July. This indicates that Warhol probably produced the series of paintings some time between late April and the end of June, in the aftermath of the mural. The same screens were used for the paintings and the panels of the mural … In late September 1964, when Warhol joined the Leo Castelli Gallery, eight canvases were recorded in the gallery registry … According to the registry, these canvases were consigned to Ileana Sonnabend in May 1966, a year before they were exhibited at her Paris gallery … The catalogue of the Sonnabend exhibition in Paris is not dated, but contemporary reviews place it between February 26 and May 7, 1967 … The Sonnabend exhibition traveled to Galerie Rudolf Zwirner, Cologne, where it was on view in September and October, and to the Rowan Gallery, London, in March 1968.

Andy asked me if I could stretch a canvas, which I could, and he brought out a stack of unstretched canvases of the *Most Wanted Men*, versions on canvas of the big panels he had made for the World's Fair. Those paintings were around for a long time. They were shown at the Sonnabend Gallery in Paris and even at the Rowan gallery in London, where I also showed my work, in 1968. It was the first-ever Warhol show in London. It opened March 7th 1968. He didn't come. There were ten or twelve *Wanted Men*, some paired as front and profile views, and in the same show a set of the recently made big silkscreen prints of Marilyn Monroe. I think they were about $500 for the set of 10, and I always wish I had bought one. One of the *Wanted Men* canvases was still at the Union Square Factory in 1984 or 85. I had been there for lunch, and Andy had retreated afterwards into his "painting area" in the back, as he always did. I went in to say goodbye and one of those paintings was leaning against the wall. I said "Gee, Andy, we made that painting in 1964" and he gave me a sly look and a little smile, as if to say, without saying it, "Well I made it, you just stretched it."

Comenas, "Lancaster"

Several months after completing *Thirteen Most Wanted Men*, Warhol shot a silent 16mm film entitled *Thirteen Most Beautiful Boys*, a film that extends and renders explicit the homoeroticism of the World's Fair mural. The *Thirteen Most Beautiful Boys* were in fact young men variously associated with the Factory.

Meyer, *Outlaw*, p. 140

After the Fair, he began making the *Screen Tests*, which were inspired both by the *Thirteen Most Wanted* mug shots and the photobooth pictures Warhol began using in 1963.

Allen, "On Warhol"

Philip Johnson rejected Warhol's proposal for a Robert Moses mural. As Johnson would later recall, "I forbade that, because I just don't think it made any sense to thumb our noses … I don't like Mr. Moses, but inviting more lawsuits by taking pot shots at the head of the Fair would seem to me very, very bad taste. Andy and I had a little battle at the time, though he is one of my favorite artists."

Meyer, *Outlaw*, p. 146

Warhol's painting, *Robert Moses Twenty-five Times* consisted of 25 panels with Robert Moses's headshot, taken from *Life* magazine.

Allen, "World's Fairs"

The Moses panels were lost or destroyed.

Frei, King-Nero, and Printz, p. 26

Racism

Moses despised the animal warmth and the decadent, multiethnic, walled-in artifice of urban leisure of the 1920s. During the opening of his new West Side Manhattan / Riverside Drive project in 1935 he mused, "I wonder sometimes whether people, so obsessed with the seamy interior of Manhattan, deserve the Hudson."

Peretti, p. 146

It's a great amorphous mass to him: it needs to be bathed, it needs to be aired, it needs recreation.

Ibid., p. 147

He kept the swimming pool in Harlem unheated because he believed that blacks avoided cold water.

Ibid., p. 162

"Don't you have this problem with the Negroes overrunning you?"
 "Well, they don't like cold water and we've found that helps."

Caro, p. 514

Ibid., p. 457	Priests blessed the waters of the Astoria Pool before it opened.
Ibid., p. 513	How to force swimmers to wash their feet before entering the pool.
Ballon and Jackson, p. 82	Fears of the new public pools: prospects of racial intimacy as well as being associated with racist ideas of unclean bodies.
Caro, p. 457	Believing that what Negroes liked most to do was dance and sing, he arranged that the opening ceremonies for the Colonial Park Pool in Harlem include an exhibition by Bojangles Bill Robinson (identified by the *Times* as a "negro tap dancer"), a rendition of the Battle Hymn of the Republic by "negro tenor" Roland Hayes ... and community singing.
Ibid., p. 513	He built one pool in Harlem, in Colonial Park, at 146th Street, and he was determined that that was going to be the only pool that Negroes—or Puerto Ricans, whom he classed with Negroes as "colored people"—were going to use. He didn't want them "mixing" with white people in other pools, in part because he was afraid, probably with cause, that "trouble"—fights and riots—would result; in part because, as one of his aides puts it, "Well, you know how RM felt about colored people."
Ballon and Jackson, p. 83	In some pools, the parks department staff tolerated black and white bodies coming in close contact with one another.
Caro, p. 560	He had always displayed a genius for adorning his creations with little details that made them fit in with their setting, that made the people who used them feel at home in them. There was a little detail on the playhouse–comfort station in the Harlem section of Riverside Park that is found nowhere else in the park. The wrought-iron trellises of the park's other playhouses and comfort stations are decorated with designs like curling waves. The wrought-iron trellises of the Harlem playhouse–comfort station is decorated with monkeys.
Ballon and Jackson, p. 116	"We have, it is true, a Negro problem," Moses announced.
Ibid., p. 69	As Moses responded early in 1968 to a question about the concentration of low-income people in a few neighborhoods: "There's only one answer. That is to tear down every building in the slums and put new ones on less land, then bring the people back."
Caro, p. 951	"I was coming up to one bridge across the parkway and just as I was about to go under it, I noticed how low it seemed to be. I took a good look at the next bridge, and goddammit, it *was* low! I pulled over and measured it with my arm at the curb, and I could see that it wasn't any fourteen feet high. At the next exit I got off and found a store and bought a yardstick and got back on the parkway and measured the next bridge. At the curb it was eleven feet high. And I didn't have to go and measure all the other bridges. I knew right then what I was going to find. I knew right then what the old son of a gun had done. He had built the bridges so low that buses *couldn't* use the parkways!"
Ibid.	Most buses were about twelve feet high.
Ibid., pp. 318–19	Underlying his strikingly strict policy for cleanliness in his parks was the deep distaste for the public that was using them. "He doesn't love the people," he used to say ... "It used to shock me because he was doing all these things

for the welfare of people … He'd denounce the common people terribly. To him they were lousy, dirty people, throwing bottles all over Jones Beach. 'I'll get them! I'll teach them!'" … Now he began taking measures to limit the use of his parks. He had restricted the use of state parks by poor and lower-middle-class families in the first place, by limiting access to the parks by rapid transit; he had vetoed the Long Island Rail Road's proposed construction of a branch spur to Jones Beach for this reason.

Now he began to limit access by buses; he instructed Schapiro to build the bridges across his new parkways low—too low for buses to pass. Bus trips therefore had to be made on local roads, making the trips discouragingly long and arduous. For Negroes, whom he considered inherently "dirty," there were further measures. Buses needed permits to enter state parks; buses chartered by Negro groups found it very difficult to obtain permits, particularly to Moses's beloved Jones Beach; most were shunted to parks many miles further out on Long Island. And even in these parks, buses carrying Negro groups were shunted to the furthest reaches of the parking areas. The Negroes were discouraged from using "white" beach areas—the best beaches—by a system Shapiro calls "flagging"; the handful of Negro lifeguards (there were only a handful of Negro employees among the thousands employed at the Long Island State Commission) were all stationed at distant, less developed beaches.

Moses was convinced that Negroes did not like cold water; the temperature at the pool at Jones Beach was deliberately icy to keep Negroes out. When Negro civic groups from the hot New York City slums began to complain about this treatment, Roosevelt ordered an investigation and an aide confirmed that "Bob Moses is seeking to discourage large Negro parties from picnicking at Jones Beach, attempting to divert them to some other of the state parks." Roosevelt gingerly raised the matter with Moses, who denied the charge violently—and the governor never raised the matter again.

By banning public transportation, he had barred the poor from the state parks.

Ibid., p. 492

In building his state parks, he had been uninterested in building for the "lower classes," who didn't "respect" or "appreciate" what was done for them, in particular the Negroes who were "dirty" and wouldn't keep his beautiful creations clean … The protests about this policy from the slums themselves were faint and few; slum dwellers—particularly slum dwellers with black skin—weren't making many protests in the 1930's.

Ibid., pp. 489–90

Robert Moses spent millions of dollars enlarging Riverside Park through landfill, but he did not spend a dime for that purpose between 125th and 135th Streets. He added 132 acres to the parts of the park most likely to be used by white people—but not one acre to the part of the park most likely to be used by black people.

Ibid., p. 557

Moses's arrogance was first of all intellectual; he had consciously compared his mental capacity with other men's and had concluded that its superiority was so great that it was a waste of time for him to discuss, to try to understand or even listen to their opinions … For not only could Robert Moses not help showing his contempt for others, he seemed actually to take pleasure in showing this contempt—a deep, genuine pleasure, a pleasure whose intensity leads to the suspicion that, in a way, he *needed* to display his superiority, with a need so great that he simply could not dissemble it.

Ibid., pp. 424–5

| Ballon and Jackson, p. 73 | The public is a great amorphous mass to him; it needs to be bathed, it needs to be aired, it needs recreation, but not for personal reasons—just to make it a better public. |

Caro, p. 426 — FDR on Moses: "I don't trust him. I don't like him."

Ibid. — La Guardia on Moses: "Jesus Christ! Jesus Christ! Seven million people in the city and I had to pick the one Roosevelt can't stand!"

Ibid., p. 447 — "That dago son of a bitch," "that wop son of a bitch" and "that guinea son of a bitch" were three of Moses's favorite private descriptions of La Guardia ... he referred to him as "the little organ grinder."

Ibid., p. 472 — If Robert Moses was a pioneer in the fields of parks and highways, he was also a pioneer in McCarthyism, twenty years before McCarthy.

Ibid., p. 688 — Comparisons of Moses to Hitler: "He is the original smear artist, like Hitler" ... "He is a liar. And he is a liar in the way Hitler was a liar. He doesn't lie because he can't help it. He lies as a matter of policy."

Ibid., p. 741 — Moses was known as Cardinal Spellman's "pet Jew."

Berman, *Solid*, pp. 294–5 — There are people who like things as they are. I can't hold out any hope to them. They have to keep moving further away. This is a great big state, and there are other states. Let them go to the Rockies.

Beach

Koolhaas, p. 79 — The final conquest and definitive eradication of Coney's original urbanism are assured in 1938 when Commissioner Robert Moses brings beach and boardwalk under the jurisdiction of the Parks Department, ultimate vehicle of the Urbanism of Good Intentions. For Moses, Coney becomes—again—a testing ground for strategies intended ultimately for Manhattan.

"Engrossed in dreams of lawn-flanked parkways and trim tennis courts," he considers the thin strip of oceanfront under his control as merely the base for an offensive that will gradually replace Coney's street grid with innocuous vegetation. The first block to fall is the site of Dreamland, where he establishes the new New York Aquarium in 1957.

It is a modern structure, an incarnation of the "whitewashed barracks," painfully cheerful in the upward sweep of its concrete roofline, implanted in a vast lawn.

"Its lines are trim and clean."

The aquarium is a Modernist revenge of the conscious upon the unconscious: its fish—"inhabitants of the deep"—are forced to spend the rest of their lives in a sanatorium.

When he is finished, Moses has turned 50 percent of Coney's surface into parks.

Mother island to the bitter end, Coney Island has become the model for a modern Manhattan of Grass.

Diehl, p. 165 — The WWII scrap metal drive dovetailed with Robert Moses's urban renewal schemes. Buildings were pulled down to make way for Moses's ideas, even stripping the old Aquarium—the circular structure that was once Castle Garden—of its metal was okay, since the structure was being threatened with demolition to make way for the Brooklyn Battery Tunnel.

"The Battery is no *place* for an aquarium," I once heard Mr. Moses say
angrily.

Atkinson, p. 79

The demolition of the old aquarium in Battery Park. Moses threatens to dump
the fish into the sea. He also suggests that the fish be made into a chowder.

Caro, pp. 681, 682

The sand he imported for Jones Beach blew away because it was not
anchored. He sent teams of men out on their hands and knees illegally
yanking out grass from private homes. The next weekend, when people
arrived at the summer homes, they found men yanking out the grass on their
beach.

Ibid., p. 832

He dispatched landscape architects to other Long Island beaches to find
out why the sand on older, natural dunes was more stable. They reported
that it was because of the presence on these dunes of a form of beach grass
whose roots, seeking water in the dry sand, spread horizontally rather than
vertically and thus held sand around it in place. But to be effective, they
reported, the grass had to be planted thickly—hundreds of thousands, even
millions, of clumps would be required to hold down the new dunes on Jones
Beach—and it could be planted only by hand. In the summer of 1928, on the
desolate sand bar on the edge of the ocean, amid half-completed building
skeletons that looked like ancient ruins, was a panorama out of the dynasties
of the Pharaohs: hundreds, thousands, of men, spread out over miles of sand,
kneeling on the ground digging little holes and planting in them tiny bundles
of grass.

Ibid., p. 233

On weekends a continuous procession of small planes cruise just above the
shoreline, skywriting or bearing banners to proclaim the glories of various
brands of soda or vodka, or roller discos and sex clubs, of local politicians and
propositions. Not even Moses has devised ways to zone business and politics
out of the sky.

Berman, *Solid*, p. 297

Terrain

In 1949 Robert Moses answered the question: "What Will New York City
Look Like in the Year 1999?": "Nature, not man, will still be predominant ... a
fourth of The Bronx will remain field, forest, and stream ... Staten Island will
be largely rural ... Traffic will flow freely in 95 percent of the city ... There
will be no sign of decrepitude, decay or resignation."

Caro, pp. 909–10

Inwood Hill Park was not a park at all, but a wilderness, a wonderful
wilderness, a last reminder, crowded into the craggy hills in the
northwesternmost corner of Manhattan Island by the relentless spread
of concrete, that once almost all of the island had been covered with lush
green forests. To the east, the hills sloped down into a valley that opened on
a beautiful, peaceful cove formed by a U-curve in the Harlem River. In the
valley, the site of the old Algonquin village of Shora-Kap-Kock ("in between
the hills"), was a little museum operated by an Indian woman and a pottery
studio, complete with kilns capable of the most delicate ceramics. In the cove,
the last bit of natural waterfront on Manhattan Island and the reputed site of
the landing of a longboat from Henry Hudson's *Half Moon* 300 years before
and of a battle between the longboat crew and the Algonquins, stood a giant
tulip tree under which Hudson had held a powwow with the Indians. On the
opposite, or Hudson River, side of the park's hills, 200 feet below the steep
escarpment that formed their western edge, was a narrow strip of landfill

Ibid., pp. 541–2

that held a New York Central roadbed. But in the 300 acres covered by the hills themselves, there was hardly a sign of the hand of man. The Lords of Lord & Taylor had once lived in two mansions on the escarpment, but these had burned to the ground decades before. When Exton turned off the city's asphalt streets and wandered up the steep slopes—it was their steepness that had saved them from development—he found himself in a different world, a world of wild underbrush and towering trees. Hiking up to their crest, under foliage so thick that it all but blotted out the sun, he could pick wild blackberries and blueberries or, in spring and early summer, could stop and look for a while at the fragrant purple- or white-blossomed lilac bushes, some of them three times as tall as he. At the crest, out on the escarpment, was a view that guidebooks marveled over—"perhaps the finest Manhattan offers," said one: the broad sweep of the Hudson below and, looming above the river on its far shore, the endless miles of the Palisades, unmarked north of the George Washington Bridge by a single man-made structure. If Exton sat so that he couldn't see the bridge, there was nothing to remind him of what he had left behind at the foot of the hills except for the occasional passage, far below him, of a little toy New York Central train.

"It was the only real woodland left on Manhattan," he would recall years later. "It was the last unique hunk of primeval forest and the whole metropolitan area. It was unique. It was irreplaceable."

And to alter it with a *highway*! "When you were up on top there, you were away from the roar of cars and the smell of gasoline. It was the only place in Manhattan where you could still say that." Moses's proposed Henry Hudson Parkway would bring the roar and the smell right into that beautiful spot. In fact, it would, to a large extent, eradicate it, bury it under six lanes—140 feet in width—of concrete, since Moses' plan was to run the highway right along the escarpment. Moses was saying that running the road through the park would destroy "only a few trees."

Ibid., p. 553

Moses was more than satisfied with his handiwork. The sheer cliffs of the forest-topped Palisades, opposite the sheer cliffs of Manhattan's apartment houses, were "the most magnificent river wall anywhere," he felt, and the wall he created was its match. Now that it was complete, the Hudson vista was the greatest river vista in the world. The Rhine? The Rhine with its "silly, quaint, Wagnerian castles"? Thanks to the West Side Improvement, the Hudson absolutely *dwarfed* the Rhine.

Ibid., p. 554

All sweeping curves and spacious straightaways, lined with woods, underbrushy and shadowy and deep, that drenched them in autumn colors, and with clearings in which black boulders sat dramatically in the center of sun-dappled grass.

Kinkead, *Central Park*, p. 110

Robert Moses: a practiced nighttime marcher.

Ibid., pp. 110–11

In April of 1956, a new parking lot was to be made for Tavern on the Green. The spot selected was a greasy hollow shaded by maple trees, barely to the northwest at 68th Street. Neighborhood mothers, however, habitually frequented it with their children. It was a small, secluded amphitheater, ideal for rest and recreation, safe for youngsters, and soothing for adults. Learning of the plan through observation of an exposed blueprint left on the grass by Park engineers, twenty-three mothers signed a petition to Moses asking that the parking lot idea be abandoned and their children's play area left as it was.

Without public notice, Moses dispatched a bulldozer to the site to take off the turf and topple the trees. Seeing this, a few indignant mothers

quickly assembled and stood in front of the machine. Whereat the operator stopped work.

Within a week Moses struck back under the cover of darkness, shortly after midnight, when the watchful eyes of the mothers were closed. An elite task force composed of gardeners, laborers, a bulldozer, its operator, and more than thirty police officers under the command of an inspector went to work. A fence was erected, ringed by the police. Inside, the bulldozer started up and axmen attacked the trees.

Power

Moses's fingers drummed impatiently on a table when someone dared to disagree with him.

Caro, p. 241

Power is being able to laugh at people who oppose you and to laugh at them with impunity, to antagonize them without fear of reprisal. Now Robert Moses seemed to be going out of his way to laugh at people ... Power is being able to ruin people, to ruin their careers and their reputations and their personal relationships. Moses had this power, and he seemed to use it even when there was no need to, going out of his way to use it, so that it is difficult to escape the conclusion that he enjoyed using it.

Ibid., p. 499

The City Builder must have an odd mixture of qualities. He must have a basic affection for his community, he must hate what is ugly, barren and useless. He must have an instinctive dislike of things which are built or run wrong. He must have a healthy contempt for the parasite, the grafter, the carpetbagger, the itinerant expert, the ivory tower planner, the academic reformer and the revolutionary. He must have the barge captain's knowledge of the waterfront, the engineer's itch to build, the architect's flair for design, the merchant's knowledge of the market, the local acquaintance of a political district leader.

Ibid., p. 832

As he was above the rules, he was above the law.

Ibid., p. 831

Once you did something physically, it was very hard for even a judge to undo it.

Ibid., p. 218

Once you sink that first stake, they'll never make you pull it up.

Ibid.

Misleading and underestimating, in fact, might be the only way to get a project started.

Ibid., p. 219

Once they had authorized that small initial expenditure and you had spent it, they would not be able to avoid giving you the rest when you asked for it. How could they? If they refused to give you the rest of the money, what they had given you would be wasted, and that would make them look bad in the eyes of the public. And if they said you had misled them, well, they were not supposed to be misled. If they had been misled, that would mean that they hadn't investigated the projects thoroughly, and therefore had been derelict in their own duty. The possibilities for a polite but effective form of political blackmail were endless.

Ibid.

You can draw any kind of picture you like on a clean slate and indulge your every whim in the wilderness in laying out a New Delhi, Canberra or Brasília, but when you operate in an overbuilt metropolis, you have to hack your way with a meat ax.

Ibid., p. 849

Ibid., p. 220

For the rest of his life, when a friend, an enemy—or one of his own lawyers— would protest that something he was doing or was proposing to do was illegal, Moses would throw back his head and say, with a broad grin, a touch of exaggeration and much more than a touch of bravado: "*Nothing I have ever done has been tinged with illegality.*"

Ibid.

Would dreams—dreams of real size and significance and scope—the accomplishment his mother had taught him was so important, ever be realized by the methods of the men in whose ranks he had once marched, the reformers and idealists? He asked the question of himself and he answered it himself. No.

Glanz and Lipton, p. 137

The Port Authority: "an unconquerable Frankenstein ... no one has successfully opposed it in the past."

Caro, p. 814

Waiting to lunch with Robert Moses, a guest would be ushered at Randall's Island into an anteroom lined with pictures of Robert Moses's bridges, Robert Moses's parks, Robert Moses's parkways, of Robert Moses posing with Hoover, of Robert Moses posing with Roosevelt, of Robert Moses posing with Truman, with Eisenhower ... with Kennedy, Johnson—and Pope John.

Ibid., p. 20

For decades, to advance his own purposes, he systematically defeated every attempt to create the master plan that might have enabled the city to develop on a rational, logical, unified pattern—defeated it until, when it was finally adopted, it was too late for it to do much good.

Decline

Caro, p. 807

Moses had no hobbies or relaxations. He did not golf, play bridge, attend sporting events or theater ... Guests at his home can recall no single day that he spent with his family, on which he did not disappear for hours into his study and shut the door behind him. He still refused to allow any of the chores that consume chunks of other men's lives—buying clothes and getting haircuts, for example—to consume chunks of his. As she had been doing since the day she married him, Mary still ordered his socks and underwear, bought his suits, carried them home, if they weren't the correct size took them back and brought home others, and when she got ones that fit, arranged for a tailor to come to his office and make minimum alterations, and when she saw he needed a haircut, had a barber brought in, and, if he was going out to dine, placed money in his pocket. (If she forgot, he would have to ask his companion for a dollar or two for the waiter.)

Ibid., p. 268

Moses had a table in his office, never a desk.

Ibid., p. 836

Moses claimed that golf was not a game in which the masses were interested; it was, he said, played only by the "privileged few." Golf was now a game played by millions in all walks of life. But Moses didn't know this. His statement would have been true in the Twenties and he thought it was still true in the Fifties.
Because he didn't know anything had changed.

Ibid., p. 269

No longer the face of a poet, it was the face of a man accustomed to command.

Ibid., pp. 835–6

His lieutenants first noticed about 1950 that the boss was having difficulty understanding what people were saying to him. His hearing deteriorated

rather rapidly thereafter, and doctors told him there was nothing to be done for the condition, a simple result of age—Moses was, after all, in his 60s—except for him to wear a hearing aid. Robert Moses wearing a hearing aid?!? He refused to even consider the suggestion. The condition grew worse. More and more frequently, if he was asked a question at the big conference table, his reply would not be responsive—he would be answering the question he *thought* he had been asked ... In a way, of course, Moses's deafness was symbolic. He had, in a way, been deaf all his life—unwilling to listen to anyone, public, Mayor, Governor, deaf to all opinion save his own ... Now, thanks to the deafness, he was unable to hear the views of others.

Reality had changed; the reality of the 1920s was not the reality of the 1950s. *Ibid.*, p. 834
The metropolitan area that Moses was now attempting to shape was not the metropolitan area that he had begun shaping; there were more people in it, so many more that the very fact of their numbers alone changed all the dimensions of life in the area; they covered so much more of its land surface with their homes; they were, moreover, a different people: the population of the area had been transformed; to mention just one change, there had been fewer than 200,000 nonwhites in the area when Moses had begun his public career, there were more than 2 million now; embarking on a recreational policy that deliberately excluded nonwhites from most parks may have had in Moses's mind some sort of rationale in 1923; it is difficult to believe that that mind would formulate the same policy in 1953; Moses was nothing if not realistic, and excluding so large a part of an area's population from parks was not realistic. Quality, Hegel said, changes with quantity. Automobiles had meant weekend excursions to the country, leisurely drives, pleasure, freedom, in the 1920's when there had been relatively few automobiles. Automobiles meant something very different now.

But Robert Moses did not see those changes. He did not see that reality had changed. Not only the sycophancy with which he had surrounded himself but also three hard physical facts of his existence insured this.

The scenery amid which the New Yorker traveled around his city was a vast *Ibid.*, p. 933
mosaic of FUCK and SUCK and COCK and CUNT.

When he died in 1981, Robert Moses's estate was valued at $50,000, less than Ballon and Jackson, p. 70
many individuals who were born with nothing and worked for a salary all their lives.

Would New York have been a better place to live if Robert Moses had Caro, p. 21
never built anything? ... It is only possible to say that it would have been a different city.

Baldwin, p. 30

Before him, then, the slope stretched upward, and above it the brilliant sky, and beyond it, cloudy and far away, he saw the skyline of New York. He did not know why, but there arose in him an exultation and a sense of power, and he ran up the hill like an engine, or a madman, willing to throw himself headlong into the city that glowed before him.

O'Connell, p. 291

A city burning with the itch to Grab It Now.

Sharpe, p. 277

The city's love of excess is replicated in its very name: New York, New York.

McNeil and McCain, p. 163

The possibilities were endless.

Haden-Guest, p. xxi

It was really all about Me! Me! Me! Me!

Stevens and Swan, p. 301

The eternal question of the ambitious: "Why not me?"

Kingwell, p. 17

The city: its weird gravitational pull, extending in all directions; the way, even if you have never been here before, it seems to exist in order *to make all things seem possible.* Even or especially.

Sharpe, p. 186

Our whole scheme of life and progress and profit was perpendicular. There was nothing for us but height. We were whipped up the ladder. We depended upon the ever-growing possibilities of girders and rivets as Holland depends on her dikes.

Ibid., p. 233

It should be *tall*, every inch of it tall.

Ibid., p. 6

Its brash, self-confident love of newness, and its dollar-driven, accelerated pace of life.

Federal Writers, *Panorama*, p. 4

Historically, it has been to an exceptional degree a city of accumulation: its methods promotion and commerce, its principle aggrandizement.

O'Connell, p. 293

Make it now! That motto burned in every heart like myocarditis.

Sharpe, p. 198

On his first night in New York in 1924, the German filmmaker Fritz Lang suddenly had a vision of a looming, overbuilt, power-hungry city: "I looked into the streets—the glaring lights and the tall buildings—and there I conceived *Metropolis.*"

Douglas, p. 64

On November 14, 1925, *The New Yorker* described the city as a "gymnasium of celebrities" and would-be celebrities; there are always "more non-entities trying to attract attention and failing than celebrities trying to avoid attention and succeeding." New York attracted those who wanted, sometimes desperately, to find out not so much who they were as who they could appear to be, those who needed the gaze of others to come alive, exhibitionists and attention addicts who possessed, in Fitzgerald's words, "theatrical innocence," the preference of the "role of the observed to that of the observer." Cynical Thomas Beer thought the "whole 'Lost Generation' movement ... as coldly commercial as a burlesque show"; if this was a "lost generation," it was lost in plain sight of all the spectators America could summon ... As Al Jolson put it in an ad he placed in *Variety* in the 1910s: "Watch me—I'm a Wow!"

Gopnik, p. 6

In New York, the space between what you want and what you've got creates a civic itchiness: I don't know a content New Yorker. Complacency and self-satisfaction, the Parisian vices, are not present here, except in the hollow form

of competitive boasting about misfortune. (Even the very rich want another townhouse but move into an apartment, while an exclusive subset of the creative class devotes itself to dreaming up things for the super-rich to want, if only so they alone will not be left without desire.)

New York is the concentrate of art and commerce and sport and religion and entertainment and finance, bringing to a single compact arena the gladiator, the evangelist, the promoter, the actor, the trader and the merchant. It carries on its lapel the unexpungeable odor of the long past, so that no matter where you sit in New York you feel the vibrations of great times and tall deeds, of queer people and events and undertakings.

White, *Here*, p. 19

"Insincerity is a necessary element of material progress."

Hapgood, p. 126

It's a drama that is monumentally present, dwarfing, bullying, pounding into submission.

Brook, p. 15

Years before, he'd moved to New York believing himself to be penetrating to the center of the world, and all of the time he lived there the illusion of a center had held: the sense of there always being a door behind which further mysteries were available, a ballroom at the top of the sky from which the irresistible music wafted, a secret power source from which the mad energy of the metropolis emanated.

O'Connell, p. 299

Babe Ruth: our national exaggeration.

Douglas, p. 65

You have to fight the city constantly, carving out your own space. When you're feeling jaunty and high, full of zest, Manhattan will back you up, opening the door to pleasure and wonder. But when your spirits are low, or you're caught in a tangle of sadness and heartache, the city won't offer you any relief as it asserts that the race goes unwaveringly on even if you choose to stand aside for a while.

Brook, p. 16

I always marvel at those who are willing, seemingly, to pay any price, *the* price, whatever it may be—for one sip of this poison cup. What a stinging, quivering zest they display. How beauty is willing to sell its bloom, virtue its last rag, strength an almost usurious portion of that which it controls, youth its very best years, its hope or dream of fame, fame and power their dignity and presence, age its weary hours, to secure but a minor part of all this, a taste of its vibrating presence and the picture that it makes. Can you not hear them almost, singing its praises?

Dreiser, p. 4

The original necessity of enduring noise, dirt, conflict, confusion as symptoms of a transitional phase developed into a taste for the mindless intoxicant of sensation.

Josephy and McBride, p. 41

I was a failure—mediocre at advertising work and unable to get started as a writer. Hating the city, I got roaring, weeping drunk on my last penny and went home. Incalculable city. What ensued was only one of a thousand success stories of those gaudy days, but it plays a part in my own movie of New York.

Fitzgerald, "My Lost City," p. 108

But sometimes in New York you run across the disillusioned—a young couple who are obviously visitors, newlyweds perhaps, for whom the bright dream has vanished. The place has been too much for them; they sit languishing in a cheap restaurant over a speechless meal.

White, *Here*, p. 33

Brook, p. 16	Its exhilaration is also a kind of terror.
Ibid., p. 40	It strews in your path every dreamed-of gratification.
Ibid., p. 42	While the many consume, a few are consumed.
Blandford, p. 81	To be intelligent here is the equivalent of being a starlet in Los Angeles.
Brainard	I remember daydreams of being a big success in New York City. (Penthouse and all!)
Ibid.	I remember fantasies of all of a sudden out of the blue announcing "An evening with Joe Brainard" at Carnegie Hall and surprising everybody that I can sing and dance too, but only for one performance. (Though I'm a smash hit and people want more.) But I say "no": I give up stardom for art. And this one performance becomes a legend. And people who missed it could shoot themselves. But I stick to my guns.
McInerney, *Bright Lights*, p. 151	Getting out of the taxi next to the famous fountain, you seemed to be arriving at the premiere of the movie which was to be your life. A doorman greeted you at the steps. A string quartet played in the Palm Court. Your tenth-floor room was tiny and overlooked an airshaft; though you could not see the city out the window, you believed that it was spread out at your feet. The limousines around the entrances seemed like carriages, and you felt that someday one would wait for you. Today they put you in mind of carrion birds, and you cannot believe your dreams were so shallow.
Wolf, *Gossip*, p. 95	Warhol: "Success is a job in New York."
Brook, p. 255	Here, on drab Tenth Avenue, was a definition of an inexhaustible city, a place where even at 4:30 on a winter's morning you have to queue for a table at a restaurant.
Ford, *America*, pp. 78–9	Indeed I am being driven out of New York by the ceaseless ringing that goes on on my telephone all the morning when I ought to be working.
White, *Here*, p. 25	I am not defending New York in this regard. Many of its settlers are probably here merely to escape, not face, reality. But whatever it means, it is a rather rare gift, and I believe it has a positive effect on the creative capacities of New Yorkers—for creation is in part merely the business of forgoing the great and small distractions … Although New York often imparts a feeling of great forlornness or forsakenness, it seldom seems dead or unresourceful; and you always feel that either by shifting your location ten blocks or by reducing your fortune by five dollars you can experience rejuvenation. Many people who have no real independence of spirit depend on the city's tremendous variety and sources of excitement for spiritual sustenance and maintenance of morale. In the country there are a few chances of sudden rejuvenation—a shift in weather, perhaps, or something arriving in the mail. But in New York the chances are endless. I think that although many persons are here from some excess of spirit (which caused them to break away from their small town), some, too, are here from a deficiency of spirit, who find in New York a protection, or an easy substitution.
Goldsmith, *Theory*	The great pitfall of young artists coming to New York is the lure of the social. Every evening there are more openings, readings, performances, dinners and parties than one could ever attend. In order to succeed as an

artist, one must decline most of these invitations and stay in the studio working, attending the very few which will truly open doors. I have seen more artists fall by the wayside in this way, pulled by the allure of glamorous distraction.

It is astonishing how little New York figures in American literature. Think of the best dozen American novels of the last generation. No matter which way your taste and prejudice carry you, you will find, I believe, that Manhattan Island is completely missing from at least ten of them, and that in the other two it is little more than a passing scene, unimportant to the main action. Perhaps the explanation is to be sought in the fact that very few authors of any capacity live in the town. It attracts all the young aspirants powerfully, and hundreds of them, lingering on, develop into very proficient hacks and quacks, and eventually adorn the Authors' League and the National Institute of Arts and Letters. But not many remain who have anything worth hearing to say. They may keep quarters on the island, but they do their writing somewhere else.

Primarily, I suppose, it is too expensive for them: in order to live decently they must grind through so much hack work that there is no time left for their serious concerns. But there is also something else. The town is too full of distractions to be comfortable to artists; it is comfortable only to performers. Its machinery of dissipation is so vastly developed that no man can escape it— not even an author laboring in his lonely room, the blinds down and chewing gum plugging his ears. He hears the swish of skirts through the key-hole; down the area-way comes the clink of ice in tall glasses; someone sends him a pair of tickets to a show which whisper promises will be the dirtiest seen since the time of the Twelve Apostles. It is a sheer impossibility in New York to escape such appeals to the ductless glands. They are in the very air. The town is no longer a place of work; it is a place of pleasure. Even the up-State Christian must feel the pull of temptation, though he has been warned by his pastor. He wanders along Broadway to shiver dutifully before the Metropolitan Opera House, with its black record of lascivious music dramas and adulterous tenors, but before he knows what has struck him he is lured into a movie house even gaudier and wickeder, to sweat before a film of carnal love with lewd music dinning in his ears, or into a grind-shop auction house to buy an ormolu clock disgraceful to a Christian, or into an eating-house to debauch himself with such victuals as are seen in Herkimer county only on days of great ceremonial.

No time for consciousness.

No place for the working hours of the contemplative.

"A peaceful Sunday on Long Island takes years off my life," he confessed.

There are more frauds and scoundrels, more quacks and cony-catchers, more suckers and visionaries in New York that in all the country west of the Union Hill, N.J., breweries. In other words, there are more interesting people. They pour in from all four points of the compass, and on the hard rocks of Manhattan they do their incomparable stuff, day and night, year in and year out, ever hopeful and ever hot for more. Is it drama if Jens Jensen, out in Nebraska, pauses in his furrow to yearn heavily that he were a chiropractor? Then why isn't it drama if John Doe, prancing in a New York night club, pauses to wonder who the fellow was who just left in a taxi with Mrs. Doe? Is it tragedy that Nils Nilsen, in South Dakota, wastes his substance trying to horn into a mythical Heaven? Then why isn't it tragedy when J. Eustace Garfunkel,

after years of effort, fails to make the steep grade of St. Bartholomew's Church?

Ibid. The Present tantalizingly sublimated.

Ibid. New York has made up its mind. New York won't wait.

Riesenberg and Alland, p. 202 City of actions first, and thoughts afterwards.

Donleavy Teeth sparkling for stardom.

Jackson and Dunbar, p. 569 The promise of glorious fulfillment, of love, wealth, fame—or unimaginable joy—is always impending in the air. He is torn with a thousand desires and he is unable to articulate one of them, but he is sure that he will grasp joy to his heart, that he will hold love and glory in his arms, that the intangible will be touched, the inarticulate spoken, the inapprehensible apprehended; and that this may happen at any moment.

Ibid., p. 607 And lastly from that period I remember riding in a taxi one afternoon between very tall buildings under a mauve and rosy sky; I began to bawl because I had everything I wanted and knew I would never be so happy again.

Bushnell "We're leading sensory-saturated lives," Peter said. "High density. Intensity. Millions of appointments. Millions of lawyer appointments. A simple thing is no longer fun. Now you have to have two or three girls, or exotic strippers at Pure Platinum."

Ibid. Or maybe it's proof that the sex drive is stronger than ambition, even for New Yorkers.

Brainard Ten years ago I left home to go to the city and strike it big. But the only thing that was striking was the clock as it quickly ticked away my life.

Bushnell New York should be their oyster. But is it?

Hamilton, p. 55 Would he end up lionized on Fifty-seventh Street, or bleeding to death in some West Street gutter? Or maybe both, plus a tactfully phrased obituary in *The New York Times*.

Ambition

Bushnell New York is a place where people come to fulfill their fantasies. Money. Power. A spot on the David Letterman show. And while you're at it, why not two women? (And why not ask?) Maybe everyone should try it at least once.

Haden-Guest, p. 164 Power beats sex anytime.

Bushnell Another option in a city of options.

Blandford, p. 43 "But enough about me, let's talk about you ... how do you really feel about me?" is a New York joke that is wearing thin.

Ibid., p. 49 Like everything else in New York, sharing is about power.

Sharpe, p. 203 Charged with power—the double meaning of the Battery.

We will discover and uncover this new Imperial City of Today, celebrating its peak of arrogance.

Riesenberg and Alland, p. 56

In a city where success and power are prized so highly, the velvet glove means nothing without the iron fist.

Blandford, p. 81

This is not about statistics. Or exceptions. We all know about the successful playwright who married the beautiful fashion designer a couple of years older than he is. But when you're beautiful and successful and rich and "know everyone," the normal rules don't apply.

Bushnell

Welcome to the Age of Un-Innocence. The glittering lights of Manhattan that served as backdrops for Edith Wharton's bodice-heaving trysts are still glowing but the stage is empty. No one has breakfast at Tiffany's, and no one has affairs to remember—instead, we have breakfast at seven a.m. and affairs we try to forget as quickly as possible. How did we get into this mess?

Ibid.

Truman Capote understood our nineties dilemma: the dilemma of Love vs. the Deal all too well. In *Breakfast at Tiffany's*, Holly Golightly and Paul Varjak were faced with restrictions—he was a kept man, she was a kept woman—but in the end they surmounted them and chose love over money. That doesn't happen much in Manhattan these days. We are all kept men and women by our jobs, by our apartments, and then some of us by the pecking order at Mortimers and the Royalton, by Hamptons beachfront, by front-row Garden tickets, and we like it that way. Self-protection and closing the deal are paramount. Cupid has flown the co-op.

Ibid.

There's still plenty of sex in Manhattan but the kind of sex that results in friendship and business deals, not romance. These days, everyone has friends and colleagues; no one really has lovers even if they have slept together.

Ibid.

This is a real question for women in New York these days. For the first time in Manhattan history, many women in their thirties to early forties have as much money and power as men or at least enough to feel like they don't need a man, except for sex.

Ibid.

Fame, Celebrity

I was famous! But for all the wrong reasons.

Haden-Guest, p. 277

The puddle of limelight.

Ibid., p. 103

No matter where you walk, you are likely to pass people who were once the toast of the town.

Talese, p. 130

Susan Strasberg once said that she and her friend Marilyn Monroe were walking down Fifth Avenue and no one noticed them.

Marilyn, who was studying at Lee Strasberg's Actor's Studio, said to Susan, "Do you want them to see me do *her*?"

The private Norma Jean, standing on the street, adjusted her posture, her walk, and her face.

Suddenly she was mobbed.

Fritscher, p. 182

In 1944 Cornell briefly captured—with his eye only—Marlene Dietrich, who was waiting for a cab at the curb of Jay Thorpe's.

Conrad, pp. 311–12

McCourt, p. 32

Margot Channing returning from time to time, stalking the old locations, sitting alone in winter, a shopping-bag lady in a sable coat, in the pocket park where the Stork Club once stood, and skulking through decrepit Broadway byways where she had swaggered not all that long ago, then quietly boarding the Brewster train at Grand Central for "that little place just two hours from New York."

Trebay, p. 29

Diana Ross stopped traffic on Sheridan Square Wednesday night. Teetering in black patent pumps, she hiked her skirt, tossed her head back for the wind to catch her mane, and let out a patented diva whoop.

Warhol, *Diaries*, p. 561

It was such a beautiful day. The whole town came out of the woodwork. Walked toward the park and a woman lunged at me and said, "I'm Mary Rosenberg, you gave me my best advice, you told me, 'Hang in there,'" but I didn't know who she was. I just closed my eyes and headed through the park with people pointing at me all the way—"That's that famous artist."

Warhol, *POPism*, p. 175

The next day as I walked along 57th Street I realized how powerful television is, because so many of the Christmas shoppers were pointing at me and saying, "It's him," and "No, it's not, look at the hair," and "Yes, but the sunglasses," and "Yes ... no," etc. Up until then I'd been in *Time* and *Life* and all the newspapers a lot and nothing had ever made me be recognized this much, but now just a few minutes on TV had really done it.

White, *Here*, p. 38

I've been remembering what it felt like as a young man to live in the same town with giants. When I first arrived in New York my personal giants were a dozen or so columnists and critics and poets whose names appeared regularly in the papers. I burned with a low steady fever just because I was on the same island with Don Marquis, Heywood Broun, Christopher Morley, Franklin P. Adams, Robert C. Benchley, Frank Sullivan, Dorothy Parker, Alexander Woollcott, Ring Lardner and Stephen Vincent Benet. I would hang around the corner of Chambers Street and Broadway, thinking: "Somewhere in that building is the typewriter that Archy The Cockroach jumps on at night." New York hardly gave me a living at that period, but it sustained me. I used to walk quickly past the house in West 13th Street between Sixth and Seventh where F. P. A. lived, and the block seemed to tremble under my feet—the way Park Avenue trembles when a train leaves Grand Central. This excitation (nearness of giants) is a continuing thing. The city is always full of young worshipful beginners—young actors, young aspiring poets, ballerinas, painters, reporters, singers search depending on his own brand of tonic to stay alive, each with his own stable of giants.

Fitzgerald, *My Lost City*, p. 110

A dive into a civic fountain, a casual brush with the law, was enough to get us into the gossip columns, and we were quoted on a variety of subjects we knew nothing about.

Haden-Guest, p. xiv

Camera bait.

Allen and Brickman, *Manhattan*, p. 184

Gossip is the new pornography. We have it in the daily newspapers.

McNeil and McCain, p. 31

I was walking down Eighth Street and I heard these two girls behind me say, "Isn't that Jim Morrison?" Ha ha ha. I felt like saying, "No, my jaw is a bit more angular."

A bunch of us were on Oprah Winfrey. Oprah asked, "What do you do in your spare time?" We said, "Oh, we sit around and read articles about ourselves."

Haden-Guest, p. 116

Jolie Bernard used to be an agent who handled rock bands at International Creative Management. Five years ago, when she wasn't stomping the globe in her cowboy boots, hanging out with rock stars and sometimes sleeping with them, she lived in New York, in a one-bedroom apartment decorated with black leather couches and a giant stereo system. She had long blond hair and a tight little body with big tits, and when she came home she had a million messages on her answering machine, and when she went out, she had money and drugs in her purse. She was kind of famous.

Bushnell

There are only a half-million big men in New York.

Conrad, p. 278

I'm getting my M.A. in fame, and I'll be getting my Ph.D. in money.

Haden-Guest, p. 277

The line in front of the Paramount Theatre on Broadway starts forming at midnight. By four in the morning there are over five hundred girls ... they wear bobby sox (of course), bow ties (the same as Frankie wears) and photos of Sinatra pinned to their dresses ... They bring their lunches ... sandwiches wrapped in paper bags ... and thermos bottles full of hot coffee ... with paper cups ... By seven in the morning when daylight breaks, some of the girls read movie fan magazines, others play cards, a favorite game being "Old Maid." While still others proudly show their scrap books of Sinatra photos clipped from newspapers and magazines to the others in line ...

Weegee, *Naked*, pp. 112–15

By eight in the morning there are over ten thousand trying to get in line ... that's the time the box office opens up ... The opening day there was a riot. The next day the cops were prepared. There were:

5 policewomen
5 cops with their horses
41 temporary cops in civilian clothes with P. D. arm bands
60 cops
200 detectives
2 emergency trucks
20 radio cars
and an unannounced number of truant officers
and also ...
Reporters
Photographers
and curious bystanders, etc.

The line moves slowly towards the box office ... Policewomen yank out of the line those that appear to be under sixteen years ... some of the girls cry, offer to show their Social Security cards as proof of age, and plead to be allowed to go inside the theatre as they had come all the way from Brooklyn and Long Island ... Meanwhile big trucks loaded with rolls of newsprint arrive at the Times Building which adjoins the theatre, unable to back up and unload, the Times guards clear the entrances and act as ushers, keeping the mob behind the ropes. (The next day an editorial appeared in the *New York Times* on the Sinatra menace.)

A big blow-up picture of Sinatra in front of the theatre is marked red with lipstick impressions of kisses, endearing messages of love, and even telephone numbers. The theatre is soon filled. The show starts with the feature (*Our Hearts Were Young and Gay*). This is the most heckled movie of

all times ... not that its a bad movie ... just the opposite ... but the girls simply didn't come to see that ... as far as they are concerned they could be showing lantern slides on the screen.

Then the great moment arrives. Sinatra appears on the stage ... hysterical shouts of Frankie ... Frankie ... you've heard the squeals on the radio when he sings ... multiply that by about a thousand times and you get an idea of the deafening noise ... as there is no radio control man to keep the noise within ear level. Sinatra does a few numbers and leaves the stage hurriedly. Now the whole theatre is a bedlam of noises with the audience refusing to quiet down. Shouts of Frankie! ... Frankie! ... don't leave us ... but the orchestra starts playing The Star Spangled Banner ... they all get up ... the noises cease ... and then they slump into their seats ...

Inside the lobby a big crowd is waiting patiently for seats ... with the management wondering where to put them ... as those inside are going to remain all day and night in the theatre for the full five shows ... and that goes for Frankie too ... a big mob is waiting at the stage door entrance ... he dares not leave ... so he's marooned inside the theatre ... with a steady stream of messengers bringing him his lunch ... laundry ... and even a barber arriving in a taxi ...

At two in the morning the theatre closes up ... the porters come in to clean up ... some of the girls having been in all day and night and having seen all the five shows refuse to leave ... and try to hide in the ladies room ... but the matrons chase them out ... so those having had some sleep during the picture, go outside and wait in line again ... others take the subway home ... will they get Hell when they get home! They are a clannish bunch, the Bobby Soxers ... and they talk among themselves that Frankie should be in the White House as President. One of the girls remarks sadly that that couldn't be ... because Frankie is too skinny.

Haring, p. 266

NOVEMBER 4, 1987
Back in New York. But had to write this down. It's almost a full moon.
Today Claude and Sydney and Jasmine Picasso stopped in to visit.
Tina Chow called to say hello.
Called George Condo about Julian Schnabel's opening at the Whitney tomorrow.
I bought a piece of mine at auction for $10,000.
Stephen Sprouse fashion show is tomorrow, but I can't even bring a date.
Allen Ginsberg called to invite me to be his date to a dinner at the American Academy of Arts & Letters but I can't go because I already promised to go see my friend Molissa Fenley dance at Dia Foundation.
Yves and Debbie Arman are in New York and tried to buy my piece at auction, but stopped at $8,000.
Grace Jones invited me to dinner.
Larry Levan stopped in to see me.
What a day! Is this New York on a full moon in 1987, or what?

Ellis, *Glamorama*, p. 21

There's always a car waiting.

Ibid.

There's always a Steven Meisel photo shoot.

Bushnell

It's Friday night at the Bowery Bar. It's snowing outside and buzzing inside. There's the actress from Los Angeles, looking delightfully out of place in her vinyl gray jacket and miniskirt, with her gold-medallioned, too-tanned escort. There's the actor, singer, and party boy Donovan Leitch in a green down jacket and a fuzzy beige hat with earflaps. There's Francis Ford Coppola at a table with his wife. There's an empty chair at Francis Ford

Coppola's table. It's not just empty: It's alluringly, temptingly, tauntingly, provocatively empty. It's so empty that it's more full than any other chair in the place. And then, just when the chair's emptiness threatens to cause a scene, Donovan Leitch sits down for a chat. Everyone in the room is immediately jealous. Pissed off. The energy of the room lurches violently. This is romance in New York.

It's so diabolically crowded outside Bowery Bar that I have to climb over a stalled limo parked crookedly at the curb to even start pushing through the crowd while paparazzi who couldn't get in try desperately to snap my photo, calling out my name … Candy Bushnell suddenly pushes through the crowd screaming "Richard," and then when she sees me her voice goes up eighty octaves and she screams "Pony!" and places an enormous kiss on my face while slipping me a half and Richard finds Jenny Shimuzu but not Scott Bakula and Chloe is surrounded by Roy Liebenthal, Eric Goode, Quentin Tarantino, Kato Kaelin and Baxter Priestly, who is sitting way too close to her in the giant aquamarine booth and I have to put a stop to this or else deal with an unbelievably painful headache. Waving over at John Cusack, who's sharing calamari with Julien Temple, I move through the crowd toward the booth where Chloe, pretending to be engaged, is nervously smoking a Marlboro Light … Naomi Campbell, Helena Christensen, Cindy Crawford, Sheryl Crow, David Charvet, Courteney Cox, Harry Connick, Jr., Francesco Clemente, Nick Constantine, Zoe Cassavetes, Nicolas Cage, Thomas Calabro, Cristi Conway, Bob Collacello, Whitfield Crane, John Cusack, Dean Cain, Jim Courier, Roger Clemens, Russell Crowe, Tia Carrere and Helena Bonham Carter—but I'm not sure if she should be under B or C … We sit there sort of looking out over the rest of the room, my eyes fixed on the big table in the center, beneath a chandelier made of toilet floats and recycled refrigerator wire, where Eric Bogosian, Jim Jarmusch, Larry Gagosian, Harvey Keitel, Tim Roth, and oddly enough, Ricki Lake are all having salads … Um, table one is you and Alison and Alec Baldwin and Kim Basinger and Tim Hutton and Uma Thurman and Jimmy and Jane Buffett and Ted Field and Christy Turlington and David Geffen and Calvin and Kelly Klein and Julian Schnabel and Ian Schrager and Russell Simmons, along with assorted dates and wives … Nodding as Russell Simmons walks past me and out onto Fourth Street.

Ellis, *Glamorama*, p. 35

In fact, the guy was so into the place that he didn't want me to write about it because he was afraid that, like most decent places in New York, it would be ruined by publicity.

Bushnell

Money

I wasn't there to become famous. I was there to make as much money as I possibly could.

Haden-Guest, p. 6

F. Scott Fitzgerald to Edmund Wilson: "Culture follows money. New York, not London, will soon be the 'capital of culture.'"

Douglas, p. 4

Money and power are everywhere, and the sense of a bubble, a perfect glass dome that extends over the city, is palpable—one can almost see its highlight, its gleam.

Gopnik, p. 88

Does money ever sleep? Do the machines in a factory ever need rest?

Conrad, p. 275

Irreverent ravishing city of dollar signs.

Riesenberg and Alland, p. 205

Donleavy

The bull's eye of wealth in this town. Makes me so nervous I need to take another pee.

O'Connell, p. 298

Financial miners had discovered fat veins of money coursing beneath the cliffs and canyons of the southern tip of Manhattan. As geological and meteorological forces conspire to deposit diamonds at the top of one continent and to expose gold at the edge of another, so a variety of manmade conditions intersected more or less at the beginning of the new decade to create a newly rich class based in New York, with a radical new scale of financial well-being. The electronic buzz of fast money hummed beneath the wired streets, affecting all the inhabitants, making some of them crazy with lust and ambition, others angrily impoverished, and making the comfortable majority feel poorer.

Irwin, p. 186

Sidewalk and curb alike flaunt super-refined wealth.

Blandford, p. 56

A place of business, not a nursery.

James, p. 373

Crowned not only with no history, but with no credible possibility of time for history, and consecrated by no uses save the commercial at any cost.

Petronius, p. 6

Such a tight mecca of mechanized, commercial efficiency that every throb and whistle sounds prerecorded or piped, every flirtatious come-on is reduced to a paid announcement, hand-holding seems unsanitary, a fleeting hump the only practical reality.

Lefebvre, Stage, p. 98

Space as a whole enters into the modernized mode of capitalist production: it is utilized to produce surplus value. The ground, the underground, the air, and even the light enter into both the productive forces and the products. The urban fabric, with its multiple networks of communication and exchange, is part of the means of production. The city and its various installations (ports, train stations, etc.) are part of capital.

Warhol, Philosophy, p. 135

I have a fantasy about money: I'm walking down the street and I hear somebody say—in a whisper—"There goes the richest person in the world."

Kolbert

When world realization of its unlimited wealth has been established there as yet will be room for the whole of humanity to stand indoors in greater New York City, with more room for each human than at an average cocktail party.

Transaction

Glickman, p. 20

Money in New York has oddly different values. A gardenia may cost ten cents, but an orchid five dollars. A nickel is charged for a forty-eight mile ride on the subway. Twenty-five cents will buy an excellent lunch at an automat, but, at more expensive restaurants, as much as $2.50 is charged for one dish.

Warhol, Philosophy, p. 137

American money is very well designed, really. I like it better than any other kind of money. I've thrown it in the East River down by the Staten Island Ferry just to see it float.

Depero, "24th Street," p. 428

thousands-millions-trillions
of probabilities of percents
of accounts-credits-debits
provisions-customs-tariffs

m Power — Transaction

The plastic credit card is pioneered by Brooklyn-born Long Island banker William Boyle, who has devised the Franklin Charge Account Plan for Franklin National Bank. Franklin markets its plan with the slogan, "Just charge it." The Franklin Charge Account Plan will play a major role in fueling the rise of Long Island suburbs.

Trager, p. 581

Only one out of ten cash machines seems to have any cash in it.

Ellis, *Glamorama*, p. 18

Transactions fluctuate like thermometer mercury

Voronca, p. 463

On the sidewalks, braving the weather, stand Bowery diamond dealers whose whole stock in trade may consist of one diamond, wrapped in tissue paper and carried in the vest pocket.

WPA *Guide*, p. 120

The city, the urban space, and the urban reality cannot be conceived simply as the sum of the places of the consumption of goods (commodities) and the places of production (enterprises).

Lefebvre, *Stage*, p. 188

Max Weber argued that the emergence of the modern city is distinguished by the market. The market, so much less heroic in the traditional sense and apparently so formless and morally empty as a public phenomenon, symbolically represents—and on occasion creates—the public culture of modern cities. In the market—as in the modern city generally—there is an "incomplete integration" of participants. People enter and withdraw from the market of public life without relinquishing other structural attachments.

Bender, *Unfinished*, pp. 58–9

The sociology of a service economy.

Sassen, p. 9

The very richness of life in New York creates a spectacular undertow.

Berman, *Town*, p. xxxvi

The divinity of engineering is summed up by the doors of safes, "so extremely well made," in a bank he visits. Léger, too, was impressed by the steel vaults of the Irving Bank. In this impregnable tabernacle resides, perhaps, the posthuman genius of the city.

Conrad, p. 138

Irving Trust Building's vault has a chemical coating designed to emit a paralyzing gas should it be attacked by a safecracker's blowtorch.

Trager, p. 471

A determined misreading of money-making structures as religious fanes.

Conrad, p. 73

Deep in New York's downtown financial district, with its odd collection of illuminated architectural styles—Corinthian columns cheek by jowl with neo-Baroque doorways, Gothic towers loftily disdaining mid-Victorian embellishments—lies an innocuous building that houses the Stock Exchange. The twin green domes of this place, where a nation's fortunes may be jeopardized, are ironically reminiscent of Monte Carlo's Casino, where fortunes are won and lost for pleasure.

 Looking down, they are bewilderingly like ants, their every movement accelerated as in old-time movies, when even a funeral was a breathless business. These human ants swarm wildly, weaving in and out, chewing gum, snatching at newspapers, hurling them down, scribbling fanatically on pocketpads, never attempting to do less than three things at a time. Paper lies thick on the floor like giant confetti, and we see a sudden white fountain as a cloud of it shoots into the air, settling down again gently like snow.

Beaton, *Portrait*, pp. 76–7

To the strange underworld of the Counting House. Neat little ants here, with immaculate creases in sober suits, hair unruffled, eyes impersonal but bright as buttons. They sit behind tall desks, in front of them long books in which they write without respite. All day this has gone on, yet they remain unruffled, neat, methodical, efficient. Into their long books go strings of figures, chronicling in mathematics the rise and fall of family fortunes.

These rooms are bare, severe; so lacking adornment of any kind that the telephones, in regular rows, become decorative rather than functional, the only decorative feature in them. "We're geared up to high speed and big business, eh?" winks an ant with a cigar in his mouth.

Each of these rooms has eight or more of these inhumanly neat little men, human adding-machines, tabulating the gains and losses of others' financial bets, in perfect running order always. Do they ever break down? And if so what fate befalls them? Unimaginable that they could break down, but one day, perhaps.

The President of the Exchange mounts a marble balcony and strikes the three o'clock gong. The horseplay is suddenly halted. The men reach for bowler hats, their eyes turn to stone, their mouths become grim as they leave for respectable homes in Long Island, Westchester, Park Avenue and Riverside Drive. With the striking of the gong life changes utterly. The feckless boys have become alarmingly transformed into heads of families, dignified, intimidating pillars of New York society.

When later you meet these same schoolboys away from the Exchange it is difficult to believe your recollections of tooth-paste and wet pockets, and unthinkable to remind them of such things.

Rock, Moore, and Lobenstine, p. xvi

Men and women may have created Wall Street, but it has lost any human scale.

Riesenberg and Alland, p. 95

Your Empire State creation may presage an apotheosis of the dying profit bug.

James, p. 373

One story is only good till another is told, and sky-scrapers are the last word of economic ingenuity only till another word be written. This shall be possibly a word of still uglier meaning, but the vocabulary of thrift at any price shows boundless resources, and the consciousness of that truth, the consciousness of the finite, the menaced, the essentially *invented* state, twinkles ever, to my perception, in the thousand glassy eyes of these giants of the mere market.

Glickman, p. 202

Until the World War II blackout, a perpetual oil flame burned at the Standard Oil Building in the Financial District and could be seen for miles around.

Ibid., p. 20

An empty pedestal in the lobby of the Standard Oil Building where a statue of John D. Rockefeller used to stand.

Ibid.

Before the salt air damaged it, the entire ceiling in the lobby of the Standard Oil Building was gilded.

Davis, "Flames," p. 12

On the original Black Tuesday in 1929, Lorca, the Andalusian poet, wandered through the canyons of Wall Street, watching in amazement as ruined investors flung themselves from windows of monstrous buildings. "The ambulances collected suicides," he wrote, "whose hands were full of rings." Amidst the "merciless silence of money," Lorca "felt the sensation of real death, death without hope, death that is nothing but rottenness." It was easy, then, for him to visualize the inevitable destruction of lower Manhattan by "hurricanes of gold" and "tumults of windows."

Lorca was on Wall Street on the day of the stock market crash and afterward
claimed to have seen six people commit suicide during Black Tuesday.

Lorca, *Poet*, p. xii

Time for the cobras to hiss on the uppermost levels,
for the nettle to jostle the patios and roof-gardens,
for the Market to crash in a pyramid of moss.
Time for the jungle lianas that follow the rifles—
soon, soon enough, ever so soon.
Woe to you, Wall Street!

Lorca, *Collected*, p. 667

December 1929
PAISAJE DE LA MULTITUD QUE VOMITA
(Anochecer de Coney Island)
LANDSCAPE OF THE VOMITING CROWD
(Twilight at Coney Island)
New York, 29 de diciembre de 1929.
New York, December 29, 1929
PAISAJE DE LA MULTITUD QUE ORINA
(Nocturno de Battery Place)
LANDSCAPE OF THE URINATING CROWD
(Nocturne of Battery Place)

Lorca, *Poet*, p. 53

But it is necessary to make money, and in the commodious corners of the
bright city, as everywhere in the world, depravity laughs disdainfully at
hypocrisy and falsehood. Of course the depravity is hidden, and, of course, it's
a wearying, tiresome depravity, but it also is "for the people." It is organized
as a paying business, as a means to extract their earnings from the pockets of
the people. Fed by the passion for gold it appears in a form vile and despicable
indeed in this marsh of glittering boredom.

Gorky, "Boredom," p. 314

I regard all bankers with distrust as being the root of most of the evil of the
world; all financiers outside bankers I would export, as was done with the
dogs of Constantinople, to a small desert island where they might subsist on
each other's flesh.

Ford, *America*, p. 82

More than a film, almost a period documentary. The unbridled luxury of the
coastal home of the broker Gordon Gekko, crammed with artworks from
Picasso to Louise Nevelson; the "uniform" of the powerful, impeccable suits,
elegant suspenders silhouetted against immaculate shirts, the hair slicked
back and the brand-named cigarillo always lit, the décor of the office, white
and aseptic for the lower echelons, sumptuously post-déco and with a view
over Manhattan for those who really count. *Wall Street* depicted the lifestyle
of excess even in seemingly ordinary yet revealing details, such as the
sequence showing the "rewards" for young Fox in the form of a limousine,
cocaine and a high-class call girl, or the total refurbishment of his apartment,
transformed into an orgy of faux marble stucco, rich drapes, and hi-tech
furniture.

Frisa and Tonchi, p. 112

The new law of evolution in corporate America seems to be survival of the
unfittest. Well, in my book you either do it right or you get eliminated. In
the last seven deals that I've been involved with, there were 2.5 million
stockholders who have made a pretax profit of 12 billion dollars. Thank you. I
am not a destroyer of companies. I am a liberator of them! The point is, ladies
and gentleman, that greed—for lack of a better word—is good. Greed is right.
Greed works. Greed clarifies, cuts through, and captures the essence of the

"Wall Street"

ɯ Power — Transaction

evolutionary spirit. Greed, in all of its forms—greed for life, for money, for love, knowledge—has marked the upward surge of mankind.

Atkinson, p. 132

"What we need is a teensy-weensy depression," somebody said. "We have too much prosperity. It makes for greed."

The city as an antic consumerism, a big store supplying fantasies for free. Conrad, p. 310

In the city of consumerism, art is a search for the recondite treasures New York has randomly buried. *Ibid.*, p. 311

In commodity society all of us are prostitutes, selling ourselves to strangers. Jones, *Modernism*, p. 185

I am truly withering in the sordid materialism of New York. *Ibid.*, p. 229

The objects purchased are devalued by the act of purchasing. Buse, p. 18

F. Scott Fitzgerald's *Gatsby*, lavishing wealth on clothes, entertainment, and the purchase of a dream, is a latter-day version of the Jamesian New Yorker, except that the superstitious Jamesian reticence about wealth has changed to the alternative policy of apologetic splurging. Gatsby's extravagant consumerism uses wealth for the satiation of appetites and the requisitioning of visions. He desolidifies possessions. He'll never wear all the shirts he owns; he seldom attends his own parties. He spends to expend, disperse, dissipate himself. The orgy is an experiment in controlled self-destruction, and New York is the emporium catering to such exorbitant and drastic whims as these. Conrad, p. 193

Window Display, Mannequin

The question of shop windows Duchamp
To undergo the interrogation of shop windows
The exigency of the shop window
The shop window proof of the existence of the outside world

In 1939 Dalí was commissioned to design a shop window for Bonwit Teller on Fifth Avenue. He began from a detestation of those mannequins. Dalí dislikes them because they're immune to decay and refuse to be consumed: "so hard, so inedible," as he calls them, they have defeated surrealism. He revenges himself by surreally aging them. In the window he placed some musty, cobwebbed models exhumed from an attic. They extruded—as corpses continue to do, and as Lorca surreally chooses to do when deciding, on arrival in New York, to let his hair grow—"long natural dead women's hair." For Kiesler and the purists the shop window had been a laboratory exhibiting the abstract future; Dalí makes it a charnel house of surreal memory. At Bonwit Teller his elderly mannequins bathed in a tub with a hirsute lining of astrakhan and slept on charred sheets under a canopy from which trickled the blood of a pigeon. The management of the store, aghast, dismantled the display. Dalí insisted on its restoration and, when the management refused, clambered into the window to upset the furry bathtub. His intention was only to embarrass Bonwit Teller by spilling the water, but as he dislodged the tub it slid across the floor, smashed the plate glass, and deluged the sidewalk. Dalí followed it through the gaping pane to join the crowd on Fifth Avenue. In doing so, he was acting out the forced entry into consciousness which he wanted his irrational images to make. They, too, crave to splinter the glass that flattens and suppresses them, to rebel into a third dimension. They are the interior which vomitously insists on exteriorizing itself. Dalí was arrested for his pains and remarked that the affair did more for his glory than if he'd devoured Fifth Avenue entire. This constitutes his triumph: a parabolic digestion of the city; a surreal conquest by cannibalism. Conrad, pp. 148–9

Lowe, p. 78
The window-dressing is one of the city's chief features. Each new fashion lives brilliantly, but dies an early death, in the shop windows, as the seasons of the year pass prematurely. In this clean, new world Christ is born in November, and Bergdorf Goodman has robbed surrealism of its novelty before Dalí's new exhibition.

de Chirico, p. 401
Parallel infinities into the improbable kaleidoscope of its shop windows, its transparent towers … its windows lit all through the long nights of winter.

Conrad, p. 122
Mayakovsky sees a model demonstrating shaving gear in a Woolworth window. Through the plate glass he tells her in Russian that she's being a fool. She lip-reads him and imagines he's asking her in English to open the door. You've been made an idiot, he rails; she translates his fulmination into a declaration of love.

Sharpe, p. 195
Fashionable women examining shop windows at night—to buy a painting.

Ibid., p. 283
Her eye is caught by something in the window; sexual adventure and drugstore accessories gently rub shoulders in the warm night air.

Talese, pp. 4–5
By this time Fifth Avenue is deserted by all but a few strolling insomniacs, some cruising cab drivers, and a group of sophisticated females who stand in store windows all night and day wearing cold, perfect smiles—smiles formed by lips of clay, eyes of glass, and cheeks that will glow until the paint wears off. Like sentries they line Fifth Avenue—these window mannequins who gaze onto the quiet street with tilted heads and pointed toes and long, rubber fingers reaching for cigarettes that aren't there. At 4 A.M., some store windows become a strange fairyland of gangling goddesses, all of them frozen in the act of dashing to a party, diving into a swimming pool, or sashaying skyward in a billowy blue negligee.

While this wild illusion is partly due to the runaway imagination, it is also partly due to the incredible skill of mannequin makers, who have endowed mannequins with certain individual characteristics—the theory being that no two females, not even plastic or plaster females, are quite alike. As a result, the mannequins at Peck & Peck are made to look young and prim, while at Lord & Taylor they seem wiser and wind-blown. At Saks they are demure but mature, while at Bergdorf's they look agelessly elegant and quietly rich. The profiles of Fifth Avenue's mannequins have been fashioned after some of the world's most alluring women—women like Suzy Parker, who posed for the Best & Co. mannequins, and Brigitte Bardot, who inspired some mannequins at Saks. The preoccupation with making mannequins almost human, and equipping them with curves, is perhaps responsible for the rather strange fascination so many New Yorkers have for these synthetic virgins. This is why some window decorators frequently talk to mannequins and give them pet names, and why naked mannequins in windows inevitably attract men, disgust women, and are banned in New York City. This is why some mannequins are attacked by perverts, and why the svelte mannequin in a White Plains shop was discovered in the basement not long ago with her clothes torn off, her make-up smeared and her body possessing evidence of attempted rape. The police laid a trap one night and caught the attacker—a shy, little man: the porter.

Early, p. 59
Some years back, a lot of manikins looked like Greta Garbo, or the Duchess of Windsor. A few years later, they looked like Greer Garson. Manikins with broad shoulders often resembled Joan Crawford. And when the sloped shoulder came in, they looked like Gainsborough's Duchess of Devonshire.

Window shopping is a delightful pastime, because manikins on Fifth Avenue are even more glamorous than models. For a woman is only a woman, but a manikin is a creature with hair of spun gold and silvered glass, with breasts so high she can rest her chin on them, and eyelashes so long you can hang your hat on them.

Ibid., p. 58

There's nothing more boring than narcissism—the tragedy of being totally … me. We're all capable of it. And we all know examples of it—these beautiful tragedies. Many of them, of course, are mannequins. Mannequins are either divine—or they're the most boring girls in the world.

Vreeland, *Papers*

Mannequins, immaculately outfitted and attitudinizing in a shop window at night or nude and virginally sheeted in cellophane. Their robust sensuality defeats the city's attempts to douse or chill it.

Conrad, p. 174

Legs,
what do you know about legs?
you who think about skirts
when you pass the windows of the department store.
What do you know
about the legs
of the twentieth century?

Parland, p. 345

In the bleakly radiant, renovated New York foreseen by Le Corbusier, the ideal citizens would be the effigies of femininity he admires in the window displays on Fifth Avenue.

Conrad, p. 140

The wax manikins in the windows of the smart dress shops on Fifth Avenue make women masters, with conquering smiles. Square shoulders, incisive features, sharp coiffure—red hair and green dress, metallic blonde hair and ultramarine blue dress, black hair and red dress.
 The Greek coiffure, the Doric and Ionic of Asia Minor, predominates. The face, with its strong features, stands out. The *casque* is gold, platinum, auburn, sandy, even white.
 The manikins in the windows have the heads of Delphic goddesses. Green, lamp-black, red hair. Antique-like heads, here one as if from a tragedy, there one like a Caryatid, Athenas from the Acropolis Museum. Polychromy. When polychromy appears it means that life is breaking out.

Corbusier, p. 165

In the window of the GAP a young man and woman froze in mannequin poses. "They do it for about an hour and a half at a time," the store guard said. The "mannequins" had Astor Place haircuts and bright cotton clothes.

Trebay, p. 77

The shop windows are dressed with a few dispirited dummies.

Atkinson, p. 144

You stand in front of Saks Fifth Avenue and stare at the mannequin. Sometime last week, when you started shouting at it, a policeman came over and told you to move along. This is just how she looked at the end, the blank stare, the lips tight and reticent.

McInerney, *Bright Lights*, p. 78

Two men and a woman were dressing a shop window. From the middle of the upper legs down the manikins were all wire. Empty shoe boxes lay banked against the window like last year's snow.

Jackson and Dunbar, p. 600

Gene Moore was the head of Tiffany & Co. design team when he hired two young artists, Robert Rauschenberg and Jasper Johns, in 1956 to create

Gaboriault

a memorable window design inspired by a book on famous still lifes and nature.

While the artists pursued careers in galleries, they took on window design work. Moore said, "Although I was not showcasing their serious work, the window design was serious work to me. One influenced the other—it can't help it. What you are comes out, whether you are doing windows or a painting."

Rauschenberg met Johns on a winter night in 1954 walking home on the corner of 57th and Madison Avenue in New York. The two would become friends and, at times, collaborators. Rauschenberg was full of conceptual ideas and Johns had the precise craftsmanship to execute them.

Under their fictitious name Matson Jones Custom Display, a name created for all their commercial work to not confuse them with their art careers, Johns and Rauschenberg got steady work for their ability to create striking theatrics within windows.

To create these natural settings, fruits and flowers were cast in plaster, while actual moss, rocks and dirt were used. Their miniature environments ranged from highways with telephone poles, swamp scenes, and winter landscapes after an ice storm. They would split open pomegranates and cassata melons, cast them, and spill out Tiffany diamonds and jewels from inside.

Accompanied with dramatic lighting, they really did appear like actual paintings.

After their careers took off, window design at both Tiffany & Co. and Bonwit Teller wasn't needed to pay the rent. And they proceeded to preserve their own places in art history with target paintings and taxidermy sheep.

Allen, "Melons"

The filmmaker and impresario Emilio de Antonio had, as "an artists' agent," been involved in arranging commissions from Moore for Rauschenberg, Johns, and Andy Warhol. One project Matson Jones executed for Moore client I. Miller involved "a kind of three-dimensional window display" interpretation of Andy Warhol's shoe drawings, which were featured in the company's ads at the time.

Another display for a Moore client [and Tiffany neighbor] Bonwit Teller included Johns's 1957 painting, *Flag on Orange Field*. After *Construction with J.J. Flag / Short Circuit*'s inclusion at the Stable Gallery Annual in 1955, this may have been the second public exhibition of Johns's *Flag* paintings; neither was credited to him.

Despite this professional overlap, and their mutual friendship with de Antonio, Johns told Paul Taylor in 1990 that he only met Warhol for the first time in 1961, when Andy bought a drawing out of Johns's second solo show at Castelli. Soon after that, Warhol's own comic strip–based paintings were shown in a Bonwit Teller window display, where they were likely seen by Roy Lichtenstein.

Weintraub

In April 1961 Andy Warhol exhibited five large paintings in the window of Bonwit Teller, a New York department store where he had been working for some time producing window displays. The paintings, which were based on comic strips and black-and-white newspaper advertisements and positioned behind mannequins wearing the latest fashions, marked a turning point in Warhol's transition from a highly successful commercial illustrator to an iconic figure in the New York avant-garde. Through the lowbrow subject matter of his canvases and its collapsing of the distinction between the space of art and the space of commerce, Warhol's Bonwit Teller window display in many ways announced the artist's forthcoming assault on the form, content

and production of mainstream art and on how we look at and understand art in the context of popular and consumerist culture.

Andy was doing ad sketches for Bonwit's, and I decided that he should do some windows ... I remember one thing that was very exciting: he painted directly onto the glass [of the show window].

Smith, *Warhol*, p. 111

Blake stopped opposite here and looked into a store window. It was a decorator's or an auctioneer's. The window was arranged like a room in which people live and entertain their friends. There were cups on the coffee table, magazines to read, and flowers in the vases, but the flowers were dead and the cups were empty and the guests had not come.

Cheever, "Five-Forty-Eight," p. 4

A shopkeeper in 1957 arranges a street display of frilly crinoline petticoats which, hung above his doorway, seem to be floating through the air to the pavement like angels with parachutes.

Conrad, pp. 173–4

Splendid city of dream within dream, city of Plate Glass, Plate Glass City, Shop Window City.

de Chirico, p. 401

If the store window with the scribble on it were washed, she'd be unable to find her way home.

Conrad, p. 122

I stopped and
looked in the window of a stationery
shop. A mechanized pen
was suspended in space in such a
way that, as a mechanized roll of paper
passed by it, the pen went
through the motions of the same
penmanship exercises I had learned
as a child in the third grade.
Centrally placed in the
window was an advertisement explaining
the mechanical reasons for the
perfection of the operation of
the suspended mechanical pen.
I was fascinated,
for everything was going wrong.
The pen was
tearing the paper to shreds and
splattering ink all over the window
and on the advertisement,
which,
nevertheless, remained legible.

Cage, *Indeterminacy*

Revlon cosmetic salesmen "accidentally" destroy displays set up by the competition in urban drugstores. As a result, Revlon will have a virtual monopoly on beauty salon sales by 1941.

Trager, p. 471

Angels in samite descended from white cloud in the Lord & Taylor windows. The Tree of Light that reaches from roof to sidewalk was radiant on massed, upturned faces.

Berger, *New York*, pp. 241–2

Ghouls look into brilliant restaurant windows.

Riesenberg and Alland, p. 205

Gopnik, p. 209

All life in a mercantile society, one sometimes feels, is dedicated to the disguises of wanting. The sin of capitalism, perhaps, is to make wants feel like needs, to give to simple silly stuff the urgency of near-physical necessity: I must have it. The grace of capitalism is to make wants feel like hopes, so that material objects and stuff can feel like the possibility of something heroic and civic. The urge of the great department stores was to hide acquisition as sociability, to disguise acquisitiveness as membership, so that one entered them not as one entered a store—with one eye on the beseeching salesgirl, one hand on the knob of the door, just looking—but as one entered a library or a club: striding in with pleasure. The department store was the cathedral of that material aspiration, and its diminishment leaves us with one less place to go and hope in.

Hamill, "Lost"

You can shop at the Hester Street market or at Wanamaker's, at Namm's or Loeser's or Mays or Martin's in Brooklyn, at Gertz in Jamaica, at Best and Company or Ohrbach's, at Masters or Korvette's. You can still go to Gimbel's.

Gopnik, p. 201

The great department stores of New York now lie on the avenues like luxury liners becalmed in a lagoon, big shops in shallow water. Saks and Bergdorf's and Bloomingdale's, immense and slow, look down at them and try to continue on a stately course, but the water is ebbing from around their keels.

Ibid., p. 204.

For over half a century, in New York particularly, department stores presided over everything from Thanksgiving Day parades and patriotic lectures to Cubist exhibitions.

Morris, *Manhattan '45,* p. 255

In 1942, Gimbel's and Macy's begin selling old master paintings. Gimbel's offers one of its Rembrandts at $9,999.99.

Marcuse, p. 293

One window on Sixth Avenue was apparently reserved for fascinating displays of *objets d'art* for which Benjamin Altman had a decided predilection.

Gopnik, p. 204

John Wanamaker at Astor Place and Broadway had an entrance hall and an art gallery and was said to have more windows than the Empire State Building. The model and master of the department store as a civic-seeming institution.

Hamill, "Lost"

If you are poor, you can go to S. Klein on Union Square and battle for bargains with the toughest women in the history of New York.

Trager, p. 459

S. Klein's policy of never advertising.

Ibid.

Women cram their purses down the fronts of their blouses to free both hands to pluck dresses off the racks.

Ibid.

If a shoplifter is apprehended she is immediately placed on display in one of the store's glass-enclosed "crying rooms."

Atkinson, p. 145

Sign at S. Klein: "Honesty is its own reward. The penalty of *dis*honesty is JAIL."

Trager, p. 476

Traffic sweeps around the square. Long before the doors of Klein's Dress Shop opens, crowds of women and girls have gathered. Private policemen in gray uniforms try to keep order at about nine-thirty, because at that time all the doors are unlocked and the women sweep forward in a powerful surge,

grabbing at the dresses on the racks, searching and clawing for bargains. It is cash down here, "on the Square," each woman holds her money in her fist.

It looks at first sight like an accident or a riot; then you perceive that the units are women—all young, mostly pretty. Intently, expectantly, they are tilting up their chins to peer at the doors of two or three large bargain-sale stores whose windows display presentable but frail-looking dresses, priced as low as $4, and hats, in which a man sees no fault, going for less than $2. Suddenly there is a massed rush forward. Two policemen have opened the doors to let out a store full of sated shoppers; are admitting the shoving, struggling, laughing, squealing replacements. The floor jammed to capacity, the police close the doors again. So it goes; shops emptying and refilling at half-hour intervals all Saturday afternoon long.

Irwin, p. 164

Throngs charging through the doors of the department store.

Donleavy

Women with set faces were charging in all directions, pawing at whatever is displayed on the counters.

Atkinson, p. 145

When the noontime crowds are surging through it—the girls and women in their bright dresses, their eager eyes darting from window to window and their voices raised in never-ending chatter, the men, less colorful, but very alert and vigorous and full of plans for spending money.

Ibid., p. 95

New York women are the most beautiful in the world. They have their teeth straightened in early youth. They get their notions of chic from S. Klein's windows instead of the movies.

Jackson and Dunbar, p. 623

I remember Klein's at Christmas time.

Brainard

Noon on Union Square. Selling out. Must vacate. WE HAVE MADE A TERRIBLE MISTAKE … Noon sunlight spirals dimly into the chopsuey joint. Muted music spirals Hindustan. He eats fooyong, she eats chowmein … Highest value, lowest price. Must vacate. WE HAVE MADE A TERRIBLE MISTAKE. Must vacate.

Dos Passos, p. 144

In order to appease protesting residents, B. Altman erects a building whose mundane function is decorously hidden by a façade resembling a Florentine palace; until recently not even the owner's name appears on the exterior. As commerce—having thus crept in disguise into Fifth Avenue—appropriates most of the district, residents move farther up the avenue.

WPA Guide, p. 217

Betty Isaacs went shopping at Altman's. She spent all her money except her last dime, which she kept in her hand so that she'd have it ready when she got on the bus to go home and wouldn't have to fumble around in her purse since her arms were full of parcels and she was also carrying a shopping bag. Waiting for the bus, she decided to make sure she still had the coin. When she opened her hand, there was nothing there. She mentally retraced her steps trying to figure out where she'd lost the dime. Her mind made up, she went straight to the glove department, and sure enough there it was on the floor where she'd been standing. As she stooped to pick it up, another shopper said, "I wish I knew where to go to pick money up off the floor." Relieved, Betty Isaacs took the bus home to the Village. Unpacking her parcels, she discovered the dime in the bottom of the shopping bag.

Cage, Indeterminacy

Josephy and McBride, pp. 148–9

Lovely expensive laces, rugs, furniture and tapestries make Altman's a kind of rare merchandising museum constantly replenished by buyers who travel all over the world and brave war, bandits and pestilence in line of duty.

An Altman rug buyer was held up by bandits in Persia and robbed not only of his rugs but his clothes. A lace buyer was three times blown up during the war and once was locked in a military prison. He also sailed the Bay of Biscay when it was a sea of mines and went into Switzerland on a diplomatic passport when the border was closed.

That's what laces mean to Altman's—and no wonder since customers sometimes order $50,000 worth of them at a time.

Perhaps it ought to be explained that one can't just drop in and buy these special laces over the counter. They must first be ordered and the order must be transmitted to Europe by a buyer who will, more likely than not, go down on his knees on the mud floor of a lacemaker's hut to plan the pattern. In two years or maybe three, the order will be finished and the buyer will go back and collect it.

Gopnik, p. 202

The seventh floor of Bergdorf Goodman hums, the eighth floor of Saks sings, and there are few places that seem more entirely of Manhattan than Fred's at Barneys on a Saturday at noon.

Josephy and McBride, pp. 224–5

And there are apartments in stores—the Goodmans live on the top floor of Bergdorf Goodman, opposite The Plaza. Many banks and business houses also have penthouses.

Maffi, p. 7

The origin of the name Bloomingdale's goes back to a lovely spot on the Upper West Side called "blooming dale" (*Bloemendael* in Dutch).

Brobston, p. 302

My favorite thing here is the parties they give in the different sections. The last party was in the rug room. That was for Martha Graham and Halston. I was a model in that show. It was my longest modeling assignment, eight hours. The other great party was at the hardware room.

Ibid., pp. 305–6

Warhol: In Bloomingdale's. As soon you give them cash they don't know what to do with it. You have to have a card. I don't believe in credit cards. (*To salesgirl*) Do you have anything good to say about Altman's, I mean, Bloomingdale's?
Salesgirl: It's a beautiful place to work.
Warhol: Oh really? Oh. Well, that's good. Thanks a lot. 'Bye. Now we're going to the perfume department.

Allen and Brickman, *Annie Hall*

If the Gestapo would take away your Bloomingdale's charge card, you'd tell 'em everything.

Vreeland, *DV*, p. 135

I don't know how to shop in America … Bloomingdale's is the end of shopping because there isn't anyone to wait on you; you just sort of *admire* things.

Ellis, *Psycho*, p. 179

Some kind of existential chasm opens before me while I'm browsing in Bloomingdale's.

McInerney, *Bright Lights*, p. 173

The face that launched a thousand trips to Bloomingdale's.

Gopnik, p. 202

As recently as the early nineties, when Bloomies almost fell and women wept, department stores still mattered.

But we miss the big stores, because they defined a world, little duchies of commerce, with their faith in literal display: the things themselves shown as the things themselves, these shirts, these ties—the wooden escalators and crowded elevators, and the ghosts of elevator operators wearing small hats and announcing, "Notions." *Ibid.*, pp. 202–3

Lord & Taylor still gives one a sense of the department store as it once was, a last lingering resonance of the old dispensation. It is not a very distant world. The first floor of the store, at Thirty-eighth and Fifth, is laid out sweetly and expectantly, all mirrors and cosmetics; the salespeople in the Clinique department look serious in their white coats, as though actually about to attempt something cliniqual. There are no divisions, no urgency, no one spraying perfume—it is a ground floor seemingly arranged by the hand of God for displaying goods. There are striped men's ties placed like salmon fillets and men's shirts hanging like partridge. There are hats. The store plays the national anthem at ten o'clock every morning. The old Lord & Taylor implies a rhythm of time, of women's time, in particular, a pace not slowed but purposeful and expansive: It takes a morning and lunch, or tea and an afternoon, to make a survey of the place, shopping as a setting out rather than a dropping in.

At last, up on the tenth floor, in the men's department, one can find an awe-inspiring demonstration of the sheer numbing stasis that capitalism can achieve—for it is insensitivity to the immediate pressure of the market that separates big-ticket capitalism from the rug bazaar and the vegetable stall. Capital slows down the market and places it within the shell of The Firm, firm in every sense, so that things can linger after their appeal to the market has passed. The brand names are Jack Victor and Grant Thomas, name brands that are neither really names nor really brands, and seem to set off the commercial logic of brand-naming in a twilight zone of pure performance: No one wants to wear Jack Victor slacks, but there they are, hanging in poignant rows, their creases abjectly offered. It is a kind of installation piece: the department store as an abstract exercise in naming and branding and display, without commercial urgency and, mostly, without customers.

When it begins to get dark, and all the shoppers have left Macy's, ten black Doberman pinschers begin to tip-tap up and down the aisles sniffing for prowlers who may be hiding behind counters or lurking in clothes racks. They wander though all twenty floors of the big store, and are trained to climb ladders, jump through window frames, leap over hurdles, and bark at anything unusual—a leaky radiator, a broken steamline, smoke, or a thief. Should a thief try to escape, the dogs can easily overtake him, run between his legs—and trip him. Their barks have alerted Macy's guards to many minor hazards, but never to a thief—none has dared to remain in the store after closing hours since the dogs arrived in 1952. Talese, p. 25

Upon Gertrude Stein's arrival in New York, Macy's, charmed by the brash ring of Stein's *Four Saints in Three Acts*, was advertising its fall collection as "Four Suits in Three Acts" and the electric message running around the *New York Times* building in Times Square read: "Gertrude Stein has arrived in New York, Gertrude Stein has arrived in New York," *ad infinitum.* Douglas, p. 121

There are no skillets in any Fifth Avenue department store! And Macy's has no goldfish. Josephy and McBride, p. 145

Alexander Woollcott claimed to have been born in Macy's show window. Douglas, p. 48

Harris, *Diary*, p. 16

Not long ago, I made my first pilgrimage to the MAC counter at Macy's, a minute "boutique" crowded with a throng of hungry women, their hands extended like starving refugees at a camp kitchen where they beseeched the Red Cross cosmeticians for a little eye shadow, a smidgen of brow gel or bronzer, a lip gloss to save a dying child. They stood there three and four deep, milling about impatiently, craning their necks, their eyes fixed greedily on elegant pyramids of eye shadows and ziggurats of compacts and black velvet powder puffs.

Capote, p. 40

What I've found does the most good is just to get into a taxi and go to Tiffany's. It calms me down right away, the quietness and the proud look of it; nothing very bad could happen to you there, not with those kind men in their nice suits, and that lovely smell of silver and alligator wallets. If I could find a real-life place that made me feel like Tiffany's, then I'd buy some furniture and give the cat a name.

Conrad, p. 201

The city no longer needs to be constructed, which was Whitman's self-appointed task. On the contrary it flirts, as Saks's naming of the Metropolis shoe indicates, with its own teetering imbalance.

Vreeland, *DV*, p. 135

Or I go into, say, Saks Fifth Avenue, and there on a rack on wheels are two dozen five-thousand-dollar dresses. On a rack! It shocks me. I mean, first of all, to get *through* Saks is quite a performance. You get off the elevator; you're in the wrong department; you turn and get back on the elevator. Then you get off again, past the lingerie, past the cosmetics, and on for miles through the shoe department, and then finally you get to the five-thousand-dollar dresses, dangling there, Oscar de la Rentas, Bill Blass, each next to the others on a rack. Of course, lots of people enjoy the variety. They go home empty-handed. But they've shopped. In Paris it's a serious interval in one's life—perhaps twice a year. It's a pilgrimage.

Sanders, *Beatnik*, p. 366

She was very fast, very efficient, and had never been caught. She was an expert at confusion—she would affix a Bendel tag, say, to a garment from Saks, then dispose of the Saks tags with a twist of the wrist quicker than a pit stop at the Grand Prix.

Gopnik, p. 206

Kmart on Astor Place—an occupying space—with an irony harder than iron, in the original Wanamaker's. It is a grim place to visit, with its fluorescent glare, its vast area marked but undivided, as though made for surveillance, its antitheatrical insistences: The stuff is here, and the stuff is as cheap as we can make it, or so these orchestrations suggest. The choice is now between Kmart and Prada, and the institutions that joined them together are finished. We've gone from shopping through trust to a culture of discounting and edge, and edge is the one thing that seems to baffle the department store.

Atkinson, p. 97

I stopped in at a Woolworth store when I was walking down Nassau Street the other day. It was about two-thirty and the place looked as though a typhoon had been through it. The noon hour had been active and profitable. Paper lay ankle deep all over the floor—discarded paper bags, tattered labels, wrappings of one kind and another. A couple of men were attacking the wreckage with brooms. The salesclerks looked weary and pale. They were languidly trying to put their stock in order. The store still seemed to quiver with noise, and a few belated shoppers stood at the jewelry and cosmetic counters. At the belt counter (largest size carried, twenty-six) two young saleswomen were straightening out some black velvet, rhinestone-studded belts.

For a long time everybody walked on the west side of Fifth Avenue and business houses scrambled to build there. Then, apparently because the east side of town became fashionable, the east side of Fifth Avenue began to thrive and now pedestrians prefer to do their window shopping there. Merchants actually count the walkers, so anybody from this time forth who seems to have to wedged his way along the west side of Fifth will know he is suffering from the delusion. Practically *nobody* walks there; the statisticians say so!

Josephy and McBride, p. 61

Archer walked down Fifth Avenue, past the shops with their windows full of dresses, coats and furs, and the women rushing in and out of the doors, their faces lit with the light of purchase. It is the new profession of the female sex, he thought—buying. If you wanted to set up an exhibition to show modern American women in their natural habitat, engaged in their most characteristic function, he thought, like the tableaux in the Museum of Natural History in which stuffed bears are shown against a background of caves, opening up honeycombs, you would have a set of stuffed women, slender, high-heeled, rouged, waved, hot-eyed, buying a cocktail dress in a department store. In the background, behind the salesgirls and the racks and shelves, there would be bombs bursting, cities crumbling, scientists measuring the half-life of tritium and radioactive cobalt. The garment would be democratically medium-priced and the salesgirl would be just as pretty as the customer and, to the naked eye at least, just as well dressed, to show that the benefits of a free society extended from one end of the economic spectrum to the other. One goes into the room—but the resources of the English language would be much put to the stretch, and whole flights of words would need to wing their way illegitimately into existence before a woman could say what happens when she goes into a room. The rooms differ so completely; they are calm or thunderous; open on to the sea, or, on the contrary, give on to a prison yard; are hung with washing; or alive with opals and silks; are hard as horsehair or soft as feathers.

Lefebvre, *Critique*, p. 28

What was once a living is now an empty routine. Memories and hopes are buried among the jumble. Wives have passed on. Sitting outside the doorway, looking back over fifty, maybe sixty, summers passed this way, the old shopkeepers remember another age as the young go by in their satin shorts.

Blandford, p. 118

Shop-girl "refinement" is based upon a clever imitation of genuine refinement. To imitate the "real thing," exaggeration is necessary; so that the "swell" shop-girl is refined in head-lines, so to speak. The subtle refinement, which is the real thing, would have no effect in the store. It must be sharp and screaming to be noticed in the crowd. Shop girl refinement is like stage scenery—unreal, but prominent and obvious. It *must* be seen. It cannot escape the crowd.

Hapgood, p. 127

There is hardly a single weird store left on Broadway from Forty-second Street to Forty-sixth Street—hardly a single place in which a peculiar passion seems to have committed itself to a peculiar product.

Gopnik, p. 220

All buildings used by diamond merchants in Forty-seventh Street between Fifth Avenue and the Avenue of the Americas are single-ended. Diamond men will not operate in a structure that might give thieves easy run-through from one street to another.

Berger, *New York*, p. 20

Conrad, p. 87

Madison Square as a giddy havoc of shoppers engaged in sportive contest with the wind.

Blandford, p. 117

Along the traditional shopping roads from Broadway on the Upper West Side to the narrow lanes of the Lower East Side.

Irwin, pp. 183–4

Your grandmother, middle-aged madame, bought her crinolines and basques in Canal Street; your mother her shirt-waists and brush braid in the Ladies' Mile between Union Square and Madison Square; you purchase your transparent hose and your sport sweaters in the Woman's City above Thirty-fourth Street. And it is not unlikely that your great-granddaughter will shop for her synthetic diamonds and her Tibetan sandals in this identical spot.

Ibid., p. 122

The department-store nearest the corner of Fourteenth Street and Fifth Avenue, very fashionable once, then exceedingly cheap and "common"; and now, with the recrudescence of the district, growing smart again.

Trebay, p. 75

But reason doesn't animate the retail trade, impulse does, and on Broadway from 14th Street south to Houston there may be more unchecked impulse than in any location outside the Pentagon. There are several latitudes here and several economies at work. For present purposes Broadway begins at Mays, the world capital of nylon tricot shells, and ends at Getty's gas station on Houston, where Don Henry stores his squeegee when he's not in traffic smearing windshields for a quarter. The northern reach of this stretch is given over to the wholesale antiquarians and the limousine trade. On any given afternoon rafts of decorators pilot clients from Biedermeier chair to Georgian fall-front secretary to (if they're hip and under 40) 1905 Venetian glass vases. Piped Belgian loafer shoes line up outside Hyde Park, the smartest of the antiquarians, docilely waiting to be buzzed in. You hear a lot of Texan spoken, although rarely to the one-legged mendicant who works the corner of 13th … It's Broadway south of 8th that's changed most radically and developed headlong into a boutique strip whose hip graphics and pop colorations seem like the latest gleeful ripple of retailing fashion, but are in fact an emblem of political cynicism in a city whose social fabric is threadbare. Between 8th Street and Houston you can fling your disposable income at spin-art T-shirts, parachute pants, Bermuda shorts, short shorts, droll "modernist" postcards, prewashed button-fly jeans, modishly tattered corselets, then stop off for a tuna-stuffed avocado or perhaps a serving of thinnest carpaccio drizzled with virgin olive oil and flaked with aged Parmesan. While you're at it, you can mentally or morally or visually engage one of the people intended by the graffitist who stenciled "People Starve on this Block" outside Caramba!! Or you can just turn your chair to the window and order another blue margarita.

Crisp, p. 133

In my neighborhood, traffic was in chaos this week because some kind of street fair was in full swing. Someone explained that the same objects are offered for sale at all New York's open-air markets. The vendors simply pretend that they and their wares are Italian one week, Ukrainian the next, and so on all summer long.

Conrad, p. 310

Its gutters are emporia, where the trinkets don't have price tags. It's a place where commodities, surfacing again after death, have their second coming in the bazaars of Canal Street.

Hamill, "Lost"

Red Devil paint, Cat's Paw soles and heels, Griffin All-Black might still exist, but I don't see them anymore. Nor do I see beers called Trommers White

∏ Commodity — Shopping

Label, Ruppert's, and Rheingold, candies called Sky Bars, Houten's, and B-B Bats. And for young men going out on dates, a repulsively flavored package of licorice microchips called Sen-Sen that is guaranteed to keep your breath sweet while kissing.

The men are smoking Fatimas and Wings.

Ibid.

In the candy stores, they are selling loosies (2 cents apiece, two for 3), mel-o-rolls, Nibs, hard car'mels, Bonomo Turkish taffy, long pretzels, Mission Bell grape and Frank's orange soda, twists, egg creams, lime rickeys, and a nice 2-cents plain.

Ibid.

And here you always have spaldeens. An endless supply. Pink and fresh and beautiful.

Ibid.

Midtown takes up only one square mile, not much more space than many a regional shopping mall.

WPA Guide, p. xxiii

The place where the greatest numbers of choices are available in the smallest geographical area.

Krieger, p. 8

False choice in spectacular abundance.

Debord, *Spectacle*

City that orders without looking at the prices.

Riesenberg and Alland, p. 203

clothes of a thousand fabrics;
meats; booksellers; machines

Depero, "24th Street," p. 429

An index of consumption: How many millionaires are there in the city? How much does land cost per square inch on Wall Street? What's the lucrative length of Fifth Avenue?

Conrad, p. 65

Shouters, sales boosters, sales executives, sales girls, sales bodies, sales women, sales scientists, sales resistance, sales softening, sales campaigns, sales organizations, sales philosophy, sales religions, sales happiness, sales ecstasy, sale singing, sale stories, sales poetry, sales plugs, and no sales; all are in and of our city of the cash.

Riesenberg and Alland, p. 203

On August 6, 1979, I hit the street clutching a $10 bill. With that sum ($9.98, to be precise) I bought three slices of pizza, a can of Welch's Strawberry Soda, a pack of Viceroys, six joints, two quarts of orange juice, two containers of yogurt, and a pint of milk. For some reason I was moved to enter those details in my notebook. I often revisited the entry. On May 29, 1981, I noted that the shopping list would cost around $12 at current prices. On March 24, 1983, the sum had risen to $13.50, and a year later to $15. On August 2, 1986, I calculated the cost as $39–35—loose joints were rare on the street, and by then a dime bag of marijuana yielded about two joints. On December 1, 1990, the cost had reached $72—$12 minus the marijuana. On March 28, 1993, I figured it had attained $92.75, or $22.75 for everything but the pot.

Sante, "Commerce," p. 111

Thus it runs, mostly, throughout the entire region on this joyous occasion, a wealth of feeling and desire expressing itself through the thinnest and most meager material forms. About the shops and stores where the windows are filled with cheap displays of all that is considered luxury, are hosts of other children scarcely so satisfactorily supplied, peering earnestly into the world

Dreiser, p. 282

of make-believe and illusion, the wonder of it not yet eradicated from their unsophisticated hearts.

Goffman, p. 23

In talking about a social setting such as a fashionable New York store, it is possible to speak of someone present as being properly or improperly dressed for the time and place.

Atkinson, p. 23

About June our stores begin to mention autumn merchandise. Then, about September, they begin to nag about Christmas. As soon as Christmas is past, they sing the praises of spring. Seldom does anybody settle down to endure winter. "Once Christmas is past, spring is nearly here," New Yorkers tell one another. It's nothing of the kind, of course, but we have a blind spot for winter. Only the most beat-up kind of winter merchandise is available in the stores, even in January. "Spring stocks, of course," say the haughty salesgirls. It's a New York mania.

Buse, p. 26

A world of retailing rather than a world of production.

Atkinson, p. 95

Every street is dotted and spangled with shops to lure the office workers' salary.

Riesenberg and Alland, p. 154

Necktie bargains, the razor-blade transformers, the empty non-pickable purses, the blood tonic and iron cement and manhood pills, are offered for a mere pittance, together with wonderful devices that improve the radio set and purify the air.

Morris, *Incredible*, p. 289

It was characteristic that the vast railroad terminals suggested neither arrivals nor departures, that the trains which justified their erection were buried far underground. Immense public concourses with labyrinthine arcades of shops.

Gopnik, p. 205

The precincts of New York retailing, Fifth Avenue, Broadway, and Soho, became, as many people noted, mall-like themselves, with a predictable range of national boutiques and a predictable effect on the department stores, which continued to "make" the neighborhoods and continued to lose market share.

Koolhaas, p. 120

In his [Harvey Wiley Corbett] scheme for elevated and arcaded walkways (first proposed 1923), the entire ground plane of the city—now a chaos of all modes of transportation—would gradually be surrendered solely to automotive traffic. Trenches in this plane would allow fast traffic to rush through the metropolis even faster. If cars needed more room again, the edges of existing buildings could be set back to create still larger areas for circulation.

On the second story, pedestrians walk along arcades carved out of the buildings. The arcades form a continuous network on both sides of streets and avenues; bridges provide its continuity. Along the arcades, shops and other public facilities are embedded in the buildings.

Atkinson, p. 98

Someday I'm going to take a big shopping bag and five dollars and set myself adrift on Park Place.

Buse, p. 26

Warm, desultory, idle, pleasure-grabbing, but also clean and safe.

n Commodity — Shopping

Posing for the sidewalk as if the plate glass were a proscenium.

Conrad, p. 107

Has there ever been a designer's runway that produced better fashion than a city sidewalk?

Frisa and Tonchi, p. 271

"Everything in fashion begins in the street," Diane von Fürstenberg once observed.

Ibid.

Avenues of lovely women and clean-cut men.

Riesenberg and Alland, p. 205

City of shirt fronts and backless vests.

Ibid., p. 206

City of anklets, bracelets, slave chains, solitaires, tiaras.

Ibid., p. 208

It is not nature that decrees the seasons in Manhattan but the wardrobe of its inhabitants.

Blandford, p. 28

In summer, people do not dress for those whom they are off to meet but for those whom they might get to know along the way. It becomes a city of bright plumage, of exotic creatures dipping and diving along the sidewalks, each flashing color and consciousness. If there are any drab, mousy relics of good taste, garbed in discreet and sensible cottons, they vanish into concrete undergrowth. Summer in Manhattan is a neon moment that dazzles and delights.

Ibid., p. 114

In summer they dress too warmly, in winter they wear too little.

Ibid., p. 139

Raincoats are IN … even if it's sunny.

"Fashion at the Top"

Cruising up Madison, stopping at a light in front of Barneys, and Bill Cunningham snaps my picture, yelling out, "Is that a Vespa?" and I give him thumbs-up.

Ellis, *Glamorama*, p. 20

I go to work in sensible heels, a conservative pleated skirt, and a white blouse with a floppy bow, but I walk around my apartment wearing my wigs and panties.

Harris, *Diary*, p. 54

Lovecraft's sartorial tastes and epic pursuit of the best suit at the lowest price deserves an essay all of their own. He put an enormous amount of effort into the presentation of his public personality, but it was only in small details of dress that this was manifest. He refused to change the style of his suits to accommodate fashion, and felt that sloppy dressing was heralding a new, distinctly American style that would presage the decline of the West.

Haden, p. 49

And finally there was the matter of Vernon's pants. They were worn out when I met him. Now, a year later they are still worn out. In the course of the year they have been sewn together, patched, studded, and, for all I know, lithographed, into a veritable harlequinade of fabric and leather improvisation. Other people might work on a diary, Vernon worked on his pants, and like artists before him, he went through various periods. During the time that he and I were lovers, he was in his leather and silver-stud period. From there, under the influence of a horde of Puerto Ricans, he went into a flowered print period. He's now back on solid colors, like late Matisse.

Hamilton, pp. 30–1

| Dreiser, p. 78 | For here comes one whose clothes are good but tasteless, or dirty; and I would not have his taste or his dirt. |

Collins, *Money*, p. 296 — A pair of sleek shoes with buttoned spats on the subway: these are not proletarian feet.

Conrad, p. 201 — Raymond Loewy designs an advertisement in 1927 for a new shoe called Metropolis. An athletic female nude holds a sample in the air on top of a pyramidal pile of skyscrapers, the sky behind her raked with searchlights. The shoe's a metonym for the buildings, and the comparison associates architectural vertigo with the stratagems of sexual enticement, since the high heel is the female's signal to the male that she won't be able to outrun him.

Frisa and Tonchi, p. 271 — A dedicated observer could pause at a Manhattan corner—say, Eighth Street and Broadway—and snap a mental picture later to be diagrammed for the unconscious influences on parade—of social currents and movements, from hippies to Black Panthers to feminists and homosexuals.

Ibid. — There is the athletic sock. For quite a long time, this striped tube of white stretch cotton has signified not just the dregs of unfashionable dressing, but also a pretty intractable marker of class. Tube socks have always conjured images of clothes sold from binds to people not likely to have heard of Coco Chanel, much less the darlings of style cognoscenti like Alexander McQueen or Nicholas Ghesquière. That was before a group of young urbanites got hold of the tube sock and subjected it to what in theoretical circles might be called a critique. Deciding that its lack of cool was in itself a kind of cool, and not altogether an ironic one, they put the tube sock back into fashionable circulation.

Spillane, p. 157 — His suit would have been snappy in Harlem, edged with sharp pleats and creases.

X, p. 78 — Off the train, I'd go through that Grand Central Station afternoon rush-hour crowd, and many white people simply stopped in their tracks to watch me pass. The drape and the cut of a zoot suit showed to the best advantage if you were tall—and I was over six feet. My conk was fire-red. I was really a clown, but my ignorance made me think I was "sharp." My knob-toed, orange-colored "kick-up" shoes were nothing but Florsheims, the ghetto's Cadillac of shoes in those days.

Donleavy — Over all these fur coats of fox, sable, mink, beaver, leopard, and maybe even chipmunk and polar bear. Pull mine out. Woven from sheep on the outer Hebrides.

Highberger, p. 53 — One night, I found a beautiful Russian sable coat neatly folded over a railing outside a brownstone in the Village. Someone was probably getting in a cab to go to the airport or somewhere and forgot it. It fit me like a glove, and it looked fantastic. It was one of those magic things, like it was meant to be mine.

Trebay, p. 8 — On Fordham Road, a 200-pound woman clutches a Fendi bag to her bosom like Alberich's gold. Three pairs of door-knocker earrings just from her small ears beneath a rich crop of Senegalese corkscrews. The woman peers at the window of a discount appliance shop where a bank of televisions show eighteen Tina Turners strutting by gas-guzzling Plymouth automobiles. The woman cackles, tosses her head back, addresses the strangers who happen at

that moment to be sharing her air. "Tina Turner is my girl! Don't have to talk. Don't have to sing. Don't have to dance, do nothing. All she has to do is get out there and walk that mad, mad walk!"

Just before nine and just after five, the very pavement runs brimful with office people, hurrying between the ferry and their jobs. And on any late afternoon, you are likely to encounter a group in peasant costumes of Italy or Hungary or the Tyrol, making their way northward with a chattering escort in stiffly worn American clothes.

<small>Irwin, p. 24</small>

New Yorkers wear the softest lambswool and silken fur as though they were breastplates.

<small>Blandford, p. 81</small>

The new ideology was Jane Jacobs dressed in latex and leather.

<small>Gopnik, p. 217</small>

Lingerie sold in sex shops seems constructed to fall apart within the first half hour. Yet it costs many times the price of lingerie sold in department stores. It is ironic that a pair of crotchless pants winds up being so much more expensive than cotton briefs.

<small>Califia, p. 221</small>

Trousers with one leg rolled the way Rikers Island inmates used to wear them.

<small>Frisa and Tonchi, p. 270</small>

Model

Modeling Todd's new '70s-influenced punk/New Wave/Asia-meets-East-Village line are Kate Moss paired with Marky Mark, David Boals with Bernadette Peters, Jason Priestley with Anjanette, Adam Clayton with Naomi Campbell, Kyle MacLachlan with Linda Evangelista, Christian Slater with Christy Turlington, a recently slimmed-down Simon Le Bon with Yasmin Le Bon, Kirsty Hume with Donovan Leitch, plus a mix of new models—Shalom Harlow (paired with Baxter fucking Priestly), Stella Tennant, Amber Valletta—and some older ones including Chloe, Kristen McMenamy, Beverly Peele, Patricia Hartman, Eva Herzigova, along with the prerequisite male models: Scott Benoit, Rick Dean, Craig Palmer, Markus Schenkenberg, Nikitas, Tyson … In the audience I'm able to spot Anna Wintour, Carrie Donovan, Holly Brubach, Catherine Deneuve, Faye Dunaway, Barry Diller, David Geffen, Ian Schrager, Peter Gallagher, Wim Wenders, Andre Leon Talley, Brad Pitt, Polly Mellon, Kal Ruttenstein, Katia Sassoon, Carré Otis, RuPaul, Fran Lebowitz, Winona Ryder (who doesn't applaud as we walk by), René Russo, Sylvester Stallone, Patrick McCarthy, Sharon Stone, James Truman, Fern Mallis. Music selections include Sonic Youth, Cypress Hill, Go-Go's, Stone Temple Pilots, Swing Out Sister, Dionne Warwick, Psychic TV and Wu-Tang Clan … It's freezing backstage even with all the lights from the video crews, and huge clouds of secondhand smoke are billowing over the crowd. A long table is covered with white roses and Skyy martinis and bottles of Moët and shrimp and cheese straws and hot dogs and bowls of jumbo strawberries. Old B-52 records blare, followed by Happy Mondays and then Pet Shop Boys, and Boris Beynet and Mickey Hardt are dancing. Hairstylists, makeup artists, mid-level transvestites, department store presidents, florists, buyers from London or Asia or Europe, are all running around, being chased by Susan Sarandon's kids. Spike Lee shows up along with Julian Schnabel, Yasmeen Ghauri Nadege, LL Cool J, Isabella Rossellini and Richard Tyler.

<small>Ellis, Glamorama, p. 139</small>

<small>■ Commodity — Model</small>

Bushnell

Modelizers inhabit a sort of parallel universe, with its own planets (Nobu, Bowery Bar, Tabac, Flowers, Tunnel, Expo, Metropolis) and satellites (the various apartments, many near Union Square, that the big modeling agencies rent for the models) and goddesses (Linda, Naomi, Christy, Elle, Bridget).

Kornbluth, "Warhol"

On the Tuesday before he died, Warhol still wasn't well, so Paige Powell canceled a lunch for potential advertisers. That night, however, Warhol and Miles Davis were scheduled to model Koshin Satoh's clothes at the Tunnel. And there was no way Andy Warhol could have tolerated an announcement that he was indisposed.

"Andy stood in a cold dressing room for hours, waiting to model," says Stuart Pivar, a trustee of the New York Academy of Art and, for the past five years, Warhol's best friend. "He was in terrible pain. You could see it in his face." Still, Warhol went out and clowned his way through the show. Then he rushed backstage.

"Stuart, help. Get me out of here," he gasped. "I feel like I'm gonna die."

Hamilton, p. 6

One of those long, lean, languid people who might've led me into the world of fashion, theater, decoration, and the outer reaches of High Culture.

Girdner, p. 38

He imagines that the young woman who walks Sixth Avenue, unkempt, and dressed in cheap, ill-fitting clothes, is an entirely different creature when he sees her powdered and perfumed, and dressed in the height of fashion, walking on Fifth Avenue, or lolling in the scented atmosphere of the Turkish room of a modern hotel.

Flow, Circulation

Irwin, p. 190

Before the war there may have been some excuse for a woman's going to Europe for the purpose of adorning her person or her house. But since New York became by a capricious gift of the gods financial capital of the world, her only excuse is the excitement of the trip. The most cunningly fabricated silks of Lyons come to our Woman's City, either in the bolt or in the finished product of the Parisian *modistes*; the rarest furs of the Siberian steppes and the Hudson Bay forests; the filmiest laces of Brussels, Dublin, Le Puy, Venice; the bonanza discoveries of the South Sea pearl divers; the most cunning creation of the Quimper and Limoges potters.

Josephy and McBride, pp. 154–5

The stories behind Wanamaker's Oriental House would fill a book—the indefatigable buyers have been through innumerable plagues, civil wars, bandit raids. A woman brought back one of Wanamaker's great treasures—a carved and painted Chinese screen from the Imperial Palace in Pekin, obtained after a six-month's journey of 50,000 miles by train, steamer, camel-back and bullock cart through an area torn by civil war. The route list of such a buyer sounds like something from the voyages of Marco Polo—Seven Fountains in the Vale of Kashmir, Holy City of Benares, Pink City of Jaipur and golden road to Samarkand are stop-overs.

Atkinson, p. 125

Many a happy traveler, returning laden with treasure from the bazaars of Teheran or the street booths of Cairo, from the sidewalk displays of Java or the evil little cubbyholes of Peking, from any foreign place at all, has found to his chagrin and astonishment that whatever was purchased so eagerly abroad could have been had in New York for less than the price paid elsewhere and with none of the nuisance of lugging the stuff home and easing it through the customs.

n Commodity — Flow, Circulation

During many a single week, I daresay, more money is spent in New York on useless and evil things that would suffice to run the kingdom of Denmark for a year. New York, indeed, is the heaven of every variety of man with something useless and expensive to sell. There come the merchants with their bales of Persian prayer-rugs, of silk pajamas, of yellow girls, of strange jugs and carboys, of hand-painted oil-paintings, of old books, of gim-cracks and tinsel from all the four corners of the world, and there they find customers waiting in swarms, their checkbooks open and ready. What town in Christendom has ever supported so many houses of entertainment, so many mimes and mountebanks, so many sharpers and coney-catchers, so many bawds and pimps, so many hat-holders and door-openers, so many miscellaneous servants to idleness and debauchery? One must go back to the oriental capitals of antiquity to find anything even remotely resembling it. Compared to the revels that go on in New York every night, the carnalities of the West End of Berlin are trivial and childish, and those of Paris and the Côte d'Azur take on the harmless aspect of a Sunday-school picnic.

Mencken, p. 181

The late afternoon sun glitters on windshields, chauffeurs' caps, on Parisian gowns, Chinese ivories, ebony from Africa, Mexican pottery, and furs from Siberia.

WPA Guide, pp. 50–1

New York takes its place among the fabled cities of ancient times, treasure laden, filled to overflowing with gold, frankincense and myrrh, with jewels and costly raiment.

Atkinson, p. 142

Jimmy Walker

Jimmy Walker as dandy: His tailor created unique clothes for his slight frame in which shirttails never became visible and "his clothes seemed to cling to him perfectly, no matter what his posture." Walker's single-button suit jackets (pinched at the waist), "toothpick"-pointed shoes, fedoras and derbys, narrow cravats, and garish colors received much notice. On a 1927 European vacation he toured Venice in "purple striped trousers and a green sweater" and arrived in Paris wearing a brown hat, "a tie of emerald and brown stripes, a blue shirt, a blue-striped suit, low black shoes, a beige sport coat, and, completing the picture, a lavender handkerchief with dashes of purple and brown protruding from his only coat pocket."

Peretti, pp. 53–4

The real mayor's widely publicized short workdays were built around nocturnal activity. Usually rising at midday, Walker dispatched official business quickly. At sunset he presided at political conferences and public hearings and then began long nights at the theater, restaurants, and nightclubs. Walker did not frolic in public to make himself available to the populace. He was a claustrophobe who feared crowds and elevators; in nightclubs he specialized in grand entrances and exits, but otherwise isolated himself in private booths and hidden tables. Like the gambler Arnold Rothstein, another Broadway habitué, Walker was a hypochondriac who inhabited his body uncomfortably.

He was also strikingly passive. He went to baseball games, he confessed in a revealing interview, "because there I found the thing I liked best—a game, the drama, the spectacle, the emotions of human-beings … When I go to the theatre I do not go to criticize. I go to be entertained. I give myself over to the player, and I do not want to see the inconsistency in the plot. I want to live in that make-believe world, the theatre … Broadway is nothing but the world passing in review."

Walker was a 1920s New York version of the flâneur. He loved public display and artifice; he disdained personal intimacy. Walker's individuality was bound up in the generally passive consumption ethic of the era of Broadway shows and the cinema. The passivity of spectatorship militated against the nightclubs' encouragement of customer participation, but it also suggested that even in clubs, individuals might retreat into their own private subjectivities. Mayor Walker, for his part, reveled in keeping a safe physical distance from other people in order to gain the most pleasure from their social and artistic performances.

Lerner, p. 161

Just turned forty-five, but with the appearance of a man still in his early thirties. His hair is black, thick and unruly. His eyes are dark and restless. He has the slim build of a cabaret dancer, of a gigolo of the Montmartre. He dresses in the ultra advanced fashion redolent of the tenderloin. He is a native New Yorker, smokes cigarettes continuously, has a vast contempt for the Volstead Act, and reads nothing but the sporting pages. He knows the speakeasies, the hotels and the nightclubs. If Alfred E. Smith comes from the sidewalks of New York, Jimmy Walker comes from the dance floors.

Peretti, p. 55

Walker blended public and private business in a new and theatrical way.

Ibid.

The nightclub mayor.

Sharpe, p. 6

He claimed it was a sin to go to bed on the same day you got up.

Peretti, p. 8

He gained fame for rising regularly at noon.

Ellis, *Epic*, p. 525

Walker confessed, "I've read not more than fifteen books cover to cover."

Lerner, p. 163

When Republicans in the Senate proposed a Clean Books Bill in 1923, Walker famously ridiculed it, telling his fellow Senators, "I have never yet heard of a girl being ruined by a book."

Ibid.

Walker vacationed extensively, missed work frequently, and raised his own salary from $25,000 to $40,000.

Ibid.

Walker was caught in a gambling raid at the Montauk Island Club, mistress at his side, and unsuccessfully tried to sneak out disguised as a waiter.

Diana Vreeland

Vreeland, *Papers*

I can't stand the vulgarity of a woman who makes a noise when she walks— it's o.k. for soldiers, but, when I was growing up, the quintessence of breeding in a lady was a quiet footstep.

Ibid.

Maintenance is so essential. I mean that is what we are lacking today. Nobody maintains anything—not the insides of cabs or beautiful floors and walls. Beautiful buildings are torn down; there are potholes in the streets; people don't maintain their clothes so they have to go out and buy something new.

Ibid.

And whatever you do, *don't* try to make it grammatical! Don't forget the dots and dashes! As this is *entirely a visual age* …

I never wore clothes from Seventh Avenue myself, you understand. I always kept a totally European view of things. Maybe that's why I was so appreciated there. I was independent. In those days, don't forget, fashion traveled very slowly. When I arrived back in this country after the war started, I couldn't believe what I saw. In the summer, every woman wore diamond clips on crêpe de chine dresses. And they all wore silk stockings—this was before nylons—under these hideous strappy high heels. This is in the summer, you understand—in the *country*. It was *unbelievable*.

Ibid.

Vulgarity is a very important ingredient in life. I'm a great believer in vulgarity—if it's got vitality. A little bad taste is like a nice splash of paprika. We all need a splash of bad taste—it's hearty, it's healthy, it's physical. I think we could use *more* of it. *No* taste is what I'm against.

Vreeland, *DV*, p. 122

What catches my eye in a window is the hideous stuff—the *junk*. Plastic *ducks*!

Ibid., p. 163

Unshined shoes are the *end* of civilization.

Vreeland, *Papers*

I'm mad about her nose. A nose without strength is a *pretty* poor performance. It's the one thing you hold against someone today. If you're born with too small a nose, the one thing you want to do is build it *up*.

Ibid.

The girl's legs in the picture were superb, but she was quite thick around the middle and her face was ghastly. So I said, "The legs are great but as for the face—forget it! Let's use just the legs and combine them with this torso and that … "

Ibid.

I *approve* of plastic surgery. None of my friends can understand why I haven't done it myself. I have my own reasons. But the only point is, now it's as normal as taking an aspirin. Whereas only fifteen years ago …

Ibid.

Then, at *Vogue* … I *really* went to town! I put *legs* and *arms* and *heads* and everything *else* together … to give the perfect whole. And I was the world's greatest retoucher. A girl moving looked the way I'd retouched her standing still. I never took out fewer than two ribs.

Ibid.

They couldn't publish half the things I did on *Vogue*. I remember Elliott Erwitt did some pictures for us of an eye-lift operation. *That* was a scene. The pictures were shown to various members of the staff. One left immediately to throw up, others were gagging and carrying on, others … these were *professional* women working on a *woman's* magazine, you understand—not a gaggle of housewives. It was *un*-believable!

Now most of what looked like blood was Mercurochrome, because it's a special operation where the knife almost heals the blood flow, and the pictures were *marvelous*.

Ibid.

Fashion

The late Forties were the golden years of the fashion magazines when they were among the liveliest publications in America and provided a haven for the new and daring. A handful of powerful European-born art directors and designers developed a new, sophisticated, Bauhaus-influenced commercial art that was strikingly graphic and visually alive.

Bockris, *Warhol*, p. 81

Ellis, *Epic*, p. 459 Like artichokes, women were covered by layer after layer of clothing—chemise, drawers, corset, corset cover, and one or more petticoats. Skirts were so long that they merely showed the tip of the shoe. Ladies exposed much more of their bosoms for a formal evening on the town, but during the day they wore shirtwaists with high collars. It was considered fashionable for well-dressed women to walk in such a forward-sloping position that they seemed to be falling forward. Gentlemen wore blue serge suits most of the time, and only dudes put on garters. Men's shoes had tips as sharp as toothpicks. In hot weather, men might remove their jackets in their offices, but never, *never* were they allowed to take off their vests. To appear hatless, whatever the season, was unthinkable. Men wore derby hats in the winter and hard straw hats in the summer.

Hawes The raising of hemlines, rooflines, and consciousness proceeded in concert.

Douglas, pp. 464–6 By mid-November 1929, women's hemlines, which had risen dramatically in the early 1920s and fluctuated nervously throughout the decade somewhere around the knee, dropped conclusively to the lower calf. Breasts and waists reappeared. Recently mandatory "bobs" seemed to grow out overnight; the back of the neck was once again a secret. Young women no longer looked freightless, no longer seemed designed for the possibilities of sudden and violent motion. They aspired to "glamour" (a word that came in big in the early 1930s); they had reacquired mass ... Langston Hughes now denounced as "Bunk!" the notion on which the Harlem Renaissance had been founded, that "art could break down color lines and prevent lynching." "There is no cure ... in poetry or art ... for unemployment ... civic, neglect, and capitalistic exploitation."

Naumann, p. 8 Early one afternoon in 1913, a young New York debutante named Mary Phelps Jacob sat quietly in her boudoir trying to decide which dress she would wear to a dance that evening. Exasperated at the thought of once again being harnessed into her stiff, heavily starched whalebone corset, she decided to give some more consideration to a more comfortable alternative. Apparently, she understood the important role necessity plays in the process of invention and set about devising a replacement for this constricting undergarment. With two handkerchiefs, some baby ribbon, and the assistance of her French maid, Miss Jacob invented the prototype of today's modern brassiere.

This new method of support not only left the midriff free for the important requirement of breathing, but also eliminated the rounded artificial look of the low-fronted bosom, popular since Edwardian times, and gave the breasts a more natural separation. The new Backless Bra, as Miss Jacob called her invention, was an overnight success. In November 1914, she was granted a patent.

Douglas, p. 66 Dorothy Parker writing ad copy for women's underwear at *Vogue*: "Brevity is the soul of lingerie."

"Straw Hat Riot" The Straw Hat Riot of 1922 spread due to people wearing straw hats past the unofficial date that was deemed socially acceptable, September 15th. In the early 20th century, there was an unwritten rule that one was not supposed to wear straw hats past September 15th. This date was arbitrary; it had earlier been September 1st, but it eventually shifted to mid-month. If someone was seen wearing a straw hat, they were, at minimum, subjecting themselves to ridicule, and it was a tradition for youths to knock straw hats off of wearers' heads and stomp on them. This tradition was well established, and newspapers of the day would often warn people of the impending approach

of the fifteenth, when people would have to switch to felt hats. The riot itself began on September 13th of 1922, two days before the supposed unspoken date, when a group of youths decided to get an early jump on the tradition. This group began in the former "Mulberry Bend" area of Manhattan by removing and stomping hats worn by factory workers who were employed in the area. The more innocuous stomping turned into a brawl when the youths tried to stomp a group of dock workers' hats, and the dock workers fought back. The brawl soon stopped traffic on the Manhattan Bridge and was eventually broken up by police, leading to some arrests. Although the initial brawl was broken up by police, the fights continued to escalate the next evening. Gangs of teenagers prowled the streets wielding large sticks, sometimes with a nail driven through the top, looking for pedestrians wearing straw hats and beating those who resisted. Several men were hospitalized from the beatings they received after resisting having their hats taken, and many arrests were made. The tradition of hat smashing continued for some time after the riots of 1922, although they marked the worst occurrence of hat smashing. In 1924, one man was murdered for wearing a straw hat. 1925 saw similar arrests made in New York. The tradition died out along with the tradition of the seasonal switch from straw to felt hats.

City Has Wild Night of Straw Hat Riots

"City Has Wild"

Gangs of young hoodlums ran wild in various parts of the city last night, smashing unseasonable straw hats and trampling them in the street. In some cases, mobs of hundreds of boys and young men terrorized whole blocks. Complaints poured in upon the police from men whose hats were stolen and destroyed but as soon as the police broke up the gangs in one district, the hoodlums resumed their activities elsewhere.

A favorite practice of the gangsters was to arm themselves with sticks, some with nails at the tip, and compel men wearing straw hats to run a gauntlet. Sometimes the hoodlums would hide in doorways and dash out, ten or twelve strong, to attack one or two men. Along Christopher Street, on the lower west side, the attackers lined up along the surface car tracks and yanked straw hats off the passengers as the cars passed.

The streets where such incidents occurred were strewn with broken hats. Hat stores which kept open last night were crowded with purchasers of fall hats.

The complaint was made of a gang swarming on an open street car and attacking the passengers to get their hats. A man who said he was E. C. Jones, a promoter of 70 West Ninety-third Street, telephoned to THE TIMES that this happened when he was riding uptown on an Amsterdam Avenue car between 135th and 136th Street about 9 o'clock last night. He said the car was attacked by a group of boys who later disappeared in a mob of about 1,000 who were destroying straw hats along Amsterdam Avenue. Jones said he complained at the West 152nd Street Station and the mob was dispersed.

[...]

At Madison and Thompson Streets a boy knocked off a man's hat with a long stick. Then other boys kicked the hat along the street until it reached another boy, waiting to jump on it ...

The clerks and stenographers of lower New York were among the first to show the metamorphosis. The postwar male shaved early and often; he wore white collars or even more fashionable blue ones; he looked more like the clothing advertisements than would seem to be humanly possible. The postwar female was engaged in an epochal struggle for youth. The result, of course, was a good deal of ridiculousness: old faces on young bodies, young faces on old bodies, fat legs in thin stockings, wide hips in narrow skirts,

Brown, *Valentine's*, pp. 24–5

Commodity — Fashion

nobody old, nobody young, more grotesqueness than beauty; but withal a modicum of sense.

Ironically, as fashions became "more revealing," the "fevered conjecture" that so "fired the imagination" of the City's sidewalk "ankle connoisseurs," undoubtedly lost some of its former "heat." Today's styles are more "in your face," but all these 8-inch heeled 6'3" women with anatomically enhanced "nearly everything," barely constrained or covered, while "thrilling at a distance," seem somehow "less approachable" as they get closer.

It took quite a time to allure the dandies of the Seventies and Eighties away from the cast-iron "shield" bosom shirt that would deflect a bullet. It opened only at the back and had a tab on it with a button-hole for some mysterious purpose connected with underwear … Once freed from the yoke of this armorial garment we swing to the other extreme and men's shirtwaists appeared in the shop windows with no sign of mob violence. The shirtwaist brought the belt in place of suspenders and removed this unsightly blot on the landscape, to the further advancement in popularity of the shirtwaist.

'60s–'80s



Warhol, *POPism*, p. 73

Paraphernalia opened late in '65, and another trend started—stores opening late in the morning, even noontime, and staying open till maybe ten at night. Paraphernalia sometimes stayed open till two in the morning. You'd go in and try on things and "Get Off My Cloud" would be playing—and you'd be buying the clothes in the same atmosphere you'd probably be wearing them in. And the salespeople in the little boutiques were always so hip and relaxed, as if the stores were just another room in their apartment—they'd sit around, read magazines, watch TV, smoke dope.

Ibid., p. 206

Boutiques started opening up around St. Mark's Place, and used fur coat places and, of course, Limbo. Limbo was the most popular place in the area, because it was basically army-navy surplus (at first) and all the kids had started wearing military clothes. I recall an item in Howard Smith's *Voice* column about Limbo's selling strategy / psychology—it said a lot about the way kids were thinking: the store couldn't sell a bunch of funny-looking black hats, so one morning they made a sign that said, "Polish Rabbis' Hats" and they were sold out by that afternoon.

Ibid., p. 223

Tiger Morse opened her tiny new boutique called Teeny Weeny on upper Madison Avenue at the end of August. Her policy there was man-made materials only—vinyl, Mylar, sequins. There were mirror bricks all over the walls. Wherever I saw fragmented mirrors like that around a place, I'd take the hint that there was amphetamine not too far away—every A-head's apartment always had broken mirrors, smoky, chipped, fractured, whatever— just like the Factory did. And Tiger did take a lot of amphetamine. She always boasted, "I am living proof that speed does not kill."

A little bit later Tiger got the backing of some big company to design a line of pajamas and nightgowns for them, and to launch that, she gave a big party at the Henry Hudson Baths on West 57th Street that was sort of a fashion show "happening" around the pool, with models walking out onto the diving board, sometimes diving in, sometimes just turning around and walking back. As I said, it was Tiger who made happenings pop, turning them from something artistic into big parties. She'd stand around in her silver jeans and huge sunglasses, having a ball herself. People got so drunk they jumped into

the pool with all their clothes on and then later tried to dive to the bottom for things like wallets that had fallen out of their pockets.

I'd done a few movie sequences with Tiger at her old boutique, Kaleidoscope, on East 58ᵗʰ Street, above Reuben's Restaurant, where she had about six seamstresses sewing for her and hundreds of jars of beads and sequins all around. Before that she'd sold her clothes out of a house on 63ʳᵈ Street near Madison. In those days she did very expensive, chic, silk-and-satin, brocade-and-lamé–type designs for women who wanted nicely made couture-type dresses—a little froufrou sometimes—the kind of outfits that would have a hand-stitched lining that was more elaborate than the dress itself. Then Tiger went off to England, and after she came back she went plastic and started to make dresses out of shower curtains. Eventually she took over the Cheetah boutique on Broadway, right outside the club—it stayed open as late as Cheetah did, and people would just pop in and buy new disco clothes on their way in to dance.

Tiger designed that famous dress that said "Love" on the front and "Hate" on the back. And she did dresses that lit up on the dance floor, only there would always be some problem with the technology—the lights wouldn't work or the batteries would be dead, etc. Women used to have old-fashioned problems like slips hanging and bra straps showing, but now there was this whole new slew of problems.

I've heard people say, "Tiger Morse was a fraud." Well, of course she was, but she was a *real* fraud. She'd make up more stories about herself for the newspapers than I did. Nobody knew where she came from, really, but who cared? She was an original, and she showed a lot of people how to have fun.

An editor was describing to me how when you were sent clothes from a designer's showroom, you were usually sent the clothes neatly wrapped—period. When Tiger sent something over, you got the dress as well as the misplaced cotton ball or syringe cap. Brandes

Morse took a native African cloth, Kanga, put it in a tank of vinyl, and made unique clothes out of it. *Ibid.*

Morse said, "I'm making dresses that make noises, I'm making dresses that whisper, dresses that smell." "Tiger Morse"

One of Tiger's sayings, "I am living proof that speed does *not* kill" came to be sadly ironic in 1972. She passed away from an overdose of sleeping pills. *Ibid.*

Max's became the showcase for all the fashion changes that had been taking place at the art openings and shows: now people weren't going to the art openings to show off their new looks—they just skipped all the preliminaries and went straight to Max's. Fashion wasn't what you wore someplace anymore; it was the whole reason for going. The event itself was optional—the way Max's functioned as a fashion gallery proved that. Kids would crowd around the security mirror over the night deposit slot in the bank next door ("Last mirror before Max's") to check themselves out for the long walk from the front door, past the bar, past all the fringe tables in the middle, and finally into the club room in the back. Warhol, *POPism*, p. 236

Pop fashion really peaked about now—a glance around the Gymnasium could tell you that. It was the year of the electric dress—vinyl with a hip-belt battery pack—and there were lopsided hemlines everywhere, silver-quilted minidresses, "microminiskirts" with kneesocks, Paco Rabanne's dresses of plastic squares linked together with little metal rings, lots and lots of *Ibid.*, p. 263

Nehru collars, crocheted skirts over tights—to give just the idea of a skirt. There were big hats and high boots and short furs, psychedelic prints, 3-D appliqués, still lots of colored, textured tights and bright-colored patent leather shoes. The next big fashion influence—nostalgia—wouldn't come till August, when Bonnie and Clyde came out, but right now everything mod-mini-madcap that had been building up since '64 was full-blown.

Something extremely interesting was happening in men's fashions, too—they were starting to compete in glamour and marketing with women's fashions, and this signaled big social changes that went beyond fashion into the question of sex roles. Now a lot of the men with fashion awareness who'd been frustrated for the last couple of years telling their girl friends what to wear could start dressing themselves up instead. It was all so healthy, people finally doing what they really wanted, not having to fake it by having an opposite-sex person around to act out their fantasies for them—now they could get right out there and be their own fantasies.

Skirts were getting so short and dresses so cut-out and see-through that if girls had still been the sexy Playboy or Russ Meyer types, there might have been attacks all over the streets. But instead, to counteract all these super-sexy clothes, to cool down the effect of, say, microminis, the kids had new take-it-or-leave-it attitudes about sex. The new-style girl in '67 was Twiggy or Mia Farrow—boyishly feminine.

Ibid., p. 216

And the *Sgt. Pepper* was the general uniform for the boys at this point—the high-collar military jacket with red epaulets and piping that they wore with stovepipe pants—nobody was wearing bell-bottoms anymore. As for hair, lots of the boys had theirs Keith Richard–style—spiky and all different lengths.

Ibid., p. 294

The girls in California were probably prettier in a standard sense than the New York girls—blonder and in better health, I guess; but I still preferred the way the girls in New York looked—stranger and more neurotic (a girl always looked more beautiful and fragile when she was about to have a nervous breakdown).

Ibid., pp. 282–3

One hot August afternoon during that Love Summer of '67, Fred and I were out walking around the West Village on our way to pick up some pants I was having made up at the Leather Man. There were lots of flower children tripping and lots of tourists watching them trip. Eighth Street was a total carnival. Every store had purple trip books and psychedelic posters and plastic flowers and beads and incense and candles, and there were SpinArt places where you squeezed paint onto a spinning wheel and made your own Op Art painting (which the kids loved to do on acid), and pizza parlors and ice cream stands—just like an amusement park.

Wolfe, *Painted*, pp. 77–8

By the time the Museum's big Op Art show opened in the fall, two out of every three women entering the glass doors on West Fifty-third Street for the opening-night hoopla were wearing print dresses that were knockoffs of the paintings that were waiting on the walls inside. In between the time the show had been announced and the time it opened, the Seventh Avenue garment industry had cranked up and slapped the avant-garde into mass production before the Museum could even officially discover it. (They liked knocking off Bridget Riley's fields of vibrating lines best of all.)

Walford, p. 117

When paint-it-yourself dress kits were introduced onto the market in spring 1967, the Brooklyn department store Abraham & Straus commissioned Andy Warhol to paint a dress during an in-store "happening." Warhol stenciled

"FRAGILE" onto a dress while it was being worn by a model, and then signed the dress "Dalí."

In the eighties, Madonna wanted to dress you up in her love.

Frisa and Tonchi, p. 412

East Village street fashion of the eighties: mohawks, brothel creepers, knee-belted bondage trousers, septum piercings and shredded schoolgirl uniforms.

Ibid., p. 273

On 80s fashion: The body begins to define its own structure with aerobics and the gym. The garment is designed to give personality and power to individuals. Padding builds up the shoulders and lends an imposing and authoritative touch to the female figure … The female superbody is at its ease in the uniform of the career woman as well as in the costume of the sexy heroine. The male superbody is sculpture and has no fear of turning into a neoclassical gay icon.

Ibid., p. 15

On Mike Nichols's *Working Girl* (1988): "Melanie Griffith smiles with satisfaction in the office she has won at such a high price, while the lens frames her from outside the building and zooms back. To show her buried in a skyscraper filled with thousands of offices like her own, among a myriad of skyscrapers filled with other offices, just one ant in the anthill … If you're a woman in a world of men you have to adopt their uniform.

Ibid., p. 64

Sigourney Weaver: assertive and confident in her Donna Karan suits, sure of her upper-class accent, a successful female executive, an insincere feminist and therefore a real bitch … To do it, they need to have attitude, but above all the right clothes and well-padded shoulders."

Rei Kawakubo opened her first American shop on Wooster Street in 1983. It looked absolutely nothing like the traditional idea of a shop. There was no merchandise in the window, and not much in the store itself. Instead of broadcasting its wares to passersby, the store acted as a filter. Its character demanded a certain confidence from the customer—those who would not feel comfortable with the clothes would be unlikely to brave the front door.

Ibid., p. 399

Luxury

Yuppie culture: a cityscape of chrome mirrors, Ermenegildo Zenga suits, Salvatore Ferragamo shoes, portable scanners, compact disk players, mobile telephones, keyboards with incorporated telephones for transmitting stock exchange orders with electronic displays showing constantly moving market prices. Rooms fitted out with saunas, gyms, and squash facilities. Paintings by Julian Schnabel, Mimmo Paladino, Sandro Chia, Francesco Clementa and Enzo Cucci; brie-fragranced popcorn and Chardonnay wine.

Frisa and Tonchi, p. 451

In the early light of a May dawn this is what the living room of my apartment looks like: Over the white marble and granite gas-log fireplace hangs an original David Onica. It's a six-foot-by-four-foot portrait of a naked woman, mostly done in muted grays and olives, sitting on a chaise longue watching MTV, the backdrop a Martian landscape, a gleaming mauve desert scattered with dead, gutted fish, smashed plates rising like a sunburst above the woman's yellow head, and the whole thing is framed in black aluminum steel. The painting overlooks a long white down-filled sofa and a thirty-inch digital TV set from Toshiba; it's a high-contrast highly defined model plus it has a four-corner video stand with a high-tech tube combination from NEC with a picture-in-picture digital effects system (plus freeze-frame); the audio

Ellis, *Psycho*, pp. 24–9

includes built-in MTS and a five-watt-per-channel on-board amp. A Toshiba VCR sits in a glass case beneath the TV set; it's a super-high-band Beta unit and has built-in editing function including a character generator with eight-page memory, a high-band record and playback, and three-week, eight-event timer. A hurricane halogen lamp is placed in each corner of the living room. Thin white venetian blinds cover all eight floor-to-ceiling windows. A glass-top coffee table with oak legs by Turchin sits in front of the sofa, with Steuben glass animals placed strategically around expensive crystal ashtrays from Fortunoff, though I don't smoke. Next to the Wurlitzer jukebox is a black ebony Baldwin concert grand piano. A polished white oak floor runs throughout the apartment. On the other side of the room, next to a desk and a magazine rack by Gio Ponti, is a complete stereo system (CD player, tape deck, tuner, amplifier) by Sansui with six-foot Duntech Sovereign 2001 speakers in Brazilian rosewood. A downfilled futon lies on an oakwood frame in the center of the bedroom. Against the wall is a Panasonic thirty-one-inch set with a direct-view screen and stereo sound and beneath it in a glass case is a Toshiba VCR. I'm not sure if the time on the Sony digital alarm clock is correct so I have to sit up then look down at the time flashing on and off on the VCR, then pick up the Ettore Sottsass push-button phone that rests on the steel and glass nightstand next to the bed and dial the time number. A cream leather, steel and wood chair designed by Eric Marcus is in one corner of the room, a molded plywood chair in the other. A black-dotted beige and white Maud Sienna carpet covers most of the floor. One wall is hidden by four chests of immense bleached mahogany drawers. In bed I'm wearing Ralph Lauren silk pajamas and when I get up I slip on a paisley ancient madder robe and walk to the bathroom. I urinate while trying to make out the puffiness of my reflection in the glass that encases a baseball poster hung above the toilet. After I change into Ralph Lauren monogrammed boxer shorts and a Fair Isle sweater and slide into silk polka-dot Enrico Hidolin slippers I tie a plastic ice pack around my face and commence with the morning's stretching exercises. Afterwards I stand in front of a chrome and acrylic Washmobile bathroom sink—with soap dish, cup holder, and railings that serve as towel bars, which I bought at Hastings Tile to use while the marble sinks I ordered from Finland are being sanded—and stare at my reflection with the ice pack still on. I pour some Plax antiplaque formula into a stainless-steel tumbler and swish it around my mouth for thirty seconds. Then I squeeze Rembrandt onto a faux-tortoiseshell toothbrush and start brushing my teeth (too hungover to floss properly—but maybe I flossed before bed last night?) and rinse with Listerine. Then I inspect my hands and use a nailbrush. I take the ice-pack mask off and use a deep-pore cleanser lotion, then an herb-mint facial masque which I leave on for ten minutes while I check my toenails. Then I use the Probright tooth polisher and next the Interplak tooth polisher (this in addition to the toothbrush) which has a speed of 4200 rpm and reverses direction forty-six times per second; the larger tufts clean between teeth and massage the gums while the short ones scrub the tooth surfaces. I rinse again, with Cepacol. I wash the facial massage off with a spearmint face scrub. The shower has a universal all-directional shower head that adjusts within a thirty-inch vertical range. It's made from Australian gold-black brass and covered with a white enamel finish. In the shower I use first a water-activated gel cleanser, then a honey-almond body scrub, and on the face an exfoliating gel scrub. Vidal Sassoon shampoo is especially good at getting rid of the coating of dried perspiration, salts, oils, airborne pollutants and dirt that can weigh down hair and flatten it to the scalp which can make you look older. The conditioner is also good—silicone technology permits conditioning benefits without weighing down the hair which can also make you look older. On weekends or before a date I prefer to use the Greune Natural Revitalizing

Shampoo, the conditioner and the Nutrient Complex. These are formulas that contain D-panthenol, a vitamin-B-complex factor; polysorbate 80, a cleansing agent for the scalp; and natural herbs. Over the weekend I plan to go to Bloomingdale's or Bergdorf's and on Evelyn's advice pick up a Foltene European Supplement and Shampoo for thinning hair which contains complex carbohydrates that penetrate the hair shafts for improved strength and shine. Also the Vivagen Hair Enrichment Treatment, a new Redken product that prevents mineral deposits and prolongs the life cycle of hair. Luis Carruthers recommended the Aramis Nutriplexx system, a nutrient complex that helps increase circulation. Once out of the shower and toweled dry I put the Ralph Lauren boxers back on and before applying the Mousse A Raiser, a shaving cream by Pour Hommes, I press a hot towel against my face for two minutes to soften abrasive beard hair. Then I always slather on a moisturizer (to my taste, Clinique) and let it soak in for a minute. You can rinse it off or keep it on and apply a shaving cream over it—preferably with a brush, which softens the beard as it lifts the whiskers—which I've found makes removing the hair easier. It also helps prevent water from evaporating and reduces friction between your skin and the blade. Always wet the razor with warm water before shaving and shave in the direction the beard grows, pressing gently on the skin. Leave the sideburns and chin for last, since these whiskers are tougher and need more time to soften. Rinse the razor and shake off any excess water before starting. Afterwards splash cool water on the face to remove any trace of lather. You should use an aftershave lotion with little or no alcohol. Never use cologne on your face, since the high alcohol content dries your face out and makes you look older. One should use an alcohol-free antibacterial toner with a water-moistened cotton ball to normalize the skin. Applying a moisturizer is the final step. Splash on water before applying an emollient lotion to soften the skin and seal in the moisture. Next apply Gel Appaisant, also made by Pour Hommes, which is an excellent, soothing skin lotion. If the face seems dry and flaky—which makes it look dull and older— use a clarifying lotion that removes flakes and uncovers fine skin (it can also make your tan look darker). Then apply an anti-aging eye balm (Baume Des Yeux) followed by a final moisturizing "protective" lotion. A scalp-programming lotion is used after I towel my hair dry. I also lightly blow-dry the hair to give it body and control (but without stickiness) and then add more of the lotion, shaping it with a Kent natural-bristle brush, and finally slick it back with a wide-tooth comb. I pull the Fair Isle sweater back on and reslip my feet into the polka-dot silk slippers, then head into the living room and put the new Talking Heads in the CD player, but it starts to digitally skip so I take it out and put in a CD laser lens cleaner. The laser lens is very sensitive, and subject to interference from dust or dirt or smoke or pollutants or moisture, and a dirty one can inaccurately read CDs, making for false starts, inaudible passages, digital skipping, speed changes and general distortion; the lens cleaner has a cleaning brush that automatically aligns with the lens then the disk spins to remove residue and particles. When I put the Talking Heads CD back in it plays smoothly. I retrieve the copy of *USA Today* that lies in front of my door in the hallway and bring it with me into the kitchen where I take two Advil, a multivitamin and a potassium tablet, washing them down with a large bottle of Evian water since the maid, an elderly Chinese woman, forgot to turn the dishwasher on when she left yesterday, and then I have to pour the grapefruit-lemon juice into a St. Rémy wineglass I got from Baccarat. I check the neon clock that hangs over the refrigerator to make sure I have enough time to eat breakfast unhurriedly. Standing at the island in the kitchen I eat kiwifruit and a sliced Japanese apple-pear (they cost four dollars each at Gristede's) out of aluminum storage boxes that were designed in West Germany. I take a bran muffin, a decaffeinated herbal tea bag and a box of

oat-bran cereal from one of the large glass-front cabinets that make up most of an entire wall in the kitchen; complete with stainless-steel shelves and sandblasted wire glass, it is framed in a metallic dark gray-blue. I eat half of the bran muffin after it's been microwaved and lightly covered with a small helping of apple butter. A bowl of oat-bran cereal with wheat germ and soy milk follows; another bottle of Evian water and a small cup of decaf tea after that. Next to the Panasonic bread baker and the Salton Pop-Up coffee maker is the Cremina sterling silver espresso maker (which is, oddly, still warm) that I got at Hammacher Schlemmer (the thermal-insulated stainless-steel espresso cup and the saucer and spoon are sitting by the sink, stained) and the Sharp Model R-1810A Carousel II microwave oven with revolving turntable which I use when I heat up the other half of the bran muffin. Next to the Salton Sonata toaster and the Cuisinart Little Pro food processor and the Acme Supreme Juicerator and the Cordially Yours liqueur maker stands the heavy-gauge stainless-steel two-and-one-half-quart teakettle, which whistles "Tea for Two" when the water is boiling, and with it I make another small cup of the decaffeinated apple-cinnamon tea. For what seems like a long time I stare at the Black & Decker Handy Knife that lies on the counter next to the sink, plugged into the wall: it's a sliver/peeler with several attachments, a serrated blade, a scalloped blade and a rechargeable handle. The suit I wear today is from Alan Flusser. It's an eighties drape suit, which is an updated version of the thirties style. The favored version has extended natural shoulders, a full chest and a bladed back. The soft-rolled lapels should be about four inches wide with the peak finishing three quarters of the way across the shoulders. Properly used on double-breasted suits, peaked lapels are considered more elegant than notched ones. Low-slung pockets have a flapped double-besom design—above the flap there's a slit trimmed on either side with a flat narrow strip of cloth. Four buttons form a low-slung square; above it, about where the lapels cross, there are two more buttons. The trousers are deeply pleated and cut full in order to continue the flow of the wide jacket. An extended waist is cut slightly higher in the front. Tabs make the suspenders fit well at the center back. The tie is a dotted silk design by Valentino Couture. The shoes are crocodile loafers by A. Testoni. While I'm dressing the TV is kept on to The Patty Winters Show. Today's guests are women with multiple personalities. A nondescript overweight older woman is on the screen and Patty's voice is heard asking, "Well, is it schizophrenia or what's the deal? Tell us."

n Commodity — Luxury

McInerney, "Yuppies"

DIE YUPPIE SCUM
EAT THE RICH

Ibid.

Who are all those upwardly mobile folk with designer water, running shoes, pickled parquet floors, and $450,000 condos in semi-slum buildings?

Ibid.

Dhurrie rugs, potted ferns, pickled parquet floors, European automobiles, gourmet kitchens, computer literacy, designer clothing, sushi.

McInerney, *Bright Lights*, p. 4

You see yourself as the kind of guy who wakes up early on Sunday morning and steps out to cop the *Times* and croissants. Who might take a cue from the Arts and Leisure section and decide to check out an exhibition—costumes of the Hapsburg Court at the Met, say, or Japanese lacquerware of the Muromachi period at the Asia Society.

Ibid., p. 94

Vicky stops in front of an antique shop window on Bleecker and points to a wooden carousel horse, painted red and white, mounted on a pedestal. "I'd

like to have the kind of house someday where a carousel horse wouldn't be out of place in the living room."

James Bryce: The rich could be divided neatly into "best men" and "capitalists."

Hammack, p. 104

In mysterious New York luxury and wealth create, in an apotheosis of fireworks, those strange paradises in the very center of this antique, mechanical and polymorphous city, those paradises that transport us with a gentle and imperceptible speed.

de Chirico, p. 401

Smoking cigars wrapped in $100 bills or ordering gold-plated and gem-encrusted bicycles from Tiffany's.

Conrad, p. 65

If you could go breezing down the FDR Drive in a taxi, then why file into the trenches of the urban wars?

Wolfe, *Bonfire*, p. 54

McKim, Mead and White shaped a new city in which the luxury apartment could find a natural place.

Hawes

On Park Avenue, above Grand Central, many people—at a very high cost—believe they are living in style.

Wilson, "Leaving New York," p. 477

Lower Park Avenue, with its smoking open cut and clangor of steam engines, its fringe of disused breweries, livery stables and ancient factories, was roofed over and transformed into an esplanade bordered by luxury hotels and splendid apartment houses. Gradually, Park Avenue extended its arrogant magnificence, its costly, pampered residential exclusiveness for nearly three miles northward, to sink at last into the misery of East Harlem slums.

Morris, *Incredible*, p. 289

Park Avenue offered a new and revised version of well-to-do urbanity; it spelled out how the modern aristocracy intended to live now: lavishly, privately, but also cooperatively and efficiently, well served and well serviced, "near 'business' (and yet not actually, in their homes, on a business street)." From a Park Avenue address, it was walking distance to the new "Little Wall Street" of Madison Avenue, to the theaters and clubs of the West 40s, to Grand Central and points north and west. The city encircled, but it did not encroach.

Hawes

200 bronze dolphins from the Juilliard mansion on 57th St. are sold to a decorator who used them for lamp bases.

Berger, *New York*, p. 55

Eight-twenty Fifth Avenue is a vortex of desire in Manhattan residential real estate. Stand on the corner of East Sixty-third Street and Fifth Avenue, it looks like money.

Gaines, p. 22

A 24-hour-a-day population … being replaced by a 7-hour-a-day population for a period of only a 5-day week. We therefore have to look at this expensive machine—Park Avenue—being developed for usage only 30 hours per week.

Trager, p. 43

Waldorf-Astoria Hotel built with a private railroad siding, which enables guests with their own railcars to have them routed to the hotel's special elevator on Track 61, whence they can be whisked directly to their suites or to the lobby. Two subbasement levels extend far below the tracks to accommodate service facilities.

Ibid., p. 465

Berger, *New York*, p. 8 The Waldorf-Astoria has its wine cellars on the fifth floor. The hotel is built on steel and concrete stilts over the New York Central tracks. A stabilizer keeps the wine from being rocked by passing trains.

Moscow, p. 102 The first and only parlor car on New York's subways was built in 1904 for August Belmont, the financier who organized the Interborough Rapid Transit Construction Company, which built the IRT. The only known private subway car in the world, it was named *Mineola* and contained a bar, a washroom with stained-glass windows, full-length windows for observation, an arched Empire ceiling tinted green, and such amenities as pads against which strikers could strike their matches. Besides its motorman—*Mineola* had its own motor—the car's staff included a white-coated waiter who served caviar and drinks to guests. It was sold for scrap in 1973.

Bushnell Roger was sitting in a restaurant on the Upper East Side, feeling good and drinking red wine. He's thirty-nine, and he runs his own fund and lives on Park Avenue in a classic-six apartment.

Ibid. He's sitting in his junior loft in SoHo, which is paid for by his parents, as are all the rest of his expenses, his father being a coat-hanger magnate in Minneapolis.

Quan, p. 7 In my case, it's about leaving my cozy East Side cocoon for the shopless tree-lined wasteland that is Riverside Drive.

Morris, *Incredible*, p. 298 The conversion of a slum into New York's most fashionable quarter: on the edge of the East River and overshadowed by noisy Queensboro Bridge, several blocks of ancient, decaying brownstone dwellings lined the deserted continuation of Avenue A. It was here that Mrs. W. K. Vanderbilt chose to erect a handsome Georgian residence when she abandoned her Fifth Avenue chateau. Her friends bought and rebuilt adjoining houses. Old dwellings were remodeled as small, expensive apartments. Great apartment houses soon encroached on this exclusive precinct: "A Sutton Place address." A colony of millionaires, people of the theater, highly paid artists and writers.

Conrad, p. 278 Mrs. Astor's social quota of four hundred had been multiplied by O. Henry into four million.

Weegee, *Naked*, pp. 124–5 The crime teletype machine was quiet at police headquarters ... so I decided to sneak away and go to the opening of the opera. I watched the last minute rehearsal. I had no invitation but my press card was enough. War or no war, the Rolls Royces, big and shiny, kept arriving. Some had two chauffeurs with the usual gas ration sticker in the windshield. I guess if they ran out of gas one would steer while the other one would push.

I took stock of the situation. It was a cold night. Inside the warm lobby about two dozen photographers were lined up Wolf Gang Fashion. If one flashed a bulb all the others did too. It was like a game of "follow the leader." This is a big night for the cameramen, with the papers and syndicates sending only high class photographers who know society to cover because before a paper will publish a photo of the opening night the subject's name must be listed in the Social Register.

I like to get different shots and don't like to make the same shots the other dopes do ... so I went outside into the street. I started talking to a cop. On stories I always make friends with cops ... gangsters ... prostitutes, etc. A nice Rolls Royce pulled up ... I waited till the occupants got out and snapped the picture. I couldn't see what I was snapping but could almost

smell the smugness. I followed the women into the lobby, where the other photographers then snapped their picture too. I knew then that I had photographed real society so I asked the two women their names and made them spell them out too. Reporters gathered around them and asked them, if, in these critical times, it was appropriate to wear so much jewelry. The older woman first apologized for wearing last year's jewels and added the reason she did it was to help morale.

N. W. Ayer & Son, the big advertising agency who has the account of De Beers Consolidated Mines Ltd., that's the diamond trust, bought this picture for their files. They examined the photograph with a magnifying glass and said the diamonds were real …

The theatre was jammed so I went into the grand tier where the board of directors of the Metropolitan Opera House have their private boxes and picked myself a nice private box. There was another occupant, a director who kept his high silk hat on. I gave him a couple of dirty looks but he paid no attention to me or to the usher, who was evidently afraid to go near him.

During the intermission I went into the packed salon to watch what was going on. Cameramen were shooting fast and furious. Press agents, seeing my camera, pointed out notables to me but I refused to waste film or bulbs as I don't photograph society unless they have a fight and get arrested or they stand on their heads.

One woman dressed in ermine was pleading with her escort for a ham sandwich. Another couple was saying it was "well done." I don't know whether they were talking about their Thanksgiving turkey or the opera.

There are women who have charge accounts, plenty of leisure, poodle dogs, chauffeurs, a box at the opera and the right to sit in Gramercy Park. They have regular appointments with hairdressers.

Mitchell, *Ears*, p. 260

The wife perhaps of a Wall Street plunger; a woman who, in her startling clothes, and soaring hat, is the target in her box at the Broadway theater for all the bourgeois, vulgar eyes in the audience. If you talk to such a person you will find her, as you know, inconceivably empty, with her few ideas distorted perversely from anything important or universal.

Hapgood, pp. 377–8

It is a well-known fact among those with access to a broad spectrum of bank statements that the widows of Manhattan are in possession of its money.

Blandford, pp. 89–90

He said he'd rather paint an old suit of clothes than a new one because things used and frayed have "character, reality is exposed and not disguised." The wealthy, he thought, "spend money to disguise themselves."

Conrad, p. 97

Why did they all come to New York? "These kids from Cambridge in their early twenties," Danny said, "represented inherited wealth, inherited beauty, and inherited intelligence. These were the most glamorous young people in all America. I mean, they were *so* rich and *so* beautiful and *so* so smart. And so *crazy*. But up in Cambridge, all together, all they could think was, 'Oh, God, we're so bored, we're so tired of going to classes. We want to move out into the *real world*.' Moving out into the real world meant getting their picture in the papers and getting written up in the magazines."

Warhol, *POPism*, p. 123

I've always been fascinated by the assumptions that rich kids make. A lot of them think it's normal, the way they live—because it's all they've ever known. I love to watch their minds operate. There are two kinds of rich kids— the ones who're always trying to act poor and prove that they're just like everybody else and who secretly worry that people only like them for their

money, and the ones who relax and have fun with it, who even play it up. The second kind are fun.

Riesenberg and Alland, p. 73

The higher your class, the less patient you are. Class determines intervals between cars, and also the length of time you can be caged in a car.

Hilder, p. 595

Smartness, nowadays, is a relative term; and Society an elastic one. It is possible to be smart without being in the Social Register and to be in the Social Register without being smart, in the present-day sense. These people lunching about us are of mixed origins.

Federal Writers, *Panorama*, p. 84

The New Yorker of foreign white stock, having made tremendous contributions to the city for 300 years, is now in the process of becoming socially invisible.

Auchincloss, p. 35

The society of the so-called WASPs ... continued until World War II to dominate certain institutions: private schools, subscription dances for teenagers, debutante parties, and clubs, but the city's well-to-do had become too numerous and heterogeneous to be rallied under any single group, and the charm of a closed society had largely collapsed ... Ancestry now counts for nothing; family for little. Looks are far more important than a century ago, when they hardly counted at all. Society today cares very much about appearance and clothes. It likes to make an attractive picture, which is part of the immense role that public relations plays in modern life.

Chase, p. 4

In order to be a *real* New Yorker, one must have been *born* in New York, or else have lived in New York *ten full years*! ... It is permissible for newcomers to mention the fact that they *reside* in New York, and when they travel they may register at hotels as *from* New York, but under no circumstances may they claim to *be* New Yorkers, until they have served their full ten years of apprenticeship. New Yorkers are proud of New York. They are unwilling to permit strangers who merely *move* to the city to declare themselves New Yorkers until they have lived here sufficiently long to have achieved something or done their bit in adding to New York's prestige.

Blandford, p. 57

The problem with Manhattan is that there is no acceptable way of going to seed.

This is not an account of the city's changes but of the changes in this writer's feeling for the city.

Fitzgerald, *My Lost City*, p. 110

SoHo

The neighborhood around us transformed like a slowly developing photograph. The factories and loading platforms vanished one by one. Galleries and restaurants and boutiques proliferated like new life-forms escaped from some laboratory experiment. Once SoHo was declared chic, the rich descended on the area. They bought out the lofts that the artists vacated or were forced to leave. "The zombies," my father called them.

Pinchbeck

A few years earlier, when I'd first moved to Sullivan Street, I'd run into Dick Serra on the corner of West Broadway and Spring. After a muttered hello, he fixed me with a fierce scowl, flung his arm out, and snarled, "Some day all this will be fucking boutiques!" I laughed.

Tucker, p. 140

One can now climb long flights of wooden stairs to a loft, there to be greeted by a woman in a hostess gown. In the huge space, the furniture is chromium and black leather. The floors shine. The walls are white-on-white. The paintings hang splendidly. Over drinks, conversation is smart and knowing, and from the "kitchen space" (all stainless steel with a *fantastic* restaurant stove) wafts the odor of a bubbling *boeuf bourguignon*.

Anderson-Spivy and Archer, p. 11

One day a big artist realized that if he took all of the sewing machines and bales of rags out of a three-thousand-square-foot loft and put in a bathroom and kitchen he would be able to live and make big art in the same place. He was quickly followed by other big artists and they by big lawyers, big boutique owners, and big rich kids. Soon there was a Soho and it was positively awash in hardwood floors, talked-to plants, indoor swings, enormous record collections, hiking boots, conceptual artists, video communes, art bookstores, art grocery stores, art restaurants, art bars, art galleries, and boutiques selling tie-dyed raincoats, macramé flowerpots, and Art Deco salad plates … Scores of nine-by-twelve photo-realist renderings of gas stations, refrigerators, pieces of cherry pie, art collectors, diners, '59 Chevys, and Mediterranean-style dining room sets.

Lebowitz, pp. 131, 133

Making homes of the factory lofts of SoHo produced a new interior design for living. Loft space was not divided into a series of rooms, specialized areas, and personal territories. There was a great deal of variation in how lofts were converted for residential use; the common denominator, however, was the emphasis on large open areas. Lofts, with the same number of square feet as many American homes, are frequently entirely free of interior walls; a usual exception is the bathroom, but even that is open in some lofts. All lofts have high ceilings ranging up to fifteen feet. Areas for eating, sleeping, entertaining, and other routine functions are widely scattered. The following cases are extreme, in that they represent some of the most dramatic examples of loft living and life-style; however, since they are taken from the mass media, they indicate how the style of loft living was being presented to the public.

Hudson, pp. 56–60

A flatbed elevator opens onto polished hardwood and hanging greenery. The whole vista is partitioned by track-lighting into living, working and dining space. There are modular couches and Breuer chairs; a work in monumental burlap covers an entire wall. The owner greets you with cashews and Perrier. She's a buyer in the garment center. Her boss doesn't understand why she

Gentrification



won't live on Third Avenue. But what good is the East Side if you can't get into Regine's? And besides, her shrink lives down the block.

$1,200 king-size bathtubs and enough hot water to fill them, acres of exotic plants, uniformed housekeepers, children in private schools, Chinese chefs, touch-tone phones, closed-circuit TV surveillance, light dimmers, ice makers, trash compactors, industrial vacuum cleaners, Steinway pianos, antique pool tables, imported eighteenth-century beams, 24-foot-long leather sofas, original Rietveld chairs, Directoire settees, foundations, fireplaces, and more Bloomingdales. And the most middle-class hang-up of all—good housekeeping, and I don't mean the magazine.

Most people have to go outdoors to jog. Neils Diffrient and his wife, Helena Hernmarck, do their jogging in their loft, running past her looms and his drawing board, around the Ping Pong table, the open kitchen area, the freestanding fireplace and the open bedroom, while Thomas, the ginger cat, gets out of the way by bedding down on a table full of yarn … However, for all its high ceilings, white walls, and vast space, the Diffrients' loft hasn't the barren look of a gymnasium. The tools of their separate crafts form some of the furniture and certainly most of the decorative aspects of the loft.

These examples illustrate loft living and lifestyle at its most complete and polished. Their variety demonstrates the creative uses the tenants made of such spaces. Large numbers of loft dwellers, however, made only modest changes to handle the necessities of living: e.g., repairing broken windows, installing toilets that worked, and covering up holes in the floor. A few created museums of modernity.

The methods of dividing living and work space varied, as the quotations above indicate. Living and work spaces often overlapped. In other lofts there were clear separations. One loft owner installed three overhead garage doors to separate his work space from his family's living space. These could be opened at the end of the work day so that the spaciousness of the entire loft could be enjoyed by all. A printmaker kept his nineteenth-century press at the back of the loft: because of his very neat work habits, there was no jarring contrast between the living and work areas. In part, it was this variety of styles that led to the public attention and popularity enjoyed by loft living. In 1977, the Village Voice made the following assessment: "The presence of a unified avant-garde within a single neighborhood has profoundly altered the New York style, from the way we furnish our homes (high tech) to the way we envision public space. Even the decision to wear a solid T-shirt over painter's pants, reflects the SoHo aesthetic—combining the minimal with the found."

Loft living as a style became a recurrent subject for the media. A sampling of titles from contemporary magazine articles gives some of the flavor of this coverage: "Living Big in a Loft" (*Life*); "SoHo: Brave New Bohemia" (*Art News*); "SoHo: The Most Exciting Place to Live in the City" (*New York Magazine*); "Still Funky but oh so chic SoHo" (*Art News*); "Loft Living: Can You Make it on the Urban Frontier?" (*Apartment Life*). SoHo was even chosen as the locale for the film *An Unmarried Woman*.

Anderson-Spivy and Archer, p. 67

Said one woman tourist to another standing on the corner of Prince and Wooster: "And this is where she threw up after he told her that he was leaving her."

Ibid., p. 14

Within easy memory, you couldn't eat out in SoHo except in hero sandwich shops for the factory workers. It is now a place where limousines line up and idle in the evening darkness while rock stars as rich as they are dumb (to-wit preposterously) vie for tables in little bistros with pretentions that are grand indeed.

"Art" as both lifestyle and commodity is the basis of transformation. The actual form is the loft.

So the outcome of these combined developments was at least understandable, if not inevitable: SoHo became one of the major New York tourist attractions. By 1978, a 274-page SoHo guidebook had been published, complete with street maps, suggested walking tours, and a directory of eighty-five art galleries, twenty-five restaurants, and sixty-five shops and boutiques. In the huckster style of such books, Seigfried and Seeman provided the eager tourist with this opening description: "You are now about to enter SoHo, one of the most exciting 'new' neighborhoods in New York City." SoHo was in. In 1981, a novel entitled *SoHo* (Byrd) appeared, further enhancing the romantic image of the area. In 1984, the *New York Review of Books* published *The SoHoiad: or the Masque of Art: A Satire in Heroic Couplets*, by the pseudonymous Junius Secundus, which satirized many of SoHo's pretensions and mythological history. This work did not diminish SoHo's luster, but rather added to its notoriety.

Close by the Hudson, in MANHATTAN's town,
The iron palaces of Art glare down
On such as, wandering in the streets below,
Perambulate in glamorous SoHo,
A spot acclaimed by savant and by bard
As forcing-chamber of the *Avant-Garde*.

The district between Houston and Canal Streets in which all the buildings contain huge rooms—not just on the ground floor, where they are art galleried, but at all levels. These huge salons have ceilings as high as churches, and beautiful dance floors, all of laths of wood the same width, polished to the same color, and all installed on the same day. They have never been walked on.

Ever since there has been a SoHo, people have been grimly pronouncing it to be "over." It isn't "over": It wasn't over when the epitaph was first delivered: it is not "over" now.

Anderson-Spivy and Archer, p. 14

By that fall, SoHo was getting very trendy. People were already talking about this new urban frontier: Tribeca.

Frank O'Hara angrily lamented one night, "Jane [Freilicher] cares more about her new refrigerator than she does about her painting"—this, after spending a perfectly decent evening at the Hazan's new place, an apartment he apparently found alarmingly comfortable and middle class.

Kitchens are becoming less like kitchens and more like works of art.

Lefebvre, *Critique*, p. 8

The "Juddian" Kitchen.

Stills from Chloe's loft in a space that looks like it was designed by Dan Flavin: two Toshiyuki Kita hop sofas, an expanse of white-maple floor, six Baccarat Tastevin wineglasses—a gift from Bruce and Nan Weber—dozens of white French tulips, a StairMaster and a free-weight set, photography books—Matthew Rolston, Annie Leibovitz, Herb Ritts—all signed, a Fabergé Imperial egg—a gift from Bruce Willis (pre-Demi)—a large plain portrait of Chloe by Richard Avedon, sunglasses scattered all over the place, a Helmut Newton photo of Chloe walking seminude through the lobby of the Malperisa

Ellis, *Glamorama*, p. 45

o Gentrification — SoHo

in Milan while nobody notices, a large William Wegman and giant posters for the movies *Butterfield 8*, *The Bachelor Party* with Carolyn Jones, Audrey Hepburn in *Breakfast at Tiffany's*. A giant fax sheet taped above Chloe's makeup table lists Monday 9am Byron Lars, 11am Mark Eisen, 2pm Nicole Miller, 6pm Ghost, Tuesday 10am Ralph Lauren, Wednesday 11am Anna Sui, 2pm Calvin Klein, 4pm Bill Blass, 7pm Isaac Mizrahi, Thursday 9am Donna Karan, 5pm Todd Oldham and on and on until Sunday. Piles of foreign currency and empty Glacier bottles litter tables and countertops everywhere. In her refrigerator the breakfast Luna has already prepared: ruby-red grapefruit, Evian, iced herbal tea, nonfat plain yogurt with blackberries, a quarter of a poppy-seed bagel, sometimes toasted, sometimes not, Beluga if it's a "special day." Gilles Bensimon, Juliette Lewis, Patrick Demarchelier, Ron Galotti, Peter Lindbergh and Baxter Priestly have all left messages.

Goldsmith, *Theory*

While walking through the streets of Soho with Alison Knowles, where she has lived for decades, I asked her how she dealt with the drastic changes in the neighborhood. She smiled and said, "When I walk down the streets, I just look up at the tops of the buildings. And it's the same as it always was."

General

McInerney, *Bright Lights*, p. 134

This was your neighborhood. These shops were your shops. You possessed these streets as securely as if you held title. Now the vista is skewed slightly, someone has tilted the ground a few degrees, and everything is the same and not the same.

Freeman, p. 336

New York had become more like the rest of the country, the rest of the country, in some respects, had become more like New York.

Gopnik, p. 293

It's no accident that New York, as Paris did twenty years ago, is becoming a tourist spot (a tourist trap). People come to see the streets where bohemians once roamed. The city is dead, killed by the growth of the edge cities where suburban sprawl meets the semi-urban mall; by the final triumph of the car; by the need for schools and lawns and cheap shopping. Flight from the city, which seemed, in the past twenty years, to have been stemmed by the property tycoon's child-bearing revolution, the late-arriving baby is really (the argument goes) a force as inevitable as continental drift or evolution itself. All of life will soon be an exchange of pixels from seated positions in secure rooms.

Ibid., p. 11

By "city" we mean more than an urban amusement park; we mean a collection of classes, trades, purposes, and functions that become a whole, giving us something more than rich people in their co-ops and condos staring at other rich people in their co-ops and condos.

Ibid., pp. 293–4

So cities are dying, though their death will not be, as we long thought, slow and violent. They are just being strangled. Cities will die sighing, not screaming, but they will die. They will be inherited not by feral gangs and rampaging hordes but by aging yuppies, professionals, like ourselves, who will linger to remember the Last Bohemia, Soho and the Village, after their children have fled to the edge or to the Sunbelt, as they age and their apartments drip value, like coffee filters, year after year. If the city remains intact at all, it will be as a relic, just as Venice is now, which people will visit for "culture" (rather than for the life of art) and for recreation (meaning sex in a hotel room, for people who can afford it). London is already nearly

Londonland, Paris already a city of the rich and retired, and there is no more
Venice at all, really, just a kind of simulacra of it, drained of inhabitants, if not
of floodwater, and all in the past twenty-five years. Ten years ago New York
seemed as much a city as Dickensian London was a city—a great grim lamp
shining with greed and need, drawing people, like insects, to a doom they
didn't quite mind. Now New York is sinking beneath our feet.

I have an interest in this, as someone whose entire wealth, or, rather,
whose entire weight of optimistic debt, is sunk into the city, and as one who
has learned that he will never be able to drive (or sail or swim or do anything
save walk), and so I do not want it to be true. But when I walk the streets,
I don't feel something coming to an end, as one did in the early seventies,
when the previous New York of immigrant manufacture was dying and no
new thing was yet clearly being born. What I feel instead is a thing coming
into being through common need, which is all a city is. The immigrant
stories of this generation will be epic when the immigrant children come to
write them.

Picture a city with polite taxi drivers and children in strollers crowding the
avenues, where everyone is addicted to strong, milky coffee.

Ibid., p. 29

One might have the impression that it is the Upper West Side atheist and the
Lancaster County Amish who dispute the prize for who can be most obsessive
about having the children around the table at six p.m. for a homemade dinner
from farm-raised food.

Ibid., p. 19

As for the LES, the forces of McDisneyfication began a new assault around
1995—or at least that's when I began to notice it. Squats were attacked with
tanks. Rents began to skyrocket. Bohemia was holding on by the skin of its
teeth. Precious gardens were bulldozed and cheap shitty yuppie housing was
jacked up in the old sad vacant lots.

Wilson, "Tar," p. 103

There was an old Dominican guy who had a tiny garden next to my
building, with flowers, Virgin Mary, chairs, strange white "Chinese" chickens,
and afternoons of rum and dominoes. He got swept away. After a few months
of hideous pile-driving construction, a big new apartment building appeared.
In the lobby I saw arty b&w photos of picturesque LES people like crusty-
punk girls and old Dominican guys—the very people displaced to raise this
deluxe lazarette—like trophies in some rod 'n' gun club of bourgeois splendor.
"Everything that once was real moves away into representation."

The new office buildings and lofts are flanked by apartment houses as
stupidly planned, as extravagantly designed, as crazily and as dishonestly
financed as the business buildings themselves. The megalopolitan architects
who designed these puerile structures gloated over the prospect of a whole
city composed of skyscrapers, with aerial drives for the rich, and in the murky
canyons below the working and living quarters for the poor—artificially
lighted! artificially ventilated!—a city in which sunlight would be supplied
by sunlamps, grass by green tiles, and babies, presumably, by mechanical
incubation.

Mumford, *Sidewalk*, p. 34

The concert of the expensively provisional.

Nordenson, p. 15

What do you want to live in a Black neighborhood for? Motherfuck
gentrification.

Lee and Jones, p. 31

It briefly seems as though the hour of reckoning has arrived, when all those
outsiders will seize control.

Sante, "My Lost City"

Mars

In 1914, the government of New York City took ownership of a Manhattan apartment building belonging to David Hess. The city used a legal power called eminent domain, which allows a government to seize private property for public use—in this case New York City wanted to expand the subway system. Hess fought them and lost, and when all was said and done, his building was torn down, and he was left with a triangle-shaped piece of property. It was about the size of a large slice of pizza.

Later, the city tried to get him to donate his pizza-shaped property so that they could build a sidewalk. He refused again. They built the sidewalk anyway, and in the middle of the sidewalk is Hess's triangle, with a tile mosaic that reads:

PROPERTY OF THE
HESS ESTATE
WHICH HAS NEVER
BEEN DEDICATED
FOR PUBLIC
PURPOSES

Mumford, *Sidewalk*, p. 43

The water and soil, as the prime environment of life, were becoming "immaterial," that is to say, they were of no use to the canny minds that were promoting the metropolis, unless they could be described in a legal document, appraised quantitatively, and converted ultimately into cash. A farm became for the speculator a place that might be converted into building lots … There was always the chance that some negligible patch of earth might become, in the course of the city's growth, a gold mine. That was magic. In the atmosphere of magic, the desire to get something for nothing, a whole population hoped and breathed and lived.

N. cit.

The ordinary lives caught in the spectacle of Manhattan.

Hawes

Set plumb down in the midst of slums, antique warehouses, discarded breweries, slaughter houses, electrical works, gas tanks, loading cranes, coal-chutes, the very wealthy have begun to establish their city residence in huge, new palatial apartments.

Johnson, "Minor," p. 972

The denial of the tenement as a tenement and insisting upon it as "a charming place" once it had been stripped to its core, taken back virtually to its prehistory as a dwelling. Plaster was laboriously scraped off brick that had always been plastered; windowsills and lintels were sanded raw; decades of linoleum were ripped up to reveal floorboards underneath, even parquet, sometimes, perfectly preserved by generations of housewives who always put a covering on anything "good."

Zukin, pp. xii–iii

If authenticity has a schizoid quality, it can also be deliberately made up of bits and pieces of cultural references: artfully painted graffiti on a shop window, sawdust on the floor of a music bar, an address in a gritty but not too thoroughly crime-ridden part of town.

Hawes

Every building seemed to be of the very highest type, of the very best construction, have the latest conveniences, be blessed with the most exclusive neighborhood. Quite ordinary buildings were described as monuments or ornaments, their addresses as breeze-swept or panoramic, even if they happened to be set back in the middle of the island.

© Gentrification — General

Like many young people, I'd assumed the world—the physical reality of stores, restaurant locations, apartment buildings, and movie theaters and the kinds of people who lived in this or that neighborhood—was far more stable than it was.

Delany, p. xiv

Essex St. ... Where Jewish People Used To Be
Forsyth St. ... Where Puerto Ricans Used To Be
"Little Italy" ... Where Italians Used To Be

Maffi, p. 13

Apartment buildings are being torn down and replaced by offices ... This is the real estate man's answer to a need for additional income. Space, which as apartments is returning $3 a square foot, is being replaced by space, which as offices is returning $8 a square foot—a very simple arithmetic improvement.

Ibid.

There will always be some corner of this city the developers can't reach. Some run-down parcel full of garbage that can pass for a backyard.

Trebay, p. 314

There is, in fact, a kind of creeping bank disease laying a cold, dead hand on New York wherever the shiny new construction appears.

Huxtable, *Goodbye*, p. 23

A century ago, this vibrant city neighborhood made a kind of quantum leap and became a hyper-city neighborhood.

Berman, *Town*, p. xxi

When the city is totally renovated, when gays have restored all the tenements, garden restaurants have sprouted on the Lower East Side, and the meatpacking district is given over entirely to boutiques and card shops—then we'll build an island in New York Harbor composed entirely of rotting piers, blocks of collapsed walls, and litter-strewn lots. Ruins become décor, nostalgia for the mud.

Holleran, "Nostalgia," p. 69

The coffee bar in the television show *Friends*, ostensibly in New York, could be in any American city, unlike the coffee shop in the slightly earlier *Seinfeld*, which had a distinctly New York ambience.

Huxtable, *Goodbye*, p. 22

A commissioner of Cobb County, in Gingrich's congressional district outside of Atlanta, told a *New York* magazine reporter, "We're the power now. These suburbs, built on white flight, are only going to become more conservative and more powerful. New York has been deposed."

Freeman, p. 336

So many neighborhoods in New York are recent inventions.

Brook, p. 236

Transition

The cult of change, of substitution, pretends that new locations are best.

Riesenberg and Alland, p. 20

Leave town for a week and you will notice changes when you return. It is quite possible to pay a visit to your lawyer or your bank only to discover that the erstwhile building in which their business was formerly transacted has disappeared in favor of a deep hole in the ground. Contrariwise, a new and glittering tower, fifty or more stories in height, may rise in another direction before you are aware of the preparatory excavations. It is quite possible in New York to lease an apartment on the thirty-fourth floor with a splendid and uninterrupted view and a great deal of sunlight only to find before a year has passed that both view and sunlight have been blocked out by taller neighbor. It is even possible to live on a short, narrow street which suddenly, through

Van Vechten, pp. 137–40

an aldermanic whim, becomes longer and broader. Elevated and street-car lines, traditional for a quarter of a century or longer, have been known to disappear in a week. Even a New York taxi driver—and New York taxi drivers are celebrated for their charm, wit, and intelligence—cannot hope to keep himself informed in regard to the hotels, theaters, and restaurants. In Victorian days such landmarks as Delmonico's and Martin's moved northward every decade, the Hartigan Theater became the Mansfield, and later the Garrick. Now, the changes are accomplished more swiftly. Almost before the last stone had been removed from the old Waldorf-Astoria, a new Waldorf-Astoria was rising on Park Avenue. Stanford White's Madison Square Garden, with its celebrated replica of the Giralda Tower, *in Madison Square*, has been supplanted by a Madison Square Garden on Eighth Avenue. Maxfield Parrish's mural decoration representing Old King Cole which so recently graced the Knickerbocker Hotel bar has been transformed to the Racket Club, but what has become of Saint-Gauden's Diana nobody seems to know. Famous old theaters devoted to the drama become movie picture houses overnight, and new theaters arise on every corner. Only exceptionally does a hotel hold its prestige or its clientele over long periods, and when a friend telephones that he is stopping at the New Neptune, although one has never heard of it before, he knows that it is the latest thing in hostelries. You must ask its location so you can inform your taxi driver, for he probably will not be acquainted with it. Probably even the telephone company is ignorant of the telephone number and by the time it learns it, the number will have changed. Once Bryant, Gramercy, Riverside, Columbus, Stuyvesant, Chelsea, and a few other simple names, suggestive of New York families and localities, designated the exchanges. Now scarcely a day passes but what some fantastic appellation like Lifeguard, Volunteer, Caledonia, El Dorado, Medallion, Galsworthy, or Nightingale is added to the list. It is not beyond possibility that there are more telephones in New York than there are people.

Like the restaurants—and many speakeasies are restaurants—this or that speakeasy or bootlegger goes in or out of fashion. It is one man's gin this month, another's next. A bootlegger must have unusual qualities to retain his custom over a long period of time. It is not that New Yorkers are more fickle than the citizens of another town, it is perhaps that they do not exist homogeneously. If they applaud this concert artist in 1927, and neglect him in 1928, if they buy their Corton 1915 on Sixth Avenue in 1929 and on Lexington Avenue in 1930, it is not so much because they are forgetful as because for the most part they are entirely different people who have moved in from London and Chicago while the New Yorkers of the twelve months earlier have gone to Africa, Palm Beach, and China. It is also quite certain, as Paul Morand has repeatedly pointed out, that what is *new* in New York is always more beautiful and better than what is old. This statement may not be comprehensible to the inhabitants of Bruges or Segovia, but nevertheless it is quite true.

Ibid., p. 142

The "sights" of New York change perpetually: McGowan's Pass Tavern, Jack's, Shanley's, Rectors, have all disappeared, while the new Casino in Central Park would not be on speaking terms with the old. The Brooklyn Bridge is still to be observed, but the Hudson Tube is a more modern wonder. Negro Harlem has supplanted Chinatown and the Bowery in the affections of those who seek diversion at night. The Woolworth Building, once the eighth wonder of the world, is no longer solitary or even paramount. Towers have sprung up on every hand—and continue to rise—until New York begins to resemble in the twilight a greater and more glittering San Gimignano in which the machine-gun battles of the gangsters and racketeers remind one of the medieval conflicts between the Guelphs and Ghibellines.

If the Chanin Building were to be torn down next week, nobody in New York would realize it was gone.

 "The Chanin Building? It's all right with me. Let 'em tear it down!"
 "The Chanin Building? A very good idea!"
 "The Chanin Building? Jeez, miss, they tore that down years ago!"

Atkinson, p. 38

The vanished ornaments of our city: the beautiful Produce Exchange at Beaver and Bowling Green, destroyed in the mid-fifties; the three Brokaw mansions at 79th and Fifth, two of which were smashed into rubble in 1965, to be replaced by an ugly high rise; Rhinelander Gardens on 11th Street between Sixth and Seventh Avenues, with their cast-iron filigreed balconies and deep front gardens, demolished in the late fifties; the splendid Studio Building at 51-55 West 10th Street, designed by Richard Morris Hunt, inhabited by a string of artists, including John La Farge and Winslow Homer, until it was demolished in 1954; the elegant, high-ceilinged cast-iron buildings on Worth Street between Church and Broadway, torn down in 1963 to make way for a parking lot; the old Ziegfeld Theater at 54th and Sixth; the Astor Hotel on Broadway between 44th and 45th; dozens of others. A city is always more than its architecture, but to destroy the past that is expressed by enduring architecture is an assault on history itself. Growing up here, you learned one bitter lesson: Whenever something was destroyed for the crime of being old, what replaced it was infinitely worse.

Hamill, "Lost"

Luxury apartment buildings rose up, and French flats, family brownstones, and historic mansions were carted off in pieces to the dump.

Hawes

The records show that the streets were always in a state of disrepair; the city was always being torn down and rebuilt.

Atkinson, p. 262

There is a geometric progression of chaos.

Corbusier, p. 111

The latest skyscraper is always the best.

Federal Writers, *Panorama*, p. 13

A metropolis forever in the making, New York is a constant reminder of the mutability of urban landscapes and the radical impermanence of the city.

Lindner, p. 197

On January 1, 1898, New York had become Greater New York, verified the passing of Old New York, and relegated the old ways and the old cityscape to the history books.

Hawes

Looking back on the splendid relaxation of 1945, it seems that just for a spell the city *was* finished, *was* staying the same, as it contemplated its new status in the world and breathed the long sigh of victory.

Morris, *Manhattan '45*, p. 11

New York is not a finished or completed city. It gushes up. On my next trip it will be different.

Corbusier, p. 45

He visited again in 1928.

Hawes

When Henry James returned to New York in 1904, he saw gold dust in the air. New York looked like a boom town, he said, and surmised that the changes were mere tokens of those yet to come. Describing the twenty-story triangulated Fuller Building, which had just risen on a strange and stingy little pie-shaped piece of real estate pointed uptown at the southern end of Madison Square, Saltus pointed out, like a clairvoyant, that "Its front is lifted to the future. On the past its back is turned."

Ibid.

Brook, p. 15

It scarcely seems possible that this vertical island, as frail as skittles, as solid as trees, could exist. And yet you know it's not just a fantasy of form but a living city. It changes not just because its permutation of relationships, one building to another, is close to infinite, but because the city itself is dedicated to change. With cannibalistic delight New York consumes itself, tearing down the old and then creating, and not always for the worse, a new structure in its place. New York, constantly surprising you, constantly tightening the screws of its own intensity, is the ultimate city of the world, the last word in urban existence; around the clock it will make its demands of you, never letting you go, rarely allowing you to relax, repeatedly assaulting the senses.

Hawes

As a whole section of the city like the Upper West Side changed its contours, it was like a great geological event—the collision of continents or the birth of mountain ranges. The territory literally erupted. Dynamite blasts rocked the neighborhood, shaking houses and scaring horses in the street. Broadway opened up like a fault. In almost every block of the grid, there were yawning pits in the bedrock, created by the vast excavations necessary for the foundations of the new, oversized buildings.

Sanders, *Celluloid*, p. 207

To define a building is to tell its history. Originally a row house, built for a single family in the nineteenth or early twentieth century, it has since been converted into apartments, usually one to a floor. Kitchens have been added on the upper stories, and bathrooms, too, to make each floor a self-contained unit. The old house's staircase has become a common area, giving access to each apartment's door. There are thousands of such buildings, all across the city.

Gooch, p. 218

For Frank O'Hara, New York was the New Jerusalem. I remember just going down the street with him when they were tearing down some brownstones. I said, in the usual clichéd way, "Oh what a pity they're tearing down those brownstones." Frank said, "Oh no, that's the way New York is. You have to just keep tearing it down and building it up. Whatever they're building they'll tear that down in a few years."

Merrill, p. 21

As usual in New York, everything is torn down
Before you have had time to care for it.
Head bowed, at the shrine of noise, let me try to recall
What building stood here. Was there a building at all?
I have lived on this same street for a decade.

Hawes

Throughout the 1920s, new buildings appeared every fifty-one minutes.

Caldwell, p. 313

Midtown, since shortly after 1900 the city's nighttime center, looked more threadbare and tired every year, with decades-old institutions like the Stork Club, Lindy's, or Toots Shor's aging and moribund. Yet by the 1960s the suburbs were beginning to show unmistakable hints of senescence as well … full of passive human livestock who lumbered unseeingly through mindless workdays, they sat out their evenings, faces gaping and gray-blue in the light from television sets. To the baby boom children, dangerous or not, New York started to seem desirable, even its decrepitude romantic and alive with opportunity.

Berman, *Town*, p. 6

Early in the twentieth century, every city had its "Great White Way." Most of these went dark after World War Two, when the Federal Highway System

engineered the destruction of downtowns all over the country; New York alone survived to tell the tale.

Yesterday's solution became today's problem.

Feininger, *Face*

At present, [New York] is like a house-moving, all the furniture in confusion, scattered about, unkempt. But order will come.

Corbusier, p. 45

What follows demolition is preordained by the divine right of development. There will be the same new buildings out of the same old mold, sleekly commercial or shoddily residential; and in the ground floor store space of all, as if by some holy decree, there will be banks.

Huxtable, *Goodbye*, p. 23

Neighborhoods fall like dominoes.

Ibid., p. 17

Every building shown here has since been demolished.

Laredo, p. 22

I've begun work on the west side, and in Washington Market I have somewhat of a jump on the demo men. The Trade Center site is practically impossible to work in. PATH has the ruins guarded, and the wrecking is going so fast that buildings have disappeared overnight. As I see it now I might weave a kind of song of destruction. The base of it would be a documentary record of buildings and blocks soon to be demolished, and a record of demolition work … The market, located in the area since the War of 1812, was moved one day to a new quarters in Hunts Point, the Bronx. The silence left in the streets was startling. As one wanderer put it, everyone left one night, even the dogs and the rats.

Lyon, p. 12

There's nothing quite like a good house wrecking. Come one, come all. You are cordially invited to a demolition watching. It's a great performance of a kind being given with increasing frequency in Manhattan, one that could replace the "happening" as the most chic of avant-garde architectural events … Free demolition watchings will be offered in all of New York's best styles and periods: High Victorian, Early Skyscraper, Cast Iron Commercial in Lower Manhattan, Greek Revival on the waterfront.

Huxtable, *Goodbye*, p. 20

Last call for anyone who wants to see the wonders of old New York, the real, live, genuine, remaining bits of the old city in Lower Manhattan, sitting at the feet of the most famous skyscrapers in the worlds. The biggest buildings on the smallest streets, the newest next to the oldest, the soaring present and the small-scale past. There is no doubt about it, this jam-packed mass of spectacular stone and steel with its dash of historical seasoning is the most spontaneously romantic and shatteringly magnificent cityscape ever known.

Ibid.

Fate probably never meant Lower Manhattan to attain any semblance of hoary antiquity anyway. Almost every vestige of the original Dutch village was burned away by great fires in 1776 and 1778. The area was leveled to ash again in 1835.

Berger, *New York*, pp. 279–80

The splendor of the necessary acts of destruction are almost magnificent in themselves—small wonder that some planners find ruthless change fascinating.

Silver, p. 12

The esteemed cobbled slips and lanes, the Greek Revival coffee and spice houses just about the Battery that are rapidly disappearing and taking with

Huxtable, *Goodbye*, p. 116

them the sense of the harbor's historic sailing age, the shabby Georgian-Federal structures redolent of fish in the old Fulton Market; dormered and pitch-roof brick houses against the Gothic stone and spiderweb steel of the Brooklyn Bridge; the granite blocks and Greek lintels that still face ropeworks and casual bars and beaneries in the old city; the 19th-century breaks in the 20th-century skyscraper-lined canyons that let in the sleety New York sky and the ghosts of New York history. It is all going, going, gone.

Ibid., pp. 115–16

Remember Brooklyn Bridge South? The city crushed the life and color out of it and handed the wreckage to developers for urban renewal superblocks. We won't bore you with the losses again; they are recorded in New York histories and architectural textbooks. They are also preserved on hundreds of feet of underground movies and uncounted photographs by artists, historians and observers of the New York scene who roamed the rosy brick rubble—there is no brick quite as handsome as that of the 18th and early 19th centuries—while recording film and grim despair. (You meet some of the most interesting people on demolition sites.)

Berman, *Calling*, p. 19

For several years the *Times* carried a box that contained addresses of buildings destroyed the previous day or night.

Ibid., p. 25

And then, instantly, as if by magic, *the fires stopped*. In the last year of fire insurance, the Bronx lost about thirteen hundred buildings; in the first year of no fire insurance, it lost twelve.

Sante, "My Lost City"

I got used to seeing large fires in that direction every night, usually set by arsonists hired by landlords of empty buildings who found it an easy choice to make, between paying property taxes and collecting insurance. Avenue C was a lunar landscape of vacant blocks and hollow tenement shells.

Atkinson, p. 28

Without giving much thought to it, New Yorkers naturally consider that they are living in the most modern and most luxurious city in the world. Nothing could be farther from the truth. As a matter of fact, most of this city is tumble-down, old-fashioned, battered and crumbling. Walking about the streets and observing the state of dwelling houses in general, you get the uncomfortable feeling that this is a doomed city.

Conrad, p. 79

The illustrations of Joseph Pennell wishfully ruin the city in order to make it pictorially appealing. Thus, while the engineers are building New York, Pennell is picturesquely demolishing it.

Huxtable, *Architecture of NY*, pp. 32–3

A splayed lintel or the double keystone of an eighteenth-century survival rates with the spotting of a pileated woodpecker.

Conrad, p. 169

Abbott's images are obituaries. These houses no longer exist, she noted in 1943 of a Cherry Street row she had photographed in 1931.

Abelli, "Tricks"

We could tear the Chrysler building down in nine months. The Woolworth Building would take my army eight months to reduce to dust.

Baudrillard, *America*, p. 17

Modern demolition is truly wonderful. As a spectacle it is the opposite of a rocket launch. The twenty-storey block remains perfectly vertical as it slides towards the center of the earth. It falls straight, with no loss of its upright bearing, like a tailor's dummy falling through a trap-door, and its own surface area absorbs the rubble.

In an unusual challenge for demolition experts, contractors are planning to lop off the top 12 floors of a 31-story tower at 108 East 96th Street, just east of Park Avenue.

Kaplan, p. 40

Workers strip the Ansonia Hotel of four 100-pound cornices during the wartime scrap metal drive.

Diehl, p. 148

Of course the Woolworth is nothing but yesterday's little old skyscraper, and nobody pays attention to it any more.

Atkinson, p. 93

Gentrification — Transition

White, *Here*, pp. 27–8

The commuter is the queerest bird of all. The suburb he inhabits has no essential vitality of its own and is a mere roost where he comes at day's end to go to sleep. Except in rare cases, the man who lives in Mamaroneck or Little Neck or Teaneck, and works in New York, discovers nothing much about the city except the time of arrival and departure of trains and buses, and the path to a quick lunch. He is desk-bound, and has never, idly roaming in the gloaming, stumbled suddenly on Belvedere Tower in the Park, seen the ramparts rise sheer from the water of the pond, and the boys along the shore fishing for minnows, girls stretched out negligently on the shelves of the rocks; he has never come suddenly on anything at all in New York as a loiterer, because he has had no time between trains. He has fished in Manhattan's wallet and dug out coins, but has never listened to Manhattan's breathing, never awakened to its morning, never dropped off to sleep in its night. About 400,000 men and women come charging onto the Island each weekday morning, out of the mouths of tubes and tunnels. Not many among them have ever spent a drowsy afternoon in the great rustling oaken silence of the reading room of the Public Library, with the book elevator (like an old water wheel) spewing out books onto the trays. They tend their furnaces in Westchester and in Jersey, but have never seen the furnaces of the Bowery, the fires that burn in oil drums on zero winter nights. They may work in the financial district downtown and never see the extravagant plantings of Rockefeller Center, the daffodils and grape hyacinths and birches and the flags trimmed to the wind on a fine morning in spring. Or they may work in a midtown office and may let a whole year swing round without sighting Governors Island from the sea wall. The commuter dies with tremendous mileage to his credit, but he is no rover. His entrances and exits are more devious than those in a prairie-dog village; and he calmly plays bridge while buried in the mud at the bottom of the East River. The Long Island Rail Road alone carried forty million commuters last year; but many of them were the same fellow retracing his steps.

The terrain of New York is such that a resident sometimes travels farther, in the end, than a commuter. Irving Berlin's journey from Cherry Street in the Lower East Side to an apartment uptown was through an alley and was only three or four miles in length; but it was like going three times around the world.

LeDuff, p. 114

The Connecticut contingent of Wall Street and Park Avenue arrived in waves of cologne. They were bond traders and advertising executives, lawyers and radio personalities, the blue bloods and blue shirts. The men wore tasseled loafers, suede loafers, wing tips. They sported gold watches and legal briefs. The woman wore a power suit.

Cheever, "Five-Forty-Eight," p. 287

The place was crowded with commuters putting down a drink before the ride home. They had brought in on their clothes—on their shoes and umbrellas—the rancid smell of the wet dusk outside.

Bushnell

And then something happened. No one thought it would, but it did, which just goes to show that you can never tell about these things. She turned thirty-five and she met this investment banker who worked for Salomon Brothers, and before you knew it, they were married, she was pregnant, and they were moving to Greenwich.

Ibid.

"Nothing will change," she said. "We'll still get together all the time and you can come to visit us and we'll have barbecues in the summer."

We all said, Yeah, yeah, yeah.

The suburbanite is merely an intelligent heretic who has discovered that the mass of New York or Chicago or Zenith is a mean environment.

Mumford, "Intolerable," pp. 283–93

A substitute hometown in which everyone lives and no one is at home.

Federal Writers, *Panorama*, p. 5

Long Island as a gigantic cul-de-sac, a dead end.

Caro, p. 942

You can't think east; it's got to be west. Your raw materials have to come in from the west; your finished products have to go out to the west. And the west is New York, and New York is congestion.

Ibid.

you will split the heavens of Long Island
and resurrect your living human Jesus from the
superhuman tomb

Ginsberg, *Howl*, p. 7

Wantagh, Seaford, Massapequa, Massapequa Park, Amityville, Copiague, Lindenhurst, Babylon.

Trebay, p. 312

Onto Long Island's potato fields was going to be dumped a population the size of Philadelphia.

Caro, p. 943

Girls coming to live in New York, like any out-of-towner here for a spree, are often grotesque caricatures of the well-turned-out New York Girl. Their hair is too high, teased, pampered or dated. Their clothes too short, bizarre or tight. Their make-up too extreme … Not yet aware that even models don't appear in public as they do in the ads, the new girls imitate them and wind up looking like animated cartoons. Depending on whose hands they fall into … or through … or are influenced by … they may eventually acquire the New York polish.

Petronius, p. 8

A giant orphanage. Many of those who come here have lost or purposely mislaid those parents they once had. At Thanksgiving they gather friends and talk of having a real "family" holiday, meaning the peer group of the moment.

Blandford, p. 56

I knew I couldn't live in America and I wasn't ready to move to Europe so I moved to an island off the coast of America—New York City.

Gray, "Quotes"

A mysterious island in the *mare tenebrosum*.

Stokes, *Iconography*, p. i

So that the one thing I am certain of is what I set out with … that *New York Is Not America* … and of that I am certain—certain sure—because all, all the rest, the inhabitants of Terre Haute, of Seattle, of Los Angeles, of St. Augustine, of Norfolk, Va., or Boston, Mass … all, all the rest of the inhabitants of the Republic of the United States of North America will assure you that New York is not that.

Ford, *America*, p. 233

America collapses inside New York.

Maffi, p. 76

The American who settles in New York becomes at once an ex-American.

Ford, *America*, p. 95

The sense of not being a part of America.

Freeman, p. 26

I don't like New York. It's just another foreign country.

Ibid.

I would remain physically in Harlem and psychologically in Alabama.

Ellison, "NY, 1936," p. 1000

Hardwick, "Shot," p. 103	Somewhere in the grainy, indivisible out-there: area code 718, and what did that signify—the Bronx, Queens?
Moorhouse, p. 58	The Bronx/No Thonx
Allen and Brickman, *Annie Hall*	I-I-I mean, I'm comparatively normal for a guy raised in Brooklyn.
Mumford, *Sidewalk*, p. 134	Brooklyn has all the luck.
Sullivan, *1001*, p. 201	Staten Island is the Australia of New York City.
Josephy and McBride, pp. 235–6	Three kinds of New Yorkers move to the country—the small-salaried family man, the Bohemian, real or pseudo, who now finds it smart to commune with nature, and the very rich cosmopolitan who automatically has a home in Long Island or Westchester just as he does in Paris or Palm Beach, and stays in none.
Strong, p. 565	I hereby prophesy that in 1900 A.D. Brooklyn will be the city and New York will be the suburb.
Morris, *Incredible*, p. 291	To Manhattanites, Brooklyn remained a vague region lying between the East River and the Atlantic Ocean at Coney Island, a human reservoir that released its floods into the subway during the early morning rush-hour and drew them back during the evening one.
Atkinson, p. 266	Speaking for myself, I know I'm very tired of this city.

Commuter Train

Caro, pp. 935–9	Living standards on affluent Long Island were high even for America. The homes of many Long Island Rail Road commuters were large, luxurious, thickly carpeted, richly draperied, crammed with the most modern appliances for cleanliness and cooking. The vicissitudes of climate were eliminated for them not only in their homes—no county in America had so many centrally air-conditioned homes as Nassau—but in their automobiles, all of them heated, most of them air-conditioned. These automobiles—the automobiles out of which Long Islanders stepped every weekday morning to board the Long Island Rail Road—symbolized the degree to which the affluence and technological genius of America had given its people a life cushioned against physical discomfort.

Then the train arrived, and the Long Islanders climbed aboard.

The linoleum on the floors of the coaches into which they stepped was cracked and split, impacted with layers of grime. Paint was flaking off grimy walls. The windows, so thickly smeared with grime that you could hardly see through some of them, were filled with spider webs, and with the lacy spread of thin cracks radiating out from holes smashed in them and never repaired. Some of the holes were covered with bits of cardboard held on with tape; others gaped jaggedly.

The seats were ripped and humped. Their springs were sprung. Their backs sagged limply backwards. Sitting in those seats meant sitting in dirt. If you rested your arm on a windowsill, your coat sleeve came away covered with dust. You sat with your feet among wads of chewed-up gum on which the spittle had long since dried, among gum and candy wrappers, sheets of newspapers, fragments of ice-cream cones and, occasionally, discarded hunks of food. It was a good idea not to let your eyes focus on the floor. You might see

drobs of spittle, or fat bugs scuttling by your bright and shiny shoes. Yet men pushed and shoved for those seats, for those who didn't get them had to stand, and standing on the Long Island's swaying, lurching coaches wasn't easy.

Particularly because one might have to stand for quite a long time. Even when it was running on time, the Long Island Rail Road was slow—incredibly slow. And the railroad seemed almost never to be running on time. There were days, in fact, on which, because of equipment malfunction in the LIRR's main Pennsylvania Station terminal, every Long Island train was late. There were days on which every Long Island train was hours late; some commuters couldn't remember when last they had been on time.

Getting a seat was not total victory. Getting an end seat was what counted. Many of the LIRR seats had been designed for three people—but they had been designed half a century before, when people were smaller. There wasn't enough room for three people. Sitting in even an end seat was indignity; it was sitting with your shoulder and thigh tight against a stranger's shoulder and thigh, pressing into him at every lurch, pushing against him while opening a newspaper or reaching into a pocket for your train ticket, surreptitiously taking advantage of shifts in his position to gain an extra quarter inch of room for your leg or arm. But sitting in the middle was indignity doubled. The person sitting there was crushed from both sides, leaned into from both sides, without room to make an unrestricted movement of any kind. "Of all the things I hated about the Long Island Rail Road," says one woman, "the worst was sitting in the middle on those seats. You'd have men pressing against you on both sides. They didn't mean anything by it. Some of them were sleeping and lying all over you. But it made me feel dirty. Standing at rush hour—it was the same thing. There'd be men leaning all over you. But being stuck in the middle on those seats was worse. There was never a time it happened that I didn't get off the train feeling dirty." It was no wonder that the first two persons to reach the three-man seats took the two end positions, and that when a third arrived, invariably the one sitting on the outside, closest to the aisle, would, instead of politely sliding over to make room for the new man on the outside, stand up and let him by to take the middle seat, careful not to look him in the eye.

In winter, the trips were cold. Heating equipment half a century old and haphazardly maintained could not be expected to work well. Not that even modern, well-maintained equipment could have kept heated a coach in which it seemed that every other window either had a hole in it or could not be shut tightly. A reporter who took a thermometer onto a LIRR train one winter day—not by any means the coldest day of the winter—found that the temperature aboard was 29 degrees. Men who in home and office enjoyed temperature controlled to the precise degree, had to travel between home and office huddled shivering in their coats.

And winter was, perhaps, better than summer. The crush in the cars kept the temperature up, and in winter that was a help. In summer, it was not, and help was needed, since 70 percent of the LIRR's ancient rolling stock did not have air-conditioning equipment. Men who tried frantically to open windows—one could watch them tug on them furiously every few minutes on a long summer ride home—found them stuck fast. A reporter who took a thermometer onto a jam-packed LIRR train one summer day—not by any means the hottest day of the summer—found that the temperature aboard was 98 degrees. Men who would not have dreamed of living in a home or working in an office that was not air-conditioned, rode each day between home and office sweltering, the sweat forming in their armpits and crotches and running down their backs and legs.

Long Island Rail Road trains did not always run late. Sometimes they did not run at all. Year by year, as already old equipment grew older, the number

of trains that simply broke down on the track increased. It was no longer unusual to see a train arrive in Jamaica being pushed along by another train. The number of trains that didn't even make it out onto a track increased. By 1964, it was not unusual for the railroad to cancel ten trains per day. One train, the 7:45 a.m. from Babylon to Brooklyn, did not appear for 102 consecutive days; would-be passengers named it "the Phantom."

Long Islanders' lives were cushioned—approximately twenty-two hours out of every twenty-four—by all the material wonders the twentieth century could provide. For those other two hours—two hours that could with accuracy have been called "Robert Moses's Two Hours," for he had made them what they were—they lived like nineteenth-century Russian peasants.

There comes a time, H. L. Mencken said, when every normal man is tempted "to spit on his hands, haul up the black flag and begin slitting throats." The LIRR's conductors were not responsible for conditions on the railroad. The commuters knew that—rationally. But the conductors were a visible symbol of the railroad's management on which the commuters could vent their frustration. Men normally rational found themselves snarling and cursing conductors, refusing to show them their tickets; as a result, men who would not have been able to conceive of themselves being arrested suddenly found themselves in that state. "Arrested!" as one reporter put it: "Portly, balding, mild-mannered, 53-year-old Seymour Cummins, district sales manager, commuter, family man. Seymour Cummins, of all people, being led off the train by two policemen, one on each arm, as his wife watched in disbelief." By 1968, the year Robert Moses left power, commuters were, as one writer put it, "so ... surly that the conductors occasionally choose, like prudent lion tamers, not to enter the cage." One freezing evening, at Jamaica, while commuters huddled in downstairs waiting rooms because the waiting rooms near the tracks upstairs were unheated, a malfunctioning public-address system prevented them from hearing announcements of incoming trains. Storming upstairs in sudden senseless fury, 250 commuters began pounding on the glass walls of the announcer's booth, trying to get at the terrified occupant—they had broken the glass when police arrived to pull them away. On another freezing night, a train broke down some miles from the nearest station. Its passengers got off and began throwing rocks at it. Similar incidents occurred again and again. One evening in Penn Station— with 150 rush-hour trains running late—a fifty-eight-year-old bank employee from Bayside, enraged because a conductor would not open the doors to let him on a train that had loaded but had been standing for close to half an hour on the platform, reached through the window to the engineer's booth, grabbed something and refused to let go. And when the railroad police rushed up to pull him away, suddenly, as one police sergeant put it, "this place was wall-to-wall people, thousands of people"—pulling at the policemen, punching them. "It was a riot down there," the sergeant said. "It was actually a riot." And it was testimony to the rage to which conditions on New York's railroads could drive men.

Actual physical violence was, of course, unusual, and therefore it is not in violence that the true toll of commuting on the Long Island Rail Road should be computed. It is in the norm—to which the violence is only occasional, violent punctuation—the norm that endures day after day, week after week, year after year, for tens of thousands of commuters (the LIRR carried 80,000 daily), that the toll of commuting should be computed. The true extent of this toll can perhaps be described in psychiatric terms. The chairman of the Nassau County Mental Health Board, in one of the first detailed studies of the subject, discovered a "commuter syndrome," "a mild state of chronic stress resulting from internalized rage and frustration due to the uncertainty of disrupted schedules." It was most serious in commuters who were "business

executives, overly worrying, driving, ambitious and aggressive types …
Such a person, who preserves his valuable time by living to a tight schedule,
is tremendously vulnerable, psychologically speaking, to transportation
failures." But the commuter syndrome, the study found, was not present only
in executives. Three out of every four commuters tested suffered from its
symptoms.

Chronically.

But it did not take a psychiatrist to compute the toll. A layman could do it—
by asking commuters in a relaxed setting—a cocktail party, perhaps—about
commuting and then taking note of the contrast between the answers he gets
from young men—or men recently moved to a new home on Long Island—
and those he gets from older men.

A young man might say, as twenty-six-year-old Michael Liberman of Dix
Hills did one evening, "People's lives revolve around the railroad. You can
spend five hours a day on it, and then you're just too tired to work." He might
say, as thirty-six-year-old Allen Siegal of Roslyn did one evening, "I think
we're out of our minds to do this. The trip home is worse than eight or nine
hours at the office." Men who have been commuting for years, however,
generally do not go into detail. Nor do they complain much. Their standard
reply—one so standard that the questioner can hear it a dozen times in a
dozen conversations—apparently sincere, is: "Oh, you get used to it after a
while."

The implications of that reply should be considered.

"Get used to it!" Accept as part of your daily existence two or three—or
more—hours sitting amid dirt, crammed against strangers, breathing foul
air, sweating in summer, shivering in winter. Accept that you will be doing
this for a substantial portion of every working day of your life, until you are
old. "Get used to it!" One has to think about what those words, so casually
uttered, really mean. One has to realize that the man uttering those words
has accepted discomfort and exhaustion as a part—a substantial part—of the
fabric of his life. Accepted them so completely that he no longer really thinks
about them—or about the amount of his life of which they are, day by day,
robbing him. We learn to tolerate intolerable conditions. The numbness that
is the defense against intolerable pain has set in—so firmly that many of the
victims no longer even realize that the pain is pain.

In Grand Central Station nearly took a train on track twenty eight for Boston
because it was called the Puritan. Needed to go where there's that kind of
beauty.

You can go to Grand Central and pick up the *20th Century Limited* for Chicago
on Track 34.

Or you can meet that girl in the polo coat who is arriving at Penn Station from
college in Vermont or Ohio or Philadelphia.

(margin: Donleavy)

(margin: Hamill, "Lost")

(margin: Ibid.)

(side tab: p Suburbs — Commuter Train)

Lees, p. 291

There's more wickedness in one block of New York City than there was in a square mile of Nineveh.

Burroughs, p. 475

You can walk in the Native Quarter of Tangier with less danger than on Third Avenue of New York City on a Saturday night.

McLoughlin, pp. 196–7

People start putting "no radio" signs on their car windows. It begins as a hopeful deterrent to theft and vandalism, but quickly degenerates into a shameless advertisement for self-pity. The first signs that appeared were professionally printed stickers by manufacturers of security devices. *No Radio. I take it with me!* was the logo of Benzi Box, one of the first such designs. Soon, though, the signs became homemade, personalized, and increasingly desperate. *No radio* gave way to *No radio, you already got it* and, ultimately, *Window broken three times, radio and spare gone. You got it all.*

Wilson, *Earthquake*, p. 122

People coming home late at night in the upper East Eighties and Nineties are compelled to struggle with three Yale locks in order to get into apartments which they will subsequently find have been robbed. (1926)

Brook, p. 45

I have calculated that if the average New Yorker makes three excursions each day, then 3.3% of his or her waking existence is spent getting in and out of an apartment. There are not too many doors in New York with fewer than four locks. To add to the difficulty, American locks turn in the opposite way from European ones, and the reflexes of a lifetime have to be reversed.

Ibid.

A lockable chain welded to the door frame so it could also be locked from the outside. To do so, two fingers had to be inserted between door and frame and the what's-it at the end of the chain inserted into the bit on—in other words, unless you have fingers the width of knitting needles, you can't get the damn thing to work.

Barry, p. xiv

Funny, isn't it, how the life possessions of a man could vanish in Manhattan, just like that.

Hapgood, pp. 49–50, 50–1

The thief attempts to look "swell," the tough glories in careless dirt. The thief is, in his way, an artist with his hands: he can do something. The tough can do nothing but talk and glories in his inactivity. The thief, on the other hand, is proud of his skill at the graft. Both the thief and the tough are unsentimental and hard; they both, however, believe in being "on the level" but in different ways. The thief, if he is a good thief, is "on the level" with his pals, and is consistent and honest in his attempt to "do" the respectable world. There is, as is so often said, honor among thieves. The tough, on the other hand, if he is a good tough, obeys the law; he is "on the level" in the ordinary sense. He thinks the grafter is a brute with low taste who violently attempts to get more out of the world than is necessary. What, asked the bum, is necessary further than a little booze and a lodging house in which to sleep? And you can get that much easy; and have all the rest of your time free for philosophy and sociability at the corner saloon. The thief, therefore, is ambitious and the tough is not, except as an artist in words.

[…]

One night I was walking down the Bowery with my friend, the ex-thief, when I met my friend, the tough. We all had a drink together, and it was amusing to see them eye each other, and watch to take the other at a disadvantage. There was a kind of hostile equality between them; but when a broken-down grafter, who is now a bum, entered, he received the cold shoulder from both the thief and the *bona fide* bum. He had fallen away

from one society and was only tolerated in the society into which he had dropped.

Our imagination can no longer take refuge in the unknown. The disagreeable has become a cosmopolitan fact, and the transient dream of possible good nature in others has become quite a vanishing quantity, like the receding smile of the Cheshire cat.

Ibid., p. 193

In the course of its imperialistic expansion the metropolis, as Patrick Geddes put it, becomes a megalopolis, concentrating upon bigness and abstract magnitude and the numerical fictions of finance; megalopolis becomes parasitopolis, dominated by those secondary pecuniary processes that live on the living; and parasitopolis gives way to patholopolis, the city that ceases effectively to function and so becomes the prey of all manner of diseases, physical, social, moral. Within such a town, graft and corruption are normal processes; the greater part of the population shares the animus of the criminal, applauds him when he "gets away with it," and condones his crime when he is caught red-handed.

Mumford, *Modern*, p. 46

So every profession has its racket; every man his price. The tonsil snatcher and the ambulance chaser and the insurance fixer and the testimonial writer have their counterparts in the higher reaches of the professions. The more universal forms of dishonor become honorable, and graft and shakedowns, like the private toll exacted for automobile and marriage licenses, become so common that they even escape notice. Those who actively oppose these customary injustices and these systematic perversions of law and decency are looked upon as disappointed men who have set their own price too high. Force, fraud, lying, chicane, become commonplaces; the law is enforced by illegal methods, the constitution protected by unconstitutional practices; vast businesses are conducted in "peace" by judicious connivance with armed thugs—now passive blackmailers, now active strikebreakers—whose work proceeds under the amiable eyes of the very agents supposed to combat it. No one believes that the alternative to living with honor is to die with honor: it is easier, it is more comfortable, to live sordidly, accepting dishonor. In such a city, an honest man looms high. He is a lighthouse on a low and treacherous coast. To attain even a human level becomes, in this megalopolitan environment, an arduous, almost a superhuman, task.

The more grimy the subways became, the more graffiti those people scrawled on the cars, the more gold chains they snatched off girls' necks, the more old men they mugged, the more women they pushed in front of the trains.

Wolfe, *Bonfire*, p. 54

If you fall asleep and travel to the end of the line, you will still have your wallet and your life.

Hamill, "Lost"

Fluctuations in currency and all the balderdash about gold and silver standards amuse the chiselers. They explain that you can live in New York, and live pretty well, without money. You use slugs instead.

Berger, *Eight Million*, pp. 187–8

Slug manufacturing is an organized industry now, employing agents to peddle the disks from the Battery to 181st Street. The best markets are in midtown Manhattan along Sixth, Seventh, and Eighth Avenues, and, of course, Broadway. The chiselers pay ten cents for fifteen nickel-size slugs, and slightly more for the dime and quarter sizes. Sometimes the agents get into a trade war and the chiselers get bargain rates.

The Telephone Company is more heavily beslugged than any of the other corporations, because the chiselers spend the equivalent of hundreds of

dollars a week on out-of-town telephones. No profit in it, but most chiselers are not native New Yorkers and it is a cheap way to keep in touch with the folks back home. It isn't sentiment so much; they just do it for the fun of the thing. This winter one of the Telephone Company operatives caught a chiseler in an Eighth Avenue telephone booth passing the time of day with some of his pals in Sacramento, and it got into the newspapers. They found five pounds of assorted slugs on him. Once in a while the chiselers make local calls with a cent dipped in damp salt. The salt, it seems, makes the coin as thick as a nickel and, being a good conductor, establishes the necessary electrical contact. The chiseling guild claims credit for that discovery.

Dwyer, pp. 226–8

The life of a slug-manufacturer: Alan Campbell worked on a scale of dizzying, historic proportion, manufacturing slugs by the millions over years and years, but remained a phantom, hidden behind layers of distributors. Unable to hunt him down, the transit system struggled to mount a defense. It deployed an army of police officers. It tinkered with turnstile mechanisms. Even the design of the token was changed over and over.

Living rent-controlled on Clinton Street in Brooklyn Heights, he read a pamphlet on how the ordinary, cheap No. 14 brass washer could be used to make dime phone calls. It was an epiphany. "You had to Scotch-tape over one side of the hole," he said. "The phone could defend itself against the washer if the hole went all the way through. The tape blocked the hole."

He discovered a supply house in a loft near Chambers Street that sold fasteners, nuts and bolts, and, eureka, No. 14 washers. He bought loads. Around 1970—the year the fare increased from 20 to 30 cents, triggering a mad run on all available slug supplies—he was introduced to the reciprocating press, an industrial-strength hole puncher.

In the 70s, 2,000, 8,000, 10,000 slugs a day were being collected from turnstiles. By 1985, the turnstiles were collecting 13,000 slugs per day, roughly the equivalent of all public transit ridership in Kansas City.

Campbell sent his crew to peddle token slugs by the tens of thousands, churning them out from a new factory in Paterson, N.J., and depositing bags of slugs at self-storage places around Brooklyn.

In 1986, around the time the fare went to a dollar, the transit system took its boldest anti-slug action by switching to the bull's-eye token, with an alloy center. The slug take in the turnstiles quickly dropped to about 400 per day, a 97 percent decrease, then gradually climbed back up.

Hoffman, *Steal Yourself,* p. 92

DANISH 25 ORE PIECE: works in 95% of all subway turnstiles. A very safe coin to use since it will not jam the turnstile. It is 5/1000th of an inch bigger than a token.

PORTUGUESE 50 CENTAVO PIECE: the average Portuguese Centavo Piece is 2/1000th of an inch smaller than a token.

JAMAICAN HALF PENNY, BAHAMA PENNY and AUSTRALIAN SCHILLING: these coins are 12/1000th to 15/1000th of an inch smaller than token. They work in about 80% of all turnstiles. We have also had good success with FRENCH FRANC PIECE (WWII issue), SPANISH 10 CENTAVO PIECE, NICARAGUAN 25 CENTAVO PIECE.

London, p. 141

The thief routinely puts a slug in the slot so that your token cannot be inserted. With a deft motion of his sleek metal plunger he removes the slug and your token and pulls the turnstile back so that you can slide around the barrier onto the station. He can be found selling these tokens he steals when commuters are frustrated by the rush hour line at the one toll booth on the uptown side.

q Crime

In 1969 alone the phone company estimated that over 10 million dollars worth of free calls were placed from New York City.

Hoffman, *Steal Yourself*, p. 75

By April 1971 Abbie Hoffman was being interviewed on New York City's WNET-TV, channel 13, promoting *Steal This Book*. He read directly from his book into the camera: "This is going to be a public disservice announcement," he told his viewers. "To make your own credit card numbers, the 1971 credit card consists of ten digits and a letter. The first seven digits comprise any New York City telephone number. The phone company will bill this number, so make sure the number you use is nonexistent or the number of a large corporation. The next three digits are the credit card code. For New York City it's 021. The letter is based on the sixth digit of the phone number. If the sixth digit is one, then the letter is Q. If it's a two, it's A … " Hoffman went through the complete list and concluded, "For example, for New York, you would dial 581-6000-021-Z and Channel Thirteen would pick up the bill." The host of the TV show quickly disclaimed responsibility for this idea.

Lapsley

Hoffman: "Until AT&T and the other corporations really become public services rather than power and profit gobblers, we'll continue to rip them off every chance we get. If you want to discuss this further, call me up some time. Because of all the agencies claiming to have me under surveillance, it's one of the fastest ways to speak directly to your government."

Ibid.

The World's First Phone Phreak Convention took place in New York City on July 29, 1972. The phreaks congregated in the basement ballroom of the Hotel Diplomat, a Times Square hotel that was developing a reputation for hosting rock 'n' roll shows and fringe political gatherings—Yippies, Communists, and Libertarians all had held conventions there. Alan Fierstein ("Al Bell") of YIPL was the master of ceremonies, presiding over attractions that included a black-and-white film showing three simple ways to make free phone calls from pay telephones, a presentation on the black box for receiving free calls, and breakout sessions on building answering machines and blue boxes. Yippie founder Abbie Hoffman led a workshop on the legality of phone phreaking and exhorted the attendees to support the Captain Crunch defense fund. A spy from New York Telephone later reported to the FBI that some seventy-five people were in attendance.

Ibid.

ON JUNE 21, 1975, John Draper did something a little bit stupid.

That day he entered a telephone booth in New York City and dialed an 800 number in Oakland, California. While the call was going through he held a blue box up to the phone and pressed a button, sending a burst of 2,600 Hz down the line.

Ibid.

"Bleeep!" said the blue box. "Kerchink!" responded the telephone network.

Draper pressed more buttons. Key pulse. 127 552 2155. Start. A few seconds later the telephone network rewarded him with what sounded like a bad imitation of Donald Duck talking to one of his nephews. If you squinted your ears and used your imagination you might think it sounded almost— almost—like two people talking.

Draper pressed another button and sent another quick blip of 2,600 Hz down the line. Donald Duck was replaced by the clear voices of two people talking about a work-related matter. Draper was now in the middle of their conversation, listening quietly. He eavesdropped for a few minutes and then hung up.

Draper had just used his blue box to hack into an internal telephone company service called verification.

Ibid.	It went, dee de de de de de de dup and then the operator came on and said, "New York."
Walrod, p. 45	Artist Ray Johnson used to walk around New York City clogging pay phones by inserting dimes covered in mustard.
Berrigan, "Growing Up," p. 235	Daniel Rakowitz, who cut up his girlfriend and ground her bones into soup that he fed to homeless people in Tompkins Square Park.
"Man Held"	Rakowitz, 31, roamed the East Village selling marijuana, carrying a live rooster and quoting Adolf Hitler's *Mein Kampf.*
Patterson, "Butcher"	At his subsequent sanity trials, like the repeated cannibalism charge, the district attorney went on about "the Rakowitz stare." There is no Rakowitz stare—just a dull expression.
Walker, *Night Club*, p. 14	There was, clearly, blood on the moon hovering over the East Village. Something ominous was in the air.
Donleavy	The stabbings and stompings.
Ginsberg, *Howl*, p. 3	listening to the Terror through the wall
Donleavy	Cut through the tip of the park. Where the evening marauders are lurking. Swiftly to get you in headlocks or at knifepoint across the throat. If they don't smash you first to the ground from behind. Look back.
Conrad, p. 308	His wife intends to keep his ashes in an urn and scatter them, a handful a day, from her tenth-floor balcony over the East River Drive; after he kills her, he considers feeding her into the kitchen disposal and packaging the long bones to hurl across the highway into the river, but instead he simply throws her out of the window onto the traffic.
Bockris, *Burroughs*, p. 155	Since returning to New York William S. Burroughs has gradually equipped himself with a small arsenal of weapons that includes a cane, a tube of teargas, which can be released in an assailant's face by depression of a plunger and is particularly effective in subway situations, and a blackjack. "I never go out of the house without all three on me," he says pointedly. "I don't feel dressed without them." It was a bitterly cold, icy December night as I ran up the Bowery from the phone box on the corner of Canal Street to the gates of the Bunker where William was waiting concernedly. "If I'd known it was like this I wouldn't have asked you out," were his first words as he opened the metal gates. He was wearing a jaunty tweed jacket, brown suede shoes, light brown pants, shirt, tie and sweater. "I went out today," he said on the way upstairs. "It's on days like this that you really [*opening the front door and ushering me in*] get to appreciate the Bunker. All the heat you can use."
Ibid., p. 158	BURROUGHS: Did you read about those young scoundrels who terrorized a train? We must get our cane brigade organized. BOCKRIS: Bill and I have organized a cane fighters group. Everyone has a cane like this and we're going to go on the subways. Three or four of us in the evening.

GINSBERG: New York City, 1980—the Cane Brigade! On my block everyone is armed with a staff or cane.
BURROUGHS: These are great, terrifically effective weapons.
BOCKRIS: There are many things you can do.
BURROUGHS: I'm ordering a blackjack for you.

My eyes travel to the spectacle of Burroughs as he turns and says, "Guns are a part of my life. I was brought up around them." Suddenly in the middle of the meal, he walks calmly over to a storage area behind a small walk-in closet and re-emerges carrying a toy M-16. Posting himself in the middle of the room, some six feet away from the table, he snaps the thing up to his shoulder and carefully aims at the other end of the loft. "Yep! This is what they use," he states flatly—and for a moment I get a frozen flash of him, a close-up that knocks me out of my seat. *Ibid.*, p. 85

The last few days have been hectic and contained much violence. Hanging around a restaurant on the corner of the Bowery, I have participated in adventures one might expect of scenes from a Hollywood movie. Hoodlums and shady characters—drug addicts, prostitutes, pimps, nickel and dime hustlers, Brooklyn mobsters, goof-ball addicts, odd types and Bowery bums. Reay, p. 269

Surely, Walt Whitman would have reveled in the scene: for here were human beings as lacking in misery and respectability as even the great poet could desire. Hapgood, p. 137

In a set of "Bad, Worse & Worst" jokes in a *Betty* comic book, one entry read: "Bad: lost tooth; Worse: lost homework; Worst: lost in New York." Freeman, p. 336

I don't even know why they have human police officers. They should just put animals out there patrolling the streets. Word up! Cause they're worse than animals. It's like they're animals with a mind. Courgois, p. 37

Gangs in northern Brooklyn in the 70s: Sinners, Mad Caps, Sons of Devils, Young Survivors, Driggs Boys of Justice, Dirty Ones, Spanish Kings, Justice of Brooklyn, Phantom Lords, Satan Souls, Screaming Pharaohs, Unknown Savages, Spanish Knights, Devils Rebels, Latin Tops, Black Slabbers, Savage Nomads, Homoside Laws, Imperial Survivors, Soul Latineers, Pure Hell, Bachelors, T & T Bachelors, Latin Secret Bachelors, Warlords, Brooklyn Hell Devils, Outlaws, Black Attacks, Vanguards, Black Hands, Rasta Farians, Wicked Ones, Trouble Bros., Tikwando Bros, Excons, Organization, Unknown Outlaws, Egyptian Warriors, B'nai Zaken, Inc., Tomahawks, Unknown Riders, Young Barons, Blacks Bulls, Pure Hells. "Brooklyn Youth," p. 33

The Gophers (Goofers) in Hell's Kitchen: Such names as Newburgh Gallagher, Marty Brenna, Stumpy Mallarkey, Happy Jack Mullraney. O'Connor, p. 164

A murdered man lies below a target shape painted in the O of a gang's name, ROYALS. Sharpe, p. 294

For six dollars a night, plus expenses, the detective agreed to show Reverend Parkhurst the seamy side of New York life. Naturally, they would need disguises. Ellis, *Epic*, pp. 425–7
 The first night out on the town the three men stopped at Tom Summers' Saloon at 33 Cherry Street, where they drank whiskey that tasted like embalming fluid and watched little girls buy booze at ten cents a pint to take home to their fathers. Next, they headed for a whorehouse at 342 Water

Street, where painted women stood in the doorway soliciting trade. The next stop was another red-light house, where a young prostitute asked Parkhurst to dance.

On their next nocturnal trip the explorers headed for the Bowery and visited several brassy cabarets, known as concert gardens. Then they saw "tight houses," where all women wore tights. Brothels were then classified by the nationalities of their inmates, so on Forsyth Street the three men visited a "German house." Feeling better physically, Parkhurst demanded that Gardner "show me something worse."

In Chinatown, northeast of what is now Foley Square, they watched a game of fan-tan and then padded into the murky room of a nearby building, where they found a Chinese man, his Caucasian wife, and their eight-year-old son smoking opium. Next came a visit to the Negro district around Sullivan and West Houston Streets, called Coontown. Then Frenchtown on the southern fringe of Washington Square in Greenwich Village. Entire blocks consisted of houses of prostitution—of all kinds. Worst of all, to the sensitive Parkhurst, was a four-story brick house on West Third Street, called the Golden Rule Pleasure Club. There they were greeted by "Scotch Ann," who bade them enter the basement. This was partitioned into small dens, each containing a table and a couple of chairs.

As Gardner described it: "In each room sat a youth, whose face was painted, eyebrows blackened, and whose airs were those of a young girl. Each person talked in a high falsetto voice, and called the others by women's names."

Charyn, *Gangsters*, pp. 69–70

The gangster is the man of the city, with the city's language and knowledge, with its queer and dishonest skills and its terrible daring. He's a creature embroidered with myth, who inhabits "that dangerous and sad city of the imagination" … He is under the obligation to succeed not because the means he employs are unlawful. In the deeper layers of modern consciousness *all* means are unlawful … one is *punished* for success.

Bushnell

Like girlfriends, bikes are always getting stolen in New York. "If you go into a bookstore for ten minutes, you come out and your bike is gone," said Mr. Eccles. "The bike pays for itself in three months if you compare it to subway fare," he said. "One month, if you take taxis."

Quan, p. 58

Wear a casual fur on Avenue C and you'll be totally misunderstood, maybe even assaulted—what was I thinking? … As the cab rolled up in front of a run-down redbrick walk-up, I was glad I had changed into my quilted black jacket, the perfect transitional outfit for traveling below 14th and back. A coat for all zip codes. You can't tell what it costs unless you look carefully—at the inside.

Capote, p. 44

Passing a Woolworth's, she gripped my arm: "Let's steal something," she said, pulling me into the store, where at once there seemed a pressure of eyes, as though we were already under suspicion. "Come on. Don't be chicken."

McInerney, *Bright Lights*, p. 67

You consider performing an act of inspired madcappery at her behest: stealing the hat from a policeman, or the handcuffs from one of the gay caballeros of Christopher Street. Maybe climb a lamppost and wave her scarf from the top.

Carter, p. 59

They would shoplift from the local A&P grocery, or sometimes they would steal from Smilers.

Lyford, p. 71

Booster: a shoplifter who carries stuff out of stores between her legs.

In 1999 Tom Sachs got his gallerist, Mary Boone, arrested for unlawful distribution of ammunition, possession of unlawful weapons, and resisting arrest. Sachs landed her in trouble with his Alvar Aalto glass vase filled with live bullets, which were given away as party favors in Hermès-style airsick baggies, and a gun cabinet, called *Ace Boone Coon*, stocked with his signature homemade handguns.

Walrod, p. 78

Early one summer evening, there was a loud altercation directly across the street in the doorway of the Russian-Turkish Baths. Suddenly, one man picked up a chair and brought it down with tremendous force on the head of another man. The latter toppled and rolled down a dozen steps to the foot of the stoop, where he lay dead on the sidewalk in a great puddle of blood.

Binzen

The three old ladies observed all this with aplomb and very little dismay, and long before the corpse was lugged away they had returned to their evening chat.

Later, after the handyman at the baths had hosed down the steps and sidewalks, the kids pre-empted the location for a rousing game of cops and robbers.

Naked City

A loner married to his job, sleeping in his clothes next to a police radio, Weegee tacitly accepts the dadaist coupling of man and mechanism: Picabia's mechanical portraits and Duchamp's erotics of the machine.

Sharpe, p. 292

When he goes to bed in his room across the street from police headquarters, the city murmurs to him from the police-approved shortwave radio beside his bed. Even in slumber he is responsive to her. He will sleep through fifteen unpromising police calls and leap out of bed at the promising sixteenth. In sickness and in health he will take his camera and ride off in search of new evidence that his city, even in her most drunken and disorderly and pathetic moments, is beautiful.

Weegee, Naked, p. 6

From midnight to one o'clock, I listen to calls to the station houses about peeping Toms on the rooftops and fire escapes of nurses' dormitories.

Ibid.

Naked City: Weegee's title suggests that he uses his lens to strip bare the behavior and emotions of New Yorkers, but it also alludes to the erotic appeal of looking at anything proposed as naked—a city, a street, or even a sidewalk, never mind naked violence, naked suffering, and naked truth.

Ibid., pp. 292–3

Wet, shimmering pavements, round-fendered cars reflect the light, misty halos around the lampposts.

Ibid., p. 293

The city surrenders itself to Weegee at night because sleep relaxes its guard.

Conrad, p. 271

Weegee understood the night to be an exact inversion of the working day. Rather than an uneventful intermission in consciousness, it has an agenda of its own. He dutifully audited its schedule on his police radio. Its crimes were a punctilious mimicry of diurnal routine.

Ibid.

Between midnight and 1 a.m., the peeping toms would be out snooping.

Ibid., pp. 272–3

Between 1 and 2, late-night delis would be held up.

Ibid., p. 273

q Crime — Naked City

Ibid.	Between 2 and 3 came the auto accidents and fires.
Ibid.	At 4 the bars closed, so the police would round up drunkards.
Ibid.	From 4 to 5 was the hour sacred to burglaries.
Ibid.	After 5 came the suicides of insomniac despairers.
Ibid.	Weegee adjusted himself to this nocturnal regime by starting his day at midnight. If he slept, he would leave the police radio playing by his bed. Its babble of accident and mayhem could then insert itself into his subconscious, transmitting directly from the city's dream-life to his own.
Sharpe, p. 294	He deglamorizes the night, cheapens its charm, using his flash to blast away shadows and eliminate subtle gradations of tone. In fact, in Weegee's world of black and white, it's often hard to tell if it even *is* night.
Ibid.	In his crime and accident scenes, detail litters the street like an old newspaper: gum spots, cigarette butts, awnings, railings, moldings, trash, and above all signs, letters, and words, rendered both trivial and oracular by the disasters occurring beneath them.
Ibid.	Weegee reglamorizes the night as a place of danger and bizarre coincidence, the Grim Reaper working from a script by O. Henry.
Ibid.	He is the Matthew Brady of the New York night.
Ibid.	There are no gray areas in Weegee's photos.
Ibid.	Things are black and white, or more accurately, alive and dead, though it is sometimes hard to tell the difference.
Ibid.	Weegee opens *Naked* with a series of shots of people sleeping outdoors in the summer—we see the soles of their shoes, their outflung arms, their heads thrown toward us flat on the pavement. They resemble Riis's sleepers and Weegee's own corpses. There's even one man who bridges the gap, stretched on the sidewalk in front of a funeral parlor.
Ibid.	Weegee likes his subjects to have "nice white, chalky faces."
Weegee, *Naked*, p. 11	I catch New Yorkers with their masks off.
Sharpe, p. 294	Bleached out by the flash, the flesh of his subjects seems like it has been soaking in the river for a few days; at its best it has that artificially lit whiteness we find in Hopper's women.
Ibid.	It was Weegee's genius to make ordinary crime seem both exceptional and pervasive.
Ibid., p. 295	If O. Henry killed off the refined literary flâneur, Weegee resurrects the figure in vulgar tabloid form.
Ibid., p. 296	If we compare Weegee to his great contemporaries in London and Paris, Bill Brandt and Georges Brassai, he makes the former look static and stuffy, and the latter seem overly artistic and contrived.

A 1942 photo shows cops covering up a body underneath a movie marquee that advertises the Irene Dunne film *The Joy of Living*.

Ibid., p. 297

Nocturnal urban theater at its finest, a good view of a bad thing.

Ibid.

Face down on the sidewalk "the deceased," as the cops say, has hardly ceased bleeding, but the manhole cover just behind him reminds us where he is headed.

Ibid., p. 301

There was a sudden drop in Murders and Fires (my two best sellers, my bread and butter).

Weegee, *Naked*, p. 11

These are the men, women, and children on the sidewalks of New York … always rushing by … as if life itself depended on their reaching their destination … but always finding time to stop and look at a fire … murder … a woman about to jump off a ledge … also to look at the latest news flashes on the electric sign on the Times Building in Times Square … the latest baseball results pasted in windows of stores … and to listen to music coming out of phonograph stores.

Ibid., p. 34

They always want to know what paper I'm from and if the person is dead. They seem to be disappointed if they see a sign of life as the stretcher with the injured is carried before them.

The cops have their hands full at fires with the spectators, and have to watch out that they don't get injured by falling debris … high pressure hose lines break! When they have had their fill of the scene, they disappear as quickly as they came … in a terrific hurry …

The surprising thing about New York families, living as they do in such crowded conditions, is that they still manage to crowd in pets like dogs, cats, parrots, which they always try to save at fires. At one fire, I saw a woman running out holding a cardboard box with a couple of snakes inside. I questioned her. (It was none of my business, but I'm curious about people.) … She told me she was a dancer who used the snakes in her act. At fires in which persons are burned to death … the bodies are brought out wrapped in canvas bags … by firemen … while a police radio car will go to the nearest church, wake up the priest, who will rush to the scene in the cop's radio car and give the last rites. This always makes me cry … but what can I do … taking pictures is my job … and besides I'd rather take a picture of someone being rescued alive—it makes a better picture. At fires I also make shots of the crowds watching the fires for the detectives and fire marshals who are always on the scene … on the look out for pyromaniacs … jealous lovers … thrill seekers … disappointed would-be firemen who having failed in their examinations will start fires … Also at fires where there are rescues … different firemen will take credit for such rescues … my photos decide who did make the rescue and end all disputes.

Ibid., p. 52

Someone rushed in and saved the Torah (Holy Scroll) from the synagogue … strange at fires holy objects seem to be immune to flames … God must watch over them.

Ibid., p. 67

A couple driven out from the burning tenement … I don't know their names … but I did hear someone call him "Pincus" … so here they are right across the street from their burning tenement … it looks like Pincus had time to grab a woman's dress … his best coat … but minus the pants.

Ibid., p. 71

Ibid., p. 72 These are dead bodies ... wrapped by firemen in "bodybags." The priest is giving the last rites to all that's left of a mother and her two babies ... besides the firemen ... there are no spectators ... it's early morning ... people are rushing to work ... and can't stop to look ... they'd be late ... and the boss will holler like hell ...

Ibid., p. 74 I cried when I took this picture. Mother and daughter cry and look up hopelessly as another daughter and her young baby are burning to death in the top floor of the tenement ... firemen couldn't reach them in time ... on account of the stairway collapsing.

Ibid., p. 78 People get bumped off ... on the sidewalks of New York. The only unusual thing about these killings is that they are never solved. The guys are always neatly dressed ... fall face up ... with their pearl gray hats alongside of them. Some day I'll follow one of these guys with a "pearl gray hat," have my camera all set and get the actual killing ... could be ... I got the above statement with check from *Life* magazine. Twenty-five dollars was for the murder picture on the right ... the other picture they bought was only a cheap murder, with not many bullets ... so they only paid ten dollars for that.

Ibid., p. 79 This happened in Little Italy. Detectives tried to question the people in the neighborhood ... but they were all deaf ... dumb ... and blind ... not having seen or heard anything.

Ibid., p. 80 One looks out of the windows ... talks about the weather with a neighbor ... or looks at a murder.

Ibid., p. 83 This happened at eight o'clock on a Sunday night ... People were rushing to the movies ... there was a good double feature at Lowe's Delancey Street ... one being a gangster picture ... a few blocks away ... in the Essex Diner ... a busy boy was pasting a sign in the window, "Chef's Special." A man walked in ... he wasn't looking for any specials, he had a gun. And this was a stickup. He grabbed the money from the cash register and ran out. A cop saw him and gave chase. The holdup man hid behind a parked car and started firing at the cop. The policeman fired back and killed the bandit. Here's the cop after the shooting ... very nervous, for he might have hit some innocent passers by, giving the gun to the sergeant. The cop got a medal ... the gunman got the bullets.

Ibid., p. 84 This was a friendly game of Bocci, an Italian game very popular on the East Side and played on empty lots. An argument started and one of the players was shot and killed. The dead man's wife arrived ... and then she collapsed.

Ibid., pp. 86–7 A woman relative cried ... but neighborhood dead-end kids enjoyed the show when a small-time racketeer was shot and killed ... Here he is ... as he was left in the gutter. He's got a D.O.A. tied to his arm ... that means Dead On Arrival.

Ibid., p. 88 It's a lovely evening ... the full moon is out. A car somehow or other drives off the pier into the river. The couples in the parked cars in "Lovers' Lane," as the pier is called, run out of the cars dressed in pajamas. Police boats arrive with powerful searchlights which illuminate the waters as other cops try to get a "bite" on the car. It is a long, trying job to locate the car in the river.

686

This man covered up with newspapers was killed in an auto accident. The driver of the car was arrested, but he put up such a terrific battle … cops had to put handcuffs on him.

Ibid., p. 89

Bread delivery truck
… in collision with woman driver.

Ibid., p. 90

Sudden death for one
… sudden shock for the other.

Ibid., p. 91

This was a fashionable society funeral. The obituary had received almost a whole column in the *New York Times*. It was just like opening night at the opera. The cute Rolls Royces arrived with their invited guests. A mob of spectators stood on the sidewalk, watching and listening to the beautiful organ music coming from the church. The uniformed chauffeurs and the professional pallbearers were grouped in a huddle on the steps of the church … they were bored and kept asking what time it was … hoping that they would get it over with, as they had some bets to place on the day's races with their bookies. The talk drifted on which tipster was best to follow in the papers. One of the pallbearers started cursing the *New York Daily Mirror* and their tipsters Joe and Asbestos, who daily give out tips in their comic strip, saying he was out over sixty dollars by following them, and that they were nothing but a couple of bastards who must be working for the bookies instead of the players. Across the street from the church, delivery men were bringing in baskets of chopped meat to the Hamburger Heaven for the dinner rush; the group on the steps broke up with the pallbearers and the chauffeurs hiding their racing forms and scratch sheets inside their coats. Then the casket came down the steps and was placed hurriedly inside the hearse. An auto driving by stopped to watch … "Oh, what a beautiful morning" was coming out of the radio, sung by a tenor with a pansy voice. Somehow the car got sandwiched in with the funeral procession and they all made a turn up Fifth Avenue.

Ibid., p. 92

Ball at the Waldorf-Astoria. A gay time was had by all except the guy whose shoelaces became untied … and at the United Mine Workers' Ball in the Hotel Diplomat on West 43rd Street. The young miners … liked the blues singer "Oh so much."

Ibid., p. 97

At No. 267 Bowery, sandwiched in between Missions and quarter-a-night flop houses, is "Sammy's," the poor man's Stork Club. There is no cover charge nor cigarette girl, and a vending machine dispenses cigarettes. Neither is there a hat check girl. Patrons prefer to dance with their hats and coats on. But there is a lively floor show … the only saloon on the Bowery with a cabaret license.

As the customers arrive from uptown in cabs, they are greeted by a bunch of panhandlers who don't ask for the usual "got a nickel for a cup of coffee mister," but instead for a dime for a glass of beer … and get it too. Inside, the place is jammed with the uptown crowd mingling with the Bowery crowd and enjoying it. But towards midnight some odd types drop in for a quick one. There is a woman called "Pruneface," a man called "Horseface" … "Ethel" the queen of the Bowery who generally sports a pair of black eyes that nature did not give her, a man with a long white beard, who old timers say is looking all over the Bowery for the man who forty years ago stole his wife … they wonder when the two meet whether the wife-stealer will get beat up or thanked.

While I was there absorbing the atmosphere and drinks, a midget walked in … he was about three and a half feet. I invited him for a drink. He told me

Ibid., pp. 138–9

Crime — Naked City

that he had just arrived from Los Angeles, where he had been working for a Brown & Williams Tobacco Co., walking the streets dressed as a penguin. The midget was flush and started buying me drinks. He proudly showed me his social security card, told me that he was thirty-seven years old, was single as the girls were only after money, that once in a while he got some affection, but had to pay for it ... After the seventh round he got boisterous and offered to fight any man his size in the house. Sammy grabbed the midget and threw him out through the doorway which has a red neon sign saying "Thank you, call again," hollering at him not to ever come back again. Sammy's has a blacklist just like Billingsley's Stork Club uptown.

Sammy greets all his patrons at the door. I noticed he frisked some of the Bowery ones. He told me that they were the "bottle" babies and he could spot them by the bulge in their hip pockets. They would try to smuggle in a bottle of "smoke" into Sammy's place to drink in the washroom because if they drank out in the street or hallways the cruising patrol wagons would pick them up. Sammy is wise to all the tricks of the Bowery chiselers, but he is also a friend and always ready to lend a helping hand ... lending money so a man can get cleaned up, food and a room while he is getting over a hangover. I know Sammy gave $100 without being asked for it for a woman in the neighborhood who died and there was no money for the funeral. He also takes care of his customers' valuables. I saw one woman at the bar give Sammy her wrist watch and thirty dollars to save for her till the following day, and I also saw him turn men away from his bar, telling them not to drink till their day off.

Sammy is known as the "Mayor of the Bowery" and his ambition is to become Mayor of New York City. And when that happy day arrives Sammy promises free drinks in every gin mill in town.

Ibid., p. 147

Introducing Norma, the star of Sammy's Foolish Follies ... shaking everything that nature gave her ... and not getting much response from the Bowery playboy, on left ... Norma's ambition is to understudy Mae West ... but that will be a sorry day on the Bowery ... because who will understudy Norma?

Ibid., p. 157

But there is beauty along this street of forgotten men ... it lies in the patterned black and gold along the trolley tracks where the morning sun breaks through.

Ibid., p. 158

Not so long ago I, too, used to walk on the Bowery, broke, "carrying the banner." The sight of a bed with white sheets in a furniture store window, almost drove me crazy. God ... a bed was the most desirable thing in world. In the summer I would sleep in Bryant Park ... But when it got colder I transferred over to the Municipal Lodging House ... I saw this sign on a wall there. A Sadist must have put it up. I laughed to myself ... what Cash and Valuables ... I didn't have a nickel to my name. But I was a Free Soul ... with no responsibilities ...

Ibid., p. 160

Every morning the night's "catch" of persons arrested is brought down from the different police stations to Manhattan Police Headquarters where they are booked for their various crimes, fingerprinted, "mugged" in the rogues gallery, and then paraded in the police line where they are questioned by police officials on a platform with a strong light on their faces ... as detectives in the darkened room study them ... and make mental notes for future reference ... The parade never ceases as the "Pie" wagons unload. I've photographed every one of importance from gangsters, deflated big shot racketeers, a president of the N.Y. Stock Exchange, a leader of Tammany

Hall and even Father Divine, who kept muttering as he was booked, "Peace, brother, peace." The men, women and children who commit murders always fascinate me … and I always ask them why they killed … the men claim self defense, the women seem to be in a daze … but as a rule frustrated love and jealousy are the cause … the kids are worried for fear the picture might not make the papers … I will say one thing for the men and women who kill … they are Ladies and Gentlemen cooperating with me so I will get a good shot of them … the ones that "cover" up their faces are the Fences … Fagins and jewel thieves … who start crying and pleading with me not to take their picture … as their poor mothers will see it in the newspapers and it will break their hearts … they should have thought of that before they went into the crime business … I disregard their pleas and crocodile tears …

The scum of the underworld arrives for the line-up … handcuffed to cops and detectives … These are a couple of hoodlums who went around holding up small store keepers … from the line-up the next stop is the court … then Sing Sing prison … *Ibid.*, p. 161

The dead lie still … while the living cry … *Ibid.*, pp. 202–3

Life's problems become too complicated for some people … so they jump into the river. Cops in cruising cars hear more than just what comes their radios … this cop hears a splash … he jumps out, takes off his coat, his shoes, then his pants which he rolls up in a bundle to hide and also to protect his gun … places all of them on the edge of the pier … and jumps into the icy water in his shirt and underwear, cursing. After a rescue the cop always has to take the trip to the hospital along with the would-be suicide to get thawed out … they have equally good chances of catching pneumonia. *Ibid.*, p. 216

The radio cars cruising the water-front are well stocked for rescue work … they carry ropes … life preservers … everything except K-rations and a Bible.

And fights … The best fights in town are on the sidewalks … they are free for the spectators to enjoy … that is, till a cop arrives to break it up … but the cops always arrive when the fights are over. This was a little argument outside Madison Square Garden. It was a much better fight than one sees inside on Friday nights … I don't know what they were fighting about but I guess it was nothing trivial. *Ibid.*, p. 222

A man was killed by a falling cornice. I was not a party to the tragedy, and again the inches counted heavily. White, *Here*, p. 22

A joint under the el on Third Avenue. I came off the bridge and ran down Third and stopped at this joint along the way. I don't remember the street because I was too tired to look, but I'll go back and check up again and find it. There's probably a thousand places like it, but I'll find it. Spillane, p. 165

I tucked the paper in my pocket and walked down to my car. The taxis and commuters were jamming traffic all the way downtown, and by the time I had crossed over to Third Avenue, it was nearly six o'clock. I didn't have a bit of trouble finding that hash house again. There was even a place to park right outside it. I went in and climbed on a stool and laid the paper down in front of me with the picture up. Down at the end Shorty was pushing crackers and soup over to another bum. He hadn't seen me yet. *Ibid.*, p. 169

Somehow, I worked the heap across town without killing anybody and cut up Fifty-sixth Street. *Ibid.*, p. 223

Ibid., p. 62
A lot of people like to run down the cops. They begin to think of them as human traffic lights, or two faces in a patrol car cruising down the street hoping some citizen will start some trouble. They forget that a cop has eyes and ears and can think. They forget that sometimes a cop on a beat likes it that way. The street is his. He knows everyone on it. He knows who and what they are and where they spend their time. He doesn't want to get pulled off it even for a promotion, because then he loses his friends and becomes chained to a desk or an impersonal case.

Ibid., p. 317
Twice a radio car screamed its way south, the siren opening a swath down the center of the avenue.

Ibid., p. 319
A cop went by, whistling under his slicker, his night club slapping his leg in rhythm to his step. It was ten minutes after ten then.

Ibid., p. 321
From the roof there was a volley of shots that smashed into stone and ricocheted across the sky. Some didn't ricochet. A shrill scream testified to that.

690

Search a city's slums or shabbiest streets and you will find its fashionable beginnings.

Huxtable, *Architecture of NY*, p. 20

Those who love a city, in its profoundest sense, become the shame of that city, the *détraqués,* the paupers.

Jones, *Modernism*, p. 185

People on the streets of New York who give money to beggars are often people who have very little themselves.

Haring, p. 134

Ten-cent men sleep under thousand-dollar trees.

Ellis, *Epic*, p. 532

New York in 1932 was half-completed skyscrapers, work on them long since halted for the lack of funds, that glared down on the city from glassless windows. It was housewives scavenging for vegetables under pushcarts. It was crowds gathering at garbage dumps in Riverside Park and swarming onto them every time a new load was deposited, digging through the piles with sticks or hands in hope of finding bits of food. New York was the soup kitchens operated from the back of army trucks in Times Square. It was the men, some of them wearing chesterfield coats and Hamburg's, who lined up at soup kitchens with drooping shoulders and eyes that never looked up from the sidewalk. New York was the breadline, "the worm that walks like a man."

Caro, p. 323

Subways were truly for sleeping, and when patrolmen walked along station platforms rapping on souls, the men lying there arose without a protest, carefully gathering their pallets of newspapers, shuffled onto a train and rode to the next station, where they spread their papers down again.

Ibid.

Groucho Marx said he knew things were bad when the pigeons started feeding the people in Central Park.

Ellis, *Epic*, p. 533

Louis Mumford on the Gashouse District: "Their tracery of iron, against an occasional clear lemon-green sky at sunrise was one of the most pleasant aesthetic elements in the new order."

WPA Guide, p. 187

Thomas Wolfe on the Gashouse District: "As they walked away through the powerful ugliness and devastation of that district, with its wasteland rusts and rubbish, its slum-like streets of rickety tenement and shabby brick, its vast raw thrust of tank, glazed glass and factory building, and at length its clean, cold, flashing strength and joy of waters—a district scarred by that horror of unutterable desolation and ugliness and at the same time lifted by a powerful rude exultancy of light and sky and sweep and water, such as is found only in America, and for which there is yet no language—as they walked away along a street, the blue wicked shells of empty bottles began to explode on the pavements all around them."

Wolfe, *River*, p. 495

Gas, leaking from the tanks, made the neighborhood a pesthole.

WPA Guide, p. 187

A vital component of New York's modernity, its heterogeneous, polyglot immigrant population, did not sparkle at night; for many, it furnished the darkness against which the lights were lit.

Sharpe, p. 156

If by day poor or unsightly sections called out for social reform, by night the city was a purified world of light, simplified into a spectacular pattern, interspersed with now-unimportant blanks.

Ibid.

r Poverty

What a mélange in the starlight. Mothers, graybeards, lively young girls, exhausted sweatshop fathers, young consumptive coughers and spitters, all of us snored and groaned there side by side, on newspapers or mattresses. We slept in pants and undershirt, heaped like corpses. The city reared about us.

Céline, p. 554
That street was like a dismal gash, endless, with us at the bottom of it filling it from side to side, advancing from sorrow to sorrow, toward an end that is never in sight, the end of all the streets in the world.

There were no cars or carriages, only people and more people.

Abbott, "Bowery," p. 83
I never saw a child anywhere on the Bowery, which must have been an indication of something.

Federal Writers, *Panorama*, pp. 425–6
The dark and infamous "Lung Block" stood as late as 1933. Of one of its buildings, known as the "Ink Pot," Ernest Poole wrote: "Rooms here have held death ready and waiting for years. Upon the third floor, looking down into the court, is a room with two little closets behind it. In one of these a blind Scotchman slept and took the Plague in '94. His wife and his fifteen-year-old son both drank, and the home grew as squalid as the tenement itself. He died in the hospital. Only a few months later the Plague fastened again. Slowly his little daughter grew used to the fever, the coughing, the long sleepless nights … At last she, too, died. The mother and son then moved away. But in this room the germs lived on … they can live two years in darkness. Then one year later, in October, a Jew rented this same room. He was taken ill and died in the summer. The room was rented again in the Autumn by a German and his wife. She had the Plague already, and died. Then an Irish family came in. The father was a hard, steady worker … But six months later he took the Plague. He died in 1901. This is only the record of one room in seven years."

Dreiser, p. 167
But the city for me, in my time, has been flecked with these shadows of disaster in the guise of decayed mortals who stared at me out of hollow eyes in the midst of the utmost gayety. You turn a corner laughing amid scenes of enthusiasm and activity, perhaps, and here comes despair along, hooded and hollow-eyed, accusing you of undue levity. You dine at your table, serene in your moderate prosperity, and in looks wan, thin-lipped, and pale, asking how can you eat when she is as she is. You feel the health and vigor of your body, warmly clad, and lo, here comes illness or weakness, thin and pining, and with cough or sigh or halting step, cries: "See how I suffer—and you—you have health!" Weakness confronts strength, poverty wealth, health sickness, courage cowardice, fortune the very depths of misfortune, and they know each other not—or defy each other. Of a truth, they either despise or fear, the one the other.

Ibid., p. 264
I remember seeing once, in the rush of the Christmas trade in New York City a few years ago, a score of these decidedly shabby and broken brethren carrying signs for the edification, allurement and information of the Christmas trade. They were strung out along Sixth Avenue from Twenty-third to Fourteenth Streets, and the messages which their billboards carried were various. I noticed that in the budding gayety of the time these men were practically hopeless, dull and gray. The air was fairly crackling with the suggestion of interest and happiness for some. People were hurrying hither and thither, eager about their purchases. There were great van-loads of toys and fineries constantly being moved and transferred. Life seemed to say: "This is the season of gifts and affection," but obviously meant nothing to these men.

Poverty

You should have seen that Brooklyn Broadway! Instead of sky, above us Lobas, p. 166
thundered the elevated subway. The pavement was pitted with such potholes
that if a wheel had gone down into one of them it would have stayed there
forever. Lots of slums, with boarded-up windows, alternated with blocks of
burned-out buildings.

He used to panhandle on the corner. Sometimes I take the train myself. I'd Donleavy
give him a quarter. A year before he was a company vice president down on
Wall Street. But deep down in the back of his eyes you could see that he was
from Michigan, just a poor lost kid in the big city.

Lonely dignified ragpickers from Hudson Street supping soup without a word Kerouac, *Lonesome*, p. 109
to anybody, with black fingers, woe.

The scene is the side door of a bakery, once located at Ninth Street and Dreiser, p. 130
Broadway, and now moved to Tenth and Broadway, the line extending toward
the west and Fifth Avenue, where it was formerly to the east and Fourth
Avenue. It is composed of the usual shabby figures, men of all ages, from
fifteen or younger to seventy. The line is not allowed to form before eleven
o'clock, and at this hour perhaps a single figure will shamble around the
corner and halt on the edge of the sidewalk. Then others, for though they
appear to come slowly, some dubiously, they all arrive one at a time. Haste
is seldom manifest in the approach. Figures appear from every direction,
limping slowly, slouching stupidly, or standing with assumed or real
indifference, until the end of the line is reached when they take their places
and wait.

I'm in a cold wet city that is gasping for water in the worst way in its history Wojnarowicz, p. 243
and yet water makes some people miserable, the ones huddled in the barely
recessed doors around City Hall under wet sleeping bags. It recently became
illegal to be homeless in this area after the civic center and stock exchange
and department stores close up at night.

Panning down to the sidewalk there's an ugly old homeless bag lady holding Ellis, *Psycho*, p. 5
a whip and she cracks it at the pigeons who ignore it as they continue to
peck and fight hungrily over the remains of the hot dogs and the police car
disappears into an underground parking lot.

When the curtain of night rises on Riverside and reveals Grant's Tomb Strunsky, p. 705
in misty vagueness at the end of a green vista, the site is rarely for those
who sleep in the expensive caravansaries along the Drive, and most often
for the sleepers on the benches. It is the men who sleep on the benches in
Morningside Park that are the first to wonder at the dark front of poplars
holding desperate defense against the charging line of daylight, and over the
poplars the huge, squat octagon of St. John's buttressed chapels.

The panhandler is a telephone pole in the eyes of the law. Blomley, p. 88

He abandoned soap, abandoned the seasons, lived upon the concrete tracks of Sanders, *Beatnik*, p. 81
lower New York as if they were the props of a stage production.

He has fallen asleep sitting on his stoop. His hands loosely hold a brown paper Lee and Jones, p. 49
bag that is tightly twisted around a beer can.

An image of yourself curled up on the sidewalk next to a heat vent with the McInerney, *Bright Lights*, p. 89
other bums.

Ibid., p. 160

At Sheridan Square a ragged figure is tearing posters off the utility poles. He claws at the paper with his fingernails and then stomps it under his feet.

Ibid., p. 180

By the time you reach Canal Street, you think that you will never make it home. You look for taxis. A bum is sleeping under the awning of a shuttered shop. As you pass he raises his head and says, "God bless you and forgive your sins." You wait for the cadge but it doesn't come. You wish he hadn't said anything.

Jackson and Dunbar, p. 424

A typical airshaft. As usual, it is closed at both ends. It is two feet ten inches wide, forty-eight feet long, and seventy-two feet high. Forty-two windows open upon it, the sole source of light and air to the rooms … The baby's bathtub is hung outside of the window because the rooms are so small that there is no place to keep it inside. The shaft is only a little wider than the tub … The sunlight seldom penetrates below the fifth floor in these shafts. There is never a circulation of air.

Reay, p. 269

Plaster constantly sifts down in all the rooms of the place … I feel cold inside as I think of the next tomorrow.

Dreiser, p. 280

Others like her are being pushed and jostled the whole length of this crowded section. They are being nudged and admired as well as sought and schemed for. Whatever affections or attachments they have will be manifesting themselves to-night, as may be seen by the little expenditures they themselves are making. A goldfish of transparent paste or a half pound of candy, a cheap gold-plated stickpin, brooch or ring, or a handkerchief, collar or necktie bought off one of the many pushcart men, tell the story plainly enough. Sympathy, love, affection and passion are running their errant ways among this vast unspoken horde no less than among the more pretentious and well-remembered of the world.

And the homes to which they are hurrying, the places which are dignified by that title, but which here should have another name! Thousands upon thousands of them are turning into entryways, the gloom or dirtiness or poverty of which should bar them from the steps of any human being. Up the dark stairways they are pouring into tier upon tier of human hives, in some instances not less than seven stories high and, of course, without an elevator, and by grimy landings they are sorted out and at last distributed each into his own cranny. Small, dark one-, two- and three-room apartments, where yet on this Christmas evening, one, and sometimes three, four and five are still at work sewing pants, making flowers, curling feathers, or doing any other of a hundred tenement tasks to help out the income supplied by the one or two who work out. Miserable one- and two-room spaces where ignorance and poverty and sickness, rather than greed or immorality, have made veritable pens out of what would ordinarily be bad enough. Many hundreds or thousands of others there are where thrift and shrewdness are making the best of very unfortunate conditions, and a hundred or two where actual abundance prevails. These are the homes. Let us enter.

Goldmark, p. 4

Eleventh Avenue is dirty and desolate … On the west side of the avenue and lining the cross streets are machine sops, gas tanks, abattoirs, breweries, warehouses, piano factories, and coal and lumber yards whose barges cluster around the nearby piers. Sixty years ago this avenue, in contrast to the fair farm land upon which the rest of the district grew up, was a stretch of barren and rocky shore, ending in the flat unhealthy desolation of the Great Kill Swamp. Land in such a deserted neighborhood was cheap and little sought for, and permission to use it was readily given to the Hudson River Railroad.

694

Today the franchise, still continued under its old conditions, is an anomaly. All day and night, to and from the Central's yard at Thirtieth Street, long freight trains pass hourly through the heterogeneous mass of trucks, pedestrians, and playing children; and though they now go slowly and a flagman stands at every corner, "Death Avenue" undoubtedly deserves its name.

No, it is terrible to be poor in New York.

Ford, *America*, p. 181

Schmitz, pp. 270–1 Anger was the real zeitgeist in New York. Everyone was angry.

Arce, p. 24

The streets
reverberating, empty
are rivers of darkness
pouring into the sea
and the sky
threadbare
is the new
flag
that flares
over the city.

Lefebvre, *Cities*, p. 101 If there was a production of the city, and social relations in the city, it is a production and reproduction of human beings by human beings, rather than the production of objects. The city has a history; it is the work of a history, that is, of clearly defined people and groups to accomplish this oeuvre, in historical conditions.

Reitano, p. 131 Gigantic chaos.

Amin and Thrift, p. 105 Full of subtle, and not-so-subtle, acts of brutality.

Reitano, p. 131 Ethnic foment in NYC: Not a whirlpool but a perpetual thunderstorm.

Blandford, p. 156 The unguarded back is as primitive an invitation as a bared throat.

Conrad, p. 307 A social collage where the conjoining glue is mainly the knife and mutual exploitation and hatred.

Berger, *New York*, p. 10 Army tanks crack Fifth Avenue's manhole covers. Now tanks and cannons must detour around them.

Conrad, p. 194 The great city is thoroughly fed up with soldiers unless they are nicely massed into pretty formations.

Black, *Old New York* The Dewey Arch at Fifth Avenue and Twenty-fourth street, erected in 1899, was aligned with the Washington Arch, thus converting the lower stretch of Fifth Avenue into a "triumphal" thoroughfare of a type frequently found in Europe.

Talbot, p. 58 Riots, vandalism of seats and throwing of debris became forms of reaction to unpopular fight decisions.

Wells, pp. 181–2 For many generations New York had taken no heed of war, save as a thing that happened far away, that affected prices and supplied the newspapers with exciting headlines and pictures. The New Yorkers felt that war in their own land was an impossible thing … They saw war as they saw history, through an iridescent mist, deodorized, scented indeed, with all its essential cruelties tactfully hidden away. They cheered the flag by habit and tradition, they despised other nations, and whenever there was an international difficulty they were intensely patriotic, that is to say, they were ardently against any native politician who did not say, threaten, and do harsh and uncompromising things to the antagonist people.

5 Unrest

Before the Wall Street bombing, flyers were found in a nearby mailbox with hand-stamped red lettering reading: Greenburg, p. 9

REMEMBER
WE WILL NOT TOLERATE
ANY LONGER
FREE THE POLITICAL
PRISONERS OR IT WILL BE
SURE DEATH FOR ALL OF YOU.
AMERICAN ANARCHIST FIGHTERS

You have shown no pity to us! We will do likewise. We will dynamite you!— Davis, *Buda's*, p. 1
Anarchist warning, 1919.

On a warm September day in 1920, a few months after the arrest of his *Ibid.*, pp. 1–3
comrades Nicola Sacco and Bartolomeo Vanzetti ("the best friends I have
in America"), a vengeful Italian immigrant anarchist named Mario Buda
parked his horse-drawn wagon near the corner of Wall and Broad streets,
next to the new federal Assay Office and directly across from J. P. Morgan
and Company. The Morgan partners, including the great Thomas Lamont
and Dwight Morrow (Charles Lindbergh's future father-in-law), were
discussing weighty financial matters in a lower-floor conference room.
Perhaps Buda tipped his cap in the direction of the unsuspecting robber
barons before he nonchalantly climbed down and disappeared unnoticed
into the lunchtime crowd. A few blocks away, a startled letter-carrier found
strange, crudely printed leaflets warning: "Free the Political Prisoners or it
Will Be Sure Death for All of You!" They were signed: "American Anarchist
Fighters."

Buda, aka "Mike Boda," was a veteran supporter of Luigi Galleani,
anarchist theorist and editor of *Cronaca Sovversiva* ("Subversive Chronicle"),
which the Department of Justice in 1918 had condemned as "the most
dangerous newspaper in this country." The Galleanisti (probably never more
than 50 or 60 hardcore activists) were chief suspects in various dynamite
plots, including the notorious Preparedness Day bombing in San Francisco
in 1916 (for which union organizers Tom Mooney and Warren Billings were
framed) and the letter bombs sent to prominent members of the Wilson
administration as well as J. P. Morgan and John D. Rockefeller in June 1919.
The *Cronaca Sovversiva* reading circles that met in the shadows of Paterson
silk factories and Youngstown steel mills—not unlike certain contemporary
Quran study groups in gritty neighborhoods of Brooklyn and south
London—were lightning rods for immigrant alienation; an alienation that
grew into rage in the face of wartime anti-foreign hysteria, which resulted
in the so-called Palmer Raids in 1919 against radicals of all denominations.
When Attorney General A. Mitchell Palmer signed Galleani's deportation
order in February 1919, anonymous flyers appeared in New England
factories promising to "annihilate" the deporters "in blood and fire."

As Buda, who had appointed himself the avenging angel of the
imprisoned and deported anarchists, made his escape from Wall Street,
the bells of nearby Trinity Church began to toll noon. Before they had
stopped, the wagon packed with high explosive (probably blasting gelatin
stolen from a tunnel construction site) and iron slugs erupted in a huge
ball of fire, leaving a large crater in Wall Street. Windows exploded in the
faces of office workers, pedestrians were mowed down by metal shrapnel
or scythed by shards of glass, building awnings and parked cars caught

fire, and a suffocating cloud of smoke and debris enshrouded Wall Street. Skyscrapers quickly emptied. Panicked crowds fled past crumpled bodies on the sidewalks, some of them writhing in agony. On the treeless street, green leaves bearing presidents' portraits—some of the estimated $80,000 in cash abandoned by terrified or wounded bank messengers—fluttered with each choking gust of wind and ash. No one knew whether more explosions would follow, and frightened authorities suspended trading at the Stock Exchange for the first time in history.

An attack on Wall Street, of course, was immediately construed as a national emergency. One hundred regular soldiers, rifles loaded and bayonets fixed, were sent quickly from Governor's Island to guard the badly damaged Assay Office and adjacent Subtreasury, while America's chief sleuth, William Flynn, the head of the (federal) Bureau of Investigation, was dispatched from Washington on the first available train. Over the next few days, the NYPD's Detective Bureau assembled the grotesque remains of an "infernal machine": a horse's head, some severed hoofs, and the twisted metal of a wagon axle. Anarchists, the IWW, and the new-fangled Bolsheviki all automatically became suspect and the *New York Times* soon screamed "Red Plot Seen in Blast." While police and federal investigators focused on "celebrity" Reds such as labor-organizer Carlo Tresca, Buda quietly made his way home to Italy. (It is unknown whether other Galleanisti participated in the organization of the bombing or whether Buda was an astonishing one-man show.)

Meanwhile, the coroner was counting 40 dead (some mangled beyond recognition), with more than 200 injured, including Equitable Trust's president Alvin Krech and J. P. Morgan Jr's son Junius. Joseph P. Kennedy, walking in the street, was badly shaken but unharmed. Buda was undoubtedly disappointed when he learned that "Jack" Morgan himself was away in Scotland at his hunting lodge, and that his partners Lamont and Morrow were unscathed. Nonetheless, a poor immigrant with some stolen dynamite, a pile of scrap metal, and an old horse had managed to bring unprecedented terror to the inner sanctum of American capitalism.

WPA Guide, p. 88

Thirty of the noonday crowd were killed and one hundred wounded. Scars of the explosion are still visible on nearby buildings. Occurring during a period of anti-radical hysteria, the disaster was said by some to have been a protest dynamiting of this important financial corner. Others held that the wagon had belonged to an explosives company and had been using a prohibited route when its load of dynamite was accidentally discharged. Neither theory was ever proved.

Ellis, *Epic*, p. 516

Some said the Wall Street blast gave off a bluish white glare. Others described it as a white ball of fire emitting acrid yellow flames that changed color, spat tongues of green flame, and soared skyward in a pillar of thick brown smoke. Higher and higher soared the smoke, darkening from brown to black and flattening mushroom-like above the nearby skyscrapers.

Riesenberg and Alland, p. 77

The philosophy of survival acquired by the hardened inmates of New York who, unconsciously, wherever they be, seem to be preparing themselves for that inevitable shock, never long and coming: it may be a Wall Street explosion, a mere fire at a subway, filled with smoke, screens, and terror, or a cast-iron manhole lid hurtling into the ether.

Ellis, *Epic*, p. 516

The roar of the explosion bounced from building to building like a cannonball rolling free in the hold of a foundering ship.

Like the eye of a hurricane, an ominous hush followed the first roar. Then people screamed.

Ibid.

Iron fragments zinged through the air. They gashed pedestrian's arms and smashed legs and crushed skulls. The shower of metal was followed by a shower of glass, cascading onto the pavement. The blast knocked out windowpanes within a half-mile radius. A man walking along John Street, five blocks north, was felled by a four-inch length of pipe crashing on the base of his neck. Fatally stricken girls stiffened, sagged, and slumped to the pavement. Blood seeped from them and spread fanlike over the concrete. Up from the street leaped a fountain of flame that clawed the facades of buildings on both sides of Wall Street. Desks caught fire. Office workers suddenly found their hair flaming torches. People in offices as high as the sixth floor were badly burned.

Ibid.

Human bodies will all at last be torn apart by the city's stresses.

Conrad, p. 308

On June 10, 1910, J. J. Gallagher, a disgruntled dock worker, attempted to assassinate William Jay Gaynor, New York's mayor, as he boarded a German ocean liner in Hoboken, for a planned trip to Europe. Gallagher shot him through the neck. Gaynor survived, but the bullet stayed in his throat, slowly robbing him of the ability to speak. He died just a few days later on his trip to Europe—one that was meant to let him rest and get stronger. He became the second mayor of New York to die in office.

DeArment, p. 124

On October 3, 1914, a bomb exploded in St. Patrick's Cathedral. On November 11, the anniversary of the Haymarket executions, the Bronx Courthouse was bombed.

Fronc, p. 145

In the early morning hours of Sunday, July 30, 1916, a massive explosion shattered thousands of windows throughout Lower Manhattan, and some as far north as Times Square. The rumble was felt as close as Jersey City and as far away as Philadelphia. Millions of tons of war materials and explosives, stored on Black Tom Island in New York Harbor, exploded. Investigators initially blamed spontaneous combustion; the search, however, conducted in large measure by the New York City Police Department's bomb squad, eventually zeroed in on Michael Kristoff, a citizen of the Austro-Hungarian Empire.

Ibid., pp. 145–6

1933: a tear gas bomb is dropped into the ventilating system of the New York Stock Exchange.

WPA Guide, p. 84

Communism, Old Left

Radio station WEVD, founded in 1927 as a memorial to the Socialist leader Eugene V. Debs.

Federal Writers, *Panorama*, p. 298

The Daily Worker, official organ of the Communist Party of the United States, occupies an important place among New York's labor newspapers. Many well-informed persons outside the labor movement now find it necessary or desirable to supplement their reading of the regulation newspapers with a perusal of the *Daily Worker* in order to obtain a balanced and comprehensive view of current affairs.

Ibid., p. 308

699

Freeman, p. 55	Children were devoted newspaper readers, including the Communist *Daily Worker*.
Feldman and Benjamin, p. 118	The real-life Mafia connections of Teamsters Union President Jimmy Hoffa, and the cinematic portrayal of longshoremen's union corruption by the Mafia in the movie adaptation of Budd Schulberg's novel *On The Waterfront*, helped bring this aspect of organized crime most sharply into the public consciousness. In an era when private-sector labor unions enrolled many more Americans than they do now, and America's obsessive fear of illegal drugs had not yet taken hold, people cared more about the corruption of unions than they did about gangsters merely killing gangsters, or supplying prostitution or gambling opportunities to those who wanted them.
Bendiner, pp. 83–4	Some Bowery Men were Wobblies who organized as they roamed, who talked and fought for the world of "one big union" with no bosses or cops, the world of the "big rock-candy mountain."
LeSueur	I remember down-and-out parties of cheese and crackers, and jug wine. At one such gathering I was asked, quite seriously, if I was a Stalinist or a Trotskyite. I guessed right and claimed allegiance to the Trotsky camp.
Ibid.	And in a grim and industrial loft on the Bowery, Anarchist Club meetings were held on Saturday afternoons; they were solemn, earnest, somehow touching to me—it was as though its downtrodden members believed that their utopian flights of fancy may someday materialize.
Conrad, pp. 193–4	Fitzgerald dated the beginning of this "most expensive orgy in history" from the May Day riots in 1919, when the police charged demonstrators in Madison Square; its end was the stock-market crash of October 1929.
Ibid., p. 194	"May Day" begins by disestablishing New York as a place of work and consecrating the city to pleasure. Provincial capitalists gather there "to buy for their women furs … and bags of golden mesh and varicolored slippers." Those who can't afford such trinkets dream of them: working girls spend their lunch hours window-shopping on Fifth Avenue, fancying themselves the purchasers of jewelry, feather fans, silk gowns, and strings of pearls. A floral triumph greets the troops returning from the war. Merchants and clerks forget "their bickerings and figurings" to watch the parade. As well as this welcome to the carousing troops, the city houses other festivities—a fraternity dance at Delmonico's or the sordid revels at which Gordon Sterrett meets Jewel Hudson (who'd made a career for herself out of showing a good time to the soldiers back from France). Political outrage, when the mob besieges the offices of a left-wing paper, is, like pleasure, fueled by drink.
WPA Guide, p. 199	Machine guns mounted on the roof of S. Klein on Union Square and pointed into the crowd of 5,000 for the demonstration of the execution of Sacco and Vanzetti.
Stevens and Swan, pp. 111–2	Alfred Kazin described a typical night at Union Square this way: "The place boiling as usual, with crowds lined up at the frankfurter stands and gawking at the fur models who in a lighted corner window perched above the square walked round and round like burlesque queens … There was always a crowd in Union Square; the place itself felt like a crowd through which you had to keep pushing to get anywhere." Often Gorky and de Kooning, after a late night spent talking about painting, would stroll through the square and

s Unrest — Communism, Old Left

observe the scene—what Kazin described as an "eternally milling circle of radicals in argument."

As they dived back into the massed throng in the Square, a Soviet flag was run up on a flagpole over the Stars and Stripes. Police told the Communists to reverse the sequence, declaring that no one would be allowed to speak until Old Glory fluttered over the Soviet banner. Ellis, *Epic*, p. 538

1930 Union Square Communist riot: 35,000 gather for jobs and housing. Police brutality ensued. The Communists were pleased. To them, the riot was "a great success" because it showed how oppressive capitalist governments really were. Reitano, p. 143

An array of leftist rallies held at Madison Square Garden in the 1940s. Freeman, p. 55

The Communist Party was active in Harlem where a major rent strike was waged in 1934. Reitano, p. 143

Forty thousand people came out on May 1, 1946, to support the first May Day parade since before Pearl Harbor. It took the marchers four hours to enter Union Square. Freeman, p. 56

At the end of World War II, in the New York–area CIO the Communists and their allies dominated the leadership of the UE, TWU, NMU, Furriers, American Communications Association, UOPWA, UPW, Shoe Workers, and Furniture Workers, and controlled Local 65 and most of the department store locals of the RWDSU. In the AFL they led locals of bakers, building service workers, and jewelry workers, the painters union district council, and Local 6 of the Hotel and Restaurant Employees (which had well over twenty thousand members). Also some leaders of the unaffiliated International Association of Machinists worked with the Communists. *Ibid.*, pp. 60–1

The Meat Cutters began to "decommunize" the Furriers. *Ibid.*, p. 89

The motley rabble of soldiers, marines, and hangers-on which hunts the Bolsheviks down Sixth Avenue is ironically called a "procession." Conrad, p. 194

The Communist Party still had their offices on the eighth floor of 33 Union Square West in 1967–1968 when Andy Warhol moved his Factory to the building. The Factory was on the sixth floor, where Warhol was shot. Pomerance, p. 159

In 1913 the illuminati of the Village addressed their fellows as "Comrade," by 1927 they were more likely to go round giving each other the Fascist salute. Irwin, p. 120

A Moscow paper published pictures of holes dug in Broadway by repairmen, the captions declaring that the pits were caused by "bombings" and "riots." Ellis, *Epic*, p. 536

He noticed that many an idealistic socialist ceased to be a socialist as soon as he became rich. All the prophets about him became businessmen, and left the poor man alone. Hapgood, p. 284

The so-called "intellectual" Jews of Canal and Grand Streets are, as a rule, very happy. They sit around and drink tea and emit large and important ideas. They react vigorously—otherwise kick—against American conditions, sometimes wisely, but always amusingly. And they enjoy it. *Ibid.*, p. 298

Sharpe, p. 230

Inside the dream factory, the torment continued. Up close, the lights in the windows were not diamonds or dollar signs but electric meters measuring the human cost of the inhuman spectacle.

Douglas, p. 20

The 1920s were at least as post-Marxist as anti-Marxist. Remember this was the first age of the media, of book clubs, best-sellers, and record charts, of radios and talking pictures; by the end of the decade, one in every three Americans owned a radio and record player, three out of four went to the movies at least once a week, and virtually no one was out of reach of advertising's voice. Whatever the moderns' apathy toward conventional politics, they were altogether alert to the bewildering array of cultural artifacts and phenomena that a full-blown consumer society throws into the hustling stakes of history. This was the first generation to grasp the supremacy to see that mass culture would acquire, to realize that, in the late-capitalist or consumer society America was becoming, there might not be distinct classes as Marx had explicated them in his studies of early capitalism a half-century earlier; instead of a clear distinction or face-off between the oppressor and the oppressed, there might be only a handy-dandy exchange between what the metropolitans termed "suckers" and "racketeers." In a consumer society, this generation saw, everyone, wittingly or unwittingly, gets to play the "sucker" one moment and the "racketeer" the next. There are no classes in this shrewdly apolitical political vision, just people more and less deceived. Tricksters and impersonators appeared nightly as top Broadway entertainment; in mongrel Manhattan, con games were culture.

Stevens and Swan, p. 111

Even among those [artists] who were not card-carrying communists, the prevailing sentiment was left-wing. According to Isamu Noguchi, artists were such pariahs in American society that they instinctively sided with anyone else perceived as an underdog. Communism had the added appeal of defining artists as workers, thus providing them the legitimacy that they sought but could not attain in American society.

Labor, Work

Mencken, p. 182

Manhattan Island, with deep rivers all around it, seems an almost ideal scene for a great city revolution, but I doubt very much that there is any revolutionary spirit in its proletariat. Some mysterious enchantment holds its workers to their extraordinarily uncomfortable life; they apparently get a vague sort of delight out of the great spectacle that they are no party of. The New York workman patronizes fellow workmen from the provinces even more heavily than the Wall Street magnate patronizes country mortgage-sharks. He is excessively proud of his citizenship in the great metropolis, though all it brings him is an upper berth in a dog kennel. Riding along the elevated on the East Side and gaping into the windows of the so-called human habitations that stretch on either hand, I often wonder what process of reasoning impels, say, a bricklayer or a truck driver to spend his days in such vile hutches. True enough, he is paid a few dollars more a week in New York than he would receive anywhere else, but he gets little more use out of them than an honest bank teller. In almost any other large American city he would have a much better house to live in, and better food; in the smaller towns his advantage would be very considerable. Moreover, his chance of lifting himself out of slavery to some measure of economic independence and autonomy would be greater anywhere else; if it is hard for the American workman everywhere to establish a business of his own, it is triply hard in New York, where rents are killingly high and so much capital is required to launch a business that only

Jews can raise it. Nevertheless, the poor idiot hangs on to his coop, dazzled by the wealth and splendor on display all around him. His susceptibility to this lure makes me question his capacity for revolution. He is too stupid and poltroonish for it, and he has too much respect for money. It is this respect for money in the proletariat, in fact, that chiefly safeguards and buttresses capitalism in America. It is secure among us because Americans venerate it too much to attack it.

The poor sindicalist city
scaffolded all over
with cries and hurrahing.

Workmen
are red
and yellow.

Arce, pp. 20–1

A visitor wandering the streets of mid-twentieth-century New York would have had no trouble discerning the social centrality of its working class.

Freeman, p. xiii

On September 24, 1945, barely three weeks after the end of World War II, the main business districts of New York City ground to a halt. For a week over a million-and-a-half workers milled around the streets or stayed home. Mail and railway express delivery halted, and federal tax collections fell by eight million dollars a day. This estimated one hundred million dollar loss to the economy stemmed from a strike by fifteen thousand elevator operators, doormen, porters, firemen, and maintenance workers employed in commercial buildings.

Ibid., p. 3

Hundreds of thousands of blue-collar workers, executives, clerical workers, mailmen, deliverymen, and tax collectors could not or would not walk up dozens of flights of steps to reach their shops or offices.

Ibid.

New York strikes during the year after the war included a weeklong walkout by ten thousand painters; a four-week strike by seven thousand members of the American Communications Association that disrupted telegraph communication into and out of the city; a 14-day strike against the Brooklyn-based Mergenthaler Co., the largest maker of linotype equipment in the country; and a series of trucking strikes culminating in a September 1946 walkout by twelve thousand Teamsters that led to empty grocery store shelves and factory closings ... Sprinkled among these clashes were a myriad of smaller confrontations: a strike of Times Square motion picture projectionists, a lockout of thirty Newspaper Guild members at *Billboard* magazine, a walkout by eight hundred Brooklyn and Manhattan bakers.

Ibid., p. 4

An air of unreality hung over the city. Incidents took on a staccato, dream quality; sharply etched, touched with hysteria, cockeyed.

Ibid., pp. 5–6

All the signs were that it would be the supreme city of the Western world, or even the world as a whole.

Ibid., p. 7

In a city where the largest, most advanced warships and passenger liners in the world regularly docked, fish still got delivered to the Fulton Fish Market in sail-powered boats. In a city where sophisticated defense electronics got designed and built, St. Patrick's Cathedral and Bellevue Hospital still operated on DC current. In a city where preliminary work for atomic fission

Ibid.

had been done, potbellied stoves were being sold for home heating, and ice blocks were delivered for home refrigeration.

Ibid., p. 8

A visitor to Manhattan, seeing the tall office buildings dwarfing all other structures, and passing no huge steel mills with blast furnaces belching fire and smoke as in Chicago or Pittsburgh, or giant automobile factories as in Detroit, or long cotton mills as in New England or the South, might easily conclude that New York was mainly a region of white-collar workers supported by wholesale trade and banking.

Ibid., p. 15

New York was a non-Fordist city during the age of Ford.

Ibid., p. 19

To get on that subway on the hot mornings in summer. To devote your whole life to keeping stock, or making phone calls, or selling or buying. To suffer fifty weeks of the year for the sake of a two-week vacation, when all you really desire is to be outdoors, with your shirt off. And always to have to get ahead of the next fella.

Ibid., p. 21

The images of the emergence of mass society in New York were not of workers on an assembly line but of rows and rows of clerical workers engaged in seemingly mindless, interchangeable, soul-deadening labor.

Ibid., pp. 21–2

In the 1940s it was almost impossible to look out of a skyscraper window and not see men engaged in physical labor, be it pushing racks of clothes in the garment district, floating railroad cars across the harbor, or maneuvering trucks full of printed material, toys, or machine tools through the congested streets of Manhattan. When financiers and lawyers and marketing men left their offices they rubbed shoulders in the streets and subways with the secretaries and clerks and elevator operators with whom they shared their buildings and the furriers and typographers and waitresses and warehousemen who worked nearby.

Donleavy

Even in these gloomy ravines of sweaty armpits pushing trolleys of pink and blue dresses through this dingy garment district.

Freeman, p. 22

Just blocks from Wall Street, where paper symbols of property—securities, bonds, and commodity futures—were traded, there were wholesale markets for butter, eggs, cheese, tea, coffee, and spices where not just the ownership of those goods but the goods themselves were exchanged. As the postwar era dawned, the sounds of tugboats and the smell of freshly roasted coffee beans still penetrated the corridors where bankers and businessmen accumulated money and power on a scale unsurpassed anywhere in the world.

Ibid., p. 23

In some respects the Kramdens and Nortons were distinctly New Yorkers. Where else did neighbors visit one another via the fire escape?

Sanders, *Celluloid*, p. 211

A secret route, a private connection between two floors and two souls. The fire escape is theirs; others use the building's staircase.

Freeman, p. 35

The roster of New York unions has a Whitmanesque quality to it: there are four locals of Airline Dispatchers; eleven of Barbers and Beauty Culturists; eleven of Boilermakers; forty-two of Carpenters; one of Commercial Artists and three of Coopers; one each of Dental Technicians, Diamond Workers, Firemen, Foremen, and Funeral Chauffeurs; thirty-eight of Hod Carriers, Building and Common Laborers (including the Hose Wreckers and the Curb Setters); twenty-five of Machinists; fifty-three of Railway and Steamship

Clerks; one each of Screen Publicists, Seltzer Water Workers, Sightseeing Guides, and Theater Ushers; six of Upholsterers; and one of Vending Machine Service Workers.

When members of the International Association of Machinists voted to strike against the E.W. Bliss Projectile Company in Brooklyn at the end of April 1911, every union member and all but one non-union worker joined the walkout. The issue was the company's refusal to adopt the eight-hour workday. The lone holdout was Harry Gorrie, a thirty-year-old machinist who lived not far from the Bliss plant on 53rd Street. Gorrrie's decision enraged his fellow workers. For several days the strikers merely argued with him, but after about a week he was surrounded by a jeering, threatening mob, on his walks to and from work. He sought and was granted police protection.

By May 10, Gorrie's slow treks from his home to the factory and back, accompanied by mounted police and patrolmen, attracted crowds of men and women who pelted the group with bits of street rubble and refuse. Gorrie seemed nonplussed as he walked along, calmly smoking a pipe and occasionally chatting with the patrolmen by his side, which naturally further inflamed the crowd. The air was thick with hurled projectiles and invective.

Carlebach, p. 5

The city is peculiarly constructed to absorb almost anything that comes along without inflicting the event on its inhabitants; so that every event is, in a sense, optional, and the inhabitant is in the happy position of being able to choose his spectacle and so conserve his soul.

White, Here, p. 22

Kipling in 1892: "We lingered in New York till the city felt so homelike that it seemed wrong to leave it. And further, the more we studied it, the more grotesquely bad it grew—bad in its paving, bad in its streets, bad in its street-police."

Javits, p. 111

A woman in a fur coat lying on the sidewalk, daring the police to attack her.

Freeman, p. 51

Burly, white-capped sailors battling policemen before an audience of hundreds.

Ibid.

Police wagons inching their way forward through crowds of financial workers trying to get to work.

Ibid.

Co-op City was the Vietnam of the nonprofit cooperative housing movement.

Ibid., p. 119

The move in the 1950s from manual unloading of ships to containerization: "Clean it may be, interesting it isn't," said one longshoreman.

Ibid., p. 164

When ships began docking at New Jersey piers far from Manhattan, and staying only a day instead of the better part of a week, many sailors stopped going into the city at all, depriving it of a presence that went back to colonial days. The ships chandlers, rope works, and saloons that had lined the shores of Brooklyn and Manhattan since the days of Melville disappeared.

Ibid.

An I. M. Pei–designed convention center, a palace of meeting and selling filled with men and women in smart suits, replaced what had been a major freight handling center, where longshoremen, teamsters, and railroad men held sway.

Ibid., p. 293

Almost completely missing were ordinary working people.

Ibid., p. 304

On September 7, 1981, some 200,000 New Yorkers marched in the city's first Labor Day parade in thirteen years. Four thousand air traffic controllers led a seven-hour procession up Fifth Avenue.

Ibid., p. 326

On June 30, 1998, 40,000 construction workers, protesting the use of a non-union firm to build a subway communications center, blocked Madison Avenue … To many mid-town regulars, the construction workers seemed an alien presence. A *New York* magazine editor, commissioning an article about the demonstration, described them as "an invading army," an odd description for a group which probably had a higher proportion of native New Yorkers and in-city residents than the advertising, media, and corporate executives working along Madison Avenue whose lives they momentarily disrupted. A full-page article in the *New York Post,* headlined "Hunk Heaven," treated the protesters as sexual exotica. "In a neighborhood dominated by men in suits who usually confine themselves to loosening their tie at the end of the day," the paper commented, "the sight of guys ripping off wet muscle shirts or stuffing flannel shirts in torn jean pockets was something of a revelation."

Ibid., p. 328

The white light of new money, radiating from Wall Street, made other economic groupings look pale, difficult to discern. New York financiers did not have to have any relationship with working-class New York to exert economic and political power. Economically, they depended on global markets, not local production. Politically, their national influence rested not, as in the past, on political parties or coalitions that required attention to the interests of varied bases, but on direct ties to the Treasury Department and the Federal Reserve Bank.

Ibid., p. 336

When World War II ended, New Yorkers took for granted the sight of manual workers and labor protests in the heart of the city, even if they opposed what labor stood for and how it acted. By the late 1990s, many Manhattanites were startled by the mere presence of protesting workers.

Ibid., p. xiii

By the 1990s, the tenor and trajectory of New York increasingly derived from its position as a global city connected to markets and tastemakers throughout the world, while its own toiling majority receded into the background.

Dreiser, p. 189

I am returning one day from a serious inspection of the small stores and shops of the neighborhood. As I near my door I am preceded up the street by three grim coal-heavers, evidently returning from work in an immense coal-yard in Eleventh Avenue.

Ibid., p. 278

The street, with its mass of life, lingers in this condition until six o'clock, when the great shops and factories turn loose their horde of workers. Then into the glare of these electric-lighted streets the army of shop girls and boys begins to pour. Here is a spectacle interesting and provocative of thought at all seasons, but trebly so on this particular evening. It is a shabby throng at best, commonplace in garb and physical appearance, but rich in the qualities of youth and enthusiasm, than which the world holds nothing more valuable.

Brook, p. 4

Office workers were darting into delicatessens to pick up groceries or prepared foods for their suppers before returning to the tall characterless white-brick apartment buildings where they occupy a room or two.

Sanders, *Celluloid*, p. 107

The dark, oppressive underworld that supported these towers was to be found not so much in their basements as in grimy industrial towns across the United

States, where ten and twelve hour days of toil sustained the extravagance of a Chrysler Building or a Rockefeller Center.

Uprising of the 20,000 in September 1909; precursor to Triangle Shirtwaist fire. Reitano, p. 122

In the wake of the Triangle fire, angry cries were heard to blow up City Hall. *Ibid.*, p. 123

On one block I see the windows through which scores of young women once leapt to their deaths, fire driving them from factory floor to the cool of the open air; their hair held in place with ribbons of flame as they fell. I knew their names: *Jennie, Rose, Rachel, Essie, Annie* … How quiet this place seems now, the screams of that hour followed by years of silence. College students run by without thinking. Sometimes, someone else who remembers places white roses on the sidewalk. Brooks, *In the City*, p. 4

Small girls jumping out of windows from the Triangle Shirtwaist Factory. "Life nets? What good were life nets? The little ones went right through the life nets and the pavement, too. Nobody could hold a life net when those girls from the ninth floor came down." A trio of girls landed on one net, it broke, and the firemen holding its edges were jerked in on the mangled bodies. The sky seemed to rain flesh. Spectators winced at the sound of bodies hitting the ground. Now fire trucks dared not move closer for fear of running over the dying. People standing on the sidewalk twisted damp fingers together as they watched the death of a pair of lovers. Suddenly silhouetted against the glare in a ninth-story window stood a man and girl. Their clothing was stitched with flames. They kissed. Then, entwining their arms about each other, they stepped into eternity. Ellis, *Epic*, p. 492

"The screams were getting worse. I looked up and saw the whole elevator shaft getting red with fire … It was horrible. They kept coming down from the flaming floors above. Some of their clothing was burning as they fell. I could see streaks of fire coming down like flaming rockets." Drehle, p. 154

One girl tried to keep her body upright. Until the very instant she touched the sidewalk, she was trying to balance herself. *Ibid.*, p. 157

When two young women jumped together, they tore the life net like "a dog jumping though a paper hoop." Before the firemen could move the ruined device, another girl's body flashed onto it. *Ibid.*

When they came down one at a time we could have helped. When they came down entwined with one another, it was impossible. *Ibid.*

When the first jumper lurched into the thin air, a net was ordered open to catch the others. They caught one girl: "She was tipped out onto the sidewalk … I lifted her up when they tipped it, and I said, 'Now, go right across the street.' She walked ten feet, but it was like an automatic motion. Probably six feet—and dropped." *Ibid.*, p. 156

An ambulance driver ran his vehicle up on the sidewalk, hoping that the jumpers might land on the roof of the ambulance and thus break their falls. *Ibid.*, pp. 156–7

Bodies fell with such force that at least one crashed through the glass bricks of a basement skylight set in the sidewalk. *Ibid.*, p. 157

Ibid.	The first ten shocked me.
Ibid., p. 159	The last body fell at 4:57 P.M. The dress snagged on a steel hook on the sixth floor. For a moment she hung there grotesquely until her clothing burned and tore away and she dropped to the sidewalk.
Ibid., p. 1	Referring to the queue outside the morgue after the Triangle fire, an angry police officer ordered his men to purge the line of ghouls and thrill seekers. "What do they think this is," he grumbled, "the Eden Musée?" That was the city's most popular silent movie house.
Talese, p. 35	Often some executives will deliberately leave scraps tottering temptingly on the edge of desks to test the charwomen's adherence to rules.
Mayakovsky, *America*, p. 49	Up until one o'clock, typewriters chatter, jacketless people sweat, columns of figures lengthen on paper.
Corbusier, p. 100	There is in it, in its enormity, a disproportion of effort. Too much energy, too much money.
Ibid., p. 101	All that money represents hours of work, work turned into noise and wind. Those sterile labors eat into the economy of the country. Those fruitless labors are the hours of daily work devoted to paying for that noise and wind.
Ibid., p. 100	The fabulous machinery of skyscrapers, telephones, the press, all of that is used to produce wind and to chain men to a hard destiny.
Goldenberg, p. 7	Leon Trotsky: "New York, a city of capitalist automatism."
Ibid.	Trotsky wanted to live in a "workers' district," so he moved his family into an $18-per-month apartment in the Bronx at 1522 Vyse Avenue, near 172nd Street, just east of Crotona Park. But in his autobiography Trotsky gave 164th Street as the location (he made no distinction between East and West).
Corbusier, p. 58	During these ten years New York raised itself into the sky; but the Soviets in Moscow denounced the skyscraper as "capitalist." A denaturing of the objects in question.
Myers, p. 27	The Liberal Press at 80 Fourth Avenue. The printers were all of the anarchist-pacifist persuasion and fond of anything involving poetry and art.
Trager, p. 472	The Algonquin Hotel has labor troubles; when waiters walk off the job at 1 o'clock as the three dining rooms are filling up with luncheon patrons, men at the Algonquin's Round Table, including playwright George S. Kaufman, don waiters' white jackets, the women (including actress Ina Claire) put on frilly aprons, and they all go to work serving lunch to the other patrons.

Mad Bomber

Greenburg, p. 81	Terror in the Age of Eisenhower.
Ibid., p. xi	At 7:55 on the evening of December 2, 1956, as the epic narrative of *War and Peace* begins to unfold on the screen of Brooklyn's Paramount Theater, there is no mistaking the sudden and violent explosion that rips through the rear of the auditorium for anything remotely connected to the evening's movie

presentation. In a blinding moment of fierce light, smoke, and fire, a powerful device has detonated at precisely the moment determined by a simple timing mechanism within. Panic begins to envelop the room, and, as *War and Peace* continues without pause, patrons begin rushing for the exits.

Shortly after noon on November 18, 1940, an employee of the Consolidated Edison Company, in one of a maze of Con Ed buildings located within the West Sixty-fourth and Sixty-fifth Street city blocks, has come across a curious sight while on break from one of his duties. A small wooden toolbox has been left on a second-story windowsill, containing a length of iron pipe about 4½ inches long, neatly capped on each side. There is a sheet of paper wrapped around the pipe that reads, "CON EDISON CROOKS. THIS IS FOR YOU. THERE IS NO SHORTAGE OF POWDER BOYS." In the pipe is a Parke-Davis throat lozenge. *Ibid.*, pp. 1–3

On July 4, 1940, a suitcase containing sixteen sticks of dynamite has been found at the British Pavilion of the World's Fair. While being examined on the outskirts of the fairgrounds, the container explodes, killing two bomb squad detectives and critically injuring two other police officers on the scene. Though the explosion is felt throughout the 1,260-acre park, most of the holiday throng mistakes the blast for a rather raucous feature of the patriotic celebration. *Ibid.*, p. 2

On September 24, 1941, traffic in and around the area of Nineteenth Street between Fourth Avenue and Irving Place is disrupted by the discovery of a strange object in the roadway. Crammed into a red wool sock is a contraption similar in construction and appearance to the pipe bomb found the previous November on the Con Ed windowsill. Once again, there is an inexplicable throat lozenge included. *Ibid.*, p. 9

Metesky uses throat lozenges in his bombs as timing devices. By applying varying amounts of water to a disc that has been meticulously filed down to a prescribed thickness, he can predict, with some accuracy, the time it takes for the disc to melt. A spoonful of water, for example, will disintegrate the disc in half an hour, while two to three drops will take several days. As the lozenge dissolves, it brings the fusing wires into contact, thus detonating the bomb. *Ibid.*, p. 41

On March 29, 1951 at 5:25 in the afternoon, at the peak of rush hour, Metesky detonates a bomb in Grand Central outside of the Oyster Bar in the Whispering Gallery. *Ibid.*, pp. 39–40

At 6:10 in the evening of April 24, 1951, Metesky's bomb in a telephone booth at the New York Public Library on Forty-second Street and Fifth Avenue goes off. *Ibid.*, p. 42

On August 27, 1951 at 9 p.m. he sets off another bomb in Grand Central, this time in a telephone booth. *Ibid.*, p. 43

On November 28, 1951 a small explosion rips through several coin-operated parcel lockers on the southbound mezzanine of the IRT subway station located at Union Square on Fourth Avenue and Fourteenth Street. *Ibid.*, p. 40

An explosive device found in the 15th row at the Paramount Theater at Broadway and 43rd St. after a showing of Hitchcock's *The Wrong Man*, is taken from the theater in a steel mesh envelope to a waiting transport vehicle, where it is whisked, under motorcycle escort, through the streets of Manhattan to *Ibid.*, p. 118

the beachfront of Fort Tilden, where the device is placed in a hole dug in the sand and detonated.

Ibid., p. 50

In 1952, Metesky strikes three more times: once at a telephone booth in the Forty-first Street Port Authority Bus Terminal, twice at the Lexington Theater on Fiftieth Street and Lexington Avenue.

Ibid., pp. 50–1

He buys an admission ticket shortly after the theater opens in the morning, about 10:00 a.m., possibly the fiftieth patron. He has nothing in his hands, for his bomb is in one pocket of his coat and an ordinary cheap jackknife in another.

This shadowy figure sits in an empty section of the orchestra, away from other persons. In the darkness of the show, he reaches to the seat next to him, slits the bottom with his knife, and slides in both the bomb and the knife (presumably so if anything goes wrong and he is searched before he leaves the theater, the knife will not be found on him).

Then he moves to another section of the theater and watches the show. As the theater fills up, and the early customers begin to leave—and the time for the explosion draws near—the machinist gets up, tags along behind someone who is leaving, and vanishes.

Ibid., p. 51

On December 8, 1952, Metesky's second bomb at the Lexington Theater explodes and, for the first time, a patron is injured. A woman, innocently watching MGM's song and dance film production of *Everything I Have Is Yours*, is struck with shards of metal and debris that causes several deep lacerations on her feet and legs.

Ibid.

By the start of 1953, Metesky begins to experiment with flashlight bulbs and batteries. He discontinues the use of throat lozenge discs as timing devices.

Ibid., p. 53

The afternoon of March 10, 1953, Metesky sneaks into Radio City Music Hall. At a voluble moment of the movie presentation, *The Story of Three Loves*, when he is certain that all eyes will be fixed on the screen, he removes a pocketknife from his overcoat and rips a hole into the undercushion of the seat next to him. At an awkward slant, he reaches underneath and, with a dexterous backhanded scoop, thrusts the bomb and the knife into the gap, where he leaves both. A few moments later he is headed out of the auditorium and toward the lobby.

As Metesky reached the exit doors of the Radio City auditorium, his bomb explodes much earlier than planned. The blast—a "funny" sound—echoes off the eighty-four-foot ceilings and through the hall. "It sounded like a rocket. It went *zzzzz*—BANG!" recalled Metesky. Realizing what had happened and beginning to hear the harried sounds of confusion, if not panic, behind him, he rushes from the theater. As he passes through the lobby, Metesky is detained by the sudden grasp of an usher who catches hold of his arm. He freezes in near panic.

"We're sorry about this sir. We regret the inconvenience."

Eyes squinting with quizzical amazement, Metesky frees himself from the usher's grip and nervously informs him that he is fine but that he still wishes to leave. Foisting a free movie pass into his hand, the man urges him to please come back at a later date and promises that it will never happen again. As Metesky exits Radio City Music Hall, the wailing sound of police cars converging on the building has already begun. He smiles and whispers to himself, *If I come back, it'll happen again alright.*

Metesky returns to Radio City Music Hall—this time with injurious results. During a 1954 preholiday viewing of Bing Crosby's *White Christmas*, a "crude, homemade time bomb" rips through a seat cushion in row 14 of the orchestra level, sending a concussive sound through the auditorium, "as if a big electric bulb had been broken." The capacity audience of 6,200 that had crammed into the orchestra level as well as three balconies of the theater are confused and panicked by the commotion, and four patrons receive an array of puncture wounds and contusions that require a trip to the hospital for treatment. "All seats were taken and there were a number of standees in the auditorium, while a line numbering about a thousand stretched through the lobby and into the street," wrote the *Herald Tribune*.

Ibid., pp. 57–8

Weeks after the second Radio City bombing, thirty New York police officers and bomb squad detectives again rush to the 8th Avenue Port Authority bus terminal, where a bomb has detonated in a telephone booth, driving metal fragments and debris through a pedestrian corridor, startling throngs of weekend bus travelers. A Port Authority attendant and Navy veteran, in the process of checking the lights in the "suburban concourse" telephone booths, throws himself facedown on the ground. Upon hearing the blast, he regains his composure, rises, and contacts the authorities.

Ibid., p. 58

A blast in the lower level men's washroom of Grand Central terminal on March 16, 1953, timed precisely for the start of the heavily traveled rush-hour, slams fragments of iron and debris into several porcelain fixtures, causing extensive damage, sending three commuters to the hospital for treatment of shock and bruises. The explosion echoes throughout the depot, causing hundreds to rush toward the sound in a "fervor of excitement," prompting the washroom attendant to complain, "My ears are still deaf."

Ibid., p. 57

On January 11, 1955, he strikes Penn Station during the evening rush hour, blowing a 2-inch gouge into a concrete wall, sending clouds of smoke billowing from the lower-level of the terminal. As detectives cordon off the surrounding area and conduct a detailed search for fragments and additional devices, he places a telephone call to the switchboard operator of Grand Central Station, warning that a bomb has been placed in a coin-operated locker on the south side of the building and that it will detonate in 15 minutes. A frenzied team of 30 additional officers rush to the scene and conduct a painstaking search, turning up nothing.

Ibid., p. 60

In October, a man is slightly injured as a bomb explodes in the 12th row of the Paramount Theater in Times Square during an evening showing of *Blind Alley*, and in December, emergency crews disperse a large crowd of rush-hour commuters in Grand Central terminal who gather for a look after an explosion rips through the upper level in the main men's lavatory.

Ibid., p. 64

On February 21, 1956, a 74-year-old porter named Lloyd Hill, who is working on the lower-level of Penn Station, is informed by a young man that there is a clog in the toilet in the men's washroom. Shortly before 4 o'clock in the afternoon, as he applies a plunger to the obstruction, the fixture explodes, firing shards of metal and porcelain in every direction—and into Hill's head and legs. "The whole inside of the booth was wrecked. People were running in every direction, scared. So was I," reported one witness. "The porter must've been seriously hurt. He was bleeding all over. I could see blood on his face, hands, arms and legs as police arrived."

Ibid., p. 65

Ibid., p. 66 By the end of summer 1956, Metesky strikes an IRT subway train, a telephone booth at Macy's in Herald Square, and the RCA building in Rockefeller Center. He will later admit to planting several other bombs in 1956 that apparently failed to detonate and were ultimately unaccounted for—including one in the Empire State building—which, as far as anyone knows, could still be unceremoniously launched into a little-noticed cranny of the 37 million cubic foot structure a half-century later.

Ibid., p. 67 On the afternoon of August 4th, a security guard at the RCA Building stumbles upon what he thinks to be a harmless length of pipe that could be put to good use. He gives the pipe to another guard who is near the end of his shift. That guard carries the pipe with him all that evening throughout his guard duties and during the bus ride home after work. Upon arriving at his house in New Jersey, he removes from his pocket the length of pipe, puts it on the kitchen table and goes to bed. At precisely 6:00 AM, he is awakened by what he describes as a sound "like two cars coming together." Rushing into the kitchen, fighting the pungent smoke, he witnesses what his wife would later describe as "a mess … like an atomic bomb hit it."

Ibid., p. 77 In newspapers around the city, words such as "GHOULS," "JUSTICE," "YELLOW PRESS," and "CON. EDISON CO," appear in obtrusive stories beneath headlines such as "DO YOU RECOGNIZE THIS WRITING?"

Ibid. A faceless man driven by a desire to have the power of life and death over others.

Ibid. What this man really needs is love.

Ibid., p. 80 The public begins to withdraw into a cocoon of fear.

Ibid. Train stations, bus terminals, and movie theaters, all favorite targets of the Bomber, report dramatic reductions in patronage, and a comparable drop in local retail activity marks an overall sense that people have begun to avoid the city.

Ibid., p. 90 He seems like a ghost, but he has to be made of flesh and blood. He has been born, he has a mother and father, he eats and sleeps and walks and talks. He lives somewhere. Somewhere people know him, see his face, hear his voice … he has a name. Probably thousands of people in and around New York have had some fleeting contact with him at one time or another. He sits next to people on subways and buses. He strolls past them on sidewalks. He rubs elbows with them in stores … he patently does exist.

Ibid., pp. 114–15 Beginning in early December, a flood of anonymous and malicious telephone calls poured into theaters, department stores, air terminals, office buildings, schools, newspapers, subway stations, police precincts, and even an army base. The calls are placed by a variety of deep-voiced males, harsh-sounding women, and squeaky-pitched teenagers, each informing bewildered call recipients of planted bombs and pending explosions … In the final weeks of 1956, the targets of the hoax calls and imitation pipe bombs include such locations as a crowded-to-capacity Madison Square Garden, a bustling Grand Central Terminal, Yankee Stadium, the Coliseum, the Waldorf Astoria Hotel, and even the Egyptian consulate on Park Avenue.

Ibid., p. 161 The face might have been that of a successful political candidate or winner of a Nobel Prize … smiling … no, not smiling: *beaming* … He shouts cheerful

greetings to the crowds who gather … Under one arm he carries a neatly wrapped brown-paper parcel containing a change of underwear. It is as though he is going on a vacation. He seems to be enjoying every minute of it.

The notorious and often quoted phrase "remanded to Bellevue for observation" is decreed by New York judges more than 1,500 times each year by the late 1950s.

Ibid., p. 185

Abbie Hoffman begins adopting the name "George Metesky" as a public front to his various theatrics. In August 1967, Hoffman organizes a demonstration at the New York Stock Exchange, where he and a group of others throw fistfuls of dollar bills onto the trading room floor in an effort to disrupt the flow of business and to make a comment on the futility of capitalism. When apprehended and cited for the act, Hoffman and each of his accomplices identify themselves as "George Metesky," to the puzzlement of police and Exchange security.

Ibid., pp. 241–2

Hoffman offers several "how to live free in New York" handbooks and one, *Fuck The System*, is published under the Metesky pseudonym. It isn't until 1971, when Hoffman's *Steal This Book* comes out with very similar style and content, that conjecture over the authorship of the first booklet is settled.

Abbie Hoffman attempts to make contact with Metesky at Matteawan at various times in the late 1960s in an effort to identify with and take up the cause of mental health abuses. Conservative in his political views and sharing nothing in common with Hoffman's leftist antics, Metesky wants no part of the man and rebuffs his attempts at communication. "He is known as the Eisenhower of psychotics," says a lawyer who works on the Metesky case. Metesky's traditional beliefs could not have been more diametrically opposed to those of Hoffman's, and the possibility of either successfully working with the other is remote.

The first time you may have seen me was in the gallery of the New York Stock Exchange, hurling money on the brokers below. Of course, you didn't actually *see* me because no photographs of the incident exist: newsmen are not allowed to enter the sacred temple of commerce.

Hoffman, *Autobiography*, pp. 100–1

It all began with a simple telephone call to the Stock Exchange. I arranged for a tour, giving one of my favorite pseudonyms, George Metesky, the notorious Mad Bomber of Manhattan. Then I scraped together three hundred dollars which I changed into crispy one-dollar bills, rounded up fifteen free spirits, which in those days just took a few phone calls, and off we went to Wall Street.

We didn't call the press; at that time we really had no notion of anything called a media event … We just took our places in line with the tourists, although our manner of dress did make us a little conspicuous … We started clowning, kissing and hugging, and eating money … I passed out money to freaks and tourists alike, then all at once we ran to the railing and began tossing out the bills. Pandemonium. The sacred electronic ticker tape, the heartbeat of the Western world, stopped cold. Stockbrokers scrambled over the floor like worried mice, scurrying after the money. Greed had burst through the business-as-usual façade.

It lasted five minutes as most. The guards quickly ushered us out with a stern warning and the ticker tape started up again.

On a steamy summer morning—Aug. 24, 1967—about a dozen young men and women led by James Fourrat and Abbie Hoffman entered the visitors' entrance to the New York Stock Exchange at 20 Broad Street. (The trading floor gallery had been open to visitors since 1939.) They waited while a

"The Day"

member of the security staff approached; the group had previously phoned the exchange and asked for a tour, but the guards became nervous about the way that some in the group were dressed.

Still, the group went up to the visitors' gallery, two stories above the busy trading floor. They snaked their way past exhibits showing the virtues of the industrial revolution and the development of modern capitalism. As they turned the corner, they encountered a horde of reporters and cameras.

This made exchange officials nervous. John Whighton, the captain of the exchange's security force, told the group that no demonstration of any kind would be tolerated. Whighton asked the group for a name, and Fourrat said: "George Metesky," and identified his group as ESSO, the East Side Service Organization (the first a reference to New York's "Mad Bomber" from the 1950s, the second to the successor to Rockefeller's Standard Oil). The guard wrote "George Metesky and friends" on a pad, and escorted the group up to the railing directly above the trading floor.

Immediately, the group of pranksters began throwing handfuls of one-dollar bills over the railing, laughing the entire time. (The exact number of bills is a matter of dispute; Hoffman later wrote that it was 300, while others said no more than 30 or 40 were thrown.)

Some of the brokers, clerks and stock runners below laughed and waved; others jeered angrily and shook their fists. The bills barely had time to land on the ground before guards began removing the group from the building, but news photos had been taken and the Stock Exchange "happening" quickly slid into iconic status.

Once outside, the activists formed a circle, holding hands and chanting "Free! Free!" At one point, Hoffman stood in the center of the circle and lit the edge of a $5 bill while grinning madly, but an NYSE runner grabbed it from him, stamped on it, and said: "You're disgusting."

If the prank accomplished nothing else, it helped cement Hoffman's reputation as one of America's most outlandish and creative protestors. Along with Jerry Rubin and others, Hoffman had founded the Youth International Party earlier that year, and the "Yippie" movement quickly became a prominent part of America's counterculture.

The event was not the first political assault on Wall Street, and certainly not the most violent. At noon on Sept. 16, 1920, a bomb in a horse-drawn carriage exploded near the Wall Street office of J. P. Morgan & Co., ultimately killing 38 people and wounding hundreds. Trading at the NYSE stopped for the rest of the day; although no one was ever charged with the crime, authorities suspected Italian anarchists as having been responsible.

The Yippie prank obviously had less impact. Don Charles, a photographer who shot the event for the *New York Times*, today has no particular recollection of the event, and says that in his mind, the Yippie demonstrations at the following year's Democratic convention in Chicago stood out more.

Still, Hoffman would later boast of his NYSE exploit: "In the minds of millions of teenagers the stock market had just crashed."

Perhaps. Although Hoffman was speaking largely of a symbolic crash, the Dow Jones industrial average did in fact finish that week down 24.97 points, at 894.07. And in 1967 the market began one of the most sustained bear periods in its history.

Of course, no one would attribute that bear market directly to the Yippies' intervention. The U.S. economy began to suffer under the weight of spending on the Vietnam War and Great Society programs, and the stock market's lackluster performance reflected that economic stagnation.

The event did appear to have one direct effect: officials moved to insure that nothing like it could occur again. Some three months later, the NYSE installed bulletproof glass panels, 1-3/16 inches thick, around the visitors'

gallery, as well as a metal grillwork ceiling. An exchange spokesman told the *New York Times* at the time that it was for "reasons of security."

Showering money on the Wall Street brokers was the TV-age version of driving the money changers from the temple.

Hoffman, *Autobiography*, p. 102

Metesky could be seen as a precursor to the 1960s militant, neo-anarchist organizations and finally, to the Unabomber.

Greenburg, p. 243

Motherfuckers / Weather Underground

A common local political chant was, "U.S. out of the Lower East Side."

Miller, "Habitation," p. 137

The Motherfuckers described themselves as a kind of politicized street gang, but in the media they were known only as "a group with a certain unprintable name."

McMillan, p. 532

"We are the ultimate Horror Show," read one. "Hideous Hair & Dangerous Drugs … Armed Love striking terror into the vacant hearts of the plastic Mother & pig-faced Father."

Ibid., p. 533

The Motherfuckers were the downright dirtiest, skuzziest, and loudest group of people I'd ever laid eyes on.

Stern, *Weathermen*, p. 22

"They lived like gutter rats," Abbie Hoffman once recalled. Journalist Thai Jones … quipped that although the Motherfuckers "referred to themselves as 'a street gang with analysis' … they seemed to emphasize the street gang part." Yippie Stewart Albert … put the difference between the Diggers and the Motherfuckers this way: "In the West Coast, there were flower children. In the East Coast, there were weed children. They just grew out of the sidewalk."

McMillan, p. 536

In 1967, during a New York City garbage strike, they carried piles of stinking, festering trash uptown on the subway and dumped it on the steps and in the fountain of Lincoln Center. "WE PROPOSE A CULTURAL EXCHANGE," they declared in an accompanying leaflet: "garbage for garbage."

Ibid., p. 533

In 1969, the Motherfuckers cut the fences at Woodstock, helping to turn it into a free concert for hundreds of thousands.

Ibid.

Postbeat, postbiker, would-be Hells Angels with manifestos … deploying direct action against strategy, extravagance against tedium.

Ibid., p. 534

After Solanas shot Andy Warhol in June 1968, the Motherfuckers staged a street performance on her behalf in Washington Square Park. Morea drew up an accompanying leaflet, wherein he described Warhol as a "nonman shot by the reality of his dreams," and lionized Solanas as a "cultural assassin—a tough chick with a bop cap and a thirty-eight." "America's white plastic cathedral is ready to burn," Morea concluded. "Valerie is ours and the Sweet Assassin lives. SCUM in exile."

Ibid., p. 537

I put the question bluntly: How could you rationalize supporting Valerie Solanas?

"Rationalize? I didn't rationalize anything," Ben says. "I loved Valerie and I loathed Andy Warhol, so that's all there was to it." A few seconds later he

shrugs and adds, "I mean, I didn't want to shoot him." But then he doubles back again. "Andy Warhol ruined art."

Ibid., p. 540
Our idea was, if you're gonna pick up a machine gun, it shouldn't be plastic.

Neumann, p. 7
Against the vapid spaciness of "flower power" we proclaimed the need for "Armed Love." Our rhetoric was inflammatory and often violent.

Ibid., pp. 8–9
In becoming a Motherfucker I renounced my commitment to ordered discourse, the traffic in abstractions, respect for explanations, the demand for coherence, and the subordination of impulse and emotion—all of which I thought of as characteristic of a life committed to reason. I grew fierce in my scorn for theory. I felt most alive when running in the streets with no thoughts in my head but where the cops were and how to avoid them. But my apostasy was never complete. As the Mafia don longs for respectability, as the dealer in prostitutes and drugs can be the staunchest proponent of family values, so I, the rebellious child of reason, longed for the respectable cloak of rationality and pledged allegiance to reason even as I plunged headlong into the irrational.

Hahne and Morea, pp. 37–8
Down Fifty-ninth Street, revolutionary banners … black flags. The crowd of eight to ten thousand breaks into a mad stampede—they realize they have the streets! Fearful drivers roll up their windows. Traffic is halted on the busiest street in the city!

Hoffman, *Autobiography*, p. 110
When Secretary of State Dean Rusk came to town to speak to some war hawk assemblage at the Waldorf-Astoria, we rallied at 57th Street and Seventh Avenue, ready to "bring the war home." Plastic bags filled with cow's blood flew through the night air. Tape recordings of battle sounds screamed above the crowds.

Ibid., p. 100
Abbie Hoffman: "Typically American, we had no ideology."

Ibid., p. 109
The Army recruiting center in Times Square was plastered with stickers: SEE CANADA NOW.

Ibid.
Stop signs on street corners now read STOP WAR.

Ibid.
Hundreds crowded the lobby of the *Daily News* smoking grass and passing out leaflets to employees that began, "Dear Fellow Members of the Communist Conspiracy."

Ibid.
A tree was planted in the center of St. Marx Place while 5,000 celebrators danced to rock music.

Ibid.
Midnight artists snuck into subway stations and painted huge murals on the walls.

Ibid.
Naked people ran through churches.

Ibid.
Panhandlers worked the streets for hours, took the change they collected to the nearest bank and scattered it on the floor.

Ibid.
A giant yellow Submarine mysteriously kept appearing in tow-away zones.

The house at 18 West 11th Street exploded on March 6, 1970 at 11:55 a.m. when it was used as a bomb factory for the Weather Underground. Three bomb makers, Theodore Gold, Diana Oughton and Terry Robbins were killed. Two others, Kathy Boudin and Cathlyn Wilkerson, escaped and remained fugitives for more than a decade. The first was the daughter of the civil liberties lawyer Leonard Boudin, the second the daughter of James P. Wilkerson, the owner of the house at No. 18.

The house ... and those surrounding it, beautifully matched four-story town houses of Federal design, were built in the 1840's by Henry Brevoort Jr. and were known as the Brevoort Row. Early in the 20th century, No. 18 was owned by Charles Merrill, a founder of Merrill Lynch & Company. His son, the poet James Merrill, was born there.

In 1930, Charles Merrill sold the building to Howard Dietz, a successful Broadway lyricist and a movie executive. Merrill followed up with a note saying that he hoped the new owner would enjoy "the little house on heaven street." Dietz lived there lavishly with each of his three wives. When he gave a party, sometimes for as many as 250, all the furniture was placed in a van, which was parked on the street until the guests finished "dancing in the dark," as Dietz phrased it in his most famous song.

James Wilkerson, an advertising executive, bought the house in 1963 and moved in with his second wife, Audrey. He continued the high style of living to which the house had become accustomed. The dwelling had 10 rooms, including a double-size drawing room, a paneled library, where the owner kept his valuable collection of sculptured birds, and a sauna. He restored antique furniture in the subbasement workroom. The house still had the original mantles on its fireplaces and was filled with Hepplewhite furniture. In the garden was a fountain with a mirror behind it.

In 1964, Mr. Wilkerson celebrated his 50th birthday with a masked ball for 90 people, dancing to an orchestra until 2 a.m. Among the guests were two daughters from his first marriage, Ann and Cathy.

Further down the street, Susan Wager, a neighbor, was in her kitchen. "I felt my house tremble," she said. "It was like an earthquake." *Ibid.*

She rushed to No. 18 and saw two grime-covered young women coming out of the downstairs door. One, Cathy Wilkerson, was naked. The other, Kathy Boudin, was partly clad in jeans. The assumption was that their clothes were torn off in the blast.

Mrs. Wager took them back to her house, gave them fresh clothes and offered them the use of a shower. Then she went back into the street to see what was happening. By the time she returned home, the two women had left, one wearing Mrs. Wager's favorite boots and coat. She never saw the women again. "I thought they were in an accident," Ms. Wager said. "I never thought they could have been responsible."

By the time I arrived, the street was swarming with firemen, policemen and sightseers. Seeing the smoke pour out of No. 18, we felt that our house would also be destroyed. That afternoon, each tenant in our building was allowed to make one quick trip inside and rescue items of property. In our apartment, the walls creaked, as if a ship had been torpedoed and was about to sink beneath the sea. None of the tenants of No. 16 ever spent a night in that house again.

On the evening news, there was a picture of a red tricycle and the suggestion that a child might be missing in the explosion. It was Ethan's tricycle. It had been in the lobby of the building and the fireman had put it outside. Our upstairs neighbor, a playwright, rescued his tax forms, a Picasso drawing and a tin of truffles. His top hat and tails, worn for openings at the opera, were never recovered.

Devastated by the explosion, the splendid house at No. 18 had been reduced to shattered walls and windows. Mr. Hoffman's living room wall had a huge hole torn in it. His desk had fallen into the rubble next door.

Ibid.

Eventually, Hugh Hardy, the architect, and Francis Mason, then an executive at Steuben Glass, bought the land. Mr. Hardy designed a startlingly modern structure. After considerable debate, the radical design was finally approved by the Landmarks Commission. The Hardys and the Masons planned to turn the new house into a two-family dwelling. But as time passed, the two couples changed their minds and put the property back on the market.

For eight years, the plot remained vacant. Then, in 1978, it was sold to David and Norma Langworthy, a wealthy Philadelphia couple. They used Mr. Hardy's design for the exterior, with a facade jutting out toward the street. They moved in the following year, and Mrs. Langworthy remained after her husband's death in 1994.

Inside, the new one-family house has two levels, with perspective-distorting angles and open spaces allowing for dramatic views. The former bomb factory is now a laundry room. Nowhere is there a hint of the building's past.

The signature touch is a Paddington bear in the jutting window. Its costume is changed according to the weather. On rainy days, Paddington wears a raincoat. During a storm, he switches to snow wear. For the first day of school, he is decked out in his schoolboy outfit. By special request, one day two bears appeared in the window dressed as a bride and groom; on cue, a neighborhood doctor fell to his knees on the sidewalk and proposed to his girlfriend.

Every March 6, people place flowers around the tree in front of the building.

"Weather Underground"

It took nine days of collecting body parts to determine how many persons had died in the blast. Fingerprint records were required to identify the corpses of Theodore Gold, a leader of the 1968 Columbia University student protests, and Diana Oughton, the organizer of the 1969 SDS national convention.

McNeil and McCain, pp. 21–2

The problem with the hippies was that there developed a hostility within the counterculture itself, between those who had, like, the equivalent of a trust fund versus those who had to live by their wits. It's true, for instance, that blacks were somewhat resentful of the hippies by the Summer of Love, 1967, because their perception was that these kids were drawing paisley swirls on their Sam Flax writing pads, burning incense, and taking acid, but those kids could get out of there any time they wanted to.

They could go back home. They could call their mom and say, "Get me outta here." Whereas someone who was raised in a project on Columbia Street and was hanging out on the edge of Tompkins Square Park can't escape. Those kids don't have anyplace to go. They can't go back to Great Neck, they can't go back to Connecticut. They can't go back to boarding school in Baltimore. They're trapped.

Hahne, p. 26

We have marched on Wall Street (Feb. 10). We have changed it to War Street.

Schmitz, pp. 270–1

"DIE YUPPIE SCUM" was everywhere, as was the upside-down, cocktail glass graffiti of the anarchist band Missing Foundation.

(right margin, rotated) s Unrest — Motherfuckers / Weather Underground

Mayor La Guardia receives a small package December 8 containing a live .22-caliber long cartridge and a note, signed with a crayoned swastika, reading, "You will get this if you continue to attack the German Nazi Party." The mayor is punched in the face and knocked down on the steps of City Hall.

Trager, p. 506

When the mayor visits the White House to keep an appointment, President Roosevelt extends his right arm and says, "Heil, Fiorello"; La Guardia, also extending his right arm, replies, "Heil, Franklin."

Ibid.

City garment workers jeer at Jewish communists with shouts of "Heil, Hitler!"

Trager, p. 513

"Restricted building" and "good building," both euphemisms for a building that does not allow Jews.

Gross, p. 10

Did you ever notice … what a Jewy-looking thing the Singer Tower is when it's lit up?

Sharpe, p. 187

Public interest in New York Hospital found expression in an unusual way in 1938 when more than one hundred donors of all denominations contributed a total of one thousand dollars for the removal of swastika designs from the 325-foot chimney. The ancient symbol that had been given a new significance by Chancellor Hitler's rise to power in Germany was replaced by Greek crosses.

WPA Guide, p. 248

With "Don't buy meat" as their watchword and "Don't sell meat" as their battle-cry, the indignant housewives succeeded last week in putting out of business for the time being some 1,500 of the 2,000 Jewish butcher-shops in the greater city. Armed with milk-bottles of kerosene, bands of women and children would descend upon such shops as had the temerity to keep open, maul the proprietor, drench his stock with oil, and often, if the police did not appear in time, wreck his place. Sometimes a courageous butcher armed his family with horsewhips to repel the invaders, while others, possessed of finer generalship, met the combination of kerosene and femininity with streams of water from the hose.

"Topics," p. 798

A Jewish butcher was accused of selling meat to Italians.

"1,500"

Police who were trying to rescue the butchers were assaulted by slabs of liver.

Reitano, p. 119

The kosher meat riots were followed by America's most extensive episode of anti-Semitic violence. Irish factory workers threw water, wood, nails, and iron bolts from windows.

Ibid., p. 120

Several Nazi propaganda agencies maintained headquarters in Yorkville. The German-American Bund and its official paper, *Deutscher Weckruf und Beobachter*, which under the leadership of Fritz Kuhn directed Nazi work throughout the country, had their national offices at 178 East Eighty-fifth Street. The German-American Business league, in the same building, published directories of firms to be patronized by Nazi adherents. The Nazis occasionally paraded through Yorkville in their uniforms, which were of three kinds: black trousers, white shirts with swastika armbands, and black caps, for the rank and file members; olive-drab military uniforms, for the guards; and imported regulation German uniforms for the storm troops. In the spring

WPA Guide, p. 251

of 1938 the Yorkville Casino was the arena of a bloody fight between Nazi sympathizers and a group of people who were members of the American Legion.

Ellis, *Epic*, p. 559 Nazi propaganda was disseminated by a Nazi agent, whose luxurious apartment at 305 Riverside Drive was decorated with a portrait of Hitler.

WPA Guide, p. 252 The German Central Book Store, 218 East Eighty-fourth Street, was stocked with German books banned by Hitler.

Diehl, p. 4 February 1934, Second Avenue: "The room, about fifteen feet by twenty, was a detailed reproduction of a Berlin Storm Troop cellar … I counted twenty-two uniformed men. Brown shirts, breeches, boots, Sam Browne belts with pistol holsters. Their Troop Führer faced them. He lifted his harm half-way, elbow close to his side, palm out and clipped 'Heil Hitler.'"

Ibid. A huge swastika sewn atop of an American flag: "This is the flag we shall carry through the streets of New York when we wipe them clean of the Jewish scum."

Ibid., p. 5 309 E. 92nd St.: Headquarters for Paul Manger's Gau-USA, a precursor to the American Bund. Meetings were held in a back room and Nazi paraphernalia could be seen in the window.

Ibid., p. 8 Heinz Spanknoebel invited his fellow Nazis for an evening cruise around Manhattan Island on the German steamer SS Resolute. Decked out in full uniform, they hoisted their steins and belted out "Deutschland, Deutschland über Alles" with the New York skyline and Statue of Liberty serving as background.

Ibid., p. 9 In October 1939, a Nazi flag made its way across East 86th Street during the German Day Parade.

Ibid., p. 10 During the 1930s, if you went into a tavern in Yorkville and weren't pro-Hitler, you'd be given a hard time.

Ibid., p. 13 Fritz Kuhn, the president of the Amerikadeutscher Volksbund, aka The Bund: "Like the German Führer, he regarded himself as a great man, a man chosen to unify his racial brothers in America. He was rarely out of uniform. His black leather jack boots apparently glued to his six-foot frame, his thinning hair slicked back over his broad head, his legs, apart, and his thumbs fixed in his Sam Browne belt, Kuhn loudly proclaimed himself the American Führer."

Ibid. The Bund had their own tailor in Queens who custom made Nazi uniforms.

Ibid., p. 14 Camp Siegfried in Yaphank, Long Island. A forty-four acre Nazi recruiting and training center. At the Yaphank station, a small army of uniformed children greeted hundreds of Bundists coming from Penn Station; together they marched through the town of Brookhaven, swastikas waving, as an eighteen-piece tuba-led band played *Die Spielmannszug*. Strains of Wagner drifted through the air. On the lawn grew a giant swastika made of bright red salvia and boxwood.

Neuss At Camp Siegfried: On more than one Sunday parading with the Brown Shirts were a group of Black Shirts, pro–Italian Fascists.

February 20, 1939: more than 20,000 Nazi sympathizers attended a rally at Madison Square Garden. *Diehl, p. 20*

Yorkville temporarily closed its movie houses lest people think they were showing German movies. *Ibid., p. 78*

In December of 1941, an underwater anti-submarine net was strung two miles below the Narrows, from Norton's Point on the western edge of Coney Island to Hoffman Island, a merchant marine training center off Staten Island, in hopes of preventing U-boats from entering the harbor. *Ibid., p. 86*

German U-boat subs were grounded on Rockaway Beach. *Ibid., p. 87*

U-boat Commander Reinhard Hardegen drove his submarine past the carnival lights of Coney Island's Wonder Wheel and the Parachute Jump, keeping clear of land as it neared lower New York Bay. He pressed on, urged by the need to reach New York City. It was 10 o'clock when the U-boat approached the area south of Manhattan just beyond the Narrows. Hardegen wrote "I cannot describe the feeling with words but it was unbelievably beautiful and great … and for the first time in this war a German soldier looked upon the coast of the USA." *Ibid., pp. 87–8*

Hardegan wondered, "What form the life of the city was taking at that hour … Were the Broadway shows just getting out? Were the jazz clubs just getting started? Were the newsboys hocking the last editions—or the first?" In his imagination he fantasized how clever would it be to walk around Times Square and tip his hat to passersby.

German submarines sowed mines around Sandy Hook in the path of outbound ships, so 16 tugs were outfitted as minesweepers. Working in pairs, they found and exploded floating mines. *Ellis, Epic, p. 505*

A statue symbolizing Germany was one of twelve figures decorating the sixth-floor façade of the Customhouse just south of Bowling Green. A sculptor was hired to chip the imperial eagle from the breastplate of this Valkyrie. *Ibid.*

Dachshunds, a breed of dogs well liked by Germans, were kicked on the sidewalks of New York and renamed liberty pups. Sauerkraut became liberty cabbage. German measles were liberty measles. The Bank of Germany at First Avenue and Seventy-fourth Street changed its name to the Bank of Europe. *Ibid.*

At Rockefeller Center, the entrance to the Palazzo D'Italia was deprived of its coat of arms, and Italian sculptor Attilio Piccirilli's cartouche depicting commerce and industry above the entrance to 636 Fifth Avenue was covered with wooden planks. The work had the misfortune of being cast in 1936, when Mussolini came into power. *Ibid., p. 78*

Romano Mussolini, son of Benito, sang "Over The Rainbow" and "Summertime" with his jazz quartet at Town Hall. *N. cit.*

Meir Kahane: "A .22 for every Jew." *Moorhouse, p. 116*

Many "Russian" entrepreneurs were Jewish immigrants who chose not to broadcast their religious affiliation. *Peretti, p. 17*

Hoffman, *Autobiography*, p. 107

GUARD: Sorry, hippies are not allowed in the Stock Exchange.

ACTOR: But we're not hippies, we're Jewish. Should we tell the press you kept Jews out of Wall Street?

Allen and Brickman, *Annie Hall*

I distinctly heard it. He muttered under his breath, "Jew" … Wh—How am I a paran—? Well, I pick up on those kind o' things. You know, I was having lunch with some guys from NBC, so I said … uh, "Did you eat yet or what?" and Tom Christie said, "No, didchoo?" Not, did you, didchoo eat? Jew? No, not did you eat, but Jew eat? Jew. You get it? Jew eat?

Ibid., p. 40

Right, right, so g-get back to what we were discussing, the failure of the country to get behind New York City is—is anti-Semitism.

Max, the city is terribly worried.

But the—I'm not discussing politics or economics. This is foreskin.

No, no, no, Max, that's a very convenient out. Every time some group disagrees with you it's because of anti-Semitism.

Don't you see? The rest of the country looks upon New York like we're-we're left-wing Communist, Jewish, homosexual, pornographers. I think of us that way, sometimes, and I—I live here.

Max, if we lived in California, we could play outdoors every day, in the sun.

Sun is bad for yuh. Everything our parents said was good is bad. Sun, milk, red meat, college …

Ibid., p. 53

You're what Grammy Hall would call a real Jew.

Yeah, well … you—she hates Jews. She thinks that they just make money, but let me tell yuh, I mean, she's the one yeah, is she ever. I'm tellin' yuh.

Ford, *America*, pp. 127–30

This intellectual vividness New York owes partly to the presence of an immense Jewish population, partly to the absence of a Governing Middle Class. I don't like Jews. I make the statement quite advisedly and not without tact—for, if I don't like Jews and still make the statement that the arts flourish in New York largely because of its Jewish population, the assertion may be regarded as more accurate than if I were dealing with people whom I liked and to whom in consequence I might be suspected of handing out large spoonfuls of apple-sauce. Apart from that whether I like Jews or not can be of no importance to any one.

And the fact of their artistic helpfulness is incontestable … at any rate as regards the plastic arts and the art of the theatre. Jews in New York buy a great many pictures; they buy probably the greater part of the sculpture that is sold and the more recondite theatre—the less recondite also I daresay—exists solely by the suffrage, the subsidy or the attendance, of the rich or the poor Jew. The present theatrical season has not been a good one: one might indeed say that it has been pretty rotten. I at least have seen only one play that I have not been slightly ashamed of having gone to. But that is merely temporary. Two years ago I saw here more interesting plays in one month than in either London or Paris during two years and no doubt when I get forcibly taken to the play in New York this autumn the balance will again have redressed itself in favor of New York.

I don't indeed profess to be a haunter of playhouses; I never, indeed, go to one unless I am more or less forcibly taken—but that makes me a fair judge of the state of the more "advanced" theatre in any place in which I happen to be: The people who say to me: "Oh, you must go to So-and-So" and who take tickets and lead me to it are of a class whose enthusiasms are not roused by the theatre of commerce. Thus on the whole the *Dybbuk* in Hebrew was about the only play in New York last season that was incontestably worth being

dragged to, and I was duly dragged to it by an enthusiastic young lady, not a Jewess.

That may stand as a symbol for certain sides of the artistic life of New York. There you have an amazing new art—or, if you prefer it, an amazing development of an old art; it is subsidized by richish Jews, supported amazingly by the poorer Jewish population, and produces the only play to which a young Christian enthusiast can drag an elderly and case-hardened, foreign non-enthusiast with some chance of finding her choice approved.

How it may be with literature I do not so exactly know. At any rate the only people I have found in New York—and I have not found them anywhere else at all—who really loved books with a real, passionate, yearning love that transcended their attention to all other terrestrial manifestations were Jews—and the only people who subsidized young writers during their early non-lucrative years. But rich Jews seem to do this automatically all the world over. Rich Christians never will, though poor ones will be found to do so.

Obviously this Israelite support of the arts would not suffice in itself to make New York the art center that it is or is becoming; the majority of the support that the arts here receives is Gentile enough all right … but that support would hardly suffice to maintain a very vigorous artistic life in this city without the Jewish addition. It makes the difference between hardly supportable indigence and just bearable comfort.

Prison

For beneath its futuristic trappings, *Escape from New York* embodied a notion dating back to the mid-nineteenth century, when New York City was limited to Manhattan, isolated by wide rivers from mainland United States and even from its sister city, Brooklyn. It was easy for Americans of the time to consider the city as a place apart, a narrow, confined island whose strange and different ways were often unfathomable to the rest of the country. The notion was diluted somewhat in the twentieth century, when Manhattan was laced to the larger world by dozens of rail and road crossings, and the city itself redefined as an enormous, five-borough metropolis, but it has retained a residual power in the American imagination. *Escape from New York* would bring the old vision back to life with a vengeance: Manhattan as nothing less, literally or figuratively, than America's Devil's Island.

Sanders, *Celluloid*, p. 379

The film's prologue describes the city's conversion into the federal government's penal colony in the late 1980s, conveniently eliding all social or economic detail to focus instead on topography: the distinctive shape of Manhattan now outlined by a bright green line indicating a high "containment wall" that, as if quarantining a virus, has finally rid the nation of its offshore anomaly. The great river crossings, the bridges and tunnels that allowed the metropolis to transcend its geography, have literally been subverted— mined with explosives—in order to restore the city to its nineteenth-century boundaries.

The film then surveys the dark jungle that the city has become: its buildings vandalized and burned, its nighttime streets filled with "crazies" who come up from the subway, and its population a throng of criminal gangs, wreaking havoc under the supremely violent Duke of New York (Isaac Hayes). At times, the place portrayed hardly resembles New York at all: the climactic escape takes place on the "69th Street Bridge"; power is provided by pumping crude oil from deposits beneath the island; and the exterior scenes take place on ruined blocks that look nothing like Manhattan—for the good reason that they were shot in downtown St. Louis, in an area that had been recently

ravaged by fire. Yet at other times the film plays off the audience's shivery recognition of the city's landmarks: the World Trade Center, now a hulking ruin toward which Snake Plissken (Kurt Russell) glides his sailplane; Central Park, now a jungle clearing where inmates gather for monthly food drop-offs; the Statue of Liberty, now the island's security post. In its way, the film offers a kind of inverted tribute to the sheer iconic status of New York. As Carpenter surely appreciated, a film titled "Escape from St. Louis" would hardly draw much of a crowd.

Sante, "My Lost City"

A sort of apotheosis appeared in John Carpenter's *Escape from New York* (1981), in which the city has become a maximum-security prison by default. The last honest folk having abandoned the place, the authorities have merely locked it up, permitting the scum within to rule themselves, with the understanding that they will before long kill one another off. The story may have been a futuristic action-adventure, but for most Americans the premise was strict naturalism, with the sole exception of the locks, which ought by rights to have been in place. Aside from the matter of actual violence, drugs, and squalor, there was the fact that in the 1970s New York City was not a part of the United States at all. It was an offshore interzone with no shopping malls, few major chains, very few born-again Christians who had not been sent there on a mission, no golf courses, no subdivisions.

Conrad, p. 172

Whereas the spaces of the elderly, childish New York are gardens, even if they're rubble-strewn vacant lots or tenement courtyards bedecked with dripping laundry, those of the new New York are jails. The shadows cast by the El in the streets beneath construct a caging lattice of light; the steel tiers of Rockefeller Center as it rises are a penitentiary. The girders trap the steelworkers inside a system of endless repetition, allotting to each a see-through cell in which to labor. The El projects an illusory prison of barred shadows; Rockefeller Center rearing in the air is a diagrammatic, conceptual prison.

Corbusier, p. 188

But the street has been killed and the city made into a madhouse.

McDarrah, *Artist's*, p. 10

Anxiety flavors the coffee at Rikers.

Donleavy

Rikers Island out there on the grey East River. Charlie said three quarters of it was made from subway excavations.

Courgois, p. 38

They don't rape niggas in the bullpen no more 'cause a' AIDS. You don't even get raped on Rikers no more.

Donleavy

East chilling wind bursting out of the crosstown streets. Blown over Brooklyn. Through the bars of all the institutions. Where the imprisoned troubled eyes stare.

Reitano, p. 184

In 1970, inmates mounted protests against horrific prison conditions in five jails in three boroughs involving thirty-two hostages. The first riot occurred in August at the Tombs, where inmates held three guards hostage for seven hours and controlled the facilities. The riots were organized by two radical groups—the Black Panther Party and the Puerto Rican Lords. As they ignited mattresses, clothing, and furniture, the prisoners declared their intention "to burn ourselves out of here."

The Tombs, a decaying dungeon in its early forties, a structure suffering from every ill known to the building trades, a shaky keep about to be added to the city's memories.

Riesenberg and Alland, p. 102

I would not get arrested in New York. I try not to get arrested in New York because Puerto Ricans disappear in the system in New York.

N. cit.

Stonewall

The Stonewall Inn takes its name from the autobiography of "Mary Casal," *The Stone Wall*, published in 1930, a rare American book to depict lesbian love at that time.

Carter, p. 8

The bar's first name, in the 1930s, was Bonnie's Stone Wall, which soon gained a reputation as one "of the more notorious tearooms in the Village." By the 1940s, its name had been changed to the more bucolic-sounding Bonnie's Stonewall Inn, and by the 1960s it had been changed again to the Stonewall Inn Restaurant. It was the former Stonewall Inn Restaurant that, in 1967, having sat vacant for some time after a fire gutted it, metamorphosed into the gay club the Stonewall Inn.

Ibid.

The Stonewall is reopened after the fire by mobsters.

Ibid., p. 67

Most of the men are wearing outer jackets. They aren't wearing so much leather or denim … some men wear top hats.

Ibid., p. 70

The lighting is dim throughout … the darkness creates a cavern-like feel. Smoky air fills the bar.

Ibid., p. 72

The men like to wear perfumes, such as Tabu and Ambush, both marketed to women, whose aromas give the place a rich, saturated atmosphere.

Ibid.

If the Tenth of Always is like a little parish church, the Stonewall is like St. Peter's in Rome … It is big in its scope …

Ibid., p. 77

It is possible to buy any known substance available in capsule form. All the hairdressers are into Desbutols, Desoxyn mixed with Nembutol.

Ibid., p. 81

Music playing at the Stonewall: Shangri-Las, Diana Ross, "Let It Be Me," Martha Reeves and the Vandellas, "Third Finger, Left Hand," "Forget Me Not," Dionne Warwick.

Ibid., pp. 85–7

The raid begins at 1:00 A.M. on a summer Saturday morning.

Ibid., p. 143

The arrival of the cops and the blare of the lights transforms the scene from one of festivity to sadness. The jukeboxes fall silent, and the shimmering go-go boys leave their cages to put on their street clothes.

Ibid., p. 139

The transvestites put up a great resistance, refusing to go into the Stonewall's bathrooms to be "examined."

Ibid., p. 140

A couple of drag queens dance by themselves to a Stevie Wonder tune on the jukebox.

Ibid., p. 141

When did you ever see a fag fight back?

Ibid., p. 143

Ibid.	Grumbling could be heard among the limp-wristed set.
Ibid., p. 144	More and more people start to mill around the front.
Ibid.	Ostentatious drag queens walking in twos and threes down Christopher towards the bar, shrieking little sentences.
Ibid.	It is a hot, seething night. A real New York summer night.
Ibid.	What's going on? Is something going to happen? Why is this taking so long?
Ibid.	The drag queens kind of chant and skitter along. It's entertaining.
Ibid., p. 145	The crowd on Christopher Street continues to grow as the club's ejected patrons reach the pavement, where they are joined by a considerable number of tourists who, having come to the Village on a Friday night looking for excitement, find it for free on the street.
Ibid.	We all figured that the Black Panthers were going to start the revolution.
Ibid.	One young man swishes by the detective posted at the door. "Hello there, fella!"
Ibid.	Wrists are limp, hair is primped.
Ibid., p. 146	No one knows this is going to turn into a riot.
Ibid.	Some of the men ejected from the bar throw their arms up and out in a V shape as if they are performers making a grand entrance on a stage.
Ibid.	Noticing the crowd's skittish hilarity, he pauses to peer up at the moon. It's full.
Ibid., p. 147	The first prisoners to be loaded inside the paddy wagon are members of the Mafia, who are brought out of the club one by one.
Ibid.	Everyone hears the cry that reverberates through the night air: "Gay Power!"
Ibid.	The idea seems too unreal, too radical, to be taken seriously, and the newly heard slogan soon dissolves into giggles.
Ibid., p. 148	Someone begins to sing "We Shall Overcome" and a few in the crowd start singing along. But after a few verses this, too, seems too dignified to be taken seriously by a bunch of homosexuals, who begin to camp on the solemn lyrics.
Ibid.	A police officer shoves one of the transvestites, who turns and smacks the officer over the head with her purse.
Ibid.	"Nobody's going to fuck around with me. I ain't going to take this shit," a guy in a dark red t-shirt shouts, dancing in and out of the crowd.
Ibid., p. 151	A "beefy, good-sized, typical New York butch" loses her mind in the streets of the West Village—kicking, cursing, screaming, and fighting. It is the moment when the scene becomes explosive.

All four tires of a police car are slashed. *Ibid.*, p. 152

A cobblestone is hauled, landing on the trunk of a police car with a terrible screech. *Ibid.*

The gay throng makes a useful discovery: a large stack of new bricks at a construction site on Seventh Avenue South. *Ibid.*, p. 155

Coins are thrown at the policemen, making pinging sounds as they hit the pavement and the Stonewall Inn's windows. *Ibid.*, p. 156

Shouts of "Pigs!" and "Faggot cops!" fill the night air. *Ibid.*

Pennies and dimes. Nickels were the next thing to be thrown. Followed by quarters. *Ibid.*

A glass bottle was lobbed. *Ibid.*

And then another one came flying through the dark air. And another. *Ibid.*

On the ground, a worm's eye view. Looking at legs. *Ibid.*, p. 157

Inside the Stonewall, the cops barricade themselves using the club's tables against the doors. *Ibid.*, p. 159

It is silent and dark and dank and strongly smells of beer. *Ibid.*

The fey beings have suddenly and inexplicably metamorphosed into raging tigers. *Ibid.*, p. 160

The officers, who fought in Africa and Sicily in World War II, are still shaking an hour later. "Believe me, I've never seen anything like it." *Ibid.*

I'm sick of being told I'm sick. *Ibid.*, p. 161

Inside the Stonewall, bricks are felt pounding the door. The floor shudders at each blow. *Ibid.*, p. 162

The police trapped inside peer through peepholes into the street. "Where are the reinforcements?" "I don't know. There must be some mix-up." *Ibid.*, p. 163

Pieces of paper are stuffed into cracks at the bottom of the plywood inside the Stonewall's window and cigarette lighters are held up to them. *Ibid.*, p. 164

A parking meter is dug up out of the ground and is used as battering ram on the Inn's doors. *Ibid.*, p. 165

The attack on the police creates a cacophony as the sounds of glass shattering up and down the street are mixed with the pounding of the parking meter on the doors, while cries of "Liberate the bar!" fill the air. *Ibid.*

Bottles are thrown at demonstrators from apartment dwellers along Grove Street who want to get some sleep. *Ibid.*

We're the pink panthers! *Ibid.*

Ibid.	A mad Negro queen whirls like a dervish with a twisted piece of metal in her hand and breaks the remaining windows.
Ibid.	The doors begin to give.
Ibid., p. 166	The night reverberates again with the boom of the parking meter on the Stonewall's doors.
Ibid., p. 167	In the park across the street, several people quietly and methodically pour liquid into empty Coke bottles.
Ibid., p. 168	The flames are blue and have little yellow tips.
Ibid., p. 169	Everybody is really perspiring—I mean *really* sweating.
Ibid., p. 171	People are crying. People are cut up.
Ibid.	A policewoman escapes through a vent up to the roof.
Ibid.	The detectives locate a fire hose, but can't see where to aim it, wedging the hose through a crack in the door. It sends out a weak stream.
Ibid.	One of the kids shouts, "Grab it! Grab his cock!"
Ibid., p. 172	The door is broken down, and the kids systematically dump refuse from waste cans into the Wall, squirt it with lighter fluid, and ignite it. Huge flashes of flame and billows of smoke.
Ibid., p. 177	Kids line up in a Rockette lines, kicking their legs up at the police.
Ibid.	"The girls in blue" and "Lily Law."
Ibid., p. 178	The protests continue into the night. Angry gay men set fires in trash cans and break store windows, screaming "Gay power! Gay power!"
Ibid.	Well, this is boring. All we're doing is running around the block, here. We've done it ten times now and it's dull. Let's do something else.
Ibid., p. 179	So we sort of vanished.
Ibid., p. 181	Christopher Street is empty. The sky is very dark, there is a terrific moon, and the Village is eerily quiet.
Ibid.	Morning comes to Christopher Street, diamondlike glass all over.
Ibid., p. 182	Incredible. The fucking queens rioted.
Ibid., p. 185	After the Stonewall riots, the Mafia owners were doing their best to attract customers back inside by giving away free soft drinks.
Ibid.	The day after the riots was the hottest June 28th in New York City history.
Ibid., p. 188	He looked up and saw red sparks falling from on high, through the night air, as in a gentle rainfall.

Lesbian black and Latina prisoners at the Women's House of Detention were setting toilet paper on fire and dropping it from their cell windows in support of the rioters.

Ibid.

Harlem Riot

The gathering of crowds, the rise of looting and its relapse.

Orlansky, p. 20

Sunday night is an ordinary one in Harlem, but hot: windows are wide open, the sidewalks are full of men and women, strolling or idling; children play on the streets, mothers wheel their babies.

Ibid., p. 4

Soldiers, respectably dressed men with jackets and ties, men and boys with open collars or polo shirts, youths in zoot suits, women, girls, and children. Young men and boys predominate.

Ibid., p. 5

Many persons smile when their pictures are taken.

Ibid.

A bottle is thrown toward the hospital and falls on the sidewalk. Other bottles follow.

Ibid.

Of 40 liquor stores in the district, 30 are cleaned out completely with not a bottle left in place.

Ibid.

Favorite articles of loot are: food—groceries, meats, fruits, vegetables; clothing—fur coats, sweaters, suits, corsets, dresses; furnishings—rugs, linoleums, lamps, mattresses, radios, second-hand chairs and coffee tables; and liquor and jewelry.

Ibid., p. 6

Every piece of furniture, even cheap pictures hanging on the wall, is carried off (except for a torn sofa left standing on the sidewalk).

Ibid.

The cellar is emptied, office files upset, and the telephone ripped from the wall.

Ibid.

Refrigeration systems of meat shops are ripped out.

Ibid.

Bread is stamped on in the street.

Ibid.

When the riot begins, Negro store-owners place signs reading "Colored" in their windows. These stores are left intact, although others nearby, owned by whites, are totally destroyed. Negro stores without signs in the window are also generally not molested.
"Wherever somebody had told the mob this was a Negro place, they leave it alone. Sometimes a brick is thrown into the window before the word got around, but that is as far as it went. Despite the broken window, not a thing is touched, not a box out of place."

Ibid., p. 8

Negro families peacefully sleeping through the night.

Ibid., p. 9

Lights are on in all the apartment houses. People sit in windows watching.

Ibid.

Better-dressed members of the middle class.

Ibid.

More *substantial* residents.

Ibid.

Ibid., p. 10	Children do much of the food looting. Three boys about 10 years old load their arms with shoes from the shelves of a store. Other children take clothing, cheap candies, and toys.
Ibid.	At 6 a.m. the kids come out to search within the rubble. I see one little boy with a handful of candy bars and a penny whistle.
Ibid.	Women take: dresses, hats, sweaters, fur coats, corsets, jewelry, small pieces of furniture, mattresses, blankets, linen, children's clothes, milk, groceries, meat, fruit, vegetables, and household furnishings such as lamps and electric bulbs. Boys and older men take: food, meat, suits, hats, shoes, luggage, jewelry, carpets, furniture, typewriters, radios, musical instruments, liquors, and goods from pawnshops; some boys try to make off with automobiles. The fact that electric light bulbs are listed under women and girls does not mean men or children did not take any, but that the only instances mentioned in the press were of women.
Ibid., pp. 10–11	Children do not take cases of liquor.
Ibid., p. 11	Women do not take penny whistles.
Ibid.	Girls do not take men's suits.
Ibid.	One man is arrested for stealing two pairs of ladies' silk hose.
Ibid.	In looting, each person takes what he or she had wanted but is denied or limited in obtaining. The poorer classes protest against property because they have been denied it, and against authority because that is the constant and palpable instrument of denial and suppression; and, of course, the Negroes protest against whites because the most pervasive and omnipresent fact of Negro life is a denial of the status and privileges of whites.
Ibid.	A person wants something, say, grapes. Assume the grapes are denied him. But he still wants them. What can he do?
Ibid., p. 12	"The grapes are sour anyway, I don't really want them."
Ibid.	There is every reason for believing that young Negro girls are as frustrated racially and sexually as young Negro boys.
Ibid.	If we have exact measures of the bitterness, and know the strength or weakness of inhibiting factors, we will be able to predict just when another riot will occur.
Ibid., p. 14	Frustration is fairly common in normal times, and the resentment accumulates.
Ibid., p. 15	For the most part, people are stealing food, for they were hungry.
Ibid., p. 16	The increased distance between the Negro's goal and reality induced by wartime conditions.
Ibid.	He is a servant in the Navy.
Ibid.	And, a crowning indignity, he is not even allowed to give his blood.

He must wait until all the white passengers are accommodated before he can get transportation. He may even hold his tongue when he is forced to get out of the bus in which he is seated in order to make room for white passengers.

Ibid., p. 17

Violent and unreasoning reprisals.

Ibid.

Rumor will not spread in Harlem that penguins have killed an Eskimo thief, because no one is concerned with the matter.

Ibid., p. 19

Older women taking armfuls of loot and come back for more.

Ibid., p. 22

Unless police are around, there is often no rush about looting.

Ibid.

Women, while ransacking a clothing store, stopping to judge the size of dresses.

Ibid.

In one grocery a teen-aged boy stands behind the counter passing out articles of food to a small crowd of people waiting almost as if they had been customers.

Ibid.

The riot as a colored man's New Year. As on any holiday, people got drunk, made noises, and had a good time.

Ibid.

After the looting, many new suits, hats and shoes were in evidence.

Ibid.

Negro boys who put on stolen dress coats, silk hats, and blond wigs, dancing in the street.

Ibid.

One old man says, "It's a disgrace. We should pay for the goods."

Ibid.

Homosexual or effeminate factors are also involved.

Ibid.

Some boys even make threats at stores that had escaped the damage: "You'll get yours yet" is often hurled at these storekeepers.

Ibid., p. 23

I'm glad they got that highway robber. You can go in to buy a container of milk and one time it's 14 cents and a few minutes later it's 18.

Ibid.

The rioters' excessive mutilation of manikins: Clothing store dummies are stripped naked and thrown onto the sidewalk, arms, legs and heads are sometimes broken off, and the body is often kicked around (*The Amsterdam News*, catching something of this meaning, referring in a picture caption to the "raped" dummies).

Ibid., p. 27

Most of the white merchants in Harlem are Jews. Although most of the land is owned by white Christians—banks, insurance companies, estates and churches—the fact is that the landlord agents are, for the most part, Jews. It is they who have the unpleasant task of collecting rents, refusing repairs, keeping expenses down for the landlords, and even bringing about evictions. Similarly, the Jews predominate among the principals of the public schools in Harlem. On them is the onus of having to discipline children.

Ibid., p. 28

Men and women in Harlem wait for garbage trucks to arrive at city dumps and scavenge for food; they compete with dogs and cats for the contents of garbage cans.

Trager, p. 458

Orlansky, p. 4

The mantle of being sub-human savages unworthy of being treated as human beings.

Ibid.

The gathering of crowds, the rise of looting and its relapse.

Ota Benga

Bradford and Blume, p. 208

Ota Benga was brought from the Belgian Congo in 1904 by noted African explorer Samuel Phillips Verner along with other pygmies and displayed in an exhibit in the 1904 St. Louis World's Fair. Ota Benga (or "Bi," which means "friend" in his language) was born in 1881 … Although he was referred to as a boy he had been married twice. His first wife had been captured by a hostile tribe and his second wife died by a snake bite.

Ibid., p. xix

Phillips described Ota as "an extremely interesting little fellow."

Goldenberg, pp. 22–3

For two miserable, tumultuous weeks in 1906, Ota Benga, a 23-year-old pygmy from the Belgian Congo, was put on display at what was then called the New York Zoological Society in the Bronx. The public, appalled and entertained in equal measure, flocked to the primate house, where Benga could be observed playing with Dahong, the zoo's orangutan, beneath a sign that read in part, "Height 4 feet 11 inches. Weight 103 pounds. Exhibited each afternoon during September."

It was agreed that Benga would live and hunt in a forest of several hundred acres, apart from the exhibit area. He was displayed before as many as 40,000 spectators a day. Facing protests from newspapers and black clergymen, the zoo's director allowed Benga to leave his cage and wander freely around the zoo during the day, then return to the primate house at night.

Bradford and Blume, pp. 21–2

At one point, he got hold of a knife and flourished it around the park, another time he produced a fracas after being denied a soda from the soda fountain. Finally, after fabricating a small bow and arrows and shooting at obnoxious park visitors he had to leave the park for good.

Ibid., p. 208

After his park experience, several institutions tried to help him. He was placed in Virginia Theological Seminary and College but quit school to work in a tobacco factory. According to Hornaday (who probably had evolutionary racist views) "he did not possess the power of learning" … Moving to Lynchburg, Virginia, he changed his name to Otto Bingo and presented himself as a gentleman from New York … Growing homesick, hostile, and despondent, Benga borrowed a revolver, and shot himself in the heart, ending his life in 1916.

Ibid., pp. 170–88

Ota did nothing particularly unusual that first day on exhibit at New York Zoological Park. Still, it was more interesting to watch him drink soda than to see Hannibal the lion tear raw steak. It was so engrossing to see him shoot his arrows—he rarely missed—the crowds forgot all about the hour when the seals were scheduled to be fed.

How did the pygmy like sleeping in the Monkey House, people wondered? How did he feel about living at the zoo? Next day the *Times* editorialized: "It is probably a good thing that Benga does not think very deeply. If he did it isn't likely that he was very proud of himself when he woke in the morning and found himself under the same roof with the orangutans and the monkeys, for that is really where he is."

Ota, that first day, was locked into his enclosure, except when his keepers let him out. When he was let out of the Monkey House the crowd stayed glued to him, and a keeper stayed close by.

After wandering, Ota settled back indoors into his hammock. The crowd loved it. He resumed weaving his mats and caps, then shot his arrows again. If he missed, the children made faces at him. Ota made faces back, and the crowd loved that. Day one, and he was already a sensation.

Overnight, Director Hornaday made a few last minute additions and refinements. Saturday had been dress rehearsal. The real show was about to begin.

On Sunday, September 9, thousands "took the Subway, the elevated, and the surface cars to the New York Zoological Park, in the Bronx ... " according to the *Times*.

There was always a crowd before the cage, most of the time roaring with laughter, and from almost every corner of the garden could be heard the question: "Where is the pygmy?" And the answer was, "In the monkey house."

There was a more elaborate setting in the Monkey House than had been prepared the day before. Bones were now scattered around the cage to increase the impression of savagery and danger. In addition, Director Hornaday had posted a sign on the enclosure:

The African Pygmy, "Ota Benga." Age, 28 years. Height, 4 feet 11 inches. Weight, 103 pounds. Brought from the Kasai River, Congo Free State, South Central Africa, by Dr. Samuel P. Verner, Exhibited each afternoon during September.

Dohong [an orangutan] was admitted into the enclosure. The orangutan imitated the man. The man imitated the monkey. They hugged, let go, flopped into each other's arms. Dohong snatched the woven straw cap off Ota's head and placed it on his own. Ota snatched it back. He picked the monkey up and let him drop, then turned his back to walk away. Dohong jumped up on his shoulders to hold him back. Ota shrugged him off, turned again to walk away. Dohong grabbed an ankle with one arm. Ota took big, limping steps around the cage, shackled to the ape. The crowd hooted and applauded. Dohong and Ota hugged. If Hornaday had thought to supply them with canes and Derby hats, they might have obliged with an old soft-shoe.

Children squealed with delight. To adults there was a more serious side to the display. Something about the boundary condition of being human was exemplified in that cage. Somewhere man shaded into non-man. Perhaps if they looked hard enough the moment of transition might be seen.

If Saturday's exhibit had somehow been too subtle, Sunday's entertainment compensated. To a generation raised on talk of that absentee star of evolution, the Missing Link, the point of Dohong and Ota disporting in the Monkey House was obvious. " ... the pygmy was not much taller than the orangutan," reported the *Times*, "and one had a good opportunity to study their points of resemblance. Their heads are much alike, and both grin in the same way when pleased."

Day two of the Pygmy at the Zoo already contained the first whisper of controversy. In response to a *Times* reporter, Director Hornaday admitted men were not, as a rule, exhibited in European zoos, but saw no reason to apologize: the pygmy was completely comfortable in the Monkey House. Hornaday claimed he had the full support of the Zoological Society in what he was doing.

The press in general seemed willing to indulge Hornaday, asking a few easily deflected questions now and then to maintain a semblance of balance

and fair play. The entrance of the black community into the matter of the pygmy in the zoo lent it an entirely new dimension.

The Rev. R. S. MacArthur of the Calvary Baptist Church was an unsmiling face in the light-hearted crowd at the zoo on September 9. "The person responsible for this exhibition," he said, "degrades himself as much as he does the African. Instead of making a beast of this little fellow we should be putting him in school for the development of such powers as God gave him … We send our missionaries to Africa to Christianize the people and then we bring one here to brutalize him." Dr. Gilbert of the Mount Olivet Baptist Church vowed that "he and other pastors would join with Dr. MacArthur in seeing to it that the Bushman was released from the monkey cage and put elsewhere."

Meanwhile Ota Benga was given what the crowd was led to think of as his first pair of shoes. According to the *Times*, "He seemed to like the shoes very much. Over and over again the crowd laughed at him as he sat in mute admiration of them." Did he object to the crowd laughing at him? "He has grown used to the crowd laughing, has discovered that they laugh at everything he does. If he wonders why he does not show it."

On Sunday, September 16, forty thousand visitors roamed the New York Zoological Park. The zoo was becoming a draw on the order of magnitude of Coney Island. The sudden surge in interest, as the *Times* attested, was entirely attributable to Ota Benga:

"Nearly every man, woman, and child of this crowd made for the monkey house to see the star attraction in the park—the wild man from Africa. They chased him about the grounds all day, howling, jeering and yelling. Some of them poked him in the ribs, others tripped him up, all laughed at him."

When the crowds cornered Ota, the reporter added, "they asked him how he liked America," to which he was heard to answer, "Me no like America; me like St. Louis."

Ibid., p. 188

The zoo routinely filed photographs of all its animals, but there was no filing category for human beings. Filing the pictures of Ota Benga posed a problem; as in the matter of racial identity, Ota defied prevailing labels. The solution was to photograph him holding a baby chimpanzee. Archivists then filed the picture under the label reserved for monkeys; the pretense was that the chimp was the subject, the pygmy nothing more than background.

The chimp averts its gaze, content to be cradled in Ota's right arm. Ota's expression remains constant through all the pictures taken in what was probably a single sitting. He is calm—almost too calm. There is the suggestion of sadness, a hint of resignation, and something more: Ota, who had been the object of so much scrutiny, is not merely being seen in these photos, he is seeing. He is seeing back, seeing the camera, the cameraman, and the whole civilization that seems, in his gaze, to be arrayed directly behind them.

African-American

Reitano, p. 114

The 1900 riot: "On a hot August night, an African-American woman waited for her boyfriend, Arthur Harris, at 41st Street and Eighth Avenue, in a racially mixed, rough neighborhood. When a plainclothes policeman accused her of soliciting, Harris, unaware that the white man was a cop, rushed to her defense. In the ensuing fight, the policeman was mortally wounded with Harris's penknife. Word quickly spread that a black man, newly arrived from the South, had killed a white cop … Mobs of whites surged through the streets of the West Side, from the 20s to the 30s, attacking any blacks in sight,

dragging them off streetcars and pulling them out of their homes … Only one white youth was arrested."

The 1905 San Juan Hill riot was sparked by the rare conviction of an Irish policeman for killing a black night-watchman. *Ibid.*, p. 115

On July 4, 1910, after Jack Johnson defeated Jim Jeffries (the "Great White Hope"), angry white gangs roamed the city seeking revenge. All along the West Side, blacks were assaulted and their homes set afire … Calls went out for a lynching. *Ibid.*, pp. 116–17

Marcus Garvey demanded that a capital "N" be used for the word Negro. In 1929, this spelling revision was accepted by the NYC Board of Education and the *New York Times* "in recognition of racial self-respect for those who have been for generations in the lower case." *Ibid.*, p. 138

Adam Clayton Powell took on Con Ed by threatening to have all Harlemites turn off the electricity one night a week. Next his followers flooded the New York Telephone Company with phone calls that tied up all the lines. Both companies quickly capitulated and slowly started hiring blacks. *Ibid.*, p. 149

In 1939 Powell's group descended upon the World's Fair offices at the Empire State Building where Broadway chorus girls, Bill "Bojangles" Robinson, and other prominent figures joined the picket lines and won blacks six hundred World's Fair jobs. *Ibid.*

In 1968, Columbia's few African-American students formed a Students Afro-American Society (SAS) who opposed Moses's building of a gym on public land in Morningside Heights. They took over a college building, holding three administrators hostage. Police swarmed, attacking students with nightsticks and blackjacks, beating injured persons already on stretchers, and dragging people on the ground or down concrete stairs by their hair. Students in dorms retaliated by throwing down bottles and plants. The confrontation was one of the worst in U.S. history and "The Battle for Morningside Heights" became symbolic of student protests nationwide. *Ibid.*, p. 175

In April of 1969, two hundred minority students seized CCNY's south campus, proclaiming it the "University of Harlem." *Ibid.*, p. 176

The Brooklyn slum of Brownsville went up in flames in 1970 and again in 1971. Fires of garbage piled high in the streets and fires set in local stores reflected desperation turned to rage. The riot of May 7, 1971 logged one hundred fires, fifty burned-out buildings, and scores of injuries. *Ibid.*, p. 187

During the 1977 World Series, the camera in the Goodyear Blimp showed a night panorama of Yankee Stadium and, maybe half a mile away, an anonymous building on fire. Head announcer Howard Cosell started shouting, "What's wrong with these people? Why are they doing this to themselves?" Berman, *NY Calling*, p. 19

On September 15, 1980, sixty people occupied Harlem's Sydenham Hospital, renamed it Fort Sydenham, and hung Mayor Koch in effigy. Reitano, p. 194

On a freezing January 21, 1987 (MLK's birthday), Sharpton and five thousand people marched down Fifth Avenue for a "Day of Outrage." *Ibid.*, p. 196

In August 1987, Yusef Hawkins, a sixteen-year-old African-American male, was shot dead when attacked by a gang of ten to thirty youths in the predominantly Italian American community of Bensonhurst, Brooklyn. Accompanying friends to view a secondhand car, Hawkins was mistaken for another black male who was purportedly dating a local white female … Bensonhurst residents greeted marchers with cries of "Niggers go home," pointed obscenities, mocking renditions of calypso songs, and watermelons held up as symbols of contempt. Taunts of "Central Park" were met with counter-taunts of "Howard Beach." Conflict continued for weeks as Sharpton organized more "Days of Outrage." An attempt by seventy-five hundred protestors to cross the Brooklyn Bridge ended in a major confrontation with the police. Sharpton warned that the city would "burn" if the defendants were set free and, during one march, he was stabbed in the chest.

Ibid., p. 198

July 1992 Washington Heights riots in response to a 24-year-old Dominican immigrant killed by a policeman in the lobby of a building where he had sought refuge from pursuit. For six days, young men set fire to cars and looted stores. They were met by police in riot gear who made many arrests and foiled an attempt to stop traffic on the George Washington Bridge.

Ibid., p. 202

On September 16, 1992, ten thousand off-duty police officers rallied at City Hall and stopped traffic on the Brooklyn Bridge for an hour. They stomped on cars, jumped barricades and used offensive language regarding Dinkins, including "nigger" and other epithets and profanity.

Ibid., p. 203

A West Indian woman who had lived in Gotham for decades decided to spend her weekends seeing what it was like to "be some other ethnicity … " Accordingly, she attended as many ethnic events as she could—the Puerto Rican and the St. Patrick's Day parades on Fifth Avenue, the Dominican Day parade in Washington Heights, an African-American festival in Harlem, an Asian celebration in Flushing, Queens, a Russian event in Brighton Beach and the West Indian–American Carnival Day parade on Eastern Parkway in Brooklyn. Proud of her adventures, she asked, "Where else are you going to be able to do all that but in New York?"

Ibid., pp. 206–7

Giuliani's Street Crime Unit (SCU) became the police department's "commandos," their slogan, "We own the night," acquired loaded implications for communities of color.

Ibid., p. 217

The men from the tactical patrol force sent to the scene are members of a group of about 200 handpicked men, all over six feet tall, all trained in judo and all under 30 years of age. The force was organized in 1958 as a roving unit that could be dispatched to danger areas.

Furer, p. 133

In 1906, a so-called Italian squad, the first incarnation of the bomb squad, had been formed as an arm of the New York City Police Department for the sole purpose of protecting the Italian immigrants of the city from the extortionist methods of a clandestine underworld cartel calling itself the Black Hand, a group of ex-cons and outlaws that preyed on immigrant populations.

Greenburg, p. 6

A Haitian immigrant, Abner Louima, was brutally sodomized with a toilet plunger handle by a cop in a Brooklyn police station on August 9, 1997. In response, 7,000 people marched across the Brooklyn Bridge in another Sharpton "Day of Outrage." Signs depicted Giuliani as "Ghouliani," "Crueliani," and "Brutaliani." The *Times* called the Louima case "a civic trauma."

Reitano, p. 218

Unrest — African-American

On February 4, 1999, an unarmed West African immigrant named Amadou Diallo was killed in the entrance to his Bronx apartment house. Mistaking him for a rapist and his wallet for a gun, four SCU cops fired forty-one bullets at Diallo, nineteen of which met their mark. 1,200 people were arrested at protests in March of 1999. Giuliani dismissed the protests as "silly" and the protestors as the "worst elements of society." *Ibid.*, pp. 219–20

The slums are the easiest to destroy, while the thick-walled armories, prisons, banks and churches are the hardest. Talese, p. 114

The high-rise complex called Morningside Gardens in Morningside Heights was built by David Rockefeller, whose central strategy was to create a barricade to shield the Acropolis of America—as it was envisioned—from Harlem. Glanz and Lipton, p. 18

The hot summer of '89 when *Do The Right Thing* came out and people were in the mood to kill. Schmitz, p. 272

It's time for them to go to work at Sal's Famous Pizzeria in the heart of Black Brooklyn. Lee and Jones, p. 2

Mookie stares at the gold "brass knuckles" rings Radio Raheem wears on each hand. Spelled out across the rings are the words "LOVE" on the right hand and "HATE" on the left hand. *Ibid.*, p. 45

Either dem Koreans are geniuses or we Blacks are dumb. *Ibid.*, p. 36

The infamous Michael Stewart choke hold. *Ibid.*, p. 80

VOICES OF MOB *Ibid.*, p. 81
THEY KILLED HIM
THEY KILLED RADIO RAHEEM
IT'S MURDER
DID IT AGAIN
JUST LIKE THEY DID MICHAEL STEWART
MURDER
ELEANOR BUMPURS
MURDER
IT'S NOT SAFE
NOT EVEN IN OUR OWN NEIGHBORHOOD
IT'S NOT SAFE
NEVER WAS
NEVER WILL BE

All hell breaks loose. The dam has been unplugged, broke. The rage of a people has been unleashed, a fury. A lone garbage can thrown through the air has released a tidal wave of frustration. *Ibid.*, p. 82

Look at those Korean motherfuckers across the street. I betcha they haven't been a year off da motherfucking boat before they opened up their own place. A motherfucking year off the motherfucking boat and got a good business in our neighborhood occupying a building that had been boarded up for longer than I care to remember and I've been here a long time. *Ibid.*, p. 35

I don't wanna be here, they don't want us here. We should stay in our own neighborhood, stay in Bensonhurst. *Ibid.*, p. 50

Dago, wop, garlic-breath, guinea, pizza-slinging, spaghetti-bending, Vic Damone, Perry Como, Luciano Pavarotti, Sole Mio, nonsinging motherfucker.

You gold-teeth, gold-chain-wearing, fried-chicken-and-biscuit-eatin', monkey, ape, baboon, big thigh, fast-running, high jumping, spear chucking, three-hundred-sixty-degree-basketball-dunking, titsun, spade Moulan Yan.

You little slanty-eyed, me-no-speaky-American, own-every-fruit-and-vegetable-stand-in-New-York, bullshit Reverend Moon, Summer Olympics '88, Korean kickboxing son of a bitch.

Goya-bean-eating, fifteen-in-a-car, thirty-in-an-apartment, pointed shoes, red-wearing, Menudo, meda-meda Puerto Rican cocksucker.

It's cheap, I got a good price for you, Mayor Koch, "How I'm doing," chocolate-egg-cream-drinking, bagel and lox, B'nai B'rith Jew asshole.

Ibid., p. 47

When you come in Sal's Famous Pizzeria, no music. No rap, no music. Capisce? Understand? … This is a place of business. Extra cheese is two dollars.

Reitano, p. 203

1991 Crown Heights riots, when a car driven by a Hasidic Jew jumped the curb and killed a seven-year-old Guyanese boy. The rioting continued for two days and nights. Only blacks were arrested.

Wolfe, *Bonfire*, p. 16

It was that deep worry that lives in the base of the skull of every resident of Park Avenue south of Ninety-sixth Street—a black youth, tall, rangy, wearing white sneakers.

Riot

Reitano, p. 117

1900–18, Tongs waged three lethal wars against each other in Chinatown.

Ibid., p. 143

1932 rent riot in the Bronx.

Ibid., p. 145

1943 taxi strike: drivers swooped through the streets around Times Square, the Pennsylvania Railroad terminal, and lower Broadway, attacking scabs, vandalizing their cabs, setting vehicles afire. 500 young Communists staged a sympathy march.

Hahne, p. 43

July 7, 1967, as reported in the *New York Times*: "At times, amidst the scenes of riot and destruction that made parts of the city look like a battlefield, there was an almost carnival atmosphere."

Reitano, p. 171

1968 Transit Workers Union strike, lasting twelve days: 35,000 bus and subway workers. Thousands of New Yorkers walked to work, but hundreds of thousands more could not get to work at all, including 65 percent of garment district workers. The *Times* deemed it the biggest disruption since the 1863 draft riots. An effigy of Lindsay was burned.

Berman, *Solid*, p. 320

Dropped thousands of cardboard cluster bombs on the Park Avenue headquarters of the company that made the real ones.

Furer, p. 132

People from the area run up and down the streets from group to group. Refuse baskets are set afire and Molotov cocktail bombs, bottles filled with gasoline, are thrown into the streets.

The shooting death of four antiwar protestors by National Guardsmen at Ohio's Kent State University inspired a Wall Street antiwar rally by a thousand college and high school students on May 8, 1970. In a counterdemonstration, two hundred construction workers attacked the students with fists, pipes, tools, and hard hats. On what became known as "Bloody Friday," ten thousand spectators witnessed construction workers taking over the steps of Federal Hall while waving U.S. flags and singing "God Bless America." Descending on City Hall, the men demanded that officials raise the flag, which was flying at half-mast in memory of the students killed at Kent State. Lindsay was burned in effigy and vilified as the "Red Mayor."

Reitano, p. 185

Newsday headline, Friday, February 7, 1964: "Beatles Flying In: Riot Squad Ready."

Samuel, *Cultural*, p. 23

Harlem is vicious
modernism. BangClash.

Within this area of less than two square miles live more than two hundred
thousand Negroes, more to the square acre than in any other place on earth.

Negroes at every turn; up and down Lenox Avenue, up and down One
Hundred and Thirty-Fifth Street; big, lanky Negroes, short, squat Negroes;
black ones, brown ones, yellow ones; men standing idle on the curb, women,
bundle-laden, trudging reluctantly homeward, children rattle-trapping about
the sidewalks; here and there a white face, but Negroes predominantly,
overwhelmingly everywhere.

Not merely a colony or a community or a settlement—not at all a "quarter" or
a slum or a fringe—but a black city, located in the heart of white Manhattan,
and containing more Negroes to the square mile than any other spot on earth.
It strikes the uninformed observer as a phenomenon, a miracle straight out of
the skies.

In Harlem, a suppressed surreal region, the physical delight and native
lyricism of the blacks has been enslaved to the service of the city's machines.
The blacks are the victims of the abstractly ordered metropolis. Le
Corbusier applauds their helotry: his jazzy trumpeters and tap dancers are
piston-operated rhythmic gadgets. Lorca's poems lament this same servility,
for which his surrealism is an enraged restitution. His blacks fear relapse
into their prerational past, terrified of forgetting the menial skills New York
has taught them—lighting stoves, fastening collars, driving automobiles.
The city has perversely robotized them, tortured flesh into an automaton.

Lorca's black hero, "El Rey de Harlem," is a surreal gourmand who punishes
the mechanical city by cannibalizing it.

If you ride northward the length of Manhattan Island, going through Central
Park and coming out on Seventh Avenue or Lenox Avenue at One Hundred
and Tenth Street, you cannot escape being struck by the sudden change in
the character of the people you see. In the middle and lower parts of the city
you have, perhaps, noted Negro faces here and there; but when you emerge
from the Park, you see them everywhere, and as you go up either of these
two great arteries leading out from the city to the north, you see more and
more Negroes, walking in the streets, looking from the windows, trading in
the shops, eating in the restaurants, going in and coming out of the theatres,
until, nearing One Hundred and Thirty-fifth Street, ninety per cent of the
people you see, including the traffic officers, are Negroes. And it is not until
you cross the Harlem River that the population whitens again, which it does
as suddenly as it began to darken at One Hundred and Tenth Street. You have
been having an outside glimpse of Harlem, the Negro metropolis.

In nearly every city in the country the Negro section is a nest or several
nests situated somewhere on the borders; it is a section one must "go out to."
In New York it is entirely different. Negro Harlem is situated in the heart of
Manhattan and covers one of the most beautiful and healthful sites in the
whole city. It is not a fringe, it is not a slum, nor is it a "quarter" consisting
of dilapidated tenements. It is a section of new-law apartment houses and
handsome dwellings, with streets as well paved, as well lighted, and as well
kept as in any other part of the city. Three main highways lead into and out
from upper Manhattan, and two of them run straight through Harlem. So

Harlem is not a section that one "goes out to," but a section that one goes through.

Harlem is the cheap, vertically distant gallery of the New York theater from where the blacks watch the white world sitting down below in the good seats in the orchestra.

Conrad, p. 199

The Congo was a real throbbing little Africa in New York. It was an amusement place entirely for the unwashed of the Black Belt. Or, if they were washed, smells lingered telling the nature of their occupation. Pot-wrestlers, third cooks, W.C. attendants, scrub maids, dish-washers, stevedores.

McKay, *Home*, p. 29

Up and down, along and between Lenox and Seventh and Eighth avenues, Harlem was like some technicolor bazaar. Hundreds of Negro soldiers and sailors, gawking and young like me, passed by. Harlem by now was officially off limits to white servicemen. There had already been some muggings and robberies, and several white servicemen had been found murdered. The police were also trying to discourage white civilians from coming uptown, but those who wanted to still did. Every man without a woman on his arm was being "worked" by the prostitutes. "Baby, wanna have some fun?" The pimps would sidle up close, stage-whispering, "All kinds of women, Jack—want a white woman?" And the hustlers were merchandising: "Hundred-dollar ring, man, diamond; ninety-dollar watch, too—look at 'em. Take 'em both for twenty-five."

X, p. 74

On that night I had started on my way to becoming a Harlemite. I was going to become one of the most depraved parasitical hustlers among New York's eight million people—four million of whom work, and the other four million of whom live off them.

Ibid., p. 75

But catch a subway and keep on downtown. Anywhere you may want to get off, *look* at the white man's apartments, businesses! Go right on down to the tip of Manhattan Island that this devilish white man stole from the trusting Indians for twenty-four dollars! Look at his City Hall, down there; look at his Wall Street! Look at yourself! Look at *his* God!

Ibid., p. 221

Harlem is a parade ground. During the warmer months of the year no Sunday passes without several parades. There are brass bands, marchers in resplendent regalia, and high dignitaries with gorgeous insignia riding in automobiles. Almost any excuse for parading is sufficient—the funeral of a member of the lodge, the laying of a corner-stone, the annual sermon to the order, or just a general desire to "turn out." Parades are not limited to Sundays; for when the funeral of a lodge member falls on a weekday, it is quite the usual thing to hold the exercises at night, so that members of the order and friends who are at work during the day may attend. Frequently after nightfall a slow procession may be seen wending its way along and a band heard playing a dirge that takes on a deeply sepulchral tone. But generally these parades are lively and add greatly to the movement, color, and gaiety of Harlem. A brilliant parade with very good hands is participated in not only by the marchers in line, but also by the marchers on the sidewalks. For it is not a universal custom of Harlem to stand idly and watch a parade go by; a good part of the crowd always marches along, keeping step to the music.

Johnson, *Black Manhattan*, pp. 168–9

"Harlem! Harlem!" thought Jake. "Where else could I have all this life but Harlem? Good old Harlem! Chocolate Harlem! Sweet Harlem! Harlem, I've got you' number down. Lenox Avenue, you're a bear, I know it … "

McKay, *Home*, p. 14

Harlem

Ibid., p. 15

Oh, to be in Harlem after two years away. The deep-dyed color, the thickness, the closeness of it. The noises of Harlem. The sugared laughter. The honey-talk on its streets. All night long, ragtime and "blues" playing somewhere … singing somewhere, dancing somewhere! Oh, the contagious fever of Harlem. Burning everywhere in dark-eyed Harlem …

Lamont, p. 82

In every subway station, fruit market, grocery shop, at every bargain counter, clusters of darkly distinctive people huddle, pattering in patois, clutching their exile proudly to them, foundering in the sea called Broadway.

Hughes, *Collected*, p. 33

I could take the Harlem night
and wrap around you,
Take the neon lights and make a crown,
Take the Lenox Avenue busses,
Taxis, subways,
And for your love song tone their rumble down.
Take Harlem's heartbeat,
Make a drumbeat,
Put it on a record, let it whirl,
And while we listen to it play,
Dance with you till day—
Dance with you, my sweet brown Harlem girl.

Sharpe, p. 129

In the restless languor of the summer evening the Negroes wandered restively over the tar-daubed roofs, squatted negligeed on shelterless window sills, carried on connubial pantomimic chatter across the circumscribed courts, swarmed, six to a square inch, upon curb and step, blasphemously jesting.

Ibid., p. 182

If it was good to be a lamppost in Harlem, it was probably a lot better to be a spotlight in a nightclub or cabaret.

Ibid.

A late wet night on Lenox Avenue, when all forms are soft-shadowy and the street gleams softly like a still, dim stream under the misted yellow lights.

Ibid., p. 184

A blue haze descends at night and with it strings of fairy lights on the broad avenues … From the window of an apartment on Fifth Avenue and 129th Street I look over the rooftops of Negrodom and try to believe my eyes. What a city! What a world!

Ellington, p. 182

If you ever sat on a beautiful magenta cloud overlooking New York City, you were on Sugar Hill.

Ginsberg, *Howl*, p. 16

Harlem crowned with flame under the tubercular sky.

Morris, *Manhattan '45*, p. 104

Ellington called it "an illusion."

Johnson, *Black Manhattan*, p. 160

A visit to Harlem at night—the principal streets never deserted, gay crowds skipping from one place of amusement to another, lines of taxicabs and limousines standing under the sparkling lights of the entrances to the famous night-clubs, the subway kiosks swallowing and disgorging crowds all night long gives the impression that Harlem never sleeps and that the inhabitants thereof jazz through existence. But, of course, no one can seriously think that the two hundred thousand and more Negroes in Harlem spend their nights on any such pleasance. Of a necessity the vast majority of them are ordinary, hardworking people, who spend their time in just about the same way that

other ordinary, hardworking people do. Most of them have never seen the inside of a nightclub.

Dusk gathered in blue patches over the Black Belt. Lenox Avenue was vivid. The saloons were bright, crowded with drinking men jammed tight around the bars, treating one another and telling the incidents of the day. Longshoremen in overalls with hooks, Pullman porters holding their bags, waiters, elevator boys. Liquor-rich laughter, banana- ripe laughter …

McKay, *Home*, pp. 204–5

The pavement was a dim warm bustle. Women hurrying home from day's work to get dinner ready for husbands who worked at night. On their arms brown bags and black containing a bit of meat, a head of lettuce, butter. Young men who were staggering through life, passing along with brown-paper packages, containing a small steak, a pork chop, to do their own frying. From out of saloons came the savory smell of corned beef and cabbage, spare-ribs, hamburger steaks. Out of little cook-joints wedged in side streets, tripe, pigs' feet, hogs' ears and snouts. Out of apartments, steak smothered with onions, liver and bacon, fried chicken. The composite smell of cooked stuff assaulted Jake's nostrils.

The lovely trees of Seventh Avenue were a vivid flame-green. Children, lightly clad, skipped on the pavement. Light open coats prevailed and the smooth bare throats of brown girls were a token as charming as the first pussy-willows. Far and high over all, the sky was a grand blue benediction, and beneath it the wonderful air of New York tasted like fine dry champagne.

Ibid., p. 279

Jake loitered along Seventh Avenue. Crossing to Lenox, he lazied northward and over the One Hundred and Forty-ninth Street bridge into the near neighborhood of the Bronx. Here, just a step from compactly built, teeming Harlem, were frame houses and open lots and people digging. A colored couple dawdled by, their arms fondly caressing each other's hips.

From the pool-room they went to Aunt Hattie's chitterling joint in One Hundred and Thirty-second Street, where they fed. Fricassee chicken and rice. Green peas. Stewed corn.

Ibid., p. 20

Aunt Hattie's was renowned among the lowly of Harlem's Black Belt. It was a little basement joint, smoke-colored. And Aunt Hattie was weather-beaten dark-brown, cheery-faced, with two rusty-red front teeth sticking together conspicuously out of her twisted, spread-away mouth. She cooked delicious food—home-cooked food they called it. None of the boys loafing round that section of Fifth Avenue would dream of going to any other place for their "poke chops."

They had walked down Madison Avenue, turned on One Hundred and Thirtieth Street, passing the solid gray-grim mass of the whites' Presbyterian church, and were under the timidly whispering trees of the decorously silent and distinguished Block Beautiful … The whites had not evacuated that block yet. The black invasion was threatening it from One Hundred and Thirty-first Street, from Fifth Avenue, even from behind in One Hundred and Twenty-ninth Street. But desperate, frightened, blanch-faced, the ancient sepulchral Respectability held on. And giving them moral courage, the Presbyterian church frowned on the corner like a fortress against the invasion. The Block Beautiful was worth a struggle. With its charming green lawns and quaint white-fronted houses, it preserved the most Arcadian atmosphere in all New York. When there was a flat to let in that block, you would have to rubber-neck terribly before you saw in the corner of a window-pane a neat little sign worded, Vacancy. But groups of loud-laughing-and-acting black swains and their sweethearts had started in using the block for their afternoon

Ibid., pp. 300–1

promenade. That was the limit: the desecrating of that atmosphere by black love in the very shadow of the gray, gaunt Protestant church! The Ancient Respectability was getting ready to flee …

The beautiful block was fast asleep. Up in the branches the little elfin green things were barely whispering. The Protestant church was softened to a shadow. The atmosphere was perfect, the moment sweet for something sacred.

X, p. 81

That, in fact, was one of my biggest surprises: that Harlem hadn't always been a community of Negroes.

It first had been a Dutch settlement, I learned. Then began the massive waves of poor and half-starved and ragged immigrants from Europe, arriving with everything they owned in the world in bags and sacks on their backs. The Germans came first; the Dutch edged away from them, and Harlem became all German.

Then came the Irish, running from the potato famine. The Germans ran, looking down their noses at the Irish, who took over Harlem. Next, the Italians; same thing—the Irish ran from them. The Italians had Harlem when the Jews came down the gangplanks—and then the Italians left.

Today, all these same immigrants' descendants are running as hard as they can to escape the descendants of the Negroes who helped to unload the immigrant ships.

I was staggered when old-timer Harlemites told me that while this immigrant musical chairs game had been going on, Negroes had been in New York City since 1683, before any of them came, and had been ghettoed all over the city. They had first been in the Wall Street area; then they were pushed into Greenwich Village. The next shove was up to the Pennsylvania Station area. And then, the last stop before Harlem, the black ghetto was concentrated around 52nd Street, which is how 52nd Street got the Swing Street name and reputation that lasted long after the Negroes were gone.

Then, in 1910, a Negro real estate man somehow got two or three Negro families into one Jewish Harlem apartment house. The Jews flew from that house, then from that block, and more Negroes came in to fill their apartments. Then whole blocks of Jews ran, and still more Negroes came uptown, until in a short time, Harlem was like it still is today—virtually all black.

Ibid., p. 76

Dirt, garbage cans overflowing or kicked over; drunks, dope addicts, beggars. Sleazy bars, store-front churches with gospels being shouted inside, "bargain" stores, hockshops, undertaking parlors. Greasy "home-cooking" restaurants, beauty shops smoky inside from Negro women's hair getting fried, barbershops advertising conk experts. Cadillacs, secondhand and new, conspicuous among the cars on the streets.

Ibid.

I went to one of these—thirty or forty Negroes sweating, eating, drinking, dancing, and gambling in a jammed, beat-up apartment, the record player going full blast, the fried chicken or chitlins with potato salad and collard greens for a dollar a plate, and cans of beer or shots of liquor for fifty cents.

McKay, Home, p. 10

He thrilled to Harlem. His blood was hot. His eyes were alert as he sniffed the street like a hound. Seventh Avenue was nice, a little too nice that night.

Ibid., p. 26

"Harlem! Harlem! Little thicker, little darker and noisier and smellier, but Harlem just the same. The niggers done plowed through Hundred and Thirtieth Street. Heading straight foh One Hundred and Twenty-fifth. Spades beyond Eighth Avenue. Going, going, going Harlem! Going up! Nevah befoh

I seed so many dickty shines in sich swell motor-cars. Plenty moh nigger shops. Seventh Avenue done gone high-brown. O Lawdy! Harlem bigger, Harlem better ... and sweeter."

"Street and streets! One Hundred and Thirty-second, Thirty-third, Thirty-fourth. It wasn't One Hundred and Thirty-fifth and it wasn't beyond theah ... O Lawd! how did I fohgit to remember the street and number. I reeled outa there like a drunken man. I been so happy ... Thirty-fourth, Thirty-second, Thirty-third ... Only difference is the name. All the streets am just the same and all the houses 'like as peas.'"

He dressed and went out. "Oh, Lenox Avenue, but you look good to me, now. Lawdy! though, how the brown-skin babies am humping it along! Strutting the joy-stuff! Invitation for a shimmy. O Lawdy! Pills and pisen, you got turn me loose, quick." *Ibid.*, p. 213

Lenox Avenue cannot be expressed in a Shakespearian sonnet. Douglas, p. 374

There were too many people full of hate and bitterness crowded into a dirty, stinky, uncared-for closet-size section of a great city. Brown, *Manchild*, p. 8

Living in Harlem was like living in a tent with everything that goes on inside it open to the world because the flap won't close. Freeman, p. 30

I appreciated the shared sense of public space that echoes through Spanish Harlem's streets on warm sunny days. Courgois, p. 33

An old Puerto Rican man rings a bell as he pushes a cart on wheels. On the side of the cart is hand-lettered HELADO DE COCO, and a big block of ice rests on top surrounded by different colored bottles of flavors. A group of kids eagerly waits for the ices. The man scrapes the block of ice, puts the shavings in a paper cup, and drowns it with syrup. Lee and Jones, p. 59

"Stop here," she ordered the driver, and we pulled to the curb of a street in Spanish Harlem. A savage, a garish, a moody neighborhood garlanded with poster-portraits of movie stars and Madonnas. Sidewalk litterings of fruit-rind and rotted newspaper were hurled about by the wind, for the wind still boomed, though the rain had hushed and there were bursts of blue in the sky. Capote, p. 85

On a stoop, a group of Puerto Ricans sits talking, drinking cerveza frío, and playing dominoes. One of their cars is parked near the stoop, and blasts salsa music. Lee and Jones, p. 29

The Tree of Hope, which grew in the middle of Seventh Avenue, at 131st Street. A gathering place for African-American actors, artists and musicians. Exhaust fumes had withered it, and during the summer of 1934 it was chopped up and sold off as souvenirs and firewood when the Avenue was widened. Morris, *Manhattan '45*, p. 95

The Tree of Hope, which by day and night was one of the chief centers of Harlem street life ... and superstitious people believed it to have magical powers. Leaning against it was said to bring you luck, so there was usually a crowd gathered about it. The dope peddlers found many of their clients there. Morris, *Incredible*, p. 335

Morris, *Manhattan '45*, p. 95

What the sidewalks in front of the Palace Theatre on Broadway are to the white actor, so is the well-trodden space around the Tree of Hope, the stamping ground of the colored thespian.

This tradition has it that many years ago—even this date is in doubt—an unemployed Negro actor stood under the tree, wished for a job, and immediately got it. Thankful, he spread the legend of the power of the tree to get employment for those who stood beneath it and lifted a prayer to its leafy branches.

Harlem's new "wishing tree," larger than a sapling but bare of leaves, thinly branched, and wrapped in bandages, has already begun to carry on. It began yesterday afternoon. "We rubbed that tree and it stopped raining," announced Bill Robinson, "Mayor" of Harlem and tap dancer, into a double row of microphones. The announcement was made just before the new tree was officially "planted" by rhythmic shovelers at 131st Street and Seventh Avenue, near the spot where the old "wishing elm" stood for so many years (some say thirty-five, some say longer).

A now legendary section of the trunk was secured by Ralph Cooper, Sr., a former presenter at the Lafayette Theatre, who was retooling his popular "Amateur Night" for the stage of the new, more socially progressive, Apollo Theater. The Tree of Hope remains an integral part of the Amateur Night tradition. To this day, Wednesday night contestants ritualistically rub the wood for good luck as they approach center stage to face the best critics in show business—the Harlem audience.

Ellis, *Epic*, p. 534

Father Devine: "Personifiable and repersonifiably metaphysicalizationally reproducible."

Ibid., p. 535

Father Devine's followers took names such as Angel Flesh, Blessed Mary Love, Peaceful Dove, Love Note, and Gladness Darling.

Ibid.

The trademark of Father Devine was the banquet. Devotees would sit down to the table at his most important "heaven," located at 152 West 126th Street, and feast on twenty kinds of meat, five salads, eleven relishes, fifteen kinds of bread, six desserts, six different beverages, and cheeses and cakes "as big as automobile tires." For this each disciple paid only fifteen cents.

Ottley and Weatherby, p. 187

Pig Foot Mary: a huge Amazon who arrived in New York in 1901. She mounted a steaming boiler of pig's feet on top of a baby carriage and sold them on the Upper East Side. She took the money she made in pigs' feet and bought Harlem properties, becoming one of the wealthiest landowners in Harlem.

Ibid., p. 184

It was not an unknown thing for a colored washerwoman to walk into a real-estate office and lay down several thousand dollars on a house.

Barnet, p. 151

A'Leila Walker: being wealthy and extremely dark-skinned was a combination that both intrigued and repulsed black and white Manhattan in the 1920s.

Johnson, *Black Manhattan*, p. 154

A very large part of the property in Harlem occupied by Negroes is owned by Negroes.

X, p. 85

Harlem's numbers industry hummed every morning and into the early afternoon, with the runners jotting down people's bets on slips of paper in apartment house hallways, bars, barbershops, stores, on the sidewalks.

But the middle-Harlem narcotics force found so many ways to harass me that I had to change my area. I moved down to lower Harlem, around 110th Street. There were many more reefer smokers around there, but these were a cheaper type, this was the worst of the ghetto, the poorest people, the ones who in every ghetto keep themselves narcotized to keep from having to face their miserable existence. I didn't last long down there, either. I lost too much of my product. After I sold to some of those reefer smokers who had the instincts of animals, they followed me and learned my pattern. They would dart out of a doorway, I'd drop my stuff, and they would be on it like a chicken on corn. When you become an animal, a vulture, in the ghetto, as I had become, you enter a world of animals and vultures. It becomes truly the survival of only the fittest.

Ibid., p. 102

From there, on the other side of 125th Street, at Seventh Avenue, I saw the big, tall, gray Theresa Hotel. It was the finest in New York City where Negroes could then stay, years before the downtown hotels would accept the black man. (The Theresa is now best known as the place where Fidel Castro went during his U.N. visit, and achieved a psychological coup over the U.S. State Department when it confined him to Manhattan, never dreaming that he'd stay uptown in Harlem and make such an impression among the Negroes.)

Ibid., p. 73

The Muslim program began with recognizing that color and addiction have a distinct connection. It is no accident that in the entire Western Hemisphere, the greatest localized concentration of addicts is in *Harlem*.

Ibid., p. 259

Muslim Mosque, Inc. will have its temporary headquarters in the Hotel Theresa in Harlem. It will be the working base for an action program designed to eliminate the political oppression, the economic exploitation, and the social degradation suffered daily by twenty-two million Afro-Americans.

Ibid., p. 314

The Carver Ballroom of the Hotel Theresa, which is at the corner of 125th Street and Seventh Avenue, which might be called one of Harlem's fuse-box locations.

Ibid., p. 315

Bespectacled and dapper, in a dark suit, his sandy hair glittering in the light, Malcolm said: "Brothers and sisters … " He was interrupted by two men in the center of the ballroom about four rows in front and to the right of me who rose and, arguing with each other, moved forward. Then there was a scuffle in the back of the room and, as I turned my head to see what was happening, I heard Malcolm X say his last words:
 "Now, now brothers, break it up," he said softly. "Be cool, be calm."
 Then all hell broke loose.

Felix, p. 152

Upon Malcolm X's death Sister Betty was called a "black Jacqueline Kennedy."

X, p. 442

At Simpson Street and Westchester Avenue they pose wearily against buildings and lampposts or scuttle about in an attempt to retrieve discarded boxes upon which to sit. Not only is human labor bartered and sold for the slave wage, but human love is also a marketable commodity. Whether it is labor or love, the women arrive as early as eight a.m. and remain as late as one p.m. or until they are hired. In rain or shine, hot or cold, they wait to work for ten, fifteen, and twenty cents per hour. They wash floors, clothes, windows, etc. Some have been maids and domestics in wealthy homes. Some were former marginal workers.

Ottley and Weatherby, p. 270

X, p. 74	Kitchen Mechanics' Night at the Savoy, the traditional Thursday night off for domestics.
Ibid., p. 88	Things had grown so tight in Harlem that some hustlers had been forced to go to work. Even some prostitutes had gotten jobs as domestics, and cleaning office buildings at night.
N. cit.	A white real estate corporation, Shaw & Company, of 1 West 125th Street, circularized for "an incorporated real estate company to rid of colored people."
Ottley and Weatherby, p. 186	The "Negro scare" racket: a scheme in which Negro tenants, anxious for better living quarters, were moved into white neighborhoods by unscrupulous men, who then waited for the alarmed white residents, who desired to prevent Negroes from entering the area, to bid for their property at outrageous prices. Suburban areas were particularly plagued by these men. One Negro operator made the scheme very profitable. He threatened to open a beach for Negroes in Nassau County on one occasion and, on another, he announced the opening of a "Negro cult."
Ibid., p. 272	In 1932 proportionately twice as many people died at Harlem Hospital as at Bellevue Hospital. It was for this reason that Negroes feared going to Harlem Hospital and referred to it fiercely as the "morgue" or the "butcher shop."
Ibid., p. 273	In March 1937, the wife of W. C. Handy, composer of "St. Louis Blues," lay critically ill in an ambulance for more than an hour while officials of Knickerbocker Hospital discussed whether to admit her.
Lobas, p. 62	White drivers, black drivers; none wanted to take the black girls.
Ellis, *Epic*, p. 521	Ofay, the secret Negro word for the white man—foe—in pig Latin.
Douglas, p. 25	Fats Waller moved from Harlem to St. Albans, Long Island, where crosses were burned on his lawn.
Subscriber	*To the Editor of the* New York Times*:* Can nothing be done to put a restriction on the invasion of the negro into Harlem? At one time it was a comfort and a pleasure to ride on the Sixth and Ninth Avenue elevated, but that is a thing of the past. Now you invariably have a colored person sitting either beside you or in front of you. They are defiantly bold and offensive, with the feet sprawled all over the seat. There is an enormous colony of them around 135th Street and Lenox Avenue, and they are coming closer all the time. If one's business takes him along Seventh Avenue it is annoying, to say the least, to have to walk in the driveway because the sidewalk is taken up by these blacks, who haven't had either the good grace or manners to move an inch. Why cannot we have Jim Crow laws for these people now that they are turning Harlem over to them? SUBSCRIBER New York, July 5, 1912.
Weegee, *Naked*, p. 198	Weegee on Harlem: "These are the people the papers don't write about or photograph."
Greenfield	Sufi Abdul Hamid, who in gaudy Egyptian uniform preached anti-Semitism on the street corners and was regarded by Harlem's Jewish merchants as a

"Black Hitler" ... [He wore] a cape and the turban, sometimes combined with Nazi style military shirt and pants, and jackboots, along with a fez. In his stepladder speeches, he declared himself the only man who could stop the Jews, accusing them of spreading filth and disease, and called on his followers to tear out the tongue of any Jew they met.

Hamid was not the only one working the streets of Harlem. The Communists in the form of the Young Communist League and the Young Liberators had been there first looking for cannon fodder for the revolution. The Japanese were dreaming of a black army that would serve as their fifth column in the conquest of the United States.

Ibid.

Socialism was frankly advanced as the instrument of Negro emancipation. The streets of Harlem were the scenes of nightly outdoor forums with terminology such as "class war," "imperialist ambitions," and "proletariat" bandied about.

Ottley and Weatherby, p. 188

It should be noted that Harlem was taken over without violence.

Johnson, *Black Manhattan*, p. 155

Harlem Riots, 1964:
 "Why don't you go home," pleaded a policeman through a bull-horn on one block.
 "We are home—this is our home," answered a person from the crowd.

Furer, p. 131

Forty-two Negro Red Caps in Grand Central and Penn Stations have Ph.D's.

Ellington, p. 182

Old-timers told me that Harlem had never been the same since the 1935 riot, when millions of dollars worth of damage was done by thousands of Negroes, infuriated chiefly by the white merchants in Harlem refusing to hire a Negro even as their stores raked in Harlem's money.

X, p. 113

Many families had been reduced to living below street level. It was estimated that more than ten thousand Negroes lived in cellars and basements which had been converted into makeshift flats. Packed in damp, rat-ridden dungeons, they existed in squalor approaching that of the Arkansas sharecroppers. Floors were of cracked concrete and the walls were whitewashed rock, water-drenched and rust-streaked. There were only slits for windows. A tin can in the corner covered by a sheet of newspaper was the only toilet. There was no running water in some, and no partitions to separate the adults from the curious eyes of the young. Packing boxes were used as beds, tables, and chairs. In winter rags and newspapers were stuffed in the numerous cracks to keep out the wind.

Ottley and Weatherby, p. 266

Envied was the family who had a night worker as a lodger. He would occupy a bed in the day that would be rented out at night—same room, same bed, same sheets, and same bedbugs. This was described as the "hot bed." If the family had a bathtub, it, too, after being covered with boards, would be rented out.

Ibid., p. 267

Rosalie Keith's house was not in Harlem, certainly, but enough Negroes often congregated in her drawing-room to persuade one unacquainted with the locality to believe that it was.

Van Vechten, p. 63

An average group of Negroes can in dancing to a good jazz band achieve a delightful state of intoxication that for others would require nothing short of a certain per capita imbibition of synthetic gin.

Johnson, *Black Manhattan*, p. 162

Hughes, *Big Sea*, pp. 637–9

Cards for Harlem Saturday night rent parties in the 1930s:
We got yellow girls, we've got black and tan
Will you have a good time?—YEAH MAN!

Fall in line, and watch your step, For there'll be
Lots of Browns with plenty of Pep at
A Social Whist Party

If Sweet Mamma is running wild, and you are looking
for a Do-right child, just come around and
linger awhile at a
SOCIAL WHIST PARTY

Black Wax, says change your mind and say they
do and he will give you a hearing, while MEAT
 HOUSE SLIM, laying in the bin
 killing all good men.

Some wear pajamas, some wear pants, what does it matter
just so you can dance, at
A Social Whist Party

Ottley and Weatherby, p. 250

There'll be brown skin mammas
High Yallers too
and if you ain't got nothing to do
Come on up to
ROY and SADIE'S
228 West 126th St.
Sat. Night, May 12
There'll be plenty of pig feet
And lots of gin
Jus ring the bell
And come on in.

Ibid., p. 249

A small bare room, with a dull red glow for light, was the ballroom. The only furniture was a piano at which a "box-beater" extracted weird and dissonant harmonies. In the kitchen a pot of chitterlings and pigs' feet were steaming, ready for the hungry dancers. A jug of corn liquor was a staple for such affairs and was sold in the kitchen or at a makeshift bar in the hallway. There would be revelry until daybreak and rent for the landlord the next day. Saturday night was the big night. Thursday night was also a favorite since it was then that "sleep-in" domestic workers usually had their day off and were free to "pitch" and "carry on."

Ibid., p. 251

One of the frequent house-rent party visitors was the Barefoot Prophet, so-called because winter or summer he literally strode the streets of Harlem in his bare feet. A towering man, with his luxuriant mane of gray hair, flowing beard and a long heavenly robe from which peeked gigantic feet, he was an eternal beacon along Harlem's highways. Patrons of gin-mills, cabarets, taverns and buffet flat were seldom surprised to see the Prophet stride in, quote a few passages of Scripture, take up a small collection, and then vanish into the night.

Douglas, pp. 458–9

Hubert Fauntleroy Julian, the West Indies–born black pilot who emigrated to Harlem in 1921 and was dubbed the "Black Eagle" by the New York *Telegram*, was the first Negro to obtain a pilot's license. He attempted to fly

to Africa in the summer of 1924 but the cheap plane crashed into Flushing Bay five minutes after takeoff. In the late 1930s, he attempted to assassinate Mussolini, or so he said, and on another occasion, he challenged Hermann Göring to a duel in the air. (Göring did not accept the challenge.) In April 1923, there were signs everywhere reading: "WATCH THE CLOUDS— JULIAN IS ARRIVING FROM THE SKY." He parachuted from a plane down onto Seventh Avenue and 140th Street dressed in a skin-tight scarlet outfit bearing a sign for Hoenig Optical (the Harlem eyeglasses concern that funded the leap). Six months later, he descended on Harlem once more, this time wearing a devil's costume, complete with horns and tail, and playing a saxophone. Before air traffic was regulated, Julian liked to swoop his plane daringly close to Harlem's buildings, as if making a raid or preparing to land.

James Baldwin argued that Harlem's new hyper-functionalist, concrete-slab housing projects were hated almost as much as policemen, and "this is saying a great deal." *Bennett, Deconstructing, p. 54*

Baldwin on the racist contradictions and brutal functionalist aesthetics of international style modernist urbanism itself: The projects are hideous, of course, there being a law, apparently respected throughout the world, that popular housing shall be as cheerless as a prison. They are lumped all over Harlem, colorless, bleak, high, and revolting … Harlem got its first private project, Riverton—which is now, naturally, a slum—about 12 years ago because at the time Negros were not allowed to live in Stuyvesant Town. Harlem watched Riverton go up, therefore, in the most violent bitterness of spirit, and hated it long before the builders arrived. They began hating it about the time people began moving out of their condemned houses to make room for this additional proof of how thoroughly the white world despises them. And they had scarcely moved in, naturally, before they began smashing windows, defacing walls, urinating in the elevators, and fornicating in the playgrounds. Liberals, both black and white, were appalled at the spectacle. I was appalled by the liberal innocence—or cynicism, which comes out in practice as much the same thing. *Ibid., p. 56*

It was not until 1991 that a feature film took the first truly sustained look at a New York housing project. An inside look by a young filmmaker at what the housing project had become, more than four decades after its idealistic inception. *Sanders, Celluloid, p. 170*

After Hollywood fetishized and romanticized the slums, a cry came to demolish them and replace them with grass, trees, backyards. Urban renewal bulldozes slums and Projects arise. Hollywood, nevertheless, ignores the Projects and further romanticizes slums, making them the theme of ever more films. *Ibid., p. 133*

In debunking the "Negro Renaissance," the Negro writer Wallace Thurman spoke of the artists and writers who exploited the white people who supported it as the "Niggeratti." "Being a Negro writer in these days is a racket and I'm going to make the most of it while it lasts. I find queer places for whites to go in Harlem … out-of-the-way primitive churches, side-street speakeasies, and they all fall for it. About twice a year I manage to sell a story. It is acclaimed. I am a genius in the making. Thank God for this Negro Literary Renaissance! Long may it flourish!" *Ottley and Weatherby, p. 245*

Joyce's *Ulysses* influenced some of the Harlem Renaissance writers; and even the gospel of Gertrude Stein claimed a number of Negro adherents. *Federal Writers, Panorama, p. 143*

Douglas, p. 85 Most of the 1920s literature of black Manhattan did not survive its time; much of it went out of print and stayed out of print for decades.

Ibid., p. 102 When Eugene O'Neill cast the white actress Mary Blair as the female lead opposite Paul Robeson in his 1924 drama of miscegenation, *All God's Chillun Got Wings*, he was breaking a centuries-long taboo. Before the play opened, word got out that Blair was called upon by the play to kiss Robeson's hand; a furor swept New York and, from New York, much of the nation. The New York *American* gleefully warned of the "RIOT" *God's Chillun* was sure to produce; various groups lobbied to stop the play from opening. O'Neill had protected himself by making his white heroine go crazy before she kissed his black hero's hand.

Ellington, p. 64 Night Life is cut out of a very luxurious, royal-blue bolt of velvet. It sparkles with jewels, and it sparkles in tingling and tinkling tones. Some of its sparkles are more precious than precious stones; others are just splashes of costume jewelry. Night Life seems to have been born with all of its people in it, the people who had never been babies, but were born *grown*, completely independent. Some of them were wonderful people, and some were just hangers-on of the sort. Some of them experienced untold misfortunes, and some of them were lucky. Some of them glittered in Night Life even more brightly than their names on the marquee. Some played sure things, others were inclined to gamble. There were a few hustlers, who were dependent upon finding suckers for survival. And there were some who were too wise to hustle, who only wanted to have enough money to be able to afford to be a sucker. Night Life had a song and dance. Night Life was New York … Uptown, downtown, Harlem … Anywhere where they wore that gorgeous velvet mantle.

But something seems to have happened to Night Life … Broadway is a one-way street.

I've worked nightspots ever since the beginning of my piano-plunking career, but I'm proud to say that I've never hustled a man. Back in the old days when I first came to New York, I worked at Barron's (Barron Wilkins's joint was at 134th Street and Seventh Avenue, and it was considered absolutely the *top* spot in Harlem), which catered to big spenders, gamblers, sportsmen, and women, all at the peak of their various professions. People would come in who would ask for change for a C-note in half-dollar pieces. At the end of the song, they would toss the four-bit pieces up in the air, so that they would fall on the dance floor, making jingling fanfare for the prosperity of our tomorrow. The singers—four of them, including Bricktop—would gather up the money, and another hundred-dollar bill would be changed, and this action would go jingling deep into the night. At the end of the evening, at 4 A.M. or maybe 6, when our bountiful patron thought we had had enough setting-up exercises picking up halves, he would graciously thank us and wish us good luck. With our "See you soon again, baby," we looked forward to, and wished for, his good health and happy return.

Campbell, "Night-Club" The Radium Club, near Lenox and 142nd, has a *[b]ig breakfast dance every Sunday morning [at] 4 or 5 am.*

In the Club Hot-Cha, near 7th Avenue and 134th Street, *[n]othing happens before 2 am. Ask for Clarence.*

Tillie's, on 133rd Street, *[s]pecializes in fried chicken – and it's really good!*

The next-door Log Cabin is *[a]n intimate little spot*, especially if you know to *[a]sk for Geo[rge] Woods.*

If you want to go to the Yeah Man, near 7th and 135th, *[g]o late!*

752

You've never heard a piano really played until you hear Garland Wilson, is the enticing prospect for the Theatrical Grill, not too far from Gladys' Clam House, where *Gladys Bentley wears a tuxedo and high hat and* [also] *tickles the ivories.*

At Lafayette Theatre, you can catch a show with *Bill "Bojangles" Robinson, the world's greatest tapdancer* (and the original Man with the Golden Gun, apparently). *Friday nite* [at the Lafayette] *is the midnight show … Most Negro Revues begin and end here.*

The Savoy Ballroom was the home of the Lindy Hop, and nearby (or possibly at the same location; it's hard to make out as the map is cropped somewhat on all sides), Earl Tucker launched another dance craze, the Snakehips.

The star at the Cotton Club is Cab Calloway, who can be seen (and almost heard) howling his signature refrain: *Ho De Hi De Ho!*

A nocturnal fleet of twenty thousand cab drivers ferried revelers to Harlem nightclubs in the 1920s.

Peretti, p. 8

The Negroes said: "We can't go downtown and sit and stare at you in your clubs. You won't even let us in your clubs." But they didn't say it out loud—for Negroes are practically never rude to white people. So thousands of whites came to Harlem night after night, thinking the Negroes loved to have them there, and firmly believing that all Harlemites left their houses at sundown to sing and dance in cabarets, because most of the whites saw nothing but the cabarets, not the houses.

Wilson, "Leaving NY," p. 634

Some of the owners of Harlem clubs, delighted at the flood of white patronage, made the grievous error of barring their own race, after the manner of the famous Cotton Club. But most of these quickly lost business and folded up, because they failed to realize that a large party of the Harlem attraction for downtown New Yorkers lay in simply watching the colored customers amuse themselves. And the smaller clubs, of course, had no big floor shows or a name band like the Cotton Club, where Duke Ellington usually held forth, so, without black patronage, they were not amusing at all.

Many of the Harlem night clubs which catered to an exclusively white trade barred Negroes.

Ottley and Weatherby, p. 245

Only light-skinned Negroes were allowed into the Cotton Club. On one occasion a famous Negro composer, in company with a white publisher and his wife, was barred. The explanation given at the time was that the Cotton Club never admitted "mixed parties."

Ibid., p. 248

An English-born gangster, Owney Madden, controlled 90 percent of the storefront liquor traffic in the district, including The Cotton Club. Madden, they argued, had turned Harlem into a modern-day plantation for white thrillseekers.

Lerner, p. 200

At the Cotton Club the noise is deafening. Copper-colored girls emulate the frenzies of the jungle, wheeling and tap-tapping with negroes in white satin coat-tails, sequin lapels, white top-hats and tennis-shoes. At Jack Dempsey's night spot the usherettes wear pink hunting-coats.

N. cit.

The Cotton Club was a classy spot. Impeccable behavior was demanded in the room while the show was on. If someone was talking loud while Leitha Hill, for example, was singing, the waiter would come and touch him on the

Ellington, p. 80

shoulder. If that didn't do it, the captain would come over and admonish him politely. Then the headwaiter would remind him that he had been cautioned. After that, if the loud talker still continued, somebody would come and throw him out.

Ibid., p. 82

At the Cotton Club during Prohibition, they used to have what they called Chicken Cock. It was in a can, and the can was sealed. It cost something like fourteen dollars a pint … I drank it, never got drunk, and nothing ever happened.

Peretti, p. 9

Coin-matching, dice, cards, and watered-down liquor.

Beaton, *Portrait*, p. 104

The glow of the Apollo Theatre's running lights dispels the slate-grey fog. White lights advertise … Stuffed lions and tigers in the lobby burlesque the jungle origins from which these people's ancestors came, a proud race robbed of its pride by the unscrupulously enterprising white men.

Ibid., p. 168

Under red and orange lights are hundreds of dancing negroes. Legs flare and twine, stamp and wriggle. Legs in purple, legs in checks, in evening black, in brown, in tweed skirts and evening gowns are wildly juggling, turning and twisting in rhythm to the facetious syncopation of dark hands.

Van Vechten, pp. 183–5

Every decade or so some Negro creates or discovers or stumbles upon a new dance step which so completely strikes the fancy of his race that it spreads like water poured on blotting paper. Such dances are usually performed at first inside and outside of lowly cabins, on levees, or, in the big cities, on street corners. Presently, quite automatically, they invade the more modest nightclubs where they are observed with interest by visiting entertainers who, sometimes with important modifications, carry them to a higher low world. This process may require a period of two years or longer for its development. At just about this point the director of a Broadway review in rehearsal, a hoofer, or even a Negro who puts on "routines" in the big musical shows, deciding that the dance is ready for white consumption, introduces it, frequently with the announcement that he has invented it. Nearly all the dancing now to be seen in our musical shows is of Negro origin, but both critics and public are so ignorant of this fact that the production of a new Negro review is an excuse for the revival of the hoary old lament that it is a pity the Negro can't create anything for himself, that he is obliged to imitate the white man's reviews. This, in brief, has been the history of the Cake-Walk, the Bunny Hug, the Turkey Trot, the Charleston, and the Black Bottom. It will probably be the history of the Lindy Hop.

The Lindy Hop made its first official appearance in Harlem at a Negro dance Marathon staged at Manhattan Casino sometime in 1928. Executed with brilliant virtuosity by a pair of competitors in this exhibition, it was considered at the time a little too difficult to stand much chance of achieving popular success. The dance grew rapidly in favor, however, until a year later it was possible to observe an entire ballroom filled with couples devoting themselves to its celebration.

The Lindy Hop consists in a certain dislocation of the rhythm of the fox-trot, followed by leaps and quivers, hops and jumps, eccentric flinging about of arms and legs, and contortions of the torso only fittingly to be described by the word epileptic. After the fundamental steps of the dance have been established, the performers may consider themselves at liberty to improvise, embroidering the traditional measures with startling variations, as a coloratura singer of the early nineteenth century would endow the score of a Bellini opera with roulades, runs, and shakes.

To observe the Lindy Hop being performed at first introduces gooseflesh, and second, intense excitement, akin to religious mania, for the dance is not of sexual derivation, nor does it incline its hierophants toward pleasures of the flesh. Rather it is the celebration of a rite in which glorification of self plays the principal part, a kind of terpsichorean megalomania. It is danced, to be sure, by couples, but the individuals who compose these couples barely touch each other during its performance, and each may dance alone, if he feels the urge. It is Dionysian, if you like, a dance to do honor to wine-drinking, but it is not erotic. Of all the dances yet originated by the American Negro, this one most nearly approaches the sensation of religious ecstasy. It could be danced, quite reasonably and without alteration of tempo, to many passages in the *Sacre de Printemps* of Stravinsky, and the Lindy Hop would be as appropriate for the music, which depicts in tone the representation of certain pagan rites, as the music would be appropriate for the Lindy Hop.

Blacktown crawled with white people, with pimps, prostitutes, bootleggers, with hustlers of all kinds, with colorful characters, and with police and prohibition agents. Negroes danced like they never have anywhere before or since. *X, p. 82*

Within the first five minutes in Small's, I had left Boston and Roxbury forever. *Ibid., p. 80*

My friends now included musicians like Duke Ellington's great drummer, Sonny Greer, and that great personality with the violin, Ray Nance. He's the one who used to stag in that wild "scat" style: "Blip-blip-de-blop-de-blam-blam." And people like Cootie Williams, and Eddie "Cleanhead" Vinson, who'd kid me about his conk—he had nothing up there but skin. He was hitting the heights then with his song "Hey, Pretty Mama, Chunk Me in Your Big Brass Bed." I also knew Sy Oliver; he was married to a red-complexioned girl, and they lived up on Sugar Hill; Sy did a lot of arranging for Tommy Dorsey in those days. His most famous tune, I believe, was "Yes, Indeed!" *Ibid., p. 77*

A record player maintained the right, soft music. There was any kind of drink. And Bill sold plates of his spicy, delicious Creole dishes—gumbo, jambalaya. *Ibid., p. 96*

The white man visits Harlem with a sense of adventure, as if he is violating something indefinable, like a workman entering to demolish an ancient church. *Caldwell, p. 239*

Your New York is all so frightfully boring except Harlem. *Van Vechten, p. 68*

You sort of go primitive up there. *Sharpe, p. 178*

In Harlem, the whites come to visit the Negroes in the hope of enjoying among them a little color and warmth; and the Negroes are making an effort to live as much as possible like the whites. *Wilson, "Leaving NY," p. 478*

Recently there has been a steady infiltration of society, bohemian and co-ed recruits among white females who go to Harlem for its lurid pleasures. Many women in the professional labor movement have heard the call to prove openly that they are broadminded. Many avowed Communists all but push themselves on the Negroes and it is a tenet of the party line in New York City that white women must go out of their way to mingle with the colored comrades. *Mortimer and Lait, p. 120*

Ibid., p. 116

White slumming in Harlem was known as "changing my luck" or "dealing in coal."

McCourt, p. 104

And before dawn you found out in what exact way it was completely unnecessary to go all the way up to Harlem to do the uptown lowdown.

Lerner, p. 220

Well-dressed and bejeweled white men and women are seen entering these cabarets, and at dawn, just before their colored maids have turned over for their final morning naps, they hurry to their homes, drunk and well amused.

Ibid., p. 218

Harlem's The Plantation Club was decorated with slave cabins and real-life mammies … re-created the bygone era of the antebellum South for white audiences.

Ibid., pp. 218–19

The journalist Stephen Graham recounted an evening trip uptown to Harlem with several colleagues, which he described in the exotic language of an urban safari. Graham marveled at the sounds of a jazz band "trumpeting like enraged elephants in battle" and described "a gay Negro populace, dressed to the last limit in finery … swarming in dance." On the dance floor, he encountered "tall elegant negresses with carven faces, held by bellicose fighting bulls, sun-bonneted mammas with crazy rustic boys, mightily hipped hostesses keeping time by contortioning their buttocks in unison with the males who gripped their waists." Graham admitted that he and his white companions were "interlopers" in this realm who "really did not belong," but he was delighted by the sights and sounds of the Harlem night, of "white men dancing with colored girls, and Negroes dancing with white women." In search of the genuine Harlem experience, Graham and his white companions feasted on barbecued ribs and drank gin and ginger ale, while one of the revelers told jokes about "some white man [who] comes down here, gets very drunk and finds himself dancing with his wife's coloured maid … or when a white woman discovers that she has 'got off' with the elevator boy from the apartment house where she lives." The evening ended at dawn, Graham recalled, with the group bundling into a taxi, which then "crossed the Congo, 125th Street, leaving the black compound to enter once more the domain of civilization."

Describing his "experimental" attempts to dance with "an elephantine colored girl," Graham noted, "You change into a bit of a Negro when you join the dance or you do not enjoy it; some of the black comes off on you, none of the white comes off on them. It was like dancing with a big black wooden doll."

Lerner, p. 219

The efforts of the Nordics to be carefree are grotesque, the so-called emancipated whites being the worst of the lot. No group of Negroes anywhere could be louder or rowdier than [whites] are in their efforts to impress the neighborhood with the fact that they are having a good time.

Ibid., p. 220

The "slumming craze" in Harlem.

X, p. 93

When the downtown nightclubs had closed, most of these Harlem places crawled with white people. These whites were just mad for Negro "atmosphere," especially some of the places which had what you might call Negro soul. Sometimes Negroes would talk about how a lot of whites seemed unable to have enough of being close around us, and among us, in groups. Both white men and women, it seemed, would get almost mesmerized by Negroes.

Dancing only with Negroes, she seemed to go nearly into a trance. If a white *Ibid., p. 94* man asked her to dance, she would refuse. Then when the place was ready to close, early in the morning, she would let a Negro take her as far as the subway entrance.

During World War II, Mayor La Guardia officially closed the Savoy Ballroom. *Ibid., p. 113* Harlem said the real reason was to stop Negroes from dancing with white women. Harlem said that no one dragged the white women in there. Adam Clayton Powell made it a big fight. He had successfully fought Consolidated Edison and the New York Telephone Company until they had hired Negroes. Then he had helped to battle the U.S. Navy and the U.S. Army about their segregating of uniformed Negroes. But Powell couldn't win this battle. City Hall kept the Savoy closed for a long time. It was just another one of the "liberal North" actions that didn't help Harlem to love the white man any.

A few of the white men around Harlem, younger ones whom we called *Ibid., p. 94* "hippies," acted more Negro than Negroes. This particular one talked more "hip" talk than we did. He would have fought anyone who suggested he felt any race difference … Every time I saw him, it was "Daddy! Come on, let's get our heads tight!" … He even wore a wild zoot suit, used a heavy grease in his hair to make it look like a conk, and he wore the knob-toed shoes, the long, swinging chain—everything. And he not only wouldn't be seen with any woman but a black one …

Especially after the nightclubs downtown closed, the taxis and black *Ibid., p. 112* limousines would be driving uptown, bringing those white people who never could get enough of Negro *soul*. The places popular with these whites ranged all the way from the big locally famous ones such as Jimmy's Chicken Shack, and Dickie Wells', to the little here-tonight-gone-tomorrow-night private clubs, so-called, where a dollar was collected at the door for "membership."

Inside every after-hours spot, the smoke would hurt your eyes. Four white people to every Negro would be in there drinking whisky from coffee cups and eating fried chicken. The generally flush-faced white men and their makeup-masked, glittery-eyed women would be pounding each other's backs and uproariously laughing and applauding the music. A lot of the whites, drunk, would go staggering up to Negroes, the waiters, the owners, or Negroes at tables, wringing their hands, even trying to hug them, "You're just as good as I am—I want you to know that!" The most famous places drew both Negro and white celebrities who enjoyed each other. A jam-packed four-thirty A.M. crowd at Jimmy's Chicken Shack or Dickie Wells' might have such jam-session entertainment as Hazel Scott playing the piano for Billie Holiday singing the blues. Jimmy's Chicken Shack, incidentally, was where once, later on, I worked briefly as a waiter. That's where Redd Foxx was the dishwasher who kept the kitchen crew in stitches.

It was the world where, behind locked doors, Negroes catered to moneyed *Ibid., p. 117* white people's weird sexual tastes … Harlem was their sin-den, their fleshpot. They stole off among taboo black people, and took off whatever antiseptic, important, dignified masks they wore in their white world. These were men who could afford to spend large amounts of money for two, three, or four hours indulging their strange appetites.

But in this black-white nether world, nobody judged the customers. Anything they could name, anything they could imagine, anything they could describe, they could do, or could have done to them, just as long as they paid.

⊢ Harlem

Ibid., p. 119

A funny thing, it generally was the oldest of these white men—in their sixties, I know, some maybe in their seventies—they couldn't seem to recover quickly enough from their last whipping so they could have me meet them again at 45th and Broadway to take them back to that apartment, to cringe on their knees and beg and cry out for mercy under that black girl's whip. Some of them would pay me extra to come and watch them being beaten. That girl greased her big Amazon body all over to look shinier and blacker. She used small, plaited whips, she would draw blood, and she was making herself a small fortune off those old white men.

Ibid., p. 130

In all of my time in Harlem, I never saw a white prostitute touched by a white man. White girls were in some of the various Harlem specialty places. They would participate in customers' most frequent exhibition requests—a sleek, black Negro male having a white woman. Was this the white man wanting to witness his deepest sexual fear? A few times, I even had parties that included white women whom the men had brought with them to watch this. I never steered any white women other than in these instances, brought by their own men, or who had been put into contact with me by a white Lesbian whom I knew, who was another variety of specialty madam.

Ibid.

As a Harlem habitué, she had known Harlem Negroes who liked white women.

Heap, p. 259

At one popular Harlem flat which featured a performance that "Sappho in her most daring moment never imagined." One New York tabloid reported that the sound of "high laughter, strangled ere it completes its hysterical peal, reveals the presence of women slummers … Little yellow girls, little black girls, little white girls … all writhing together on the dark blue velvet carpet under the white glare of the spot light."

X, p. 114

Today the white people who visit Harlem, and this mostly on weekend nights, are hardly more than a few dozen who do the twist, the frug, the Watusi, and all the rest of the current dance crazes in Small's Paradise, owned now by the great basketball champion "Wilt the Stilt" Chamberlain, who draws crowds with his big, clean, All-American-athlete image. Most white people today are physically afraid to come to Harlem—and it's for good reasons, too. Even for Negroes, Harlem night life is about finished. Most of the Negroes who have money to spend are spending it downtown somewhere in this hypocritical "integration," in places where previously the police would have been called to haul off any Negro insane enough to try and get in. The already Croesus-rich white man can't get another skyscraper hotel finished and opened before all these integration-mad Negroes, who themselves don't own a tool shed, are booking the swanky new hotel for "cotillions" and "conventions." Those rich whites could afford it when they used to throw away their money in Harlem. But Negroes can't afford to be taking their money downtown to the white man.

Maffi, p. 55

One afternoon in 1968, a white youth had gone for a stroll around the ghetto to savor anew its splendid architecture when, all of a sudden, he felt a hand around his arm—an old black man took him quietly but firmly to the nearest subway station and told him: "Now you better get on the first train back downtown."

In the eighteen months from the beginning of season one in April 1964 and end of season two in October 1965, a bevy of key events related to the two major sources of conflict in the mid-1960s—civil rights and the Vietnam War—took place. While fairgoers munched on their Bel-Gem waffles and rode Avis's Antique Car Ride at a top speed of six miles per hour, thousands were marching (and a few dying) in Mississippi to register black voters during the Freedom Summer of 1964. Other seminal milestones of the civil rights movement—the assassination of Malcolm X in February 1965, the Selma to Montgomery marches the following month, and the Watts riots in August—were also happening as "peace through understanding" reigned in Flushing Meadows. Similarly, the amazing string of civil rights laws that were signed by LBJ during the run of the Fair—the Civil Rights Act in July 1964, the Voting Rights Act in August 1965, and affirmative action the next month—stood in stark contrast to Moses's city-state in Queens where America's "Negro problem" did not exist and time appeared to stand still. The Vietnam problem, too, was rapidly becoming a nightmare as global harmony, or at least Moses's version of it, ruled at the Fair. From the Tonkin Gulf Resolution in August 1964 to Operation Rolling Thunder in March 1965 and the start of "search and destroy" missions in June of that year, Vietnam was top of mind for most Americans exactly at the time when millions were gathering in Flushing Meadows in celebration of international brotherhood. As more troops were sent to Southeast Asia throughout 1964 and 1965, students and organizations such as the Students for a Democratic Society marched and "sat-in" in protest of the escalation of the war. Against the backdrop of all this conflict and social unrest, Robert Moses created a space that was essentially free from the turmoil of the mid-1960s.

Samuel, *End*, p. xvi

While change, uncertainty, and angst reigned outside the fairgrounds, the world inside Robert Moses's tightly controlled universe (patrolled by thousands of Pinkerton guards) remained known and safe. A few groups tried to use the Fair as a stage to voice their concerns, most successfully on opening day, but Moses and his World's Fair Corporation [WFC] adeptly used the law and, when that failed, good old muscle to keep protesters at bay. For the overwhelming majority of visitors, the Fair's conservative tone was thus not a liability, as critics have argued, but a key asset, contributing heavily to its tremendous popularity. Rattled by immense cultural upheaval—racial unrest; an escalating, unpopular war; increasingly fuzzy gender roles; and a growing, unprecedented divide along generational lines—American visitors in particular found the Fair's postwar swagger and bravado to be a welcome anchor, providing stability and ballast. The Fair's imaginary universe looked backward as much as forward, offering visitors a bridge over the troubled waters of the times. (Guy Lombardo, a personal favorite of Robert Moses, headed the unofficial house band at the Fair.)

Ibid., pp. xvii–iii

The postwar world may have had its anxieties, but, after twenty years, they were known, familiar, and contained, the Fair told visitors, whereas the post-postwar world represented completely uncharted territory that the nation appeared unprepared to navigate. And by bypassing the uninviting near future for a more palatable far-distant one, the Fair offered its millions of visitors hope and confidence that utopia or something like it was not an entirely lost cause.

In short, the American Dream was still very much alive in these 646 acres of land in Queens, an oasis of faith and optimism. Heavily inspired by Walt Disney, whose theme park in Anaheim had been open for a decade by 1964 (and who wanted to open his second park on the Fair's site after its run), Moses thus sought and succeeded in creating a safe bubble that was virtually free from worldly concerns in order to make the event a popular success. As

the quintessential fantasy world that offered visitors refuge from the often less-than-magical realities of everyday life, the Magic Kingdom provided an ideal blueprint for Moses to follow in building his own interpretation of the happiest place on earth.

Chaos may have reigned in the WFC's boardrooms and in the offices of elected officials, but precious little of it could be detected on the fairgrounds. "Any hint of inequality, conflict, or injustice was excluded from the social purview of the Fair," observes Morris Dickstein, an accurate assessment of the protective cocoon that was Flushing Meadows. Within its grounds, foreign nations sang in harmony, corporations existed to produce things that made life better, and, most important, the future looked brighter than ever. The same formula of success that had proved so reliable the past couple of decades—science and technology—would lead America to an even more abundant promised land, this one made up of limitless energy, computerized efficiency, and push-button convenience. The make-believe universe of the 1964–65 New York World's Fair was, in short, the final gasp of American innocence, the last time and place in which the harsh realities of the mid-1960s could be ignored on such a large scale.

Caro, p. 1101

Moses rages at the press, the "assorted dyspeptics, grouches, grumblers, hit-and-run writers and talkers who hint broadly that our Fair will be artless, boycotted, funless, foodless, constipated, strangled and tasteless."

Samuel, *End*, p. 33

Opening day, five months after the JFK assassination, would be the only one in which the contained universe of the Fair would be disrupted by the outside world in any significant way. Hundreds of sit-ins were scattered about the Fair. Groups of demonstrators—chanting slogans, singing songs, and sitting in front of pavilion entrances—had gathered at dozens of different locations on the grounds … Opening day was a day in which President Johnson came to the world of fantasy and encountered the world of fact.

Ibid., p. 28

Dialing the numbers 1-9-6-4 on a special telephone, the president gave the go-ahead for a clock to begin the year's countdown to the Fair's opening. In typical Fair fashion, however, the publicity stunt did not go smoothly when a bus ran over a cable and the five hundred guests at the fairgrounds to hear the president's message had to wait for it to be retransmitted, this time on tape. "It's reassuring … that this is not the hot line to Moscow," an official said. Two days before the Fair opened, people realized that the clock had miscalculated the countdown.

Ibid., p. xx

Moses said that he would not consider the Fair to be a success unless the three most powerful organizations in the world—the U.S. government, the Vatican, and General Motors—took part.

Ibid., p. 22

"Into the gap left by the departing Communists," Moses said in 1962 after the Soviets announced they would not make a return to Flushing Meadows, "the saints have come marching in." Eight pavilions on seven acres were devoted to religion. All major Christian faiths were invited to participate: There would be a Protestant and Orthodox Center, a Christian Science Pavilion, a Greek Orthodox Church exhibit, a Christian Life Convention Pavilion, and of course, the Vatican Pavilion. (The 1939 Fair had just one faith-based pavilion, the Temple of Religion.)

Caro, p. 1101

Every one of the major religions was represented at the Fair, save one, and Jewish leaders were increasingly perturbed by the absence of any representation of their faith.

A federal judge ruled that although the WFC could maintain its ban on picketing, it would be legal for handbills to be passed out on the grounds. The WFC protested, saying it would "convert the fairgrounds into an ideological battlefield." Samuel, *End*, p. 36

Groups of demonstrators—chanting slogans, singing songs, and sitting in front of pavilion entrances—had gathered at dozens of different locations on the grounds. "Bearded and untidy, the seats of their pants muddied from sitting on the soggy ground, the pickets repelled and fascinated the fairgoers," a *New York Times* reporter wrote. *Ibid.*, p. 34

James Farmer, National Director of CORE, stopped at the Louisiana Pavilion, to which he carried a three-foot electric cattle prod and a sign saying that such a device was used on Negroes in that state … Farmer and Bayard Rustin were arrested at the New York State pavilion, the latter having led a march of about 300 people in front of the building and barricading it. *Ibid.*

Farmer's goal at the Fair was to publicize what he referred to as "the melancholy contrast between the idealized, fantasy world of the Fair and the real world of brutality, prejudice, and violence in which the American Negro is forced to live." *Ibid.*

The beer company
did not hire Blacks or Puerto Ricans,
so my father joined the picket line
at the Schaefer Beer Pavilion, New York World's Fair,
amid the crowds glaring with canine hostility. Espada

A worker at the Wisconsin Pavilion, nineteen-year-old Michael Cohen arrived at the Fair's gates with a bunch of signs with slogans like "All Hands Off Vietnam." Cohen was stopped by Pinkerton guards and his permanent pass taken away. Undeterred, Cohen paid the $2.50 regular admission fee and went to work. Samuel, *End*, p. 78

The *New York Times*: "The Fair was a gayer place after the protestors had departed." Samuel, p. 34

If every Negro in New York
 cruised over the Fair
in his fan-jet plane
 and ran out of fuel
 the World
would really learn something about the affluent
 society. O'Hara, p. 480

During the World's Fair time, the mayor didn't want there to be a gay image to the city so he closed virtually all the bars. It felt to me, like where as gays used to cruise rather furtive way on Greenwich Avenue, they were now coming down Christopher Street and moving further and further down towards the water. Carter, p. 37

Louisiana's pavilion featured a minstrel-style show called "America, Be Seated" which was picketed by CORE as a planned "stall-in" (inspired by the ever growing number of "sit-ins" that were taking place) by having two thousand cars "run out of gas" on Moses's new highways leading to the Fair. "We're going to block every street that can get you anywhere near the Samuel, *End*, p. 35

World's Fair and give New York the biggest traffic jam it's ever had." The automobiles failed to appear. The major flaw of the protest was that it was left up to each volunteer to choose the time and place where he or she would stall and then how to deal with the inevitable arrival of the police and tow trucks. The lack of a coordinated plan of attack discouraged most would-be stallers, as did a court injunction declaring the protest illegal, the disagreeable weather, and the simple fact that many had reservations about possibly never seeing their cars again. Fearing the worst, however, the city mobilized an army of wreckers, which had waited patiently on the Triborough Bridge and the Grand Central Parkway and scooped up the dozen or so cars that "did run out of gas." A helicopter capable of lifting a car hovered above, a clear sign that city officials believed the stall-in might indeed ruin the day.

O'Hara, p. 481

We are happy
here
facing the multiscreens of the IBM Pavilion.
We pay a lot for our entertainment. All right
 roll over.

Samuel, *End*, p. 77

Chrysler's puppet show which included a song called "Dem Parts." In the number, four purple puppets sang to the tune of "Dem Bones" (a well-known minstrel song), the lyrics went:

 Dem nuts, dem bolts, dem pistons;
 Dem rings, dem rods, dem gaskets;
 Dem plugs, dem lugs, dem clutch plates
 All of dem made of steel.

Chrysler insisted that the number was color-free. "There's no reference at all to human beings or race," a company spokesman insisted, but the NAACP disagreed, threatening demonstrations at the pavilion and a boycott against Chrysler dealerships in the NYC area if the song was not changed or dropped. Just two days later, Chrysler not only agreed to change all mentions of "dem" to "them" and any "de" to "the" but also agreed to change the color of the puppets from purple to yellow.

Ibid., p. 76

The Society for the Prevention of Negroes Getting Everything (SPONGE) showed up. SPONGE consisted of high school students who wore Confederate caps and carried signs of support for Alabama governor George Wallace.

Ibid., p. 27

Picketers carried signs saying "End Apartheid at the Fair" and "African Pavilions Built with Lily White Labor."

Ibid., p. 37

GM's Futurama: 19 of 38 hosts and hostesses were black. Ford was pleased as punch to claim that 26 of its 200 greeters were black, and Du Pont was equally happy that visitors would notice that 8 of its 45 hosts and hostesses were black. GE considered its hiring of 10 black hostesses out of a total of 110 at its Progressland exhibit such a progressive step that the company proudly made it known in its in-house magazine for employees and shareholders.

Caro, p. 1101

There was, of course, not a single Negro or Puerto Rican on the Fair's 200-person administrative staff.

Right before opening day, the owner of an employment agency, Mrs. Claire
Gaber, had placed a newspaper ad seeking "blue-eyed blondes" to work at
the Fair.

Ibid., p. 77

Wanting to maximize the Fair's profits in order to build his dream park after
the event (and probably dreading the scenario of thousands of poor African
American and Puerto Rican children invading Flushing Meadows), Moses
was determined to make kids in groups pay the full price.

Ibid., p. 23

Upon learning that the Spanish Pavilion had hired some nonunion workers,
the Teamsters prevented garbage collectors from picking up the pavilion's
trash. The Spaniards threatened to dump the trash into the Unisphere's
fountain if it was not collected, with the Teamsters saying they would then
retrieve the garbage from the fountain and throw it back into the pavilion.

Ibid., p. 19

The Malaysians were spending more on just window washing in 1964 than
their entire maintenance budget, making them wonder if they would be able
to afford to be back in 1965. Huge pavilion lawns in the International Area
were going unmowed, untrimmed, unwatered, and unweeded, the costs of
landscaping upkeep simply too dear. Run-ins with unions were making it
difficult for the Moroccans to keep their air conditioning running properly,
and the Spaniards' garbage situation was even worse.

Ibid., p. 160

The Japanese artisans—the only foreign group of construction workers
at the Fair—could not understand why they had to stop working at 3:30 in
the afternoon as well as collaborate with an American team, as labor rules
mandated. To get ready for their visit, the artisans had spent six months
learning English, eating American food, and getting familiar with New York
City by reading the *New York Times* every day, but nothing could prepare
them for the city's very un-Zen-like union regulations. The American
workmen were equally thrown by the Japanese's more improvisational
approach to construction. Stones for the pavilion were pre-numbered for
easy assembly on the site, and the Japanese foreman's sudden decision
to interchange number 7 with number 43 did not go over well with union
workers trained to think of architectural plans as the gospel. It took two hours
and much persuasion for the Americans to agree to swap the two stones.

Ibid., p. 159

Rather than "peace through understanding," the tit-for-tat gamesmanship
between the Jews and the Arabs was resulting in violence, a small-scale
foreshadowing of the Six-Day War just two years away. In response to the
Arabs' handing out of leaflets urging visitors to not buy "Israel war bonds,"
the Jews one day set up a table near them offering kosher bologna sandwiches
and Israeli beer. The Arabs did not take the Jews up on the free lunch.

Ibid., p. 76

The WFC made it clear that because of an 1864 land deed between NYC and
the Mohawks stating that the latter had unfettered access to the area "to cut
bulrushes," the tribe could get into the Fair anytime free of charge:
"Ye Indians hath reserved Liberty to cut bulrushes for them and their
heyers for ever in any place within ye Tract," the deed said, the tract being
"all Meadows, feeding marshes, woodes, underwoodes, waters and ponds …
scittuate upon ye North Shore of Long Island known by ye name of fflushing
within Queenes County."
Even this deal, written a couple of centuries before the area became a
valley of ashes, caused dissent however. One Princess Sun Tamo of the
Matinnecocks promptly came forth to argue that it was her tribe, not the
Mohawks, who had the legal right for free admission to the Fair. Experts in

Ibid., p. 26

Indian history supported her claim, and it was agreed that the Mohawks, like everyone else except the Matinnecocks would have to fork over two bucks if they wanted to experience the greatest event in history. Would any aspect of the Fair reflect its theme of "peace through understanding"?

Schulman, "Vazquez-Pacheco"

Feeling guilty about the Indians was a sixties thing in New York.

Samuel, *End*, p. 162

A number of efforts were made to turn the entire Fair into much more of a multilingual event in order to turn it into a true "global holiday." A year before the Fair opened, a New York–based group, the International Committee for Breaking the Language Barrier, called for some sort of system to assist non-English-speaking visitors "to facilitate and promote communication among people speaking different languages." Through signs and language, the group imagined, the upcoming World's Fair would be the perfect opportunity to break down some of the barriers that unnecessarily separated citizens of the world. Esperanto associations, too, urged speakers of the world language to visit the Fair in order to put a "non-native tongue" in greater circulation. "*Vizitu la Novjorkan Mond Foiron!*" exclaimed Esperantists in a pamphlet sent to fellow speakers of the artificial language, urging them, "Come to the Fair!" The state railways of Germany and Austria as well as the Netherlands' tourism information service were already promoting themselves in Esperanto, giving its proponents hope that the language was beginning to become a legitimate option for millions of travelers around the world.

Ibid., p. 50

Peter Lyle, a nineteen-year-old cashier at one of the Brass Rail snack stands, was spending his downtime reading four volumes of Winston Churchill's *History of the English-Speaking Peoples*.

Ibid., p. 45

Seven people were injured when a Glide-a-Ride bus hit the General Foods arch near the ground's entrance. The hospital on the fairground was unfinished at the time.

Ibid.

A Pinkerton guard was run over by one of Ford's 144 automatic convertibles.

Ibid., p. 39

A few of Times Square's most visible panhandlers had moved their operations to Flushing Meadows, working the gates near the main entrance and the boardwalk that visitors had to cross after pouring out of or into the IRT subway. A blind man who had been raising money for an "eye transplant" for more than a decade in midtown Manhattan was doing gangbusters business at the Fair, finding happy visitors heading back to the city relatively easy picking. Not too surprisingly, pickpockets and confidence men were active at the Fair, moving to where the action was.

Ibid., p. 44

Even before opening day, things were disappearing from some of the buildings. Sudan had lost a large, decorated ostrich egg, while Hong Kong was continually losing and then recovering twelve foot-long spears. Most puzzling was the disappearance of a stuffed, seven-foot, fifty-four-pound white marlin from the Long Island Rail Road exhibit.

Ibid., pp. 92–4

In the 1930s, with capitalism in crisis, world's fairs were assigned the grander cultural role to shore up Americans' faith in a consumer-based society. The 1934 Century of Progress exposition in Chicago not only reminded Americans of our past accomplishments but also sent a strong message that the popular value of thrift was not in the best long-term interests of either the nation or the individual. Although President Roosevelt backed the Century of Progress as a form of economic (and psychological)

recovery, private corporations, most notably General Motors and Ford, championed the somewhat damaged idea that spending money was the essence of the American way. Other American fairs of the 1930s, that is, San Diego (1935–36), Dallas (1936), Cleveland (1936–37), and San Francisco (1939–40), carried similar ideological themes, but it was the 1939–40 New York World's Fair that most enthusiastically celebrated the American way of life steeped in consumerism and rebutted the pessimism of the Great Depression. Tubular chairs, nylon, and television all made their debut in 1939 in New York, just a few of the "products of tomorrow" that would lead us to a better, happier future.

With a board of directors dominated by business leaders and an all-star team of industrial designers, including Walter Dorwin Teague, Norman Bel Geddes, Raymond Loewy, and Henry Dreyfus, commerce was clearly at the core of the 1939–40 Fair. All the major carmakers and an assortment of other large companies, including AT&T, Kodak, RCA, U.S. Steel, and Westinghouse, exhibited at the Fair, a re-coming out of sorts for big business that had been largely blamed for the Depression. GM's Futurama ride, designed by Geddes, not only offered visitors a peek into a utopian world of 1960 but also correctly predicted that much of tomorrow would be brought to us by corporate America. It was thus virtually inevitable that the 1964–65 New York World's Fair would not just continue along this trajectory of consumerism but, given the postwar American experience, exponentially advance it. The Fair was grounded in commerce from the get-go, dependent on the blessings of local businessmen for it to move from idea to reality. This Fair, even more than previous ones, would embrace the promise of science and technology to make our lives easier and more fulfilling.

The commercial nature of the Fair trickled down from its leader, Robert Moses, who, viewing the event as a business opportunity for the city, filled his board of directors with men of industry. From Moses's perspective, it was also essential that the Fair itself be profitable in order for the WFC to pay back the bonds it had borrowed, to silence the many critics, and, most important, to pave the way for the realization of his ultimate dream—a world-class park in Queens, perhaps even carrying his name.

Business, not political differences or social inequities, would define the 1964–65 New York World's Fair, offering both visitors and exhibitors a strong sense of comfort surrounded by the familiar and friendly ideology of American free enterprise and the fruits of the marketplace. Long before opening day, it was already apparent that commerce at the Fair would crush almost everything else in its path. As soon as the WFC moved into its headquarters in the Empire State Building, in fact, critics came out of the journalistic woodwork to voice their concerns about the Fair becoming a yearlong advertisement for exhibitors and for the idea of business itself. Some were simply concerned that the commercial aspects of the Fair would make the event less than an entertaining affair.

A full four years before opening day, for example, Robert Fontaine of *Atlantic Monthly* predicted, "The place will be cluttered with the latest color TV sets, the newest in prefabricated houses, the finest dynamos available, and, quite possibly, a machine that can take all the available statistics and come out with an answer to the effect that these are precisely the things the Fair should have exhibited." Fontaine also anticipated that the typical fairgoer would be exiting the grounds "haggard and bored, his arms weighed down with pamphlets and brightly printed books of statistics." By late 1963, it was quite clear that the type of scenario Fontaine imagined was not too much of an exaggeration. Even some Fair officials had been taken aback by the overt commercialism of the event as it took shape. "We have to crack down on this," one staffer observed as it became clear that corporate

pavilions would dominate the Fair's landscape. "It's beginning to look like a bazaar."

Writing for *The Nation* in November of that year, C. Gervin Hayden described the Fair that was rapidly taking shape as "646 acres of mammoth ads, corporate images and soft-sell" and "the biggest array of wallet-tempting sales messages of the decade." Hayden added, "U.S. industry has seized upon the New York Fair as a rare marketing opportunity, masquerading as a public-service endeavor [but] becom[ing] a hard-nosed, profit-oriented business operation." Other journalists were struck by the Fair's evolution as a pure, unadulterated exercise in marketing. "The Fair offers an unmatched opportunity for on-the-spot consumer research and product exposure, and the business exhibitors are making the most of it," a writer for *Business Week* observed a month before opening day. True to form, Ford was doing consumer research at the Fair even before it opened, hiring four hundred people to try out its Magic Skyway to make sure it was up to snuff.

Hard proof that business ruled the Fair roost were the swank, exclusive executive lounges hidden in most of the corporate pavilions. Filled with wall-to-wall deep-pile carpet, recessed lighting, station wagon–size stereophonic cabinetry, and more martinis than in a James Bond movie, executive lounges at the Fair resembled bachelor pads for men in gray flannel suits. Ford had three such hideaways, including one ultra-plush lounge just for company officers and directors and their guests, featuring Ford vinyl-coated fabrics on the furnishings and a chef imported from the Four Seasons in New York. The Tower of Light Pavilion, which represented 150 private utility companies, had two lounges that separated employees like military clubs did for officers and noncoms. For company brass and VIPs there was the Kite and Key Club, equipped with rosewood paneling, dining and bar facilities, and a one-way mirror to view the hoi polloi on the outside. In their lounge, however, utility-company worker bees were treated to not much more than a soft-drink vending machine. Although they ranged in amenities and appointments, companies kept hush-hush about these rooms because they contradicted the democratic spirit of the Fair, symbols of the vast inequalities and discrimination across class, racial, and gender lines in business and virtually every other sphere of life around the world. Interestingly, executive lounges at the 1939–40 New York World's Fair were even bigger and more ornate, as there was no central private club for entertaining as there was at the 1964–65 Fair. Corporate members and individuals gained access to the exclusive Terrace Club for $3,750 to $12,500 and $1,250, respectively, a pricey but affordable option for those sponsors wanting to do some private entertaining at the Fair.

Ibid., p. xiv

Not as beautiful as the Columbia Exposition's White City in Chicago in 1893, not as progressive as the St. Louis World's Fair in 1904, and not as optimistic as the 1939–40 New York World's Fair, the 1964–65 Fair is considered, in short, the ugly ducking (or perhaps Ugly American) of global expositions. Overshadowed by its financial losses, European no-shows, heavy commercial orientation, and, above all, the looming and rather sinister presence of its president, Robert Moses, the Fair has been summarily dismissed by critics as the World's Fair that permanently put an end to major world's fairs.

Ibid., p. xx

This new Fair, executives believed, represented an unprecedented opportunity to build goodwill among tens of millions of consumers from all around the world, a promotional vehicle that promised to pay dividends for decades.

With corporate America more powerful than ever in the mid-1960s and consumer culture at an all-time high, the 1964–65 New York World's Fair would make all previous expositions pale in comparison in terms of their commercial nature.

Ibid.

Although the Fair was officially about "peace through understanding," it was really mostly about dollars and cents.

Ibid., p. 11

Corporate America was committed to protecting its huge investment, and was not about to let this great opportunity to make a favorable impression among a global audience of consumers slip away.

Ibid., p. 64

In fairs on the scale of the present one at Flushing Meadows, the free-enterprise system mirrors itself as flatteringly and seductively as it knows how. Neither permanence nor restraint hobbles a project whose aim is an artful fantasy in which individual products are not nearly so important as the spectacular packaging of the business idea itself.

Ibid., p. 94

From the moment you enter Flushing Meadows, you become a fetus in the bulging womb of commerce, suspended in an amniotic fluid of ballyhoo and gimmickry. You are disoriented and cushioned, and thus made porous to the seepage of advertising copy which is the sole reason for the Fair … The Fair is only nominally a gathering of nations. In fact it is a promotional orgy for American business.

Ibid., p. 95

America indeed appears to have turned a corner, with large corporations taking the charge in defining our national identity and social values as charismatic visionary political leadership waned.

Ibid., p. 96

This Fair, like virtually all past ones, would be almost entirely disposable.

Ibid.

One visitor from Albany, New York, however, was more critical, considering the Fair to be steeped in "crass commercialism." "The pretty showcases containing overpriced products and hack commercials in the form of vapid ditties and sterile exhibits do not, I hope, portray our future for the next 25 years," he griped. Another observer simply thought it was odd and a little disturbing that the Fair "omitted Russia, all central Europe and most of Asia, while including Clairol, General Cigar, Mastro Pizza, Johnson's Wax and Seven-Up."

Ibid., p. 97

With commerce the common denominator or Esperanto of the Fair, national pavilions tended to take on the appearance of corporations and vice versa. Because the exhibits of the Big 3 automakers dwarfed the displays of many nations, in fact, *Time* referred to their pavilions as "the sovereign republics of Ford, Chrysler, and General Motors."

Ibid.

Ironically, religious and state exhibits had been actively sought to lessen the grounds' resemblance to the world's largest shopping center, but, as some noted at the time, these exhibitors, too, were much about selling.

Ibid.

Some foreign pavilions did not represent the character of the nations whose names they take and they are, in fact, little more than merchandise bazaars.

Ibid., p. 104

The Lake Amusement Area was also intended to serve as a way to balance out the heavy representation of industry at the Fair. Because little actual amusement could be found in the area, however, a result of Moses's insistence

Ibid., p. 97

that everything at the Fair be as inoffensive as his billboard-free parkways, corporations took on the role as lead entertainer.

Ibid., p. 98

As the Fair took shape as the ultimate trade show, American businesses spent a huge amount of money—a total of three hundred million dollars—on their exhibits. "We couldn't afford not to spend," one executive remarked. "You can't look cheap." Cheap was the last thing some corporations looked. GM's exhibit cost more than fifty million dollars, Ford's thirty million, GE's fifteen million, AT&T's fifteen million, Chrysler's twelve million, NCR's three million, and Singer's two million.

Ibid., p. 99

Having a presence at the Fair not only suggested that a company was forward thinking, research oriented, and public minded but also represented a rare chance to relate to consumers when they were in a festive mood. "Where else could we get the undivided attention of a captive audience of 74 million people?" asked Steven Van Voorbis, manager of GE's Progressland.

Ibid., p. 114

In the "Fair within the Fair," some 175 exhibitors displayed fashions, furnishings and foods, and the center's hyperconsumerism, over the top even for the Fair, was not lost on critics. *Time*, one of the pavilion's harsher critics, considered the Better Living Center a "trap," where "predator salesmen claw for the jugular."

Ibid., p. 99

If this is Futurama architecture, many a sensitive youth of today may flatly refuse to take the trip into the twenty-first century.

Ibid., p. 98

It was no coincidence then that industry's most powerful marketing tool—television—would heavily shape fairgoers' experience. Almost twenty years of television had forever changed how entertainment, and thus world's fairs, would be presented and consumed.

Ibid., p. 123

The public no longer had the wide-eyed wonder when it came to world's fairs. "They've seen it all on television," explained one exhibit manager.

Davidson

In his 1980 essay "Within the Context of No Context," George W. S. Trow, who had worked at the Fair, wrote: "What was the Fair? It was the world of television but taken seriously … At the Fair, one could see the world of television impersonating the world of history. It was the world of television, but they wouldn't let you in on the joke."

Samuel, *End*, p. 98

"Once he commences a ride or tour, he is systematically fed an entertaining, and hopefully convincing, sales message," *The Nation* observed, with visitors traveling through time and space by conveyer belts and hydraulic lifts and then deposited near the exit, cogs in a literal entertainment machine. The impact of television—arguably the most important technological innovation of the second half of the twentieth century—on the Fair experience could be rivaled only by the most important technological innovation of the first half of the century: Henry Ford's assembly line.

Ibid., p. 107

Futuramas took a trip to the moon, relaxed under the ocean at an aquatic resort, visited a jungle in which trees were knocked down like toothpicks, and cruised through a desert where crops thrived in soil irrigated by desalted seawater and machines planted and harvested crops by remote control.

Ibid., p. 108

Its City of Tomorrow, which channeled Le Corbusier's Radiant City, was all about transportation (midtown airports amid super skyscrapers, high-speed

bus-trains, moving sidewalks, underground freight-conveyor belts), a utopian metropolis with no slums or parking problems.

Curved, finned, corporate Tomorrowland, as presented at the 1964 World's Fair, was over before it began.

Samuel, p. xv

The Cab of Tomorrow driver said he would keep the meter running just to find out how much it would cost to take a taxi around the world.

Samuel, *End*, p. 30

At the Coca-Cola Pavilion, an employee had started to pose as a Disney animatronic, amazing crowds as a colleague pressed a button to supposedly make her smile and another to get her to take a drink from a bottle of Coke. "That's the most lifelike figure I've seen at any of the exhibits," one delighted visitor exclaimed.

Ibid., p. 51

GE asked Walt Disney to go back to his workshop to make the figures in the Carousel of Progress more realistic, not wanting last year's model of animatronic figures for its Magic Skyway ride.

Ibid., p. 65

Walt Disney was sixty-three when the Fair opened and would die a year after the exposition closed.

Ibid., p. xv

It was "Plastics Day" at the Fair, when the construction material in all its chemical splendor was honored, as were the men who made it possible.

Ibid., p. 164

Eight Fiberglas dinosaurs floated down the Hudson River on a barge in October, headed to their ultimate destination in the Sinclair Oil exhibit.

Ibid., p. 29

A 12-year-old boy, who had been reported missing for nine days from his home on Long Island, was discovered on the grounds, having spent the entire time there quite happily living off change he plucked out of the Fair's numerous fountains. "I slept in the Gas Pavilion for three nights, four nights in the Continental Insurance Pavilion, one night at Coca-Cola and one night in the Johnson's Wax Theater."

Ibid., p. 39

The theaters themselves were a tribute to the versatility of chemistry, made up of a bevy of Du Pont–branded materials, including a Tedlar roof, Delrin doorknobs, Antron and Fabrilite seats, Dacron fire hoses, Zytel hinges, Mylar stage curtains, Hylene foam undercoating, and Nylon carpets.

Ibid., p. 168

The pièce de résistance was when the Du Pont chorus sang "The Happy Plastics Family," something that occurred, rather amazingly, forty cheery times a day.

Ibid., pp. 168–9

Inside the next room, we watched as one of the craftsmen manipulated the shop's huge Vac-u-Form machine. Originally specially built for the 1964 World's Fair, the room-sized contraption turns large sheets of anonymous plastic into three-dimensional walls, columns, carriages, trees, statues, or anything else that can be imagined and sculpted.

Groce, p. 47

For twelve months Flushing Meadows was turned into what may very well have been the most culturally diverse place on earth.

Samuel, *End*, p. 162

At the Belgian Village, a visitor might have mistaken twentieth-century Flushing Meadows for eighteenth-century Antwerp. The village was actually designed in 1930 and shown in Antwerp, constructed for the 1933–34 Chicago

Ibid., pp. 43–4

World's Fair and then again in Brussels in 1958 for its Fair, described as "a meticulous copy of a walled Flemish village as it might have appeared in 1800." "Picturesque Belgium," as it was also called, consisted of no less than a hundred houses, a replica of the fifteenth-century Gothic church of Saint Nicolas in Antwerp, a town hall with an underground rathskeller, forty shops, a canal, and an arched stone bridge. The owner, taking a loss of two million dollars on the project, had been talking with Hugh Hefner about putting a Playboy Club in the town hall, planning to dress up the Bunnies in medieval Flemish costumes à la Breughel.

Ibid., p. 105 At the Hong Kong Pavilion, one could have a custom-made tweed or brocade suit jacket or dress measured, sewn, and delivered in twenty-four hours, something Macy's or Gimbels sure couldn't do.

Ibid., p. 160 Immediately upon their arrival at JFK Airport, the Burundis promptly laid down on the escalator, having no familiarity with stairs at all much less moving ones.

Ibid. The Africans were particularly intrigued by Jack LaLanne's exercise show on television.

Ibid. All twenty-two of the Burundis slept in a single room just as they would have back at home.

Ibid. The Africans insisted on maintaining their habit of drinking a quart of beer with every meal—including breakfast—although they found the American version weak compared with their own banana-based brew.

Ibid., p. 153 Ethnic food at the Fair: the pineapple turnovers at Hawaii's pavilion were more Betty Crocker than King Kamehameha.

Ibid., p. 163 Walter Carlson in the *New York Times*: "What is a World's Fair? It's being able to sit in the Caribbean outdoor restaurant sipping a tall mai tai while listening to a calypso singer on the stage, while outside a bagpipe band skirls by and across the street Mexican Indians swing upside down from a 114-foot pole in a prayer for rain."

Ibid., p. 51 The Lowenbrau Gardens brought over eleven young, titled women to work as barmaids in its replica of an eighteenth-century Bavarian hamlet, complete with Alpine chalets. The nine baronesses and two countesses from Munich, some of whose families had dated back to the ninth century, hauled beer steins to thirsty commoners in the open-air café, proud to serve as cultural ambassadors before returning home to their privileged lives.

Ibid., p. 154 Many of the African women dancers could be seen continually tugging at their halter tops, not used to wearing such an article of clothing back home.

Ibid., p. 153 As for Korea and Japan, much attention was paid to the selection of the "girls" who worked in the Indonesian pavilion's restaurant, with President Sukarno personally choosing them and even advising them on their behavior ("I do not want you to wiggle around with tight skirts," the president made perfectly clear).

Ibid., pp. 20–2 All or virtually all of the major expositions of the past had offered entertainment charged with sexuality appropriate to the time. At Chicago's World's Columbian Exposition of 1893, for example, Little Egypt did her

danse du ventre in the Streets of Cairo Area of that Fair, the first time belly dancing was so widely seen in the United States. Dancing girls appeared at the racy Streets of Seville exhibit of the 1904 St. Louis Fair, Sally Rand did her famous fan dance at Chicago's 1933 Century of Progress, and six years later, Gypsy Rose Lee performed her "Streets of Paris" burlesque at the 1939–40 New York Fair.

Such naughty doings, however, would have no place at all at Moses's Fair. Despite the youth-driven revolutions in both entertainment and sexuality that lay just around the cultural corner, and the fact that strip clubs were a very popular form of entertainment for men at the time, Moses insisted that amusements at the Fair be "free of honky-tonk," reflecting his clear bias toward middle-class, family-oriented values and his distaste for any form of grit. Like his highways and this former ash dump, it appeared, Moses wanted his Fair clean and pure, to minimize the effects of actual human occupancy and physicality. A bemused writer for *Atlantic Monthly* poked fun at Moses's insistence that there be "no strip-teasers, no razzle-dazzle and whoop-dee-do" and that "a husband will not have to leave his wife and children for ten minutes to see any of the features." (The rumor was that Moses even made the puppets in the "Les Poupees de Paris" show wear bras.) Poletti reinforced the WFC's official position, telling the media that the Fair would have "plenty of amusement ... but no belly dancers," referring to Little Egypt's scandalous (and very popular) performance. Not wanting to be seen as a prude or party pooper, Moses argued that he simply wanted to raise the bar of entertainment at the Fair. "We are not against gaiety," he said in March 1962. "We shall inaugurate many new inventions infinitely more diverting than whiskered women, tattooed giants and nudes on ice—such as worldwide color television." Spotting an opportunity, some Manhattan nightclub operators began talking about adding stripteasers to close what *Newsweek*, mocking the "gap"-drenched rhetoric of the cold war, referred to as the Fair's "nudity gap."

In the place of such a gap, what gradually emerged was a genre of entertainment that was highly theatrical and sensational yet decidedly free from eroticism or even sensuality. With Flushing Meadows on the shore, much of the entertainment was planned to be watery, just like at the 1939–40 Fair. In addition to commissioning a "Dancing Waters" show, the WFC hired the folks from Radio City Music Hall to produce "Wonderworld," a musical extravaganza in the amphitheater on Flushing Meadows Lake. Other amusements included "Ice-Travaganza" (an ice show created and performed by Olympic skating star Dick Button in the New York City Pavilion), a Ringling Brothers circus, and a wax museum, which included not only the figures of Cleopatra, Dr. Kildare, Lady Godiva, the Beatles, Superman, and Jesus but also another cultural icon—Robert Moses. Moses had another idea of how to make the Fair squeaky clean and wholesome as apple pie, free from the sinful trappings of the carnival: old-time religion. Moses ensured that considerable space—eight pavilions on seven acres—was devoted to religion, covering his bases by inviting all major Christian faiths to participate. The decision to make religion a significant presence at the Fair was in some ways a curious one, as the Supreme Court had just banned official prayer in public schools, deeming it a violation of the First Amendment's guarantee to separate church and state. With the Fair a public event (but run by a private corporation), a strong religious and specifically Christian orientation could have been construed as somewhat inappropriate. Regardless of the way the cultural winds were blowing, religion would be heavily represented at the Fair, contributing to its overall conservative tone.

Ibid., p. 52

A film of a passion play at the Protestant and Orthodox Center was set in a circus where Christ, as a mime or clown, was crucified in a Punch and Judy show. "It's fine, but I can't understand it," said one viewer.

Ibid., p. 75

Moses occasionally referred to the Fair as "Flushing Meadow [*sic*] University," once claiming that visitors would "get a well-rounded education for the entrance price of second rate movies." As he argued to critics who thought the Fair was low-brow and pure fluff, "This is the opportunity of millions to obtain wisdom without pain." It was obvious to all that the Fair desperately needed more business in the evening if it was going to turn a profit, but nearly naked women was apparently not the answer.

Ibid., p. 62

Mid-1960s hipsters considered the event in Queens totally Squaresville.

Ibid., p. 67

Guy Lombardo and his Royal Canadians, a personal favorite of Robert Moses, symbolized the decidedly "square" entertainment offerings at the Fair.

Gooch, pp. 423–4

In preparation for its visitors—twenty-seven million finally attended, less than anticipated—there had been months of crackdowns, cleanups, and security measures anticipating political demonstrations. A campaign to control gay bars had already begun in January, when the Fawn in Greenwich Village was closed by the police. Reacting to this closing by police department undercover agents, known as "actors," the *New York Times* on January 17 ran a front-page story headed "Growth of Overt Homosexuality in City Provokes Wide Concern," which addressed "the city's most sensitive open secret—the presence of what is probably the greatest homosexual population in the world and its increasing openness."

Frank O'Hara was quick to report to John Ashbery in Paris on the article, debate about which was keeping dinner parties in Manhattan animated that winter: "You may be interested to know that the *New York Times* had a front page (and a full page continuation inside) story on how New York is the world center of homosexuality, with somewhere between 100,000 and 600,000 of THEM prowling the areaways of Fair Gotham. Kind of exciting, isn't it? It also explains how they identify one another by a fraction of a second longer look than normal people give. I'll keep you informed. I think it was all triggered by the closing of The Fawn, a charming little dancing *boite* on Christopher Street near the Hudson River which the police used to like to visit even more than the fags (three times a night, and with blinders on) until obviously someone wouldn't pay them off anymore. *Adieu, petit faune!*"

By mid-April repressive measures were stepped up. O'Hara wrote irately to Rivers, who was in London as an informal artist-in-residence at the Slade School of Fine Arts: "In preparation for the World's Fair New York has been undergoing a horrible cleanup (I wonder what they think people are *really* coming to NYC for, anyway?). All the queer bars except one are already closed, four movie theatres have been closed (small ones) for showing unlicensed films like Jack Smith's *Flaming Creatures* and Genet's *Chant d'amour* (Jonas Mekas has been arrested twice, once for each) … Lots of committees are springing up to protest all this, everything from a lawyers committee, a free speech committee to protest the closing of coffee houses which have non-profit poetry readings (Allen and I read for this one), and one Diane has started to protest all this plus the new zoning laws which are driving artists out of their lofts … The Fair itself, or its preparations, are too ridiculous and boring to go into, except for the amusing fact that [Robert] Moses flies over it in a helicopter every day to inspect progress. And CORE has promised to totally stop traffic the first day by lying down on the highway. I hope they do."

The Better Living Center: Juxtaposed against works by John Singer Sargent, Samuel, *End*, pp. 113–14 Edward Hopper, and Jackson Pollock, was an actual tractor-trailer truck filled with groceries, a ninety-day supply of food for the average family, to be precise.

Spain's world-class art collection, much of it from the Prado Museum in *Ibid.*, p. 147 Madrid, was immensely popular, all the more so because of the pavilion's sixty female guides, all wearing Balenciaga.

A design critic saw the architectural grab bag of the Fair as a metaphor for *Ibid.*, p. 42 something much bigger and more important, believing that "its inability to send me home exploding with ideas is a real indication of the decline of the nation."

The Panorama of the City of New York, the world's largest (a half acre) three- *Ibid.*, p. 137 dimensional model that featured every structure, bridge, highway, and park of the city. One could (and still can in what is now the Queens Museum of Art) pick out one's home, school, or workplace, with binoculars for rent to make it a little easier. Besides the narration by announcer deluxe Lowell Thomas and the ability for the scale (one inch to one hundred feet) model to go from day to night and back again, one could take a seven-minute helicopter ride over the mini-city, skimming over the panorama by just two feet. The model, which had taken Richard Lester of Lester Associates two years and the city six hundred thousand dollars to create, was not just an amazing piece of design but also without question a monument to Robert Moses's career. One could not look more than a few feet without bumping into something Moses had built, a fact that surely did not go unnoticed by the seventy-five-year-old man.

In March 1962, it became clear that the Vatican would go all out for the *Ibid.*, pp. 144–5 New York Fair when, after the pope met with Cardinal Francis Spellman, the archbishop of New York and future president of the pavilion, it agreed to exhibit two of its most prized statues, Michelangelo's *Pietà* and the Good Shepherd. The Carrara marble *Pietà*, which depicts the body of the dead Jesus in the arms of the Virgin Mary after the Crucifixion, had never left the Basilica of St. Peter in Vatican City in the 465 years since its completion, whereas the Good Shepherd, residing in the Lateran Museum, was believed to be the earliest representation of a beardless Christ. Although the coup made WFC staffers jump for joy (the corporation immediately predicted the *Pietà* would be the single largest draw at the Fair), the pope's rather bold decision did not go over well with the Italian artistic community, who feared the three-thousand-pound statue might get damaged and resented their cultural icons even temporarily leaving the country.

A few days after the announcement, a group of Florentine artists drove a truck carrying a plaster cast of the *Pietà* through their city, claiming it was the real thing that they had hijacked to keep it in the country. The clever hoax fooled more than a few Florentines and served as the start of a long global debate over whether the statue should be brought to New York. Many people, including the director of the Fogg Art Museum in Boston, were firmly against it leaving its native turf, agreeing with many Italians that the masterpiece should not be treated like an animatronic Abe Lincoln.

Ignoring the party poopers, the WFC tried to parlay their winnings by beginning negotiations with the Louvre to bring over Da Vinci's *Mona Lisa*, while a Greek newspaper proposed that Praxiteles's *Hermes Carrying the Infant Dionysius*, a prized statue standing in south Greece's Olympia Museum, be sent to the Fair. (A reader of the newspaper agreed, thinking that the average American would be much more impressed by Hermes than

"the chick-peas of Santorini or the prunes from Skopelos.") Although Greek archaeologists made it clear that the risk of shipping the twenty-three-hundred-year-old statue overseas was too great, Fair officials would not give up on the piece, urging the Greek ministry to bring it over and sweetening the deal by not only guaranteeing its safety but also offering four million dollars in shared revenues. Neither the *Mona Lisa* or *Hermes* would make it to Flushing Meadows, however, turning the *Pietà* into that much more of the crown jewel of the Fair.

Gooch, p. 425

Insured for six million dollars, the fragile *Pietà* arrived at the Vatican Pavilion on loan from St. Peter's in a special waterproof, floatable crate designed to free itself from a sinking ship. *Art News* published an editorial protesting the transport in February 1964. O'Hara, always slightly more amused than hysterical on most public issues, wrote in "Poem": "when the cartoon / of a pietà / begins to resemble Ava Gardner / in Mexico / you know you're here."

Samuel, *End*, p. 144

Fair officials decided not to accept the offer from a wealthy Catholic Manhattanite to keep the *Pietà* in his Fifth Avenue apartment before heading to Flushing.

Ibid., p. 146

A new base was designed for better visibility and Broadway stage designer Jo Mielziner was hired to build, in effect, a set for the star of the Fair. Mielziner, whose credits included *Annie Get Your Gun* and *A Streetcar Named Desire*, sprinkled hundreds of dark-blue flickering votive candles around the *Pietà* and had Gregorian chants played over the speakers, attempts perhaps to make the bulletproof glass in front of it and armed guards around it a little less obtrusive. Most visitors rode past the sculpture on a conveyer belt moving at two miles per hour and then were invited to purchase *Pietà* souvenirs—medals, rosaries, charms, and miniatures—from the Vatican's gift shop.

Ibid., p. xvi

The Fair exposed Michelangelo's *Pietà* to millions and popularized the Belgian waffle.

Ibid., p. 76

Robert Moses had an idea on how to increase traffic at the Fair: have the Weather Bureau take a more "positive" approach in its forecasts for the area. Rather than saying there was a "20 percent chance of precipitation," Moses asked Anthony F. Tancreto, head of the New York division of the bureau, in a letter, why not say there was an "80 percent chance of Fair weather." Amazingly, and as a testament to the power Moses wielded, the bureau agreed to use the phrase "variable sunshine" in place of "variable cloudiness." The God-like Moses could, it appeared, even change the weather.

Ibid., p. 100

Like all architectural symbols of world's fairs since 1889, the Unisphere aspired to match the grandeur of Alexandre-Gustave Eiffel's tower, a losing proposition but one that Fair presidents, including Moses, could not resist. The grandson of Eiffel was even invited to attend the Unisphere's pedestal ceremony, an attempt to try to link the two icons, but few then or now likely confused the one in Paris for the one in Queens, despite the latter's use of the most advanced technology available.

Ibid.

Roger M. Blough is credited with determining the Unisphere's height, this decision made by less than scientific methods. Looking out his window one day, he saw a twelve-story redbrick building and decided on the spot that that was how tall the globe should be.

NYC appropriated the Unisphere as a universal code to let visitors know how to get to the Fair. "Orange-and-blue Unisphere directional signs have broken out like German measles all over town." *Ibid.*, p. 19

The Unisphere, was, appropriately enough, also a 140-foot corporate logo. A two-million-dollar "gift" to the Fair, U.S. Steel insisted that anytime the Unisphere was depicted, a line saying "Presented by United States Steel" had to be included. *Ibid.*, p. 99

Although it was without a doubt a marketing coup, the Unisphere too was less than warmly received by architectural critics, especially when compared to the Atomium of the 1958 Brussels Fair, the Space Needle at Seattle in 1961, or, for that matter, Sir Joseph Paxton's Crystal Palace in London in 1851 or Alexandre-Gustave Eiffel's tower in Paris in 1889. "The Unisphere is a bore," said Horace Sutton, "and a commercial bore at that." *Ibid.*, p. 100

The Unisphere was described by *Newsweek* as "the world's biggest birdcage." *Ibid.*, p. 18

Moses said that the Unisphere was "certainly distasteful to lovers of abstract art." *Ibid.*

The first season was a financial disaster. Because of its disappointing numbers and the cloud of conflict that continually hovered over the grounds, it would have been easy to judge the first season (and the enterprise as a whole) a dismal failure. *Ibid.*, p. 59

On the last day of the Fair's first season in October, the crowd scooped up bargains galore, as exhibitors slashed their prices on merchandise. *Ibid.*, p. 57

Despite the hundreds of extra security personnel assigned to the grounds on the final day, a significant number of visitors were determined to take home a literal piece of the Fair. Flowers and shrubbery—including the chrysanthemums that had just been planted for the new park—were ripped up and countless souvenirs taken, even the black plastic "You Are Here" tags on the outdoor maps. Vandals, too, struck the fairgrounds, with signs torn down from buildings and trash cans dumped into fountains. More than a few tipsy men wandered into the Unisphere pool, too good of a photo op to miss out on as anarchy reigned. Flags were taken from the United Nations Pavilion and, somehow, a few twenty-foot flagpoles. Booty accumulated at the Fair's gates, as guards took away visitors' pickins. Adding to the chaos of the last day was when two cars of a train ride at the Long Island Rail Road Pavilion toppled over, sending three adults and four children to the ground's Atomedic hospital. *Time* described the last day's happenings as a "scene straight out of a Federico Fellini film," bookending the chaos of the first day. The Fair was going out just like it came in. *Ibid.*, p. 88

On October 16, 1965, the day before the exposition closed, VIPs gathered in Flushing Meadows to put the 1964–65 New York World's Fair into their own time machine. Just ten feet south of where a similar ceremony occurred a quarter century earlier, guests signed their names in a special book that was then put into a time capsule to be opened in five thousand years. The capsule was a replica of the one buried in 1940, when officials of that Fair along with executives from the Westinghouse Electric Corporation buried circa 1930s artifacts and microfilmed records to document their time and place for the benefit of those individuals finding themselves in Queens in the seventieth century. Such things as a woman's hat, a slide rule, and an assortment of *Ibid.*, pp. 190–1

newspaper and magazine articles describing the (mostly sorry) state of world affairs at the turn of the decade were sunk into a fifty-foot steel shaft, not to be opened until the year 6939. Dozens of experts also deemed that the Lord's Prayer (in three hundred languages), a newsreel of a Miami fashion show, and a copy of the book *Gone with the Wind* were worth preserving for five thousand years. The location (in longitude and latitude) and a description of the time capsule's contents were recorded in a Book of Records, hundreds of copies of which were scattered around the world to help humans (or others) in five millennia find the thing and decipher what was inside.

Time Capsule II, also sponsored by Westinghouse, included twice as much material as the first, reflecting how much had occurred over the past twenty-five years. "In a quarter of a century," stated Westinghouse in its brochure for Time Capsule II, "man split the atom, danced the twist, ran the four-minute mile, scaled Mt. Everest, fought another World War and began to probe space and the seas." The eighty-plus items were selected by a fourteen-person committee led by Dr. Leonard Carmichael, vice president of research and exploration for the National Geographic Society, with input solicited from fairgoers.

Included in the seven-and-a-half-foot-long, torpedo-shaped, three-hundred-pound metal (a new "super" alloy called Kromarc) capsule were such recent innovations as a few credit cards, a bikini, contact lenses, birth control pills, tranquilizers, a plastic heart valve, a pack of filter cigarettes, an electric toothbrush, and a heat shield from Apollo 7. The arts, too, were represented, with such items as photographs of an Andrew Wyeth painting (Wyeth was a member of the selection committee) and a Henry Moore sculpture, a microfilmed book by Ernest Hemingway and poetry by Dylan Thomas and Robert Frost, and a tape of a Danny Kaye television show. Records by the Beatles, Joan Baez, and Thelonious Monk were also part of the capsule— progressive music by artists that the WFC never considered inviting to the Fair because they were, ironically, a bit too ahead of their time. Photographs of important cultural figures of the 1940s and 1950s, including the rather odd triumvirate of Joe DiMaggio, Errol Flynn, and Adolf Hitler, were also tossed in the airtight glass envelope within the capsule. A photo of Robert Moses, who would definitely qualify as an important cultural figure of the last generation (or two), was, interestingly, not slipped into the capsule, an indication perhaps of his sullied reputation or, conversely, a sign that he and others knew that his legacy was already ensured.

Ibid., pp. 81–2

As the committee and others pondered which buildings to save, a colossal yard sale was soon under way, with pavilion managers unloading everything they could not or did not want to carry out with them come mid-October. The sell-off, taking place via both auctions and set prices and listed in an eighty-page catalog, was nothing less than the largest sale of surplus goods since the end of World War II, when huge supplies of military equipment were auctioned off. The variety of things (and creatures) for sale was startling, reflecting the almost psychedelic experience that was the Fair.

The New York Roman Catholic Archdiocese, a little oddly, got dibs on the RCA color TVs scattered around the Fair. Borden, the dairy company, was pleased as punch to score the world's largest cheese (cheddar, weighing it at 34,591 pounds and 14.5 feet long), from the Wisconsin Pavilion, which would soon be the star of a traveling "cheesemobile" show. The Spaniards were hawking a sixteenth-century painted wood sculpture of the Virgin Mary for $11,590, while the Filipinos were auctioning twelve hand-carved acacia-wood panels depicting the history of their country, something that had taken thirty workers more than a year to construct. Guinea was looking to unload its voodoo tom-toms, native spears, and, somewhat anachronistically,

a forty-ton air conditioner, while Florida was asking $50,000 for its trained porpoise, Smokey, who could not only play basketball but also extinguish fires by spitting. Montana had some interesting items up for grabs—a 300-foot-long boardwalk, 56-foot-long bathroom, and three live elk ($500 per, corral extra), as did Mississippi, which was trying to find a new home for its $7,000 paddle wheeler. A Beatles fan in Cleveland had grabbed the Fab Four replicas from the Fair's wax museum for $6,000, with the equally lifelike Charles de Gaulle headed to the big-time, *Ripley's Believe It or Not* on Broadway. Caroline Kennedy, who adored the Fair on both of her two visits, was going to be the lucky recipient of Coca-Cola's electronically croaking bullfrog courtesy of the company. Walt Disney's robotic dog from GE's Carousel of Progress, which Caroline also loved, was going to—where else? Disneyland, along with its animatronic kin: Illinois's Abe Lincoln, Ford's cavemen, and, of course, Pepsi's "It's a Small World" puppets.

With costs to demolish larger buildings running from $100,000 to $300,000, most exhibitors were offering their buildings to anyone who would pay for the cost of moving them and restoring the grounds they sat on. U.S. Rubber offered its giant tire Ferris wheel to the city, adding that it would give it away to the first taker if the city did not want it. By August, some inquiries had been made for specific items, but no one seemed to be in the market for a whole building, except for the Spanish Pavilion, the crown jewel of the architecture at the Fair. Mobile, Alabama, was interested in the pavilion, as was the New York State Arts Council and the New York Trade Board, the latter wanting to keep the building on the present site. No one really knew what to do with AMF's seven-car, dual-track Monorail that had carried so many happy (and air-conditioned) fairgoers over the grounds. Clearly, the most innovative proposal for it came from Councilman O'Dwyer, who suggested that the city take the thing and use it as a form of mass transit running crosstown at both Forty-second and Thirty-fourth Streets. Rumor was that the Monorail, which had cost $5.5 million to build, could be scooped up by the first taker for just a million bucks.

One day after the Fair locked its gates, wreckers had already started taking down the Ford and RCA Pavilions, a vivid reminder that the clock was ticking on all the other buildings on the grounds. Pavilion operators had ninety days after the Fair closed to get their buildings off the site one way or another, their contracts with the WFC specified. With at least a baker's dozen exhibitors having gone belly up, however, it looked like the WFC or the city was going to have to pick up some of the demolition tab.

There was no doubt the much praised Spanish Pavilion would survive, with St. Louis Mayor A. J. Cervantes keen on locating it on a bank of the Mississippi River near the recently completed Gateway Arch and sports stadium. The $2.7 million needed to move the building was being raised from private sources, although Mobile (like St. Louis, ruled by Spain for a time in the late eighteenth century, hence its interest in it) was not giving up on its bid. St. Louis, partly because it had hosted the 1904 World's Fair, won the prize, however. Mayor Cervantes, whose Hispanic heritage certainly didn't hurt in swaying the Spaniards, toured the pavilion with a delegation of no fewer than ninety-two people in January 1966 before it was dismantled, shipped, and reconstructed in the Gateway City, where it remains today as the lobby of the Marriott Pavilion Hotel.

Councilman O'Dwyer's proposal to move the Monorail to midtown Manhattan was apparently a little too ahead of its time, with the airborne people mover purchased by a wrecking company that was now trying to unload the thing, noting in its advertising that it was "used just two summer seasons." Some other pavilions were able to avoid the wrecking ball by finding

Ibid., pp. 85–6

a good home somewhere in the world. A ski resort in Jamestown, New York, bought the Austrian Pavilion for use as a lodge for just $3,000, whereas Japan's Pavilion, stone wall and all, was given to Manhattanville College of the Sacred Heart in Purchase, New York, for use as an Asian studies center.

Indonesia was packing up its pagoda-style building and taking it back to Jakarta, whereas the Danish Pavilion's next home would be in a Westport, Connecticut, shopping center as the "Danish House," a Danish-themed store and restaurant. Although the price of the pavilion was a bargain at $40,000, given that the building originally cost more than $1 million, it cost another $500,000 to dismantle, truck, and rebuild it.

The Christian Science Pavilion was headed to Poway, California, via the Panama Canal, to be born again as a church, a real steal at $79,000, and the Mormon Pavilion still serves the faithful as a church in Plainview, Long Island. Wreckers took down the Vatican Pavilion but not before the Pietà and Good Shepherd statues were carefully packed up and shipped back to Rome. Thankfully, there was no need to cash in the $6 million insurance policy on the *Pietà*, which arrived safely back home at St. Peter's Basilica in November, unlikely to ever leave again.

Some corporate pavilions or parts of them made it out of Flushing Meadows in one piece. After the city approved the acquisition of the New York State Pavilion but rejected the U.S. Rubber Ferris wheel, the company planned to move the giant tire to its Allen Park, Michigan, headquarters, but it ended up being bought by a Lake George, New York, amusement park operator (who also snagged a few of the fifty-four-passenger Greyhound Glide-a-Ride trams). The Johnson Wax Pavilion did return to its corporate headquarters in Racine, Wisconsin, where it now functions as S. C. Johnson's Golden Rondelle Theater, whereas Coca-Cola's carillon now chimes for visitors to Stone Mountain Park near Atlanta. Thailand's eighteenth-century Buddhist shrine was taken apart for reassembly in Montreal at Expo 67, and in March, U.S. Steel donated $100,000 to make its Unisphere a permanent part of Flushing Meadows Park.

The Unisphere lives on not just as the primary architectural symbol of the Fair but, along with the Brooklyn Bridge, Guggenheim Museum, and Washington Square Arch, as one of what can be considered second-tier New York City icons. It may be less recognizable than the city's Big 3—the Empire State Building, Chrysler Building, and Statue of Liberty—but it is at least as durable, ensuring its long-term survival as a cultural icon.

A couple of other corporate pavilions were converted into mobile exhibits after the Fair by marketers wanting to get more bang from their promotional buck. Clairol put a smaller, transportable version of its Color Carousel on the road in March 1966, wanting to leverage the popularity of the pavilion that had drawn two million women over the two seasons. Retrofitted into two huge vans, the Carousel stopped at shopping centers in eighteen cities across the country, where four thousand women a day got personal consultations from the company's color advisers. Knowing the publicity mileage it got when its huge plastic dinosaurs floated to the fairgrounds on a barge down the Hudson River, Sinclair also sent a scaled-down version of its exhibit on a shopping center tour from New York that ended with a five-day prehistoric stand in Miami.

Wrecking of the grounds and salvage operations continued throughout 1966, with Moses hoping to turn the refurbished park over to the city by the end of that year. Although his Fair had lost versus made millions, Moses still had designs to, as he put it in March, "make the post-Fair park the greatest park in the center of the greatest city." Moses was now going to use $3 million in TBTA funds—less than half of what he had originally planned—to convert the grounds for public use, justifying the controversial expenditure

by claiming that the Fair was leaving a legacy of $225 million in permanent improvements, including roads, remaining structures, and park amenities.

The physical legacy of the Fair would indeed stretch significantly beyond the 646-acre site itself because of the new and improved highways that Moses had built to handle the expected traffic. Just following the 1939–40 Fair, in fact, there was an increased demand for housing in Queens, as residents of both the city and Long Island "discovered" the borough and its great roads. Knowing many commuters would love the location, location, location, builders again rushed to construct new housing near the grounds, with homes and apartment complexes squeezed into already fairly dense bedroom communities like Bayside and Douglaston. "Say what you will about the Fair," gushed one builder, Skee Taubin of the aptly named Trylon Realty Corporation, "it left us with a terrific highway system."

Disney made a stab at turning Flushing Meadows into a permanent theme park after the Fair, but naturally Moses refused to give up the site as the planned future home of his great public park. Disney packed up his ride along with his animatronic Lincoln and Carousel of Progress and shipped them to Anaheim, his company ultimately creating replicas of all three for Disney World, which opened in 1971.

Ibid., p. 110

Moses consistently and freely admitted that the "main attraction" would actually come after the Fair, when Flushing Meadows Park would be considered the most important park in the city, or as he described it, "a new sort of super Central Park."

Ibid., p. 11

Isaac Asimov, the famous writer of science fiction (and "science fact," he liked to make clear), too, mused about what both life and a World's Fair in the year 2014 might be like. In fifty years, Asimov predicted, underground homes like the one at the 1964–65 Fair would be common, "free from the vicissitudes of weather." And with most of us living beneath the surface of the earth, the scientist happily concluded, "less space [would be] wasted on actual human occupancy." Asimov went even further by proposing that people would be living not only underground in 2014 but underwater as well. "The 2014 World's Fair will have exhibits in the deep sea with bathyscaphe liners carrying men and supplies across and into the abyss," he prophesied. And just as living underground would make weather irrelevant, living under the sea would have its side benefits as well. "Underwater housing will have its attractions to those who like water sports," the esteemed scientist wrote in all seriousness.

Ibid., p. 189

Robert Moses: "We rivaled the Seven Wonders of the Ancient World. We evolved [*sic*] Renaissance, Louis XIV, Tudor, Jacobian, Jeffersonian, Victorian, General Grant, Bogart, Sanford White, Nervi, Bauhaus, Lloyd Wright, Baroque, Rococo, Igloo, Ankhor Wat, Animated Typewriters, Frozen Music and the ecstasies of Viennese pastry cooks."

Ibid., p. 87

One day during the winter of 1964–65, the mayor of New York City found himself driving along the Long Island Expressway. Passing the deserted fairgrounds, Mayor Wagner found the site depressing, as debris swirled around what he later likened to "some ghost town on Mars." The Unisphere was capped with ice.

Ibid., p. 61

Beneath the haze stirred up by the winds, the urban island, a sea in the middle of the sea, lifts up the skyscrapers over Wall Street, sinks down at Greenwich, then rises again to the crests of Midtown, quietly passes over Central Park and finally undulates off into the distance beyond Harlem. A wave of verticals. Its agitation is momentarily arrested by vision. The gigantic mass is immobilized before the eyes. It is transformed into a texturology in which extremes coincide—extremes of ambition and degradation, brutal oppositions of races and styles, contrasts between yesterday's buildings, already transformed into trash cans, and today's urban irruptions that block out its space. Unlike Rome, New York has never learned the art of growing old by playing on all its pasts. Its present invents itself, from hour to hour, in the act of throwing away its previous accomplishments and challenging the future. A city composed of paroxysmal places in monumental reliefs. The spectator can read in it a universe that is constantly exploding. In it are inscribed the architectural figures of the *coincidatio oppositorum* formerly drawn in miniatures and mystical textures. On this stage of concrete, steel and glass, cut out between two oceans (the Atlantic and the American) by a frigid body of water, the tallest letters in the world compose a gigantic rhetoric of excess in both expenditure and production.

To what erotics of knowledge does the ecstasy of reading such a cosmos belong? Having taken a voluptuous pleasure in it, I wonder what is the source of this pleasure of "seeing the whole," of looking down on, totalizing the most immoderate of human texts. To be lifted to the summit of the World Trade Center is to be lifted out of the city's grasp. One's body is no longer clasped by the streets that turn and return it according to an anonymous law; nor is it possessed, whether as player or played, by the rumble of so many differences and by the nervousness of New York traffic. When one goes up there, he leaves behind the mass that carries off and mixes up in itself any identity of authors or spectators. An Icarus flying above these waters, he can ignore the devices of Daedalus in mobile and endless labyrinths far below. His elevation transfigures him into a voyeur. It puts him at a distance. It transforms the bewitching world by which one was "possessed" into a text that lies before one's eyes. It allows one to read it, to be a solar Eye, looking down like a god. The exaltation of a scopic and gnostic drive: the fiction of knowledge is related to this lust to be a viewpoint and nothing more.

Must one finally fall back into the dark space where crowds move back and forth, crowds that, though visible from on high, are themselves unable to see down below? An Icarian fall. On the 110th floor, a poster, sphinx-like, addresses an enigmatic message to the pedestrian who is for an instant transformed into a visionary: It's hard to be down when you're up.

The desire to see the city preceded the means of satisfying it. Medieval or Renaissance painters represented the city as seen in a perspective that no eye had yet enjoyed. This fiction already made the medieval spectator into a celestial eye. It created gods. Have things changed since technical procedures have organized an "all-seeing power"? The totalizing eye imagined by the painters of earlier times lives on in our achievements. The same scopic drive haunts users of architectural productions by materializing today the utopia that yesterday was only painted. The 1,370-foot-high tower that serves as a prow for Manhattan continues to construct the fiction that creates readers, makes the complexity of the city readable, and immobilizes its opaque mobility in a transparent text.

Is the immense texturology spread out before one's eyes anything more than a representation, an optical artifact? It is the analogue of the facsimile produced, through a projection that is a way of keeping aloof, by the space planner urbanist, city planner or cartographer. The panorama-city is a "theoretical" (that is, visual) simulacrum, in short a picture, whose condition

of possibility is an oblivion and a misunderstanding of practices. The voyeur-god created by this fiction, who, like Schreber's God, knows only cadavers, must disentangle himself from the murky intertwining daily behaviors and make himself alien to them.

The ordinary practitioners of the city live "down below," below the thresholds at which visibility begins. They walk—an elementary form of this experience of the city; they are walkers, *Wandersmänner*, whose bodies follow the thicks and thins of an urban "text" they write without being able to read it. These practitioners make use of spaces that cannot be seen; their knowledge of them is as blind as that of lovers in each other's arms. The paths that correspond in this intertwining, unrecognized poems in which each body is an element signed by many others, elude legibility. It is as though the practices organizing a bustling city were characterized by their blindness. The networks of these moving, intersecting writings compose a manifold story that has neither author nor spectator, shaped out of fragments of trajectories and alterations of spaces: in relation to representations, it remains daily and indefinitely other.

Escaping the imaginary totalizations produced by the eye, the everyday has a certain strangeness that does not surface, or whose surface is only its upper limit, outlining itself against the visible. Within this ensemble, I shall try to locate the practices that are foreign to the "geometrical" or "geographical" space of visual, panoptic, or theoretical constructions. These practices of space refer to a specific form of operations ("ways of operating"), to another spatiality (an anthropological, poetic, and mythic experience of space), and to an opaque and blind mobility characteristic of the bustling city. A migrational, or metaphorical, city thus slips into the clear text of the planned and readable city.

Immortality is conferred in devious and unexpected ways. If you're an architect, there's always hope. The latest switch in architectural immortality has come with the remake of *King Kong*. The producers have been running a full-page ad announcing that their first full-page ad was so popular—with 25,000 requests for full-color reprints—that they are working around the clock to fill orders. The ad shows King Kong breaking up airplanes with his right hand and clutching whoever plays Fay Wray in his left hand, standing astride—and this is the point—not the Empire State Building, as in the original film, but the World Trade Center towers.

Huxtable, *Goodbye*, pp. 155–8

The Empire State Building, of course, is a star in its own right, with an enduring romantic charisma. Somehow it implies every cherished legend of New York glamour, from the glittering speakeasy era to the suave luxe of the 1970s. It is genuinely immortal. By contrast, and as a symbol of the city, the World Trade Center towers are consummately uninspiring. And whether the producers of the film are aware of it or not, the change they have made is fraught with cultural and aesthetic implications.

Today's tall buildings are not stars. They are impersonally impressive at best, giant nonentities at worst. Another movie, *The Towering Inferno*, for example, was not about a building you could recognize or cherish. This was simply a large object to which catastrophe happened.

I could offer an intellectually seductive explanation of the change, with dithyrambs about the antihero and the anti-symbol and how our vision of men and monuments has been altered. This is a populist age in the arts, led, of course, by the elite, and we are tearing down symbols (symbolically) and elevating the ordinary with determined reversals of good and bad and beautiful and ugly. It is a vision that can be hopelessly counterproductive, or it can provide some rich dividends in much more complex and

sophisticated ways of seeing life and the world. Anti-art is true to our times.

But the real reason for the change in the tall building is far more down to earth. It is just as rooted in culture and history, but it is less an act of philosophy than an expression of profitable pragmatism. It is a truism that today's tall building is strictly the product of economic calculations, tempered by codes and the law. Those boxy flattops that have replaced slender spires to jar the skyline and the viewer (architects and city fathers would be surprised at the amount of public concern over a city's skyline) represent the best buy in structural space.

Corporate growth and computerizing are also prime contributing factors. Today's huge corporations require huge floor areas in stacks; no builder is going to offer them a tapered tower. And no one could care less about a skyscraper version of the Mausoleum at Halicarnassus, a favorite conceit of the 1920s. Status is conferred by sheer size and the comparative quality and solidity of materials and fittings. The business of America may be business, as Coolidge said, but it has also become its art.

This phenomenon has been reinforced uncannily by the modernist architectural aesthetic. The 20th-century architectural revolution claimed the higher beauty of utility over ornament; it endorsed the look of the machine product as an artistic end. It enshrined the functional aesthetic. But it is an awfully short and dangerous step from the kind of expert and delicate adjustments that turn utility into art, and from the recognition of those adjustments to the most ordinary solution, or the least design for the money.

This deterioration is sanctioned, in a sense, by the modernist "less is more" philosophy. At its finest, less is more, and the finest is limited to a few men, such as Mies van der Rohe. Mies's work is magnificent, with a stripped, subtle, hard-edged and demanding beauty that is going to symbolize the 20th century for the rest of time. It is also poorly understood and badly knocked off. Even so, the glass box vernacular that grew out of his style is some of the best "background" architecture in history.

But this is an arcane and specialized aesthetic—it was undoubtedly easier for the popes to buy the overt grandeur of Borromini. Business clients rarely understand or want it. They are pursuing sleek space-profit formulas and effective technological solutions that no longer aspire to the kind of moving artistic greatness in the timeless and spiritual sense that architecture, and particularly the big building, has always held a primary concern. (Try standing in front of a Hawksmoor building in London without this visceral hit.) Objectively, the skyscraper's immense, efficient and impersonal blandness is a perfectly accurate picture of much of the architectural art of our age.

So dull, so prosaic, in fact, are most of today's ambitious big buildings that New Yorkers now value, for their quite accidental aesthetics, the staggered shapes of the setback buildings required by law until the early 1960s. The zoning code was changed then to encourage straight-sided towers, something architects had pushed for in the name of both architectural and civic art. Now the "wedding cakes" add the interest of eccentric form, at least, to the speculative norm. Their outlines also define a style and a time and a place, a combination of which art and culture are made.

Sanders, *Celluloid*, pp. 100–2

Smoothing their new buildings into sheer, boxy slabs; giving them flat, sheared-off tops instead of spires or pinnacles; and setting them on broad, plaza-like open spaces would convert the old, thickly carved city into an airy, enlightened landscape. We need not speculate on how the mighty Kong would have reacted to this rationalized city; we have explicit evidence in the 1976 remake of *King Kong*, produced by Dino De Laurentiis.

From the start, the new Kong failed to establish Cooper's imaginative parallel between Manhattan and Skull Island: it begins not on the New York waterfront, but aboard an oil-exploration vessel off Indonesia. And no sooner has the film reached New York than it commits the crucial error that Cooper wisely avoided: it exhibits Kong in a stadium, whose wide open space instantly destroys any sense of crowding or oppression that might motivate a thousand-foot climb. In fact, the entire city that this Kong passes through is virtually deserted, having been conveniently "evacuated." Nothing could be farther from the first film's feeling of intense, panicky compression as Kong moved through the crowded city streets. Palpably devoid of urban excitement, the updated "adventure" comes to its dreary climax when Kong finally reaches the twin towers of the World Trade Center. These buildings had, of course, supplanted the Empire State as tallest in the world (only to be supplanted themselves by Chicago's Sears Tower), and thus formed the likeliest Manhattan site for the new Kong's climactic climb. But what an uninspiring sight greets the big ape upon his arrival! The cold, empty plaza at the base of the towers—thin, desolate, vast—actually dwarfs the creature, intended to seem so ferociously large. Worse still, it offers no motivation at all for his formidable ascent. Where are the madding crowds and canyon-like streets that might propel him to the airier, more kingly precincts above? What lonely grandeur will he achieve up there that he cannot find below?

When Kong actually does start climbing (if only to fulfill expectations established forty-three years before), the sheer, unbroken shape of the World Trade Center's tower makes his effort seem almost absurd. The sight of the original Kong rising up the side of the Empire State, for all its spirit of fantasy, struck a deeply plausible note: the building's stepped-back shape was, at heart, made for ascent—if not by humans, then by something like a three-story ape. But in place of the Empire State's mountain-like, masonry surface, Kong now faces a smooth, metal-sheathed slab, unbroken from top to bottom, endlessly vertical. After watching Kong's attempt to somehow shimmy up this thousand-foot pole, we face a sight no less silly at its top. In the original film, Kong clung precariously to the Empire State's mooring mast, a narrow, vertiginous perch piercing the clouds and sky, where one false step meant doom. The flat tops of the twin towers, by contrast, offer nothing to grab on to—almost nothing to do at all, in fact, except jump from one tower to another, which the great creature inevitably proceeds to do. Atop the second identically large, flat surface, he is forced to stand like a dummy while helicopter gunships open fire. Some effort has to be made, in fact, to ensure that Kong actually falls over the side, rather than simply plops down on this football field of a roof. (In the original film, by contrast, it felt like a sheer act of will, a scary balancing act, for Kong to remain on his narrow roost, reaching out in vain at the circling planes.)

But fall he does, to a final indignity. The huge plaza below swallows up Kong's body and again makes him seem almost puny; the crowd that has gathered for this most remarkable of sights scarcely fills half the space. Kong's body sits like the centerpiece of a party whose guests mill about aimlessly; how different from the original film's rushing crowds and traffic on 34th Street, the dead Kong interrupting the massive urban superflux with his even more massive presence! Even in death, the original implied, Kong belonged up in the sky, not among the thick crowds below from whom he sought so hard to escape. In this last shot of the remake, on the other hand, neither "Beauty" nor aerial gunships seem to have done in the Beast so much as the cool, rational planning of postwar architecture.

Neither the Empire State Building nor the World Trade Center, needless to say, were designed to have a giant ape climb their sides; both were simply large commercial structures, filled with rentable office space. But there is

something revealing in the way that the shape of the Empire State lent itself to the film—in fact, in some ineffable way, became itself, found its essential identity—through the story of King Kong. The shape of the Trade Center, in contrast, fought the story all the way. The producers of the remake turned inevitably to the World Trade Center as the tallest building in New York, but the Trade Center itself seemed to have forgotten why it was tallest. The whole significance of height, its power to impress in more than an abstract, statistical sense—number of stories, distance from sidewalk to roof—had been lost in the interim. The placement of an open plaza at the base of the buildings, meanwhile, removed the extremes of density (at their bottom) and openness (at their top) that gave the old towers their drama, making them, in Vincent Scully's words, "not salubrious but sublime." It was hardly surprising that New York's newer office buildings offered so little to the fantasies of the movie city—or to fantasies of any sort.

Kingwell, p. 166

In 1986, lawyers for Turner Broadcasting, which had acquired the rights to the original film, along with scores of other classics soon to be violated by "colorization," tried to stop the Empire State from using any Kong imagery in their promotions without first paying a permission fee—a move the building's lawyers countered by employing nameless gorillas in promotions whose taglines went conspicuously Kongless. The building's owners knew they could not lose in such a battle of icons, confident that tourists and consumers would reliably supply the suppressed premise of this media enthymeme: if there is a gorilla (or, rather, man in a gorilla suit) in or around the Empire State Building, then, name or no name—trademark or no trademark—that gorilla must be King Kong. It was as if Turner had tried to trademark the name of a bearded fat man in a red suit between Thanksgiving and New Year's Eve.

Huxtable, *Goodbye*, p. 169

The towers of the mammoth World Trade Center rise aggressively over everything else, gleaming like new-minted money—the architecture of power.

Wojnarowicz, p. 125

The World Trade Center, the very top of it emerging into a dim sunlight of rising dawn, it was framed by crossbars of metal on top of the far warehouse roof and it was like some kinda vision in all of this.

Goldenberg, p. 28

The initial scheme for the World Trade Center was located along the East River, extending from the financial district to the South Street Seaport.

Baudrillard, *Symbolic*, pp. 69–70

Why has the World Trade Center in New York got two towers? All Manhattan's great buildings are always content to confront each other in a competitive verticality, from which there results an architectural panorama that is the image of the capitalist system: a pyramidal jungle, every building on the offensive against every other. The system itself can be spotted in the famous image we have of New York on arriving by sea. This image has changed completely in a few years. The effigy of the capitalist system has passed from the pyramid to the punch card. The buildings are no longer obelisks, but trustingly stand next to one another like the columns of a statistical graph. This new architecture no longer embodies a competitive system, but a countable one where competition has disappeared in favor of correlation. (New York is the only city in the world to have retraced, throughout the entire length and breadth of its history, the contemporary form of the capitalist system in this way, instantaneously changing according to this system. No European city has ever done this.) This architectural graphism belongs to the monopoly: the World Trade Center's two towers are perfect parallelepipeds, four hundred meters high on a square base;

they are perfectly balanced and blind communicating vessels. The fact
that there are two identical towers signifies the end of all competition, the
end of every original reference. Paradoxically, if there were only one, the
WTC would not embody the monopoly, since we have seen that it becomes
stable in a dual form. For the sign to remain pure it must become its own
double: this doubling of the sign really put an end to what it designated.
Every Andy Warhol does this: the multiple replicas of Marilyn Monroe's
face are of course at the same time the death of the original and the end of
representation. The two towers of the WTC are the visible sign of the closure
of a system in the vertigo of doubling, while the other skyscrapers are each
the original moment of a system—continually surpassing itself in the crisis
and the challenge.

 This doubling, this replication, inspires a particular fascination. However
high they are and however much higher than all the others, the two towers
nevertheless signify an arrested verticality. They ignore the other buildings,
they are not of the same race, they no longer challenge them nor compare
themselves to them; the two towers reflect one another and reach their
highest point in the prestige of similitude. They echo the idea of the model
they are for one another, and their semi-detached altitude no longer has
a transcendent value, but only signifies that the commutative strategy of
the model will now historically prevail over the heart of the system itself
(as New York truly is), over the traditional strategy of competition. The
buildings of the Rockefeller Center also mirror their glass and steel façades
in one another, in the city's infinite specularity. The towers are themselves
blind and no longer have a façade. Every reference to habitat, to the façade
as "face," to the interior and exterior, that we still find even in the Chase
Manhattan Bank or in the most daring mirror buildings from the sixties
has been erased. At the same moment that the rhetoric of verticality is
disappearing, so too is the rhetoric of the mirror. There now remains
only a series based on the binary code, as if architecture, in the image of
the system, proceeded only by means of an unchanging genetic code, a
definitive model.

The "bathtub": The rows of the stubby snouts were noticeably wavy, reflecting Glanz and Lipton, p. 3
great irregularities in the wall. It had been constructed as the foundation wall
in 1967 and 1968, the first part of the World Trade Center to be built, using
what was then a fancy new method that involved squirting concrete into a
deep trench with no wooden planks inside to smooth up the sides. When
the concrete hardened and the soil was scoured away from what would be
the Trade Center's basement, the huge wall looked as if it had been born
ancient. The soil and stones of Lower Manhattan clung to it, and had left it
with an imprint of the island's subsurface textures, a crude version of casting
bronze with wax. Some of the bumps were as big as a kitchen table. Men with
jackhammers had to stand on them and chip them away. Most of the textures
remained, and they didn't matter much: the wall's main function was to seal
the basement against the terrific pressure of soil soaked with groundwater
fed by the Hudson River. And if the wall was not especially pretty, it would
soon be covered up with more elegant structures and never seen.

At the 1939 World's Fair, the International Chamber of Commerce built *Ibid.*, p. 30
a new exhibit dedicated to "world peace through trade" and called it the
World Trade Center … In 1946, a new state agency initiated by the head
of the International Chamber of Commerce was named the World Trade
Corporation, slated with expanding international trade. Governor Dewey
said that the assignment now was to build a permanent World Trade Center
in New York.

Ibid. *New York Times* headline, November 1946: "PLANS ARE TABLED FOR TRADE CENTER," a project that would have covered ten blocks in Manhattan, with twenty-one buildings and plenty of underground parking, and would have been loosely modeled on the seven-hundred-year-old Leipzig Fair in Germany.

Ibid., p. 33 The first written mention of the World Trade and Finance Center appears in May of 1959, nearly two decades since the concept had made its debut at the New York World's Fair.

Ibid., p. 60 In its inception, the World Trade Center was measured against the Pentagon as a metric of immensity.

Ibid., p. 71 When the proposal to move the WTC from the East Side to the lower West Side became public in 1962, the shop owners at Radio Row could not possibly imagine what lay ahead of them. Radio Row was not merely business for the shop merchants who owned stores, it was their livelihoods—for some, generations of a past stretching back to the 1920s—and the WTC took that away from these small businessmen and their families.

Oscar Nadel came from a family of Eastern European Jews and lived in the Lower East Side. He opened his first shop, "Oscars Radio Shop," in 1925, a year before TV was invented. He was known as the king of Cortlandt Street and the whole area of Radio Row meant everything to him. He refused to give in to the political powers behind the WTC and there was no way he would allow his shop to be demolished. The Port Authority planned to raze the whole area, especially Washington, West Broadway, Fulton, Dey, Cortlandt and Greenwich streets, and that meant the end of Radio Row. Therefore, to oppose this proposal, Nadel with the other merchants formed a Downtown West Small Business Survival Committee, which stood up to Tobin for its rights ... In 1962, Tobin offered Nadel a spot for a radio shop in the World Trade Center, but Nadel turned the offer down. He wanted Radio Row, not the World Trade Center ... Why did the Port Authority need to wipe them out and create an artificial version of the same thing? It might not prime the international trading markets, but Nadel himself was already selling Sonys and Blaupunkts alongside his RCA Victors and Sylvanias; places like World Happiness and American Machine Tool Export, inside the north terminal building, were moving products around the world; and Walter Nussbaum, one of the original merchants on Radio Row, was selling cut-rate German wine at $1.09 a bottle. ("When Low in Spirits" was the slogan at Nussbaum's.)

Ibid. Courtesy Sandwich Shop vs. Port of New York Authority

Ibid., pp. 89, 101 Yamasaki was a Japanese-American who grew up in a slum two miles from the Seattle fairgrounds ... In his application to be the architect for the World Trade Center, he said it would be big and unmistakable, yet intimate and humane.

Ibid., p. 105 Early sketches for WTC: There was a triplet of slim towers slightly staggered, reaching just above the height of the nearby Woolworth Building. The team tried a cluster of four identical towers erected face-to-face in a tight square, like the legs of a stool. Then two long, thick, slablike buildings, running parallel to the shoreline and enclosing, like hedgerows, a modest-size duo of towers. There was even a single, monstrous, bulky tower of a huge raised pedestal that may have represented the ultimate parking garage.

v World Trade Center

"A whole bunch of little buildings," Tozzoli would say. "Bullshit. That'll never get anywhere." Now here was an interesting predicament for an architect whose reputation had been built on jewel box–size buildings that celebrated the human scale. No one had previously mentioned that Yamasaki was supposed to design the world's tallest building. *Ibid., p. 106*

The model shop constructed mockups of the Empire State Building, the Chrysler Building, and the city's other tallest towers, so whatever Yamasaki and his team now came up with, it could be compared directly to what Tozzoli and Levy made clear was the competition … "Yama, I have something to tell you. President Kennedy is going to put a man on the moon. You're going to figure out a way to build me the tallest buildings in the world" … No one had even contemplated this possibility: a model so tall that it could not stand upright in the drafting room. Jerry Karn tried to lower the plywood base. That didn't work. The architects started looking up at the tiles of the drop ceiling. Herman grabbed a small ladder and, struggling to control his laughter, he punched out two of the tiles. Karn moved the base so that the twins did not bump into the metal braces that held the tiles. Then the behemoths were finally moved into place. "It fits," Herman announced, to a rousing round of applause. *Ibid., pp. 107, 109*

Yamasaki was afraid of heights … Narrow windows meant Yamasaki, and the office workers in the towers, could approach a window and have the security of being able to rest arms against two vertical barriers. "The narrow windows, they give me none, if any, sense of acrophobia." The result of these compulsions was a façade of extraordinary monotony. *Ibid., pp. 109–10*

Its two towers are scheduled to be 1,350 feet high. But at that height they will so thoroughly foul up TV reception that the Port Authority has agreed to top them out with new TV broadcasting facilities. By the time antennas are added, the North Tower, according to one TV expert, will be close to 1,700 feet high … 800 feet taller than anything else in the immediate area. This means, according to the Federal Aviation Administration, that air traffic patterns will have to change, landing approaches will have to be altered, minimum altitudes in the area will be affected. The total potential hazard is staggering. No wonder airline pilots feel the risk is unjustified. Unfortunately, we rarely recognize how serious these problems are until it's too late to do anything. *Valenti, p. 21*

But in this case, there's still time.

The problem can be solved by keeping the height of the Trade Center at 900 feet.

The most famous and distinguishing feature about New York City's landmark skyscrapers had been their most visible spot: their tops. The decorative turrets atop the Woolworth Building; the floodlit stainless steel spire that caps the Chrysler Building. But Yamasaki wanted a flat, square top to his flat, square tower. *Glanz and Lipton, p. 110*

January 18, 1964 headlines: "BIGGEST BUILDINGS IN WORLD TO RISE AT TRADE CENTER." "Trade Center to Be Colossus." *"New Trade Center Towers to Be Taller Than Empire State."* "BIGGEST BUILDINGS HERALD NEW ERA." "Going Up—World's Two Tallest Buildings." "THE TALLEST. THE NEWEST. THE MOST." *Ibid., p. 113*

| *Ibid.*, p. 137 | "Empire State Building Jealous? Trade Center says, Yes," bellowed the *Sunday Journal-American*, as realtors feared the $350 million World Trade Center would cause the Empire State Building to lose prestige. |

Ibid., p. 137 "Empire State Building Jealous? Trade Center says, Yes," bellowed the *Sunday Journal-American*, as realtors feared the $350 million World Trade Center would cause the Empire State Building to lose prestige.

Ibid., p. 114 The design for the plaza and walkway was inspired by Piazza San Marco.

Ibid., p. 176 Five thousand years stand between the World Trade Center, now rising in lower Manhattan, and the Great Pyramid of Cheops at Giza in Egypt.

Ibid., p. 116 Critics of WTC's design: so plain that they could have been the shipping boxes for the Chrysler and Empire State Buildings.

Ibid., p. 120 "You don't need to make them that big."

Ibid. WTC's pinstripes: Wall Street meets the Yankees.

Ibid., p. 121 WTC's engineering akin to stiff tubes. Even after all the masonry and cross-bracing was stripped away, the structure would be ten times stiffer than a traditional structure.

Ibid., p. 123 The Port Authority appropriates a line from Walt Whitman for the WTC press release: "high growth of iron, slender, strong, light, splendidly uprising toward clear skies … " They then added: " … captured with succinct eloquence the structural characteristics and spirit of the twin 110-story towers."

Ibid., p. 170 The dirt taken out of the foundation for WTC was used as landfill to make Battery Park City.

Ibid., p. 216 Battery Park City was not much more than a weed-and-gravel–filled plot where pools of rainwater would freeze over in the winter.

Ibid., p. 141 Even in an 80-mile-per-hour gale, the very top of the Empire State Building swayed less than four inches. The flexible, lightweight design of the twin towers would allow them to sway several feet at the top, and possibly much more.

Ibid., pp. 142–3 The WTC's ability to sway in wind was tested in a simulated room on wheels in Eugene, Oregon. The room shifted back and forth with extraordinary gracefulness, almost as if it really swaying in a breeze off the Atlantic Ocean. The testing took two weeks. Each eight-hour day, the participants would become seasick. They would recover at home, come in the next morning, and get sick again.

Ibid., p. 144 The Port Authority was not ready to accept the Eugene results so they redid the experiment by swinging a huge packing crate—made to look like an office inside—from cables inside one of the Lincoln Tunnel's ventilation towers.

Ibid., p. 163 Wind vortices that gave the structure a rhythmic, side-to-side shove as they spun away, one after the other, like eddies around a blade of grass in a stream.

Ibid. Imagine a giant finger reaching down from the sky and pushing the top of the Empire State Building sideways a foot or so, and then letting go. The building would spring back and sway from side to side in about eight seconds. But the swaying would quickly stop, because all that brickwork and old concrete and

tile and the masonry walls inside would creak and rub together like arthritic joints and put a brake on the motion … If there was one thing the sleek twin towers were not, it was creaky—a push from the giant finger, and one of those towers would spring back and forth again and again and again.

But how were they going to make steel towers creaky?

Ibid., p. 164

No longer true twins, the north tower's core would run east-west, and the south tower's north-south. The change would discourage the towers from dancing in unison.

Ibid.

Who's afraid of big, bad buildings? Everyone, because there are so many things about gigantism that we just don't know. The gamble of triumph or tragedy at this scale—and ultimately it is a gamble—demands an extraordinary payoff. The Trade Center towers could be the start of a new skyscraper age or the biggest tombstones in the world.

Huxtable, *On Architecture*, p. 377

Petit walked across the void. Eight times.

Glanz and Lipton, p. 219

George "Human Fly" Willig's mother was in the Empire State Building when it was struck by the B-52 bomber in July 1945.

Ibid., p. 220

All of a sudden—after Willig and Petit—the towers were not looking like mere aluminum boxes anymore. They had become supersized toys to go with New York's supersized ego. Like the Eiffel Tower—which at first had been condemned as a "gigantic black factory chimney, its barbarous mass overwhelming and humiliating all our monuments," and then was printed on the 200-franc bank note—something fundamental had changed.

Ibid.

I do know that from my standpoint, it seems that without any supervision, without being accountable to anybody in the city of New York, to build the largest buildings in the world with a method of construction which has not been tested and tried and proved appropriate, subjects the city of New York to the possibility of a major physical disaster.

It may never happen; it probably will never happen. But that there should be such—the remotest possibility of such a thing is, in my opinion, ridiculous. And the city should insist that there be no such risk.

Ibid., p. 153

This type of building has never been tried on this scale before, and there is a chance, he alluded, that it might fall or collapse.

Ibid.

$$\frac{(amplitude)^{WTC}}{(amplitude)^{ESB}} = 2.67$$

Ibid., p. 167

Simply the effort to manufacture the hundreds of thousands of pieces for the World Trade Center, before they were assembled in Lower Manhattan, would take years and involve dozens of factories across the country. This mammoth scale was beyond anything ever attempted in a high-rise project. It would be likened, at one time or another, to the Pyramids, the Panama Canal, the Brooklyn Bridge, the Apollo space program, and the effort to build an atomic bomb in World War II. More than 200,000 pieces of steel for the Trade Center were already being fabricated in more than a dozen cities around the country, from Seattle to Gainesville, Virginia. The Trade Center would call for 3,000 miles of electrical wiring, 425,000 cubic yards of concrete for the floors, 2.2 million square feet of aluminum cladding for the tower facades, seven

Ibid., p. 177

thousand plumbing fixtures, 170 miles of connecting pipe, forty thousand doors, and 43,600 windows. There would be almost six acres of marble and a $1,547,800 tandem of automated window washers designed to crawl up and down the face of the towers.

Ibid., p. 187

It seemed that an entire nation had been mobilized to build the World Trade Center.

Ibid., p. 189

One panel, for instance, was marked: PONYA A-251-92-95. Decoded, that meant the panel would span three floors, from the ninety-second to the ninety-fifth, in the north tower, also called tower A. The faces of each building were numbered from 1 through 4, clockwise starting with the north, so the first digit of 251 meant that this one would go on the east face. Finally, there were a total of fifty-nine columns per side, and this was number 51. Because the numbers on the east face started on the northern edge and went south (once again in the clockwise sense), the designated column would end up about thirty feet from the tower's southeast corner. PONYA, of course, stood for Port of New York Authority.

Ibid., p. 177

The astonishing attempt to suspend the long-buried Hudson Tubes in the air as the dig went right past them and commuter trains continued to rumble inside. The tubes had not seen the light of day since they were completed in 1909.

Ibid., p. 184

Nonelective intestinal surgery on a cosmic scale.

Ibid., p. 177

The biggest ditch in Manhattan.

Ibid., p. 179

The top twenty or thirty feet of the soil held ballast from the European ships that would jettison stones before picking up cargo for the trip back.

Ibid., p. 185

Workers dug up cannonballs, animal carcasses, a goat's horn, clay pipes, oyster shells, the muzzle of a cannon, a Portuguese fishing gaffe, a century-old bedroom slipper, ancient bottles, and a time capsule from the cornerstone of the Washington Market containing some old newspapers and the cards of some of the produce sellers at the market.

Ibid., p. 193

For the entire construction, a Port Authority helicopter hovered at 1,350 feet, the height of the Tower Buildings.

Ibid., pp. 200–1

During the construction, studies showed that exposure to asbestos was linked to cancer. In April 1979, a CBS crew showed up and used the rising north tower as the backdrop for a news report on the dangers of loose asbestos. Tobin ordered an abrupt switch to a non–asbestos-containing material, an untested new product. Wind-driven rains stripped the material from the steel, rust flaked off and took the fireproofing with it. The building was built without proper fire protection on the steel girders.

Ibid., p. 125

"In this great project of yours, how do you propose to fight a fire on the high floors?"
 "If your fire chief was really good, he would simply drive up the steps into the plaza and put the ladders up there."

Ibid., p. 136

Point number three on the list of WTC design features (1964):
3. THE BUILDINGS HAVE BEEN INVESTIGATED AND FOUND TO BE SAFE IN AN ASSUMED COLLISION WITH A LARGE JET AIRLINER

TRAVELING AT 600 MILES PER HOUR. ANALYSIS INDICATED THAT SUCH COLLISION WOULD RESULT IN ONLY LOCAL DAMAGE WHICH COULD NOT CAUSE COLLAPSE OR SUBSTANTIAL DAMAGE TO THE BUILDING AND WOULD NOT ENDANGER THE LIVES AND SAFETY OF OCCUPANTS NOT IN THE IMMEDIATE AREA OF IMPACT.

Transforming the towers from high-rise innovations to experiments-in-the-sky. *Ibid.*, p. 167

New Yorker cartoon just after WTC opened: "For once," said a disgruntled-looking man in a hard hat to a coworker as they stood atop the north tower during its construction, "let's start the day without you telling me there's a taller one going up in Chicago." The World Trade Center remained the tallest building in the world for only two and a half years. The Sears Tower took the crown a month after the Port Authority held its formal dedication ceremony. *Ibid.*, p. 216

"The United Nations of Commerce" *Ibid.*, p. 172

Record-setting parking garages. *Ibid.*, p. 67

Gleaming metal. *Ibid.*, p. 113

Steel balloons. *Ibid.*, p. 118

General Motors Gothic. *Ibid.*, p. 116

A port without water. *Ibid.*, p. 40

Others blamed the twin towers for killing migrating birds. *Ibid.*, p. 216

The tenant list now had almost nothing to do with the importing and exporting of goods—financial firms dominated … The Twin Towers were just enormous office buildings with sweeping views, and they did not pretend to be anything else. *Ibid.*, pp. 233–4

In the 1970s, the Port Authority teamed up with the United Nations for an exhibit of goods manufactured in Third World countries, with the intention of kicking off the World Trade Mart, the showplace that had been proposed in 1961—a throwback modeled after the first World Trade Center at the 1939 World's Fair. *Ibid.*, p. 216

The construction site became plagued with bomb threats, and just 30 minutes after one of them was phoned in, a huge explosion at the foot of the south tower blew out windows along Liberty Street and sent flames shooting 100 feet into the air. Men scattered and some jumped from the steel. *Ibid.*, p. 203

More than forty fires had been reported at the Trade Center. Most have been small affairs, but often times the towers had acted like chimneys, as the smoke rose through ducts and shafts dozens of floors above the spot where the fire was taking place. Fire experts called the phenomenon the stack effect. *Ibid.*, p. 208

A list of fire weaknesses: the lightweight floors, the large open spaces across which a fire could quickly spread, the substandard fireproofing on the steel, and, worst of all, no automated sprinklers. "The bottom line is that it is not a place I would want to be in a fire," he told her. *Ibid.*, p. 209

Ibid.

The Port Authority is exempt from city building codes.

Ibid.

The coat hooks on the bathroom stall doors were installed a tad lower than usual to prevent thieves from reaching over the top and grabbing coats or handbags.

Ibid., pp. 210–11

On the 95th floor Huntington thought the views were superb. On the most routine day, he could sit at his desk and watch the land and sea mutate as the light from the sky turned from noontime intensity to dusk. In the summer, each approaching thunderstorm was a marvel, the angry gray clouds and sheets of rain moving ever so slowly across the horizon. In the winter, Huntington watched snowfall upward, carried by the wind. On some days he could see giant ice flows moving slowly down the Hudson. When the fog or low cloud cover had settled over New York, Huntington and his staff would be left there alone, towering over an infinite meadow of soft, gray cotton spread out below his deck. The only evidence that they were atop one of the world's greatest concentrations of humanity came from the silvery spires of the Empire State and Chrysler buildings and the suspension towers of the Verrazano-Narrows Bridge, glinting above the clouds.

Ibid., p. 211

Irene Humphries, a file clerk, was at her desk one windy spring day, feeling a bit nauseated. Humphries stood up and walked to the bathroom, hoping to gain her composure. Once there, she heard a creaking noise, as if from the hold of a ship that was being thrown around in a rough sea. The building was making noise. Water was sloshing back and forth in the toilets. The twin towers, as these early tenants learned, were so tall that when the wind in the New York Harbor started to blow, it whipped up whitecaps—and not just in the harbor.

Ibid., pp. 211–12

Candice Tevere came into the World Trade Center to apply for a job at Fiduciary, but she never made it to the interview. As soon as she stepped into the cattle-car-size express elevators, she felt uneasy. The doors closed, and with fifty or so people standing around her, she could not lean against any wall. Then the elevator started to move. It was impossible to tell just how fast, but it felt to Tevere as if she were on a supersonic jet. As soon as she reached the seventy-eighth-floor sky lobby, Tevere said to herself, "That's it. This is nuts." She rode back down and then went home. Two days later, a staff member at Fiduciary called, urging her to give it another try. Tevere did go back. And she did take a job. But she could never step into one of those express elevators without a friend or colleague by her side. While the elevator was moving, she would keep her mind occupied by looking through her purse. She never left the building for lunch.

The strategy worked fine until one Friday morning. As usual, she had a girlfriend by her side, ready for that uncomfortable ride into the sky. But then, midway up, the elevator just stopped. It sat there for one hour and fifty-five minutes. "How many people are in the elevator?" the security guards kept asking through the intercom. "Why? So that the papers will know that twenty-two of us in here died on Friday the thirteenth?" one man yelled back.

Tevere stayed calm until the firefighters arrived, took the side wall off the elevator, set up a plank, and then told everyone there to walk across the plank to the next elevator. "I am not going over," Tevere said, convinced she would fall. "Just look at me, just walk to me," the firefighter replied. "Just don't look down."

It was not long before Huntington started to hear about his employees' fears. So, with his usual panache, he decided to show them how unconcerned he was. One day, as dozens of people on the ninety-fourth floor watched

with puzzlement, Huntington turned toward the nearest window and started running across the floor. He finally turned his shoulder, pushed himself off the ground like a football player throwing a flying block, and slammed his side into the window glass. Thankfully, he bounced back.

Death by compression of the riders in the elevator at the World Trade Center. Conrad, p. 322

In 1974 and 1975, events that seemed to step from movie screens into reality Glanz and Lipton,
pp. 212–13
began turning the World Trade Center into a famously scary place to work. It began with *The Towering Inferno*. Late in 1974, advertisements for the movie, starring McQueen as a grimy-faced Fire Department battalion chief, starting running across the nation: "One minute you're attending a party atop the world's tallest skyscraper. The next, you're trapped with 294 other guests in the middle of a fiery hell … No way down. No way out."

The plot: a fire starts in a utility closet on the eighty-first floor of a 138-story skyscraper and then quickly spreads upward. The automated fire alarm fails and the security staff does not respond quickly to hints that something might be wrong. By the time firefighters arrive, hundreds of partygoers, including the mayor, the building's developer, the architect, and many other dignitaries, are trapped in an opulent penthouse ballroom. Shoddy fireproofing—duct holes did not have proper "fire-stopping" components—the lack of a working sprinkler system, and a blocked fire stair combine to doom many of the people in the tower. The building's developer repeatedly assures anyone who will listen that no fire could threaten his tower. "I don't believe you are familiar with the many modern safety systems we have designed into this building. We have got them all," William Holden, playing the developer, says. But the message of the movie was clear: "If you had to cut costs," Paul Newman, as the architect, asks the developer, "why didn't you cut floors instead of corners?"

Although the acting was mediocre, the special effects were nothing short of thrilling. Vincent Canby of the *New York Times* called it "this year's best end-of-the-world movie." Among the many truly awful scenes were burning victims tumbling from windows, an elevator filled with panicked partiers that caught fire and then fell, a helicopter crashing and exploding as it attempted a rooftop rescue. In other words, it was a World Trade Center tenant's worst nightmare.

The New York City Fire Department loved the film so much that Fire Commissioner John T. O'Hagan was there for the gala Times Square screening in December 1974, with six fire engines outside as his escort. McQueen ended the film by looking over at victims laid out in body bags and telling the architect, "One of these days, they are going to kill ten thousand in one of these fire traps. And I am going to keep eating smoke and bringing out bodies until somebody asks us how to build them." The firefighters cheered.

Oswald Adorno, a tall, somewhat chubby nineteen-year-old kid from the *Ibid.*, pp. 213–14
Bronx who held a nighttime job as a World Trade Center custodian—his unenviable assignment was washing the buildings' ceilings and walls—decided to become an arsonist. Angry that he had too many floors to clean, Adorno started by setting a fire on the eleventh floor of the north tower, down the hall from Rick Boody's office. He lit it just before midnight on February 13, 1975, inside a closet filled with telephone switching equipment and filing cabinets filled with paper. Another custodian happened to pass by and hear a crackling sound as the fire burned.

New York City Fire Department captain Harold Kull soon led his men into what could only be described as a towering inferno. As it happened, the room also held a large supply of alcohol-based duplicating fluid for

mimeograph machines; feeding on all the combustibles in the room, the blaze was already out of control. There was another reason the fire spread so quickly. For anyone who knew nothing of the longstanding problems with fireproofing at the Trade Center, this unexpected factor would be shocking: just as in the make-believe tower where Steve McQueen did the firefighting, the "firestopping" at the World Trade Center was missing. A foot-wide hole between the floors allowed hot gases to snake upward, sending fires all the way to the seventeenth floor, while burning embers dropped down the hole, igniting fires all the way to the ninth floor. Kull concentrated on the eleventh floor, which he said "was like fighting a blowtorch," so hot that all of his men got their necks and ears burned. A second and then a third alarm had to be called, ultimately drawing 132 firefighters to the north tower.

It would be three hours before the last of the fire was out. The damage would take weeks to repair—the southeast corner of the eleventh floor was little more than a charred shell—but the impact of the fire would be permanent. After assuring the New York City Fire Department that the fire-protection systems in the twin towers were first rate, the Port Authority now had to contend with clear evidence to the contrary. "Had the building been occupied, and given the stack action that exists in this 110-story building," Fire Commissioner O'Hagan later wrote, "the rescue problem would have been tremendous."

Adorno was not finished with his mischief. "More fires," a man said in an anonymous call to the Port Authority security desk, unless the maintenance workers received a promised raise. Adorno then waited three months. Over the night of Monday, May 19, 1975, he set seven fires, this time in the south tower, on the twenty-fifth, twenty-seventh, twenty-eighth, thirty-second, and thirty-sixth floors. He was arrested one day later.

Ibid., p. 227

When O'Sullivan looked at security at the Trade Center, he found one vulnerability after another. Explosive charges could be placed at key locations in the power system. Chemical or biological agents could be dropped into the coolant system. The Hudson River water intake could be blown up. Someone might even try to infiltrate the large and vulnerable subterranean realms of the World Trade Center site, he said. One threat in particular was troubling to him. There was no control at all over access to the underground, two-thousand-car parking garage. "A time bomb–laden vehicle could be driven into the WTC and parked in the public parking area," O'Sullivan wrote. "The driver could then exit via elevator into the WTC and proceed with his business unnoticed. At a predetermined time, the bomb could be exploded in the basement. The Assistant Deputy Director of the FBI thinks this is a very likely scenario for the WTC and has described it graphically in conversations with OSP staff." Many groups might try such an attack, the report continued, but "extremist Muslims pose an especially disturbing threat to the Trade Center. They are not deterred by typical security measures and they have little regard for inflicting large numbers of innocent casualties, as evidenced by their heinous attacks on American and French installations overseas."

"1993 WTC"

On Friday, February 26, 1993, Ramzi Yousef and a Jordanian friend, Eyad Ismoil, drove a yellow Ryder van into Lower Manhattan, and pulled into the public parking garage beneath the World Trade Center around noon. They parked on the underground B-2 level. Yousef ignited the 20-foot fuse, and fled. Twelve minutes later, at 12:17:37 pm, the bomb exploded in the underground garage. The bomb opened a 98-foot-wide hole through four sublevels of concrete. Initial news reports indicated a main transformer may have blown, not realizing a bomb had exploded in the basement.

The bomb instantly cut off the World Trade Center's main electrical power line, knocking out the emergency lighting system. The bomb caused smoke to rise up to the 93rd floor of both towers, including through the stairwells, which were not pressurized. With thick smoke filling the stairwells, evacuation was difficult for building occupants and led to many smoke inhalation injuries. Hundreds were trapped in elevators in the towers when the power was cut, including a group of 17 kindergartners, on their way down from the South Tower observation deck, who were trapped between the 35th and 36th floors for five hours.

Also as a result of the loss of power, most of New York City's radio and television stations lost their over-the-air broadcast signal for almost a week, with television stations only being able to broadcast via cable and satellite via a microwave hookup between the stations. Telephone service for much of Lower Manhattan was also disrupted.

In a notebook, handwritten in Arabic: the idea was not just to bomb the World Trade Center, but to knock it down. "Break and destroy the enemies of Allah," Nosair wrote. "And this by means of destroying [and] exploding the structure of their civilized pillars such as the touristic infrastructure which they are proud of and their high world buildings."
Glanz and Lipton, p. 228

A rocket ship flies between the Twin Towers.
Valenti, p. 31

Against the backdrop of the 1980s New York City sky an airplane flies ostensibly through two buildings that resemble the Twin Towers.
Ibid., p. 32

A squadron of military aircraft fly by the Twin Towers and bomb the main theater district of Broadway.
Ibid., p. 36

On May 2, 1968, one of the radio merchants who was displaced by the World Trade Center ran a nearly full page ad showing an artist rendering of a large commercial airliner, flying due south, a fraction of a second before it rammed the offices in the upper stories of the north tower, which stood directly in its path. The ad, titled "The Mountain comes to Manhattan," suggested the towers posed a danger for commercial aviation and pointed out that the north tower's proposed television mast, for example, would be some 800 feet taller than anything else in the immediate vicinity. "The total potential hazard is staggering," said the ad.
Glanz and Lipton, p. 175

"We built these towers," he said once to me, deliriously tramping around Washington Square charging Japanese tourists a buck or two to take his picture. "Me and Bird, and Jimi Hendrix built these fucking towers," pointing up over SoHo at World Trade.
Kopasz, p. 245

Finney, p. 162	No colors, no neon, nothing to read, just a vast blackness pricked with lights.
Brox, p. 239	Countless people were trapped in elevators like hamsters in cages.
Ibid.	Those riding on escalators glided down more and more slowly, until, at last, they were scarcely moving at all.
Ibid.	All the stoplights failed.
Ibid.	Some native New Yorkers walked across the bridges—flashlights and transistors in hand—for the first time in their lives.
Talese, p. 43	It was possible to have a quiet drink and walk though imaginary red lights.
Ibid.	It was a dark town of stopped clocks, warm beer, soft butter and intimate candlelit conversations in saloons without television.
Brox, p. 239	It would be said of that night that it was easier to cross the Atlantic to Cairo than to get from Manhattan to Brooklyn.
Talese, p. 43	200 blind workers, who knew every inch of the place by touch, led seventy sighted workers down the steps and safely onto Broadway.
Brox, p. 240	High above the city, airplanes lost their ground orientation and were unable to land. "It was a beautiful night," recalled one pilot. "You could see a million miles."
Ibid., p. 241	The true quiet of the world felt strange, as if the darkness had somehow smudged away the horns and the other noises of the traffic.
Mittlebach and Crewdson, p. 3	If the city's skies were entirely dark, about 2,000 stars would be visible to the naked eye. But such a complete view of the heavens has been visible only once in recent years.
Sharpe, p. 231	Stacked up in the right order, carving light and space in a bold new way, a few million office lights were worth far more than a bunch of stars, any night of the week—especially when the innumerable lights had made the paltry stars invisible.
McKay, "Song," p. 46	The moonlight broke upon the city's domes.
McCourt, p. 210	The borrowed light of the moon is enough for sissy.
Sharpe, p. 217	Maybe the moon was, as Charles Reznikoff said, "only another street-light."
Brox, p. 242	Night was truly night again, just as in the Middle Ages, and, also as in the Middle Ages, light became precious once more. People struck match after match to light their way down flights of stairs: two matches, carefully tended, were enough to light the distance between one floor and the next. "Walking down 18 flights to the lobby, we used exactly 36 matches."
Haden, p. 61	There was a general increase in light pollution and this must have meant that street name signs were more visible at night. The "thick veil of night" that had lain over the English-speaking cities of the world in the 19th century, and

ω **Light**

which had given rise to potently grotesque English literature from Dickens to the "city mystery" novels to the early urban detective novel, had been largely dispelled by the 1920s.

The moonlight lay on the streets like thick snow, and we had a curious, persistent feeling that we were leaving footprints in it. Something was odd about buildings and corners in this beautiful light. The city presented a tilted aspect, and even our fellow pedestrians, chattering with implacable cheerfulness, appeared foreshortened as they passed; they made us think of people running downhill. It was a block more before we understood: The shadows, for once, all fell in the same direction—away from the easterly, all-illuminating moon … We were in a night forest, and, for a change, home lay not merely uptown but north. Brox, p. 242

Without that moon, the night would've been very different. Air tragedy, it was said, had been averted because its light, along with that made possible by auxiliary power in the main control towers at the airports, was enough for pilots already in descent to see by. The previous night, rainstorms had soaked the region, and clouds had covered the moon and stars. Had the lights gone out then, there surely would have been more than one disaster. Ibid., pp. 242–3

In the writing of it later, no one waxed poetic about the moon on the buildings. Ibid., p. 248

The lost hours eventually faded into a strange dream full of quirky things, though there were moments that would be intensely remembered afterward—of lighting grease pencils to see by, or being given coffee and pastries by transit workers while waiting in a darkened subway car, of the sheen of the moonlight on the side of a skyscraper. Ibid., p. 246
Here, above, cracks in the buildings are filled with battered moonlight. Jackson and Dunbar, p. 582

All the way back to New York, we kept hoping the blackout would still be going on when we got there. We couldn't go through any tunnels—the radio was saying they couldn't ventilate them without electricity—and when we got to the bridge, we couldn't see any lights on the whole Manhattan skyline, just car headlights. The moon was full and it was all like a big party somehow— we drove through the Village and everybody was dancing around, lighting candles. There were no traffic lights on, so of course everything moved very slowly—the buses were just creeping. People in suits and briefcases were sleeping in doorways, because all the hotels were booked solid, and Governor Rockefeller had to open the armories up. Warhol, POPism, p. 173

 There were cute National Guard soldiers around helping people up out of the stuck subways and I thought that down there must be the worst place to be—the only thing that could ruin a beautiful idea like this. It was the biggest, most Pop happening of the sixties, really—it involved everybody.

 After driving around a little, we went over to Ondine and then on to Le Club where we stayed until the lights started going on around four. Then all around the city things started coming to life like the Sleeping Beauty castle.

There were no lights all the way up Fifth Avenue, throughout Greenwich Village, in the fog and rain of Harlem, or along the crooked, narrow streets of Chinatown. On the East Side, shades were drawn over the seventh candles and the windows. Millions breathed in the dark, sitting in living rooms or standing at the sink or in entry halls, on the dance floor or by their workstations. Although there was no order for quiet, few spoke above a whisper. Brox, p. 224

Ibid., p. 241

In the relative hush, suddenly a million little things were in danger of perishing. Damp glass greenhouses were beginning to cool down. At the Bronx and Central Park zoos, the men, working without sleep, stuffed blankets between the bars in the small-mammals house, where diminutive, heat-sensitive lemurs, flying squirrels, and small monkeys began their nocturnal peregrinations. The reptile house presented a different problem, since no one was willing to try to wrap a cobra in a blanket. Small particle propane gas heaters were taken in to warm the cold-blooded vipers, anacondas, iguanas, caymans, crocodiles and their ilk. It may have been too cold for iguanas, but the temperature outside was just perfect for storing blood.

Ibid., pp. 243–4

Time and task were both disorienting, for if you were to remove everything from our lives that depends on electricity to function, homes and offices would become no more than the chambers and passages of limestone caves—simple shelter from wind and rain, far less useful than the first homes at Plymouth Plantation or a wigwam. No way to keep out the cold, or heat, for long. No way to preserve food, or to cook it. The things that define us, quiet as rock outcrops—the dumb screens and dials, the senseless clicks of on-off switches—without their purpose, they lose the measure of their beauty, and we are left alone in the dark with countless useless things. Skyscrapers take on a geological sheen, and the stars resemble those of ancient times.

Yet unlike in ancient times, people were accustomed to giving into long night. For most, the dark wasn't restful; it simply felt as if the world had stopped and everyone and everything were suspended in amber, especially after the novelty of the first hour wore off. For as long as no one had any idea at all how long the helplessness would go on, there was no future, and no knowing the future. After a few hours, theaters canceled their scheduled performances, and people ran out of pocket money. They were lined up outside phone booths waiting to call home, but what could they say other than they were somewhere? This night became known as "the night of the long night," and it was particularly long for those trying to sleep in hotel lobbies or on office floors; in barber chairs or on cots in banquet rooms; curled up in hallways or sprawled on subway stairs or benches in train stations.

Ibid., p. 247

The pale sliver of the new moon set before the lights went out at 9:34 PM, so there was no consoling light reflecting off the skyscrapers, nothing but the torch on the Statue of Liberty to relieve the blackness.

Philips, pp. 45–8

Midtown Manhattan was divided for a while last night—half-blaze, half-black—as the island's vital center became an odd patchwork of darkness and light. The contrasts were everywhere and sometimes they seemed inexplicable: at points there was light east but none west, or light north but none south, or light low but none high. Either you had it or you didn't, and there was a world of difference to be traversed from one curbstone to the next. Like the moon, Broadway had a light side and a dark side for a while. A man moving down the main stem from upper Manhattan had a margin of light to his right but he glanced eastward into thick blackness, like the blackness of a rain forest on a moonless night. Whiplash winds and driving rain with hail made it a rather eerie scene. Pedestrians huddled under movie marquees for semi-shelter, dashing out in clusters for the few taxis that came along. The march of lighted street lamps on Forty-second Street from the Hudson River ended abruptly on the west side of Fifth Avenue and there were no more lighted posts along the street to the East River. The Chrysler Building, all dark, was a silent silhouette stabbing the cloud cover, and its top was snuffed from sight by rolling mists.

At Turtle Bay, the United Nations glass secretariat was a slab of ghostly gray, except for a spine of yellow emergency lights running up the middle.

The zone of light and the zone of darkness fell in eccentric patterns over the broad waist of mid-Manhattan. In spots, where the blackness was almost palpable, a man felt he could reach out and scoop in handfuls of it. The north face of the City at the end of Central Park was alight. Nearer Times Square, a hotel's swinging door swung into darkness. A moving sign wrote in the night. The silhouette of a basketball player went right on dribbling across the animated electric board on Seventh Avenue at Forty-sixth Street. Hurrying pedestrians below stamped boot prints on the hail-speckled pavement.

The Great White Way suffered a kind of electrical schizophrenia. On the east side of Times Square, film shows failed in the Criterion Theater. Hundreds of patrons sat in darkness for half an hour before leaving and getting their money back. The Victoria Theater's patrons on the west side of Broadway did not know that anything unusual had happened. A film called *Brewster McCloud* continued to unreel there.

The blackout left the wax museum on the west side alight, but it hit the marquee and screen at Lowe's State I and II, stopping *Love Story*.

The spiral of light on the "Pure Wool" sign in Times Square cast its glow throughout the emergency, but opposite it the swirl of neon smoke curling from the yards-long Kent cigarette blacked out—no smoking.

Power is distributed to the city on a checkerboard grid, and many people and places found that they were sitting on the black squares. At first, dwellers untouched by the failure gazed out at buildings a few yards away, where the only light was the occasional gleam of a match or a cigarette lighter. The contrasts softened later. Instead of chunks of brightness and blackness in the moonless night, there were towers of light next to others emitting only the warm, dim glow of candlelight.

The temperature-weather beacon atop the Mutual of New York Tower functioned during the power-out but it seemed to be subject to mild electrical fits. At 9:50 p.m. it flashed the right time, but it gave the temperature as 3:30 (instead of 30 degrees).

Above Fiftieth Street, places that didn't need any were prodigal with light. A deserted Daitch-Shopwell supermarket was day-bright with fluorescent candles. In a store nearby, sun lamps kept bagels hot. The first word continued to chase the last word around the electric sign that spins along the brim of the hatbox entrance to the Paramount Theater at Columbus Circle.

An M104 bus moving along East Forty-second Street, headlights slicing the darkness, seemed a fitting symbol of the crisis. The fluorescent tubes in its front half were on but others were out and the rear of the bus was shadowed. Rain fell in twisting sheets in the light-cones of auto headlamps.

A curious and especially inconvenient combination of dark and light affected the Commodore Hotel. The closed and empty shops along its street level were ablaze, but the hotel's face was otherwise entirely dark, from lobby to roof. Guests were stranded high in their hotel rooms. Some could look down and see cops with flashlights directing traffic, the rapid motions creating quick-fading coils of light.

Tad's on Forty-second Street was all dark inside, but steaks were kept sizzling over the charcoal pit. Plumes of fire sent big orange streaks flashing across the frosted window, making the place look from the outside as if it were being gutted by fire.

The façade of Grand Central Terminal was lighted, including the red and blue face of its clock, but across the street a Horn and Hardart Automat, with an "Open All Night" sign in its window, closed during the blackout.

Across the way, in the terminal, blackness prevailed for a time in the passages. As some newsmen groped to interview bemused passengers, the lights for television cameras pierced the dark interior. To cover a blackout for television, you've got to have plenty of light.

Lofland, p. 170

During the blackout, aboard one train, a man who called himself Lord Echo got everybody to join him in calypso songs; two hours later astonished rescuers found 50 passengers dancing in the aisles.

Brox, p. 245

Sometime after three in the morning, in section after section of the city, signs of a world coming to life again registered in little whirrings and tickings, faint and then full.

Basile, p. 228

The police blamed widespread use of air-conditioners for the 1965 blackout. The *New York Times*: "The heavy drain of air-conditioners was said to be a major cause of these local failures."

Brox, p. 245

The following day, the headline of an Italian newspaper read: "New York Cancelled by Darkness."

WWII Blackout, Brownout, Eclipse

Caldwell, p. 279

Christmas tree sans lights in Madison Square 1942: carolers sang out beneath it in a forestlike darkness.

Ellis, *Epic*, p. 559

In Foley Square the thirty-two-story Federal Building had a pyramidal roof covered with gold leaf; because this glinted on moonlit nights, black paint was daubed onto it.

Trager, p. 532

At the Navy's request, Times Square signs, including the news "Zipper" on the Times Tower, are extinguished at night above street level (although the man in the Camel cigarette sign will continue throughout the war to emit rings of Con Ed steam as the man dons a uniform, changed periodically to vary his service). People have drawn blackout curtains to minimize the light that silhouettes merchant ships leaving the port of New York for Europe.

Greenburg, pp. 48–9

At 10:33, air-raid sirens pierce through the chaotic drone of Times Square, bringing the usual tangle of traffic to a complete stop and sending drivers, passengers, and pedestrians alike for the cover of designated bomb shelters. "With horns silenced and other noises stilled, an eerie quiet settles on the streets, deserted except for policemen and a few defense workers," says the *New York Times*. "It lasts until the first wailing note of the all-clear was heard at 10:43 A.M. and then within seconds the city bustles back to life and New Yorkers go about their affairs as if nothing unusual had happened."

Trager, p. 532

The cloud of manmade darkness that has hovered over various parts of the metropolitan area during the last few weeks settled last night upon eight square miles of the lower Bronx, where 935,000 persons cooperated in the latest blackout drill. In a night so bright that the moon coated countless apartment house windows with silvery luster, nearly one-fifth of the borough showed what it could do in case the dread drone of enemy planes sounded overhead.

Caldwell, p. 278

Blackout precautions: any lamp visible from outdoors had to beam downward. Anyone living above the fifteenth floor of a skyscraper with

lights visible from the sea had to douse them or hide them behind blackout curtains. Streetlights had crews daubing their globes with black paint to block light.

People don't realize it, but when they move around in the dark their speech is softer. The roar of traffic had dulled: a third of the city's cabs were off the streets, grounded when their drivers volunteered or drafted.

Ibid.

Traffic lights were covered in metal masks with narrow slits for the red and green signals to show through ... Car and taxi headlights wore hoods or "eyelids" so that the light they cast would shine down ... Light bulbs in trolleys and subways were dipped in black paint with just their necks exposed.

Diehl, p. 121

Dimout unlit signs appeared, made of quarter-sized sequins stitched onto painted block letters (these made their debut and survived into the 1980s, reaching their tawdry best when the sequins began falling off).

Caldwell, p. 6

When the all-clear was sounded at 9:50 P.M. and the lights came on, they had been doused long enough to give people's eyes time to adjust to the dark. Chemical changes in the retina had not yet occurred. In Times Square, almost immediately after the drill, voices rose above the noise of traffic starting up, and dance music leaked out of nightclubs. Crowds poured out of the entryways and up the subway stairs and moved steadily along the streets once more. As the lights came on in hotels and shop windows and traffic lamps winked red and green through the rain, the crowd cheered.

Brox, p. 225

It left the Empire State Building girdled with two thin belts of light.

Conrad, p. 257

In 1973, Richard Nixon called for the dimming of nonessential lighting such as advertisements and all decorative Christmas lights, both public and private, including the lights in New York City's Times Square. "It's very sad to be a party to darkening a city so renowned for its lights—it's just heartbreaking," the municipal service administrator for New York City commented. "But it has a psychological effect, because it's difficult to get someone to turn down his thermostat if he sees lights blazing in a public space."

Brox, p. 252

After the 1973 oil embargo, American industry crashed; giant firms like GM, whose names had always defined the Square, lowered their profiles and put their fire signs out. Huge billboard niches went dark, and empty spaces opened up in the Square that no one had ever seen ... In Times Square: the swimming fish in the Wrigley sign, the peanuts that endlessly tumbled from a Planters bag, and the glowing Sunkist sunburst all froze into stillness and went dark. The Camel billboard, now unlit, nevertheless still puffed out his five-foot smoke rings (actually heating steam), which floated out over the darkened square. Outside, the hulking buildings shouldered themselves broodingly into a space once made airy and ebullient by moving lights.

Caldwell, p. 278

In the city's diurnal power tide comes a low, after the main factory motors have slowed and thousands of machines are off. With daylight saving there is a longer slump before the normal nighttime current is turned on. The giant power units idle for a while.

Riesenberg and Alland, p. 99

Sharpe, p. 2	The physical paraphernalia of light, from the lamppost to the gasworks or the power plant, became permanent daytime reminders that a visual newfound land was being charted every evening.
Mumford, *Empire*, p. 32	The external change in the city itself was profound. Within the darkened alleyways of the financial district, people lost their sense of day and night; just as they lost the occasional glimpse of the sky which makes the worst routine bearable. In the new subways they lost even the sight of the sun over the rooftops of Manhattan, which had once been theirs from the ramshackle elevated roads. Nature in its most simple form, the wonder of the morning and the night, was missing from the metropolitan routine.
Haden, p. 150	This great crucible of modernity was plunged into darkness by a total eclipse of the sun in January 1925. Some 10 million people in New York and New England saw the eclipse on that day. Lovecraft recalled the eclipse in a letter of 1932: "In 1925 (when I was in New York) some of us tramped up into the cold of northern Yonkers to see the January eclipse."
"Eclipse"	ECLIPSE PUTS CITY IN DARK AND MILLIONS WATCH IN AWE … WIPING OUT OF SUN STRIKES GAZERS AS THREAT FROM SKIES
Haden, p. 153	January 1925 looking across at the city's towering black monolith-like skyscrapers, from the height of a raised aqueduct, and seeing New York as if it were a sunken city risen from the bottom of the ocean, with semi-darkness all around and the brightest stars shining suddenly above.

Night

Sharpe, p. 32	The city after dark is a snare, a canvas, a foreign land, a fantasy, a stage.
Riesenberg and Alland, p. 205	City often entered by night.
Sharpe, p. 29	I have been one acquainted with the night.
Ibid., p. 1	Now the nights of one period are not the nights of another. Neither are the nights of one city the nights of another.
Ibid., p. 2	To banish night so that artifice could reign supreme.
Strunsky, p. 698	The moral laxities of the dark.
Sharpe, p. 2	The decked-out city of night ostentatiously burned its candle at both ends.
Ibid., p. 277	In the country the darkness of night is friendly and familiar, but in a city, with its blaze of lights, it is unnatural, hostile and menacing. It is like a monstrous vulture that hovers, biding its time.
Ibid., p. 5	"Daytime" activities—the constant construction and demolition; the influx of immigrants, industries, and capital.
Ibid.	A nocturnal semiotic arsenal that no other city could match.
Ibid.	The proliferation of skyscrapers began to change the topography of the city itself, as their lights broke the ceiling of darkness that in cities had hovered at the five-story level since the Middle Ages.

w Light — Night

Public and private experiences shade into each other; even the most dreamy nocturne hints at the brassy world it renounces, while even the brightest lights may become mirrors to the secret desires of anonymous crowds or hidden observers.

Ibid., p. 27

Names of paintings with nocturnal themes: *Sunday Night on 40th Street*; *Stars on Sixth Avenue*; *3 a.m. in the Sun Office*; *Police Station Lodgers—Madison Street*; *Easter Eve, Washington Square*; *Sunset On West 23rd Street Night on the El Train*; *Night Windows*; *Nocturne in Grey and Gold—Chelsea Snow*.

Ibid., pp. 277, 278, 290

The light-driven editing of the nocturnal landscape after 1900 effectively dematerialized the night city, destroying any sense of depth or perspective. It became a self-canceling concatenation of messages, an "ethereal abstraction" that in its sheer size and complexity transcended the human capacity for comprehension. Whereas the natural sublime dwarfed and chastened human spectators, and the technological sublime exalted the human mastery of natural forces, this "unintended" electrical sublime of commercial light managed to tear viewers in both directions at once. In so doing, it created a "disembodied spectacle with an alluring promise of personal transformation" that "urged the viewer to merge the scintillating landscape into the self."

Ibid., p. 214

You have traveled in the course of the night from the meticulous to the slime.

McInerney, *Bright Lights*, p. 3

Streetlight

Night is abolished.

Still, *Mirror*, p. 297

I raise my head and look at the deserted street below—the pools of light under the street lamps, the tops of the parked cars, the square patterns of the cracks in the sidewalk—and there is a cleanliness and orderliness to things.

Conroy, p. 175

Everything is stripped naked by the dispassionate glare. The glare is everywhere, and nowhere a shadow. Each building stands there like a dumbfounded fool with wide-open mouth, and sends forth the glare of brass trumpets and the whining rumble of orchestrations. Inside is a cloud of smoke and the dark figures of the people. The people eat, drink and smoke.

Gorky, "Boredom," p. 311

In its glare, my shadow is vividly cast on the wet pavement.

Ellis, *Psycho*, p. 163

Although the rectangles of light on the cobblestones are far from regular, their repetition invokes a kind of urban talisman.

Rock, Moore, and Lobenstine, p. 287

And the lamps of the city prick my eyes.

Lowell, p. 36

Second Avenue, south of 14th Street, was deserted after sundown. One of the few sources of illumination was the row of spotlights shining down on the sidewalk from the East River Savings Bank branch between 6th and 7th streets.

Berman, *Calling*, p. 27

Nights, after the lighting-fixture and restaurant-supply stores have rolled down their metal sliding doors, the avenue is deserted, lit only by the thin yellow glow of streetlights and of traffic slowly making its way downtown.

Lawson

Watching the illumination of the streetlamps progress up Fifth Avenue, he commented, "Probably there is a man at a switchboard somewhere, but the

Sharpe, p. 130

effect is like destiny, and regularly each night, like the stars, we have the lighting up of the Avenue."

Ibid., p. 164 Appearances are deceptive—and Fifth Avenue is so imperfectly lighted.

Rock, Moore, and Lobenstine, p. xix The glow of street lights punctuates the growing darkness, and the city seems to float in silence in the shimmer of light reflected on the wet pavement.

Conroy, p. 44 Blue light from outside angles through the large windows to spill on the waxed wooden floor.

Wojnarowicz, p. 185 just a faint light over the sill coming in through the curtains from a streetlamp

McInerney, *Bright Lights*, p. 172 The Caddy floats over the downtown streets. You can tell you are moving only by the passage of lights across the tinted windows. Some of the lights have dim halos and others spill crystalline shards into the night.

Ellis, *Glamorama*, p. 164 Looking up through the limo's sunroof, spacing on the sweeping patterns spotlights are making on the black buildings above and around us.

Electricity

Haden, p. 62 The old 19th-century gaslight had made everything at night seem as if lit by a gauzy and romantic twilight.

Galwey, p. 420 Straight scream of electric arcs.

Lorca, "Landscape," p. 226 The dirty night gay light height and rope.

Roche, p. 405 Electric light in screeching maze. A spell.

Jolas, p. 473 Electric lights glare against a huge zodiac sketched upon a poster.

Conrad, p. 131 Electrification is a symptom of violent mobility.

Ibid., p. 132 Electricity is New York's protest against the demoded restrictions of night.

Ibid., p. 77 The electrified city abolishes the difference between day and night.

Ibid., p. 146 The city's electrification is explained by the pornography and pathology of metaphor: lust, Dalí exclaims, keeps the buildings alight and warm.

Mayakovsky, *Discovery*, p. 47 You get dressed thanks to electricity, on the streets there is electricity, the buildings are bathed in electricity.

Sharpe, p. 9 manufactured light

Depero, "24th Street," p. 429 *near the base of this building there appears a semi-circular assortment of lights:*
"pneumatics of lights"
"chains red light"
"rack of lamps"

—*adjoining a sign for*
—*an* "American dish"

Unlike sunlight, limelight has, more or less, the qualities of neon. Sunlight has been around for at least a few billion years, while a neon light lasts a few months or, used sparingly, a few years.

Mueller, p. 256

I remember walking at night in Chelsea with Bill during the depression, and his pointing out to me on the pavement the dispersed compositions—spots and cracks and bits of wrappers and reflections of neon-light—neon-signs were few then.

Denby and Cornfield, p. 2

the sins of streets are hidden in a mist
Pale yellow, shot with topaz, amethyst.

Hall, p. 622

the neon shapes
that float and swell and glare
down the gray avenue between the eyes

Auden, "Watchers," p. 63

The secrets of the night are simultaneously pried open and clamped shut by the tireless ubiquity of electric light. As the light renders public everything it touches, it confers on it an unsought stage presence, indifferently bestowing significance in all directions.

Sharpe, p. 282

The city was one long banner of light that sparkled and scintillated in the crisp night air, paling even to insignificance a moon of harvest splendor.

Ibid., p. 153

Objects that are dark by day incandesce at night. In the afternoon the Singer Tower is a gray smudge; in the evening it wears a cap of electricity.

Conrad, p. 243

The incandescence of its lights, its fancied liquidity.

Ibid., p. 74

The harsh jazz of the jagged skylines is muted by a velvet curtain of darkness painted with a silver river and bespangled with innumerable points of light.

Sharpe, p. 201

Little dots and glimmers of light in the tall buildings ahead.

Donleavy

The rain in Lola's hair reflected a thousand lights, each one shimmering separately on its deep-toned background.

Spillane, p. 311

the glimmer of a young girl's platinum blonde hair

Federal Writers, *Panorama*, p. 292

Spurning the grimy pavements with their feet, the sun making rainbows on their vigorous hair.

Atkinson, p. 40

The symbolic instant of light coming up in a face as the coin is dropped in the subway slot and the turnstile jerks.

Federal Writers, *Panorama*, p. 422

Sit looking through this polished window at the lights changing. In this cathedral of a city. Where the skyscraper organ pipes trumpet.

Donleavy

In the dim light of one bare bulb hanging from a rusted tin ceiling, the old Mee Heung Chow Mein Corporation, on Mott Street, was quiet.

Kinkead, *Chinatown*, p. 17

w Light — Electricity

Berger, *New York*, p. 9 New York's subway cars and subway stations use left-hand threads in the electric-light bases. This discourages bulb snatchers from going after them for home use.

Maffi, p. 19 In that fleeting moment when the road cut out of the rock opens mirage-like onto the New York skyline before disappearing into the neon unreality of the Lincoln Tunnel.

de Torre, "Upon Landing," p. 58 Androgynous girls manipulate electrical switches of morning stars!

Corbusier, p. 90 The night was dark, the air dry and cold. The whole city was lighted up. If you have not seen it, you cannot know or imagine what it is like. You must have had it sweep over you. Then you begin to understand why Americans have become proud of themselves in the last twenty years ... The sky is decked out. It is a Milky Way come down to earth; you are in it. Each window, each person, is a light in the sky. At the same time a perspective is established by the arrangement of the thousand lights of each skyscraper; it forms itself more in your mind than in the darkness perforated by illimitable fires. The stars are part of it also—the real stars—but sparkling quietly in the distance.

Mayakovsky, *Discovery*, p. 52 It really is white, and there really is a feeling that it's brighter than day on it, since it's light all day, but this road is as bright as day and, what's more, it's against the background of darkest night. The light of the street lamps, the light of the darting advertisements, the light of the glowing window displays and the window panes of the never-closing shops, the light from lamps illuminating the huge daubed posters, the light bursting out from the doors of cinemas and theatres as they open, the racing light from the cars and elevated transport, the light from underground trains flashing under your feet in the window panes along the pavements, the light of publicity messages in the sky.

Wolfe, *Bonfire*, p. 17 On each floor a single bare 22-watt circular fluorescent tube, known as the Landlord's Halo, radiated a feeble tubercular-blue glow upon the walls, which were Rental Unit Green.

Ellis, *Glamorama*, p. 98 It's so cold in Tower that everything—the air, the sounds revolving around us, the racks of CDs—feels white, snowed in. People pass by, moving on to the next register, and the high-set fluorescent lighting that renders everyone flat and pale and washed out.

Huxtable, *Goodbye*, p. 90 The Astor Library closed at sundown because it had no artificial light.

Riesenberg and Alland, p. 17 Thousands work there under artificial light.

Conrad, p. 81 The sliver of artificial light on Broadway, deep down among the cold, blank, moonlit buildings, is an electric sunrise, proceeding in the opposite direction from the actual dawn, which first catches the peaks of the buildings and only later—if at all—reaches the gouged crevasses of the streets.

Sharpe, pp. 304–5 My hole is warm and full of light, Yes, *full* of light. I doubt if there is a brighter spot in all New York than this hole of mine, and I do not exclude Broadway. Or the Empire State Building on a photographer's dream night ...

Ellis, *Glamorama*, p. 193 Outside, more light, some of it artificial, opens up the city.

Mayakovsky, *Discovery*, p. 52 Light, light and light. You can read a newspaper, and what's more you can read your neighbor's—and in a foreign language, too. It's bright in the

w Light — Electricity

restaurants and in the theatre center. It's clean on the main streets and in the places where the bosses or the aspiring bosses live.

The trip to New York only took thirty minutes, and as they flew around the glazed fluorescent curves of the Holland Tunnel, a false promise of daylight around each bend drew them on.

O'Connell, p. 295

The gleam of the overhead bulbs is as steady as the sun in a cloudless sky.

Philips, p. 6

The city's light is votive offering, not commercial enticement.

Conrad, p. 73

The lighting-up of cities boldly advertised their advance into the future.

*Ibid.*, p. 131

The light burns out at the foot of 23rd Street, 22nd Street, 21st, 20th, 19th.

*WPA Guide*, p. 51

The slow lights of barges.

Wojnarowicz, p. 133

The lights on the bridges went off, and so did the red light in the lantern of the lighthouse at the north end of Welfare Island.

Maxwell, p. 3

Shadows, Sun, Daylight

Seeing things from such a steep height that faces are obscured and objects supplanted by the shadows they cast.

Conrad, p. 105

Buildings sliced across, sometimes half eliminated by the disposition of light.

*Ibid.*, p. 83

The "second life" of shadow and vagrant movement.

Kozloff

He sat on the line where the sun and the shade met.

Hapgood, p. 151

During the day if it got too hot in the sun he would go to the shady side of the street and though it was warm he was still able to wear his coat.

Hollander, p. 164

All afternoon the shadows have been building
A city of their own within the streets

Tomlinson, p. 137

The shadows on the mirror-like streets, the dark mass of the overhanging buildings, overpowered, perhaps, their imminent imagination and moved it for the first time with a touch of the sublime which makes the whole world forgetful.

Hapgood, pp. 369–71

The vicinity of Broadway and Manhattan Street, where the enormous black iron arch of the Subway viaduct casts its shadow over all the cars that run west to Fort Lee Ferry and north to Fort George and south into the deserted regions of lower Broadway.

Strunsky, p. 703

Look back and see a thin shaft of light, ethereal, tremulous, almost of faery, and that pillar of light will be Broadway cañon between its brick walls still clad in shadow.

*Ibid.*, p. 705

Festoons of sun pulverizing shadows.

Przybos, p. 328

w Light — Shadows, Sun, Daylight

Federal Writers, *Panorama*, p. 12	The utilitarian imperative, which covers blocks with sunless tenements and no less sunless apartment houses, makes night and day indistinguishable under the overhanging scarps of lower Manhattan.
Wojnarowicz, p. 33	Sunlight drifts over New Jersey cliffs illuminates sparse architecture and great warehouses and piers and ships all shapeless from the blinding show making it all look like India with orange postal card skies and you expect a huge herd of cows to be flat-walking over the river surface—where's the Taj Mahal!?
Ibid., p. 28	The sunlight, dazzling and beautiful, almost unreal against the shady streets of Brooklyn Heights.
Walker, *Night Club*, p. 41	A man can live a fairly complete life in New York without having to go out into God's clean sunlight at all.
de Torre, "Upon Landing," p. 58	Sunlit yearnings of Ultraist Lucifers crystallize electric charges!
Hamill, "Lost"	The slanting yellow light on 125th Street.
O'Connell, p. 294	The sun rose behind the Gowanus Parkway lighting the oil-filmed water of the Gowanus Canal and the red bricks of the Project.
O'Hara, p. 340	ozone stalagmites deposits of light
Campbell, Knox, and Byrnes, p. 93	A dim light came from windows crusted with dirt.
McDarrah, *Artist's*, p. 10	Gray light and sense of tension.
Tucker, p. 194	That part of the loft always held a kind of awe for me. Plus it being a kind of underworld sort of light with an enormous shaftway window that always appeared like an aquarium. I was never sure what time of the day it was, although after a while one could tell the time according to the subtle and soothing tranquil light in the space.
Wojnarowicz, p. 111	dim lights from tree-filled building, grainy light like a film made of New York traffic Expressway sounds
Ibid., p. 160	the dim light from the courtyard windows easing across the surface of the wall
WPA Guide, p. 51	The light leaves the flat roofs of the ghetto along the river.
Riesenberg and Alland, p. 98	When black clouds cap the city and light blazes along its canyons, a daytime lighting load is suddenly superimposed on the industrial demand.

Traffic Lights

Corbusier, p. 101	The traffic lights cause vertigo.
Donleavy	Wait for the red light to change.
Finney, p. 115	Uselessly clicking from green to red, red to green.

w Light — Traffic Lights

Green yellow and red. And a breeze blows my dreams abandoned down the street.

Donleavy

Red lights are now seen as street ornaments, a year-round extension of Christmas decorations, rather than as instruction.

Brook, p. 144

Color is the scream emitted by expiring light.

Conrad, p. 239

neon blinking traffic light

Ginsberg, *Howl*, p. 3

Guessing the rhythm of the changing traffic lights correctly, catching the crest of the "green wave."

Lobas, p. 32

Traffic signals in New York are rough guidelines.

Hamann, p. 35

They set down their feet, they walk
green, red; green, red
 Every two minutes, the green lights of the numerous traffic signals go off, and the red lights come on. Within two minutes, the green signal again lights up on the traffic lights, while the side roads are barred by the red lights on the street corners.

Sharpe, p. 336

Red light. Bell.
 A block deep four ranks of cars wait at the grade crossing, fenders in taillights, mudguards scraping mudguards, motors purring hot, exhausts reeking, cars from Babylon and Jamaica, cars from Montauk, Port Jefferson, Patchogue, limousines from Long Beach, Far Rockaway, roadsters from Great Neck … cars full of asters and wet bathingsuits, sunsinged necks, mouths sticky from sodas and hotdawgs … cars dusted with pollen of ragweed and goldenrod.
 Green light. Motors race, gears screech into first. The cars space out, flow in a long ribbon along the ghostly cement road, between blackwindowed blocks of concrete factories, between bright slabbed colors of signboards towards the glow over the city that stands up incredibly into the night sky like the glow of a great lit tent, like the yellow tall bulk of a tentshow.

Dos Passos, p. 217

The electric lights on lampposts come on at night and go off during the day: thus they mark and regulate night and day. The attached traffic and pedestrian light signals likewise regulate traffic, telling one to go, or to wait before going. These signals consist of two colors, red (dark) and green (light), with the transitional blinking yellow. "Without rigid adherence to predictable routines a large compact society would scarcely be able to maintain itself. The clock and the traffic signal are symbolic of the basis of the social order in the urban world."

Wirth, p. 74

The taxis and private cars fluttering about like jeweled flies.

Dreiser, p. 3

Varied, layered tones mount gradually from traffic-torn streaks of light at street level.

Sharpe, p. 125

seeing two bright spherical yellow lights like car headlights anchored on jersey cliffs sending vertical lines of light, gold breathin' light across the surface of the dark rolling river, like two railroad track lines laid out into some hobo's heaven

Wojnarowicz, p. 118

Josephy and McBride, pp. 400–1

Three colored lights passed overhead, very high up and in the cluster, blinking. There were also lights strung through the park at intervals, and on East End Avenue, where taxicabs cruise up and down with their roof lights on. Nobody wanted them. As if they had never in their life shot through a red light, the taxis stopped at Eighty-third Street, and again at Eighty-fourth, and went on when the light turned green. East End Ave. was as quiet as the grave. So were the side streets.

Atkinson, p. 22

Any New Yorker fairly sound in mind and limb will step without a tremor into the most frightening whirlpool of traffic rather than wait a few seconds for the lights to change in his favor. At the three or four intersections where pedestrian lights have been installed, and the lights flash out Walk or Don't Walk, the crossers-over wriggle under the restraining arms of the policemen stationed there to save their lives, and dart like snakes between the onrushing cars. A movie short taken at any busy corner would show how deep-rooted is this particular form of our madness. It seems to be considered a little shameful to wait till it's legal to cross.

Allen and Brickman, *Annie Hall*

I don't want to live in a city where the only cultural advantage is that you can make a right turn on a red light.

Color

Conrad, p. 133

The frenetic vermillion or vitriolic yellow of Coney Island, the silvery alarm of electricity shining from the Brooklyn Bridge, or the sulphurous effulgence which burns inside skyscrapers.

Ibid., p. 239

Coney Island is carnal vermillion and acidulous neon lemon: colors are the siren's blandishments.

Sharpe, p. 193

"I used the intact purity of the vermillion," Stella said, "to accentuate the carnal frenzy of the new bacchanal and all the acidity of the lemon yellow for the dazzling lights storming all around."

Caldwell, p. 2

Behind the red crosses that mark the hospitals and the green globes of the police stations, shifts change.

Dreiser, p. 7

Great gold and scarlet streets.

Conrad, p. 105

The pavement is white, the figures black.

Demuth

I Saw the Figure Five in Gold (1928)

Williams, *Collected*, p. 174

Among the rain
and lights
I saw the figure 5
in gold
on a red
firetruck
moving
tense
unheeded
to gong clangs
siren howls
and wheels rumbling

through the dark city.

The river was smooth, sleek as a bluesteel gunbarrel. The shadows between the wharves and the buildings were powdery like washingblue. Masts fringed the river; smoke purple chocolatecolor fleshpink climbed into light.

Dos Passos, p. 125

Color enters in violently whenever money is involved. To call, you cry out; to cry out effectively in the uproar of the crowd, you use signs colored red, yellow, green, and blue. Magic incantation on Broadway.

Corbusier, p. 110

Oranges blazed on the carts; calico was for sale, clocks, sweet potatoes, herrings, potted geraniums and galoshes.

Gold, p. 16

Tool & Die Works red and Subway I-Beam green and Restaurant Exhaust-Fan Duct Lint gray.

Wolfe, *Painted*, p. 89

hum-colored cabs

Bennett, *Deconstructing*, p. 8

On a particularly deformed strip of the low Sixties around Second Avenue there is a building that's constructed of a material which cannot be identified. It's a color between that of a dead salmon and a dead rat.

Remnick, p. 320

The colors of the neighborhood lighten as limestone replaces brownstone.

Hawes

The Hell Gate section of the Triborough Bridge was a necklace of sickly-green incandescent pearls.

Davis-Goff, p. 175

A bright green spot moved swiftly down the East River late yesterday afternoon. The spot—a light, minty green—covered an area much larger than a tennis court. Borne along by ebb-tide currents, it slid under the Queensboro Bridge, swirled past the United Nations and Bellevue Hospital on its course to Wall Street and the harbor.

Philips, p. 41

In the spring morning it seemed that every ash barrel was green-wreathed with spinach.

Cowley, p. 49

New York's landscape is red, brick red or brownstone red. Manhattan spring is red.

Jones, *Dynamite*, p. 176

The rose-red of sunrise, of infant day, the fiery blood-shot red of the setting sun, flushing towers spires with crimson. But this rose glow soon fades to gray. To me this is a gray city, massively gray, abstruse, elusive. At moments it is a clear gray, understandable, friendly. It has one mood today and another tomorrow. The one who seeks its colors may walk from an avenue into a side street and find the spectrum swiftly changed. New York is a palette on which all colors appear sharply by turns and then mingle. But its dominant note, at last, is gray.

Riesenberg and Alland, p. 189

The tints of color in the passing throngs. Fanning themselves with the cool riches on sale.

Donleavy

Screen changes suddenly into luminous colors of every description. The new moon tumbles down. A planet burns rose against a poster for United States Rubber.

Jolas, p. 472

w Light — Color

Caldwell, p. 279

Summer of 1948—last summer before air-conditioning.

Sanders, *Celluloid*, p. 233

The introduction of residential air-conditioners tended to close up windows, especially in summer; television offered spectacles more distracting than any real sidewalk view; and automobiles, rather than subways, buses, or walking, became an increasingly common means of transport, even in much of New York. Life moved away from the window, away from the stoop, away from the street, as middle-class city dwellers withdrew into secure, climate-controlled interiors.

"Air Conditioning," p. 11

We shall have to change the habits of a lifetime when domestic air-conditioning arrives … And how blessedly silent the interior will be! It may vibrate as a ten-ton truck rumbles by, but of the clatter of garbage cans, the backfire of a passing car, the din and bustle of the street—not a vestige. Like dirt amid germs, the din and bustle of the street will be filtered out.

N. cit.

In terms of the way it changed the ecology of the city, the invention of the air conditioner is to the twentieth century what the elevator was to the nineteenth.

Sanders, *Celluloid*, p. 233

In the days before residential air-conditioning became common, summer life in the city naturally gravitated toward open windows, or to outdoor spaces like fire escapes.

Ackermann, p. 150

The 1950s idea of *cool*: "The demise of city night life, done in by television and suburbanism: a bland affront to unrestrained human nature, a nature stripped of the 'heat' of natural passion. The wan gentility of an East Side art movie theater had replaced late, hot nights of dancing. In 1955 Gilbert Millstein writes: 'Maybe it's all these new buildings breeding more of these cool Brooks Brothers cats. They're too cool.' He refers to the totally air-conditioned skyscrapers then turning Manhattan's grubby Sixth Avenue into a gentrified Avenue of the Americas where businessmen in suits could fancy that they were hip.

Riesenberg and Alland, p. 139

The air shaft: a primitive attempt at air-conditioning.

Trager, p. 512

The city's first centrally air-conditioned apartment house is completed at 23 East 83rd Street. Air is drawn in at the roof and circulated through the interior ductwork.

Ibid., p. 499

In 1936, 400 Park Avenue becomes the city's (and the nation's) first apartment house to have every room air-conditioned.

Ibid., p. 521

Tiffany & Co.'s store on the southeast corner is the first fully air-conditioned store of any kind.

Whitaker, p. 102

Macy's installs air-conditioning in 1929.

O'Donnell

New York's ice age is brought to a close not by reformers but by inventors. In the spring of 1916, the city's newspapers began carrying large ads for the Domelre electric refrigerator. Promoted as "The Electric Iceman," it promised to deliver "no ice—just cold." Domelre and its successors would not become a basic feature of most New York homes for several decades, but

by 1950 the iceman had been become as much a relic of a long-ago age as the blacksmith and the lamplighter.

Air-conditioning and soundproofing guarantee that nothing that smells of earth remains to destroy your illusion of flight.

Conrad, p. 264

In May of 1925, the Rivoli movie theater just north of Times Square becomes the first air-conditioned theater, refrigerated with "mountains of ozone."

Ackermann, p. 48

The Rivoli had "a novel feature … 'olfactory music,' or a system of atomizers which spray perfume—oriental, clover, new-mown hay—and in accord with the orchestra, the screen and the stage settings literally imbue one's senses with the atmosphere of the play."

Basile, p. 111

Roxy's understanding of Fantastic Technology inspires a further intensification of his metaphor: questioning the conventional use of the air-conditioning system—ventilation and cooling—he realizes that this would only add chill to the sunset. With the same maniacal logic that characterized his earlier visions, Roxy then considers adding hallucinogenic gases to the atmosphere of his theater, so that synthetic ecstasy can reinforce the fabricated sunset. A small dose of laughing gas would put the 6,200 visitors in a euphoric mood, hyper-receptive to the activity on the stage. His lawyers dissuade him, but for a short period Roxy actually injects ozone—the therapeutic O3 molecule with its "pungent refreshing odor" and "exhilarating influence"—into the air-conditioning system of his theater. Combining super-time with super-health, Roxy defines the definitive formula of the metropolitan resort with his slogan, "A visit to Radio City Music Hall is as good as a month in the Country."

Koolhaas, pp. 210–11

A long foyer led to six sets of bronze-trimmed doors. Passing through them, patrons entered a grand rotunda. (Roxy threatened to fire any of his ushers who referred to it as "the lobby.")

Miller, *Supreme*, p. 272

"Fifteen degrees cooler inside," said a sign in letters encrusted in icicles.

N. cit.

The air-cooling requires a careful and scientific arrangement of all pipes and ducts so that drafts along the floor may not discomfort ankles in sheer silk stockings or other drafts be felt by sensitive heads and throats.

N. cit.

Instead of offering melodramas and air-conditioning, let the theatres sell air-conditioning alone. For a price, a hot and weary pedestrian would be permitted to sit comfortably in the cool darkness. If this appears too unexciting, the theatre could introduce sound effects such as the splashing of a fountain or the trilling of a mountain stream. There might even be a musical accompaniment and, even, if the theatre was generous and enterprising, appropriate pictures: an ice-breaker at work, Niagara Falls in midwinter, last year's blizzard, yesterday's mob at Coney Island.

Curci

Spent air-conditioning fluid from Rockefeller Center is used to build bombs during WWII.

N. cit.

Carrier's "Igloo of Tomorrow" at the 1939 World's Fair. Scantily clad women ("snow bunnies") shoveled manufactured slush in 90-degree heat. Carrier closed the igloo for the season with the arrival by dog-sled of the fur-clad Mayokok family, who ostensibly planned to "hibernate" there until the Fair reopened in 1940 … The exhibition received its greatest publicity on August

Ackermann, p. 101

23, 1939, when the company gathered seven hundred hay fever sufferers in the igloo to demonstrate the therapeutic value of air-conditioning. As reported in the August 24 *New York Times*, allergists selected eighteen sneezers for a demonstration of how to enhance the "air-conditioning function" of their noses. Said the *Times*: "The contestants could not sneeze in the Carrier Building, so the contest took place outdoors."

"Heating," p. 2

Haven't we accomplished air-conditioning indoors? All we have to do is to accomplish the same thing on a larger scale outdoors. What are we waiting for?

"70-Foot Igloo," p. 25

The outline of a far-reaching plan for a gigantic artificial climate center that would assemble in one spot all the mineral and thermal waters of the world, and would enable the people of New York to enjoy the advantages of all the world's exclusive summer resorts and spas ... The artificial climate center would also contain medical baths of all kinds—hot air, electrical vapor, etc. ... It also was proposed "to create an artificial beach of fine sand on the verge of a vast pool, warmed by an artificial sun and atmosphere, the whole establishment to be situated in the city itself, close to the main thoroughfare and open all the year around."

In this "climate paradise for the millions" the visitor would be able to bask in the sunshine of an "artificial Florida," or breathe the dry air of Arizona and New Mexico, or enjoy the benefits of the seashore or mountaintops of Carlsbad, Saratoga Springs or other famous spas in various parts of the world. While the climate would be manufactured artificially, with the proper requirements of humidity, air pressure, ultra-violet radiation and temperature, the natural mineral waters of the world's spas would be available in bottles.

An igloo far greater than any ever built by Eskimos, with a temperature cooler inside than out and with the "aurora borealis" glowing on schedule on the ceiling of the dome, while outside the sun beats down on a simulated snow exterior, will squat as part of the exhibit of the Carrier Corporation, maker of air-conditioning equipment ... Two 80-foot thermometers, one reminding the World's Fair visitors of the temperature out of doors and the other indicating the comfort afforded in the air-conditioned interior, will flank the igloo.

Curci

A refrigerating engineer invents the phrase "weather manufacturing" for this process; technically, it is "air-conditioning."

Ibid.

Making climate to order was begun originally as a means of assuring quality of goods, not for the summer comfort of humanity. Then it occurred to industrialists that if employees had the atmosphere of a perfect day about them always they would have clearer minds, be affected less by fatigue during the afternoon, make fewer mistakes and reduce accidents. So in the last five years the theatrical interests, taking up the idea, have been remaking climate indoors both summer and winter, to their own great advantage and the comfort of the public. They have been paid in increased attendance. It is an open secret that one large New York motion picture theatre which last year installed a $50,000 air-cooling plant charged it off as paid for at the end of the summer season through the increased attendance.

N. cit.

To manufacture weather at home, in the office or on a train, there must be a way of handling the atmosphere as if it were a tangible fabric.

Talman, p. 4

A revolutionary possibility is suggested by the fact that efficient operation of an air-conditioning system in a building implies the permanently closed window.

x Air — Air-Conditioning

The finial-towered profile of Lower Manhattan, crowned with the aeries of corporate chairmen, was obliterated by the advent of air-conditioning: thick, fat buildings, harboring vast interior reaches for the bulk corporate population, were possible. In contrast, the RCA Building was planned on the notion that no occupant should sit more than twenty-seven feet from a window and that air-conditioning was provided by opening the window.

White, *Physical*, p. 74

The slenderness that made these towers so elegant necessitated their smallish office floors, limited in size by the requirement (in those pre–air-conditioning days) to have every desk no more than twenty-eight feet from an operable window.

Sanders, *Celluloid*, p. 133

In 1902 … air-conditioning was in operation, making one Brooklyn printing plant owner very happy. Fluctuations in heat and humidity in his plant had caused the dimensions of the printing paper to keep altering slightly, enough to ensure a misalignment of the colored inks. The new air-conditioning machine created a stable environment and aligned four-color printing became possible. All thanks to the new employee, Willis Carrier, at the Buffalo Forge Company, who started on a salary of only $10.00 per week.

Bellis, p. 12

Minetta Brook, Minetta Lane. NYU thought to put Minetta Brook to work for air-conditioning but the stream was found to be temperamental, not to be counted on in rainless periods.

Berger, *New York*, p. 7

The air-conditioning is spotty. Sometimes the windows are open, driving the stale and fetid air around in an illusion of cooling. When the air-conditioning works, it is worse. You walk from steambath to refrigerator, as if changing continents, and your perspiration seems to freeze within your shirt, a phenomenon previously known only to Antarctic explorers.

Gopnik, p. 192

A rush of cool air greeted me; and though the day was one of the hottest of late June, I shivered as I crossed the threshold into a large apartment whose rich and tasteful decoration surprised me in this nest of squalor and seediness.

Lovecraft, "Cool Air," pp. 29–34

Last weekend, the Long Island Expressway smoldered with traffic jams and anyone who couldn't talk about "going out to the beach" crawled into some Manhattan corner and turned on the air-conditioner.

Blandford, p. 12

Breathed with air-conditioning and jammed with heat-producing machines.

Talbot, p. 17

My first direct contact with an air-conditioner came only in the sixties, when I was living in the Chelsea Hotel. The so-called management sent up a machine on casters which rather aimlessly cooled and sometimes heated the air, relying, as it did, on pitchers of water that one had to pour into it. On the initial filling, it would spray water all over the room, so one had to face it toward the bathroom rather than the bed.

Miller, "Before," p. 26

On any given summer afternoon, you can stroll down any residential street and be dripped upon by someone's condensation (A/C Pee).

Ibid., p. 2

Look up; most of the windows are occupied by droning metal posteriors. Surrounding you is an unmistakable, comforting hum that issues from battalions of compressors.

Ibid.

Blandford, p. 32 In the cool September nights, the noise of air-conditioners extinguished for another year, windows thrown open to catch the breeze from the Hudson River.

Air, Wind, Atmosphere

Gopnik, p. 314 The air around us, the atmosphere that just sits here, is filled with us. Intimacy and anonymity, the two New York poles between which our lives endlessly oscillate, continue to produce their own kind of field. We live in it. We can't ride the light. There isn't really any light to ride. But we can share the air.

Ibid., p. 159 New York restaurants now have a new thing—they don't sell their food, they sell their atmosphere. They say, "How dare you say we don't have good food, when we never said we had good food. We have good *atmosphere*." They caught on that what people really care about is changing their atmosphere for a couple of hours. That's why they can get away with just selling their atmosphere with a minimum of actual food. Pretty soon when food prices go really up, they'll be selling only atmosphere. If people are really all that hungry, they can bring food with them when they go out to dinner, but otherwise, instead of "going out to dinner" they'll just be "going out to atmosphere."

Grimes, p. 215 The air in our shop and luncheon room is changed every eight minutes; in our kitchen it is changed every four minutes.

Huxtable, *Goodbye*, p. 55 That solid gold air is there to stay, and if its superheated values continue to rise as anticipated in the coming half century, Manhattan could someday replace Fort Knox.

Talese, p. 86 In some parts of New York City the air is worth nearly a dollar a whiff.

Ibid., p. 91 "Everybody is buying light and air these days," Mr. Kyle said.

Douglas, p. 434 William James's perception of "the air [as] itself an object" was translated in the 1920s into the commodification of the air as a marketable product, as radio frequencies, airplanes, and skyscrapers.

Blandford, p. 11 For once the air has been cold but scrubbed clean.

McDarrah, *Artist's*, p. 9 Matisse said, "New York has the clear, saline air of Venice."

Gooch, p. 195 The night paints inhaling smoke and semen.

Dos Passos, p. 28 Hot, full of tinkle and perfume and smoke.

Irwin, p. 226 Does he breathe as yet the intoxicating, perfumed vapor, or only the common outer air?

Kozloff Savoring the airy weight of the environment itself, and not least, its variable influences on the body.

Peretti, p. 6 Manhattan's heavy air … shadowing the explicit acts, daring desires, and unconscious mediations of a multitude of night wanderers.

The air in the air shaft lies dead, a column of vitiated gas, dank below, but slightly less poisonous than its upper, richer strata. Dull gray calcimine, chipping off, falls to the bottom like last year's unmeltable snow.

We think as little about air as we do about water.

Moving slowly sweating a lot
I am pushed by a gentle breeze
outside the Paradise Bar on
 St. Marks Place

Mrs. Cornelius Vanderbilt still lives in vast splendor low down on Fifth Avenue, though the surrounding skyscrapers blow such draughts down her chimneys that many of her sitting-rooms have become impossible.

New York buses have sliding windows that do not open in summer because of air-conditioning and cannot be opened in winter because of heating.

At every intersection a fresh breeze from Twelfth Avenue, a concrete bank of the Hudson River, refreshed horse and rider, cooled the hot black engine that gave warning hoots behind them.

The gorge above Broadway is spotted with gigantic, glittering snowflakes, laced with white streamers that weave and intertwine as though moved by the invisible hands of the People of the Air.

"I didn't want to paint anymore, so I thought that the way to finish off painting for me would be to have a painting that floats," Warhol said to his friends. "So I invented the floating silver rectangle that you fill up with helium and let out of your window."

Warhol had been interested in weightlessness since 1964, when he approached Billy Klüver about designing a floating light bulb, perhaps in homage to the Jasper Johns's drawing of a light bulb that Warhol bought in 1960. Klüver was the ideal person to think about weightlessness, for he was trained as an engineer, worked in collaboration with artists, and understood what was technologically possible.

Klüver determined that it would be impossible to create a light bulb that floated, but he came up with an alternative plan, using a material called ScotchPak that had been recently developed by Minnesota Mining and Manufacturing. An extremely thin silver material, it could be sealed with the use of an inexpensive heat machine. The interior could be filled with helium. Andy loved the idea. It reminded him of a balloon, and ScotchPak was inexpensive (50 cents for 20 inches, and in bulk he could get 700 yards for $400). He bought a secondhand heat machine and was ready to produce his farewell work.

On October 4, 1965, while Pontus Hulten was visiting New York to plan the Warhol retrospective in Stockholm, a group of people gathered at the Factory and played with the possibilities of creating a huge silver balloon. Warhol thought of it as a farewell to art. Equipped with his omnipresent tape recorder, Andy interviewed Billy Klüver, who said, "I'm an engineer in the daytime, making Infinite Sculpture for Stockholm using land design." Pontus Hulten held the ScotchPak while Billy Klüver cut it and helped seal it. Then they took the freight elevator to the roof and filled the silver tube with helium. Warhol asked what the floating sculptures should be called. Pontus Hulten suggested calling them "superstar," and Andy said the sculpture should be as big as the roof, "as big as Elvis."

Riesenberg and Alland, p. 139

Atkinson, p. 227

O'Hara, p. 336

Beaton, *New York*, p. 291

Blandford, p. 111

Puzo, p. 4

Irwin, p. 41

Watson, *Factory*, pp. 244–5

The first Silver Cloud was a forty-foot tubular balloon that looked like a snake. Andy grew excited about the process, peppering the conversation with exclamations about its beauty. "Oh, look at it, it's right out of a movie. With the movies everything is called Up—Up movies, Up art."

The wind was light that day, Billy Linich shot several photographs, and then with bells ringing in the background, Warhol released the silver form into the air. As it floated up, Warhol wondered if people might take it as a delegation for Pope Paul VI, who was arriving down the street at the United Nations that afternoon at 3:40 to declare, "No more war, never again war!" Then as a helicopter went overhead, Warhol grew afraid it would cause a wreck. Most of all he was afraid the police were going to come and investigate. Maybe, he suggested, it would be wise to have a remote control for the silver balloon. Far outweighing his anxiety was the sheer exhilaration of the event. "It is the first art sent into space," Pontus Hulten said to him. Of all the Happenings that Hulten had seen, he added, "I think this is the only thing that ever really happened."

Andy returned to the Factory and telephoned Genevieve Charbon to tell her that the launching was "one of the most exciting things that ever happened. Up to God, all the way up."

Franck and Stevens, p. 1	Tying down loose space.
Trager, p. 779	Ceremonies for the opening of Jones Beach State Park are disrupted by a sudden windstorm that drives sand into Robert Moses's and Governor Al Smith's eyes. Temperatures on that day—August 4—are well below normal at 70 degrees.
Maxwell, p. 15	The wind was out of the southeast and smelled of the sea, fifteen miles away on the other side of Long Beach and Far Rockaway.
Maffi, p. 60	I take a look to see how the trees of Central Park are coping with all these violent gusts … By now the wind is furious, bending the trees backward and sending whirlwinds of leaves in the air. A sight to behold.
Gammel, p. 232	City stir—wind on eardrum—
WPA Guide, p. 52	The river wind lifts yesterday's paper the length of a block.
Conrad, p. 232	Newspapers revolving and winging in corners of carriages.
Mayakovsky, America, p. 47	In the narrow chasms between the buildings, a kind of adventurist wind hums through the chimneys, tears down signs and grumbles about them, attempts to knock you off your feet, and then flees, unpunished and uncaught, for miles through the ten avenues that slice across Manhattan from the ocean to the Hudson.
Donleavy	Walk east crosstown. Wind biting and raising whorls of grit and paper scraps. See the sky blown blue somewhere far out over Flushing. As a little boy I thought it was some strange big toilet bowl. Where giants took their craps.
Ibid.	East chilling wind bursting out of the crosstown streets. Blown over Brooklyn.
N. cit.	The shrill mountain wind, moaning outside the windows of a skyscraper room.

X Air — Air, Wind, Atmosphere

Suddenly it's warm out, and there's a big wind blowing. The wind is soft. It makes the Bronx feel like a Caribbean island. Trebay, p. 158

Breezes blow in the little park when no breezes seem to stir in the hot streets. Atkinson, p. 215

New York's sometime fierce crosstown winds are emblematic of the world city as a cyclonic zone, drawing in so many different currents. McCourt, p. 75

A sunny, windy day on the Lower East Side of New York. The year is 1942. Conroy, p. 167

The river was dirty and coming towards me in the wind, a smooth chest trembling with sweat. Wojnarowicz, p. 137

Now just windy noise clashing with silence of night, big tin sheets banging in the wind and dense burnt breezes flowing from shattered windows and twisted roofs, the stars above, the winter still riding over the mouth of the structure, ships still passing ominously in the darkness, lights of the Jersey cliffs burning and winking, a huge cigar-like cloud of steam tilting from the lip of a factory smokestack, the neon red cup of coffee dripping continuously there against the snow-covered rocks of the coast. Ibid., p. 136

Things change when the air changes. Ibid., p. 170

In the very middle of the city, we can feel the fluid of life to be present. We know the space beyond Staten Island hill is no more filled with the elixir than the air about the buildings. Rosenfeld, p. 471

If you've got a scratch, deluge yourself in iodine: the New York air is chock full of all kinds of muck that will make sties grow, and cause any scratches to swell up and fester. It's the air that is lived off by millions who have nothing and are unable to go away anywhere. Mayakovsky, *America*, p. 56

Breathing fetid air I whiff boozy bourbon emanating from the Brevoort's riotously noisy basement room behind a window opened. Jones, *Modernism*, p. 224

Later, we wandered toward Fifth Avenue, where there was a parade. The flags in the wind, the thump of military bands and military feet, seemed to have nothing to do with war, but to be, rather, a fanfare arranged in my personal honor. Capote, p. 43

The air aboveground wasn't very clean, but it smelled like a million bucks after the fog in the Zero Zero. Spillane, p. 220

Dirt, Soot, Dust

When Mount Pinatubo erupted in the Philippines in 1991, the volcano spewed particles into the atmosphere, causing unusually red sunsets in NYC for more than a year. Mittlebach, p. 6

Much of the dust around New York has come from volcanoes and may stay in the air under suspension for as long as three to six years. New Yorkers, without realizing it, have been breathing dust from the Krakatoa volcano in the East Indies in the form of minute crystals carried in the upper currents of air. Ibid.

Riesenberg and Alland, p. 213	Besides humidity there is a great amount of dust in the atmosphere of the city, and since each drop of rain contains a speck of dust at its core, it is best to photograph the city right after a rain.
N. cit.	The air is filled with a pungent smoke, and crowds of black specks whirl in the sudden gusts of wind as the waifs create a blaze from the bonfire of wooden boxes on which matting and newspapers are piled.
Caro, p. 557	Soot and smoke that spread a coat of gritty grime, confined to windowsills in the winter, over walls and furniture.
Dos Passos, pp. 240–1	After crossing Lafayette Street roaring with trucks and delivery wagons there is a taste of dust in her mouth, particles of grit crunch between her teeth.
Lichtenstein, p. 513	Dull daily labor cloaks the people in dust.
Huxtable, *Architecture of NY*, p. 16	The blackface disguise of city soot.
Hapgood, p. 192	I have noticed that others object to a slight quaver of air, when I have a perfectly clear and rational conviction that the air is foul.
McDarrah, *Artist's*, p. 10	Anxiety floats in the mote-filled air of the lofts.
Donleavy	New world. Soot lies smearing the soles of my feet.
Depero, "24th Street," p. 409	Smoke into the metallic mauve metropolis.
Ibid., p. 429	intersecting spirals of "clear smoke" and "dark smoke"
Serviss, p. 96	The deluging rains appeared to be confined to the Middle West and the Northwest, while at New York the sky simply grew thicker and seemed to squeeze out moisture in the form of watery dust.
Kozloff	Moisture that condenses by heat changes on windows, which smear the contours of object and people.
Donleavy	The dirt and grime of the train windows.
Ibid.	Smoke from garbage dumps.
Ibid.	Up Fifth Avenue. Through the flood of yellow cabs. Folk waiting. Doormen's whistles blowing. People stepping in under the canopies. In thunder wind and lightning. Flashing up the underside of the leaves in the park. The whole city washed clean. Dust and grime down the sewers. All ready for a brand new layer.
Loy, p. 509	Cyclones of ecstatic dust and ashes whirl crusaders from hallucinatory citadels of shattered glass into evacuate craters

x Air — Dirt, Soot, Dust

There is, I suppose, a good deal of soft coal still being used, and what has been used during past times of stress seems indelibly to have left a film over the white buildings and even to have taken the edge off the very clearness of the air. The buildings round the Woolworth Tower, seen even from the distance towards Sandy Hook, have no longer their pristine whiteness; they have rather the gray bones that have been long exposed to the air.

Ford, *America*, p. 52

Future indoor environments will exclude outdoor noises as well as outdoor dust.

American Meteorological Society, p. 88

The murk of Queens, the smoky, sullen air interferes with sight and the sun's nimbus is smoggily discolored.

Conrad, p. 82

During the heavy smog of 1953, schools closed, flights were cancelled at LaGuardia, two ferryboats collided in the harbor; the Yonkers ferry service was suspended; and a rash of rear-end collisions littered the city's highways. Hospitals were deluged with New Yorkers suffering from respiratory illnesses.

Javits, pp. 111–12

Private cars, jalopies, Rolls-Royces, and ten-ton trucks, cover the city with carbon monoxide gas. Thousands of taxi cabs reek poison from their exhaust.

Riesenberg and Alland, p. 69

I'm immortalizing your exhaust, Avenue A bus.

Ginsberg, *Collected*, p. 744

Lest we leap at conclusions in weighing this phase of transportation in our processed city, the daily dose of carbon monoxide is slight. People, now and then, get a rarefied snootful as they pass behind a bus; they only gasp and cough. It may be, in the wisdom of a divine providence, that this occasional gassing of the civilians is beneficial, if not preparatory; a gratis germicidal immunizing treatment, abating bad breath, relieving, and maybe even curing, dangerous deep-seated complaints. We know that medicine employs lethal drugs, in proper doses, for curative ends. Carbon monoxide, given in just the right New York proportions, may be a great unappreciated blessing bestowed upon us citizens by the age of internal combustion. Auto clotting is now known as "motor blight," tomorrow the disease may be called "motorphantiasis," with recommended bleeding into mechanical parks. In another month the traffic doctors may declare it "power paralysis," calling for amputation before the new production jobs plug the city's arteries, bringing it to a stop.

Riesenberg and Alland, pp. 69–70

Whirlwinds of dust and newspaper.

Gold, p. 14

The value of polluted Manhattan air is another curiosity that will go down in history.

Huxtable, *Goodbye*, p. 53

The Chrysler Building's one-time stainless steel begins to dull under coatings of city soot, its tin gargoyles, taken from some mythical five-and-ten, mellow to a bluish hue.

Riesenberg and Alland, p. 95

Sky, Fog, Clouds

I have learned to love its sky. In the low-roofed cities of Europe, the sky crawls along the ground and seems tamed. The beauty of the New York sky comes from its being raised so far about our heads by the skyscrapers. Pure and lonely as a wild beast, it stands guard and watches over the city. And it isn't

Sartre, p. 123

x Air — Sky, Fog, Clouds

just a local protection: you feel that it stretches right out over the whole of America; it is the whole world's sky.

Brainard, p. 414

Today the sky is so blue it burns.

Jones, *Modernism*, p. 224

The sky is still above, breathing heaving Washington Square. The city bounces—horizontals and verticals—vertiginously.

Dos Passos, p. 185

Across Park Avenue the flameblue sky is barred with the red girder cage of a new building.

Conroy, p. 167

"An absolute pip of a day. Look at that blue sky! The clouds! Seventh Street! Look how vivid the colors are!"

Hecht, p. 320

East Fortieth Street is filled with gigantic, new gray-and-black buildings—if the sky is blue on any day, there is no way to see it.

O'Connell, p. 295

Underlit by the city, the sky is an eerie muddy purple.

Rock, Moore, and Lobenstine, p. 370

Triangles press against the sky, carving it into a dramatic vault.

Hawes

The Statue of Liberty was unveiled in thick fog in 1886.

Conrad, p. 234

Fog in February 1925 embroils the harbor again in sick and guilty fantasy. It blots out the view (nothing can be seen more than "six feet from the window") and makes of it a phantasmagoria. Crane is kept awake by an assembling orchestra of tormentors, a bedlam of "bells, grunts, whistles, screams and groans of all the river and harbor buoys," which persuade him that he's at "the mouth of hell."

Collins, *Money*, pp. 284–7

This impenetrable cloudiness settles over New York City like a Grand Bank fog. It imposes ignorance, invites fantasy. That is why there is less information and more misinformation about the history of America's largest city than about any other important place in the so-called civilized world.

Keller, p. 296

New York has a special interest for me when it is wrapped in fog. Then it behaves very much like a blind person. I once crossed from Jersey City to Manhattan in a dense fog. The ferry-boat felt its way cautiously through the river traffic. More timid than a blind man, its horn brayed incessantly. Fog-bound, surrounded by menacing, unseen craft and dangers, it halted every now and then as a blind man halts at a crowded thoroughfare crossing, tapping his cane, tense and anxious.

Sanders, *Beatnik*, p. 135

The tan fog of particulate dooky lay low 'tween the high clouds and barren skyline cenotaphs of New York City.

Baudrillard, *America*, p. 16

Clouds spoil our European skies. Compared with the immense skies of America and their thick clouds, our little fleecy skies and little fleecy clouds resemble our fleecy thoughts, which are never thoughts of wide open spaces … In Paris, the sky never takes off. It doesn't soar above us. It remains caught up in the backdrop of sickly buildings, all living in each other's shade, as though it were a little piece of private property. It is not, as here in the great capital New York, the vertiginous glass façade reflecting each building to the others. Europe has never been a continent. You can see that by its skies. As soon as you set foot in America, you feel the presence of an entire continent—space there is the very form of thought.

As long cigar shaped clouds sneak over from Hoboken. The storm heading north east across Patchogue, the Hamptons and Sag Harbor.

Donleavy

Cigar of land sitting in the East River.

*Ibid.*

The sun rose somewhere in the middle of Queens, the exact moment of its appearance shrouded in uncertainty because of a cloud bank.

Maxwell, p. 3

On a cloudy morning the sky-scraper district becomes a pattern of slate-colored silhouettes on an ashes-of-roses background.

Irwin, p. 17

The afternoon was gorgeous, with a sky clarified and starkened by white clouds. The 19th-century cast-iron buildings were thrown into handsome relief.

Trebay, p. 78

A dark April afternoon in Washington Square, pulling New York after us over every portal into strange apartments, through the soft nights.

Douglas, p. 58

A gray, grainy vista onto an unmade bed in a room in Queens.

Harris, *Diary*, p. 63

Rain

New York in the rain is an extraordinary place.

Wolitzer

There are fewer suicides in New York when it rains.

Talese, p. 16

A street full of thunder smells of lightning.

ve Poljanski, p. 365

At Broadway and 110th, the windshield wipers screech as they toss the rain from the glass.

Cook, p. 25

The cheap rain
swings the tinfoil leaves
against the bensonhurst wind

Fearing, "Blues," p. 529

Beyond to the northwest a shining head of clouds soared blooming compactly like a cauliflower. Oh if it would only rain. As the thought came to her there was a low growl of thunder above the din of building and traffic. Oh if it would only rain.

Dos Passos, p. 185

Rain smears the light and washes the long straight lines of the buildings into streaky tears.

Conrad, p. 81

Alone at night
in the wet city

O'Hara, p. 33

Imagine a day on Centre Street, overcast and threatening rain; a day through which shuffles flickering tramps like wicks that are dying.

Barnes, p. 305

the cheap rain
lacquers the pavement

Dahlberg, p. 529

There were black spots of rain on the sidewalk and I saw him walking briskly through the crowd wearing a tan raincoat over his inevitable brown get-up; I noted with a shock that he was carrying a light cane. This was his afternoon

Fitzgerald, *Lost*, p. 106

walk, this hurry along with his stick through the gathering rain, and as I was not to meet him for an hour it seemed an intrusion to happen upon him engrossed in his private life.

Lobas, p. 132

As soon as a little rain drizzles down, the lifeless street suddenly turns into a forest of waving hands.

Berger, *New York*, p. 284

Gentleman with high-piled turban in Times Square cutting through wind-blown rain yesterday with plastic cover protecting the turban.

Hapgood, pp. 369–71

The rain that came down about 10 o'clock temporarily scattered the ravenous crowd but by midnight they had returned … Fifth Avenue was wet and like a mirror of reflections and shadows. It was chilly and unfriendly.

Dos Passos, p. 207

A slate sky sagging between the tall buildings was spatting the pavements with fiftycent pieces. Men were running to cover with their straw hats under their coats. Two girls had made hoods of newspaper over their summer bonnets. The rain advanced down the street in a solid sheet glimmering, swishing, beating newspapers flat, prancing in silver nipples along the asphalt, striping windows, putting shine on the paint of streetcars and taxicabs. Above Fourteenth there was no rain, the air was sultry.

Ibid., pp. 235–6

Lightning flickered along the staring rows of dead windows. The rain seethed along the pavements, against storewindows, on brownstone steps … He walked on through Brooklyn. Obsession of all the beds in all the pigeonhole bedrooms, tangled sleepers twisted and strangled like the roots of potbound plants. Obsession of feet creaking on the stairs of lodginghouses, hands fumbling at doorknobs. Obsession of pounding temples and solitary bodies rigid on their beds …

"Golly I'm wet," Jimmy Herf said aloud. As far as he could see the street stretched empty in the rain between ranks of dead windows studded here and there with violet knobs of arclights. Desperately he walked on.

Conrad, p. 175

A metallic clock against a rain-bleared window, with the stormy sky and the smudged downtown towers outside.

Ibid., p. 262

Rain could fall onto the stage through perforated pipes and would then be siphoned into a trough and disposed of; steam, fog, and clouds could be exhaled from nozzles in the floor.

Wolitzer

The falling water serves to give the entire landscape a certain allure that it doesn't have when the pavement is dry and the umbrellas are rolled tight in closets. Flowers planted on the meridians of Park Avenue open up and drink, their color ratcheted up to new brightness. Central Park starts to look pastoral, and the water flooding along the gutters on Fifth Avenue creates a Joycean "riverrun past Eve and Adam" effect, or at very least, a pleasing gurgling noise. The rain is like a cleansing sorbet between courses, those courses being spring and summer.

Ibid.

New York in the rain gives a sense of limited possibilities. New York is largely about limitlessness, and that's why we live here, but it can also be exhausting. When the weather in the city is good, you're expected to partake of all the urban delights available … However, when the weather is bad, you are left within the confines of a sub-city, a smaller, wetter version of New York.

x **Air — Rain**

New York in the rain: the vision of blurry taxi lights up and down Lexington Avenue at rush hour, the view of lightning flaring up over Midtown at night, the kid of manageable drizzle that isn't quite umbrella-worthy, but also can't quite be ignored.

Ibid.

A heavy summer rainstorm had emptied the sidewalks of Greenwich Village. Shortly after 8:00 p.m., the dark rain clouds gave way to a faint image of the twin towers of the World Trade Center.

Duneier, p. 100

The storm never quite seems to break, and it's unsettling. I fiddle about with the papers and books on my desk, try to get some reading done while sitting on the couch, and peer down the street from my fifth-floor window—"a New York state of mind," as Billy Joel would say. I finally decide to go up onto the roof and watch the battle being waged between the wind and a mass of black clouds (how fascinating, these New York roofs, early in the morning or late in the evening or, at moments like this, when the city skyline takes on the semblance of a storm-tossed sailing ship).

Maffi, p. 60

The rain began at nine in the morning. Most New Yorkers welcomed it. It had been a dry spring, warm for May, and the big drops splattered down on the pavements and cobblestone streets like some harsh benediction. It was the season's first thunderstorm. It came from the north, down the funnel of the Hudson Valley, announcing itself in the city with a low rumbling and quick flashes of light … Gutters backed up and made miniature lakes at the curbs.

Bales, p. 1

The light is fading now beneath a curtain of rain and cloud.

Maffi, p. 71

In 1950 during a drought, municipal authorities, abreast of scientific developments, hired a rain-maker to seed clouds above the upstate watershed. A large Park Avenue hotel, built on a site where years earlier a brewery had stood with a spring-fed well, brought in a dowser from rural New England, who located the well with his divining-rod. As a result, the hotel was able to restore air-conditioning to the residents, whose baths continued to be rationed.

Morris, *Incredible*, p. 355

During the long drought in the summer of 1953 I was in the city on a broiling August day. As I walked through the streets I saw fire hydrants pouring forth great streams of precious water. Not giving showers to children, not giving a cooling bath or drink to tired or exhausted people. Just flowing, and the water running in rivers into the sewers. Nobody seemed to notice, much less be indignant or try to turn off the water. Along Broadway at about seven o'clock one evening the water from an open hydrant was up to the hub caps of the parked cars. People looked at the rushing stream at the curb and smiled. It looked so nice and cool.

Atkinson, p. 228

Divining rods won't find leaks through twenty inches of pavement.

Berger, *New York*, p. 77

When it rains in Manhattan, automobile traffic is slow, dates are broken and, in hotel lobbies, people slump behind newspapers or walk aimlessly about with no place to sit, nobody to talk to, nothing to do.

Talese, p. 15

Rain ruins the mascara on the eyes of fashion models who cannot find cabs.

Ibid., p. 16

The only recorded instance of rain on Sutton Place occurred when a scene from a big budget movie was being shot in the vicinity and the script called

Lebowitz, p. 102

for inclement weather. The moment the powerful Hollywood director yelled "Cut!" the rain stopped.

Serviss, p. 62

The moisture collected on all exposed surfaces—on the roofs, the walls, the pavements—until its quantity became sufficient to form little rills, which sought the gutters, and there gathered force and volume. Presently the streams became large enough to create a noise of flowing water that attracted the attention of the anxious watchers at the open windows. Then cries of dismay arose. If the water had been visible it would not have been terrible.

Riesenberg and Alland, pp. 189–90

And, in the rain, the theme is blue, the blue of gray thunderclouds, the metallic nimbus of rain, and the stamp of white. Usually after a hot spell, late in a midsummer afternoon, blue smoke-like threatening clouds, split by flashes of purple fire punctuated by hard salvos, roll over the dark and lit-up city. The sides of tall buildings on Forty-second Street reflect the lightnings and amplify the crashes. The heat grows momentarily more oppressive. Winds gratefully cool, then eddy through the chasms. People run, and when New Yorkers run *en masse*, the site is terrifying. Comes the refreshing deluge, and close and terrifying the bolts, amid sheets of pelting water splashing noisily against glistening walls, cascading into streets far down the overflowing sidewalks, washing out choked sewers, flooding basements.

Jones, *Modernism*, p. 224

I pass out again into gleaming streets after spit rain—what a whirlpool I am— they want my corpse to shave and dangle forth.

Brennan, p. 32

In the summer it rains—sudden summer rain that hammers against the windowpanes and causes the ailanthus to stagger and shiver in gratitude for having enough water for once in its life. What a change in the weather, as the heavy breathless summer lifts to reveal a new world of freedom—free air, free movement, clean streets and clean roofs and easy sleep. Bianca stares at the rain as it streams down the glass of the window. One drop survives the battering and rolls, all in one place, down the pane.

Corbusier, p. 66

Certain strong winds cause the rain to sweep up the side of a skyscraper from bottom to top instead of from the top down. Windows designed for the natural fall of rain were found to be insufficient. It was necessary to modify them.

Wojnarowicz, p. 147

Rain streaking through the spheres of lampposts, making the sidewalks and streets and especially the curbsides boil and foam while taxis sail through it all.

Atkinson, p. 21

The first thing is that no New Yorker wants to pay any attention to rain. We consider rain a nuisance and something to be ignored as much as possible. Most New Yorkers refuse to carry umbrellas, except in a real downpour. Whereas an Englishman considers an umbrella a part of his sartorial make-up and takes one along daily with the pessimistic certainty that there will be rain, the New Yorker will leap into the street while the first drops are already falling and dodge from doorway to doorway in the hope that it is all a mistake. New Yorkers never say, "Well, after all, we need rain." Need rain? What for? The reservoirs may be showing mud at the bottom of their storage beds, crops all over the country may be wilting on stalk and vine, but if rain falls in the City, the New Yorker considers it a personal insult and complains about the dreadful weather.

Ibid., p. 225

It's a scary thought that the entire rainfall of New York for a year is not enough to supply New York City with water for one day.

x Air — Rain

A rainy city below. See the Hudson River and the stony steep ridge of the Palisades. And north past a peek of Central Park and over all the Harlem crazy streets. To the sad unsung gothic splendors of the Bronx.

Donleavy

In rain, or when there are mists floating around, it is still more beautiful; the rain becomes golden water; the skyscrapers vanish halfway up, and nothing more can be seen but the haloes of their cupolas suspended in a colored mist …

Berman, *Town*, p. 124

The rain starts coming down harder. You wonder if you own an umbrella. You've left so many in taxis. Usually, by the time the first raindrop hits the street, there are men on every corner selling umbrellas. Where do they come from, you have often wondered, and where do they go when it's not raining? You imagine these umbrella peddlers huddled around powerful radios waiting for the very latest from the National Weather Service, or maybe sleeping in dingy hotel rooms with their arms hanging out the windows, ready to wake at the first touch of precipitation. Maybe they have a deal with the taxi companies, you think, to pick up all the left-behind umbrellas for next to nothing. The city's economy is made up of strange, subterranean circuits that are as mysterious to you as the grids of wire and pipe under the streets. At the moment, though, you see no umbrella vendors whatsoever.

McInerney, *Bright Lights*, p. 86

It is still raining. Getting a cab is a long shot. Knots of people on every corner wave their arms at the passing traffic. You walk down Seventh to the bus stop, where some twenty souls huddle in the shelter. A bus packed with grim faces goes by and doesn't stop.

Ibid.

I hit New York in the middle of a rainstorm and drove straight to my apartment to change my clothes and down a bottle of beer. As soon as I finished I grabbed a quick bite in a luncheonette and headed back toward the office. The rain was still coming down when I found a parking space two blocks away, so I hopped a cab to save my only remaining suit.

Spillane, p. 182

It was raining harder than before, slanting down against the sidewalk, driving people into the welcome shelter of the buildings. Cars were going past, their windshield wipers moving like agitated bugs, the drivers crouched forward over the wheels peering ahead intently. I backed out of the garage, turned around and cut over to Broadway, following the main stem downtown. The Village should have been crammed with tourists and regulars, but the curbs were empty and even the taxis were backed up behind their hack stands. Once in a while someone would make a dash for another saloon or run to the subway kiosk with a newspaper over his head, but if life was to be found in the Village this night, it would be found under a roof somewhere.

Ibid.

The wind picked up and began throwing the rain around. The few pedestrians left on the sidewalks were huddled under marquees or bellowing for cabs that didn't stop. Every time I stopped for a red light I could see the pale blur of the faces behind the glass store fronts, the water running down making them waver eerily. All with that same blank look of the trapped when nothing can be done to help.

Ibid., p. 295

The rain had turned into a steady drizzle that left a slick on the pavement and deadened the evening crowd.

Ibid., p. 185

There was still a threat of rain in the air. Overhead the clouds were gray and ruffled, a thick, damp blanket that cut the tops off the bigger buildings and

Ibid., p. 186

promised to squat down on the smaller ones. From the river a chill wind drove in a wave of mist that covered everything with tiny wet globules. Umbrellas were furled, ready to be opened any instant; passengers waiting for buses or standing along the curb whistling at taxis carried raincoats or else eyed the weather apprehensively.

Winter

de Torre, "Mental," p. 460 Every winter there's a subversive theoretical cyclone

Strausbaugh, p. vii Bob Dylan: "You could sit on a bar stool and look out the windows to the snowy streets and see heavy people going by, David Amram bundled up."

Van Vechten, pp. 170–2 In midwinter in New York Mei-Lan-Fang introduced his traditional Oriental art to large groups of delighted Occidentals; ten thousand fish, including an eel four feet long, were removed from the Central Park reservoir; Babe Ruth signed a contract with Col. Ruppert to play ball with the Yankees for two more years at a salary of $160,000; the Europa came into port with an ocean record; Webster Hall, on East Eleventh Street, the scene of so many radical balls, burned down; Mrs. Patrick Campbell lectured on Beautiful Speech and the Art of Acting; Anthony Mortelito stabbed the head keeper at Auburn Prison seven times with crude, improvised knife; William Howard Taft died; La Argentinita presented the authentic beauty of Spanish dancing to an unappreciative Broadway audience; Charles Schwab's historic Riverside Drive chateau was sold to an apartment-house builder; the Havemeyer collection of paintings and art objects was opened to the public at the Metropolitan Museum; four thousand persons, trying to get into the Natural History Museum to see a showing of a film developing the Einstein theory of relativity, overturned cases, broke windows and doors, and injured one another; a "modernistic" Childs restaurant was opened on Lexington Avenue; Maurice Chevalier sang Dits-moi, ma mere; the news-reel at the Embassy, a moving picture theater, informed the public pictorially that Sydney Franklin, a Brooklyn boy turned matador, had been gored by a savage bull in the Plaza de Toros at Madrid; the planet Pluto was discovered; Toscanini conducted the Philharmonic Society in the Bacchanale from Tannhäuser, the Ride of the Valkyries, and the Trauermarsch from Götterdämmerung (this last in commemoration of the death of Frau Cosima Wagner) in so superb a manner that hoary-headed music lovers searched their memories in vain for comparisons; Marc Connelly gave God back to the world in The Green Pastures; forty thousand communists, gathered peaceably in Union Square, were trampled down in Cossack fashion by the horses of the mounted police, while children were knocked over the head with clubs; a jury of twelve men was unable to agree concerning the pornographic aspects of a play entitled The Pleasure Man by the ebullient Mae West and as a consequence the defendant regained her precarious liberty; and in an Italian restaurant on Macdougal Street ten canaries, accompanying a performance over the radio, sang in lusty unison the Overture to William Tell and negotiated the high notes in the sextet from Lucia.

The social life of the metropolis also continued. In mid-winter in New York, as in other capitals of the world, a great many dinner, theater, and luncheon parties were given. Guests were invited to formal and informal dances to observe prize-fighting, wrestling, dance marathons, and six-day bicycle races. There were musical entertainments and extended yachting parties which embraced cruises to the West Indies or even to the Pacific, by way of the Canal and the glamour of Panama City. In these respects, perhaps, New York

life did not differ to any great extent from the of other great cities during the season, but in another respect, the matter of cocktail parties, since the laws were passed prohibiting the sale of liquor, it could be said that more were held in one day in Manhattan than in a month elsewhere. A man with an extensive acquaintance, therefore, could drink steadily in New York from the beginning of cocktail time until eleven in the evening without any more expense than that entailed by car- or cab-fare.

A certain kind of winter evening—six-thirty in the Seventies, say, already dark and bitter with a wind off the river, when I would be walking very fast toward a bus and would look into the bright windows of brownstones and see cooks working in clean kitchens and imagine women lighting candles on the floor above and beautiful children being bathed on the floor above that.

Didion, "Goodbye," p. 171

J. and I went up to a street in Harlem just as the winter sky was turning black. Darkened windows with thin bands of watchful light above the sills. Inside, the halls were dark and empty, filled only with the scent of dust.

Hardwick, "Sleepless," p. 936

roaring winter dusks of Brooklyn

Ginsberg, *Howl*, p. 3

At night in the cold winter moonlight, around 1943, the city pageantry was of a benign sort. Adolescents were sleeping and the treat was only in the landscape, aesthetic. Dirty slush in the gutters, a lost black overshoe, a pair of white panties, perhaps thrown from a passing car. Murderous dissipation went with the music, inseparable, skin and bone.

Hardwick, "Sleepless," p. 933

Snow

It's the day before February 17th
it is not snowing yet but it is dark and may snow yet
dreary February of the exhaustion from parties and the exceptional de-
 sire for spring which the ballet alone, by extending its run,
 has made bearable

O'Hara, p. 257

Trucks are salting the streets.

Christopher, p. 203

It was beginning to snow. The flakes are giltedged where they pass the streetlamp. Through the plate glass the Cosmopolitan Café full of blue and green opal rifts of smoke looks like a muddy aquarium: faces blob whitely round the tales like illassorted fishes. Umbrellas begin to bob in clusters up the snowmottled street. The orator turns up his collar and walks briskly east along Houston, holding the muddy soapbox away from his trousers.

Dos Passos, p. 255

The sky above the cardboard buildings is a vault of beatenlead. It would be less raw if it would snow.

Ibid., p. 262

It was a snowy night on the Staten Island ferry as O'Hara traveled in the wintry dark to the reading.

Gooch, p. 386

I remember seeing Auden that winter, on Second Avenue, near St. Mark's Place, shuffling through the snow in his bedroom slippers.

LeSueur

Men in the snow who profit from nature's inclemency by signing on to clear the streets.

Conrad, p. 182

Feininger, *New York*, p. 72 A taxi driver, inspired by the first snowfall brushing its gleaming strands along the lamppost and lighted windows, says, "Let's make believe we're in a gondola—I'll sing to you." He does, in full Sicilian voice and olive-oil quavers.

Blandford, p. 112 There is nothing like a good snowfall to make a New Yorker feel pleased with life. Nothing cheers like the thought of all those wheels turning helplessly out in the suburbs, that land of watered lawns and summer pools. Here in the white, hushed city, everything the heart desires is but a shuffle away along those sidewalks which shopkeepers and doormen are required by law to keep spanking clean.

Dreiser, p. 229 A glimmer appears through the transom overhead, where someone is lighting the night. It sends a thrill of possibility through the watchers. On the old hats and peaked shoulders snow is piling. It gathers in little heaps and curves, and no one brushes it off. In the center of the crowd the warmth and steam melt it and water trickles off hat-rims and down noses, which the owners cannot reach to scratch. On the outer rim the piles remain unmelted. Those who cannot get in the center, lower their heads to the weather and bend their forms.

Ibid., p. 231 Winter days in a great city bring some peculiar sights. If it snows, the streets are at once a slushy mess, and the transaction of business is, to a certain extent, a hardship. In its first flakes it is picturesque; the air is filled with flying feathers and the sky lowery with somber clouds. Later comes the slush and dirt, and not infrequently bitter cold. The city rings with the grind and squeak of cold-bitten vehicles, and men and women, the vast tide of humanity which fills its streets, hurry to and fro so as to be through with the work or need that keeps them out of doors.

Ibid., p. 233 But these men are a bit of dramatic color in the city's life, whatever their sufferings. To see them following in droves through the bitter winter streets the great wagons which haul the snow away is fascinating, at times pitiful. I have seen old men with white beards and uncut snowy hair shoveling snow into a truck. I have seen long, lean, red hands protruding from undersized coat sleeves, doing the same thing. I have seen anemic benchers and consumptives following along illy clad but shoveling weakly in the snow and cold.

Brook, p. 93 Snow had fallen and the city was transformed. The bumps and excrescences of the streets—cars, skips, trash-cans, dogs—had been evened out. The white blanket was the great unifier, obliterating all distinctions of color and putting the brakes on the pace of the city. Traffic did move, but slowly, with headlights picking out the fat white flakes that continued to fall.

Ibid., pp. 93–4 Blizzards are an invitation to anarchy. When the city breaks down, and a blizzard inevitably shreds all the routines of getting about, it's a joy to see it with its guard down. The mechanisms of bustle and traffic are snagged. The webs of communication fray or snap as buses break down, stations are closed, and the airports shut down for two days. The inhabitants of the city gleefully take possession once again, stepping onto the quiet streets, walking unchallenged down the middle of a road that would normally be clotted with traffic. On the cross streets cars are stuck, and there's a whirring of tyres skating ineffectually over hard-packed snow that turns to ice as the rubber compresses it. Fluffy clouds of breath rise from the scarved heads of helpers trying to push a recalcitrant car away from the kerb. A gust of wind drives a few flakes onto the tongue as one opens one's mouth to speak or breath, and

x **Air — Snow**

a delicious freshness invades the moist caverns of mouth and throat. There's laughter too at the prospect of the disruption to come. Offices will close early or not open at all; the radio waves the next morning will be thick with lists of school closures.

Gray snow, which matches the sky, is falling. Wilson, "Thoughts," p. 476
 The gray snow, as soon as it has fallen, begins rising in exhalations.

Don't forget that a *low-ceilinged* town is quite different from a high-ceilinged Vreeland, *DV*, p. 171
city like New York, all cluttered up with bricks and mortar and hideous glass
skyscrapers. New York is really quite meager in a snowstorm.

A snowfall sparks sudden crackling flashes from the third rail of the El tracks. Conrad, p. 132

Snow on the elevated train roaring past down the street. Enter here. Warm Donleavy
and comforting. Snow melting inside my shoe.

New York's lovely weather hurts my forehead Berrigan, *Collected*, p. 740
here where clean snow is sitting, wetly
round my ears.

It was the night of the great snowstorm. The streets of New York, even in Hapgood, p. 205
the dark, were vaguely white, but there was nothing vague about the depth
of the snow for those persons unfortunate enough to wade about in it, nor
was there any doubt in the minds of the three men in the café of a little hotel
near Washington Square that it was comfortable to be where they were.

Space heaters in the Chrysler Building's steeply sloping roof to stop the Moorhouse, p. 52
formation of mid-winter ice which could slide off into Lexington Avenue with
lethal results.

Pennsylvania Station: "They seemed to bring with them the smell of the snow Faulkner, p. 609
falling in Seventh Avenue. Or perhaps the other people who had entered
before them had done it, bringing it with them in their lungs and exhaling
it, filling the arcade with a stale chill like that which might lie unwinded and
spent upon the cold plains of infinity itself. In it the bright and serried shop
windows had a fixed and insomniac glare like the eyes of people drugged with
coffee, sitting up with a strange corpse.
 In the rotunda, where the people appeared as small and intent as ants,
the smell and sense of snow still lingered, though high now among the steel
girders, spent and vitiated too and filled here with a weary and ceaseless
murmuring, like the voices of pilgrims upon the infinite plain, like the voices
of all the travelers who had ever passed through it quiring and ceaseless as
lost children."

A freezing wind descends upon the city from the north. A change in the Maffi, p. 86
weather. Maybe even snow. I realize it has gotten late and start walking
faster. The north wind blows its way along the streets and the odd
snowflake drifts groundward: the evening is beginning to take on a spectral
note. Over the next few days the city will change face. It will be bathed in a
new light, in new tonalities, sounds and scenarios. It will be bewitching and
cruel. The whiteness of the snow and ice will make outlines and volumes
stand out, and it will cover and erase. But in the freeze it will also expose
men and things …

Barnet, p. 226

My first snowfall. I kind of liked it. The first day the snow's very pretty, a blanket of coconut flakes sprinkled over awnings and cars. But then it gets all grimy and hardens to ice on curbs, in puddles, on stoops.

Donleavy

With this snow cleansed air and a fresh change of people.

Ibid.

Traffic crawling through the deepening snow. Abandoned cars little mounds of white.

Singer, p. 279

Snow had been falling. After the snow came rain, then frost. I stood at my window and looked out at Broadway. The passersby half walked, half slipped. Cars moved slowly. The sky above the roofs shone violet without a moon, without stars, and even though it was eight o'clock in the evening, the light and emptiness reminded me of dawn. The stores were deserted. For a moment, I had the feeling I was in Warsaw.

Finney, pp. 115–16

I stood at the window for what must have been half an hour, watching the big flakes whirl past the glass, watching Central Park turn into an etching as the black branches loaded up with white, watching the humps and depressions that marked paths and streets level off and disappear.

Ibid., p. 116

Nothing moved outside now but the snow in the wind, and the silence was complete. Staring down into Central Park, I wondered suddenly if it had also snowed in January 1882.

Ibid., p. 121

The air was sharp in my lungs, and snowflakes occasionally caught in my lashes, momentarily blurring the streetlamps just ahead, already misty in the swirls of snow around them.

O'Hara, p. 393

well if Mayor Wagner won't allow private
cars on Manhattan because of the snow, I
will probably never see her again.

Sanders, *Beatnik*, p. 485

The blizzardy wind made the banner flap over sidewalks so thick with snow that pants legs were whitened to the middle of the shins. It was sieving downward on East 10th near Avenue B, obliterating footprints in a few seconds, and one's attention was turned from the mystery *of* the city to the mystery *above* the city.

Ibid., p. 497

For hours John walked the snow, crisscrossing all the streets from Houston to 12th and First Avenue to C. He who never felt down was feeling a rare gulch of total depression.

Ibid., p. 498

East Side snow slush. Brown rivulets of frosty-freeze surge over the curbs, wherefrom strange bubbles slowly rise amidst a flotage of straws, dog dook, can lids, wrappers, plus, sunken as in quicksand, a slashed chair of wettened plaid, its stuffing the color of a dirty old football, covered with sooty white, and at the curb's edge: rows of dingy tan tire tracks like zippers on a vast spattered cloth.

X Air — Snow

The ground is white with snow.
It's morning, of New Year's Eve, 1968, & clean
City air is alive with snow, its quiet
Driving. I am 33.

Berrigan, *Collected*, p. 163

When it first starts to snow, the round tops of the garbage cans become dramatically white before anything else gets the notion. If you look down on the sidewalks from above, the tops appear to be white holes punched out of the still-dark pavement.

Binzen

Cold

Battling the city's itchy flames, which rage even during winter, Weegee's firemen change into anthropoid icicles. As they aim their hoses, stalactites harden on their helmets and the collars of their uniforms.

Conrad, p. 291

This happens in January on a brilliant, cold afternoon.

Trebay, p. 5

I walked on Madison and it was cold in the shade and warm in the sun. (Tuesday, October 29, 1985)

Warhol, *Diaries*, p. 688

He covers his fields like a fine mist, he's in his home in New York City, he's behind me, it's wet and cold but I like it, like the way it numbs my fingers, makes them white and red at the knuckles.

Wojnarowicz, p. 200

Shivering the air has crept
behind the next street corner.

Parland, p. 346

Rawness, sunshiny rawness down the end streets of the city.

Jackson and Dunbar, p. 679

crossing Saint Mark's Place
face cold in air
tonight
when
that girlish someone waving
from a bicycle
turned me back on.

Berrigan, *Collected*, p. 148

Heating, Radiator

It is wonderfully hot in New York in winter. Temperatures of 75 and 80°F are not uncommon. Outside, of course, it is miserably cold. But after November, the outdoors is merely something one crosses en route to some other indoors.

Blandford, p. 111

It is divisive, this heat. People who work in warm offices and go home to warm apartments meet only those who exist in similarly warm boxes. In winter, the middle classes hibernate.

Ibid.

It's freezing and the heat's not coming up.

Warhol, *Diaries*, p. 536

The boiler was broken and it was freezing in there. And I want to take the key away from those two bathrooms outside my office because every other minute somebody's going in and out and I can't stand it, the constant production of peeing all day. (Wednesday, November 7, 1984)

Ibid., p. 613

Ibid., p. 641 And there's a radiologist in the building next door to me. He just bought a million-dollar machine and they had to knock a wall out to get it in, and I keep wondering if the radium stuff can get to me, because we share steam heat. Everybody says the machines are "foolproof." (Thursday, April 11, 1985)

Spring

Gold, p. 16 Spring excited us. The sky was blue over our ghetto. The sidewalks sparkled, the air was fresh.

Donleavy It's showing signs of spring. A heavy rain the like of that washes the winter away. Won't be long now till we're scalding fried eggs on every street corner.

Berrigan, *Collected*, p. 488 It's just another April almost morning, St. Mark's Place

Blandford, p. 28 This morning, as predicted by the WQXR weather bulletins, there was precipitation and the wind chill factor eased. In short, it has been wet and warm. With the last vestiges of yellow-stained snow and grime encrusted ice washed away some weeks ago now, the denizens of West 86th Street have emerged from hiding to greet their corner of the world.

Van Vechten, p. 237 Spring in New York is as attractive as spring anywhere else, but her appearance has a peculiar effect on the inhabitants of Manhattan Island. Every true Englishman returns to England to enjoy the English spring, but when the buds begin to burst and the birds begin to warble and trill in New York parks every real New Yorker longs to travel. Hamish then was quite within the tradition when, strolling up Madison Avenue on a heavenly spring day, he was filled with nostalgia for the countries he did not belong in. The Sheffield plate and Georgian silver in one window, the Venetian glass in a second, the Russian samovars in a third, and the Czechoslovakian peasant blouses in a fourth, made him sigh in turn for Mayfair, the Grand Canal, the Kremlin, and the Moldau, and it occurred to him that he should immediately book his passage to one of these places.

Cheever, "Moving," p. 805 It was in the spring and there was a heady, vernal fragrance from Central Park, for in New York the advance of the seasons is not forgotten but intensified. Autumn thunderstorms, leaf fires, the primeval stillness that comes after a heavy snowfall and the randy smells of April all seem magnified by the pavings of the greatest city in the world.

LeSueur, p. 298 As I watched Frank and Larry heading toward Broadway and Tenth Street, with Frank resolutely leading the way, I suddenly became aware of the weather. It was especially beautiful, almost balmy, and since it was still the shank of the evening and I felt horny—nice weather always had that effect on me when I was younger—I saw no reason why I shouldn't go cruising.

Didion, "Goodbye," p. 174 Walking uptown in the mauve eight o'clocks of early summer evenings and looking at things, Lowestoft tureens in Fifty-seventh Street windows, people in evening clothes trying to get taxis, the trees just coming into full leaf, the lambent air—all the sweet promises of money and summer.

Blandford, p. 28 And so this year there was no spring. One moment it was chilly and then over night the limp, humid heat of summer sank into the city.

Summer in New York is a season passed in hell. Conrad, p. 291

On the first hot, humid day of summer, when the air is so wet that it almost Blandford, p. 181
is impossible to breathe and the sun turns tinted hair a faint shade of orange,
the ladies of New York vanish from its streets. They linger in air-conditioned
apartments and scurry between icy stores where they do battle over skimpy
T-shirts in which they will later freeze. The sound of their summer greeting
is of high-heeled shoes clicking impatiently across marble floors and white
patent bags snapping shut.

With daylight saving, daylight dining begins, and an orchestra plays the Beaton, *New York*, p. 41
March from *Aida* at night in the Lewisohn Stadium. Everybody is sunburnt.
Those who must remain in the city think only of trying to keep cool. Sweat
pours from the forehead, neck, waist, temples and arms, as in a steam-room;
and several times a day the shirt must be changed. Children lie naked in the
streets, waiting for the watercarts to come past and spray them. Journalists
fry eggs on the pavement. People go to the cinema not so much to see the film
as to feel the violent chill of the air-conditioned movie-houses (and very likely
to come out with pneumonia). Another cold bath is drawn; even the ice-cream
no longer tastes cool, and there is nothing for it but to leap from the window.
Every Saturday and Sunday, eight hundred thousand people come to bathe at
Coney Island, reached by subway in half an hour.
 I went to Coney Island with Jean Cocteau one night. It was as if we had
arrived at Constantinople—the electric bulbs silhouetting the minarets,
domes and turrets, illuminating the skeletons of the scenic railways and Eiffel
Towers. The passengers on the roller-coasters, rending the air with their
concerted screams, were so many muezzins calling the azan. Cocteau, like
many great personalities, manages to create a world of his own wherever he
goes, so vivid and personal that those with him can share the surprises of
his impressions; and one wondered why the popcorn had never been put to
use as confetti before, and why one had not realized that it must have been
he who designed the waxwork booths of magic and squalor combined, the
backgrounds of the "quicktime" photographers and the unique architecture of
the "Haunted House."

It is a hot day. The citizens of the biggest city in the world suffer with Mitchell, *Ears*, p. 183
the heat-jitters. In tenement windows tired wives rest their stout elbows
on pillows and stare blankly at the raucous elevated trains. High-priced
blossoms in the show-windows of Fifth Avenue florists are shriveled. Subway
guards, sweating in their heavy blue coats, mutter surly curses and push
people into the hot cars.
 It takes ten beers to quench one's thirst. The damp, insistent heat has
placed blue lines beneath the eyes of subway passengers. The flags on the
skyscrapers are slack; there is no breeze.
 Drowsy citizens stand in wet garments beneath the most popular
thermometer in town—the giant in front of the Pulitzer Building on Park
Row—and watch, fascinated, while the mercury climbs inexorably into the
nineties. The asphalt in the streets is so soft that heels leave their marks in
it. When two people meet one is almost certain to inquire, inanely, "Is it hot
enough for you?"
 Summer has the city in a stranglehold.

High heat creates irrational solutions: linen suits that collapse into deep Miller, "Before," p. 26
wrinkles when one bends an arm or a knee, and men's straw hats as stiff as

matzohs, which, like some kind of hard yellow flower, bloom annually all over the city on a certain sacred date—June 1st or so. Those hats dig deep pink creases around men's foreheads, and the wrinkled suits, which are supposedly cooler, have to be pulled down and up and sidewise to make room for the body within.

Granick, p. 58 For the first time in the recorded history of the Temperate Zone, architects began erecting buildings without chimneys. It is cheaper to buy steam than to make it.

Conrad, p. 103 Mean rooftops, fire escapes, and untenanted windows. The most that can be hoped for from outside is a cooling breeze to make one's imprisonment more bearable.

Lee and Jones They sit on a fire escape, trying to keep still, trying to find a cool spot in the shade. No one says a word.

Roche, p. 404 Summer malaise in deserted neighborhoods.

Conrad, p. 161 In the heat, the residents take their lives outdoors. Washing is strung on fire escapes or across the courtyard between buildings. A fat woman uses her windowsill as a patio. The window is equipped with a sagging grate, into which one of her pudgy arms just fits. Its purpose is to repel intruders, but she's pressing against it from inside, employing it as an alfresco room for socializing, as she's seen doing with a neighbor who pauses on the stoop. She's an adipose overspill from inside the house, as are the plants in window boxes in another of these photographs. The room within seems to be a summer garden, a seething hothouse where things grow so riotously that they spread across the sill and send roots trailing into the street to tease the pavement. The people clustered round the stoop have annexed the street as a gregarious sitting room. The children playing with dolls and comic books domesticate the pavement, erecting there a fantasy house which, to accommodate the camera, is transparent. One of the girls wears a toy stethoscope and is supplying medical services to the dolls.

Blandford, p. 28 Sunshine makes him restless.

Huncke, p. 60 New York was exceedingly hot that summer of 1943. The heat had settled down over the city in a huge blanket. The days were long and humid, and nobody was any more active than was absolutely necessary.

O'Hara, p. 325 and I am sweating a lot by now and thinking of
leaning on the john door in the 5 SPOT
while she whispered a song along the keyboard
to Mal Waldron and everyone and I stopped breathing

Blandford, p. 29 By three o'clock when the hot and smoggy air hangs over the corner, his ice starts to melt, running down his boots and into the road.

LeSueur, p. 13 The old, now defunct Greyhound terminal off Times Square, the acme, the crown jewel, of all the vile bus stations, and especially hellish now because of the foul air and stultifying heat of the city in midsummer.

Finney, p. 267 Pausing to check the temperature at Hudnut's giant thermometer.

The sun already hot simmers slantily on the pavements, on plateglass, on dustmarbled enameled signs. Men's and women's faces as they pass her are rumpled and gray like pillows that have been too much slept on.

Dos Passos, pp. 240–1

I am sitting at the moment in a stifling hotel room in 90-degree heat, halfway down an air shaft, in midtown. No air moves in or out of the room, yet I am curiously affected by emanations from the immediate surroundings.

White, *Here*, p. 19

He finds New York alluring on summer Sunday afternoons, over-ripe, as if all sorts of funny fruits were going to fall into your hands.

Conrad, p. 197

"New York has been like a blazing furnace for the last two days," Crane reports in June 1923. Yet the temperature vouchsafes him "the intense and interesting spectacle of the streets."

Ibid., p. 228

A hot sun shining in slits along the crosstown streets.

Donleavy

In the dead of this stifling June night in the back of the taxi it hits me that I'm still wearing the bloody raincoat.

Ellis, *Psycho*, p. 218

A burning Broadway movie house happens to be playing *The Heat's On*, a 1943 Mae West musical.

N. cit.

Weegee sought out people being treated for sunburn or heat exhaustion under the boardwalk at Coney Island—casualties of the city's grilling.

Conrad, p. 291

The heat hit us like a blast from a furnace. The air was dead … The town smelled like rotten eggs.

Ibid.

The heat afflicting New York sours and rots it. At the same time, it's an agency of benefit. It cauterizes, immunizes, insures the city. Heat disintegrates but also disinfects. Cooking its inhabitants, the sweltering city leaves them with that unfeeling rind which is the existential bravado of the 1940s: they become, as New York already is, hard-boiled. Hard-boiling is a torture of matter, a chemical inducement of molecular disorder, altering a physical state from liquid to solid. It's an experiment that can preserve by a calculated self-extermination.

Ibid., p. 294

On August 13, 1975, at 3:00 PM, the temperature on Fourteenth Street and Eighth Avenue was ninety-four degrees—the humidity 85 percent. On the exact same date and same time the temperature on Seventy-third Street and Fifth Avenue was a balmy seventy-one degrees—the humidity a comfortable 40 percent. I know, because I was there.

Lebowitz, p. 102

The heat jiggles along every street,
Reverberates from the scorching pavement,
Hot brick walls, stone walls and side walks—
Runs everywhere
With licking-hot, laughing tongues
Driven by the sun.

Harris, "City Heat," p. 532

Summer is the great equalizer; there is no way to buy stage presence or a sense of theatre and that, after all, is what street life is about—it's a gigantic theater without walls.

Blandford, p. 115

Lee and Jones	The Block begins to awake from its slumber, ready to deal once again with the heat of the hottest day of the year.
Blandford, p. 117	In summer the magic people come out to play on the streets. The worthy ones, bankers, businessmen, middle-aged sturdies, are shut away behind the throb of air-conditioning, off in the country, gone to Europe or Colorado. This is the special time that young and old come out of hiding to live out their fantasies on hot, hard sidewalks from which they have no escape.
Donleavy	This morning's sunshine came down the street bright and fresh.
Blandford, p. 117	Suddenly the city is covered in chairs.
Ibid., p. 119	And as the life of the summer streets hums and bustles through the image of dusk, it is possible to pretend, just for a second, that Manhattan is indeed some far away island where all is harmony.
Lee and Jones	Even though the white-hot sun is gone, nonetheless the heat is still stifling. And in a peculiar, funny sort of way, it's worse. You expect it to be hot during the light of day when the sun is beating down on the cement and tar, but at night it should be considerably cooler; well, not tonight, it's hot. All the people WE'VE SEEN throughout the day are now coping with the night-time heat, plus it's *humid as shit*. Everyone is outside, sitting on stoops, on cars and you know the kids are playing, running up and down the block. Now it's *the hottest night of the year*.
Mitchell, *Ears*, p. 189	The plentiful inhabitants of the Lower East Side sit on the shady side of their disheveled streets and make no unessential motions. No breezes stir.
Blandford, p. 182	Watch the New York ladies when forced momentarily into the stifling air. Feet swell in ungiving shoes that were bought in another of those icy stores. Hair sags, faces draw. Linen skirts crumpled from damp taxi rides, they still try to maintain a perfection that is beyond reason. Steps never slacken, bodies rigidly deny the very existence of languor. They run the obstacle course in full dress. All is armor. Ungracious anger becomes a shield.
Dreiser, p. 3	A May or June moon will be hanging like a burnished sliver disc between the high walls aloft.
Brook, p. 2	The windows were rolled down to air out the sweltering cab. It was 80 degrees and the heat bounced off the concrete and mingled lushly with the exhaust fumes.
Brook, p. 16	New York can render you invisible, it can seem oppressive beyond endurance. In the summer especially, with the heat, already in the 90s, amplified by high humidity and the stifling air trapped by the buildings and the street tarmac softening underfoot.
Puzo, p. 3	He cantered through the hot summer night, his desert a city of stone.
O'Hara, p. 325	perfect in the hot humid morning on my way to work
Kapralov, p. 88	Oh, yes, today the streets are also melting.
Dreiser, p. 100	It was the close of summer. The great mountain and lake areas to the north of New York were pouring down their thousands into the hot, sun-parched city.

X Air — Summer

Oh boy, it's now ninety-six degrees and still rising. Not a single leaf moves above us, not one pigeon, not one squirrel. The dogs lie ominously quiet, perhaps they are already boiled. Even the concrete of our chess tables is hot. The tall cans of Rolling Rock which we buy at the Arab bodega on Avenue A become undrinkable in exactly seven minutes.

Kapralov, p. 87

At the corner of Third Avenue he stopped and stood shivering in the hot afternoon sunlight, sweat running down behind his ears.

Dos Passos, p. 158

A South African gentleman once told me that New York in August was hotter than any place he knew in Africa, yet people here dressed for a northern city. He had wanted to wear shorts but feared that he would be arrested for indecent exposure.

Miller, "Before," p. 26

It is widely believed that in the summer rich people leave New York to go to Southampton because the weather is cooler there. This is not true. What actually happens is that in the summer the cooler weather leaves New York and goes to Southampton because it doesn't want to stay in New York with a lot of underpaid writers and Puerto Ricans.

Lebowitz, p. 102

apartments all heat-roached and sticky with summer weather

Wojnarowicz, p. 25

Anybody can insult New York with complete impunity. No New Yorker ever resents it. We have no local pride. Say to us, "You have, without doubt, the vilest climate on earth," and New Yorkers will eagerly agree. "You just can't believe how hot it was here last summer," we will tell you. "It broke all records. We were all gasping like grounded fish. It was terrible!"

Atkinson, p. 18

Visibility and climate affect each other in ratios of loveliness.

Kozloff

In the summer, there is somehow a lightening of earnestness.

Atkinson, p. 214

On some nights New York is as hot as Bangkok. The whole continent seems to have moved from its place and slid nearer the equator, the bitter gray Atlantic to have become green and tropical, and the people, thronging the streets, barbaric fellahin.

Bellow, *Victim*

The summer of 1912 in Brooklyn: serene.

N. cit.

Right now, folks, we're gonna suspend the narrative and show how people are coping with the oppressive heat.
People are taking cold showers.
Sticking faces in ice-cold, water-filled sinks.
Heads stuck in refrigerators.
A wife tells her husband, "Hell no, I'm not cooking. It's too hot. The kitchen is closed."
Men downing six-packs of ice-cold brew.
Faces stuck directly in front of fans.
A young kid cracks an egg on Sal's Cadillac. The moment the egg hits the car hood it starts to cook.
And how can I forget the papers, the newspaper headlines.
New York Post: "A SCORCHER"
New York Daily News: "2 HOT 4 U?"
New York Newsday: "OH BOY! BAKED APPLE"
New York Times: "RECORD HEATWAVE HITS CITY"

Lee and Jones

Marquis, p. 109	Entering New York Harbor for the first time, Duchamp recalled being dumbfounded by the heat: "I thought there must be a fire somewhere."
O'Hara, p. 335	I walk though the luminous humidity
Blandford, p. 11	Humidifiers go day and night to counter the effect of tropical central heating.
N. cit.	It is a trite but true observation of the weatherman that humidity makes more difference to humanity than does torridity. The high percentage of moisture in the air induces a depressed and languid feeling in summer. There can be no satisfactory lowering of a room's temperature for human comfort unless this humid factor is considered.
Sullivan, *1001*, p. 64	The night was oppressive ... one of those New York summer evenings when even the walls seem to sweat ...
Barnes, p. 22	How slow the city is in summer.
Harris, "City Heat," p. 532	Soughing swamp breathings In the pestilential city.
O'Hara, p. 325	I walk up the muggy street beginning to sun and have a hamburger and a malted and buy an ugly NEW WORLD WRITING to see what the poets in Ghana are doing these days
Conrad, p. 291	The city perspires through opened hydrants.
Weegee, *Naked*, pp. 110–11	Escape from the heat ... these tenement people opened up the water hydrant ... placed a barrel over it ... and got cooled off. But a cop came around and shut the hydrant off ... As soon as the cop leaves ... the hydrant will be opened up again.
Depero, "Coney Island," p. 422	Fetid heat of August with fecundity at play.
Morley, *NY*, p. 208	The first "heat wave" of the season had arrived and everyone was thinking of the Decoration Day weekend. The thermometer in New York City went to 85 the preceding afternoon and there were one death and one prostration.
Serviss, p. 61	Everybody had noticed the excessive humidity of the dense air. Every solid object that the hands came in contact with in the darkness was wet, as if a thick fog had condensed upon it. This supersaturation of the air (a principal cause of the difficulty experienced in breathing) led to a result which would quickly have been foreseen if people could have had the use of their eyes, but which, coming on invisibly, produced a panic fear when at last its presence was strikingly forced upon the attention.
Donleavy	Double parked. In the humid afternoon. Taxis squeal by as doormen's whistles blow. A haze covering the sky. To make more thunder clouds collect in the west.
Harris, "City Heat," p. 533	From out the city Oozes forth A sticky, cloying, stinking thickness, Sucked to the surface By the sun.

X Air — Summer

Things are hot. It's summer on the streets of New York.

Blandford, p. 117

Fall

It is a street with trees that in the summer make cool patterns on the pavement; but now the leaves were yellowed and mostly down, and the rain had made them slippery, they skidded underfoot.

Capote, p. 9

"April in Paris" is a fiction, but "Autumn in New York," by the same songwriter, is a glorious fact.

Gopnik, p. 73

River-watching along the eastern edge of Manhattan can be a desultory pleasure these autumn days, especially toward evening when the sky is changing and the wind coming off the water is often strong and cool.

Philips, p. 125

October's in the air, in the Indian Summer sun of door.

Kerouac, *Lonesome*, p. 105

this October sixth, in New York City
during the nineteen eighties

Joseph, p. 191

Weather

In New York there are certain wonderful seasons in which this feeling grows to a lyrical intensity. One of these are those first tender days of Spring when lovely girls and women seem suddenly to burst out of the pavements like flowers: all at once the street is peopled with them, walking along with a proud, undulant rhythm of breasts and buttocks and a look of passionate tenderness on their faces. Another season is early Autumn, in October, when the city begins to take on a magnificent flash and sparkle: there are swift whippings of bright wind, a flare of bitter leaves, the smell of frost and harvest in the air; after the enervation of Summer, the place awakens to an electric vitality, the beautiful women have come back from Europe or from the summer resorts, and the air is charged with exultancy and joy.

Jackson and Dunbar, p. 569

Finally, there is a wonderful, secret thrill of some impending ecstasy on a frozen Winter's night. On one of these nights of frozen silence when the cold is so intense that it numbs one's flesh, and the sky above the city flashes with one deep jewelry of cold stars, the whole city, no matter how ugly its parts may be, becomes a proud, passionate, Northern place: everything about it seems to soar up with an aspirant, vertical, glittering magnificence to meet the stars. One hears the hoarse notes of the great ships in the river, and one remembers suddenly the princely girdle of proud, potent tides that bind the city, and suddenly New York blazes like a magnificent jewel in its fit setting of sea, and earth, and stars.

Above all, there is the sky; pervading all these activities is the weather. The sharp crystalline days of early autumn, with intense blue sky and a few curls of cloud, drifting through space like the little jets of steam that were once such characteristic outlets of the older skyscrapers: the splendors of sunset on the waters, over the Palisades, crossing the Brooklyn Ferry, looking toward the Jersey shore from the Brooklyn Bridge; the swift, whiplike changes from heat to cold, from fog to clarity, from the sharp jeweled contours of Bellini to the soft tones of Whistler and Fuller. Occasionally, too, the sulphurous hell of the dog days, to whip up appetite for the dank clouds in the west and the brave crackle of lightning and the drenching showers. At the

Mumford, *Empire*, pp. 28–9

other extreme the benignity and quiet of a city quenched by snow: the jingle of sleighbells in the 1890's, the cold flash of electricity on the elevated tracks twenty years later.

No matter how great the confusion on the surface, beneath it all, in the rocks themselves, is order: no matter how shifty man's top layer, the foundations are solid. If the streets are dingy, there is the dazzle of the sky itself: if the alleys and yards are foul, heavy with ancient dirt, with the effluvia of the sewers or the factories, there is the sanative taste of salt in the first wind that blows from the Atlantic. The cold sea fog in spring, sweeping inland in the mid-afternoon, calls one to the ocean as imperatively as the proud, deep-throated roar of the steamer, claiming the channel as she passes out to sea. So the ocean and the sky and the rivers hold the city in their grip, even while the people, like busy ants in the cracks and crevices, are unconscious of these more primal presences, save when they read a report in the morning paper, and reach for an umbrella, an overcoat, a fan.

Van Vechten, p. 137

The city of New York is difficult to describe or understand save in terms of paradox, and so, perhaps, it is more satisfactory, for those who may, to instinctively feel the metropolis rather than to attempt to comprehend her. Not infrequently some of the balmiest days of the year there fall in January and February. Buds are nearly ready to burst on the boughs of the trees in the Park, and the birds are tempted to return from the south. The temperature become so impressive that electric fans and filmy garments are sought from store-closets, but no sooner have they been discovered than a passing and perverse breeze ushers in another week of winter. Snow or rain or sun may follow: there is no means of determining by precedent. Some of the coldest days in the year are likely to happen in June or July. It is strange that Americans have never adopted the English habit of carrying umbrellas, for New York is quite able to produce a cloud-burst out of the sky on the most clement day. When, however, the sun shines in New York, be it warm or cold, the heart is happy, and it is probable that the sun shines more often there than in any other capital of the world.

Henderson, pp. 17–18

In all weathers, in all seasons, at all times of day or night, the island, from whatever point of observation, is a thing of wonder and delight. In the early morning it shines and glistens in the dazzling sun; its walls giving back white effulgence in marvelous contrast to the blueness of an habitually cloudless sky, and the deeper note of constantly agitated waters.

Mittlebach, p. 1

And the weather—hot or cold, stormy or clear—is viewed askance, not as a meteorological phenomenon, but as a hindrance to the morning commute.

Koolhaas, p. 91

We shall have perfect control of the atmosphere, so that there will be no need of going to Florida in the winter or to Canada in the summer. We shall have all varieties to order in our big buildings of Manhattan.

Conrad, p. 77

The city manufactures its own alternative seasons indoors.

Mittlebach, p. 7

New York City is on the track of almost every major weather system in North America. We are blasted by frigid winter air from Canada, struck by coastal storms from North Carolina, parched by heat waves from the Midwest, and even bombarded by hurricanes that start off of the coast of Africa.

Warhol, *Diaries*, p. 681

Watched Hurricane Gloria all morning on TV because there was nothing else to watch. For some reason they decided to cancel the Today Show

X Air — Weather

and everything to bring constant storm updates and they made it sound so horrible. But then it never really hit New York. (Friday, September 27, 1985)

As an unseasonably warm day became evening, a wind blew in from the north carrying spooky gray clouds across the hangnail moon. The temperature dropped with the barometer, and the sudden change made people giddy.

Trebay, p. 291

Awnings begin to disappear from city apartment houses as building managers find it hard to find men to put them up in the spring and take them down in the fall.

Trager, p. 537

David Tudor and I took a taxi down town. He was going to Macy's; I was going on to West Broadway and Prince where I get my hair cut. After David Tudor got out, I began talking with the driver about the weather. The relative merits of the Old Farmers' Almanac and the newspapers came up. The driver said they were developing rockets that would raise the weatherman's predictions from 50 to 55 per cent accuracy. I said I thought the Almanac starting from a consideration of planets and their movements, rather than from winds and theirs, got a better start since the x-quantities involved were not so physically close to the results being predicted. The driver said he'd had an operation some years before and that while his flesh was dead and numb, before the wound healed, he was able to predict weather changes by the pain he felt in the scar, that when the flesh lost its numbness and was, so to speak, back to normal, he could no longer know in advance anything about changes in weather.

Cage, *Indeterminacy*

The pace of this city is forged in its chilled seasons—rushing and bustling, invigorated by the challenge of a harsh climate and harsher people. It would make sense for New York to live on two time clocks—one for the urgency of its winter months, another for the stupor of its heat. It is, however, part of its tradition to make no allowances for weather. For those who can afford heat and air-conditioning, protection from its reality, weather simply does not happen. It is a rude noise made at a polite dinner table.

Blandford, p. 182

Its climate is a scandal.

Maffi, p. 75

The blind were forgotten in this big city of Conversation about The Weather.

Talese, p. 43

There was an earthquake Sunday night at 8:40 in New York. And we had one last year, too. It's really scary. I thought Manhattan was built on the stuff that wouldn't have it. (Monday, April 23, 1984)

Warhol, *Diaries*, p. 568

Generally speaking, the weather is better on the East Side than on the West Side. All in all, the weather considered this arrangement satisfactory except for the problem posed by the better buildings on Central Park West. The problem was solved by means of a trade-off with certain buildings in the East Seventies that are largely populated by beyond-their-means airline stewardesses and the proprietors of leather boutiques. Thus the San Remo and the Dakota receive weather appropriate to their architecture and airline stewardesses and the proprietors of letter boutiques are perhaps are among those who most fully understand the meaning of the term "fair-weather friend."

Lebowitz, p. 102

x Air — Weather

Riesenberg and Alland, p. 28

This city, with its quivering prismatic lights, changes face, as the hours change with the sun and stars; snow, rain, smoke, and the pluming of steam waved by the wind.

Crosby, p. 9

A significant change in our climate to one of a very different rainfall or temperature would have a dramatic effect on all our social structures.

Morand, p. 192

It is neither hot nor cold nor damp, there is only one latitude left, the latitude of pleasure.

I once stood within a few feet of one of the city's most tragic suicides. I was walking through East Forty-sixth Street, having crossed Vanderbilt from Madison. It was high tide in the wave of self-destruction; 1,595 was the official tally for that year of 1932. A noon-hour crowd filled the Midtown streets. The copper-red sun shone through the blue humid air. For a moment the summertime city hushed, one of those pauses in its roar more imaginary than real. Then, all of a sudden, piercing shrieks volleyed from high office windows. I jerked upward. The cries came from the blanched faces of a great gallery of office girls, sitting at open windows. A gray figure, arms and legs waving, was involved in grotesque somersaults. I jumped backward. The body missed me and cleared two young women, a matter of inches—they fell from fright. A worn-thin suit hit the sidewalk near the curb, landing with a bone-cracking thud. It flattened as if filled with a huge lump of subsiding putty. A stream of sluggish blood oozed from under its matted gray hair. The cries stopped; a crowd pressed close, whistles screeched. Then, ghastly afterthought, his raffish hat, an old straw skimmer, circled gaily to the street, landing near the bleeding head.

Riesenberg and Alland, p. 50

In May 1947, *Life* magazine devoted a full page to a picture taken by a photography student named Robert Wiles. The photograph is extraordinary in several ways—not least because it remains, seven decades later, one of the most famous portraits of suicide ever made … The woman in the photo was 23-year-old Evelyn McHale. Not much is known of her life, or of her final hours, although countless people have put enormous effort into uncovering as much about the troubled, attractive California native as they possibly could … In Wiles's photo, Evelyn (it doesn't feel right to refer to her as "Ms. McHale") looks for all the world as if she's resting, or napping, rather than lying dead amid shattered glass and twisted steel. Everything about her pose—her gloved hand clutching her necklace; her gently crossed ankles; her right hand with its gracefully curved fingers—suggests that she is momentarily quiet, perhaps thinking of her plans for later in the day, or daydreaming of her beau.

Cosgrove

For its part, *Life* magazine captioned the picture with language that veers strikingly from the poetic to the elemental: "At the bottom of Empire State Building the body of Evelyn McHale reposes calmly in grotesque bier, her falling body punched into the top of a car."

A single paragraph, meanwhile, describing how the scene came about is at once unsentimental and elegiac:

On May Day, just after leaving her fiancé, 23-year-old Evelyn McHale wrote a note. "He is much better off without me … I wouldn't make a good wife for anybody," she wrote. Then she crossed it out. She went to the observation platform of the Empire State Building. Through the mist she gazed at the street, 86 floors below. Then she jumped. In her desperate determination she leaped clear of the setbacks and hit a United Nations limousine parked at the curb. Across the street, photography student Robert Wiles heard an explosive crash. Just four minutes after Evelyn McHale's death Wiles got this picture of death's violence and its composure.

Death by suicide was another morbid theme that haunted Warhol, who now sought photographs of people in the act of or shortly after killing themselves. His friends scourged magazines and newspapers for him and came up with pictures that led to paintings such as *1947 White*. The image derives from a 1947 photograph of a young model who had jumped from the eighty-sixth floor of the Empire State Building, landing on a car. (The artists' source was a tearsheet from the January 18, 1963, New York regional edition of *Life*, which featured a brief history of the Empire State Building; the photograph first appeared in the April 12, 1947, issue of the magazine.) She lies as if in repose

Bourdon, p. 154

atop the crumpled roof of the automobile, her gloved hands raised gracefully toward her unblemished face. Only the bunched stockings at her ankles provide a clue to the violence of her demise.

Brooks, *In the City*, p. 58

One day, a woman bustling off to a meeting in midtown is struck by the errant arm of an elderly man who has jumped from the building above her. She crumples to the ground but survives. *You hear stories about debris falling,* she notes, *but you never hear about people falling.*

Donleavy

And my short wave says there's someone ready to jump down on Fifth and Fiftieth. If the snow stays and gets any deeper they'll be a lot more. They go out the windows like popcorn off a red hot pan. Happens every time there's a blizzard.

Ellis, *Epic*, pp. 533–4

There was much talk of suicide. A favorite joke concerned a hotel clerk who asked guests if they wanted a room for sleeping or jumping.

Donleavy

This jumper could be a prospective customer. Who may have to be cleaned off the street. Unless he's on the sixteenth floor of a doll's house. Might get embedded in the roof of a car. Or land on five pedestrians.

Conrad, p. 182

Consumption by one of these oblivious elements can seem a mercy: the purpose of the city's rivers is to wash away the biologically unequal despairers who drown themselves there.

Crisp, p. 122

Final Exit is a handbook for anyone wishing to commit suicide. This was sent to me by a Mr. Hofsess who, some years ago, came to New York, like the rest of us, in the hope of ruling the world.

Brooks, *In the City*, pp. 59–60

One week a visitor sets out to claim a world record, scaling five city bridges in four hours. He's climbed in public before in other places, he's famous for it. He chooses to begin his challenge here with the most celebrated of the group, an elegant but unforgiving structure that claimed its own designer before the last stone was set in place a hundred or some years earlier. This time, it's no contest, the climber loses his footing soon after he starts up and slips downward, his glide impossible to arrest.

No one records the fall itself, but there's a picture in the paper of the empty alleyway where he landed.

Depero, "Coney Island," p. 422

A million strangled deaths of trapped souls.

McCourt, p. 21

Barbara Stanwyck lay strangled on her bed on Sutton Place while the BMT rumbled over the Queensboro Bridge.

Conrad, p. 285

Sauntering down Broadway in the spring, he feels death near and, knowing it's not good to lie dead in the street, hurriedly buys a ticket for a movie and quietly seats himself inside to await his fatal seizure.

Huxtable, *Goodbye*, p. 18

Come and get it before it is too late. This seems like a death-wish city.

Sharpe, p. 335

Here, even the sky is dead.

Torres-Padilla and Rivera, p. 44

The skyscrapers seem like tall gravestones.

Dreiser, p. 1

It was an amazing city, so far-flung, so beautiful, so dead.

Do corpses walk around on Broadway?

Singer, p. 283

Interviewer: When did you start with the "Death" series?

Swenson, p. 19

Andy Warhol: … I realized that everything I was doing must have been Death. It was Christmas or Labor Day, a holiday, and every time you turned on the radio they said something like, "Four million are going to die." That started it. But when you see a gruesome picture over and over again, it doesn't really have any effect.

When President Kennedy was shot that fall, I heard the news over the radio while I was alone painting in my studio. I don't think I missed a stroke. I wanted to know what was going on out there, but that was the extent of my reaction.

Warhol, *POPism*, p. 78

It seemed like no matter how hard you tried, you couldn't get away from the thing. I rounded up a bunch of people and got them to come over and we all went out to one of the Berlin bars on 86th Street for dinner. But it didn't work, everyone was acting too depressed. David Bourdon was sitting across from Susi Gablik, the art critic, and John Quinn, the playwright, and he was moaning over and over, "But Jackie was the most glamorous First Lady we'll ever get … " Sam Wagstaff, down from the Wadsworth Atheneum in Hartford, tried to console him, and Ray Johnson, the artist, kept dipping dimes into the mustard we were using on our German frankfurters, then going out to drop the mustard-covered dimes into the telephone slot.

The assassination of JFK: At Stuyvesant Station on 14th Street taxis were beginning to stop in the middle of the street. People stepped from the sidewalks to crowd around them, demanding the drivers turn up their radios. Pay phone circuits went dead. There was shouting, there was weeping, there was anger, there was disbelief.

Sanders, *Beatnik*, p. 411

Lee Harvey Oswald lived in New York—first on East 92nd Street in Manhattan, later on Sheridan Avenue and then East 179th Street in the Bronx—from August 1952 to January 1954, leaving for New Orleans almost a decade before the Kennedy assassination.

Goldenberg, pp. 25–6

In 1899, America's first auto fatality occurred when a sixty-eight-year-old real estate broker, named Henry H. Bliss, was knocked down as he stepped off a southbound streetcar at Central Park West and Seventy-fourth Street.

Ellis, *Epic*, p. 461

On December 13, 1931, Winston Churchill was hit by a taxi and kept at Lenox Hill Hospital for nearly a month with a sprained shoulder and cuts to his nose and forehead.

Ashton and Nazionale, p. 95

The 1962 Macy's Thanksgiving Day parade. Sprawled in the street, undergoing inflation from the helium cylinders, Father Christmas could be an accident victim in need of artificial resuscitation.

Conrad, p. 274

Run one of the buses into a clothes shed, keep the motor going for little while, and all of the passengers, and anyone else remaining within, will croak, as we call it. The shiny conveyances powered by heavy motors—"See the Wonder City of New York"—spill toxic fumes among us people.

Riesenberg and Alland, p. 69

Architect Louis Kahn died of a heart attack in a men's bathroom at Penn Station in 1974.

Walrod, p. 46

O'Hara, p. 257

First
Bunny died, then John Latouche,
then Jackson Pollock. But is the
earth as full as life was full, of them?

Wilcock, "Gay Street," p. 142

The old man lay dead, and in dying he had bequeathed a problem. For he was not only an old man but an excessively fat man and, try as they might, his undertakers saw no way to get him out of the door of his tiny Gay Street apartment.

They might have taken him out the window and down the fire escape, but the landlord refused to allow such an undignified exit. "The old man," he said, "always came in and out like a gentleman in the 30 years he lived here. He'll go out for the last time, too, like a gentleman." And a mason was ordered to cut a hole in the wall.

Brooks, *In the City*, p. 61

A salesman dies after plunging thirteen stories through a floor-to-ceiling plate-glass window. He had just signed off on a multi-million-dollar business deal. *The last time we saw him*, someone on the scene noted, *he was laughing*.

Conrad, p. 318

The city resurrects its dead as authoritarian bogies on pedestals.

Riesenberg and Alland, p. 203

City of expectant undertakers open all night.

Donleavy

All the undertakers we know live on Park Avenue.

Drehle, p. 1

Manhattan's Charities Pier was known as Misery Lane because that was where the bodies were put whenever disaster struck.

Brook, p. 138

In a city which is constantly devouring itself, it was oddly satisfying to be standing about in a place that had been deliberately entombed, yet preserved. It had the stillness and dignity of a crypt, and the three of us wandered slowly around, letting its anachronistic charm seep in.

Bennett, "Smashing Down"

There is quite a market for granite, much in demand by stone-cutters and monument dealers who buy granite for graveyard markers. When we made room for the Standard Oil Building at 26 Broadway, we found a stone weighing nineteen tons at a height of 250 feet. I could never understand why any man ever wanted a stone like that way up there. That stone went to a number of graves.

Asch, p. 406

lunch on the tombs of the Trinity churchyard

Culbertson and Randall, p. 193

In Woodlawn Cemetery, not far from the water, lies a teenager, George Spence Millet (1894–1909), who, as his monument explains, "Lost life by stab in falling on ink eraser, evading six young women trying to give him birthday kisses in office of Metropolitan Life Building."

Conrad, p. 252

The urban dead in a Jewish cemetery in Queens. The only irregularity in this silent city must be ascribed to wayward nature: the wintry trees branch at random, in contrast with the mapped placement of the graves.

Ibid., p. 285

Damon Runyon's son hired a plane and decanted Runyon's remains above Times Square.

Maffi, pp. 24–5

Yesterday afternoon, while laborers were engaged in uprooting trees at the new entrance to Central Park, corner of Eighty-fifth Street and Eighth

Avenue, they discovered, fourteen inches beneath the surface, a black rosewood coffin, richly mounted and in a state of good preservation. On the lid was a plate with the engraving, "Margaret McIntay, died February, 1852, aged sixteen years, three months and fourteen days." Within the coffin was the body of a woman, decayed almost to a skeleton. At a short distance from the spot another coffin was found, enclosing the body of a negro, decomposed beyond recognition. This land was dug up five years ago, when the trees were planted there, and no such coffins were there at the time.

Chase National Bank maintains a crematory at 11 Broad St. for burning bond issues. A single burning may see a single bond issue of, say, $200,000,000 go into a sub-basement gas furnace in a single day. Special chimneys that carry off the smoke and charred ends of the bond and coupon burning are covered with wire, but there are cases where bonds only slightly charred have worked through, lifted by heat, and have been offered for payment by people who found them.

Conrad, p. 223

 Bank customers who know about the crematories sometimes ask—and get—permission to burn diaries or other possessions in them. Chase even burned a whole batch of custom shirt bands once for a rich patron who didn't want them to get into circulation after he died.

Wall Street is a pyramidal burial ground, exhibiting the monuments which the millionaires have erected as their cenotaphs.

Diehl, p. 161

Grant's Tomb is less indispensable to New York than the West Side Highway.

Conrad, pp. 137–8

Funereal entrances of the Empire State Building (the largest skyscraper, which has since been dethroned by Rockefeller Center) … The black of polished stones, the walls faced with dark, gleaming slabs.

Corbusier, p. 155

Cemeteries were not off-limits, as owners were urged to give up the heavy metal chains and bronze posts surrounding their family plots during WWII for ammunition.

Ibid.

St. Mark's Church in-the-Bouwerie, whose
Stones hold in tight grip one wooden leg & all of Peter Stuyvesant's bones?

Berrigan, *Collected*, p. 537

Rows of caskets bearing the bodies of fallen American soldiers have become an all too familiar sight beneath the high vaulted ceilings of the Forty-third Street entrance to Grand Central during World War II. The terminal has been used by the military as a stop-over point from which grieving families can retrieve their loved ones and then continue the final journey home.

Greenburg, pp. 39–40

Drone of cars along Astoria Boulevard. Barren landscape of headstones. Patches of grey dead grass. A single mausoleum on a rise of hill. Die slowly so I can see where my own life is going to end. Drop suddenly in your tracks and no telling where they might shove you.

Donleavy

… grabbing, giving, sighing, dying, just so they could be buried in one of those awful cemetery cities beyond Long Island City.

McDarrah, *Beat*, p. 3

You don't have to practice parapsychology; or even be especially imaginative, to feel the presence of the dead in New York. For all the development this city has sustained over the last several hundred years, much of New York remains old, by American standards anyway. Half our compatriots live in homes built since 1970, but 90 percent of New Yorkers live in homes built before

Rasenberger, p. 26

that year, according to the Census Bureau's New York housing survey. More remarkable, more than 40 percent of us live in homes constructed before 1930, and nearly 18 percent in homes built before 1920.

Wherever we live, others have probably lived before us. They ate their dinners in our dining rooms, slept in our bedrooms, read the newspaper in our living rooms. They gave parties, listened to the radio on winter evenings, worried about the latest stock market crash, or war. They invented strange new candies and tallied their inheritances and celebrated their anniversaries.

Our relationship to these people is complicated. On one hand, we share intimate space with them, trespassing where their most private moments occurred, removed from them by a few thin coats of paint. On the other hand, they are dead strangers.

Goodman, *Secret*, p. 9 Ghosts. There are ghosts in New York. Someday I'll be one of them.

Subterranean

N. cit. Rumors of Manhattan's subterranean network surface occasionally like vapors: I've heard tales of Central Park caverns large enough to hold platoons, of tunnels beneath the West Side Highway where people engage in strange sexual acts.

Goodman, *Secret*, p. 9 Con Edison workers rising up out of the sewer at Forty-fifth Street.

Goodman, p. 9 I think of the construction workers as undertakers, digging down beneath the temporary holes in the skyline where buildings, like people, have departed.

Beaton, *New York*, p. 17 The plumes of steam from the city's heating plant, spouting at varying intervals from the underworld, are the only signs, on a Sunday, that Wall Street is not part of a long forgotten, dead city.

Riesenberg and Alland, p. 85 The catacombed city in exile even burrows beneath the foundation of its upper half: thieves use the vaulted sewers as a runway for speedy escapes.

Bishop, p. 16 He emerges from an opening under the edge of one of the sidewalks and nervously begins to scale the faces of the buildings.

Maffi, p. 25 The *underneath* of New York, the American metropolis par excellence, is the most disconcerting of all. Much the same has already been said of London and Paris, as the works of Dickens and Gissing, and Sue, Hugo, and Zola testify—and Walter Benjamin consider the Parisian passages and Métro stations as places providing access to the collective unconscious. But Europe, steeped in its past as it is, really holds no surprises, what with its archaeological remains, its ruins, crypts, and vaults, its underground canals and sewers, the whole repertoire of gothic and romantic, realist and surrealist. What *does* surprise is the singular and often unappreciated fact that the underneath of the city like New York is overwhelmingly present, too.

Toth, p. 21 The further down you go, the weirder people get, and I mean real weird. There are people down there, man, I swear they have webbed feet … Can't hardly see them at times, they're so sneaky. They make strange noises and sounds, like trains, but they are not trains; they are communicating with each other. They said I could stay but that I could only be allowed to go back up with their permission. I ran from that place man, and I ain't never going back. They're the *mole people*.

Underground, they live often in groups, as if huddled like prehistoric man against the elements—as well as against the rats, human creditors, and the dark … there are communities of families, runaways, homosexuals, and diverse independent individuals.

Ibid., p. 38

The best feature of this tunnel was the fresh water. The "Tears of Allah," as Bernard named them, pulsed from a broken pipe twenty feet overhead and fell in one seamless curtain to the floor. The pipe went unrepaired for five years, during which time they provided an oasis for the tunnel dwellers.

Ibid., p. 99

You notice that it is never totally black in his tunnel during daylight hours. Grates allow light through, always enough to see something … "And there is peace in the dark," he says. "I sit here at night at the fire with a pot of tea and just the solitude of the tunnel. I think what I've discovered down here is that what one really seeks in life is peace of mind."

Ibid., p. 105

Flimsy little saplings growing spontaneously where light filters down from above, lovingly looked after cats and dogs, movingly furnished rooms, tunnel-born children who reach adulthood already at the age of five or six, groups that have organized themselves for survival and resistance to attacks, individuals who spend the whole day anxiously looking for and preparing food, a mysterious population living in the darkest depths of these labyrinthine tunnels that now communicates solely in cries and grunts, and a voluntary network of information and mutual assistance.

Maffi, p. 33

It so happened that just to one side of my bench there was a big hole in the sidewalk, something like the Métro at home. That hole seemed propitious, so vast, with a stairway all of pink marble inside it. I'd seen quite a few people from the street disappear into it and come out again. It was in that underground vault that they answered the call of nature. I caught on right away. The hall where the business was done was likewise of marble. A kind of swimming pool, filled only with filtered, moribund light, which fell on the forms of unbuttoned men surrounded by their smells, red in the face from the effect of expelling their stinking feces with barbarous noises in front of everybody.

Céline, p. 168

The obsession with what lies underneath the surface is peculiarly American, on a par with the obsession with what lies outside. Yet while the outside represents everything that is extraneous to the American way of life (the "alien," the "foreigner," and the "menace from outer space," to use the terminology of mass cultural products, often so effective at unveiling the hidden dynamics of the society), the underneath is a far more disturbing dimension. This is because it acknowledges and openly declares that the threat (or, putting it more mildly, the sense of unease) comes from within— from something that is inside, buried in the labyrinthian tunnels of the past or the compressed layers of the present.

Maffi, p. 25

The cavernous stations, dark, dirty, some desolate, some uncomfortably crowded, go by monotonously. The haunted quality of the neglected streets above reaches down into this long, seemingly never-ending tunnel.

Blandford, p. 178

Town moles seem to be a little slow in trying the new gray-tiled and generously lighted tunnel that leads out of the new Socony-Mobil Tower to Grand Central terminal, to the Commodore, the Chanin and Chrysler Buildings, to the crosstown shuttle the Graybar, the Post Office, the Biltmore

Berger, *New York*, p. 205

and—if you know the old route—clear up to the Roosevelt at Forty-sixth Street.

On a rainy day, a knowing mole might work his way from Forty-first Street and Third Avenue all the way to Forty-sixth and Madison without feeling a drop. The first leg would take him through the Socony-Mobil concourse. The warren to Grand Central was dug primarily to drain off the thousands who will work in that building; to keep them from flooding into Forty-second Street rush-hour traffic.

Wilkinson, p. 137

Another time I walked through an underground section of the New York Public Library on Forty-second Street that carried steam pipes and was sufficiently remote from the rest of the library that employees who lived in boardinghouses and did their laundry in sinks in the library basement hung it in the tunnel to dry.

Riesenberg and Alland, p. 183

Depths of disconcerting extent, tunnels, pipes and subway tangles lie under Bryant Park. The immense holes, as in a lower row of drilled-out teeth, are filled with concreted steel, and are wired with copper nerves of enormous power.

Kingwell, p. 53

However high above the city we may rise, we can only see the above-ground levels of that logic. The guts and wires, the piping and phone lines and electric cables—also the subways and tunnels and underground passages—that make the city work, the hidden veins and arteries of urban life, remain concealed. The skin of concrete is largely unbroken, and so the essence of the city's genius invisible … Attempts to read the world from above always fail, then, and not least because we must, at some point, return to the ground. More important, our desires for transcendence cannot ever completely outstrip the material circumstances of their arousal. The tall building points up, inviting us to the sublimity of its summit. But it always stops at some point in the sky, cannot actually reach the heavens it indicates. Moreover, human desire being what it is, every tall building is also an invitation for another taller one to supplant it at this other summit, the abstract title of "world's tallest building." Tallness strains and collapses in the same moment.

Cosmic

Miles, p. 99

Ginsberg's vision while reading Blake in East Harlem, summer 1948: "The afternoon sunlight through the window takes on an extraordinary clarity. Silhouetted against the bright living light of the sky he sees the grimy rooftops of Harlem." It is the first time he looks carefully at the pressed metal cornices with their ornamental consoles and entablatures; he understands what human intelligence has gone into their creation, five decades before, so that they can stand there "like buttresses in eternity!"

Everywhere he notices evidence of a living hand, even in the arrangement of bricks, and he is aware that each brick has been placed there by someone, that people built the entire vast city placing each stone and manufacturing each cornice and window-frame.

Ginsberg, *Collected*, p. 134 Holy New York

Ginsberg, *Howl*, p. 9 Mohammedan angels staggering on tenement roofs illuminated

Ibid., p. 84 the skyscrapers standing in the long streets like endless Jehovahs

Perhaps those aren't pushful cabs jockeying and tooting in the streets beneath us on the earth but angels silently going about their salvific business above us in the sky, logically revolving within the orbits fixed for them by the celestial grid.

Conrad, p. 121

He imagines himself roller-skating down the streets into the sky, using the buildings as a launching pad, up the Flatiron Building, scooting across the cables of the Brooklyn Bridge.

Ibid., p. 187

The lights on the Brooklyn Bridge at night resemble galaxies of falling stars, and the tops of the skyscrapers, stranded in the air by fog beneath, are like flaming meteorites held momentarily motionless in their tracks. A new DIVINITY makes itself immanent on the bridge, and a form of worship artists for it: a cult of fire and of the dynamo which is a demiurge, a tireless manufacturer of life.

Ibid., p. 133

Four ballerinas leap in concert from the dingy sidewalk against a discolored wall, watched by amazed children. They are visions in orbit through the city.

Ibid., p. 174

The nymphs who once fluttered down onto the city from the sky have returned to midair and live there in celibate claustration.

Ibid., p. 175

Once the city is geared for and goaded to transport itself into the future, its buildings begin to resent their anchorage to the earth.

Ibid., p. 257

Firbank calls a skyscraper under construction on Fifth Avenue "a fifty-five story clouds' rest."

Ibid., p. 204

The terrestrial city is a sunless underworld, impounding the condemned; the aerial city celestially abandons earth and the curse of materiality. The anti-gravitational city, whirling off into regions of scientific surmise, is no longer a mere city. It's an alternative world, a small planet.

Ibid., p. 260

What Freddy did when he got inside was go and take a bath. The apartment was stuffed with stage props and collage things—gold fabric covering bare brick walls, a Tintoretto-like eighteenth-century baroque heaven scene on the ceiling, a picture of some ballerinas framed with a toilet seat, a photograph of Orion the Witch of Bleecker Street, a portable wall of postage stamps, and so forth. After his bath, Freddy put Mozart's *Coronation Mass* on the hi-fi. He said he had a new ballet to do and he needed to be alone. He herded the people there out of the room. As the record got to the "Sanctus," he danced out the open window with a leap so huge he was carried halfway down the block onto Cornelia Street five stories below.

Warhol, *POPism*, pp. 107–8

One night, I was walking with Billy Name and Freddy on the Lower East Side. There was no wind, but it was very cold, it was winter. We came to a group of buildings that were being razed. One of them was a church. There was sort of an altar place you could just make out in the rubble. Freddy rushed across the street into a store that was still open and bought a penny candle, came back and took all his clothes off, lit the candle, and danced through the set for the life of the candle.

Ibid., pp. 74–5

On some winter afternoon, cross to the New Jersey Shore and between five and six take the Cortlandt Street Ferry back to Manhattan. At that hour and season it is already dark, but the offices are not yet closed; every window blazes with electric lights from which the mists have filtered out of the

Irwin, p. 20

garishness. The distinction between buildings has disappeared now; only the sky-line wavers faintly against the glare beyond. The rest is just windows— by thousand and thousands. It all seems one enormous structure, a palace beyond human imagination for splendor and height and extent. A primitive man, magicked onto the Cortlandt Street Ferry at this hour, would fall on his knees, believing that he saw the Heavenly City.

Conrad, p. 73

From the Staten Island Ferry, Manhattan gleams like a mystic fantasy, the ideal image of a religious dream, the white fingers of the slender towers stretching in supplication towards the sky.

Ellis, *Epic*, p. 34

One ship brings a group of thirty whirling dervishes to Ellis Island. Their religion forbids them to eat any food over which the shadow of an infidel had passed. To them all the cooks, waiters, and helpers on Ellis Island are infidels, so the dervishes refuse to eat.

Conrad, p. 195

Two drunks in "May Day" stagger into the Biltmore and are sped skyward by the elevator. When they arrive at the top floor, they instruct the operator to have another story built on. One urges him "Higher," the other calls out "Heaven."

Chase, p. 13

Probably by 1982, transportation lines will operate hourly air ships between New York and Heaven itself.

Conrad, p. 198

Ronald Firbank was writing a novel set there at the time of his death in 1926, though he had never visited the city. His ignorance of it seemed to him a positive qualification, and he assured his publisher that New York would "be the New Jerusalem before I have done with it!"

Sharpe, p. 228

New Jersey is next door to the New Jerusalem.

Conrad, p. 69

An Arab entrepreneur on the Lower West Side who peddles "holy earth" from the Battery as a direct importation from Jerusalem.

O'Hara, p. 371

Heaven on Earth Bldg
near the Williamsburg Bridge

Conrad, p. 81

Streetlights explode into stars, and Sixth Avenue becomes galactic.

Patchen, p. 53

23rd Street runs into heaven.

Conrad, p. 261

The philosopher H. B. Alexander devises a thematic scheme for the buildings that interpret the setback tiers as the stages by which man remounts to godliness. The steps induct the eye through the successive phases which Alexander calls "experience, understanding, magnanimity, prophecy."

N. cit.

The cosmological aspiration of the elevator shaft, where man's vertical strife aims to free himself from want, from subjugation to material necessity, and from ethical ignorance.

Conrad, p. 261

Climbing the staircase in Radio City Music Hall also re-enacts an ascent to paradise, which the movies have made electrically recoverable.

Ibid., p. 73

Up close, the skyscrapers are crass and hectoring. From afar they undergo a picturesque death as bodies to be reborn as spirits: their material fabrication melted into a thing unreal.

It was something which was completely new and nearly fairy-tale-like for a European in those days.

Sanders, *Celluloid*, p. 106

Pervading ill, suspended between the layers of the skin, like the distillate of ruddy smoke, is the secondary sexual sweat—public, Orphic, mammalian—a heavy incense smuggled in by night on velvet pads of musk. No one is immune, not even the Mongoloid idiot. It washed over you like the brush and passage of camisoled breasts. In a light rain it makes an invisible ethereal mud. It is of every hour, even when rabbits are boiled to a stew. It glistens in the tubes, the follicles, the papillaries. As the earth slowly wheels, the stoops and banisters turn and the children with them; in the murky haze of sultry nights all that is terrene, volupt and fatidical hums like a zither. A heavy wheel plated with fodder and feather-beds, with little sweet-oil lamps and drops of pure animal sweat. All goes round and round, creaking, wobbling, lumbering, whimpering sometimes, but round and round and round. Then, if you become very still, standing on a stoop, for instance, and carefully think no thoughts, a myopic, bestial clarity besets your vision. There is a wheel, there are spokes, and there is a hub. And in the center of the hub there is—exactly nothing. It is where the great goes, and the axle. And you are there, in the center of nothingness, sentient, fully expanded, whirring with the whir of planetary wheels. Everything becomes alive and meaningful, even yesterday's snot which clings to the door knob. Everything sags and droops, is mossed with wear and care; everything has been looked at thousands of times, rubbed and caressed by the occipital eye.

Miller, *Sexus*, pp. 535–7

In 1908 he sets out on a hopeful religious quest in the streets, but is disappointed. He has been asked by a newspaper to provide a drawing of the head of Christ. He goes for a walk, scrutinizing "the face of each Jew I met to see some Christlike traits," searching for divinity in the crowd. He finds no one who qualifies for the role.

Conrad, p. 94

We put out an anonymous leaflet telling people to gather at St. Mark's Place at 9 P.M., to wait for a signal from God.

Hoffman, *Autobiography*, p. 104

We bought two pounds of magnesium which we packed in coffee tins and put on the roofs around St. Mark's Place. Then we rigged the cans with delay fuses by shoving lighted cigarettes in match packs. Once done, we raced down to the streets where people were milling around, waiting for God. All of a sudden the whole sky lit up with a huge blast of exploding magnesium.

Ibid.

New York builds apartments even in its churches. Thus, Broadway Temple at 174th Street and Broadway is an apartment house-church or church-apartment house, whichever you please, and so is the Calvary Baptist on 57th Street between Sixth and Seventh Avenues.

Josephy and McBride, pp. 224–5

Next to the steeple of St. Mark's Church a skywriting plane traces an arabesque of smoke. Of course, the plane is far above and beyond the church, but they share the same two-dimensional space, and contest it. The elegant tapering spire is contradicted by the writhing coil of smoke. The tower is mottled and spotted by age; in contrast with its endurance, the smoke wraps itself into the shape of a spring, a device for storing energy, which is doomed to exhaustion and will, when emitted, soon evaporate. Both building and machine have proclamations to make: the age of faith here meets the age of advertising.

Conrad, pp. 167–8

y Death — Cosmic

Goodman, *Secret*, p. 9

In the pre-dawn of Manhattan the doormen and night watchmen—hovering in front of their buildings, sitting on the loading docks, leaning against alley gates, wispy cigarette smoke curling from their mouths into an ink sky—could be spectral sentinels of another world.

Riesenberg and Alland, p. 97

It is impossible to measure the miraculous; comets cannot be calipered. Try to stretch a sentence so as to turn a fourth dimension, attempt to make a stubborn paragraph reflect the things you feel but cannot see. All such speculations lead to bedlam. But the subject, the city, is here, and so are the people and the times.

In a city where sphinxes occupy the information booths, where secrets of the future are sold with a cup of tea, where guides get lost, where policemen commit murders and padres put out fires, nothing, however fantastical, is beyond the reach of being.

Conrad, p. 72

Darkness to mute harsh actuality: observing the Brooklyn Bridge at dusk when the "bold outlines" of the buildings will be softened. If you adopt the right point of vantage and if the weather concurs, the headquarters of Mammon can be seen evanescing into a New Jerusalem, purging itself of cupidity, casting off solidity. The Woolworth Building, thus atmospherically gilded and pardoned, becomes a "Cathedral of Commerce," soaring "like a battlement of the paradise of a God which St. John beheld."

Roth, p. 98

The Lincoln Tunnel: hell with tiled walls.

Lindner, p. 107

A metropolis forever in the making,

Trager, p. 620

The illuminated numerals 666 appear atop 666 Fifth Ave. in 1958.

Miller, *Supreme*, p. 443

Lewis Mumford called New York his Walden Pond.

Brook, p. 16

To return to New York is to repossess it.

Ibid., p. 285

It is a good city to leave, for in your absence it will continue to live and breathe and grow, and, in its altered state, like a body in which most of the cells have been replaced, it will be ready for you when, as you surely will, you return.

Gopnik, pp. 294–5

A sense of still-here pervades even the bits that are long-standing. To stand in Fairway on a Saturday afternoon, where the olive-oil tasting goes on alongside the search for monster boxes of All, or to walk through the meatpacking district, now decarcassed, where the twentysomethings with their BlackBerrys send each other—what, exactly, I don't know—billets-doux of the newer kind, is to see a world of engagement, of brief exchanges, of bumping into, something that certainly feels necessary and urgent, not indulgent and nostalgic. Every time I take a taxi home from LaGuardia, I don't feel anything like nostalgia (as I must admit I do when the cab from the airport turns toward Paris) but rather wonder, relief—relief that it's still there, that I will be there soon, delivered from the netherworld of other places, my flat feet solidly on the flat ground.

Hawes

McKim, Mead and White instilling a sense of permanence to New York, the desire to endure.

New York replaced by another city.

Sante, "My Lost City"

"What a ruin it will make!," H. G. Wells is reported to have said upon first seeing the skyline of Manhattan.

Sanders, *Celluloid*, p. 388

In this ruined city, there are only landmarks.

Ibid.

New York is scenic only in an emergency.

Conrad, p. 257

Manhattan is an accumulation of disasters that never happen.

Koolhaas, p. 27

The city as magnificent catastrophe.

Huxtable, *Goodbye*, p. 7

Le Corbusier: "A hundred times I have thought, New York is a catastrophe, and fifty times: it is a beautiful catastrophe."

Corbusier, p. 90

What will be the end of this carnival? If historical precedent counts for anything, it will go on to catastrophe. But what sort of catastrophe? I hesitate to venture a prophecy … The thing simply cannot last. If it does not end by catastrophe, then it will end by becoming stale, which is to say, dull.

Mencken, p. 189

The apocalypse Oldenburg imagines for New York is an appetitive luxury. The intersection of Canal Street and Broadway—which is the putative site where the atom bomb will be dropped—is a premature funeral pile of concrete. The block would be so crushingly heavy that it would subside through the pavement and crush the subway tunnels underneath. But for Oldenburg this disaster is a soft, edible expiry, a delicious molten death. He first thought of the concrete slab as a pat of butter. Its sinking through the street, foreknowing the end of New York, would be the butter's trickling and seeping into the crevices of a hot baked potato.

Conrad, p. 320

Films in which New York City is damaged, destroyed, or otherwise devastated: *King Kong* (1933)—destroyed by a giant monster rampage; *Five* (1951)—destroyed by nuclear weapons; *When Worlds Collide* (1951)—destroyed by multiple natural disasters; *Invasion U.S.A.* (1952)—destroyed by a nuclear war; *Captive Women* (1952)—unknown cause of destruction of the city; *The Beast from 20,000 Fathoms* (1953)—destroyed by a giant monster rampage; *Earth vs. the Flying Saucers* (1956)—destroyed by an alien invasion; *The World, the Flesh and the Devil* (1959)—the city was not destroyed, but it was abandoned from a "radioactive disease"; *The Day the Sky Exploded* (1961)—destroyed by multiple natural disasters; *Fail-Safe* (1964)—destroyed by nuclear war and plane crashes; *Destroy All Monsters* (1968)—destroyed by Godzilla and a giant monster rampage; *Planet of the Apes* (1968)—unknown cause of destruction of the city; *Beneath the Planet of the Apes* (1970)— unknown cause of destruction of the city; *End of the World* (1977)—destroyed by multiple natural disasters; *Meteor* (1979)—destroyed by a meteor strike; *Zombi 2* (1979)—destroyed by a zombie apocalypse; *Escape from New York* (1981)—the city was partially destroyed by prison riots, but it is converted to a large prison; *Q* (1982)—destroyed by a giant monster rampage, 2019; *After the Fall of New York* (1983)—unknown cause of destruction of the city; *Ghostbusters* (1984)—parts of the city are destroyed by a giant monster known as the "Stay Pufft Marshmallow Man"; *Solar Crisis* (1990)—destroyed by a solar flare and a solar storm; *A Troll in Central Park* (1994)—parts of the city are destroyed by a tornado; *The Stand* (1994)—the city is overcome by mass anarchy and a worldwide plague before being abandoned; *Daylight* (1996)—only the Holland Tunnel is destroyed by terrorists; *Independence*

"List of Films Set in NYC"

z Apocalypse

Day (1996)—destroyed by an alien invasion; *Armageddon* (1998)—destroyed by a meteor shower; *Deep Impact* (1998)—destroyed by a mega-tsunami resulting from an asteroid impact; *Godzilla* (1998)—destroyed by a giant monster rampage; *Aftershock: Earthquake in New York* (1999)—destroyed by an earthquake.

Ibid.

Films in which New York is destroyed by an alien invasion, set in the future: *Captive Women* (1952); *Planet of the Apes* (1968)—set in 3978; *Beneath the Planet of the Apes* (1970)—set in 3955; *Soylent Green* (1973)—set in 2022, 2019; *After the Fall of New York* (1983)—set in 2019; *The Fifth Element* (1997)—set in 2263; *Bicentennial Man* (1999)—set from 2005 to 2205.

White, *Here*, p. 54

All dwellers in cities must live with the stubborn fact of annihilation; in New York the fact is somewhat more concentrated because of the concentration of the city itself, and because, of all targets, New York has a certain clear priority. In the mind of whatever perverted dreamer might loose the lightning, New York must hold a steady, irresistible charm.

Ibid., p. 32

Mass hysteria is a terrible force, yet New Yorkers seem always to escape it by some tiny margin: they sit in stalled subways without claustrophobia, they extricate themselves from panic situations by some lucky wisecrack, they meet confusion and congestion with patience and grit—a sort of perpetual muddling through. Every facility is inadequate—the hospitals and schools and playgrounds are overcrowded, the express highways are feverish, the unimproved highways and bridges are bottlenecks; there is not enough air and not enough light, and there is usually either too much heat or too little. But the city makes up for its hazards and its deficiencies by supplying its citizens with massive doses of a supplementary vitamin—the sense of belonging to something unique, cosmopolitan, mighty and unparalleled.

Ibid., p. 54

The subtlest change is something people don't speak much about but that is in everyone's mind. The city, for the first time in its long history, is destructible.

McNeil and McCain, p. 256

Nothing's worked, so let's get right to Armageddon.

Lorca, *Collected*, p. 123

This is not hell, but the street.

Conrad, p. 73

Tongues of flame crackle from Broadway, and the theater district is a scorching hell.

Ibid., p. 260

To plunge into the streets is like Dante's descent into Hades.

Ibid., p. 136

Brooklyn is a seething cauldron which fuels the war machine.

Ibid.

Futurism makes an inferno of New York.

Wells, pp. 210–11

Lower Manhattan is a furnace of crimson flames, from which there is no escape. Cars, railways, ferries, all have ceased, and never a light lights the way of the distracted fugitives in the dusky confusion but the light of burning … Dust and black smoke come pouring into the street, and are presently shot with red flame.

Wolfe, *Bonfire*, p. 83

Utterly empty, a vast open terrain. Block after block—how many?—six? eight? a dozen?—entire blocks of the city without a building left standing. There are streets and curbing and sidewalks and light poles and nothing else. The eerie grid of a city is spread out before him, lit by the chemical yellow of the street

z Apocalypse

lamps. Here and there are traces of rubble and slag. The earth looks like concrete, except that it rolls down this way ... and up that way ... the hills and dales of the Bronx ... reduced to asphalt, concrete, and cinders ... in a ghastly yellow gloaming.

Many of the buildings appear deserted or semi-deserted. Many have stained marble facades and steps. The streets are narrow. A park ... is a twisted tangle of roots and vines and misshapen trees.

Burroughs, p. 1745

He sees smoky air, smells the gassy fumes, sees the harried thousands charging through the narrow streets.

Atkinson, p. 263

At a corner they look up Broadway, narrow and scorched as if a fire has gutted it.

O'Connell, p. 141

Skyscrapers shake in laughter and fall down

Mayakovsky, "Great," p. 506

The tower of St. Paul's in lower Manhattan looks as if its vertebral column has snapped, leaving its separate levels knocking about independently of each other; the arches of the Brooklyn Bridge tilt giddily to one side; the Municipal Building seems about to teeter forward into the crevasse of a street; and the structures flanking the Telephone Building dash themselves insensible on its sides.

Conrad, p. 128

She grips my arm, whispering, "The Plaza Hotel is gone!"

Finney, p. 141

We dream through the saffron glow of a contaminated sunset, fearsomely prescient in our imaginings, seeing red-beaked cormorants and green-clawed vultures with jagged wings wheeling over a spread of ragged ruins.

Riesenberg and Alland, p. 101

A single flight of planes no bigger than a wedge of geese ends this island fantasy, burns the towers, crumbles the bridges, turns the underground passages into lethal chambers, cremates the millions. The intimation of mortality is part of New York now: in the sound of jets overhead, in the black headlines of the latest edition.

White, *Here*, p. 54

Airships sail along, smashing up the city as a child will shatter its cities of brick and card. Below, they leave ruins and blazing conflagrations and heaped and scattered dead: men, women and children mix together as though they are no more than Moors, or Zulus, or Chinese.

Ibid., pp. 182–3

In the gaps between skyscrapers, full of blazing ore,
where the steel of trains came clattering by,
an aeroplane falls with a final roar
into the fluid oozing from the sun's hurt eye.

Mayakovsky, "Great," p. 505

An avaricious dragon coiled round the Woolworth Building flaps its scaly wings, while albino alligators frolic in the sewers beneath Rector Street.

Conrad, pp. 321–2

A pencil sketch of the Woolworth Building traces the course of the apparently foundering skyscraper as it crumples through the air.

Ibid., p. 128

When daybreak comes we zoom through New Jersey with the great cloud of Metropolitan New York rising before us in the snowy distance. Dean has a sweater wrapped around his ears to keep warm. He says we are a band of Arabs coming to blow up New York.

Kerouac, *Road*, p. 117

Berman, *NY Calling*, p. 19

It is hard to believe the enormity of these ruins. They go on and on, block after block, mile after mile, year after year. Some blocks seem almost intact, with live people—but they look around the corner, and there is no corner.

O'Connell, p. 299

Buildings disappear overnight in the city, like black rhinos from the African savanna. In the morning only a smoking pile of brick and mortar is left, the skin and bones.

Serviss, p. 18

Upon waking, New York is startled by seeing, in huge red letters, on every blank wall, on the bare flanks of towering sky-scrapers, on the lofty stations of aeroplane lines, on bill-boards, fences, advertising-boards along suburban roads, in the Subway stations, and fluttering from strings of kites over the city, the following announcement:

THE WORLD IS TO BE DROWNED!
Save Yourselves While It Is Yet Time!
Drop Your Business: It Is of No Consequence!
Build Arks: It Is Your Only Salvation!
The Earth Is Going To Plunge into a Watery
Nebula: There Is No Escape!
Hundreds of Millions Will Be Drowned: You Have
Only a Few Months To Get Ready!

When New York recovers from its first astonishment over the extraordinary posters, it indulges in a loud laugh. New York laughs a whole day and night at the warning red letters. They are the talk of the town. People joke about them in cafés, clubs, at home, in the streets, in the offices, in the exchanges, in the street-cars, on the Elevated, in the Subways. Crowds gather on corners to watch the flapping posters aloft on the kite lines. The afternoon newspapers issue specials which are all about the coming flood, and everywhere one hears the cry of the newsboys: *"Extra-a-a! Drowning of a Thousand Million People! Predicts the End of the World!"* On their editorial pages the papers are careful to discount the scare lines, and terrific pictures, that cover the front sheets, with humorous jibes at the author of the formidable prediction.

Ibid., pp. 369–70

It begins with the skeleton tower itself, which has only once or twice been exceeded in height by the famous structures of the era of skyscrapers. In some places the granite skin is in situ, but almost everywhere it has been stripped off, probably by the tremendous waves which sweep over it as the flood attains its first thousand feet of elevation. There are no living forms, except a few curiously shaped phosphorescent creatures of no great size, which scurry away out of the beam of the search-light. There is no trace of the millions of beings who have been swallowed up in this vast grave. The soil of Madison Square has evidently been washed away, for no signs of the trees which have once shaded it are seen, and a reddish ooze has begun to collect upon the exposed rocks. All around are the shattered ruins of other great buildings, some, like the Metropolitan tower, retain their steel skeletons, while others tumble down, lying half-buried in the ooze.

Finding nothing of great interest in this neighborhood they turn the course of the bell northward, passing everywhere over interminable ruins, and as soon as they begin to skirt the ridge of Morningside Heights, the huge form of the cathedral of St. John falls within the circle of projected light. It is unroofed, and some of the walls have fallen, but some of the immense arches retain their upright position. Here, for the first time, they encounter the real giants of the submarine depths. One creature, which seems to be the unresisted master of this kingdom of phosphorescent life, appears to have

exceeded in strangeness the utmost descriptive powers of all those who look upon it, for their written accounts are filled with jaculations, and are more or less inconsistent with one another. The reader gathers from them, however, the general impression that it makes upon their astonished minds.

Avoiding the neighborhood of the cathedral, they steer the bell down the former course of the Hudson, but afterward venture once more over the drowned city until they arrive at the site of the great station of the Pennsylvania Railroad, which they find completely unroofed. They sink the bell into the vast space where the tunnels enter from underneath the old river bed, and again they have a startling experience. Something huge, elongated, spotted, and provided with expanding claw-like limbs, slowly withdraws as their light streams upon the reddish ooze covering the great station floor. This nondescript animal retreats backward into the mouth of a tunnel. They endeavor, cautiously, to follow it, turning a magnifying window in its direction, and obtain a startling view of its glaring eyes, but the creature hastens its retreat, and the last glimpse they have is of a grotesque head, which throws out piercing rays of green fire as it passes deeper into the tunnel.

They are terror-stricken now, and pushing the propellers to their utmost, they flee toward the site of the Metropolitan Tower. On their way, although for a time they pass over the course of the East River, they see no signs of the great bridges except the partly demolished but yet beautiful towers of the oldest of them, which had been constructed of heavy granite blocks.

The actual drowning of New York cannot happen until the Hudson and the East River should become so swollen that the water will stand above the level of the highest buildings, and turn the whole region round about, as far as the Orange hills, the Ramapo Mountains, the Highlands, and the Housatonic hills, into an inland sea.

Ibid., p. 116

In this unearthly light, many tall structures of the metropolis, which had as yet escaped the effects of undermining by the rushing torrents in the streets, tower dimly toward the sky, shedding streams of water from every cornice. Most of the buildings of only six or eight stories have already been submerged, with the exception of those that stand on the high grounds in the upper part of the island, and about Spuyten Duyvil.

Ibid., pp. 133–4

In the towers and upper stories of the lofty buildings still standing in the heart of the city, crowds of unfortunates assemble, gazing with horror at the spectacles around them, and wringing their hands in helpless despair. When the light brightens they can see below them the angry water, creeping every instant closer to their places of refuge, beaten into foam by the terrible downpour, and sometimes, moved by a mysterious impulse, rising in sweeping waves which threaten to carry everything before them. Every few minutes one of the great structures sways, cracks, crumbles, and goes down into the seething flood, the cries of the lost souls being swallowed up in the thunder of the fall. And when this occurs within sight of neighboring towers yet intact, men and women can be seen, some with children in their arms, madly throwing themselves from windows and ledges, seeking quick death now that hope is no more!

Strange and terrible scenes are enacted in the neighborhood of what had been the water-fronts. Most of the vessels moored there have been virtually wrecked by the earlier invasion of the sea. Some have been driven upon the shore, others have careened and been swamped at their wharves. But a few have succeeded in cutting loose in time to get fairly afloat. Some try to go out to sea, but are wrecked by running against obstacles, or by being swept over the Jersey flats. Some meet their end by crashing into the submerged pedestal of the Statue of Liberty. Others steer up the course of the Hudson

River, which has become a narrow sea, filled with floating and tossing debris of every sort, and all landmarks being invisible, the luckless navigators lose their way, and perish, either through collisions with other vessels, or by driving upon a rocky shore.

The fate of the gigantic building containing the offices of the municipal government, which stand near the ancient City Hall, and which have been the culminating achievement of the famous epoch of "sky-scrapers," is a thing so singular, and at the same time dramatic, that in a narrative dealing with less extraordinary events than we are obliged to record, it would appear altogether incredible. With its twoscore lofty stories, and its massive base, this wonderful structure rises above the lower quarter of the city, and dominates it, like a veritable Tower of Babel, made to defy the flood. Many thousands of people evidently regard it in that very light, and they have fled from all quarters, as soon as the great downpour begins, to find refuge within its mountainous flanks. There are men—clerks, merchants, brokers from the downtown offices—and women and children from neighboring tenements.

Ibid., pp. 57–8

In the middle of the night, at New York, hundreds of thousands simultaneously awake with a feeling of suffocation.

They struggle for breath as if they have suddenly been plunged into a steam bath.

The air is hot, heavy, and terribly oppressive.

The throwing open of windows brings no relief. The outer air is as stifling as that within.

It is so dark that, on looking out, one cannot see his own doorsteps. The arc-lamps in the street flicker with an ineffective blue gleam which sheds no illumination round about.

House lights, when turned on, look like tiny candles inclosed in thick blue globes.

Frightened men and women stumble around in the gloom of their chambers trying to dress themselves.

Cries and exclamations ring from room to room; children wail; hysterical mothers run wildly hither and thither, seeking their little ones. Many faint, partly through terror and partly from the difficulty of breathing. Sick persons, seized with a terrible oppression of the chest, gasping, never rising from their beds.

At every window, and in every doorway, throughout the vast city, invisible heads and forms are crowded, making their presence known by their voices—distracted householders strive to peer through the strange darkness, and to find out the cause of these terrifying phenomena.

Some manage to get a faint glimpse of their watches by holding them close against lamps, and thus note the time. It is two o'clock in the morning.

Neighbors, unseen, call to one another, but get little comfort from the replies.

Ibid., pp. 204–5

Just at the time when the waters have mounted to the eighteenth story of the beleaguered Municipal Building, a sudden change occurs in these currents. They sweep westward with resistless force, and the *Uncle Sam* is carried directly over the drowned city. First she encounters the cables of the Manhattan Bridge, strikes them near the western tower, and, swinging round, wrenches the tower itself from its foundations and hurls it beneath the waters.

Then she rushes on, riding with the turbid flood high above the buried roofs, finding no other obstruction in her way until she approaches the Municipal Building, which is stoutly resisting the push of the waves.

Those who are near the windows and on the balconies, on the eastern side of the building, see the great battleship coming out of the gray gloom

like some diluvian monster, and before they can comprehend what it is, it crashes, prow on, into the steel-ribbed walls, driving them in as if they had been the armored sides of an enemy. So tremendous is the momentum of the striking mass that the huge vessel passes, like a projectile, through walls and floors and partitions. But as she emerges in the central court the whole vast structure comes thundering down upon her, and ship and building together sink beneath the boiling waves. But out of the awful tangle of steel girders, that whips the air and the water as if some terrible spidery life yet clings to them, by one of those miracles of chance which defy all the laws of probability and reason, a small boat of levium, that belongs to the *Uncle Sam*, is cast forth, and floats away, half submerged but unsinkable; and clinging to its thwarts, struggles for breath, insane with terror, are two men, the sole survivors of all those thousands.

Night is now beginning once more to drop an obscuring curtain over the scene, and under that curtain the last throes of drowning New York are hidden. When the sun again faintly illuminates the western hemisphere, the whole Atlantic seaboard is buried under the sea.

Ibid., p. 141

As the light becomes stronger, he says, "Steer toward New York. I wish to see if the last of the tall buildings on the upper heights have gone under."

Ibid., p. 143

Where New York had stood nothing is visible but an expanse of turbid and rushing water.

Ibid., p. 144

A tremendous bolt, which seems to have entered the Pennsylvania tunnel on the Jersey side, follows the rails under the river, throwing two trains from the track, and, emerging in the great station in the heart of the city, expands into a rose-colored sphere, which explodes with an awful report, and blows the great roof to pieces. And yet, although the fragments are scattered a dozen blocks away, hundreds of persons who are in the stations suffer no other injury than such as resulted from being flung violently to the floor, or against the walls.

Ibid., p. 45

Others make their way to the roofs, persuaded that the flood is already inundating the basements and the lower stories of their dwellings.

Ibid., p. 62

Alarm deepens into terror when the time for the tide to ebb arrives and there is no ebbing. On the contrary, the water continues to rise. The government observer at the Highlands telephones that Sandy Hook is submerged. Soon it is known that Coney Island, Rockaway, and all the seaside places along the south shore of Long Island are under water. The mighty current pours in through the Narrows with the velocity of a mill-race. The Hudson, set backward on its course, rushes northward with a raging bore at its head that swells higher until it licks the feet of the rock chimneys of the Palisades.

Ibid., p. 67

Out over the incredible mausoleum of civilization they peer. Now and again they fortify their vision by recourse to the telescope. Nowhere, as he says, is any slightest sign of life to be discerned. Nowhere a thread of smoke rises; nowhere a sound echoes upward. Dead lies the city, between its rivers, whereon now no sail glints in the sunlight, no tug puffs vehemently with plumy jets of steam, no liner idles at anchor or noses its slow course out to sea. The Jersey shore, the Palisades, the Bronx and Long Island all lay buried in dense forests of conifers and oak, with only here and there some skeleton mockery of a steel structure jutting through. The islands in the harbor, too, are thickly overgrown. On Ellis, no sign of the immigrant station remains.

England, p. 19

Castle William is quite gone. And with a gasp of dismay and pain, she points out the fact that no longer Liberty holds her bronze torch aloft. Save for a black, misshapen mass protruding through the tree-tops, the huge gift of France is no more. Fringing the water-front, all the way round, the mournful remains of the docks and piers lie in a mere sodden jumble of decay, with an occasional hulk sunk alongside. Even over these wrecks of liners, vegetation is growing rank and green. All the wooden ships, barges and schooners have utterly vanished … The sun, declining, shoots a broad glory all across the sky. Purple and gold and crimson lie the light-bands over the breast of the Hudson. Dark blue the shadows stream across the ruined city with its crowding forests, its blank-staring windows and sagging walls, its thousands of gaping vacancies, where wood and stone and brick have crumbled down—the city where once the tides of human life had ebbed and flowed, roaring restlessly. High overhead drifts a few rosy clouds, part of that changeless nature which alone does not repel or mystify these two beleaguered waifs, these chance survivors, this man, this woman, left alone together by the hand of fate.

Serviss, p. 63

People who expected at any moment to feel the water pitilessly rising about them look out of their windows, and are astonished to see only tiny rivulets which are already shriveling out of sight in the gutters. In a few minutes there is no running water left, although the dampness on the walls and walks show how great the humidity of the air has been.

Glanz and Lipton, pp. 129–30

"The Titanic was unsinkable—yet she went down; our skyscrapers are unburnable—yet we shall have a skyscraper disaster that will stagger humanity."—Alfred Ludwig, NYC Chief Buildings Inspector, 1911.

Ibid., p. 60

For the first time in its history, it could not be seen; it could not be heard; it made no sign. As far as any outward indication of its existence was concerned the mighty capital had ceased to be.

Klosterman, p. 39

That's how all New York anecdotes seem to end: "It was a nightmare."

z Apocalypse

864

It is a miracle that New York works at all. The whole thing is implausible. White, *Here*, p. 31 Every time the residents brush their teeth, millions of gallons of water must be drawn from the Catskills and the hills of Westchester. When a young man in Manhattan writes a letter to his girl in Brooklyn, the love message gets blown to her through a pneumatic tube—pfft—just like that. The subterranean system of telephone cables, power lines, steam pipes, gas mains and sewer pipes is reason enough to abandon the island to the gods and the weevils. Every time an incision is made in the pavement, the noisy surgeons expose ganglia that are tangled beyond belief. By rights New York should have destroyed itself long ago, from panic or fire or rioting or failure of some vital supply line in its circulatory system or from some deep labyrinthine short circuit. Long ago the city should have experienced an insoluble traffic snarl at some impossible bottleneck. It should have perished of hunger when food lines failed for a few days. It should have been wiped out by a plague starting in its slums or carried in by ships' rats. It should have been overwhelmed by the sea that licks at it on every side. The workers in its myriad cells should have succumbed to nerves, from the fearful pall of smoke-fog that drifts over every few days from Jersey, blotting out all light at noon and leaving the high offices suspended, men groping and depressed, and the sense of world's end. It should have been touched in the head by the August heat and gone off its rocker.

Postscript

"1,500 In Kosher Riot In Brownsville and Manhattan." *Brooklyn Eagle*. May 24, 1902.

"1927 George Antheil Presents the US Premiere of His Ballet Mécanique." *A History of Carnegie Hall*. N.p., n.d. Web. 03 Jan. 2015.

"1993 World Trade Center Bombing." *Wikipedia*. Wikimedia Foundation, n.d. Web. 21 Dec. 2014.

"70-Foot Igloo To Be Built; Model of Huge Air-Conditioning Exhibit Given to Whalen." *New York Times*. September 14, 1938: 25.

"A Complete Reversal of Art Opinions by Marcel Duchamp, Iconoclast." *Arts & Decoration*. September 1915: 5.

"A Leap from the Bridge: Steve Brodie's Plunge into the East River." *New York Times*. July 24, 1886.

Abbott, Berenice, and Elizabeth McCausland. *New York in the Thirties [Changing New York]*. New York: Dover Publications, 1973.

Abbott, Jack Henry. "On The Bowery." *Low Rent: A Decade of Prose and Photographs from the Portable Lower East Side*. Ed. Kurt Hollander. New York: Grove Press, 1994: 78.

Abelli, Alfred. "Filling in the Hudson." *Modern Mechanix*. March 1934: 38.

———. "Tricks of the House-Wreckers." *Modern Mechanix*. June 1930. N. pag.

Abrams, Charles. "Washington Sq. and the Revolt of the Urbs." *The Village Voice Reader: A Mixed Bag from the Greenwich Village Newspaper*. Eds. Daniel Wolf and Edwin Fancher. Garden City, NY: Doubleday, 1962: 205.

Abril, Xavier. "X-Ray of Chaplin." *Burning City: Poems of Metropolitan Modernity*. Eds. Jed Rasula and Tim Conley. Notre Dame, IN: Action, 2012: 135.

Abu-Lughod, Janet L. *From Urban Village to East Village: The Battle for New York's Lower East Side*. Oxford, UK: Blackwell, 1994.

Ackermann, Marsha. *Cool Comfort*. Washington, D.C.: Smithsonian Institution Press, 2002.

The ACT UP Oral History Project, n.d. Web. 07 Jan. 2015.

"Air Conditioning Methods Studied." *Montreal Gazette*. July 28, 1933. N. pag.

Allen, Frederick Lewis. *Look at America: New York City*. Boston: Houghton Mifflin, 1948.

Allen, Greg. "Melons And Pomegranates, Matson Jones Custom Display." *Greg.org: The Making Of*. N.p., May 6, 2014. Web. 08 Dec. 2014.

———. "On Warhol And The World's Fairs." *Greg.org: The Making Of*. April 25, 2014. Web. 21 Nov. 2014.

Allen, Irving L. *The City in Slang: New York Life and Popular Speech*. New York: Oxford University Press, 1993.

Allen, Oliver E. *New York, New York: A History of the World's Most Exhilarating and Challenging City*. New York: Atheneum, 1990.

Allen, Woody, and Marshall Brickman. *Annie Hall*. London: Faber, 2000. Epub.

———. *Manhattan. Four Films of Woody Allen: Annie Hall, Interiors, Manhattan, Stardust Memories*. New York: Random House, 1982.

Amin, Ash, and Nigel Thrift. *Cities: Reimagining the Urban*. Cambridge, UK: Polity, 2002.

Anderson-Spivy, Alexandra, and B. J. Archer. *Anderson & Archer's SoHo: The Essential Guide to Art and Life in Lower Manhattan*. New York: Simon and Schuster, 1979.

Arce, Manuel Maples. "T.S.F. (Radiophonic Poem)." *Burning City: Poems of Metropolitan Modernity*. Eds. Jed Rasula and Tim Conley. Notre Dame, IN: Action, 2012: 331.

Arnett, Frank S. "The Doorways of New York." *Munsey's Magazine*. October 1902.

Arter, Rhetta M. *Living in Chelsea: A Study of Human Relations in the Area Served by the Hudson Guild*. New York: New York Savings Bank, 1954.

Asbury, Herbert. "Doyers Street." *American Mercury Magazine.* May–August 1926: 118.

Asch, Nathan. "Downtown." *Burning City: Poems of Metropolitan Modernity*. Eds. Jed Rasula and Tim Conley. Notre Dame, IN: Action, 2012: 406.

Ashbery, John. *Selected Prose*. Ann Arbor, MI: University of Michigan Press, 2004.

Ashton, Jean, Nina Nazionale, and the New-York Historical Society. *When Did the Statue of Liberty Turn Green?: And 101 Other Questions about New York City*. New York: Columbia University Press, 2010.

Atkins, Robert. "From Stonewall to Ground Zero." *New York Calling: From Blackout to Bloomberg.* Eds. Marshall Berman and Brian Berger. London: Reaktion Books, 2007: 253–65.

Atkinson, Oriana. *Manhattan and Me*. Indianapolis, IN: Bobbs-Merrill, 1954.

Auchincloss, Louis. "Society in New York." *Our Town: Images and Stories from the Museum of the City of New York*. Ed. Museum of the City of New York. New York: Harry N. Abrams, 1997.

Auden, W. H. "September 1, 1939." *Poems of New York*. Ed. Elizabeth Schmidt. New York: Knopf, 2002: 72.

———. "The Watchers." *Collected Poems*. Ed. Edward Mendelson. New York: Modern Library, 2007: 63–4.

Auster, Paul. *City of Glass*. New York: Avon Books, 1994.

———. "Fogg in the Park." *Central Park: An Anthology*. Ed. Andrew Blauner. New York: Bloomsbury, 2012: 97–109.

Aycock, Colleen, and Mark Scott. *Tex Rickard: Boxing's Greatest Promoter*, Jefferson, NC: McFarland & Company, Inc., 2012.

"Ayds." *Wikipedia*. Wikimedia Foundation, n.d. Web. 17 Dec. 2014.

Bahrampour, Tara. "There's No Place Like Home. But There's … No Place." *New York Times*. December 31, 2000. Web. 30 Nov. 2014.

Balaban, Dan, "Witless Madcaps Come Home to Roost." *The Village Voice Reader: A Mixed Bag from the Greenwich Village Newspaper*. Eds. Daniel Wolf and Edwin Fancher. Garden City, NY: Doubleday, 1962: 40.

Baldwin, James. *Go Tell It on the Mountain*. New York: Dell, 1985/1953.

Bales, William Alan. *Tiger in the Streets*. New York: Dodd, Mead, 1962.

Balliett, Whitney. *New York Voices*. Jackson, MS: University Press of Mississippi, 2006.

Ballon, Hilary, and Kenneth T. Jackson. *Robert Moses and the Modern City: The Transformation of New York*. New York: W. W. Norton, 2007.

Banes, Sally. *Greenwich Village 1963: Avant-Garde Performance and the Effervescent Body*. Durham, NC: Duke University Press, 1993.

Baraka, Amiri, "Return of the Native." *The Oxford Anthology of African-American Poetry*. Ed. Arnold Rampersad. New York: Oxford University Press, 2006: 59.

Barnes, Djuna. *New York*. Los Angeles: Sun & Moon, 1989.

Barnet, Andrea. *All-Night Party: The Women of Bohemian Greenwich Village and Harlem, 1913–1930*. Chapel Hill, NC: Algonquin, 2004.

Barry, Dan. *City Lights: Stories about New York*. New York: St. Martin's, 2007.

Barthes, Roland. *A Barthes Reader*. New York: Noonday Press, 1988.

———. *Camera Lucida*. New York: Hill and Wang, 1980.

———. *The Eiffel Tower and Other Myths*. New York: Hill and Wang, 1979.

Basile, Salvatore. *Cool: How Air Conditioning Changed Everything*. New York: Fordham University Press, 2014.

Baudrillard, Jean. *America*. London: Verso, 1989.

———. *Selected Writings*. Ed. Mark Poster. Stanford, CA: Stanford University Press, 2001.

———. *Simulacra and Simulation*. Ann Arbor, MI: University of Michigan Press, 1994.

———. *Symbolic Exchange and Death*. London: Sage Publications, 1993.

Bauman, Zygmunt. *Postmodern Ethics*. Oxford, UK: Blackwell, 1993.

Beaton, Cecil. *Cecil Beaton's New York*. Philadelphia: J. B. Lippincott, 1938.

———. *Portrait of New York*. London: B. T. Batsford, 1948.

Beauduin, Nicolas. "Music Halls." *Burning City: Poems of Metropolitan Modernity*. Eds. Jed Rasula and Tim Conley. Notre Dame, IN: Action, 2012: 283.

Beck, Louis J. *New York's Chinatown: An Historical Presentation of Its People and Places*. New York: Bohemia Pub. Co., 1898.

Behan, Brendan. *Brendan Behan's New York*. New York: B. Geis Association, 1964.

Behrens, Franz Richard. "The Asta Ode." *Burning City: Poems of Metropolitan Modernity*. Eds. Jed Rasula and Tim Conley. Notre Dame, IN: Action, 2012: 315.

Beller, Thomas. "Negative Space." *Central Park: An Anthology*. Ed. Andrew Blauner. New York: Bloomsbury, 2012: 119–135.

Bellis, Mary. "The Father of Cool—Willis Haviland Carrier and Air Conditioning." *About.com Inventors*. March 5, 2014. Web. 26 Nov. 2014.

Bellow, Saul. "A Father-to-Be." *The New Yorker*. February 5, 1955: 26.

———. *Mr. Sammler's Planet*. New York: Viking, 1970.

———. *The Victim*. New York: Vanguard, 1947.

Bender, Thomas. *New York Intellect: A History of Intellectual Life in New York City, from 1750 to the Beginnings of Our Own Time*. New York: Knopf, 1987.

———. *The Unfinished City*. New York: The New Press, 2002.

Bendiner, Elmer. *The Bowery Man*. New York: Nelson, 1961.

Benjamin, Walter. *The Arcades Project*. Cambridge, MA: Belknap, 1999.

Bennett, Lincoln. "Smashing Down Skyscrapers for Progress." *Modern Mechanix*. May 1931: 52–3.

Bennett, Robert B. *The Aesthetic Politics of Urban Space: Interart Representations of Post-WWII New York City*. Ann Arbor, MI: University of Michigan Press, 2001.

———. *Deconstructing Post-WWII New York City*. New York: Routledge, 2003.

Bercovici, Konrad. *The Dust of New York*. New York: Boni & Liveright, 1919.

Berger, Joseph. *The World in a City: Traveling the Globe through the Neighborhoods of the New New York*. New York: Ballantine, 2007.

Berger, Meyer. *The Eight Million: Journal of a New York Correspondent.* New York: Columbia University Press, 1983.

———. *Meyer Berger's New York.* New York: Random House, 1953.

Bergman, David. *Gay American Autobiography: Writings from Whitman to Sedaris.* Madison, WI: University of Wisconsin Press, 2009.

Berliner, Michael S. "Howard Roark and Frank Lloyd Wright," *Essays on Ayn Rand's* Anthem. Ed. Robert Mayhew. Lanham, MD: Lexington, 2005: N. pag.

Berman, David. "City-As-School." *Poems of New York.* Ed. Elizabeth Schmidt. New York: Knopf, 2002: 237.

———. "New York, New York." *I Speak of the City: Poems of New York.* Ed. Stephen Wolf. New York: Columbia University Press, 2007: 277–8.

Berman, Marshall. *All That Is Solid Melts into Air: The Experience of Modernity.* New York: Simon and Schuster, 1982.

———. "Introduction." *New York Calling: From Blackout to Bloomberg.* Eds. Marshall Berman and Brian Berger. London: Reaktion, 2007: 9–39.

———. *On The Town: One Hundred Years of Spectacle in Times Square.* New York: Random House, 2006.

Berman, Steve, ed. *Best Gay Stories 2010.* Maple Shade, NJ: Lethe, 2010.

Berrigan, Edmund. "Growing Up Unrented on the Lower East Side." *New York Calling: From Blackout to Bloomberg.* Eds. Marshall Berman and Brian Berger. London: Reaktion, 2007: 231–8.

Berrigan, Ted. *The Collected Poems of Ted Berrigan.* Berkeley, CA: University of California Press, 2007. Epub.

Binzen, Bill. *Tenth Street.* New York: Paragraphic, 1968.

"Birth of the Subway Crash." *New York Tribune.* October 28, 1904: N. pag.

Black, MacKnight. *Thrust at the Sky and Other Poems.* New York: Simon and Schuster, 1932.

Black, Mary. *Old New York in Early Photographs, 1853–1901.* New York: Dover Publications, 1973.

Blandford, Linda. *America on Five Valium a Day.* London: Methuen, 1983.

Blauner, Andrew, ed. *Central Park: An Anthology.* New York: Bloomsbury, 2012.

Bletter, Rosemarie Haag. *Remembering the Future: The New York World's Fair from 1939–1964.* New York: Rizzoli, 1989.

Blomley, Nicholas K. *Rights of Passage: Sidewalks and the Regulation of Public Flow.* Abingdon, UK: Routledge, 2011.

Bloom, Harold. *Tom Wolfe.* Philadelphia: Chelsea House, 2001.

Blotcher, Jay. Written statement. Bill Bytsura ACT UP Photography Collection; MSS 313; Box No. 1; Folder No 15; Fales Library and Special Collections, New York University Libraries.

Boas, Franz. *Papers on Interracial Problems Communicated to the First Universal Races Congress Held at the University of London, July 26–29, 1911.* Ed. Gustav Spiller. Boston: Ginn and Co., 1912: 99–103.

Bockris, Victor. *Warhol.* New York: Da Capo, 1997.

———. *With William Burroughs: A Report from the Bunker.* New York: Seaver Books, 1981.

Bohan, Ruth L. *Looking into Walt Whitman: American Art, 1850–1920.* University Park, PA: Pennsylvania State University Press, 2006.

Boland, Ed. "Bye, Bye Bumper Boys." *New York Times.* December 14, 2002. Web. 20 Dec. 2014.

Bonnelycke, Emil. "Century." *Burning City: Poems of Metropolitan Modernity.* Eds. Jed Rasula and Tim Conley. Notre Dame, IN: Action, 2012: 10.

Boorstin, Daniel J. *The Americans: The Democratic Experience.* New York: Random House, 1973. Epub.

Botkin, Benjamin Albert. *A Treasury of American Folklore: Stories, Ballads, and Traditions of the People.* New York: Crown, 1944.

Bourdon, David. *Warhol.* New York: Abrams, 1989.

Bower, Millicent. "The Greenwich Village Girl." *The Village Voice Reader: A Mixed Bag from the Greenwich Village Newspaper.* Eds. Daniel Wolf and Edwin Fancher. Garden City, NY: Doubleday, 1962: 19.

———. "Those Village Men." *The Village Voice Reader: A Mixed Bag from the Greenwich Village Newspaper.* Eds. Daniel Wolf and Edwin Fancher. Garden City, NY: Doubleday, 1962: 29.

Bowes, Richard. "In History's Vicinity." *Best Gay Stories 2010.* Ed. Steve Berman. Maple Shade, NJ: Lethe, 2010: 105–7.

Bradford, Phillips Verner, and Harvey Blume. *Ota Benga: The Pygmy in the Zoo.* New York: St. Martin's, 1992.

Brainard, Joe. *The Collected Writings of Joe Brainard.* New York: Library of America, 2012. Epub.

Braly, James. "Monthly Nut." *Lost and Found: Stories from New York.* Ed. Thomas Beller. New York: Mr. Beller's Neighborhood, 2009.

Brandes, Wendy. "Light Up With Tron: Legacy, Tiger Morse and Diana Dew." *Wendy Brandes Jewelry Blog.* N.p., December 21, 2010. Web. 12 Aug. 2014.

Brass, Tom. *Peasants, Populism, and Postmodernism: The Return of the Agrarian Myth.* London: F. Cass, 2000.

Braunstein, Peter. "The Last Days of Gay Disco." *The Village Voice*. June 30, 1998. Web. 31 July 2014.

Brennan, Maeve. "I See You, Bianca." *The New Yorker*. June 11, 1966: 32.

Britt, Albert. *Turn of the Century*. Barre, MA: Barre, 1966.

Brobston, Tracy. "A Shopping Spree in Bloomingdale's with Andy Warhol." *Dallas Morning News*. November 25, 1981. Reprinted in *I'll Be Your Mirror: The Selected Andy Warhol Interviews*. Ed. Kenneth Goldsmith. New York: Carroll and Graf, 2004: 301–11.

Brook, Stephen. *New York Days, New York Nights*. New York: Atheneum, 1985.

"Brooklyn Youth Gangs Concentrating on Robbery; Young Members Involved." *New York Times*. August 1, 1974: 33.

Brooks, Colette. *In the City: Random Acts of Awareness*. New York: W. W. Norton, 2002.

Brooks, Michael W. *Subway City: Riding The Trains, Reading New York*. New Brunswick, NJ: Rutgers University Press, 1997.

Broom: An International Magazine Of The Arts. Volume 4, Number 2, January 1923.

Brown, Carolyn. *Chance and Circumstance: Twenty Years with Cage and Cunningham*. New York: Knopf, 2007.

Brown, Claude. *Manchild in the Promised Land*. New York: Macmillan, 1965.

Brown, Henry Collins. *Valentine's Manual of Old New York, No. 7, New Series, 1923*. New York: Valentine's Manual, 1922.

——. *Valentine's Manual of Old New York*. New York: Valentine's Manual, 1928.

Brox, Jane. *Brilliant: The Evolution of Artificial Light*. Boston: Houghton Mifflin Harcourt, 2010.

Buford, Bill. "Lions and Tigers and Bears." *Central Park: An Anthology*. Ed. Andrew Blauner. New York: Bloomsbury, 2012: 174–87.

Bulletin of the American Meteorological Society. Easton, PA: American Meteorological Society, 1931.

Bunyan, Patrick. *All Around the Town: Amazing Manhattan Facts and Curiosities*. New York: Fordham University Press, 1999.

Burns, Ric, James Sanders, and Lisa Ades. *New York: An Illustrated History*. New York: Knopf, 1999.

Burroughs, William S. *Word Virus: The William S. Burroughs Reader*. New York: Grove Press, 1998.

Buse, Peter. *Benjamin's Arcades: An Unguided Tour*. Manchester, UK: Manchester University Press, 2006.

Bushnell, Candace. *Sex and the City.* New York: Warner, 1997. Epub.

Buzzi, Paulo. "Highway to the Stars." *Burning City: Poems of Metropolitan Modernity.* Eds. Jed Rasula and Tim Conley. Notre Dame, IN: Action, 2012: 56.

Bynum, Richard T. *Insulation Handbook.* New York: McGraw-Hill, 2001.

Byrne, D. S. *Understanding the Urban.* Basingstoke, UK: Palgrave, 2001.

Bytsura, Bill. *ACT UP Photography Collection.* MSS 313, Box No. 1, Folder No. 15. Fales Library and Special Collections, New York University Libraries.

Cage, John. *Conversing with Cage.* Ed. Richard Kostelanetz. New York and London: Routledge, 2003.

———. *Indeterminacy.* LCDF.org, n.d. Web. 22 Jun. 2010.

———. "John Cage about Silence." *YouTube.* N.d. Web. 07 Jan. 2015.

Caldwell, Mark. *New York Night: The Mystique and Its History.* New York: Scribner, 2005.

Califia, Pat. *Public Sex: The Culture of Radical Sex.* San Francisco: Cleis Press, 1994.

Campbell, E. Simms. "Night-Club Map of Harlem." 1932. N.p., February 27, 2009. Web. 17 Dec. 2014.

Campbell, Helen, Thomas Wallace Knox, and Thomas Byrnes. *Darkness and Daylight: Or, Lights and Shadows of New York Life; A Pictorial Record of Personal Experiences by Day and Night in the Great Metropolis.* Detroit: Singing Tree, 1969.

Capote, Truman. *Breakfast at Tiffany's: A Short Novel and Three Stories.* New York: Random House, 1958.

Carco, Francis. "On the Bouelvard." *Burning City: Poems of Metropolitan Modernity.* Eds. Jed Rasula and Tim Conley. Notre Dame, IN: Action, 2012: 220.

Carlebach, Michael L. *Bain's New York: The City in News Pictures, 1900–1925.* New York: Dover Publications, 2011.

Caro, Robert A. *The Power Broker: Robert Moses and the Fall of New York.* New York: Vintage Books, 1975.

Carpenter, Teresa. *New York Diaries, 1609 to 2009.* New York: Modern Library, 2012.

Carter, David. *Stonewall: The Riots That Sparked the Gay Revolution.* New York: St. Martin's, 2004.

Castells, Manuel. *The City and the Grassroots: A Cross-Cultural Theory of Urban Social Movements.* Berkeley, CA: University of California Press, 1983.

Cather, Willa. *Coming, Aphrodite! And Other Stories.* New York: Penguin, 1999.

Céline, Louis-Ferdinand. "Journey to the End of the Night." *Writing New York: A Literary Anthology*. Ed. Phillip Lopate. New York: Library of America, 1998: 562.

Chabon, Michael. *The Amazing Adventures of Kavalier & Clay*. New York: Picador, 2000.

Charyn, Jerome. *Gangsters and Gold Diggers: Old New York, the Jazz Age, and the Birth of Broadway*. New York: Four Walls Eight Windows, 2003.

———. "Wild Masonry, Murderous Metal and Mr. Blonde." *New York Stories*. Ed. Constance Rosenblum. New York: New York University Press, 2005: 175–80.

Chase, W. Parker. *New York, The Wonder City, 1932*. New York: New York Bound, 1983.

Chatwin, Bruce, and Robert Mapplethorpe. *Lady, Lisa Lyon*. New York: Viking, 1983.

Chauncey, George. *Gay New York: Gender, Urban Culture, and the Making of the Gay Male World, 1890–1940*. New York: Basic Books, 1994.

Cheever, John. "The Five-Forty-Eight." *The New Yorker*. April 10, 1954: N. pag.

———. "Moving Out." *Esquire's Big Book of Great Writing: More than 70 Years of Celebrated Journalism*. Ed. Adrienne Miller. New York: Hearst, 2003: 93.

Cheever, Susan. "My Little Bit of Country." *Central Park: An Anthology*. Ed. Andrew Blauner. New York: Bloomsbury, 2012: 154–62.

Chin, Henin, ed. *Official Chinatown Guide Book*. New York: Henin & Co., 1939.

Christman, Henry M. *Walt Whitman's New York: From Manhattan to Montauk*. New York: Macmillan, 1963.

Christopher, Nicholas. "1972, #43." *Atomic Field: Two Poems*. New York: Harcourt, 2000: 45.

Churcher, Sharon. *New York Confidential*. New York: Crown, 1986.

"City Has Wild Night of Straw Hat Riots." *New York Times*. September 16, 1922. Web. 22 July 2014.

Clapp, James. *The City: A Dictionary of Quotable Thoughts on Cities and Urban Life*. New Brunswick, NJ: Transaction Publishers, 2012.

Clarke, Donald. *Billie Holiday: Wishing on the Moon*. Cambridge, MA: Da Capo, 2009.

Cohen, Caryl E., and Albert Alexander. *New York, Today and Tomorrow*. New York: College Entrance Book, 1943.

Cohen, Gerald L., and Barry A. Popik. *Origin of New York City's Nickname "The Big Apple."* New York: Peter Lang, 2011.

Coleman, Joseph. "Letter to the Editor." *The Village Voice Reader: A Mixed Bag from the Greenwich Village Newspaper.* Eds. Daniel Wolf and Edwin Fancher. Garden City, NY: Doubleday, 1962: 206.

Collins, Frederick L. *Money Town: The Story of Manhattan Toe: That Golden Mile Which Lies between the Battery and the Fields.* New York: G. P. Putnam's Sons, 1946.

Collins, Glenn. "101 Things to Love About New York City." *New York Times.* June 13, 1976.

Comenas, Gary. "Abstract Expressionism 1954." *Abstract Expressionism 1954.* Warholstars, n.d. Web. 07 Dec. 2014.

———. "Mark Lancaster Interview." *Warholstars.org.* 2004. Web. 21 Nov. 2014.

Conrad, Peter. *Art of the City.* Oxford, UK: Oxford University Press, 1984.

Conroy, Frank. "Midair." *The New Yorker.* February 27, 1984: 44.

Cook, Thomas H. "Rain." *Fatherhood: And Other Stories.* New York: Pegasus, 2013.

Corbett, William. *New York Literary Lights.* Saint Paul, MN: Graywolf, 1998.

Corbusier, Le. *When the Cathedrals Were White: A Journey to the Country of Timid People.* Ed. Francis Edwin Hyslop. New York: Reynal & Hitchcock, 1947.

Cosgrove, Ben. "The Most Beautiful Suicide: A Violent Death, an Immortal Photo." *Time.* March 19, 2014. Web. 09 Dec. 2014.

Courgois, Philippe. *Selling Crack in El Barrio.* Cambridge, UK: Cambridge University Press, 1995.

Cowley, Malcolm. *Exile's Return: A Literary Odyssey of the 1920s.* New York: Viking, 1951.

Cracknell, Andrew. *The Real Mad Men: The Renegades of Madison Avenue and the Golden Age of Advertising.* London: Quercus, 2011.

Crane, Hart, and Walker Evans. *The Bridge: A Poem.* New York: Horace Liveright, 1930.

Crane, Hart. "The Bridge: The Tunnel." *Complete Poems of Hart Crane.* New York: Liveright, 2001: 95.

Crane, Stephen. *Active Service: A Novel.* New York: Frederick A. Stokes, 1899.

Creeley, Robert. "John Wieners: A Day in the Life." *Memorial Broadside.* Raymond Foye, n.d. Web. 16 Sep. 2013.

Crisp, Quentin. *Resident Alien: The New York Diaries.* Los Angeles: Alyson Books, 1996.

Crosby, Robert W. *Cities and Regions as Nonlinear Decision Systems.* Boulder, CO: Westview, 1983.

Culbertson, Judi, and Tom Randall. *Permanent New Yorkers: A Biographical Guide to the Cemeteries of New York*. Chelsea, VT: Chelsea Green Pub., 1987.

cummings, e. e. "even if all desires." *A Survey of Modernist Poetry*. Ed. Laura (Riding) Jackson and Robert Graves. Garden City, NY: Doubleday, Doran, 1928: 85.

Curci, J. Milo, "Cooling the Air to Outwit Heat: Hot Patrons of Amusement Places Are Relieved Now by a Refrigeratory Process from the Discomforts of the Summer." *New York Times*. July 22, 1928.

Dahlberg, Edward. "November Blues." *Burning City: Poems of Metropolitan Modernity*. Eds. Jed Rasula and Tim Conley. Notre Dame, IN: Action, 2012: 529.

Daly, Michael. "Topsy the Elephant Slain by Thomas Edison." *NY Daily News*. June 29, 2013. Web. 08 Dec. 2014.

Danto, Arthur C. *Playing with the Edge: The Photographic Achievement of Robert Mapplethorpe*. Berkeley, CA: University of California Press, 1996.

Davidson, Ian. "Frank O'Hara's Places." *Jacket Magazine*. No. 36, 2008. Web. 21 Nov. 2014.

Davis-Goff, Annabel. "Reading *War and Peace* to William Maxwell." *A William Maxwell Portrait: Memories and Appreciation*. Eds. Charles Baxter, Michael Collier, and Edward Hirsch. New York: W. W. Norton, 2004.

Davis, Mike. *Buda's Wagon: A Brief History of the Car Bomb*. London: Verso, 2007.

———. "The Flames of New York." *New Left Review*. No. 12, November–December 2001. Web. 16 Jun. 2010.

"The Day the NYSE Went Yippie." *CNNMoney*. Cable News Network. August 23, 2007. Web. 22 Aug. 2014.

de Amat, Carlos Oquendo. "New York." *Burning City: Poems of Metropolitan Modernity*. Eds. Jed Rasula and Tim Conley. Notre Dame, IN: Action, 2012: 403.

de Certeau, Michel. *The Practice of Everyday Life*. Berkeley, CA: University of California Press, 1984.

de Chirico, Giorgio. "I Was in New York." *Burning City: Poems of Metropolitan Modernity*. Eds. Jed Rasula and Tim Conley. Notre Dame, IN: Action, 2012: 401.

De Quincey, Thomas. "Confessions of an English Opium-Eater." *Gutenberg*. N.p., April 20, 2005. Web. 31 July 2014.

de Torre, Guillermo. "Mental Diagram." *Burning City: Poems of Metropolitan Modernity*. Eds. Jed Rasula and Tim Conley. Notre Dame, IN: Action, 2012: 458.

———. "Upon Landing." *Burning City: Poems of Metropolitan Modernity*. Eds. Jed Rasula and Tim Conley. Notre Dame, IN: Action, 2012: 57.

Deák, Gloria-Gilda. *Picturing New York: The City from Its Beginnings to the Present*. New York: Columbia University Press, 2000.

DeArment, Robert K. *Gunfighter in Gotham: Bat Masterson's New York City Years*. Norman, OK: University of Oklahoma Press, 2013.

Debord, Guy. "Positions situationnistes sur la circulation." *Internationale Situationniste* #3. December 1959: N. pag.

———. "The Situationist International Text Library / The Society of the Spectacle." *The Situationist International Text Library/The Society of the Spectacle*. N.p., n.d. Web. 18 July 2014.

———. *The Society of the Spectacle*. New York: Zone, 1994.

Delaney, Edmund T. *New York's Turtle Bay, Old & New*. Barre, MA: Barre, 1965.

Delany, Samuel R. *Times Square Red, Times Square Blue*. New York: New York University Press, 1999.

Delgiannakis, Tatiana. "Sir Harry's Wall Brawl." *New York Post*. April 30, 2006. Web. 09 Dec. 2014.

Denby, Edwin, and Robert Cornfield. *Edwin Denby: Dance Writings and Poetry*. New Haven, CT: Yale University Press, 1998: 1–5.

Dennis, Richard. *Cities in Modernity: Representations and Productions of Metropolitan Space, 1840–1930*. Cambridge, UK: Cambridge University Press, 2008.

Depero, Fortunato. "24th Street." *Burning City: Poems of Metropolitan Modernity*. Eds. Jed Rasula and Tim Conley. Notre Dame, IN: Action, 2012: 428.

———. "Coney Island." *Burning City: Poems of Metropolitan Modernity*. Eds. Jed Rasula and Tim Conley. Notre Dame, IN: Action, 2012: 157.

Deyo, L. B., and David Leibowitz. *Invisible Frontier: Exploring the Tunnels, Ruins, and Rooftops of Hidden New York*. New York: Three Rivers, 2003.

Dickerson, Leah. "Interview with James Rosenquist." N. p., April 24, 2012. Web. 30 July 2014.

Didion, Joan. "Goodbye to All That." *We Tell Ourselves Stories in Order to Live: Collected Nonfiction*. New York: Knopf, 2006: 168–77.

———. "Introduction." *Some Women*. Boston: Bulfinch Press, 1989.

Diehl, Lorraine. *Over Here! New York City During World War II*. New York: Smithsonian/HarperCollins, 2010.

Donleavy, J. P. *A Fairy Tale of New York*. New York: Delacorte/S. Lawrence, 1973. Epub.

Dos Passos, John. *Manhattan Transfer*. Boston: Houghton Mifflin Company, 1925.

———. John. *Novels, 1920–1925: One Man's Initiation: 1917; Three Soldiers; Manhattan Transfer*. New York: Literary Classics of the United States, 2003.

Bibliography

Douglas, Ann. *Terrible Honesty: Mongrel Manhattan in the 1920s*. New York: Farrar, Straus and Giroux, 1995.

Dray, Philip. "I Am A Renter." *New York Calling: From Blackout to Bloomberg*. Eds. Marshall Berman and Brian Berger. London: Reaktion Books, 2007: 223–30.

Drehle, David Von. *Triangle: The Fire That Changed America*. New York: Atlantic Monthly, 2003.

Dreiser, Theodore. *The Color of a Great City*. Syracuse, NY: Syracuse University Press, 1996.

Duchamp, Marcel. "A L'Infinitif (The White Box)." *Duchamp Through Shop Windows by Hannah Higgins*. Electronic Book Review, September 1, 2001. Web. 21 Apr. 2014.

Duffy, Peter. *Double Agent: The First Hero of World War II and How the FBI Outwitted and Destroyed a Nazi Spy Ring*. New York: Scribner, 2014.

"DuMont Building." *Wikipedia*. Wikimedia Foundation. January 12, 2014. Web. 07 Dec. 2014.

Duneier, Mitchell. "Sidewalk." *Intersection: Sidewalks and Public Space*. Eds. Marci Nelligan and Nicole Mauro. Oakland, CA: ChainLinks, 2008: 86.

Dwyer, Jim. "Fare-Beater Inc." *New York Stories*. New York: New York University Press, 2005: 225–8.

Dylan, Bob. *Chronicles*. New York: Simon & Schuster, 2004.

Early, Eleanor. *New York Holiday*. New York: Rinehart, 1950.

"Eclipse Puts City In Dark And Millions Watch In Awe." *New York Evening News*. January 24, 1925.

Edholm, Charlton Lawrence. "City Windows." *Everybody's Magazine*. November 1920: 104.

Edmiston, Susan, and Linda D. Cirino. *Literary New York: A History and Guide*. Boston: Houghton Mifflin, 1976.

Einstein, Izzy. *Prohibition Agent No.1: The Startling and Humorous Experiences of America's Most Famous Prohibition Agent*. Introduction by Stanley Walker. New York: Stokes, 1932.

Eiseley, Loren C. "From *The Immense Journey*." *Writing New York: A Literary Anthology*. Ed. Phillip Lopate. New York: Library of America, 1998: 790–1.

Eisen, Jonathan. "Dylan's Garbage's Greatest Hits." *Twenty Minute Fandangos and Forever Changes*. New York: Random House, 1971: 176–8.

Eisenberg, Deborah. "What It Was Like, Seeing Chris." *The New Yorker*. July 29, 1985: 26.

Ekstract, Richard. "Pop Goes the Videotape: An Underground Interview with Andy Warhol." *I'll Be Your Mirror: The Selected Andy Warhol Interviews.* Ed. Kenneth Goldsmith. New York: Carroll & Graf, 2004: 71–9.

The Electrician, 1925, n.d. Web. 07 Jan. 2015.

Ellington, Duke. *Music Is My Mistress.* Garden City, NY: Doubleday, 1973.

Ellis, Bret Easton. *American Psycho.* New York: Vintage, 1991.

———. *Glamorama.* New York: Knopf, 1999.

Ellis, Richard Robb. *The Epic of New York City.* New York: Kondansha, 1996.

Ellison, Ralph. "An Extravagance of Laughter." *Going to the Territory.* New York: Random House, 1986: 145–96.

———. *Invisible Man.* New York: Vintage, 1995.

———. "New York, 1936." *Writing New York: A Literary Anthology.* Ed. Philip Lopate. New York: Library of America, 1998: 995–1003.

England, George Allan. *The Vacant World.* Boston: Small, Maynard, 1914.

Erenberg, Lewis A. *Steppin' Out: New York Nightlife and the Transformation of American Culture, 1890–1930.* Westport, CT: Greenwood, 1981.

Ericson, Raymond. "Max Neuhaus Music Made Especially for Times Square." *New York Times*, November 27, 1977: 113.

Espada, Martin. "The Sign in My Father's Hands." *Poetry Foundation.* N.p., n.d. Web. 22 Dec. 2014.

Falter, Casey. "Song History: Doctor Robert." *Doctor Robert Tribute.* N.p., n.d. Web. 31 July 2014.

Farfa. "Newyorkcocktail." *Burning City: Poems of Metropolitan Modernity.* Eds. Jed Rasula and Tim Conley. Notre Dame, IN: Action, 2012: 296.

"Fashion at the Top." *Women's Wear Daily.* October 12, 1963.

Faulkner, William. *The Penguin Collected Stories of William Faulkner.* Harmondsworth, UK: Penguin, 1985.

Fearing, Kenneth. *Collected Poems of Kenneth Fearing.* New York: Random House, 1940.

———. "Twentieth-Century Blues." *Burning City: Poems of Metropolitan Modernity.* Eds. Jed Rasula and Tim Conley. Notre Dame, IN: Action, 2012: 495.

Federal Writers Project. *Almanac for New Yorkers, 1938.* New York: Modern Age, 1937.

———. *New York Panorama: A Comprehensive View of the Metropolis.* New York: Random House, 1938.

Feininger, Andreas, and John Von Hartz. *New York in the Forties*. New York: Dover Publications, 1978.

Feininger, Andreas, and Kate Simon. *New York*. New York: Viking, 1964.

Feininger, Andreas. *The Face of New York: The City as It Was and It Is*. New York: Crown, 1957.

Feldman, Daniel L., and Gerald Benjamin. *Tales from the Sausage Factory: Making Laws in New York State*. Albany, NY: Excelsior Editions/State University of New York Press, 2010.

Felix, Antonia. *The Post's New York: Celebrating 200 Years of New York City through the Pages and Pictures of the* New York Post. New York: HarperResource, 2001.

Fillia. "Typography." *Burning City: Poems of Metropolitan Modernity*. Eds. Jed Rasula and Tim Conley. Notre Dame, IN: Action, 2012: 49.

Finkelstein, Avram. "Welcome to New York." *Stonewall 25, 1994*. ACTUP, NY, n.d. Web. 16 Sept. 2013.

Finney, Jack. *Time and Again*. New York: Simon and Schuster, 1970.

Fisher, Rudolph. "City of Refuge." *The New Negro: Voices of the Harlem Renaissance*. Eds. Alain Locke and Arnold Rampersad. New York: Touchstone, 1999: 57–8.

Fitch, Robert. *The Assassination of New York*. London: Verso, 1993.

Fitzgerald, F. Scott. *My Lost City: Personal Essays, 1920–1940*. Cambridge, UK: Cambridge University Press, 2005.

———. *The Crack-up*. New York: New Directions, 1956.

———. *The Great Gatsby*. New York: Harper Collins, 2013.

———. *The Jazz Age*. New York: New Directions, 1996.

———. *Tender Is the Night*. New York: Charles Scribner, 1962.

Fitzgerald, Zelda. *Save Me the Waltz*. Carbondale, IL: Southern Illinois University Press, 1967.

Fitzpatrick, Kevin C. *A Journey Into Dorothy Parker's New York*. Berkeley, CA: Roaring Forties Press, 2005.

Fitzpatrick, Tracy. *Art and the Subway: New York Underground*. New Brunswick, NJ: Rutgers University Press, 2009.

Flaherty, Joe. *Tin Wife*. New York: Bantam Books, 1986.

Fontenot, Robert. "Why Did John Lennon and Yoko Ono Originally Move to the United States?" *About Entertainment*. About.Com, n.d. Web. 23 July 2012.

Ford, Ford Madox. *New York Is Not America: Being a Mirror to the States*. New York: Albert & Charles Boni, 1927.

Ford, Henry. "How Jews Capitalized a Protest Against Jews." *The Dearborn Independent*. January 22, 1921: N. pag.

"Four Seasons Restaurant." *Wikipedia*. Wikimedia Foundation. November 30, 2014. Web. 07 Dec. 2014.

Franck, Karen A., and Quentin Stevens. *Loose Space: Possibility and Diversity in Urban Life*. London: Routledge, 2007.

Frank, Waldo David. *City Block*. Darien, CT: Waldo Frank, 1922.

Franzen, Jonathan. "I Just Called to Say I Love You: Cell Phones, Sentimentality, and the Decline of Public Space." *Technology Review*. Sep/Oct. 2008: 88–97.

Freeman, Joshua B. *Working-Class New York: Life and Labor since World War II*. New York: The New Press, 2000.

Frei, George, Sally King-Nero, and Neil Printz. *Andy Warhol Catalogue Raisonné Volume 2B: Paintings and Sculptures 1964–1969*. London: Phaidon, 2004.

Friedberg, Anne. *The Virtual Window: From Alberti to Microsoft*. Cambridge, MA: MIT, 2006.

"French Artists Spur on an American Art." *New York Tribune*. October 24, 1915: N. pag.

Frisa, Maria Luisa, and Stefano Tonchi. *Excess: Fashion and the Underground in the '80s*. Milan: Edizioni Charta, 2004.

Fritscher, Jack. *Mapplethorpe: Assault with a Deadly Camera*. Mamaroneck, NY: Hastings House, 1994.

Fronc, Jennifer. *New York Undercover: Private Surveillance in the Progressive Era*. Chicago: University of Chicago Press, 2009.

Furer, Howard B. *New York: A Chronological & Documentary History, 1524–1970*. Dobbs Ferry, NY: Oceana, 1974.

Fyfe, Nicholas R. *Images of the Street: Planning, Identity, and Control in Public Space*. London: Routledge, 1998.

Gaboriault, Holly. "Matson Jones: Window Designs by Robert & Jasper." *Madam Meow / Holly Gaboriault*. N.p., August 8, 2012. Web. 24 Aug. 2014.

Gaines, Steven S. *The Sky's the Limit: Passion and Property in Manhattan*. New York: Little, Brown, 2005.

Galwey, Charles. "Stadium Concert." *Burning City: Poems of Metropolitan Modernity*. Eds. Jed Rasula and Tim Conley. Notre Dame, IN: Action, 2012: 421.

Gamble, Teri Kwal, and Michael Gamble. *Literature Alive!: The Art of Oral Interpretation*. Lincolnwood, IL: NTC Pub. Group, 1994.

Gammel, Irene. *Baroness Elsa: Gender, Dada, and Everyday Modernity: A Cultural Biography.* Cambridge, MA: MIT, 2002.

Garfias, Pedro. "Cinematographer." *Burning City: Poems of Metropolitan Modernity.* Eds. Jed Rasula and Tim Conley. Notre Dame, IN: Action, 2012: 305.

Garn, Andrew. *Subway Style: 100 Years of Architecture & Design in the New York City Subway.* New York: Stewart, Tabori & Chang, 2004.

Gasche, Rodolphe. *The Tain of the Mirror: Derrida and the Philosophy of Reflection.* Cambridge, MA: Harvard University Press, 1986.

"George Jessel (actor)." *Wikipedia.* Wikimedia Foundation, n.d. Web. 22 Dec. 2014.

Ginsberg, Allen. *Collected Poems, 1947–1980.* New York: Harper & Row, 1984.

———. *Howl: Original Draft Facsimile, Transcript & Variant Versions, Fully Annotated by Author, with Contemporaneous Correspondence, Account of First Public Reading, Legal Skirmishes, Precursor Texts & Bibliography.* Eds. Barry Miles and Carl Solomon. New York: Harper & Row, 1986.

Girdner, John H. *Newyorkitis.* New York: The Grafton Press, 1901.

Glanz, James, and Eric Lipton. *City in the Sky: The Rise and Fall of the World Trade Center.* New York: Times, 2003.

Glashteyn, Jacob. "Twelve." *Burning City: Poems of Metropolitan Modernity.* Eds. Jed Rasula and Tim Conley. Notre Dame, IN: Action, 2012: 498.

Glickman, Toby, and Gene Glickman. *The New York Red Pages: A Radical Tourist Guide.* New York: Praeger, 1984.

Goffman, Erving. *Relations in Public: Microstudies of the Public Order.* New York: Basic, 1971.

Gold, Mike. *Jews Without Money.* New York: Carroll & Graf, 2004.

Goldenberg, Stuart. *Only in New York: 400 Surprising Answers to Fascinating Questions About New York City.* New York: St. Martin's, 2004.

Goldin, Nan. "Nan Goldin on Cookie Mueller." *American Suburb X.* N.p., 2001. Web. 07 Aug. 2014.

Goldmark, Pauline Dorothea. *West Side Studies.* New York: Survey Associates, 1914.

Goldsmith, Kenneth. "Displacement Is the New Translation." *Rhizome.org.* N.p., June 9, 2014. Web. 14 Aug. 2014.

———. *Theory.* Paris: Jean Boîte Editions, 2015.

———. *Traffic.* Los Angeles: Make Now, 2007.

———. *The Weather.* Los Angeles: Make Now, 2005.

Goll, Claire. "Twentieth Century." *Burning City: Poems of Metropolitan Modernity*. Eds. Jed Rasula and Tim Conley. Notre Dame, IN: Action, 2012: 5.

Gooch, Brad. *City Poet: The Life and Times of Frank O'Hara*. New York: Knopf, 1993.

Goodman, Fred. *The Secret City: Woodlawn Cemetery and the Buried History of New York*. New York: Broadway, 2004.

Goodman, Paul, and Percival Goodman. "Banning Cars from Manhattan." *Dissent*. Summer 1961: 304.

Gopnik, Adam. *Through the Children's Gate: A Home in New York*. New York: Knopf, 2006.

Gorky, Maxim. "Boredom." *The Independent*. August 8, 1907: 309–17.

———. *In America*. Honolulu, HI: The Pacific Press, 2001.

Gottehrer, Barry. *New York City in Crisis*. New York: D. McKay, 1965.

Graham, Stephen. *New York Nights*. New York: George H. Doran, 1927.

Granick, Harry. *Underneath New York*. New York: Rinehart & Company, 1947.

Gratz, Roberta Brandes. *The Battle for Gotham*. New York: Nation Books, 2010.

Gray, Christopher. "The Beaux-Arts Ball; A New Age Of Architecture Ushered In Financial Gloom." *New York Times*. December 31, 2005. Web. 06 Dec. 2014.

Gray, Spalding. "Spalding Gray Quotes." *BrainyQuote*. N.p., n.d. Web. 22 Dec. 2014.

Greenburg, Michael M. *The Mad Bomber of New York*. New York: Union Square Press, 2011.

Greenfield, Daniel. "Sufi Abdul Hamid, the Black Hitler of Harlem." *Sultan Knish Blog*. N.p., April 13, 2011. Web. 14 Dec. 2014.

Grimes, William. *Appetite City: A Culinary History of New York*. New York: North Point Press, 2009.

Groce, Nancy. *Lox, Stocks, and Backstage Broadway*. Washington, D.C.: Smithsonian Institution Scholarly Press, 2010.

Gross, Michael. *740 Park: The Story of the World's Richest Apartment Building*. New York: Broadway, 2005.

Guillén, Nicolás. "Small Ode to a Black Cuban Boxer." *Burning City: Poems of Metropolitan Modernity*. Eds. Jed Rasula and Tim Conley. Notre Dame, IN: Action, 2012: 466.

Gussow, Mel. "The House On West 11th Street." *New York Times*. March 4, 2000. Web. 26 Nov. 2014.

"Häagen-Dazs." *Wikipedia*. Wikimedia Foundationn, n.d. Web. 14 Aug. 2014.

Haden, David. *Walking with Cthulhu: H. P. Lovecraft as Psychogeographer, New York City 1924–26*. Self-published, 2011. PDF.

Haden-Guest, Anthony. *The Last Party: Studio 54, Disco, and the Culture of the Night*. New York: William Morrow, 1997.

Hahne, Ron, and Ben Morea. *Black Mask & Up Against the Wall Motherfucker: The Incomplete Works of Ron Hahne, Ben Morea, and the Black Mask Group*. Oakland, CA: PM, 2011.

Haines, Chelsea. "13 Most Wanted Men." *Artforum*. Artforum.com. Summer 2014. Web. 23 Aug. 2014.

Hall, James Norman. "Fifth Avenue in Fog." *The Century*. November 1913–April 1914. New York: The Century Co: N. pag.

Halle, David, and Andrew A. Beveridge. *New York and Los Angeles: The Uncertain Future*. New York: Oxford University Press, 2013.

Hamann, Horst. *New York Vertical*. New York: Te Neues, 1997.

Hamill, Pete. *Downtown: My Manhattan*. New York: Little, Brown, 2004.

———. "New York That We've Lost." *New York Magazine*, December 21, 1987. Web. 09 Dec. 2014.

Hamilton, Wallace. *Christopher and Gay: A Partisan's View of the Greenwich Village Homosexual Scene*. New York: Saturday Review Press, 1973.

Hammack, David C. *Power and Society: Greater New York at the Turn of the Century*. New York: Russell Sage Foundation, 1982.

Hapgood, Hutchins. *Types from City Streets*. New York: Garrett, 1970.

Harding, Gardner. "World's Fair, New York." *Harper's Monthly*. July 1939: 193–200.

Hardwick, Elizabeth. "Shot: A New York Story." *The New Yorker*. October 11, 1993: 103.

———. "Sleepless Nights." *Writing New York: A Literary Anthology*. Ed. Phillip Lopate. New York: Library of America, 1998: 449–59.

Haring, Keith. *Journals*. New York: Penguin Books, 1996.

Harris, Daniel. *Diary of a Drag Queen*. New York: Carroll & Graf, 2005.

Harris, Lawren. "City Heat." *Burning City: Poems of Metropolitan Modernity*. Eds. Jed Rasula and Tim Conley. Notre Dame, IN: Action, 2012: 533.

Hauser, Philip M., and Leo Francis Schnore. *The Study of Urbanization*. New York: Wiley, 1965.

Hawes, Elizabeth. *New York, New York: How the Apartment House Transformed the Life of the City (1869–1930)*. New York: Knopf, 1993. Epub.

Hayes, John Michael, and Cornell Woolrich. *Rear Window: Screenplay*. Los Angeles: Script City, 1953.

Heap, Chad C. *Slumming: Sexual and Racial Encounters in American Nightlife, 1885–1940*. Chicago: University of Chicago Press, 2009.

Heating, Air Conditioning, Sheet Metal Contractor, Volume 11, E. A. Scott Publishing Corporation, 1920.

Hecht, Julie. *Do the Windows Open?* New York: Random House, 1997: 26–51.

Heckscher, August, and Phyllis C. Robinson. *When LaGuardia Was Mayor: New York's Legendary Years*. New York: W. W. Norton, 1978.

Hell, Richard. "Go Now." *Low Rent: A Decade of Prose and Photographs from the Portable Lower East Side*. Ed. Kurt Hollander. New York: Grove Press, 1994: 26.

Henderson, Helen Weston. *A Loiterer in New York: Discoveries Made By A Rambler Through Obvious Yet Unsought Highways And Byways*. New York: Doran, 1917.

Henry, O. *The Complete Works of O. Henry*. Garden City, NY: Garden City Pub., 1911.

———. "The Duel." *Writing New York: A Literary Anthology*. Ed. Phillip Lopate. New York: Library of America, 1998: 382–6.

———. *The Four Million*. Garden City, NY: Doubleday, Page, 1906.

———. "The Making of a New Yorker." *The Trimmed Lamp: And Other Studies of the Four Million*. Garden City, NY: Doubleday, 1907.

———. *The Trimmed Lamp; The Voice of the City*. New York: P. F. Collier, 1908.

Highberger, Craig B. *Superstar in a Housedress: The Life and Legend of Jackie Curtis*. New York: Chamberlain Bros., 2005.

Hilder, John Chapman. "New York Speakeasy: A Study of a Social Institution." *Harper's Monthly*. April 1932: 591–5.

Hinderer, Eve. "Ben Eagle." *Resistance*. Ed. Clayton Patterson. New York: Seven Stories Press, 2007: 543–5.

"Historic Wine Cellars Reopened After Dry Era." *Pittsburgh Post Gazette*. July 12, 1934: 24.

Hoffman, Abbie. *The Autobiography of Abbie Hoffman*. New York: Four Walls Eight Windows, 1980.

———. *Steal This Book*. New York: Pirate Editions / Grove Press, 1971. PDF.

———. *The Steal Yourself Rich Book*. New York: Anarchism, 1971.

Holiday, Billie. *Billie Holiday: Lady Sings the Blues*. Ojai, CA: Creative Concepts, 1976.

Hollander, Kurt. *Low Rent: A Decade of Prose and Photographs from the Portable Lower East Side*. New York: Grove Press, 1994.

Holleran, Andrew. "Anniversary." *Christopher Street* #121, 11.1, 1988: 11.

———. "Nostalgia for the Mud." *The Christopher Street Reader*. Eds. Michael Denneny, Charles Ortleb, and Thomas Steele. New York: Coward, McCann & Geoghegan, 1983: 69.

Hood, Raymond M. "A City under a Single Roof." *The Sphere and the Labyrinth*. Ed. Manfredo Tafuri. Cambridge, MA: MIT, 1987: 190–5.

Howells, William Dean. *A Selected Edition of W. D. Howells*. Vol. 16. Bloomington, IN: Indiana University Press, 1976.

———. *Through the Eye of the Needle: A Romance*. New York: Harper & Brothers, 1907.

Hudson, James R. *The Unanticipated City: Loft Conversions in Lower Manhattan*. Amherst, MA: University of Massachusetts Press, 1987.

Huffa, Joanne. "Max's Kansas City: Art, Glamour, Rock and Roll." *Magenta Magazine*. MagentaMagazine.com. July 3, 2007. Web. 31 July 2014.

Hughes, Langston. *The Big Sea*. New York: Knopf, 1940.

———. *The Collected Poems of Langston Hughes*. New York: Knopf, 1994.

Hughes, Robert. "Culture as Nature." *The Shock of the New, Episode 7*. YouTube. March 14, 2014. Web. 30 Nov. 2014.

Humphrey, Robert E. *Children of Fantasy: The First Rebels of Greenwich Village*. New York: John Wiley & Sons, 1978.

Huncke, Herbert. *Guilty of Everything: The Autobiography of Herbert Huncke*. New York: Paragon House, 1990.

Huneker, James. *New Cosmopolis*. London: Laurie, 1925.

Hustvedt, Siri. "Look Away." *New York Times*. December 7, 2002. Web. 30 Nov. 2014.

Huxley, Michael, and Noel Witts, eds. *The Twentieth-Century Performance Reader*. London: Routledge, 2002.

Huxtable, Ada Louise. *The Architecture of New York: A History and Guide*. Garden City, NY: Anchor, 1964.

———. *Goodbye History, Hello Hamburger: An Anthology of Architectural Delights and Disasters*. Washington, D.C.: Preservation, 1986.

———. "Lively Original Versus Dead Copy," *New York Times* (May 9, 1965), reprinted in *Goodbye History, Hello Hamburger: An Anthology of Architectural Delights and Disasters*. Washington, D.C.: Preservation, 1986: 171.

———. "Lower Manhattan: Where Ghosts Can Be at Home," *New York Times*, April 7, 1968: D25.

———. *On Architecture: Collected Reflections on a Century of Change*. New York: Walker, 2008.

"I'll Be Your Mirror." *Wikipedia*. Wikimedia Foundation, n.d. Web. 13 Dec. 2014.

"If 'Improvement' Plans Had Gobbled Central Park." *New York Times*. March 31, 1918: 78.

"In Search of Tin Pan Alley." *The Parlor Songs Academy*. N.p., March 2000. Web. 10 Aug. 2014.

Inam, Aseem. "Meaningful Urban Design: Teleological / catalytic / relevant." *Writing Urbanism: A Design Reader*. Eds. Douglas Kelbaugh and Kit Krankel McCullough. London: Routledge, 2008: 14–23.

Ingram, Gordon Brent, Anne-Marie Bouthillette, and Yolanda Retter. *Queers in Space: Communities, Public Places, Sites of Resistance*. Seattle, WA: Bay, 1997.

Ings, Richard. "Street Ballet / Urban Drama: Harlem's Sidewalks in Photography, 1900–1960." The 3Cities Project: New York. November 16, 2000. Web. 06 Dec. 2014.

Irwin, Will. *Highlights of Manhattan*. New York: Century, 1927.

Jacks, Ben. "City Walking: Laying Claim to Manhattan." *Writing Urbanism: A Design Reader*. Eds. Douglas Kelbaugh and Kit Krankel McCullough. London: Routledge, 2008: 34.

Jackson, Kenneth T., and David S. Dunbar. *Empire City: New York through the Centuries*. New York: Columbia University Press, 2002.

Jacobson, Mark. *American Gangster and Other Tales of New York*. New York: Black Cat, 2007.

James, Henry. *The American Scene*. London: Chapman & Hall, ltd., 1907.

Janowitz, Tama. *Area Code 212: New York Days, New York Nights*. London: Bloomsbury, 2002.

Javits, Eric M. *SOS New York: A City in Distress and What Can Be Done about It*. New York: Dial, 1961.

Jobs, Sebastian. *Welcome Home, Boys!: Military Victory Parades in New York City, 1899–1946*. Frankfurt: Campus Verlag, 2012.

Johnson, James Weldon. *The Autobiography of an Ex-colored Man*. Boston: Sherman, French & Company, 1912.

———. *Black Manhattan*. New York: Arno, 1968.

Johnson, Joyce. "Minor Characters." *Writing New York: A Literary Anthology*. Ed. Phillip Lopate. New York: Library of America, 1998: 972–6.

Johnson, Tom. *The Voice of New Music: New York City, 1972–1982: A Collection of Articles Originally Published in the Village Voice*. Eindhoven, NE: Apollohuis, 1989.

Jolas, Eugene. "Sleep in Ur (Dream-Scenario)." *Burning City: Poems of Metropolitan Modernity*. Eds. Jed Rasula and Tim Conley. Notre Dame, IN: Action, 2012: 471.

Jones, Amelia. *Irrational Modernism: A Neurasthenic History of New York Dada*. Cambridge, MA: MIT, 2004.

Jones, Joe, and Chicken to Kitchen. *Fluxsaints*. Weisbaden, DE: Artware Production, 1994. CD.

Jones, Richard Lezin, and Oren Yaniv. "Signs Point to Metal Plate In Electrocution of Woman." *New York Times*. January 17, 2004. Web. 15 Dec. 2014.

Jones, Thai. *More Powerful than Dynamite: Radicals, Plutocrats, Progressives, and New York's Year of Anarchy*. New York: Walker, 2012.

Joseph, Lawrence. "In the Age of Postcapitalism." *Poems of New York*. Ed. Elizabeth Schmidt. New York: Knopf, 2002: 190.

Josephy, Helen, and Mary Margaret McBride. *New York Is Everybody's Town*. New York: G. P. Putnam's Sons, 1931.

Joshi, S. T., and David E. Schultz, eds. *Lovecraft Letters Volume 2: Letters from New York*. San Francisco: Night Shade Books, 2005. Epub.

Jumonville, Neil. *Critical Crossings: The New York Intellectuals in Postwar America*. Berkeley, CA: University of California Press, 1991.

Kaiser, Charles. *The Gay Metropolis: 1940–1996*. Boston: Houghton Mifflin, 1997.

Kane, Daniel. *All Poets Welcome: The Lower East Side Poetry Scene in the 1960s*. Berkeley, CA: University of California Press, 2003.

Kaplan, Peter W. *The Kingdom of New York: Knights, Knaves, Billionaires, and Beauties in the City of Big Shots*. New York: Harper, 2009.

Kapralov, Yuri. "Christodora: The Flight of a Sea Animal." *Resistance*. New York: Seven Stories Press, 2007: 87–100.

Kardon, Janet. *Robert Mapplethorpe: The Perfect Moment*. Philadelphia: Institute of Contemporary Art, University of Pennsylvania Press, 1988.

Kasson, John F. *Amusing the Million: Coney Island at the Turn of the Century*. New York: Hill & Wang, 1978.

Keillor, Garrison. *Wobegon Boy*. New York: Viking, 1997.

Kelbaugh, Doug, and Kit Krankel McCullough. *Writing Urbanism: A Design Reader*. London: Routledge, 2008.

Keller, Helen. *Midstream: My Later Life*. Garden City, NY: Doubleday, Doran, 1929.

Kennedy, Randy. "When Meals Played the Muse." *New York Times*. February 20, 2007. Web. 13 Dec. 2014.

Kennedy, Randy. *Subwayland*. New York: St. Martin's Griffin, 2002.

Kerouac, Jack. *Lonesome Traveler*. New York: McGraw-Hill, 1960.

——. *On the Road: The Original Scroll*. Ed. Howard Cunnell. New York: Viking, 2007.

Khlebnikov, Velimir. "Untitled Poem." *Burning City: Poems of Metropolitan Modernity*. Eds. Jed Rasula and Tim Conley. Notre Dame, IN: Action, 2012: 48.

Kilgannon, Corey. "Recalling Childhoods Spent Romping Under the Statue of Liberty's Gaze." *New York Times*. July 4, 2012. Web. 25 Nov. 2014.

Kilham, Walter Harrington. *Raymond Hood, Architect: Form through Function in the American Skyscraper*. New York: Architectural Book Pub., 1974.

Kingwell, Mark. *Nearest Thing to Heaven: The Empire State Building and American Dreams*. New Haven, CT: Yale University Press, 2006.

Kinkead, Eugene. *Central Park, 1857–1995: The Birth, Decline, and Renewal of a National Treasure*. New York: W. W. Norton, 1990.

Kinkead, Gwen. *Chinatown: A Portrait of a Closed Society*. New York: Harper Collins, 1992.

Kissel, Howard. *David Merrick, the Abominable Showman: The Unauthorized Biography*. New York: Applause, 1993.

Kittler, Friedrich A. "The City Is a Medium." *New Literary History* 27.4 (1996): 717–29.

Klosterman, Chuck. "Everyone Knows This Is Somewhere, Part II." *New York Stories*. Ed. Constance Rosenblum. New York: New York University Press, 2005: 36–40.

Koestenbaum, Wayne. *Andy Warhol*. New York: Viking, 2001.

Kolbert, Elizabeth. "Dymaxion Man." *The New Yorker*. June 9, 2008. Web. 25 Nov. 2014.

Koolhaas, Rem. *Delirious New York: A Retroactive Manifesto for Manhattan*. New York: The Monacelli Press, 1994.

Kopasz, Paul. "Going Downtown (On an Uptown Train)." *New York Calling: From Blackout to Bloomberg*. Eds. Marshall Berman and Brian Berger. London: Reaktion Books, 2007: 242–52.

Kornblum, William. *At Sea in the City: New York from the Water's Edge*. Chapel Hill, NC: Algonquin, 2002.

Kornbluth, Jesse. "Inside Area." *New York Magazine.* March 11, 1985: 33–41.

———. "The World of Warhol." *New York Magazine.* March 9, 1987. Web. 03 Jan. 2015.

Kostelanetz, Richard. *Soho: The Rise and Fall of an Artists' Colony.* New York: Routledge, 2003.

Kozloff, Max. "Introduction." *Saul Leiter.* New York: Thames & Hudson, 2009.

Krauss, Rosalind. "Grids." *October,* Vol. 9 (Summer 1979): 50–64.

Krieger, Alex. "The Virtues of Cities." *Places Journal.* January 1996: 64–71.

Kriendler, H. Peter, and H. Paul Jeffers. *"21": Every Day Was New Year's Eve: Memoirs of a Saloon Keeper.* Dallas, TX: Taylor Pub., 1999.

Kunstler, James Howard. *The City in Mind: Meditations on the Urban Condition.* New York: Free Press, 2001.

Laguerre, Michel S. *Urban Multiculturalism and Globalization in New York City: An Analysis of Diasporic Temporalities.* Basingstoke, UK: Palgrave Macmillan, 2003.

Lamont, Barbara. *City People.* New York: Macmillan, 1975.

Lancaster, Clay. *Old Brooklyn Heights: New York's First Suburb. Including Detailed Analyses of 619 Century-old Houses.* Rutland, VT: C.E. Tuttle, 1961.

Lapsley, Phil. *Exploding the Phone: The Untold Story of the Teenagers and Outlaws Who Hacked Ma Bell.* New York: Grove Press, 2013.

Laredo, Victor. *New York City: A Photographic Portrait.* New York: Dover Publications, 1973.

Lawrence, Tim. *Voguing and the House Ballroom Scene of New York City 1898–1992.* London: Soul Jazz Books, 2011.

Lawson, Guy. "Hotel Providence: Scenes from a Bowery Flophouse." *Harper's.* December 1999: N. pag.

Leach, Neil, ed. *Rethinking Architecture.* London: Routledge, 1997.

Leavitt, David. "The Town That Gags Its Writers." *New York Times.* February 17, 2001. Web. 26 Nov. 2014.

Lebowitz, Fran. *The Fran Lebowitz Reader.* New York: Vintage, 1994.

LeDuff, Charlie. *Work and Other Sins: Life in New York City and Thereabouts.* New York: Penguin, 2004.

Lee, Spike, and Lisa Jones. *Do the Right Thing.* New York: Fireside, 1989. PDF.

Lees, Andrew. *Cities Perceived: Urban Society in European and American Thought, 1820–1940.* New York: Columbia University Press, 1985.

890

Lefebvre, Henri. *Critique of Everyday Life Volume 1*. London and New York: Verso, 1991.

———. *Stage, Space, World: Selected Essays*. London and Minneapolis, MN: University of Minnesota Press, 2009.

———. *Writings on Cities*. Oxford, UK: Blackwell, 1996.

Lehman, David, ed. *The Oxford Book of American Poetry*. Oxford, UK: Oxford University Press, 2006.

———. *New and Selected Poems*. New York: Scribner, 2013: 157.

Leipzig, Arthur, and Sylvia Böhmer. *Arthur Leipzig: Next Stop New York*. Munich: Prestel, 2008.

Lerner, Michael. *Dry Manhattan: Prohibition in New York City*. Cambridge, MA: Harvard University Press, 2007.

LeSueur, Joe. *Digressions on Some Poems by Frank O'Hara*. New York: Farrar, Straus and Giroux, 2003.

Levin, Gail. *Edward Hopper: An Intimate Biography*. New York: Knopf, 1995.

Levison, Pearl Esther. *The Official Poem of the New York World's Fair, 1939 and Other Prize Winning Poems*. New York: The Academy of American Poets, 1939.

Léyeles, A. "New York." *Burning City: Poems of Metropolitan Modernity*. Eds. Jed Rasula and Tim Conley. Notre Dame, IN: Action, 2012: 405.

Li-Young, Lee. "The City in Which I Love You." *Poems of New York*. Ed. Elizabeth Schmidt. New York: Knopf, 2002: 223.

Lichtenstein, Alfred. "After the Ball." *Burning City: Poems of Metropolitan Modernity*. Eds. Jed Rasula and Tim Conley. Notre Dame, IN: Action, 2012: 513.

Liebling, A. J. *Back Where I Came From*. San Francisco: North Point, 1990.

Lin, Jan. *Reconstructing Chinatown: Ethnic Enclave, Global Change*. Minneapolis, MN: University of Minnesota Press, 2004.

Lindner, Christoph. *Globalization, Violence, and the Visual Culture of Cities*. London: Routledge, 2010.

"List of Books Set in New York City." *Wikipedia*. Wikimedia Foundation. May 8, 2014. Web. 10 Aug. 2014.

"List of Films Set in New York City." *Wikipedia*. Wikimedia Foundation. June 8, 2014. Web. 10 Aug. 2014.

Little, Craig B. *Deviance & Control: Theory, Research, and Social Policy*. Itasca, IL: F. E. Peacock, 1989.

Lobas, Vladimir. *Taxi from Hell*. New York: Soho Press, 1991.

Lockwood, Charles. *Bricks & Brownstone: The New York Row House, 1783–1929: A Guide to Architectural Styles and Interior Decoration for Period Restoration*. New York: Abbeville, 1972.

———. *Manhattan Moves Uptown: An Illustrated History*. Boston: Houghton Mifflin, 1976.

Lofland, Lyn H. *A World of Strangers: Order and Action in Urban Public Space*. New York: Basic Books, 1973.

London, Herbert I. *The Broken Apple: New York City in the 1980s*. New Brunswick, NJ: Transaction, 1989.

Long, Kat. *The Forbidden Apple: A Century of Sex & Sin in New York City*. Brooklyn, NY: Ig Pub., 2009.

Lopate, Phillip. *Seaport: New York's Vanished Waterfront: Photographs from the Edwin Levick Collection*. Washington, D.C.: Smithsonian, 2004.

———. *Waterfront: A Journey around Manhattan*. New York: Crown, 2004.

———. *Writing New York: A Literary Anthology*. New York: Library of America, 1998.

Lorca, Federico García. *Collected Poems Revised Bilingual Edition*. Ed. Christopher Maurer. New York: Farrar, Straus and Giroux, 2002.

———. "Landscape of a Vomiting Multitude." *Burning City: Poems of Metropolitan Modernity*. Eds. Jed Rasula and Tim Conley. Notre Dame, IN: Action, 2012: 426.

———. "New York (Office and Denunciation)." *The City That Never Sleeps: Poems of New York*. Ed. Shawkat M. Toorawa. Albany, NY: Excelsior Editions / State University of New York Press, 2015: 11.

———. *Poet in New York*. New York: Grove, 1955.

Lott, Philip B. "The Birth and Evolution of a New Social Movement Organization: The AIDS Coalition to Unleash Power (ACT UP)." Unpublished paper, undated.

Loukaitou-Sideris, Anastasia, and Renia Ehrenfeucht. *Sidewalks: Conflict and Negotiation over Public Space*. Cambridge, MA: MIT, 2009.

Lovecraft, H.P. "Cool Air." *Tales of Magic and Mystery* 1.4. March 1928: 29–34.

———. "He." *Weird Tales* 8.3. September 1926: 373–80.

———. *H. P. Lovecraft Fiction Collection*. Google Books, n.d. Web. 17 Dec 2014.

———. "The Lurking Fear." *Home Brew* 2.6. January 1923: 4–10; 3.1 Feb. 1923: 18–23 ; 3.2. March 1923: 31–7, 44, 48; 3.3. April 1923: 35–42.

———. "Pickman's Model." *Weird Tales* 10.4. October 1927: 505–14.

Lowe, David. *Art Deco New York*. New York: Watson-Guptill Publications, 2004.

Lowell, Amy. "The Taxi." *Sword Blades and Poppyseeds*. New York: Macmillan, 1914: 54.

Lowenthal, David. "Conserving the Heritage: Anglo-American Comparisons." *The Expanding City*. Ed. John Patten. London: Academic, 1983.

Loy, Mila. "Lunar Baedeker." *Burning City: Poems of Metropolitan Modernity*. Eds. Jed Rasula and Tim Conley. Notre Dame, IN: Action, 2012: 46.

Lyford, Joseph P. *The Airtight Cage: A Study of New York's West Side*. New York: Harper & Row, 1966.

Lyon, Danny. *The Destruction of Lower Manhattan*. New York: Macmillan, 1969.

Lyotard, Jean-François. "Domus and the Megalopolis." *Rethinking Architecture*. Ed. Neil Leach. London: Routledge, 1997: 281.

Machen, Arthur. *The Arthur Machen Megapack*. Rockville, MD: Wildside Press, 2013.

———. *The Three Imposters*. Toronto: Macmillan, 1923.

Maffi, Mario. *New York City: An Outsider's Inside View*. Columbus, OH: Ohio State University Press, 2004.

Mahler, Jonathan. *Ladies and Gentlemen, The Bronx Is Burning: 1977, Baseball, Politics, and the Battle for the Soul of a City*. New York: Farrar, Straus and Giroux, 2005.

Malanga, Gerard. *Archiving Warhol: An Illustrated History*. London: Creation, 2002.

———. "Interview with Andy Warhol on *EMPIRE*." *I'll Be Your Mirror: The Selected Andy Warhol Interviews*. Ed. Kenneth Goldsmith. New York: Carroll & Graf, 2004: 54–120.

Maloney, Fred. "Rockaway Idyll." *New York Stories*. Ed. Constance Rosenblum. New York: New York University Press, 2005: 109.

"Man Held in Cult Slaying of Ballerina Flesh Was Fed to Homeless, N.Y. Police Say." *Baltimore Sun*. February 18, 1992. Web. 07 Aug. 2014.

Manrique, Jaime. *Latin Moon in Manhattan*. New York: St. Martin's, 1992.

Manville, Bill. "Saloon Society," *The Village Voice Reader: A Mixed Bag from the Greenwich Village Newspaper*. Eds. Daniel Wolf and Edwin Fancher. Garden City, NY: Doubleday, 1962: 345.

Mapplethorpe, Robert. "Biography." *The Robert Mapplethorpe Foundation*. Web.

———. *Pistils*. New York: Random House, 1996.

Marcuse, Maxwell F. *This Was New York: A Nostalgic Picture of Gotham in the Gaslight Era*. New York: LIM, 1969.

Bibliography

Mariani, Paul L. *The Broken Tower: A Life of Hart Crane*. New York: W. W. Norton, 1999.

Marinetti, F. T. "Destruction of Syntax - Wireless Imagination - Words in Freedom." *Burning City: Poems of Metropolitan Modernity*. Eds. Jed Rasula and Tim Conley. Notre Dame, IN: Action, 2012: 46.

Marquis, Alice Goldfarb. *Marcel Duchamp, the Bachelor Stripped Bare: A Biography*. Boston: MFA Publications, 2002.

Mars, Roman. "What Happens to 'Holdouts' Who Refuse to Sell Their Homes to Developers?" *Slate Magazine*. September 3, 2014. Web. 03 Sept. 2014.

Marsh, Katherine. "Waiting to Exhale." *New York Stories*. Ed. Constance Rosenblum. New York: New York University Press, 2005: 119–26.

Marshall, Richard. *Robert Mapplethorpe*. New York: Whitney Museum, 1988.

Marx, Karl and Frederick Engels. *The Collected Works of Karl Marx and Frederick Engels*. New York: International Publishers, 1975.

Maull, Samuel. "Garbage Piles Up in New York Strike." *The Prescott Courier*. July 2, 1975: 2.

Maxwell, William. *Over by the River and Other Stories*. New York: Knopf, 1977.

Mayakovsky, Vladimir. "Brooklyn Bridge." *The Bedbug and Selected Poetry*. Bloomington, IN: Indiana University Press, 1975: 173–82.

———. "Great Big Hell of a City." *Burning City: Poems of Metropolitan Modernity*. Eds. Jed Rasula and Tim Conley. Notre Dame, IN: Action, 2012: 505.

———. *My Discovery of America*. London: Modern Voices, 1926.

Mayer, Grace M., Percy C. Byron, and Edward Steichen. *Once Upon a City: New York from 1890 to 1910*. New York: Macmillan, 1958.

McCourt, James. *Queer Street: Rise and Fall of an American Culture, 1947–1985*. New York and London: W. W. Norton, 2004.

McDarrah, Fred. *The Artist's World in Pictures*. New York: E. P. Dutton, 1961.

———. "Letter to the Editor." *The Village Voice Reader: A Mixed Bag from the Greenwich Village Newspaper*. Eds. Daniel Wolf and Edwin Fancher. Garden City, NY: Doubleday, 1962: 33.

McDarrah, Fred W., and Gloria S. McDarrah. *Beat Generation: Glory Days in Greenwich Village*. New York: Schirmer, 1996.

McGuigan, Cathleen. "New Art, New Money." *New York Times*. February 10, 1985. Web. 10 Aug. 2014.

McInerney, Jay. *Bright Lights, Big City*. New York: Vintage, 1984.

———. "Yuppies in Eden." *New York Magazine*. September 28, 2008. Web. 20 June 2014.

894

McIntyre, Iain. "Up Against the Wall Motherfucker." *Interview with Ben Morea*. Libcom.org, n.d. Web. 26 Nov. 2014.

McKay, Claude. "A Song of the Moon." *Complete Poems*. Chicago: University of Illinois Press, 2004: 212.

———. *Home to Harlem*. Boston: Northeastern University Press, 1987.

McLoughlin, Tim. "New York State of Crime." *New York Calling: From Blackout to Bloomberg*. Eds. Marshall Berman and Brian Berger. London: Reaktion Books, 2007: 193–203.

McMahon, J. P. "Vito Acconci's Following Piece." *Conceptual Art*. Smart History, n.d. Web. 12 Dec. 2014.

McMillan, John. "Garbage Guerrilla: The Mystery Man Behind the East Village Art Gang with the Unprintable Name." *Resistance*. Ed. Clayton Patterson. New York: Seven Stories Press, 2007: 532–42.

McNamara, Robert P. *Sex, Scams, and Street Life: The Sociology of New York City's Times Square*. Westport, CT: Praeger, 1995.

McNeil, Legs, and Gillian McCain. *Please Kill Me: The Uncensored Oral History of Punk*. New York: Grove Press, 1996.

McReynolds, David. "The Hipster General Strike." *The Village Voice Reader: A Mixed Bag from the Greenwich Village Newspaper*. Eds. Daniel Wolf and Edwin Fancher. Garden City, NY: Doubleday, 1962: 345–9.

Mehring, Walter. "Berlin-Paree." *Burning City: Poems of Metropolitan Modernity*. Eds. Jed Rasula and Tim Conley. Notre Dame, IN: Action, 2012: 34.

Meltzer, Richard. "At Least It's Not New York." *New York Calling: From Blackout to Bloomberg*. Eds. Marshall Berman and Brian Berger. London: Reaktion Books, 2007: 188–92.

Mencken, H. L. *A Second Mencken Chrestomathy*. New York: Knopf, 1995.

Merrill, James Ingram. *Selected Poems, 1946–1985*. New York: Knopf, 2001.

Metz, Christian. *The Imaginary Signifier: Psychoanalysis and the Cinema*. Bloomington, IN: Indiana University Press, 1982.

Meyer, Alfred Richard. "Manhattan-Cocktail." *Burning City: Poems of Metropolitan Modernity*. Eds. Jed Rasula and Tim Conley. Notre Dame, IN: Action, 2012: 295.

Meyer, Richard. *Outlaw Representation: Censorship & Homosexuality in Twentieth-Century American Art*. Boston: Beacon Press, 2002.

Milbank, Caroline Rennolds. *New York Fashion: The Evolution of American Style*. New York: Abrams, 1989.

Miles, Barry. *Ginsberg: A Biography*. New York: Simon and Schuster, 1989.

Milford, Nancy. *Savage Beauty: The Life of Edna St. Vincent Millay*. New York: Random House, 2002.

Miller, Arthur. "Before Air-Conditioning." *The New Yorker*. June 22, 1998. Web. 26 Nov. 2014.

Miller, Donald L. *Supreme City: How Jazz Age Manhattan Gave Birth to Modern America*. New York: Simon and Schuster, 2014.

Miller, Eric. "Festive Art in a Festive Neighborhood: Street Mosaics in New York City's East Village." *Mosaics Paper*. Storytelling and Videoconferencing, n.d. Web. 24 Nov. 2014.

Miller, Eric. "Some Habitation Attitudes and Practices on New York City's Lower East Side, 1982 to 2002." *Resistance*. Ed. Clayton Patterson. New York: Seven Stories Press, 2007: 126–40.

Miller, Henry. *Sexus*. New York: Grove Press, 1965.

Miller, Terry. *Greenwich Village and How It Got That Way*. New York: Crown, 1990.

Mitchell, Joseph. "Joe Gould's Secret." *Up in the Old Hotel and Other Stories*. New York: Knopf Doubleday, 1993: 624–5.

———. *My Ears Are Bent*. New York: Pantheon, 1983.

Mitgang, Herbert. *Once Upon a Time in New York: Jimmy Walker, Franklin Roosevelt, and the Last Great Battle of the Jazz Age*. New York: Free Press, 2000.

Mittlebach, Margaret, and Michael Crewdson. *Wild New York*. New York: Crown, 1997.

Młodożeniec, Stanisław. "Twentieth Century." *Burning City: Poems of Metropolitan Modernity*. Eds. Jed Rasula and Tim Conley. Notre Dame, IN: Action, 2012: 324.

Monaghan, Frank. *Official Guide Book of the New York World's Fair, 1939*. New York: Exposition Publications, 1939.

Monson, Christopher. "Mathematics of the Ideal Roadtrip." *Writing Urbanism: A Design Reader*. Eds. Douglas Kelbaugh and Kit Krankel McCullough. London: Routledge, 2008: 24–33.

Moore, Marianne. "New York." *The Poems of Marianne Moore*. New York: Penguin, 2005: 146.

Moore, Peter, Barbara Moore, Eric P. Nash, and Lorraine B. Diehl. *The Destruction of Penn Station: Photographs by Peter Moore*. New York: D.A.P., 2000.

Moorhouse, Geoffrey. *Imperial City: The Rise and Rule of New York*. London: Sceptre, 1989.

Morales, Ed. "Spanish Harlem on His Mind." *New York Stories*. Ed. Constance Rosenblum. New York: New York University Press, 2005.

Morand, Paul. "From *New York*." *Writing New York: A Literary Anthology*. Ed. Phillip Lopate. New York: Library of America, 1998: 509–17.

Morley, Christopher, *Christopher Morley's New York*. New York: Fordham University Press, 1988.

———. *Internal Revenue*. New York: Doubleday, Doran, 1933.

Morris, Catherine. *Food: An Exhibition by White Columns*. New York: Walther König, 2000.

Morris, Jan. *Manhattan '45*. New York: Oxford University Press, 1987.

Morris, Lloyd. *Incredible New York*. Syracuse, NY: Syracuse University Press, 1951.

Morrison, Toni. *Jazz*. London: Chatto & Windus, 1992.

Morrisroe, Patricia. *Mapplethorpe: A Biography*. New York: Random House, 1995.

———. "The Punk Glamour God." *New York Magazine*, n.d. Web. 22 July 2014.

Mortimer, Lee, and Jack Lait. *New York: Confidential!* Chicago: Ziff-Davis Pub., 1948.

Moscow, Henry. *The Book of New York Firsts*. Syracuse, NY: Syracuse University Press, 1995.

Moss, Frank, and C. H. Parkhurst. *The American Metropolis: From Knickerbocker Days to the Present Time: New York City Life in All Its Various Phases: An Historiograph of New York*. New York: P. F. Collier, 1897.

Mueller, Cookie, and Amy Scholder. *Ask Dr. Mueller: The Writings of Cookie Mueller*. New York: Serpent's Tail High Risk, 1997.

Mumford, Lewis. *The City in History: Its Origins, Its Transformations, and Its Prospects*. New York: Harcourt, Brace & World, 1961.

———. "The Intolerable City: Must It Keep Growing?" *Harper's*. February 1926: 283–93.

———. *Mumford on Modern Art in the 1930s*. Ed. Robert Wojtowicz. Berkeley, CA: University of California Press, 2007.

———. *Sidewalk Critic: Lewis Mumford's Writings on New York*. Ed. Robert Wojtowicz. New York: Princeton Architectural Press, 1998.

———. *Sketches from Life*. New York: Dial Press, 1982.

Murphy, Tim. "New Yorkers Recall the Days of the AIDS Epidemic." *New York Magazine*, May 29, 2014. Web. 08 Aug. 2014.

Musto, David F. "Opium, Cocaine and Marijuana in American History." *Scientific American* 265.1, 1991: 40–7.

Myers, John Bernard. *Tracking the Marvelous: A Life in the New York Art World*. New York: Random House, 1981.

Nabokov, Vladimir. "Symbols and Signs." *Wonderful Town: New York Stories from* The New Yorker. Eds. David Remnick and Susan Choi. New York: Random House, 2000: 224–8.

Nagle, Robin. *Picking Up: On the Streets and Behind the Trucks with the Sanitation Workers of New York City*. New York: Farrar, Straus and Giroux, 2013.

Naumann, Francis M. *New York Dada, 1915–23*. New York: Abrams, 1994.

Neumann, Osha. *Up Against the Wall Motherf**ker!: A Memoir of Anarchism in the '60s*. New York: Seven Stories Press, 2008.

Neuss, Gustave. "The German American Bund." Longwood Central School District, November 2002. Web. 06 Jan. 2015.

New York Journal of American History, Vol. 65, New-York Historical Society, 2003.

Nichols, Mary. "Norman Mailer's LEGO Vision of New York." *The Village Voice*. February 18, 1965, Vol. X, No. 18: N. pag.

Nordenson, Guy. *Tall Buildings*. New York: Museum of Modern Art, 2003.

Norman, Philip. *John Lennon: The Life*. New York: Ecco, 2008.

Norwood, Christopher. "The Subway Syndrome." *New York Magazine*. August 9, 1982: 39–41.

O'Connell, Shaun. *Remarkable, Unspeakable New York: A Literary History*. Boston: Beacon Press, 1995.

O'Connor, Richard. *Hell's Kitchen: The Roaring Days of New York's Wild West Side*. Philadelphia: Lippincott, 1958.

O'Donnell, Edward T. "The Dawn of New York's Ice Age." *New York Times*. July 30, 2005. Web. 30 Nov. 2014.

O'Hara, Frank. *The Collected Poems of Frank O'Hara*. Ed. Donald Allen. New York: Knopf, 1971.

O'Neill, Joseph. "Cornerville." *New York Times*. November 30, 2008: CY1.

Oatman-Stanford, Hunter. "A Filthy History: When New Yorkers Lived Knee-Deep in Trash." *Collectors Weekly*. June 24, 2013. Web. 14 Aug. 2014.

"Odd Lots: Revisiting Gordon Matta-Clark's Fake Estates." *CABINET*. N.p., n.d. Web. 02 Jan. 2015.

Okrent, Daniel. *Last Call: The Rise and Fall of Prohibition*. New York: Scribner, 2010.

Oppen, George. *Collected Poems*. New York: New Directions, 1975.

———. "Tourist Eye." *The Materials*. New York: New Directions, 1962: 27.

Orlansky, Harold. *The Harlem Riot: A Study In Mass Frustration*. New York: Social Analysis, 1943.

Ottley, Roi, and William J. Weatherby. *The Negro in New York: An Informal Social History, 1626–1940*. New York: Praeger, 1967.

Owen, David. "Green Manhattan." *The New Yorker*. October 18, 2004: 11.

Panchyk, Richard. *New York City Skyscrapers*. Charleston, SC: Arcadia Pub., 2010.

Parland, Henry. "The Ideals Clearance." *Burning City: Poems of Metropolitan Modernity*. Eds. Jed Rasula and Tim Conley. Notre Dame, IN: Action, 2012: 344.

Parsons, Deborah L. *Streetwalking the Metropolis: Women, the City, and Modernity*. Oxford, UK: Oxford University Press, 2000.

Patchen, Kenneth. *Selected Poems*. New York: New Directions, 1957.

Patterson, Clayton. "The Case of the Butcher of Tompkins Square Park." *The Villager*. February 2, 2012. Web. 07 July 2014.

Patterson, Clayton, Joe Flood, and Alan Moore. *Resistance: A Radical Political and Social History of the Lower East Side*. New York: Seven Stories, 2007.

Patterson, Jerry E. *The City of New York: A History Illustrated from the Collections of the Museum of the City of New York*. New York: H. N. Abrams, 1978.

Paumgarten, Nick. "Getting There: The Science of Driving Directions." *The New Yorker*. April 24, 2006. Web. 09 Dec. 2014.

Peel, Roy V. *The Political Clubs of New York City*. Port Washington, NY: I. J. Friedman, 1968.

Perelman, S. J. "Farewell, My Lovely Appetizer." *The New Yorker*. December 16, 1944: 21.

Peretti, Burton W. *Nightclub City: Politics and Amusement in Manhattan*. Philadelphia: University of Pennsylvania Press, 2007.

Perrin, Noel. "New York Drowns Another Valley." *Harper's Monthly*. August 1963: 76–81.

Perry, George Sessions. "Look, Ma—Real Grass!" *Saturday Evening Post*. November 15, 1947: 28.

Peter, Peter. *The Subway Pictures*. New York: Random House, 2004.

Petronius. *New York Unexpurgated: An Amoral Guide for the Jaded, Tired, Evil, Non-Conforming, Corrupt, Condemned, and the Curious, Humans and Otherwise, to Under Underground Manhattan*. New York: Matrix House, 1966.

Bibliography

Peyton, Bernard. *From the Heart of the Earth: Four Years, 1949–1953*. Place of Publication Not Identified: Priv., 1953.

Pfanner, Jim, and Bob Khoury. "Robert Does a Photograph of Tom and Tom Does a Drawing of Robert." *The Leather Report*. YouTube, 1998. Web. 1 Dec. 2010.

Philips, McCandlish, *City Notebook*. New York: Liveright, 1974.

Pile, Steve. *The Body and The City: Psychoanalysis, Space and Subjectivity*. London: Routledge, 1996.

Pinchbeck, Daniel. "Prince at Greene: Daniel Pinchbeck on Peter Pinchbeck." *Artforum*. Summer 2002. Web. 07 Jan. 2015.

Pinder, David. *Visions of the City: Utopianism, Power, and Politics in Twentieth-century Urbanism*. New York: Routledge, 2005.

"Plan to Drain a New York River." *Popular Science Monthly*. December 1924: 47.

Pomerance, Murray, ed. *City That Never Sleeps: New York and the Filmic Imagination*. New Brunswick, NJ: Rutgers University Press, 2007.

Pope.L, William. "Crawling in Public." *Intersection: Sidewalks and Public Space*. Eds. Marci Nelligan and Nicole Mauro. Oakland, CA: ChainLinks, 2008: 75.

Pound, Ezra. "N.Y." *The New Poetry: An Anthology*. Eds. Harriet Monroe and Alice Corbin Henderson. New York: Macmillan, 1917: 283.

———. *Personæ: The Collected Poems of Ezra Pound*. New York: New Directions, 1950.

Powell, Dawn. *The Diaries of Dawn Powell, 1931–1965*. South Royalton, VT: Steerforth Press, 1995.

Przybos, Julian. "Roofs." *Burning City: Poems of Metropolitan Modernity*. Eds. Jed Rasula and Tim Conley. Notre Dame, IN: Action, 2012: 328.

Puzo, Mario. *The Fortunate Pilgrim*. New York: Random House, 1964.

Quan, Tracy. *Diary of a Manhattan Call Girl*. New York: Crown, 1998.

Queens Museum. "Panorama of the City of New York." *Queens Museum*. The Queens Museum, n.d. Web. 30 Nov. 2014

Rabinowitz, Paula. "Mogul and Star." *Public Space, Private Lives: Race, Gender, Class, and Citizenship in New York, 1890–1929*. Eds. William Q. Boelhower and Anna Scacchi. Amsterdam: VU University Press, 2004: 155.

Rapoport, Amos. "Culture and the Urban Order." *The City in Cultural Context*. Eds. John A. Agnew, John Mercer, and David Edward Sopher. Boston: Allen & Unwin, 1984: 51–2.

Rasenberger, Jim. "The Old Neighbors." *New York Stories*. Ed. Constance Rosenblum. New York: New York University Press, 2005: 26.

Reay, Barry. *New York Hustlers: Masculinity and Sex in Modern America*. Manchester, UK: Manchester University Press, 2010.

Rechy, John. *City of Night*. New York: Grove, 1963.

Reinicke, Gesine. "Metamorphoses of the Flâneur in New York: Reflections on Aesthetics and Ethics of Urban Perception in William Dean Howells's *A Hazard of New Fortunes*." The 3Cities Project: New York. November 16, 2000. Web. 06 Dec. 2014.

Reitano, Joanne R. *The Restless City: A Short History of New York from Colonial Times to the Present*. New York: Routledge, 2006.

Remnick, David, and Susan Choi. *Wonderful Town: New York Stories from* The New Yorker. New York: Random House, 2000.

Reublin, Rick. "Tin Pan Alley." *Wikipedia*. Wikimedia Foundation. July 22, 2014. Web. 10 Aug. 2014.

Reznikoff, Charles. "Walk About the Subway System." *The Poems of Charles Reznikoff: 1919–1975*. Jaffrey, NH: David. R. Godine, 2005: 97.

Rich, Adrienne. "Upper Broadway." *Later Poems: Selected and New, 1971–2012*. New York: W. W. Norton, 2013: 57.

Rich, Joan. *How to Be a New Yorker*. Garden City, NY: Doubleday, 1964.

Richards, Simon. *Le Corbusier and the Concept of Self*. New Haven, CT: Yale University Press, 2003.

Riesenberg, Felix, and Alexander Alland. *Portrait of New York*. New York: Macmillan, 1939.

Roche, Juliette. "Déja-Vu." *Burning City: Poems of Metropolitan Modernity*. Eds. Jed Rasula and Tim Conley. Notre Dame, IN: Action, 2012: 404.

Rock, Howard B., Deborah Dash Moore, and David Lobenstine. *Cityscapes: A History of New York in Images*. New York: Columbia University Press, 2001.

Rodgers, Cleveland, and Rebecca B. Rankin. *New York: The World's Capital City, Its Development and Contributions to Progress*. New York: Harper, 1948.

Roditi, Eduardo. "Manhattan Novelties." *Burning City: Poems of Metropolitan Modernity*. Eds. Jed Rasula and Tim Conley. Notre Dame, IN: Action, 2012: 427.

Roman, Kenneth. *The King of Madison Aveune*. New York: Palgrave Macmillan, 2009.

Rooney, Jim. *Organizing the South Bronx*. Albany, NY: State University of New York Press, 1995.

Rorem, Ned. "From *The New York Diary*." *Writing New York: A Literary Anthology*. Ed. Phillip Lopate. New York: Library of America, 1998: 813–4.

Rosenblum, Constance. *More New York Stories: The Best of the City Section of* The New York Times. New York: New York University Press, 2010.

Rosenfeld, Paul. "From *Port of New York.*" *Writing New York: A Literary Anthology.* Ed. Phillip Lopate. New York: Library of America, 1998: 463–72.

Rosenwaike, Ira. *Population History of New York City.* Syracuse, NY: Syracuse University Press, 1972.

Roth, Philip. *Goodbye, Columbus and Five Short Stories.* Boston: Houghton Mifflin, 1959.

Royte, Elizabeth. *Garbage Land: On the Secret Trail of Trash.* New York: Little, Brown, 2005.

Russo, Vito. "Why We Fight." ACT UP New York. May 9, 1986. Web. 07 Aug. 2014.

Rybczynski, Witold. "New York's Rumpus Room." *New York Times.* June 21, 2003. Web. 30 Nov. 2014

Rydell, Robert W. *World of Fairs: The Century-of-Progress Expositions.* Chicago: University of Chicago Press, 1993.

Salinger, J. D. *The Catcher in the Rye.* Boston: Little, Brown, and Company, 1951.

"Samuel Beckett Attends a Doubleheader." *Lapham's Quarterly.* N.p., n.d. Web. 07 Dec. 2014.

Samuel, Lawrence R. *The End of Innocence: The 1964–1965 New York World's Fair.* Syracuse, NY: Syracuse University Press, 2007.

———. *New York City 1964: A Cultural History.* Jefferson, NC: McFarland, 2014.

Sánchez, Lucía. "Cinemas." *Burning City: Poems of Metropolitan Modernity.* Eds. Jed Rasula and Tim Conley. Notre Dame, IN: Action, 2012: 306.

Sanders, Ed. *Tales of Beatnik Glory.* New York: Stonehill Pub, 1975.

Sanders, James. *Celluloid Skyline: New York and the Movies.* New York: Knopf, 2001.

Sante, Luc. "Commerce." *New York Calling: From Blackout to Bloomberg.* Eds. Marshall Berman and Brian Berger. London: Reaktion Books, 2007: 102–12.

———. *Low Life: Lures and Snares of Old New York.* New York: Farrar, Straus and Giroux, 1991.

———. "My Lost City." *New York Review of Books.* November 6, 2003. Web. 31 July 2014.

Sartre, Jean-Paul. *We Have Only This Life to Live: Selected Essays of Jean-Paul Sartre, 1939–1975.* New York: NYRB Classics, 2013.

Sassen, Saskia. *The Global City.* Princeton, NJ: Princeton University Press, 1991.

Schäfer, Horst. *New York in the Sixties.* Cadolzburg, DE: Ars Vivendi, 2003.

Scheerbart, Paul, Bruno Taut, and Dennis Sharp. *Glass Architecture*. New York: Praeger, 1972.

Schiavi, Michael R. *Celluloid Activist: The Life and Times of Vito Russo*. Madison, WI: University of Wisconsin Press, 2011.

Schmidt, Elizabeth, ed. *Poems of New York*. New York: Knopf, 2002.

Schmitz, Kate. "Sex Before Dot.com." *New York Calling: From Blackout to Bloomberg*. Eds. Marshall Berman and Brian Berger. London: Reaktion Books, 2007: 266–76.

Schneider, Daniel B. "Sign Language Signs." *New York Times*. November 1, 1998. Web. 20 Dec. 2014.

Schneider, Daniel B. "Chateau Brooklyn." *New York Times*. January 9, 1999. Web. 09 Dec. 2014.

Schulman, Sarah, and Hubbard, Jim. "Interview with Gregg Bordowitz." *ACT UP Oral History Project*. December 17, 2002. PDF.

———. "Interview with Robert Vazquez-Pacheco," *ACT UP Oral History Project*. December 14, 2002. PDF.

———. "Interview with Sandy Katz." *ACT UP Oral History Project*. October 16, 2004. PDF.

Schulyer, James. *Collected Poems*. New York: Farrar, Straus and Giroux, 1995: 244.

Schwartz, Delmore. *Last & Lost Poems*. New York: New Directions, 1989.

Secundus, Junius. "The SoHoiad: or, The Masque of Art: A Satire in Heroic Couplets," from Robert Hughes, *Nothing If Not Critical: Selected Essays On Art And Artists*. New York: Knopf, 1990.

Seferis, George. "Tuesday." *Burning City: Poems of Metropolitan Modernity*. Eds. Jed Rasula and Tim Conley. Notre Dame, IN: Action, 2012: 303.

Segal, Gillian Zoe. *New York Characters*. New York: W. W. Norton, 2001.

Seifert, Jaroslav. "!! Hello!!" *Burning City: Poems of Metropolitan Modernity*. Eds. Jed Rasula and Tim Conley. Notre Dame, IN: Action, 2012: 462.

Sennet, Richard. *The Uses of Disorder*. London: Faber, 1996.

Serviss, Garrett Putman. *The Second Deluge*. London: Grant Richards, 1912.

Severini, Gino. "Rescherche nouvelle de Gino Severini." *Burning City: Poems of Metropolitan Modernity*. Eds. Jed Rasula and Tim Conley. Notre Dame, IN: Action, 2012: 49.

Severo, Richard. "Mining Trash Heap for Answers to Riddles." *New York Times*. October 4, 1989. Web. 30 Nov. 2014.

Sewall-Ruskin, Yvonne. *High on Rebellion: Inside the Underground at Max's Kansas City.* New York: Thunder's Mouth Press, 1998.

Shapiro, Fred C., and James W. Sullivan. *Race Riots: New York, 1964.* New York: Crowell, 1964.

Sharpe, William Chapman. *New York Nocturne.* Princeton, NJ: Princeton University Press, 2008.

Shefter, Martin. *Capital of the American Century: The National and International Influence of New York City.* New York: Russell Sage Foundation, 1993.

"She'll Be Good to You." *The Big Round Table.* N.p., n.d. Web. 31 July 2014.

Shepherd, Jean. "The Night People: Dig the Folk," *The Village Voice Reader: A Mixed Bag from the Greenwich Village Newspaper.* Eds. Daniel Wolf and Edwin Fancher. Garden City, NY: Doubleday, 1962: 156.

Shershenevich, Vadim. "The Rhythm of the Future." *Burning City: Poems of Metropolitan Modernity.* Eds. Jed Rasula and Tim Conley. Notre Dame, IN: Action, 2012: 31.

Sieden, Lloyd Steven. *Buckminster Fuller's Universe.* Cambridge, MA: Perseus Publishers, 1989.

Silver, Nathan. *Lost New York.* Boston: Houghton Mifflin, 1967.

Silverman, Kenneth. *Begin Again: A Biography of John Cage.* New York: Knopf, 2010.

Simpich, Frederick. "Spin Your Globe to Long Island." *National Geographic.* April 1939: 281.

Singer, Issac Bashevis. "The Cafeteria." *Wonderful Town: New York Stories from* The New Yorker. Eds. David Remnick and Susan Choi. New York: Random House, 2000: 271–84.

Sischy, Ingrid. "A Society Artist." *Robert Mapplethorpe.* Ed. Richard Marshall. Boston: Little, 1988.

Small, Michael. "Art After Midnight." *People.* August 20, 1984. Vol. 22 No. 8. Web. 26 Nov. 2014.

Smith, Chris. "Central Park Revisited." *New York Magazine*, n.d. Web. 06 Dec. 2014.

Smith, Francis Hopkinson. *Charcoals of New and Old New York.* Garden City, NY: Doubleday, Page, 1912.

Smith, Howard. "Postscript to Christmas." *The Village Voice Reader: A Mixed Bag from the Greenwich Village Newspaper.* Eds. Daniel Wolf and Edwin Fancher. Garden City, NY: Doubleday, 1962: 69.

Smith, Patrick S. *Warhol: Conversations about the Artist.* Ann Arbor, MI: UMI Research, 1988.

Solis, Julia. *New York Underground: The Anatomy of a City*. New York: Routledge, 2005.

Spillane, Mickey. "My Gun Is Quick." *The Mike Hammer Collection, Vol. 1*. New York: New American Library, 2001. Epub.

Springer, J. F. "The Hudson River Subway." *Technical World Magazine*. Vol. 9, 1908: 332.

Stahl, Kenneth. "Harlem Riot 1964." *Detroit's Great Rebellion*. N.p., n.d. Web. 17 Aug. 2014.

Stanton, Jeffery. "Coney Island - Globe Tower Swindle." *Coney-Globe Tower Swindle*. N.p., 1997. Web. 06 Aug. 2014.

Steele, Tom. "Quentin Crisp: Bourne to Play." *Out*. January 2001.

Stefanile, Felix. *The Blue Moustache*. London: The Carcanet Press, 1981.

Stein, Gertrude. *Paris France*. New York: Liveright, 1940/2013.

Stein, Jean, and George Plimpton. *Edie: American Girl*. New York: Grove Press, 1982.

Stern, Anatol. "Europe." *Burning City: Poems of Metropolitan Modernity*. Eds. Jed Rasula and Tim Conley. Notre Dame, IN: Action, 2012: 515.

Stern, Gerald. "96 Vandam." *This Time: New and Selected Poems*. New York: W. W. Norton, 1998: 55.

Stern, Susan. *With the Weathermen: The Personal Journey of a Revolutionary Woman*. New York: Doubleday, 1975.

Stern, Zelda. *The Complete Guide to Ethnic New York*. New York: St. Martin's, 1980.

Stettner, Louis. *Louis Stettner's New York, 1950s–1990s*. New York: Rizzoli International Publications, 1996.

"Steve Brodie (Bridge Jumper)." *Wikipedia*. Wikimedia Foundation, n.d. Web. 05 Jan. 2015.

Stevens, Mark, and Annalyn Swan. *De Kooning: An American Master*. New York: Knopf, 2004.

Stevens, Wallace. *Letters of Wallace Stevens*. New York: Knopf, 1966.

Stieglitz, Alfred. "Letter to Sherwood Anderson." *Alfred Stieglitz: Photographs & Writings*. Eds. Alfred Stieglitz, Sarah Greenough, and Juan Hamilton. Washington, D.C.: National Gallery of Art, 1983.

Stieglitz, Alfred, Sarah Greenough, and Juan Hamilton. *Alfred Stieglitz, Photographs & Writings*. Washington, D.C.: National Gallery of Art, 1983.

Still, Bayrd. *Mirror for Gotham: New York as Seen by Contemporaries from Dutch Days to the Present*. New York: Fordham University Press, 1956.

————. *New York City, A Students' Guide to Localized History*. New York: Teachers College, Columbia University Press, 1965.

Stokes, I. N. Phelps. *The Iconography of Manhattan Island, 1498–1909*. New York: Arno, 1967.

————. *New York Past and Present: Its History and Landmarks 1524–1939: One Hundred Views Reproduced and Described from Old Prints, Etc., and Modern Photographs*. New York: Plantin, 1939.

Stone, Michael. "Robert Chambers, Jennifer Levin, and a Death That Shocked the City." *New York Magazine*. November 10, 1986. Web. 06 Dec. 2014.

Straubenmüller, Gustave. *A Home Geography of New York City*. Boston: Ginn, 1905.

Strausbaugh, John. *The Village: 400 Years of Beats and Bohemians, Radicals and Rogues: A History of Greenwich Village*. New York: Ecco, 2013.

"Straw Hat Riot." *Wikipedia*. Wikimedia Foundation. July 20, 2014. Web. 22 July 2014.

Strong, George Templeton, Allan Nevins, and Milton Halsey Thomas. *The Diary of George Templeton Strong*. New York: Macmillan, 1952.

Strunsky, Simeon. "When the City Wakes." *Harper's Monthly*. October 1914: 697–706.

Subscriber. "Dislikes Negroes in Harlem." *New York Times*. July 7, 1912: 10.

Sullivan, Al. "Liza Williams: The Forgotten Beat." *Scrap Paper Review*. N.p., n.d. Web. 21 Dec. 2014.

Sullivan, C. J. *1001 Greatest Things Ever Said About New York*. Guilford, CT: The Lyons Press, 2006.

Swenson, G. R. "What Is Pop Art? Answers from 8 Painters, Part 1." *I'll Be Your Mirror: The Selected Andy Warhol Interviews*. Ed. Kenneth Goldsmith. New York: Carroll & Graf, 2004: 15–20.

Szeman, Imre, and Timothy Kaposy. *Cultural Theory: An Anthology*. Chichester, NY: Wiley-Blackwell, 2011.

Talbot, Allan R., and Klaus Lehnartz. *New York in the Sixties*. New York: Dover Publications, 1974.

Talese, Gay. *New York: A Serendipiter's Journey*. New York: Harper, 1961.

Tallack, Douglas. "New York, New York." The 3Cities Project: New York. November 16, 2000. Web. 06 Dec. 2014.

Talman, C. F. "Now the Windowless Building with its Own Climate." *New York Times*. Aug 10, 1930: 4.

Teale, Edwin. "Building A World's Fair." *Popular Science*. March 1938: 35–8.

Teasdale, Sara. *The Collected Poems of Sara Teasdale.* New York: Macmillan, 1937: 50.

Tester, Keith. *The Flâneur.* London: Routledge, 1994.

Thomas, Pat. *Down These Mean Streets.* New York: Knopf, 1967.

Thomas, Phil. "Brave New World: A Giant Rubbish Heap? Garbage Explosion Threatening." *Palm Beach Post-Times.* November 24, 1968.

"Tiger Morse." *Born Late.* N.p., March 25, 2011. Web. 12 Aug. 2014.

Tomlinson, Charles. "All Afternoon." *Poems of New York.* Ed. Elizabeth Schmidt. New York: Knopf, 2002: 137.

Tonkiss, Fran. *Space, the City and Social Theory: Social Relations and Urban Forms.* Cambridge, UK: Polity, 2005.

"Topics of the Day: New York's Meat Riot." *The Literary Digest.* April 23, 1910: 798.

"Topsy (elephant)." *Wikipedia.* Wikimedia Foundation. April 8, 2014. Web. 11 Aug. 2014.

Torres-Padilla, José L., and Carmen Haydée Rivera. *Writing Off the Hyphen: New Critical Perspectives on the Literature of the Puerto Rican Diaspora.* Seattle, WA: University of Washington Press, 2008.

Toth, Jennifer. *The Mole People: Life in the Tunnels Beneath New York City.* Chicago: Chicago Review, 1993.

Trager, James. *The New York Chronology.* New York: HarperResource, 2003.

Trebay, Guy. *The Place To Be.* Philadelphia: Temple University Press, 1994.

Trotsky, Leon. *My Life.* New York: Charles Scribner's Sons, 1930.

Tucker, Marcia. *A Short Life of Trouble.* Berkeley, CA: University of California Press, 2008.

"Tuli Kupferberg." *Wikipedia.* Wikimedia Foundation. October 8, 2014. Web. 11 Aug. 2014.

Turner, George Kibb. "Red Friday." *The Saturday Evening Post.* April 26, 1919.

Turner, Grady T. *NYC Sex: How New York City Transformed Sex in America.* London: Scala, 2002.

Turner, Mark W. *Backward Glances: Cruising the Queer Streets of New York and London.* London: Reaktion Books, 2003.

Tytell, John. *The Living Theatre: Art, Exile, and Outrage.* New York: Grove, 1995.

Vale, Lawrence J., and Sam Bass Warner. *Imaging the City: Continuing Struggles and New Directions*. New Brunswick, NJ: Center for Urban Policy Research, 2001.

Valenti, John. *Imagining 9/11*. Self-published, 2011. PDF.

Van Dorston, A. S. "A History of Punk." *Fast N Bulbous*. N.p., n.d. Web. 30 July 2014.

Van Vechten, Carl. *Parties: Scenes from Contemporary New York Life*. Los Angeles: Sun & Moon, 1993.

Varèse, Louise. *Varèse: A Looking Glass Diary*. Vol. 1. New York: W. W. Norton, 1972.

ve Poljanski, Branko. "Journey to Brazil." *Burning City: Poems of Metropolitan Modernity*. Eds. Jed Rasula and Tim Conley. Notre Dame, IN: Action, 2012: 364.

Venturi, Robert, Denise Scott Brown, and Steven Izenour. *Learning from Las Vegas: The Forgotten Symbolism of Architectural Form*. Cambridge, MA: MIT, 1977.

Vinea, Ion. "Empty Words." *Burning City: Poems of Metropolitan Modernity*. Eds. Jed Rasula and Tim Conley. Notre Dame, IN: Action, 2012: 54.

Vining, Donald. *A Gay Diary 1954–1967*. New York: Pepys, 1979.

Voronca, Ilarie. "Ulysses in the City [IX]." *Burning City: Poems of Metropolitan Modernity*. Eds. Jed Rasula and Tim Conley. Notre Dame, IN: Action, 2012: 463.

Vreeland, Diana, *The Diana Vreeland Papers,* Box 38, New York Public Library.

Vreeland, Diana, George Plimpton, and Christopher Hemphill. *D.V.* New York: Knopf, 1984.

Waldman, Anne. *Another World: A Second Anthology of Works from the St. Mark's Poetry Project*. New York: Bobbs-Merrill, 1971.

Walford, Jonathan. *Sixties Fashion*. London: Thames & Hudson, 2013.

Walker, Stanley. *The Night Club Era*. New York: Frederick A. Stokes, 1933.

Walker, Stephen. *Gordon Matta-Clark: Art, Architecture and the Attack on Modernism*. London: I. B. Tauris, 2009.

Wall, Diana diZerega. *The Archaeology of Gender: Separating the Spheres in Urban America*. New York: Plenum, 1994.

"Wall Street - Greed Is Good." *American Rhetoric*, n.d. Web. 19 Aug. 2014.

Wallock, Leonard, ed. *New York, Culture Capital of the World, 1940–1965*. New York: Rizzoli, 1988.

Walrod, Jim. *I Knew Jim Knew*. New York: powerHouse Books, 2014.

Walton, Eda Lou. "Lorca's Poems." *The New Masses*. June 4, 1940: N. pag.

Warhol, Andy, and Pat Hackett. *America*. New York: Harper & Row, 1985.

———. *The Andy Warhol Diaries*. Ed. Pat Hackett. New York: Warner, 1989.

———. *I'll Be Your Mirror: The Selected Andy Warhol Interviews*. Ed. Kenneth Goldsmith. New York: Carroll & Graf, 2004.

———. *The Philosophy of Andy Warhol: From A to B and Back Again*. New York: Harcourt Brace Jovanovich, 1975.

———. *POPism: The Warhol '60s*. Comp. New York: Harcourt Brace Jovanovich, 1980.

Wark, McKenzie. Email to author, September 3, 2014.

———. *The Beach Beneath the Street: The Everyday Life and Glorious Times of the Situationist International*. London: Verso, 2011.

Waterman, Bryan. *Marquee Moon*. New York: Continuum, 2011.

Watson, Steven. *Factory Made: Warhol and The Sixties*. New York: Pantheon Books, 2003.

———. *Strange Bedfellows: The First American Avant-garde*. New York: Abbeville, 1991.

"Weather Underground." *Wikipedia*. Wikimedia Foundation. November 29, 2014. Web. 30 Nov. 2014.

Weberman, A. J. *My Life in Garbology*. New York: Stonehill, 1980. PDF.

Weegee. *Naked City*. New York: Essential Books, 1945.

———. *The Village*. New York: Da Capo Press, 1989.

Weideman, Ryan. *In My Taxi: New York after Hours*. New York: Thunder's Mouth, 1991.

Weintraub, Max. "Andy Warhol and the Anxiety of Effluence." *Art 21 Blog*. ART21 Magazine. October 4, 2012. Web. 08 Dec. 2014.

Wellmer, Albrecht. *Endgames: The Irreconcilable Nature of Modernity: Essays and Lectures*. Cambridge, MA: MIT, 1998.

Wells, H. G. *The War in the Air*. London: Bell, 1908.

"When City Sanitation Workers Went on Strike." *Ephemeral New York*. N.p., 10 August 10, 2010. Web. 06 Sept. 2014.

Whitaker, Jan. "The Craftsman, a Model Restaurant." *Restauranting through History*. N.p., November 7, 2011. Web. 13 Dec. 2014.

———. *Service and Style: How the American Department Store Fashioned the Middle Class*. New York: St. Martin's, 2006.

White, E. B. *Here Is New York*. New York: Harper, 1949.

White, Edmund, and Robert Mapplethorpe. *Altars*. New York: Random House, 1995.

White, Norval. *New York: A Physical History*. New York: Atheneum, 1987.

Whitehead, Colson. *The Colossus of New York: A City in Thirteen Parts*. New York: Doubleday, 2003.

Wilcock, John. "Gay Street: One Block—but You Can't See One End from the Other." *The Village Voice Reader: A Mixed Bag from the Greenwich Village Newspaper*. Eds. Daniel Wolf and Edwin Fancher. Garden City, NY: Doubleday, 1962: 142–5.

———. "The New Girl in Town," *The Village Voice Reader: A Mixed Bag from the Greenwich Village Newspaper*. Eds. Daniel Wolf and Edwin Fancher. Garden City, NY: Doubleday, 1962: 155.

———. "New Neighbor (Chapter 2)." *The Village Voice Reader: A Mixed Bag from the Greenwich Village Newspaper*. Eds. Daniel Wolf and Edwin Fancher. Garden City, NY: Doubleday, 1962: 164.

Wilkinson, Alec. "The Hidden Life." *Central Park: An Anthology*. Ed. Andrew Blauner. New York: Bloomsbury, 2012: 136–44.

"William Grant Still." *Wikipedia*. Wikimedia Foundation, n.d. Web. 03 Jan. 2015.

Williams, Emmett and Ann Noël. *Mr. Fluxus: A Collective Portrait of George Maciunas, 1931–1978*. New York: Thames and Hudson, 1998.

Williams, Mason B. *City of Ambition. FDR, La Guardia, and the Making of Modern New York*. New York: W. W. Norton, 2013.

Williams, William Carlos. *The Collected Poems of William Carlos Williams*. New York: New Directions, 1986.

Wilson, Edmund. *The American Earthquake: A Documentary of the Twenties and Thirties*. Garden City, NY: Doubleday, 1958.

———. "Thoughts on Leaving New York for New Orleans." *Writing New York: A Literary Anthology*. Ed. Phillip Lopate. New York: Library of America, 1998: 476–8.

Wilson, Peter Lamborn. "Under the Tar Beach." *Resistance*. Ed. Clayton Patterson. New York: Seven Stories Press, 2007. 101–3.

Wilson, Rufus Rockwell. *New York: Old & New: Its Story, Streets, and Landmarks*. Philadelphia & London: J. B. Lippincott, 1902.

Winkleman, Michael. *The Fragility of Turf: The Neighborhoods of New York City*. Albany, NY: New York State Museum, 1986.

Wirth, Louis. *On Cities and Social Life: Selected Papers*. Ed. Albert J. Reiss, Jr. Chicago: University of Chicago Press, 1964.

Wojnarowicz, David, *In the Shadow of the American Dream: The Diaries of David Wojnarowicz*. New York: Grove, 1999.

Wolf, Daniel, and Edwin Fancher, eds. *The Village Voice Reader: A Mixed Bag from the Greenwich Village Newspaper.* Garden City, NY: Doubleday, 1962.

Wolf, Reva. *Andy Warhol, Poetry, and Gossip in the 1960s.* Chicago: University of Chicago Press, 1997.

Wolf, Stephen, ed. *I Speak of the City: Poems of New York.* New York: Columbia University Press, 2007.

Wolfe, Thomas. *Of Time And The River: A Legend Of Man's Hunger In His Youth.* New York: Charles C. Scribner's Sons, 1935.

———. *You Can't Go Home Again.* New York: Simon and Schuster, 2001.

Wolfe, Tom. "A Sunday Kind of Love." *The Kandy-Kolored Tangerine-Flake Streamline Baby.* New York: Farrar, Straus and Giroux, 1965.

———. *From Bauhaus to Our House.* New York: Washington Square Press, 1981.

———. *The Bonfire of the Vanities.* New York: Farrar, Straus and Giroux, 1987.

———. *The Painted Word.* New York: Picador, 1975.

Wolitzer, Meg. "Rain, Rain, Come Again." *New York Times.* June 28, 2003. Web. 22 Dec. 2014.

Wondrich, David. *Imbibe!: From Absinthe Cocktail to Whiskey Smash, a Salute in Stories and Drinks to "Professor" Jerry Thomas, Pioneer of the American Bar.* New York: Perigee Book/Penguin Group, 2007. Epub.

Wooster, Ann-Sargent. "Sol LeWitt's Expanding Grid." *Art in America,* 68 no. 5. May 1980: 143–7.

Wornov, Mary. *Swimming Underground.* Boston: Journey Editions, 1995.

The WPA Guide to New York City: The Federal Writers' Project Guide to 1930s New York. New York: Pantheon, 1982.

Wynn, Jonathan R. *The Tour Guide: Walking and Talking New York.* Chicago: University of Chicago Press, 2011.

X, Malcolm. *The Autobiography of Malcolm X.* New York: Grove Press, 1966.

Yau, Jon. "An Incomplete History of New York Galleries." *New York Calling: From Blackout to Bloomberg.* Eds. Marshall Berman and Brian Berger. London: Reaktion Books, 2007: 277–86.

Yellen, Samuel. *American Labor Struggles.* New York: Harcourt, Brace, 1936.

Yeoash. "Broadway." *Burning City: Poems of Metropolitan Modernity.* Eds. Jed Rasula and Tim Conley. Notre Dame, IN: Action, 2012: 407.

Young, Ian. "The Poppers Story." *Duesberg on AIDS. Steam*, Vol. 2, Issue 4, n.d. Web. 31 July 2014.

Young, Ian. *The Stonewall Experiment: A Gay Psychohistory*. London: Cassell, 1995.

Zukin, Sharon. *Naked City: The Death and Life of Authentic Urban Places*. Oxford, UK: Oxford University Press, 2010.

Lily Applebaum, Laura Beiles, Derek Beaulieu, Vicki Bennett, Charles Bernstein, Marcus Boon, Christian Bök, Robert Buck, Mairead Byrne, Simon Castets, Howie Chen, Mathieu Copeland, Peter Decherney, Cheryl Donegan, Craig Dworkin, Pamela Echeverria, Al Filreis, Mashinka Firunts, Robert Fitterman, Bettina Funcke, Claudia Gould, Pablo Helguera, Jens Hoffman, Andrew Hsaio, Anne Jamison, The Jewish Museum, Bill Kennedy, Philip Leventhal, Claire MacCrory, Chus Martinez, Katie McGowan, MoMA Public Programs and Education, Simon Morris, Tracie Morris, Ingo Niermann, Hans Ulrich Obrist, Marjorie Perloff, Lucia della Paolera, Vanessa Place, Seth Price, Rachel Rosenfelt, Kim Rosenfield, Ingrid Schaffner, Lytle Shaw, Sarah Shin, Richard Sieburth, Danny Snelson, Paul Stephens, Jacob Stevens, Mika Tajima, Marvin Taylor, Nick Thurston, Alan Thomas, McKenzie Wark, Jenna Weiss, Darren Wershler, Wendy Woon, David Wondrich.

Portions of this work were presented at the 2012 Works-in-Progress Festival in Iowa City. Short excerpts from this book's pre-publication Twitter feed were printed in *Convolution 3*.

"Method of the project: literary montage, I needn't say anything. Merely show. I shall purloin no valuables, appropriate no ingenious formulations. But the rags, the refuse—these I will not inventory but allow, in the only way possible, to come into their own: by making use of them."

Walter Benjamin, <u>The Arcades Project</u>